NATIONAL GALLERY CATALOGUES
THE SEVENTEENTH CENTURY
FRENCH PAINTINGS

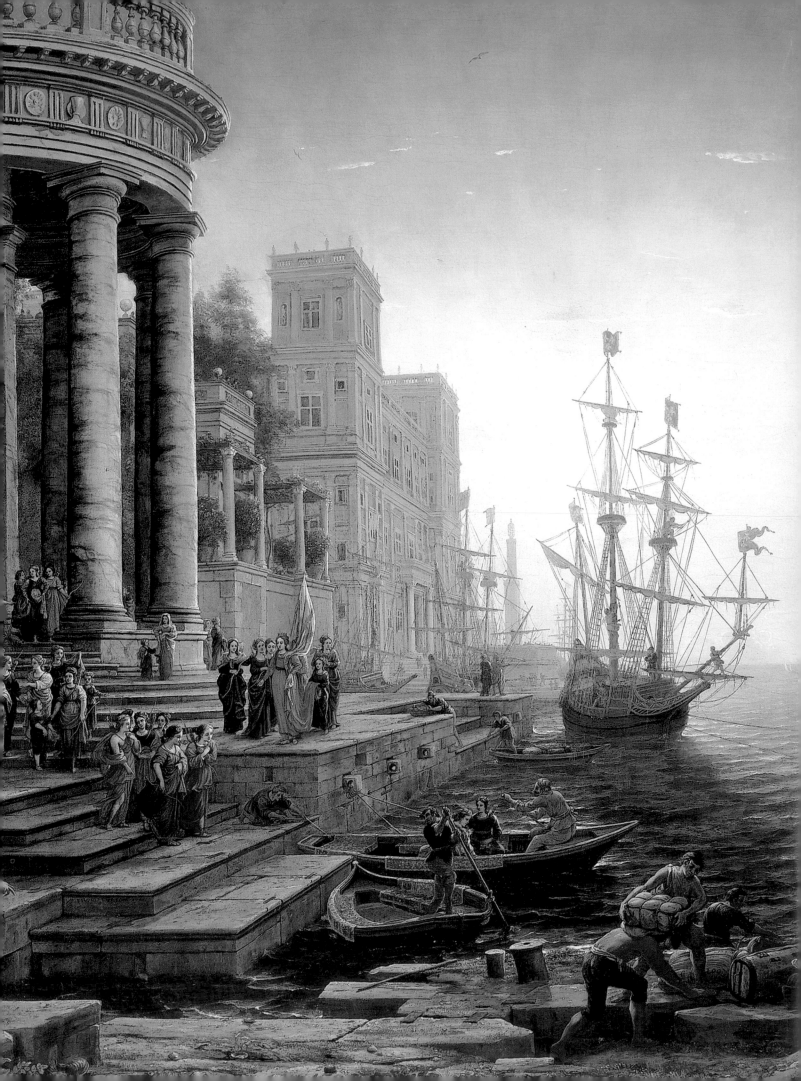

NATIONAL GALLERY CATALOGUES

THE SEVENTEENTH CENTURY FRENCH PAINTINGS

Humphrey Wine

National Gallery Company, London

Distributed by Yale University Press

This catalogue has been generously supported by The Arthur and Holly Magill Foundation through the American Friends of the National Gallery, London, Inc.

Dedicated to Sir Denis Mahon and in memory of Michael Kitson (1926–1998)

First published in Great Britain in 2001 by
National Gallery Company Limited
St Vincent House, 30 Orange Street, London WC2H 7HH
www.nationalgallery.co.uk

ISBN 1 85709 283 X hardback
525312

British Library Cataloguing-in-Publication Data
A catalogue record is available from the British Library
Library of Congress Catalog Card Number: 2001095555

Edited by Diana Davies
Designed by Gillian Greenwood
Typeset by Helen Robertson
Managing editor: Jan Green
Picture researchers: Francesca Geens and Cristina Robins

FRONTISPIECE: Claude, *Seaport with the Embarkation of Saint Ursula* (NG 30), detail
PAGE VI: Laurent de La Hyre, *Allegory of Grammar* (NG 6329), detail
PAGES XXXII–XXXIII: Nicolas Poussin, *A Bacchanalian Revel before a Term* (NG 62), detail

Printed and bound in Italy by Grafiche Milani

Contents

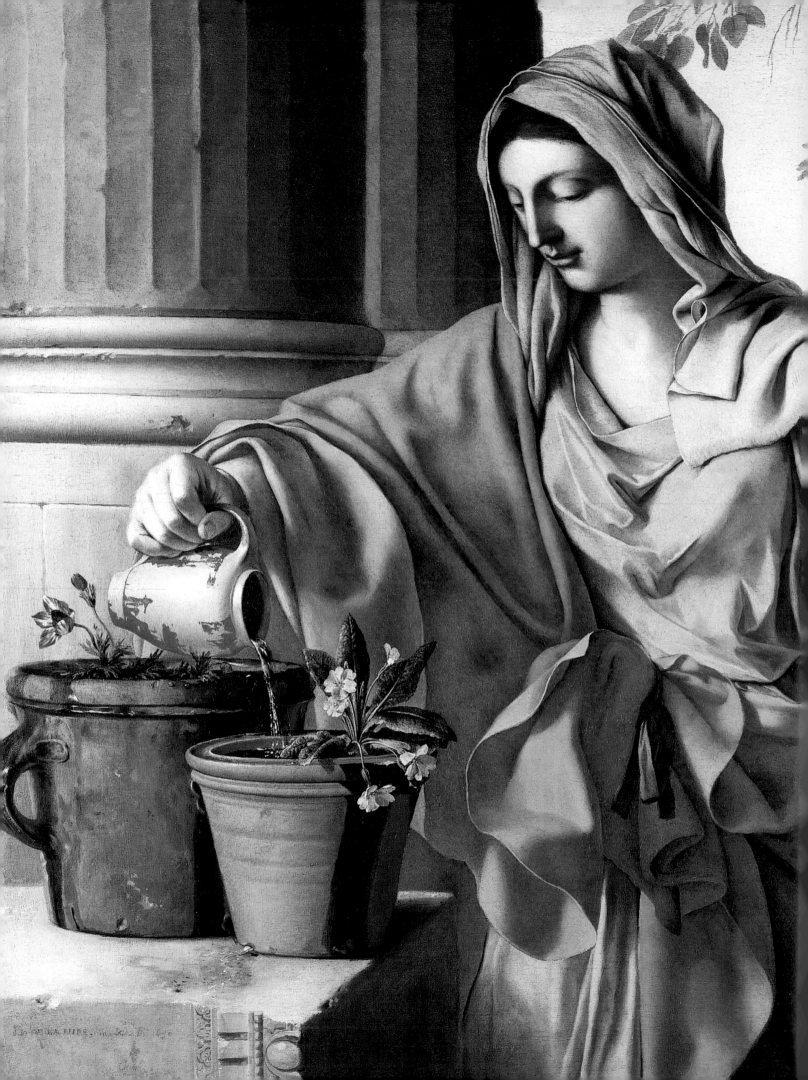

Foreword

During the Second World War, when the entire collection of the National Gallery was evacuated to a remote slate mine in Wales, the curatorial staff accompanied it into involuntary exile. There, with no duties of public display or presentation to claim their time, they embarked on the work of compilation and research that was to result, in the decades after 1945, in a series of catalogues of the collection which were internationally acclaimed as setting new standards. The editor of the series was the then Keeper, William Gibson, but the defining presence was without question Martin Davies, later Director of the Gallery, a scholar of laconic and frequently acid style and of indefatigable erudition.

These catalogues are one of the proudest traditions of the National Gallery, exemplary in their succinct presentation of fact and cautious advancement of hypothesis. Yet all Gallery catalogues need to be constantly updated, rewritten and republished. We must keep pace with new acquisitions and with what has been learnt and revealed during conservation work. We need to incorporate new information about the pictures and their painters resulting from continuing scholarly research. Advances in techniques of scientific examination have, over the past forty years, transformed our understanding of how a great many pictures were made. Finally, new methods of photography and reproduction have ensured that the recent publications in this latest series are not only works of energetic scholarship, but are distinguished by the clarity and accuracy of their colour plates, technical photography, enlargement of details and comparative illustrations. The editor of this new series is the current Keeper, Nicholas Penny.

The present volume, compiled by Humphrey Wine, deals with the French pictures of the seventeenth century.

It is a collection dominated by two artists: Claude and Poussin, both represented in depth. The Poussins are probably the strongest group outside the Louvre, the Claudes certainly the finest collection in any museum in the world. Yet their histories are very different. When the National Gallery opened its doors in 1824, it had more paintings by Claude than by any other artist – a tribute to the huge esteem in which he was held in Britain. The Poussins, on the other hand, have for the most part been acquired since the Second World War and illustrate every phase of Poussin's long and influential career; their acquisition is also in large measure a vicarious homage to that hero of twentieth-century artists, Cézanne.

Publications of this kind are, needless to say, extremely expensive to produce and must be subsidised if they are to be made available at prices affordable not just by libraries and specialists, but by a wider interested public and by students. The Gallery is delighted to report that a succession of benefactors has made it possible to publish and print these catalogues to ever rising standards, for sale at moderate prices. For this, our thanks, and the thanks of all those who use and enjoy these catalogues, are due to a distinguished company of donors, ranging from corporations such as Unilever and the British Land Company plc, through charitable organisations such as the Getty Grant Program and the American Friends of the National Gallery, to individual friends and supporters such as Anthony Speelman. Our latest, and perhaps our greatest, debt of gratitude is to Arturo and Holly Melosi, whose magnificent generosity, through The Arthur and Holly Magill Foundation, has secured the future for the rest of this series of National Gallery catalogues.

Neil MacGregor, DIRECTOR

Preface and Acknowledgements

This is a catalogue of the National Gallery's French seventeenth-century paintings. 'Seventeenth century' is exact, but 'French' is not. For one thing, all the paintings by Claude, De Nomé, Dughet, Poussin and Valentin included in this volume were painted in Italy. Philippe de Champaigne, three of whose works are in the Gallery's collection, was Flemish by origin and French only by naturalisation. Claude, whose works form a substantial part of this catalogue, was called Le Lorrain because he was born in the Duchy of Lorraine, which did not become part of France until 1766. Hence, there is the anomaly that the works of a non-Frenchman working outside France are called French. Nevertheless, they have long been so classified both by art historians and by the wider public, so it would not be helpful, even if it would be more accurate, to entitle this catalogue 'More or less French seventeenth-century paintings'. In any event, had I started down that path – given that the two paintings by Parrocel may have been painted a little after 1699 rather than a little before 1700, and the *Holy Family with Saint Elizabeth* after Poussin (NG 1422) is certainly later than seventeenth century, although after a seventeenth-century composition – I should have been driven to adopt the title 'More or less French paintings of the seventeenth century or thereabouts'.

This elastic definition of the term 'French' has allowed me to include some paintings which elude certain attribution but which may be or may not be French. Among these is one picture which, although in the collection since 1837, has never before been included in any 'Schools' catalogue. *Phineus and his Followers turned to Stone* (NG 83), once attributed to Poussin, escaped Martin Davies's French School catalogue of 1957, presumably because he regarded it as Flemish. However, by the time Gregory Martin published *The Flemish School circa 1600–circa 1900* in the same series in 1970, NG 83 had, like some border town during the campaigns of Louis XIV, become French again. Another picture which Davies excluded, but which is included here, is De Nomé's *Fantastic Ruins with Saint Augustine and the Child* (NG 3811). Davies reserved it for the seventeenth-century Italian School, but it was not in fact included when that catalogue was published in 1986. A picture which Davies did include, and which I have retained, is the portrait of *Cardinal de Retz* (NG 2291). Davies ascribed it to Philippe de Champaigne, but here it is given to the Flemish painter Jakob Ferdinand Voet. My excuse for stretching the definition of 'French' this far is the previous attribution and the certain (French) identity of the sitter. Doubtless, if the attribution of NG 2291 to Voet is generally accepted, it will in due course appear also in the catalogue of the Gallery's seventeenth-century Flemish paintings. On the other hand, four pictures which were in Davies's catalogue are excluded, NG 1862, an *Adoration of the Shepherds* after Poussin, was

transferred to the Victoria and Albert Museum in 1960, and NG 2757, a drawing of the *Entrance to Hell* ascribed by Davies to Jean-Bernard-Honoré Toro but not necessarily seventeenth century, was transferred to the British Museum in 1995. The other exclusions, *Landscape with Figures* and *Landscape with Fishermen* (NG 2723 and NG 2724, both called 'Style of Gaspard Dughet' by Davies), have been published in the Gallery's literature since 1995 as attributed to the Italian painter Crescenzio Onofri, and will appear in due course in the catalogue of seventeenth-century Italian paintings. The Gallery's paintings by André Bouys (formerly ascribed to Robert Tournières) and by or after Largillière and Rigaud, all artists who straddled the seventeenth and eighteenth centuries, are eighteenth-century paintings and therefore do not belong here.

Since Martin Davies's catalogue was published in 1957 there have been a significant number of additions to this part of the collection, including works by artists not previously represented. Moreover, the literature on French seventeenth-century painters has grown enormously. Davies did not have the benefit of either Marcel Roethlisberger's catalogue raisonné on Claude's paintings (1961) or that of Anthony Blunt on those of Poussin (1966), or the several publications by Sir Denis Mahon which have been so important for our understanding of Poussin's chronology. In the wake of the 400th anniversary of Poussin's birth there has been a spate of publications devoted to the artist, including a magisterial catalogue raisonné of his drawings by Rosenberg and Prat (1994). An equally comprehensive catalogue of Claude's drawings was published by Roethlisberger in 1968, and Claude studies, while not as numerous as Poussin studies, have benefited from some substantial exhibition catalogues as well as from Michael Kitson's book on the British Museum's *Liber Veritatis* (1968). Major publications have been devoted to, among others, Bourdon, Philippe de Champaigne, Dughet, La Hyre, the Le Nain brothers and Le Sueur. Additionally, our knowledge of French seventeenth-century collections has been increased by archival researches, including those of Mireille Rambaud and Antoine Schnapper. More generally, provenance studies have benefited from the interest in collecting generated by Francis Haskell, one reflection of which is the exhaustive analyses of auction records edited by Burton Fredericksen at the Getty Institute for Art History. I hope this summary of some of the recent literature helps to explain why I felt it better to begin again rather than just to revise Davies's catalogue. Nevertheless, that catalogue has provided the groundwork for much of the research and methodology of this one, and I am greatly indebted to it.

I have also benefited from the help given in many different ways by past and present colleagues in the National Gallery,

not least those in the Curatorial Department, in the Conservation and Scientific Departments, without whom the Technical Notes would have been impossible, in the Library, to whose good humour and patience I am much indebted, in the Photographic Department, whose contribution is evident on nearly every page, and in the editorial department and publishing team of National Gallery Company, with whom it has been a pleasure to work. My decision not to name individuals in no way reflects any lack of appreciation on my part, but rather an awareness that, while in preparing this catalogue I have had close contact with many colleagues, it is a Gallery-wide project to which numerous others have contributed.

As to those outside the Gallery, I wish firstly to express gratitude to The Arthur and Holly Magill Foundation for its generous support for the production of this catalogue. I wish particularly to thank Sir Denis Mahon and Richard Verdi, both of whom read my draft Poussin entries 'cover to cover', and to record my deep appreciation of the late Michael Kitson, who was reading and commenting upon my draft Claude entries during his last illness. I would also like to record thanks to the staff of numerous institutions, including the Archives Nationales and the Bibliothèque Nationale in Paris, the British Library, the British Museum's Department of Prints and Drawings, the Courtauld Institute Library, the National Art Library, the Warburg Institute and the Witt Library in London, and the Frick Collection Library in New York. I am also delighted to be able formally to thank the following archivists, art historians, collectors, conservators, dealers, librarians, owners and others who have helped me, often more substantially than a mere mention may suggest, at the same time apologising to those whose names I have inadvertently omitted on account of my poor filing system and my worse memory:

Monique Antilogus, John Ayers, Isabel Azcàratc, Colin B. Bailey, Forest R. Bailey, Joseph Baillio, Thierry Bajou, István Barkóczi, Lord Barnard, Kathryn Barron, Victoria Beck Newman, Sergio Benedetti, Hanna Benesz, Richard Beresford, Jean Bergeret, Joseph Bergin, Nancy Bialler, Olivier Bonfait, Michel Borjon, Jean-Claude Boyer, Helen Braham, Emma Braid-Taylor, Arnauld Brejon de Lavergnée, Hugh Brigstocke, Sonja Brink, Christopher Brown, Emanuelle Brugerolles, Caterina Caneva, Juliet Carey, Patrizia Cavazzini, Marjorie Caygill, Janice H. Chadbourne, Alain Chevalier, Gilles Chomer, Paulette Choné, Arabella Cifani, Martin Clayton, Eric Coatalem, James Collett-White, Natalie Coural, Anne-Marie Cousin, Earl of Crawford and Balcarres, Andrea Czère, N. Daliès, Véronique Damian, Earl of Darnley, Christopher Date, Sonia Dean, Ian Dejardin, Jan de Maere, Madeleine de Terris, Marianne de Voogd, Brigitte Donon, Gosem C. Dullaart, JoLynn Edwards, Judy Egerton, Christine Ekelhart, Mark Evans, Jean-Louis Faure, Richard Feigen, Frank Felsenstein, Celia Fisher, Brendan Flynn, Jean-Charles Forgeret, Burton Fredericksen, Gabriele Frings, Clara Gelly-Salidas, Nigel Glendenning, Carl Goldstein, Elise Goodman, Richard Green, Antony Griffiths, Linda Gurr, Brett Harrison, Earl of Harrowby, François Heim, Kristina Herrmann Fiore, Michel Hilaire, Michel Hochman, Martin Hopkinson, Victoria Hutchings, Mary Jackson Harvey, Paul Joannides, Derek Johns, Susan Jones, Paul Joyner, Henry Keazor, George Keyes, Mary Kisler, Christian Klemm, Gerbrand Kotting, Guy Kurajevski, Yves Lacambe, Alastair Laing, Helen Langdon, Graham Larkin, Marie-Hélène Lavallé, Sylvain Laveissière, Agatha Leach, Jean Le Pottier, Christophe Leribault, Jean Letherby, Sir Michael Levey, Reino Liefkes, Iva Lisikewycz, Christopher Lloyd, James Lomax, John Lonsdale, Michael Loup, Lord Lucas of Crudwell, Doron Lurie, Rosemary MacLean, Vera Magyar, John Mallet, David R. Marshall, Claire McCarthy, Elizabeth McGrath, Julian Melgrave, Manuela B. Mena Marqués, Alain Mérot, Patrick Michel, Elizabeth Miller, James Mitchell, Eric Moinet, Franco Monetti, Jennifer Montagu, Andrew Moore, Gabriel Naughton, Rupert Neelands, Angela Negro, Jacques Nicourt, Susan North, Francesca Odell, John Orbell, Mark Ormond, Karen Otis, Felicity Owen, S.E. Owens, Mrs L.B. Palmer, Mireille Pastoureau, Mark Patton, Jean Penent, Sarah Perry, Francesco Petrucci, Jordana Pomeroy, A.W. Potter, Michel Rerolle, Jeremy Rex-Parkes, Aileen Ribeiro, Mary L. Robbins, Robin Robertson-Glasgow, Delphine Robin, John Martin Robinson, Marcel Roethlisberger, Cindy Roman, Pierre Rosenberg, Martin Royalton-Kisch, Ruth Rubinstein, Xavier Salmon, Peter Schatborn, John E. Schloder, Antoine Schnapper, Maurice Segoura, François-Gerard Seligmann, Maurice Shellim, Tessa Sidey, Devorah Simon, Clare Simpson, Michael Simpson, Kim Sloan, Michael Snodin, Lawrence E. Stager, Timothy Standring, Anne Starkey, Perrin Stein, William G. Stout, Anne Thackray, Monique Théron-Navatel, Judy Throm, Michael Tollemache, Jennifer Tonkovich, Patrizio Turi, Cindy van Weele, Shirley Veer, Roy Vickery, James Waldegrave, Susan Ward, Moana Weil-Curiel, Paul J. Weis, Robert Wenley, Jane Wess, Aidan Weston-Lewis, Lance Whitehead, Jon Whiteley, Clovis Whitfield, Erich Wilberding, Joshua Wine, Philip Winterbottom, Hugh Woodeson, James Yorke, Henri Zuber.

Finally, as with so many other challenging tasks I have faced, my wife Carol has given me unfailing support and encouragement. My deepest debt is to her.

Collecting French Seventeenth-Century Paintings in England

In 1834 a painting, once among the best known in Europe, went into limbo. Placed high above eye level, and set into an ornate oval frame which covered a fifth of its surface, Eustache Le Sueur's *Alexander and his Doctor* (NG 6576) became a forgotten fixture in a London house, substantially lost to view and certainly lost to scholarship for more than 150 years.[1] Yet when Lady Amabel Lucas bought the picture in 1799 to hang in her family mansion in St James's Square, it had enjoyed one hundred years of celebrity, and its subsequent relegation to a merely decorative function would have been as shocking to her contemporaries as the fact that such a demeaning role for so long went unnoticed. The fate of the Le Sueur was an extreme one. It is fair to say, however, that it illustrates the yo-yo of fashion which has beset the appreciation of individual French seventeenth-century painters in England and from which even Poussin has not been exempt. Perhaps the ideal way to assess shifts in taste would be to offer a detailed analysis of collecting trends from the mid-seventeenth century until the present day, but in the current state of knowledge that would be impossible.[2] There are too many gaps for the earlier years concerning what passed through the art market, and too many problems of attribution. Moreover, any merely statistical analysis would leave out of account the appeal of individual paintings, along with the views of individual collectors and critics who inevitably had their own particular preferences. What is here offered, therefore, can only be an overview with the generalisations which that approach necessarily involves.

Fig. 1 Simon Vouet, *Martha and Mary Magdalene*, c.1625. Oil on canvas, 110 × 140 cm. Vienna, Kunsthistorisches Museum.

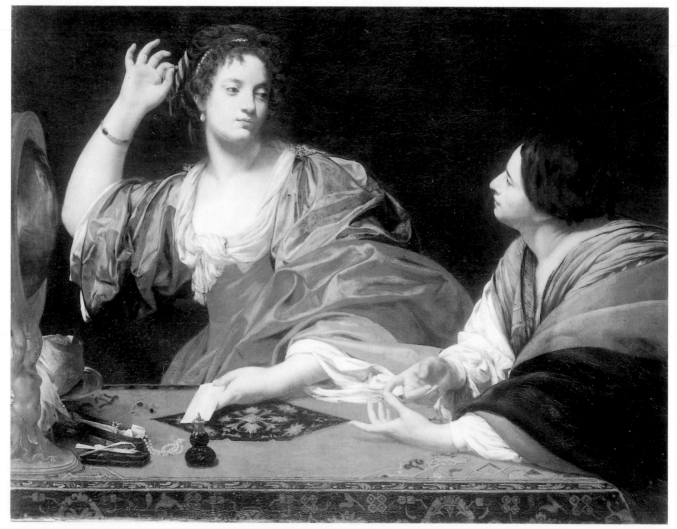

The Seventeenth Century

For a small group of Charles I's courtiers, as well as for the king himself, the 1620s were a period of passionate acquisition. Thomas Howard, Earl of Arundel (1585–1646), George Villiers, Duke of Buckingham (1592–1628), and James, Marquis of Hamilton (1606–49), all formed major collections. The focus of their acquisitions was the Italian Renaissance, although they also acquired Flemish paintings. At this period the British would have had little idea of a stylistically distinctive French School, whether contemporary or of old masters, and in any event the number of pictures by French artists in these courtly collections was insignificant. Arundel's collection had none,[3] but Buckingham's collection, although formed too early to have included a Poussin,[4] contained a Vouet, namely *Martha and Mary Magdalene* (Vienna, Kunsthistorisches Museum, inv. no. 255; fig. 1).[5] Simon Vouet, who was the principal painter at the French court during the 1630s, would have been better known than Poussin during Buckingham's lifetime. Nevertheless, although his name was recalled when the *Martha and Mary Magdalene* was pawned from the Buckingham collection in May 1649,[6] an inventory of 1635 referred to him only as 'Frenchman'.[7] Two other paintings then noted were 'A Frenchm[ns] Work – A little piece of a Supper. / An Italian with a Ruffle', making a total of three anonymous French pictures in a collection of some 330 paintings.[8]

Some portraits of French sitters in the royal collection were, as might be expected, by French painters. Otherwise a catalogue of the collection, completed by 1639, recorded only two paintings there attributed to a French artist, namely 'A peece of Fruict, with Raddishes' by Louise Moillon and another still life by the same artist described more fully in 1640 as 'A Baskett of Aprecocks, grapes & plumbes'.[9] Vouet sent paintings to England for King Charles I. None can be identified with certainty, but one likely candidate is the *Diana* (Royal Collection), which may have been painted as an overdoor.[10] The king's collection included no painting by Poussin, a strange omission given that in the 1630s Cardinal Francesco Barberini was selecting pictures by artists then working in Rome to send to Charles I[11] and did in fact present paintings by Poussin to the French and Imperial Courts.

The first painting attributed to Poussin known to have entered an English collection was a 'quadro d'amorini di monsù Poussino' bought in 1639 by Lord Feilding for James, Marquis of Hamilton – probably the copy now at Wilton House after two of the figures in *A Bacchanalian Revel before a Term* (NG 62).[12] This painting was evidently peripheral within the Hamilton collection, which consisted of some six hundred pictures, and may have been bought as a contemporary rendering of the type of art (Venetian) which appealed to its owner.[13] Certainly the painting was not representative of Poussin's style at the time Feilding bought it. Few other French paintings are recorded in this country before the Restoration of the monarchy in 1660: two large history pictures 'supposed to bee [sic] of [Sébastien] Bourdon', but not in fact by him, a *Rape of Europa* and a *Judgement of Midas* probably painted in Italy in the years 1634–7, were in Sir Ralph Bankes's collection by

1659;[14] and two landscapes by Claude, the National Gallery's *Landscape with Narcissus and Echo* (NG 19) and *Landscape with a Temple of Bacchus* (Ottawa, National Gallery of Canada) were painted in 1644 for 'Angletere', according to Claude's *Liber Veritatis*. Unfortunately, he did not record the name of his patron. These paintings were most likely the first of many by Claude which came to England during the next two hundred years.

The pattern of royal collecting did not greatly change after the Restoration. Of 72 pictures which the king agreed to buy in 1660 from the art dealer William Frizell, most were Italian and many were Dutch or Flemish. Probably only three were French: 'A small peece of Pu—[ss?]in', 'One peece of the painting of Burdon [Bourdon]', which, as the description 'in the manner of Bassan[o]' makes clear, was not typical of Bourdon's style after he had returned to France, and the *Saint Jerome reading* by Georges de La Tour which was described in Frizell's list as 'of the manner of Albert Durer'! As has recently been pointed out, what is remarkable is the absence of a taste for French paintings, which Charles II might have been expected to have acquired during his exile in France.[15] In the later years of the seventeenth century, the importation of French paintings, itself not especially significant numerically, seems to have gone hand in hand with a growing English taste for landscape. By 1700 there were at least a half-dozen Claudes in England.[16] Some were sold at the Lely sale of 1682. Claude's *Landscape with Jacob and Laban* (Petworth House, National Trust) figured in the second (cancelled) Banqueting House sale four years later when it and Claude's small *Landscape with an Imaginary View of Tivoli* on copper (Courtauld Institute of Art) – or more probably the larger version on canvas at Petworth – belonged to Sir Robert Gayer (c.1639–1702).[17] These, and other sales which took place in London in 1691 and 1692, also included paintings by, or attributed to, Poussin and Dughet.[18] Those 'by' Poussin included copies of *The Four Seasons*, the originals of which are in the Louvre.[19] Besides landscapes, a *Mount Parnassus* and a *Bacchanal* by Poussin were sold in London in 1684;[20] John Evelyn singled out for praise a Poussin *Entombment of Christ* in Lord Newport's collection in 1685;[21] and among the pictures which the young Sir Thomas Isham (1657–81) bought in Rome in 1677 was a copy of Poussin's *Death of Germanicus* (Minneapolis Institute of Art) the original of which was described in a list, probably made soon after Isham's death, as 'ye Originall famous'.[22]

By the second half of the century Poussin's works were being praised in an increasing number of English-language publications. The first such reference to Poussin, and to a French school of painting, was by the historian and writer William Sanderson, who noted in 1658: 'The ancient French Masters were Le petit Barnard [Bernard Salomon], Voget [Vouet], Lehere [La Hyre], Blancher [Blanchard], And at present, the most Excellent Nicholas Posen [Poussin] for History, Foquere [Fouquière] and Claude Delaverne [presumably Claude Lorrain], for Landskip.'[23] When Sanderson wrote this, prints after Poussin were most probably available in England,[24] paintings by Vouet[25] and Claude were certainly in English collections, and quite possibly prints after La Hyre and

Jacques Blanchard had by then arrived. For the remainder of the seventeenth century, however, neither La Hyre nor Blanchard was mentioned in any English-language publication. Indeed, the only French painter named in William Lodge's translation of Giacomo Barri's account of painting in Italy, *The Painters Voyage of Italy* (1679), was Poussin.[26] Poussin was also the only French painter singled out in the translation of Henri Testelin's *Sentimens* published in England in 1688 with explanatory marginal notes by the (anonymous) translator. One of these notes is worth quoting as an indication of the early pre-eminence of Poussin in English-language appreciation:

> There was in these French Tables [of Precepts] a Picture to express the Ordonnance, but because 'tis lost by me, I think it enough to send you to Raphael's *Gymnasium Atheniense* [i.e. *The School of Athens* in the Vatican], and the like, especially the seven Sacraments, and the rest of Poussins things the only *Tramontan* [i.e. North European] Painter that the Italians seem to envy, and who is glorious on the account of the Expression, his Ordonnances, which are exact as to the particular Groups, Masses, advantageous Contrasts, and the Union of the Tous ensemble.[27]

Another example of the pre-eminence of Poussin may be found in Elsum's *Epigrams* published in 1700. These were a series of poems mainly devoted to individual paintings. The relatively large reading public to which Elsum's book was addressed, and the dreadful quality of his poetry, may be judged from Epigram CXLV on a *Saint Cecilia* by (Pierre?) Mignard: 'Here's nothing seen unworthy of Mignard,/ Nothing too faint, and nothing that's too hard.'[28] Mignard would probably have been relieved that Elsum epigrammatised only one other of his works. Le Brun and Jacques Callot had one epigram each devoted to them, but Poussin had five, in one of which he is called 'great Poussin the Raphael of France'.[29]

In *A Short Account of the Most Eminent Painters*, first published in 1695, Richard Graham cited as authorities for his remarks on the French School the French authors Félibien, de Piles and Perrault. Certainly, when Graham wrote of Poussin's 'Colouring inclined rather to the antique Marble, than to Nature' he echoed the criticism of de Piles. Graham's book went into several editions over the following seventy years or so, as did translations of works by de Piles, although many English collectors also read books on art in Latin, French and Italian.[30] In general, Graham found Poussin worthy of the highest praise ('in expressing the Passions and Affections with such incomparable Skill, ... all his Pieces seem to have the very Spirit of the Action, and the Life and Soul of the Persons they represent...'). On the other hand, Vouet, while Graham allowed that he had agreeable colouring and a brisk and lively pencil, was described as having 'no Genius for grand Composition' and of being 'unhappy in his Invention, unacquainted with Rules of Perspective' and so on. Le Brun fared better, albeit, in another echo of de Piles, with reservations about his colouring and his use of chiaroscuro.[31] Graham's omissions were significant. He found no room to discuss a number of French painters who had figured in Félibien's *Entretiens*, namely Blanchard, Jean-Baptiste de Champaigne, Philippe de Champaigne, La Hyre, the brothers Le Nain, Le Sueur, or even Jacques Stella in spite of his evidently Poussiniste style and the fact that two of his paintings were at Ham House by 1683.[32]

The two artists who emerged from Graham's *Short Account* with unqualified praise were Claude, who spent most of his working life in Rome, and Dughet, who lived and died in Rome. They, together with Poussin, who also worked mainly in Rome, would dominate English taste for French seventeenth-century painting well into the nineteenth century. It was the treatment by English art lovers of these three artists as part of the Roman School of painting which underpinned their overwhelming critical success relative to that of other French artists during the eighteenth century.[33]

It is tempting to conclude from Graham's comments and omissions that enthusiasm for Claude, Dughet and Poussin, to the exclusion of other French painters, emerged early, but some major qualifications must be made. Firstly, Graham's comments were, as he acknowledged, based on comments made by French authors and cannot be characterised as specifically English. De Piles was scathing of Vouet, Claude Vignon and Philippe de Champaigne, and critical of Le Sueur, La Hyre and Bourdon, excepting, however, La Hyre's and Bourdon's landscapes.[34] Only Raphael and Poussin were the objects of Félibien's unreserved admiration. Secondly, most of the more important seventeenth-century French painters who had worked in Paris had devoted much of their production to altarpieces for religious institutions or to decorative schemes, works not easily – or at least not happily – removed from the buildings for which they were made. By contrast Claude, Poussin and Dughet mainly produced easel paintings which could readily change hands. While their works, including some of the best known, found their way on to the market, those of Charles Le Brun, for example, were for the most part available only in the form of prints. The success in England of the series of prints after Le Brun's *Battles of Alexander* cautions against assuming that taste for French seventeenth-century painting can be measured solely by the number of paintings by French artists in English collections.[35] Thirdly, some patrons, in spite of supporting the Protestant cause, were francophile in taste, notably Ralph Montagu, who had been on several embassies to France. He brought over Charles de La Fosse, Jacques Rousseau and Jean-Baptiste Monnoyer to decorate Montagu House in about 1690,[36] also acquiring *Christ in the House of Martha and Mary* by Michel Corneille the Younger and portraits by Bourdon.[37] Finally, if there were a taste which could be called English at this time, for some it was determined by nationalistic prejudice rather than the relative merits of individual artists. Buckeridge, in Savage's translation of de Piles, ridiculously claimed that he would prove that 'the English Painters and paintings, both for their Number and their Merit, have a better Claim to the Title of a School, than those of France'.[38] The fact that for this purpose Buckeridge counted Monnoyer, Orazio and Artemisia Gentileschi, Holbein, Rousseau and Van Dyck as English reveals the poverty of his

position. In any event, if there were a battle for supremacy in the hearts of English picture collectors, it was between France and Italy:

> ...this College [Rome and Florence] teaches Force
> and Grace,
> And therefore justly claims the highest Place....
> The School of France has no establish'd Fashion,
> Its most peculiar way is Elevation.
> Observe their Works, and you will quickly see,
> In ev'ry Piece, Briskness and Gaiety.[39]

Elsum's verses suggest that no more with Poussin than without could France upset Italian supremacy.[40]

The Eighteenth Century

With the exception of *The Annunciation* (NG 5472), which was certainly in a British collection by 1802, all the Poussins now in the National Gallery probably arrived in England during the eighteenth century. Many came from France before the start of the French Revolution in 1789 – that is to say, at a time when French collectors could have bought them had they wished to do so. The trend for British collectors to acquire paintings by Poussin began in 1717 with James Thornhill's import from France of the *Tancred and Erminia* (Birmingham, The Barber Institute of Fine Arts; fig. 2). The purchase was celebrated both visually and in print. *Sir James Thornhill showing his Poussin to his Friends* (Fredericton, New Brunswick, Beaverbrook Art Gallery, Gift of Sir Alec Martin; fig. 3), attributed to Gawen Hamilton, was presumably commissioned by Thornhill. Probably shown at the right of the picture, resting his arm on his son's shoulder, is the collector, painter and writer Jonathan Richardson Sr,[41] who soon afterwards published *An Essay on the whole Art of Criticism as it relates to Painting*. The comment in Richardson's book on Poussin's *Tancred and Erminia* formed the first extended analysis of a French painting to originate in England.[42] Richardson, after correctly identifying the subject from Tasso's *Gerusalemme*, praised the picture's colours – itself significant in the context of some earlier critics' negative views on that aspect of Poussin's art[43] – the expression of emotions in it, and the artist's imaginative powers, concluding that 'The Painter has made a finer Story than the Poet'.[44] However, Richardson had reservations about some other paintings by Poussin.[45] Moreover, there was no question of taste for Poussin being promoted above that for the Roman/ Bolognese school – in spite of his praise of the *Tancred and Erminia*, Richardson was even more enthusiastic about an Annibale Carracci in Thornhill's collection ('But oh! the Sublimity of Expression!'). Nevertheless, Richardson's publication (with his son) of *An Account of Some of the Statues, Bas-reliefs, Drawings and Pictures in Italy, &c. with Remarks* described paintings in Paris collections by Poussin and, with the exception of a portrait by Le Brun, only by Poussin among French painters. This further familiarised the English reading public both with the French master and with the idea of his supremacy within the French School.

In 1722, the same year that Richardson's *Account* was published, the tariff on goods imported from France was

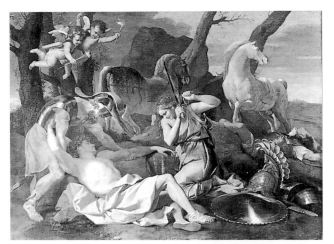

Fig. 2 Nicolas Poussin, *Tancred and Erminia*, c.1634. Oil on canvas, 75.5 × 99.7 cm. Birmingham, Barber Institute of Fine Arts.

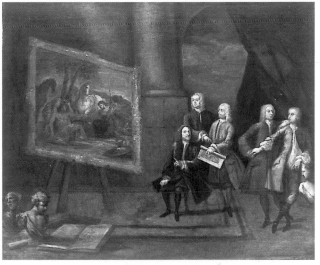

Fig. 3 Attributed to Gawen Hamilton, *Sir James Thornhill showing his Poussin to his Friends*, c.1730. Oil on canvas, 62.9 × 75.6 cm. Fredericton, New Brunswick, Beaverbrook Art Gallery. Gift of Sir Alec Martin.

reduced to the same level as those on goods imported from elsewhere. Given the relative ease of travel to France compared to Italy, France became a readier source from which to buy paintings.[46] During the following years, among the more significant pictures by Poussin imported from France – or lost to France, as the French eighteenth-century dealer/connoisseur Pierre-Jean Mariette saw it[47] – were *Moses striking the Rock*, *The Holy Family with Saint John and Saint Elizabeth* and *The Continence of Scipio*, which were in Sir Robert Walpole's collection by 1741 (all are now in the Hermitage). In the same year *The Adoration of the Golden Calf* (NG 5597) and its companion *The Crossing of the Red Sea* (Melbourne, National Gallery of Victoria) were bought in Paris for Sir Jacob de Bouverie, and in 1743 *The Triumph of Bacchus* (Kansas City) and *The Triumph of Pan* (NG 6477) were seen by Vertue in Peter Delmé's collection in London; *The Crucifixion* (Hartford, Wadsworth Atheneum) was in England by 1744, *Landscape with Orion* (New York, Metropolitan Museum of Art) in 1745, and *The Arcadian Shepherds* (Chatsworth) probably by 1751. Other pictures by Poussin imported from France later in the century included

The Rape of the Sabines (New York, Metropolitan Museum of Art), which belonged to Henry Hoare at Stourhead by 1762,[48] *The Finding of Moses* (NG 6519) and *Landscape with a Man killed by a Snake* (NG 5763), both in England by 1773, and the two Phocion landscapes by the following year, while *Landscape with Pyramus and Thisbe* (Frankfurt, Städelsches Kunstinstitut) had arrived in London from Italy by 1750. In addition, Sir Robert Walpole would have bought the Dal Pozzo *Sacraments* at a date before 1745 had the pope not stopped their export from Rome.[49] The Chatsworth *Arcadian Shepherds* was engraved in 1763 as one of the *Collection of Prints, Engraved from the most Capital Paintings in England* published by John Boydell,[50] but English connoisseurs did not restrict their admiration of Poussin to his paintings in England: Poussin's *Et in Arcadia Ego* then in the French royal collection (Paris, Musée du Louvre) inspired poetry and paintings, as well as a sculpted group at Shugborough in Staffordshire executed by Thomas Scheemakers between 1745 and 1773.[51]

Paradoxically, growing admiration for Poussin in England went hand in hand with the growth of nationalism and of distaste for the French, who were said to be vain, frivolous and effeminate.[52] For Thomas Hollis, who visited Paris in 1753, Poussin seemed 'the only Frenchman that never fell in any degree into the flutter and affectations of his country; on the contrary, all is propriety, simple, natural, and graceful, with him'.[53] Such sentiments are echoed in George Turnbull's praise of Poussin's 'manly Temper, his Accuracy, his penetrating solid Judgement, & his high Idea of the moral uses to which Painting might be rendered conducive'.[54] The connection between national character and painting style became a commonplace in comments on the French School. Writing of his visit to the Orléans Collection, the author of *The English Connoisseur* claimed that 'he could not but often smile to see the tawdry productions of [the French] artists set upon a level, nay sometimes, with true French vanity, even jostling or thrusting aside the divine productions of the Italian Pencils'.[55] It may have been this general denigration of the French school which led Reynolds to reclassify those French painters he admired. In his Fourth Discourse, delivered to students of the Royal Academy in 1771, he stated: 'The best of the French school, Poussin, Le Sueur, and Le Brun, have formed themselves upon these models (Roman, Florentine, Bolognese), and consequently may be said, though Frenchmen, to be a colony from the Roman school.'[56] Such views seem to have been widely held. On her visit to Paris in 1778, Lady Amabel Yorke, later to become Lady Amabel Lucas and future owner of Le Sueur's *Alexander and his Doctor*, noted two rooms in the Luxembourg Palace with pictures by (mainly) Claude and Poussin before characterising the next room as 'Pictures of the French School, few good';[57] and Robert Bromley maintained that Claude and Poussin should be 'most properly considered as of the Roman school, although they were natives of other situations'.[58]

Although Horace Walpole counted Poussin, Claude and Dughet as French, he called Claude 'the Raphael of Landscape-Painting', thus investing him with the same rank as the Italian Renaissance painter whom he regarded, along with Guido Reni and Annibale Carracci, as perfect.[59] Claude and Dughet also benefited from the fact that their landscapes were views, or most often imaginative reconstructions of views, of Italy, painted in a classical style which experience of the Grand Tour had instilled in English collectors.[60] The rage for Claude among eighteenth- and early nineteenth-century British collectors is well known. Laing has pointed out that of the 195 paintings recorded in Claude's *Liber Veritatis* – itself bought by William Cavendish, 2nd Duke of Devonshire (1673–1729), around 1720[61] and the subject of a set of prints made by Earlom in 1774–7[62] – at least 125 have been at some time or other in a British collection.[63] Many of these arrived consequent on the French Revolution, but at least thirty came to England before then, including most famously eight Claudes bought by Thomas Coke, Earl of Leicester (1697–1759), four acquired by Frederick, Prince of Wales (1707–1751),[64] and (probably) six of the Claudes now in the National Gallery. In the 1740s Arthur Pond and the Knapton family published a series of 48 engravings after landscape paintings in British collections, of which nine were by Claude and 31 by Dughet.[65] Matthew Pilkington claimed of Claude in 1770 that 'His pictures are now very rare, especially such as are undamaged; and those are at this time so valued, that no price, however great, is thought to be superior to their merit'.[66]

Dughet's paintings were less rare than Claude's, but it is worth emphasising, because of the relatively modest prices they now fetch, the enthusiasm with which they were once collected, as is evident from their preponderance among the Pond/Knapton prints.[67] Dughet, or Gaspar Poussin as he was then more usually known, was called 'one of the greatest Masters in his age' by Richard Graham,[68] and Matthew Pilkington, although admitting some 'small imperfections', said of him that 'no painter ever studied nature to better purpose, or represented the effects of land forms more happily than Gaspar; every tree shews a proper and natural degree of agitation, every leaf is in motion'.[69] Seven of Dughet's paintings were in the sale in 1722 of Henry, 1st Duke of Portland,[70] four Dughets were bought by Frederick, Prince of Wales,[71] and paintings by Dughet were to be found at Wilton House,[72] Houghton Hall,[73] Holkham Hall[74] and Devonshire House, Piccadilly.[75] Commentators and diarists regularly mentioned his pictures when noting the more important items of a collection. Vertue, for example, on visiting the Earl of Essex's house at Cassiobury in 1731 described 'a Room with a choice Collection of good pictures' and listed works by, among others, Rubens, Giordano, Murillo, Guercino and Jacopo Bassano as well as by Dughet before concluding, 'this Collection is well worth seeing'.[76] There were enough paintings by Dughet on view for judgements to be made of their relative quality, Vertue saying of a *View of Tivoli* that it was 'the strongest of the greatest force that possible can be. Sombrous manner',[77] and Thomas Martyn noting 'Two Landskips, by Gaspar Poussin ...in his finest green manner, and extremely well preserved'.[78]

The popularity of Claude and Dughet, and to some extent Poussin, can be attributed to the English taste for the kind of landscape painting that breathed an air of antiquity, a taste which incidentally encouraged eighteenth-century British

landscapists such as Richard Wilson and Jacob More. Among French seventeenth-century painters this kind of painting was to be found in the works of Pierre Patel the Elder, whose work was eagerly acquired by eighteenth-century English collectors,[79] Francisque Millet[80] and Sébastien Bourdon. It was Bourdon who, according to Pilkington, 'in several branches of his art was an excellent painter, but, principally, in landscape',[81] and who Reynolds said 'leads us to the dark antiquity of the Pyramids of Egypt'.[82] Richardson had excepted him, along with Poussin and Le Sueur, from his general disapproval of the French,[83] and the present limited representation of Bourdon's works in British public collections does not reflect the frequency with which works by or attributed to him appeared in English eighteenth-century collections: the Prince of Wales bought a *Jacob and Rachel* in 1742;[84] Sir Charles Wyndham, 2nd Earl of Egremont (1710–63), owned three paintings by him,[85] including *Joseph sold by his Brethren* (Petworth, Sussex, National Trust) bought in London in 1756; and Thomas Martyn noted paintings by Bourdon in the collections of John Barnard and Charles Jennens, and at Chiswick, Devonshire House, Houghton Hall and Wilton.[86] His *Return of the Ark* (NG 64) was sold in London in 1775 and bequeathed by Reynolds in 1792 to Sir George Beaumont, who later gave it to the National Gallery. Finally, Bourdon's *Seven Acts of Mercy* (one of which is reproduced as fig. 4), now for the most part in a ruined state, were surely the pictures seen by Lady Amabel Lucas on her visit to George Aufrere's house in Chelsea in 1770.[87] All seven scenes take place against a background of antique architecture set in landscape and are late works made after Bourdon had fully assimilated the grave style of Poussin's own later paintings.[88] For these reasons alone they might have been expected to appeal to eighteenth-century British taste, but the *Seven Acts of Mercy* would also certainly have been associated with Poussin's *Seven Sacraments*, of which the second set, then in the Orléans collection in Paris, was especially well known.

Eustache Le Sueur was another French seventeenth-century painter admired by eighteenth-century British critics. Pilkington said he had 'extraordinary merit, but that merit is blended with great imperfections'.[89] Richardson had exempted him from his general criticism of the French, and Walpole called him a disciple of Poussin, praising his study of the Antique and of Raphael which 'had his life been longer, would have raised him high above Poussin'.[90] Reynolds also

Fig. 4 Sébastien Bourdon, *Welcoming the Strangers* (from the *Seven Acts of Mercy*), 1660s. Oil on canvas, 121.9 × 175.3 cm. Sarasota, Florida, The John and Mable Ringling Museum of Art. Bequest of John Ringling.

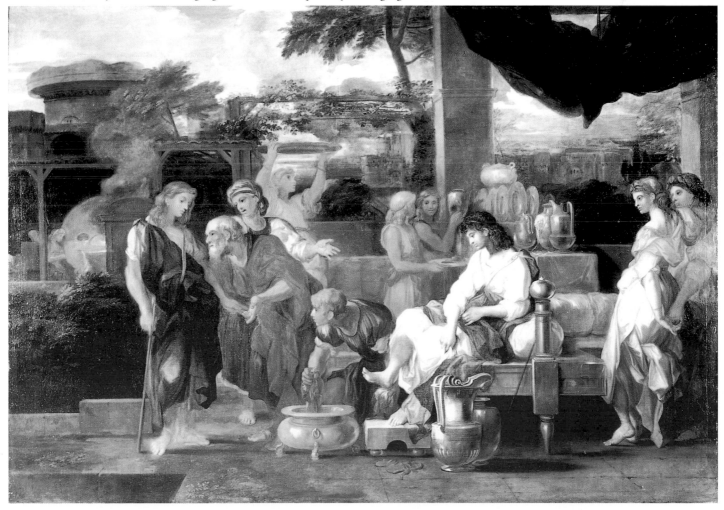

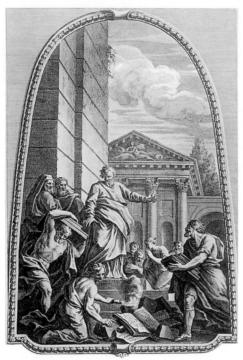

Fig. 5 Gerard Vandergucht after Sir James Thornhill, *Qui illicita tractaverant cremabant libros*, 1719. Engraving, 43.4 × 26.7 cm. London, British Museum, Department of Prints and Drawings.

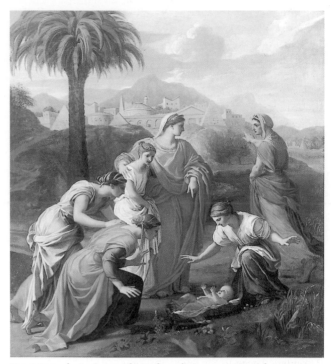

Fig. 6 Eustache Le Sueur, *The Finding of Moses*, c.1652. Oil on canvas, 105 × 101 cm. Private collection.

associated Le Sueur with Poussin, naming them both as 'great examples of simplicity'[91] and on another occasion counting him, together with Poussin and Le Brun, as the best of the French school,[92] all of which was high praise for a French artist who had never even visited Rome. In both England and France, Le Sueur's series of paintings on the life of Saint Bruno, then in the Chartreuse in Paris, excited particular praise: 'What airs of heads! What harmony of colouring! What aerial perspective! How Grecian the simplicity of architecture and drapery!'[93] It was another painting by Le Sueur, however, to which the English public (indirectly) looked up: James Thornhill's *Qui illicita tractaverant cremabant libros*, one of a series of eight paintings on the life of Saint Paul for the dome of St Paul's Cathedral that he completed in 1719,[94] prints of which were issued the same year (fig. 5), is surely influenced by Le Sueur's *Saint Paul preaching at Ephesus*, then in the cathedral of Notre-Dame, of which the National Gallery owns the sketch (NG 6299).[95]

Given Le Sueur's favourable reputation in England, it need be no surprise that his works were represented in a number of eighteenth-century collections. The Prince of Wales hung Le Sueur's *Caligula depositing the Ashes of his Mother and Brother in the Tomb of his Ancestors* (Royal Collection) over the chimney at Leicester House;[96] Horace Walpole noted 'Two emblematic Women in clouds, a design for a cieling [sic], by Le Soeur [sic], good' at Lord Ilchester's house at Redlinch;[97] and Thomas Martyn recorded Le Sueur's *Solomon and the Queen of Sheba* (Birmingham, Barber Institute of Fine Arts) at Devonshire House, Piccadilly. *The Stoning of Saint Stephen*, which Martyn described as 'remarkable for expressing a most masterly variety of grief', and *The Finding of Moses* (both St Petersburg,

Hermitage) were in Walpole's collection at Houghton Hall; a *Saint Paul before King Agrippa*, a *Nativity* and a *Hagar and Ishmael*, all attributed to Le Sueur, were in Charles Jennens's collection near Holborn; and *The Ordination of Saint Denis* (Corsham Court), now attributed to Jacques de Létin but then given to Le Sueur, was in Paul Methuen's collection in Grosvenor Street.[98] An *Annunciation* was with the 2nd Earl of Egremont;[99] *The Marriage of Tobias and Sara* was in the Bessborough collection;[100] the Earl of Harcourt had a *Holy Family*;[101] *The Martyrdom of Saint Lawrence* (Boughton House) was bought some time after 1770,[102] as were *The Finding of Moses* (fig. 6)[103] and an *Esther before Ahasuerus*.[104] To this (incomplete) list may be added the sketch for *Saint Paul preaching at Ephesus* (NG 6299) and (just) *Alexander and his Doctor* (NG 6576).[105] That some of the eighteenth-century attributions may have been wrong does not undermine the fact that Le Sueur was widely perceived as an artist worth representation in the most distinguished collections.

Le Brun was well regarded,[106] albeit with reservations about his colouring.[107] There were numerous prints after his paintings at Versailles,[108] but he was not well represented by paintings until after the French Revolution, when the pictures now at Nottingham Castle (*Hercules and Diomedes*) and Dulwich (*Horatius Cocles defending the Sublician Bridge* and *The Massacre of the Innocents*) arrived in England. *The Brazen Serpent* (Bristol, City Museum and Art Gallery; fig. 7) was bought by a Dr Ward in Paris in 1742, Horace Walpole noted a *Holy Family* at Woburn Abbey in 1751,[109] and Martyn noted a *Daedalus and Icarus* at the Walpole seat, Houghton Hall, commenting, however, that it was in 'a different manner from what he generally painted'.[110] Le Brun was best represented

on a large scale by derivative works. Tapestries after his *Battles of Alexander* hung at Hampton Court,[111] and William Kent's decoration of the King's Staircase at Kensington Palace undertaken around 1725–7 (fig. 8) has obvious affinities to Le Brun's (now destroyed) *Escalier des Ambassadeurs* at Versailles.[112] It is paradoxical that with Thornhill's crib from Le Sueur in St Paul's Cathedral and with 'Le Brun' in the royal palaces, two artists from a school of painting widely disparaged in England should dominate the decoration of some of its most important buildings.

English eighteenth-century collections had a scattering of works by other French seventeenth-century artists. The history painting – as opposed to portraiture – of Pierre Mignard was represented by *Christ and the Woman of Samaria* (Raleigh, North Carolina Museum of Art), which was in Earl Waldegrave's sale in London in 1763.[113] La Hyre seems to have been represented mainly by landscapes, which Pilkington said were the most pleasing of his works.[114] The first recorded painting by him in London was a *Narcissus* in the 1724 sale of pictures belonging to the artist Philip Mercier.[115] A *Noah and his Family sacrificing*, noted by Walpole in the Ilchester collection,[116] probably had a landscape background, as did *Rebecca bringing Presents to Laban* in Sir Sampson Gideon's collection[117] and *The Parting of Laban and Jacob*. This last picture was among the most expensive bought by Sir Charles Wyndham, Earl of Egremont.[118] Besides his appeal as a landscapist, La Hyre's principal distinction for eighteenth-century English collectors may have been that he was not Simon Vouet. The latter's only defender seems to have been the painter Joseph Highmore, who praised him highly in a then unpublished journal.[119] Few of Vouet's paintings were bought in the eighteenth century, an important exception being his *Allegory of Peace*, which has been at Chatsworth since 1715 or earlier.[120] The published critical reception of Vouet and La Hyre was lukewarm;[121] their works would have been relatively unfamiliar even to visitors to the Orléans and royal collections in Paris.[122] Although much of their production had been for decorative schemes and hence previously unavailable on the art market, this was ceasing to be true as redecoration and rebuilding of various seventeenth-century Paris *hôtels particuliers* were carried out. For example, La Hyre's *Allegory of Grammar* (NG 6329) was probably removed from its original location by 1760, and the Vouet and studio *Ceres and Harvesting Cupids* (NG 6292) by 1785. Consequently, it seems likely that these artists' relative neglect by most English collectors in the second half of the eighteenth century was a matter of choice.

French paintings that were not (principally) landscapes or by Poussin, for example genre pictures by Bourdon, also appeared occasionally in London collections and sales.[123] A painting by the Le Nain brothers was in Matthew Prior's collection by 1719,[124] and others appeared in London sales from the 1740s.[125] They subsequently joined some notable collections, for example that of Sir Luke Schaub (the painting now in Lowther Castle). A large painting now attributed to Le Maître des Cortèges (Paris, Musée Picasso; fig. 9) was installed by 1761 over a chimney at Lord Royston's house in St James's Square. When Lady Amabel Lucas later lived in the property,

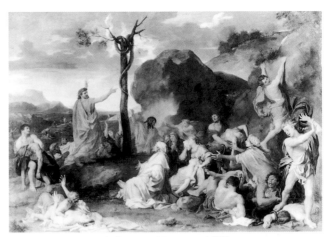

Fig. 7 Charles Le Brun, *The Brazen Serpent*, *c*.1650. Oil on canvas, 95.2 × 133.3 cm. Bristol Museums and Art Gallery.

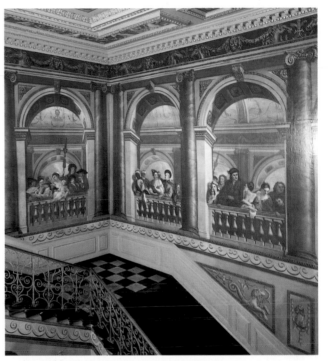

Fig. 8 William Kent, Decoration of the King's Staircase, *c*.1725–7. Oil on canvas. Windsor, The Royal Collection.

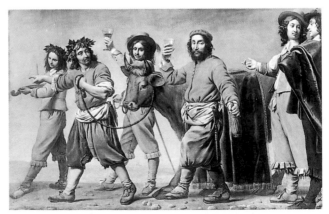

Fig. 9 Le Maître des Cortèges, *The Procession of the Ox*, *c*.1650. Oil on canvas, 108 × 166 cm. Paris, Musée Picasso.

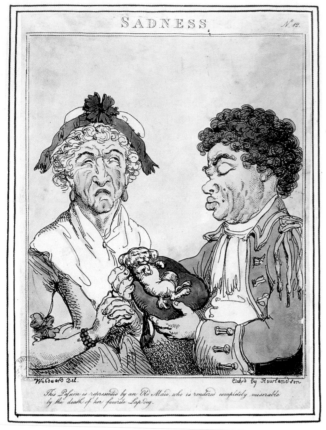

Fig. 10 Thomas Rowlandson, *Sadness*. Engraving (coloured impression), 20.4 × 17.8 cm, from *Le Brun Travested, Or Caricatures of the Passions*, London 1800. London, British Museum, Department of Prints and Drawings.

she was pleased to record that Sir George Beaumont 'without having heard [the dealer] Mr. Bryan's Opinion, thought the Men leading an Ox over the Great Room Chimney appear'd like Le Nain'.[126] Nevertheless, even an informed observer like Lady Lucas seems to have regarded the Le Nain as belonging not to the French school, but to the Dutch.[127] Conversely, paintings by the Le Nain that were not recognised as such were attributed to Italian seventeenth-century masters. This was the fate of the Le Nain in the Royal Collection,[128] which was once attributed to Caravaggio, and of *The Adoration of the Shepherds* (NG 6331), which was attributed to Giordano, albeit perhaps only in the nineteenth century. This may have been part of a pattern. Although the painter Jacques Blanchard was known, as a name at least, to eighteenth-century connoisseurs,[129] two of his paintings had attributions to Italian masters: *The Death of Cleopatra* (Reims, Musée des Beaux-Arts, inv. no. 976.7), which was in the Devonshire Collection, was given first to Paris Bordone and then to Sébastien Bourdon,[130] and a *Saint Bishop adoring the Christ Child in the Arms of the Virgin* (Paris, Musée du Louvre), once in Margam Castle, Glamorganshire, was thought to be by Savoldo until cleaning in 1942 revealed Blanchard's signature.[131] Consequently, it is not surprising that Caravaggesque pictures by French artists should have been in English collections, sometimes misattributed to Italian hands.[132] For example, La Tour's *Musicians' Quarrel* (Los Angeles, The J. Paul Getty Museum) was attributed to Caravaggio when in Lord Trevor's collection

in 1928.[133] However, Valentin's *Fortune Teller* (Toledo Museum of Art) was in the Rutland Collection at Belvoir Castle by 1788,[134] and the same artist's *Four Ages of Man* (NG 4919) was bought by J.J. Angerstein in London at the Orléans sale in 1798, both paintings under their correct attribution.

The Nineteenth Century

The enormous influx of paintings onto the art market consequent upon the French Revolution and the Napoleonic invasion of Italy did not disturb eighteenth-century patterns of taste. On the contrary, at that very period Uvedale Price, whose writings assumed his readers' complete familiarity with Claude's works, was asserting that Claude 'is a touchstone of beauty',[135] and Nelson arranged a special naval convoy to accompany William Beckford's 'Altieri Claudes' from Italy to England.[136] These were also the years when Flaxman, West, Reynolds, Haydon, Romney and Lawrence owned paintings or drawings ascribed to Poussin, or prints after him,[137] when his *Deluge* (Paris, Musée du Louvre) was being especially admired by English artists and critics,[138] and when the Marquess of Stafford created a 'Poussin Room' for the second set of the *Seven Sacraments* on opening Cleveland House to the public in 1806.[139] Had such patterns of taste not persisted well into the nineteenth century, arguably the National Gallery would not have been founded, or at least not when it was, in 1824. Then, on the back of a promise by Sir George Beaumont to give the nation his collection, which included, as then thought, four paintings by Claude, one by Poussin and one by Bourdon, public money was found to buy the Angerstein Collection, which included five paintings by Claude, two by Dughet and one then firmly attributed to Poussin. The Holwell Carr bequest of 1831 included one painting by Claude, three by Dughet and one by Poussin, and the Cholmondeley bequest of the same year included two paintings by Poussin. Poussin's *Bacchanalian Revel before a Term* (NG 62) was bought in 1826, and Lord Farnborough bequeathed a Dughet and a supposed Poussin in 1838. Since the total collection in 1838 amounted to no more than 166 paintings in all, it is fair to say that Claude, Dughet and Poussin were over-represented, albeit, in the case of Poussin, mainly by pictures of his earlier years when his style was at its most Venetian.[140]

The view that most other French painters were of little consequence persisted, however, and was in some cases reinforced by the visits English travellers made to the Louvre during the Peace of Amiens in 1802. Benjamin West was especially impressed by Poussin's *Landscape with Diogenes*, *Plague at Ashdod* and *The Deluge*, and both Hoppner and West were pleasantly surprised by Le Brun. Fuseli, however, was critical of the *Meleager* even though he considered it Le Brun's best picture, and found Poussin's expressions theatrical.[141] Le Brun's lectures on the depiction of expression had been published in English translation in 1701,[142] but his authority in this regard was questioned in England from the second half of the eighteenth century.[143] It is unsurprising that in the middle of the Napoleonic wars his depictions of the various 'passions' should have been lampooned by Thomas Rowlandson (fig. 10).[144]

If, in spite of such critical attitudes, the reputations of Poussin, Le Sueur and Le Brun largely survived the early years of the nineteenth century, those of most other French painters did not. In 1814 the portraitist William Owen criticised the modern French School for not studying Le Sueur.[145] Farington, however, found Le Sueur's *History of Saint Bruno* disappointing.[146] Poussin, Le Sueur, Le Brun, Bourdon and Mignard were said by one critic to be the only names 'that rescue France from the entire disgrace of the abandonment of the true principles of art'.[147] In her widely read *Information and Directions for Travellers on the Continent*, Mariana Starke added only the names of Claude and Jean Jouvenet (the latter in respect of one painting only) to the list of seventeenth-century French painters worth seeing in the Louvre; Philippe de Champaigne she classified among the Flemish school.[148] The 4th Marquess of Hertford (1800–70), who lived in London and Paris, assembled a group of paintings by Philippe de Champaigne of the highest quality between 1845 and his death. They are now in the Wallace Collection, but during Hertford's lifetime only one, *The Adoration of the Shepherds*, was in his London residence; there it was seen by Waagen, who described it as 'happily composed... the effect... is crude and the colouring unusually cold'.[149] No picture by Philippe de Champaigne entered the National Gallery until 1869, and the fact that both the *Triple Portrait of Cardinal de Richelieu* (NG 798) and the full-length portrait of Cardinal de Richelieu (NG 1449) were in English collections by the nineteenth century was probably more to do with the celebrity of the sitter than with the reputation of the artist, whose pictures were characterised by Scharf as 'all of a severe and somewhat academic character'.[150] In any event, the first recorded owner in this country of the full-length portrait of the cardinal, Yolande Lyne-Stephens, was French by birth and so hardly typical of English collectors.

In the great *Art Treasures of the United Kingdom* exhibition held in Manchester in 1857,[151] only 52 of the nearly 1100 old master paintings on display were either by or attributed to French seventeenth-century painters, and most of these were by Claude, Dughet and Poussin. Blanchard, La Hyre and, more surprisingly, Le Sueur were among the absentees. Bourdon was represented by one of the *Acts of Mercy* and two other pictures, Le Brun and Mignard by two pictures each, and Valentin and the Le Nain by one apiece. The under-representation of the French School was noted by the critic Thoré-Bürger, who bitterly lamented the hang of the few French paintings shown: 'Quelle perfidie britannique de les avoir classés entre les Flamands.'[152]

Charles Lock Eastlake, Director of the National Gallery from 1855 to 1865, did not respond to the 'rediscovery' of the Le Nain in mid-nineteenth-century France with any enthusiasm.[153] No Le Nain entered the collection until 1894 (six years before the bequest of two Le Nain paintings to the Victoria and Albert Museum by Constantine Alexander Ionides, who had bought them separately in London sales in 1882).[154] Despite the fact that Charles Eastlake – Keeper of the National Gallery from 1878 to 1898 and not to be confused with his namesake the former Director – lamented the inadequate representation of the French School,[155] no Le Sueur entered the collection until 1959 and no La Hyre until 1961. The Valentin *Four Ages of Man* (NG 4919) which had belonged to Angerstein, but which he had presumably considered unworthy of his prime collection in his Pall Mall residence, was presented to the Gallery by the 2nd Viscount Bearsted in 1938. Mignard's *Marquise de Seignelay* (NG 2967) was accepted as a bequest in 1914 against the then Director's advice, and the Gallery's François de Nomé (NG 3811, then thought to be by Jacques Callot) was bought by Sir Philip Sassoon, then a Trustee, and given by him to the Gallery in 1923 after the Trustees as a body had refused to buy it. Le Brun remains unrepresented, as does Georges de La Tour, although, given that the latter was scarcely known until shortly before the Second World War, the nineteenth century at least can be excused in his case.[156]

In 1853 Gustav Waagen, Director of Berlin's National Gallery, outlined what he saw as the ideal acquisition policy for the National Gallery in London. After urging enlargement of the collection of Italian paintings from what he called the 'Epoch of the Highest Development, 1500–1550', he opined that the Gallery 'already contains admirable specimens of the most distinguished masters of the [French] School, as Nicholas Poussin, Claude Lorraine, Gaspar Poussin, Watteau and Greuze; and the large number of these pictures in England renders it easy to supply any blanks as opportunities occur'.[157] Waagen was wrong in thinking that Watteau and Greuze were well represented in the National Gallery, and as regards the seventeenth-century masters named by him, their initial over-representation, combined with the potentially enormous supply from English private collections, must have made further acquisitions in this area a low priority. Indeed, between 1838 and the end of the Second World War only one painting by Claude was bought and none at all by Dughet or Poussin.

Over-representation of the works of Claude, Dughet and Poussin was, however, only part of the story, for a shift in taste was also developing. From the 1850s international money, including that of Lord Dudley, Lord Hertford, J.P. Morgan, the Pereire brothers and various Rothschilds, began pouring into French eighteenth-century art[158] – in 1853 Lord Hertford considered spending four times the market price to secure a picture by Lancret,[159] and twelve years later a new auction record for Drouais was established.[160] At the same time many newly wealthy English businessmen were intently buying works by contemporary British artists.[161] Furthermore, history painting as a whole lost its appeal in the middle years of the century.[162] The critical relegation of the Italian Baroque in particular had consequences for perceptions of the French seventeenth-century School. Thoré-Berger claimed in 1848 that Poussin's best pictures must have been made before he went to Rome, and that Vouet had seriously damaged French painting because of what he had learnt in Italy.[163] Although Le Sueur was included in the series 'The Great Masters of Art' published by *The Art-Journal* in the 1850s,[164] Ruskin called his religious work 'pure abortion and nuisance',[165] and some fifty years later Romney's biographers felt it necessary to make

excuses for their subject's admiration of the French painter.[166] England's relative neglect of the seventeenth-century French School is reflected in the absence of serious English-language art-historical literature on the subject in the second half of the nineteenth century. When the first part of *The Pictures by the Old Masters in the National Gallery photographed by Signor L. Caldesi* was published in 1868, none of the twelve paintings selected was a Claude, a Dughet or a Poussin, a situation that would have been inconceivable a generation earlier.[167]

Poussin was not exempt from criticism by English critics. Northcote called him the 'pedant of painters',[168] and Hazlitt found that his figures 'have too much gesticulation, and the set expression of the features borders too much on the mechanical and caricatured style'.[169] The Keeper of the National Gallery, Charles Eastlake, considered Poussin's *The Deluge (Winter)*, once the most admired of his paintings, 'monstrous as an ideal representation of the Deluge, and untrue to nature in every respect'.[170] Poussin's only painting of importance to enter an English collection at this time was *Dance to the Music of Time* (London, Wallace Collection), bought by Lord Hertford in 1845. The duc d'Aumale, Louis-Philippe's son, was able to buy three pictures by Poussin in London, including *The Massacre of the Innocents* (Chantilly, Musée Condé), returning with them to Chantilly at the end of his exile in 1871.[171] At

the Hamilton Palace sale of 1882, where the National Gallery was an active buyer (of Italian paintings), Poussin's *Entombment*, which *The Times* described as a 'work of considerable importance, conceived and treated in emulation of the famous picture by [Annibale Carracci] called The Three Marys',[172] was bought by the National Gallery of Ireland.[173] Early in the following century his *Inspiration of the Epic Poet* (Paris, Musée du Louvre), which had been in England since at least 1772 and which had formed one of the main attractions of a purpose-built private gallery (fig. 11) designed by Thomas Hope (1769–1831),[174] was bought by the Louvre without any apparent attempt by any British buyer, public or private, to intervene.

Although Ruskin largely spared Nicolas Poussin,[175] he wrote that his Bacchanals, which he regarded as Poussin's best works, were coarser and infinitely less beautiful than Titian's,[176] and that *The Deluge (Winter)* was false in its sublimity.[177] Ruskin's principal targets were Claude and Dughet, his fundamental criticism being that neither was true to nature. He mercilessly attacked their paintings in the National Gallery: Dughet's *Landscape with a Storm* (NG 36) and *Landscape with the Union of Dido and Aeneas* (NG 95) were 'abuses of nature and abortions of art',[178] and Claude's *Landscape with David at the Cave of Adullam* (NG 6) was, said Ruskin, 'in the

Fig. 11 J. Le Keux after G. Cattermole, *Mr. Thos. Hope's Picture Gallery*. Engraving, 11.6 × 17.6 cm, from C. Westmacott, *British Galleries of Painting and Sculpture*, London 1824. London, British Library.

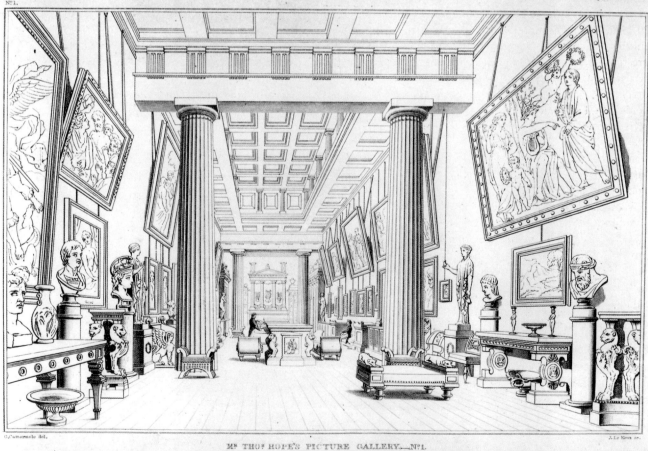

very branch of art on which [his] reputation chiefly rests, aerial perspective, hurling defiance to nature in her very teeth'.[179] This censure was directly contrary to the received wisdom that Claude's paintings represented nature and truth,[180] but was no less effective for that. Reporting in 1853 on the proceedings of the House of Commons Select Committee then considering the National Gallery, *The Art-Journal* stated that 'Sir Charles Eastlake had the courage to say that Claude's execution was what painters call "wooden"; and Sir Edwin Landseer that the sun in the "Queen of Sheba" picture was not distant enough. These remarks, so perfectly just, have disturbed the inherited notion of Claude's excellences in every point, and will lead to a fairer appreciation of his artistic qualities'.[181] It was soon after 1890, when the Gallery made its only purchase of a Claude in these years, *A View in Rome* (NG 1319), that Ruskin's strictures were republished, prompting the Director, Sir Edward Poynter, to regret that 'Mr. Ruskin's ill-considered and strongly biased invective, instead of being allowed to sink into oblivion, should have been paraded afresh as a guide to public taste'.[182]

Claude's paintings also found support from the influential art historian Roger Fry, then Curator of Paintings at the Metropolitan Museum, New York. In an article of 1907, re-published in 1920, Fry wrote: 'Claude still lives, not, indeed as one of the gods of the sale-room, but in the hearts of contemplative and undemonstrative people.'[183]

The Twentieth Century
In the first two National Loan Exhibitions in 1909–10 and 1913–14 there was not one French seventeenth-century painting.[184] When in 1927 the National Gallery Trustees were considering which paintings HM Treasury should be advised were of paramount importance, the only French School painting (of any century) on an initial list of 45 was Claude's *Enchanted Castle* (NG 6471). The Claude did not survive the list being whittled down to ten pictures.[185] On reviewing the list in 1930, the Director, Sir Augustus Daniel, recommended to the Trustees that Poussin's *Adoration of the Golden Calf* (NG 5597) be included. They declined to follow his recommendation.[186]

This lack of interest no doubt contributed to the fact that a significant number of seventeenth-century French paintings were exported during the middle years of the twentieth century. Of the 124 paintings shown in the exhibition of French seventeenth-century paintings in American collections which took place in 1982, no fewer than 58 had at some time been in a British collection, and most of these were exported in the twentieth century.[187] Important paintings by Poussin which left Great Britain were, in date order of export: after 1917, *The Holy Family with Saint Elizabeth and Saint John the Baptist* (Cambridge, Mass., Fogg Art Museum), in London since 1801; after 1918, *Landscape with Saint John on Patmos* (Chicago, Art Institute), also in England since 1801; before 1922, *Selene and Endymion* (The Detroit Institute of Arts; p. 300, fig. 3), a painting of exceptional beauty which had been in England since 1743; in 1924, *Landscape with Orion* (New York, Metropolitan Museum of Art), which had been in

Andrew Hay's sale in London in 1745 and in the Methuen Collection from 1847 until its sale abroad; by 1926, *Landscape with Pyramus and Thisbe* (Frankfurt, Städelsches Kunstinstitut), which had been in England since before 1750 and of whose originality and beauty of colour and tone Roger Fry had written in *The Burlington Magazine* in 1923;[188] in 1939, *Baptism*, one of the surviving six of Poussin's first set of *Seven Sacraments*, all seven of which Reynolds had helped acquire for the Rutland Collection in 1786; and in 1946 *The Rape of the Sabines* (New York, Metropolitan Museum of Art) which was at Stourhead by 1762 and then in London from 1883 until its sale abroad. However, subsequent renewed interest in England in Poussin, encouraged by Anthony Blunt, saw significant additions to public collections, not least that of the National Gallery, which in 1944 was bequeathed *The Annunciation* (NG 5472) and in the following year bought *The Adoration of the Golden Calf* (NG 5597) for a then record price (taking estate duties into consideration) for a Poussin.[189] Furthermore, the impact of the art of Cézanne, himself an admirer of Poussin, has encouraged public collections to acquire works other than those from his early years in Rome, for example in 1947 *Landscape with a Man killed by a Snake* (NG 5763); in 1950 *The Exposition of Moses* (Oxford, Ashmolean Museum); in 1983 *Landscape with the Ashes of Phocion* (Liverpool, National Museums and Galleries on Merseyside) and in 1988 *The Finding of Moses* (NG 6519).[190]

Notable paintings by Claude to have entered British public collections over the past hundred years include *Landscape with Ascanius shooting the Stag of Silvia*, given to the Ashmolean Museum in 1926, *The Enchanted Castle* (NG 6471), bought in 1981, and the National Museum of Wales's *Landscape with Saint Philip baptising the Eunuch*, bought the following year. Among many important losses, however, have been *Landscape with Saint George and the Dragon*, the pendant to *Seaport with the Embarkation of Saint Ursula* (NG 30) and in this country from the 1760s until bought by the Wadsworth Atheneum, Connecticut, in 1937; *Landscape with the Sermon on the Mount* (New York, Frick Museum), in William Beckford's collection before 1806 and later in the collection of the Dukes of Westminster until 1959; and *View of Carthage with Dido and Aeneas*, which until its purchase by the Hamburg Kunsthalle in 1964 had, with a mid-nineteenth-century interruption, been in England since 1799.

Other French artists have fared even less well. The Duke of Buccleuch's *Martyrdom of Saint Lawrence* by Le Sueur was lent to the National Gallery in 1917 but prompted only muted praise from Fry.[191] A major reassessment of French seventeenth-century painters other than Claude and Poussin might have begun in 1932 with the Royal Academy's *Exhibition of French Art 1200–1900*, which included works by Bourdon, La Hyre, La Tour, the Le Nain and Le Sueur, or even earlier in the case of the Le Nain, to whom the Burlington Fine Arts Club had devoted an exhibition in London in 1910. However, when Tancred Borenius reviewed the French School paintings in the Royal Academy's 1938 *Exhibition of 17th Century Art in Europe*, most of what he wrote was devoted to Claude, Dughet and Poussin. True, Borenius drew attention to

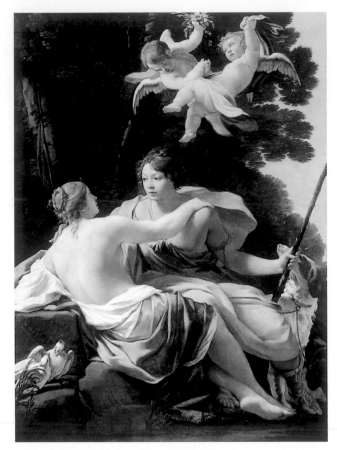

Fig. 12 Simon Vouet, *Venus and Adonis*, c.1642. Oil on canvas, 130 × 94.5 cm. Los Angeles, J. Paul Getty Museum.

Millet's *Mountain Landscape with Lightning* (NG 5593), which may have been a factor in the Gallery's purchase of it in 1945, and also highlighted a painting by Bourdon and another by Vouet, but those of Blanchard, La Hyre, Le Nain and Le Sueur were mentioned only in passing, and that of La Tour not at all.[192] The seventeenth-century section of an exhibition of French landscape painting held in London in 1949–50 was dominated by Poussin and Claude.[193]

However, pictures by French seventeenth-century artists other than Poussin and Claude were acquired by British public collections in the twentieth century. Among those given or bequeathed were Le Brun's *Brazen Serpent* (Bristol, City Art Gallery; fig. 7) in 1905, the Le Nain *Four Figures at a Table* (NG 3879) in 1924, Valentin's *Four Ages of Man* (NG 4919) in 1938, Millet's *Noblemen of Capernaum* (York, City Art Gallery) in 1955, and Philippe de Champaigne's exquisite *Annunciation* (Hull, Ferens Art Gallery) in 1964. Those bought other than by the National Gallery included De Nomé's *Martyrdom of Saint Catherine* (Southampton Art Gallery) in 1948 and Le

Sueur's *Solomon and the Queen of Sheba* (Birmingham, The Barber Institute of Art) in 1958. The losses, however, were greater. They include Vouet's *Venus and Adonis* (Los Angeles, J. Paul Getty Museum; fig. 12), which was offered to the Gallery by a French dealer in 1938 but turned down. Significant pictures sold abroad from private collections in Great Britain in the twentieth century included (in date order): the Le Nains' *Peasants before a House* (San Francisco, Fine Arts Museum), probably bought by the Duke of Rutland in 1772 for Belvoir Castle, where it remained until its sale in 1936; Le Sueur's *Annunciation* (Toledo Museum of Art), in the Normanton Collection, Hampshire, since 1857 (exported by 1947); Bourdon's *Finding of Moses* (Washington, National Gallery of Art), exhibited in Paris in 1937 as belonging to an unidentified London collector (1948), and his luminous *Landscape with a Mill* (Providence, Rhode Island School of Design; fig. 13), in England since at least 1853 and exported for a modest sum in 1951; La Hyre's *Alliance of Peace and Justice* (Cleveland Museum of Art), which turned up on the London art market shortly before it was sold abroad (1971); La Tour's *Musicians' Quarrel* (Los Angeles, J. Paul Getty Museum), which was sold in London and exported in 1972, and his *Christ with Saint Joseph* (Paris, Musée du Louvre), offered for sale to the National Gallery in 1938 but declined, apparently on account of a shortage of funds;[194] and Jacques Blanchard's *Charity* (Toledo Museum of Art), which had been at Goodwood House, Sussex, since before 1822 until its sale in 1974, although in this case another treatment of the subject by Blanchard had been given to the Courtauld Institute of Art in 1947. On the other hand, the relative disdain for French seventeenth-century painters – other than Claude and Poussin – did allow a few English private collectors of relatively modest means to buy in that field, to the National Gallery's ultimate benefit, most notably Francis Falconer Madan, who bought La Hyre's *Allegory of Grammar* in Paris in 1938 and bequeathed it to the Gallery in 1961. Nevertheless, no British private collector during the twentieth century (or earlier, save in respect of Poussin, Claude and Dughet) acquired seventeenth-century French pictures in any depth, in the way the Hertfords accumulated French eighteenth-century paintings for what later became the Wallace Collection or as Sir Denis Mahon has collected the Seicento painters. Nor has any public collection had the means to do so, save the National Gallery itself, which has since 1945 bought pictures by Philippe de Champaigne, the Le Nain, Le Sueur, Millet, Patel the Elder and Vouet (and studio). Consequently, the National Gallery is the only place in the British Isles where some idea of the range of seventeenth-century French painting can be gained. Extending the collection in this area remains a priority.

NOTES

I am grateful to Judy Egerton and Alastair Laing for reading and commenting upon a draft of this essay.

1. For the history of this painting prior to its rediscovery by Alastair Laing, see the entry for NG 6576. According to Howard Colvin (*A Biographical Dictionary of British Architects 1600–1840*, 3rd edn, New Haven and London 1995, p. 432), Thomas Philip de Grey, Earl de Grey (1781–1859), who inherited 4 St James's Square on the death of the Countess de Grey (formerly Lady Amabel Lucas) in 1833, carried out internal decorations there that same year, making all the plans and designs himself. However, it is clear from the typescript copy of De Grey's autobiographical memoirs (Bedfordshire and Luton Archives and Records Service CRT/190/45/2), which Colvin helpfully cites and of which James Collett-White has kindly sent me a copy extract, that the works started in 1833 and continued into the following year. One can assume that the installation of a painted overdoor, however under-
appreciated it may have been by De Grey, would have taken place only on completion of the works.

2. A useful (but not wholly accurate) chronology of acquisitions of French seventeenth-century paintings by British public collections has, however, been published by Christopher Wright in *Masterpieces of Reality. French 17th Century Painting*, exh. cat., Leicester 1985–6, pp. 149–56.

3. The Arundel collection contained Italian and Flemish paintings, some Dutch and a notable number of German School paintings – see the Arundel inventory of 1655 published by Mary F.S. Hervey, *The Life, Correspondence and Collection of Thomas Howard Earl of Arundel*, Cambridge 1921, pp. 473–500.

4. Francis Haskell, 'Charles I's Collection of Pictures', *The Late King's Goods. Collections, Possessions and Patronage of Charles I in the Light of the Commonwealth Sale Inventories*, ed. A. Macgregor, London and Oxford 1989, pp. 203–31 at p. 207.

5. P. McEvansoneya, 'The Sequestration and Dispersal of the Buckingham Collection', *Journal of the History of Collections*, vol. 8, no. 2 (1996), pp. 133–54 at p. 141 and fig. 12.

6. E. Duverger, *Antwerpse Kunstinventarissen uit de Zeventiende Eeuw*, vol. 5, 1642–1649, Brussels 1991, p. 482.

7. R. Davies, 'An Inventory of the Duke of Buckingham's pictures, etc. at York House in 1635', *BM*, 10, 1907, pp. 376–82 at p. 380.

8. Ibid., p. 381. The collection also included an equestrian portrait of the duc de Guise by Frans Pourbus the Younger (1569–1622) and a landscape with Pan and Syrinx by Jacques Fouquières (1590/1–1659), painters who were born in Antwerp but are sometimes included in the French School.

9. Oliver Millar, 'Abraham van der Doort's Catalogue of the Collections of Charles I', *Walpole Society*, vol. 37, 1958–60, at pp. 159 and 225, and *idem*, 'The Inventories and Valuations of the King's Goods 1649–1651', *Walpole Society*, vol. 43, 1970–2 at p. 217. The French portraitists were Frans Pourbus

Fig. 13 Sébastien Bourdon, *Landscape with a Mill*, 1650s. Oil on canvas, 86 × 107 cm. Providence, Rhode Island School of Design, Museum of Art. Museum Works of Art Fund.

the Younger (but see note 8) and Ferdinand Elle (1580–1649). Louise Moillon (1610–96) worked in Paris, specialising in still life.

10. André Félibien, *Entretiens sur les vies et sur les oeuvres des plus excellens peintres anciens et modernes*, 5 vols, London 1705, vol. 3, p. 309. Vouet's *Diana* is signed and dated 1637; it entered the Royal Collection at un unknown date: see Christopher Lloyd, *The Queen's Pictures. Royal Collectors through the Centuries*, exh. cat., London 1991, no. 30. The composition was originally oval, so it may have formed an overdoor and hence a fixture. As such it would be unlikely to have been included in any inventory of paintings.

11. Haskell 1989, cited in note 4, p. 221.

12. Blunt 1966, R 111. For the identification of this painting with that bought by Lord Feilding in 1639, see E.K. Waterhouse, 'Poussin et l'Angleterre jusqu'en 1744', *Poussin Colloque 1958*, vol. 1, pp. 283–96, and A. Blunt, 'Poussin and British Collectors', *The Connoisseur*, 208, 1981, pp. 118–21.

13. Haskell 1989, cited in note 4, p. 208.

14. Alastair Laing, 'Sir Peter Lely and Sir Ralph Bankes', *Art and Patronage in the Caroline Courts. Essays in honour of Sir Oliver Millar*, ed. D. Howarth, Cambridge 1993, pp. 107–31. Both pictures are at Kingston Lacy. Alastair Laing tells me that he agrees with Jacques Thuillier's view (for which see *Sébastien Bourdon 1616–1671*, exh. cat., Paris 2000, nos R.96 and R.100) that neither is by Bourdon, but considers the *Judgement of Midas* to be certainly French.

15. S. Gleissner, 'Reassembling a royal art collection for the restored king of Great Britain', *Journal of the History of Collections*, vol. 6, no. 1 (1994), pp. 103–15 at p. 111.

16. H.V.S. Ogden and M.S. Ogden, *English Taste in Landscape in the Seventeenth Century*, Ann Arbor 1955, p. 106, and Roethlisberger 1961, p. 41.

17. Gayer could not have bought the *Jacob and Laban* before the death of its first owner, Cardinal Cardelli, in 1662, but may have acquired the other Claude when he visited Rome in 1659/60: Kitson 1978, pp. 93, 136, and *The Prince's Gate Collection*, exh. cat., Courtauld Institute Galleries, London 1981, no. 11 (entry by Helen Braham). Alastair Laing has pointed out to me that Gayer's is the only Englishman's name recorded on the (verso of) the drawings in the *Liber Veritatis*, albeit inscribed by Claude's heirs.

18. Kitson 1978, pp. 91, 107.

19. R.F. Verdi, *Poussin's Critical Fortunes. The study of the artist and the criticism of his works from c.1690 to c.1830 with particular reference to France and England*, PhD thesis, Courtauld Institute of Art, 1976, p. 33.

20. Waterhouse, cited in note 12, p. 285.

21. *The Diary of John Evelyn*, ed. E.S. de Beer, 6 vols, Oxford 1955, vol. 4, pp. 402–3. ('[Newport] has some excellent pictures, especialy [sic] that of Sir Tho: Hanmers of V: Dyke, one of the best he ever painted: another of our English Dobsons painting: but above all, that *Christo* in gremio of *Pussino*, an admirable piece, with something of most other famous hands.') Evelyn had recorded in his diary seeing another Poussin in 1644 while in Paris, so was evidently long familiar with the artist: ibid., vol. 1, pp. 112–13.

22. G. Burdon, 'Sir Thomas Isham. An English collector in Rome in 1677–8', *Italian Studies*, vol. 15, 1960, pp. 1–25 at p. 6.

23. William Sanderson, *Graphice. The use of the Pen and Pensil. Or, The Most Excellent Art of Painting*, 2 parts, London 1658, part 1, p. 18.

24. For example, Poussin's *Plague at Ashdod* (Paris, Musée du Louvre) was engraved c.1650, and NG 62 in the 1650s: G. Wildenstein, 'Les graveurs de Poussin au XVIIe siècle', *GBA*, 46, 1955, pp. 75–371. Further, by 1666 sixty-three of Poussin's compositions had been engraved: Davies and Blunt 1962, pp. 205–22 at p. 217. Richard Symonds returned from Italy to England in 1652 with five prints after compositions by Poussin: Ogden 1955, pp. 68–9. It is also worth pointing out that from the 1640s there were available an increasing number of publications in French mentioning Poussin in laudatory terms: see Thuillier 1994a, pp. 157ff.

25. Alastair Laing has pointed out to me as a further example of the dissemination in Britain of compositions by French painters that Michel Dorigny's print, dated 1638, after Vouet's *Apotheosis of Saint Eustace* (Nantes, Musée des Beaux-Arts) was copied and adapted in the 1660s for the ceiling of the State Bedchamber in Powis Castle (then owned by the Catholic Herbert family).

26. [William Lodge], *The Painters Voyage of Italy…Written Originally in Italian by Giacomo Barri a Venetian Painter. Englished by W.L. of Lincolns-Inne, Gent*, London 1679, p. 2, where Poussin's *Martyrdom of Saint Erasmus* is referred to as a 'very beautifull piece'.

27. Henry Testling [Henri Testelin], *The Sentiments of the most Excellent Painters Concerning the Practice of Painting; Collected and Composed in Tables of Precepts*, London and Cambridge 1688 [unpaginated]. The passage quoted appears in the margin to the Fifth Table.

28. [John Elsum], *Epigrams upon the Paintings of the Most Eminent Masters, Antient and Modern. With Reflexions upon the several Schools of Painting*, London 1700, p. 111.

29. Ibid., p. 98.

30. Timothy Clayton, *The English Print 1688–1802*, New Haven and London 1997, pp. 41–2.

31. Richard Graham, *A Short Account Of the most Eminent Painters both Ancient and Modern Continued down to the Present Times according to the Order of their Succession*, London 1769. Graham's book was first published in London in 1695 with a translation of Charles-Alphonse Dufresnoy's *De Arte Graphica* with remarks on that book by de Piles. All citations are from the 1769 edition. For Graham's comments on Vouet, see pp. 265–6; for Poussin, pp. 271–2; for Claude, pp. 277–8; for Dughet, pp. 278–9; and for Le Brun, pp. 296–7.

32. I am grateful to Alastair Laing for the information about Stella.

33. The idea that Claude and Poussin were not really French was not confined to the eighteenth century. In *The Art-Journal*, 3, 1851, it was said 'we do not recognise N. Poussin in the French School, as he owed all his greatness to his Italian education' (p. 233). In *The Times* of 11 January 1884 (p. 10) a report on the Burlington House exhibition lamented that there was little that could be called 'really French; for Claude and Poussin are so thoroughly Italian in inspiration that one hardly counts them as French at all'.

34. See Roger de Piles, *The Art of Painting and the Lives of the Painters*, London 1706 (trans. John Savage; comment and essay by Bainbrigg Buckeridge). De Piles's *Abrégé de la vie des peintres* was published in 1699 and so could not have been known to Graham when he was writing his *Short Account*.

35. On the popularity of the *Battles of Alexander*, see Clayton 1997, cited in note 30, pp. 36–7. Also worth noting is the publication in 1693 of a print of the composition of Le Brun's *Tent of Darius* by the Huguenot artist Simon Gribelin, then working in England. Gribelin's print was incorporated in *The tent of Darius explain'd: or the Queens of Persia at the feet of Alexander. Translated from the French of Mr. F[élibien], by Collonel [William] Parsons*, London 1703, which was republished the following year under a slightly different title.

36. C. Brown, 'Patrons and Collectors of Dutch Painting in Britain during the reign of William and Mary', *Art and Patronage in the Caroline Courts. Essays in honour of Sir Oliver Millar*, ed. D. Howarth, Cambridge 1993, pp. 12–31. La Fosse's two gallery pictures from Montague House, *The Rape of Europa* and *Rinaldo and Armida*, are now at Basildon Park, near Reading.

37. M. Jaffé, 'The Paintings and Drawings', *Boughton House. The English Versailles*, ed. Tessa Murdoch, London 1992, p. 75. The importation of French artists was a notable feature of the English art scene in the late seventeenth and earlier eighteenth centuries. A number settled in England and had successful careers, including, for example, Louis Laguerre (who was among the first directors of Kneller's Academy when it was set up in 1711), Louis Cheron and Roubiliac. The matter of French influence on the English art scene is treated in Charles Saumarez Smith, *Eighteenth Century Decoration. Design and the Domestic Interior in England*, London 1993, pp. 19–22, 138–9 and 306–7.

38. Roger de Piles 1706, cited in note 34, p. 397.

39. [Elsum] 1700, cited in note 28, pp. 131–3.

40. On the dominance of the taste for Italian Baroque painting among British collectors in the period 1711–59, for example, and the preponderance of works by or attributed to Poussin, Claude and Dughet among seventeenth-century French paintings in this period, see Iain Pears, *The Discovery of Painting. The Growth of Interest in the Arts in*

England, 1680–1768, New Haven and London 1988, pp. 166–7 and 216ff.

41. Carol Gibson-Wood, *Jonathan Richardson, Art Theorist of the English Enlightenment*, New Haven and London 2000, p. 76, here adopting the identification cautiously accepted by Richard Verdi in *Nicolas Poussin. Tancred & Erminia*, exh. cat. 1992–3, Birmingham Museum and Art Gallery, p. 66. For Gerard van der Gucht's engraving after Poussin's painting, see ibid., p. 59 and fig. 27.

42. See Jonathan Richardson, *Two Discourses: I. An Essay on the whole Art of Criticism as it relates to Painting… II. An Argument in behalf of the Science of a Connoisseur*, London 1719, part I, pp. 75ff. For a discussion of Richardson's analysis, see Verdi 1976, cited in note 19, pp. 35–9, and Gibson-Wood 2000, cited in note 41.

43. Poussin's main critic in this respect had been Roger de Piles, whose methodology of connoisseurship Richardson criticised: see C. Gibson-Wood, 'Jonathan Richardson and the rationalisation of connoisseurship', *Art History*, 7, no. 1, 1984, pp. 38–56.

44. Richardson 1719, cited in note 42, p. 93.

45. Verdi 1976, cited in note 19, p. 35.

46. Pears 1988, cited in note 40, pp. 82–3, where Pears points out that the dealer Andrew Hay made fifteeen or more trips to France, but only six to Italy.

47. 'Les tableaux de Poussin sont devenus très-rares en France, les Anglois nous en ayant dépouillé et continuant de nous enlever tous ceux qui se présentent': Mariette, *Abecedario*, p. 205.

48. Copies from it by Samuel Woodforde (1763–1817) are still in the Picture Gallery at Stourhead, as Alastair Laing has kindly told me.

49. Blunt 1981, cited in note 12.

50. R. Verdi, 'On the Critical Fortunes – and Misfortunes – of Poussin's "Arcadia"', *BM*, 121, 1979, pp. 95–103 at p. 97, n. 31, and Clayton 1997, cited in note 30, pp. 177–8.

51. Verdi 1979, op. cit., at p. 98.

52. In *Science of a Connoisseur* (cited in note 42, p. 53) Jonathan Richardson wrote of 'the National Vanity of Some of our Neighbours', cited by Pears 1988 (see note 40), p. 172. A writer in the *Gentleman's Magazine* of August 1731 complained that instead of bringing back knowledge, travellers on the Grand Tour brought home 'the *French Coiffure*, the *Robe de Chambre* of the Women, and *Toupé* and *Solitaire* of the Men; Dancing, Gaming and Masquerades': cited by Andrew W. Moore, *Norfolk & the Grand Tour*, Norwich 1985, p. 12. For the xenophobic reaction to French imports of luxury goods, see also *Rococo Art and Design in Hogarth's England*, exh. cat., Victoria and Albert Museum, London 1984, nos C21–C24.

53. Thomas Hollis, *Memoirs*, London 1780, p. 486, cited in Verdi 1976, p. 56.

54. George Turnbull, *Treatise on Ancient Painting*, London 1740, p. 166, cited in Verdi 1976, p. 45.

55. [Thomas Martyn] *The English Connoisseur*, 2 vols, London 1766, vol. 1, p. iv.

56. Reynolds 1959, pp. 62–3.

57. *Diaries of Lady Amabel Yorke 1769–1827*, entry for 11 July 1778.

58. R.A. Bromley, *A Philosophical and Critical History of the Fine Arts, Painting, Sculpture, and Architecture*, 2 vols, London 1793–5, vol. 2, p. 471.

59. Horace Walpole, *Aedes Walpolianae: or, a Description of the Collection of Pictures at Houghton-Hall in Norfolk, The Seat of the Right Honourable Sir Robert Walpole, Earl of Orford*, 2nd edn with additions, London 1752, pp. xxxi, xxxv. The phenomenon of praising one artist by association with another was not exclusive to England – Mariette, for example, calling Pierre Patel the Elder 'le Claude Lorrain de la France': *Abecedario*, vol. 4, p. 88.

60. John Hayes, 'The response to nature in the eighteenth century', *Apollo*, 83, 1966, pp. 444–51.

61. Kitson 1978, p. 29.

62. Ibid., p. 30.

63. A. Laing, *In Trust for the Nation. Paintings from National Trust Houses*, exh. cat., National Gallery, London 1995, p. 100.

64. Kimerly Rorschach, 'Frederick, Prince of Wales (1707–51), as Collector and Patron', *Walpole Society*, vol. 55, 1989/90, pp. 1–76.

65. Clayton 1997, cited in note 30, p. 157. See also Louise Lippincott, *Selling Art in Georgian London. The Rise of Arther Pond*, New Haven and London 1983, pp. 138–9.

66. Matthew Pilkington, *The Gentleman's and Connoisseur's Dictionary of Painters*, London 1770, p. 140.

67. On Dughet's popularity with British collectors compared to that of artists now more enthusiastically bought, see Egerton 1998, pp. 383–4. On English collectors of pictures by Dughet, see Anne French in *Gaspard Dughet called Gaspar Poussin 1615–75*, exh. cat., Kenwood, London 1980, pp. 9–11.

68. *The Art of Painting by C.A. du Fresnoy, trans. John Dryden, with A Short Account of the most Eminent Painters both Ancient and Modern by Richard Graham*, London 1769, p. 278.

69. Pilkington 1770, cited in note 66, p. 486.

70. John Hayes, 'British Patrons and Landscape Painting: 2. Eighteenth century collecting', *Apollo*, 83, 1966, pp. 188–97 at p. 188, where Hayes notes also one landscape by Poussin and four by Claude in the same sale.

71. Kimerly Rorschach, cited in note 64, p. 60.

72. Boisclair 1986, no. 24.

73. Ibid., no. 139 et al.

74. Ibid., no. 157 et al.

75. Ibid., no. 164.

76. 'Vertue Note Books, volume IV', *Walpole Society*, vol. 24, 1935–6, p. 17.

77. 'Vertue Note Books, volume III', *Walpole Society*, vol. 22, 1933–4, p. 9.

78. [Martyn], 1766, cited in note 55, vol. 1, p. 8.

79. Laing 1995, pp. 106–7.

80. [Martyn] 1766, cited in note 55, p. 9, where he records 'A Landskip… with a flock of Sheep, & c. by Francesco Mille the composition is fine, and this is one of his richest pictures.' The italianisation of Millet's name is itself of interest in the context of a general distaste for French painting. Martyn also noted (vol. 1, p. 127) a landscape by Millet in Charles Jennens's collection in Holborn, and another in Sir Gregory Page's collection at Blackheath (vol. 2, p. 92). John Hayes (1966, cited in note 70) calculates that according to the evidence of surviving catalogues, sixteen paintings by Millet passed through the London salerooms in the years 1714–30.

81. Pilkington 1770, cited in note 66, pp. 84–5.

82. Reynolds 1959, p. 237 (Discourse XIII, 11 December 1786).

83. Richardson 1719, cited in note 42, p. 80.

84. Kimerly Rorschach, cited in note 64, p. 17. Presumably the picture described by Horace Walpole as 'Rebecca and Abraham's Servant, by Sebast. Bourdon' on his visit to Kew in 1761: Paget Toynbee, 'Horace Walpole's journals of Visits to Country Seats, &c.', *Walpole Society*, vol. 16, 1927–8, p. 39.

85. Pears 1988, cited in note 40, p. 261, n. 27.

86. [Martyn] 1766, cited in note 55, *passim*. Additionally, when Horace Walpole visited Henry Hoare's house at Stourhead, he noted 'In the Salon. 8 very large pictures… [including]… Midas preferring Pan to Apollo, by Sebastien Bourdon': Toynbee, cited in note 84, p. 43.

87. 'Went to see Mr. Au[ink blot]eres at Chelsea … Les Oeuvres de Misericorde 7 Pictures by Seb. Bourdon…', *Diaries of Lady Amabel Yorke*, vol. 1, fo. 153 (entry for 30 May 1770). The seven paintings had been engraved, so Aufrere's pictures could have been copies, but, as Nicholas Penny has kindly told me, the Sarasota pictures were all bought at the Earl of Yarborough's sale, Christie's, 12 July 1929 (lot 10, £210 to Newton), where they were stated to have been in Aufrere's collection. Aufrere's daughter, Sophia, married the 1st Lord Yarborough, to whom, according to Farington, Aufrere bequeathed his collection. (Aufrere died on 10 January 1801.) Farington and Benjamin West found his collection 'very indifferent' (Farington, *Diary*, vol. 7, p. 2550). For discussion of the Sarasota paintings and the prints after them, see J. Thuillier, *Sébastien Bourdon 1616–1671*, exh. cat., Montpellier and Strasbourg 2000–1, p. 413.

88. J. Thuillier, op. cit., p. 411.

89. Pilkington 1770, cited in note 66, pp. 597–8.

90. Horace Walpole, *Aedes Walpolianae*, cited in note 59. William Hayley was to go further,

proposing that had Le Sueur lived longer, his works would 'probably have enabled France to vie with Italy herself in her native production of art': W. Hayley, *The Life of George Romney*, London 1809, p. 152.

91. Reynolds, *Discourses*, p. 150 (Discourse VIII, delivered 10 December 1778).

92. See note 56. It is typical of Le Sueur's exemption from the disparaging attitude of English connoisseurs towards French painting that on her visit to Notre Dame on 14 July 1778 Lady Amabel Yorke should have commented: 'Pictures of the French School, but very few of them are even tolerable:– A Le Sueur, the Burning of the magical Books before St. Paul, which has been engraved.' (*Diaries of Lady Amabel Yorke*, fo. 236).

93. *Anecdotes of Painting in England; with some account of the principal artists; and incidental notes on other arts; collected by the late Mr. George Vertue; digested and published from his original mss; by the Honourable Horace Walpole; with considerable additions by the Rev. James Dallaway*, 5 vols, London 1826–8, vol. 4, p. xxiv.

94. The cupola was entirely repainted by E.T. Parris in 1853–6: Arline Meyer, *Sir James Thornhill & the Legacy of Raphael's Tapestry Cartoons*, New York 1996, p. 19, n. 6.

95. Thornhill received the commission for St Paul's in 1715 and completed it in September 1719: Joseph Burke, *English Art 1714–1800*, Oxford 1976, p. 97. He visited Paris in 1717. The prints were published in reverse to the painted compositions. The influence of Le Sueur's 'May' for Notre-Dame on Thornhill's rendering of the subject has also been noted by W.R. Osmun, *A Study of the Work of Sir James Thornhill*, PhD thesis, London University 1950, p. 63. Osmun also rightly noted that the Thornhill's figures of Saint Paul in *Saint Paul preaching at Athens* and *Saint Paul before Agrippa* were probably based on Le Sueur's figure of the saint in *Saint Paul preaching at Ephesus*. Osmun also saw the influence of Vouet in Thornhill's *Saint Paul Shipwrecked* – this is less certain – and the influence of Subleyras in Thornhill's *Saint Paul in Prison*, which is chronologically impossible: see Osmun, pp. 61–5.

96. C. Lloyd, *The Queen's Pictures. Royal Collectors through the Centuries*, exh. cat., National Gallery, London 1991, no. 43.

97. Toynbee, cited in note 84, p. 44.

98. [Martyn] 1766, cited in note 55, vol. 1, pp. 42, 92, 118, 120, 140; vol. 2, p. 29. For the attribution to de Létin, see *Jacques de Létin Troyes 1597–1661*, exh. cat., Musée des Beaux-Arts, Troyes 1976, no. 33. Vertue also noted in 1743 a 'history' by Le Sueur with 'Mr.-Scarlet Optician & Spectacle maker', but this may have been one of the paintings whose subjects were later identified by Martyn: 'Vertue Note Books, volume III', cited in note 77, p. 117.

99. His sale, Christie's, 7–8 March 1794, lot 43 ('The annunciation').

100. Mérot 2000, no. 66.

101. Mérot 2000, no. 156.

102. Mérot 2000, no. 158. For the date of acquisition, see Jaffé 1992, cited in note 37.

103. Mérot 2000, no. 160.

104. Mérot 2000, no. M.91.

105. See under Provenance of NG 6299 and NG 6576.

106. Pilkington (1770, cited in note 66, pp. 101–2) called him a 'truly great painter', and in *Anecdotes of Painting in England*, cited in note 93, vol. 1, p. xii, it was said that he 'would dispute precedence with half the Roman school'.

107. Richard Graham 1769, cited in note 31, pp. 296–8, and Reynolds, *Discourses*, p. 158 (Discourse VIII, delivered on 10 December 1778). See also Edward Wright, *Some Observations made in Travelling through France, Italy, &c. in the Years 1720, 1721, and 1722*, 2 vols, London 1730, vol. 1, p. 6, who, after praising the expressions, draperies and ornaments in Le Brun's 'Darius's Tent, of which we have so many Representations in England', wrote: ' 'Tis no great Advantage to it, particularly in that respect, to have a fine Picture of Paolo Veronese just opposite to it; 'Tis a Last Supper. The Battles of Alexander I did not see.'

108. See Clayton 1997, cited in note 30, pp. 36–7.

109. Toynbee, cited in note 84, p. 19.

110. [Martyn] 1766, cited in note 55, vol. 1, p. 94.

111. Ibid., p. 78.

112. See E. Croft-Murray, *Decorative Painting in England 1537–1837*, 2 vols, Feltham, Middlesex, 1962–70, vol. 2 (1970), p. 28 and fig. 43.

113. *La peinture française du XVIIe siècle dans les collections américaines*, exh. cat., Paris, New York and Chicago 1982, no. 70 (entry by P. Rosenberg).

114. Pilkington 1770, cited in note 66, p. 287.

115. 21 April 1724, lot 86. Possibly no. 199(II) of P. Rosenberg and J. Thuillier, *Laurent de la Hyre 1606–1656*, exh. cat., Grenoble, Rennes and Bordeaux 1989–90.

116. Toynbee, cited in note 84, p. 44.

117. [Martyn] 1766, cited in note 55, vol. 1, pp. 12–14.

118. Egremont bought it at the 1753 Bragge sale (lot 75) for £186 18s. – see Pears 1988, cited in note 40, p. 166 and p. 261, n. 27, where Pears notes that, although typically most of Egremont's collection was seventeenth-century Roman, Bolognese, Flemish and Italianate Dutch, he did own twenty French school pictures.

119. Matthew Pilkington (1770, cited in note 66) followed de Piles in the latter's negative judgement. Richard Graham (1769, cited in note 31, pp. 265–6) wrote that Vouet's 'greatest Perfection was in his agreeable Colouring, and his brisk and lively pencil, being otherwise but very indifferently qualified'. Joseph Highmore, however, enthused about a number of Vouet's paintings in Paris while being lukewarm about Poussin's *Seven Sacraments* in the Palais Royal: Elizabeth Johnston, 'Joseph Highmore's Paris Journal, 1734', *Walpole Society*, vol. 42, 1968–70, pp. 61–104 at pp. 74, 76, 78 and 83. Interestingly, in noting an altarpiece by La Hyre in an unnamed Paris church he wrote 'in ye manner of Vouet extremely good' (ibid., p. 80).

120. A good painting by Vouet's son-in-law, Michel Dorigny (1617–65), who painted in a similar style, was bought between 1770 and 1790 by Edward Elton. The subject is Hagar and the Angel and the action occurs against a landscape background.

121. In *Abrégé de la vie des peintres, avec des réflexions sur leurs ouvrages*, Paris 1699, Roger de Piles wrote of La Hyre: 'Etoit dans son tems en grande Réputation. Il fut le seul de tous les Peintres ses Compatriotes qui ne suivit point la manière de Voüet. La sienne n'étoit pas d'un meilleur Goût, mais elle étoit plus recherchée, plus finie, & plus naturelle, mais toûjours incipide. Ses Païsages sont plus estimez que ses Figures' (p. 487).

122. There was one painting each by Vouet and La Hyre in the Orléans Collection. Lady Yorke on her visit to it in 1778 noted neither, nor had A.N. Dezallier d'Argenville in *Voyage Pittoresque de Paris*, Paris 1749. Only a small part of the French royal collection of paintings was exhibited at the Luxembourg Palace from 1750. It included one painting by Vouet in 1773: *Catalogue des Tableaux du Cabinet du Roi*, Paris 1773, no. 58.

123. [Martyn] 1766, cited in note 55, p. 135, noted *A Conversation* in Jennens's collection, and of the relatively large number of French school paintings in the Roger Harenc sale, London, Langford, 1–3 March 1764, there was 'A Corps de Garde, in Imitation of Calfe' (lot 40 of day 1) and 'A Camp, in the Manner of Bambicio' (lot 43 of day 3).

124. H.B. Wright and H.C. Montgomery, 'The Art Collection of a Virtuoso in Eighteenth Century England', *AB*, 27, 1945, pp. 195–204.

125. P. Rosenberg, *Tout l'oeuvre peint des Le Nain*, Paris 1993, p. 108.

126. *Diaries of Lady Amabel Yorke*, vol. 19, fo. 158 (entry for 18 March 1801).

127. Ibid., vol. 1, fo. 250, where she refers to a painting of 'a Dutch Family by Le Nain' (entry for 30 January 1772), and many years later, in recording her visit to the exhibition of old master paintings at the British Institution in 1818, she included a 'Young Gamblers by Le Nain' among the Dutch pictures: vol. 32, fo. 211 (entry for 16 June 1818).

128. C. Lloyd, *The Queen's Pictures: Old Masters from the Royal Collection*, exh. cat., Melbourne 1994–5, no. 8.

129. See Matthew Pilkington 1770, cited in note 66, pp. 60–1.

130. J. Thuillier, *Jacques Blanchard 1600–1638*, exh. cat., Rennes 1998, no. 28.

131. Ibid., no. 35.

132. Jean Leclerc's (?) *Saint Stephen mourned by Gamaliel and Nicodemus* (Boston, Museum

of Fine Arts) was at Alnwick Castle by 1856 as by Caravaggio.

133. Exh. cat., Paris, New York and Chicago 1982, cited in note 113, no. 12. The practice of attributing paintings by French seventeenth-century artists to Italian hands was not restricted to Caravaggesque pictures; for example, the Gallery's Baugin (NG 2293) was once given to Garofolo.

134. Ibid., no. 42. La Tour's *Penitent Saint Peter* (Cleveland Museum of Art) was at Alleyn's College, Dulwich, by 1798, attributed, however, to the Utrecht painter Honthorst: *Georges de la Tour*, exh. cat., Paris 1997–8, no. 47 (entry by J.-P. Cuzin). However, *The Dice Players* (Stockton-on-Tees) by La Tour and studio was attributed to La Tour at its sale in London in 1842 (op. cit., no. 63). The installation at Stockton of the framed painting in a subterranean alcove screened by thick plate glass is dramatic, but makes the picture difficult to study. This is particularly regrettable in the case of an artist like La Tour, whose work is so rare in England.

135. Uvedale Price, *An essay on the Picturesque as compared with the Sublime and the Beautiful*, new edn, 2 vols, London 1796, vol. 1, p. 145.

136. *Life at Fonthill 1807–1822 With Interludes in Paris and London from the correspondence of William Beckford*, trans. and ed. by Boyd Alexander, London 1957, p. 47, n. 2.

137. Verdi 1976, cited in note 19, p. 96. For an account of Poussin's influence on Romney, see J. Wallis, 'The Mind and Soul of Romney's Art and the Poussin Connection', *Transactions of the Romney Society*, 4, 1999, pp. 4–11. As Wallis points out, the children's poses in Romney's *The Gower Children* of 1776–7 (Kendal, Abbot Hall Art Gallery) appear to derive from those of some of the dancers in Poussin's *Adoration of the Golden Calf* (NG 5597).

138. R. Verdi, 'Poussin's "Deluge": the Aftermath', *BM*, 123, 1981, pp. 389–400.

139. [Giles Waterfield], *Palaces of Art. Art Galleries in Britain 1790–1990*, exh. cat., Dulwich and Edinburgh 1991–2, p. 75. There is considerable further evidence that the upheaval of the French Revolution and of the wars against the French did nothing to alter the continuity of eighteenth-century taste in paintings, but one further example is the dealer William Buchanan's letter of 30 April 1805 to his agent Irvine in Rome: '[the] fashionable and favourite Masters [of the English] at present are to a certainty *Claude, Titian, Rubens, Vandyck, Domenichino, Annibale Carracci*, Guido's fine coloured pictures, *Velasquez, Murillo*, Gaspar Poussin, Nic. Poussin, particularly in his Bacchanalian and clear pictures – *Salvator* Rosa – and in general the taste is for Landscape with figures': see Brigstocke 1982a, p. 394.

140. The style of Poussin's paintings in the Dulwich Picture Gallery which formed part of the Bourgeois Bequest of 1811 is, however, more varied.

141. Farington, *Diary*, vol. 5, pp. 1847, 1853 and 1882.

142. *Conference of Monsieur Le Brun...upon expression, general and particular*. Translated from the French, London 1701.

143. Arline Meyer 1996, cited in note 94, pp. 56–7.

144. *Le Brun Travested or Caricatures of the Passions*, London 1800. Arline Meyer 1996 (cited in note 94) illustrates three of Rowlandson's caricatures (p. 59).

145. Farington, *Diary*, vol. 5, p. 1847.

146. Ibid., p. 1856.

147. *Blackwood's Edinburgh Magazine*, vol. 54 (338), December 1843, p. 702. The *Art-Journal*'s list of painters was shorter: Vouet, 'whose works scarcely reached a second-rate rank'; Le Brun, Le Sueur, Mignard and Jouvenet, but Poussin was excluded from the French School since 'he owed all his greatness to his Italian education': vol. 3, 1851, p. 233. For Fuseli's criticism of NG 6576, however, see the catalogue entry for that painting.

148. See 5th edn, London 1824, pp. 11–12. Haydon also implicitly regarded Champaigne as Flemish: see his *Autobiography* cited in note 150.

149. John Ingamells, *The Wallace Collection Catalogue of Pictures III French before 1815*, London 1989, p. 106.

150. G. Scharf, *A Descriptive and Historical Catalogue of the Collection of Pictures at Woburn Abbey*, 2 parts, London 1877, part 2, p. 219. For Haydon's interesting comparison between Champaigne and Rubens, see *The Autobiography and Memoirs of Benjamin Robert Haydon (1786–1846)*, ed. T. Taylor, new edn with introduction by A. Huxley, London 1826, pp. 192–3.

151. Among the French pictures were Dughet's *Falls of Tivoli* and Poussin's *Dance to the Music of Time*, chosen for exhibition by the Marquess of Hertford from his collection.

152. W. Bürger, *Trésors d'Art en Angleterre*, Brussels and Ostend 1860, p. 327. Bürger was also known as Thoré and as Thoré-Bürger.

153. On the 'rediscovery' of the Le Nain, championed mainly by the writer Champfleury, see Francis Haskell, *Rediscoveries in Art, Some Aspects of Taste, Fashion and Collecting in England and France*, London 1976, pp. 64, 114–15; and Michael Fried, *Manet's Modernism or, The Face of Painting in the 1860s*, Chicago and London 1996, pp. 66, 69–71. For some nineteenth-century British collectors with a taste for pictures by, or then attributed to, the Le Nain, see the provenance of NG 1425 and NG 4857, Rosenberg 1993, *passim*, and BFAC, *Pictures by the Brothers Le Nain*, London 1910, pp. 30–3.

154. C.M. Kauffmann, *Victoria and Albert Museum. Catalogue of Foreign Paintings*, vol. I, London 1973, pp. 169–71 (cat. nos 208, 209).

155. C.L. Eastlake, *Pictures in the National Gallery London*, 2 vols, Munich, London and New York 1896, vol. 2, p. 156. Eastlake adventurously proposed Dubois, Freminet and Vouet to represent the 'early French masters', and wrote that 'a few examples of Le Fevre [and] Verdier would be welcome additions'.

However, so far as Le Fevre and Verdier were concerned, it seems to have been the non-French aspects of their art which Eastlake admired: C.L. Eastlake, *Notes on the Principal Pictures in the Louvre Gallery in Paris*, London 1883, pp. 76, 293.

156. A scattering of French seventeenth-century pictures was acquired by British public collections in the later nineteenth century: Le Brun's *Descent from the Cross* bought as a Bourdon by the Victoria and Albert Museum in 1863 (Kauffmann 1973, cited in note 154, pp. 167–8), the Dublin Poussin mentioned in the text, and a handful of the paintings bequeathed by John and Josephine Bowes to the Bowes Museum, including Philippe de Champaigne's portrait of his wife. However, the Bowes lived mainly in Paris and so were not typical English collectors; they were anyway more interested in Spanish old masters.

157. G.F. Waagen, 'Thoughts on the new building to be erected for the National Gallery of England, and on the arrangement, preservation, and enlargement of the collection', *The Art-Journal*, n.s., vol. 5, 1 May 1853, p. 125.

158. Haskell 1976, cited in note 153, p. 103.

159. *Wallace Collection. The Hertford Mawson Letters. The 4th Marquess of Hertford to his agent Samuel Mawson*, ed. J. Ingamells, London 1981, letter 25, and letter 27, n. 1.

160. Florence Gétreau, 'Les tableaux et les dessins français du XVIIIe siècle', *GBA*, 125, 2000, pp. 177–90.

161. The draper and haberdasher James Morrison (1789–1857) may have been an exception. He bought pictures by British artists, including Constable and Turner, in the 1820s, before starting a major collection of old masters in the following decade: R. Gatty, *Portrait of a Merchant Prince. James Morrison 1789–1857*, Northallerton 1977, pp. 245–6. It may be significant that the first old master painting he acquired was a Claude, *The Rape of Europa* (LV 144).

162. Haskell 1976, cited in note 153, pp. 59, 94.

163. Ibid., p. 64.

164. *The Art-Journal*, 1852, n.s., vol. 4, pp. 273–5, 297–300.

165. Ruskin, *Works*, vol. 15, p. 497.

166. H. Ward and W. Roberts, *Romney. A Biographical and Critical Essay with a Catalogue Raisonné of his Works*, London 1904, p. 27.

167. See Verdi 1976, cited in note 19, p. 392, for the lack of literature on Poussin.

168. 'On the Independency of Painting on Poetry, By Mr. Northcote, R.A.' [a lecture given by Northcote on 9 May 1807], *The Artist; a collection of essays, relative to painting, poetry, sculpture, architecture, the drama, discoveries of science, and various other subjects*, ed. by Prince Hoare, 2 vols, London 1810, vol. 1, p. 7.

169. Cited by Verdi 1976 (see note 19), p. 141.

170. Eastlake 1883, cited in note 155, p. 176.

171. Blunt 1981, cited in note 12.

172. *The Times*, 10 July 1882, p. 9, col. 5. The painting by Annibale is now in the National Gallery (NG 2923).

173. In the mid-nineteenth century the Caracci picture was the most popular painting in England: Haskell 1976, cited in note 153.

174. See *Palaces of Art. Art Galleries in Britain 1790–1990*, cited in note 139, no. A9.

175. Ruskin called NG 40 'one of the finest landscapes that ancient art has produced – the work of a really great and intellectual mind', but nevertheless criticised some of its details: *Works*, vol. 3, pp. 263–4.

176. Ibid., vol. 7, p. 323. This comment appeared in *Modern Painters*, vol. 5, first published in 1860.

177. Verdi 1981, cited in note 138, p. 399.

178. Ibid., p. 396.

179. Ruskin, *Works*, vol. 3, p. 438. For other nineteenth-century reactions to Claude, particularly those of Constable and Hazlitt, see Claire Pace, 'Claude the Enchanted: Interpretations of Claude in England in the earlier Nineteenth-Century', *BM*, 111, 1969, pp. 733–40.

180. See, for example, Allan Cunningham, *The Cabinet gallery of Pictures, selected from the splendid collections of art, public and private, which adorn Great Britain; with biographical and critical descriptions*, 2 vols, London 1833, vol. 2, p. 93, in connection with NG 61.

181. *The Art-Journal*, 5, 1853, p. 175.

182. Sir Edward J. Poynter, *The National Gallery*, 2 vols, London 1899, vol. 1, p. 192. Presumably it was Poynter who encouraged the Royal Academy, of which he became president in 1896, to include a substantial representation of Claude's paintings and drawings in its 1902 Winter Exhibition.

183. Roger Fry's article 'Claude' appeared in *The Burlington Magazine* (which he helped to found), *BM*, 11, 1907, pp. 267ff., and in a collection of Fry's essays, *Vision and Design*, London 1920, pp. 145–52.

184. See *National Loan Exhibition in aid of National Gallery Funds*, Grafton Galleries, London, October 1909 to January 1910, and *IInd National Loan Exhibition. Woman and Child in Art*, Grosvenor Gallery, London, 26 November 1913 to 11 February 1914. The situation was remedied with the 1914–15 exhibition, which consisted exclusively of pictures from Basildon Park and Fonthill. Among the Basildon Park pictures exhibited was NG 6477.

185. National Gallery Board Minutes, 8 March 1927

186. National Gallery Board Minutes, 17 June and 8 July 1930.

187. I am grateful to Alastair Laing for this information.

188. Roger Fry, 'Pyramus and Thisbe by Nicholas Poussin', *BM*, 43, 1923, p. 53.

189. The Gallery paid £10,000. To the best knowledge of the Gallery at the time, the highest actual price had been £12,000, paid by the Philadelphia Museum of Art for *The Triumph of Neptune* in 1932. The Gallery offered £12,000 for *The Adoration of the Golden Calf* and its pair, *The Crossing of the Red Sea* (Melbourne, National Gallery of Victoria), but the attempt to buy both pictures was rather half-hearted, Kenneth Clark writing that the Trustees 'were not anxious to have both the pictures in the Gallery for reasons of space, but owing to Lord Radnor saying that he would not sell the pictures separately, they felt bound to make an offer for both'. (Letter to T.H. Bischoff, 16 March 1945 in NG Archive.) The two paintings have never since been reunited.

190. On Cézanne and Poussin, see Richard Verdi, *Cézanne and Poussin: The Classical Vision of Landscape*, Edinburgh 1990, especially pp. 57–62.

191. Roger Fry, 'Pictures lent to the National Gallery', *BM*, 30, 1917, pp. 198–202.

192. See *Catalogue of the Exhibition of 17th century Art in Europe*, Royal Academy, London 1938, and Tancred Borenius, 'The French School at Burlington House', *BM*, 72, 1938, pp. 54–64.

193. *Landscape in French Art*, Royal Academy, London 1949–50.

194. *Georges de La Tour*, exh. cat., Paris 1997–8, no. 40. The painting was offered for sale to the Gallery by Percy Moore Turner. The 'sum mentioned' according to the Board Minutes of 13 December 1938 was £15,000, and it was resolved that 'In view of the absence of funds, the Trustees decided that no action could be taken at the moment; several Trustees considered the price absurdly high.' The Gallery's purchase grant in 1938 was £7,000. Ten years later Turner gave the painting to the Louvre.

The Organisation of the Catalogue

This is a catalogue of the seventeenth-century French paintings in the National Gallery. It includes one painting by a Flemish artist (NG 2291 by Jakob Ferdinand Voet) and two which may or may not be French (NG 83 and NG 5448). An explanation of how the terms 'French' and 'seventeenth-century' are here used, are given in the Preface.

The artists are catalogued in alphabetical order. Under each artist, autograph works come first, followed by works in which I believe the studio played a part, then those which are entirely studio productions or later copies. Where there is more than one work by an artist, they are arranged in order of acquisition – that is, in accordance with their inventory numbers.

Each entry is arranged as follows:

TITLE: I have adopted the traditional title of each painting, except where it might be misleading to do so.

DATE: Where a work is inscribed with its date, the date is recorded immediately after the note of media and measurements, together with any other inscriptions. Otherwise, the date is given immediately below the title; an explanation for the choice of date is provided in the body of the catalogue entry.

MEDIA AND MEASUREMENTS: All the paintings have been physically examined and measured by Paul Ackroyd (or in the case of NG 165 by Larry Keith) and myself. Height precedes width. Measurements are of the painted surface (ignoring insignificant variations). Additional information on media and measurements, where appropriate, is provided in the Technical Notes.

SIGNATURE AND DATE: The information derives from the observations of Paul Ackroyd, Larry Keith and myself during the course of examining the paintings. The use of square brackets indicates letters or numerals that are not visible but may reasonably be assumed once to have been so.

Provenance: I have provided the birth and death dates, places of residence and occupations of earlier owners where these are readily available, for example in *The Dictionary of National Biography*, *La Dictionnaire de biographie française*, *The Complete Peerage* and *Who was Who*. Since I have generally not acknowledged my debt to these publications in individual notes, I am pleased to do so here. In some cases basic information about former owners is amplified in the notes.

Exhibitions: Although they are not strictly exhibitions, long-term loans to other collections have been included under this heading (but do not appear in the List of Exhibitions forming part of the bibliographical references at the back of the catalogue). Exhibitions are listed in date order. A number in parentheses following reference to an exhibition is that assigned to the painting in the catalogue of the exhibition.

Related Works: Dimensions have been given for paintings, where known, and these works may be assumed to be oil on canvas unless otherwise indicated. I have not given dimensions or media for drawings and prints, except for those that are illustrated, where these details are given in the caption.

Technical Notes: These derive from examination of the paintings by, and my discussions with, Martin Wyld, Head of Conservation, and Paul Ackroyd and Larry Keith of the Conservation Department; from investigation of the paintings by Ashok Roy, Head of the Scientific Department, and his colleagues Raymond White and Marika Spring; and from the publications and articles (mainly in various issues of the *National Gallery Technical Bulletin*) referred to in the relevant notes.

In the discussion of each painting I have tried to take account of information and opinions that were in the public domain before the end of 2000. Exceptionally, because I knew in advance that Poussin's *Annunciation* (NG 5472) would be lent to an exhibition held at the Louvre, Paris, early in 2001, I have mentioned, albeit in a note and without discussion, Marc Fumaroli's suggestion in the exhibition catalogue concerning the picture's original function. Except where otherwise indicated, translations are my own and biblical quotations are from the Authorised Version (King James Bible).

General References: In the case of pictures acquired by 1957, I have included a reference to Martin Davies's French School catalogue of that year; I have referred to his 1946 catalogue only when there was some material development in his views between the two dates. In the case of subsequently acquired paintings, I have referred to the interim catalogue entry published in the relevant *National Gallery Report*. In addition, General References include relevant catalogues of pictures (not necessarily catalogues raisonnés), but not other material.

List of Publications Cited: This includes only publications referred to more than once.

List of Exhibitions: This is a list both of exhibitions in which the paintings here catalogued have appeared and of exhibition catalogues cited in the notes. The list is in date order.

Abbreviations

AAF	*Archives de l'Art français*
AAF	*(NP) Archives de l'Art français (Nouvelle Période)*
AB	*The Art Bulletin*
AH	*Art History*
AN	Archives Nationales
BFAC	Burlington Fine Arts Club
BI	British Institution
BL	British Library
BM	British Museum
BM	*The Burlington Magazine*
BN	Bibliothèque Nationale
BSHAF	*Bulletin de la Société de l'Histoire de l'Art Français*
DBF	*Dictionnaire de biographie française*
DNB	*Dictionary of National Biography*
F.-B.	Friedländer and Blunt
GBA	Gazette des Beaux-Arts
JWI	*Journal of the Warburg Institute*
JWCI	*Journal of the Warburg and Courtauld Institutes*
LV	*Liber Veritatis*
MC	Minutier Central
MRD	Roethlisberger 1968b (Marcel Roethlisberger: *Catalogue raisonné of Drawings)*
NAAF	*Nouvelles Archives de l'Art français*
NACF	National Art Collections Fund
NG	National Gallery
NGCIC	*National Gallery Complete Illustrated Catalogue*
NGTB	*National Gallery Technical Bulletin*
NHMF	National Heritage Memorial Fund
RA	Royal Academy
RKDH	Rijksbureau voor Kunsthistoriche Documentatie, The Hague
R.-P.	Rosenberg and Prat 1994

List of Paintings

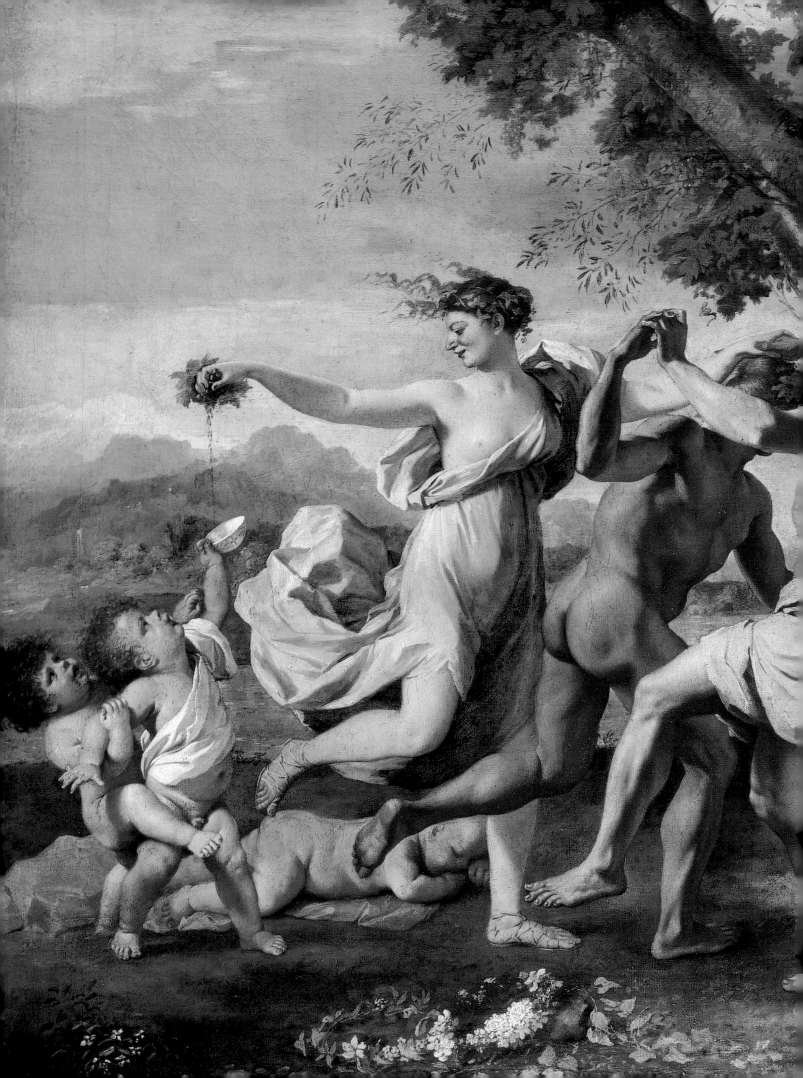

Lubin Baugin

*c.*1612–1663

Baugin was born in Pithiviers some fifty miles south of Paris. He joined the painters' guild of St-Germain-des-Prés in 1629. He was probably in Italy from around 1636 but had returned to Paris by 1641. He specialised in small paintings of religious subjects, mainly the Virgin and Child or the Holy Family. These were often on panel and were influenced by the art of Raphael and Guido Reni, but with Mannerist colour and figure contours. He also painted larger works, including a series of paintings for the cathedral of Notre-Dame in Paris – only two remain there now. In his *Dead Christ* (Orléans, Musée des Beaux-Arts) Baugin retained the elegant, elongated contours with which he is associated, but dispensed with his usual sentimentality to make a work of rare emotional intensity.

NG 2293

Holy Family with the Infant Saint John the Baptist, Saint Elizabeth and Three Figures

*c.*1642
Oil on panel, 31.6 × 22.6 cm

Provenance

In the collection of George Fielder (1811–86) of West Horsley Place, Leatherhead, Surrey, by 1878, as by Benvenuto Tisi (i.e. Garofalo); bequeathed to the National Gallery by Fielder in 1908.[1]

Exhibitions

Guildford 1884, *Surrey Art Loan Exhibition* (18) (as by Garofalo); Orléans 1958, Musée des Beaux-Arts, *Artistes Orléanais du XVIIe siècle* (7); Coventry, Derby, Doncaster, Bath 1982, p. 38.

Technical Notes

NG 2293 is somewhat worn, although many parts are thinly painted anyway. There are several horizontal splits in the panel (which has in the past been thinned to a thickness of 5 mm) including one split the entire width of the panel some 4 cm below the top edge. The wood, which has not been identified but may be poplar, has a horizontal grain. The ground appears to be a thin layer of lead-white oil paint applied directly to the panel. The painting was last restored in 1981: the oak cradle was removed and a balsa-wood backing applied with oak strips around the edges. During cleaning it emerged that in the past the full-length horizontal split had been planed from the front, revealing large areas of white ground along its length. There has been some fading of the red lake pigment in the drapery of the Virgin's right arm. Her dress is painted in natural ultramarine with lead white. The green of Saint Elizabeth's drapery is a mixture of ultramarine and lead-tin yellow. Medium analysis shows the use of walnut oil in the blue of the Virgin's dress and that of the background, and linseed oil with the addition of a little pine resin in the brownish-green of the foliage at lower left.

An infra-red photograph (fig. 1) shows a donkey's head and a rock(?) at the right, presumably part of an earlier composition. In addition the outline of the top of the cliff above Saint Elizabeth's head has been changed, as has that of the angel's right wing. What may be a head turned away from the viewer appears just to the right of Saint Joseph's head. It is also apparent that space was left in reserve for the existing figures. The lines visible to the naked eye at the bottom left of the picture may have been the outlines of rocks or fragments of ruins and were perhaps connected with the earlier composition. This is more apparent from the infra-red photograph.

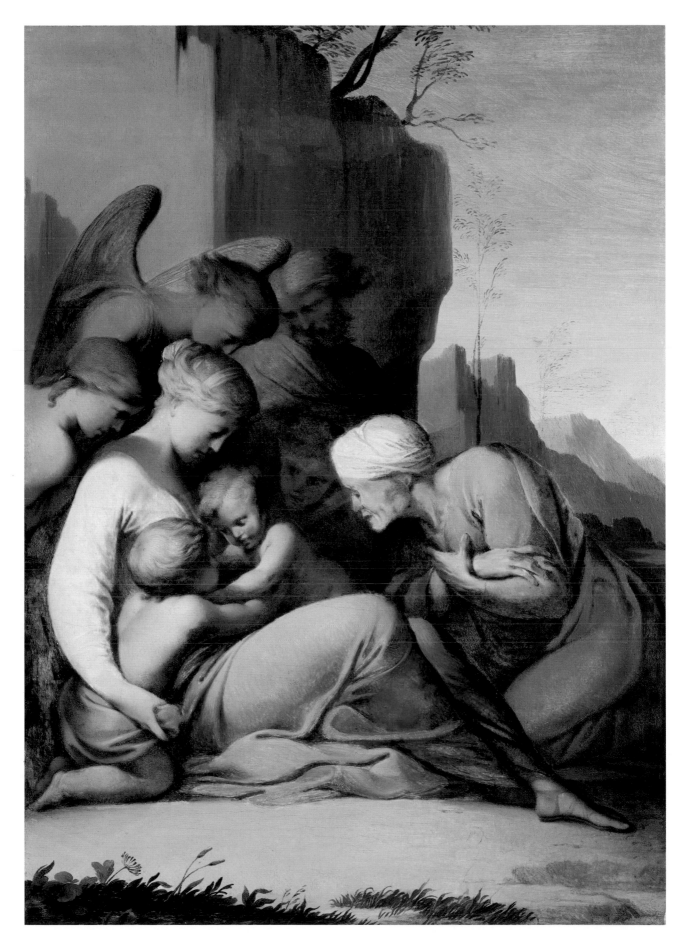

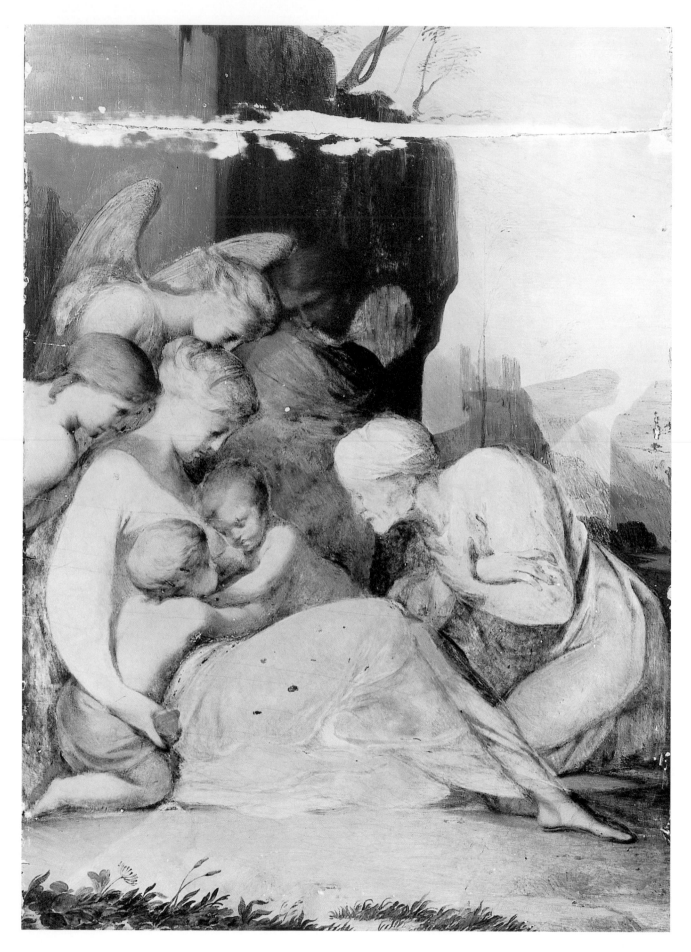

4 BAUGIN

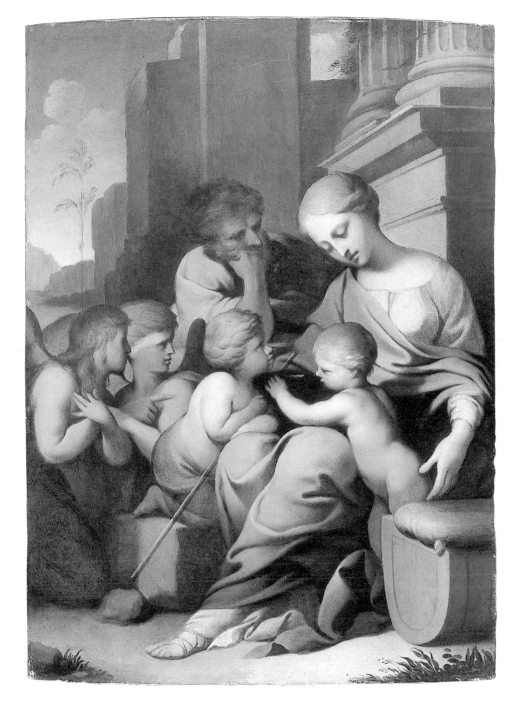

Infra-red reflectography reveals some light underdrawing, particularly of the head of Saint Elizabeth, and that the position of the Virgin's left foot as planned or as drawn was originally some 3–4 mm higher.

The attribution to Lubin Baugin first made by E.K. Waterhouse[2] is now universally accepted.[3] The painting is one of a number by Baugin of the Holy Family with accompanying saints or angels which have, by virtue of their relatively pale tonality, been assigned to 1640 or later, following Baugin's return to Paris from a probable trip to Italy in about 1636–40. These are of modest size and mostly on panel, and in a style

influenced by Raphael and Parmigianino.[4] The type of Saint Joseph with flowing whiskers can also be seen in *The Sleep of the Infant Jesus* (Paris, Louvre, inv. no. 2436), and both that painting and *The Holy Family with Saint John the Baptist and Two Angels* (Dijon, Musée Magnin, inv. no. CA223) share with NG 2293 a broadly triangular composition of figures set off against rectilinear slabs of rock in the background. Particularly noticeable in NG 2293 is the serpentine nature of the figures. These may be contrasted with the more static figures and more Raphaelesque composition of the *Holy Family with the Infant Saint John the Baptist and Two Angels* (Notre Dame, Indiana, The Snite Museum of Art; fig. 2), which possibly dates from around 1651–5 when, as a member of the Académie Royale de Peinture et de Sculpture, Baugin was most likely to

have been influenced by the classicising influences then current in French art.[5] If it is correct, as recently proposed, that Baugin prepared the supports of all his Paris-period paintings with a grey ground,[6] it may be that the National Gallery painting, the ground of which is white, was not executed in Paris. However, it is possible that NG 2293 was completed in Paris, but that it, or the original composition partially revealed by the infra-red photograph,[7] was started elsewhere. If the support of NG 2293 is indeed made of poplar,[8] it may have been carried back by the artist from Italy. The fact that, when NG 2293 was last restored, no panel-maker's mark was identified on the reverse also suggests that the panel was not acquired in Paris.[9] In addition, the use of walnut oil as a medium (see Technical Notes) would be consistent with, but certainly not conclusive of, the painting having had an Italian, rather than a French, origin.[10] Stylistically, NG 2293 seems earlier than the Snite Museum picture, but Baugin's use here of clear, relatively pale colours may owe something to Vouet's practice in some of his paintings of around 1640–5. The date proposed for NG 2293 is therefore soon after Baugin's assumed date of return to Paris in 1641, but in the absence of any securely dated work by Baugin, that proposal must remain extremely tentative.[11]

General References

Davies 1957, pp. 11–12; Auzas 1957, p. 49;[12] Auzas 1958, p. 137;[13] Thuillier 1963, p. 26; Wright 1985, p. 136; Wright 1985b, p. 84;[14] Coatalem and Delosme 1994, no. CP7.

NOTES

1. By a codicil dated 22 October 1878 to his will dated 9 October 1878 George Fielder bequeathed to the trustees of the British Museum for the National Gallery of Pictures at Trafalgar Square thirteen paintings including ' "Holy Family", Cabinet Picture by Benvenuto Tisi, called "Il Garofalo" ', that is, NG 2293. The bequest was subject to a life interest for Fielder's wife, Laura Mary, née Sanders, who died on 31 March 1908. Five of the paintings comprising the bequest were removed from West Horsley Place in May of that year, the rest being declined: NG Archives, NG7/341/1908. The minutes of the meeting of National Gallery Trustees of 12 May 1908 recording acceptance of the bequest are annotated '(school of Raphael.) Luca Penni.' by the reference to NG 2293.

2. According to Davies 1957, p. 12.

3. See under General References.

4. See E. Coatalem and N. Delosme, *Lubin Baugin. Oeuvres religieuses et mythologiques provenant de collections privées présentées à la Galerie Eric Coatalem du 30 septembre au 28 octobre 1994*, Galerie Eric Coatalem, Paris 1994, nos 12, CP6, CP8 and CP12.

5. The painting now in the Snite Museum is reproduced in colour in Colnaghi, *French and Spanish Paintings*, London and New York 1986, p. 15. It has been suggested that a closely related work in a private collection belongs to the years 1650–60: Coatalem and Delosme, op. cit., no. 12.

6. Coatalem and Delosme, cited in note 4, p. 15. See also N. Delosme and E. Coatalem, 'Le génie retrouvé de Lubin Baugin', *Estampille. L'objet d'art*, no. 299, February 1996, pp. 24–45 at p. 44. This article also reproduces Baugin's posthumous inventory, which reveals nothing like NG 2293 save 'une Vierge et ste Elizabeth' described as a small picture on wood (item 60); this, however, is scarcely an adequate description for the Gallery's painting.

7. See under Technical Notes and fig. 1.

8. See under Technical Notes.

9. It has not been possible to take a sample of the wood for analysis, or to re-examine the back of the panel. On the question of the lack of a panel-maker's mark, see Coatalem and Delosme, cited in note 4, p. 15 and nos 10/1, 10/2, CP6 and CP26.

10. Raymond White of the Gallery's Scientific Department has advised me that the use of walnut oil in the sixteenth century has strong associations with Italy. However, its use has been detected in two seventeenth-century pictures painted in France in the Gallery's collection, namely NG 64 by Bourdon and NG 2967 by Mignard, both of whom had worked in Italy. Interestingly, its use has not been detected in NG 1449 by Philippe de Champaigne nor in NG 2929 by Revel, neither of whom worked there. There is a paucity of published results in this area.

11. On the difficulty of dating works by Baugin, see J. Thuillier, *De Niccolò dell'Abate à Nicolas Poussin: aux sources du Classicisme 1550–1650*, exh. cat., Musée Bossuet, Meaux 1988–9, p. 178. In conversation (13 June 2000) Eric Moinet told me that Jacques Thuillier, then in the course of preparing a Baugin monographic exhibition at the Musée des Beaux-Arts, Orléans, considered NG 2293 to be of the 1640s.

12. P-M. Auzas, 'Lubin Baugin, dit le petit Guide', *BSHAF*, année 1957, pp. 47–54.

13. P-M. Auzas, 'Lubin Baugin à Notre Dame de Paris', *GBA*, 51, 1958, pp. 129–40.

14. J. Thuillier, 'Lubin Baugin', *L'Oeil*, no. 102, June 1963.

Marie Blancour
Seventeenth century

Nothing is known of Blancour. She was presumably French and active in the seventeenth century. The signed painting in the National Gallery is her only known work.

NG 6358
A Bowl of Flowers

1650s
Oil on canvas, 65.5 × 51.4 cm
(including additions along three margins)
Signed on ledge at bottom: *Marie Blancour f*

Provenance

Misses M.E. and C.M. Blencowe,[1] their sale, Sotheby's, 28 April 1954 (lot 1, £80 to Leggatt as 'Verbrueggen');[2] bequeathed to the Gallery in 1964 by Captain Edward George Spencer-Churchill MC (1876–1964), of Northwick Park, Glos., Trustee of the National Gallery, 1943–50.[3]

Technical Notes

In reasonable condition. There is some wear and there are drying cracks in the background, and retouchings along the bottom of the shelf, in the right-hand striped tulip, and in the orange and red flowers at lower right. Additionally, the greens have darkened and the lake pigments have faded. The signature has been reinforced. The primary support is a medium-fine plain-weave canvas which has been added to by 1.5 cm along the top and right edges and by 1.3 cm along the bottom, and which has been lined in the last hundred years with a similar canvas. *S72 NT* is stencilled on the left stretcher bar, and the top stretcher bar bears circular paper labels, one marked *J359*, the other *P90*. *14/8M* is chalked on the right stretcher bar. The stretcher is probably twentieth century. The ground is a warm buff/grey colour. There is a pentimento to the base of the left-hand striped tulip.

No record of Marie Blancour, other than the signature on this work, survives.[4] She was presumably a French artist, although there is nothing specifically French about compositions of this kind, which were associated also with Dutch and Flemish artists.

The flowers in NG 6358 have been identified by Roy Vickery and John Lonsdale (see fig. 1).[5] The red and white variegated tulips were especially popular during the tulip mania period of around 1637 but are also found earlier, in the work of Jan Bruegel the Elder (1568–1625) and his contemporaries, and later, in that of Rachel Ruysch (1664–1750) among Dutch painters[6] and of Jacques Linard (c.1600–45),[7] Jean Michel Picart (1600–82) and Jean-Baptiste Monnoyer (1634–99) among French painters.[8] A white flower similar to that identified in NG 6358 as (possibly) *viburnum lantana* appears in a painting by Simon Pietersz. Verelst (1644–1721), probably painted in England in 1672.[9] A small pink flower slightly left of centre in NG 6358 has been identified as an anemone, possibly an *anemone coronaria*. Such a flower, with different colouring, appears in works by Jacob Marell (1613/4–81) dated to c.1650,[10] Hans Bollongier (c.1600–81?) dated 1638,[11] and other artists of the period.[12] A painting by Anthony Claesz. (1607–49) dated 1642 contains both a species of *anemone coronaria* and a colombine (*aquilegia*), another of the plants identified by Vickery in NG 6358,[13] as does a picture by Johannes Goedart (1617–68) dated to after 1650.[14] Such a combination of identifiable flowers in NG 6358, together with the absence of popular eighteenth-century favourites like the hyacinth,[15] suggests a mid-seventeenth-century date for the painting, and the restrained shape and decoration of the terracotta pot seem consistent with the 1650s.[16]

Individual flower species had symbolic meanings attached to them during the seventeenth century. According to the Jesuit Leroy Alard, 'the anemone opens the heart to receive the inspirations of the Holy Spirit, the narcissus causes one to disregard the dangers of beauty...the tulip enflames the soul with desire to be embellished with many different virtues...'[17] Each of these flowers is included in NG 6358, but it is not clear that they would have been interpreted in the way Alard describes,[18] nor, more generally, that the flowers in a painting such as this would have been seen as symbolising the transience of human life rather than as decorative objects.[19]

General Reference
The National Gallery June 1962–December 1964, London 1965, p. 103.

Fig. 1 Diagram of NG 6358 identifying species. Drawn by Linda Gurr.

1. *Aquilegia c.v.*

2. *Tulipa c.v.*

3. *Narcissus*

4. *Primula auricula*

5. *Anemone ?coronaria*

6. *?Viburnum lantana c.v.*

7. *Papaver orientale c.v.* (double form)

8. *Punica granatum*

NOTES

1. Presumably Marjorie Edith and Cecilia Mary Blencowe, daughters of Oswald Charles Blencowe (1890–1916), killed at the battle of the Somme, and granddaughters of the Revd Charles Edward Blencowe (d.1929) of Marston St Lawrence, Northants: *Burke's Genealogical and Heraldic History of the Landed Gentry*, 17th edn, 1952, p. 204. I am grateful to Jacqui McComish for this reference.

2. Described as 'Flowers in a terra cotta urn 24in. by 18½in.'

3. The picture is recorded in *Northwick Rescues 1912–1961*, n.p. [1961], no. 152, with the provenance of the 1954 Sotheby's sale, and as having been described by the Louvre as 'of prime importance'.

4. She rates no mention in Thieme-Becker, Bénézit, *Allgemeines Kunst-Lexicon* or *The Dictionary of Women Artists*, nor is there any reference to her in the Fichier Laborde (Bibliothèque Nationale, Département des Manuscrits).

5. Note of 19 November 1997 from Roy Vickery, Natural History Museum, London,

and of August 2000 from John Lonsdale, Royal Botanic Gardens, Kew.

6. Sam Segal, *Flowers and Nature. Netherlandish Flower Painting of Four Centuries*, The Hague 1990, pp. 44–5 and *passim*.

7. P. Mitchell, *European Flower Painters*, London 1973, p. 37 (pl. 38).

8. M. Faré, *La Nature Morte en France. Son histoire et son évolution du XVIIe au XXe siècle*, 2 vols, Geneva 1962, vol. 2, pls 82, 230.

9. Sam Segal, cited in note 6, pp. 106, 224–5.

10. Ibid., pp. 90, 195.

11. Ibid., pp. 90, 196.

12. Ibid, pp. 91, 92, 198–9

13. Ibid., pp. 91, 197–8.

14. Ibid., pp. 92, 199–200.

15. Ibid., pp. 48–9.

16. La Hyre's *Allegory of Grammar* (NG 6329), which is signed and dated 1650, also shows an *anemone coronaria*.

17. '...l'Anémone ouvre le coeur pour recevoir les inspirations du Saint Esprit; le Narcisse fait négliger la beauté périlleuse... La Tulipe embrase l'âme d'un désir d'être embellie d'une grande variété de vertus...', R.P. Leroy Alard, *La sainteté de vie tirée de la considération des plantes*, Liège 1641, pp. a4–a5, cited by Alain Tapié in *Symbolique & botanique, le sens caché des fleurs dans la peinture au XVIIe siècle*, exh. cat., Caen 1987, p. 28.

18. On this point, see P. Taylor, 'Images de fleurs, images de Dieu? Méditation sur la nature au XVIIe siècle', *L'Empire de Flore. Histoire et représentation des fleurs en Europe du XVIe au XIXe siècle*, Brussels 1996, pp. 250–60.

19. See *Symbolique & botanique*, cited in note 17, no. 33, for an example of a flower picture regarded by Alain Tapié as having no symbolic significance. See also Arthur K. Wheelock Jr, *From Botany to Bouquets. Flowers in Northern Art*, exh. cat., Washington 1999, pp. 15, 51 and 63, on the representational and/or symbolic nature of flower paintings in the seventeenth century.

Sébastien Bourdon
1616–1671

Bourdon came from a Protestant family in Montpellier. His father was a glass painter. As a boy Sébastien was apprenticed to a certain Barthélemy in Paris, after which he is said to have gone to Bordeaux, then to Toulouse, where he enlisted. He was in Rome in 1634 making copies and pastiches of the work of his contemporaries, including Claude, but also executing genre scenes often showing a group of travellers, soldiers or peasants in an outdoor setting. Bourdon left Rome hurriedly in 1637, apparently to escape charges of heresy, and returned to Paris via Venice. His talents were quite quickly recognised: he was lodged in the Louvre before 1641 and in 1643 was commissioned to paint *The Martyrdom of Saint Peter* for the cathedral (Paris, Notre-Dame). In 1648 he was one of the founder members of the Académie Royale de Peinture et de Sculpture. From 1652 to 1654 he was working in Stockholm at the invitation of Queen Christina of Sweden, painting mainly portraits. He then returned to Paris, where he was named Rector of the Académie in 1655. He was in Montpellier in 1657–8. There he executed portraits, such as the so-called *Man with Black Ribbons* (Montpellier, Musée Fabre), and an altarpiece (*The Fall of Simon Magus*) for Montpellier Cathedral, where it still is. In the latter part of his career, Bourdon's style became more influenced by Poussin, as for example in his *Finding of Moses* (Washington DC, National Gallery of Art) and in NG 64. Between 1667 and 1670 he delivered four lectures to the Académie, including one (in 1667) on Poussin's *Christ healing the Blind Man of Jericho* (Paris, Louvre).

NG 64
The Return of the Ark

1659
Oil on canvas, 105.3 × 134.6 cm
Inscribed (?) on a stone slab at right

Provenance

An inscription on the back of the original canvas reads, *C'est La Toile du Tableau/A. Mr. Thomas./1659* (see fig. 1 and p. 13); probably item no. 60 in the post-mortem inventory dated 9 August 1768 of Jean Baptiste Maximilien Titon, there valued at 20 livres;[1] bought by Robert Strange probably after February 1771;[2] Robert Strange sale, Christie's, 5 May 1775 (lot 48), where bought for £23 2s. by 'Mr. Doubty',[3] presumably the York painter William Doughty (1757–82) then living in Sir Joshua Reynolds's house in Leicester Fields, London,[4] and so on Reynolds's behalf; in Reynolds's collection and mentioned by him in his Fourteenth Discourse (10 December 1788);[5] bequeathed by Reynolds in 1792 to Sir George Beaumont, by whom sent to Coleorton Hall, Leicestershire, in 1808 and there noted by Neale in the dining room;[6] given by Beaumont to the Gallery in 1826.

Exhibitions

London 1773, Robert Strange Collection (97); London 1819, BI (117); London 1949–50, RA, *Landscape in French Art* (8); Coventry, Derby, Doncaster, Bath 1982, p. 35; London 1988, NG, '*Noble and Patriotic*'. *The Beaumont Gift* (2); Montpellier and Strasbourg 2000–1 (316). `

Related works

PAINTINGS

(1) Whereabouts unknown. A copy made before 1798 by Lady Margaret Beaumont, wife of Sir George Beaumont;[7]
(2) A reduced-size copy (22.8 × 27.9 cm), probably nineteenth century, offered at Christie's, South Kensington, 24 February 1994, as by 'Follower of Hendrick F.van Lint' (lot 66);
(3) Christie's, South Kensington, 5 December 1997 (lot 124, £1900), 'A classical Landscape with the flight into Egypt' as by a follower of Francisque Millet, oil on canvas, 45.7 × 55.8 cm, has a landscape background like that of NG 64. By Bourdon(?).
DRAWING
The arrangement of planes in a drawing by Bourdon (New York, Metropolitan Museum of Art, inv. no. 1984.51.2) has been noted as bearing a 'remarkable resemblance' to that in NG 64,[8] but the drawing is not necessarily preparatory to that (or any other) painting.

PRINTS

(1) By Bourdon himself, according to Heinecken and others, although no copy of the print is known.[9] Poitevin owned a copy in 1811;[10]

(2) by J.C. Varrall in *The National Gallery of Pictures by the Great Masters*, n.d. (1838?).

Technical Notes

NG 64, painted on a plain-weave, medium-weight canvas, the turn-over edges of which are mainly preserved, is overall rather worn, with the red ground layer tending to show through. There is craquelure in the darks, and blanching in the foliage. The painting was last restored and relined in 1978, when it was given a new stretcher. The old lining canvas, fitted before 1853 when Gallery records began, is inscribed *This Picture was/ bequeath'd to Sir George Beaumont. Bart/ by His Illustrious friend/ Sir Joshua Reynolds/ in the year 1792*. Indications on the canvas show that the original stretcher, like many made in the seventeenth century, had diagonal cross braces in the corners and one central vertical bar.

There are visible pentimenti to the upper branches of the tall trees in the centre, to the rocks near the centre of the right edge, and to the outlines of the two figures in the left foreground. The X-radiograph is indistinct but shows scattered paint losses around the edges and elsewhere. Examination of samples revealed a warm-coloured ground composed of two layers, which is similar to that of other French seventeenth-century paintings (for example, NG 2967): namely, a light pinkish-brown lower layer of lead white and finely ground red-brown earth, with a similar upper layer, stronger in tone, containing a higher proportion of red-brown earth.[11] The use of heat-bodied walnut oil in the warm white highlights of the clouds at the left edge and in the blue-grey paint of the sky along the top edge, as shown by media analysis, would also be consistent with paintings of the period. However, an unusual mixture of linseed oil with pine resin and a trace of copaiba balsam in the greenish-grey area of the sky near the top may be evidence of intervention by another hand. If so, Sir Joshua Reynolds, who was known for his interest in the formulation of paint media with various resinous components, would be the likely candidate, but the limited area in which his(?) intervention can be detected is more consistent with restoration than repainting. Davies suggested that the mountains to the left may have been retouched by Sir Joshua Reynolds, in whose collection the painting was. An inference that the painting was restored by Reynolds seems confirmed by the results of an analysis of a fragment from the blue mountains at the left. This shows a lower layer of ultramarine-based paint and an upper, yellowed transparent layer. Only the upper layer contains a copaiba component.

Within a few years of NG 64 entering the Collection, it was described as having colouring 'not calculated to captivate the eye. The foreground, though somewhat enlivened by the white tint of one of the heifers, the blue drapery of one of the figures, and the scarlet dress of another, partakes very much of brown; and the same colour also predominates in the middle-ground.'[12]

Fig. 1 Infra-red photograph of the inscription on the back of the original canvas.

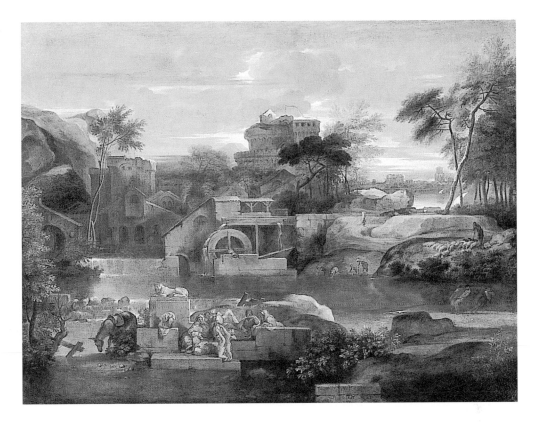

Fig. 2 *Rest on the Flight to Egypt.*
Oil on canvas, 116 × 149 cm.
New York, Lunde Collection.

The subject of NG 64 is taken from I Samuel 6. The five lords of the Philistines follow the Ark of the Lord to the border of Beth-shemesh, whose inhabitants rejoice to see it returned from captivity (see fig. 3). The cart on which the Ark has been placed is shown drawn by cattle, as related in the Bible. The subject, which is rare in seventeenth-century painting,[13] may have been chosen by the patron, for whom it could have had a special significance. It is unlikely to be connected with the return of 'true' religion (in the context of the Counter-Reformation), because, according to the Bible, the men of Beth-shemesh were themselves smitten by the Lord for having looked into the Ark, and in their turn the Israelites did not regain possession of it for at least another twenty years (I Samuel 7:2). It is possible that Bourdon or his patron sought no more than an unusual subject to lend dignity to a landscape.

The inscription on the reverse of the canvas (see fig. 1 and Provenance), discovered when NG 64 was last restored, is insufficiently precise to identify the patron. Whether that inscription is by Bourdon himself cannot be determined, although the figures in it are not dissimilar to those in a receipt dated 1657 and signed by him.[14] Wilson presumed that the 'Mr Thomas' referred to was an Englishman.[15] Although another painting by Bourdon may have been in English hands as early as 1660,[16] during the seventeenth century there were families called Thomas in France, where the abbreviations 'Mr.' as well as 'M.' for 'Monsieur' seem to have been in use.[17] Bourdon was in Montpellier, his native town, during most of 1657 and early 1658.[18] Were the commission from Montpellier, which would not be precluded by subsequent execution of this painting in Paris, a possible candidate would be Antoine de Thomas, recorded as a Conseiller à la Cour des Aides of Montpellier in 1663;[19] another would be 'Monsieur Maistre N. de Thomas, Conseiller du Roy en la Cour des Comtes, Aydes et Finances de Montpelier, Baron de Carves, Seigneur de Roquecourbe'.[20]

Geraldine Fowle has noted points of resemblance between particular motifs in NG 64 and in other paintings or etchings by Bourdon which 'in most cases [were] demonstrably executed during the latter part of the artist's career'. She has proposed dating NG 64 to *c*.1665,[21] Thierry Bajou has suggested 1663–5,[22] and Jacques Thuillier has placed it in the years 1665–71.[23] Fowle could not have been aware of the date 1659 inscribed on the back of the canvas, and even if the works she cites were securely dated to the mid-1660s – which they are not – this would not of itself exclude a slightly earlier date for NG 64. In fact, the work in Bourdon's oeuvre most comparable to NG 64 is arguably *The Rest on the Flight into Egypt* (New York, Lunde Collection; fig. 2), which shares with the National Gallery painting both a similar relationship between figures and landscape, and a similar unevenness of light. The Lunde painting, however, cannot itself be securely dated.[24] The broad influence of Poussin's *Phocion* landscapes of 1648 on NG 64 is evident, although it is not clear when these arrived in Paris and so accessible to Bourdon.[25] The glassy stillness of the water in the background of NG 64 recalls Poussin's *Landscape, a Calm* (Los Angeles, J. Paul Getty Museum) painted in 1651 for Pointel, with which – to judge by Bourdon's *Landscape with a Mill* (Providence, Museum of Art, Rhode Island School of Design) – the younger artist was evidently familiar, but NG 64 probably postdates both these paintings by several years. The composition of NG 64's

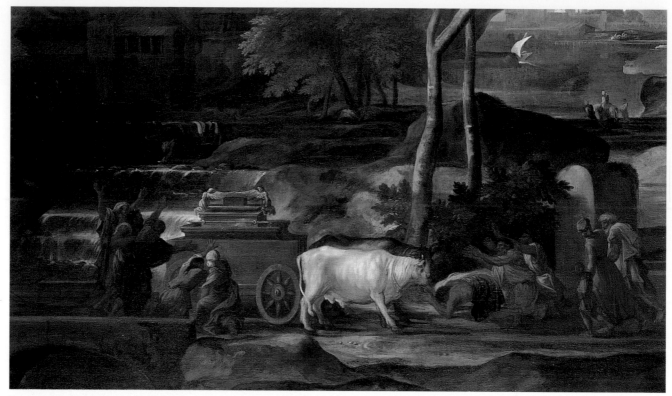
Fig. 3 Detail of NG 64.

landscape in a series of horizontal planes would have been appropriate for the subject, since 'the kine took the straight way to the way of Beth-shemesh... and turned not aside to the right or to the left' (I Samuel 6, 12). Nevertheless, although the composition may have been determined in part by the subject matter of NG 64, its rationality is not consistent with the visionary quality of the works of Bourdon's final years.[26] It is, however, consistent with, for example, the composition of *Landscape with Five Washerwomen*, one of a series of six landscapes engraved by Baudet, designed by Bourdon and published in 1664.[27] In addition, buildings like the castle with a tower in the right background of NG 64 appear at the left of *Landscape with Five Water-Carriers*, another of the series engraved by Baudet.[28] A date for NG 64 prior to 1664 therefore seems likely, and there seems no reason to doubt 1659, the date inscribed on the back of the canvas.

The appearance of NG 64 has long been problematic (see Technical Notes). The increasing transparency of the paint with age has led to a loss of definition in the predominant browns of two-thirds of the composition, and as a consequence the two figures bending over to wash clothes in the river in the middle ground at centre left can scarcely be seen. And a possible inscription on the block of stone at bottom right, possibly in an old varnish layer, cannot be deciphered – if indeed it ever existed. On the other hand, the steely blue-greys of the sky have retained considerable definition, making the painting as a whole appear unbalanced. For Sir Joshua Reynolds, however, these defects were advantageous. According to Sir Uvedale Price, Reynolds 'thought that the grandeur of [the painting's] style (which he always spoke of with admiration)

was of so peculiar a cast, and so far removed from obvious common nature, as to be incapable of being truly relished except by minds of strong original feeling, and long accustomed to contemplate the higher excellences of the art'.[29] Uvedale Price himself was also an admirer of NG 64, regarding the buildings in it as exemplifying 'the union of grandeur and picturesqueness'. He was especially impressed by the mill:

> A mill, such as those which Ruysdal, Waterlo, or Hobbima painted (excellent as they are in their kind,) would, on account of their broken forms, and strongly marked intricacy and irregularity, be ill suited to the solemnity of such a subject. Bourdon has, therefore, made the general form of the building of a more massive and uniform kind, though sufficiently varied; and at the same time that he has, with great truth, marked the intricacy of the wheels, and the effect of water in motion, he has kept the whole in such a mass of broad shadow, that nothing presses upon the eye, or interferes with the style of the picture: yet, on inspection, all the circumstances of intricacy, and motion, amuse the mind; and (what is the true character and use of the picturesque in such cases) relieve it from the monotony of mere breadth, massiveness, and uniformity.[30]

General References
Ponsonailhe 1883, p. 298; Davies 1957, p. 21; Fowle 1970, no. 11; Wright 1985b, p. 88; Thuillier 2000, no. 316.

NOTES

1. Described in the inventory: 'No 59 Item un tableau paysage représentant des beufs tirant l'arche d'alliance peint par Sébastien Bourdon prise vingt livres.' V. Lavergne-Durey, 'Les Titon, mécènes et collectionneurs à Paris à la fin du XVIIᵉ et au XVIIIᵉ siècles', *BSHAF*, Année 1989, 1990, pp. 77–103 at pp. 99 and 101, n. 140, where the author notes, 'Seule la faible prisée laisse planer un doute sur un tel rapprochement [with NG 64], bien que l'ensemble des cotations est fort bas dans cet inventaire après décès.'

2. NG 64 is not recorded in the 1769 catalogue of Strange's collection nor in his sale of 7–9 February 1771. Within days of that sale Strange was again collecting, buying in both Paris and Holland: James Dennistoun, *Memoir of Sir Robert Strange, Knt. and of his brother-in-law Andrew Lumsden, private secretary to the Stuart princes*, 2 vols, London 1855, vol. 2, p. 67. Possibly lot 88 of Strange's sale, Christie's, 5–6 March 1773 (apparently unsold), where described as 'Sebestien [sic] Bourdon A landscape'.

3. Christie's archive, 1775, vol. II, no. 31

4. For William Doughty, see John Ingamells, 'William Doughty: a little-known York painter', *Apollo*, 80, 1964, pp. 33–7.

5. Edward Malone, *The Works of Sir Joshua Reynolds Knt.*, 2 vols, London 1797, vol. 1, p. 306.

6. Malone, op. cit., p. lxviii. NG 64 was among thirteen pictures which Farington noted on 17 June 1808 as 'to be sent to Cole Orton', Beaumont's house in Leicestershire: *The Farington Diary*, vol. 9, p. 3297: 'They had been arranged by Segar for that purpose – the frames new gilt.' Coleorton Hall was built for Beaumont in 1804–8 to the design of George Dance the Younger: N. Pevsner, *Leicestershire and Rutland*, Harmondsworth 1960, p. 90. On NG 64 being hung in the dining room, see Neale 1818–23, vol. 1 (1818), p. 71.

7. F. Owen and D.B. Brown, *Collector of Genius. A Life of Sir George Beaumont*, New Haven and London 1988, p. 99 and p. 240, n. 29.

8. [Tancred Borenius], 'Drawings in the collection of Mr Archibald G.B. Russell', *The Connoisseur*, 66, 1923, pp. 3–11, fig. XI, and see Goldfarb 1989, no. 93.

9. C.H. von Heinecken, *Dictionnaire des Artistes*, 4 vols, Leipzig 1778–90, vol. 3, p. 265. The print had also been recorded by F. Basan, *Dictionnaire des Graveurs Anciens et Modernes...*, 3 parts, Paris 1767, part 1, p. 81,
and by M. Huber and C.C.H. Rost, *Manuel des Curieux et des Amateurs de l'Art*, 9 vols, Zurich 1797–1808, vol. 7, 1804, p. 167. As Davies (1957, p. 21) pointed out, the print may not correspond with NG 64. The print is not in any of the collections in London, Montpellier, New York, Paris or Vienna: G.E. Fowle, *The Biblical Paintings of Sébastien Bourdon*, 2 vols, PhD thesis, University of Michigan, 1970, vol. 2, p. 41. Nor is it in those of Dresden or Budapest (letters in the NG dossier).

10. M. Poitevin, 'Notice Historique sur Sébastien Bourdon', *Bulletin de la Société des Sciences, Lettres et Arts de Montpellier*, no. 59, pp. 41–66, read at a public lecture on 26 December 1811. Poitevin described the print as 'grande pièce en travers, eauforte, morceau très-rare' (p. 65).

11. Note from Ashok Roy dated 1 July 1996.

12. Ottley 1832, p. 38. NG 64's 'monotony of colour' was noted also by John Landseer, who, however, suspected that the Ark and its carriage had become darker since painting: Landseer 1834, p. 404.

13. The subject is unrecorded in Pigler 1974.

14. See illustration in Ch. Ponsonailhe, *Sébastien Bourdon. Sa vie et son oeuvre*, Montpellier 1883, p. 159 (opp.).

15. Wilson 1985, p. 66.

16. See introductory essay. In addition *The Lamentation* (formerly Spencer Collection, Althorp, now private collection, USA) was acquired by Robert, 2nd Earl of Sunderland, probably during his ambassadorship at the court of Louis XIV in 1672–3: Fowle, cited in note 9, vol. 2, pp. 115–16, and *DNB*, vol. 18, p. 777.

17. E. Littré, *Dictionnaire de la Langue Française*, 4 vols plus supplement, Paris 1869–84, vol. 2 (1869), p. 612.

18. Ponsonailhe, cited in note 14, pp. 145 and 183–4.

19. Odon de Lingua de Saint Blanquat, *Ville de Toulouse, Inventaire sommaire des archives antérieures à 1790*, 2 vols, Toulouse 1976–7, vol. 1, p. 484. I am grateful to Anne Thackray for bringing this reference to my attention. Bourdon was certainly in contact with other members of the cour des aides: see Ponsonailhe, cited in note 14, pp. 162 and 170–1.

20. Pierre Borel, *Les Antiquitez de Castres*, 1649 (published by Ch. Pradel, Paris 1868), pp. 26–7. For another collector called Thomas, described in a manuscript datable to
1648 or earlier as 'chantre, curieux en tout' and living in Authun, see Bonnaffé 1873, pp. 46, 93–4.

21. G.E. Fowle, cited in note 9, vol. 2, p. 38.

22. Letter of 23 August 1999.

23. See Thuillier 2000, no. 316.

24. G.E. Fowle, cited in note 9, dates it *c*.1664–5, not unreasonably on the basis of her dating of NG 64. Thuillier dates it to 1667–71 in Thuillier 2000 (no. 323).

25. The *Phocion* landscapes were painted for the Lyonnais merchant Serisier, who was recorded in Lyon in 1650: letter from Poussin to Chantelou, 19 June 1650, *Correspondance de Nicolas Poussin*, ed. Ch. Jouanny, Paris 1911, p. 416. However, Serisier was settled in Paris and may have returned there long before 1665 when the *Phocion* landscapes were seen in Paris by Bernini. At all events Serisier is referred to as being in Paris in Poussin's letter of 18 February 1664 to the abbé Nicaise: *Correspondance de Nicolas Poussin*, p. 457. And see Paul Fréart de Chantelou's *Diary of the Cavaliere Bernini's Visit to France*, ed. A. Blunt, Princeton 1985, p. 111.

26. For example, Thuillier 2000, nos 335, 336 and 340 and the suite of six engraved landscapes (Thuillier 2000, nos 318–22) which recall late landscapes by Poussin.

27. Thuillier 2000, no. 242.

28. Thuillier 2000, no. 241.

29. Uvedale Price, *Essays on the Picturesque*, 2nd edn, London 1810, p. 319, and quoted by David Blayney Brown, 'Sir George Beaumont as Collector and Connoisseur. The Taste of the Golden Age' in *'Noble and Patriotic'. The Beaumont Gift 1828*, London 1988, p. 22. In his Fourteenth Discourse (10 December 1788) Reynolds said that 'the Arc [sic], in the hands of a second-rate master, would have little more effect than a common waggon on the highway'. And referring to NG 64 and to a picture of *Jacob's Dream* by Rosa, he continued, 'yet those subjects are so poetically treated throughout, the parts have such a correspondence with each other, and the whole and every part of the scene is so visionary, that it is impossible to look at them, without feeling, in some measure, the enthusiasm which seems to have inspired the painter.' (E. Malone, cited in note 5, p. 306.)

30. Uvedale Price, cited in note 29, pp. 320–1.

Angelo Caroselli
1585–1652

Caroselli was born in Rome. According to Baldinucci, he was self-taught. He was active as a painter in Rome by 1604 and probably spent most of his working life there, although records of his whereabouts during the period 1613–27 are sparse. He is said to have known Caravaggio, whose paintings greatly influenced his independent work until the 1620s. His reputation was mainly as a talented copyist, both of the paintings of his contemporaries and of old masters, but he also made three mural paintings for S. Maria in Valicella, Rome (1611–12), genre pictures such as *The Singer* (Vienna, Kunsthistorisches Museum) and an *Allegory of Vanity* (Florence, Fondazione Longhi). Like that of others of his contemporaries in Rome, his style took on a more classical aspect from the late 1620s, as is evident in his large altarpiece of *Saint Wenceslaus* (Vienna, Kunsthistorisches Museum), completed in 1630 for St Peter's, Rome. At about the same period he painted another altarpiece, *The Mass of Saint Gregory* for the church of S. Francesca Romana.

In the late 1630s Caroselli lived in the house of the landscapist Agostino Tassi, one-time master of Claude. His second marriage, in 1642, was to Brigitta Lauri, daughter of the painter Balthazar Lauwers and sister of the painters Francesco and Filippo Lauri. Filippo was living in Caroselli's house at the time of the latter's death.

Reference

C.S. Salerno, 'Precisazioni su Angelo Caroselli', *Storia dell'arte*, no. 76, 1992, pp. 346–6.

NG 165
The Plague at Ashdod (after Poussin)

1631
Oil on canvas, 129.0 × 204.5 cm

Provenance

Probably in the collections of Fabrizio Valguarnera in 1631, then Cardinal Mazarin (1602–61) by 1645 (see p. 19); presumably given by him to Cardinal François Marie Mancini (1606–72), by whom bequeathed to Mazarin's nephew, Filippo Mancini, duc de Nevers (1641–1707), in 1672 when recorded at the Palazzo Mazzarini;[1] then presumably given by Filippo Mancini to Filippo II Colonna (1663–1714), possibly by 1693;[2] recorded at the Palazzo Colonna, Rome, in 1714,[3] in 1730[4] (figs 1 and 2) and in 1783;[5] still at the Palazzo Colonna in January 1798,[6] but sold by Filippo III Colonna (1760–1818) in that year or soon after;[7] acquired, possibly by 28 March 1801 and certainly by 28 December 1802, by Sir Simon Clarke, Rome (possibly in partnership with the artist Alexander Day),[8] from whom bought by Irvine for Buchanan by 31 January 1803;[9] in England by 17 October 1803;[10] bought in for £1050 at Christie's, 12 May 1804 (lot 10);[11] offered before 25 May 1804 to Champernowne with Van Dyck's *Venus and Satyr* (unidentified) in exchange for Rubens's *A Roman Triumph* (NG 278) and *Venus* by Carracci (unidentified);[12] apparently a half-share sold to Champernowne, and a smaller share sold to Mrs Hartley by 19 February 1805;[13] sold to Harris for £800;[14] sale of James(?) Brogden, Peter Coxe, London, 12 June 1812 (lot 14), bought in at £1050;[15] collection of Thomas Jones, 1816;[16] presented by the Duke of Northumberland, 1838.[17]

Exhibitions

London 1816, BI (43; as 'The Plague at Athens'); Rome 1994–5, Académie de France à Rome, Villa Medici, *Roma 1630: Il trionfo del pennello*, pp. 162–71; London 1995, NG, *Poussin Problems* (no catalogue); Rome 1998–9, Palazzo dell' Esposizione, *Nicolas Poussin. I primi anni romani* (41).

Related Works

For copies and variants, drawings and engravings connected with the original painting in the Louvre, see Blunt 1966, p. 25, Paris 1994–5, p. 200, Rome 1994–5, pp. 162–71, and Mahon 1999, pp. 164–5. The copy in the Museu Nacional de Arte Antiga, Lisbon, may be that noted by Otto Mündler in Rome in 1856: 'S. Maria sopra Minerva. Collection of pictures belonging to a Portuguese priest. A repetition(?) of N. Poussin's "plague of the Philistines" is the best.'[18] In addition, a copy was in the possession of E.J. Reed, Westminster, London, in 1903,[19] and a copy of the Louvre painting was sold from the collection of Lady Rose Augusta Tupper (6 November 1919,

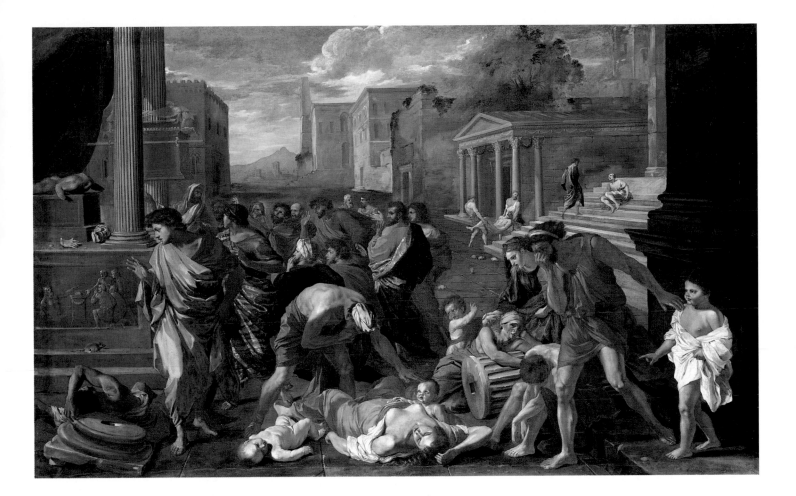

Fig. 1 Detail of fig. 2 showing NG 165, bottom centre.

Doric House, Sion Hill, Bath, lot 645, £300 to Witherby).[20] A picture which may have been a copy of NG 165, rather than of the painting in the Louvre, was noted by A.-N. Dezallier d'Argenville in his father's collection at his home in rue du Temple near the rue Pastourelle, Paris.[21]

A drawing in the Hermitage, St Petersburg (R.-P. R1110), reproduces the architectural background of NG 165 and so is not derived from the Louvre painting. For other engravings of the composition, see H.H. Mollaret and J. Brossollet, 'Nicolas Poussin et "Les Philistins frappés de la peste"', *GBA*, 73 (1965), pp. 171–8 at p. 173. The engraving by James Fittler recorded by Denio[22] is presumably of Michael Sweerts' *Plague in an Ancient City* (Los Angeles, County Museum of Art).

Technical Notes

Painted on a warm brown ground on a coarse open-weave canvas lined in 1852 and strip-lined in 1930.[23] Last cleaned and restored in 1994. There is an old repaired diagonal tear in the lower right, extending through the right-hand standing man's knee to the outstretched hand of the child at the far right.

Texture differences around the edges may be due to the canvas having formerly been glued to its stretcher. The red lakes have probably deteriorated and what is probably smalt in a mixture of smalt and green earth in the foliage above the temple and in the middle-to-distant landscape has certainly degraded. The blue in the drapery of the standing figure at the left is ultramarine and well preserved, and overall the condition of the painting is quite good. NG 165 contains an opaque yellow pigment based on lead, tin and antimony. To date, this yellow has been detected only in seventeenth-century paintings produced in Rome.[24] For the tracing lines visible on the outline of most of the principal figures, see the discussion below.

This is a variant copy of the painting of the same title by Poussin, now in the Louvre, Paris (fig. 3).[25] The subject is taken from I Samuel 5: the Philistines captured the Ark of the Lord and set it in the temple of Dagon. They then found the idol of Dagon fallen on its face with its head and hands cut off. The people of Ashdod were smitten with tumours, and, according to the Vulgate, also plagued by a multitude of mice. Poussin may well have consulted *The Antiquities of the Jews* by Josephus, who emphasises (VI: I, 1) that the fallen idol was found in a posture of adoration to the Ark, as Poussin shows here, and that the plague-stricken were 'entirely corrupted by the disease', an aspect conveyed by the foreground figures holding their noses.[26]

The Louvre painting is a key work in Poussin's career, first because it is known to have been painted during the winter of 1630/1, and secondly because it is the first of Poussin's paintings in which he so clearly uses both gesture and expression to indicate human emotion, and colour (in this case probably sombre, albeit masked by discoloured varnish) to reinforce it. The Louvre painting was acquired by the Sicilian nobleman Fabrizio Valguarnera in February or March 1631 for 110 scudi, and it was Valguarnera who commissioned, and at some time before July 1631 (when he was imprisoned) took possession of, a copy of it by the painter Angelo Caroselli.[27] Caroselli, who was known to make copies as well as independent works, was one of the few painters working in Rome who was actually born there; he apparently counted Poussin among his admirers.[28]

Fig. 2 S.C. Sciarra, *The Galleria Colonna*, 1730. Pen and watercolour, 12.7 × 51.1 cm. Chatsworth, Devonshire Collection.

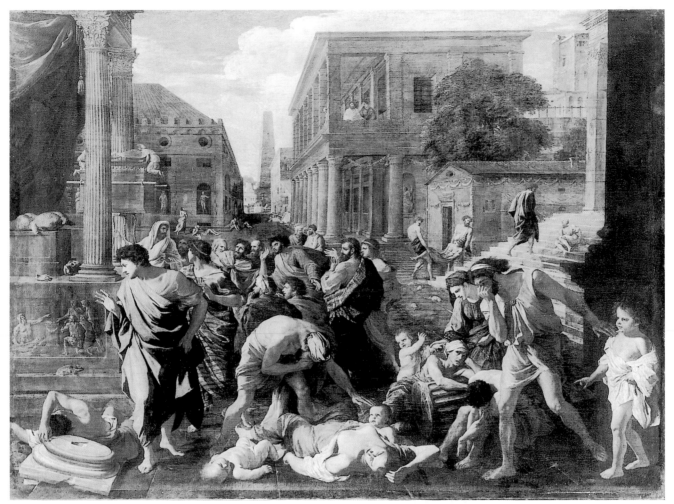

Fig. 3 Nicolas Poussin, *The Plague at Ashdod*, 1630–1. Oil on canvas, 148 × 198 cm. Paris, Musée du Louvre.

Davies catalogued NG 165 as a good old copy of the Louvre painting,[29] but it is now possible to be more precise and argue that it is the copy made by Caroselli. The identification of the London picture with the Caroselli copy rests primarily on three points. First, the composition of the yellow pigment strongly supports its origin in Rome in the seventeenth century (see Technical Notes). Secondly, the painting was certainly in the Palazzo Colonna by 1714,[30] and probably by 1693 when noted by Pietro Rossini.[31] Finally, as Patrick Michel has recently discovered, the Caroselli copy had entered the collection of Cardinal Mazarin in Rome before 1645.[32] Possibly Mazarin acquired the painting soon after the death in prison in January 1632 of Valguarnera, whose collection was then dispersed by his executors, among whom was the dealer Ferrante Carlo. Mazarin bequeathed his Roman possessions to his nephew, Filippo Mancini, duc de Nevers, whose sister Maria Mancini had married Lorenzo Onofrio Colonna in 1661, the year of the cardinal's death.[33] Prior to that, however, Mazarin must have given some of his Roman possessions, or at least the enjoyment of them, to Cardinal François Marie Mancini (1606–72) (an uncle of Maria Mancini), because it was from François Marie Mancini that Filippo Mancini inherited, among many other things, 'un

grand tableau de la peste à bordure dorée' listed in the inventory of 5 July 1672 as being in 'la 1ère chambre du jardin de l'aurore' of the Palazzo Mazzarini, Rome. It therefore seems probable that at some date shortly before 1693 Filippo Mancini gave the painting to, or deposited it with, his nephew (and Maria's first-born son) Filippo II Colonna.[34] Filippo Mancini went to Rome with his wife and fourteen-year-old son in 1690.[35] In December 1691 Filippo's sister, Maria Mancini, returned to Rome following the death of her husband, Lorenzo Onofrio Colonna, from whom she had fled. She left for Madrid in May 1692 after her sons had arranged an annual pension for her and the use of an apartment in the Palazzo Colonna.[36] It was possibly at the time of this financial settlement on Maria Mancini – that is, in early 1692 – that NG 165 was transferred from the Palazzo Mazzarini to the Palazzo Colonna with an attribution to Poussin himself, which it kept throughout its stay there.

If the London painting is indeed that by Caroselli, as now seems certain, then it is likely that it was being painted before Poussin finished the original. Given that NG 165 was finished within a few months after Valguarnera had acquired the Louvre picture, the different architectural background in the copy may represent an earlier idea of Poussin's which Caroselli

was copying almost literally before the paint on Poussin's picture was dry.[37] Such indications of an earlier background in the Louvre pictures as are visible[38] are not, however, consistent with the background of NG 165. This may mean that there were two different earlier states of the background to the Louvre painting, one copied by Caroselli and the other now partially visible. At all events, Caroselli may have derived the background to NG 165 from one of these earlier states which (or one of which) was supplied perhaps by a collaborator of Poussin. Mahon, noting that *The Plague at Ashdod* was the first of Poussin's townscapes, has suggested that the architectural specialist Jean Lemaire (1598–1659) (who was recorded as sharing lodgings with Poussin at Easter 1630) originally supplied the architectural setting, which Poussin then changed to one he regarded as more impressive.[39]

The outlines of some of the figures are marked in lead white (figs 4 and 5) and suggest that Caroselli traced Poussin's composition. This may have been done by drawing the outlines on a fine material placed over the painting and then coating the back of the traced material with lead white. The material would then have been placed on the canvas prepared for the copy, and the lines retraced, so transferring the lead white outlines onto it. It is these lines which are visible. The technique is comparable to one described by Philippe de La Hyre (1640–1718) using chalk rather than lead white.[40]

NG 165 was admired by some writers in the later eighteenth century for its colour,[41] which, as it happens, is generally brighter than that of the Louvre painting even allowing for the discoloured varnish on the latter. According to some witnesses to the 1853 Select Committee on the National Gallery, NG 165's colour was spoiled by cleaning during the previous year. The dealer Buchanan yearned for the picture as it had appeared before its cleaning in 1852, quoting with approval an anonymous correspondent who had written of 'the flesh tints in many instances deprived of their tender carnations and beautiful transparent greys',[42] and the artist George Richmond wrote to the Select Committee that NG 165 'was never a harmonious picture in colour, but the background and sky were particularly fine, and fine in colour; but in both of these particulars it has suffered [from its recent cleaning], for it is less harmonious than it was, and it has lost in beauty of tint, both in the background and sky.'[43] On the other hand, the anonymous author of a review of the British Institution's 1816 exhibition, possibly Robert Smirke, had found the picture's tone affecting in a more basic way:

Here we see a whole people suffering under the horrors of Cholera Morbus, like a girl's boarding school in a cheap and plentiful plum season. We fear in looking at it to catch the contagion; we smell, at a distance, the horrible stench, and fly from the representation as we would from reality. The tone of the picture is truly poetical. None but a great man could have thus ably conceived the hue so admirably adapted to his subject: the variegated brown pervading the whole, gives it the pathos of one vast cess-pool, one extensive field of dung and desolation. We turned from this picture with regret, but from necessity; we felt ourselves so irresistibly affected by it, that we withdrew to our closet for relief. Our bowels yearned for the miseries of man.[44]

General References

Grautoff 1914, p. 30; Magne 1914, no. 163; Davies 1957, p. 185; Blunt 1966, p. 25; Thuillier 1974, p. 93; Wright 1985b, pp. 139–40; Thuillier 1994, p. 251; Mahon 1999, pp. 164–5.

Figs 4 and 5 Details of NG 165 showing transferred lines in lead white.

NOTES

1. 'Dans la 1ère. chambre du jardin de l'aurore...un grand tableau da la peste a bordure dorée...' Paris, B.N. Ms. FR 6565, fo.44v°. *Inventaire année 1672 / 5. Juillet apres le/ décès de Mr. le Card./ Mancini a la requ:/ de Mᵣ. le Duc de/ Nevers. son her...*' I am grateful to Patrick Michel for this reference.

2. Pietro Rossini, *Il Mercurio Errante*, Rome 1693, pp. 47–8. See note 31 for the full citation from Rossini, and *Poussin Colloque 1960*, part 2, pp. 49–238 at p. 209.

3. Inventory of Filippo II Colonna, 15 December 1714 to 26 February 1716, Archivio Colonna, Rome, no. III Q.B.29, fo.183: '[668] Un quadro dj misura dj palmi

otto, e cinque in circa per traverso, rapp.te una Peste con prospettiva, e quantità di figure, originale di Niccolò Pusino con sua cornice dorata et intagliata Ereditario dj D.Filippo come s.a.': Safarik and Pujia 1996, p. 290. Among other eighteenth-century accounts of the painting at the Palazzo Colonna, see François Deseine, *Rome Moderne*, 6 vols, Leyden 1713, vol. 1, pp. 214–15 ('Dans une autre Chambre—La Peste de *Dagon*, du Poussin...'); Richardson, *Account of the Statues, etc. in Italy*, 1722, p. 189 ('A Pest, about a Yard long, and not quite so much high: Finely Colour'd, and Painted. My Father has a finished drawing (Original) of the Principal Groupe'); *Panopticon Italiano*.

Un diario di viaggio ritrovato 1759–1761 [a diary kept by the abbé de Saint-Non], ed. P. Rosenberg with collaboration of B. Brejon de Lavergnée, Rome 1986, p. 147 ('une Peste du Poussin, la même que celle du Roy') – this entry must refer to a visit made between June 1760 and April 1761: see p. 130 and p. 287, n. 231; L'abbé Richard, *Description Historique et Critique de l'Italie*, 6 vols, Dijon and Paris 1766, vol. 6, p. 56 ('...une peste, par le Poussin, d'un excellent ton de couleurs...'). Filippo Titi, *Descrizione delle Pitture...in Roma*, Rome 1763, p. 482 ('La peste famosa del Pussino'), and Ridolfino Venuti, *Roma Moderna*, 4 vols, Rome 1767, vol. 1, p. 248 ('la Peste, e un altro, di Nicoló Pussino').

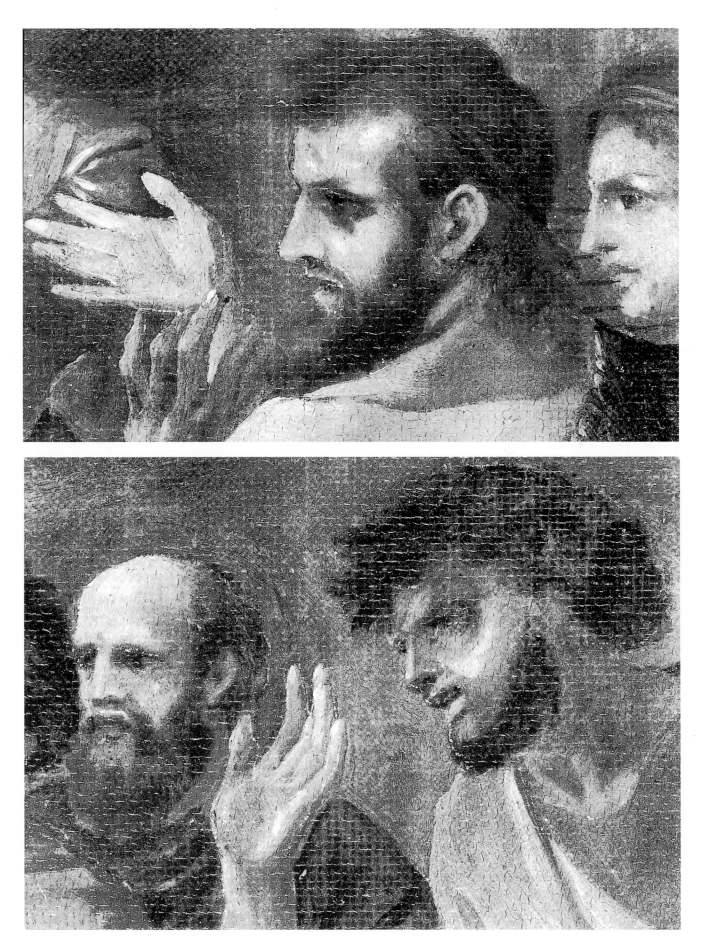

4. Safarik and Pujia 1996, pp. 596–8, citing a series of drawings of 1730 by Salvatore Colonnelli Sciarra in the Chatsworth Collection which record the pictures, and their hang, in the Galleria Colonna. Fig. 1 reproduces a part of a copy of one of these drawings. NG 165 is shown, with somewhat distorted dimensions, marked '11' just above a console table at one end of the north wall of the Galleria. For copies of two of the drawings in the Colonna collection formerly thought to date from 1703 and attributed to G.B. Chiari: see catalogue entries nos 25 and 26 by E.A. Safarik and G. Milantoni in ed. A. González-Palacios, *Fasto Romano, dipinti, sculture, arredi dai Palazzi di Roma*, Rome 1991. NG 165 is also recorded in the Galleria Colonna in an inventory, undated but probably prepared after 1740: Safarik and Pujia 1996, p. 601.

5. *Catalogo dei quadri e pitture esistenti nel...Casa Colonna*, Rome 1783, pp. 30–1: 'Parte superiore della galleria sopra la scalinata. Prima Facciata verso il Palazzetto alla Pilotta... 191. Un Quadro sotto il sudetto di 4.e.7 per traverso "La Peste" Opera rinomatissima di Nicolò Pusino.'

6. Mariana Starke, *Letters from Italy, between the years 1792 and 1798, containing a view of the Revolutions in that country*, 2nd edn, 2 vols, London 1800, pp. 29–30 ('in the gallery [of the Palazzo Colonna] is... the plague, by Nicolas Poussin!!!'). There is also a reference to NG 165 in Vasi 1797, vol. 1, p. 278 ('...un tableau représentant une peste, par Nicolas Poussin'), and another in Thomas Martyn's *A Tour through Italy*, London 1791, p. 224, which, however, presumably depended on notes taken by Martyn when he was in Rome in 1780: see Ingamells 1997, p. 647.

7. Safarik and Pujia 1996, pp. 628–9.

8. Buchanan, *Memoirs*, II, pp. 117–18 and p. 135, from which it seems that Sir Simon Clarke's agent, and partner in the acquisition of the Colonna pictures (of which NG 165 was one), was Alexander Day.

9. Buchanan, *Memoirs*, II, pp. 84, 89, 111, 118, 122, and Whitley 1928, pp. 61 and 67–8; and Brigstocke 1982a, pp. 106, 146.

10. Brigstocke 1982a, p. 106.

11. See also Brigstocke 1982a, pp. 310–11, and *Index of Paintings Sold*, vol. 1, p. 574.

12. Brigstocke 1982a, p. 315.

13. Brigstocke 1982a, p. 376. Mrs Hartley of Bernard Barn, near Edinburgh, was 'a rich old Lady friend of Buchanan's': Brigstocke 1982a, pp. 105, 360.

14. Buchanan, *Memoirs*, II, p. 111.

15. *Index of Paintings Sold*, vol. 3, part 1, p.36; part 2, p. 770, and p. 1348, where a possible identification of Brogden with James Brogden, MP for Launceston, has been suggested. NG 165 is one of six paintings bought in at the Brogden sale and subsequently in the Duke of Northumberland's collection: letter of 15 April 1991 from Burton Fredericksen in dossier of NG 164. In Wilson 1808, p. 334, James Brogden was described as 'a respectable Russia merchant, Town house – Park Lane, Country seat – Clapham'.

16. Catalogue of the British Institution, 1816, no. 43 ('The Plague at Athens (sic) from the Colonna Palace. N. Poussin. Thomas Jones, Esq.'). The error in the title (probably confused with that of the Sweerts – see below) was pointed out in [?]Smirke 1816, pp. 34–5, which also contains what may be the first published suggestion that the painting was a copy of that in the Louvre. NG 165 is not recorded in the sale of Thomas Jones of Shrewsbury, deceased (Mr Winstanley, Manchester, 23–24 August, 1821), who had a town house in Conduit Street, Hanover Square (Wilson 1808, p. 540), nor in that of T. Jones deceased (Christie's, 23 June 1837), who was presumably Thomas Jones (1747–1837) of Stapleton House, Bristol, a wealthy lawyer (see letter in NG dossier of 19 January 1996 from R. Robertson, Glasgow). Nor is it mentioned among the paintings in the collection of Thomas Johnes (1748–1816) of Hafod, either in J. Britton and E.W. Brayley, *The Beauties of England and Wales*, 19 vols, London 1801–18, vol. XVIII (1815), pp. 422–3, or by Passavant 1836, vol. 2, p. 82. Johnes, MP for Cardiganshire, was described by Wilson (1808, pp. 120–1) as having 'a taste for literature and the fine arts'. He translated Froissart's *Chronicles*. He was a patron of Fuseli: see *The Collected English Letters of Henry Fuseli*, ed. D.H. Weinglass, Millwood, NY, *c.*1982, p. 128. His town house was in Princes Street, Hanover Square, but Hafod, according to Wilson, was destroyed by fire in 1807. A painting in the collection of Henry Hope deceased, described as 'Nicolas Poussin...The Plague at Athens' and sold on 29 June 1816 (Christie's, lot 97), was, in fact, Sweerts's *Plague in an Ancient City* (Los Angeles, County Museum of Art): see R. Kultzen, *Michael Sweerts*, Doornspijk 1996, no. 63, and *Eight Paintings from the Collection of Saul P. Steinberg*, Sotheby's, New York, 30 January 1997, lot 34.

17. *A Catalogue of the Pictures in the National Gallery*, London 1840, p. 48. And see NG History File NG/36/1838 and Letter Book 1826–1851, NG6/1.

18. 'The Travel Diary of Otto Mündler', edited and transcribed by C.T. Dowd, *The Walpole Society*, vol. 51, 1985, pp. 69–254, at p. 120. Jaynie Anderson's 'Introduction to the Travel Diary of Otto Mündler' is published in the same volume, pp. 7–67.

19. Letters of 31 March and 7 April 1903 in the NG dossier, in the first of which Reed wrote: 'My picture appears to be a second replica, being almost identical with that in the National Gallery and in the Louvre, but with some differences, I believe, in the architectural background.' Unfortunately, no photograph exists, but this picture could be identical with the putative copy of NG 165 sold in 1766 (see note 21).

20. NG dossier.

21. A.N. Dezallier d'Argenville (le fils), *Voyage Pittoresque de Paris*, Paris 1752 edn, p. 207 ('La peste dans la Ville de Rome; grand Tableau du Poussin dont l'Architecture est de le Maire.'). Dezallier also records (p. 301) the painting now in the Louvre, but describes it as 'La Peste chez les Philistins', engraved by 'Picart le Romain' (Wildenstein 24). Could

d'Argenville's picture have been a copy of NG 165? It was bought by the dealer Ménageot at the sale of Antoine-Joseph Dezallier d'Argenville (le père) in 1766: see N. Willk-Brocard, 'Augustin Ménageot (ca.1700–1784), Marchand de Tableaux. Quelques Jalons', *GBA*, 131, 1998, pp. 161–82 at p. 164.

22. E.H. Denio, *Nicolas Poussin. His Life and Work*, London 1899, p. 228.

23. For comments on the 1852 restoration, see p. 20.

24. A. Roy and B.H. Berrie, 'A New Lead-Based Yellow in the Seventeenth Century', *Painting Techniques. History, Materials and Studio Practice. Contributions to the Dublin Congress 7–11 September 1998*, ed. A. Roy and P. Smith, London 1998, pp. 160–5 at p. 163.

25. For a full discussion of the Louvre painting, its subject and possible interpretations, see Paris 1994, pp. 200–2; see also Thuillier 1994, pp. 13–20 at pp. 15–16, who points out that the X-radiograph of the Louvre picture is illegible because of the use of white lead in the lining canvas, but that visual examination and photography in raking light have revealed a landscape (background?) of ruins with a view of the Coliseum which Poussin overpainted in completing the picture; and H. Keazor, 'A propos des sources littéraires et picturales de la *Peste d'Asdod* (1630–1631) par Nicolas Poussin', *La Revue du Louvre et des Musées de France*, no. 1, 1996, pp. 62–9.

26. *The Whole Works of Flavius Josephus*, trans. William Whiston, 4 vols, London n.d., vol. 1, p. 274. That Poussin was acquainted with the works of Josephus is evident from his *Destruction of the Temple in Jerusalem* (Jerusalem, The Israel Museum) painted in the winter of 1625–6. (On this picture, see Mahon 1999, p. 62.) On Poussin and Josephus, see also Olson 1994, pp. 133ff.

27. Jane Costello, 'The Twelve Pictures "Ordered by Velasquez" and the Trial of Valguarnera', *JWCI*, 13, 1950, pp. 237–84. For the respective prices of original and copy, see p. 272.

28. For a recent account of the life and career of Angelo Caroselli, see C.S. Salerno, 'Precisazioni su Angelo Caroselli', *Storia dell'arte*, no. 76, 1992, pp. 346–61. Salerno notes a move away from Caravaggesque naturalism in Caroselli's independent works towards a greater classicism from 1627 (pp. 349ff.). For Poussin's reported admiration of Caroselli as a copyist, see Filippo Baldinucci, *Notizie dei Professori del Disegno*, 5 vols, Florence 1845–7, vol. 3, p. 744.

29. Davies 1957, p. 185.

30. See note 3.

31. Pietro Rossini, *Il Mercurio Errante*, Rome 1693, p. 48, which describes the gallery of the Palazzo Colonna as containing 'un bellissimo quadro di figure di Nicolò Possini...'. There are similar references in editions of this guidebook published in 1704 (p. 58), 1715 (p. 48), 1732 (p. 42) and 1741 (p. 59), later editions edited by G.P. Rossini referring to 'un quadro di molte figure di Niccolò Possini'.

32. Letter from Patrick Michel, 3 September 1994, citing a letter dated 16 October 1645 from Elpidio Benedetti in Rome to Cardinal Mazarin in Paris (Paris, Ministerè des Affaires Etrangères, CP, Rome, 87, fo. 463r°), where Benedetti writes 'M. l'Archevêque désirait que je lui envoie ces deux grands tableaux de V.E., l'un qui est la copie de la Peste de Poussin, l'autre la concubine de Salomon de Caroselli...' (As Michel suggests, the archbishop referred to may be Michel Mazzarini, recently appointed Archbishop of Aix). Benedetti wrote of the painting again to Mazarin on 22 November 1660: 'La vedova di Mattheo scultore ne hà qualque d'uno [pictures of Poussin], et in specie quel famoso della peste, del quale n'é in Casa di V.Em. una Copia fatta del Caroselli, che fà vergogna all'originale, di cui non vuole meno di mille scudi...' M. Laurain-Portemer, *Etudes mazarines, Absolutisme et nepotisme. La surintendance de l'Etat ecclésiastique*, Paris 1981, p. 307, n. 4. See also Patrick Michel, 'Rome et la Formation des collections du cardinal Mazarin', *Histoire de l'Art*, no. 21/22, May 1993, pp. 5–16 at p. 14, n. 33, and by the same author, *Mazarin, prince des collectionneurs. Les collections et l'ameublement du cardinal Mazarin (1602–1661). Histoire et analyse*, Paris 1999, pp. 105, 125–6, 148, fig. 33, and 149, n. 250.

33. The young Mazarin had been brought up in the Colonna household of which his father was the major-domo: Victor Cousin, *La Jeunesse de Mazarin*, Paris 1865, pp. 2–9.

34. For the 1672 inventory, see note 1 above. For the date of the suggested gift to Filippo Colonna before 1693, see note 31. Similar arguments on the early history of NG 165 were advanced in Wine 1995b, pp. 25–8.

35. Lucien Perey, *Un Petit-Neveu de Mazarin. Louis Mancini-Mazarini, Duc de Nivernais*, 2nd edn, Paris 1890, p. 3.

36. Lucien Perey, *Une Princesse Romaine au XVIIe siècle. Marie Mancini Colonna*, Paris 1896, pp. 476–8.

37. This suggestion, made by Wine 1995 at p. 26, has also been made by M. Fagiolo dell'Arco, *Jean Lemaire pittore 'antiquario'*, Rome 1996, p. 13, no. 4, who points out that the architectural background in NG 165 is particularly close to that in the painting of 1629 by Jean Lemaire with the tempietto of Vignola in the Piazza del Popolo (Milan, Alberto Saibene Collection).

38. See note 25.

39. In conversation, citing the *Stati delle Anime* of 1630 showing that at Easter of that year Lemaire and Poussin were sharing lodgings. And see Rome 1998–9, pp. 28–9, 112, and Mahon 1999, pp. 39–40, 164–5. Paul Joannides has also pointed out (communication in NG Dossier) that the visible pentimenti in the background of the Louvre painting do not correspond to the architecture of NG 165, raising the question whether Poussin might not have made more than one change in this respect. That the background to the Louvre painting (the X-radiograph of which is inconclusive, as Sylvain Laveissière has told me) had been altered was noted by Mahon in 1962: Mahon 1962a, p. 169. See also O. Bonfait, 'Poussin aujourd'hui', *Revue de l'Art*, 119, 1998, pp. 62–76 at p. 75, n. 112.

Perhaps significantly, the painting in the d'Argenville sale of 1766, which cannot be either NG 165 or the Louvre painting, was described in the sale catalogue as having a background painted by Le Maire: see also note 21 above.

40. Philippe de La Hyre, 'Traité de la pratique de peinture...', *Mémoires de l'Académie Royale des Sciences... depuis 1666 jusqu'à 1699*, vol. 9, 1730, pp. 637–730 at p. 653.

41. L'abbé Richard, cited in note 3 ('une peste, par le Poussin, d'un excellent ton de couleurs, ce que n'avoit pas toujours ce [sic] Artiste, si sçavant dans toutes les autres parties de son art'); and [Cambray], *Essai sur la vie et sur les tableaux du Poussin*, Paris 1783, p. 24 ('On voit à Rome une Peste où le Poussin démontre que, si par principe il n'eû pas terni ses couleurs, elles auroient le mérite qu'on trouve dans celles des Titien & des Rubens').

42. *Report of the Select Committee on the National Gallery*, London 1853, pp. 769–70.

43. Ibid., p. 783.

44. [?]Smirke 1816, p. 34.

Philippe de Champaigne
1601–1674

According to the French seventeenth-century author Félibien, Champaigne was born in Brussels, where he trained first with Jean Bouillon, then with Michel de Bordeau, a painter of religious pictures and for whom he painted figures after nature, then in 1620 with the landscapist Jacques Fouquier. Turning down opportunities to join Rubens's studio or to go to Italy, he went to Paris in 1621 and there collaborated with the successful portraitist and history painter Georges Lallemant. Champaigne worked independently from about 1624 and around this time he probably met Poussin, for whom, according to Félibien, he painted a landscape. From 1625 to 1627 he assisted Nicolas Duchesne with decorations at the Palais du Luxembourg for Marie de' Medici. In 1628 he married Duchesne's daughter, Charlotte. On the death of Nicolas Duchesne, Champaigne succeeded to the post of Peintre de la Reine, and in 1629 he became a naturalised subject of France. Champaigne also attracted the favourable attention of Louis XIII and Cardinal Richelieu. The latter overwhelmed him with work at the Palais-Cardinal, the Sorbonne, the château de Richelieu and elsewhere. Following the death of Richelieu in 1642 and of Louis XIII in 1643, Champaigne continued to work for the court and painted part of a series on the life of the Virgin for the oratory of the Palais-Royal as well as works at the convent of the Val-de-Grâce; he also undertook other commissions, including a group portrait of the aldermen of Paris in 1647–8, and in 1657–61 three large works for the church of St Gervais, besides numerous portraits of individuals. Some of his sitters came from Jansenist circles, but they also included the three great ministers of seventeenth-century France, Richelieu (several times), Cardinal Mazarin (c.1653) and Jean-Baptiste Colbert (1655). In 1662 he painted his celebrated double portrait of Mother Catherine-Agnès de Saint-Paul Arnauld and Sister Catherine de Saint-Suzanne Champaigne (Paris, Louvre) to commemorate the recovery from illness of his daughter Catherine. He continued working almost until his death, showing a *Supper at Emmaus* (whereabouts unknown) at an exhibition in the Palais-Royal in 1673.

Champaigne was a founder member of the Académie Royale in 1648 and delivered a number of lectures there. His work (especially his portraits) is marked by precision and a sense of immediacy.

NG 1449
Cardinal de Richelieu

1633–40
Oil on canvas, 259.5 × 178.5 cm (cut down along left edge)
Once inscribed with a false signature: P. DE CHAMPAIGNE[1]

Provenance
Anon. sale, Paris, Roux du Cantal, 22ff. April 1834 (lot 16, bought in at 600 francs);[2] anon. (Roux du Cantal and others) sale, Paris, Henry, 17–18 February 1835 (lot 12, bought in at 400 francs); Thomas Henry deceased sale, Paris, George, 23–25 May 1836 (lot 38, sold 250 francs);[3] in the collection of the comte d'Espagnac in his hôtel at 15 rue d'Aguessau, Paris, by 1838;[4] comte d'Espagnac sale, Paris, Bonnefons de Lavialle, 4–8 May 1847 (lot 154);[5] comte d'Espagnac sale, Paris, Pillet, 1–3 March 1866 (lot 186, bought in at 12,050 francs);[6] comte Henri d'Espagnac sale, Paris, Pillet, 8 May 1868 (lot 7, 10,600 francs);[7] in the collection of Yolanda Marie Louise Lyne-Stephens (1813–94) at Lynford Hall, Norfolk, by 8 March 1887;[8] Lyne-Stephens sale, Christie, Manson & Woods, 9–17 May 1895 (11 May) (lot 361, £283 10s. to Charles Butler, as from 'the Espagnal [sic] Sale, 1868'); presented by Charles Butler[9] in 1895,[10] and hung 'temporarily on the staircase of the National Gallery'.[11]

Related Works[12]
PAINTINGS
(1) The Royal Collection. Oil on canvas, 207.2 × 146.3 cm (Dorival 1976, no. 208);
(2) Destroyed in 1945, formerly in the collection of the comte du Bourg de Bozas and originally in the Library of the Sorbonne. Oil on canvas, 261 × 171 cm (Dorival 1976, no. 393 and see *idem*, p. 114).
DRAWING
Paris, Bibliothèque Nationale, Cabinet des Estampes (côté B6 Réserve, folio, école française). (Dorival 1976, no. 206, where proposed as a study for the engraving by Bignon, see below.)
PRINTS
(1) By François Bignon (c.1620–after June 1671)[13] in 1650 after a drawing by Zacharie Heince (c.1611–69) for Z. Heince and F. Bignon, *Les portraits des hommes illustres françois qui sont peints dans la galerie du Palais-Cardinal de Richelieu*, Paris 1650, pl. 22, and for Marc Vulson de la Colombière, *Les Portraits des hommes illustres françois*, Paris 1655, pl. 23. After the full-length portrait once in the Galerie des Hommes Illustres in the Palais-Cardinal (later Palais-Royal). The figure is like that in NG 1449, but the background is plain. Dorival 206 bis and 389;[14]
(2) by anon. for Vulson de la Colombière, *Les Portraits des*

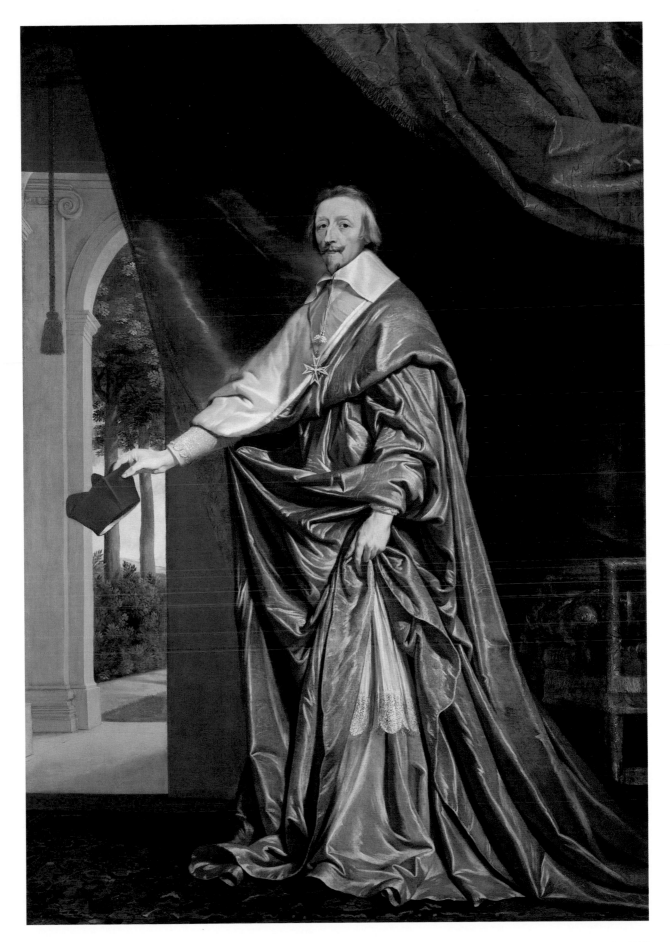

hommes illustres françois, Paris 1668, opposite p. 292, a crudely engraved version of Print (1);[15]

(3) Adrien Nargeot (b.1837, Paris) is said to have engraved a full-length standing portrait of Richelieu holding his biretta after Philippe de Champaigne. The engraving, not necessarily after the composition in NG 1449, was published in 1861.[16]

Technical Notes

There is a repaired tear centre right and some minor losses. Overall, however, the condition is good in spite of some damage along the top, bottom and right-hand edges as a result of the painting once having been fitted on to a smaller stretcher. The painting has been cut down by at least 4 cm along the left-hand edge. These damages and this reduction occurred before the Gallery's acquisition of the picture in 1895 when it was on its present, nineteenth-century stretcher. (Marks on the surface of the painting show it once to have been on a stretcher with diagonally braced corners, a typical seventeenth-century construction.)

The support is made up of three pieces of moderately fine plain-weave canvas joined horizontally. The ground is a greyish buff colour. NG 1449 was last cleaned and restored in 1971, at which time it was also double-lined. Analysis of the paint media has indicated the use of a mixture of poppy and linseed oils in the grey paint of the top moulding of the plinth of a pilaster, and linseed oil with pine resin added in the red from a fold in Richelieu's robe.[17] The red dye in the latter sample was found to be that extracted from the lac insect.[18] There is a small pentimento along the top edge of Richelieu's right hand.

Armand-Jean du Plessis (1585–1642), cardinal and duc de Richelieu, was the outstanding political figure on the European stage of the first half of the seventeenth century. Originally destined for a military career, which he abandoned when his brother Alphonse, already Bishop of Luçon, retired to a monastery, he took Holy Orders and was himself consecrated as bishop of the same see (in succession to his brother and his great-uncle) in 1607. His political career began in 1614 and for several years he allied himself to the circle around Louis XIII's mother, Marie de' Medici, thanks to whose resolve he was created a cardinal in 1622. He became chief minister to Louis XIII in 1624, an office which he retained until his death. Richelieu was made a duke in 1631 and appointed to the Order of the Holy Spirit (whose decoration he is shown wearing in both NG 798 and NG 1449) in 1633. He amassed enormous personal wealth and built for himself the Palais-Cardinal (now the Palais-Royal) just north of the Louvre, and a château at Rueil which was his favourite country residence. He also substantially rebuilt the ancestral château of Richelieu in Poitou – for one room of which he acquired paintings by Poussin (see NG 42 and 6477) and others – and founded the town of Richelieu nearby. As well as commissioning paintings by his contemporaries, he acquired numerous pictures by older masters, sculpture and other *objets* – perhaps including the chair at the right

NG 1449 which would have been known as a *fauteuil* and whose high cushion may itself have denoted high office.[19] As has often been noted,[20] for a seventeenth-century prince of the Church in France to have himself portrayed standing – in the manner of secular princes – as distinct from seated, was a daring innovation and was presumably intended to underline Richelieu's role as *homme d'état*.

There are seven extant full-length painted portraits of Richelieu showing him standing.[21] Of these, that now in the Ministère des Affaires Etrangères, Paris, and dated 1634 (Dorival 1976, no. 204) and that in a private collection recently published by Dorival (Dorival 1992, no. 95), and dated by him 1633–4, show him wearing his biretta. The remainder show him holding his biretta in his right hand and fall into two groups (although in each case the background is different). The first group comprises NG 1449 and the picture in the Royal Collection (see Related Works) which show Richelieu holding up his cape with his left hand, and the second group comprises the remaining three (Dorival 1976, nos 209, 211 and 212), respectively at the Louvre, the Chancellerie de l'Université, Paris (fig. 1), and the National Museum, Warsaw, and show Richelieu gesturing with his left hand. None of these five is dated, but in all of them Richelieu is wearing the cross of the Order of the Holy Spirit, conferred on him on 14 May 1633, so they must have been completed after that date. Félibien says that the last portrait Champaigne made of the cardinal during his lifetime was in 1640.[22] It has been proposed as that now at the Chancellerie de l'Université, Paris, and so one of the group with the gesturing left hand.[23]

According to a *Mémoire des portrets de Monseigneur le cardinal duc de Richelieu, faicts par Philippe de Champaigne, peintre par le commandement de mondit seigneur* drawn up in 1635, Champaigne had by that date painted four full-length portraits of Richelieu.[24] Since, from their descriptions none could have been NG 1449, it seems reasonable to conclude that that painting must have been executed after 1635. The two extant portraits identifiable from the list of 1635, namely that now in the Ministère des Affaires Etrangères, Paris, and that showing him seated in the Musée Condé, Chantilly (Dorival 1976, no. 205), both show the cardinal wearing his biretta. The latter was not finished until 1636. This also suggests, as Dorival proposed,[25] that full-length portraits of the cardinal holding his biretta did not appear until later. However, although none of the portraits described in the 1635 note corresponds with NG 1449, the two as yet unidentified could correspond to portraits of its type, that is to say, standing, full-length and holding the biretta. Yet more relevant to the date of NG 1449 is the engraving by Bignon (fig. 2). This was one of a series of engravings reproducing the portraits which decorated the Galerie des Hommes Illustres of the Palais Cardinal, one of which was (immodestly) a portrait of the cardinal himself (see Prints (1) above).

The construction of the Galerie began in 1628[26] and the portraits seem to have been finished by 1636, the year in which Roland Desmarest (1584–1653) wrote an *Elogia illustrium Gallorum quorum imagines in tabillis depictae cernuntur in porticu Ricelianarum aedium*.[27] Although NG 1449 was not the

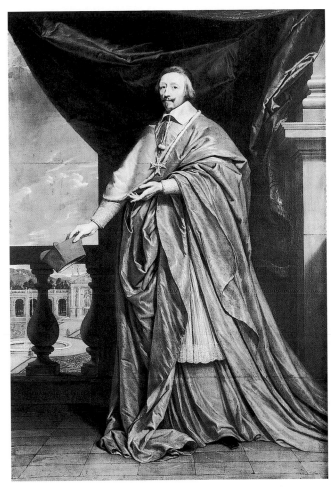

Fig. 1 Philippe de Champaigne, *Cardinal de Richelieu*, 1640? Oil on canvas, 245 × 164 cm. Paris, Chancellerie de l'Université de la Sorbonne.

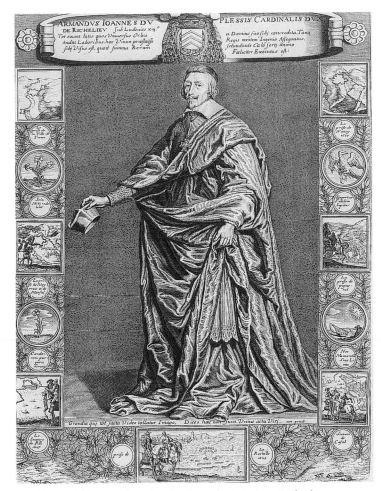

Fig. 2 François Bignon, after a drawing by Zacharie Heince, *Cardinal de Richelieu*, 1650. Engraving, 402 × 280 cm. Paris, Bibliothèque Nationale.

portrait at the Palais-Cardinal,[28] it is clear that it is of a type in existence by 1636.

Two others of this type are recorded, that (destroyed in 1945) noted by Brice in 1684 as in the Sorbonne Library and which was probably a posthumous likeness of the cardinal, and that in the Royal Collection which bears an inscription evidently postdating Richelieu's death. The inscription was painted later than the rest of the painting, but the position of the biretta appears not to have been finalised until after the space required for the inscription had been calculated. Hence the Royal Collection portrait was probably posthumous. In any event, evident studio participation in the painting of the drapery disqualifies it from being the prime version.[29] Consequently NG 1449 may have been the picture which Félibien relates was painted in 1640 and authorised by Richelieu to be kept in Champaigne's studio as the model for other portraits. The provenance of NG 1449 neither confirms nor rules out the possibility, so one must examine whether it is correct, as has been proposed, that the picture now at the University of Paris (that is, Dorival 1976, no. 211) was the one retained in the studio.[30]

The arguments in favour of that proposition are that of all the portraits of Richelieu it is the only one which Champaigne

signed, and that it is the most finished and most carefully executed – hence it must be that to which Félibien referred as having been found 'parfaitement beau' by the cardinal. However, an artist would be unlikely to sign a painting which he kept in his studio, and there is no evidence that any of the other paintings which Champaigne signed were so retained by him. The few paintings he did sign were portraits, which would generally have been immediately delivered, and pictures of religious subjects known to have been commissioned from, or given by, the artist. On the other hand, if (and this has been doubted)[31] the picture now at the Chancellerie de l'Université was that located in the cardinal's bedroom by Vignier at the Château de Richelieu (as Dorival proposed), it could not be that in Champaigne's studio at the artist's death because, although Vignier's description was published in 1676, that is, two years after Champaigne's death, the publishing privilege for his book had been granted in 1665, making it likely that it was written during Champaigne's lifetime.[32] Accordingly, on the basis of the two (probably) posthumous full-length portraits of Richelieu discussed above, the better candidate for Champaigne's 'parfaitement beau' painting is NG 1449.

Nevertheless, the suggestion that NG 1449 may be the portrait mentioned by Félibien[33] must remain tentative,

given both the large number of other portraits by Champaigne (full-length and otherwise) that once certainly existed.[34] Consequently the dating of NG 1449 to 1633–40 cannot for the time being be refined.

Dorival has suggested that the architecture of the background at the left of NG 1449 is similar to that of an arcade at Rueil and that the painting was therefore destined for that château (fig. 3).[35] Although it is not clear that there ever was a portrait of Richelieu by Champaigne at Rueil,[36] the tidy lawn surrounded by paving and the immaculately pruned trees shown in NG 1449 would surely not have looked out of place there (even if they did not precisely represent Rueil's highly ordered gardens).[37] However, even if it could be established that the background view was of the gardens at Rueil, it would not necessarily follow that NG 1449 once came from there since, for example, in 1639 Richelieu commissioned a view of Rueil (among other landscapes) for the Palais-Cardinal[38]

where in addition one of the pictures recorded at his death was a view of the château of Richelieu.[39] Nevertheless, if the background shows Rueil, the fact that it was around 1638 that Richelieu was lavishing expenditure on its gardens would support that date or later for NG 1449. The suggestion has also been made that the background view shows the gardens of the Palais-Cardinal, but this proposal, which has not been widely supported, seems unlikely.[40]

In a preface to the 1868 d'Espagnac sale Théophile Gautier wrote an appreciation of NG 1449 referring to its being painted with 'une intensité de vie, une affirmation de vérité, et comme on dirait aujourd'hui, un réalisme bien rare dans les portraits de grands personages...'

General References
Davies 1957, pp. 26–7; Dorival 1976, no. 207.

Fig. 3 Israël Silvestre, *View of the Orangerie and of the Perspective of Rueil*, 1654. Engraving, 11.8 × 24.5 cm. Paris, Bibliothèque Nationale.

Veuë de l'Orengerie et de la Perspectiue de Ruel.

Israel ex.

Cardinal de Richelieu (NG 1449), detail.

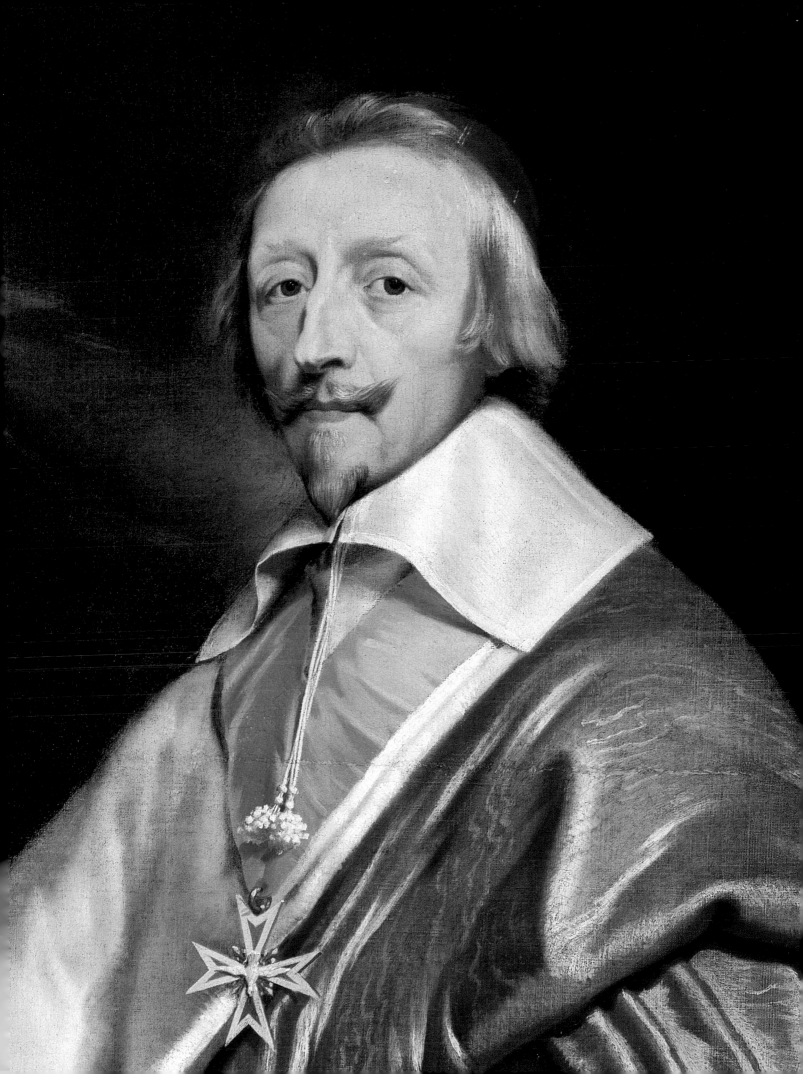

NOTES

1. The signature proved to be false on examination in 1987 and was removed: Report of 7 November 1987 by Martin Wyld in the Conservation Dossier.

2. Described as 'Le Portrait en pied du célèbre cardinal de Richelieu... T.h.98p., l.64p.'

3. Described in the catalogue as 'Portrait en pied du cardinal de Richelieu./Cet habile ministre est représenté debout et de grandeur naturelle. Il tient d'une main un pan de sa robe, de l'autre son bonnet dignitaire. Une draperie imitant un tissu d'or se déploie sur le fond du tableau; le jour qui l'éclaire vient d'une croisée ouverte et donnant sur la campagne./Ce portrait est assurément des plus remarquables sous le rapport de l'art; mais ce qui le recommande plus fortement encore à l'attention des curieux, c'est l'image du grand homme qu'il retrace si fidèlement à nos yeux./Toile.H. 98p., larg.64p./Extrait du catalogue Henry du 16 février 1836.' These dimensions are the same as those given in the catalogue of the sale of 22ff. April 1834. Their metric equivalent is 265.2 × 173.2 cm.

Thomas Henry (1767–1836) was a picture dealer and commissaire expert du Musée Royal. The Musée d'Art Thomas Henry in Cherbourg is named after him.

The painting in the Robit sale (Paris, Paillet, 13 May 1801, lot 27, 255 francs to Gamba) described as: '...portrait en pied ...89 sur 60 pouces...', annotated in a copy of the catalogue as having been in the 1791 Lebrun sale (*Répertoire 1801–1810*, p. 292), is probably the portrait of Richelieu belonging to the Chancellerie des Universités de Paris.

4. His catalogue, 1838, pp. 17–18.

5. Described in the catalogue: 'Portrait en pied du cardinal de Richelieu, d'une remarquable exécution. – Il diffère de celui du Louvre./H. 260c., l. 180c.'

6. Where described as follows:

'186 – Portrait en pied du cardinal de Richelieu.

Il ne diffère de celui du Louvre, auquel il est bien supérieur, que par sa dimension plus grande et par une perspective du parc de Ruel.

Il provient de la collection de l'intelligent expert, Henri. Félibien signala ce magnifique portrait, comme celui que préférait le grand cardinal.

Il est d'une conservation parfaite, et suffirait pour constater combien Champaigne excellait dans le portrait.'

A MS note by Soullié on the front cover of a copy of the catalogue in the Victoria and Albert Museum reads: 'beaucoup de ces tableaux furent rachetés par le propriétaire n'atteignant pas le prix qu'il en désirait et la plupart de ces derniers repassèrent à la vente qu'il fit le 8 mai 1868/ d'autres ne furent même pas mis sur table.' Another copy of the catalogue (Bibliothèque Nationale, Département des Estampes) is marked by lot 186 '10,000 Mr Richard'.

7. Where described as in the 1866 catalogue, but with (presumably) wrongly stated dimensions of 206 × 178 cm.

8. Yolande Marie Louise Lyne-Stephens (née Duvernay) was the daughter of Jean-Louis Duvernay and was born near Paris in 1813. As a dancer her professional name was Pauline Duvernay. She married Stephen Lyne-Stephens, said to be the richest commoner in England, at Putney on 14 July 1845. He died 28 February 1860. By her will dated 8 March 1887, Mrs Lyne-Stephens bequeathed to the National Gallery her collection of pictures in England and France. Included in the inventory of the same date attached to the will and translated from French was '279 Full length portrait of Cardinal Richelieu by Philippe de Champaigne. He is wearing a red robe and holds the biretta in his hand Canvas Gilt frame'. This bequest was revoked by a codicil dated 12 June 1894 (but not that contained in her French will, resulting in the bequest to the Gallery of NG 1432 and 1433). I am indebted to Lorne Campbell for this information. As noted in Davies 1957, p. 27, n. 9, there is an essay on 'Pauline Duvernay' in C.W. Beaumont, *Three French Dancers of the 19th Century*, London 1935, and she is mentioned in *The Ingoldsby Legends*. Lynford Hall, Lynford, Norfolk was built for Mr and Mrs Lyne-Stephens by William Burn, 1856–61 (N. Pevsner, *North-West and South Norfolk*, Harmondsworth 1962, p. 252). An 'H. Lyne Stevens' is recorded as living at Roehampton, London (Murray's *Handbook for Travellers in Surrey, Hampshire and The Isle of Wight*, London 1858, p. 115), possibly Grove House, Roehampton from which pictures in the Stephen Lyne-Stephens Collection were sold by Christie's in London on 16 June 1911.

9. Charles Butler (1820–1910), of Warren Wood, Hatfield, Herts, and 3 Connaught Place, Hyde Park, London, had a substantial collection of paintings, mainly Florentine. His sale took place on 25–26 May 1911 (see *The Connoisseur*, 28, 1910, pp. 49–50, and 30, 1911, pp. 201–2).

10. Butler offered NG 1449 to the Gallery two days after he bought it (NG Minutes, VI/318 and NG Archive NG 7/185/1895).

11. *The Athenaeum*, no. 3531, 29 June 1895, p. 845.

12. The only related works referred to here are those in which Richelieu is shown standing, holding his biretta in his right hand and his cloak in his left. For discussion of these and other full-length painted portraits of Richelieu which most closely resemble NG 1449, see François Boucher, 'Sur quelques portraits du Cardinal de Richelieu par Philippe de Champaigne', *BSHAF*, Année 1930, pp. 192–208; René Crozet, 'A propos des portraits de Richelieu par Philippe de Champaigne', *Bulletin du Musée National de Varsovie (BMNV)*, vol. IV, 1963, no. 1, pp. 19–27; Anthony Blunt, 'A lost portrait of Richelieu by Philippe de Champaigne', *BMNV*, vol. X, 1969, no. 1, p. 3; B. Dorival, 'Un portrait inconnu de Richelieu par Philippe de Champaigne', *Revue du Louvre*, 1970, no. 1, pp. 15–28 (Dorival 1970b); Dorival 1976, nos 208–12, 393, and 1785. For other portraits of Richelieu, see Dorival 1970b and Dorival 1976, *passim*, and Dorival

1992 (the last reviewed by Richard Beresford in *BM*, 135, 1993, pp. 702–4). In addition, Sir Joshua Reynolds owned 'A sketch for a whole length of Cardinal Richlieu (sic)': see *A Catalogue of Ralph's Exhibition of Pictures. To be seen at No. 28, Hay-Market, London* [1791], Anteroom, no. 5, where attributed to P. de Champagne (sic). It was sold anonymously, London, Phillips, 20 May 1820, lot 35; *Index of Paintings Sold*, vol. IV, p. 247. Philippe de Champaigne's portraits of Richelieu (extant and otherwise) are also discussed by Levi 1978, *passim*.

13. M. Préaud in *Allgemeines Künstler Lexikon*, Munich and Leipzig, vol. 10, 1995, p. 620.

14. See also Dorival 1970a, pp. 257–330 at p. 313. A copy of the 1655 edition of *Les Portraits des hommes illustres* is in the NG Library.

15. The engraving shows Richelieu against a plain background, and there are small differences in the costume and pose between it and NG 1449. See Dorival 1970a, pp. 257–330 at pp. 313, 322, and Dorival 1976, no. 389.

16. Le marquis de Granges de Surgères, *Iconographie Bretonne*, Rennes and Paris 1888, p. 183.

17. R. White, J. Pilc and J. Kirby, 'Analyses of Paint Media', *NGTB*, 17, 1996, pp. 98, 99 and 102, n. 51.

18. J. Kirby and R. White, 'The Identification of Red Lake Pigment Dyestuffs and a Discussion of their Use', *NGTB*, 17, 1996, pp. 56–80 at pp. 61, 62 and 73.

19. I am grateful to James Yorke for this information.

20. See, for example, Dorival 1976, p. 113; Levi 1978, pp. 115–16; and J. Melet-Sanson, 'L'Image de Richelieu', *Richelieu et le Monde de l'Esprit*, Paris 1985, pp. 135–47 at p. 140.

21. Dorival 1976, nos 204, 207, 208, 209, 211, 212, and Dorival 1992, no. 95.

22. *Entretiens 1685–88*, vol. 2, p. 579: 'En 1640 Champagne fit encore un Portrait du cardinal, qui fut trouvé parfaitement beau. C'est le dernier qu'il fit de son Eminence, qui luy commanda de le garder pour servir d'Original, estant persuadé qu'il estoit difficile d'en faire un qui fust mieux & plus ressemblant. Il luy ordonna de retoucher d'après ce dernier tous les autres qu'il avoit faits auparavant.' Félibien's testimony that Champaigne kept his last portrait of the cardinal is confirmed by the entry in the artist's post-mortem inventory of 17 August 1674, '29 Item, le portrait de M. le Cardinal de Richelieu, dernier fait, ouvrage dudit deffunt, prisé 1501.': Vicomte de Grouchy and M.J. Guiffrey, 'Les peintres Philippe et Jean-Baptiste de Champaigne. Nouveaux documents et inventaires après décès', *Revue de l'Art Français Ancien et Moderne*, no. 6, June 1892, pp. 172–92 at p. 183. That this portrait was a full-length is suggested by its value.

Champaigne was paid in 1647 '500 l.t. pour deux tableaux de Son Eminence quil avoit faicts de son vivant': *Compte*

d'administration pour Mme la duchesse d'Aiguillon opposante contre les docteurs de Sourbonne poursuivants, Archives du Château Saint-Valier (Drôme). I am grateful to Joe Bergin for this information.

23. Dorival 1976, no. 211.

24. 'Premièrement, un portret de Monseigneur, de sa hauteur, habillé d'une simarre de couleur tout couvert de broderie./ Plus un aultre portret de la même hauteur, vestu d'une simarre de satin noir avec une broderie sur les coutures./ Plus un aultre de la mesme grandeur, vestu en habit de campaigne d'escarlatte, enrichy de broderie./ Plus un aultre portret grand comme le naturel, assis, avec le rochet et le camail': L. Brièle, Documents pour servir à l'histoire de l'Hôtel-Dieu, 4 vols, Paris 1887, vol. 4, p. 291.

25. Dorival 1970b, pp. 19–20.

26. Françoise Bercé, 'Marchés pour le Palais-Cardinal de 1628 à 1642', AAF, 26, 1984, at p. 48.

27. Dorival 1974, pp. 43–60 at p. 46.

28. Because, as Dorival (1976, p. 115) points out, it lacks the Latin inscription common to the other extant portraits from the Galerie, and the collar laces hang lower in NG 1449 than they do in the engraving.

29. The background of the Sorbonne painting showed the church, which was not finished until 1644, and immediately behind the cardinal was shown a sarcophagus with mourning figures in sculpted relief: Dorival 1970b, pp. 15–28 at p. 20 and fig. 9, and Dorival 1976, no. 393. In connection with the portrait in the Royal Collection I am grateful to Kathryn Barron for advising me that an alteration to the position of the biretta was made contemporaneously with the rest of the painting (apart from the inscription). Had the biretta retained its original position, there would have been insufficient room for the complete inscription.

30. These arguments are advanced in Dorival

1976, p. 119, and repeated in Richelieu et le Monde de l'Esprit, Paris 1985, p. 307.

31. See Schloder 1988, p. 576.

32. [Benjamin] Vignier, Le Chasteau de Richelieu ou l'histoire des dieux et des héros d'antiquité, Saumur 1676.

33. Félibien, cited in note 22.

34. See Levi 1978, at n. 11, pp. 113ff.

35. Dorival 1976, p. 115, referring to an anonymous German print. A copy of the print by Silvestre was exhibited in Richelieu et le Monde de l'Esprit, cited in note 20, no. 36.

36. Levi 1978 has pointed out (pp. 120–1) that there was no portrait of Richelieu recorded in his post-mortem inventory taken at Rueil in May 1643 – although, as she also points out, items may have been removed by then, and a full-length portrait of Richelieu by an unnamed artist was recorded in the 1653 inventory of Mazarin's possessions. Blunt was more convinced by Dorival's suggestion: see Blunt 1977, pp. 574–9 at p. 576.

Although no portrait of Richelieu was recorded in the 1643 inventory, inventories did not always record paintings that were framed within wall panelling and thus not classed as movables. When Brackenhoffer visited Rueil during the autumn or winter of 1644–5, he noted two portraits of Richelieu. In that in the queen's apartment Richelieu was shown seated and writing (perhaps the original for Rousselet's engraving – Dorival 391), and Brackenhoffer reported that it was placed there only after Richelieu's death and on the king's orders. Brackenhoffer attached no such qualification to the other portrait of Richelieu which he recorded above the fire-place of the king's dining room. Regrettably, however, Brackenhoffer did not further describe this second portrait, nor record the artist's name in the case of either. He adds a comment which seems to suit the character of NG 1449 especially, namely that at Rueil 'all is neat, clean and ordered', and continues,

'the pictures and ornaments are all very good and of the best'. ('Dans ce château [i.e. Rueil], tout est coquet, propre et ordonné; les tableaux et les ornements sont tous très bons et des meilleurs'), Elie Brackenhoffer, Voyage de Paris en Italie 1644–1646, trans. Henry Lehr, Paris 1927, pp. 35–6. For the probable date of Brackenhoffer's visit to Rueil, see idem, p. (vii)ff.

37. For the gardens at Rueil, see J-P. Babelon, J. Jacquart, H. Ballon, D. Helot-Lécroart and H. Levi, 'Le château et les jardins de Rueil du temps de Jean de Moisset et du cardinal de Richelieu', Paris et Ile-de-France. Mémoires publiés par la Fédération des Sociétés Historiques et Archéologiques de Paris et de l'Ile-de-France, vol. 36, 1985, pp. 19–95 at pp. 28–30 and pls I–IV reproducing engravings by Israel Silvestre.

38. See the contract published by F. Bercé, 'Marchés pour le Palais-Cardinal de 1628 à 1642', AAF, 26, 1984, pp. 47–70 at pp. 64–5.

39. Lizzie Boubli, 'Portrait d'un homme d'Etat collectionneur de peintures: le cardinal de Richelieu. Quelques questions à propos de son inventaire après décès, dressé au Palais-Cardinal (1643)', Destins d'objets, sous la direction de Jean Cuisenier, Paris 1988, pp. 33–55 at p. 38. The painting in question was by Fouquières.

40. The proposal was made by François Boucher (cited in note 12). It was doubted by Davies (Davies 1957, p. 26), and not accepted by Dorival (Dorival 1976, p. 115), but accepted by Tony Sauvel, 'Deux oeuvres peu connues de Philippe de Champaigne', GBA, 7, 1961, pp. 181–7 at p. 184. René Crozet (cited in note 12) doubted that the arcade in NG 1449 was that of the Palais-Cardinal and tentatively identified it with that in the left background of Dorival 1976, no. 211, which itself was proposed by Dorival to be an idealised view of the garden at the château de Richelieu, but this too has been doubted (see Schloder 1988, pp. 576–7).

NG 6276
The Dream of Saint Joseph

*c.*1636
Oil on canvas, 209.5 × 155.8 cm, augmented at corners top left and right.[1]

Provenance
Possibly painted for a chapel in the now demolished monastery of the Minims near the place Royale (now place des Vosges), Paris;[2] recorded there in 1787,[3] and on 20 December 1790;[4] removed to the depot of the Petits-Augustins, Paris, by 22 November 1791;[5] in the inventory of paintings at the Petits-Augustins made by Alexandre Lenoir on 2 October 1794[6] and in another apparently of 1795;[7] possibly sent on 23 August 1797 to the administration of the Fêtes Nationales at the château of Saint-Cloud and returned to the Dépôt National, rue de Beaune, on 10 October 1797;[8] sold Paris, either 25 September 1797 for 440 livres, or 28 September 1797 for 350 livres;[9] probably purchased by Cardinal Joseph Fesch (1763–1839), half-brother to Napoleon Bonaparte's mother, in 1801;[10] his executors' sale, Rome, Palazzo Falconieri, George, 17–18 March 1845 (lot 38, 117 scudi romani to Warneck);[11] Adolphe Warneck sale, Paris, Bonnefons de Lavialle, 10–11 April 1849 (lot 30, 475 francs);[12] probably with Cécile-Charlotte Furtado-Heine, Paris, and then her relation by marriage, princesse Ney de la Moskova;[13] Château de R... sale, Paris, Baudoin, 22–23 December 1913 (lot 79, 4300 francs to Sortais);[14] anon. sale, Paris, Baudoin, 22 May 1919 (lot 98, 7100 francs to Reginald Rives);[15] anon. sale, Paris, Alph. Bellier, 24 December 1948 (lot 6 as 'attribué à Philippe de Champaigne', 119,500 francs);[16] bought by Jacques Seligmann & Co., New York, by 16 June 1950 from P. Marcus, Paris, for 450,000 francs ($1286);[17] sold by that company to the National Gallery for the US$ equivalent of £7000 in 1958.[18]

Exhibitions
Pittsburgh 1951, Carnegie Institute, *French Painting 1100–1900* (pl. 65); Paris 1952, Orangerie des Tuileries, *Philippe de Champaigne* (16); New York 1953, Jacques Seligmann and Company, *Seventeenth Century French Paintings* (3); London 1997, *Themes and Variations: Sleep* (no catalogue).

Related Works
PAINTING
Whereabouts unknown, 1 pied 1 pouce × 10 pouces (35.7 × 27 cm), lot 39 of the 1845 Fesch sale (64 scudi romani to Williams) where described: 'c'est à n'en pas douter la première pensée de la grande composition qui précéde, et il ne parait pas moins certain que l'artiste a dû en être satisfait, puisqu'on n'y remarque aucun changement notable, sinon ceux qui se rattachent aux détails que comportait le grand tableau.' Dorival 1976, no. 464. Possibly the painting once in the church of the Oratory, rue Saint Honoré (see note 11; listed as no. 465 by Dorival).

PRINT
In reverse by Pierre Lombart (or Lombard) (1612–82). Photograph in NG dossier.

Technical Notes
In good condition albeit showing some wear in the background and just above Joseph's right foot. There appears to have been some blanching in the shadows of the yellow drapery, and some fading in the purples of Joseph's tunic. The picture was last surface cleaned and revarnished in 1976. The support is a fine plain-weave canvas in three parts of differing dimensions sewn together with two additional parts sewn into the top corners later. The two corner parts are each 20.5 × 29.5 cm. The lining (with two pieces of canvas joined horizontally in the centre) seems to date from some time late in the eighteenth century. Certainly the painting is not on its original stretcher which, to judge from marks on the surface of the painting, had diagonal supports across the four corners, a vertical support down the centre and a horizontal support at about the level of Joseph's neck. Both the present lining and stretcher are consistent with a date of 1791, when NG 6276 may have been (re)lined and fixed to a new stretcher (see note 5), as are the traces of old printed paper from this (re)lining which appear at all four edges. The figures 90 appear in white chalk on the back of the lining canvas. In addition, besides labels evidently referring to the exhibitions and locations listed above, there are the following marks and labels on the back of the stretcher: (i) a small paper label marked *Z 60.21251*; (ii) *64(?)* in pencil, and again *64* in pencil; (iii) impressed in the wood, presumably soon after the Fesch sale in 1845, two circular marks *R.C.A./DOG.D1/ROMA* (a customs stamp of the city of Rome); (iv) a chalk mark *48*; (v) in pigment in a *c.*1800 hand *No. 605 du Cat*. This may be a Fesch collection mark;[19] (vi) in white chalk *USA*.

According to Matthew 1:20–1, an angel appeared to Joseph in a dream, saying: 'fear not to take unto thee Mary thy wife: for that which is conceived in her is of the Holy Ghost'. The subject was frequently depicted during the seventeenth century,[20] when the cult of Saint Joseph was widespread.[21] It was promoted by, among others, Saint François de Sales (1567–1622)[22] and Pope Gregory XV, who in 1621 made Saint Joseph's feast day (19 March) one of obligation.[23] Saint Joseph's qualities were seen as those of humility, rectitude and continence.[24] This last quality was implicitly given more emphasis by showing him, as in NG 6276, as a man of vigorous age,[25] rather than old, as had been more traditional until about 1600. He was invoked by numerous groups, including those desiring a holy death, and he was the patron saint of a number of trades including, as might be expected, those of carpenters, joiners, wheelwrights and woodcutters.[26] Here shown prominently at the bottom left of the picture (fig. 1) are a mallet, chisel, axe,[27] set square, screwdriver(?) and spanner – tools which associate Joseph more with carpentry than joinery, and certainly do not look

Fig. 1 Detail of NG 6276.

appropriate for the making of Joseph's chair, nor even Mary's simpler furniture, the manufacture of which would have been restricted to joiners.[28] The chair with its carved arms and legs, and the deeply padded and tasselled pillow on which Joseph rests his head, are inconsistent with his simple cloak and sandals, presumably intended to signify his traditional modest status.

Dorival has suggested that the position of the fingers of the angel's right hand indicate the number 250, which itself indicates that Christ was part human and part divine according to *Les Hieroglyphiques de Ian Pierre Valerian* (Lyon 1615), a copy of which Champaigne probably owned.[29] No such complex explanation, however, is needed to justify the gesture in the context of the well-known biblical episode represented, the angel pointing with one hand to Heaven and with the other to the Virgin. Dorival has also proposed that in choosing yellow as the colour of Saint Joseph's cloak Champaigne was using colour to signify meaning in accordance with Raffaello Borghini's *Il Riposo* (Florence 1584), in which yellow is said to demonstrate 'wealth, nobility, greatness of soul, constancy and wisdom'.[30]

As Dorival has pointed out, Champaigne is known to have treated the subject of the Dream of Saint Joseph three times: for the Carmelites of the Faubourg St-Jacques, for the Tuboeuf chapel in the church of the Oratory in the rue St-Honoré, and for the Minims of the place Royale.[31] The Carmelite picture is that now in the Louvre,[32] and, as Dorival has emphasised, Lenoir described the painting from the Oratory as a small painting.[33] The reference in the Fesch catalogue to NG 6276 having come from the Oratory is almost certainly wrong,[34] and given the close correspondence between the size of NG 6276 and that of the (admittedly untitled) no. 36 of

Lemonnier's memorandum of 22 November 1791,[35] it is reasonable to conclude that the National Gallery painting was that which was at the church of the Minims immediately before the Revolution, and, if so, that it was the one which, according to Guillet de Saint-Georges (*c.*1624–1705), Champaigne painted for it.[36] Some doubt remains, however, in view of the fact that so striking a picture was little noticed by writers of guidebooks either during Guillet's lifetime or during the remainder of the *ancien régime*. It is clear from their respective descriptions that the chapel in the Minims' church in which Thiéry in 1787 remarked 'un excellent tableau représentant le sommeil de S. Joseph, peint par P. de Champaigne'[37] is the same as that which both Le Maire and Piganiol de la Force had called 'la Chapelle de Saint Joseph' without, however, mentioning the presence of that or any other painting.[38] Moreover, Henri Sauval, writing in about 1655, noted only a painting by Vouet in this chapel.[39] Conceivably Piganiol referred to the chapel as he did because he recognised the subject, but not the author, of its altarpiece, but it seems as likely that the painting was not there, or not accessible. This may be presumed from A.N. Dezallier d'Argenville's account of the church published in 1749. After describing in turn five chapels on the left side of the nave looking towards the high altar, he describes only one chapel (that containing a painting of *The Holy Family* by Sarrazin) on the other side, which was the side which included the chapel of Saint Joseph.[40] It is possible that at some point damage to the fabric of the church necessitated either removal of the painting or restricted access. Certainly, the church of the Minims became increasingly dilapidated during the eighteenth century for lack of funds, and parts of it, although apparently not the chapels, were rented out for warehousing.[41]

If NG 6276 was in the church of the Minims around 1689, the year in which Guillet de Saint-Georges read to the Académie de Peinture an extract from his life of Philippe de Champaigne,[42] it may have been, as Guillet claimed, painted for the church. However, there is nothing in the iconography of the painting which might be described as specifically appropriate to the Minims. Although their church near the place Royale was fashionable and wealthy in the seventeenth century, the rule of their order was one of extreme poverty. In the one respect, however, in which poverty is suggested in NG 6276, namely the open sandals of Saint Joseph, the Minims had relaxed their rules, from 1615 allowing members to wear ordinary shoes when only open shoes or sandals had been permitted before. The Minims habit was dark grey, tied by a knotted rope. Neither of these details accord with Saint Joseph's costume in NG 6276. Finally, where one might have expected a monastery, such as the Minims which, until the death in 1648 of its member Marin Mersenne, was a centre of mathematical learning[43] to emphasise the more intellectual side of Joseph's occupation as carpenter,[44] Champaigne's choice of heavy and crude tools stresses the manual nature of the work in accordance with the then widespread concept of the saint as the Heavenly Artisan's earthly counterpart.[45]

Like most of Champaigne's paintings, NG 6276 is not signed or dated. Dorival has proposed a date of c.1638, presumably on stylistic grounds,[46] and Sutherland Harris has stated that it is generally dated around 1635–6.[47] On the other hand, the physiognomy of the angel has been likened to that of the angel in Champaigne's *Guardian Angel* (Paris, Chapelle de l'Hôpital Laennec), itself originally dated to around 1660–5,[48] and then more reasonably to around 1643–5.[49] NG 6276 is surely earlier than *The Annunciation* and *The Adoration of the Shepherds* in the Wallace Collection, both recently proposed as having been painted in the mid-1640s,[50] and in both of which the figures are more refined. The emphasis on the foreground in the composition of NG 6276 suggests a date before Poussin's classicising influences began to take hold among Parisian painters, around 1642. In its marked diagonals and general showiness NG 6276 seems to be intended to appeal to the same kind of taste as Vouet's *Dream of Saint Joseph* (fig. 2), known through an engraving by Michel Dorigny dated 1640.[51] Although this would appear to support Dorival's dating of NG 6276 to c.1638, it is impossible to ignore a certain gaucheness in the figure of the angel as well as a lack of refinement in the modelling of the Virgin's features. In these respects NG 6276 shows some characteristics of the Caen *Annunciation* (fig. 3) which can be dated 1633–4 with reasonable confidence,[52] but both the composition and the palette are more restrained, and a date of c.1636 is here proposed.

General References
Dorival 1976, no. 29; Wright 1985b, p. 90.

Fig. 2 Michel Dorigny after Simon Vouet, *The Dream of Saint Joseph*, 1640. Engraving, 27.5 × 19.6 cm. Paris, Bibliothèque Nationale.

Fig. 3 *The Annunciation*, 1633–4. Oil on canvas, 297 × 252 cm. Caen, Musée des Beaux-Arts.

NOTES

1. See under Technical Notes.

2. In his life of the artist, Guillet de Saint-Georges relates that Champaigne 'a fait encore, pour une chapelle des Minimes de la place Royale, un tableau représentant le songe de saint Joseph': Guillet de Saint-Georges, 'Mémoire Historique des principaux ouvrages de Philippe Champagne, nommé ordinairement Champagne l'oncle', in Dussieux et al., *Mémoirs inédits sur la vie et les ouvrages des membres de l'Académie Royale de Peinture et de Sculpture*, 2 vols, Paris 1854, vol. I, pp. 239–58 at p. 243. The chapel in which NG 6276 was placed has been identified as that dedicated to Saint Joseph on the west side of the nave (which was built on a north–south axis), and the fourth on the right-hand side looking from the main entrance towards the high altar. This chapel successively belonged to Sébastian Le Hardy, seigneur de La Trousse, then to Pierre Jacquet, seigneur de Tigery and Trésorier des Bâtiments du Roi, and finally in 1641 to Pierre Mérault, Maître d'Hotel Ordinaire of the queen mother, who gave 5000 livres for the chapel's decoration: see Odile Krakovitch, 'Le Couvent des Minimes de la Place-Royale', *Paris et Ile-de-France. Mémoires publiés par la Fédération des Sociétés Historiques et Archéologiques de Paris et de l'Ile-de-France*, vol. 30, Paris 1979 (publ. 1982), pp. 87–258 at p. 207. However, Henri Sauval, writing *c*.1655, noted in the chapel of St Joseph only a painting by Vouet: *Histoire et Recherches des Antiquités de la ville de Paris*, 3 vols, Paris 1724 (1969 reprint with introduction by A. Blunt), vol. 1, p. 443. Moreover, no painting corresponding to NG 6276 is mentioned, for example, by Le Maire or Brice, or by Piganiol de la Force in the latter's long description of the Minims' church in *Description Historique de la Ville de Paris et de ses environs*, 10 vols, Paris 1765, vol. 4, pp. 437ff. Le Maire says that the chapel of St Joseph belongs to 'Monsieur Merault, Conseiller du Roy, Maistre ordinaire en sa Chambre des Comptes', C. Le Maire, *Paris Ancien et Nouveau*, 3 vols, Paris 1685, vol. 2, p. 164.

3. Thiéry writes that in the third chapel to the right of the sanctuary 'Sur l'autel est un excellent tableau représentant le sommeil de S. Joseph, peint par P. de Champagne', *Guide des Amateurs et des Étrangers Voyageurs à Paris*, 2 vols, Paris 1787, vol. 1, p. 685.

4. Henri Stein, 'Etat des objets d'art placés dans les monuments religieux et civils de Paris au début de la Révolution Française publié d'après des documents inédits', *NAAF*, 3rd series, vol. 6, 1890, pp. 1–131 at p. 96 ('Autre chapelle. Le Songe de Joseph pour le départ de Nazareth, peint par Philippe de Champagne'). Stein supposed, wrongly, that this was a copy of the painting by Champaigne of the same subject once in the Musée des Beaux-Arts, Bordeaux, and now in the Louvre (Dorival 1976, no. 28).

5. *NAAF*, 3rd series, vol. 17, 1901 (1902), pp. 58–9 and 287. At a meeting of the Commission des Monuments of 22 November 1791, the painter and Academician A.-C.-G. Lemonnier (1743–1824) presented a list entitled 'Etat des tableaux qui sont dans le cas d'une réparation provisoire et très urgente, telle que d'être remontés sur de nouveaux châssis et d'être rentoilés'. A note at the end of the list read: 'Qu'il n'est point ici question de restauration entière de ces tableaux; l'estimation portée sur chaque ne comprend que des châssis neufs à refaire et à les doubler de toiles neuves pour prévenir un dégradement absolu et la perte de ces morceaux précieux.' Among the paintings listed was '36 Champagne, des Minimes 6 [poids] 6 [pouces] sur 4 [poids] 9 [pouces]'. The metric equivalent is 211.7 × 154.2 cm. The cost of restoration was estimated at 46 livres, 10 sols. The church of the Minims near the place Royale seems to have been up for sale in August 1792: op. cit., p. 114, but in July of the following year was being used as a studio by theatre decorators (op. cit., p. 244).

6. Alexandre Lenoir, 'Catalogue historique et chronologique des peintures et tableaux réunis au Dépôt National des Monuments Français', ed. P. Lacroix, *Revue Universelle des Arts*, vol. 21, 1865, pp. 61–86, 125–60, at p. 81 ('No. 130. Des Minimes – Le Songe de Joseph').

7. See *Inventaire Général des Richesses d'Art de la France*, part 2, Paris 1886, p. 263, no. 401.

8. Louis Courajod, *Alexandre Lenoir. Son journal et le musée des monuments français*, 3 vols, Paris 1878–87, vol. 1 (1878), pp. 125–6. Lenoir noted on 25 August 1797: '...remis à l'administration des fêtes nationales établies au château de Saint-Cloud, conformément à l'arrêté du ministre de l'intérieur... le Sommeil de Saint Joseph, par Champaigne.' Lenoir was asked to lend this and eighteen other paintings to the fêtes de Saint-Cloud by Ginguene on 22 August 1797: *Inventaire Général*, cited in note 7, part 1, Paris 1883, p. 82. Livernois signed a receipt on their return on 10 October 1797: ibid., part 2, Paris 1886, p. 339.

9. André Fontaine, *Les collections de l'Académie Royale de Peinture et de Sculpture*, Paris 1910, p. 105, gives the price as 440 livres, but the figure of 350 livres is given as an alternative by Dorival 1976, p. 22. I have been unable to find the source for his information.

10. Chanoine Jean-Baptiste Vauel, *Deux livres de comptes du Cardinal Fesch, archevêque de Lyon*, Lyon 1923, p. 53: 'Vendémaire an IX, chez Robert, Philippe de Campaigne (sic). Songe de Saint Joseph.' See also, *Catalogue des tableaux composant la galerie de feu Son Eminence le Cardinal Fesch*, Rome 1841, no. 416, 'L'Ange visite saint Joseph'. The height is given as 6 pieds, 2 pouces, and the width 5 pieds, 9 pouces, viz. 200.2 × 186.7 cm.

11. George, *Galerie de Feu S.E. le Cardinal Fesch*, parts 2 and 3, Rome 1844, where described as follows:

'38 – 416. Vision de Saint Joseph*
L'époux de Marie vient de céder à la fatigue du travail, comme l'indiquent les outils de sa profession qui gisent à ses pieds; profondément endormi sur un siège, la tête appuyée sur un coussin, l'âme sereine et calme, il est plongé dans les joies d'une révélation divine. En effet, l'ange Gabriel en planant au-dessus de lui, lui montre d'une main le ciel d'où émane sa mission et de l'autre lui désigne dans sa chaste épouse agenouillée, l'objet que la prédilection divine a choisi pour accomplir le mystère de la Conception.

Ce sujet peu traité par les peintres nous semble parfaitement compris par Philippe de Champaigne et d'autant plus intéressant qu'il sert à compléter la touchante histoire de la Vierge.

Comme le précédent, ce tableau se trouvait anciennement dans l'église des Pères de l'Oratoire.

T.H. 6p.6p.-L.4p.10p.'

In the preface to the catalogue it is explained that 'Les astérisques, placés après les numéros, désignent les tableaux qui ont été apportés de France par le Cardinal, et qui sont affranchis de tous droits de sortie.' Francis Haskell pointed out that George may have used asterisks generously in order to evade Roman export controls (see Francis Haskell, *Rediscoveries in Art. Some Aspects of Taste, Fashion and Collecting in England and France*, London 1976, p. 81, n. 60), but there is no reason to suppose that Fesch acquired NG 6276 other than in France.

The reference to this painting having come from the church of the Fathers of the Oratory is wrong, and may have resulted from a confusion between it and the following lot, a picture described as 'la première pensée' of the preceding lot and as having dimensions of 1 pied, 1 pouce (high), 0 pied, 10 pouces (wide). In Lenoir's 'Catalogue historique' (see note 6 above) no. 162, among numerous paintings listed under the heading Philippe de Champaigne, is one of three described as 'petits tableaux' and as 'De l'Oratoire – St. Honoré. – Le Sommeil de Joseph'.

12. The copy of the catalogue in the Rijksbureau voor Kunsthistorische Documentatie is marked '475'. Warneck was a dealer with premises at 20 rue des Jeûneurs, Paris. The auction catalogue gave no dimensions, but stated: 'Ce tableau provient de la galerie du cardinal Fesch sous le no. 38 du catalogue.'

13. See note 15 below. Mme Cécile Furtado-Heine (1821–96) had a collection of paintings in her home near the Parc Monceau *c*.1890, but lived at the Château de Rocquencourt near Versailles during the summer: *DBF*, vol. 14, Paris 1979, pp. 1457–8.

14. Photograph in the catalogue. All lots in the sale are said to have come from the Château de R., identified as Rocquencourt in Lugt (Lugt 73613). The title page of the copy of the catalogue in the RKHD (copied from the Etude Baudoin) is annotated 'Murat'. The château is identified as that of Rentilly in a manuscript note by Henri Baderou with whom Germain Seligman corresponded about the painting in 1951. The identity of Sortais as the buyer is given in the same note (copy kindly supplied by Judy Throm, Archives of American Art, Washington, DC). Georges Sortais was the expert for the old master paintings in the sale.

15. Described in the catalogue: '98 – Vision de saint Joseph-/ L'ange Gabriel, planant au-dessus de saint-Joseph, lui montre d'une main le ciel, et de l'autre la sainte vierge agenouillée./ Toile. Haut., 2m.10; larg., 1m.60./ Ancienne collection du cardinal Fesch (?)./ Ancienne collection Furtado Heine./ Ancienne collection de la Princesse Ney de la Moskowa.'

16. For the price, see Francis Spar, *Annuaire du Collectionneur 1948–9*, Paris 1949, p. 102. The expert was Robert Lebel. The catalogue records the dimensions of lot 6 as '2m.10 × 1m.60'.

17. Letter of 16 June 1950 from Germain Seligman to M. Lefebvre-Foinet (copy in NG dossier kindly supplied by Judy Throm).

18. The amount paid in US dollars was $19.672. The rate was fixed as at 2 January 1958, the date when title passed to the Gallery (NG Archives, S1110 and Minutes of Board Meetings, Director's Report of 9 January 1958).

19. As Martin Davies, according to a pencilled note in the NG dossier, deduced by comparison with the Masolino NG 5962 – see Martin Davies, *The Earlier Italian Schools*, London 1951 (revised 1961), 1986 reprint, p. 361, n. 39.

20. A. Pigler, *Barockthemen*, 2 vols and plates, Budapest 1974, pp. 241–2. For another rendering of the theme by a French painter, c.1640, see W.R. Crelly, *The Paintings of Simon Vouet*, New Haven and London 1962, p. 241 and fig. 86. According to Saint Matthew an angel also appeared to Saint Joseph in a dream on other occasions but these occurred only after the birth of Christ (Matthew 2: 13 and 19).

21. Joseph F. Chorpenning, 'The Enigma of St Joseph in Poussin's Holy Family on the Steps', *JWCI*, 60, 1997, pp. 276–81.

22. The first edition of de Sales's works was published in Toulouse in 1637 but individual works had been published during his lifetime: *Bibliotheca Sanctorum*, vol. V, pp. 1218–20. Among de Sales's works which were influential in promoting the cult of Saint Joseph were his *Traité de l'Amour de Dieu* (Lyon 1616) and no. 19 of his *Conferenze spirituali* (Lyon 1629). Another major figure who promoted the virtues of Saint Joseph was Saint Teresa of Avila, who also reformed the Carmelite Order. The other extant version of a Vision of Saint Joseph by Champaigne (now in Paris, Louvre) was given to the Carmelites of the Faubourg-Saint-Jacques by Marie de Médicis: see Dorival 1976, p. 21.

23. *Bibliotheca Sanctorum*, vol. VI, p. 1275.

24. Ed. P. Guérin, *Les Petits Bollandistes*, 7th edn, Paris 1882, vol. 3, pp. 504ff.

25. On this see Molanus, *Traité des Saintes Images*, introd. and trans. F. Boespflug et al., Paris 1996, p. 366. Champaigne probably owned Molanus's work, first published as *De picturis et imaginibus sacris*, Louvain 1570, and published in revised form as *De historia SS. imaginum*, Louvain 1594.

26. Louis du Broc de Segauge, *Les Saints Patrons des Corporations et Protecteurs*, 2 vols, Paris n.d. [1887], vol. 1, p. 196.

27. For the axe as symbol of Joseph's artisanal status, see Molanus, cited in note 25, p. 207.

28. Toussaint Gautier (rev. J-M. Lecarlatte), *Dictionnaire des Confréries et Corporations d'Arts et Métiers*, Paris 1854, p. 392.

29. B. Dorival, 'Philippe de Champaigne et Les Hiéroglyphiques de Pierius', *Revue de l'Art*, no. 11, 1971, pp. 31–41 at p. 34.

30. Dorival 1976, vol. 1, p. 79. The quotation is translated from Rafaello Borghini, *Il Reposo*, Florence 1584, p. 231: 'Significa il color dell'oro ricchezza, nobilita, grandezza d'animo, constanza, e sapienza.'

31. Paris, Orangerie, 1952, p. 48. The church of the Minims was demolished in September 1797 according to an annotation on a drawing by Antoine-Léon-Thomas Vaudoyer (1756–1846), sold Paris, 6 December 1991, Arcole, lot 180. Champaigne may have treated the subject of the Dream of Saint Joseph a fourth time. As Francis Watson pointed out (letter of 13 January 1964 in NG dossier) a *Sommeil de saint Joseph* was received by Lenoir from the Val-de-Grâce on 29 October 1796: see L. Courajod, cited in note 8, vol. 1 (1878), pp. 110, 125–6. This was, however, probably the picture from the Carmelite church that was more or less opposite the Val-de-Grâce.

32. Dorival 1976, no. 28. Described as 'grand tableau' by Alexandre Lenoir in his memorandum of 2 October 1794 (see article cited in note 6), the Carmelite picture's size is 343 × 310 cm.

33. Paris, Orangerie, 1952, p. 48, and Alexandre Lenoir, cited in note 6, p. 82.

34. See note 11.

35. See note 5.

36. See note 2.

37. See note 3.

38. See note 2.

39. See note 2.

40. [Antoine-Nicolas Dezallier d'Argenville], *Voyage Pittoresque de Paris*, Paris 1749, pp. 165–6.

41. Odile Krakovitch, cited in note 2, pp. 169, 176.

42. *Procès-Verbaux de l'Académie Royale de Peinture et de Sculpture 1648–1793*, vol. 3, Paris 1875–92, p. 13.

43. O. Krakovitch, cited in note 2, provides a thorough study of the Minims' church at the place Royale, supplementing those of J. Ciprut, 'Documents inédits sur l'ancienne église des Minimes de la Place Royale', *BSHAF*, Année 1954 (1955), pp. 151–74, and of A. Braham and P. Smith, 'Mansart Studies V: The Church of the Minimes', *BM*, 107, 1965, pp. 123–32. Also useful are M. Pinault, 'Laurent de la Hyre et le Couvent des Minimes de la Place Royale à Paris', *Revue du Louvre*, 1982, no. 2, pp. 89–98; and O. Krakovitch, 'La vie intellectuelle dans les trois couvents Minimes de la Place Royale, de Nigeon et de Vincennes', *Bulletin de la Société de l'Histoire de Paris et de l'Ile-de-France*, 1982 (publ. 1983), pp. 23–175 where it is noted (p. 26) that the Minims were anti-Jansenist (and therefore hostile to the supposed sympathies of Philippe de Champaigne).

44. As, for example, in *The Holy Family* (NG 1422, an eighteenth-century painting after a French seventeenth-century composition), once thought to be after Poussin.

45. On this concept, see Chorpenning 1997, cited in note 21.

46. Paris, Orangerie, 1952, p. 48, and Dorival 1976, p. 21.

47. In a review of Dorival 1976 in *Art Bulletin*, 61, 1979, p. 321.

48. N. Sainte-Farc-Garnot, 'La décoration de la chapelle de l'Hôpital des Incurables', *BSHAF*, Année 1974 (1975), pp. 55–61.

49. Dorival 1976, no. 95.

50. Mary Allden and Richard Beresford, 'Two altar pieces by Philippe de Champaigne: their history and technique', *BM*, 131, 1989, pp. 395–406.

51. See J. Thuillier, B. Brejon de Lavergnée and D. Lavalle, *Vouet*, exh. cat., Grand Palais, Paris 1990, p. 130.

52. Dorival 1976, no. 20.

Philippe de Champaigne and Studio

NG 798
Triple Portrait of Cardinal de Richelieu

1642?
Oil on canvas, 58.7 × 72.8 cm

Inscribed over the central head: *Celui cy...plus/Resemblant au naturel* (this one is the best likeness). Inscribed over the head at right: *De ces deux profilz c[elui]cy et la meilleur* (of these two profiles, this one is the better).

Provenance
Possibly owned by the sculptor Francesco Mochi (1580–1654) at his death in Rome;[1] acquired by Frederick Franks (d. 1844);[2] presented by his son Sir Augustus Wollaston Franks (1826–97) in 1869.[3]

Exhibition
Leningrad and Moscow 1988, *Masterpieces from the National Gallery, London* (no catalogue).

Related Works (for sculpted versions, see pp. 40–3)
PAINTINGS
(1) Strasbourg, Musée des Beaux-Arts, inv. no. 44.987.2.1. Oil on canvas, 58 × 46 cm. Apparently a fragment of an autograph version of NG 798 showing the left-hand profile and the area of Richelieu's bust hidden by the central portrait of NG 798. The Strasbourg painting may have been in the artist's possession at his death, and was that noted in Davies 1957, p. 25, as having been in the Miss Seymour Sale, Christie's, 23 January 1920 (lot 80): *Century of Splendour. Seventeenth-Century French Painting in French Public Collections*, Montreal, Rennes and Montpellier 1993, no. 35;
(2) Formerly Lady Helen Herbert, her sale, Coldbrook Park, Abergavenny, Monmouthshire, J. Straker, Chadwick & Sons, 30 September 1952 (lot 2270), 25 × 20¾ in. (Photocopy of extract of sale catalogue in NG dossier.) An identical composition to (1) above, but, as might be expected from its slightly larger size, showing more of the cross of the Order of the Holy Spirit at bottom, and more of the outline of the Cardinal's back at left;
(3) Anon. sale, London, Phillips, 10 December 1991, as Circle of Philippe de Champaigne (lot 220, unsold), 75.5 × 59 cm, derived from the central portrait of NG 798 (photo in NG dossier);
(4) According to Dorival, a replica of NG 798 may have been in the Radziwill Collection in Nieswicz in 1647: Dorival 1976, p. 121;
(5) Jabach Collection, a profile portrait of unknown dimensions (Dorival 1076);
(6) Rothan sale, Paris, Paul Chevalier, 29–31 May 1890 (lot 20, 2900 francs to Cléry), where wrongly identified as a portrait of Mazarin.[4] Oil on canvas, 54 × 44 cm, a portrait in profile turned towards the right (Dorival 1048);
(7) Musée du Château-Thierry. Oil on canvas, 55 × 46 cm. A copy of the Strasbourg painting (Dorival 1782);
(8) University of Geneva. Oil on canvas, 49.5 × 62 cm. A poor copy of a bust-length portrait possibly derived from the central head of NG 798 or from one of the portraits of Richelieu 'en pied' (Dorival 1782b);
(9) Paris, Chancellerie de l'Université. Oil on canvas, measurements unrecorded. Similar to (8) above but of better quality (Dorival 1783);
(10) Tours, Musée des Beaux-Arts. Oil on canvas, 48 × 39 cm. Similar to nos (8) and (9) above, but with some variation in the costume (Dorival 1786);
(11) Stroganoff sale, Berlin, Rudolph Lepke, 12 May 1931, 61 × 45.5 cm (lot 3, as by Philippe de Champaigne). Profile portrait looking right;
(12) Musée National du Château de Versailles, MV 4170. A copy of NG 798 by S. Schoenfels, signed and dated 1897. Oil on canvas, 61 × 76 cm;[5]
(13) For mentions of other bust-length portraits, in profile or otherwise, see Dorival nos 1094–1102. Dorival 1097 was sold anonymously in London, Christie, Manson & Woods Ltd, on 18 February 1952, and not 1852 as stated by Dorival (lot 91, 220 guineas to Smith). The measurements of the painting in the 1908 Sutherland sale (Dorival 1098) were 25½ × 21 in. and not as recorded by Dorival. In addition, the dimensions of Dorival 1112, 1115 and 1116 would be consistent with bust-length portraits.
PRINTS
(1) By Jean Morin (1600–50). Bust length, shown in an engraved octagonal frame; derived from the central head in NG 798, or from another similar portrait;
(2) by Robert Nanteuil (1623?–78). Engraving in reverse after the central head of NG 798 within a border of bay(?) leaves, and dated 1657;
(3) P. Grenier, nineteenth? century. An example is in the Bibliothèque Nationale, Département des Estampes (inv. N2-D248258).

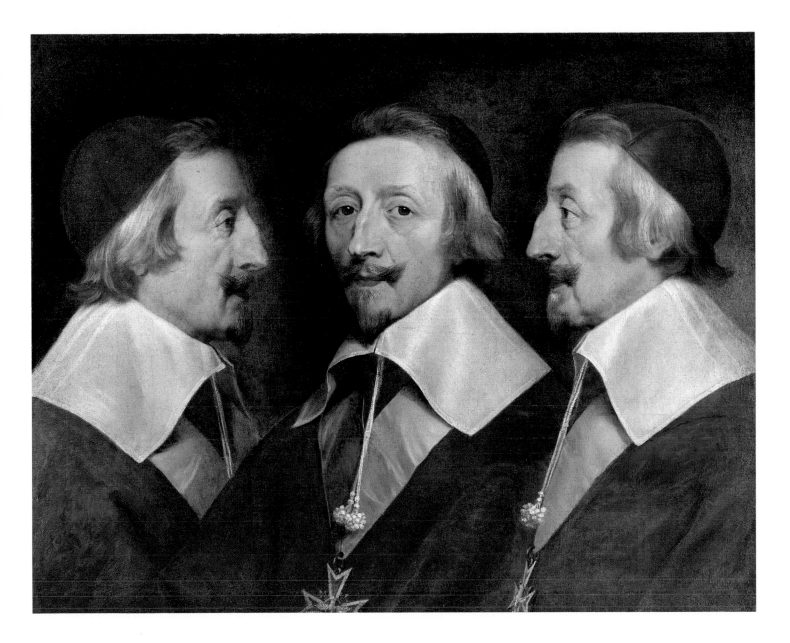

Technical Notes

In generally good condition, although there is some wear throughout, especially in the reds. There has been some retouching at the edges. There is an old loss in the cloak just under the collar of the right-hand portrait, and another to the shoulder of the central portrait. There is also a small loss at the extreme right halfway up the painting, in addition to an old horizontal split in the canvas about 2 cm from the bottom, which may have occurred when NG 798 was originally painted. The picture was last relined some time in the nineteenth century, and last cleaned and restored in 1969. The stretcher dates from the nineteenth century. The canvas is a plain weave. The ground colour is brown; analysis has shown that it is composed largely of calcium sulphate with some silica, probably bound in oil. The paint medium is poppy oil; the main pigment in the robes is vermilion mixed with a little red earth.[6] There is an inscription on pieces of old canvas stuck to the stretcher (fig. 1; see below). A thread count shows that these pieces are not the same kind of canvas as that used for the painting, but that they are consistent with canvases made before the nineteenth century.

For Cardinal Richelieu (1585–1642), see the entry for NG 1449. The inscription on pieces of canvas stuck to the stretcher reads: RITRATTO DEL CARDINALE DI RICHELIEV DI/MONSU SCIAMPAGNA DA BRUSSELLES. LO FECE/IN PARIGI PER ROMA AL STATVARIO MOCCHI/QVALE POI FECE LA STATVA E LA MANDO/(?)A PARIGI. (Portrait of Cardinal de Richelieu of Monsieur Champaigne from Brussels. He did it in Paris for Rome [to send] to the sculptor Mochi, who then made the statue and sent it to Paris.) This inscription was evidently made in Italy after the completion of Mochi's statue. Together with the inscriptions on the painting itself (see above) it shows that the portraits in NG 798 were made as likenesses to be used by Francesco Mochi (or Mocchi) (1580–1654) in preparation for a statue of the cardinal. A similar procedure had occurred when Van Dyck's *Triple Portrait of Charles I* (HM The Queen, Windsor Castle) was sent to Bernini in Rome in 1636.[7] The works of both Bernini and Mochi suffered an unhappy fate. That of Bernini was destroyed in the fire at Whitehall in 1698,[8] while Mochi's statue, formerly at the Château de La Meilleraye in Poitou, was 'decapitated' in 1793 by iconoclasts, one of

Fig. 1 Inscription on pieces of canvas stuck to the stretcher.

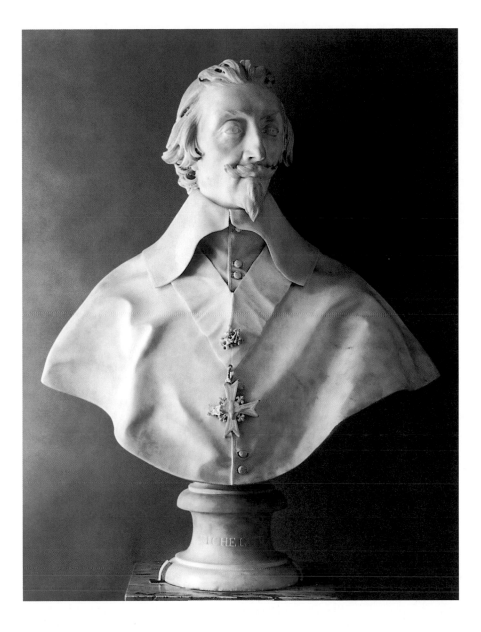

Fig. 2 Gian Lorenzo Bernini, *Bust of Cardinal de Richelieu*. Marble, height 84 cm. Paris, Musée du Louvre, Département des Sculptures.

whom used the cardinal's head as a counterweight for a roasting spit. The whereabouts of the head are unknown, but the statue is in the Musée du Pilori, Niort (Deux-Sèvres).[9]

The original intention was that Bernini should make a full-length statue of Richelieu, but for reasons to do with the delicate political relationships between the Papacy, France and England, he made only a marble bust (fig. 2).[10] When the bust arrived in France it was criticised for not sufficiently resembling Richelieu, although Mazarin, who all along had been central in negotiating for Bernini's services, recognised that this was because of the inadequacy of the painted profiles given to Bernini by the (unidentified) portraitist rather than the fault of the sculptor. The project for Bernini to make a full-length statue of Richelieu seems to have been abandoned by April 1641 when the French ambassador to Rome, the maréchal d'Estrées, was, according to a letter to Mazarin from his agent Benedetti, asking Bernini to return 'li profili e la misura per far fare la staua da qualche altro scultore' (the profiles and the measurement to have the statue made by some other

sculptor).[11] Indeed, if Mochi's letter of February 1641 to the authorities in Orvieto informing them that he was expecting to serve 'uno de'maggior Principi che siano nell'Europa'[12] was a reference to Louis XIII of France, negotiations to transfer the commission to Mochi had started some months earlier. Conceivably NG 798 had already been painted in anticipation of Mochi's involvement. However, this seems unlikely since on 30 June 1641 Cardinal Antonio Barberini wrote to Mazarin asking for a better likeness of the cardinal in the form of one full-face and two profile portraits ('Prego affet.te V.S.Ill.ma di avvisarmi che si potrà megliorare nella statua per al quale se vi sarà da ricordare cosa alcuna circa la somiglianza, la supplico a favorirmi novamente di tre ritratti di S. Em.za, uno di facia et gl'altri due in proffilo...').[13] As has been suggested by J.-R. Gaborit, although 'li profili' returned by Bernini to d'Estrées may then have been passed on to Mochi, it seems more probable that NG 798 was painted subsequent to Antonio Barberini's request.[14] This seems confirmed by the fact that on 18 December 1641 Mazarin, who may have yet

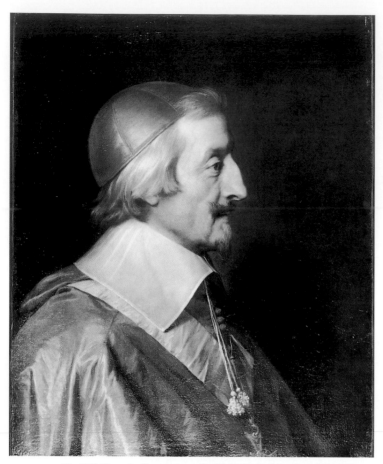

Fig. 3 Philippe de Champaigne, *Profile Portrait of Cardinal de Richelieu*. Oil on canvas, 59 × 46.5 cm. Strasbourg, Musée des Beaux-Arts.

Fig. 4 X-radiograph of fig. 3.

harboured hopes of having a statue of Richelieu made by Bernini, wrote to the latter that he planned to have Van Dyck execute profiles to send to Rome. Unknown to Mazarin, however, Van Dyck had died nine days earlier, so frustrating his plan.[15] It seems probable, therefore, that it was during the following year, 1642, that the commission for the cardinal's triple portrait was transferred to, and executed by, Philippe de Champaigne, and then that the commission for the statue was definitively transferred to Mochi.[16] Given that Mochi's best known work, the statue of *Saint Veronica* (1629–39) in the crossing of St Peter's, Rome, had been criticised by some contemporaries,[17] it may seem odd that he was chosen to execute a statue of so important a figure as Richelieu. However, Mochi was an accomplished portraitist who had sculpted busts of members of the Barberini family and their circle,[18] and his habit of losing commissions from the late 1630s may have made him more available than his rivals.

It has generally been assumed that NG 798 was executed by Philippe de Champaigne himself, but recently it has been proposed as a workshop copy by comparison to the undoubtedly autograph single profile of Richelieu in Strasbourg (fig. 3).[19] The Strasbourg painting (the height of which is identical to NG 798) is of better quality than NG 798, and the X-ray photograph of it (fig. 4) has shown under the portrait another portrait of Richelieu in three-quarters view looking towards the right, and to the right of that, and under the

ground layer of the existing picture, another similar portrait now cut by the right-hand border. From this it has been reasonably concluded that the Strasbourg picture was originally conceived as an element of a triple portrait like NG 798 but with a variation in the position of the central figure, and that a strip of 6.5 cm added to the left before the ground was applied functioned to 'centre' the profile when the triple portrait was abandoned.[20] Since the X-radiographs of NG 798 show no pentimenti, it seems likely that the Strasbourg picture is earlier and that the triple portrait once projected for the Strasbourg canvas was instead painted on that now in London.[21] That, and the condition of NG 798, may explain the relative lack of vitality of the left-hand head when compared to the Strasbourg picture, a weakness perhaps acknowledged by the preference for the right-hand head inscribed on NG 798 itself.[22] Such lack of vitality is most obvious in the costume and skull cap – in these cases delegation by Champaigne to the studio would have been sensible given that Mochi scarcely lacked models for such items in Rome. Indeed, the fact that, by contrast with the Strasbourg portrait, Richelieu is shown wearing a wide collar which obscures the blue ribbon of the Order of the Holy Spirit where the two overlap, suggests that the costume in all three portraits was copied not from the Strasbourg picture but from another portrait of the cardinal. In addition studio participation in the left-hand portrait of NG 798 – entirely possible

and sensible assuming the prior existence of the Strasbourg picture – is suggested by its relative lack of quality compared both to the Strasbourg picture and to the central and right-hand heads of NG 798, noticeable in the cardinal's beard just below his lower lip, which is uniformly brown and not flecked with grey, and in the rather schematic rendering of the quiff. The central and right heads, although not the costume, are of high quality and are surely by Champaigne himself – hence their inscribed endorsements on the painting itself. It seems unlikely that Champaigne would have risked sending a work entirely painted by his studio to Mochi if, as seems likely, Bernini's bust of Richelieu had been criticised for its lack of resemblance, a factor itself ascribed to the painted models from which Bernini had worked (see p. 40).

General References (accepting NG 798 as fully autograph)
Davies 1957, pp. 25–6; Dorival 1976, no. 213.

NOTES

1. Mochi lived in a house on the Via Gregoriana, where he died on 6 February 1654. Among his possessions included in an inventory taken on 13 March 1654 was/were 'Tre quadri ordinarij de Retratti de Cardinali franzesi con Cornice dorate' [last word cancelled]: I. Lavin, 'Dusquenoy's "Nano di Créqui" and Two Busts by Francesco Mochi', *AB*, 52, 1970, pp. 132–49, at pp. 146–7. This could be a reference to a triple portrait or to three separate portraits of different French cardinals, and, even if the former, may not have been NG 798.

2. In A.W. Franks's manuscript autobiography, *The Apology of my Life*, he wrote: 'My father collected pictures which were mostly sold after his death in 1844, and from the wreck came the portrait of Richelieu by Philippe de Champagne (sic) which I gave to the National Gallery.' Frederick Franks was a naval officer, and a descendant of Samuel Pepys on his father's side and of Jean-Pierre Gaussen, a governor of the Bank of England, on his mother's. I am grateful to Marjorie Caygill for this information. Following the death of his first wife Emily Saunders Sebright in 1822, the year of their marriage, Frederick Franks married her sister, Frederica. The couple moved to Geneva in 1822 (letter of 11 October 1983 from David Wilson in the NG dossier) where A.W. Franks was born four years later. The family moved to Rome some time between 1828 and 1833 and were still there in 1841. They returned to London in 1843: see David M. Wilson, *The Forgotten Collector: Augustus Wollaston Franks of the British Museum*, [London?] 1984.

3. A.W. Franks was Keeper of British and Medieval Antiquities at the British Museum, and became President of the Society of Antiquaries. He appears to have collected, among other things, pottery, porcelain and brass rubbings, but not pictures.

4. According to a typescript note in the dossier of the Strasbourg picture.

5. Claire Constans, *Musée National du Château de Versailles. Les Peintures*, 2 vols, Paris 1995, vol. 2, p. 825.

6. Note from Ashok Roy.

7. David Howarth, 'Charles I, Sculpture and Sculptors', *The Late King's Goods. Collections, Possessions and Patronage of Charles I in the Light of the Commonwealth Sale Inventories*, ed. A. MacGregor, London and Oxford 1989, pp. 73–113, at p. 95.

8. David Howarth, op. cit., p. 96.

9. Marguerite Charageat, 'La Statue et les Bustes de Richelieu par Francesco Mocchi', *A Travers l'Art Italien du XVe au XXe Siècle*, ed. H. Bédarida, Paris 1949, pp. 153–62. Charageat has also proposed that Mocchi executed two other works after NG 798, a bust in the Louvre (inv. MR.2165) and one in the museum at Bayeux: 'Le Buste de Richelieu par Francesco Mocchi au Musée du Louvre', *BSHAF*, 1976, pp. 95–8, but this has been convincingly refuted by Jean-René Gaborit, who attributes the Louvre bust to Bernini and that of Bayeux to a nineteenth-century copyist, 'Le Bernin, Mocchi et le Buste de Richelieu du Musée du Louvre. Un Problème d'Attribution', *BSHAF*, (Année 1977) 1979, pp. 85–91. The head of Mocchi's statue was in the Scalambrini collection, Rome, in 1951, but its present whereabouts is unknown: see V. Martinelli, 'Contributi alla scultura del 600: Francesco Mochi a Roma', *Commentari*, II (1951), pp. 224–35 at p. 235, and M. De Luca Savelli in *Francesco Mochi 1580–1654*, Florence 1981, pp. 84–5. The remainder of the statue, now at Niort, has been catalogued by De Luca Savelli, op. cit., no. 25. I am grateful to Jennifer Montagu for this reference. The remainder shows 'Richelieu' standing with his right arm extended at an angle as in NG 1449.

10. Madeleine Laurain-Portemer, 'Mazarin militant de l'art baroque au temps de Richelieu (1634–1642)', *BSHAF*, 1976, pp. 65–100 at pp. 74ff. Bernini's bust of Richelieu is the marble now in the Louvre according to Jean-René Gaborit (see note 9 above).

11. M. Laurain-Portemer, cited in note 10, p. 97, n. 123.

12. I am grateful to Jennifer Montagu for drawing my attention to this letter cited by M. De Luca Savelli, see note 9, at p. 134.

13. De Luca Savelli, cited in note 9, p. 97, n. 124.

14. J.-R. Gaborit, cited in note 9, at pp. 88–9.

15. On this episode see M. Laurain-Portemer, cited in note 10.

16. For other accounts of the genesis of NG 798, see Geneviève Bresc-Bautier, 'Richelieu et la sculpture de son temps', *Richelieu et Le Monde de l'Esprit*, exh. cat., Paris, Sorbonne, November 1985, pp. 155–68; *Le Portrait dans les Musées de Strasbourg*, ed. R. Recht and M.-J. Geyer, Strasbourg 1988, pp. 116–18; and Montreal, Rennes and Montpellier 1993, p. 138.

17. J. Montagu, 'A model by Francesco Mochi for the "Saint Veronica"', *BM*, 124, 1982, pp. 430–6 at p. 430. However, other contemporaries praised Mochi's Saint Veronica and at least two poems were written in its honour: letter of 30 January 1999 from Jennifer Montagu.

18. I. Lavin, cited in note 1, pp. 132–49.

19. Richard Beresford, 'Montreal, Rennes, Montpellier. Grand Siècle', *BM*, 135, 1993, p. 579.

20. *Le Portrait dans les Musées de Strasbourg*, cited in note 16, and draft typescript catalogue entry in the dossier of the Strasbourg painting.

21. As concluded in the material cited in note 16.

22. There are a few differences between the left-hand profile in NG 798 and the Strasbourg picture, besides the obvious one of the lower part of the former being obscured by the central portrait. In the Strasbourg picture, less of the hair flicks up at the back of the Cardinal's head, the collar toggles are painted more delicately and the buttons more clearly.

Claude (Claude Lorrain)

1604/5?–1682

Born Claude Gellée in the Duchy of Lorraine, possibly in 1600 but more probably in 1604/5. In about 1617 Claude went to Rome and is said to have worked for a pastry cook there before going to Naples, where he spent two years in the studio of the landscape painter Goffredo Wals. He returned to Rome, becoming the pupil, then the assistant, of Agostino Tassi, who painted landscapes and illusionistic architecture. In 1625 Claude went to Lorraine to help Claude Deruet with a ceiling decoration in Nancy, returning to Rome by 1627. Apart from sketching trips into the surrounding countryside (the 'Campagna') and possible visits to Naples, Claude remained in Rome until his death in 1682, unmarried but survived by his presumed illegitimate daughter Agnese (born 1653).

His early work shows the influence of Northern artists such as Bril, Breenbergh and Wals, as well as of Italians like Filippo Napoletano and, naturally, Tassi. He made numerous studies after nature on sketching expeditions in the Campagna. There, according to his fellow artist and biographer Joachim von Sandrart, Claude 'tried by every means to penetrate nature, lying in the fields before the break of day and until night in order to learn to represent very exactly the red morning sky, sunrise and sunset and the evening hours.'[1] Claude's first dated work is of 1629. In 1633 he joined the Accademia di San Luca in Rome. His career flourished, and by 1636 he began recording most subsequent compositions in his *Liber Veritatis*, as a safeguard against forgery so one biographer claimed. Many of the drawings in the *Liber* (now in the British Museum) are inscribed on the back with the name of the patron and often the date of the work.

By 1640 Claude was the most commercially successful landscape painter in Europe, commanding high prices from patrons who included Pope Urban VIII and King Philip IV of Spain. Innovative in the direct depiction of sunlight on the horizon, Claude painted idealised landscapes and port scenes, mixing the fictive with the real. From the later 1630s he more often introduced subjects from the Bible or from Ovid's *Metamorphoses*, subsequently expanding his subject matter to include Virgil and lesser-known ancient authors. By 1650, possibly influenced by Poussin, his work took on a more serious tone, and he dispensed with the dramatic backlighting of his earlier pictures in favour of a more neutral light. Claude's last paintings are marked by a balance between figures and architecture, or trees, and by a quality of light, which give them a timeless serenity.

NOTE
1. Translation by M. Roethlisberger in Roethlisberger 1961, pp. 47–8.

NG 2
Landscape with Cephalus and Procris reunited by Diana

Oil on canvas, 101.5 × 132.8 cm
Signed and dated bottom centre: CGL. (in monogram)[1] IV. ROM/.1645.

Provenance
Possibly in the collection of Ange-Laurent de La Live de Jully (1725–79) by 1757, but in any event in his sale Paris, Pierre Rémy, 5ff. March 1770 (lot 29, 4500 livres to Rémy);[2] in the collection of César-Gabriel de Choiseul, duc de Praslin (1712–85);[3] posthumous sale of Louis-César-Renaud, duc de Choiseul-Praslin,[4] Paris, Paillet, 18–25 February 1793 (lot 140, 19,000 livres to Dulac);[5] possibly in the collection of Herries, an English banker living in the rue de Bac, Paris, and seized as émigré property 2 August 1794;[6] according to Buchanan imported by [Alexis] Delahante;[7] with the dealer Philippe Panné,[8] George Street, Hanover Square, London, by February 1805; offered by him (with NG 5) for 6000 guineas,[9] and both paintings bought by John Julius Angerstein in March 1805 for £4500;[10] bought with other paintings from J.J. Angerstein's collection from his executors in 1824.

Exhibition
London 1994, NG (69).

Related Works
PAINTINGS
(for other versions of the subject by Claude, see pp. 46–7)
(1) Whereabouts unknown. John Constable deceased sale, London, Foster & Sons, 15 May 1838 (lot 46, £6 16s.). A copy by Constable;[11]
(2) Recorded with W.G. Keith, Baldock, in 1961. Oil on canvas, 64.5 × 80.5 cm. A copy with the pastoral figures only;[12]
(3) Anon. sale, Sotheby's, New York, 11 June 1981 (lot 208, $3500). Oil on canvas, 63 × 78 cm. A poor copy with the pastoral figures only. Photograph in NG dossier;
(4) With Anthony Dallas & Sons Ltd in 1981. A copy (English School, c.1800?), oil on canvas (no size recorded). Photograph in NG dossier;
(5) Anon. sale, Christie's, 21 November 1991 (lot 27, unsold, as by a follower of Jacob de Heusch). Oil on canvas, 101.5 × 135.2 cm. A copy in poor condition;
(6) Anon. sale, Bonhams, Chelsea, 5 October 1999 (lot 250, as 'Continental School, Late 19th Century', sold £420). Oil on panel, 22 × 29 cm. A copy;
(7) Anon. sale, Bonhams, Chelsea, 4 April 2000 (lot 34, as 'Studio of Miguel Canals (20th century)'). Oil on canvas, 70 × 100 cm. A copy.

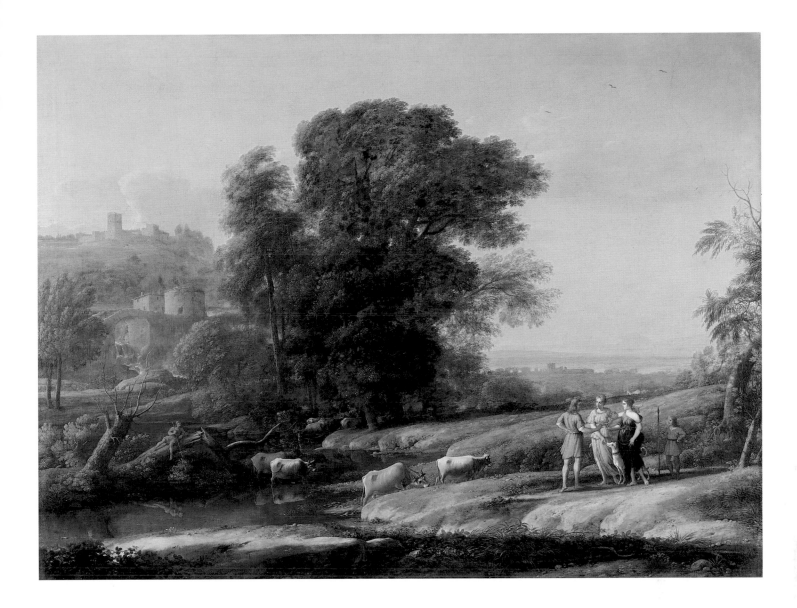

DRAWINGS (by Claude)

(1) London, British Museum, inv. no.1957-12-14-81; LV 75 (MRD 534) (fig. 1). Inscribed on the verso *quadro faict pour Anuerce* (i.e. Antwerp) and, on another occasion *Claudio fecit/ in.V.R.* Possibly the compositional starting point for NG 2;[13]

(2) London, British Museum, inv. no.1957-12-14-97; LV 91 (MRD 585). Inscribed on the verso *quadro faict pour paris* and at the lower right, on another occasion, *Claudio fecit / in. V/R.*[14] The boy holding the spear is omitted;

(3) London, British Museum, inv. no. 0o.7-204 (MRD 713). The drawing is later than NG 2 but probably a development from it.[15]

PRINTS

(1) By John Young, 1823, in *A Catalogue of the Celebrated Collection of Pictures of the late John Julius Angerstein, Esq.*, London 1823, No. 8 (as 'Landscape /Companion to the Sea-Port');

(2) by T. Starling, by 1831 in *Valpy's National Gallery* (as 'Pastoral Landscape with Figures');

(3) by J.B. Allen, 1832, in *The National Gallery of Pictures by the Great Masters*, London n.d. [1838?], no. 104 (as 'Pastoral Landscape');

(4) ?by J. Pye in 1837.

Technical Notes

Mainly in good condition albeit with some wear in the central clump of trees and in the sky. There are some flake losses along the bottom, and some raised craquelure throughout. There are some drying cracks in the foliage, and the greens and some of the blues have blanched (see below). NG 2 was last cleaned and retouched in 1948.

The primary support is a finely woven twill canvas, the tacking edges of which are intact all round, lined with a plain-weave canvas. In most cases where there is no record of a long-held picture being lined in the Gallery, it is possible only to say that it was relined before 1853, the year in which conservation records began to be kept. In this case, however, the back of the lining canvas, which is attached to the stretcher with hand-made tacks, is marked 'LDJ' in an eighteenth-century hand, most probably a reference to [La]Live de Jully in whose sale in 1770 NG 2 was included (see Provenance), suggesting that the relining occurred before 1771. The stretcher is not the original. The existing stretcher bears the remains of a ten-sided label with 'Gouvernement No...' on it, although Davies discerned 'Palais du Gouvernement' on it (Davies 1946, p. 17; Davies 1957, p. 33), linking this to the painting's possible seizure as émigré property in 1794 (see Provenance). The stretcher also bears two similar embossed marks: PORLIER in a circle with a horseshoe (?) in the centre of the circle.

Because the blanching of NG 2 has worsened since 1947 (when photographs were taken), samples of paint were analysed in 1993. EDX-mapping of the upper surfaces of the most blanched greens showed high general concentrations of silicon in relation to relatively lower concentration of lead. A contributory factor in the blanching may be loss of colour in the ultramarine and perhaps also in the smalt content of Claude's greens, which typically contained these materials in combination with green earth, copper-based green pigments, ochres, yellow lakes, lead-tin yellow, black and white, but the colour change in the trees at the centre is due to the fading of a yellow lake component.[16]

The subject is based on Ovid's *Metamorphoses*, VII: 693–758. The goddess Aurora lured Cephalus away from his wife, Procris, but when he could speak only of the pleasures of his marriage, she became jealous and cast doubts in his mind about his wife's fidelity. Cephalus resolved to test his wife and with the goddess's help was transformed into a stranger. So disguised, he made his way home and there encountered Procris, anxious for her husband's return. He tried many times to court her favour, finally causing her to hesitate when he offered a great fortune in return for her love. In anger, he revealed his identity and Procris fled with shame. She roamed the countryside as one of Diana's huntresses, spurning the company of men, saddened as she was by the trickery of her husband. But Cephalus was lonely and begged his wife's forgiveness. Procris returned to him and brought gifts that Diana had given her, a hound and a spear. The ensuing happiness of Cephalus and Procris was, however, undone by Procris' unfounded suspicions of her husband's infidelity: hidden by bushes she watched him while he was out hunting, and he mistakenly killed her with the spear. Often it was this last episode, or its aftermath with Cephalus mourning, that was depicted by painters.

Ovid does not mention Diana being present at the reunion of Cephalus and Procris, as depicted by Claude. As Davies noted, such a scene does form the happy ending to the play *Cefalo* by Nicolò da Correggio produced in 1487 and published in several editions.[17] However, in *Cefalo* the remorseful Cephalus is brought to Diana and her company of nymphs by the nymph Galatea, and neither she nor the other nymphs appear in NG 2 or, for that matter, in any of Claude's other renderings of the subject. Davies considered that a better interpretation might be that the figures here are not taking part in a particular event, but form a tableau vivant suggesting the various incidents of the story.[18] Whether Claude's unusual treatment of the subject was intended to bear any secondary meaning is unclear. Recent suggestions have been firstly that NG 2 (and Claude's other versions of the subject) shows Diana as virgin goddess in her role as saviour, investing the picture with a Christian content,[19] and secondly that the patron, familiar with the view that the activity of hunting was inimical to marriage, ordered the painting to represent the contrary: Diana, as goddess of hunting, joins the couple in a shared activity.[20]

Besides the National Gallery version, painted in 1645 for an unknown patron in Paris, Claude made several other versions of the story: one before 1638 for the Marchese Vincenzo Giustiniani (1564–1637), one of Rome's leading art collectors (Berlin, Gemäldegalerie);[21] one in 1645 in upright format for Prince Camillo Pamphilj (1622– 65) (Rome, Galleria Doria-Pamphilj);[22] and one in 1664 for the Abbé Louis d'Anglure,

sieur de Bourlemont (1627–97), a French diplomat in Rome (England, private collection).[23]

The figures in the Pamphilj painting are virtually identical in reverse to those in NG 2 and close to those of other versions. In the 1664 version the figures are more centrally placed and the landscape elements appear to frame them, whereas in NG 2 they seem to be placed where space happens to be available. The stags of the later version are more appropriate to the theme of hunting than the cattle shown in the present painting.

The composition of NG 2 appears to derive from *Liber Veritatis* 75 (fig. 1), which records a now lost painting made for a patron in Antwerp.[24] As Roethlisberger noted, there is some similarity between the buildings at top left in NG 2 and those in a drawing preparatory for a *Pastoral Landscape* of 1648 (New Haven, Conn., Yale University Art Gallery).[25]

According to Farington, NG 2 was widely admired when Angerstein bought it, more so than its then companion, *A Seaport* (NG 5), which he bought at the same time.[26] Farington reports the painter Hoppner saying of the two pictures that 'if the Greeks had painted landscapes they would have been such painters'.[27] Typically, Ruskin was less impressed, considering the foreground of NG 2 a fair example of what he called Claude's childishness and incompetence.[28]

General References
Smith 1837, nos 91 and 347; Pattison 1884, p. 227;[29] Davies 1957, pp. 32–3; Roethlisberger 1961, no. 91; Roethlisberger 1975, no. 154; Kitson 1978, pp. 110–11; Wright 1985b, p. 95.

Fig. 1 *Pastoral Landscape, c.*1643–4. Pen and brown wash, 19.5 × 26.3 cm. London, British Museum, Department of Prints and Drawings.

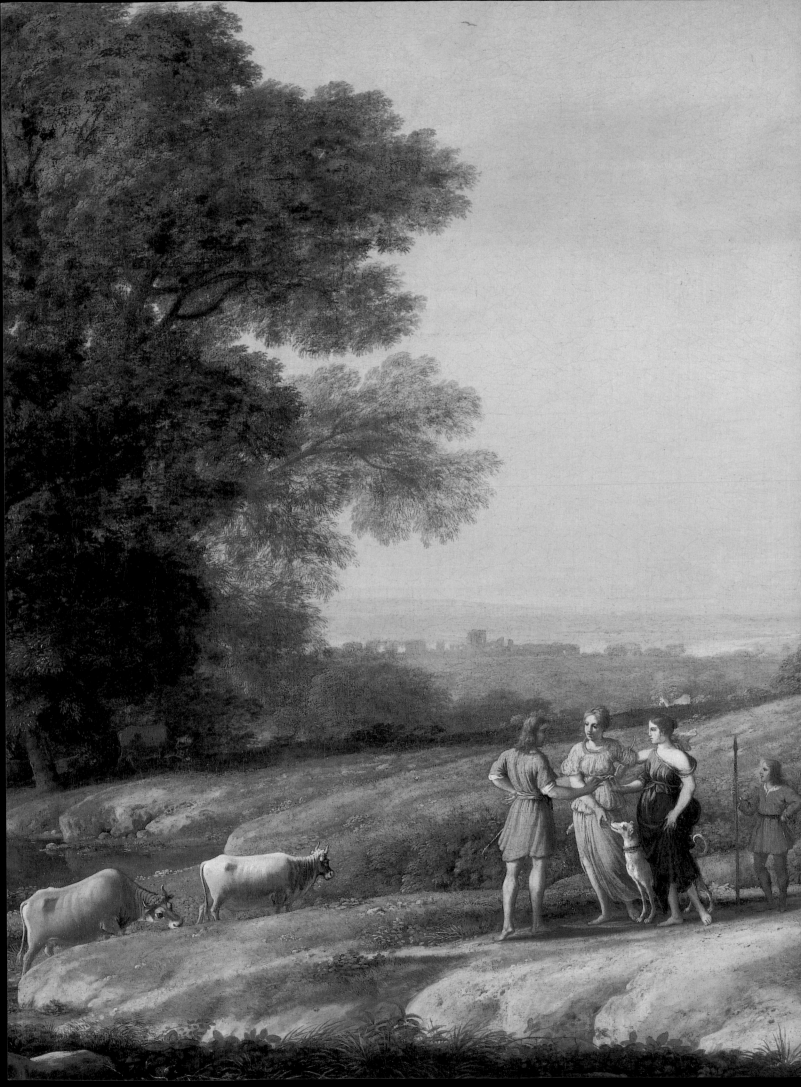

NOTES

1. The form of the monogram is, it seems, unique to this painting but nevertheless genuine: see Roethlisberger 1961, p. 248.

2. Described in the sale catalogue as: 'Un paysage peint sur toile de 3 pieds 2 pouces de haut, sur 4 pieds de large. / Ce morceau agréable, riche de composition & des plus parfaits que l'on puisse annoncer du Claude, représente un tems frais; quatre figures de 5 pouces 6 lignes de proportion, forment un groupe: le sujet paroit être le départ de Diane pour la chasse; à gauche sur un plan un peu plus éloigné, on voit des vaches qui sortent d'une riviere, un Pâtre assis sur un arbre renversé à terre, & des fabriques sur différentes élévations.'

NG 2 may already have been in La Live's collection by 1764, since a picture of the same dimensions described as 'Un grand paysage' was recorded by him in the Cabinet Flamand of his hôtel particulier in rue St Honoré, Paris: see [A.-L. de La Live de Jully and P.-J. Mariette], *Catalogue historique du cabinet de peinture et sculpture françoise de M. de Lalive, Introducteur des Ambassadeurs, honoraire de l'Académie Royale de Peinture*, Paris 1764, pp. 116–17. La Live's Cabinet Flamand housed all the paintings in his collection which he regarded as not of the French School. If it was the painting so described in the La Live 1764 catalogue, then it seems to have been in his collection by 1757 since 'Un grand Paysage de Claude le Lorrain' in the 'Cabinet Flamand' of La Live was noted by Dezallier d'Argenville in *Voyage pittoresque de Paris*, 3rd edn, Paris 1757, p. 153.

La Live was the second son of the wealthy tax farmer Louis-Denis de La Live de Bellegarde (1679–1751), and a pioneer in the collecting of pictures by French artists: see Bailey 1991–2, p. 252.

3. According to A.J. Paillet in *Catalogue des tableaux précieux des écoles d'Italie, de Flandres, de Hollande et de France... le tout provenant du cabinet de feu M. Choiseul-Praslin*, Paris 1792, preface pp. (iii)–(iv).

4. Ibid.

5. Ibid., p. 71, where described as 'Un magnifique Paysage de site italien, dont le ciel pur & brillant indique l'effet d'une belle matinée; le premier plan offre un beau terrain sablonneux, en partie couvert de mousse & coupé en différens plans admirablement sentis & distribués. A gauche de la composition, on voit un Berger qui parle à des Nymphes, suivies d'un jeune Ecuyer armé d'une pique; tandis que, sur la droite, plusieurs vaches passent un lac, & que d'autres montent un chemin pratiqué au pied d'un groupe d'arbres du plus beau feuillé; du même côté, l'on apperçoit encore un paysan assis sur un arbre renversé & cassé, & une montagne couronnée de diverses fabriques... Haut, 37p. larg. 48.T.'

For other examples of Paillet referring to left and right as from within the picture looking out, see NG 5, note 8, and his description of Dou's *Young Kitchen Maid* (Royal Collection), lot 93 of the same sale. See also J. Edwards, *Alexandre Joseph Paillet. Expert et marchand de tableaux à la fin du XVIIIe siècle*, Paris 1996, p. 274.

6. Described in a *Registre des objets d'art et d'antiquité du dépôt national de la rue de Beaune remis aux membres du conservatoire du Muséum National des Arts, etc... du quatre germinal, l'an second de la République Française, une et indivisible*, as one of 'Deux tableaux peints sur toile par *Claude Le Lorrain*, l'un représente un Soleil levant, paysage, figures, animaux, l'autre un Soleil couchant, port de mer avec figures, etc. / H.3 pds 1 p.; L.4 pds 1p.'; see M. Furcy-Raymond, 'Les tableaux et objets d'art saisis chez les émigrés et condamnés et envoyés au Muséum Central', *AAF(NP)*, vol. 6, 1912, pp. 245–343 at p. 295. Presumably the Herries referred to was Sir Robert Herries (1730–1815) who had a sale of pictures in London on 19 November 1801: see *The Index of Paintings Sold*, vol. 1, p. 998.

7. Buchanan 1824, vol. 2, p. 192. Delahante was a French dealer (d.1837) active in London and Paris: see *The Index of Paintings Sold*, vol. 1, p. 984.

8. A Flemish dealer living in London and active 1790 to 1818: see *The Index of Paintings Sold*, vol. 1, p. 1018.

9. *The Diary of Joseph Farington*, vol. 7, p. 2525.

10. Ibid., p. 2530. Buchanan gives the price paid by Angerstein for the two Claudes as 4,000 guineas, i.e. £4200: see Brigstocke 1982, p. 388 (letter of 26 March 1805 from Buchanan to Irvine).

11. The sale price is given in C.J. Holmes, *Constable and his Influence on Landscape Painting*, London 1902, p. 229, where Holmes (n. 3) calls Constable's copy probably that 'made at Cole-Orton in 1823', evidently confusing Angerstein with Beaumont to whom Coleorton belonged.

12. Roethlisberger 1961, p. 249.

13. As suggested by Kitson 1978, p. 99.

14. See Kitson 1978, p. 110.

15. As suggested by Roethlisberger 1968, p. 273.

16. J. Kirby and D. Saunders, 'Sixteenth-to eighteenth-century green colours in landscape and flower paintings: composition and deterioration', in *Painting Techniques. History, Materials and Studio Practice*, ed. A. Roy and P. Smith, London 1998, pp.155–9 at p. 157.

17. Davies 1957, p. 32. Another painting in the National Gallery which has in the past been connected with Nicolò da Correggio's play is Piero di Cosimo's *A Satyr mourning over a Nymph* (NG 698): see M. Davies, *National Gallery Catalogues. The Earlier Italian Schools*, London 1951, rev. edn 1961, p. 421.

18. Davies 1957, p. 32.

19. H. Diane Russell in Washington 1982, pp. 91 and 181.

20. H. Wine in London 1994, p. 46. For Diana's role as exemplary housewife, see Mary Rogers, 'An ideal wife at the Villa Maser: Veronese, the Barbaros and Renaissance theorists of marriage', *Renaissance Studies*, vol. 7, no. 4, 1993, pp. 379–97 at p. 392. In such a role Diana could be seen as presenting one of her disciples to Cephalus.

21. Roethlisberger 1961, no. 243; W. Schade, *Claude Lorrain, Gemälde und Zeichnung*, Munich 1996, pl. 54.

22. Roethlisberger 1961, no. 233.

23. Roethlisberger 1961, no. 163.

24. For LV 75, see Kitson 1978, no. 75.

25. Roethlisberger 1968, no. 658r.

26. For Farington's and Ward's apparent preference for NG 2 over NG 5, see Farington's entry for 1 March 1805, *The Diary of Joseph Farington*, vol. 7, 2527.

27. Ibid., p. 2530 (entry for 14 March 1805), Sir George Beaumont and Farington thought that Angerstein had bought NG 2 and NG 5 cheaply, but Farington later recorded that when Beaumont saw NG 2 in 'Mr. Angerstein's *bad light* [it appears] something like the pictures of Swanveldt': ibid., pp. 2530, 2721 (entries for 12 March 1805 and 16 April 1806).

28. Ruskin, *Works*, vol. 3 (1903), p. 484, and see also p. 491, n. 2.

29. Pattison speaks of the condition of NG 2 and NG 5 as being 'également ruinés' (Pattison 1884, p. 41).

Landscape with Cephalus and Procris reunited by Diana (NG 2), detail.

NG 5

A Seaport

Oil on canvas, 103 × 131 cm (with a tapering extension to 133 cm along the left edge towards the bottom)
Signed and dated on a slab of stone near the bottom left:
CLAVDIO.G1.V ROMAE 1644

Provenance

Possibly painted for Angelo Giori (1586–1662), chamberlain to the papal household;[1] in the collection of the marquis de Lassay, possibly Armand de Madaillan de Lesparre (1652–1738) or his only son, Léon de Madaillan, comte de Lassay (1683–1750);[2] in the collection of Louis-Jean Gaignat (1697?–1768), Receveur des Consignations, possibly by 1757[3] or 1762,[4] but certainly in his sale, Paris, Pierre Rémy, 14ff. February 1769 (lot 53, 5010 livres to Rémy for Aubert?);[5] in the collection of César-Gabriel de Choiseul, duc de Praslin (1712– 85), by 1777;[6] posthumous sale of Louis-César-Renaud, duc de Choiseul-Praslin,[7] Paris, Paillet, 18–25 February 1793 (lot 141, 15001 livres to Dulac);[8] possibly in the collection of Herries, an English banker living in the rue de Bac, Paris, and seized as émigré property 2 August 1794;[9] according to Buchanan, imported by Delahante;[10] with the dealer Philippe Panné,[11] George Street, Hanover Square, by February 1805 when offered (with NG 2) by Panné for 6000 guineas;[12] bought by John Julius Angerstein (1735–1823) together with NG 2 in March 1805 for £4500;[13] bought with other paintings from Angerstein's collection from his executors in 1824.

Exhibitions

Coventry, Derby, Doncaster and Bath 1982, pp. 31–2; London 1994, NG, *Claude: The Poetic Landscape* (13); London 1995, NG, *Gombrich on Shadows* (no catalogue).[14]

Related Works

PAINTINGS
Two paintings, apparently variant compositions of the central part of NG 5, are recorded. One is noted in an undated dossier sent by J.C. Mitchell of Huntington Beach, California, to the Gallery as in his own collection and there described as oil on canvas, 13½ × 17½ inches, and stamped on the back of the stretcher: R.C.A./DOG. DI ROMA [i.e. exported from Rome].[15] The other is noted by Roethlisberger as once in the collection of Th. Harris and having dimensions of 80 × 101 cm. To judge from the photograph of the painting in the Mitchell dossier, its composition is like that of the Harris painting as described by Roethlisberger.[16]

DRAWING (by Claude)
London, British Museum, LV 43 (inv. no. 50). Inscribed on the verso: *quad faict per 11.ᵐᵒ sigʳ/Cardinale Giorio*; and below it on another occasion: *Claudio fecit / in V.R.*

PRINTS
(1) By John Young, 1823;[17]
(2) by Edward Goodall, 1830;[18]
(3) by Thomas Starling, by 1831;[19]
(4) Anon. publication by Allan Bell & Co., Warwick Square, London, 1834, pl. XII;[20]
(5) by J.C. Armytage, by 1838?[21]

Technical Notes

The condition is generally good, although there is some wear, a few discoloured retouchings in the sky, and a damage near to the top of the left-hand mast. The primary support is a fine to medium-weave twill canvas, relined in 1979. NG 5 had been lined at some date before 1853 (when Conservation records began) and strip-lined in 1948. A new stretcher was applied in 1979 when the painting was last cleaned. The X-rays indicate that the sky was painted up to the approximate planned position of the architecture, which was then painted in. Visual examination indicates a pentimento to the foliage of the right-hand tree. When three of the Gallery's Claudes (NG 5, NG 12 and NG 14) were examined for blanching, it was observed that NG 5 showed this phenomenon to a greater extent than the other two and that Claude may have used egg tempera as an additional medium.[22] The use of smalt has been detected in the sky of NG 5, but not in NG 12 or 14.[23] Although Claude certainly used walnut oil as a paint medium for NG 5, the use by him of other media cannot be excluded.[24]

This picture, whose figures are in contemporary dress, is one of a number of seaport scenes painted by Claude with no identifiable literary source. Such seaports, like Claude's harbour scenes and marine views without a specific subject, date mainly from the 1630s. The composition of NG 5 is based on that recorded by LV 14 (fig. 1) (in respect of which two painted originals of 1637 and 1639 are known),[25] sharing with it certain details such as the nearest palace at the left with its distinctive broken pediment and semi-circular esplanade; the boat to the fore of the esplanade; the architecture of the distant palace; and the angle to the picture plane of the masted vessel at the right. The painting of 1637 recorded by LV 14 was made for Pope Urban VIII Barberini. The patron of the painting recorded by Claude in LV 43, which may be NG 5 (see below), was Angelo Giori. Giori was an intimate member of the papal household, and must have known Urban VIII's painting. He may therefore have deliberately commissioned a picture with a similar composition,[26] albeit on a larger scale,[27] in emulation of papal taste. Perhaps, however, it simply suited Claude more or less to repeat a composition which he had in any event repeated twice before.[28] Such repetitions evidence the popularity in Rome at this time of port scenes, which also formed a part of the oeuvre of Claude's former master Agostino Tassi during the 1620s and 1630s.[29] It has been suggested that the prototype for Claude's seaport scenes was a *Harbour Scene* (Rome, Pallavicini Gallery) by Tassi.[30]

In NG 5 the architecture of the distant palace, which first appeared in the 1637 painting (Northumberland Collection) recorded by LV14 and reappeared in the 1639 version (Paris, Louvre), is based on elements of various (mainly) sixteenth-century buildings in Rome: the central area of the palace

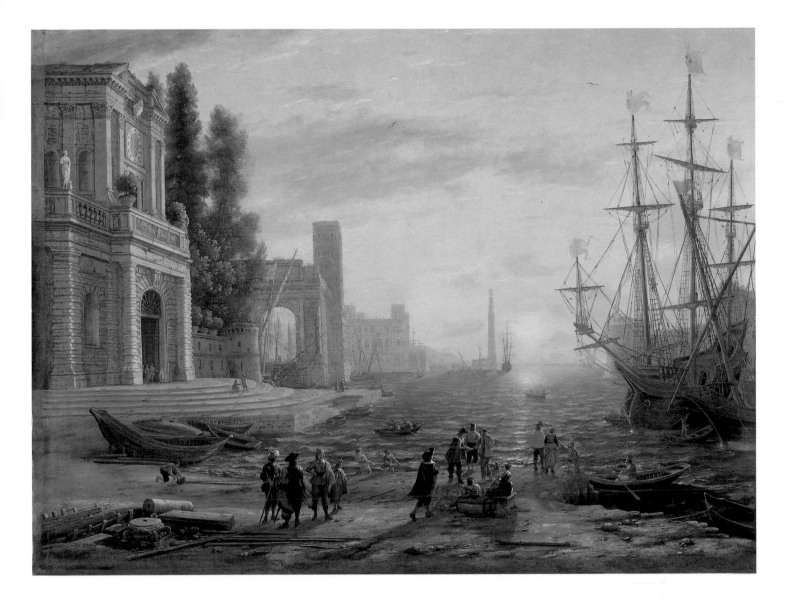

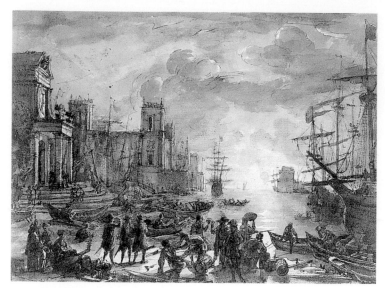

Fig. 1 *Seaport*, 1637. Pen and brown wash, 19.5 × 26.1 cm. London, British Museum, Department of Prints and Drawings.

Fig. 2 Rome, Villa Farnesina, view from the north.

Fig. 3 Rome, Palazzo Senatorio.

façade is based on the north front of the Villa Farnesina (1508–11; fig. 2), the two end bays on the late sixteenth-century Palazzo Senatorio (fig. 3), while the four towers are close in design to the Campanile (*c*.1580) of the same building, although only of a single storey. However, the relationship on almost the same plane of the central section and the two end bays of Claude's palace differentiates it from the Farnesina and recalls, for example, the courtyard façade of the Villa Mondragone, Frascati (*c*.1614).[31] The combination of a broken pediment over paired pilasters in the upper storey of the building at the left nearest the picture plane recalls the lower storey of the sixteenth-century Santa Maria di Loreto.[32] The architecture is typical of Claude's seaport architecture, which has rightly been characterised as showing 'inventiveness within a limited range'.[33] The trees growing behind a wall and the semi-circular steps of the esplanade are similar to motifs in Claude's *Port of Ostia with the Embarkation of Santa Paula Romana* (Madrid, Prado) of about 1639.[34]

The balustrade of the building at the left is decorated with Claude's representation of the Medici *Venus*, like the lower balustrade of the building at the right of Claude's *Seaport with the Villa Medici* (Florence, Uffizi).[35] The statue on the right-hand side of the balustrade is obscured by an orange tree but appears to be of Hercules.[36] The escutcheon above the clock exhibits three golden fleurs-de-lis on a blue ground, and similar coats of arms appear, more faintly, on the flags of one of the ships at the right. As Roethlisberger noted, French arms on a picture painted for Giori, a Barberini protégé, do not make sense, and he has suggested that they were overpainted while the picture was in France.[37] However, examination of the various fleurs-de-lis in NG 5 under a microscope have revealed no overpainting, so they must be assumed to be original. This raises the question – discussed below – whether NG 5 was in fact painted for Angelo Giori.

Many of Claude's paintings show the time of day as sunrise or sunset, although it is not always possible to be certain which. Roethlisberger has proposed that pink atmospheres represent evening and cool green tints morning.[38] This may be the case with pendant paintings, but seems less certain where single pictures are concerned. In NG 5 the clock below the escutcheon (fig. 4) shows the time as five o'clock which Davies took to indicate that NG 5 was an early morning scene,[39] but which Roethlisberger, on the basis of the picture's tonality, understood to mean evening. Roethlisberger has suggested that the clock has been retouched because 'its long single hand indicates five, which corresponds to the sunset atmosphere (in the *Liber* drawing it has only a short hand, on eleven)'. This suggestion is not confirmed by close examination, and it would not be unusual for there to be small discrepancies between a painting and its *Liber* drawing. Painting a clock with a long single hand would have been perfectly probable for Claude given that he would have seen external clocks of this type in Rome,[40] and there is therefore no reason to suppose that he did not intend to show the time as five o'clock from the beginning. This conclusion is supported by the fact that the clock in the Barberini version of LV 14, which was certainly the compositional model for NG 5 and quite possibly

Fig. 4 Detail showing the clock.

the inspiration for Giori's commission (see above), also shows the time as five o'clock. Although NG 5 has usually been regarded as a sunset scene, and was so regarded by Dezallier d'Argenville in 1757,[41] Davies rightly pointed out that the trees do not suggest winter, which would have to be the season for a sunset at five o'clock. Rather than assume that Claude executed a picture which was internally inconsistent in an obvious way, it is preferable to suppose that the time shown on the clock face and the abundant foliage on the trees were both deliberately included to signal that the picture was of a sunrise. That is not to say that Claude never resorted to imaginative adjustments. It has, for example, been observed that the architecture of the ship in NG 5 is imaginary because its quarter-deck would have been too steep for sailors to have worked on.[42]

The date of NG 5

A round tower with trees, seen on the left in NG 5, appears in a drawing by Claude which has been dated c.1640.[43] The arrangement of the two sailing boats at the right is close to that at the right of LV 30 which has been dated 1638.[44] This would support dating NG 5 to 1639, as proposed by Roethlisberger and Kitson,[45] as distinct from 1644 as read on the picture by Davies.[46] On the other hand the motif of the Arch of Titus in NG 5 also appears prominently in a dated painting of 1644.[47]

Fig. 5 Detail showing Claude's signature and inscription.

The argument for the date 1639, which is based both on grounds of style and on the position of the *Liber* drawing, no. 43, in the *Liber Veritatis*, is reasonable. Nevertheless, it is difficult to accept, as Roethlisberger asserts, that the fourth digit of the date as inscribed lower left (fig. 5) is a nine in Claude's characteristic form,[48] since the digit looks nothing like the figure 9 painted on the clock face in the same picture (fig. 4). Kitson suggested that the date appears to read as 1644 because of past damage or overpainting,[49] but no such damage or overpainting has been revealed by examination of the picture under a microscope. The conclusion must be that NG 5 is indeed dated 1644. Since this is not consistent with the position of LV 43 in the *Liber*, nor with the style of the painting, it may be the case that NG 5 is a repetition by Claude of a composition first painted in 1639 for Angelo Giori. Were such a repetition made for a French patron, which seems entirely possible in the 1640s when much of Claude's production was destined for France,[50] it would also explain the numerous fleurs-de-lis in NG 5. It may be objected that the pentimento to one of the trees (see Technical Notes) in NG 5 excludes it from being a repetition, but Claude may well have copied the composition from the *Liber* and then slightly adjusted it, perhaps to fit the size of the canvas.

Two manuscripts in the NG Library, written in two different hands, one of which may be that of John Young who prepared the catalogue of Angerstein's collection soon after the latter's death, contain anecdotes about NG 5.[51] One relates that the picture

> was painted for Louis the 14th. The Bourbon Arms are painted over the Building – On the death of Louis, he bequeathed this and the other Picture by Claude [NG 2] to a great favorite The Duke of P.___ During the Revolution they were both seized upon by Robespierre – However The Duke convinced Buonaparte that they were unlawfully taken possession of by Robespierre & The Emperor ordered them to be returned to the Duke who brought them over to this Country. – The circumstances of the Duke obliged him to offer them for sale, and they were purchased of him by the present proprietor.

The other relates that

> A distinguished lover of the art caused the late D[uke] of Bridgewater [1736–1803] to see this collection & as soon as he saw this picture he kept walking up & down the room exclaiming I haven't got such a Claude as this – & so he went on & it was hardly possible to draw his attention to any other Picture he was so struck with it // & were put into the Music [Room?] with all the sizeable (?) Pictures – The D [illegible] that they were improperly taken [illegible] & probably for the Duke it was of great importance[?] to his income[?] & the Purchaser of the present Picture bt it of the Duke with the Companion Picture.

Since Bridgewater died before Angerstein bought NG 5, the story is either untrue or the purchaser referred to in the second anecdote is other than Angerstein. Both accounts are, however, contained in a notebook referring to many other Angerstein pictures, so the reference to the purchaser in the second anecdote, and to the 'present proprietor' in the first, must be to Angerstein. If the Bridgewater anecdote has any truth, then it could only be in connection with *Seaport with the Embarkation of Saint Ursula* (NG 30) acquired by Angerstein in 1802 and, it must be said, a more worthy object of envy than NG 5. The reference to the 'Duke of P___' in the first anecdote is presumably a reference to the duc de Praslin (or his successor – see under Provenance), but there is no other evidence that Panné, the dealer from whom Angerstein bought NG 5, was acting other than for himself. Perhaps Panné told Angerstein that he was acting for Praslin in order to embellish the picture's provenance.

General References

Smith 1837, no. 43; Pattinson 1884, p. 227; Davies 1957, pp. 33–4; Roethlisberger 1961, no. 43; Roethlisberger 1975, no. 107; Kitson 1978, pp. 78–9; Wright 1985b, p. 95.

NOTES

1. The related sheet in the *Liber Veritatis* (LV 43) is inscribed on the verso: *quad faict per 11ᵐᵒ sigʳ/Cardinale Giorio*, and below it on another occasion: *Claudio fecit / in V.R.* (Kitson 1978, p. 76). Angelo Giori was born in Camerino in the Marches. He was introduced to the Barberini by his uncle, then entered their service, and at the age of twenty became tutor to Francesco and Taddeo Barberini. When Matteo Barberini became Pope Urban VIII (1623) Giori was appointed his secret chamberlain and cup bearer, then chamberlain of the papal bedchamber (1631), and finally in 1643 he was created a cardinal. Among his duties was the supervision of Bernini's funerary monument of Urban VIII at St Peter's and of the interior decoration of Santa Maria della Concezione. Giori formed a significant art collection including works by Romanelli, Camassei, Gimignani, Sacchi as well as Poussin: see E. Fumagalli, 'Poussin et les collectionneurs romains au XVIIᵉ siècle', *Nicolas Poussin 1594–1665*, Paris, Grand Palais, 1994–5, pp. 48–57 at p. 50. Giori also commissioned at least seven and possibly eight works by Claude during the Barberini papacy making him (with Philip IV of Spain) the most important patron of Claude's early years: see Roethlisberger 1961, p. 153, and Roethlisberger 1984b, pp. 47–65 at pp. 60–1. The inventory, dated 13 May 1669, of Giori's Roman residence near the church of S. Onofrio included 'nella stanza vicino al Giardino' as item 176 'Una Marina con calata di sole cornice tocca d'oro di Monsù Claudio'. The inventory was prepared at the request of Giori's nephew and residuary legatee, Cesareo Giori: see S. Corradini, 'La collezione del Cardinale Angelo Giori', *Antologia di Belle Arti*, 1, March 1977, pp. 83–94. Giori's likeness is recorded in an engraving, and in a sculpted bust by A. Giorgetti in the cathedral at Camerino: see S. Corradini, 'Rapporti del Bernini e del Borromini con la communità marchigiana del Seicento', *Il Seicento nelle Marche. Profilo di una civiltà*, ed. C. Costanzi

and M. Massa, Ancona 1994, pp. 158–89, figs 2 and 4.

2. According to the Gaignat sale catalogue (see Provenance and note 5 below) the painting 'vient de la collection de feu M. le Marquis de Lassay, ce Seigneur que possédoit des lumières très étendues pour tout, le regardoit comme le premier de son Cabinet'. It is not clear who is meant by this, although the last marquis de Lassay (as opposed to comte de Lassay) was Armand de Madaillan de Lesparre, who died in 1738. The comte de Lassay, Léon de Madaillan, collected pictures but also inherited some from his father and others from Mme de Verrue, who died in November 1736; Léon de Madaillan's widow, Reine de Madaillan, enjoyed a life interest in Léon's pictures which in 1755 included a 'Paysage avec figures, de Claude Lorrain, sur toile' and a 'Soleil levant, ou Port de Mer, de Claude Lorrain, sur toile', both then on loan to the comte de la Guiche: see L. Clément de Ris, *Les Amateurs d'autrefois*, Paris 1877, pp. 246–9. Reine de Madaillan died in 1763, making it unlikely that these paintings were the same as those possibly in the Gaignat collection by 1757.

3. Dezallier d'Argenville noted NG 5 in Gaignat's hôtel in the rue de Richelieu: 'Trois Tableaux de *Claude le Lorrain*, parmi lesquels on distingue une belle Vue de mer, avec un Soleil couchant', Dezallier d'Argenville 1757, p. 106.

4. L. Courajod, ed., *Livre-Journal de Lazare Duvaux marchand-bijoutier ordinaire du Roy 1748–1758*, 2 vols, Paris 1873, vol. 1, pp. cclxxii–cclxxiii: '*GAIGNAT*. M. de Gaignat, secrétaire du Roi, à l'hôtel de la Ferté, rue de Richelieu, a chez lui un tres-beau cabinet de tableaux des Ecoles flamande & françoise, qui sont: *Peinture*... trois tableaux de Claude Le Lorrain, parmi lesquels on distingue une belle vue de mer avec un soleil couchant...'

5. On Gaignat and his collection, see E. Dacier, *Catalogues de Ventes et Livrets de Salons illustrés*

par Gabriel de Saint-Aubin XI. – Catalogue de la Vente L.-J. Gaignat (1769), Paris 1921. Although the sale was advertised to take place in December 1768 it in fact only occurred in February 1769 (ibid., p. 31). Lot 53 of Gaignat's sale is wrongly identified with the Louvre *Seaport* (inv. no. 4715) (ibid., pp. 47, 73), but it is clear from Saint-Aubin's drawing in the margin of the sale catalogue that it is NG 5. The picture is described in the catalogue as: 'Un magnifique Palais & d'autres Edifices; un Vaisseau de haut bord & plusieurs Chaloupes en mer. Le rivage occupe une partie du devant du Tableau; 16 figures s'y remarquent, dont les plus grandes ont environ 5 pouces de proportion: il y en a beaucoup d'autres sur différens plans. Il est peint sur toile, de 3 pieds 1 pouce de haut, sur 4 pieds 1 pouce 6 lignes de large.' For the price at which NG 5 was sold to Rémy, see Dacier, op. cit., p.73.

For further information on the Gaignat collection, see E. Dacier, 'A propos du collectionneur L.-J. Gaignat. Les peintures historiques de l'hôtel de la Ferté, rue Richelieu', *BSHAF*, 1920, pp. 40–55, and by the same author, 'Une deuxième et une troisième peinture de l'hôtel de la Ferté retrouvées', *BSHAF*, 1922, pp. 111–26. For the reference to Aubert, see Roethlisberger 1961, p. 176, n. 3.

6. *Almanach historique et raisonné des architectes, peintres, sculpteurs, graveurs et ciseleurs, année 1777*, Paris 1777, p. xx ('Celui de M. le duc DE PRASLIN, en son hôtel, rue de Bourbon, est aujourd'hui un des plus considerables de la capitale... Parmi les tableaux de l'école française, l'on y voit une *Marine eclairée par un soleil couchant*, tableau très-capital de Claude Lorrain'). See also *Livre-Journal de Lazare-Duvaux*, cited in note 4, p. ccxcviii. César-Gabriel de Choiseul became Foreign Minister in 1761, and resigned in 1766 to become Minister of Marine. He ordered a voyage around the world for the benefit of science and navigation.

7. See notes 3 and 4 to NG 2.

8. See Paillet's catalogue (cited in note 3 under NG 2), p. 72, where described as: 'Un autre Tableau aussi étonnant dans son genre & pouvant servir d'opposition marquante en pendant au précédent; il offre le point de vue admirable & riche d'un port de mer; la partie droite se trouve entièrement occupée par un grand bâtiment de belle architecture, avec des arbres qui séparent une porte de ville, dont les édifices se distinguent dans l'éloignement & conduisent l'oeil à un fanal placé à l'horison; du côté opposé est un fort navire à trois mats, portant ses agrès: le rivage est enrichi de dix-sept figures différamment costumées, parmi lesquelles on remarque des matelots occupés à retirer leurs filets au bord de la mer, tandis que des rameurs débarquent quelques passagers. Ce Tableau, rendu à l'effet du soleil couchant, est encore une de ces merveilles d'exécution dont la comparaison seule avec la nature peut rendre un compte exact; les réflets de cet astre brûlant se répandent sur tous les objets avec une intelligence de clair obscur & de dégradation de tons si admirables & si sublimes que toute description devient insuffisante. Haut. 37 p. larg. 49.T.'; and see JoLynn Edwards, as cited in note 5 under NG 2, and at p. 142 for a reference in the catalogue of the Tolozan sale (1801) to the fame of the Gaignat and Praslin sales. For Paillet's use of left and right, see NG 2, note 5.

9. See note 6 to NG 2.

10. See note 7 to NG 2.

11. See note 8 to NG 2.

12. See note 9 to NG 2.

13. See note 10 to NG 2.

14. But NG 5 is reproduced as pl. 36 on p. 46 of the companion volume to the exhibition.

15. J.C. Mitchell, 'Prospectus, Research and Analysis Required for the Publication of a Book concerning the Marine Paintings of Claude Lorraine' (undated but about 1970, unpublished, unpaginated; copy in NG dossier).

16. 'A simplified imitation taken from the central part of [NG 5]...The palaces in the left foreground and in the distance omitted. On the right, the two ships. Three upright figures in the foreground, near the right.' Roethlisberger 1961, p. 176.

17. *A Catalogue of the Celebrated Collection of Pictures of the late John Julius Angerstein Esq.*, London 1823, no. 7 (as 'An Italian Sea-Port').

18. In *Engravings from the Pictures of the National Gallery. Published by Authority*, London 1840. A slightly larger version of Goodall's engraving appeared in *The National Gallery. A Selection from its Pictures*, London 1875.

19. In *Valpy's National Gallery*, opposite p. 29.

20. *The Portfolio comprising the original engravings from those...pictures forming the ... Stafford and Angerstein Collections, the latter of which is now known as the National Gallery*, London 1834.

21. In *The National Gallery of Pictures by the Great Masters*, London n.d. (1838?), no. 100.

22. M. Wyld, J. Mills and J. Plesters, 'Some Observation on Blanching (with Special Reference to the Paintings of Claude)', *NGTB*, 4, 1980, pp. 48–63 at p.60.

23. J. Plesters, 'Possible causes of blanching involving changes in pigment or interaction of pigment and medium', *NGTB*, 4, 1980, pp. 61–3 at p. 63.

24. J. Mills and R. White, 'Analyses of Paint Media', *NGTB*, 4, 1980, pp. 65–7 at p. 67.

25. See Roethlisberger 1961, pp. 124–6 and p. 174.

26. As suggested by Roethlisberger 1961, p. 174.

27. The Barberini painting (Duke of Northumberland, Alnwick Castle) is 74 × 99 cm.

28. LV 26 and LV 28.

29. For Tassi, whose pupil Claude was at some time in the early 1620s, see T. Pugliatti, *Agostino Tassi tra conformismo e libertà*, Rome 1977, and P. Cavazzini, *Palazzo Lancellotti ai Coronari. Cantiere di Agostino Tassi*, Rome 1998.

30. Kennedy 1972, pp. 260–83 at pp. 271–2 and fig. 44a. Tassi's painting is dated *c.*1622 by Pugliatti, cited in note 29, pl. 142.

31. Kennedy 1972, p. 276.

32. Kennedy 1972, p. 278. In Roethlisberger 1968, p. 166, the palace at the left of NG 5 is said to be inspired by Vignola's entrance gate to the Farnese Gardens on the Forum, a view endorsed by Kitson 1978, pp. 78–9, who notes 'small changes typical of Claude, such as a triangular pediment and square clock face instead of a segmental pediment and round clock face'.

33. Kennedy 1972, p. 274.

34. J.J. Luna, *Claudio de Lorena y el ideal clásico de paisaje en el siglo XVII*, Museo del Prado, Madrid, April–June 1984, p. 148.

35. Ibid.

36. As suggested by Roethlisberger 1961, p. 174.

37. Roethlisberger 1961, p. 175.

38. Roethlisberger 1961, p. 28.

39. Davies 1957, p. 33. Davies read the time shown as 4.55, evidently assuming that the clock had two hands rather than the single hand which it has.

40. For example, the clocks on the façades of the top storeys of both the Collegio Romano and the Palazzo della Sapienza as shown in near contemporary prints: see P. Ferrerio, *Palazzi di Roma de' piu celebri architetti disegnati da P. Ferrario. Libro primo*, 2 vols [Rome 1655].

41. See note 3 above.

42. D. Cordingly, 'Claude Lorrain and the Southern Seaport Tradition', *Apollo*, 53, 1976, pp. 203–13 at p. 210.

43. Roethlisberger 1968, no. 349.

44. Roethlisberger 1968, no. 191.

45. See Kitson and Roethlisberger 1959, pp. 14–25 at pp. 23–4.

46. Davies 1957, p. 33.

47. Roethlisberger 1961, no. 82.

48. Roethlisberger 1961, p. 175.

49. Kitson 1978, p. 79.

50. LV 56–62, 64, 65, 68, 79, 80, 81, 89, 90, 91, 93, 94 and 96 all record paintings made between about 1641 and 1645 for French patrons.

51. The manuscripts (*Manuscript Notes on John Julius Angerstein's Collection*, NG Archive, NG 50) were given to the Gallery by Kenneth Garlick in 1961 from among the Lawrence Papers. Gregory Martin (*National Gallery Catalogues. The Flemish School circa 1600– circa 1900*, London 1970, p. 37, n. 200), assumed that they were written by John Young, but this cannot be confirmed. They are not in the hand of Sir Thomas Lawrence, nor in the hand of Angerstein himself (by comparison with a letter written by Angerstein on 22 January(?) 1808 to Henry Hoare kindly copied to me by Victoria Hutchings of C. Hoare & Co.).

Landscape with David at the Cave of Adullam

Oil on canvas, 111.4 × 186.5 cm
Signed and dated bottom right: CLAVDIO. GILLEE/IVF.
ROM [AE] 1658

Provenance
Commissioned by Prince Agostino Chigi (1634–1705) and recorded in his collection in the Palazzo Chigi Odescalchi, Piazza Santi Apostoli, Rome, in 1658;[1] recorded in the bedroom next to the audience room of the Palazzo Chigi, Piazza Colonna, in the collection of Prince Sigismondo Chigi (1736–93) in 1770;[2] noted at the same palazzo by Ramdohr in 1787;[3] recorded there in the collection of Prince Agostino Chigi (1761–1855) in 1793;[4] acquired by the English banker Robert Sloane (d.1802) in Rome in 1799;[5] the subject of unsuccessful sale negotiations in Rome in 1802/3 between Alexander Sloane on behalf of himself and his co-heirs and James Irvine on behalf of William Buchanan;[6] brought to England by Alexander Sloane possibly by July 1803[7] and offered by the Sloane family at auction, London, Peter Coxe, Burrell & Foster, 2 June 1804 (lot 73, bought in at £1354 10s., as 'Claude... A Landscape, with Alexander in the Desart [sic]; from the Chigi Palace');[8] probably still in the Sloane family's possession in January 1805,[9] and at an unknown date thereafter bought by the dealer William Buchanan and sold by him in 1808 to Walsh Porter (d.1809);[10] offered by Buchanan as executor for Walsh Porter deceased by private contract at 39 Sackville Street, 12ff. March 1810, no. 3,[11] and then in the Walsh Porter deceased sale, Christie's, 14 April 1810 (lot 46 as 'Sinon before Priam', sold (?) £2887 10s. to Barrett),[12] and sold to the Revd W. Holwell Carr for 2000 guineas 'soon after'[13] but certainly by 1815;[14] Holwell Carr Bequest, 1831.

Exhibitions
London 1816, BI (64);[15] London 1944, NG, Picture of the Month (5 April–2 May 1944); London 1969, Hayward Gallery, *The Art of Claude Lorrain* (30); Copenhagen 1992 (13); London 1994, NG, *Claude. The Poetic Landscape* (27); Jerusalem 2000 (25).

Related Works
PAINTINGS
(1) New York, Metropolitan Museum, no. 21.184. Oil on canvas, 116.2 × 193 cm. A good copy, with figures smaller than the original, attributed to Giovanni Maldura (c.1772–1849);[16]
(2) Florence, Galleria degli Uffizi, inv. no. 1890, n. 4408. Oil on canvas, 49 × 69 cm.[17] A copy;
(3) Anon. sale, Sotheby's, 27 February 1963, lot 150 (£20 with pendant to B. Cohen, as by Heusch). A copy, oil on panel, 6¾ × 9 in. Photograph in NG dossier;
(4) 5th Duke of Sutherland deceased sale, Christie, Manson & Woods Ltd, 3 November 1972, lot 198 (£300 to Herbert as by Giovanni Maldura after Claude). A copy, oil on canvas, 48.2 × 77.4 cm. Photograph in NG dossier;

(5) Comte de Vogüé, Château de Vaux-le-Vicomte, by whom bought at an anon. sale, Sotheby's, 26 October 1988, lot 57 (£5500 as Italian School, 18th century). A copy, oil on canvas, 118 × 178 cm. Photograph in NG dossier;
(6) Anon. sale, Sotheby's, Monaco, 5–6 December 1991, lot 291 (FF.127,650 as by a follower of Claude). A copy, oil on canvas, 116.5 × 192.5 cm.

DRAWINGS (by Claude)
(1) Stockholm, Nationalmuseum, no. NM 268/1982, fo.7r. Part of sketchbook dated to the mid-1650s.[18] A landscape composition, possibly used for NG 6, but not necessarily made with the painting in mind;[19]
(2) New York, The Frick Collection (MRD 771). Suggested as the first stage for the painting of NG 6,[20] but the connection seems too remote;
(3) Rotterdam, Museum Boijmans Van Beuningen, no. F.I.10. (MRD 809) (recto, fig. 1; verso, fig. 3). The recto is a preliminary study for NG 6. The composition was subsequently expanded at the left to include Bethlehem and the Philistine camp, but the two soldiers ascending the hill are already present.[21] The figures on the verso are studies for the principal figures at the right of NG 6;
(4) Sotheby's, New York, 28 January 1998, lot 45 ($33,350 inc. premium) (fig. 2). A study for the composition of the landscape of NG 6;[22]
(5) New York, Pierpont Morgan Library, Thaw Collection (fig. 4). Inscribed bottom left: *disigne faict del quadro de principe Don Agustino/Claudio G./I.V.F. Roma*; and, below the figure of David: *Davide al desert*. (MRD 810). Perhaps a ricordo of part of NG 6, rather than a study for it;[23]
(6) London, British Museum, no 151. LV 145. Dated on the verso: *l'ano 1658*, and inscribed below this, possibly on another occasion: *Claudio Gillee tablaux faict pour/...* (word cut off) *le neveux de ppe. le ...* (word illegible). Inserted between the two lines of this inscription, possibly by another hand: *Prince don Agostino*. (MRD 811; Kitson 145). Photograph in NG dossier;
(7) Christie's, 7 July 1998, lot 176 (sold for £80,000 plus premium). Signed (?) on the verso, laid down; inscribed on the recto *Claudio Lorenese*. Dated to the late 1630s by Roethlisberger and identified by him as the Aniene bridge at Tivoli.[24] The arch of rock and the cave at the right of NG 6 are like the bridge and cave in the drawing, but these resemblances may be just coincidental.

OTHER DRAWINGS
(1) Sale of the Marquess of Bristol and the Bristol Trustees, Ickworth, Suffolk, Sotheby's, 11–12 June 1996, lot 486 (£920, as 'after Claude Lorraine'). A copy of NG 6. Photograph in NG dossier;
(2) London, British Museum, 'Fonthill' sketchbook, XLVII, p. 19v. By J.M.W. Turner. Inscribed *Alexander* at the bottom centre of the watercolour and *Gigghi* at the bottom right. A free copy of NG 6 datable probably to 1804.[25] Photographs in NG dossier.

PRINTS
(1) By Angelo Testa (born c.1775, working in Rome);
(2) by J.C. Varrall, *The National Gallery of Pictures by the Great*

Fig. 1 *Landscape with Two Warriors, c.*1657–8. Recto: chalk, pen and brown wash, some pink wash, heightened, 31.1 × 43.4 cm. Rotterdam, Museum Boijmans Van Beuningen.

Fig. 3 *Studies for the figures.* Verso of fig. 1. Chalk.

Fig. 2 *Landscape with Tall Trees in the Foreground, a Castle, the Sea and Mountains in the Distance, c.*1657–8. Pen and brown ink and wash over black chalk, 9.7 × 18.6 cm. Private collection.

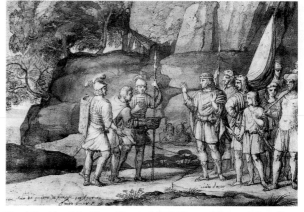

Fig. 4 *David and the Three Heroes,* 1658. Pen and brown ink, yellow-brown wash, heightened with white, over black chalk on yellow tinted paper, 24.8 × 34.7 cm. New York, Pierpont Morgan Library.

Masters, London n.d.(1838?), no. 89 (as 'Landscape with Sinon brought prisoner to Priam');
(3) by John, James and William Linnell, *Felix Summerly's Hand Book for the National Gallery*, London 1843, p. 3 (as 'Sinon brought before Priam').

Technical Notes
There is extensive wear in the sky, and considerable wrinkling due to a faulty relining in 1880 or earlier. There is also some blanching. The centre of the principal tree is damaged. It is

not clear how this occurred, but it was presumably before 1850 when the restorer H.R. Bolton noted that NG 6 was 'broke up in the Trees on the left which has been very badly repaired'.[26] There are small scattered losses elsewhere. The primary support is a fine, plain-weave canvas, (probably) double-relined in 1880 and strip-lined (in 1922) along all edges. The stretcher probably dates from 1880. It is marked in black ink at the bottom: *212*. The ground is a reddish colour. There is a small pentimento to the rear of the leftmost of the three warriors.

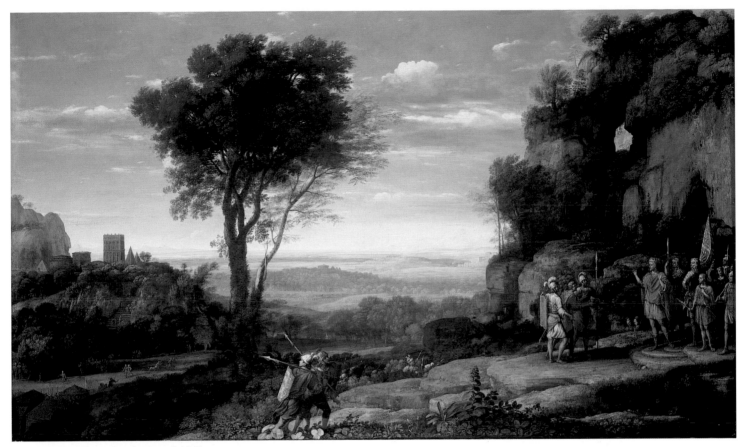

Landscape with David at the Cave of Adullam

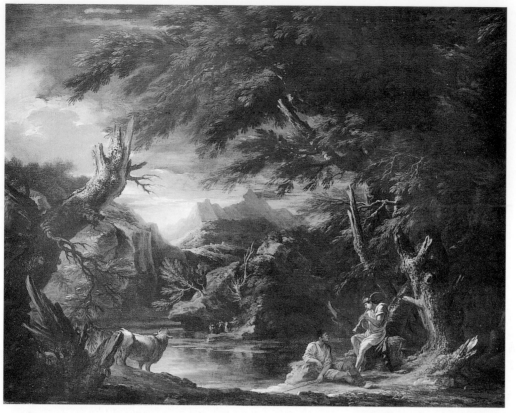

The episode shown is from 2 Samuel 23:13–17.[27] King David was unable to enter the city of Bethlehem, because it and the valley below were occupied by the Philistines, and so had to remain at the cave of Adullam, traditionally said to be between Bethlehem and the Dead Sea. When he expressed longing for a drink of water from a well by the city gate, three of his bravest warriors, Ishbaal, Eleazar and Shamma, broke through the enemy's lines to bring him some. When David realised how some of his best soldiers had risked their lives for his frivolous desire, he refused to drink the water for shame and offered it instead to the Lord. The episode was interpreted by the Church as prefiguring that of the Three Kings who, according to Matthew 2:1–12, travelled from the East to present their gifts to the newborn Christ Child. Claude has closely followed the account in 2 Samuel: the cave is shown at right and an imagined reconstruction of Bethlehem approached by a long flight of steps to its gate at the left. The extensive landscape emphasises the distance between the cave and the gate and thus the difficulty of the task undertaken by the three warriors, here shown returned and offering the water to David.

NG 6 was painted for Prince Agostino Chigi, the nephew of Fabio Chigi, who had been elected pope in 1655 and taken the name Alexander VII.[28] Alexander was initially determined to avoid all forms of nepotism, even forbidding members of the Chigi family resident in Siena to come to Rome. When finally three of his Sienese relatives did arrive in Rome in May 1656 they were told of Alexander's stringent new rules forbidding them to accept gifts for favours or income from the

sale of offices. Among these relatives was Agostino, appointed keeper of the Castel Sant'Angelo on his arrival and a year later becoming a prince on buying the Castello Farnese, then a principality, the income of which, however, was quite modest.[29] In July 1658, the year NG 6 was painted, Agostino married Maria Virginia Borghese, the pope having previously refused to countenance more influential marriage alliances proposed by the Duke of Modena and the King of Spain. The wedding was notable for its lack of pomp, being celebrated with simplicity in the pope's private chapel. Although Alexander VII ultimately yielded more and more to the demands of his relatives, when NG 6 was painted, and so even more when it was commissioned, the atmosphere of self-denial doubtless still prevailed.[30] In such a context the story of David at the cave of Adullam, a subject rarely painted previously,[31] must have seemed particularly appropriate for Agostino, then a young military commander in the papal service. Hence the subject of NG 6 seems more likely to have been suggested by Alexander VII, who had commissioned two works from Claude three years earlier, than by Agostino Chigi.

It has been tentatively suggested that drawings by Claude of a Triumph of David and of An Assault on a City may have been alternative or additional projects connected with the commissioning of NG 6.[32] This seems less likely in the light of the evidence that Agostino commissioned NG 6 as a pendant to Salvator Rosa's *Argos, Io and Mercury* (Kansas City, Nelson-Atkins Museum of Art; fig. 5) which had been painted some five years earlier,[33] or at least hung it immediately on its receipt as a pendant to the Rosa in an identical frame decorated with

Chigi emblems. As Fredricksen has pointed out, the two paintings make an unlikely pair, being linked neither by subject nor by composition.[34] However, it has been suggested[35] that the link is by way of contrast between the biblical account of princely self-restraint and Ovid's story of Jupiter's lust, Juno's jealousy and Mercury's deceit (*Metamorphoses*, I: 588 ff.), and between Claude's wilderness tamed by vegetation and Rosa's verdant retreat made to look rugged. As has recently been pointed out, the Claude and the Rosa were so different that the pair would have constituted a veritable stylistic *paragone* and this may have been the rationale for the commissioning of the Claude.[36] The stoic militarism of NG 6 is reflected in a style which is as close as Claude gets to the heroic. The importance of a rugged landscape in Claude's thinking is clear from the recto of the drawing in Rotterdam (fig. 1). In addition, between drawing the landscape study (see fig. 2 and under Drawings (4)) and painting NG 6, Claude reduced the spread, and increased the height, of the principal tree clump, moving it to the left. The trees thus ceased to be a source of shade to those standing outside the cave and became in themselves a symbol of heroic isolation.[37]

The cave and cliffs at the right of NG 6 are close to those in Claude's small *Landscape with Sheep* of 1656 (Vienna, Gemäldegalerie).[38] Claude may also have known a drawing by Annibale Carracci showing the motif of two soldiers before the face of a cliff, now known through a print by Corneille (fig. 6).[39] Roethlisberger has noted that the architecture at the left of NG 6 includes a tower combining elements of the Roman Torre delle Milizie and Torre dei Conti.[40] Although studies by Claude of soldiers in antique costume made in the mid-1650s are known, none is directly connected to any of the figures in NG 6.[41] The lion mask on the flag carried by one of David's commanders is both a reference to the princely tribe of Judah ('the lion of Judah'), where David was born, and, perhaps, to the 'lion-faced' warriors of God who were among David's most valiant troops (I Chronicles 12: 8), as suggested by the wigs of two of David's companions which are approximations of the headdress of ancient Roman standard-bearers.[42]

The painter John Constable, generally a great admirer of Claude, did not like NG 6, finding it too solemn and academic.[43] Ruskin's views were mixed. He called the central group of trees 'a very noble piece of painting' and the painting as a whole 'a really fine work of Claude's', but lamented Claude's 'ignorance of tree-structure' and considered the brown foreground and rocks were 'as false as colour can be'.[44] Some other comments of the period make evident the lack of sympathy for this attempt by Claude at painting landscape in the heroic manner.[45]

On the other hand the anonymous author of a review of the 1816 exhibition at the British Institution was more sympathetic to the picture (if not to its then owner, the Revd Holwell Carr), observing 'that of all the Pictures constituting the stock in trade of the above named Gentleman – Apothecary – Parson – Picture-Dealer, this is one of the best... Of two Pictures, by this master, in the possession of Mr. H. C_____r, he has chosen to send the least objectionable to the Gallery.'[46]

General References
Smith 1837, no. 145;[47] Pattison 1884, p. 227;[48] Davies 1957, p. 35; Roethlisberger 1961, no. 145; Roethlisberger 1975, no. 215; Kitson 1978, pp. 142–3; Wright 1985b, p. 95.

Fig. 6 Michel-Ange Corneille after Annibale Carracci, *Landscape*. Engraving, 28.2 × 21.2 cm. Paris, Bibliothèque Nationale.

NOTES

1. *Libro mastro di guardaroba per l'ecc.mo Sig.re Pn^c pe Don Agost.o Chigi. Libro mastro di guardaroba cominciato li 8 novembre 1652 come p. inventario posto in fil. di conti diversi n.13 .* '...72. Un quadro con un paese e lontananza di più paese con un Re in atto di dar udienza con soldati con bandiera et alberi alto p. mi 4½ e largo 6½ incirca con cornice intagliata e

rami di cerqua e iande con monti e stelle tutti dorati mano di CLAUDIO LORENESE', published in part by L. Salerno, *Pittori di Paesaggio*, 3 vols, Rome 1977–80, vol. 3, p. 1123; and by B.B. Fredericksen, 'A pair of pendant pictures by Claude Lorrain and Salvator Rosa from the Chigi Collection', *BM*, 133, 1991, pp. 543–6, at p. 545 where the

date of the inventory is given as 1658. The excerpt from the inventory as transcribed by Fredericksen differs slightly: 'Un quadro con un paese (di due paesi con) e lontananza di più paese con un Re in atto di dar audienza con Soldati con bandiera et alberi alto p.mi 4½ e largo 6½ in circa con cornice intagliata e rami di cerque e iande con monti e stelle

tutti dorati mano di Claudio Lorenese.' Fredericksen cites as his source the Biblioteca Apostolica Vaticana, Archivio Chigi, 1806, fol. 105 r.; he notes (p. 546) that NG 6 cannot be identified in an inventory of Agostino's possessions drawn up after his death in 1705. And see E.W. Rowlands, *The Collections of the Nelson-Atkins Museum of Art. Italian Paintings 1300–1800*, Kansas City 1996, pp. 309–17 at pp. 313, 317. For the commission by Agostino Chigi, see the inscription on LV 145 (Drawings (6)) and p. 60 below.

2. B.B. Fredericksen, see note 1, p. 546, citing Archivio di Stato, Rome, Not. A.C. Pelusius, vol. 4850, 20 February 1770, p. 189 v.: 'Altri due sotto li medesimi di palmi 9, e cinque rappresentante Paesi con figura originali uno di Salvato Rosa, e l'altro di Claudio Lorenese con cornici come sopra', and E.W. Rowlands, cited in note 1, p. 316. Noted at this time also in J.J. Volkmann, *Historisch-kritische Nachrichten von Italien*, Leipzig [1770–1], vol. 2, p. 310.

3. F.W.B. von Ramdohr, *Ueber Mahlerei und Bildhauerarbeit in Rom fur Liebhaber des Schoenen in der Kunst*, 3 vols, Leipzig 1787, vol. 3, p. 107: '*Pallast Chigi...Eine schöne Landschaft von Claude le Lorrain – Die Figuren darauf sind von fremder Hand...*' (There is no reason to suppose that von Ramdohr's statement about the figures being by another hand is correct.)

4. B.B. Fredericksen, cited in note 1, citing Archivio di Stato, Rome, Not. A.C.Jo: Alexander Paleani, vol. 4913, 27 June 1793, unpaginated: 'Altri due sotto li medesi di palmi nove, e cinque rappresentanti Paesi con figure, originali uno di Salvator Rosa, e l'altro di Claudio Lorenese con cornice come sopra.' Agostino was Sigismondo Chigi's only son. Although his father gave him all his goods (U. Fritelli, *Albero Genealogico della Nobil Famiglia Chigi Patrizia Senese*, Siena 1922, pp. 142–4), this did not include NG 6 which was among the paintings recorded in the settled estate following the death of Sigismondo Chigi: E.W. Rowlands, cited in note 1, p. 316.

5. B.B. Fredericksen, cited in note 1.

6. For references to NG 6 by Buchanan, see W. Buchanan, *Memoirs*, vol. II:

'But to proceed with an account of the purchases of importance, made by Mr. Irvine in Italy for Mr. Buchanan, and which shows the numerous objects of consequence which were at that time passing in that country, he [Buchanan] received the following letter, dated Rome, 8th December, 1802.

"I have now to inform you of another business. Mr. Sloane the banker here had purchased several pictures, for which he asked most extravagant prices. He is lately dead, and from something which dropt from his son the other day, I conceived that their pretensions would be considerably lowered. Among them are two Claudes from the Chigi and Colonna palaces, and a Guido from the Falconieri; these I have priced, and first £3000 were asked, then £2500. I made no offer; but mean to make one of £2000 for the three. Champernowne

wanted the Colonna one, and offered, I believe, £1000 without effect. For the other and companion, a Salvator Rosa, Sloane asked £5000... [information follows about banking arrangements to raise the necessary money]..." ' (pp. 111–12)

'Again, on the 14th of December, Mr. Irvine wrote another letter in continuation of the same negotiation for the pictures in Mr. Sloane's collection: viz.

"Since my last, I have been twice with young Sloane on the business of the pictures, but found him the second time more difficult to deal with than the first, having changed his demand from £2300 to £2500, so that nothing was done further than my raising my offer to £2100 for the two Claudes and Guido, or £2600 for those and a capital Salvator Rosa, that makes a companion to the Ghigi [sic] Claude, and has always been reckoned his chef-d'oeuvre; but he assured me that Lord Grantham had formerly offered £1000 for the latter. The widow I believe to be the chief cause of difficulties in settling the business. What makes me anxious to possess these for you, is to be able to make up an exhibition of first-rate things, though the profits on sale might not be very great. The value I should suppose to be nearly as follows:

Ghigi Claude . .	1500 guineas
Colonna ditto .	. 1200 guineas
Guido . .	. 500 or 600
	3300

For these reasons I mean to go as far as £2300, for which he once offered them; but should he take it, another difficulty arises respecting the extraction of them, which I am afraid will scarcely be allowed, and I make the certainty of that a condition of the purchase. He mentioned an idea they had of petitioning the Pope for that purpose, as being property to be divided among the heirs. Should this fail, I have another scheme in my head, but it is attended with some risk...

... P.S. I come from making my last offer to Sloane of £2300, on condition of three months credit for £300, and the certainty of extraction [from Rome]. He would have taken it, but his mother-in-law declared she would refuse her consent if offered £2900, so this business is ended. I told S. what a scrape he would have been in had I closed with his former demand of £2300, which he acknowledged." ' (pp. 113–14)

'I yesterday saw Sloane's pictures... They are as follow: ...The Ghigi Claude...' (pp. 122–3 [letter to Buchanan from Irvine at Rome, 8 March 1803])

Among the William Hamilton Nisbet papers in the Scottish Records Office, Edinburgh, is an undated list written by Sloane (?), 'Catalogue of Ancient Pictures painted by the best Masters existing in the hands of Mr. Alexr Slone Banker in Rome & to be sold of the Dimensions & at the following prices To wit –

No 1 Alexander in the Desarts painted by Claud Lorain for Prince Chigi in his best manner Long [] feet by []

No 2 Mercury Enchanting is painted by Salvator Rosa in his strongest Manner for the same Prince & of the said dimensions both valued at. £5,000...'

A photocopy of this list was kindly sent by S. Benedetti on 13 November 1996. Nisbet was himself in Rome in 1801–2: Brigstocke 1982, p. 472, and may have been supplied with the list by Sloane at that time.

Apparently Robert Sloane left his property (or, at least, the property in his pictures) to his children equally, 'the property to be divided when the youngest, an infant, comes of age', Buchanan, *Memoirs*, vol. 2, p. 115.

NG 6 was certainly still in Rome in the Sloane family's possession in March 1803: Buchanan, *Memoirs*, vol. 2, pp. 122–3. In a letter of 23 February 1803 Irvine wrote to Buchanan: 'I must also inform you that the Colonna Claude of Mount Parnassus [now in the Museum of Fine Arts, Boston] is universally preferred to the Chigi one, although I have put a higher price to the other as being a larger picture', Buchanan, *Memoirs*, vol. 2, pp. 120–1.

7. This date is a possible inference from Buchanan's letter written in London to Irvine on 23 July 1803, 'Sloane's collection would I *think* have been damned bad Speculation, except his largest Claude, the rest will not sell here.' Brigstocke 1982, p. 91.

8. For NG 6 and other Sloane family paintings in this sale being bought in (because the reserves proved excessive), see Buchanan, *Memoirs*, vol. 2, p. 116, and *Index of Paintings Sold*, vol. 1, pp. 43–4, and p. 196 where it is noted that the painting's title was changed by hand to 'Sinon brought before Priam' in the copy of the sale catalogue in the Isabella Stewart Gardner Museum, Boston.

9 Buchanan wrote to Irvine on 18 January, 1805: 'Tresham told me the other day that the Landscapes of Claude when fine sell for anything. He however told me likewise that Sloane's pictures being damned already here, would never do in future, even the Claudes...', Brigstocke 1982, p. 367. A few months earlier Buchanan had written to Irvine, 'Strachan tells me that before Mrs Sloane went away she was reduced to the appearance of a chagrind Ghost, he said she looked like a Devil when the subject of her sale at Cox Hay's was talked of. By her determination to bite others, she has been completely bit herself. She thinks the cunningest B—— he ever saw' (19 October 1804), Brigstocke 1982, p. 346.

10. Buchanan, *Memoirs*, vol. 2, p. 116 (where called 'Alexander in the Desert').

11. *Index of Paintings Sold*, vol. 2, part 1, pp. 68, 252. Described in the catalogue as 'Claude/ From the Gighi Palace of Rome, esteemed while in Italy, equal to those of the Altieri Palace'. See ibid., p. 68, for the possibility that the pictures in the sale were only in part Porter's property.

12. For the likelihood that NG 6 was bought in, see *Index of Paintings Sold*, vol. 2, part 1, p. 72.

13. Ibid., p. 252, quoting an annotation in a copy of the catalogue in the V&A; and see Buchanan, *Memoirs*, vol. 2, pp. 117, 169.

14. L. Caracciolo, *Liber Veritatis di Claudio Gellee Lorenese*, 2 vols, Rome 1815, vol. 2, no. 145.

15. There identified correctly as 'David encamped at the Cave of Adulam, from the Ghigi Palace – Claude – Rev. W.H. Carr'.

16. K. Baetjer, *European Paintings in the Metropolitan Museum of Art by artists born in or before 1865. A Summary Catalogue*, 3 vols, New York 1980, vol. 1, p. 112 (reproduced vol. 2, p. 182); and 1995 edn, p. 136.

17. See *Pittura francese nelle collezioni pubbliche fiorentine*, exh. cat., Palazzo Pitti, Florence 1977, p. 221, where illustrated.

18. M. Kitson, 'A small sketchbook by Claude', *BM*, 124, 1982, pp. 698–702 at p. 701.

19. See P. Bjurstrom, *Claude Lorrain Sketchbook*, Stockholm 1984, pp. 16–17, 47. As there pointed out, this drawing may itself derive from an earlier drawing by Claude in the Teylers Museum, Haarlem (RD 502r.).

20. M. Roethlisberger, *The Claude Lorrain Album of the Norton Simon, Inc. Museum of Art*, Los Angeles 1971, p. 26 and pl. 38. The connection between this drawing and NG 6 has also been doubted by H. Diane Russell in Washington 1982, p. 251. She also dates the sheet to the 1660s and so after the painting.

21. See also London 1969, no. 94.

22. Roethlisberger 1983, no. 60.

23 Roethlisberger was initially undecided on this point (Roethlisberger 1968, p.304), but was ultimately persuaded by the inscription 'faict *del* quadro' (my italics): see Roethlisberger 1983, p. 126. Kitson also regarded this drawing as made after the painting: Kitson 1968, p. 143. However, Denison considers that it may be a ricordo or a late stage of the artist's preparation for the painting: see C.D. Denison, P. Dreyer, E.J. Phimister and S. Wiles, *The Thaw Collection. Master Drawings and New Acquisitions*, New York 1994, p. 51. In addition to the exhibitions there listed, the drawing was no. 14 of *Master Prints and Drawings. 15th to 20th Centuries*, Artemis Fine Arts Ltd, London 1990.

24. Roethlisberger 1984a, pp. 93–7, at p. 96 and pl. III.

25. J. Ziff, 'Copies of Claude's Paintings in the Sketch Books of J.M.W. Turner', *GBA*, 65, 1965, pp. 51–64 at pp. 51–2. Ziff proposed a date of 1804 for Turner's drawing because he thought the time of the Sloane family sale of June 1804 the most likely opportunity for Turner to have seen NG 6. This appears confirmed by Turner's inscription on his drawing 'Alexander', being an abbreviated version of the title of NG 6 in the 1804 auction catalogue.

26. *Remarks in reference to the Condition which some of the/ Pictures are at the National Gallery/ February 28th. 1850 – H.R.Bolton*, ms., NG Archive, Bolton Papers, c.1840–56 (unpaginated).

27. The painting was wrongly called 'Sinon before Priam' in early NG catalogues, but the title was doubted in the 1838 and subsequent editions, the present title being adopted in 1913.

28. When the painting was offered for sale in London in 1804 the Chigi provenance was well known. Perhaps it was the papal name taken by Fabio Chigi, or Alexander Sloane's given name, which tempted the Sloane family to identify the subject of NG 6 as Alexander in the Desert.

29. Not more than 5000 scudi according to von Pastor's *History of the Popes*, vol. 31, p. 25. The accounts of Agostino Chigi and Alexander VII are based on von Pastor. By way of comparison, Alexander VII paid Claude 225 scudi plus a frame in 1655 for two pictures of 100 × 137 cm each (Roethlisberger 1961, p. 325).

30. Agostino took up residence early in 1657 in a palace (now Palazzo Odescalchi) on the Piazza SS Apostoli then belonging to Colonna. The pope arranged for repairs and embellishments later that year. It was bought in 1661 by Agostino's brother, Cardinal Flavio Chigi, who later had Bernini remodel the façade: Roethlisberger 1961, p. 344; Blunt 1982, p. 173.

31. And possibly unprecedented in mainland Italy: see A. Pigler, *Barockthemen*, 2 vols, Budapest 1974, vol. 1, pp. 159–60. It is not clear why Roethlisberger (1961, p. 343) calls the subject 'not uncommon', having previously called it unprecedented: M. Roethlisberger, 'The Subjects of Claude Lorrain's Paintings', *GBA*, 55, 1960, pp. 209–24 at p. 218. Nor is it clear why Roethlisberger (1961, p. 345, n. 2) took issue with the title of NG 6 as given by Davies (1957, p. 35) and as adopted here. The title is justified by the biblical account, as Kitson has pointed out in London 1969, p. 26.

32. M. Roethlisberger, 'Newly Discovered Drawings by Claude Lorrain', *Drawing*, vol. 15, no. 1, May–June 1993, pp. 7–10 at pp. 9–10, where, incidentally, Roethlisberger calls NG 6 *David at Adullam*.

33. For the dating of the Salvator Rosa on stylistic grounds to 1653/4, see E.W. Rowlands, cited in note 1, p. 313.

34. B.B. Fredericksen, cited in note 1.

35. By me in Copenhagen 1992, p. 149.

36. E.W. Rowlands, cited in note 1, p. 312. For a suggestion that the pairing of NG 6 and the Rosa may have been connected with a power struggle between the Chigi and the Colonna Families, see R. Maclean, '"O Gran Principe O Gran Prelato": Claude's Roman Patrons and the Appeal of his Landscape Easel Paintings,' *GBA*, 126, 1995, pp. 223–34 at pp. 230, 233, n. 29.

37. H. Wine, 'Metaphors for Mood and Meaning in Claude's Landscapes', exh. cat., The National Museum of Western Art, Tokyo 1998, pp. 204–7 at pp. 205–6.

38. Roethlisberger 1961, no. 240.

39. E. Knab, 'Der heutige Bestand an Zeichnungen Claude Lorrains im Boymans Museum', *Bulletin Museum Boymans*, vol. 7, no. 4 (1956), pp. 103–39 at pp. 118–20. Claude could not have known the print at the time he painted NG 6: Y. Picart, *La Vie et l'Oeuvre de Jean-Baptiste Corneille (1649–1695)*, Paris 1987, p. 139. The print is listed in Robert-Dumesnil, vol. 6, no. 82, as by J.B. Corneille (1649–95), although Knab (op. cit.) states that it was by his older brother Michel-Ange (1642–1708). As Roethlisberger has noted in respect of a copy by Claude of a Polidoro landscape in S. Silvestro al Quirinale (MRD 762), there are echoes of Polidoro in Claude's heroic landscape compositions of the 1650s, including NG 6.

40. Roethlisberger 1961, p. 343, and see I.G. Kennedy, 'Claude and Architecture', *JWCI*, 35, 1972, pp. 260–83 at p. 264.

41. Kitson 1982. These studies were copied by Claude from reliefs on the Arch of Constantine: see J. Montagu, *BM*, 125, 1983, p. 96 (letter).

42. For illustrations of the costume of Roman standard-bearers which may have been available to Claude, see Guillaume Du Choul, *Discours sur la Castramétation et discipline militaire des Romains*, Lyon 1567, pp. 27–30.

43. 'Claude's exhilaration and light, in which he was the first to delight the world, he departed from at the age of between 50 and 60, and he then became a professor of the higher walks of art, and he [fell], in a great degree, into the manner of the painters round him, so difficult it is to be natural, and so easy to be superior in our own opinion.

'When we have the pleasure of being together in the National Gallery, I think I shall not find it difficult to illustrate these remarks, as Carr has sent a large picture of the latter description.' (Letter of 14 January 1832 from Constable to C.R. Leslie, transcribed in *John Constable's Correspondence, III, The Correspondence with C.R. Leslie, R.A.*, ed. R.B. Beckett, Ipswich 1965, p. 58.)

44. John Ruskin, *Works*, vol. 3, pp. 295, 437, 581.

45. For example, Ottley 1832, p. 63: '... we wish the stiff tall figures of Sinon, and Priam with his attendants, on the right of this picture, were away; and that their place in the foreground were occupied by a shepherd with his flock, a rustic dance, or a group of nymphs at a fountain.' Ottley's catalogue was sold at the National Gallery by permission of the directors. The 1835 edition repeated these comments.

46. [?] Smirke 1816, pp. 16–18.

47. As 'David at the Cave of Adullam; or as the subject is now styled, Sinon brought Prisoner to Priam'. Smith, noting the sale price at the 1810 Walsh Porter sale as 2750 guineas, added the comment 'Now worth 3500 l'.

48. As 'Sinon devant Priam'.

NG 12

Landscape with the Marriage
of Isaac and Rebecca

Oil on canvas, 152.3 × 200.6 cm

Signed and dated bottom right: CLAVDIO.G.L. (perhaps over GILLE)/I.N.V. ROMAE 1648/.F

Inscribed on tree stump in foreground: MARI(age)/DISAC/AVEC/REBECA

Provenance

Together with NG 14, commissioned in 1647 by Frédéric-Maurice de la Tour d'Auvergne, duc de Bouillon (1605–52) (see discussion below); recorded by Dezallier d'Argenville with NG 14 in the hôtel de Bouillon, quai Malaquais, Paris, in 1745 and again in 1762, and by La Live de Jully in 1764;[1] probably the 'deux des plus grands tableaux de Claude le Lorrain' noted at the hôtel de Bouillon by Dulaure in 1785;[2] possibly among the unidentified paintings said in 1787 to be at the hôtel de Bouillon 'dans un garde-meuble où ils dépérissent, M. le Duc de Bouillon occupant rarement son Hôtel, réside presqu'habituellement au Château de Navarre';[3] in the hôtel de Bouillon in 1792 and probably removed from there during 1801, apparently being sold to 'M[onsieur] Roy';[4] said by Mireur to have been sold by the prince de Bouillon for 210,400 francs in 1805,[5] but wrongly because the two pictures were seen in London on 3 April 1803 by Farington, according to whom NG 12 and NG 14 had been imported from France by Fiezenger; purchased with NG 14 by J.J. Angerstein on that or the following day for 8000 guineas (£8400) at Erard's gallery in Marlborough St;[6] purchased from the executors of J.J. Angerstein with the other paintings of the Angerstein collection in 1824.

Exhibition

London 1994, NG, *Claude, The Poetic Landscape* (21).

Related Works

PAINTINGS

An autograph version of NG 12, more or less contemporaneous with it and varying only in details, exists in the Galleria Doria-Pamphilj, Rome (fig. 1). The relationship between NG 12 and the Doria-Pamphilj painting is discussed below. However, based on the analysis by Kitson of the differences between the London and Rome versions (see below), it would appear that most copies after NG 12 are copies after or derived from the Rome version,[7] save

(1) (possibly) a painting sold on 6 February 1963 at Sotheby's (lot 31);

(2) another painting, said to be in an oval frame and being 35½ pouces by 51½ pouces, being one of a pair corresponding to NG 12 and NG 14, recorded in the collection of William II of the Netherlands and now in an unknown location.[8]

Similar figures in reverse to those in NG 12 are recorded in paintings after Vivares's engraving of 1766 after the Doria-Pamphilj version (for example, lot 601, Sotheby's, Billingshurst, 13 May 1992, and lot 332, Christie's, 21

December 1962). A small mosaic in a British private collection (photograph in NG dossier), possibly made by Salviati & Co., Venice, in the mid-nineteenth century, is after the Doria-Pamphilj version. There is no version of NG 12 in the Museum of Fine Arts, Budapest, as stated by Roethlisberger.[9] There is a painting there (inv. no. 976) described as after Claude Lorrain and called *Landscape with the Marriage of Isaac and Rebekah*, but its composition is quite different from that of NG 12.

It has often been noted that Corot's *View near Naples* (Springfield, Mass., Museum of Fine Arts) was inspired by the composition of NG 12, although Corot would have known the Doria-Pamphilj version. The composition of either NG 12 or, more probably, the Doria-Pamphilj picture, also inspired an eighteenth(?)-century landscape with dancing figures in a private collection in Fife; a landscape by Locatelli (Vienna, Kunsthistorisches Museum, inv. no. 1650); and numerous other paintings, photographs of (some of) which are in the NG dossier. Lot 196 of the John Bell deceased sale, Glasgow, Morrison, Dick, M'Culloch, 1–5 February 1881, was probably a copy of the Doria-Pamphilj painting.[10]

DRAWINGS (by Claude)

The following seven drawings by Claude can be connected with *The Mill* and with NG 12. For fuller discussion of them, see Roethlisberger 1968, nos 402, 647–52, and London 1994, nos 22–5.[11] The significance of the inscriptions on the Bayonne drawing and LV 113 is, however, discussed below in connection with the relationship between NG 12 and the Doria-Pamphilj picture.

(1) *Liber Veritatis* 53 (British Museum no. 1957-12-14-58; MRD 402; fig 11). Inscribed by Claude on the verso: *quadro per pietro pescatore*; and below: *Claudio fecit/ in.V.R.*; and lower right: *CL*. The composition of the landscape resembles in reverse that of NG 12. The drawing is of a painting of 1640–1, but may have been Claude's point of departure when planning NG 12;[12]

(2) British Museum (no. Oo.6-129; MRD 647; fig. 10). Date: *c*.1647. The composition is like that of NG 12, but the subject is different, namely Saint John the Baptist and Angels. It may have been a by-product of work on *The Mill*;

(3) British Museum (no. Oo.7-156; MRD 648; fig. 12). A study for the composition of *The Mill*;

(4) Bayonne, Musée Bonnat (no. 220; MRD 649; fig. 5). Inscribed on the verso: *faict a Roma / 1647 / Monsieur le present disine et pancé / du taublau du prince panfille mais le / figure est un autre sujet / A Mr Passart A Paris / par amis / Claude Gillee / Ro.* See pp. 68–9 for a discussion of the significance of this drawing;

(5) *Liber Veritatis* 113 (British Museum no. 1957-12-14-119; MRD 650; fig. 4). Inscribed on the verso: *quadro faict por / il excellent.[mo] sig. / principe panfil*, and, at the bottom, *Claudio IV/ Roma / faict pour le principi* (the remaining word, obviously *panfilla*, is covered by the mount);[13]

(6) Australia, private collection (MRD 651) (on loan to the Art Gallery of New South Wales). The girl with the tambourine in this drawing appears in NG 12, but it may be an independent work rather than a preliminary study;

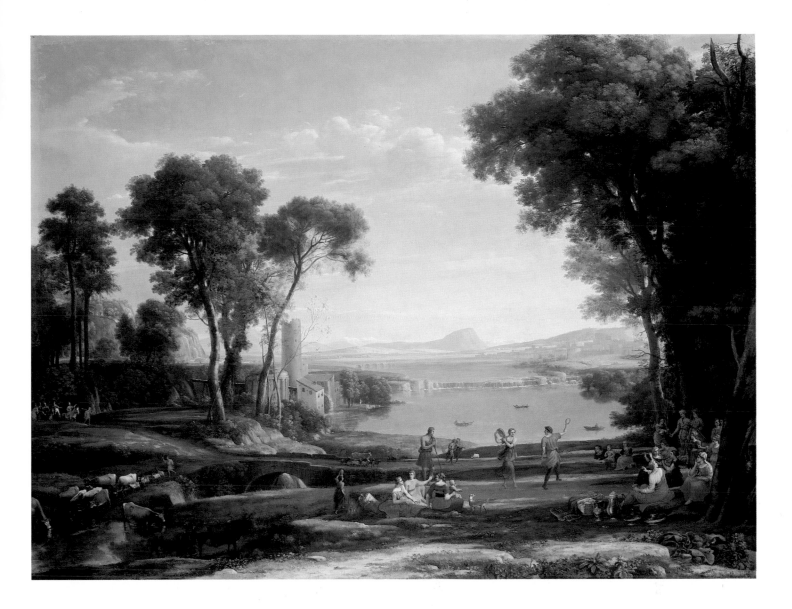

(7) Paris, Louvre (inv. no. RF 4595; MRD 652). Inscribed on the centre of the reverse, in pen: *A Monsieur Courtois / a paris Claudio Gillee / Dit le lorrain / 1665*, and, by a later hand, *Claude Lorraines*. The arrangement of the figures is similar to that of some of those in NG 12, but, like the preceding drawing, this may be an independent work done at about the same time as the painting, rather than a study for it in the strict sense.

PRINTS

(1) By John Young, 10 March 1823, in *A Catalogue of the Celebrated Collection of Pictures of the late John Julius Angerstein, Esq.*, London 1823 (no. 4);
(2) by F. Mansell, 1832, in Cunningham 1833;
(3) by Edward Goodall, 1 September 1834, in *Engravings from the Pictures of the National Gallery. Published by Authority*, London [after 1841], and in *The National Gallery. A Selection from its Pictures. Engraved by George Doo and others*, London 1875;
(4) by J. Henshall in *The National Gallery of Pictures by the Great Masters*, London n.d. [1838?], no. 81;
(5) by T. Mason, according to Nieuwenhuys 1843, p. 229;
(6) by Messrs John, James or William Linnell in *Engravings of Fifty of the most Celebrated Pictures in the National Gallery, by John, James, & William Linnell*, London n.d. [after 1841], and in *Felix Summerly's Hand Book for the National Gallery*, London 1843, p. 6;
(7) by E. Evans for *L'Art*, Paris n.d. (?c.1900).
Engravings of the Doria-Pamphilj version were made with variations by Vivares in 1766, and in reverse by J. Mason in 1774, and by F. Gmelin in 1804.[14]

Technical Notes
There are repaired scratches in the woman dancing with a tambourine, in the distant waterfall at the right, and in the lower right corner, all caused by malicious damage in 1982. Otherwise in good condition, although there is some wear, for example in the sky above the trees at left, and some damage around the edges. Lined before 1855 (probably in France around 1802, like NG 14),[15] in 1976 when it was cleaned, and in 1982 after the damage referred to above. NG 12 was among the paintings discussed before a Select Committee of the House of Commons in 1853 following its cleaning in 1852.[16]

The support is two pieces of medium-fine twill canvas with a vertical seam 119 cm from the left edge. Crack patterns on the surface of the painting show that the present stretcher is not original. The paint medium is linseed oil.[17]

Besides some darkened retouchings, there is blanching of the tree foliage at the left. The blue of the drapery of one of the figures at the right appears to have become deeper and more intense.[18]

The signature may have been in part retouched.[19] There are pentimenti visible to the naked eye in the trees at the right, above the dancing man. The dancers were painted over the landscape, but the area of the tree trunks was left in reserve.

The painting's title derives from the artist's inscription (see above) and not from the painting's intrinsic subject matter. The marriage of Isaac and Rebekah is recounted in Genesis 24, but the Bible does not mention any festivities associated with it. Claude's scene is therefore entirely imaginary and follows in concept, albeit on a more ambitious scale, other rustic dance scenes which he had already painted or etched. The title may have been suggested by the artist, but, for the reasons given below, it seems more likely to have been thought of by the patron, Frédéric-Maurice, duc de Bouillon, who commissioned the painting and to whom it was delivered.

The relationship between NG 12 and *The Mill*
The autograph status of NG 12 was doubted during its early years in the Gallery's collection by some who considered it a copy of the same composition by Claude then (and now) in the Palazzo Doria-Pamphilj, Rome, usually called 'The Mill' (fig. 1) and painted for Camillo Pamphilj (1622–65), nephew of Pope Innocent.[20] All current authorities, however, accept that NG 12 is autograph, and doubtless earlier authorities would have done so but for the existence of *The Mill*, which must have been the better known picture through most of the eighteenth and early nineteenth centuries (see Provenance and Prints above).

The measurements of *The Mill* are 150.5 × 198 cm, so it is virtually the same size as NG 12. The relationship between the two versions has been the subject of extensive comment.[21] The order in which they were painted and their respective patrons will be discussed below, but it may be useful to start with the observable differences between them. The differences in composition are small but have been summarised by Kitson as follows:

> ... the substitution of a rock in the centre [of *The Mill*] for the tree-stump bearing the inscription; the raising of the line of the river bank in the centre, so that it runs just above the head of the man leaning on a stick instead of level with his shoulders (it also runs correspondingly further above the two walking figures and behind the raised arm of the woman with the tambourine); the lowering of the line of the distant hill on the right, so that it runs below, not above, the top of the building in front of it; and the substitution of a comparatively large dead branch jutting out from the tree at the right, extending over much of the town behind, for a much smaller branch at this point.[22]

Other observations, mainly concerning colour, may be added. The grey-green dress and red belt of the woman seated in the foreground of NG 12 have been painted respectively pale turquoise and pink in *The Mill*, and the lilac breeches of the man next to her are painted blue; in the Rome version the woman next to them wears a blue dress over a white shirt and her red apron has blue stripes in it; in NG 12 she wears a pale lilac shirt; the costume of the girl with the tambourine is pale blue in the Rome version rather than grey as in NG 12 (fig. 2); in *The Mill* there are three, or possibly four, small figures in the

Fig. 1 *The Mill*, 1647. Oil on canvas, 150.5 × 198 cm. Rome, Galleria Doria Pamphilj.

Fig. 2 Detail of NG 12.

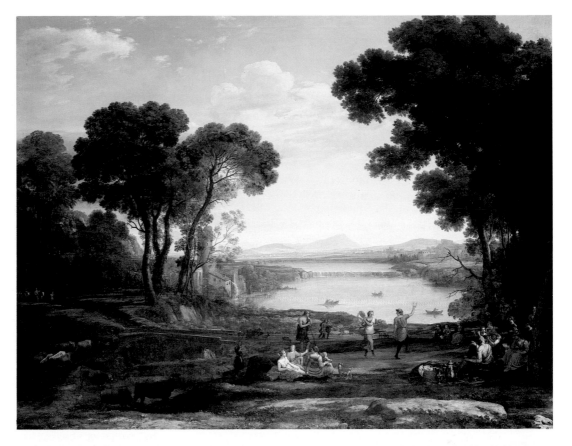

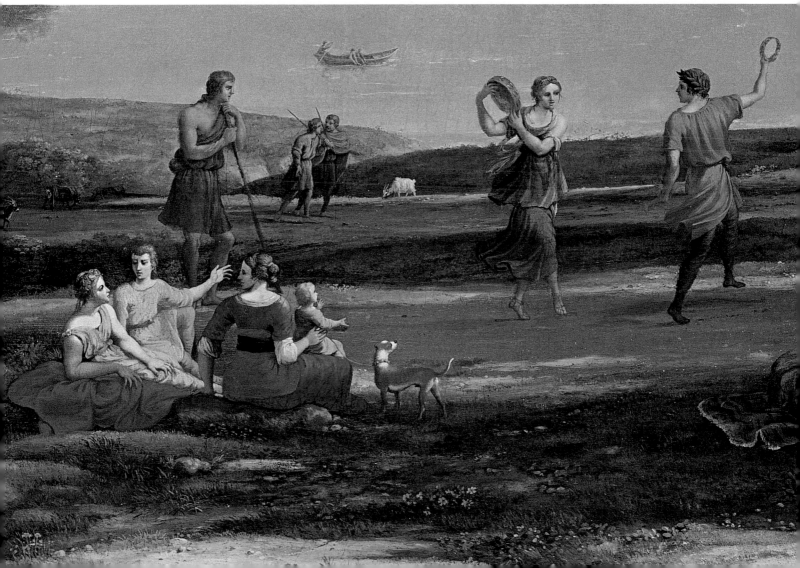

right background between the shore and the gateway to the town – these figures do not appear in NG 12 nor in the *Liber Veritatis* drawing. The Rome version differs from NG 12 in its overall appearance, looking darker in tone, but its rather dirty state and mediocre condition forbid any firm comparison in this respect. Finally, as is well known, only the London picture is inscribed by Claude with a (supposed) subject and is dated (1648) as well as signed, whereas no signature or date are apparent on the Rome picture.[23]

Most of what has been written about the relationship between NG 12 and *The Mill* has addressed two questions: (1) for whom was the composition originally conceived, the duc de Bouillon or Prince Camillo Pamphilj? and (2) which of the two pictures was painted first? To begin with, it is necessary to explain why these questions have proved so difficult to resolve. Both pictures have, so far as is known, always hung as pendants but to two quite different compositions: NG 12 as a pendant to the *Seaport with the Embarkation of the Queen of Sheba* (NG 14), inscribed by Claude both with its subject and as made for the duc de Bouillon in 1648; *The Mill* as a pendant to the *View of Delphi with a Procession* (Rome, Galleria Doria Pamphilj; fig. 3), dated 1650 and also inscribed with its subject. NG 12 and NG 14 were delivered to the duc de Bouillon. *The Mill* and the *View of Delphi* were delivered to Prince Camillo Pamphilj. The dating of the respective pendants might, in the absence of other evidence, suggest that NG 12 was made before *The Mill*. However, not only was there often a gap of several years between pendants in Claude's oeuvre, but in this case Claude's inscriptions on related drawings show that the situation is not clear-cut.

Recalling the differences in composition between NG 12 and *The Mill* noted above, Claude's only drawn record (*Liber Veritatis* 113 (fig. 4)) corresponds more closely to the former, that is, the painting that went to the duc de Bouillon. This drawing was, however, inscribed by him '*quadro faict por/il excellent.^{mo} sig./principe panfil*' and again on another occasion '*faict pour le principi[panfilla]*'. So a picture that was actually

delivered to Bouillon was in Claude's mind made for Pamphilj. The matter is further complicated by Claude's inscriptions on two of his other drawings. First, his drawn record of NG 14 (*Liber Veritatis* 114), the painting delivered to Bouillon and inscribed with his name, was inscribed by him '*prince panfile*'. This name was deleted by Claude, who inscribed the words '*Duc de Boulon*' immediately above the deleted words. LV 114 was further inscribed on another occasion '*faict pur le/Duc de boulion*'.

Secondly, there exists in the Musée Bonnat, Bayonne (inv. no. 220; MRD 649), a drawing dedicated to the Paris collector Michel Passart with a similar landscape composition to NG 12 and to *The Mill*, but with different figures (fig. 5). It may be noted in passing that this drawing, and Drawings (2) and (3), show how at this stage of Claude's career the composition of a landscape was not conceived with particular thought for the subject matter.[24] The part of Claude's inscription on the Bayonne drawing relevant to this discussion reads: '*faict a Roma / 1647 / Monsieur le present disine et pancé / du taublau du prince panfille mais le / figure est un autre sujet*'.[25] Although the wording raises problems of interpretation – is '*present*' here used as an adjective, in which case '*disine*' may be read as '*dessein*', or as a noun, in which case it may be read as '*dessiné*'; is '*et*' as it is, or is it '*est*'; and is '*pancé*' the noun '*pensée*', or, given the absence of the indefinite article, the past participle '*pensé*'? – it seems reasonable to read Claude's inscription as '*Monsieur, le present dessein est [une] pensée du tableau du prince panfille [etc.]*', meaning that the Bayonne drawing was preliminary to the painting for Pamphilj and that by 1647, the date of the inscription[26] (which is not necessarily the date of the drawing), a picture identified with Pamphilj had either been completed or was at that time well advanced.

Davies, who was the first to discuss the relative priority of the London and Rome paintings, regarded the Bayonne drawing as irrelevant to the question because of variations between its landscape and those of the paintings,[27] but Roethlisberger

Fig. 3 *View of Delphi with a Procession*, completed 1650. Oil on canvas, 150.5 × 198 cm. Rome, Galleria Doria Pamphilj.

Fig. 4 *Pastoral Landscape*, 1648. Pen and brown wash, 20 × 26 cm. London, British Museum, Department of Prints and Drawings.

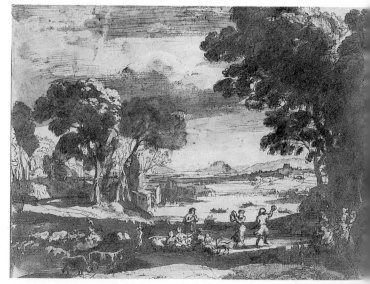

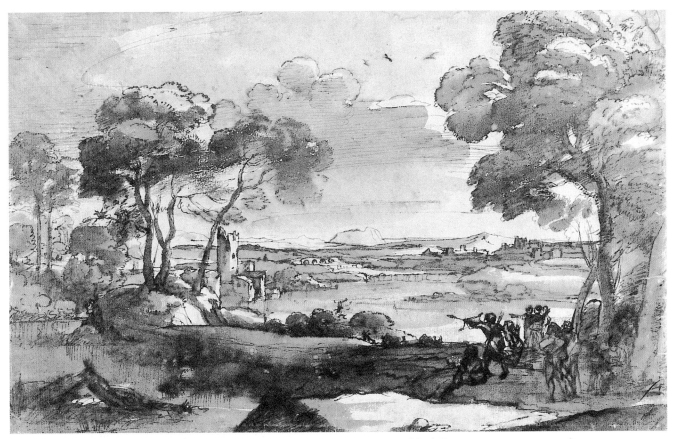

Fig. 5 *Landscape*, signed and dated 1647. Pen and brown wash, 27.9 × 42.8 cm. Bayonne, Musée Bonnat.

rightly recognised that the drawing showed that in 1647 Claude was working either on NG 12 or on the Rome picture. He argued that

> Pamphilj originally ordered [NG 12 and NG 14] as a pair and, when they were finished, Claude, as always, recorded them in the Liber, inscribed for Pamphilj ... in 1648, according to the date on the pictures in London. Their presence in London makes it obvious that Claude did not dispatch the finished works to Pamphilj, but sold them to Bouillon ... Thus only after the completion and recording of the two 1648 pictures does Bouillon come onto the scene.[28]

Roethlisberger's explanation of this turn of events was that Pamphilj's renunciation of the cardinalate and his wedding to Olimpia Aldobrandini in 1647 caused his immediate expulsion from Rome by his uncle, Pope Innocent X.[29] Although Claude then finished the pictures for Pamphilj, the latter could not, for whatever reason, take delivery, allowing Bouillon to step in. In this version of events Pamphilj would have quite quickly revived his commission to Claude, because the *View of Delphi*, the pendant to *The Mill*, was begun by 1649. Roethlisberger suggests that, 'Not wanting to withdraw from Bouillon at this point, Claude must have given him the two pictures which he had begun and recorded in 1648 for Pamphilj, and started a repetition of no. 113 directly from the first original, together with the new pendant [*The View of Delphi*]. This explains why he replaced Pamphilj's name only in drawing 114.'[30]

While Kitson was initially inclined to accept Roethlisberger's construction of events, he remained puzzled that Claude did not correct the name of the patron on the verso of LV 113 even when the painting was bought by Bouillon, contrary to Claude's treatment of LV 114. Kitson felt that 'Claude still regarded [LV 113] as referring to the picture for Pamphilj, since it was he who had given the commission and he for whom Claude had devised the composition.'[31]

When Kitson reconsidered these questions, he noted how alike in style were Claude's drawings LV 113 and LV 114, from which he reasonably inferred that they must have been executed one after the other, implying that the *Seaport with the Embarkation of the Queen of Sheba* (NG 14) must have been completed by the time that LV 113 was drawn. Since NG 14 was clearly intended for Bouillon, as its inscription shows, Kitson proposed that the patrons' names on both LV 113 and LV 114 were added several years later, as was still Claude's habit in the late 1640s. When Claude came to inscribe the drawings, he inscribed LV 113 with Pamphilj's name, because it was Pamphilj who had originally commissioned the composition, as the inscription on the Bayonne drawing suggests, and initially he did the same with LV 114 until, realising his mistake, he deleted Pamphilj's name and substituted that of Bouillon.[32]

A subsequent hypothesis proposed by Kitson was based on the supposition that (at least earlier in Claude's career) where a *Liber Veritatis* drawing could relate to more than one painting, it did not necessarily record the one painted first;

Fig. 6 Document recording the commission to Claude by the duc de Bouillon, 1647. Paris, Centre historique des Archives Nationales.

hence *The Mill* was painted first, in 1647/8, and delivered to Pamphilj, and while it was in the course of execution Bouillon or his agent commissioned a replica, at the same time ordering a 'Seaport' as a pendant. Both paintings for Bouillon were then recorded in the *Liber Veritatis*, but Claude continued to associate LV 113 with *The Mill*, and so with Pamphilj, although it recorded the Bouillon picture. While that would mean a gap of some years between the execution of *The Mill* and that of the *View of Delphi*, such a gap between pendants was not unusual in Claude's career, and for Kitson the advantage of his later hypothesis was that it avoided Roethlisberger's awkward suggestion that Camillo Pamphilj withdrew from and then renewed his commission.[33] But, as Kitson himself recognised, the differences in facture between NG 12 and *The*

Mill make it difficult to believe that both were painted around the same time, whereas the similarities between *The Mill* and the *View of Delphi*, which is dated 1650, suggest that one was painted soon after the other.

Recently discovered documents throw new light on these questions. First, it is now clear that the landscapes for Pamphilj for which Claude received 50 scudi on 20 September 1646, and which he was said two days later to be in the course of executing, must have been *The Mill* and the *View of Delphi*.[34] Secondly, a document dated 22 May 1647 in the Archives Rohan-Bouillon (fig. 6; for a transcription, see p. 78) records payments to be made by Jacques Lambin 'expeditionier' (shipping agent) on behalf of the duc de Bouillon for various works of art to be executed in Rome, and the sums paid on account

to the various artists.[35] The relevant part of the document reads: 'Mr. Jacques Lambin expeditionier payera ... a Claude le Lorrain cent et cinquante pistolles d'Italie à raison de trente juilles(?) l'une pour deux tableaux quand il les aura fourni audit Lambin.' ('Monsieur Jacques Lambin shipping agent will pay the following parties ... to Claude Le Lorrain 150 Italian pistols at the rate of thirty guillii to one [pistol] for two paintings when he shall have supplied them to the said Lambin.') From this it can be inferred that the duc de Bouillon ordered NG 12 and NG 14 as a pair when about to leave Rome at the end of May 1647, and that if the two paintings had by then been started, they were certainly not finished as confirmed by the date inscribed on them.

It is clear, therefore, that the Pamphilj commission preceded that of Bouillon by some eight months. As to the order in which the four pictures were painted, based on the date of the commission from Pamphilj, it has been proposed that *The Mill* may be dated 1646–7,[36] NG 12 and NG 14 1648 as inscribed, and the *View of Delphi* 1650, also as inscribed. That would seem to settle the matter, but there remains the awkward problem of the similarity of the facture of the two Pamphilj paintings noted by Kitson. One way of reconciling Kitson's judgement – surely correct – about the look of the paintings with known facts about them would be to suppose that *The Mill* was far advanced or even completed by 1647, as the inscription on the Bayonne drawing indicates, but that, because of Pamphilj's temporary expulsion from Rome, it was not delivered until 1649/50. Hence, when Claude came to paint the *View of Delphi*, which he may have started in 1646/7 but not completed until 1650, he was able to adopt the facture of *The Mill* then still in his studio. If *The Mill* were indeed painted first, this would be consistent with the fact that the tree trunks in it were painted over the landscape whereas in NG 12 space for them was left in reserve, suggesting that Claude already knew where they were to go.[37] The numerous small differences between *The Mill* and NG 12 may be explained as changes introduced by Claude, perhaps to distinguish between virtually identical compositions, or more likely as adjustments intended to improve the composition when he came to paint NG 12. The hypothesis advanced here is also consistent with LV 113 being a record of the Bouillon painting but being inscribed with Pamphilj's name, for it was precisely at the point that NG 12 was about to leave for France in 1648 that Claude would have wished to record its composition, which, however, he still noted as having been originally conceived for Pamphilj. As for Claude originally inscribing Pamphilj's name on LV 114, this must have been a mistake – as Kitson suggested – easily made if LV 113 and LV 114 were inscribed at the same time, and one which Claude evidently himself corrected. To recapitulate: *The Mill* was painted in 1647, but not delivered until 1649/50; the *View at Delphi* may have been started in 1646/7 but, if so, like *The Mill* it remained in the studio – in any event it was not completed until 1650; both NG 12 and NG 14 were commissioned in May 1647 by Bouillon and completed the following year – NG 12 as a virtual replica of *The Mill* then still in Claude's studio, but NG 14 as a pendant composition which was never intended for Pamphilj.

Subject matter and significance

It is not clear if the subject of *The Mill* was intended to have particular significance for Pamphilj.[38] However, the same cannot be said of NG 12 or of NG 14 given Claude's inscription of their subjects on them, and the following discussion of their significance for Bouillon will, therefore, concern both of these paintings.

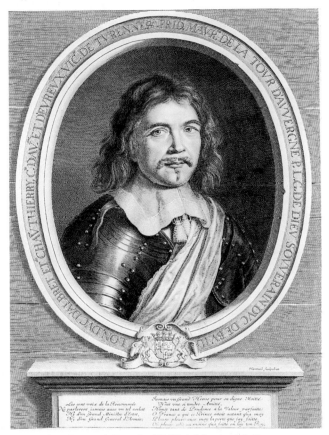

Fig. 7 Robert Nanteuil, *Portrait of Frédéric-Maurice de la Tour d'Auvergne, duc de Bouillon (1605–52)*. Engraving, 38.8 × 29 cm. Paris, Bibliothèque Nationale, Département des Estampes.

Frédéric-Maurice de la Tour d'Auvergne, duc de Bouillon (fig. 7), was a military man and the elder brother of the great general, Turenne. One of Louis XIII's less loyal subjects, he was party to the 1642/3 conspiracy of the marquis de Cinq-Mars, for which he would probably have been executed but for the astute intervention of his wife. On 1 April 1644 Bouillon went to Rome to command the Papal troops, returning to France probably in May 1647.[39] In France he was one of the leaders of the first Fronde, the revolt against the French Crown which started in August 1648. He was described by the cardinal de Retz, a younger contemporary, as a man of proven courage with the face of an ox and the perspicacity of an eagle,[40] and as afflicted with gout.[41]

The fact that Bouillon was charged with command of the Papal armies was extraordinary in its way, because, until recanting in 1633, he had been a Protestant, and, indeed, a member of a staunchly Protestant family (although converts were especially welcomed by the Catholic Church). The principal agent in his conversion was his future wife, Eléanor-

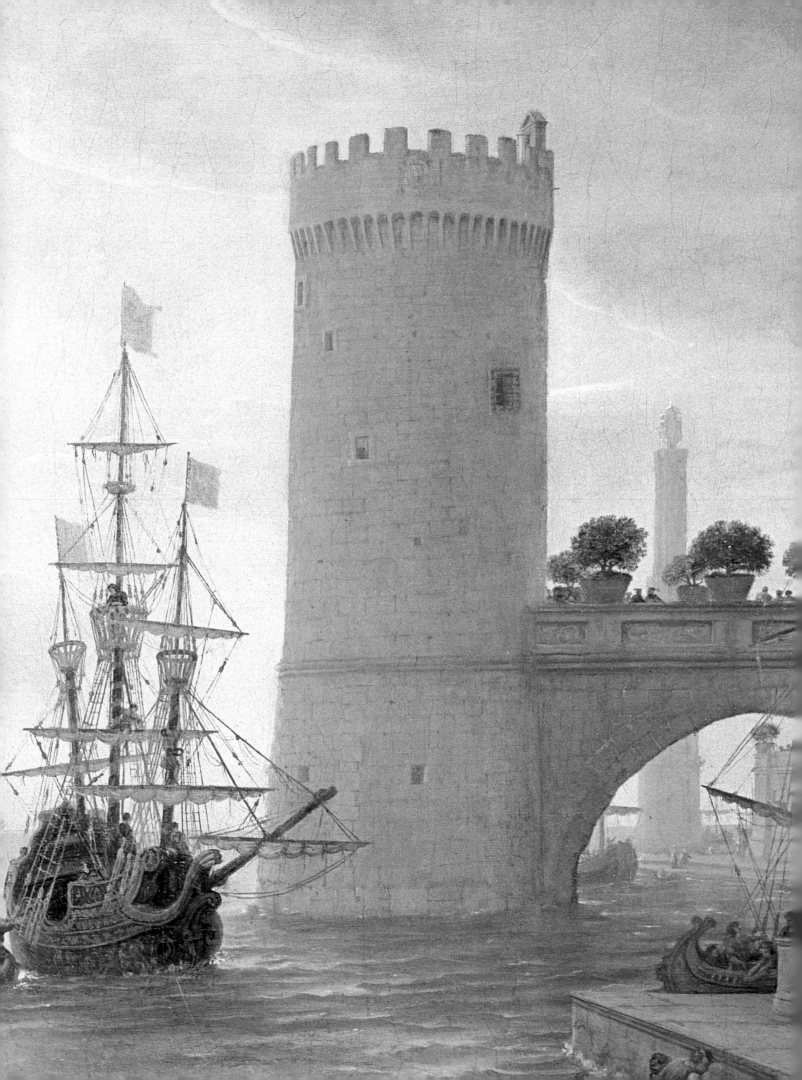

Catherine-Fébronie de Bergh (1615–57), daughter of Frédéric, comte de Bergh, governor of Frisia. Frédéric-Maurice had met Eléanor-Catherine in 1632 in Brussels. That the venue of their meeting should have been a ball held at the court of the Infanta Isabella[42] may have made the pastoral dance subject of NG 12 appropriate; that the marriage seems to have been a genuine love match and that Eléanor-Catherine was a woman of sincere piety may also have made a biblical subject such as that of Isaac and Rebekah particularly appealing.[43] The couple married on 1 February 1634 at château de Boxmer on the Meuse,[44] and Eléanor-Catherine bore Bouillon ten children before her husband's death eighteen years later.

Bouillon's biographer summarised his subject's evaluation of Eléanor-Catherine as 'a person of great birth, of astonishing beauty, and with a reputation for having much spirit and wisdom, but Catholic and with no fortune',[45] an evaluation substantially confirmed by the duc de Saint-Simon, who described her as 'belle, vertueuse, courageuse, ambitieuse et fort habile'.[46] Eléanor-Catherine's lack of wealth was scarcely appropriate for a comparison with the Queen of Sheba, but her other qualities, particularly her beauty and wisdom (admittedly inferred in the Queen of Sheba's case from the biblical account in I Kings 10:1–13, rather than made explicit), and possibly even her origins from without France, may well have seemed particularly apt. The parallels were not, of course, precise. For one thing, it was the queen who was enlightened by Solomon, whereas it was the duchesse Eléanor-Catherine who seems to have guided Bouillon and who, through her advice and example, persuaded him to convert to Catholicism. However, if it is assumed that Bouillon's motive in acquiring NG 12 and NG 14 was, at least in part, as a display of marital affection, rather than as a visual sermon, then some imprecision

seems permissible. In any event, other details in NG 12 and NG 14 may have appealed to Bouillon's dynastic pretensions. First, the story of the Queen of Sheba coming to Solomon in Jerusalem may have recalled the duc's best-known ancestor, Godefroy de Bouillon, who had led the First Crusade and was briefly ruler of Jerusalem at the end of the eleventh century. That this was not forgotten by the Bouillon family six hundred years later is evidenced by the inscription at the base of a statue of Godefroy de Bouillon commissioned as part of a monument to Frédéric-Maurice and Eléanor-Catherine by their third son, Cardinal Emmanuel-Théodose de Bouillon (1643–1715). The inscription described Godefroy as 'count of Bouillon, King of Jerusalem' (COMES/ BOLONIA/REX/ HIEROSOLIMI).[47] Secondly, in both NG 12 and NG 14 there appears a round, crenellated tower, a common enough motif in Claude's pictures, it is true, but one which happily coincided with one of the principal emblems of the duc de Bouillon, whose family name was De la Tour d'Auvergne. The tower is particularly prominent in NG 14 (fig. 8). Faintly discernible on the tower, just below the crenellation, is a shield affixed to an oval and apparently bearing a coat of arms. Unfortunately, the precise nature of the armorial device cannot be made out,[48] but it is of interest to note that inscribed on the Bouillon coat of arms were words derived from Solomon's Song of Songs, reinforcing the identification of the duc with Solomon.[49]

Drawings related to the composition

The composition of NG 12 has been said to have been unmistakably affected by Domenichino's *Landscape with Saint John* (Cambridge, Fitzwilliam Museum; fig. 9).[50] It is not certain, however, that Claude saw this painting, although Domenichino's general influence on Claude is undeniable.[51]

Fig. 8 Detail of tower in *Seaport with the Embarkation of the Queen of Sheba* (NG 14).

Fig. 9 Domenichino, *Landscape with Saint John*, 1621–31. Oil on canvas, 112.3 × 156.2 cm. Cambridge, Fitzwilliam Museum. Reproduced by permission of the Syndics of the Fitzwilliam Museum.

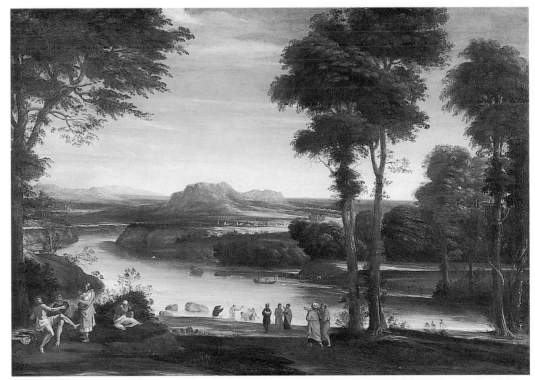

Fig. 10 *Landscape with Saint John the Baptist and Angels*, *c*.1647. Chalk, pen and brown wash, 19 × 26.7 cm. London, British Museum, Department of Prints and Drawings.

Fig. 11 *Landscape with a Country Dance*, 1640–1. Pen and brown wash, 19.6 × 26.7 cm. London, British Museum, Department of Prints and Drawings.

That the composition of NG 12 was not specific to its nominal subject matter is shown by Claude's drawings connected with it. One, MRD 647 in the British Museum (fig. 10), includes small figures of Saint John the Baptist and two angels. Another, which is discussed above, is MRD 649 in the Musée Bonnat, Bayonne (fig. 5); this shows a group of hunters, one with a cross-bow.[52] A third (fig. 12) has no figures except a small, lightly sketched man in the centre, whose function may be to indicate scale. Claude's starting point for the composition of NG 12, however, may have been a much earlier drawing, namely LV 53 of 1640–1 (fig. 11), in which most of the main compositional elements are seen in reverse.[53] The absence in

NG 12 of the steep river banks in LV 53 and of the goats falling over them, however, makes the mood of NG 12 more carefree. The group of trees at the right of NG 12 and the figures seated under them recall also a possibly earlier composition in the Albertina (fig. 13).[54] The dancer with a tambourine in NG 12 is close to that in a drawing (MRD 651) in an Australian private collection, but may be an independent work.

The export of NG 12 and NG 14 from France

It seems clear from the memorandum of 22 May 1647 that Bouillon originally commissioned both NG 12 and NG 14 as pendants, and that they were conceived as such. They were

Fig. 12 *Landscape*, c.1647.
Pen and brown-grey wash,
11.9 × 28.8 cm. London, British
Museum, Department of Prints
and Drawings.

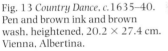

Fig. 13 *Country Dance*, c.1635–40.
Pen and brown ink and brown
wash, heightened, 20.2 × 27.4 cm.
Vienna, Albertina.

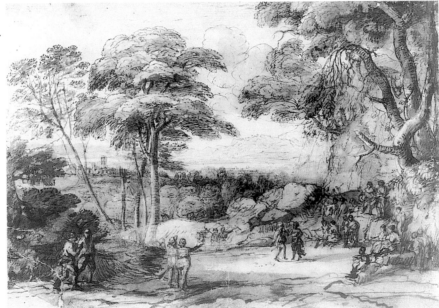

presumably the paintings noted by Dezallier d'Argenville at the hôtel de Bouillon in 1745.[55] They probably remained there throughout the rest of the century (see Provenance), although there is some evidence which suggests that they may have been removed from the hôtel for a period around 1730.[56]

Considering the size of the paintings, and their renown during much of the later eighteenth century, it is not clear how they escaped seizure during the French Revolution, particularly since the successor to the dukedom of Bouillon on the death of Godefroy-Charles-Henri on 3 December 1792, namely Jacques-Léopold Charles, was imprisoned in February 1794 and his property confiscated.[57] Immediately after

Angerstein bought the two paintings in April 1803, Farington was told that they had been 'secreted abt. 13 years, during the Revolution in France'.[58] Reiset much later asserted that the paintings 'ornaient encore à la fin du XVIIIe siècle les dessus de porte de l'hotel de [Bouillon]' ('at the end of the eighteenth century still adorned the hôtel de Bouillon as overdoors'),[59] but, unless Reiset meant that this was their situation immediately before the French Revolution, this seems unlikely because by the 1790s the paintings were being referred to as movables.[60] Certainly in 1797 Beckford was contemplating buying the two pictures, writing to his agent, Nicholas Williams, then in Paris, in terms suggesting that the

Claudes were available for purchase.[61] Possibly they escaped seizure because their ownership was then being disputed between Godefroy-Charles-Henri's widow, who was not an émigrée, and his father's creditors, with the result that whoever owned the picture it was not (according to the litigants) the then imprisoned Jacques-Léopold. Exactly who received value for the pictures when they left the hôtel de Bouillon is unclear. Perhaps they left the hôtel soon after Jacques-Léopold's death on 3 March 1802, but there is quite strong evidence that they had been removed and sold to a Monsieur Roy during the previous year.[62] Philippe d'Auvergne, who claimed the Bouillon title and possessions by right of adoption, went to Paris soon afterwards but was arrested as a spy, which presumably put a stop to any attempt he may have made to remove the pictures from the hôtel de Bouillon (assuming that they were still there).[63]

How much, if any, of this was known in London when Angerstein bought the pictures in April 1803 is not clear. Given his reputation for probity combined with business sense, it seems highly unlikely that Angerstein would have touched them were he aware of a problem with their title, let alone pay as much as he did. It is perhaps significant in this regard that when Philip d'Auvergne published his claim to the Bouillon title in London in 1803, no reference was made to the paintings.[64] In fact what Angerstein probably believed about the paintings' export from France is contained in three manuscript notes in the Gallery archives regarding what is now NG 14. Two of the three notes are certainly in different hands. Of those two, one or both may have been written, or dictated, by John Young when preparing his catalogue of Angerstein's collection soon after the latter's death. The third, which is quoted below, appears to have been written in Angerstein's lifetime, although all contain broadly similar accounts of the paintings' export from France,[65] and two contain the fallacy that NG 12 and NG 14 were, on or soon after their execution, owned by Frédéric-Maurice de la Tour's brother 'then Cardinal at Rome'. One note, possibly the earliest, continues (with an approach to historical possibilities of astonishing flexibility):

On the commencement of the French Revolution the Cardinal left France, & his Agent at the Castle in Normandy became very anxious to preserve his Masters effects at the time of Robespierre's seizure of the Loyalists property, built a Wall before the famous & valuable Pictures and had the Room newly papered. The Peace being made & all fear of further plunder being at an end the Wall was taken down, as it was feared the dampness of it had injured the Picture which was not the case, but it was found necessary to put new linings at the back of them. The Duke being afterwards in want of Money sold them and the Purchaser to deceive the Officers of the Customs, that the English were giving high prices for Pictures of any kind, and even for Copies, and assured them that these were Copies, as would be proved by the newness of the Lining, the Corners

of which he showed them; they were satisfied with his Account, and the Pictures were suffered to be embarked, and he got them safely to England. This Person sold them to the present Proprietor.[66]

Thus, the Bouillon Claudes' new linings were transformed from possible causes for suspicion into evidence of commercial acumen, which might have been expected to appeal to Angerstein, especially when exercised at the expense of the French.[67]

On 2 April 1803 Farington noted that the two Bouillon Claudes had been imported into this country by Feizinger with an asking price of £20,000. Farington saw them the following day in the company of Thomas Lawrence, and wrote:

I never saw pictures by Claude in such a high state of preservation, or that possessed such superior excellence – Lawrence desired me to go with him from thence to Mr. Angerstein's to see the Barberini Claude [NG 30] & the Gaspar Poussin [NG 31]. – On comparing them Gaspar seemed to be reduced to Wootton, and the water so celebrated in the Barberini Claude to something which might be imitated which in the Bouillon Claude appeared inimitable. – Mr. Angerstein told Lawrence the morning that after seeing those 2 pictures His own Claude seemed poor. – Lawrence asked me what price I thought Mr. A. might go to. I told him I wd. not lose them for 8000 guineas as they would so add to the reputed value of His collection, and that He would do well to part with some of his present pictures. – West told me this morning that they asked 10,000 gs. for the pictures & that He would propose 8000.

Then on 4 April Farington discussed the Claudes with Benjamin West: 'I told him I had proposed 7000 gs. He said He wd. propose 8000gs. He said the *Doria Claude* with the large buildings [the *View of Delphi*] is inferior to the *Marine Claude* at Erard's [NG 14], – being thick in Colour in Comparison.' On the same day Farington recorded Angerstein's purchase: 'He had purchased the 2 Claudes for 8000 gs. – they wanted 9000 or 8500 – but he stood to his offer & they accepted it.' And on 5 April he wrote: 'Lawrence I called on. – this morning Mr. Angerstein put up his two Claudes and paid the money for them. The Barberini Claude [NG 30] was painted in 1641 – It appears weak by the others.'[68]

After more than 150 years of relative obscurity, NG 12 and NG 14 became two of the most celebrated paintings in Angerstein's collection and were much visited by artists and others during the months that followed, as is apparent from Farington's *Diary*. They later acquired additional celebrity when J.M.W. Turner, whose *Childe Harold – Italy* (London, Tate Gallery) of 1832 recalls NG 12, stipulated in the bequest to the National Gallery of his paintings *Sun rising through Vapour* (NG 479) and *Dido building Carthage* (NG 498) that they should hang between it and NG 14. Nevertheless, nineteenth-century appreciation of the paintings was not uniform. Beaumont preferred NG 30 to NG 14, and both Beaumont and Northcote preferred NG 14 to NG 12.[69] Indeed, NG 12

was widely regarded as a copy of the Doria Pamphilj painting. Ruskin had not 'the slightest doubt of [NG 12] being a most execrable copy; for there is not one touch nor line of even decent painting in the whole picture...';[70] and the more even-minded Waagen, relating his visit to the National Gallery, said that he 'was surprised, here, where there are so many genuine and fine works of Claude, to see a copy from the celebrated Mill in the Doria Palace'. However, in 1845 the then Keeper, Wornum, defended the autograph status of NG 12, noting

that there were differences between the two versions.[71] The status of NG 12 is no longer in doubt and was recently reconfirmed when it and the Doria Pamphilj picture were seen side by side in the Gallery's Conservation Studio.[72]

General References

Smith 1837, no. 113; Pattison 1884, pp. 227–8; Davies 1946, pp. 19–24; Davies 1957, pp. 35–42; Roethlisberger 1961, no. 113; Roethlisberger 1975, no. 180; Wright 1985b, p. 95.

Landscape with the Marriage of Isaac and Rebecca (NG 12), detail.

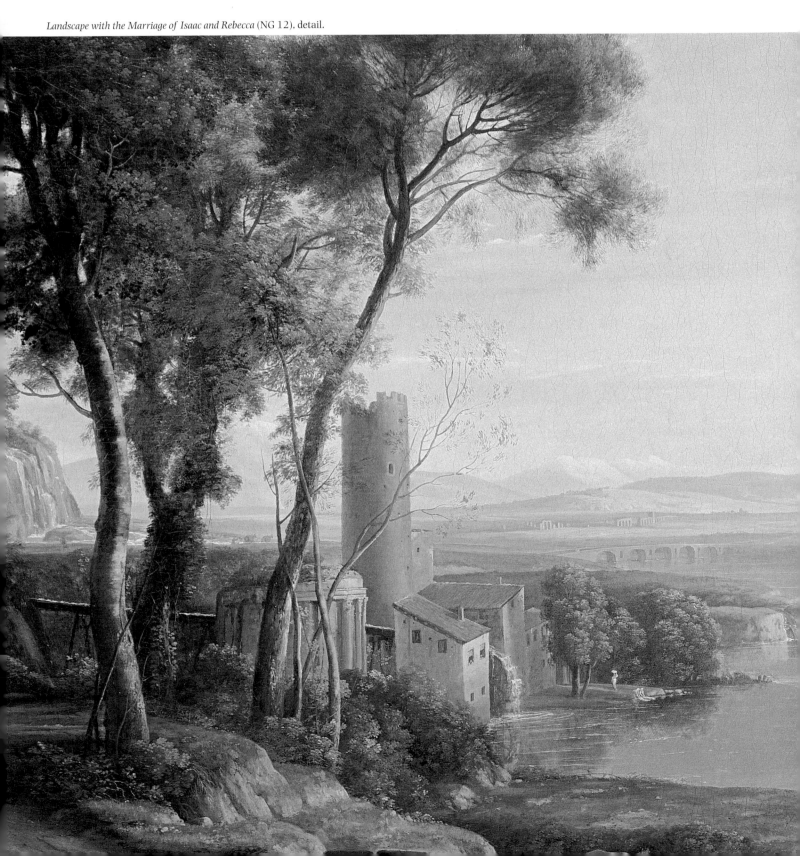

Appendix

Transcription of the document reproduced in fig. 6 (the heading is on the verso).

Memoire avec un / recepissé au bas.. / Sr. Lambin de rome de largens/ gedois baill.. po^r des ouvrages/ que.. leurs altesses fait faire/ a Rome/ 22^e may 1647

M^r. Jacques Lambin expeditionier payera les parties suivantes sçavoir

A M^r. Maffei ce qu'il conviendra pour la facture d'un Carrosse & de deux chandeliers de sale (salle?) de bois doré

Plus a Claude le Lorrain Cent et cinquante pistolles d'Italie à raison de trente juilles(?) l'une pour deux tableaux quand il les aura fourni audit Lambin

Plus au garcon dud[it] Claude le Lorrain vingt pistolles semblables pour deux tableaux

Plus à Guilleaume disciple dudit Claude le Lorrain dix-huict Pistolles pour trois Tableaux

Plus quarante pistolles semblables pour deux Tableaux de Cavalcat a ung Apoticaire a la fontaine de Trevis si M^r. Mignard les juge de ce prix là Plus ce qu'il faudra pour les Brefs(?) de Madame Led.[it] Lambin à reçeu à compte deux cents pistolles d'Espagne

Plus ledit Lambin payera au Sieur Alexandre Pietra sancta ce qu'il luy [evien?]dra pour une Pierre avec une inscription qui se doibt metre à la Madonne de la Victoire

Le susdit sieur Maffei à conte a reçeu quatre vingt pistolles

Le susd. Claude le Lorrain en a reçeu aussy trente

Et ledit Claude le Lorrain à conte de son garcon quatre autres pistolles

Le susdit Guilleaume en a reçeu aussy six autres à conte

Jay receu les susdites deux cent pistolles dEspagne de S.A. Monsig^{or}

Le Duc de Bouillon pour ester employees suivant les ordres cydessus a Rome le 22 may 1647. J Lambin

Plus [jay reçeu?] de S.A. aultres quattre vin pistolle semblables dEspagne

NOTES

1. Dezallier d'Argenville 1745, vol. 4, p. 62: 'On fait à Paris beaucoup de cas de deux grands tableaux de [Claude le Lorrain] qui sont à l'hôtel de Bouillon; ce sont deux paysages qui par leur fraîcheur, leur vaguesse, & leur grand ton de couleur, peuvent entrer en lice avec tous les tableaux des grands maîtres.' In the 1762 edition Dezallier added: 'l'un représente un beau site très-frais, avec quantité d'animaux & de figures qui dansent: l'autre est un port de mer avec un portique d'architecture extrêmement beau & très-estimé, par un beau reflet dans l'eau. On peut dire que les figures qui sont dans ces deux tableaux (si elles sont de Claude) font honneur à son pinceau.' A.N. Dezallier d'Argenville, in various editions of his *Voyage Pittoresque de Paris* published between 1749 and 1778, notes NG 12 and NG 14 at the hôtel de Bouillon, wrongly describing the latter as 'un clair de Lune' (edn 1749, p. 265; edn 1757, pp. 411–12; edn 1765, p. 399; edn 1778, pp. 386–7). It can scarcely be doubted, however, that these were the same paintings noted by Dezallier in his *Abrégé*.

NG 12 and NG 14 are presumably the paintings by Claude referred to by Laborde in his *Dictionnaire Portatif des Beaux-Arts*, Paris 1752, p. 369, as 'deux d'un très-grand prix à l'Hôtel de Bouillon', and in the *Catalogue Historique du Cabinet de Peinture et Sculpture Françoise, de M. DE LALIVE, Introducteur des Ambassadeurs, honoraire de l'Academie Royale de Peinture*, Paris 1764, p. 62: '...à l'Hôtel de Bouillon, où sont deux des plus grands tableaux de ce maître, de la derniere beauté.'

Although all nine editions of Germain Brice's *Description de la Ville de Paris* describe the hôtel Bouillon on the quai Malaquais, the only painting referred to is Charles le Brun's *Apollo on Mount Parnassus*. NG 12 and NG 14 may have been among the 'quelques tableaux de prix' in the apartment of the duchesse de Bouillon (6th edn, 1706, vol. 2, p. 395).

2. J.A. Dulaure, *Nouvelle Description des Curiosités de Paris*, 2 vols, Paris 1785, p. 314, and 1787 edn, part. 2, p. 75. The 1791 edition (vol. 2, p. 72) refers to the two paintings by Claude still being at the hôtel de Bouillon, but many of Dulaure's descriptions had by then been overtaken by events, as he himself acknowledged (vol. 1, pp. x–xi).

3. Thiéry 1787, vol. 2, p. 500. The château of Navarre was in Normandy: see *The Case of Philip d'Auvergne (Duc de Bouillon)*, London 1803, p. 7.

4. From a number of documents in the Archives Rohan-Bouillon (Paris, A.N., 273 AP 382) it appears that NG 12 and NG 14 (and a large crystal chandelier) were the subject of an ownership dispute after the death on 3 December 1792 at the château of Navarre of the then duc de Bouillon, Godefroy-Charles-Henri de la Tour d'Auvergne. The creditors of the father of Godefroy-Charles-Henri were disputing ownership of the paintings and the chandelier with his successors and Mme Slade. In an undated 'Note à consulter' (apparently a request for a legal opinion on behalf of the duc de Bouillon), the author writes that 'Parmi les objets mobiliers qui ont été données à Mad. Slade par son contrat de mariage, se trouvent, 1.° Deux grands tableaux de Claude Lorrain, représentant le lever et le coucher du soleil, qu'on estimait autrefois 100,000. .../Les tableaux.avaient appartenu au père du premier mari de Mad. Slade, et lui avaient été transmis par substitution avec d'autres biens également substitués.' Mme Slade was Marie Françoise Henriette Banastre, widow by her first marriage of Godefroy-Charles-Henri de La Tour d'Auvergne, who then married Richard Desirée Hay de Slade at some date prior to 21 March 1798. The 'Note à consulter', which must therefore have been written after 3 December 1792, continues: 'Les biens libres de la succession de ce père avaient été abandonnés à ses créanciers qui ont formé une union./ Il ne paroit pas que cette union ait réclamé les tableaux.qui sont toujours restés dans l'hôtel de Bouillon, et dont a toujours joui paisiblement le premier mari de Mad. Slade.' It is clear from other documents that Mme Slade never gained possession of the two paintings by Claude. She and her father, Le Tellier de Banastre, wrote to Le Bas, the administrator and paymaster of the hôtel de Bouillon (A.N., 273 AP 430), on 3 April 1794 expressing surprise that the movables belonging to her by her marriage contract had neither been delivered nor bought out by 'le citoyen latour d'auvergne'. 'Latour d'auvergne' was presumably a reference to Godefroy-Charles-Henri's heir, the sickly Jacques-Léopold (d.1802).

In a letter to Le Bas, undated but, judging from other letters, possibly written in or around November 1801, one Le Noble, probably an agent of Mme Slade, wrote to Le Bas at the hôtel de Bouillon, 'Je viens, Monsieur, d'être informé que le meuble de l'hôtel de Bouillon, vendu à M. Roy, en avoit été enlevé; je présume qu'il a eu de même du deux tableaux [de]? Claude Lorrain & du lustre de cristal: vous savez que Made. De Slade .[illegible] sa droite sur ces 3 objets; il lui importe donc d'en suivir la [illegible] & je vous prie de vouloir bien me dire où ils ont été déposés.' M. Roy may have been the M. Le Roy who was the duc de Bouillon's agent des affaires at the hôtel de Bouillon in 1793: see *Etat des Personnes qui doivens Composer La Maison du Citoyen Bouillon pour 1793*, A.N., 273 AP 430.

5. H. Mireur, *Dictionnaire des Ventes d'Art faites en France et à l'Etranger pendant les XVIIIe and XIXme Siècles*, 7 vols, Paris 1911–12, vol. 3, p. 278.

6. Buchanan relates that it was Sebastien Erard who purchased NG 12 and NG 14 in Paris and imported them into England: Buchanan 1824, vol. 2, p. 188. Buchanan had seen the paintings within a year of their arrival in England, and NG 14 particularly impressed him: Brigstocke 1982, pp. 205–6. However, nothing in Farington's account of this transaction affirms that NG 12 and NG 14 were owned by Sebastian Erard, as opposed to simply being shown at Erard's premises. On the contary, Farington writes 'Fiezenger has got from France two landscapes by Claude for which he asks £20,000. One of them in particular is exquisitely fine' (2 April 1803); and 'Fiezenger's I went to viz: Mesrs Erard & Co. Harp makers in Marlborough St. – There I met Lawrence & saw the two pictures by Claude...' (3 April 1803): *The Diary of Joseph Farington*, vol. VI, pp. 2003–5.

7. For example, the variant copy in reverse in the collection of Sir Francis Dashwood, West Wycombe Park, Bucks, and another such sold Sotheby's, Billingshurst, 13 May 1992, lot 601; and the variant by Hendrik Frans van Lint, once in the Dunraven collection, sold at Phillips, 3 July 1990, lot 77. Photographs of these and other copies or variants of the Doria-Pamphilj painting are in the NG dossier. A smaller variant by van Lint of the picture once in the Dunraven collection has been recorded in the Alba collection, Palacio de Liria: see J.J. Luna, *Claudio de Lorena y el ideal clásico de paisaje en el siglo XVII*, Madrid, Prado, April–June 1984, no. 37.

8. See Kitson 1978, p. 122. For references to the version recorded in the collection of William II of the Netherlands, see Nieuwenhuys 1843, no. 124 (although reference to the oval frame is specific only regarding its pendant, no. 123), and see Roethlisberger 1961, p. 282. For copies of the Doria-Pamphilj Claudes by Thomas Patch (1725–82), see Francis Russell, 'Thomas Patch, Sir William Lowther and the Holker Claude', *Apollo*, 52, 1975, p. 118.

9. Roethlisberger 1961, p. 282. Letter of 17 January 1996 from István Barkóczi.

10. This is the inference I have drawn from a letter of 25 January 1881 (in the dossier) from Moore & Brown, Chartered Accountants, Glasgow.

11. Roethlisberger 1968, vol. 1, pp.251–3. See also Wine 1994, pp. 75–7.

12. The connection between the drawing and NG 12 was made by J.J.L. Whiteley in Whiteley 1998, p. 109.

13. The verso of this drawing is illustrated in Kitson 1978 at p. 120.

14. Roethlisberger 1961, p. 283.

15. M. Wyld, J. Mills and J. Plesters, 'Some Observations on Blanching (with Special Reference to the Paintings of Claude)', *NGTB*, 4, 1980, pp. 48–63 at p. 55, referring to Seguier's belief that NG 14 had been lined in France in or before 1803; and see the manuscript account of the export of NG 12 and 14 from France quoted on p.76.

16. M. Wyld et al., cited in note 15, at p. 53. In April 1853 John Seguier described its state before its then recent cleaning as 'very much obscured, indeed, by foul dirt, but that came off with very great ease; there was a mastic varnish underneath, which I only slightly removed. That picture was quite perfect, and had only a simple mastic varnish; it was so obscured, that I am not surprised that it should appear bright...', *Report from the Select Committee on the National Gallery*, London 1853, para. 624. One of the principal critics of the Gallery's cleaning policies at the time, Morris Moore, stated that 'This picture has been reduced to a most lamentable state; the upper glazing has been almost entirely removed from it by the late cleaning; the aerial perspective is completely gone. The picture is now hard and flat like a tea-board.there is a washy, tame look about the whole picture, extremely offensive' (ibid., para. 2204). Moore's testimony was contradicted by that of another witness, Thomas Uwins RA (ibid., para. 3174).

17. J. Mills and R. White, 'Analyses of Paint Media', *NGTB*, 4, 1980, pp. 65–7.

18. M. Wyld et al., cited in note 15, at p. 58.

19. Davies's reading of the last line of the signature was 'F(?) (C or 6?) (illegible) (some of the letters run together)': Davies 1957, p. 36. His reading of it in the 1946 edition had been '.FF.LAB', and he noted that Nieuwenhuys had read 'IFC.SARAE'.

20. See Buchanan 1824, p. 188; Foggo 1845, p. 6 ('...either an unfinished or duplicate copy...'); Wornum 1845, p. 55n. ('Some connoisseurs have pronounced this picture a *copy* of the Doria Claude, but a comparison of the above-mentioned prints will show that there are considerable variations in all parts of the two pictures. The figures are very different.)' A similar note was included in the National Gallery catalogues through to 1913. See also Waagen 1838, p. 215; Passavant 1836, p. 48 ('a copy'); Jameson 1842, pp. 39–40 ('...merely a repetition (in all respects a poor one) of the celebrated pictures known as 'Claude's Mill' painted for Prince Doria Pamili though the forms are his [i.e. Claude's], the *effect* is not. The soft silvery gradations of tints, the melting splendour, the atmospheric illusion which so enchant us in his other pictures, are not here; it is crude and harsh in comparison. From its general inferiority it has been supposed that the picture is not entirely by the hand of Claude; that having an order from the Duc de Bouillon for two pictures, this was copied by one of his pupils from the picture in the Doria Palace, and merely touched up by himself').

21. See Davies 1957, pp. 36–9; Roethlisberger 1961, pp. 279–81; Kitson 1978, pp. 122–3; Russell 1982, pp. 162–4.

22. Kitson 1978, p. 122.

23. Michael Kitson kindly examined the Rome picture with me in the National Gallery's conservation studio when it was sent here in 1995–6.

24. See also on this, Wine 1994, pp. 25 and 75–6.

25. For my earlier translation of Claude's words, see Wine 1994, p. 76. I am more inclined now to think that '*disine*' should be read as '*dessein*' rather than as '*dessiné*'. This would accord with Claude's use of language where, for example, he inscribed the *Liber Veritatis* '*ce present livre*': see Kitson 1978, pp. 47, 169, and where he inscribed another drawing (LV 5) '*il present designe*' in a context where it is clear that he meant 'this present drawing'. The use by Claude of the expression '*du tableau*' on the Bayonne drawing rather than '*pour le tableau*' could mean that the drawing was derived from the painting rather than preliminary to it. For the use of '*pensée*' at this period to mean a preliminary drawing, see Poussin's letter to Chantelou of 16 February 1653; *AAF*, 1911, pp. 427–8. I do not think, as suggested in Whiteley 1998, p. 109, that '*pancé*' should be read as '*poncé*', even if the latter expression could have been used to mean transfer rather than pounce. Although Claude's spelling was erratic, there is no evidence from, for example, his many inscriptions in the *Liber Veritatis*, or in his letters to Count Waldstein (see J.J. Morper, 'Johann Friedrich Graf von Waldstein und Claude Lorrain', *Münchner Jahrbuch der bildenden Kunst*, 1961, pp. 203–17 at p. 210), that he confused the French sounds '*an*' or '*en*' with '*on*'.

26. Since Claude refers to Pamphilj as 'prince' rather than 'cardinal', the inscription must postdate 21 January 1647 when Pamphilj renounced the cardinalate: see von Pastor 1940, p. 38, and compare Claude's inscriptions on LV 51 and LV 54 recording paintings made for other cardinals.

27. For Davies's first discussion of the differences between NG 12 and *The Mill*, see Davies 1946, pp. 19–24. For Davies on the Bayonne drawing, see *idem*, p. 24, n. 22, and Davies 1957, pp. 41–2, n. 25.

28. Roethlisberger 1961, p. 280.

29. Camillo Pamphilj married outside Rome on 10 February 1647 and the couple remained exiled for several years: see von Pastor 1940, p. 38. According to one source, however, they visited Rome in November 1647: see Giacinto Gigli, *Diario Romano (1608–1670)*, Rome 1958, p. 307.

30. Roethlisberger 1961, pp. 280–1.

31. Kitson 1978, pp. 122–3. In a review of Kitson's book, Deborah Howard suggested that 'when Claude rightly corrected the patron's name on the verso of LV 114 from "prince panfile" to "Duc de Boulon", he either forgot to do the same for LV113 or saw no need to correct it since Pamphilj had ordered a version of the same picture', *BM*, 121, 1979, p. 44.

32. Letter from Michael Kitson, 4 February 1996.

33. Ibid.

34. Francesca Cappelletti in *I Capolavori della collezione Doria Pamphilj da Tiziano a Velasquez*, Milan, Fondazione Arte e Civiltà, 28 September–8 December 1996, p. 46, no. 8. I am grateful to Véronique Damian, who cites Cappelletti's study in her catalogue *Deux tableaux inédits de Giuseppe Maria Crespi et quelques récentes acquisitions*, Paris 2000, p. 39, n. 2, for sending me a copy of it.

35. A.N., 273 A P 184. A summary of this document was published by Suzanne d'Huart,

Archives Rohan-Bouillon, Paris 1970, p. 138. I am grateful to Mary Jackson Harvey for drawing my attention to d'Huart's book. The document has not been published in connection with Claude scholarship, but was found independently by Jean-Claude Boyer and, as he kindly advised me, an extract of it appears in his thesis, *Les années romaines de Pierre Mignard (1635–1656)*, Université de Paris, 1996, 2 vols, vol. 2, p. 394.

36. F. Cappelletti, cited in note 34.

37. As Paul Ackroyd pointed out when NG 12 and *The Mill* were compared in the Gallery's Conservation Studios on 8 February 1996, Michael Kitson then thought that NG 12 was likely to be later in date than *The Mill*. Paul Ackroyd also noted numerous drying cracks in *The Mill*, suggesting that a layer of paint had been applied over another layer which was not completely dry – evidence perhaps of the painting being finished hurriedly.

38. For a different view I once proposed, see Wine 1994, pp. 26, 75, written, however, when I still accepted that both NG 12 and 14 were originally destined for Pamphilj: it is conceivable that Pamphilj commissioned a rustic dance scene as seeming particularly appropriate both because of his recent marriage and because of his and his wife's exile from Rome. Camillo Pamphilj had left Rome by 19 January 1647 to avoid having to surrender his cardinalate in person, but he may briefly have returned before his marriage to Olimpia Aldobrandini on 10 February: see von Pastor 1940, p. 38.

39. J.B.P. Jullien de Courcelles, *Dictionnaire historique et biographique des généraux français depuis le onzième siècle jusqu'en 1820*, 9 vols, Paris 1820–3, vol. 9, pp. 265–6, and Aigueperse 1836, vol. 2, p. 274, both give the date of Bouillon's return as 1649. However, Martin Davies (Davies 1957, p. 39 and p. 41, n. 22) gave the date as May 1647 without citing his authority. Possibly Davies's date derived from Pierre Du Val, *La Relation du voyage fait à Rome par Monsieur le duc de Bouillon en l'année 1644*, Paris 1656, p. 18: Bouillon left Rome on 25 May 1647 (possibly leaving his family to follow him: see Paris, New York, Chicago 1982, p. 288). Such a date would be perfectly consistent with the date of the passport for the duc and duchesse de Bouillon to return from Italy, namely 5 April 1647: see Paris, Archives Nationales, Archives Rohan-Bouillon, 273 AP 177; and with the Lambin memorandum of 22 May 1647 (see above).

40. For this and other descriptions of the duc de Bouillon, see Ch. Petitjean and Ch. Wickert, *Catalogue de l'Oeuvre Gravé de Robert Nanteuil*, Paris 1925, p. 145, and for Robert Nanteuil's engraved portraits of the duc de Bouillon, see ibid., pls 29, 30.

41. J.F.P. de Gondi, Cardinal de Retz, *Mémoires*, 2 vols, with introduction and notes by G. Bulli, Paris 1965, vol. 1, p. 181 and *passim*.

42. [Jacques de Langlade], *Mémoires de la vie de Frédéric Maurice de la Tour d'Auverge, duc de Bouillon*, Paris 1692, p. 20, quoted by Mary Jackson Harvey in 'Death and Dynasty in the Bouillon Tomb Commissions', *AB*, 74, 1992, no. 2, pp. 271–96, at p. 288.

43. It has been suggested that biblical themes may have had an added appeal for the duchesse de Bouillon, who may have understood the nominal subjects of NG 12 and 14 as references to the marriage of the soul to Christ or of Christ to the Church: see Russell 1982, p. 165, who adduces this suggestion, however, to support an argument for the two subjects' appeal to Camillo Pamphilj.

44. Pierre Du Val, cited in note 39, p. 22.

45. Jacques de Langlade, quoted and translated by Mary Jackson Harvey, cited in note 42.

46. Saint-Simon, *Mémoires*, vol. XIV, p. 215, quoted by Mary Jackson Harvey, cited in note 42.

47. As noted by Jackson Harvey, cited in note 42, at p. 291, n. 114. The role of Godefroy de Bouillon in the first Crusade was in any event one of the principal themes of Torquato Tasso's widely known *Gerusalemme Liberata* (1575), part of which was first published under the title, *Il Goffredo* (1580). When they captured Jerusalem, de Bouillon's Crusaders massacred the city's Jews and Moslems. The monument to Frédéric-Maurice and Eléanor-Catherine, one of whose motifs was a crenellated tower, was never completed.

The soldiers entering from the left in NG 12 were probably not planned as a reference to Bouillon's military career, since they also appear in the Doria-Pamphilj picture. Helen Langdon has suggested that they may refer to the pastoral world being invaded by the world of the court, a motif familiar from pastoral drama: H. Langdon, 'The Imaginative Geographies of Claude Lorrain', *Transports, Travel, Pleasure, and Imaginative Geography, 1660–1850, Studies in British Art 3*, ed. C. Chard and H. Langdon, London 1996, pp. 151–78 at p. 159.

The sculptures of Frédéric-Maurice and his wife by Pierre II Legros are in the chapel of the Hôtel-Dieu, Cluny: see F. Souchal, *French Sculptors of the 17th and 18th centuries. The Reign of Louis XIV*, 3 vols, Oxford 1977–87, vol. 2 (1981), pp. 278–80.

48. From an infra-red detail the coat of arms shown may be a lion rampant. These were not the arms of the ducs de Bouillon, but could they have been those of the de Berghe family, the family of the then duchesse de Bouillon?

49. The inscription was: MILLE CLYPEI PENDENT EX EA. ('whereupon there hang a thousand bucklers', Song of Solomon 4:4). See Jackson Harvey, cited in note 42, p. 291.

50. London 1969, pp. 56–7.

51. For the painting by Domenichino, see J.W. Goodison and G.H. Robertson, *Fitzwilliam Museum, Cambridge Catalogue of Paintings*, volume II, *Italian Schools*, Cambridge 1967, pp. 45–6, and pl. 50. For a brief discussion of the relationship between that painting and *The Mill*, see *L'Ideale classico del Seicento*, p. 245; and Michael Jaffé, 'The Lunettes and After: Bologna 1962', *BM*, 104, 1962, pp. 410–19, at p. 418 ('The light on the wooded bank under the trees, and the slow majestic wind of the river [in *Landscape with Saint John Baptising*] need to be compared with these features in *The Mill*').

52. For the complete inscription on this drawing, see Roethlisberger 1968, p. 252.

53. For the suggestion that Claude's conceptual starting point for NG 12 may have been in theatrical scenography, see Roethlisberger 1984b, pp. 47–65, at p. 59.

54. Inv. no. 11,508. See E. Knab and H. Widauer, *Die Zeichnungen der Französischen Schule von Clouet bis Le Brun*, Vienna 1993, p. 492.

55. See note 1 above.

56. This evidence is in three documents now in the Minutier Central, Paris. The first in time is the marriage contract of 18 March 1725 between the then duc de Bouillon, Emmanuel-Théodose de la Tour d'Auvergne, and Louise-Henriette-Françoise de Lorraine, daughter of the prince de Guise. The contract, which records Emmanuel-Théodose as living at his hôtel on the quai Malaquais (the same location of the hôtel as recorded by Le Maire in 1685), lists the duc's chattels as including some sixty paintings. Some of these were attributed and of considerable value, but no paintings attributed to Claude were included in the list (Rambaud 1965–71, vol. 2, pp. 846–7). The second document is the same duc de Bouillon's will dated 28 February 1730 in which he bequeathed to the comte d'Evreux two paintings by Claude (not otherwise described) which he had 'nouvellement achetés' (Rambaud 1965–71, vol. 1, pp. 568–9). The third document is the duc's post-mortem inventory of 5 June 1730 drawn up at the hôtel on the quai Malaquais. The inventory includes 83 paintings valued by André Tramblin (d.1742), one time professor at the Académie de St Luc. Among these paintings, none of which was attributed to a named painter, were two large pictures on canvas representing 'marines', which with their gilded wood frames were together valued at 20,000 livres. Since the 1725 contract had listed a Titian at 3000 livres, a Veronese at 6000 livres and a Domenichino at 10,000 livres, even allowing for differing bases of valuation, the value given in the 1730 inventory to the two 'marines' was substantial, and it seems possible that they were the two Claudes referred to in the duc de Bouillon's will made a few months earlier as having been recently purchased. 'Marine' is not, of course, an appropriate description of NG 12, but nor was Dezallier especially precise when he later referred to both NG 12 and 14 as 'deux paysages' (see note 1 above). Hence it would seem that at some time between 18 March 1725 (the marriage contract) and 28 February 1730 (the will) Emmanuel-Théodose had purchased two paintings by Claude of substantial value. Were these NG 12 and NG 14?

Probably not, for two reasons. First, it would imply some curious comings and goings for NG 12 and NG 14, and some kind of deliberate attempt by Emmanuel-Théodose in his will to obscure their provenance by referring to them as newly purchased. In the absence of any known reason why he might have done this, it should be assumed that the two Claudes referred to in the 1730 will, and possibly referred to in the 1730 inventory, had indeed been recently acquired. If so, it must be admitted that they cannot be

identified, because the two other paintings by Claude which may then have been in the Bouillon collection were too small and insignificant to carry such a high value, and neither could possibly be described as 'marines'. The paintings in question are *Landscape with River*, Boston, Museum of Fine Arts, and its possible companion, *Landscape with Huntsmen and Artist* (whereabouts unknown): see Roethlisberger 1961, nos 22 and 24. (Emmanuel-Théodose de la Tour, duc de Bouillon (1668–1730) was also the comte d'Evreux, but at the date of his will he must have relinquished this title to Henri-Louis de la Tour (1697–1753) who was known by it: Aigueperse 1836, vol. 2, pp. 276, and 279–80.) Nor has any painting by Claude been identified as belonging to the comte d'Evreux, the legatee under the 1730 will. The second reason is that the exclusion of NG 12 and NG 14 from the 1725 inventory may mean no more than that at that particular time either the paintings had ceased to be movable and had been incorporated into the fabric of the hôtel de Bouillon, or that they were at a Bouillon property other than their hôtel on the quai Malaquais.

There is, in fact, some corroboration that the paintings never left the possession of the Bouillon family, although, as with other aspects of their history, the evidence raises as many questions as it answers. The owner of NG 14 (but not NG 12), as recorded in the second index to the *Liber Veritatis* drawn up between about 1716 and the early 1720s, has been read as the 'duc d'Albert', and on that basis considered inexplicable. (For the dating of the second index to the *Liber Veritatis*, see Kitson 1978, p. 178. For the reading of the then owner as 'duc d'Albert', see Roethlisberger 1961, p. 287, n. 4.) However, it is clear that 'Albert' is a misreading of the manuscript, and that the second index in fact records the owner as 'Duc d'Albret'. The duchy of Albret had been given to Frédéric-Maurice in 1652 shortly before his death as part of an exchange of fiefdoms with the French crown (De La Chenaye-Debois and Badier, *Dictionnaire de la Noblesse*, 3rd edn, Paris 1868, vol. 1, p. 276) and, until he inherited the duchy of Bouillon in 1721, Emmanuel-Théodose de la Tour d'Auvergne (1668–1730) was known as the duc d'Albret (Saint-Simon, *Mémoires*, vol. 15, p. 40). Given the likely dating of the second index, it seems that the then owner of NG 14 was indeed Emmanuel-Théodose. This, however, raises another problem: why did the compiler of the second index fail to record that NG 12 was also in the possession of Emmanuel-Théodose? Had the two paintings in fact been separated and if so, why? A possible explanation is that Emmanuel-Théodose was given NG 14 in 1718 when he married his second wife, Mlle de Barbezieux, and that when he became duc de Bouillon in 1721 the two paintings were reunited. One difficulty with this suggestion, however, is that Emmanuel-Théodose seems to have married against family opposition, making any wedding gift unlikely. (For Emmanuel-Théodose's marriage to Mlle de Barbezieux and the opposition it aroused, see Saint-Simon, *Mémoires*, vol. 15, p. 340, and vol. 17, pp. 184 and 218.) On the other hand, since Claude's patron, Frédéric-Maurice, had himself married against family opposition (Jackson Harvey, cited in note 42, p. 288) the gift of NG 14 (if not NG 12 also) may have seemed peculiarly appropriate. More likely, however, is that the compiler of this index was trying to record only original compositions by Claude, and that even if NG 12, always the less favoured of the two paintings critically, was regarded as autograph, it was seen as a replica of a picture in a Roman collection as opposed to an English or French collection, and as such of no interest to the compiler of the index.

57. Renier Chalon, *Le Dernier Duc de Bouillon (1815)*, Paris 1860, p. 5, and *The Case of Philip d'Auvergne (Duc de Bouillon)*, cited in note 3, p. 12.

58. *The Diary of Joseph Farington*, 5 April 1803.

59. [François] Reiset, *Une Visite à la Galerie Nationale de Londres*, Paris 1887, p. 267.

60. See note 4 above.

61. See F.J.B. Watson, 'Beckford, Mme de Pompadour, the duc de Bouillon and the taste for Japanese lacquer in eighteenth century France', *GBA*, 61, 1963, pp. 101–27 at p. 111.

62. The date of death is given by Chalon, cited in note 57, p. 5. For the ownership dispute and the probable sale of NG 12 and 14 to Roy in 1801, see note 4 above.

63. Philippe d'Auvergne was born and brought up in Jersey. His blood relationship to the ducs de Bouillon was tenuous and his adoption by Godefroy-Charles-Henri, duc de Bouillon, was fortuitous, the latter having secured his release from a French prison where he was a prisoner of war following his capture as a British naval officer. Philippe spent considerable time at the château de Navarre near Evreux, which was owned by his adoptive father, during the period 1779–92. I am grateful to Mark Patton for this information.

64. See *The Case of Philip d'Auvergne (Duc de Bouillon)*, cited in note 3. Philippe's right to the Bouillon title was recognised in 1814 but removed in 1816 and given to the prince de Rohan-Monbazon by arbitration nominated under the Congress of Vienna: see Aigueperse 1836, vol. 1, pp.114–15. Philippe died in London on 18 September 1816: see Chalon, cited in note 57, p. 27.

65. *Manuscript Notes on John Julius Angerstein's Collection*, NG Archive, NG 50. On these manuscripts see the entry for NG 5, note 51.

66. One of the notes contains the additional comments: 'the Sum that these 2 pictures raised caused the Duke to live independantly [interlineated: maintain him or feed him] out of France for a considerable time. / Mr. A purchased this picture of a Harp Maker.'

67. Angerstein was a marine insurance underwriter and broker who is generally credited with establishing Lloyd's reputation for probity. For a brief account of his patriotic fund-raising activities during the wars with the French, see *John Julius Angerstein and Woodlands 1774–1974*, Woodlands Art Gallery, Blackheath, 13 September to 5 November 1974, pp.13–14.

68. *The Diary of Joseph Farington*, pp. 2003–5 (entries for 2, 3, 4 and 5 April 1803).

69. The diversity of opinion on NG 12 and NG 14 is reflected in many diary entries concerning them made by Farington during 1803:

8 April (Bryant's claim that he could have bought them for £2000 in Paris; Lord Carysfort's view that they had been overcleaned)

9 April (Erard and Bonemaison thanking Farington for speaking well of the pictures)

10 April (Lawrence and Farington going to Angerstein's and changing the pictures' position; Daniell's praise of them)

14 April (Farington sees the pictures with Fountaine and Andrew Fountaine)

15 April ('Hoppner mentioned that Sir George Beaumont had seen Mr Angerstein's Claudes very fine but thought the price was ridiculous')

16 April (Beaumont's views of the paintings; his preference for NG 14 over NG 12)

17 April (Knight's preference for NG 19 over the Bouillon Claudes)

2 May (Northcote's opinion of NG 12 and NG 14; his particular objection to the former)

7 May (Fuseli's favourable opinion)

8 May (West's opinion; Beaumont's preference for NG 30)

23 May (Opie's favourable view of NG 14)

26 May (— do.—)

15 June ('Towne thinks Mr. Angerstein's, 'Marine Claude', the finest picture in the world')

1 November (Dr Munro Hearne's opinion)

8 November (— do.—)

For Turner's bequest to the National Gallery, see Egerton 1998, pp. 266, 271, n. 1, and pp. 270–1, 279; and for a recent account of Turner's appreciation of Claude, see ibid., pp. 276–7.

70. [John Ruskin], *Modern Painters*, vol. I, London 1846, pp. 274–5. See also ibid., p. XXXVI ff. for Ruskin's mocking attack on NG 12 and on the painting of 'ideal landscape'. This, and references to Ruskin's other comments on the painting in *Modern Painters*, may be found in E.T. Cook, *A Popular Handbook to the National Gallery*, London 1888, pp. 338–44, and see Ruskin, *Works*, vol. 3 (1903), pp. 41–4 and p. 41, n. 1.

71. See note 20 for the citations of Waagen and Wornum, and for some other nineteenth-century criticisms made following the acquisition of NG 12 by the Gallery. Doubts about the autograph status of NG 12 were also expressed before the 1836 Select Committee on Arts and their Connexion with Manufactures (on which see Egerton 1998, pp. 393–4) and the 1853 Select Committee on the National Gallery: see paras. 624 and 2205 of its Report.

72. By Michael Kitson and myself in 1996.

Seaport with the Embarkation of the Queen of Sheba

Oil on canvas, 149.1 × 196.7 cm

Signed: CLAUDE.GELE I.V. FAICT.POVR.SON.ALTESSE. LE.DVC.DE/BVILLON.A ROMAE.1648
Inscribed: L[A] [RE]INE DE SABA VA/...[S] ALOMON

Provenance
As for NG 12, also possibly recorded in 1772 at the hôtel de Bouillon (see Related Works, Paintings (9) and note 3).

Exhibitions
London 1947–8, NG, *Exhibition of Cleaned Pictures* (1); London 1980, NG, *Second Sight. Claude–Turner* (no catalogue); London 1994, NG, *Claude. The Poetic Landscape* (26).

Related Works
PAINTINGS
(1) The Lord Barnard, Raby Castle, no. 153 (101.5 × 137 cm) with some variations in the proportions. According to Roethlisberger, 'probably early 19th-century English';[1]
(2) Formerly in the collection of William II of the Netherlands and in his sale, The Hague, 12 August 1850 and days following (lot 114, 2500 guilders to Brondgeest), and thence unknown, an oval (?) copy (98 × 141 cm);[2]
(3) Whereabouts unknown. Lot 84 of the posthumous sale of Antoine-Félix Boisselier, Paris, Génevoix, 20–21 November 1857. Described as 'Gelée (D'après Claude) / Arrivée de la reine de Sabbat';
(4) Whereabouts unknown. A mediocre copy. Anon. sale, Sotheby's, 6 February 1963, lot 30 (35½ × 47½ in.);
(5) According to an undated, unsigned note in the dossier by Martin Davies (?) citing Tübinger Kunst-Blatt, 1823, p. 264, a careful copy of the picture was made by Miss Pearson;
(6) A replica (?) in Jeremiah Harman Sale, 17 May 1844 (lot 53, £210 to the Duke of Cleveland); in his collection 1876: see 'Private Collections', *Athenaeum*, 1876, II, 276, col. 3;
(7) There are photographs in the NG dossier of a copy recorded in a United States private collection in 1974;
(8) For the suggestion that a painting by Marco Ricci (1676–1730) was derived from NG 14, see D. Succi and A. Delneri, *Marco Ricci e il paesaggio veneto del Settecento*, Milan 1993, p. 190. Ricci's painting is more likely to have been inspired by other Claudian prototypes more readily available to him or by the works of Claude's predecessor, Agostino Tassi;
(9) A gouache under glass was in the M de Nyert deceased sale, Paris, 30 March 1772 (lot 27, 31 livres to Le Brun).[3]
DRAWINGS (by Claude)
(1) Berlin, Kupferstichkabinett, no. 4, 001 (27 × 42 cm) (MRD 653). A drawing corresponding in most details to NG 14, but slightly more elongated in shape, which according to Kitson (1978, p. 124) follows the painting but which according to Roethlisberger (1968, p. 253) precedes it;
(2) London, British Museum, *Liber Veritatis* 114 (MRD 654).

Davies (p. 42) noted that the two anchors in the left foreground were omitted from this drawing, in which 'a flag-pole rises from an embryo turret at the top left-hand side of the tower', but Roethlisberger (1968, p. 254) suggests that this may be a slip of the artist's hand;
OTHER DRAWINGS
M. Pattison (1884, pp. 291–2) records three related drawings in the collection of Robert P. Roupell (1798–1886), but see Roethlisberger 1961 (p. 287, n. 5).
PRINTS
(1) By John Young in *A Catalogue of the Celebrated Collection of Pictures of the Late John Julius Angerstein, Esq.*, London 1823, plate 3;
(2) by Thomas Starling in *Valpy's National Gallery*, London n.d. (1831?), facing p. 3;
(3) by C.O. Murray;[4]
(4) anon., pub. by Allan Bell & Co., Warwick Square, London 1834, pl. IV;[5]
(5) by J.C. Varrall in *The National Gallery of Pictures by the Great Masters*, London n.d. (1838?), no. 84;[6]
(6) by E. Evans for *L'Art*, n.d. (c.1900?).

Technical Notes
The condition is good. The painting was last relined and retouched in 1980. It had been lined at some date before 1853,[7] probably at the same time as NG 12 when both were imported into England from France (see the entry for NG 12). There is a tear about 7 cm long in the shape of an inverted 'v' to the head of the largest foreground figure at bottom right. This was caused – according to evidence dating from 1853 – when 'there was a fire close to Mr. Angerstein's, and they ran away with the picture, and knocked out nearly the whole of one figure on the right-hand side, which was put in by an Italian, a clever man, about 40 years ago, or nearly so.'[8]

The primary support is a medium-fine twill canvas in two pieces with a vertical seam 118 cm from the left edge. In all these respects, therefore, the support is similar to that of NG 12. However, the medium may have been walnut oil, whereas in NG 12 linseed oil was used.[9]

The X-radiograph reveals extensive pentimenti: the trees at the right originally extended further towards the centre of the image; the woman in blue reclining on the steps at the right has been shifted slightly to the left; the figures in the lower right corner have been altered, and the gesturing hand above the shoulder of the second largest figure has been painted out; the sun has been moved one cm to the right, there have been changes to the flags on a ship at the left in the middle distance, and there have been indistinct changes to the bottom left corner of the painting. There are also pentimenti around the top of the tower. Most evident (fig. 1) are changes to the boat into which the queen is about to step, which was originally alongside the quay rather than at right angles to it and which had different figure(s?) in it, and to the foreground, where there was a reclining figure to the left of the boat being loaded.

NG 14 was restored in 1852 (as was NG 12). That restoration was the subject of extensive discussion before a Select

Fig. 1 X-ray detail.

Committee on the National Gallery the following year.[10] The most recent restoration of NG 14 revealed Claude's palm and finger prints in many places in the sky (fig. 2).[11]

As in the case of its pair, *Landscape with the Marriage of Isaac and Rebecca* (NG 12), the identification of the subject depends on Claude's inscription (see fig. 3). According to I Kings 10: 1–2, the Queen of Sheba decided to visit King Solomon in Jerusalem after she had heard of his great wisdom. The Bible recounts how she set forth with a large retinue and many gifts for the king, but says nothing of the manner in which she travelled. NG 14 is the only depiction by Claude of this subject and the scene of the Queen of Sheba's embarkation has been said to be unique in painting.[12] As pointed out

by Russell,[13] however, the arrival by sea of the Queen of Sheba at King Solomon's court had been painted by Agostino Tassi (Marquess of Exeter collection, Burghley House), and Roethlisberger said of another painting by Tassi (Rome, private collection), which he dated 1620–5, but which has been dated *c*.1615 by Cavazzini (fig. 4), that it was not only the most direct precursor of Claude's port scenes, but that it even shared the subject of NG 14.[14] Uniquely, the patron's name was inscribed by Claude on the National Gallery painting, suggesting that it may have had particular significance for the duc de Bouillon (see under NG 12 for a discussion of this point, as well as for discussions of the commissioning of both paintings and their history thereafter).

The composition has been rightly called the culmination of a number of seaport pictures executed by Claude over the preceding years,[15] including NG 30 and *Seaport with Ulysses*

Fig. 2 Detail of sky in raking light showing palm- and fingerprints.

Fig. 3 Detail showing inscription.

Fig. 4 Agostino Tassi, *The Embarkation of a Queen, c.*1615.
Oil on canvas, 94 × 136 cm. Rome, private collection.

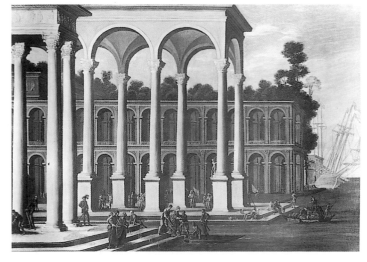

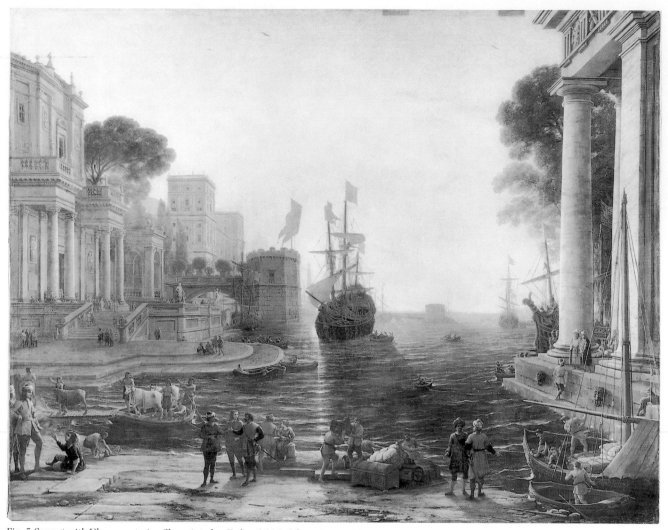

Fig. 5 *Seaport with Ulysses restoring Chryseis to her Father*, 1644. Oil on canvas, 119 × 150 cm. Paris, Musée du Louvre.

restoring Chryseis to her Father of 1644 (Paris, Louvre; fig. 5), of which NG 14 shares the composition in reverse. Particular motifs in NG 14 are also found in earlier paintings. For example, a fluted column and engaged pilaster at the left of the painting is seen in *The Port of Ostia with the Embarkation of Saint Paula* (Madrid, Prado), which also contains a round castellated tower towards the right in the middle distance; and the procession of the queen's retinue in NG 14 echoes in reverse that of Saint Ursula in NG 30.

Details of the architecture are also derived from, or developments of, architecture in earlier seaport scenes by Claude. In the distance at the right is a variant of the palace in the middle distance at the left of NG 30 (*Seaport with the Embarkation of Saint Ursula*), itself a variant of the Cancelleria, Rome.[16] The nearer palace on the right of NG 14 is a variant of the nearer palace on the left of *Seaport with Ulysses restoring Chryseis*. The palace in a much later work, *Landscape with Bacchus at the Palace of Staphylus* (Rome, Pallavicini Collection) of 1672, is itself derived from that in NG 14.[17] Compared to those in the Louvre painting, however, the architectural forms in NG 14 are more emphatic: the tower at the harbour mouth

is taller and more isolated from other motifs, so giving it more presence; the palace portico is simplified and functionally more logical; and the quayside in front of the palace, here without the projecting semi-circle of that in the Louvre painting, directs the eye towards the painting's vanishing point.

As in certain other seaport scenes by Claude, the ships are imagined combinations of what Claude may have thought to be the hulls of ancient times and the three-masted rigs of his own era.[18] It has been proposed that the ship about to carry the queen is the outer ship behind the column at the left of the picture, since it is fully manned and being towed by a boat's crew into mid-harbour where it will meet the royal barge. It will then also be pointing seawards.[19]

Claude commonly painted pictures in pairs, but NG 12 and NG 14 are the only example owned by the Gallery.[20] As Roethlisberger has noted, they are paired through a series of contrasts: the heavy columns on the left of NG 14 and the bulk of foliage on the right of NG 12, the morning atmosphere of NG 14 (appropriate for an embarkation) and the late afternoon atmosphere of NG 12,[21] and the landscape of NG 12 as opposed to the seaport of NG 14.

Both paintings were known and admired (particularly NG 14), part of their celebrity being accounted for by the then high price paid for them by Angerstein (see under NG 12, Provenance). Soon after Angerstein's purchase, Buchanan wrote that NG 12 and 14 were painted in Claude's 'finest manner'.[22] Towards the end of the century Reiset declared the two Claudes to be 'among the finest and most important by the master'.[23] Even Ruskin, who was generally highly critical of Claude, and particularly of NG 12,[24] acknowledged that 'The seas of Claude are the finest pieces of water-painting in ancient art,' although he himself did not like them.[25] Ruskin's criticisms were intended as a boost to the reputation of Turner, although the latter was both an admirer and emulator of Claude. Turner made it a condition of his bequest to the National Gallery that two of his paintings, *Sun rising*

Through Vapour (NG 479) and *Dido building Carthage* (NG 498), should hang in the Gallery between NG 12 and NG 14.[26] The composition and mood of NG 498 are indebted to NG 14. Perhaps more significant in relation to the history of the Gallery is the enormous prestige that the acquisition of Claude's two paintings gave to the reputation of Angerstein's collection. That they were part of his collection must have been a significant factor in persuading the British Government to purchase it in 1824, so founding the National Gallery.

General References

Smith 1837, no. 114; Pattison 1884, p. 228; Davies 1957, p. 42; Roethlisberger 1961, pp. 285–7; Roethlisberger 1975, no. 182; Kitson 1978, p. 124; Wright 1985b, p. 95.

NOTES

1. Roethlisberger 1961, p. 287.

2. Niewenhuys 1843, no. 123; Roethlisberger 1961, pp. 282, 287; *Catalogue des Tableaux anciens et modernes de diverses écoles... formant la Galerie de feu Sa Majesté Guillaume II*, Amsterdam 1850.

3. Described in the catalogue as 'Une marine dans le goût de Claude Gelée, hauteur 7 pouces 6 lignes, largeur 10 pouces, sous verre & bordure, dorée. Le tableau original est dans la galerie du Duc de Bouillon.'

4. According to Roethlisberger 1961, p. 286.

5. *The Portfolio comprising the original engravings from those ... pictures forming the ... Stafford and Angerstein Collections, the latter of which is now known as the National Gallery*, London 1834.

6. The print is inscribed as engraved by Varrall, although George Cooke may have had a hand in it: *Copy of List of Drawings and Plates of the National Gallery shewing the time that each plate was in hand*, [1840?], National Art Library, Victoria and Albert Museum, MSL/1930/1211/72. The engraving of 1839 by Henry Le Keux noted in Roethlisberger 1961, p. 286, is of NG 30 and not NG 14.

7. *Catalogue of the Pictures in the National Gallery, having reference more particularly to their material condition*, MS, NG Archive, NG 10, vol. 1, no. 14.

8. Evidence of John Bentley, picture cleaner, before the Select Committee, 6 May 1853: *Report of the Select Committee on the National Gallery*, London 1853, para. 1788.

9. Mills and White 1980, pp. 65–7.

10. For an account of that discussion, see London 1947–8, pp. 3–5, and Wyld, Mills and Plesters 1980, pp. 49–63, which includes at p. 54, fig. 4, an ultra-violet photograph showing the v-shaped damage referred to above. As the title of their article suggests, pigments in Claude's paintings, particularly the greens, often have a blanched appearance, although it is minimal in NG 14.

11. Wyld, Mills and Plesters 1980, p. 59.

12. Roethlisberger 1961, p. 285.

13. Russell 1982, p. 166.

14. Roethlisberger 1969, pp. 54–60 at p. 56. It may also be pointed out that the arrival of the Queen of Sheba at Solomon's court is the subject of another painting in the National Gallery, that by Lambert Sustris (1515/20–c.1570) (NG 3107). For the dating of Tassi's *Embarkation of a Queen* (Rome, private collection) to c.1615, see *The Genius of Rome 1592–1623*, ed. B.L. Brown, exh. cat., London, Royal Academy 2001, no. 94 (entry by Patrizia Cavazzini).

15. Roethlisberger 1961, p. 285.

16. I.G. Kennedy, 'Claude and Architecture', *JWCI*, 35, 1972, pp. 260–83 at p. 277.

17. Ibid., pp. 280, 282, and Wine in London 1994, p. 91.

18. David Cordingly, 'Claude Lorrain and the Southern Seaport Tradition', *Apollo*, 53, 1976, pp. 208–13.

19. Letter of 25 February 1980 from Roger Lubbock in the NG dossier.

20. On the subject of Claude's pairs, see Roethlisberger 1958, pp. 215–18; Roethlisberger 1961 *passim*; Russell 1982, pp. 88–91; and Wine in London 1994, pp. 37–42.

21. Ruskin, however, assumed that the time of day shown in NG 12 was noon: see *Modern Painters*, vol. I, p. 156.

22. See Brigstocke 1982a, pp. 204–5: letter of 20 March 1804 from William Buchanan to James Irvine. For some comments on the high quality of NG 14, see Westmacott 1824, p. 66; Waagen 1838, p. 213; Ottley 1832, pp. 19–20; and Jameson 1842, pp. 42–3. Less enthusiastic were Passavant 1836, pp. 47–8, and Foggo 1845, p. 6.

23. [François] Reiset, *Une Visite à la Galerie Nationale de Londres*, Paris 1887, p. 267.

24. *Modern Painters*, vol. I, p. 274, and see also pp. 191–2.

25. Ibid., vol. I, p. 340.

26. In Turner's first will of 1829 the companion piece to *Dido building Carthage* was to have been *The Decline of Carthage*, see A.J. Finberg, *The Life of J.M.W. Turner, R.A.*, Oxford 1939, pp. 329–31.

For comment on, among other matters, the reasons for Turner's bequest, see Jerrold Ziff, 'Turner as the defender of the art between 1810–20', *Turner Studies*, vol. 8, 1988, no. 2, pp. 13–25; and for a comparison between NG 14 and NG 498, see Kitson 1983, vol. 2, no. 2, at pp. 10–11, and Michael Wilson, *Second Sight. Claude: The Embarkation of the Queen of Sheba. Turner: Dido Building Carthage*, London, NG, 14 February–13 April 1980.

Landscape with Narcissus and Echo

Oil on canvas, 94.6 × 118.7 cm
Inscribed near bottom left: CLAVDE GILLEE 1644

Provenance

Possibly in the posthumous sale of Sir Peter Lely (1618–80), London, 18 April 1682 (£49 to Robert Huckle?);[1] in the collection of Peter Delmé (1710–89) of Grosvenor Square, London, by 1743;[2] his posthumous sale, Christie's, 13 February 1790 (lot 58, £525 to Thomas Hearne on behalf of Sir George Beaumont);[3] recorded in Beaumont's gallery at 29 Grosvenor Square, London, in 1792, by S.T. Coleridge in 1804,[4] and by Farington in 1808 as ready to send to Coleorton Hall, Leicestershire;[5] Sir George Beaumont Gift 1826.[6]

Exhibitions

London 1821, BI (83); Manchester 1956, City of Manchester Art Gallery, *John Constable 1776–1837* (4); Montreal, Ottawa, Toronto 1961–2 (17); London 1988, NG, *'Noble and Patriotic.' The Beaumont Gift 1828* (6); London 1990, NG, *The Artist's Eye: Victor Pasmore*, p. 21; Copenhagen 1992 (11); London 1994, NG, *Claude. The Poetic Landscape* (67).

Related Works

PAINTINGS
(1) Epinal, Musée des Vosges (inv. no. 1873-10). Oil on canvas, 53 × 71 cm. Photograph in NG dossier. A reduced-size copy, lacking the figure of Narcissus, but with the reclining nymph fully clothed (as in Claude's *Liber Veritatis* drawing no. 77 – see Drawings 2) and the castle on the hilltop with a taller, narrower tower. This copy is of 1858 or earlier;[7]
(2) Viscount Mersey sale, Christie, Manson & Woods Ltd, 7 March 1958 (lot 7, 20 guineas to De Caires). Oil on canvas, 27½ × 42 in. A copy in reverse. Photograph in NG dossier;
(3) A large 'Narcissus and other figures in the foreground' was in the sale of Francis Bernard and Cavalli, Christie's, 30 May 1783 (lot 100 as by Claude, £84 to Sir John Brown?);[8]
(4) A 'Narcissus looking at himself in the water' was noted in the comte de Budé collection by Lejeune.[9]
DRAWINGS (by Claude)
(1) London, British Museum, no. Oo.6-68 (MRD 548) (fig. 5). A preliminary study;
(2) London, British Museum, no. 83 (MRD 549; Kitson 77), LV 77; fig. 3, detail. Inscribed on the verso: *quadro faict pour Angletere*; and on another occasion: *Claudio fecit / in. V.R.*
PRINTS
(1) By Francis Vivares, 1743, in reverse;
(2) by Henry Dawe in *Beauties of Claude Lorraine*, London 1825, pl. 17;
(3) by John Pye, 1837, in *Engravings from the Pictures of the National Gallery*, London 1840;
(4) by W.B. Cooke in *The National Gallery of Pictures by the Great Masters*, London n.d. (1838?), no. 44;
(5) etched by E. Webb, engraved by John Pye in *The National Gallery. A Selection from its Pictures. Engraved by George Doo... and others*, London 1875.

Technical Notes

NG 19 suffers from considerable blanching in the greens, some wrinkling of the paint, and a degree of wear throughout, but especially in the foliage and the branches to the left above the tower, revealing the red-brown ground. There is also a loss in the head of the lower of the two nymphs in the foliage and small losses above the mouth and below the right breast of the reclining nymph. The primary support is a twill canvas, which was last relined in 1960, a year before the painting's most recent cleaning. There had been at least two earlier relinings (one prior to 1853) according to Gallery conservation records. There is a pentimento to the right arm of Narcissus which was formerly more bent. There are traces of drapery over the right thigh and by the right armpit of the reclining nymph, suggesting that she was not originally painted as a nude; this is discussed further in the text below.

The subject is from Ovid's *Metamorphoses* (III: 345–510): the nymph Echo was deeply in love with the handsome youth Narcissus, but, deprived of the power of speech by Juno, she could only utter the last phrase spoken by others. Startled by Echo's curious repetitions, Narcissus spurned her. One of Narcissus' companions, who had been spurned like Echo, prayed that Narcissus might fall in love with himself. When Narcissus stooped to drink from a pool of water, the goddess Nemesis caused him to be smitten by his own reflection. Unable to tear himself away, Narcissus expired by the water's edge to the grief of Echo and other nymphs. When the nymphs went to collect Narcissus' body, they found in its place a flower with white petals and a yellow centre which has ever since born his name.

In NG 19 Claude has adopted Ovid's description of the 'clear pool with silvery bright water, to which no shepherds ever came... whose smooth surface neither bird nor beast nor falling bough ever ruffled. Grass grew all around its edge, fed by the water near, and a coppice that would never suffer the sun to warm the spot'[10] (*Metamorphoses*, III: 407–12). The castle in the background does not, however, figure in Ovid's story and Claude shows Echo in bodily form as the lower of the two nymphs in the trees, although according to Ovid she had by this stage become no more than a disembodied voice. Nor has Claude shown Narcissus drained of colour, as Ovid related (*Metamorphoses*, III: 491–2). The reclining nymph with a water jar is an imaginative rendering of the stream feeding the pool which is referred to by Ovid (see above). Although this is the only surviving painting by Claude of this subject, Cardinal Richelieu's posthumous inventory taken at the Palais-Cardinal on 29 January 1643 included a large vertical format painting by Claude of 'Narcisse avec plusieurs nimphes'.[11]

Fig. 1 *Landscape with a Temple of Bacchus, c.*1640–50. Oil on canvas, 93.9 × 121.9 cm. Ottawa, National Gallery of Canada. Purchased, 1939.

Fig. 2 Detail of nymph at bottom left of NG 19.

NG 19 may be a pair to *Landscape with a Temple of Bacchus* (Ottawa, National Gallery of Canada; fig. 1). The two paintings are of a similar size, have classical subjects and light coming from contrasting directions, morning light from the left in NG 19 and evening light from the right in the Ottawa picture. Additionally, the *Liber Veritatis* drawings, nos 77 and 78, record both paintings as being destined for England, the only two so recorded in the *Liber*, and both pictures were probably in the 1682 Lely sale. However, the compositions of both paintings are left-sided, which would be unusual for pendants by Claude,[12] the question of whether or not they were conceived as a pair must remain unresolved, at least until the name of the original purchaser is discovered.[13] One possibility is that both NG 19 and the Ottawa picture were intended as part of a set of the Four Times of Day and that the other two pictures in the set were painted by another artist, or perhaps planned by Claude, who, however, never painted them. Given that England was in the middle of its Civil War and undergoing considerable upheaval when NG 19 was painted, the identity of the original purchaser may never emerge. Sir Peter Lely (see Provenance) is an unlikely possibility as early as 1644,[14] and it seems more probable that he acquired NG 19 (if indeed he did) at some later date from an English collection. Although the story of Narcissus falling in love with his own reflection was seen in the seventeenth century as replete with moral and allegorical significance,[15] it cannot be presumed that either Claude or his unknown patron intended NG 19 to be so understood.

While it is easy to identify Narcissus in NG 19, and the nymphs in the foliage can be identified as Echo (the one calling to Narcissus) and a companion, the presence of the reclining nymph at bottom left is more puzzling (fig. 2). She appears to be (ultimately) derived from the antique sculpture then usually called Cleopatra (Rome, Vatican Museum) and forming part of a fountain in the Belvedere. Until 1787 there was another version of this sculpture in the Villa Medici.[16] A more immediate source, however, may have been the reclining nude at the right of Titian's *The Andrians*, then in the Aldobrandini collection, which may have been the Titian Bacchanal which Sandrart relates that he, Claude, Poussin, Pietro Cortona and François Duquesnoy inspected and admired.[17] Clearly the character of Cleopatra has no role in NG 19; nor does that of Ariadne, whose figure in a similar pose on sarcophagi might have been another source.[18] Claude's nymph rests her right arm on an urn, which shows that she is a water nymph of a type associated with fountains and often depicted in a grotto setting.[19]

As noted above (see Technical Notes) the nymph was probably not originally painted as a nude. There are traces of drapery over her right thigh and by her left arm, and she is shown with more drapery both in the *Liber Veritatis* drawing (fig. 3) and in Vivares's engraving of 1743, suggesting that she was overpainted as a nude at some time after that date. The other possibility, however, is that Claude himself originally painted the nymph as a nude before overpainting her with drapery, and that on some occasion after 1743 Claude's own overpaint was removed. This hypothesis is supported to some extent by the bare-breasted nymph at the left of a drawing by Claude of the subject of Narcissus and Echo (fig. 4).[20] However, this drawing is dated 1660 – that is, sixteen years after NG 19 was painted – and no related painting is known. The matter has not been further resolved by visual inspection nor by X-ray or infra-red photography.

If the reclining nymph was originally draped, it is not known when her drapery was removed. She is still shown draped in Henry Dawe's engraving published in 1825 and in W.B. Cooke's engraving published in 1838(?) (see Prints), but this may have been for reasons of decorum. If the nymph shed her clothes during a cleaning at the National Gallery, this must have happened before 1899.[21] But to judge from a suggestive description of her published in 1834,[22] she may have discarded modesty by that date notwithstanding the 1838 engraving. No published reference to the discrepancy between NG 19 and the *Liber Veritatis* drawing seems to have been made until Davies published his 1946 catalogue.[23]

Fig. 3 Detail of nymph from *Landscape with Narcissus and Echo*, 1644. Pen and grey-brown wash, 19.5 × 26.2 cm. London, British Museum, Department of Prints and Drawings.

Fig. 4 Detail of nymph from *Landscape with Narcissus and Echo*, 1660. Chalk, pen and brown wash, heightened, 31.9 × 44.1 cm. Copenhagen, Museum of Fine Arts.

Fig. 5 *Landscape with Narcissus*, *c*.1644. Pen and brown wash, 11.5 × 17.6 cm. London, British Museum, Department of Prints and Drawings.

Roethlisberger has proposed that the composition of NG 19 follows and enriches a type first established by Domenichino in his fresco *Narcissus* in the Palazzo Farnese, painted in about 1604.[24] Claude's landscape construction in NG 19, however, is more complex, particularly in the gradation between foreground and middle ground, just as his gradations of light are so much more subtle. In fact the preliminary drawing MRD 548 (fig. 5) shows Narcissus and the pool in a similar spatial relationship to each other, and to the picture as a whole, as they are in Domenichino's fresco, but in most other respects the compositions of drawing and fresco are different.[25] Agostino Tassi's *Landscape with Diana and Endymion* (York, City Art Gallery) has also been compared to NG 19 and, as in the National Gallery picture, the diagonal of a verdant slope blocks off part of the horizon at the left.[26] In the drawing Claude does not include a framing tree at the right, as in the works by Domenichino and Tassi, but introduces a line of buildings descending down a slope; in addition, the view at the left in the drawing is more open. Consequently, if in certain respects

NG 19 adopts some of the compositional solutions of Domenichino and Tassi, their works were not necessarily Claude's starting point. Claude's drawing also shows that he seems first to have thought of including a rising sun on the horizon. If so, he may have had in mind Ovid's words '...as hoar frost melts before the warm morning sun, so does [Narcissus], wasted with love, pine away' (*Metamorphoses*, III: 488–90), before finally preferring the poet's descriptions of the woodland pool being in a 'coppice that would never suffer the sun to warm the spot' (III: 412).[27]

NG 19 was widely admired around 1800. It has been suggested, not very convincingly, that its water nymph, and its composition as a whole, may have influenced Guy Head's *Echo flying from Narcissus* painted between 1795 and 1798.[28] The figure of Narcissus in P.H de Valenciennes's *Narcissus admiring his Reflection* (Quimper, Musée des Beaux-Arts) is close in reverse to Claude's figure, and may therefore derive from Vivares's engraving;[29] and Constable wrote to his wife from Coleorton in 1823: 'How enchanting and lovely it is – very far surpassing any other landscape I ever beheld.'[30] On the other hand, an anonymous reviewer of the 1816 exhibition at the British Institution (in which NG 19 did not appear) said that the figure of Narcissus had 'all the graces of a clodhopper, and Echo is so characteristically made to look the image of a Q-in-a-corner'.[31] Ruskin was even less complimentary, calling the principal tree in NG 19 'a very faithful portrait of a large boa constrictor, with a handsome tail; the kind of trunk which young ladies at fashionable boarding-schools represent with nosegays at the top of them by way of forest scenery.'[32]

General References

Smith 1837, no. 77 (description apparently based on Vivares's engraving in reverse); Pattison 1884, p. 228; Davies 1957, pp. 43–4; Roethlisberger 1961, no. 77; Roethlisberger 1975, no. 139; Kitson 1978, pp. 99–100; Wright 1985b, p. 96.

NOTES

1. D. Dethloff, 'The Executors' Account Book and the Dispersal of Sir Peter Lely's Collection', *Journal of the History of Collections*, vol. 8, no. 1, 1996, pp. 15–51, at pp. 19, 27. The reference in the account book is: 'Mr Huckill A Landscape of Gland (sic) 049 00 00.' There were two other Claudes in the Lely sale recorded as 'Mr Soams A Noone Landscape of Claude Coriain 047 00 00', and 'Mr Austen A Landscape of Grand (sic) 080 00 00' (Dethloff, pp. 26, 37). These pictures corresponded to the following in the Lely sale catalogue:

of Clode Lorraine,	High	Broad
A Morning Piece with Figures	03 02	04 00
A Mid-day with Figures	03 00	04 3½
The Sun-Setting, a Temple, Shepherd and Sheep	03 3½	04 03

See [T. Borenius] 'Sir Peter Lely's Collection', *BM*, 83, 1943, pp. 185–91 at p. 186. The 'Sun-setting' etc. is presumably the *Landscape with a Temple of Bacchus* now in Ottawa.

Although Lely's executors recorded Huckle as the purchaser of the 'Morning Piece with Figures', that is to say the picture which may be NG 19, the buyer at the auction, albeit at the same price of £49, was noted as a Mr Gibbons: see *Historical Manuscripts Commission. Fifteenth Report, Appendix, Part VII. The Manuscripts of the Duke of Somerset, The Marquis of Ailesbury, and The Rev. Sir T.H.G. Puleston, Bart.*, London 1898, p. 181. It is not clear why there should be this discrepancy, but the executors' records are to be preferred. The Mr Gibbons was Grinling Gibbons who bought three portraits at the Lely sale (Dethloff, p. 37). Little is known of Robert Huckle, or Huckill, who died in 1732 and was a collector and a member of the Virtuosi of St Luke, becoming one of its Stewards in 1694 (Dethloff, pp. 19, 44). Perhaps he was the same Huckle who married Sir Godfrey Kneller's daughter (see *Vertue Note Books*, III, p. 57).

2. The date of publication by Arthur Pond of Vivares's print after NG 19 recording it as belonging to Peter Delmé is 4 March 1743. See also *Vertue Note Books*, III, *Walpole Society*, vol. 22, 1933–4, p. 117. For an account of Delmé's relationship with Pond, see L. Lippincott, *Selling Art in Georgian London. The Rise of Arthur Pond*, New Haven and London 1983, pp. 56–7, and see fig. 22 for a reproduction of Vivares's print. Peter Delmé was also recorded as the owner of NG 19 in the list of owners in Richard Earlom's *Liber Veritatis*, London 1777, pp. 10–12. Delmé was a member of the council of the British White Herring Fishery in 1762: see [Anon.], *A New Edition of the Court and City Register for the year 1762*, London n.d., p. 242. Among his colleagues was Alderman William Beckford, father of his better known namesake, builder of Fonthill Abbey. Delmé's interest in fish (if he had any) was not reflected in his collection, save lot 2 at his sale, 'A Mackarel'.

3. Described in the sale catalogue as 'the poetical subject of Narcissus with Ecco (sic)'. For the price see F. Owen and D. Blayney Brown, *Collector of Genius. A Life of Sir George Beaumont*, New Haven and London 1988, p. 75. In a copy of Earlom's *Liber Veritatis*, cited in note 2, in the British Library (683.k.6) there is a pencilled note by LV 77, 'Sir George Beaumont 1790'.

4. Owen and Blayney Brown 1988, p. 77. Lady Amabel Lucas also noted NG 19 in Beaumont's collection on her visit there on 9 May 1793: *Diaries of Lady Amabel Yorke 1769–1827*, vol. III, p. 103.

5. When seen by Farington among the pictures which Beaumont planned to send to Coleorton Hall: see *The Diary of Joseph Farington*, vol. IX, pp. 3296–7, entry for 17 June 1808. NG 19 was called 'Large Claude' by Farington, who reckoned its cost to Beaumont as £630. The Beaumonts took possession of their new house at Coleorton in August 1808: see Owen and Blayney Brown 1988, p. 131.

6. On the Beaumont gift, see Owen and Blayney Brown 1988, pp. 210 ff. and London 1988, pp. 10–14.

7. Regarded as a copy by Roethlisberger (1961, p. 223), who notes that it was in the Campana collection, Rome, by 1858. See also A. Philippe, *Musée Départemental des Vosges – Catalogue de la section des Beaux-Arts. Peintures, Dessins, Sculptures*, Epinal 1929, no. 131, where published as by Claude, but now regarded as certainly a copy: letter of 23 September 1999 from Bernard Huin.

8. See Roethlisberger 1961, p. 223.

9. Ibid.

10. Trans. by F.J. Miller in the Loeb edn, 1916 (1966 reprint).

11. 'Item, un aultre grand tableau de paysage de mesme grandeur [six piedz de hault sur quatre piedz et demy de large] du mesme Lorin où est représenté Narcisse avec plusieurs nimphes garny de sa bordure comme celle du precedent, prisé et estimé la somme de.... /1000 lt.' This picture apparently was a pendant to a Claude *Landscape with the Rape of Europa*: see Levi 1985, pp. 9–83 at p. 63.

12. Compare, for example, the contrasting compositions of *Seaport with the Landing of Cleopatra in Tarsus* and *Landscape with Samuel anointing David* (both Paris, Louvre) and datable around 1642–3, so just earlier than NG 19 and the Ottawa picture.

13. Roethlisberger (1961, p. 222) thought it likely that the paintings were a pair, noting however, the lack of contrasting composition. Kitson (1978, p. 99) expressed himself as undecided, and the pros and cons are set out without conclusion by Catherine Johnston in *Catalogue of the National Gallery of Canada Ottawa. European and American Painting, Sculpture and Decorative Arts*, vol.1, *1300–1800*, ed. M. Laskin and M. Pantazzi, Ottawa 1987, p. 82.

14. See Kitson 1978, p. 99, although, as H. Diane Russell points out (Washington 1982, p. 150), Lely may have known of Claude through Dutch painters who had worked in Italy.

15. See Wine in London 1994, pp. 43–5.

16. See O. Kurz, 'Huius Nympha Loci. A pseudo-classical inscription and a drawing by Dürer', *JWCI*, 16, 1953, pp. 171–7, who also notes a Renaissance epigram as a possible source of the sleeping nymph figure for artists; and for the sculpture, see Haskell and Penny 1981, pp. 184–7; and Bober and Rubinstein 1986, pp. 113–14.

17. J. von Sandrart, *Teutsche Academie der edlen Bau-, Bild-, und Mahlerey-Künste*, Nuremberg 1675–9, vol. 1, part 2, p. 160.

18. Bober and Rubinstein 1986, p. 115, and E.B. MacDougall, 'The Sleeping Nymph: Origins of a Humanist Fountain Type', *AB*, 57, 1975, p. 359.

19. MacDougall, cited in note 18, pp. 357–65 at p. 361. In Pausanias' version of the story of Narcissus, he fell in love with his twin sister and when she died he would go to the spring to gaze upon his reflection, imagining it was that of his sister. But the nymph in NG 19 is asleep not dead and so cannot be Narcissus' sister: see Wine in London 1994, pp. 44–5. McDougall, p. 359, notes Ovid's story of Byblis (*Metamorphoses*, IX: 452ff.), a girl who was turned into a nymph or spring as punishment for her incestuous love of her brother, who was not, however, Narcissus.

20. Copenhagen, Royal Museum of Fine Arts (MRD 832).

21. See the photograph of NG 19 in *The National Gallery*, ed. Sir E.J. Poynter, vol. 1, London 1899, p. 195.

22. One description of the nymph written soon after NG 19 entered the Gallery could, however, be construed as a reference to her being a nude: 'She has the longest limbs and body of any Naiad whom we have ever had the pleasure of seeing': Landseer 1834, p. 366. The Epinal copy of NG 19 (see under Related Works) shows the nymph clothed, but since it may have been based on the Vivares engraving, or even that of W.B. Cooke, no conclusion can be drawn from this.

23. Davies 1946, p. 25, where Davies also noted another, smaller difference between NG 19 and LV 77 in the left arm of the topmost nymph. Now, as then, it is not possible to see if there are pentimenti or repaints in this area and, as Davies further noted, Vivares's engraving is like the present state of the picture in this region.

24. Roethlisberger 1961, p. 222. For the dating of Domenichino's fresco, see R.E. Spear, *Domenichino*, New Haven and London 1982, p. 132.

25. Helen Langdon has tentatively suggested that NG 19 may have been inspired by an illustration in J.W. Baur's series of engravings illustrating scenes from Ovid's *Metamorphoses* and published in 1641: see Langdon 1996, pp. 151–78 at pp. 155–6. There is some resemblance between the figures of Narcissus in Baur's engraving and in NG 19, but it is probably coincidental and it does not seem that Claude was influenced by any other engraving in Baur's *Begin. Dem hoch edlen und gestrengen Herren Herren Jonae von Heyssperg*, Vienna 1641.

26. For a similar comparison between NG 19 and the Tassi as between the former and the Domenichino fresco, see Roethlisberger 1961, p. 222. For the attribution of the York picture to Tassi, see M.R. Waddingham, 'Alla ricerca di Agostino Tassi', *Paragone*, 139, 1961, pp. 9–23.

27. Trans. F.J. Miller in the Loeb edn, 1916 (1966 reprint). For the suggestion of Claude's change of concept, see Wine in London 1994, p. 106.

28. N.L. Pressly, 'Guy Head and His Echo Flying from Narcissus: A British artist in Rome in the 1790s', *Bulletin of the Detroit Institute of Arts*, vol. 60, nos 3/4, 1982, pp. 68–79 at p. 74. Pressly also resurrects the idea that the reclining nymph in NG 19 may be Echo, and although she has been so identified by some – for example, John Smith and R.N. Wornum (see Smith 1837 and Wornum 1847, p. 57) – it is surely incorrect.

29. See Bailey 1991–2, pp. 538–41 who, however, points out that Valenciennes saw his aspirations for landscape painting as being of a higher order than those of Claude.

30. *John Constable's Discourses*, compiled and annotated by R.B. Beckett, Ipswich 1970, p. 54, n. 2. For another reference to NG 19 by Constable, see Pace 1969, pp. 733–40 at p. 737. For other early nineteenth-century appreciations of NG 19 see, for example, Landseer 1834, and an anonymous author in *The New Monthly Magazine and Literary Journal*, vol. 3, London 1821, p. 446, who wrote that 'even the recollection [of the painting], after seeing it in the British Institution Gallery, brings a "nectared sweet" to the mind.' For Richard Payne Knight's preference of NG 19 over NG 12 and NG 14 (then in the Angerstein collection), see Farington's *Diary*, vol. VI, p. 2013 (entry for 17 April 1803).

31. The meaning of the expression 'Q-in-a-corner' is unclear. Judy Egerton has suggested (letter of 10 February 2000) that 'Q' may stand for 'Quean', defined as 'A slut, or worthless woman, a strumpet' in the *Dictionary of the Vulgar Tongue*, 1811, reprinted unabridged with foreword by Robert Crombie, Chicago 1971. This would seem right if the reference were to the nude nymph in the lower left corner of the painting. However, the term 'characteristically' could not be so applied to Claude, whose female (and male) figures were generally modestly draped. This suggests that the phrase was meant to have the meaning certainly used in legal circles later in the century as 'something not at once seen but brought to subsequent notice': *The Oxford English Dictionary*, 2nd edn, Oxford 1989, p. 950. This would make sense were reference being made to the nymph in the foliage calling to Narcissus, and would be consistent with notions of Claude as a weak storyteller.

32. John Ruskin, *Works*, vol. 3, 1903, p. 578, and see a further brief reference to NG 19 at pp. 579–80. The comment was first published by Ruskin in 1843 in *Modern Painters*, vol. 1. For criticism of Claude's trees at the right of NG 19, see Foggo 1845, p. 8.

Seaport with the Embarkation of Saint Ursula

Oil on canvas, 112.9 × 149.0 cm
Signed and dated on one of the steps towards the bottom left:
CLAVDIO. I.V.F. ROMAE 1641

Provenance

Painted for Fausto Poli (1581–1652), when he was Pope Urban VIII's major domo and administrator of the Barberini possessions;[1] bequeathed by Poli to Cardinal Francesco Barberini (1597–1679), nephew of Urban VIII;[2] inherited by Cardinal Carlo Barberini (1630–1706) and recorded at some date during the years 1692–1704 in the ground-floor apartment of the Palazzo Barberini alle Quattro Fontane;[3] recorded in the posthumous inventory of Cardinal Francesco Barberini (1662–1738);[4] bought by William Lock (1732–1810) from the Palazzo Barberini[5] some time in or after 1751 and probably by 1774;[6] sold by Lock to Gerard Levinge van Heythusen in 1781;[7] sold by van Heythusen to the French picture dealer resident in London, Noel Joseph Desenfans (1745–1807), for 2500 guineas;[8] sold by Desenfans to Thomas Moore Slade, picture dealer, for £1200 after July 1786;[9] in the gallery at Slade's home at Rochester before being removed to Slade's house in London;[10] bought from Ward by John Julius Angerstein for £2500 and in his collection by 19 November 1802;[11] purchased with other paintings in the Angerstein collection from his executors in 1824.

Exhibitions

London, April 1786, 125 Pall Mall (420);[12] London, June 1786, 125 Pall Mall (244);[13] London 1806, BI (lent for copying);[14] London, August 1943, *National Gallery Picture of the Month* (temporarily removed from wartime store at Manod, Wales);[15] London 1982, NG, *Watch this Space* (no catalogue); Amsterdam 1991, Rijksmuseum, *Meeting of Masterpieces: Jan Both – Claude Lorrain*; Copenhagen 1992 (10); London 1994, NG, *Claude. The Poetic Landscape* (15); London 1996–7, NG, *John Julius Angerstein* (no catalogue).

Related Works (for the pendant[16] see text)
PAINTINGS

(1) Anon. sale, London, Stewart, 2 May 1812 (lot 77, 'The Embarkation of St. Ursula, painted with fine effect, and variety of Ships, Vessels, and Figures, judiciously introduced, a truly capital picture, from the Prince of Conti's Collection, and purchased by Mr. Dens Enfan's for the late King of Poland', bought in at £410).[17] No painting in the Conti sale of 8ff. April 1777 corresponds to such a description. Evidently not the copy after Claude's *Embarkation of Saint Paula* now at Dulwich (no. 220), which was part of the Bourgeois bequest of 1811 and is the only seascape by Claude included in Desenfans's 1801 catalogue. Possibly a different subject to NG 30, which had indeed gone through Desenfans's hands (see Provenance);

(2) Copy by Douglas Guest (1781–after 1828), sold by Alexander Davison, prize-agent and friend of Admiral Lord Nelson and government contractor,[18] London, Stanley's, 28 June 1823 (lot 16);

(3) Sale of Lord Northwick deceased, Thirlestane House, Cheltenham, Phillips, 23 August 1859 (lot 1656, £47 5s.) to Prior (as 'Claude (after). The Embarcation of St Ursula');[19]

(4) A similar composition to NG 30, but not illustrating the story of Saint Ursula, in the manner of Claude. Oil on canvas, 116.8 × 145.4 cm. Formerly the property of The Museum of Fine Arts, Boston, Mass. Sold New York, Christie's, 10 October 1990 (lot 177, $16,500 inc. premium);[20]

(5) A nineteenth-century copy. Oil on canvas, 108 × 147 cm, sold Copenhagen, Brun Rasmussen, 6 February 1991 (lot 112, 21,500 kr.);

(6) Anon. Sale, Bonhams, Chelsea, 5 October 1999 (lot 262, sold as '20th century, After Claude, £180), oil on metal, 49 × 60 cm. A copy;

(7) A version of the subject attributed to Claude by Waagen and seen by him in the Earl of Normanton's collection at Somerley, near Ringwood, Hants, was evidently a different composition.[21]

DRAWINGS (by Claude)

(1) London British Museum, inv. no. 60, LV 54 (MRD 458).[22] Inscribed on the verso: *quadro faict pour lem^no / Cardinale poli / si ritrova nel* ('nel' crossed out) */ dal lemi^mo Cardinale / Barberino*; and on another occasion: *Claudio fecit / in. V.R.*;

(2) New York, private collection. A preparatory compositional drawing probably connected with NG 30;[23]

(3) London, British Museum, inv. no. Oo.6-97 (MRD 455). A preparatory compositional drawing possibly connected with NG 30.[24]

(4) London, British Museum, inv. no. 204, LV 198 (MRD 457). A study for NG 30, rather than a record of an independent composition as once assumed;[25]

(5) London, British Museum, inv. no. 1866.7.14.60 (MRD 459). A study for the figures in NG 30, although it has recently been suggested that the drawing may have been copied from the painting;[26]

(6) Private collection (MRD 454). (See p. 119, fig. 3). In some respects resembling NG 30, but not necessarily preparatory to it, or to it alone;

(7) London, Witt Collection, inv. no. 1,859 (MRD 456). Possibly a study developed from MRD 454 itself not necessarily connected with NG 30 (see p. 119, fig. 3);[27]

(8) Rome, Rospigliosi collection, inv. no. 53. Signed and dated *Claud ... 665* (MRD 944, and see A. Negro, *La Collezione Rospigliosi: La quadreria e la committenza artistica di una famiglia patrizia a Roma nel sei e settecento*, Rome 1999, p. 228). A repetition of LV 54 with modifications, preparatory for Barrière's etching (see Prints (1)).

PRINTS

(1) Etching by Dominique Barrière (c.1610–c.1678) inscribed and dated *l'Imbarcamento di S^ta Orsola cavato nella vita di S^ti Claudio Gillee inven. in Rome 1665. con licenza de superiori. & D.B.sculp.*, approximately 19.3 × 25 cm;[28]

(2) by James Fittler (1758–1835), 1787;[29]

(3) by John Young in *A Catalogue of the Celebrated Collection of Pictures of the late John Julius Angerstein, Esq.*, London, 1823,

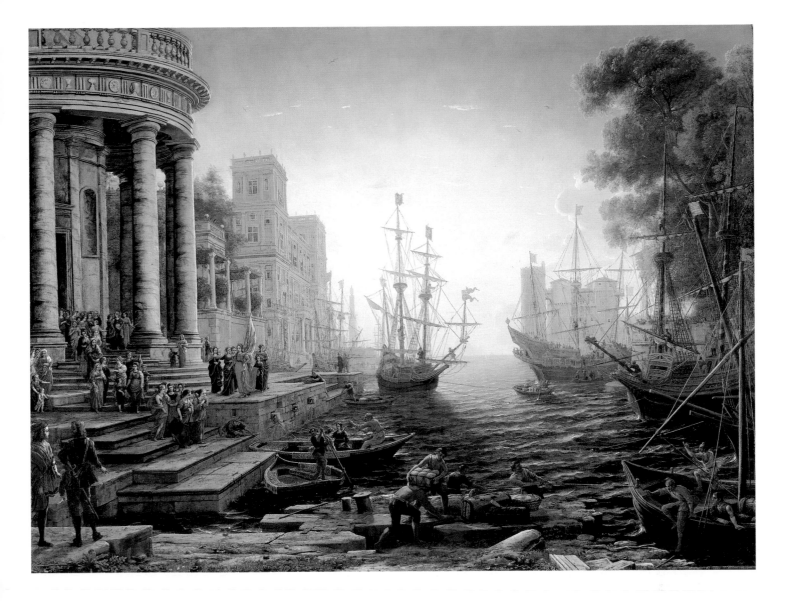

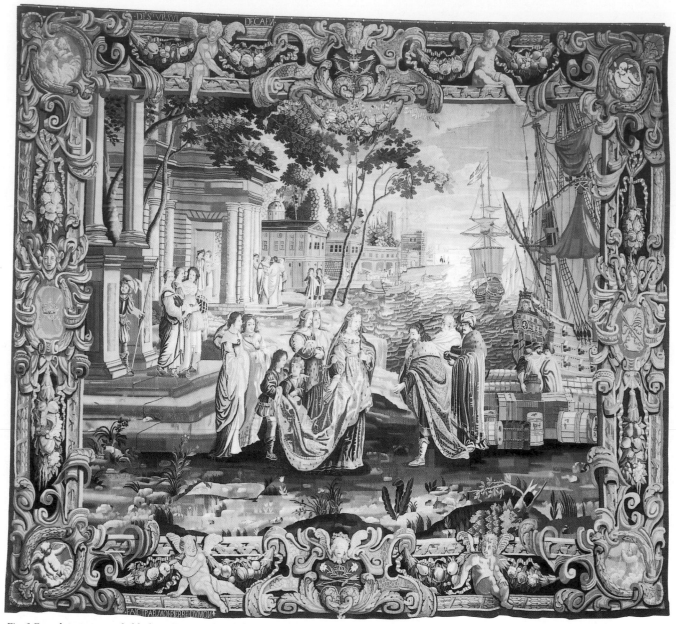

Fig. 1 French tapestry, probably from Caen, and probably designed by La Champagne La Faye, *The Embarkation of Saint Ursula, from the series 'The Story of Saint Ursula'*, c.1654–6. Wool warp, wool and silk, 419 × 470 cm. Boston, Museum of Fine Arts. Gift of Hugh R. Sharp, Jr, and Bayard Sharp.

no. 11 (in which a number of details of NG 30 have been simplified);

(4) by Reveil in Duchesne, *Museum of Painting and Sculpture*, 14 vols, London 1828–33, vol. 11 (1831), no. 749;

(5) by Henry Le Keux, 1839, in *Engravings from the Pictures of the National Gallery*, London [1840], and in *The National Gallery. A Selection from its Pictures. Engraved by George Doo... and others*, London 1875;

(6) by J.C. Armytage in *The National Gallery of Pictures by the Great Masters*, London n.d. [1838?], no. 103.

TAPESTRY

Boston, Mass., Museum of Fine Arts (inv. no. 1976.735) 419 × 470 cm, inscribed at top: DE ST VRSVL DE CAEN, and at bottom: FAICT PAR MOI. PIERRE. DVMON (fig. 1).

Datable *c.*1654–6, probably designed by La Champagne La Faye, woven by Pierre Dumon probably in Caen. Perhaps loosely based on the composition of NG 30.[30]

Technical Notes

In very good condition, albeit with some disfiguring drying cracks to the figure wearing a blue jacket at bottom left, and repaired in an area to the left and above Saint Ursula following malicious damage in 1917. There is also some blanching in the foliage, probably caused by the breaking up of a layer of oil medium perhaps applied during an old restoration.[31] The primary support is a twill canvas lined with a medium-weight plain-weave linen applied following the damage in 1917. The painting had already been lined at some date before 1853,

according to Gallery conservation records. At that date in evidence to the Select Committee on the National Gallery Sir Charles Eastlake stated: 'I think I can trace in [NG 30] evidence of a former unequal cleaning; the discoloured varnish seems to have accumulated in the horizon, and the upper part of the picture appears to have been more cleaned at some former period than the rest; but the effect is generally very agreeable, except in the columns of the portico, which look a little cold, even now; but, if I am correct, it is proof that time does bring pictures into harmony, even after they have been unequally cleaned.'[32] The stretcher probably dates from about 1800 and is marked *19* in black ink (?) at the top. NG 30 was last cleaned and retouched in 1990.

NG 30 is further inscribed *G(?)209* on a bale of goods and *1403(?)* on another. The inscription EMBARQE... ORS noted in Davies 1957 as almost effaced, and doubted by him,

has now disappeared. There are pentimenti to the alignment of both legs of the standing male figure wearing a blue jacket at bottom left. There are numerous fingerprints (presumably Claude's) in the surface of the paint in the sky.[33]

An infra-red photograph shows that the two flags at topmost right were originally horizontally striped. The X-ray photograph (fig. 2) taken before the last restoration shows that Claude made some alterations to the composition: the return wall of the loggia to the right of the martyrium did not originally project beyond the columns of the latter; the alignment of the punt at bottom left may have been altered; in the centre foreground there was once a triangular projecting slab of stone; at bottom right the alignment of the sailing boat was slightly altered and there appears to have been a change to the position of the legs of the figure disembarking from it.

Fig. 2 X-radiograph.

Fig. 3 Detail of ship's flag showing the Barberini arms.

The subject is from the popular *Golden Legend* of Jacobus de Voragine (*c.*1230–98).[34] As there told, Ursula was the daughter of the Christian and British king Notus. To delay her marriage to the pagan king of Anglia she stipulated that she and ten virgin companions, each accompanied by a thousand virgins, should make a three-year journey to Rome while her betrothed was instructed in Christianity. This large party sailed from Britain to Basel and continued overland to Rome, where they met Pope Cyriacus, himself from Britain. Cyriacus left Rome with the virgins. When the party arrived at Cologne they were attacked and beheaded by Huns, save for Ursula who, rejecting the advances of their chieftain, was killed with an arrow. Jacobus dated the legend to the mid-fifth century.

The embarkation of Saint Ursula seems to have been a rare subject in seventeenth-century painting, and NG 30 is the only known example. Whether Claude or his patron intended to show the saint leaving Britain or Rome is unclear, but the latter seems more likely: the building at the extreme left is based on Bramante's Tempietto di San Pietro in Montorio, and it has been suggested that the substantial palace to the right of it is based on the Palazzo Cancellaria,[35] both well-known buildings in Rome. The Tempietto was built on the supposed site of Saint Peter's martyrdom and, as Kennedy has pointed out,[36] since its round form was partly inspired by the shape of early Christian martyria, Claude may have used it to refer to Ursula's impending martyrdom, clearly alluded to by the arrows being carried by her companions.[37] Ursula herself carries her banner, a red cross on a white ground.[38] The resemblance of the palace to the Palazzo Cancellaria, where Cardinal Francesco Barberini, nephew of Pope Urban VIII, was vice chancellor, may have been intended as an indirect

reference to the picture's patron, Fausto Poli, who was administrator of the Barberini possessions when NG 30 was painted. The Barberini connection has been further reinforced by the fictional palace being given a doorway like that of the Palazzo Barberini,[39] and as noted by Roethlisberger, the flags of the ship in the centre bear the Barberini arms (fig. 3).[40] The fortress at the harbour mouth is based on the Castello di Santa Severa between Santa Marinella and Palo, although it differs from the original in that it reaches out into the water like the Castello dell'Ovo at Naples.[41] The ships depicted in NG 30 are of the period between 1605 and about 1635.[42]

It is not known why Poli should have commissioned a painting of this unusual subject.[43] Its pendant, *Landscape with Saint George killing the Dragon* (Hartford, Conn., Wadsworth Atheneum, fig. 4), was painted perhaps two years later.[44] It has been suggested that Claude wanted to pair a passive female martyr with an active male saint, the two being linked by their saintly victories: over death in the case of Ursula, and over the devil, symbolised by the dragon, in the case of Saint George.[45] It seems more likely that Fausto Poli rather than Claude would have been the originator of any such idea. The scene of NG 30 is set against a rising sun – suitable for an embarkation – which would eventually be contrasted with the dusk setting of the Saint George, just as the pair contrast a marine view and a landscape.[46]

Two drawings, both in the British Museum, can be definitely connected with the preparation of NG 30. The earlier, LV 198 (fig. 5), shows the broad lines of the composition, albeit without the ship at the centre and with a narrow foreground shore. More significant are two iconographical developments in NG 30 compared to the drawing. First, although Claude already seems to be thinking of Bramante's Tempietto in the drawing, the spires of the building behind it are Gothic, suggesting that at this stage Claude, or his patron, was thinking of situating the scene in Cologne, site of Saint Ursula's eventual martyrdom. Secondly, the figure of the saint in the drawing is more prominent than in the painting – in the latter her height, as was typical of Claude's painted figures at this period, is about one tenth of the height of the picture, whereas it is about one quarter of the height in the drawing.[47] Although in the painting the saint and her entourage were ultimately made subservient to the architecture, the later drawing (fig. 6), the largest and most elaborate of Claude's figure drawings at this stage of his career,[48] indicates the care with which the artist approached the complex figural groupings required by the saint's extensive entourage.

Fig. 4 *Landscape with Saint George killing the Dragon, c.*1643. Oil on canvas, 111.7 × 149.5 cm. Hartford, Connecticut, Wadsworth Atheneum. The Ella Gallup Sumner and Mary Catlin Sumner Collection Fund.

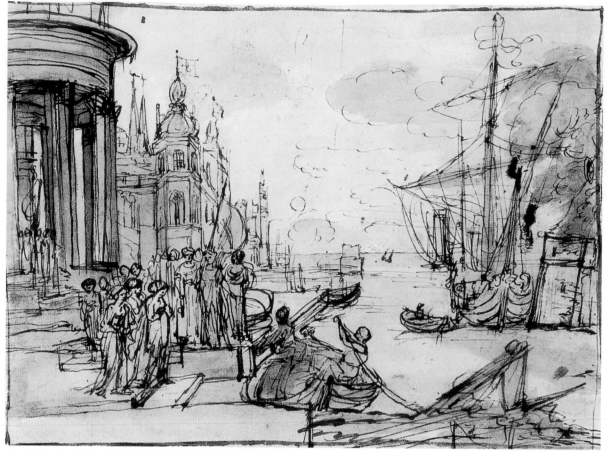

Fig. 5 *Seaport with the Embarkation of Saint Ursula*, 1640 or 1641. Pen and grey-brown wash, some black chalk lines, 18.9 × 26 cm. London, British Museum, Department of Prints and Drawings.

Fig. 6 *Saint Ursula and her Companions*, 1641. Pen and brown wash, 26.7 × 41.9 cm. London, British Museum, Department of Prints and Drawings.

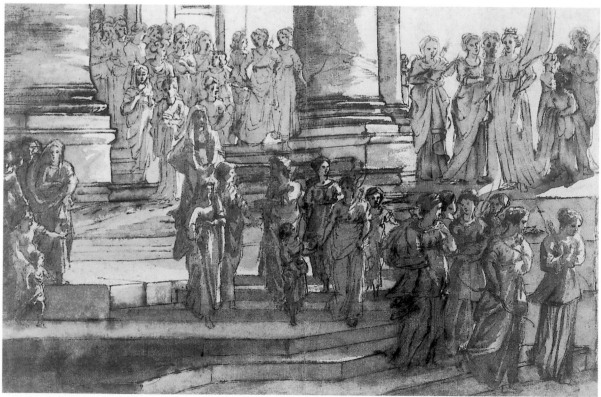

NG 30 was unfavourably compared to NG 14 after Angerstein's purchase of the latter,[49] and the figures in it reportedly criticised by Fuseli.[50] In addition, at the very time that the purchase of NG 30 and the rest of the Angerstein collection was under discussion, the author of the sale catalogue in which Douglas Guest's copy was offered (see Related Works above) claimed that it had been 'copied with so much precision, and at the same time with so much kindred spirit, that were the original lost, or should the Country be deprived of the possession, [the copy] would supply the place so well as to leave little to be regretted.' However, NG 30 was not without defenders. In his *Essays on the Picturesque* Uvedale Price called it 'not only one of the best painted pictures of that studious observer of what is beautiful in art and nature, but also one of the best preserved'. He claimed it as an example of what was beautiful, as opposed to sublime or picturesque: 'I could wish that any person who well recollects, or can again examine the picture, would reflect on the peculiar beauty (in its strictest sense) which arises from the even surface, and silver purity of tint in that furthest building, from the soft haze of the atmosphere, and the aerial perspective produced by the union of these circumstances, which, without any false indistinctness, or uncertainty of outline, make the architecture retire from the eye and melt into the distance.'[51] Turner also admired the painting. When as a young man he saw the picture in the Angerstein collection, he reportedly burst into tears, explaining that it was 'because I shall never be able to paint anything like that picture'.[52] And Constable said of NG 30 that it was 'probably the finest picture of *middle tint* in the world'.[53] Finally, it may be noted that NG 30 appears just to the right of the self portrait included in the imaginary picture gallery painted by Pieter Christoffel Wonder (1780–1852), perhaps completed by 1826 but certainly exhibited in 1831.[54]

General References

Smith 1837, no. 54; Pattison 1884, p. 228; Davies 1957, pp. 44–5; Roethlisberger 1961, no. 54; Roethlisberger 1975, no. 118; Kitson 1978, pp. 85–7; Wright 1985b, p. 96.

NOTES

1. Poli was in the service of Matteo Barberini from before the latter's election to the papacy, and in the service also of Prince Taddeo Barberini. He was made a cardinal on 13 July 1643, and in 1644 Bishop of Orvieto, where he restored and added to the episcopal palace. For some further information on Poli, see Elena Fumagalli, 'Poussin et les collectionneurs romains au XVIIᵉ siecle', in *Nicolas Poussin 1594–1665*, Grand Palais, Paris 1994–5, pp. 48–57 at p. 50 and nn. 27–30, and Lorenzo Cardella, *Memorie storiche de' Cardinali della Santa Romana Chiesa*, 9 vols, Rome 1792–97, vol. 7 (1793), pp. 23–5. For Poli's role as the Barberini liaison with the Cappella Pontificia, see F. Hammond, *Music and Spectacle in Baroque Rome. Barberini Patronage under Urban VIII*, New Haven and London 1994, pp. 165ff. For the date and circumstances of Poli's creation as a cardinal, see von Pastor, vol. 29 (1938), pp. 163–4.

2. Frances Vivian, 'Poussin and Claude seen from the Archivio Barberini', *BM*, 111, 1969, pp. 719–26 at p. 725. NG 30 was described in Poli's will as 'il Quadro dell'Imbarco di Sta Orsola di Monsù Claudio'.

3. M.A. Lavin, *Seventeenth-Century Barberini Documents and Inventories of Art*, New York 1975, p. 440: described as 'Una marina coll'imbarco di S. Orsola al: p. mi 6: 1:7 cornice noce, e oro di monsù Claudio Lorenese'. NG 30 hung in the third room after the anteroom on the right of the ground-floor apartment. The pendant *Landscape with Saint George* (Hartford, Wadsworth Atheneum) hung in the same room: Lavin, p. 431. Carlo Barberini was the eldest son of Taddeo Barberini and Anna Colonna, and a nephew of Cardinal Francesco.

4. Frances Vivian, cited in note 2, p. 725 and n. 85: described as 'Altro di simᵉ grandezza [largo pmi 6 alto pmi 5] rapᵗᵉ l'imbarco di S. Orsola, con veduta di vascelli, navj, mare, Porto, e figure divᵉ, Opera dell'istesso con cornice simᵉ'. This Francesco Barberini was the son of Matteo Barberini, prince of Palestrina, and Olimpia Giustiniani. He was made a cardinal in 1690, and was nominated as one of the Inquisitors-General of the Congregation of the Holy Office in 1726: see L'abbé G.B., *Dictionnaire des Cardinaux*, Paris 1857, p. 315.

5. According to Thomas Moore Slade in a letter quoted in W. Buchanan, *Memoirs*, vol. 1, p. 321, 'The celebrated picture of the Saint Ursula by Claude, lately purchased by the British government, was brought from Italy with a few other fine pictures by Mr Locke about sixty years ago. It was purchased out of the Barberini Palace by that gentleman, and was considered at that time a most important acqusition to the stock of fine pictures in England.'

6. Wornum gives the date of Lock's purchase as 1760: Wornum 1847, p. 58, but this has not been verified. William Lock travelled from Venice to Rome with the painter Richard Wilson, arriving in late 1751 or early 1752: see W.G. Constable, *Richard Wilson*, London 1953, pp. 24–5. It is not clear when Lock returned to London; it was presumably by 1765, when he began to have built for himself a London house (now 21 Portman Square), but he may have been in Italy again by 1767. He was certainly in Rome in 1774 with his wife Frederica Augusta, daughter of the diplomat and picture collector Sir Luke Schaub: see *John Julius Angerstein and Woodlands 1774–1972*, London, Woodlands Art Gallery, 1974, pp. 22–3. Father Thorpe, writing on 15 January 1774, referred to Lock having 'two of the most beautiful & largest Claudes': see Ingamells 1997, pp. 608–9.

7. Buchanan 1824, p. 321: 'Mr Locke, on leaving his house in Portman square, sold the St. Ursula along with some other fine pictures to Mr Van Heythusen for £3000.' Lock was last rated for property in Portman Square in 1781: letter of 2 March 1932 from Duncan Gray, Borough Libraries of the Borough of St Marylebone (in the NG dossier).

8. Desenfans is best known in connection with his collection of paintings, many of which are now at Dulwich Picture Gallery: see Peter Murray, *Dulwich Picture Gallery. A Catalogue*, London 1980, pp. 17–20. Buchanan 1824, vol. 1, pp. 321–2, relates that Van Heythusen sold NG 30 to Desenfans after buying the collection of Sir Gregory Page of Blackheath (d.1775). The 'few Pictures remaining undisposed of, from that superlative Assemblage, collected by the late Sir Gregory Page, Bart.' were sold at auction, London, 8–9 May 1783, so Van Heythusen's purchase of the Page collection must have occurred by then. For the price paid for NG 30 by Desenfans, see Noel Desenfans, *A Descriptive Catalogue.. of some Pictures.. purchased for His Majesty the Late King of Poland*, London 1801, pp. 9–10.

9. NG 30 was in Desenfans's exhibition at 125 Pall Mall, London, from 8 April 1786 (no. 420), and his exhibition at the same premises from 8 June 1786 (no. 244) where described as 'A sea port with St. Ursula, the history of the eleven thousand virgins going to the Holy Land – out of the palace Barberini. Mr Fittler, engraver to His Majesty, is now engraving this picture for Alderman Boydell. 5ft.2 by 6ft.5, on canvas', and was lot 42 of the Desenfans sale, Christie's, 17 July 1786. Referring to the Desenfans exhibition, James Dallaway wrote that 'many capital pictures were eclipsed by the landscape of

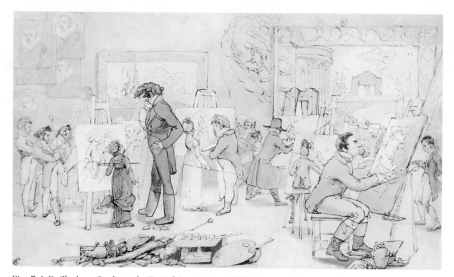

Fig. 7 A.E. Chalon, *Study at the British Institution*, 1806. Pen and brown ink, 31.7 × 53 cm. London, British Museum, Department of Prints and Drawings.

Claude Lorraine, of the procession of St Ursula, and the eleven thousand virgins': *Anecdotes of the Arts in England*, London 1800, p. 518. Slade was active 1795–1822: *Index of Paintings Sold*, vol. 1, p. 1028. Lady Amabel Lucas noted NG 30 ('a fine Sea-Port by Claude Lorraine with the Embarkation of St. Ursula, from Mr. Locke's Collection') when she visited Desenfans's premises on 12 April 1786: *Diaries of Lady Amabel Yorke 1769–1827*, vol. 8, p. 313.

10. Buchanan 1824, vol. 1, pp. 326–7. Slade relates that after it had been removed to London 'my charming St. Ursula of Claude I likewise offered to Lord Darnley and Sir Philip Stephens, as also to the late Lord Kinnard for the same price I gave Des Enfans for it, which was £1200, although I was certain I would get much more, but they all declined it'. Slade's letter continues: 'I then got £1700 conditionally, and it was soon after sold to Mr Angerstein for £2500.' The conditional sale was possibly that negotiated by Desenfans in his own name on 24 May 1791 when he sold to Lord Lansdowne, '1 St. Ursula Claude, 2 Salvator Rosas viz Two Historys of Pythagoras one giving money to the Fisherman, the other Pythagoras coming out of the Cave for two thousand Guineas but Ld.L agrees that it is in Mr Desenfans Power to sell the three last Pictures to any body else for his greater advantage during a Fortnight to come': D. Sutton in *Country Life*, vol. 116, December 1954, p. 1958, and ibid., 'A Wealth of Pictures', *Apollo*, 119, 1984, pp. 346–56 at p. 348.

11. In a letter of that date William Buchanan, then in Edinburgh, wrote to James Irvine listing the pictures in Angerstein's collection 'from my private notes': Brigstocke 1982, p. 51. The paintings so listed included 'Lock's famous Claude'. Although Angerstein finally acquired five paintings by Claude, only NG 30 had once been in Lock's collection. In a letter written by Buchanan to David Stewart on 23 April 1804 he says that the price for NG 30 had been 2500 guineas: Brigstocke 1982a.

p. 276, but Slade gives the price as £2500 (see above). For Farington's and Angerstein's own unfavourable comparison of NG 30 with the Bouillon Claudes (NG 12 and NG 14) see *The Diary of Joseph Farington*, vol. 6, pp. 2004–5 (entries for 3 and 5 April 1803). Slade's account of the sale of NG 30 (see note 10) hints that he did not sell it directly to Angerstein. In *Notes connected with Young's Catalogue of the Angerstein Collection* (NG Archive 1995/48), facing p. 6, the anonymous author wrote of NG 30 'purchased of a Mr. Ward', who may have been the dealer of that name active early in the nineteenth century: see *Index of Paintings Sold 1801–1805*, p. 1041.

12. See note 9 above.

13. See note 9 above.

14. Whitley 1928, p. 111. A pen and ink and watercolour drawing by A.E. Chalon in the British Museum (inv. No.1879-6-14-757) shows artists and students at the British Institution copying paintings with NG 30 hanging on the wall behind (fig. 7). The drawing is described in the BM Register as 'Study at the British Institution 1805', but, as Kim Sloan has written (14 February 1997), this date must be wrong since the old masters were lent only after closure of the exhibition of modern masters which took place in January 1806. The drawing is catalogued in L. Binyon, *Catalogue of Drawings by British Artists in the British Museum*, London 1898, p. 205.

15. Information derived from the dossier and from the Conservation Dossier, vol. I, p. 5. The picture was scheduled to be shown in August 1943 but may not have been because too small a case was sent for transport, and no press reports of its exhibition have been found.

16. Roethlisberger 1961, no. 73.

17. Annotations in copies of the sale catalogue give the painting's size as 3 × 3ft or 3½ft: *Index of Paintings Sold 1811–1815*,

Part 1, p. 277. The vendor was said to be a Worcestershire gentleman: ibid., p. 31.

18. See *A Descriptive Catalogue of Paintings by British Artists, executed for A.Davison, Esq., of subjects selected from the History of England, as arranged in his house in St. James's Square*, printed by Bulmer & Co. in 1806.

19. Sold from one of the upper bedrooms of Thirlestane House. Possibly the same picture as that described as 'Landscape, with Buildings and a group of Figures on the Sea-shore, Claude', numbered CLV and recorded in the drawing room of Thirlestane House in 1846: *Hours in the Picture Gallery of Thirlestane House*, Cheltenham 1846, p. 36, and in the 1858 edition of that work as no. 351.

20. A photograph of this painting in the NG dossier is inscribed on the reverse 'In poss. Marshall Spink, 1945'. Additional provenance is given in Roethlisberger 1961, no. 247; there described as probably Italian, eighteenth or later seventeenth century.

21. Waagen 1857, p. 368.

22. Part traced on the verso. See Kitson 1978, pp. 85–6.

23. See also Roethlisberger 1971, no. 19.

24. J.J.L. Whiteley has suggested that this drawing has a better correspondence to Claude's *Seaport with the Landing of Cleopatra* (Paris, Louvre): Whiteley 1998, p. 106.

25. By, for example, John Smith (Smith 1837, vol. 8, p. 304).

26. Whiteley 1998, pp. 32, 111–12.

27. As suggested by M. Kitson in London, Kenwood, 1969, no. 75.

28. For a discussion of this and other etchings by Barrière after Claude, see Roethlisberger 1961, pp. 192–4, and by the same author, 'From Goffredo Wals to the Beginnings of Claude Lorrain', *Artibus et Historiae*, 32, 1995 (published 1997), pp. 9–37.

29. See Ch. Le Blanc, *Manuel de l'Amateur d'Estampes*, 4 vols, Paris 1854–89, vol. 2, p. 237 (with date wrongly given as 1782), and note 9 above.

30. I am grateful to Susan Ward for this information and for the photograph. The museum also owns another tapestry of the same manufacture and of similar size showing the Martyrdom of Saint Ursula (inv. no. 1976.736).

31. On possible causes of blanching generally, see J. Plesters, 'Possible causes of blanching involving changes in pigments or interaction of pigment and medium', *NGTB*, 4, 1980, pp. 61–3.

32. For comment on the 1917 cleaning, see Sir Charles Holmes, 'Notes in the National Gallery, II, The "Tone" of Claude', *BM*, 33, 1918, pp. 30–5. For an account of how NG 30 looked in 1853, see the evidence of Sir Charles Eastlake, *Report from the Select Committee on the National Gallery*, 1853, para. 6229; for Samuel Palmer's delight in 1865 in its 'dirtiness', see A.H. Palmer, *The Life and Letters of Samuel Palmer, Painter and Etcher*, London 1892, p. 267.

33. As noted by Wyld, Mills and Plesters 1980, pp. 49–63 at p. 59.

34. Jacobus de Voragine, *The Golden Legend*, trans. by W.G. Ryan, 2 vols, Princeton 1993, pp. xiii–xiv. Louis Réau (*Iconographie de l'Art Chrétien*, 3 vols, Paris 1955–9, vol. 3 (1959), p. 1297) has said that the story of Saint Ursula originated with Geoffrey de Monmouth's *Historia Regum Britanniae*; according to J.E. Gugumus, it originated with the monk Enrico di S. Bertino, who dated Ursula's birth to 975 (*Bibliotheca Sanctorum*, vol. 9, pp. 1254–5) but the inscription on Barrière's etching (see Prints (1)) seems to confirm that in the case of NG 30 the source was the *Golden Legend*, which was known in numerous editions.

35. Kennedy 1972, pp. 260–83, at pp. 277, 279. The composition of the left-hand side of NG 30, and of some other seaport scenes by Claude, may be based ultimately on a capriccio scene frescoed c.1625 by Agostino Tassi at the Palazzo Lancellotti (fig. 8): Patrizia Cavazzini, *Palazzo Lancellotti ai Coronari. Cantiere di Agostino Tassi*, Rome 1998, p. 137. I am grateful to Ms Cavazzini for drawing my attention to this and for providing a photograph of Tassi's fresco.

36. Kennedy 1972, p. 279.

37. For a suggestion that the saint may have been perceived as travelling through martyrdom towards God as symbolised by the sun, see Wine 1994, p. 34. Similarly derived from the Tempietto are the eucharistic symbols in the metopes: Roethlisberger 1961, p. 191. Visible in NG 30 are a chalice, a paten and an incense burner. For the significance of the use of such symbols, and of the Doric Order in the Tempietto, see P. Murray, *Bramante's Tempietto*, Newcastle 1972, pp. 8–10.

38. A similar banner is shown, for example, in Carpaccio's *Ursula* cycle (Venice, Accademia), and Benozzo Gozzoli's *Saint Ursula with Angels and Donor* (Washington, National Gallery of Art).

39. Kennedy 1972, p. 277. The palace in NG 30 has also been wrongly seen as derived from the Villa Medici (D. Graf, 'Die "Villa Medici" in den Hafenbildern des Claude Lorrain', *Kunstgeschichtliche Studien für Kurt Bauch zum 70. Geburtstag von seinen Schülern*, Munich and Berlin 1967, p. 204).

40. Roethlisberger 1961, p. 191 (i.e. three golden bees on a blue background, here somewhat roughly indicated).

41. Kennedy 1972, p. 275, n. 61, who, however, wrongly calls the town San Severo; Roethlisberger 1979, pp. 20–8 at p. 27, and in a review of Kitson 1978 in *Master Drawings*, vol. 16, no. 2, 1978, p. 179, where he points out that the view of the castle in NG 30 is in reverse (presumably looking out to sea).

42. D. Cordingly, 'Claude Lorrain and the Southern Seaport Tradition', *Apollo*, 103, 1976, pp. 208–13 at p. 209 (text to fig. 4).

43. Among other things, Saint Ursula was invoked for a holy death. She was the patron saint of the Sorbonne, and of drapers:

L. Du Broc de Segange, *Les Saints Patrons des Corporations*, 2 vols, Paris 1887, vol. 2, pp. 366–8. The Ursuline Order had been founded in 1534 at Brescia. Shortly before NG 30 was completed there was a real-life embarkation of three Ursulines when Marie Guyart and two companions from the convent at Tours sailed from Dieppe to found an Ursuline mission to the Huron and Iroquois near Quebec. They arrived on 1 August 1639 and were joined a year later by two Ursulines from the Paris convent. The first stone of the new convent in Quebec was laid in the spring of 1641: see [Claude Martin] *La Vie de la venerable Mere Marie de l'Incarnation premiere superieure des Ursulines de la Nouvelle France Tirée de ses lettres et de ses Ecrits*, Paris 1677; AMDG, *Les Ursulines de Québec depuis leur établissement jusqu'à nos jours*, 4 vols, Quebec 1863–6, vol. 1 (1863), *passim*; J.L. Beaumier, *Marie Guyart de l'Incarnation*, Three Rivers (Canada) 1959, pp. 127–34. It is clear from these accounts that the Ursulines worked closely with the Jesuits in Canada. One of the latter, Père Le Jeune, superior of the Jesuit mission in Canada, who could not have seen NG 30, nevertheless wrote c.1639 of the Ursulines' voyage there in terms which could evoke it: 'Voilà des vierges tendres et délicates, toutes prêtes à exposer leur vie aux hasards de l'océan, pour venir chercher de petites âmes sous un climat rigoureux et pour subir des travaux qui étonnent des hommes mêmes...', quoted in Beaumier, op. cit., p. 119.

44. See Roethlisberger 1961, no. 73, and Kitson 1978, no. 73.

45. J.C. Forte, 'St George and the Dragon', *Portfolio*, vol. 4, no. 5 (1982), pp. 97–101, developing a point briefly made in Roethlisberger 1961, p. 191. It has also been suggested that both paintings may allude to the dissemination of the Christian faith, and that they are linked by the theme of female purity: Russell 1982, p. 144.

46. NG 30 has traditionally been regarded as a morning picture: see, for example, *Report of the Select Committee on the National Gallery*, London 1853, paras 857, 2144–5.

47. Similar points were made by me in Copenhagen 1992, p. 130.

48. As pointed out in Roethlisberger 1968, p. 197.

49. See note 11 above.

50. 'FUSELI gives a decided opinion on WILSON's figures – figures, it is difficult to say, which of the two introduced or handled with greater infelicity; treated by CLAUDE or WILSON, St. URSULA with her Virgins, and Aeneas landing; NIOBE with her family, or CEYX drawn on the shore, have an equal claim on our indifference or mirth': William Carey, *Letter to J*** A***, Esq. A Connoisseur in London*, Manchester 1809, p. 24. Whatever the source of Carey's comment, it was not one of Fuseli's lectures as subsequently published in *Lectures on Painting delivered at the Royal Academy*, London 1830.

51. The last passage has been quoted by J. Sunderland in 'Uvedale Price and the Picturesque', *Apollo*, 93, 1971, pp. 197–203

at p. 200, from vol. 2, p. 241 of the 1810 (2nd edn) of Uvedale Price's book, which had been first published in 1794. Uvedale Price's discussion of NG 30 in the context of the distinctions between the beautiful, the sublime and the picturesque is at pp. 240–5 of that volume. In vol. 1, pp. 351–2, Uvedale Price had written: 'Mr. Gilpin cannot but remember that beautiful seaport which did belong to Mr. Lock, and which, could pictures choose their own possessors, would never have left him; he must have observed that the architecture on the left hand was regular, perfect, and as smooth as such finished buildings appear in nature.' The reference to Gilpin was to Dr William Gilpin, Prebendary of Salisbury, the second edition of whose *An essay upon prints: containing remarks upon the principles of picturesque beauty* had been published in 1768.

52. Kitson 1983, pp. 2–15 at p. 5. As Kitson points out, the story, written by George Jones after Turner's death, may be apocryphal, but Turner at all events knew the painting, because in a note made in 1821 on Claude's *Seaport with Ulysses restituting Chryseis* he observed a 'grey green tone like the St Ursula': see J. Ziff, 'Copies of Claude's paintings in the sketch-books of J.M.W. Turner', *GBA*, 65, 1965, pp. 51–64 at p. 58.

53. For the full quotation, see ed. R.B. Beckett, *John Constable's Discourses*, 1836, Ipswich 1970, p. 53. For a possible response to NG 30 by John Keats, see C. Pace, 'Claude the Enchanted: Interpretations of Claude in England in the earlier Nineteenth Century', *BM*, 111, 1969, pp. 733–40 at p. 734. For Ruskin's criticism of the perspective of the curved portico at the left of NG 30, see Ruskin, *Works*, vol. 3 (1903), p. 607 (first published in 1843 in *Modern Painters*, vol. 1).

54. Egerton 1998, p. 402 and p. 403, fig. 2. Wonder's painting was entitled *Patrons and Lovers of Art, or The Imaginary Picture Gallery*.

Fig. 8 Agostino Tassi, *Capriccio*, c.1625. Fresco. Rome, Palazzo Lancellotti.

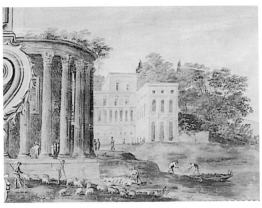

Landscape with a Goatherd and Goats

*c.*1636–7
Oil on canvas, 52 × 42 cm

Provenance
Possibly Robert Ansell sale, Christie's, 8 February 1772 (lot 11, sold for 7½ guineas);[1] apparently in the collection of Lord Londonderry, presumably the Irish peer Robert Stewart, 1st Marquis of Londonerry (1739–1821);[2] in the collection of Sir George Beaumont by 1787, possibly bought in January of that year for £200 from Vandergucht;[3] probably removed by Beaumont from 34 Grosvenor Square, London to Coleorton Hall, Leicestershire, in 1808;[4] noted there by Neale in the drawing room;[5] given to the National Gallery by Beaumont in 1826.

Exhibitions
London ?1816, British Exhibition (66);[6] London 1969, Hayward Gallery (11); Cambridge 1980–1, Fitzwilliam Museum, *Painting from Nature. The Tradition of open-air oil sketching from the 17th to 19th centuries* (1); Leicester 1985–6, *Masterpieces of Reality, French 17th Century Painting* (27); London 1988, NG, *'Noble and Patriotic', The Beaumont Gift 1828* (5); Copenhagen 1992 (9); London 1994, NG, *Claude. The Poetic Landscape* (9); London 2000, NG, *Encounters: New Art from Old*, pp. 116–27.

Related Works
PAINTINGS
(1) Rome, Rospigliosi-Pallavicini collection. Oil on canvas, 49.7 × 39 cm, signed lower left: CLAV...ROM[7] (fig. 2). An autograph variant of NG 58, or an autograph painting of which NG 58 is an autograph variant (see discussion below);
(2) In 1985 with Chaucer Fine Arts, London. Oil on canvas, 51.5 × 43 cm. A good quality copy, said to be seventeenth century.[8] Photograph in NG dossier;
(3) Anon. sale, Sotheby's, Sussex, 13 May 1992, a copy, oil on canvas, 52.5 × 42 cm (lot 602 as 'After Claude'). Photograph in NG dossier;
(4) Sydney, The Art Gallery of New South Wales. Oil on canvas, 53.3 × 44.5 cm (fig. 5). A copy made by John Constable in 1823. (He may have made another in 1801.[9])
DRAWING (by Claude)[10]
London, British Museum, no. 1957-12-14-21 (MRD 134; LV 15) (fig. 1). Inscribed on the verso: *faict pour moig^{re}* (crossed out) *mons^{re} Roispiose/ Roma*; and below: *Claudio fecit/ in VR*.[11] Only the left-hand section of this drawing corresponds to the landscape of NG 58.
PRINTS
(1) An etching by Claude in horizontal format (Mannocci 8.i, p. 328; fig. 4) has been linked to LV 15 (and so to NG 58) by Roethlisberger (1961, p. 130) and Kitson (1968, p. 61), but this relationship has been questioned by Mannocci on the basis that the etching is at least four years earlier than LV 15.[12]
(2) by G.A. Chocarne in *The National Gallery of Pictures by the Great Masters*, London n.d.[1838?], no. 41.

Technical Notes
There are retouchings in the sky and to the tree trunk at the extreme left, and wear and restorations at the lower left and top right of the picture. The support is a quite fine plain-weave canvas. There are remnants of the tacking edges on all four sides, and a photograph of the back of the original canvas taken in 1961, when the picture was last restored and relined, shows the inscription 331 in what is possibly an eighteenth-century hand. A note on the Conservation Dossier records that NG 58 had previously been relined at some date before 1855. The stretcher is probably late eighteenth century or early nineteenth century. A pentimento to the goatherd's left knee is visible. The X-ray photographs suggest that the position of some branches was marked with scratches in the wet paint; and show that the principal figure may originally have been wearing knee-length breeches. There also appears to have been another goat facing right in front of the central clump of trees.

Not based on any known text, NG 58 is a visual equivalent of pastoral poetry, for example that in the *Eclogues*, a series of poems composed by Virgil between 42 and 37 BC. The *Eclogues* describe a countryside of shady groves and murmuring streams peopled by contented rustics whose main concerns are those of love.

The painting is related to LV 15 (fig. 1), the left half of which, however, corresponds more closely to a Claude in the Rospigliosi-Pallavicini collection, Rome (fig. 2). It is this painting which an inscription of the back of LV 15 records as having been made for Giulio Rospigliosi (1600–69), who was to become Pope Clement IX in 1667. Since the inscription refers to Rospigliosi as 'monsignore', it must have been written before he was made an archbishop in 1644.[13] It has been suggested[14] that the London picture is the one which Baldinucci said Claude painted for himself after nature. Baldinucci relates that 'a most beautiful [painting], he painted for himself from nature at the Vigna Madama near Rome; for this His Holiness Clement IX offered him as many doubloons as were necessary to cover it completely, but it was never possible to get it out of his hands, because he said, as indeed was true, that he used it every day to see the variety of trees and foliage.'[15] Pascoli, writing in 1723(?),[16] repeats this story and adds that after Claude's death the picture remained with his heirs, 'who still keep it, and it is on a canvas *di mezza testa*, upright, and I have seen it and returned to see it more than once'.[17] This suggests that the painting was with Joseph Gellée, Claude's nephew and heir, who was the main source of information for both Baldinucci's and Pascoli's biographies.[18] However, no painting like NG 58 is identifiable among the pictures recorded in Joseph Gellée's posthumous inventory of 1731.[19] If the painting identified by Pascoli was NG 58, then its absence from Joseph Gellée's inventory may be accounted for by one of two possibilities: the painting was by 1731 in the possession of another member of the family, or, more likely, Joseph, who had already sold the *Liber Veritatis* in or soon after 1717,[20]

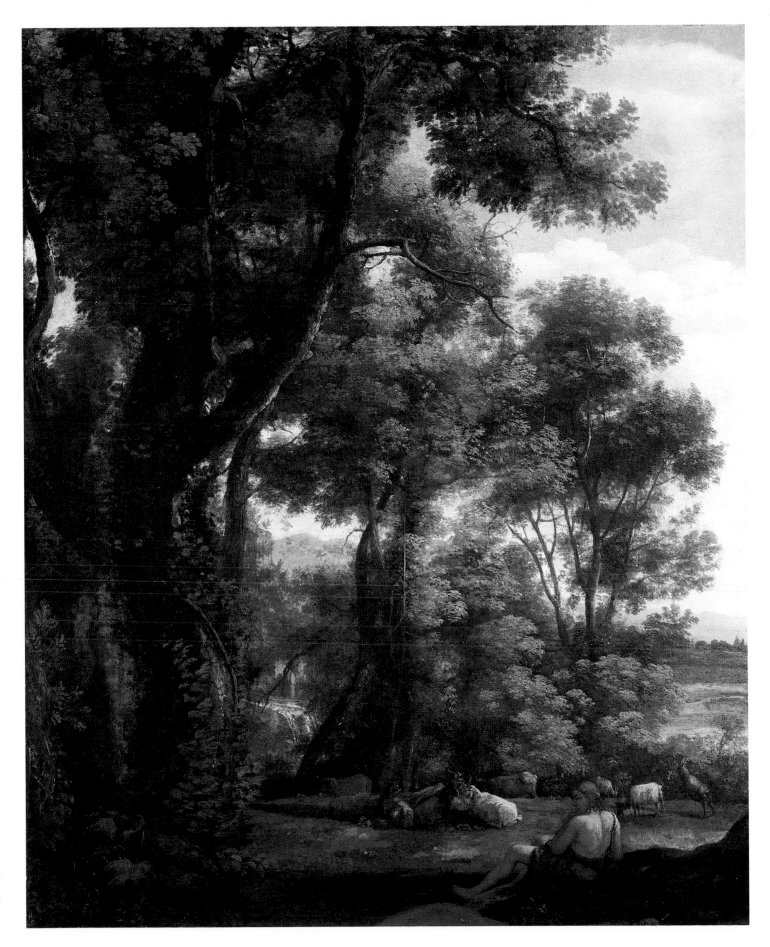

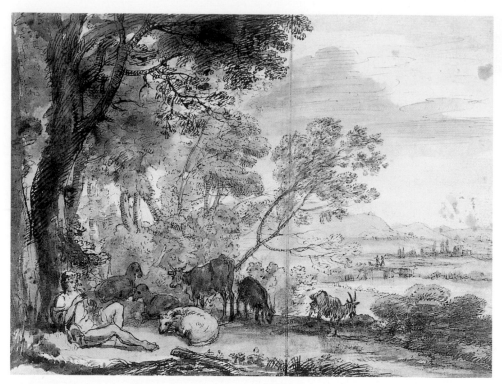

Fig. 1 *Landscape with a Goatherd*, *c.*1636–7. Pen, brown and grey ink, grey-brown and grey wash, 19.5 × 26 cm. London, British Museum, Department of Prints and Drawings.

Fig. 2 *Landscape with a Goatherd and Goats, c.*1637. Oil on canvas, 49.7 × 39 cm. Rome, Rospigliosi-Pallavicini Collection.

decided to sell this painting too at some date after Pascoli wrote his account.

The arguments for identifying that painting with the one which, according to Baldinucci, Claude kept for himself are fourfold.[21] First, the size *mezza testa*, or about 50 cm, corresponds to the height of NG 58, which is, like the painting identified by Baldinucci, an upright. Secondly, NG 58 is said to be Claude's only painting which closely resembles a nature study. This is more problematic. At least two of the tree trunks, for example, have a serpentine shape which looks more contrived than natural; the foliage is painted with the same minute handling as in Claude's other paintings; and at the very least the figure and the goats were painted in the studio, as the pentimenti show. Further, if, as the X-ray photographs suggest (fig. 3), the position of some of the branches was marked by Claude with scratches in the wet paint, this in turn suggests a more meditated approach than would be expected from a painting from nature. The third argument is that the composition has affinities with several drawings inscribed as having been made in the Vigna Madama (that is, the gardens of the Villa Madama at Monte Mario to the north-west of Rome). The resemblance, however, between NG 58 and these drawings is rather too general to be persuasive in this regard and there is no other indication that NG 58 was made in, or of, the Vigna Madama.[22] The final argument is that it is close in composition to the painting made for Giulio Rospigliosi, and that the Rospigliosi picture must have been painted to compensate the prelate for the one painted from nature which, according to Baldinucci, he coveted, but with which Claude refused to part. However, Baldinucci does not say this, as one might have expected had it been correct.[23] Furthermore, if the attraction of the picture to Rospigliosi was that it

had been painted from nature, then would he not also have wanted a picture so painted rather than a variant made in the studio?

Hence, although it is undeniable that the colours of the foliage and of the sky have that 'breezy freshness' Constable would later see in the picture as a whole,[24] it is difficult to see in NG 58 an example of 'plein-air' painting, even though, according to Sandrart, Claude did practise it in his earlier years.[25]

If Baldinucci did not mean to say that the painting he was referring to had been painted 'en plein air', but rather that it was based on nature of the kind to be seen at the Vigna Madama, then it might become easier to accept that it was NG 58. Nevertheless, NG 58 cannot be convincingly identified with any painting referred to in Claude's will or codicils, or in his posthumous inventory,[26] or, as has been seen, in that of his nephew, Joseph. It follows from this that the picture now in the Rospigliosi-Pallavicini collection is not necessarily a later variant of NG 58. NG 58 may, however, be the earlier of the two for a different reason, because in another case where two paintings[27] are known, both of which relate to one *Liber Veritatis* drawing, the painting more similar to the drawing – as the Rospigliosi-Pallavicini version of NG 58 is to LV 15 – is the one that was executed later.[28] At all events all commentators seem to agree that the two pictures were executed within a year of each other, Roethlisberger proposing *c.*1636 for NG 58 and 1637 for the Rospigliosi-Pallavicini painting,[29] Kitson 1637 for both,[30] and Russell possibly earlier than 1636 for both.[31] Russell tentatively proposed dating the paintings earlier than the position of LV 15 in the *Liber* would imply on

Fig. 3 X-radiograph.

Fig. 4 *Goats*, c.1630–3.
Etching, 19.4 × 25.5 cm.
London, British Museum,
Department of Prints and
Drawings.

Fig. 5 John Constable,
*Landscape with Goatherd and
Goats*, 1823. Oil on canvas,
53.3 × 44.5 cm. Sydney, Art
Gallery of New South Wales.

the basis that LV 15 was a ricordo of Claude's etching (fig. 4) datable to before 1634 and that both paintings followed the ricordo (in which case NG 58 could certainly not have been painted from nature). However, the etching may not be formally connected with LV 15 or either painting,[32] and it would seem odd to make a ricordo of an etching unless Claude intended to part with the copperplate. This, however, appears not to have been the case,[33] and the date generally ascribed to NG 58 of *c.*1636/7 seems reasonable.[34]

John Constable was much taken with NG 58 in 1801, expressing a preference for it to all other paintings then in the Beaumont collection.[35] He copied it in 1823 when the picture was at Coleorton Hall (fig. 5),[36] and it was then that he wrote to his friend John Fisher that the painting, which he saw as a noon-day scene, 'diffuses a life & breezy freshness into the recess of trees which make it enchanting'.[37] Possibly it was in respect of NG 58 that Constable wrote to his wife from Coleorton Hall in November 1823: '...I have slept with one of the Claudes every night. You may well indeed be jealous, and wonder I do not come home.'[38] Corot seems to have been another admirer of NG 58. His *Le Petit Berger* (Metz, Musée de la Cour d'Or) was apparently influenced by Claude's composition.[39]

General References
Pattison 1884, p. 228; Davies 1957, p. 45; Roethlisberger 1961, no. 15; Roethlisberger 1975, no. 69; Kitson 1978, no. 15(2); Wright 1985b, p. 96.

NOTES

1. Described in the catalogue as 'A landscape with a shepherd, goats, & c. [height]1 9 [width]1 5'.

2. Ottley 1832, p. 32. If Beaumont bought NG 58 in 1787, then Ottley's reference to Lord Londonerry is unlikely to be to the 2nd Marquess (better known as Viscount Castlereagh), who would then have been only eighteen. Further, if the date 1787 is correct, references in Davies 1957 and elsewhere to Londonderry's 1791 sale as a possible link in the provenance of NG 58 cannot be right.

3. F. Owen and D.B. Brown, *Collector of Genius. A Life of Sir George Beaumont*, New Haven and London 1988, p. 65. As evidence that Beaumont owned the painting by 1787, the authors cite a letter from Jacob More to Beaumont of June 1787 in Edinburgh University Library, Laing MSS, IV, 25, fo.70. Felicity Owen has kindly written to me (8 February 2000) regarding NG 58: 'Looking at Beaumont's bank account again and Farington's later estimate of the costs [of £44 2s. to Beaumont of NG 40] ... the £200 paid to Vandergucht could have been for this painting rather than the Poussin (NG 40). The date was January 1787 whereas in January 1785, Weston was paid £40 and I believe he was a dealer.'

4. When Farington dined at the Beaumonts' London home on 17 June 1808 he looked at the pictures to be sent to Coleorton and 'reckoned what many of them cost him'. Among these paintings were a 'Small do. [Claude] [£]210.', and a 'small trees do. abt.[£]40', either of which could be NG 58, see *The Diary of Joseph Farington*, vol. 9, p. 3297.

5. Neale 1818–23, vol. 1 (1818), p. 71.

6. Described in the British Institution handlist as 'Landscape and Figures – Claude *Sir G. Beaumont, Bart.*' For the reasons why NG 58 is the most likely of Beaumont's Claudes to have been in the 1816 exhibition, see the entry to NG 61, note 10.

7. According to Kitson 1978, p. 61. Roethlisberger 1961, p. 128, however, read the inscription as CLAVDIO.

8. Exhibited in Maastricht and London by Galleria Gasparrini and Chaucer Fine Arts, *Old Master Paintings*, no. 12 (as 'Circle of Claude. Seventeenth Century').

9. See AGNSW. *Collections*, Sydney 1994, pp. 118–19, where reproduced in colour, and L. Parris, I. Fleming-Williams and C. Shields, *Constable. Paintings, Watercolours and Drawings*, Tate Gallery, London, 1976, no. 223. There is a photograph of the painting in the dossier dated 1960, the year before it was acquired by the Art Gallery of New South Wales.

10. There are a number of drawings by Claude inscribed as views in the Vigna Madama, or not so inscribed but with similar motifs or views, namely MRD 291, 294, 295 and 540. Of these the closest compositionally to NG 58 is MRD 294 (Boston, Mass., Museum of Fine Arts, no. 38.756), but it is not close enough to justify its being called a preparatory drawing for that painting.

Whiteley, who has recently written a catalogue entry on MRD 295, noted that there is 'a general likeness between this study and a pastoral painting in the National Gallery in London which is not close enough to be identified as a study for the painting but it suggests the kind of study which Claude may have employed in preparing his composition' (Whiteley 1998, p. 87).

11. These details are taken from Whiteley 1998, no. 29.

12. L. Mannocci, *The Etchings of Claude Lorrain*, New Haven and London 1988, pp. 71–2; the etching has been dated to before 1634 by H. Diane Russell in Washington 1982, p. 331.

13. Roethlisberger 1961, p. 128.

14. Landseer 1834, p. 359; Ottley 1832, p. 32; Roethlisberger 1961, pp. 128, 130; Bologna 1962, pp. 233–5; L. Gowing, 'Nature and the Ideal in the Art of Claude', AQ, 37, no. 1, 1974, pp. 91–6 at p. 94; Conisbee 1979, pp. 413–28 at p. 417 ('maybe at least the lovely trees were worked from nature'); M. Roethlisberger, 'New Works by Tassi, Claude and Desiderii', *Apollo*, 120, 1984, pp. 93–7 at p. 94; R. Cafritz, L. Gowing and D. Rosand, *Places of delight: the pastoral landscape*, Washington 1988, p. 201; P. Conisbee, 'The Early History of Open-Air Painting', *In the Light of Italy. Corot and Early Open-Air Painting*, Washington, Brooklyn, St Louis 1996–7, p. 35.

15. F. Baldinucci, *Notizie de' professori del disegno*, Florence 1681–1728, pt 5/6 (1728), p. 356, trans. by Roethlisberger 1961, p. 58. The story is repeated by L. Pascoli, *Vite de' Pittori Scultori ed Architetti Moderni*, 2 vols, Rome 1730–6, vol. 1 (1730), p. 26.

16. Pascoli's *Vite de' Pittori*, op. cit., was published in two vols in Rome in 1730–6, but the dedication in vol. 1 (1730) is dated January 1729. Nevertheless, Roethlisberger has deduced that one passage on the life of Claude was written c.1723 (Roethlisberger 1961, p. 77, n. 3).

17. Pascoli, cited in note 15, vol. 1, p. 26 (translation by M. Roethlisberger in Roethlisberger 1961, p. 77). As Conisbee 1979, p. 426, n. 7, has pointed out, Baldinucci says the picture was made 'dal naturale' (from nature), whereas Pascoli writes 'al naturale' (in a natural manner).

18. Roethlisberger 1961, pp. 4, 79.

19. G. Michel, 'Quelques tableaux de Claude Lorrain', *AAF*, n.p., vol. 26 (1984), pp. 89–90. The closest possible candidates are a 'campagne, longhi palmi 3 3/3, larghi palmi 2 2/3' which is too large, and 'Uno ... rappresentanti cinque bovi in campagna, lungo palmi 3 1/3, largo palmi 1 2/3...', which is about the right size, but the animals are clearly goats, not oxen, and no mention is made of the goatherd.

20. Kitson 1978, p. 29.

21. See Roethlisberger 1961, p. 128.

22. Kitson 1978, p. 62.

23. Ibid.

24. *John Constable's Correspondence*, ed. R.B. Beckett, vol. 6, Ipswich 1968, p. 143.

25. J. von Sandrart, *Der Teutschen Academie zweyter Theil*, Nuremberg 1675, vol. 2, part 3, 22 (trans. in Roethlisberger 1961, pp. 51–2): 'As in Rome and in Tivoli I went for several months, with colours and canvases, into the country and painted all from life, and as all I had made from such natural models I would then reproduce at home in copies, my neighbour Claude Gilli... saw and recognised the enormous difference so palpably that this showed the true way to perfection, and he likewise followed the same way until he has finally become a master in landscapes.' Sandrart left Rome in 1635. He makes other references to himself and Claude painting out of doors.

26. For Claude's will, codicils and posthumous inventory, see Roethlisberger 1961, pp. 62, 64–76.

27. Roethlisberger 1975, nos 82 and 83.

28. Kitson 1978, pp. 67–8. It may also be worth mentioning, as previously pointed out in Copenhagen 1992, p. 125, that the fact that the *Liber* drawing is closer to the Rospigliosi-Pallavicini picture than to NG 58 would be consistent with Claude having made the latter for himself, since he would have no need to make a record of a painting which he intended to keep. However, my doubts about NG 58 being the picture with which Claude would not part remain.

29. Roethlisberger 1961, pp. 128–9. Federico Zeri has also proposed c.1636 for the Rospigliosi-Pallavicini picture: Federico Zeri, *La Galleria Pallavicini in Roma, Catalogo dei dipinti*, Florence 1959, p. 126. Angela Negro has kindly advised me that the reference in her *La Collezione Rospigliosi. La quadreria e la committenza artistica di una famiglia patrizia a Roma*, Rome 1999, p. 40, to the Rospigliosi-Pallavicini picture being signed and dated 1637 is an error that occurred during editing, which will be corrected in the second edition now in preparation.

30. Kitson 1978, p. 61.

31. H. Diane Russell in Washington 1982, p. 331.

32. See Mannocci, cited in note 12.

33. Mannocci, cited in note 12, pp. 17–18.

34. NG 58 is also dated c.1636–7 by Thuillier 1982, p. 288.

35. *The Diary of Joseph Farington*, vol. 4, p. 1527 (entry for 25 March 1801): 'Constable called – Goes to Sir George's Gallery to study – prefers the little wood scene of Claude to all others.'

36. *John Constable's Correspondence*, cited in note 24, vol. 2, pp. 293, 295, 297, 300, and vol. 6, 1968, pp. 139, 142–3.

37. Ibid., vol. 6, p. 143.

38. Ibid., vol. 2, p. 296.

39. See *Corot*, exh. cat., Grand Palais, Paris 1996–7, no. 76, for the picture by Corot and the suggestion that it was influenced by the composition of NG 58.

NG 61

Landscape with Hagar and the Angel

Oil on canvas mounted on wood, 52.2 × 42.3 cm

Signed and dated at bottom near the centre: [CL] AVD/1646[1]

Provenance

Possibly Jeanne-Baptiste d'Albert de Luynes, comtesse de Verrue (1670–1736), her posthumous sale, Paris, 27ff. March 1737 (lot 100 or 101, 380 livres);[2] possibly Augustin de Blondel de Gagny (1695–1776), Trésorier Général de la Caisse des Amortissements des Dettes du Roy, of place Vendôme, Paris, Pierre Rémy, 10ff. December 1776 (lot 198, 4050 livres to Basan 'pour langleterre');[3] probably Matthew Duane's posthumous sale, London, Greenwood, 23 April 1785 (lot 66, £210 to Hearn on behalf of Sir George Beaumont);[4] seen by Constable at Dedham in 1795;[5] seen by Coleridge in Beaumont's collection in 1804;[6] probably one of the three paintings by Claude transferred by Beaumont to Coleorton Hall, Leics., in 1808;[7] later noted there by Neale in the drawing room;[8] transferred to the National Gallery in 1826,[9] but at Beaumont's request lent to him for life, finally entering the Gallery in 1828.

Exhibitions

London ?1816, BI (66);[10] London 1945, NG, *Fifty-four pictures on exhibition at the reopening of the Gallery 17th May 1945* (no catalogue); Bologna 1962, Palazzo dell' Archiginnasio, *L'ideale classico dei seicento in Italia e la pittura di paeseggio* (96); London 1973–4, Tate Gallery, *Landscape in Britain circa 1750–1850* (1); London 1975, NG, *The Rival of Nature. Renaissance Painting in its context* (202); Leicester 1985–6, The Leicestershire Museum and Art Gallery, *Masterpieces of Reality – French 17th Century Painting* (29); London 1988, NG, *'Noble and Patriotic'. The Beaumont Gift 1828* (4); London 1994, NG, *Claude. The Poetic Landscape* (19).

Related Works

PAINTINGS

(1) Collection of F.W. Willis, Ratby, Leics., in 1984. Oil on canvas, 'same size as original, apparently late eighteenth or early nineteenth century, fairly poor quality, almost certainly English';[11]

(2) Private collection, USA(?), in 1967. Oil on twill canvas, 21⅞ × 18 in. According to a letter of 12 March 1967 from Gerard Stern, the same painting as that owned by Lord Windsor in 1894.[12] A good quality albeit worn copy to judge from photographs in the NG dossier. The X-ray photographs in the dossier show it mounted on a stretcher which is keyed and so eighteenth century or later;

(3) Anon. sale, Christie's, 2 August 1956, oil on canvas, 19 × 17 in., lot 274, £6 6s. to Cohen (as 'Woody Lake Scene with Tobias and the Angel'). A copy. Photograph in NG dossier;

(4) Anon. sale, Sotheby's, 22 July 1953, 20 × 17 in., lot 127, £10 to James. Mediocre copy. Photograph in NG dossier;

(5) Private collection, USA(?). Support and dimensions unknown, but possibly 52 × 44 cm.[13] Photograph in NG dossier. A copy;

(6) Collection of Mr Bingham in 1959. Photograph in NG dossier inscribed on the reverse by Martin Davies: 'claimed to be Constable's copy. Size approx. that of the original'. The painting of the background of this copy seems to be especially dull;

(7) John Constable deceased sale, London, Foster & Sons, 15 May 1838, lot 48, £53 11s., and owned by Marshall in 1853.[14] A copy by Constable of 1799/1800(?);[15]

(8) Anon. sale, Phillips, Bayswater, 4 December 1995, lot 28, oil on canvas, 53.5 × 43 cm, £520 plus buyers' premium (as 'after Claude Lorraine, 19th Century'). No photograph made;

(9) Anon. sale, Newbury, Dreweatt Neate, 4 June 1997, lot 28, watercolour, 42 × 33 cm. Purchased by Richard Knight and resold by him minus the frame by the same auctioneers later that month. No photograph made. (See correspondence in NG dossier);

(10) Anon. sale, Bonhams, Chelsea, 6 September 2000, lot 215, oil on canvas, 54.5 × 47 cm, £340. A copy without the figures, described as 'English School, 19th Century'.

DRAWINGS (by Claude)

(1) London, British Museum, no. Oo.7-154 (MRD 625). Inscribed at bottom: *Agare et ismael l'Angelo mostre l'acqua.* Possibly a preliminary study for the figures;

(2) London, British Museum, no. 112. LV 106 (MRD 626) (fig. 2). Inscribed on the verso: *quadro pour paris*; and on another occasion: *Claudio ivf.*

PRINTS

(1) By John Pye, March 1832 in *Engravings from the Pictures of the National Gallery*, London 1840 (as 'The Annunciation'); and in *The National Gallery. A Selection from its Pictures. Engraved by George Doo... and others*, London 1875 (as 'A Landscape, with figures; said to represent the Annuciation of the Virgin, but considered to be the appearance of the angel to Hagar');

(2) by Thomas Starling in *Valpy's National Gallery*;

(3) by W. J. Tayler in Cunningham 1833, no. 45;

(4) by J.C. Varrall in *The National Gallery of Pictures by the Great Masters*, London n.d. (1838?), no. 39 (as 'The Annunciation');[16]

(5) H.J. Pisan in Ch. Blanc et al., *Histoire des peintres de toutes les écoles*, 11 vols, Paris 1861–76, *Ecole Française* by Charles Blanc, vol. 7 (1865), p. 13 (as 'Tobie et l'Ange'[17]).

Technical Notes

Some blanching, some losses around the edges, some drying creases in the paint and some old toning in the foliage and foreground, but otherwise in good condition. The primary support is a twill canvas mounted on an oak panel before 1852; the canvas shows stretcher cracks and therefore was not originally so mounted. Before the 1853 Select Committee on the National Gallery it was claimed by John Seguier in relation to NG 61 that Sir George Beaumont 'was very much in the habit of rubbing his pictures over with oil',[18] and by Baring Wall, one of the Committee members, that Beaumont was 'in the constant habit of cleaning, varnishing, and washing with some preparation that little Claude, with which he always travelled'.[19]

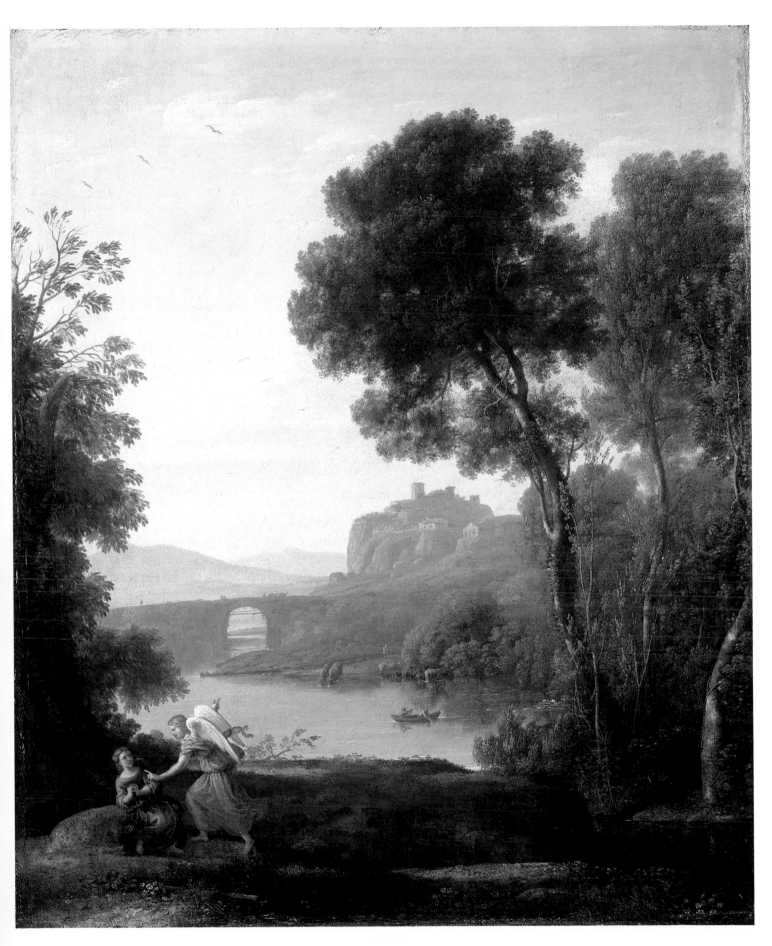

Fig. 1 X-ray detail.

The back of the oak panel is marked in crayon (?) *X 1*5. NG 61 was last cleaned and restored in 1961 (it had previously been cleaned in 1852) when the partial signature and the date were discovered (see above), although the middle *6* and the *4* of the date may have been retouched. Following the 1852 cleaning Cavalcaselle claimed that orange 'undoubtedly was once the colour of the Angel's vestment, as may be seen indeed upon the shoulder, where traces of that tint are visible; but now the greater part of the vestment is merely the blue preparation deprived of its orange glazings. The wings of the Angel are likewise deprived of their glazings, and their original

colour gone.'[20] This is not, however, confirmed by examination under a microscope – although the orange-red colour over the blue drapery on the angel is original, and slightly worn in places, it appears that Claude intended to convey the effect of shot drapery rather than paint it uniformly orange.

An X-ray photograph (fig. 1) shows that the angel's right arm from wrist to elbow was originally painted in, but is now covered by a wing; that the main arch of the bridge was originally slightly wider; and that some branches at the right were painted out. There also seems to have originally been an object (a water jug?) below the angel's left foot.

The subject is from Genesis 16: 7–15. Hagar, an Egyptian servant, was expecting a child by Abraham and was banished from his home by his wife, Sarah, who was childless. An angel appeared to Hagar beside a spring in the desert and ordered her to return to Sarah, saying: 'I will multiply thy seed exceedingly, that it shall not be numbered for multitude.' This is the first of four paintings by Claude showing an episode from the story of Hagar.[21] In addition, in his will of 1663 Claude left 'a landscape picture with the Angel and Hagar', presumably by himself, to the apostolic notary Renato della Borna.[22] As Roethlisberger has pointed out, with the exception of the picture now in the Alte Pinakothek, Munich, the last to be painted, all were painted without pendants.[23] LV 106 (fig. 3) records NG 61 in horizontal format, but without the boat and with a second smaller arch in the bridge to the left of the main arch,[24] and, as Davies noted, more of the angel outlined against the water.[25] All of these changes may be accounted for by Claude wishing to reduce the horizontal emphases in a drawing which recorded a composition already 'stretched' into a horizontal format.

NG 61 has been wrongly called 'The Annunciation' (see Prints), although the correct subject was identified in print soon after the picture permanently entered the Gallery's collection.[26] A copy of NG 61 has also been called 'Tobias and the Angel' (see Related Works: Paintings (3)), as may have NG 61 itself (see notes 2 and 3). The later confusion may have been encouraged by the long recognised compositional similarity between NG 61 and Domenichino's *Landscape with Tobias* (NG 48; fig. 3).[27] It seems unlikely, however, that Claude had the Domenichino directly in mind (assuming that he knew it at all) when planning NG 61 since he had previously used a similar composition for paintings of other subjects.[28] On the other hand he surely referred to LV 106 (fig. 2) when conceiving his own *Landscape with Tobias and the Angel* (Leningrad, Hermitage, no. 1236) recorded in LV 160 (fig. 4).[29]

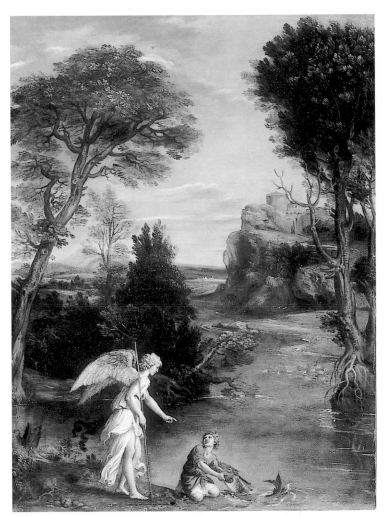

Fig. 3 Domenichino, *Landscape with Tobias laying hold of the Fish*, c.1610–13. Oil on copper, 45.1 × 33.9 cm. London, National Gallery.

Fig. 2 *Landscape with Hagar and the Angel*, 1646. Pen and dark brown wash on blue paper, heightening, 19.4 × 25.9 cm. London, British Museum, Department of Prints and Drawings.

Fig. 4 *Landscape with Tobias and the Angel*, 1663. Pen and brown wash, heightened, on blue paper, 19.8 × 25.9 cm. London, British Museum, Department of Prints and Drawings.

Fig. 5 John Constable, *Dedham Vale*, 1802. Oil on canvas, 43.5 × 34.4 cm. London, Victoria and Albert Museum.

NG 61 was greatly admired by Constable, who in 1836 called it one of Claude's best pictures;[30] he had probably first seen it some forty years previously.[31] Its composition influenced his *Dedham Vale* of 1802 (London, Victoria & Albert Museum; fig. 5),[32] and, less closely, his *Dedham Vale* of 1827–8 (Edinburgh, National Galleries of Scotland).[33] It also seems to have influenced Turner's compositions in *Mercury and Herse* (England, private collection) and *Crossing the Brook* (London, Tate Gallery).[34] The latter painting was vehemently criticised in 1815 by Sir George Beaumont, who called it 'weak' and 'of peagreen insipidity',[35] perhaps by comparison with, and in

defence of, his dearly beloved *Landscape with Hagar and the Angel*, which Beaumont then owned and with which he reportedly dealt 'almost as a man would deal with a child he loved; he travelled with it; carried it about with him; and valued it... beyond any picture that he had.'[36]

General References

Smith 1837, no. 106; Pattison 1884, p. 228; Davies 1957, pp. 45–6; Roethlisberger 1961, no. 106; Roethlisberger 1975, no. 171; Kitson 1978, pp. 117–18; Wright 1985b, p. 96 (and no. 29).

NOTES

1. For the discovery of the signature and date, see M. Levey, 'A Claude Signature and Date revealed after cleaning', *BM*, 104, 1962, pp. 390–1. Levey was able to decipher the signature as LAVD, but the L cannot now be seen.

2. The NG Library has photostats of 4 MSS of the Verrue sale from the RKDH: (i) *Catalogue des Tableaux du cabinet de Me. la Comtesse De Verruë Année 1737* has as lot 100, 'Un

tableau de Claude Petit representant Tobie −380'; (ii) *Catalogue des Tableaux de Madame la Comtesse de Verrue dont la Vente a comencée le Mercredi 27 mars 1737* has as lot 101, 'Un Tableau de Claude Petit ou Gelée dit le Lorrain represt. Tobie− 380'; (iii) *Catalogue de la Vente Des Tableaux de Me. la Comtesse de Verruë. Année 1737*, in its '14e Vacation' has as lot 100, 'Un de Cl. Petit representant Tobie−380'; (iv) *Catalogue avec Les Prix de la vente de La Ctesse de Verrue faite en 1737. les 27 28 & c*

mars. has as its lot 101, 'Claude Lorrain Tobie − 380'.

As Davies (1957, p. 47, n. 1) pointed out, 'Petit' in the first three of these catalogues may be assumed to refer to the picture's size.

For the comtesse de Verrue (1670–1736) of rue du Cherche-Midi, Paris, see Barbara Scott, 'The Comtesse de Verrue. A Lover of Dutch and Flemish art', *Apollo*, 97, 1973, pp. 20–4, who states as a fact (p. 23) that the countess owned NG 61.

3. Described in the sale catalogue as: 'Un paysage piquant par son site, par sa fraîcheur & la bonté de sa touche, Claude Gelée qui en est l'auteur, y a placé Tobie prosterné aux pieds de l'Ange, son conducteur. / Ce tableau est encore d'un mérite sublime sur une toile de 19 pouces 3 lignes de haut, sur 16 pouces de large.' Curieusement Rémy gave a Verrue provenance for the immediately preceding lot, NG 1018, although nothing like it is recorded in any of the MSS catalogues of the Verrue sale (for which see note 2 above). As Anne Thackray has pointed out (note in NG dossier), the cataloguer may have confused which of lots 197 and 198 had been in the Verrue collection. For Blondel de Gagny, see L. Clément de Ris, *Les Amateurs d'autrefois*, Paris 1877, pp. 343–58.

4. Described in the catalogue (according to a typed transcript in the NG Library, Box AXI 6 17) as: 'CLAUDE and LORAIN 66 A landscape (came out of Monsieur De Gagny's collection).' The typescript is annotated '210' in ink in the margin. The reference to NG 61 having been in the Duane collection is in Ottley 1832, p. 32. For Matthew Duane (1707–85), lawyer, antiquary and trustee of the British Museum, see *DNB*.

In October 1786 Jacob More, writing to Beaumont from Rome, was 'glad to hear you have purchased a fine Claude', which has been assumed to be NG 61: F. Owen and D. Blayney Brown, *Collector of Genius. A Life of Sir George Beaumont*, New Haven and London 1988, p. 65. Felicity Owen has kindly advised me (letter of 8 February 2000) that Hearn was the same Thomas Hearn who bid for NG 19, that Beaumont met him in 1771 as Woollett's apprentice and that Hearn accompanied Beaumont on many British tours, and even on his honeymoon. She also points out that the dates of acquisition by Beaumont of his other Claudes preclude any of them from being that acquired by him in 1785. He seems to have bought NG 58 in 1787 and NG 19 in 1790, while NG 55 was not recorded in Beaumont's collection before 1790 at the earliest.

5. Constable first saw NG 61 in July 1795 at Dedham: Ian Fleming-Williams, *Constable and his Drawings*, London 1990, pp. 35, 77, and Felicity Owen, 'Early Influences on John Constable', in *From Gainsborough to Constable. The emergence of naturalism in British Landscape Painting 1750–1810*, exh. cat., Gainsborough's House, Sudbury, and Leger Galleries, London 1991, pp. 15–30, at p. 15. Felicity Owen tells me (letter of 8 February 2000) that NG 61 would have been taken to Dedham when Beaumont visited his mother there, and that it used to be transported under the roof of his carriage. Leslie 1845, pp. 5–6, and *Life and Letters of John Constable, R.A.*, London 1896, p. 6, where said to be the first painting by Claude seen by Constable. Constable briefly referred to NG 61 as among the best by Claude in a lecture at the Royal Institution on 2 June 1836: Leslie 1845, p. 383. According to Owen and Blayney Brown (cited in note 4, p. 77), NG 61 was among the paintings hung in Beaumont's new gallery in his house at 34 Grosvenor Square (renumbered 29 in 1833), when the gallery was completed in 1792.

6. Owen and Blayney Brown, 1988, p. 77.

7. *The Diary of Joseph Farington*, vol. IX, p. 3297 (entry for 17 June 1808), notes three paintings by Claude to be removed to Coleorton together with Farington's estimate of what they had cost Beaumont:

	£
Large Claude	630
Small do.	210
Small trees do.	abt. 40

The 'Large Claude' must be NG 19 and the 'small trees do.' is surely NG 58, but 'small do.' could be either NG 61, or NG 55 (then believed to be by Claude).

8. All four paintings by Claude in Beaumont's collection were noted at Coleorton by Neale, NG 19 and 55 in the Breakfast Room, and NG 58 and 61 in the Drawing Room (Neale 1818–23, vol. 1 (1818), p. 71).

9. George Agar Ellis saw NG 61 (together with NG 19, 55 and 58) at the National Gallery on 5 April 1826: Owen and Blayney Brown 1988, p. 215.

10. Described in the exhibition handlist as 'Landscape with Figures'. Since Beaumont was so attached to NG 61, the picture exhibited in 1816 at the British Institution seems more likely to have been NG 58 or NG 55. It could not have been *Landscape with Narcissus and Echo* (NG 19) because the anonymous author of *A Catalogue Raisonné of the Pictures Now exhibiting in Pall Mall, Part Second*, London 1816, wrote in connection with the exhibited pictures: '...we are disposed to ask why...the owner of this picture has withheld his leathern sun-set, wherein Narcissus has all the graces of a clodhopper, and Echo is so characteristically made to look the image of a Q-in-a-corner' (p. 19). The subject of NG 55 was surely too well known to have been described simply as 'Landscape with figures'.

11. Note in NG dossier by M. Wilson dated 11 April 1984.

12. For the intermediate provenance, see Roethlisberger 1961, p. 269.

13. Letter in NG dossier of 14 October 1972 from M.E. Petersen, Fine Arts Gallery of San Diego, Ca.

14. *Report of the Select Committee on the National Gallery*, London 1853, para. 5072.

15. Farington's diary entry for 29 May 1800 records, 'Sir George Beaumont I called on this morning – Constable copying small upright Claude.' (*The Diary of Joseph Farington*, vol. 4, p. 1399). See also Leslie 1845, p. 10, for an undated letter from Constable to John Dunthorne expressing his hope 'to go on with my copy from Sir George Beaumont's little Claude'. The letter may have been written in the spring of 1800: see *John Constable's Correspondence*, II, ed. R.B. Beckett, Ipswich 1964, p. 23.

16. The anonymous author of the accompanying text (John Landseer?) recognised the subject as more probably intended to represent Hagar and the Angel.

17. But called *Agar dans le desert* by Charles Blanc in the text (p. 15).

18. *Report of the Select Committee on the National Gallery*, London 1853, para. 3025.

19. Ibid., para. 5080.

20. Letter of 9 June 1853 printed and translated in *Report of the Select Committee on the National Gallery*, London 1853, pp. 784–7.

21. The others are Roethlisberger 1961, nos 133, 140, 174.

22. See Roethlisberger 1961, p. 67.

23. Roethlisberger 1961, p. 268; and M. Roethlisberger, 'The Subjects of Claude Lorrain's Paintings', *GBA*, 55 (1960), pp. 209–24, at p. 218.

24. It does not appear, *pace* Roethlisberger 1961, p. 269, that this smaller arch ever existed in NG 61.

25. Davies 1957, p. 46.

26. Ottley 1832, pp. 31–2; and *Valpy's National Gallery*, pp. 41–2; and see note 16 above. Beaumont himself called the picture 'A small Hagar & Ishmael' in June 1823; NG Archive, NG5/1/1823.

27. Recognised implicitly in *Valpy's National Gallery*, pp. 39–42, where the discussions of the two pictures follow each other and the engravings appear side by side. See also Kitson 1961, 2, p. 155; Roethlisberger 1961, p. 268; and Bologna 1962, p. 243. The Domenichino was certainly in the Palazzo Colonna, Rome, in 1783 and quite possibly long before then: Levey 1971, p. 92. Jaffé noted as the main difference between the two paintings that in the Domenichino 'there is no such light-drenched atmosphere of intimate enclosure [redolent of Elsheimer]': M. Jaffé, 'The Lunettes and After: Bologna 1962', *BM*, 104, 1962, pp. 410–19 at p. 418.

28. See LV 47, 88, 92 recording paintings dating from 1639/40 to 1645. The compositional affinities between NG 61 and these other three paintings were noted by Roethlisberger (1961, p. 268).

29. See Roethlisberger 1968, p. 339.

30. *John Constable's Discourses*, compiled and annotated by R.B. Beckett, Ipswich 1970, p. 54.

31. Leslie 1845, pp. 5–6.

32. G. Reynolds, *Victoria and Albert Museum. Catalogue of The Constable Collection*, London 1973, p. 46; L. Parris and I. Fleming-Williams, *Constable*, Tate Gallery, London 1991, no. 2.

33. Parris and Fleming-Williams, op. cit., no. 169. There are numerous other references in the Claude and Constable art historical literature to the inflence of NG 61 on Constable's two paintings of Dedham Vale.

34. M. Butlin and E. Joll, *The Paintings of J.M.W. Turner. Revised Edition*, New Haven and London 1984, nos 114 and 130, exhibited respectively in 1811 and 1815.

35. Ibid., p. 94.

36. Lord Mounteagle in evidence to the Select Committee on the National Gallery: see its *Report*, cited in note 14, para. 5080.

NG 1018

Landscape with Aeneas at Delos

Oil on canvas, 99.6 × 134.3 cm

Signed and dated on the parapet: CLAU[DE.] [G]ILLE. INV.FE. [R]OM[AE]/1672, and inscribed (also on the parapet) ANIVS R[OY] S[ACERD]O[TE DI A]P[OLLO.,] ANCHISE. ENEA [ASCANVS][1] (Anius king priest of Apollo, Anchises, Aeneas, Ascanius)

Provenance
According to the inscription on LV 179, painted for 'Monsieur Dupassy le gout';[2] according to the second index to the *Liber Veritatis*[3] with 'Mr. de Viviers a Paris', presumably the Du Vivier, Officier aux Gardes Françaises, who lodged at the Arsenal, Paris;[4] in which case probably inherited by his nephew, Louis-Auguste Angran, vicomte de Fonspertuis (d.1747), since in his sale, Paris, Gersaint, 4ff. March 1748 (lot 427, 2001 livres to Barran(?));[5] in the collection of Augustin Blondel de Gagny (1695–1776), Intendant des Menus Plaisirs du Roi, of place Royale (now place des Vosges), Paris, by 1757;[6] his sale, Paris, Rémy, 10ff. December 1776 (lot 197, 9900 livres to Donjeux);[7] in the collection of Jeremiah Harman (1764?–1844), banker, of Higham House, Woodford, Essex, by 1837;[8] in his posthumous sale, Christie & Manson, 18 May 1844 (lot 115, £1837 10s. to Nieuwenhuys);[9] in the collection of Edmund Higginson (d.1871) of Saltmarshe, Herefordshire,[10] by 1846 when offered in his sale, Christie & Manson, 6 June 1846 (lot 222, bought in at 1200 guineas);[11] his sale, Christie, Manson & Woods, 16 June 1860 (lot 46, £892 10s. to Pearce probably for Wynn Ellis);[12] bequeathed by Wynn Ellis (1790–1875) of Cadogan Place, London, and Whitstable, Kent, in 1876.[13]

Exhibitions
London 1994, NG, *Claude. The Poetic Landscape* (53); Tokyo 1998, The National Musuem of Western Art, *Claude Lorrain and the Ideal Landscape.* (58).

Related Works
DRAWINGS (by Claude)
(1) Norfolk, Holkham Hall, Viscount Coke (MRD 1039). Inscribed bottom left: *Claudio fecit 1670*;
(2) Amsterdam, Rijksmuseum (inv. no. RP-T-1965-290) (MRD 1040);
(3) Private collection (MRD 1041). Inscribed: *Claudio I.V. fecit Roma*;
(4) Rome, Gabinetto Nazionale delle Stampe (no. 125, 304; MRD 1042). Inscribed below the figures: *Ascanio Enea Anchise Re Anius*;[14]
(5) Boston, Brandegee collection (MRD 1043). Said to be inscribed below the parapet: *Roma / 1672*; below the bridge: *Claudio G. inventore*; and at the bottom: ... *Anius ... Apolon al tempio di Delphes Anchise Enea*.... Probably a ricordo of, rather than a study for, NG 1018;[15]
(6) London, British Museum, no. 185 (MRD 1044; Kitson 1978, no. 179), LV 179. Signed bottom left: *CLAVDIO IV*

ROMA, and inscribed on the verso: *tablaux faict pour /monsieur Dupassy le gout*, and on another occasion: *Roma Claudio IV.F.*

Technical Notes
In good condition except for the upper part of the sky, which has suffered some losses, and there is some wear to the principal figures and to the area just above them. A thin strip along the right edge has been retouched. There has been some blanching of the greens. The primary support is a fine twill canvas, last relined in 1984. A photograph was taken at that time of the back of the canvas, and no marks or inscriptions are discernible. The stretcher is older than the lining, but still twentieth century and marked 232 at the top. NG 1018 was last cleaned and retouched in 1984.

Some pentimenti are visible to the naked eye: there was once a small tree or bush at lower left; the position of Aeneas' spear and of Anchises' staff has been changed; the tree at the left was originally painted some 4 cm further to the right. NG 1018 has a double ground: the lower layer is a fairly standard composition for a red-brown ground, being a mixture of iron oxide pigment, lead white, carbon black and some translucent material, probably calcium carbonate or silica. The upper layer is pinkish grey made up of a mixture of lead white, charcoal and very finely ground particles of vermilion or red ferric oxide. Similar double grounds have been found in NG 5, 6 and 14, and in the Dulwich *Landscape with Jacob, Laban and his Daughters* and the Ashmolean's *Landscape with Ascanius shooting the Stag of Silvia*, suggesting that their use by Claude was general from the 1640s until the end of his career.

The subject is based on Virgil's *Aeneid* (III: 73ff.) and Ovid's *Metamorphoses* (VI: 335 and XIII: 630ff.) Fleeing from Troy, Aeneas put to sea with his father, Anchises, and his son, Ascanius. When they reached Delos, an island sacred to Apollo, they were greeted by its king, Anius, who showed them the landmarks of the city, including Apollo's temple, of which Anius was the priest. The principal figures standing on the balustrade are, from left to right, Anius,[16] Anchises, Aeneas and Ascanius. In the central middle ground are an olive and a palm, the two trees sacred to Apollo. Claude, or his patron, consulted both Virgil's and Ovid's texts closely. Virgil describes Anius as having 'his brows bound with fillets and hallowed laurel' (*Aeneid*, III: 81) and how he 'meets us, and in Anchises finds an old friend' (III: 82).[17] But it is Ovid who writes of the palm and the olive to which the Titaness, Latona (Leto), had clung when giving birth to Apollo and his twin sister, Diana (Artemis) (*Metamorphoses*, VI: 335–6), and describes how Anius, as Claude depicts, showed Aeneas and Ascanius 'his city, the new-erected shrines and the two sacred trees beneath which Latona had once brought forth her children' (*Metamorphoses*, XIII: 634–5).[18] Ovid also describes Anius' head as 'bound with snowy fillets' (XIII: 643).[19] Here, however, Claude prefers Virgil's description of the priest-king, and Claude's description of Anius on the painting as 'Sacerdote di Apollo' is close to the Italian translation of the *Aeneid*

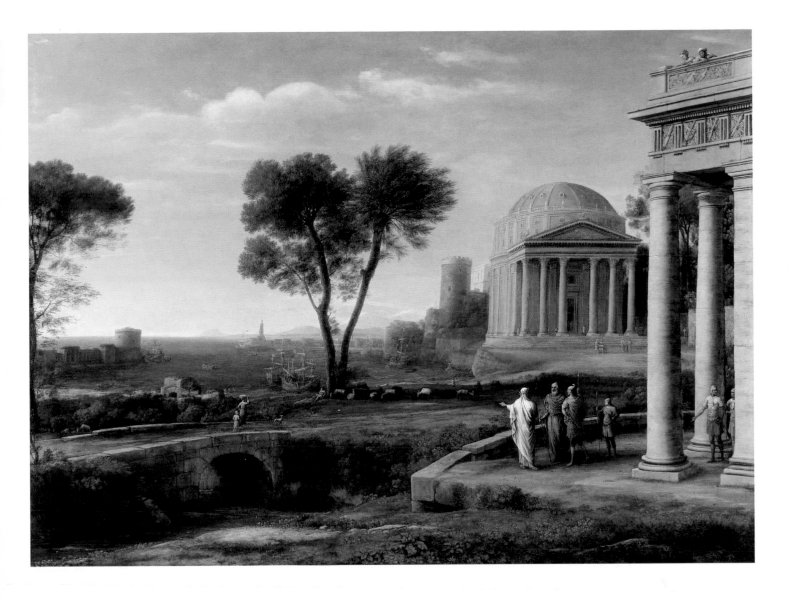

Fig. 1 Detail of the architecture.

which he is known to have used in the year NG 1018 was painted.[20] A detail of the architecture at top right (fig. 1) is derived from neither Virgil nor Ovid but from Pausanias' *Description of Greece* (III: 18, 15). Referring to the throne of an unknown king of Lacedaemon, Pausanias describes the numerous reliefs with which it was decorated, including one in which Apollo and Artemis are shooting with arrows the giant Tityus for having, as related by Hyginus (*Fabulae*, 55), attempted to rape Latona, their mother.

The oracular prophecy of Apollo, related by both Ovid and Virgil, that Aeneas and his companions would find a permanent home in Italy, is alluded to by the temple in the background – its architecture is a variation of the Pantheon in Rome,[21] and the golden eagles at the corners of the pediment may allude to Apollo's father, Jupiter,[22] and to the Roman Empire. In the absence of further information about the patron, it is not possible to say what, if any, significance this episode from the story of Aeneas, which was a prelude to Apollo's oracular prophecy, may have had for him. It is perhaps worth observing that this is a rare, if not unique, subject in Baroque art,[23] and that of the six scenes from the story of Aeneas illustrated by Claude during the last decade of his life this is the only one painted for a French patron.[24]

As preliminary drawings show (see Related Works: Drawings (2), (3) and (4) above), Claude first conceived the composition in reverse and in terms like that of his immediately preceding painting, *Landscape with Bacchus at the Palace*

of Staphylus (Rome, Rospigliosi-Pallavicini collection), painted in 1672 for Lorenzo Onofrio Colonna and recorded in LV 178.[25] In certain respects these drawings can be related back to drawings connected with NG 30, in particular MRD 454 (fig. 3) of *c.*1640 with which MRD 1042 (fig. 2), drawn over thirty years later, shares a number of elements: architecture at the left receding in depth towards the centre of the picture, figures on a platform in front of the foremost building, a harbour at the centre, and a building inspired by the Pantheon (although in MRD 454 it appears on a smaller scale and on the right-hand side).[26] Claude then reversed the composition. No pendant for NG 1018 has been identified, but possibly Claude's patron had it in mind as a pendant for a 'left-handed' picture by Claude, or by another artist, which he already owned. At all events the reversal of the composition occurred no later than at the point of the making of MRD 1043 (if indeed this drawing precedes the painting) which is inscribed with the date 1672,[27] and reverted to another much earlier composition, namely *Coast View with Mercury and Aglauros* (Rome, Rospigliosi-Pallavicini collection; fig. 4), recorded in LV 70. From this Claude adapted the curved parapet before a temple at the right overlooking a harbour. That drawing would have been relatively fresh in the artist's mind, since in 1667–8 he had made near copies of it in preparation for an etching by Dominique Barrière.[28] He adapted from LV 178 a low stone bridge in the foreground (and perhaps reutilised in this respect LV 119, the record of *View of Delphi*

Fig. 2 *Aeneas at Delos*, 1670–2. Chalk, brown pen, grey wash on greyish-green tinted paper, 31.2 varying to 31.6 × 43.4 cm. Rome, Istituto Nazionale per la Grafica, Gabinetto Nazionale delle Stampe.

Fig. 3 *Seaport*, c.1640. Pen, 18.5 × 26.4 cm. Private collection.

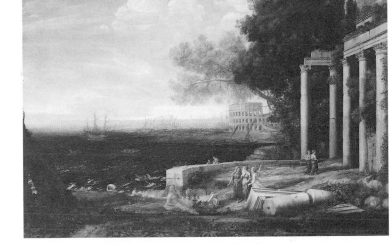

Fig. 4 *Coast View with Mercury and Aglauros*, 1643. Oil on canvas, 96.5 × 123.5 cm. Rome, Rospigliosi-Pallavicini Collection.

with a Procession (see p. 68, fig. 3) which has a Pantheon-like structure at the right), gave added emphasis to the 'Pantheon', which here looks more like the Roman original,[29] and differentiated between the foliage of the two trees at the centre, which according to Ovid were an olive and a palm (see above). However, neither in this drawing nor in NG 1018 do the trees look much like an olive and a palm, and Claude may have done no more than rely for these motifs on an earlier drawing of a pastoral landscape (fig. 5) (see Related Works: Drawings (1)).

The composition of NG 1018 as a whole has been proposed as an example of a perspective system using a scheme of bifocal construction with vanishing points located to the left and right of the canvas;[30] and of a sharing of a compositional language with the world of the stage: 'foreground platforms for the actors, lateral framings, a clear succession of planes arranged parallel to the picture surface (there are no roads leading towards the viewer), and open views to the distance.'[31] At all events, elements of the composition of NG 1018, including a Pantheon-like temple, were to reappear in Claude's *View of Carthage with Dido and Aeneas* (Hamburg, Kunsthalle) painted some four years later.

General References

Smith 1837, no. 179; Davies 1957, pp. 47–8; Roethlisberger 1961, no. 179; Roethlisberger 1975, no. 255; Kitson 1978, pp. 164–5; Wright 1985b, p. 96.

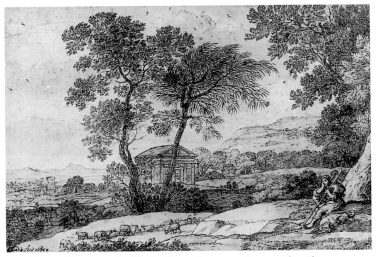

Fig. 5 *Pastoral Landscape*, 1670. Chalk, pen, brown and grey wash with some heightening, 25.6 × 39.2 cm. Norfolk, Holkham Hall.

1. Davies recorded the inscription and signature as ANIVS ROY. SACER[D]OTE [DI] APOLLO., ANCHISE, ENEA. .CLAUDE.GILLE.INV.FE.ROMAE./1672, noting at the time 'several of the letters run together, and very faint in parts', and 'The inscriptions are probably retouched; the picture has been cleaned since the [1946] edition of this catalogue and a little not then read has now been deciphered, but the name of ASCAN(i)VS, recorded then on the parapet, is no longer legible' (Davies 1957, p. 47). From the photographic records it is unclear how Davies deciphered as much as he did, and it seems from a colour transparency of a detail of NG 1018 taken in 1982 that the inscription appeared then as it does now (fig. 6). The 'T' of 'SACERDOTE', scarcely visible to the naked eye, is confirmed by examination under ultra-violet light, and 'ENEA' is visible only under such light.

2. This individual has defied identification. As Davies noted (Davies 1957, p. 48, no. 4), he may have been a member of the family Le Gouz, seigneurs du Plessix, recorded in De La Chenaye and Badier, *Dictionnaire de la noblesse*, 3rd edn, Paris 1863–76, vol. 9, cols. 564–70. As Anne Thackray has pointed out (note in NG dossier), the best-known member of the family in the seventeenth century was François Le Gouz, who, like Aeneas, was a great traveller, but he could not have commissioned NG 1018 since he died in 1664 in Ispahan. Roethlisberger (1961, p. 422) has proposed François du Plessis, seigneur du Mée, who married Marguerite de Gouys in 1633 or 1639 and was maintained in the nobility in 1667: De La Chenaye and Badier, op. cit., vol.15, col. 934, and subsequently (Roethlisberger 1968, p. 384) Henri du Plessis-Guénégaud (1609–76); Jacob Spon records a 'Commandeur de Gotz' (or de Gost or de Gaults) as a collector of pictures living in rue des Petits-Champs, Paris: *Recherche des antiquités et curiosités de la ville de Lyon ... avec un mémoire des principaux antiquaires et curieux de l'Europe*, Lyon 1676, p. 214. De Gotz's inventory has not been found (Schnapper 1994, p. 17), and anyway his name is rather distant from that recorded by Claude.

The first index to the *Liber Veritatis*, probably compiled soon after Claude's death from his inscription on the back of the *Liber* drawings, calls the patron of NG 1018 'Mr. Legut': Kitson 1978, p. 178 and photograph (unpaginated). The last page of the first index is a fair copy, replacing a torn original, and so possibly quite late, as Michael Kitson pointed out to me in conversation, suggesting that this may have caused the patron's name to be further distorted.

3. Compiled between about 1716 and the early 1720s: Kitson 1978, p.178.

4. Brice 1698, vol. 1, p. 376, and 2 vols, 1706, vol. 1, pp. 465–6, according to whom Du Vivier owned 'tableaux de prix, ... porcelaines rares, ... bronzes des meilleurs Maîtres, ... pagodes des plus bizarres & des plus monstrueuses, ... pendules travaillées avec Art & placées tres-à propos'. Du Vivier was the uncle of Angran de Fonspertuis, who inherited Du Vivier's taste for porcelain: see

E.F. Gersaint, *Catalogue raisonné des bijoux, porcelaines ... provenans de la Succession de M.ANGRAN, Vicomte de Fonspertuis*, Paris 1747, pp. v–vi. Angran's mother on the other hand had been a devout Jansenist (*DBF*, vol. 2, 1936, col. 1234) and so may have been outraged by her son's extravagant taste.

5. Lot 427 was described as measuring 37 pouces high by 50 pouces wide – that is, about 100×135 cm: E.F. Gersaint, cited in note 4, p. 189. It was sold separately from the slightly larger *Landscape with the Judgement of Paris* by Claude, comprising the immediately preceding lot, although they probably hung as pendants in the Fonspertuis collection: Gersaint, pp. 188, 192. Gersaint correctly identified the figures of Anchises and Aeneas in NG 1018, but identified the priest as Helenus, son of Priam, and the subject as the episode from the *Aeneid*, Book III, when Helenus addresses Aeneas: 'Voici cette terre d'Ausonie que vous avez tant desirée : mettez promptement à la voile pour y aborder.' (Gersaint, pp. 190–1). This partial misidentification suggests that Claude's inscription on the picture was difficult to read even then.

Davies read the buyer's name as d'Arras (Davies 1957, p. 48), but by comparison with the name D'Argenson written in the same hand by lot 424, the final letter of the buyer's name for NG 1018 is more likely to be 'n'. The initial letter is more likely to be 'b' than 'd'. 'Basan', the name of a prominent eighteenth-century Paris engraver and print dealer, is not a possible reading.

6. Recorded in the 'deuxième cabinet' and with the subject 'Antenor, qui montre à Enée qu'il doit tenir pour arriver en Italie', Dezallier d'Argenville, *Voyage pittoresque de Paris*, 3 vols, Paris 1757 edn, p. 280. In the 1765 edition of the *Voyage pittoresque* Dezallier described the subject as 'Helenus qui montre à Enée la route qu'il doit tenir pour arriver en Italie' (pp. 132–3). The latter description of the subject of NG 1018 was retained until Davies's 1946 catalogue. For Blondel de Gagny, see L. Clément de Ris, *Les Amateurs d'autrefois*, Paris 1877, pp. 343–58. He moved from the place Royale to the place Louis-le-Grand (now place Vendôme) in 1758: J. Proust-Perrault, 'No. 10 Hôtel Chastillon', *De la place Royale à la place des Vosges*, Paris 1996, pp. 324–30 at p. 328.

7. Described as 'Un autre paysage, dans lequel est représenté Enée arrivant avec Anchise son père, on les voit auprès du Temple, dans lequel Helenus vient de faire un sacrifice aux Dieux. La flotte Troyenne s'apperçoit à la rade dans l'éloignement ... 37 pouces de hauteur, sur 50 pouces de largeur. Il a appartenu à Madame la Comtesse de Verrue, & à M. de Fonspertuis.' No painting clearly identifiable with NG 1018 can be identified in the comtesse de Verrue's posthumous sale of 27ff. March 1737. One of the Claudes in that sale to which it could correspond would be that one of the pair comprising lot 73 and described simply 'une marine'. But this is scarcely likely since the other part of the pair is the considerably smaller (56×72 cm) *View of the Campo Vaccino* in the Louvre (Roethlisberger 1961, pp. 111–13). The only

other candidate is one of another pair comprising lot 85 (or lot 86?) described in a manuscript catalogue as 'Deux grands Tableaux de Claude Gelée dit le Lorrain representant un paysage et une Marine acheté par Godefroy pour l'Angleterre ... 8007 livres', but these are surely the Radnor paintings, *Pastoral Landscape with the Arch of Titus* and *Seacoast with the Landing of Aeneas in Latium* (Roethlisberger 1961, pp. 233, 301). It is this last with which Rémy may have confused NG 1018. Although the comtesse de Verrue (1670–1736) may have sold paintings in her lifetime, she had no need to and seems to have been an avid collector: B. Scott, 'The Comtesse de Verrue. A Lover of Dutch and Flemish art', *Apollo*, 97, 1973, pp. 20–4 at pp. 20–1. *Pace* Scott (p.23), it is improbable that the comtesse de Verrue ever owned NG 1018.

Vincent Donjeux and his son were dealers in pictures. It was presumably the former who bought NG 1018 at the Blondel de Gagny sale, but whether for himself or a client is unknown. Vincent Donjeux's posthumous sale took place in Paris on 29ff. April 1793. No painting corresponding to NG 1018 was included.

8. According to Smith 1837, p. 293. Smith also says that NG 1018 was in the Henry Hope sale of 1816, where it was sold for £260. Henry W. Hope (1736–1811) was a merchant based in Amsterdam until 1794 when he came to England with his family and their collection of pictures. A Claude was sold for £267 15s. in his posthumous sale of 6 April 1811, but from its description is clearly not NG 1018. The only picture which could correspond to NG 1018 was lot 87 of the Hope sale of 29 June 1816, described as 'A Sea-port, evening, the companion [to lot 86, A.Landscape, Morning]', which sold for £273 to Norton: *Index of Paintings Sold*, vol. 3, part 1, pp. 10, 274, and vol. 4, part 1, p. 253. This seems far too weak a description for the auctioneer, Christie's, to have applied to a painting whose subject had been identified (albeit wrongly) and which had been in collections as well known as those of Blondel de Gagny and (allegedly) the comtesse de Verrue, information which, if it had been lost in 1816, had all resurfaced by 1837 when Smith published his account of NG 1018.

Harman was consulted on banking matters by, among others, Lord Liverpool, one of the National Gallery's original trustees: Ward 1885, p. 399. It was Harman who in 1810 gave Charles Lock Eastlake, later to become Director of the National Gallery, his first commission for a picture: *DNB*, vol. 6, p. 330.

9. Described as 'Aeneas, with his Father and Son, visiting Helenus, at Delos'. A manuscript note in the copy of the catalogue in the NG Library reads: 'Afterwards in the Collection of E. Higginson Esq. At whose sale it was Bot in for £1260.0.0.' According to 'Nemo', 'La vente des tableaux de M. *Harmans* avait attiré un grand concours d'illustres de tous genres. Dès le matin, le duc de Cleveland, sir Robert Peel, les lords Grosvenor, Hawarden, Radstock et Normanton, la duchesse de Sutherland et un grand nombre d'autres personages distingués, étaient venus visiter l'exposition...

Trois noms surtout ont été distingués, REYNOLDS, HOBBEMA, CLAUDE LORRAIN... Nous ignorons le nom de l'acquéreur du Claude qui s'est vendu 42,500 fr.': 'Ventes Publiques. Angleterre', *Le Cabinet de l'Amateur et de l'Antiquitaire*, vol. 3, 1844, pp. 204–8 at p. 212.

Christian Johannes Nieuwenhuys (1799–1862), art critic and dealer, lived in London, where he was visited by Passavant (Passavant 1836, vol. 1, pp. 256–8). Nieuwenhuys published a description of the collection of paintings of William II of the Netherlands (Brussels 1843).

10. Edmund Barneby assumed the name Higginson on being left the estates of his great uncle, William Higginson, a London merchant, who erected Saltmarshe Castle (now demolished) early in the nineteenth century: [Murray's] *Handbook for Travellers in Worcestershire and Herefordshire*, 4th edn, London 1894, p. 155.

11. Described in this sale as 'Aeneas with his Father and Son, visiting Helenus at Delos'.

12. Described as in Higginson's 1846 sale, and as 'canvas; 37 inches by 50'.

13. For Wynn Ellis, silk importer and Liberal MP, see *Illustrated London News*, 8 January 1876, and Ivan Gaskell in *National Gallery Master Paintings from the Collection of Wynn Ellis of Whitstable*, Canterbury Museum, 1990–1 (n.p.); according to Gaskell the London dealer Pearce acted regularly on Ellis's behalf at the London auction sales. Ellis had houses at Ponsbourne Park, near Hatfield, Tankerton Tower (now called Whitstable Castle), Whitstable, and 30 Cadogan Place, London. Waagen (1854, vol. 2, pp. 293–8) visited his collection in London in 1835 and in 1850 or 1851. It was probably at Cadogan Place that NG 1018 was hung: *January 1876 / The Wynne Ellis Gift /*

number of pictures, NG Archives, NG5 / 484 / 1876. On his later visit Waagen noted five paintings by Claude, including 'A seaport, of his middle period, very transparent and light, and of admirable solidity of execution'. It was probably this painting, rather than NG 1018, which Ellis lent to the British Institution in 1862, no. 29, as Roethlisberger (1961, p. 424, n. 8) suggested. No. 29 of the 1862 exhibition was exhibited as 'An Italian Seaport', but NG 1018, had it been exhibited, would surely have borne the title which it had by then been repeatedly called, namely 'Aeneas with his Father and Son visiting Helenus on Delos' or suchlike.

14. This drawing has been dated *c.*1672/3 by Niemeijer 1965, pp. 41–4, but there seems no reason to depart from Roethlisberger's dating of 1670–2. The height of the drawing varies between 31.2 and 31.6 cm.

15. See Kitson 1978, pp. 164–5.

16. This was first observed by Davies (1946, pp. 27–8) by reference to the inscription on the painting. The priest had up until then often been called Helenus, making the subject 'Aeneas on Epirus' (*Aeneid*, III: 294ff.). Davies's observation is in any event confirmed by the inscriptions on MRD 1042 and 1043 (see Related Works: Drawings (4) and (5) above).

17. Trans. H. Rushton Fairclough, Loeb edn, Cambridge, Mass., and London 1974.

18. Trans. F.J. Miller, Loeb edn., Cambridge, Mass., and London 1966.

19. Ibid.

20. See Wine in London 1994, p. 47 and p. 59, n. 100.

21. I.G. Kennedy has suggested that the pilaster articulation of the walls of Claude's building may be a reference to Palladio's reconstruction of the Pantheon as in *Quattro*

Libri, IV, ch. xx: Kennedy 1972, pp. 260–83 at p. 267.

22. As suggested by Kennedy 1972, p. 267, n. 31.

23. Roethlisberger (1961, p. 421) claims that although the story of Aeneas is a frequent source of Baroque painting, none of the scenes painted by Claude has ever been illustrated by another artist.

24. For a brief discussion of the various uses to which the character of Aeneas was put in the seventeenth century, see Wine in London 1994, p. 47.

25. For earlier works having a similar composition, see Roethlisberger 1968, p. 384.

26. See Roethlisberger 1968, p. 385, on this. He has also seen MRD 816 as anticipating elements of NG 1018, and noted that figures like the standing soldier in MRD 1025v. appear in various of Claude's late paintings, including NG 1018, but the connection he makes between the painting and MRD 997 (Roethlisberger 1971, p. 31) is more tenuous.

27. MRD 1043 may well be after LV 179 as Roethlisberger (1968, p. 385), Kitson (1978, pp. 164–5) and Niemeijer (1963) have pointed out.

28. Kitson 1978, p. 96. See also Whiteley 1998, p. 152, for discussion of a drawing copied by Claude from LV 70.

29. Kitson (1978, p. 164) has noted the use of a similar building in *Landscape with the Nymph Egeria mourning over Numa* (Naples, Museo Nazionale, Capodimonte), painted in 1669 for Lorenzo Onofrio Colonna and recorded in LV 175.

30. Damisch 1984, at pp. 32–3.

31. Roethlisberger 1984b, pp. 47–65 at pp. 58–9.

Fig. 6 Detail of inscription, photographed in 1982.

A View in Rome

Oil on canvas, 60.3 × 84.0 cm

Signed and dated bottom right on the base of the fallen capital:
CLAVDE. [..]/ROM[..]1632

Provenance

Probably in the collection of Sir Gregory Page (1685–1775) of
Blackheath, Kent, by 1761;[1] presumably bought by van
Heythusen with the Page collection c.1781,[2] or by 1783 when
the rest of that collection was sold;[3] probably purchased from
van Heythusen by Noel Joesph Desenfans (1745–1807) and
offered for sale by him by private contract at 125 Pall Mall,
London, 8ff. April 1786, no. 71,[4] and similarly 8ff. June 1786,
no. 255;[5] if so, Desenfans's sale, Christie's, 17 July 1786 (lot
19);[6] Edward Coxe sale, London, Peter Coxe, 24 April 1807
(lot 56, £105 to Lord Grey or Lord Hampden);[7] in the collection
of Thomas, 2nd Viscount Hampden (1746–1824), of Green
Street, Mayfair, and Glynde, Sussex, from whom, or from
whose estate, acquired by Cesare Ambrogio San Martino,
Count d'Aglié (1770–1847), Sardinian ambassador to London
1812–37, by 1828;[8] sold by his son(?) Count St Martin
d'Aglié, Turin, to the National Gallery for £175 in 1890.

Exhibitions

London 1828, BI (168) (loaned by Count d'Aglié); London
1838, BI (136) (loaned by Count St Martin d'Aglié); Sheffield
1934–5, Graves Art Gallery, long-term loan; London 1938–41,
10 Downing Street, long-term loan; Newcastle and London
1969, Laing Art Gallery and Hayward Gallery, *The Art of
Claude Lorrain* (4); Coventry, Derby, Doncaster and Bath 1982,
p. 30; London 1994, NG, *Claude. The Poetic Landscape* (4).

Related Works

DRAWINGS (by Claude)
(1) St Petersburg, Hermitage Museum, inv. no. 7134 (fig. 1)
(MRD 48r). A view of Santa Trinità de' Monti, presumably
preparatory to NG 1319;[9]
(2) Cambridge, Fitzwilliam Museum, inv. no. 2921 (fig. 3)
(MRD 47). Probably preparatory for another painting,[10] but
the right-hand side of the drawing may have also been used
for the right-hand side of NG 1319;
(3) By Claude? whereabouts unknown (MRD 1145).

Technical Notes

Considerable wear, some blanching at lower right and in the
foliage, discoloured retouches, and darkening of the shadows.
There is a vertical tear to the left of the twin towers of Santa
Trinità de' Monti, and another smaller one a little to the left
of the leftmost column. The buff-coloured ground is showing
through some of the foliage of the principal tree. The primary
support is a coarse plain-weave canvas, certainly coarser than
Claude's other canvases in the Gallery, but possibly reflecting
the early date of NG 1319. The painting was last lined in
1891; it was last fully restored in 1956. The stretcher is

nineteenth century and bears a partly illegible label: '... & Sons
Ltd./ ... ckers Frame makers/ A68392 17&18 Nassau Street,
Mortimer Street, W. /Phones:– Museum 1871 & 7588.' An
X-radiograph (detail fig. 2) shows that there was originally
another woman standing behind the seated woman. It also
seems that the *veduta* background originally extended as far
as the temple at the right, and that the tree was painted over
it. It is not clear what the shape at the bottom right of the X-
radiograph detail is – possibly the fallen capital was originally
shown lying flat like a table, rather than, as now, on its side.

The distant view is of the sixteenth-century church of
Santa Trinità de' Monti (where Claude would be buried)
and of the adjacent convent of the Sacro Cuore (before the
Spanish Steps were built in the eighteenth century).[11] To the
right is the Palazzo Zuccari and, on the horizon, the Quirinal
Palace. This viewpoint may well be from the top of Claude's
house on the corner of Via Margutta and Via del Babuino (now
Via Paolina).[12] The right half of the picture is an imaginary
view, at least in the sense that, if such a temple and statue of
Apollo existed, they did not exist there. It has been proposed
that the combination of the real and imaginary had their
origin in the type of Roman view produced by William van
Nieulandt II (1584–1635?), the Antwerp-born landscape
painter and printmaker who was in Rome from 1601/2 to
1604.[13] Claude often used the pictorial formula of a temple
before a screen of trees to close off one side of his compos-
ition.[14] A statue on a pedestal, as on the right of NG 1319, is
less usual (at least on this scale), but one may be found in
an early drawing by Claude in the Royal Collection (MRD24).
The scene of prostitution in the foreground (once interpreted
as a peasant woman receiving alms[15]) is unique in Claude's
paintings, and may well have contributed to the doubts
formerly expressed about the authenticity of NG 1319.[16] Its
placement in the shadow of a ruined pagan temple may have
been intended as a deliberately symbolic contrast with the
Trinità de' Monti bathed in light.[17]

At the time of the negotiation for the purchase of the
picture, it seems that Sir Frederic William Burton, then director
of the Gallery, expressed doubts to the vendor as to whether it
was by Claude or by Swaneveldt.[18] Nevertheless, the painting
entered the Gallery's collection as by Claude.[19] It was catalogued
as 'Ascribed to Claude' in 1929,[20] an attribution retained by
Davies in 1946.[21] The doubts which he then expressed had
perhaps been reinforced by Walter Friedländer's opinion that
NG 1319 was not an early Claude,[22] and in his 1957 catalogue
Davies remained doubtful in spite of the signature and date
revealed by then recent cleaning.[23] Roethlisberger regarded
the picture as 'certainly genuine', but doubted whether the
figures were by Claude,[24] later, however, he seemed to accept
the entire picture as authentic,[25] before again suggesting that
the figures were by another hand.[26] Kitson has also accepted
the picture as by Claude while expressing some reservations
about the figures, some of which (especially the old woman) he
saw as close to the work of Pieter van Laer and his followers.[27]

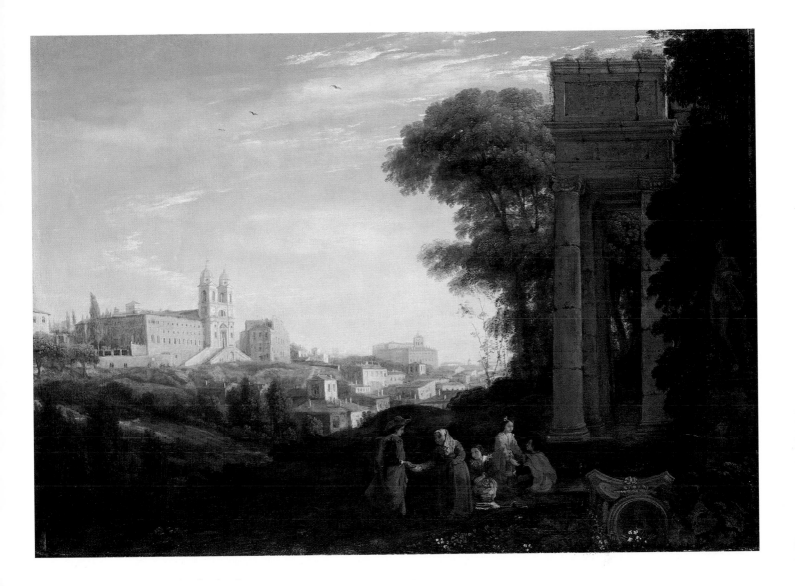

Fig. 1 *View of Santa Trinità de' Monti*, 1632. Pen and brown wash, 14 × 20.5 cm. St Petersburg, Hermitage Museum.

Although Baldinucci relates that Claude farmed out his figures to another, usually Filippo Lauri, Lauri would have been too young to collaborate on a picture of the early 1630s.[28] Indeed, there would appear to be relatively few paintings by Claude in which the figures are not by him,[29] and what is noticeable about those is that the figures have a solidity and poise not usually shared by Claude's own. The genre figures in NG 1319, however, have just that awkwardness and naivety which one might expect of Claude, and which are apparent, for example, on the verso of the Hermitage drawing.[30] Additionally, the X-radiograph (fig. 2) shows changes to the figure group, the landscape and the fallen capital, which would have entailed a rather complicated process of continual adjustment if the canvas had to go back and forth between Claude and his collaborator, a process probably not justified by the size, subject or (then) likely value of the picture. For these reasons NG 1319 may be regarded as entirely autograph.

The topographical nature of the left-hand side of NG 1319, relatively unusual in Claude's painted work,[31] and the relatively broad brush with which he has painted the buildings, have led to speculation that that part of the picture may have been painted direct from nature.[32] Although the existence of a preparatory drawing, that in St Petersburg (fig. 1), may indicate that NG 1319 was painted in the studio, the most significant difference between the painting and the drawing is the relative closeness of the church to the picture plane in the latter, suggesting that there was no direct transportation from drawing to painting. The drawing may, rather, have been a study of the architecture of the individual buildings and of the distance relationships between them in which the study of light is incidental. Such a drawing may well have been a necessary prelude to a painted study from nature, in which, as in NG 1319, the effects of light and broad shapes seem to have been rapidly recorded, the architectural minutiae having already been worked out in the drawing. Certainly the strong midday light in the painting[33] is not apparent in the drawing, nor the specificity with which the shadow is cast on the roof of the church nave by the superstructure of the portico. This part of NG 1319 has a stronger claim than NG 58 to have been painted from nature, but the question cannot be finally resolved. In any event, the influence of other artists is apparent in NG 1319, namely that of Willem van Nieulandt II for the combination of the real and the imaginary,[34] Agostino Tassi possibly for the insertion of a *bamboccesque* scene in a warm Italian landscape,[35] and Cornelis van Poelenburgh for the effects of light.[36]

General References

Smith 1837, no. 380; Davies 1946, pp. 28–9; Davies 1957, p. 49; Roethlisberger 1961, no. 214; Roethlisberger 1975, no. 29; Wright 1985b, p. 96.

Fig. 2 X-ray detail.

Fig. 3 *Coast View*, 1630. Pen and brown wash, 18.2 × 26.5 cm. Cambridge, Fitzwilliam Museum. Reproduced by permission of the Syndics of the Fitzwilliam Museum.

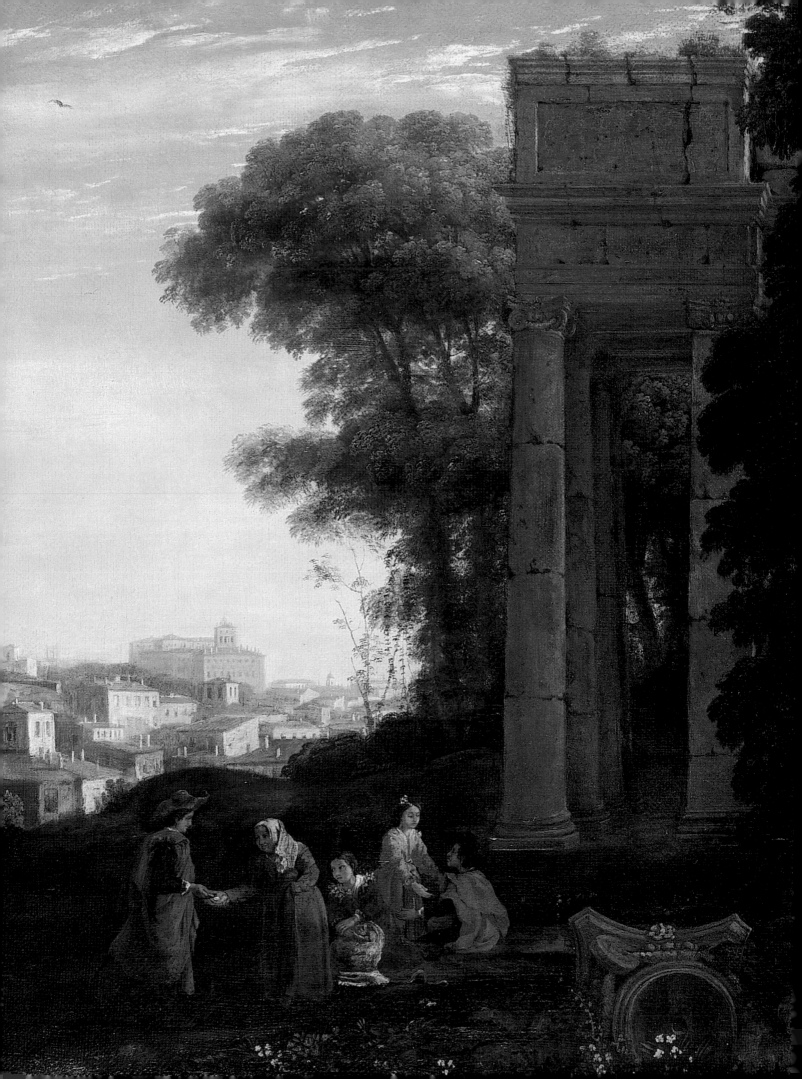

NOTES

1. According to the sale catalogue of Edward Coxe, for which see note 7 below, the painting was in Page's collection. There seems no reason to doubt this, nor that NG 1319 may be identified as that described as 'A landskip with figures [Height] 2 0 [Breadth] 2 9 [Painted by] Claude Lorrain' in the catalogue of Page's collection in *London and its Environs described...*, 6 vols, London 1761, vol. 1, pp. 315–22 at p. 317. There is a description of Page's mansion at pp. 313–14 and an engraving of it facing p. 314. It had been built soon after 1721 and dismantled in 1787: see Pevsner 1952, p. 159. The description of Page's mansion and its collection of pictures (including the Claude) is repeated in *The Ambulator; or, the Stranger's Companion in a Tour Round London*, London 1774, pp. 14–17. See also *The English Connoisseur*, 2 vols, London 1766, vol. 2, p. 92, and the anon. MS in the Frick Library (1765ff.) referred to by Roethlisberger 1961, p. 478. For Sir Gregory Page, see J. Burke and J.B. Burke, *A Genealogical and Heraldic History of the Extinct and Dormant Baronetcies of England*, London 1838, p. 395, and *Complete Baronetage*, ed. G.E. Cokayne, vol. 5, Exeter 1906, p. 24. Sir Gregory left his estates to his great nephew, Sir Gregory Turner, 3rd Baronet of Ambrosden, who thereupon changed his name to Page-Turner.

NG 1319 may have been seen by Horace Walpole in the Page collection in 1779: *Letters of Horace Walpole, Fourth Earl of Orford*, ed. Mrs Paget Toynbee, 19 vols, Oxford 1903–25, vol. 11 (1914), p. 53. In a letter of 14 November 1779 Walpole wrote to the Countess of Upper Ossory of 'a glorious Claude' at Blackheath, but would NG 1319 justify such enthusiasm on his part?

2. According to Buchanan 1824, vol. 1, p. 321, van Heythusen bought the Page collection at about the same time as he bought William Lock's Claude (NG 30), which Lock sold when he left his house in Portman Square. This Lock did in 1781 (see NG 30, note 7).

3. London, 8–9 May 1783 (no auctioneer's name given). No picture like NG 1319 was in the sale.

4. Described in the catalogue as 'Claude le Lorraine – 71 A landscape with figures – View near Rome/ 2 ft.6 by 3ft. 3, on canvas'. These measurements are some six inches longer in each direction than those of NG 1319, but a *nota bene* at the head of the catalogue states: 'The Measurements of each Picture comprehends its frame.' According to Buchanan (cited in note 2), van Heythusen, concerned that he had overinvested in paintings, sold to Desenfans some of the pictures he had bought from Lock, so a sale of some of the Page pictures to Desenfans at this time seems entirely possible. Desenfans had already held a sale on 11ff. May 1785 (Christie's). In that sale lot 14 of 14 May was 'Claude —— 14 A landscape and figures (school of)' (£2 12s. 6d. to Jenkins), and lot 59 was 'Claude le Lorraine – 59 A most capital landscape with figures' (bought in(?) to a bid of £66 from Turner). Possibly the latter was no. 71 of Desenfans's 1786 exhibition.

5. Where described as 'Claude le Lorraine – 255 A landscape with figures. view near Rome/ 2 ft.6 by 2ft. 3, on canvas'. Presumably the stated width of 2ft 3in. was a misprint for 3ft 3in.

6. Described as 'A landscape and figures, view near Rome'. Although the names of the buyers and prices paid are annotated in Christie's copy of the catalogue for the first three days of the sale (13, 14, 15 July), there are no such annotations for the final day (17 July), suggesting that it may have been cancelled. Thomas Moore Slade's account of his purchase of NG 30 (see note 10 to that entry) suggests that he bought that painting direct from Desenfans rather than at auction.

7. See *Index of Paintings Sold*, vol. 2, part 1, pp. 25, 249. Lord Hampden seems the more likely purchaser in the light of the subsequent provenance. It was not bought there by Beckford as stated in Davies 1957 and Wright 1985b.

The painting is clearly identifiable from its description in the catalogue:

Claude le Lorraine/ A celebrated Picture from the Blackheath Collection of the late Sir Gregory Page. The View representing a warm Evening, with the Church of the Trinità di Monte, (where this Painter was buried,) as the chief Object; together with the Pope's Summer Residence, and other Buildings; being a View of Monte Cavallo, and the Buildings descending to Piazza d'Espagna. The Ruins, Trees, and Figures in the Foreground are Composition. Nothing can exceed the golden hue of Light diffusing itself over the Architectural Buildings in the middle Distance, from the charming Effect of an Italian Sunshine; while the pure Atmosphere of a genial Climate, is painted with all that Knowledge and Mastership, for which this extraordinary Painter was so renowned – truly Capital. – A peculiar Incident attaches to the Picture; as Claude may be said in this Performance almost to have painted his own Monument, he having painted the Church that contains it.

8. A letter in the dossier dated 16 October 1890 from d'Aglié refers to the picture having 'passed from Lord Hampden's collection into our hands'. This certainly occurred by 1828 when NG 1319 was lent to the British Institution by Count d'Aglié. For Cesare Ambrogio San Martino, see C. Baudi di Vesme's entry in *Dizionario Biografico degli Italiani*, Rome 1960–, vol. 1 (1960).

9. The St Petersburg drawing was first published by M. Dobroklonsky, 'The Drawings of Claude Lorrain in the Hermitage', *BM*, 103, 1961, p. 395.

10. Roethlisberger 1961, no. 297.

11. Roethlisberger 1968, p. 91, has noted a similar view taken from a different angle by Wm. van Nieulandt I in 1603 (see *150 Tekeningen uit Vier Eeuwen uit de verzameling van Sir Bruce en Lady Ingram*, Rotterdam and Amsterdam 1962, no. 66).

12. Roethlisberger 1961, p. 477, and London 1961, p. 14.

13. Kennedy 1969, pp. 304–9 at p. 306, giving as an example Nieulandt's *View of Santa Maria Maggiore* of 1610 (Groningen Museum voor Stad en Lande).

14. See LV1, LV5, LV9, MRD43 and MRD 47.

15. *Descriptive and Historical Catalogue of the Pictures in The National Gallery Foreign Schools*, London 1892, p. 184. So interpreted also by E. Knab, 'Die Anfänge des Claude Lorrain', *Jahrbuch der kunsthistorischen Sammlungen in Vien*, 56, 1960, pp. 63–164 at p. 150.

16. '...the incident introduced in the foreground is not one that would recommend itself to the mind of [Claude]', E. Dillon, *Claude*, London 1905, pp. 183–4.

17. See London 1994, no. 4.

18. Letter of 15 September 1890 from Count St Martin d'Aglié in the NG dossier.

19. 1892 catalogue, cited in note15.

20. *National Gallery Trafalgar Square. Catalogue Eighty Sixth Edition*, London 1929, p. 69.

21. Davies 1946, pp. 28–9.

22. Note in the NG dossier of a letter of 2 August 1932 from Walter Friedländer.

23. Davies 1957, p. 49.

24. Roethlisberger 1961, pp. 477–8.

25. Roethlisberger 1968a, pp. 115–19 at p. 116.

26. Roethlisberger 1975, p. 88.

27. M. Kitson in London 1969, p. 14.

28. Roethlisberger 1961, p. 56, n. 15.

29. They are listed by Roethlisberger 1961, p. 5, n. 18.

30. MRD 48v. The figures in NG 1319 have been likened to those in two other early pictures by Claude, namely *The Mill* (Boston, Museum of Fine Arts), and *A Seaport at Sunset* (Detroit Institute of Arts) by H. Diane Russell in Washington 1982, p. 117.

31. Roethlisberger 1960, p. 213.

32. P. Conisbee, 'Pre-Romantic "Plein-Air" Painting', *AH*, 2, 1979, pp. 413–28 at p. 417, and by the same author, 'The Early History of Open Air Painting', *In the Light of Italy. Corot and Early Open-Air Painting*, Washington, Brooklyn and St Louis 1996–7, pp. 33–4, where Conisbee concludes that 'there are no convincing candidates as real oil studies from nature'. The most positive assertion that the view was painted by Claude from direct observation has been by L. Gowing, 'Nature and the Ideal in the Art of Claude', *AQ*, 37, no. 1, 1974, pp. 91–6 at p. 95.

33. The effects of light in NG 1319 have been compared to those in paintings by Poelenburgh: see M. Chiarini, 'Appunti sulla pittura di paesaggio a Roma tra il 1620 e il 1650', *Paragone*, 175, 1964, pp. 74–81 at p. 77.

34. See note 13 above.

35. For this suggestion, see Waddingham 1961, pp. 9–23 at p. 19.

36. See note 33 above.

A View in Rome (NG 1319), detail.

NG 6471

Landscape with Psyche outside the Palace of Cupid ('The Enchanted Castle')

1664
Oil on canvas, 87.1 × 151.3 cm

Provenance

According to the inscription on the verso of LV 162, painted for Lorenzo Onofrio Colonna (1637–89) in 1664;[1] in the possession of the Marchese Pallavicino by 1696;[2] according to the second Index to the *Liber Veritatis*, owned by 'Mr Davenant';[3] offered for sale, and possibly sold, by auction by 'Mr. D'Avenant' at an unknown date (lot 45, 46, 47 or 48);[4] apparently sold together with its pendant, *Psyche saved from drowning* (Cologne, Wallraf-Richartz Museum), by Mr Bragge, his sale, London, Prestage, 15 February 1750 (lot 71 or 72, £6 10s. and £6 6s., both to 'Dr Chauncy');[5] according to Earlom's engraving after LV 162 published in 1777, then in the collection of Nathaniel Chauncey of Castle Street, Leicester Fields, London;[6] his posthumous sale together with its pendant, Christie's, 27 March 1790 (lot 90 or 91, sold for 135 and 145 guineas respectively);[7] probably sold with its pendant by the mortgagees of Charles Alexandre de Calonne (1734–1802), formerly 'Prime Minister' of France,[8] London, Skinner & Dyke, 28 March 1795 (lot 86, 520 guineas to Bryan);[9] sold to Coxe by 7 June 1795 for about £700;[10] probably sale of Richard Troward of Pall Mall, London, Phillips, 18 April 1807 (lot 8, 1000 guineas);[11] posthumous sale of Walsh Porter (d.1809) of Argyle Street, London, Christie's, 14 April 1810 (lot 44, 900 guineas (?) to Buchanan (?));[12] bought by William Wells (1768–1847) of Redleaf Park, near Penshurst, Kent, from Buchanan for £1000 by 27 April 1810;[13] sale of the executors of William Wells deceased, Christie & Manson, 12–13 May 1848 (lot 122, £2100 to Farrer, presumably on behalf of Lord Overstone);[14] exhibited in 1851 as owned by Lord Overstone; noted by Waagen in Lord Overstone's collection at 2 Carlton Gardens, London;[15] by inheritance in 1883 to Harriet Sarah, Lady Wantage (d.1920), of Lockinge, near Wantage, Berks, and thence to A.T. Loyd;[16] recorded at Lockinge in 1905,[17] and on the north wall of the drawing room of Lockinge House in 1928;[18] on A.T. Loyd's death in 1944 removed from Lockinge House to Betterton House nearby;[19] on long-term loan to the National Gallery from 1974; purchased in 1981 from the trustees of Thomas Loyd through Thomas Agnew & Sons Ltd with help from the NHMF and the NACF.

Exhibitions[20]

London(?)1795, Bryan's Gallery, Savile Row (128);[21] London 1819, BI (4), exhibited as 'The Enchanted Castle' at this and all following exhibitions until 1969; London 1836, BI (23);[22] London 1851, BI (18); London 1888, RA, *Exhibition of Works by the Old Masters* (138); London 1892, Guildhall, *Descriptive Catalogue of the Loan Collection of Pictures* (78);[23] London 1902, RA, *Exhibition of Works by the Old Masters* (67);[24] Paris 1925, Petit Palais, *Exposition du Paysage Français de Poussin à Corot*

(123); London 1930, *The Magnasco Society at Messrs Spink & Son, Landscape Pictures of Different Periods* (8);[25] London 1932, RA, *Exhibition of French Art 1200–1900* (162);[26] Oxford 1934, Ashmolean Museum, *Pictures from Lockinge House, Wantage* (5); Paris 1937, Palais National des Arts, *Chefs d'Oeuvre de l'Art Français* (75);[27] Birmingham 1945, City Museum and Art Gallery, *Catalogue of Paintings and Tapestries from Lockinge House Wantage lent by Captain C.L. Loyd, MC* (7);[28] London 1947, Wildenstein & Co Ltd, *A Loan Exhibition of French Painting of the XVIIth Century in aid of The Merchant Navy Comforts Service* (14); Birmingham 1948–9, City Museum and Art Gallery, *Richard Wilson and his Circle* (135); London 1949, Tate Gallery, *Richard Wilson and his Circle* (134); London 1949–50, RA, *Landscape in French Art* (27); London 1956, Thos Agnew & Sons Ltd, *Summer Exhibition of Pictures by Old Masters Including a Group on Loan from the Lockinge Collection* (17); Stockholm 1958, Nationalmuseum, *Fem Sekler Fransk Konst* (43); London 1967, Christie's, *Christie's Bi-Centenary Exhibition* (4); London 1969, Hayward Gallery, *The Art of Claude Lorrain* (34), as 'Landscape with Psyche at the Palace of Cupid'; London 1982, NG, *Acquisition in Focus. Claude. The Enchanted Castle*; Washington 1982–3, National Gallery of Art, *Claude Lorrain 1600–1682* (45A);[29] 1987, London, NG, *Director's Choice. Selected Acquisitions 1973–1986* (22); London 1988–9, British Museum, *Treasures for the Nation: conserving our heritage* (41); Copenhagen 1992 (14); London 1994, NG, *Claude. The Poetic Landscape* (38); London 1995–6, British Library, *John Keats* (no catalogue); London 1997, Christie's, *Treasures for Everyone Saved by the National Art Collections Fund* (no catalogue).

Related Works

PAINTINGS

(1) Rome, Pallavicini collection. Oil on canvas, 22.5 × 28 cm. According to Roethlisberger, an Italian copy of the early eighteenth century, presumably made when the original left the collection;[30]

(2) Whereabouts unknown. Anon. sale, Nottingham, Gaskill and Newcomb, 22 October 1811 (lot 46, £157).[31] Presumably a copy;

(3) Whereabouts unknown. The 'broad free' version in Robert Archer's sale, Oxford, 1818(?), no. 3, and then in his sale in London, Christie's, 7 June 1819 (lot 106, £18 7s. to Bartie);[32]

(4) Whereabouts unknown. Possibly a copy, Lord Berwick sale, London, Phillips, 6–7 June 1825, lot 159, where described as 'Claude Lorraine... A grand beautiful Landscape. The subject Cupid and Psyche – from the Colonna Palace';

(5) A copy with Mrs R. Langton Douglas, near Eton, recorded in 1961;[33]

(6) Two copies in reverse are noted in Roethlisberger 1961 (p. 387). One of these could be the painting formerly in the E. Stowes Johnson collection, of 63.5 × 88.8 cm, sold at Christie's, South Kensington, 10 May 1990, lot 213;

(7) Earl of Wemyss, Gosford House. Apparently a late painting by Richard Wilson (1713/14–82), evidently inspired by NG 6471 or an engraving, but the figure of Psyche is omitted. Oil on canvas, 37.5 × 58 cm;[34]

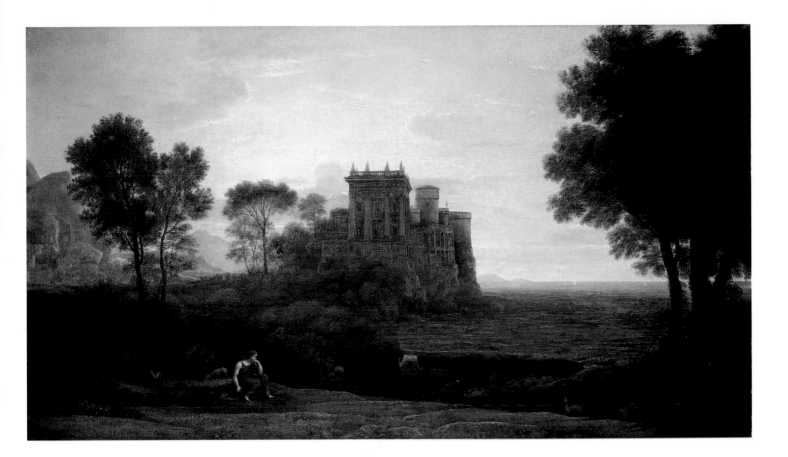

(8) Whereabouts unknown. A copy, oil on canvas, 108 × 144 cm. Sold Christie's, South Kensington, 27 October 1999 (lot 100, £9200 including premium).

DRAWINGS (by Claude)

(1) Private collection. Inscribed at the bottom: *Claud 1663*. And on the reverse: *Claudio Gillee dit le loraine fecit/ A Roma 1666/ Mr. Gulquin*. (MRD 929);[35]

(2) Chantilly, Musée Condé, no. 271 bis. Inscribed at bottom right by a later hand: *claudio f.ᵗ / A.o 1660*. (MRD 930; fig. 3);

(3) Karlsruhe, Staatliche Kunsthalle, no. 1983-10. Inscribed with five deleted p's at the bottom left, and at bottom right: *p... 1663 Roma*, partly cut off. Inscribed on the verso: *Al Molto Illʳᵉ e Reverendo padre sorba / il padre maestro nel humanita del / Collegio Romano*, and again, *Al Reverendo Padre sorba / Al Molto illʳᵉ e Re Reverendo padro sorba padro / Al Coleigio Romano* (MRD 931).[36] Like Drawings (1) and (2) above, a preliminary compositional drawing;

(4) London, British Museum, no. 166. LV 162. Inscribed on the verso: *faict Allᵐᵒ et excellᵐᵒ sigʳᵉ / il sigʳᵉ Contestable Colonna / A Roma 1664 / Claudio Gellee / in fecit*. (MRD 932);

(5) Oxford, Ashmolean Museum. Inscribed on the verso: *Claude Gellee fecit Roma le 2* [deleted] *deuz juin / A Roma 1666 / A monsieur Gilquin* (MRD 933). Possibly done independently of NG 6471 but derived from MRD 931, the left-hand addition of which its scenery resembles; but possibly preparatory for the painting and so earlier than the date inscribed, which may be the date of the inscription rather than that of the drawing.[37]

PRINTS

(1) In reverse by F. Vivares (1709–80) and W. Woollett, begun in 1780 by Vivares, and published 12 March 1782 as 'The Enchanted Castle'.[38] Fig. 1;

(2) by Thomas Hodges in *Beauties of Claude Lorrain*, London 1825, pl. 16;

(3) by Byrne according to Smith, and so by 1837, or earlier if the reference is to William Byrne (1743–1805), as is likely, but no copy of the print has been found.[39]

Technical Notes

There is considerable wear throughout, particularly in the rocky landscape and trees on the left, the castle, the sea, the edges of the foliage and the trunk of the large tree on the right. This tree has been heavily retouched, but there are numerous retouchings throughout. There is an old diagonal stretcher mark at top left, and feather cracking caused by a blow a few centimetres above the sun; the varnish is blotchy and discoloured, and parts of the foliage are blanched.

There has also been some flaking of the paint in the castle, leaving a darker underlayer showing. All of these defects were apparent on examination when NG 6471 was acquired in 1981 (it was said to have been partly cleaned around 1950), but further cleaning or restoration was not undertaken, since the risks involved outweighed the likely benefits. NG 6471 may also have been cleaned after its exhibition in 1851, when Waagen opined that a 'discreet cleaning would greatly improve this picture', and before 1857, when he published *Cabinets of Art in Great Britain*, where the comment is not repeated.[40]

The primary support is a medium-weave twill canvas, double-lined. The stretcher is wood, probably nineteenth century, and may date from the possible cleaning in the 1850s. There are various exhibition labels on the stretcher, and in addition the following marks: (i) 27 in chalk; (ii) *GL* incised with pencil in a cursive script; and (iii) at lower left, in pencil, what looks like *b* or *6*.

A pentimento shows that the large tree at the right was originally some 5 cm to the left of its present position.

Fig. 1 F. Vivares and W. Woollett, *The Enchanted Castle*, 1782. Engraving, 48.5 × 59.5 cm. British Museum, Department of Prints and Drawings.

This painting has been popularly known as 'The Enchanted Castle' since publication of the Vivares/Woollett engraving in 1782 (fig. 1). As is apparent from the catalogues of the Calonne and Troward sales, held respectively in 1795 and 1809, in which NG 6471 probably figured,[41] the castle in question was identified as that of Armida, the beautiful enchantress who in Torquato Tasso's epic poem *La Gerusalemme Liberata* seduces the virtuous knight Rinaldo but is ultimately abandoned by him. Tasso's poem, first published in complete form in Italian in 1581, had been published in a loose English translation by Edward Fairfax in 1600, but around 1800 the better known translation would have been that of John Hoole published in numerous editions between 1763 and 1807.[42] In Hoole's translation, after her abandonment by Rinaldo Armida 'seeks not then Damascus' regal dome,/ but shuns her once-lov'd seats and native home;/ And guides her chariot to the fatal lands,/ Where, midst Asphaltus' waves, her castle stands./ There from her menial train and damsel's eyes,/ All pensive, in a lone retreat she lies;/ A war of thought her troubled breast assails;/ But soon her shame subsides, and wrath prevails.' The popularity of the subject of Rinaldo and Armida as a subject for painting might have encouraged the identification of NG 6471 with it (although it does not explain use of the term 'enchanted castle' which does not appear in Hoole's translation). However, this identification is almost certainly wrong because the two figures in the boat in the

background have no place in Tasso's story at this point, when Rinaldo was out of sight, and, in any case, Rinaldo would have had two companions, Carlo and Ubaldo, not one, and the boat was a sailing boat. Nevertheless, identification of the pensive female figure as Armida for a period obscured recognition of her as Psyche, an identification made earlier by Baldinucci,[43] referred to from time to time in the nineteenth-century literature on the painting,[44] but given due emphasis again only since the 1960s.[45] There is no reason to doubt Baldinucci, because in the first place he probably knew Claude and in the second place such an identification is consistent with the subject of the pendant now in Cologne, namely *Psyche saved from drowning* (fig. 4).

The story of Psyche was told by the second-century author and philosopher Apuleius in Books IV to VI of his *Metamorphoses*, also known as *The Golden Ass*: the beautiful Psyche, a mortal, threatened with marriage to a monster, is wafted away by the West Wind. She awakes and sees a magical palace. There she meets Cupid who becomes her lover, but makes her promise not to look upon his (divine) face. Psyche's sisters, however, overcome with jealousy, eventually persuade her that Cupid is a monster whom she should murder while he sleeps. As Psyche gazes upon the sleeping Cupid, falling hopelessly in love with him, a drop of burning oil from her lamp wakes him. After berating her for breaking her promise, Cupid abandons the now wretched girl.

In NG 6471 Psyche is shown in a pose usually interpreted as melancholic (fig. 2). This, together with her isolation in the landscape and the cool colouring, led to the assumption that Claude was showing Psyche after her abandonment by Cupid.[46] Levey, however, argued that this was impossible because in Apuleius' tale Psyche did not sit in contemplative melancholy following her abandonment.[47] On the contrary, she 'lay flat upon the ground and watched her husband's flight as far as her sight enabled her, tormenting her soul with the most piteous lamentations. But after her husband, speeding on his oarage of wings, had been removed from her view by vastness of distance she threw herself over the edge of a nearby river.'[48] Levey proposed that Claude had shown the earlier moment in the story when Psyche had been deposited outside Cupid's palace by the West Wind – consequently before her meeting with Cupid – and further that NG 6471 was intended as a reference to the marriage in 1661 of the patron, Lorenzo Onofrio Colonna, to Maria Mancini, who, like Psyche, had come from the west, that is from France to Rome.[49] It is also related that Maria Mancini was unimpressed by the exterior of the Palazzo Colonna, but changed her mind when she saw the works of art and luxury within,[50] so it could be argued that Claude's architecture alludes to the Palazzo Colonna's interior magnificence. However, neither Psyche's pose, which is at least contemplative if not melancholic, nor the sombre hues of the picture fit the much lighter mood of that moment in the story. For, after being wafted by the West Wind to a flowery valley,

Psyche lay pleasantly reclining in the soft lawn on her bed of dew-covered grass, her great mental distress was relieved and she fell peacefully asleep.

When she had been restored by enough slumber, she arose feeling calm. She saw a grove planted with huge, tall trees; she saw a glistening spring of crystal water. At the midmost centre of the grove beside the gliding stream is a royal palace, constructed not with human hands but by divine skills [there then follows a description of the palace]... Psyche, attracted by the allurement of this beautiful place, came closer...[51]

There is, however, another moment in the story when Psyche is alone,[52] namely when her two jealous sisters leave after persuading her to murder Cupid:

Psyche was left alone, except that a woman driven by hostile furies is not alone. In her grief she ebbed and flowed like the billows of the sea. Although she had determined her plan and her mind was made up, nevertheless, as she turned her hands towards the act itself, she still wavered irresolutely, torn apart by the many emotions raised by her dilemma. She felt haste and procrastination, daring and fear, despair and anger; and worst of all, in the same body she loathed the beast but loved the husband.[53]

It is tempting to see in the figure of Psyche seated by the seashore a reference to her having 'ebbed and flowed like the billows of the sea', and in the two figures in the rowing boat a reference to her departing sisters. This interpretation is reinforced by the likelihood of Claude having based Psyche on an illustration of the personification of Meditation in Baudouin's *Iconologie* (see below). Although the rowing boat motif is common in Claude's work, its importance in his thinking in relation to this picture is suggested by its prominence in one of

Fig. 2 Detail of Psyche.

Fig. 3 *Psyche in a Landscape*,
c.1663. Chalk, pen, brown wash,
25.1 × 38.8 cm. Chantilly, Musée
Condé.

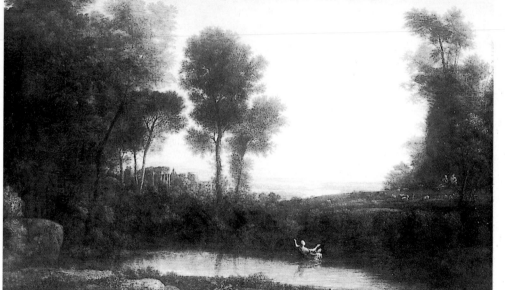

Fig. 4 *Psyche saved from drowning*,
1666. Oil on canvas,
92 × 156.5 cm. Cologne,
Wallraf-Richartz Museum.

his preparatory drawings (MRD 930; fig. 3), where the two figures are clearly rowing away from the pensive Psyche.[54] So interpreted, the pairing of NG 6471 with its pendant, *Psyche saved from drowning* (fig. 4), becomes more poignant – a moment of despair induced by indecision, followed by a decision (to commit suicide) induced by despair.

If the London and Cologne paintings were, by their choice of subjects, intended to refer to Colonna's personal circumstances, it is not clear how. Although depictions of the story of Psyche and Cupid were considered appropriate to the celebration of marriage, neither the London nor the Cologne painting has a celebratory air. It seems unlikely that Claude would have alluded to the difficulties which Colonna and Mancini experienced in their initially happy marriage,[55] which was breaking down by 1665, the year before completion

of the Cologne painting.[56] On the other hand it is clear that Claude consulted closely with Colonna on the Cologne picture, and so by extension on NG 6471,[57] and it is also the case that neither the London nor the Cologne painting seems to have been in Colonna's collection in 1679.[58] If he had disposed of the pictures by then, it could have been on account of disillusion with his marriage. Any supplementary or allegorical meanings in the paintings must, however, remain a matter of conjecture, as must any allegorical interpretation based on the tradition of equating Psyche with the Soul.[59]

Wilson proposed that the figure of Psyche in NG 6471 was taken from a similarly thickset Psyche in an engraving by the Master of the Die after Michiel Coxie (fig. 5),[60] and Russell that Claude knew the image of the melancholy woman (fig. 7) in Antonio Francesco Doni's *I Marmi* (Venice 1552) with

Fig. 5 Master of the Die (fl. c.1530–c.1560) after Michiel Coxie, *Zephyr carrying Psyche off to an Enchanted Palace*. Engraving, 19.4 × 22.8 cm. London, British Museum, Department of Prints and Drawings.

Fig. 7 *A Melancholy Woman*, engraving, from Antonio Francesco Doni, *I Marmi*. Venice 1552. London, British Library.

Fig. 6 Engraving from Apuleius, *Les metamorphoses, ou L'asne dor*, Paris 1631. Page size 17.6 × 12 cm. Washington DC, Library of Congress.

Fig. 8 *Meditation*, engraving from Cesare Ripa, *Iconologia*, translated by J. Baudouin, Paris 1644. London, British Library.

accompanying text indicating that she had been abandoned and isolated.[61] Another possible source would have been a then relatively recent French edition of Apuleius' *Metamorphoses, Les metamorphoses, ou L'asne dor*. As Russell noted, in the bottom right-hand corner of one of the engravings (fig. 6), Psyche appears seated in an attitude similar to that of Psyche in NG 6471.[62] If this was his source, then Claude's alteration to the position of Psyche's left hand, and (assumed) direction of gaze, lends support to the idea, first advanced by Levey,[63] that the Psyche in NG 6471 was not intended to be understood as a figure of melancholy. If, however, Claude intended to show Psyche at a moment of (in)decision, as here proposed, his source may well have been the illustration of the personification of Meditation (fig. 8) in Jean Baudouin's edition of Ripa's *Iconologia* published in Paris in 1644,[64] although Claude

has shown Psyche younger than the woman of mature age described by Baudouin and has dispensed with Meditation's book and furniture. However, the description by Baudouin of Meditation's 'dreamlike action [being] a sign of the gravity of her thoughts'[65] seems particularly appropriate to the moment in the story after Psyche had been left by her sisters.

The architecture of the palace as originally envisaged by Claude, to judge from MRD 931 (fig. 9), was medieval and military. Some of this remains in NG 6471 but as part of a far more complex edifice with a curious covered tower, a double storey of blind arcades, and to the fore a wing of a contemporary palazzo. Although the last has been compared to Algardi's Palazzo Doria-Pamphilj,[66] the likeness is purely generic, the Doria-Pamphilj building lacking, for example, the giant pilasters which give Claude's palace such an imposing air.[67] Russell

Fig. 9 *Psyche in a Landscape with the Palace of Amor*, 1633. Pen, brown wash, 18 × 34.5 cm on two pieces of paper stuck together. Karlsruhe, Staatliche Kunsthalle.

has suggested that the round tower may be a reference, requested by Lorenzo Onofrio, to a feature of the hill town above Lake Nemi where the Colonna family had long owned a castle, since such a reference, as Kitson had earlier pointed out, appears to be included in another picture Claude painted in 1669 for Onofrio, *Landscape with the Nymph Egeria mourning Numa* (Naples, Museo e Gallerie Nazionali di Capodimonte).[68] For his part Levey has suggested that the elaborate palace with its mixture of old and new may symbolise the Colonna family's long-standing activity as builders. Among other things, they had built in Rome in medieval times fortifications adjoining, and out of the ruins of, a giant classical temple.[69]

NG 6471 arrived in England by 1723, when Henry Davenant presumably returned with it from Italy at the end of his eight-year stay as envoy extraordinary to various ducal courts.[70] Davenant also owned the pair to NG 6471, now in Cologne, and the two paintings remained together probably until 1795, when it seems that they were sold by Calonne.[71] NG 6471 exercised a considerable hold on the Romantic imagination, as is clear from the picture's description in the catalogue of Walsh Porter's posthumous sale of 1810.[72] Frequently quoted is Keats's letter of 25 March 1818 to John Hamilton Reynolds in which he writes: 'You know, I am sure, Claude's Enchanted Castle, and I wish you may be pleased with my remembrance of it.' That remembrance was verse, which included the lines 'You know the Enchanted Castle it doth stand / Upon a Rock on the border of a Lake / Nested in Trees, which all do seem to shake / From some old Magic like Urganda's sword.'[73] The following year Keats may have seen the painting itself at the British Institution exhibition, rather than the engraving which had inspired his lines to Reynolds, and this in turn may have inspired the lines in his *Ode to a Nightingale* published in July 1819: 'The same that oft-times hath / Charm'd magic casements, opening on the foam / Of

perilous seas, in faery lands forlorn.'[74] Francis Danby (1793–1861) responded with his visually poetic *Enchanted Castle–Sunset* (London, Victoria and Albert Museum; fig. 10) exhibited at the Royal Academy in 1841, which does not, however, follow Claude's composition nor the character of his landscape.[75] Finally, it has been suggested that the architecture in NG 6471 may have inspired Matthew Digby Wyatt's design for the St James's Park elevation of the former Foreign & India Offices, built in 1862–75,[76] but such similarities as there are may be only coincidental.

General References
Smith 1837, p. 282; Pattison 1884, p. 233; Roethlisberger 1961, no. 162; Roethlisberger 1975, no. 233; Kitson 1978, pp. 153–4; *The National Gallery Report January 1980–December 1981*, pp. 52–5; Wright 1985b, pp. 96–7.

Fig. 10 Francis Danby, *The Enchanted Castle*, exhibited 1841. Oil on canvas, 83.8 × 116.8 cm. London, Victoria and Albert Museum.

NOTES

1. The inscription reads *faict All^{mo} et excell^{mo} sig^{re} / il sig^{re} Contestable Colonna / A Roma 1664 / Claudio Gellee / in fecit*. See Kitson 1978, pp. 153–4. The Colonna inventories of 1664 contain no reference to any painting by Claude corresponding to NG 6471, nor does that of 1679: see Safarik and Pujia 1996.

2. Filippo Baldinucci died in 1696. He wrote 'Otto [quadri] ne dipinse per lo Contestabile Colonna, fra' quali uno se ne conta di estrema bellezza, dove egli aveva dipinto Psiche alla riva del mare: e questo venne poi in potere del Marchese Pallavicino', *Notizie de' professori del disegno*, 13 vols, Milan 1812, vol. 13, pp. 13–14 (the volume containing the life of Claude was first published in Florence in 1728). The Marchese Pallavicino in question was Niccolo Maria (d.1714) according to E. Waterhouse (letter of 8 July 1982 and 'The Paintings of Claude Lorrain', *BM*, 104, 1962, p. 397).

3. For the dating of the beginning of the second index to between about 1716 and the early 1720s, see Kitson 1978, p. 178. Davenant is also there recorded as owning three other paintings by Claude represented by LV 166, LV 167 (the pendant to NG 6471) and LV 168. Henry Davenant (b.1681), envoy extraordinary to the courts of Modena, Genoa, Parma and Florence, was in Italy in the years 1715–23, including Rome in 1722, but he was already buying pictures in the years 1715–17 from the Livio Odescalchi and Bardi collections: Ingamells 1997, p. 280.

4. All described as 'A large landscape... C. Lorrain', and presumably corresponding to the four paintings recorded as belonging to him by the second index to the *Liber* (see note 3 above). For the auction catalogue, see MS Sales 1711–1759, vol. I (C), V & A Museum (photograph in NG Library)

5. According to annotations in the catalogue, a photograph of which is in the NG Library, although the low prices achieved suggest caution. (There was no other pair of Claudes in the 1790 Chauncey sale.) It is not known whether Mr Bragge, described in the title page to the catalogue as 'intending to retire from business', is the same person as Dr Bragge, who had numerous subsequent sales in the 1750s and thereafter. However, in a *Catalogue of Capital Pictures of the Italian, Dutch, Flemish, French, and English Schools; which are now daily exhibiting for sale, by private contract, at R. Archer's Picture Gallery, High-Street,* Oxford n.d. (1818), lot 3 is described as 'Claude The enchanted Castle painted in his broad free Manner. This is much nearer in the Design to the Drawing in the Libro (sic) Veritatis, than the duplicate Picture which was in the Collection of the late Dr. Bragge.' Dr Bragge's executor's sale took place in February 1778.

6. Dr Nathaniel Chauncey, who collected paintings, succeeded to the collection of Dr Charles Chauncey, a physician, and the combined collections of paintings were sold on 26/27 March 1790. Charles died on 25 December 1777, making it possible that, according to Earlom's print of that year, Nathaniel had previously bought NG 6471, rather than inherited it, from his brother. See also note 71.

7. Described in the catalogue as follows: 'Claude -- 90 A landscape. Above all other landscape painters, Claude possessed the most elevated choice and poetic fancy; he leads you through countries the abode of peace and happiness, as if inhabited by a superior race of mortals; this magic is equally distributed between this and following lot the companion.'

8. Calonne came to London in August 1787 after he had been dismissed from his post by Louis XVI. He married a wealthy heiress, remaining in London until October 1790 and returning again, intermittently, between 1792 and his death ten years later. In 1792 he valued his picture collection at £60,000: see R. Lacour-Gayet, *Calonne. Financier Réformateur Contre-Révolutionnaire 1734–1802*, Paris 1963, p. 435, n. 1.

9. Lot 86 is described as 'A LANDSCAPE. This pleasing and enchanting scene presents one of the most delightful landscapes of Italy, with a sweetness and serenity of air truly in character with that country, the happy embellishment of the castle on the rising ground, forms an elegance and divides the distance. The whole is captivating, and one of the finest pictures of this admired artist.' The following lot (87) was described as 'Ditto, the companion. Of equal beauty and merit.' The name 'Bryan' is annotated beside lot 86, and 'Do.' beside lot 87 in the copy of the catalogue bought by Ellis Waterhouse in 1946 and now at the Paul Mellon Centre for Studies in British Art. In his *Memoirs* (Buchanan 1824, vol. 1, p. 251), Buchanan added the information in respect of lot 86 that, 'This picture is known by the name of the Enchanted Castle, and is now in the possession of W. Wells, Esq. who paid Walsh Porter, Esq. 1000 guineas for it', and that it had sold for 520 guineas, and lot 87 for 500 guineas. These last figures are confirmed by annotations in the ex-Waterhouse copy of the Calonne sale catalogue. Buchanan also relates (pp. 218–19) that most of the pictures in the Calonne sale were bought in by Calonne's mortgagees and then exhibited by Bryan in his Savile Row Gallery.

Thus far it would seem reasonably clear that NG 6471 and its companion were in the Calonne collection and were bought by, or at least deposited for sale with, Bryan. However, a doubt arises because no. 128 of Bryan's exhibition catalogue of 27 April 1795, being the picture corresponding to lot 86 of the Calonne sale, is described as: 'This grand and captivating picture presents one of the most delightful views of Italy, with a castle of the most exquisite architecture on the rising ground; the subject, the Departure of Rinaldo.' This subject does not correspond to that of NG 6471, although there are grounds for the confusion and NG 6471 does contain 'a castle of the most exquisite architecture'. The greater difficulty in identifying NG 6471 with lot 86 of the 1795 Calonne sale lies in the manuscript annotations to the copy of the catalogue of that sale in the NG Library. These annotations, made according to an inscription on the flyleaf by 'J.(?)G. March 21st 1795', seem (in spite of the date on the flyleaf) to have been made at the sale and

occasionally added to during the next few years. The notes to lots 86 and 87 read 'For the Empress of Russia', and then by lot 86 '520. [gs]/Mr Cox, a Russia Machⁱ (Merchant?)', and by lot 87 '500 [gs.]/do./ Bt in at Gs.200'. As significant, however, are annotations after lot 86, namely 'abt. 3½ 3', and after lot 87, namely 'Do.'. These measurements, which must be assumed to be in feet, if correct, do not correspond to those of NG 6417 or of its pendant (LV 167) now in Cologne. This in turn means that NG 6417 cannot, as an alternative to being identified with item 128 of the 1795 Bryan exhibition catalogue, be identified with the item described as 'The Companion, of equal excellence, with the story of Cupid and Psyche.' (These two paintings – that is, items 127 and 128 – may be lots 29 and 30 of Bryan's sale of 19 May 1798, the latter being described as 'from the collection of M. de Calonne', although there were other Claudes in the 1795 Calonne sale, and possibly lots 72 and 73 of his sale of 7 May 1804.)

10. Farington, *Diary*, vol. 2, p. 350 (entry for 7 June 1795) where NG 6471 is described as 'the long Claude with the Castle near the Sea'. Peter and Edward Coxe were brothers; both were dealers. Farington's letter recorded that the 'Colonna Claudes' were bought by Beckford (ibid., vol. 4, p. 1240 (entry for 17 June 1799)), but he must have meant the Altieri Claudes.

11. There is a photograph of this catalogue in the NG Library from which it appears that the catalogue was annotated with the same hand as that which annotated the 1795 Calonne catalogue. The annotations to lot 8 are 'G.1000/5½ ... ¼ ?. fine green trees... Green...', and the lot is described as 'Rinaldo and Armida, or the Enchanted Castle, in finest time and in most perfect preservation – this inestimable landscape from Monsieur de Calonne's cabinet, and is esteemed one of the finest specimens of this admired master'. The annotated measurements could be those of NG 6471, and so would appear to confirm its Calonne/Bryan/Troward provenance. Yet NG 6471 certainly appeared in the Walsh Porter sale in 1810 (see Provenance and note 12 below), when no mention was made of the picture having been in the celebrated Calonne collection or of the subject of Rinaldo.

12. Walsh Porter was art consultant to the Prince of Wales. NG 6471 was described in the catalogue as follows: 'The celebrated Sea Port usually termed the Enchanted Castle – upon an advance promontory appears a castle of highly ornamented architecture, backed by woods and rocky scenery – a female in a pensive attitude is seated on the front ground watching a boat which has put off into the bay where a few vessels with their white sails catch the last gleams of evening light – the apparent freshness of the evening breeze, and the stillness of the scene, are expressed with delightful effect – this charming picture is undoubtedly one of the most poetic productions of this great painter. It was formerly in the collection of Dr. Chauncey – the sketch of it by Claude, is given in the *Liber Veritatis*, no. 162.'

Walsh Porter was described as having 'one of the first collections of Italian and Dutch pictures, collected with great care, taste, and expence [sic]. — To those who are <u>personally</u> known to him, he takes great delight in shewing them, and to all <u>foreigners</u> Mr. Porter is particularly attentive': see *The Picture of London for 1807*, London n.d., p. 302. This virtually repeats what was written of Porter in *The Picture of London for 1806*, including a reference to Porter owning 'his two <u>Claudes</u>, from the Choisseul [sic] Gallery', which he had sold in 1803.

For the probable purchase by Buchanan, see *The Diary of Joseph Farington*, 27 April 1810: 'Wm. Wells I called upon — [He] told me He had purchased the picture by Claude called "The Inchanted Castle" from Mr. Buchannan, the Picture dealer for £1000, & that He shd. now cease from purchasing. This picture which was in the possession of Mr Troward, the Solicitor, was sold at the sale of Dr Chauncey's collection for 850 guineas.'

13. See note 12 above. Wells was a well-known collector of paintings. He was appointed a trustee of the National Gallery in 1835. He bequeathed to the Gallery Guido Reni's *The Coronation of the Virgin* (NG 214): Whitley 1930, pp. 229–30; and see Passavant 1836, vol. 1, p. 227 and vol. 2, pp. 71–2, and Waagen 1838, vol. 1, pp. 160–2. Other paintings in the National Gallery once in his collection at Redleaf are NG 775, 796, 946, 1000, 1689, 2533 and 2542. I am grateful to W.A.A. Wells and to David Carter for this additional information.

14. Described in the catalogue as:

'The Enchanted Castle. In accordance with the romantic title, this capital picture exhibits a noble edifice composed of ancient and modern architecture, standing on the extreme verge of a rock in the centre, with the sea flowing around its base. The interval between the castle and the spectator presents broken ground overgrown with bushes, amongst which thrive a few young trees; from here the view extends on the right over rising ground to the distant hills. The composition is further aided by a beautiful clump of trees of various kinds rising from a bank on the left, the tones of whose verdure give effect to the receding landscape. A female (styled in the index to the *Liber Veritatis*, Pysche) is seated in a contemplative attitude on the right of the foreground: this figure was probably intended to personify Melancholy, whose moping mood assimilates with the solemn gloom of the twilight which pervades the scene. This highly poetic production was painted in 1664, for the Constable Colonna, and was subsequently in the possession of Mr. Davenant, Dr. Chauncey, and M.D. Calonne. Engraved by Byrne. Again in the collection of Walsh Porter, Esq., 1810. 3 ft. 10 in, by 5 ft. 0½ in. C. Smith's Catalogue, No. 162.'

For the assumption that Farrer bought on Overstone's behalf, see [A.T. Loyd], *Guide to the Pictures at Lockinge House*, n.l., 1928, p. 13, and [L. Parris], *The Loyd Collection of Paintings and Drawings at Betterton House, Lockinge near Wantage, Berkshire*, London 1967, p. 8.

Samuel Jones Loyd (1796–1883), banker and trustee of the National Gallery (1850–71), was created Baron Overstone of Overstone (his place of birth in Northants) and of Fotheringhay (also in Northants) in 1850. He died at 2 Carlton Gardens, London, but was buried at Lockinge, where his only daughter and heir, Harriet Sarah, lived with her husband, Robert James Lindsay, who was created Baron Wantage of Lockinge in 1885. On his death Overstone left personal estate in excess of £2,000,000 and real estate yielding nearly £60,000 p.a.: *The Complete Peerage*, vol. 10, pp. 191–2.

15. G.F. Waagen, *Galleries and Cabinets of Art in Great Britain*, vol. 4, London 1857, p. 140.

16. [A.T. Loyd] *Guide*, cited in note 14, preface. Arthur Thomas Loyd (1882–1944), one time Conservative MP, was made a trustee of the Wallace Collection in 1942.

17. [A.G. Temple], *A Catalogue of Pictures Forming the Collection of Lord and Lady Wantage at 2 Carlton Gardens, London, Lockinge House, Berks and Overstone House and Arlington House*, London 1905, no. 43.

18. [A.T. Loyd] *Guide*, cited in note 14, p. 13.

19. [L. Parris], *The Loyd Collection*, cited in note 14, p. (i) (preface by C.L. Loyd).

20. If NG 6471 was lent to the 1857 Manchester exhibition and/or to the 1871 RA Winter Exhibition, as stated in Paris 1937, p. 41, then in both cases it was ex-catalogue. The pendant to NG 6471 was in the 1857 exhibition (no. 962) and was probably confused with the London picture by the author of the 1937 catalogue. A.W. Potter of the Royal Academy has kindly confirmed that there is no reference to NG 6471 in the Winter exhibition catalogues of 1870–2 nor in the Council Minutes of 1871 (letter of 5 March 1998).

21. See note 9 above.

22. Annotated as 'full of air & light... water fluid... a female sittg. disconsolate,' in British Institution catalogue with manuscript notes by Lady Palgrave and/or Mrs Harriet Gunn (BL, 7856.e.24).

23. For an early photograph of NG 6471, see A.G. Temple, *Reproductions by the collotype process of some of the works in the loan exhibition of pictures, held in the art gallery of the Corporation of London, at the Guildhall, 1892*, London 1892, facing p. 34.

24. Gallery II of the Royal Academy was devoted to paintings by Claude, and the so-called Black and White Room to his drawings, making him far and away the best represented artist of the 1902 exhibition.

25. O. Sitwell, 'The Magnasco Society', *Apollo*, 79, 1964, pp. 378–90 at p. 390.

26. Exhibited as 'The Enchanted Castle', but the catalogue entry (p. 84) notes that the painting is also entitled *Landscape with the Story of Psyche* and *Psyche abandonné regardant le Palais d'Eros*. NG 6471 is no. 85 of the Commemorative Catalogue of the same exhibition.

27. And no. 55 of the illustrated selection of exhibited works published as vol. 1 of *Chefs d'Oeuvre de l'Art Français*, preface by G. Huisman and entries by R. Burnand, Paris 1937.

28. The loan, which was for an indefinite period, continued until 1952. [L. Parris], *The Loyd Collection*, cited in note 14, p. 8.

29. Not shown at the exhibition when it moved to the Grand Palais, Paris in 1983, but no. 45 bis of the catalogue of the Paris exhibition.

30. Roethlisberger 1961, p. 386.

31. See *Index of Paintings Sold*, vol. 3, part I, pp. 21, 276. Claimed to be the original in the auction catalogue, but that was already owned by William Wells, who retained it until his death many years later.

32. See *Index of Paintings Sold*, vol. 4, part 1, pp. 43, 254, 256.

33. According to Roethlisberger 1961, p. 387.

34. See W.G. Constable, *Richard Wilson*, London 1953, p. 230 and pl. 125a; Roethlisberger 1961, p. 387, and D. Howard, 'Some Eighteenth-century English followers of Claude', *BM*, 111, 1969, pp. 726–33, at p. 731.

35. See also London 1994, no. 40. The composition of the drawing may have had its starting point in an earlier drawing by Claude, MRD 500: see London 1994, no. 39.

36. See also M. Roethlisberger, *Im Licht von Claude Lorrain*, Munich 1983, no. 72; and *100 Zeichnungen und Drucke aus dem Kupferstichkabinett*, Karlsruhe 1988, no. 26; and London 1994, no. 41.

37. As suggested in Whiteley 1998, p. 149.

38. The print was clearly well known: see J. Strutt's account of Vivares published in 1785–6 and reproduced in E. Miller, 'Landscape Prints by Francis Vivares', *Print Quarterly*, 9 (1992), no. 3, pp. 272–81, at p. 272. See also D. Howard, cited in note 34.

39. J. Smith, *A Catalogue Raisonné of the Most Eminent... Painters*, London 1837, vol. 8, p. 282.

40. Waagen 1854, vol. 3, p. 27.

41. See Provenance and notes 9 and 11.

42. Torquato Tasso, *Torquato Tasso's Jerusalem Delivered translated into verse and with an introduction by Joseph Tusiani*, Rutherford 1970, pp. 13, 22, 28.

43. See note 2 above. Richard Earlom had also correctly identified the subject in his aquatint after LV162 published in 1777.

44. For example by Waagen, *Galleries and Cabinets of Art in Great Britain*, 1857, vol. IV, p. 140, and Mrs M. Pattison, *Claude Lorrain. Sa vie et ses oeuvres d'après des documents inédits*, Paris 1884, p. 233.

45. In Roethlisberger 1961, and by M. Kitson in London 1969.

46. For example, *The National Gallery Report 1980–1981*, London 1982, p. 53; M. Wilson in London 1982.

47. M. Levey, ' "The Enchanted Castle" by Claude: subject, significance and interpretation', *BM*, 130, 1988, pp. 812–20 at p. 815.

48. Apuleius, *Metamorphoses* (V: 25), trans. J. Arthur Hanson (Loeb edn, 1989).

49. M. Levey, cited in note 47, p. 817. M. Roethlisberger had implicitly reached the same conclusion when he called NG 6471 'Psyche Newly Transported in the Realm of Amor', in 'The Subjects of Claude Lorrain's Paintings', *GBA*, 55, 1960, pp. 209–24 at p. 220.
The marriage of Lorenzo Onofrio Colonna and Maria Mancini took place by proxy on 15 April 1661. The couple met in Milan after Maria had with difficulty crossed the Alps, and she reached Rome on 30 June 1661: see Prospero Colonna, *I Colonna dalle origini all'inizio del secolo XIX*, Rome 1927, pp. 283 4.

50. V. Celletti, *I Colonna principi di Paliano*, Milan 1960, p. 210.

51. Apuleius, cited in note 48 (IV: 35; V: 1, 2).

52. As L. Parris noted, cited in note 14, p. 7.

53. Apuleius, cited in note 48 (V: 21).

54. A similar argument was advanced by me in London 1994, pp. 52–4.

55. Besides Levey, cited in note 47, who connected NG 6471 to Colonna's marriage to Maria Mancini, H. Diane Russell has suggested that it and its pendant, 'in their general theme of the travails of love, had a particular relevance for the couple, the London painting alluding to Mancini's exile in France before she was saved by Cupid/ Colonna, and that of Cologne alluding to her once again saved by Colonna's love for her': 'Claude's Psyche Pendants: London and Cologne', *Claude Lorrain 1600–1682: A Symposium, Studies in the History of Art*, vol. 14, 1984, pp. 67–81 at p. 78.

56. According to the date inscribed on LV 167. For the start of the breakdown of the marriage in 1665, see Prospero Colonna 1927, cited in note 49, p. 285, and p. 284 for the initial happiness.

57. M. Roethlisberger, 'Claude Lorrain, Nouveaux dessins, tableaux et lettres',

BSHAF, Année 1986 (1988), pp. 33–55 at pp. 48–50.

58. See note 1 above.

59. See H. Diane Russell, cited in note 55, p. 76, and Wine in London 1994, p. 55.

60. London 1982, pp. 11–12. Roethlisberger has suggested (Roethlisberger 1961, p. 385) that the figure of Psyche was derived from an engraving by Marcantonio Raimondi after Raphael (*The Illustrated Bartsch*, no. 252), but this seems unlikely.

61. H. Diane Russell, cited in note 55, pp. 74–5.

62. Ibid.

63. Levey, cited in note 47.

64. *Iconologie, ou, explication novvelle de plvsievrs images... Tirée des Recherches & des Figures de Cesar Ripa, moralisées par I.Bavdoin*, Paris 1644, pp. 109–10 and fig. XCIV.

65. 'Son action resveuse, est vne marque de la grauité de ses pensées, qui n'ont pour but que les choses profitables, que le sage se doit tousiours proposer, pour agir parfaitement, & non pas à la volée.' (*Iconologie*, op. cit., p. 110).

66. By M. Roethlisberger in Roethlisberger 1961, p. 385.

67. M. Kitson in Kitson 1978, p. 154, has proposed the façade of St Peter's as a possible source for the giant pilasters. At all events the palace in NG 6471 looks nothing like the Palazzo Colonna as it appears in a map of Rome by Giambattista Falda and dated 1676: see E. Lavagnino, 'Palazzo Colonna e l'architetto romano Niccolò Michetti', *Capitolium*, Rome 1942, pp. 139–47 at p. 144. Levey (cited in note 47, p. 817, n. 25) suggested that the giant pilasters may be a punning allusion to the patron's name, Colonna, but it seems unlikely that either Claude or his patron would have mistaken a pilaster for a column.

68. H. Diane Russell, cited in note 55, p. 77 and figs 11 and 12. This geographical connection is here preferred to that suggested by M. Levey (cited in note 47, p. 817), namely between the painting's 'marine coastal setting, vaguely Neapolitan in air [and

Colonna's] position as Grand Constable of the Kingdom of Naples'.

69. M. Levey, cited in note 47, p. 818.

70. See note 3.

71. See note 9 for doubts about the Calonne provenance. Between times they were owned by Nathaniel Chauncey, in whose possession NG 6471 was recorded in 1777, but otherwise their provenance is unclear. Bragge's sale in 1750 included two paintings sold to 'Dr. Chauncy' described respectively as 'A Landscape...C Lorrain' and 'Its Companion...Ditto', but the prices achieved, £6 10s. and £6 6s., seem too low, and a reference made in 1818 to a version of the *Enchanted Castle* being closer to the *Liber Veritatis* than 'the duplicate Picture which was in the Collection of the late Dr. Bragge' suggest that Bragge's pictures may have been copies (see notes 5 and 6). If so, perhaps it was Charles Chauncey who bought Bragge's pictures, but Nathaniel Chauncey who acquired NG 6471 and the Cologne painting from elsewhere.

72. See note 12.

73. Presumably a reference to Don Quixote's friend, Urganda.

74. See M. Wilson in London 1982, pp. 14–16, and M. Levey, cited in note 47, p. 820; and for a more general discussion of the relationship between Claude's paintings (including NG 6471) and Romanticism, see Claire Pace, 'Claude the Enchanted: Interpretations of Claude in England in the earlier Nineteenth-Century', *BM*, 111, 1969, pp. 733–40.

75. Ronald Parkinson, *Catalogue of British Oil Paintings*, Victoria and Albert Museum, London 1990, pp. 59–60.

76. Letter of 31 August 1995 from Jean Letherby of Cecil Denny Highton, Architects. For the suggestion that the building in NG 6471 may have been one of the Claudian sources of inspiration for Richard Payne Knight's Downton Castle, near Ludlow, Shropshire (built 1774–8), see N. Pevsner, 'Richard Payne Knight,' *AB*, 31, 1949, pp. 293–320 at p. 296.

Studio of Claude

Landscape with the Death of Procris

c.1647

Oil on canvas, 38.0 × 48.6 cm (including later additions at top and left)

Provenance

Possibly purchased by comte de Hoym (d.1736), Saxon ambassador in Paris, at the sale of Jacques-Louis de Beringhen, marquis de Châteauneuf (d.1723), Paris, 24 July 1724;[1] in the collection of Sir George Beaumont perhaps by 1790;[2] probably moved by Beaumont to Coleorton Hall, Leics., in 1808[3] and certainly there by 1823 when copied by John Constable;[4] transferred to the National Gallery by Beaumont in 1826[5] as part of the Beaumont Gift 1826.

Exhibitions

Brighton 1958–63, Brighton Museum and Art Gallery, long-term loan under the auspices of the Arts Council of Great Britain; London 1988, NG, *'Noble and Patriotic'. The Beaumont Gift 1828* (7).

Related Works

PAINTINGS

(1) The assumed lost autograph version;

(2) Whereabouts unknown, a copy by John Constable (see note 4), his sale, London, Foster & Sons, 15 May 1838, lot 46;[6]

(3) Private collection, The Netherlands. Oil on canvas laid down on panel, 38 × 48 cm, sold Sotheby's, Amsterdam, 3 May 1999 (lot 6, bought in). A copy, probably nineteenth century. Photograph in NG dossier.

DRAWING (by Claude)

London, British Museum, no.106 (fig. 1), LV 100. Signed on the verso: *Claudio fec./ in.v.*

PRINTS[7]

(1) By Thomas Starling in *Valpy's National Gallery;*[8]

(2) presumably by Ebenezer Challis (d.1863)[9] in *The National Gallery of Pictures by the Great Masters* (1838?), no. 67.

Technical Notes

The canvas has been added to at the top (some 2.7 cm) and at the left (some 4 cm) at some time before 1856.[10] These additions are of a medium-weight canvas, closer and more regular in weave than the fairly open coarse plain weave of the original canvas. The original uncut canvas edges show garland-like distortions caused by the initial stretching of the fabric onto its stretcher. Such distortions are absent from the top and left edges. This indicates that the bottom and right edges have not been trimmed. Furthermore, the additions are primed with lead white suggesting that they were attached

after the seventeenth century when darker grounds were more common. The original canvas has what appears to be a terracotta-coloured ground, but is unlike the finer supports usually used by Claude. The whole was relined in 1870 over an earlier pre-1853 lining.[11] Minor restoration along the joins between the original canvas and the added strips was carried out in 1955 when the picture was revarnished. The stretcher is nineteenth century and bears the stamp of the liner, W. Morrill, but whether this refers to the pre-1853 or to the 1870 relining is unknown.

NG 55 is discoloured and worn. It is damaged just above the skyline to the left of the distant town, and there is a loss in the body of the dog, and a repaired abrasion some 7 cm long which goes through Cephalus' head. The picture has been considerably repainted, including most of the figure of Cephalus and parts of the body and legs of Procris. Faintly discernible to the naked eye is the outline of part of a reclining nymph(?) lying on drapery, who appears clearly in the X-radiograph (fig. 2). This figure is some 30 cm long from her right elbow to the end of her left foot, and so larger by far than the figures Claude usually painted, although her form is quite Claudian. Just discernible in the X-radiograph above the head of the nymph(?) is the profile of a standing horse facing right, and there are indistinct shapes just below the horse's belly. It is unclear whether the nymph(?) and the horse belong to the same original composition, but the position of the former suggests that the original canvas of NG 55 was cut from the lower left corner of a larger canvas.

Recent pigment analysis has shown that, although Procris' dark blue drapery is painted in fairly pure natural ultramarine (now rather blanched) combined with discoloured medium, that pigment also occurs in the sky at the horizon and, with smalt, in certain of the mixed greens. The foliage paints contain pigment combinations typical of genuine pictures by Claude – for example, NG 30, dated 1641, NG 14, dated 1648, and NG 1018, dated 1672.

The subject is from Ovid's *Metamorphoses* (VII: 835–62). Cephalus, while hunting, threw his javelin at a rustling sound, assuming it to be the noise of a wild beast. It turned out, however, to be his beloved wife, Procris, who had followed Cephalus in the mistaken belief that he loved another. Procris died from her wound, but not before Cephalus had explained the mistake, and 'she seemed to die content and with a happy look upon her face'.[12] The tragic tale was well known in the seventeenth century and frequently depicted by painters.[13]

The ruined state of NG 55 makes any assessment of its quality difficult.[14] It retained its attribution as an autograph work by Claude in National Gallery catalogues until 1946,

when Davies described it as either an original or a copy,[15] later, in 1957, relegating it to 'clearly a copy'.[16] Davies's later assessment of NG 55 is probably correct. The composition on the original canvas (see Technical Notes) broadly corresponds to that of LV 100 (fig. 1), which records a painting that would have been executed around 1646. In the *Liber Veritatis* drawing, however, Procris appears to wear a headdress, Cephalus has more drapery and his right leg is bent at the knee, the deer on the horizon is a stag rather than a doe, the group of trees in the centre look more robust and there are birds in the sky. Although there frequently are differences between Claude's paintings and the related *Liber Veritatis* drawings, the differences in this case seem too many for LV 100 to be a record of NG 55. In addition, the articulation of the landscape is much clearer in the drawing than it is in the painting. Furthermore, the fact that NG 55 was painted over a figure larger than those which Claude usually painted on canvas (see Technical Notes) also suggests that it is a copy, as does the coarse quality of the canvas. However, Davies's other conclusion, namely that NG 55 was probably eighteenth rather than seventeenth century, is more questionable. Analysis shows the pigment combinations in the foliage to be typical of Claude (see Technical Notes) and of other seventeenth-century landscape painters working in Italy. In addition, the use of ultramarine rather than Prussian blue, the terracotta-coloured ground of the original canvas and the style of the reclining nude shown by the X-radiograph (fig. 2) also suggest a seventeenth- rather than an eighteenth-century date.

If a seventeenth-century date for NG 55 seems probable, its place of origin is less certain, as LV 100 is one of the few *Liber Veritatis* drawings not inscribed with the name of a patron or a destination. However, it is possible that NG 55 originated from within Claude's studio. A studio origin would be consistent both with the technical evidence and with the fact that certainly by 1647, that is, most likely within a year after the original was made, Claude had at least two assistants working for him. These are the individuals referred to in a document dated 22 May 1647 (set out in an Appendix to the entry for NG 12) as in turn his 'garçon', who may be Gian Domenico Desiderii, recorded as living in Claude's house in the Via Margutta and then in the Via Paolina from 1633 to 1656,[17] and 'Guilleaume disciple dudit Claude le Lorrain', who cannot be further identified.[18] If indeed NG 55 came from within Claude's studio, it may have derived from a rapid sketch made from the original, or perhaps (as with, for example, Caroselli's copy after Poussin's *Plague at Ashdod* [NG 165], in which certain details of the copy differ from the original) it derived directly from the original before the latter was finished.

Lavin has suggested that the composition of the principal figures in NG 55 (which he seems to have assumed to have been an autograph work by Claude) are derived from a fresco of *Aurora and Cephalus, and the Death of Procris* in the Sala delle Prospettive, Villa Farnesina, Rome, attributed to Peruzzi by Vasari (fig. 3).[19] This may be correct, and Claude's *Adoration of the Golden Calf* (Manchester, City Art Gallery) may be suggested as another example of his study of the works of Raphael and

Fig. 1 Claude, *Landscape with the Death of Procris*, c.1646–7. Pen, brown and brown-grey wash, 19.7 × 26.1 cm. London, British Museum, Department of Prints and Drawings.

Fig. 2 X-radiograph.

Fig. 3 Attributed to Baldassare Peruzzi, *Aurora and Cephalus and the Death of Procris, c.*1516–17. Fresco. Rome, Palazzo Farnese, Villa Farnesina, Sala delle Prospettive.

his followers in Rome, in this case the fresco of the same subject in the Vatican Loggia. However, these examples should not be regarded as typical of Claude's working method, and certain other borrowings by Claude from Raphael which have been suggested seem unlikely.[20]

During the period in which the painting was believed to be by Claude, it seems to have been widely appreciated by, among others, Constable, who declared in a lecture that 'the expression of [Cephalus] is very touching; and, indeed, nothing can be finer than the way in which Claude has told that affecting story throughout... Above [Procris] is a withered tree clasped by ivy, an emblem of love in death...'[21] For George Foggo the painting's poetic appeal was in its obscurity: 'A dark, rich, transparent effect with a single glowing speck of sun emerging from behind a shrouding cloud scarce above the horizon. This is in character with the subject and beautifully painted. It may not so generally please as Claude's more distinct pictures, but its poetical claim is much higher and, alone in a good light, would make a deeper impression on men of superior taste.'[22]

General References

Smith 1837, no. 100 (as autograph); Pattison 1884, p. 228 (as autograph); Davies 1946, p. 28 (as Ascribed to Claude); Davies 1957, pp. 48–9 (as a copy); Roethlisberger 1961, p. 263 (as a copy); Roethlisberger 1975, p. 107 (as a copy); Kitson 1978, p. 115 (as a copy); Wright 1985b, p. 99 (as after Claude).

NOTES

1. This provenance has been proposed in Roethlisberger 1961, p. 263, based on J. Pichon, *La Vie de Charles-Henry Comte de Hoym*, 2 vols, Paris 1880. Item 304 of de Hoym's inventory of 1726(?) was described as 'Un petit paysage du même [Claude Lorrain], peint sur toile, de 1 pied 2 pouces de haut sur 1 pied 6 pouces de large, représentant la Mort d'Adonis, avec sa bordure / Acheté le 24 juillet 1724 (à la vente de M. De Beringhen, Inventaire de 1725). 350 l. / Dans le petit cabinet sur la terrasse' (J. Pichon, vol. 2, p. 62). Adonis was killed by a wild boar, so the maker of the inventory would have had to be confused both by the sex of the wounded figure and by the manner of its death to have so described NG 55. On the other hand the metric equivalents of the inventoried measurements (37.9 × 48.7 cm) are very close to those of NG 55.

In 1720 de Hoym was appointed as Saxon ambassador to Paris, where he went the following year, residing in a hotel in the rue Cassette. His inventory included eleven paintings by Claude, all bought between 1717 and 1727. He was a friend of Sir Luke Schaub, appointed English ambassador to Paris in 1722 and another major collector of paintings (Pichon, op. cit., *passim*). A sale of his library, comprising nearly 5000 lots, was held in Paris in 1738. De Beringhen became Premier Ecuyer du Roi in 1704: see Rambaud 1964–71, vol. 2, p. 784.

2. In the copy of Richard Earlom's *Liber Veritatis* in the British Library (shelf mark 683.k.6) there is a pencilled inscription recording the owner of NG 55, 'Sir George Beaumont 1790'. This volume was bequeathed to the Library by the Revd C.M. Cracherode (1730–99), by whom in all likelihood this inscription was made.

3. *The Diary of Joseph Farington*, vol. 9, pp. 3296–7 (entry of 17 June 1808), recording the planned transfer of three pictures by Claude from Beaumont's London house to Coleorton. These pictures were most likely NG 19, NG 58 and either NG 61 or NG 55. Since Beaumont always carried NG 61 with him (see the entry for NG 61), it was probably NG 55, the permanent removal of which to Coleorton was planned in June 1808.

4. Constable wrote to Fisher from Coleorton Hall on 2 November 1823: 'I have copied one of the small Claudes – a breezy sunset – a most pathetic and soothing picture. Sir G. says it is a most beautiful (sic) copy.' *John Constable's Correspondence VI. The Fishers*, ed. R.B. Beckett, Ipswich 1968, p. 142. Later in the same letter Constable writes of having begun to copy NG 58. Since 'a breezy sunset' could not describe NG 61 (*Hagar and the Angel*), it must refer to NG 55, the only other small Claude in Beaumont's collection (although the death of Procris occurred at sunrise, not sunset). Presumably Sir George Beaumont's reference to the beauty of the copy, as reported by Constable, is to Constable's copy after NG 55 rather than to NG 55 itself.

5. Where seen by George Agar Ellis with Beaumont's other three Claudes: see F. Owen and D.B. Brown, *Collector of Genius. A Life of Sir George Beaumont*, New Haven and London 1988, p. 215. NG 55 was called 'A Small sun set by Claude Cephalis (sic) & Procris' in a list of pictures written by Beaumont(?) in 1823: NG Archive, NG5/1/1823.

6. Described in the catalogue 'COPIES BY MR. CONSTABLE... / Cephalus and Procris, from the original, by Claude, in the National Gallery' presumably meaning NG 55, and not NG 2.

7. The engraving by Browne mentioned by Smith 1837, p. 244, and Pattison 1884, p. 228 (who states that the engraving is of the same dimensions as the painting), is after LV 163: Roethlisberger 1961, p. 263, n. 1.

8. Where noted (p. 75) that NG 55 'seems to have suffered from time, though the whole is sufficiently perfect to display the coloring (sic) and design in all their excellence'.

9. Saur's *Allgemeines Künstler-Lexicon*, vol. 18, Munich and Leipzig 1998, p. 103.

10. *Catalogue of the Pictures in the National Gallery, having reference more particularly to their material condition*, ms. cat., NG Archive, NG 10, vol. 1, no. 55.

11. Ibid.

12. Trans. F.J. Miller, Ovid, *Metamorphoses*, vol. 1, p. 403.

13. A. Pigler, *Barockthemen*, 2 vols, Budapest 1974, vol. 2, pp. 56–8. For a brief summary of how seventeenth-century moralists interpreted the story, see Wine in London 1994, pp. 45–6.

14. Davies (1957, p. 48) thought that NG 55 was probably eighteenth century.

15. Davies 1946, p. 28.

16. Davies 1957, p. 48.

17. See E. Knab, 'Die Anfänge des Claude Lorrain', *Jahrbuch der Kunsthistorischen Sammlungen in Wien*, vol. 56, 1960 (1961), pp. 63–164 at pp. 162–3.

18. The Stati delle Anime for 1648 record a Francesco Ragusa and a Monsù Besnito, both painters, living at Claude's house as well as Desiderii: E. Knab, cited in note 17, p. 163. One possibility is that Guillaume is Angeluccio, mentioned by Pascoli as Claude's only pupil, as Michael Kitson tentativley suggested to me in correspondence. For Angeluccio, see M. Roethlisberger, *Im Licht von Claude Lorrain*, Munich 1983, pp. 154–5.

19. I. Lavin, 'Cephalus and Procris. Transformations of an Ovidian Myth', *JWCI*, 17, 1954, pp. 260–87 at p. 282, n. 3, and p. 285.

20. For example, *pace* Roethlisberger (1961, p. 385) the figure of Psyche in NG 6471 is not very close to the male figure in reverse in a Marcantonio engraving after Raphael (not specified by Roethlisberger, but presumably *The Illustrated Bartsch*, vol. 26, p. 250, no. 252); and the figures of David and Goliath in a drawing by Claude (MRD 591v.) have little to do with the poses of these two figures in Raphael's fresco of the same subject in the Vatican Loggia. In fact, the pose of David in Claude's drawing seems derived from Bernini's *David* (Rome, Galleria Borghese).

21. John Constable, *John Constable's Discourses*, compiled and annotated by R.B. Beckett, Ipswich 1970, p. 54. Constable's lecture was delivered on 2 June 1836. For other appreciations of NG 55, see Landseer 1834, pp. 368–73; and Foggo 1845, p. 22.

22. Foggo 1845.

Gaspard Dughet

1615–1675

Dughet was born in Rome in 1615. He entered Poussin's studio in 1631, the year after Poussin had married his sister, Anne-Marie, and remained there until 1635. Around this time he adopted the name Gaspard Poussin, by which he was often known. He then spent short periods away from Rome with patrons, first in Milan and then at Castiglione del Lago, before returning to undertake a fresco cycle at the Palazzo Muti Busi around 1636, and two paintings for the Spanish ambassador to the Holy See, the Marquis of Castel Rodrigo. Following an illness he left Rome with his friend and patron the Duke della Cornia for Perugia and then Florence, where Pietro da Cortona arranged a commission for him from Grand Duke Ferdinand II. He is again recorded in Rome in 1644.

From 1646 he settled in Rome, renting houses in both Tivoli and Frascati. His most important commission at this period was for a cycle of frescoed landscapes illustrating episodes from the lives of Elijah and Elisha for the church of San Martino ai Monti, Rome (1645/6–50/1). This established his reputation. Other important commissions included fresco decoration at the Quirinal Palace in 1657, the year he was elected to the Accademia di San Luca, and at the Palazzo Pamphilj at Valmontone in 1658. From around 1672 a severe illness, which continued until his death three years later, forced him to give up painting, as well as hunting, fishing and walks in the countryside, and depleted his fortune.

The precise dating of Dughet's work is difficult as there are few fixed points. His style developed around 1635 and he took increasing care with the composition of his landscapes. In the frescoes of Muti Busi his landscapes are more open and luminous, suggesting some familiarity with Claude's paintings. Dughet then seems to have studied the structured compositions of Domenichino's landscapes. In many of his works from the mid-1650s onwards there is a sense of nature only just under control, and of man's insignificance in relation to it. He was particularly praised by eighteenth-century critics for his storm scenes. From the 1660s architecture plays a more important role in his paintings.

NG 31

Landscape with Abraham and Isaac approaching the Place of Sacrifice

*c.*1665
Oil on canvas, 152.2 × 195.2 cm

Provenance
Probably in the collection of Lorenzo Onofrio Colonna (1637–89) by 1679;[1] included in the posthumous inventory of Filippo II Colonna (1663–1714) of 1714–16;[2] presumably one of the paintings by Dughet recorded after 1740 in the Stanza de' Paesi of the Palazzo Colonna in the collection of Fabrizio Colonna (1700–55);[3] probably recorded in 1783 in the gallery of the Palazzo Colonna;[4] recorded at the Palazzo Colonna by Ramdohr;[5] exhibited for sale in London by the picture dealer Alexander Day (1773–1841) in 1801;[6] bought from Day by John Julius Angerstein in 1801,[7] possibly for 2000 guineas;[8] bought from Angerstein's executors in 1824.

Exhibitions
London 1951–7 and 1958–68, Arts Council of Great Britain (on long-term loan).

Related Works
PAINTINGS
(1) P.C. Thomas collection, Isle of Man; an autograph(?) replica, 91 × 127 cm;[9]
(2) Whereabouts unknown, probably a copy, 29 × 38 in., Christie, Manson & Woods Ltd, 24 July 1953, lot 185 (18 guineas to Grant) as by Orizzonte. Photograph in NG dossier;[10]
(3) Milan, Gandini collection, oil on canvas, 144 × 194 cm. A copy;[11]
(4) Whereabouts unknown, oil on panel, 28.5 × 39 cm, sold Vienna, Dorotheum, 13 November 1979, lot 15. A copy. Photograph in NG dossier;
(5) Exeter, Royal Albert Memorial Museum. A copy on canvas by John White Abbott (1763–1851), 86 × 115 cm.[12]
PRINTS
(1) By Giuseppe Cunego (b.1760),[13] possibly dated 1781;[14]
(2) by Pietro Parboni (fl. Rome, *c.*1800);[15]
(3) by John Young, 1823;[16]
(4) by Thomas Starling, probably by 1831;[17]
(5) by John Pye (1782–1874), 1834;[18]
(6) by William Radclyffe (1780–1855), by 1838(?);[19]
(7) woodcut by John, James or William Linnell, 1842/3;[20]
(8) anon., produced by the Typographic Etching Company for H. Blackburn, *Illustrated Catalogue to the National Gallery [Foreign Schools]*, London 1878, p. 8.

Technical Notes

NG 31 has extensive retouchings in the sky, some blanching, and the red ground is showing through. Additionally, there is a large horizontal and vertical repaired tear in the upper left quarter of the picture, the retouchings to which are discoloured. This tear, noted in 1855 as already having been repaired,[21] may have been the reason for NG 31 being double-lined in 1878 with a resulting shrinkage of the canvas throughout. The painting was 'Pettenkofered'[22] in 1865, strip-lined in 1927, and last fully restored in 1951.

The primary support consists of two pieces of plain-weave canvas joined horizontally 38.5 cm above the picture's bottom edge. The stretcher is probably nineteenth century.

There are pentimenti to the figures of Abraham and Isaac.

The subject is from Genesis 22. As a test of faith, God ordered Abraham to sacrifice his only son on one of the mountains in the land of Moriah.[23] Verses 5 and 6 relate that Abraham and his son approached the place of sacrifice alone and that Abraham laid the wood for the burnt offering upon Isaac. It was only on the third day of his journey that Abraham saw the place of intended sacrifice in the distance, so a setting in an extensive landscape is particularly appropriate.

The dating of NG 31 is problematic. It may be one of the paintings paid for in 1660 by Lorenzo Onofrio Colonna, in whose collection it probably was, but this is questionable.[24] Dughet may have been working for Colonna, one of his most important patrons, by 1653–4[25] and was certainly doing so in 1667–8.[26] The composition of NG 31 has been compared to that of Dughet's *Wooded Landscape* (New Orleans, private collection) for which a date of 1657–8 has been proposed by Harris on the basis of a similar composition in Berlin.[27] The New Orleans landscape has, however, been dated on stylistic grounds to 1664–5 by Boisclair,[28] and to *c*.1665 by Roethlisberger.[29] There are certainly compositional similarities between NG 31 and the New Orleans and Berlin landscapes,

although neither of the latter two has such extensive views to the horizon as NG 31. NG 31 itself was assigned to 1660 by Boisclair,[30] but its absence from the March 1664 inventory of Lorenzo Onofrio Colonna suggests late 1664 as the earliest possible date for the work, assuming, as seems likely, that a work of this size would have been commissioned by Lorenzo directly from Dughet. Accordingly, NG 31 is here dated *c*.1665.

Boisclair has noted a compositional resemblance between NG 31 and Gainsborough's *Grand Landscape* (Worcester, Mass., Worcester Art Museum, inv. 1919.1), datable to the early 1760s,[31] but the resemblance can only be coincidental since the English artist never visited Rome and no image of NG 31 seems to have been available in England until *c*.1781 (see Prints).

NG 31 was widely but not universally admired in the nineteenth century. Waagen regarded it as the finest of the paintings by Dughet in the National Gallery and one which 'justifies the high reputation which it there [the Colonna Palace] enjoyed'.[32] Mrs Jameson called it 'perhaps one of the most beautiful landscapes in the world',[33] and the author of *Valpy's National Gallery* wrote that 'No praise is too great for this work'.[34] Even John Ruskin, usually a savage critic of Dughet, allowed that NG 31 was 'a fine picture, one of the best of Gaspar's that I know'. But Ruskin objected to the 'impossible' colour of the sky which 'colour holds its own, without graduation or alteration, to within three or four degrees of the horizon, where it suddenly becomes bold and unmixed yellow.'[35] According to Farington in 1801, '[Benjamin] West & Sir George [Beaumont] concurred in thinking the Horizon light... painted upon & too yellow – West said it is very fine but does not appear to him as it did in the Palace at Rome',[36] and Farington found the picture disappointing when he himself saw it a few days later.[37]

General References

Davies 1957, p. 86; Wright 1985b, p. 105; Boisclair 1986, no. 197.[38]

NOTES

1. Item [111] of 1679 – *Inventario della Guardarobba, e Palazzo dell'Ecc.mo Sig:r Gran Contestabile D. Lorenzo Onofrio Colonna* is described as 'Un Quadro di p.mi 6 e 8 con paese con cornice intagliata con fogliami d'oro, opera di Gasparo Posino': Safarik and Pujia 1996, p. 126.

M-N. Boisclair (Boisclair 1986) has proposed that NG 31 is one of the paintings referred to in a note in the Archivio Colonna first cited by S.J. Bandes in 'Gaspard Dughet's frescoes in Palazzo Colonna, Rome', *BM*, 133, 1981, pp. 77–88 at p. 78, n. 19. The note reads 'Nicola Foresta pagarete a Gaspare Duche Pittore scudi novanta m[one]ta che le facciam pagare per il prezzo et intcrio pagamento di due quadri di paesaggi depinti da lui in tela d'Imperatore, venduteci cosi d'accordo che con sue ricevute q[ues]ta di febraro 1660. 90 scudi'. Boisclair has

proposed that the canvas sizes of NG 31 and NG 1159 (which also has a Colonna provenance) correspond with the two pictures referred to in that note: Boisclair 1986, p. 233. However, this has been disputed by Schleier on the basis that the size 'tela d'imperatore' is equivalent to about 90 × 135 cm, and so much smaller than NG 31 (or NG 1159): Erich Schleier, 'Una veduta quasi reale di Gaspard Dughet', *Scritti in onore de Giuliano Briganti*, Milan 1990, pp. 195–204 at pp. 201–2. In fact, these two paintings are presumably the two pictures comprising item [158] of Lorenzo Onofrio's inventory of March 1664 (Safarik and Pujia 1996, p. 97).

2. [Item 636] 'due quadri in tela di palmi otto e sei in circa rapp.ti due Paesi, cioè uno. rapp.e Prospettiva con diverse Donzelle Cacciatrici originale dj Claudio Lorenese,

e l'altro compagno originale dj Gaspare Pussino con diverse figure': *Inventario...doppo la Morte dell' Ecc. Sig.re D. Filippo Colonna*: Safarik and Pujia 1996, p. 289. Also published by Salerno 1977–8, vol. 3, pp. 1125–8 at p. 1126, and cited by Boisclair 1986, pp. 152–5 and p. 232, in slightly different form.

3. Safarik and Pujia 1996, p. 600.

4. '142 Un Quadro verso il Loggione misura simile [di 6. e 8. per traverso] = Paese con Figure = Pussino', *Catalogo dei quadri, e pitture esistenti nel palazzo dell'eccellentissima Casa Colonna in Roma*, Rome 1783, p. 24. No. 141 describes a landscape by Claude Lorrain, so it and no. 142 were probably the same pictures as those referred to in note 2 above. NG 31 may be among the landscapes hung in the vestibule to the gallery of the Palazzo Colonna

referred to by Marien Vasi in *Itinéraire instructif de Rome*, Rome 1797, p. 278.

5. 'Zwei der schönsten Landschaften Poussins./Abraham ersteigt mit seinem Sohne Isaac einen waldichten Berg, auf welchem dieser geopfert werden soll. Rechts auf dem Vorgrunde der Ausgang auf den waldichten Berg, links in der Ferne über eine weite Ebene hin, die Aussicht aufs Meer. Die schönste Landschaft, die man vom Poussin wenigstens in Roms kennt. Die Erfindung ist vortrefflich, und die Ausführung entspricht ihr völlig. Der Mahler hat mit wenigen Pinselstrichen eine Ebene geschaffen, die der Zuschauer raum mit dem Auge abreichen zu können glaubt. Der Baumschlag ist vorzüglich in den Eichen wohl geratten. Es ist ein Fehlgemälde.' Ramdohr 1787, vol. 2, pp. 76–7. NG 31 was also seen in the Palazzo Colonna by Philip Hackert (1737–1807), who was in Rome in the years 1768–86: see J.W. von Goethe, *Philip Hackert. Nachträge über Landschaftsmalerei*, Tübingen 1811, p. 323.

6. See Buchanan 1824, vol. 2, pp. 4–5; and *The Diary of Joseph Farington*, vol. 4 (1979), p. 1511. In his entry for 4 March 1801 Farington writes: 'Day has brought from Rome some pictures of extraordinary merit, which are now exhibiting at the room late Vanderguchts, in Brook St. – Among them is the celebrated Gaspar Poussin from the Colonna Palace, valued at 4000 guineas.'

7. *The Diary of Joseph Farington*, p. 1548: 'Exhibition in Brook St. I went to, – but found that the Venus & Adonis & the Ganymede by Titian, and the landscape by Gaspar Poussin were removed. They were purchased by Mr Angerstein on Wednesday last.' (Entry for Friday 8 May 1801.)

8. Brigstocke 1982a, p. 276. See ibid., p. 51, for a reference in a letter of 19 November 1802 from Buchanan to Irvine to the former having seen NG 31 in Angerstein's collection.

9. Regarded as mainly autograph by Anne French according to a letter of 10 January 1983 from J.M.R. Melgrave (NG dossier), but rejected by Boisclair 1986, p. 233. Sold by Melgrave to Derek Johns Ltd in 1990 and then sold to Philip Conway Thomas, Isle of Man: letter of 3 February 1998 from Derek Johns. I have not seen the painting.

10. Possibly the same painting as appeared in sales in London on 19 February 1954 (lot 137), 25 February 1955 (lot 148) and, as by Gaspar Poussin, 28 July 1955 (Christie, Manson & Woods, lot 159, 65 guineas to Goldblatt).

11. According to Boisclair 1986, p. 232.

12. See London, Kenwood 1980, no. 78 and pl. 78, and London, Marble Hill House 1973, *Francis Towne 1739/40–1816, John White Abbott 1763–1851, Paintings and Watercolours from the Exeter Museum and Art Gallery*, no. 19. Abbott's only possible trip to London (he lived in Exeter) seems to have been as a young man, and so presumably before NG 31 was exhibited by Day in 1801: A.P. Oppé. 'John White Abbott of Exeter (1763–1851)', *Walpole Society*, vol. 13, 1924–5, pp. 67–84 at p. 69.

13. According to Jameson 1842, p. 60.

14. See Thieme-Becker, vol. 8 (1913), p. 196.

15. G.K. Nagler, *Künstler-Lexicon*, vol. 10 (1841), p. 523, and Ch. Le Blanc, *Manuel de l'amateur d'estampes*, 4 vols, Paris 1854–89, vol. 3, p. 139.

16. *A Catalogue of the Celebrated Collection of Pictures of the late John Julius Angerstein, Esq.*, London 1823, no. 22.

17. *Valpy's National Gallery*.

18. *Engravings from the Pictures of the National Gallery*, London 1840; and *The National Gallery. A Selection of its Pictures. Engraved by George Doo... and others*, London 1875.

19. *The National Gallery of Pictures by the Great Masters presented by individuals or purchased by grant of Parliament*, London n.d. (1838?), pl. 79.

20. *Engravings of Fifty of the most Celebrated Pictures in the National Gallery; by John, James, & William Linnell*, London n.d. (after 1841); and [Henry Cole], *Felix Summerly's Handbook for the National Gallery*, London 1843, p. 14, where Cole asks 'Was this sold among Mr. W.Y. Ottley's pictures for 650 guineas, to Sir T. (sic) Beaumont in 1811?' Cole has confused this picture in the Ottley collection with NG 161, which was in fact sold to Sir Charles Long.

21. *Catalogue of the Pictures in the National Gallery, having reference more particularly to their material condition*, ms. cat., NG Archive, NG 10, vol. 1, no. 31.

22. Pettenkofering, so called after the German chemist Max von Pettenkofer (1818–1901), is the name of the process used to try to restore blanched paint by reforming it with solvents and essential oils.

23. Possibly Mt Gerizim near present-day Nablus. The easily recognisable subject of NG 31 was noted by the late eighteenth century (see note 5 above) and in the earliest NG catalogues.

24. See note 1 above.

25. See Boisclair 1986, no. 132.

26. Boisclair 1986, p. 61 and nos 300–13.

27. A.S. Harris, *Landscape Painting in Rome 1595–1675*, New York, Richard L. Feigen & Co., 1985, p. 170, and Boisclair 1986, no. 178, for the Berlin painting.

28. Boisclair 1986, no. 237.

29. Roethlisberger 1975, no. 5.

30. Boisclair 1986, p. 232. She had earlier proposed 1659–65 in 'Gaspard Dughet: une chronologie révisée', *Revue de l'Art*, no. 34, 1976, pp. 29–56, at p. 50.

31. See St John Gore in *European Paintings in the Collection of the Worcester Art Museum*, Worcester, Mass., 1974, p. 27.

32. Waagen 1838, vol. 1, pp. 217–8.

33. Jameson 1842, p. 59, and see also p. 28.

34. *Valpy's National Gallery*, p. 85.

35. [John Ruskin], *Modern Painters*, vol. 1 (3rd edn, revised by the author), part II, sec. III, ch. I, para. 10.

36. *The Diary of Joseph Farington*, vol. 4, p. 1522 (entry for 15 March 1801).

37. Ibid., p. 1525 (entry for 19 March 1801). 'I cannot say that at first sight the Colonna Gaspar struck me so much as I expected it wd. have done, yet it is very scientific and judiciously managed, – & certainly a great effort of art.' For other early nineteenth-century comments on NG 31, see [P.G. Patmore], *British Galleries of Art*, London 1824, p. 25; C.M. Westmacott, *British Galleries of Painting and Sculpture*, London 1824, p. 70; M. Passavant 1836, p. 46; and Foggo 1845, pp. 12–13. These comments were all favourable to the picture, although Patmore preferred Angerstein's other painting, *Landscape with a Storm*, now NG 36.

38. The article of 16 June 1884 of *The Times* cited in Boisclair's bibliography may be found in G. Redford, *Art Sales*, London 1888, vol. I, pp. 361–3. The reference in Boisclair's bibliography to 1903, Bryan M., III, p. 97, should be to vol. II of that work.

NG 36
Landscape with a Storm

*c.*1660
Oil on canvas, 137.5 × 185.2 cm

Provenance
Probably in the sale of Peter Delmé (1710–89), Christie's, 13 February 1790 (lot 61, £141 15s. to Martin),[1] and in the sale of William Petty, 1st Marquis of Lansdowne (1737–1805), at Lansdowne House, Berkeley Square, London, through Peter Coxe, Burrell & Foster, 20 March 1806 (lot 44, £493 10s. to Charles Birch);[2] sold by Birch to John Julius Angerstein (1735–1823),[3] of Pall Mall, London, presumably by 1811;[4] purchased by HM Government with other paintings from the Angerstein collection in 1824.[5]

Related Works
PAINTING
A copy of a large painting by Dughet in the Lansdowne collection was made by Thomas Daniell (1749–1840) by April 1801.[6] The Dughet may have been NG 36 or the picture that was its companion in the Delmé and Lansdowne collections. The whereabouts of Daniell's copy is unknown.
PRINTS
(1) By John Young, 20 March 1823;[7]
(2) by S. Lacey by 1838(?);[8]
(3) ?by Vivares on a large scale.[9]

Technical Notes
Underneath a very yellowed varnish, there are areas of discoloured retouchings and some wear throughout. There is a vertical 5 cm tear right of centre. NG 36 was last surface cleaned and varnished in 1888 but the varnish covering the picture when it was acquired, a mastic mixed with drying oil,[10] has never been removed.

The primary support is a coarse open-weave canvas which retains its original tacking edges, double-lined before 1853 according to Gallery conservation records, and possibly during the eighteenth century. There is a vertical join in the lining canvas. The stretcher is probably seventeenth century, and may be the original. However, diagonal marks on the surface of the canvas at the top left may have been caused by a stretcher brace. They do not correspond to the brace on the present stretcher, which may therefore be an early replacement for the original.

There is a label on the lining marked *No. 16* in what appears to be an eighteenth-century hand. The top member of the stretcher is marked *235* in black pencil or crayon. The central bar is marked *CR BAY [...]* in chalk, and *B* is scratched on it.

The X-radiograph suggests that the figure at the right of the pair in the left foreground may originally have been holding on to something, but it is not easy to read. The original composition is now easier to ascertain from the infra-red photograph (fig. 1) than from the painting.

Dughet's storm scenes were among his most admired works.[11] He may have started to paint them around 1650, but they developed from his earlier paintings of squally weather. Among the earliest published appreciations of NG 36 was that written by John Landseer, who noted the light gleaming 'on a mountain ridge and the watch-tower of a romantic castle, which stands, a stately image of stability, where all else seems going to wreck... Gaspar has placed this perpendicular, enduring, and immovable castle... by way of contrast, where all other objects are bent, agitated and yielding to the destructive power that sweeps across the landscape'.[12] Possibly following similar comments made in the 1806 Lansdowne sale catalogue, Ottley admired the contrast between 'partial gleams of light' and 'the gloom which pervades every other part of the picture' and also praised the foliage in the foreground.[13] Almost inevitably a deeply critical view of the picture was taken by Ruskin, who wrote that 'the foreground tree comprises every conceivable violation of truth which the human hand can commit, or head invent, in drawing a tree – except only, that it is not drawn root uppermost'.[14]

The difficulties of dating Dughet's canvases are compounded in the case of NG 36 by the extremely dirty state of the picture. Sutton tentatively suggested a date shortly after Dughet's completion of the frescoes at San Martino ai Monti,[15] themselves dated by Sutton to 1640–4.[16] These frescoes have more recently been dated 1645/6 50/1 by Boisclair,[17] who has dated NG 36 1653–4.[18] Salerno, however, saw NG 36 as belonging to Dughet's final style, assigning it to a period after 1657–8.[19] The question of whether Dughet influenced Poussin or vice versa in relation to storm landscapes remains unresolved. There is certainly a broad resemblance between the composition of NG 36 and Poussin's *Storm* in Rouen (fig. 2), painted for Pointel in 1651 and once itself attributed to Dughet.[20] However, there is a fundamental difference in concept. Dughet's interest lies mainly in the effects of the storm on the landscape, Poussin's in the human responses it provokes. This is even more true of Poussin's *Pyramus and Thisbe* in Frankfurt. Poussin had been interested in the relationship between landscape and human response for at least three years,[21] and it seems unlikely that the Rouen and Frankfurt paintings were responses to Dughet's storms. More probably NG 36 followed the Rouen painting, possibly by several years. It is an assured composition on a large scale by an artist well practised in scenes of this type, but probably earlier than the Holkham Hall *Storm* (fig. 3), with which it shares the motif of the broken tree in the foreground, but whose sky seems more dramatic than that of NG 36. The Holkham Hall painting has been dated by French to the late 1660s,[22] and by Boisclair to 1664–8.[23] If this is correct, Salerno's dating of NG 36 to after 1657–8 is to be preferred.

General References
Davies 1957, p. 86; Wright 1985b, p. 105; Boisclair 1986, no. 134.

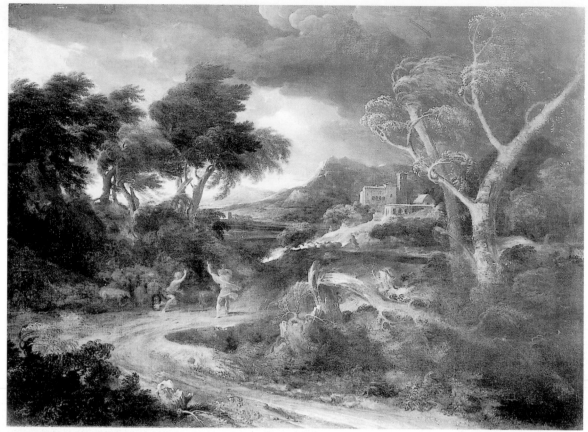

Fig. 1 Infra-red photograph of NG 36.

Fig. 2 Nicolas Poussin, *Storm*, 1651. Oil on canvas, 99.5 × 132 cm. Rouen, Musée des Beaux Arts.

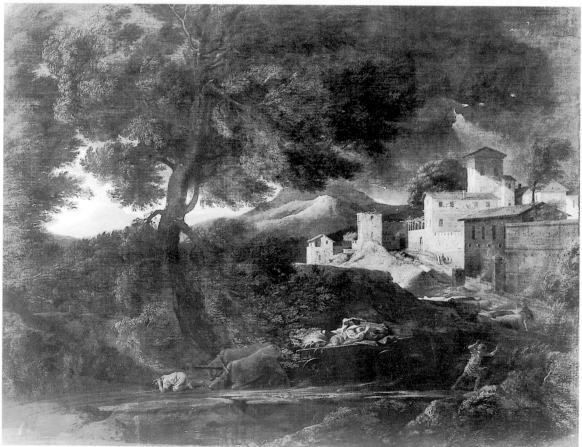

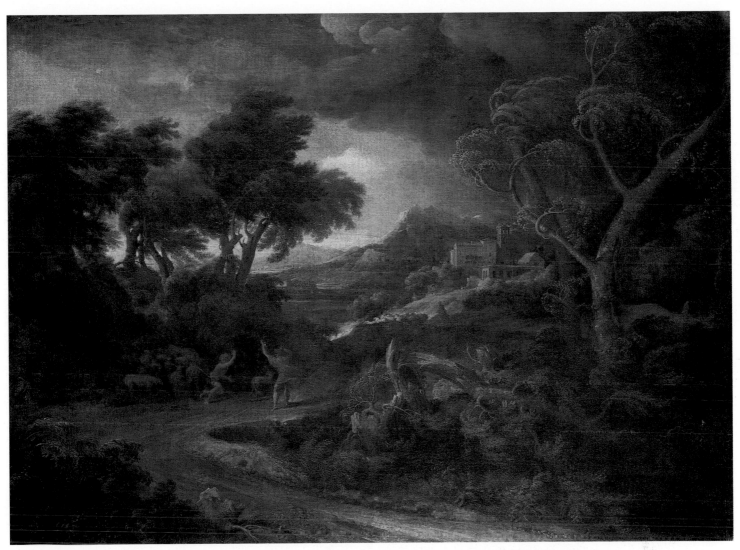

Landscape with a Storm

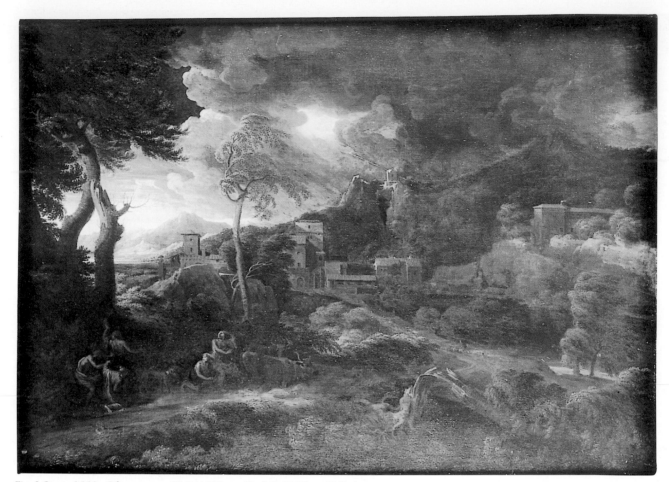

Fig. 3 *Storm*, 1660s. Oil on canvas, 95.9 × 134 cm. Norfolk, Holkham Hall.

NOTES

1. Described in the catalogue as 'A land storm. The companion [to lot 60]; of equal merit.' Lot 60, also given to Dughet, was described as 'A large and capital landscape, truly in a grand stile, equal to Nich. Poussin.' Lots 60 and 61 have been proposed as being *Le Temps Calme* (Malibu, J. Paul Getty Museum) and *L'Orage* (Rouen, Musée des Beaux-Arts), both by Nicolas Poussin: C. Whitfield, 'Nicolas Poussin's "Orage" and "Temps Calme'", *BM*, 119, 1977, pp. 4–12, at p. 7, but the description of and annotations to lot 61, when it reappeared in the 1806 Lansdowne sale (see note 2 below), do not accord with the Rouen picture, although they do with NG 36.

Lots 60 and 61 of the Delmé sale may be the 'two large landskips of Gaspar Poussin' which Vertue saw in 1743 at the house of Peter Delmé's father (also called Peter Delmé) in Grosvenor Square, London: 'Vertue Note Books', vol. III, p. 117 in *Walpole Society*, vol. 22, 1933–4.

The painting referred to by Davies (Davies 1957, p. 86), on the basis of a note by the translator of Passavant 1836 (vol. 1, p. 46), as said to have been bought in 1803 from Sir Simon Clarke by Irvine for Buchanan was, as Boisclair has noted (Boisclair 1986, p. 213), in upright format, and so seems a most unlikely candidate for NG 36. It is not clear from the letter in Buchanan's *Memoirs* cited by Davies that the picture, whichever it was, was bought from Clarke.

A painting attributed to Dughet and described as 'A Land Storm' was in the Swinney sale, London, Langford, 28 February to 1 March 1755 (lot 56), but was not (apparently) sold with any companion. This would seem to exclude it from being the same picture as lot 61 of the 1790 Delmé sale, unless Delmé had himself paired it with lot 60.

2. Described in the catalogue: '44 Gaspar Poussin... A Land Storm – That well known picture, formerly in the possession of Mr. Delme, painted with infinite boldness and effect, harmonious in color (sic), and rich in execution and management. The marks of the passing storm is finely expressed by the tree broke asunder in the foreground, while the awfulness of the dreadful gloom is admirably contrasted by the clearing of the horizon in the distance. The figure by Nicolo Poussin.' A copy of this catalogue, of which there is a photocopy in the NG Library, is annotated '493.10 – Mr Birch since sold to Mr Angerstein'. This annotation would seem to establish the Delmé/Lansdowne provenance of NG 36 but for an annotation in another copy of the catalogue in the Metropolitan Museum, New York, that the format of the painting was oval: *Index of Paintings Sold*, vol. 2, part 1, p. 326. No such annotation is recorded in *Index of Paintings Sold* in any other copy of the catalogue recorded there, nor does such an annotation appear by lot 46, which may well have been the companion picture, and whose dimensions are otherwise recorded as the same as those of lot 44, namely 5 ft × 6 ft. In any event, oval paintings on canvas by Dughet are rare. The annotation in the Metropolitan Museum copy of the 1806 Lansdowne sale catalogue is therefore most

probably wrong. *Pace* Boisclair 1986, p. 256, lots 44 and 46 of the 1806 sale were not re-offered at the Lansdowne sale of 26 May 1810.

William Petty was created 1st Marquis of Lansdowne in 1784, having succeeded his father in 1761 as Earl of Shelburne and Viscount Fitzmaurice. He followed a political and military career. He was created a general in 1783, and was briefly Prime Minister (1782–3) before retiring from public affairs. Contemporary opinions of his character were wildly divergent. Lansdowne (formerly Shelburne) House was bought by Lansdowne in 1765. He employed Adam to finish it *c*.1762–8 and Gavin Hamilton to furnish it with sculptures in the 1770s. Lansdowne House occupied the whole south side of Berkeley Square. Only a part of it now exists: see ed. H.A. Doubleday and Lord Howard de Walden, *The Complete Peerage*, vol. 7 (1929), pp. 436–8; Lord Edmond Fitzmaurice, 'Letters of Gavin Hamilton, edited from mss. at Lansdowne House', *The Academy*, vol. 14, July–December 1878, pp. 141–244; Pevsner 1973, p. 558. The Lansdowne pictures removed from Bowood House were sold separately in London on 25 February 1806. Birch has been identified as Charles Birch, picture cleaner and dealer, active 1796–1828: *Index of Paintings Sold*, vol. 2, part 2, p. 1300.

3. See note 2 above.

4. The date when Angerstein retired from business and seems to have stopped collecting: *John Julius Angerstein and Woodlands 1774–1974*, London, Woodlands Art Gallery 1974, p. 35.

5. Described by Young 1823, p. 46, as 'originally in the collection of Peter Delmé, Esq., and it afterwards became the property of the first Marquess of Lansdowne. At the sale of the pictures in Lansdowne House in 1816 (sic), it was purchased by Charles Birch, Esq., and afterwards transferred to this collection'. In a note John Young(?) wrote of NG 36: 'This Picture was in the Collection of the first Marquess of Lansdowne & was sold after his death – There are some who prefer it to the Companion picture in this collection – the Abraham & Isaac by the same Master–.' (NG Archive, NG31).

6. *The Diary of Joseph Farington*, vol. 4, p. 1535 (entry for 8 April 1801): 'Daniell I called on. He shewed me a Copy made by him from a large picture of Gaspar Poussin belonging to Lord Lansdown. He sd. It took him 3 months to copy it.'

7. Young 1823, no. 23.

8. *The National Gallery of Pictures by the Great Masters*, London n.d. (1838?), no. 78.

9. According to R.N. Wornum, revised by C.L. Eastlake, *Descriptive and Historical Catalogue of the Pictures in the National Gallery*, London 1847, p. 133, presumably referring to Francis Vivares (1709–80). Davies 1957, p. 86, refers to an engraving by Vivares after a *Storm* in the Delmé collection having a different composition to NG 36, but Boisclair 1986, p. 213, who was unable to trace such an engraving, has suggested that no *Storm* in the Delmé collection was engraved by Vivares. No print by Vivares after NG 36 is recorded in the (incomplete) oeuvre catalogue by H. Vivarez, *Prom Domo Mea Un Artiste Graveur au XVIIIe siècle François Vivares/Un Artiste Ferronnerie au XVIIIe siècle Jean Vivarais*, Lille 1904, nor in the series of prints by Vivares after Claude and Dughet published by Arthur Pond in 1741–3: see Elizabeth Miller, 'Landscape Prints by Francis Vivares', *Print Quarterly*, vol. 9, no. 3, 1992, pp. 272–81 at p. 272, n. 3 and pp. 276–7 for these references. Vivares did engrave a Dughet landscape which was in the Delmé senior collection in 1741 (and is now at Holkham Hall, inv. no. 179), but this is not a storm scene.

For the suggestion that the *Storm* in the Delmé collection sold at the 1806 Lansdowne sale may have been acquired in 1810 by the Earl of Leicester and so could not be NG 36, see Boisclair 1986, p. 256. This seems very unlikely. As Anne French has pointed out, most of Dughet's landscapes now at Holkham Hall were there by 1773, and Delmé may have owned paintings by Dughet other than lots 60 and 61 of his 1790 sale: London, Kenwood 1980, p. 51.

10. *Report from the Select Committee on the National Gallery*, 1853, p. 747.

11. Baldinucci related that his 'last canvas, the crown of his production... was a marvellous representation of a stormy landscape with a violent tempest, wind-swept trees, dark clouds, lightning and dust-storm'. (*Notizie de' professori del disegno*, 6 parts, Florence 1681–1728, pt 5/6 (1728), p. 475, as translated by M. Roethlisberger in Roethlisberger 1975, pp. 10–11). See also L. Pascoli, *Vite de' Pittori, Scultori ed Architetti Moderni*, 2 vols, Rome 1730–6, vol. 1 (1730), p. 57. For a suggestion that Dughet painted direct from nature, see Mariette, *Abécédario*, ed. P. de Chennevières and A. de Montaiglon, 6 vols, Paris 1851–60, vol. 2 (1853–4),

p. 127. For the date when Dughet may have started to paint storm scenes, see Boisclair 1986, no. 101, and for an earlier scene of squally weather datable to the mid-1630s, see ibid., no. 22. For the influence of Dughet's storm scenes in England, see Anne French in London, Kenwood 1980, pp. 21–2.

12. J. Landseer, *A Descriptive, Explanatory, and Critical, Catalogue of Fifty of the Earliest Pictures contained in the National Gallery of Great Britain*, London 1834, pp. 321–2, repeated in the *National Gallery of Pictures by the Great Masters*, London n.d. (1838?), no. 78. For an essentially derivative appreciation, see Mrs Jameson, *A Handbook to the Public Galleries of Art in and near London*, 2 parts, London 1842, part 1, pp. 67–8.

13. W.Y. Ottley, *A Descriptive* [sic] *Catalogue of the Pictures in the National Gallery*, with critical remarks on their merits, London 1832, pp. 16–17. For other favourable comment on NG 36, see C.M. Westmacott, *British Galleries of Painting and Sculpture*, London 1824, p. 70; [P.G. Patmore], *British Galleries of Art*, London 1824, pp. 24–5; G.F. Waagen, *Works of Art and Artists in England*, 3 vols, London 1838, vol. 1, p. 217 (and pp. 215–16, for a Romantic appreciation of Gaspar's storm scenes); Passavant 1836; R.N. Wornum, revised by C.L. Eastlake, *Descriptive and Historical Catalogue of the Pictures in the National Gallery*, London 1847, p. 133; Waagen 1854, vol. 1, pp. 342–3.

14. [John Ruskin], *Modern Painters*, vol. 1 (1843), part II, sec. VI, ch. 1, para. 12. Ruskin's criticism of Dughet continues in the following paragraph: see vol. 3, pp. 583–4. He criticises the cloud forms in the picture in ibid., vol. 1, pt II, sec. III, ch. IV, para. 6: see vol. 3, p. 396.

15. Denys Sutton, 'Gaspard Dughet: some aspects of his art', *GBA*, 60, 1962, pp. 269–312 at p. 293.

16. Ibid., p. 285.

17. Boisclair 1986, pp. 193ff.

18. Ibid., p. 213.

19. Salerno 1977–8, vol. 2, p. 528; and see Salerno 1975, at p. 233.

20. Paris 1994, no. 200.

21. As evidenced by, for example, NG 5763.

22. See London, Kenwood 1980, no. 19.

23. Boisclair 1986, no. 275.

NG 68

Landscape with a Shepherd and his Flock

c.1670
Oil on canvas, 48.6 × 65.3 cm

Provenance
Possibly Palazzo Corsini, Piazza Fiammetta, Rome, by 1703 or (more likely) Palazzo Corsini, Via della Lungara, by 1750;[1] possibly one of the paintings seen by Lalande in 1767,[2] by Ramdohr (as supposedly by Dughet) in 1787,[3] and by Vasi in 1797;[4] bought in Rome by William Young Ottley in 1798, 1799 or 1800;[5] offered for sale by Ottley by private contract at 118 Pall Mall between January and April 1801 (no. 32);[6] offered by Ottley, Christie's, 16 May 1801 (lot 21, bought in at £252 bid from 'Lord D');[7] sale of Sir Scrope Bernard Morland (1758–1830), Christie's, 25 April 1818 (lot 126, £126 to Holwell Carr);[8] bequeathed to the Gallery in 1831 with other paintings by the Revd William Holwell Carr of Devonshire Place, London,[9] by his will dated 28 August 1828, as a memorial to his wife, Charlotte, and his son, William, when called 'Gallery at Albano'.[10]

Exhibitions
London 1801, 118 Pall Mall (32 or 33);[11] London 1822, BI (76 or 82).[12]

Related Works
PAINTINGS
(1) Whereabouts unknown. A copy by James Stark (1794–1859), 18 × 25 in. Sold by anon., Christie, Manson & Woods Ltd, 27 October 1961, lot 149 (25 guineas to Douglas);
(2) Whereabouts unknown. A signed copy by Philip Reinagle (1749–1833), 49.5 × 67.5 cm. Sold anon., New York, Sotheby's, 3 November 1983, lot 147 (U.S. $990 inc. premium).
DRAWING
Formerly in the Howard Bliss Collection, 1948, as by Gainsborough. Black and white chalk on paper (?). 8¾ × 11¾ in. Photograph in NG dossier.[13]
PRINTS
(1) By Thomas Starling, c.1831, 'Road scene, with a shepherd and sheep';[14]
(2) by J.B. Allen, 1838(?), 'Landscape, with Shepherd and Flock';[15]
(3) by John, James and William Linnell, c.1842, 'View near Albana'.[16]

Technical Notes
There is some overall wear and, especially at the centre of the picture, blanching, and some flaking paint. There is a damage at the left in the foliage, along the top edge of the sky and at the right edge level with the shepherd. The primary support is a medium plain-weave canvas, lined sometime before 1855,[17] when the tacking edges were ironed onto the canvas. The stretcher is nineteenth century, stamped *I-PEEL/LINER* and marked *207* in black chalk or crayon. The ground is a double ground of red (lower) and buff (upper). NG 68 was last fully restored in 1950.

The painting has been called 'Landscape near Albano (?)',[18] which is a town some 30 km south-east of Rome. The first printed reference to NG 68 being a view of Albano seems to have been in *The National Gallery of Pictures by the Great Masters*, published in 1838(?),[19] in which the anonymous author (probably John Landseer) wrote: 'The late possessor of this picture, the Rev. William Holwell Carr, who obtained it from the Corsini Palace, has inscribed beneath it, "A View near Albano". Having resided for some considerable time in Italy, Mr. Carr probably knew the very spot which is here represented.' The picture was also later described as a view near Albano by Wornum.[20] Although it is not impossible that NG 68 is a view looking north-east towards Monte Cavo, the lack of distinctive landmarks makes this unlikely. Furthermore, no reference to Albano was made by W.Y. Ottley, a previous owner of the picture, in his catalogue of the National Gallery's paintings published in 1832.[21] A title derived from that of Ottley is accordingly adopted here.[22]

NG 68 has been dated to the years 1669–71 by Boisclair,[23] and to c.1670 by Arcangeli[24] and Waddingham;[25] Thuillier considered it a late work.[26] Both the freedom of the brushwork and the confident composition support a late date and c.1670 seems reasonable.

NG 68 was praised in the nineteenth century for what was perceived as the simplicity of its composition,[27] but Ruskin thought the canvas was covered 'with about as much intelligence or feeling of art as a house-painter has in marbling a wainscot, or a weaver in repeating an ornamental pattern';[28] he was particularly critical of the trees.

Boisclair has noted what may be a derivative composition by Jan Frans van Bloemen (called Orizzonte) in the Galleria Doria Pamphilj, Rome (inv. no. 299).[29]

General References
Davies 1957, pp. 86–7 (as 'a comparatively early work'); Wright 1985b, p. 106; Boisclair 1986, no. 347.

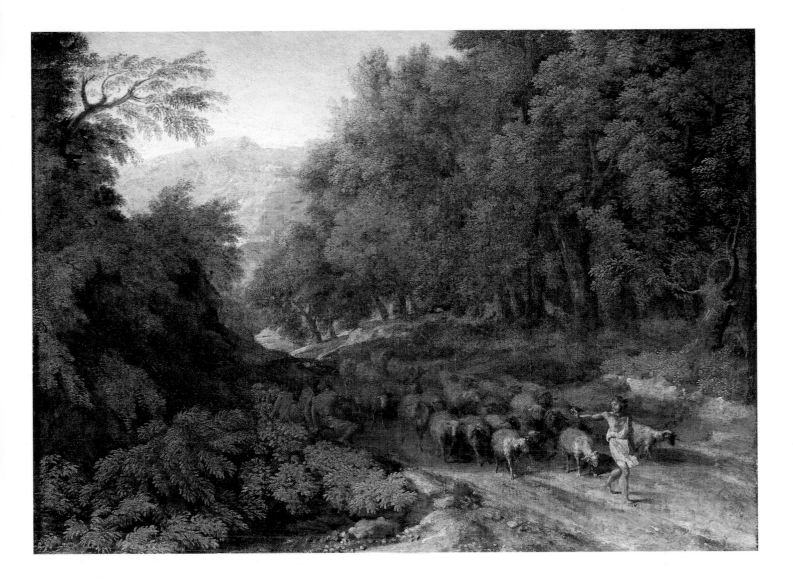

NOTES

1. There are eight landscapes by Dughet identified by Boisclair 1986 as having been in the Corsini collection. Of these, six have remained in the Palazzo Corsini (having been acquired with much of the Corsini collection along with the palazzo, by the Italian state, and two are NG 68 and NG 98. Five of the Dughets now in the Galleria Nazionale have dimensions close to those of NG 68 and NG 98, namely Boisclair no. 215 (50 × 66 cm), no. 298 (51 × 67 cm), no. 404 (49 × 66 cm), no. 405 (50 × 67 cm) and no. 406 (50 × 63 cm). Since the Corsini inventories typically describe pictures by Dughet – there called 'Gaspare Pussino' or 'Pussino', although the latter could in some cases refer to Nicolas – as 'vedute' or 'paesi' without further detail beyond size, NG 68 and 98 cannot be distinguished in the Corsini collection from the Galleria Nazionale pictures. There are Corsini inventories dated 1625, 1630, 1636, 1642, 1679, 1703, 1750, 1770, 1771, 1784 and 1797, and others which post-date 1800. The following entries in Corsini inventories may refer to, or include, NG 68 and 98. These inventories are all published in M.L. Papini, *L'ornamento della pittura. Cornici, arredo e disposizione della Collezione Corsini di Roma nel XVIII secolo*, Rome 1998, save the 1750 inventory, which is published in G. Magnanimi, 'Inventari della collezione romana dei principi Corsini' *Bollettino d'Arte*, no. 7, 1980, pp. 91–126, and no. 8, pp. 73–114.

A. 19 December 1703. List of paintings at the Palazzo di Piazza Fiammetta attached to the will of Neri di Andrea Corsini (d.1703).

(38–39) 'Due paesini, di mezza testa, grandi, con cornici intagliate e dorate/di Possino' (see Papini, op. cit., pp. 26, 157).

B. Inventory of pictures acquired by Cardinal Neri Maria di Filippo Corsini (1685–1770). This inventory's assumed date is 1750.

'36. Dal Masucci. 36. Un Paesino di Gaspero Pussinos 30.'
'83.94. Dall'Abe Costa provenienti da Casa Costaguti. 83.94. Dodici Paesi, o Architetture dei due Pussini s 120' (see Magnanimi, op. cit., pp. 96, 98. Masucci was presumably the painter Agostino Masucci who worked for the Corsini family: Papini, op. cit., pp. 37, 45, n. 44).

C. Inventory dated 1750 of paintings in the Corsini collection

GALLERIA …

149. Del Sig.ʳ:	149. Due Paesini di
Card: Lorenzo.	Gaspero Pussino be –
150. Comprato.	150. nissimo conservati

GALLERIA DLLA SIGᴿᴬ: DUCHESSA….

49. Regalo dl Sig.ʳ:	49. Due Paesi di
50 Duca di Bracciano	Gaspero Pussino 50. …

CAMERA DEL LETTO DL SIGᴿ: DUCA….

149. Del Sig.ʳ: Card:	149. Due Paesi di
150. Lorenzo.	Gaspero Pussino 150.
174. 185 Comprati dalla casa Costaguti. Erano gli sportelli delle finestre dl casino di porto d'Anzio.	174. 185. Dodici quadretti, tra Paesi, una Tempesta dalla e diverse Architetture dei due Pussini, Niccolò, e Gaspero.

ANTICAMERA DI SOPRA…

207. Del Sig.ʳ:	207. Quattro Paesi di Gaspero Pussino..
208. Card:	208. con cornici Nere, fillettate d'oro
209.	209.
210. Lorenzo	210.

(see Magnanimi, op. cit., pp. 104, 114, 117, 118). Dughet may have worked for the Costaguti in the period 1653–4: Boisclair 1986, p. 53. NG 68 and 98 are, however, probably of the following decade or later, suggesting that they were not among the uncertain number of Dughets bought from the Costaguti. No paintings by Dughet are listed in another (undated) inventory made during the papacy of Lorenzo di Bartolomeo Corsini, Clement XII (1730–40). This suggests that, other than the two Dughets mentioned in the inventory of 19 December 1703, the pictures by Dughet in the Corsini collection were acquired between 1730 (when Lorenzo Corsini became Pope Clement XII) and 1750 when Inventory C was prepared.

D. Posthumous inventory of pictures at the Palazzo Corsini of Cardinal Neri Maria di Filippo Corsini (1685–1770)

(136) 'Un paesino, di Gasparo Pussini sc. 30'/ (140–151) 'Dodici paesi ed architetture, de' due Pussini sc. 120' (see Papini, op. cit., p. 167).

E. Inventory drawn up in 1771 of paintings in the apartment of Cardinal Andrea Corsini (1735–95) at the Palazzo Corsini.

'Prima anticamera…

(20–23) 'Quattro quadri, di palmi 2 per traverso, rappresentanti vedute. Di Gaspare Pussino/…

Prima Galleria…/Altra colonna tra le finestre…

(63–64) 'Due quadri, di palmi 2½ per traverso, rappresentanti vedute. Di Gaspare Pussino.

Altra galleria, verso il giardino… Facciata incontro le finestre…

(179–180) 'Due quadri, di palmi 2 per traverso, rappresentanti paesi, assai belli. Del Pussino…'

(see Papini, op. cit., pp. 168, 170, 174 for the above, and pp. 87–100 for a reconstruction of the hang of the Corsini collection according to this inventory).

F. Inventory of 1784 'Terza anticamera…/ (70–71) Facciata passato la finestra, due paesi compagni. Copie di Posino… Nota delli quadro esistenti nell' appartamento di Sua Eminenza il Sig. Cardinale Andrea Corsini/ Prima anticamera…/ (24–25) Due paesi in testa traverso. Originale di Gaspero Posino./ (32–35) Facciata passato la porta, 4 paesi in misura di testa traverso, 3 delli quali di Gaspero Posino ed uno con una torre, di Salvator Rosa./ Galleria entrando dalla parte destra…/ (139–140) … due paesini in traverso. Originali di Gaspero Posino./ Camera verde…/ (380–381) Due paesi, in tela di testa traverso. Originali di Gaspero Posino.'

(see Papini, op. cit., pp. 182, 189, 192, 199).

G. A note of payments made from 6 October 1746 to 21 November 1747 to Domenico Michelini includes: 'A dì 18 Dicembre per aver fatti fare due telari da mezza testa, e foderatoci, e ripulito due Paesi di Posino – sc. – 80… E più foderati, e telari nuori, e ripuliti, e stuccati alcuni buchi a trè quadri, cioè due da testa di Gaspero Posino, et altro un poco più piccolo che da testa di Claudio Lorenese – sc. 12.50.'

H. Inventory of Corsini movables drawn up between 1798 and 1801. 'Cammera del letto… /Facciata frà la fenestra e la Porta che conduce al Gabinetto…/Sopra la Porta due quadretti larghi p.ⁱⁿᵒ 2 circa altri p.ⁱⁿᵒ 1½ circa Paesi Scuola del Pusini.' None of the other paintings attributed to Dughet in this inventory could be NG 68 or 98.

2. [Joseph-Jérôme Lefrançois de Lalande], *Voyage d'un françois en Italie fait dans les années 1765 & 1766… Nouvelle édition corrigée & considérablement augmentée par un Savant très-distingué, qui a parcouru cette charmante partie de l'Europe l'année 1767*, 8 vols, Yverdon 1769–70, vol. 4 (1769), p. 340: 'Quatre petits tableaux de Gaspard Poussin: une belle représentation de la nature, mais dont les sites ne sont pas si intéressans que ceux de Nicolas Poussin son beau-frère.' The present Palazzo Corsini was begun in 1736 (A. Blunt, *Guide to Baroque Rome*, London 1982, p. 176) under the direction of Cardinal Neri-Maria Corsini (1685–1770), nephew of Lorenzo Corsini (1652–1740), who became Pope Clement XII in 1730. Cardinal Neri was a keen collector of art: Luigi Passerini, *Genealogia e Storia della Famiglia Corsini*, Florence 1858, p. 180, but the family owned numerous works of art before the present Palazzo Corsini was built: *Guide Rionali di Roma. Rione XIII Trastevere, parte I*, ed. L. Gigli, Rome 1980, p. 96.

3. F.W.B. von Ramdohr, *Ueber Mahlerei und Bildhauerarbeit in Rom für Liebhaber des Schönen in der Kunst*, 3 vols, Leipzig 1787, vol. 2, p. 157: 'Zwei angebliche Landschaften von Poussin'. Ramdohr saw these paintings in the gallery of the Palazzo Corsini.

4. Marien Vasi, *Itinéraire instructif de Rome*, Rome 1797, vol. 1, p. 456: '…dans la galerie, on voit… deux paysages, par le Poussin.'

5. 1798 or 1799 according to W. Buchanan, *Memoirs*, vol. 2, p. 20. For the date of 1800 for Ottley's purchase of NG 68 and NG 98, see the catalogue cited in note 6 below.

6. *A Catalogue of Pictures from the Colonna, Borghese, and Corsini Palaces, &c. &c. purchased in Rome in the years 1799 and 1800. Now on exhibition and sale by private contract, at No. 118, Pall Mall, late the Milton Gallery* [London 1801]:

'PALACE	32.} Gaspar Poussin. Two
CORSINI/	Landscapes, with Figures;
	33.} one a view of L'Arriccia, near Rome. Breadth, 2 ft. 2 in. Height, 1 ft. 7½ in.'

7. 'Gaspar Poussin – 20 LANDSCAPE WITH FIGURES – the Entrance to L'Arriccia, near Rome. This Picture and its Companion, when in the Corsini Palace, were esteemed the finest small Examples of the Master in Rome – 2 feet 2, by 1 foot 7½ / Ditto – – 21 The Companion to the Former, & Woody Scene, a Shepherd leading his Flock; – out of the Picture – striking – 2 feet 2, by 1 foot 7½.'

Its companion, NG 98, was lot 20 of the same sale, was bought in to a bid of £252 from Robinson. For the possibility that both NG 68 and NG 98 were in the collection of Sir Abraham Hume before being in that of Morland, see note 9 to the catalogue entry for the latter.

8. 'Gaspar Poussin/A Road through a Wood, with a Flock of Sheep; from the Prince Corsini's Collection.' The companion picture, NG 98, was lot 125 of the same sale where described as 'Gaspar Poussin / A View of Larici – a clear and beautiful chef d'oeuvre, in his

finest manner. From the Prince Corsini's Collection'. It too was sold to Holwell Carr, but for £136 10s.: Boisclair 1986, pp. 276–7, and *The Index of Paintings Sold*, vol. 4, part 1, p. 317.

9. For the Revd William Holwell Carr, see Judy Egerton, *National Gallery Catalogues. The British School*, London 1998, pp. 399–405.

10. An extract of the Will, in which NG 98 is called 'Larici', is in NG Archive NG5/15/1831.

11. See note 6 above.

12. Holwell Carr lent these paintings to the British Institution's 1822 exhibition, not the 1821 exhibition as stated in [Rev. James Dallaway], *An account of all the pictures exhibited in the rooms of the British Institution from 1813 to 1823*, London 1824, pp. 120–1, at least according to the British Institution's own list of pictures exhibited in 1821.

13. This drawing is not included in John Hayes, *The Drawings of Thomas Gainsborough*, London 1970. The Bliss collection was sold in 1950: Hayes, op. cit., p. 102.

14. *Valpy's National Gallery*, facing p. 61.

15. *The National Gallery of Pictures by the Great Masters presented by individuals or purchased by grant of Parliament*, London, n.d. (1838?), pl. 87.

16. *Engravings of Fifty of the most Celebrated Pictures in the National Gallery, by John, James, & William Linnell*, n.d. [after 1841]; and *Felix Summerly's Hand Book for the National Gallery*, London 1843, p. 25.

17. *Catalogue of the Pictures in the National Gallery, having reference more particularly to their material condition*, ms. cat., NG Archive, NG 10, vol. 1, no. 68.

18. Davies 1957, p. 86; Boisclair 1986, p. 276.

19. See note 15 for full citation.

20. Ralph N. Wornum, revised by C.L. Eastlake, *Descriptive and Historical Catalogue of the Pictures in the National Gallery*, London 1847, p. 133.

21. Ottley 1832, pp. 64–5, where NG 68 was called 'A Landscape, with a Shepherd and a Flock of Sheep'. There is no reference in any nineteenth-century title of NG 68, or of any engraving after it, to the two figures seated on a bank of earth left of centre. This may mean that they were, as they are now, difficult to see.

22. Boisclair 1986, p. 276 with information from G. Redford, *Art Sales*, 2 vols, 1888, vol. 2, p. 280, noted that a now untraced painting by Dughet from the Falconieri Palace was sold at Christie's in 1868 with the title *The Mountain of Albano*, but that title may have been imaginative, and in any event seems of little consequence in determining whether the landscape in NG 68 is or is not imaginary and, if the latter, where it is.

23. Boisclair 1986, p. 276.

24. F. Arcangeli in Bologna 1962, p. 289.

25. M. Waddingham, 'The Dughet Problem', *Paragone*, no. 161, 1963, p. 47.

26. J. Thuillier, 'Tableaux attribués à Poussin dans les galeries Italiennes', *Poussin Colloque 1958*, vol. 2, p. 268.

27. For example in *The National Gallery of Pictures by the Great Masters*, cited in note 15 (unpaginated); in *Valpy's National Gallery*, pp. 61–2; by Passavant 1836, vol. 1, p. 46; G.F. Waagen, *Treasures of Art*, vol. 1 (1854), p. 343.

28. [John Ruskin], *Modern Painters*, 3 vols, 1846–56, vol. 1 (1846), part II, section VI, chapter I, paragraph 19; and see paragraph 7 for other critical remarks by Ruskin.

29. Boisclair 1986, p. 276. The Van Bloemen is reproduced as pl. 156.1 of L. Salerno, *Pittori di Paesaggio del Seicento a Roma*, 3 vols, Rome 1977–8, vol. 2, p. 156.

NG 98
Imaginary Landscape with Buildings in Tivoli

*c.*1670
Oil on canvas, 49.2 × 66.2 cm

Provenance
As for NG 68 until 1800;[1] offered by Ottley by private contract at 118 Pall Mall between January and April 1801 (no. 33);[2] offered by Ottley, Christie's, 16 May 1801 (lot 20, bought in at £252 to a bid by 'Lord D');[3] sale of Sir Scrope Bernard Morland (1758–1830), Christie's, 25 April 1818 (lot 125, £136 170s. to Holwell Carr);[4] bequeathed in 1831 with other paintings by the Revd William Holwell Carr of Devonshire Place, London, by his will dated 28 August 1828, as a memorial to his wife, Charlotte, and his son, William, when called 'Larici'.[5]

Exhibitions
As for NG 68.

Related Works
PAINTINGS
(1) Karlsruhe, Staatliche Kunsthalle (inv. no. 2570). Variant composition, oil on canvas, 38 × 49 cm (fig. 1);[6]
(2) Karlsruhe, Staatliche Kunsthalle. A variant replica (or copy) of (1) above, 39.4 × 48.3 cm.[7] Perhaps the painting in the Philippe Panné deceased sale, Christie's, 26–28 March 1819 (lot 11);
(3) Whereabouts unknown. A copy of (1) above, 36.1 × 46.9 cm, formerly in the Anthony Blunt collection;[8]
(4) Whereabouts unknown. A copy of NG 98, 49.5 × 67.3 cm, sold Christie's, South Kensington, 2 July 1997, lot 427 (£1610). Photograph in NG dossier;[9]
(5) Whereabouts unknown. A copy of NG 98, 48.5 × 66 cm, sold Newbury, Dreweatt Neate, 29 April 1998, lot 168 (£720, as 'Continental School'). Photograph in NG dossier;
(6) Whereabouts unknown. A copy of NG 98, 63.5 × 76.2 cm, sold Christie's South Kensington, 8 July 1998, lot 304 (£1995).
PRINT
By Alfred Smith, *c.*1831, 'A View of La Riccia'.[10]

Technical Notes
In reasonable condition. There are some losses at top left and right in the sky and along the bottom of the picture, some flaking due to excess glue in the lining, some blanching of the foliage and some wear. The primary support is a medium plain-weave canvas lined some time before 1853.[11] The stretcher, probably nineteenth century, is stamped: *I. PEEL/LINER*. It is also marked in black chalk or crayon *206*. The double ground is like that of NG 68, as is the restoration history.

As with NG 68, the figures have been painted on top of the landscape.

This painting was said to be a view of L'Ariccia when in the Ottley collection,[12] and this identification has been assumed in all National Gallery catalogues and most other publications since the painting was acquired by the Gallery.[13] Salerno may have questioned this identification (although his meaning is unclear),[14] and Boisclair has questioned it, citing Salerno.[15]

Ariccia is a small, and ancient, town a kilometre southeast of Albano (see NG 68) on the Appian Way, with an altitude of 412 m. It was sold in 1661 by the Savelli to the Chigi family,[16] who had Bernini enlarge and renew the palazzo and build the church of S. Maria dell'Assunzione. Although Ariccia was described as a small village by Vasi at the end of the eighteenth century,[17] Lalande had in the 1760s described it as a large town,[18] and one may suppose that during its ownership by the family of Alexander VII Chigi – who was pope from 1655 until 1667, the period shortly before Dughet was likely to have painted NG 98 – Ariccia, unlike the settlement shown in the painting, would have been a town of substance. This factor and the lack of a Chigi provenance would be sufficient reasons for doubting that Ariccia is depicted in NG 98. Recently, however, David Marshall has identified the hilltop buildings as derived from, albeit not precise representations of, structures not in Ariccia but in Tivoli as they appeared in Dughet's lifetime. At the left of NG 98 the causeway on arched substructures recalls the road now called the Via di Quintilio Varo;[19] to its right the tower with a gateway is based on the the the Porta S. Angelo, the gateway leading to the Via di Quintilio Varo and the Via Valeria; and to the right of that, and separated from it by foliage, the low tower with a pitched roof is like the so-called Villa of Maecenas. This last building, however, would have been impossible to see from the viewpoint from which Dughet has shown the gateway,[20] so Dughet has here constructed an imagined landscape which incorporates actual architectural elements.

NG 98 and NG 68 were treated as a pair by some visitors to the Corsini collection.[21] Their size is virtually identical and they function as a pair compositionally, NG 98 at the left and having an upwards focus and NG 68 at the right with a view looking downhill. The two paintings are also stylistically consistent, so NG 98 is, like NG 68, datable to *c.*1670.[22] It is perhaps worth noting, however, that there were two other late works by Dughet of nearly identical size in the Corsini collection,[23] and that these may once have hung together with the National Gallery pictures when Lalande visited the Palazzo Corsini in 1767.[24] The possibility that NG 68 and NG 98 were originally two of a group of four paintings, or that each was once paired with one of the other two paintings in the Corsini collection, can not therefore be entirely excluded.

General References
Davies 1957, p. 87; Wright 1985b, p. 106; Boisclair 1986, no. 348.

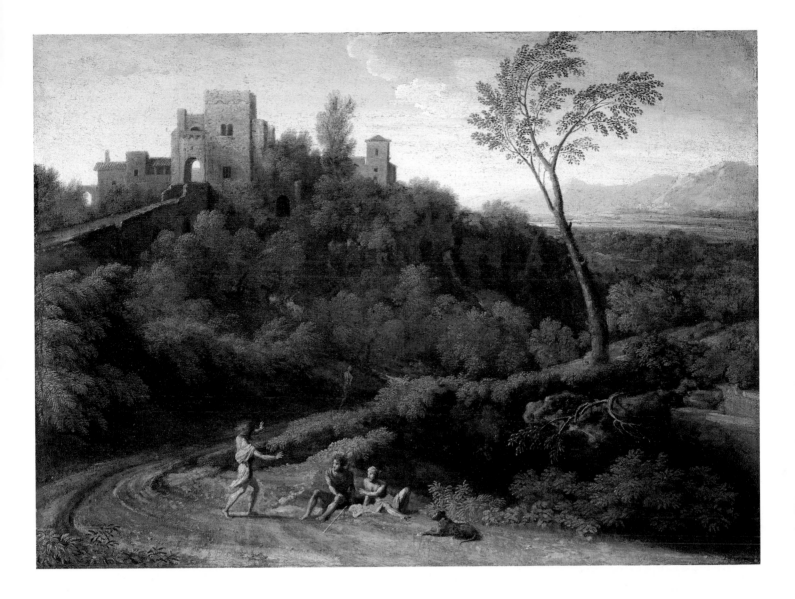

Fig 1 *Imaginary Landscape with Buildings in Tivoli*, *c.*1670. Oil on canvas, 38 × 49 cm. Karlsruhe, Staatliche Kunsthalle.

NOTES

1. For NG 68, Dughet's *Landscape with a Shepherd and his Flock*, see pp. 152–5.

2. Sixty-two paintings were offered by Ottley at 118 Pall Mall between 24 January and 25 April 1801: *Index of Paintings Sold, 1801–1805*, p. 3.

3. See note 7 to NG 68.

4. See note 8 to NG 68.

5. See note 10 to NG 68.

6. Boisclair 1986, no. 380.

7. Boisclair 1986, no.R4, as a copy; ed. J. Lauts, *Staatliche Kunsthalle Karlsruhe. Neuerwerbungen Alter Meister 1966–1972*, Karlsruhe 1973, p. 54, as autograph.

8. Boisclair 1986, no. R47.

9. This painting had been offered for sale at Christie's East, New York, 26 February 1997, lot 115. Alastair Laing, who inspected the painting prior to the London sale, has kindly advised (letter of 24 June 1997 in NG dossier) that there is an inscription, mistranscribed from an earlier one, on the lining canvas: *C. LORRAIN/COLL. SOPHIA HUME ESQ.* [sic.]/*–1809*; and a further inscription on the stretcher: *Gift from Sir A. Hume to Lady Elizabeth Cust of the Family of Lord Brownlow*. Laing supposes that the original inscription may have said that the copy was by Sophia Hume, who was the daughter of Sir Abraham Hume and who in 1809 copied a picture by Mola in her father's collection. As Laing points out, it is conceivable that NG 98 passed through the collection of Sir Abraham Hume (1749–1838) before it was acquired by Morland, in which case NG 68 could be presumed to have followed the same route. However, neither painting is recorded in the *Manuscript catalogue of the collection of Sir Abraham Hume*, *c.*1820, Victoria & Albert Museum, National Art Library, RC.V.19, nor in *A Descriptive Catalogue of a Collection of Pictures comprehending specimens of all the various schools of painting: belonging to [Sir Abraham Hume]*, London 1824, with Appendix, 1829 or later, both of which postdate the acquisitions by Morland. Conceivably, NG 68 and 98 were lots 87 and 88 of the sale of Sir William Young (who was William Young Ottley's uncle), London, Peter Coxe, 20 May 1802, described respectively as *View of Tivoli* and *View near Tivoli*, and both measuring 15 × 24 in. However, although lot 87 was bought by Hume, and an annotated description 'high buildings, small thin figures' could apply to NG 98, lot 88 was not (it was bought by Admiral Waldegrave). Also, as David Marshall has kindly pointed out to me, it would be odd for two paintings to be separated and then reunited (by Morland), not to mention NG 98's title being changed from 'Ariccia' to 'Tivoli' and back again. See *Index of Paintings Sold, 1801–1805*, p. 253. For further information on Sir Abraham Hume, see Laing 1995, p. 226.

10. *The National Gallery of Pictures by the Great Masters presented by individuals or purchased by grant of Parliament*, London n.d. (1838?), pl. 85.

11. When conservation records began.

12. See note 6 to NG 68.

13. For example, Ottley 1832, p. 64; R.N. Wornum, revised by C.L. Eastlake, *Descriptive and Historical Catalogue of the Pictures in the National Gallery*, London 1847, p. 134; Davies 1946, p. 39; Davies 1957, p. 37.

14. Salerno 1977–8, vol. 2, p. 526: 'In the landscape illustrated here there is the same view of a village that appears in another picture in the National Gallery in London.' The captions to the reproductions of both pictures in Salerno's book say 'View of Ariccia'.

15. Boisclair 1986, pp. 276–7.

16. *Guida d'Italia del Touring Club Italiano. Roma e dintorni*, Milan 1965, p. 674.

17. M. Vasi, *Itinéraire instructif de Rome*, vol. I, Rome 1797, p. 632.

18. [Joseph-Jérôme Lefrançois de Lalande], *Voyage d'un françois en Italie fait dans les années 1765 & 1766... Nouvelle édition corrigée & considérablement augmentée par un Savant très-distingué, qui a parcouru cette charmante partie de l'Europe l'année 1767*, 8 vols, Yverdon 1769–70, vol. 5 (1769), p. 222.

19. David Marshall notes that the older form of the name 'Via di Quintilio Varo' was usually 'Via di Quintilio', and that the road has also been called 'Via di S. Angelo' in reference to the monastery of S. Angelo on Monte Catillo nearby (communication of 25 September 2000).

20. David Marshall, 'Gaspard Dughet's View of "Ariccia" in the National Gallery' (to be published).

21. See notes 3 and 4 to the entry for NG 68.

22. For the dating of NG 68, see that entry.

23. Boisclair 1986, nos 404 and 405, both bequeathed to the Galleria Nazionale d'Arte Antica, Rome, by Prince Tommaso Corsini in 1883. Boisclair no. 406 is also close in size to NG 68 and 98, but as a storm scene would not fit well with the other paintings, which are not obviously of 'the seasons'.

24. See note 2 to the entry for NG 68.

Imaginary Landscape with Buildings in Tivoli (NG 98), detail.

NG 161
Tivoli (?)

*c.*1670
Oil on canvas, 71.1 × 166.9 cm

Provenance

Possibly acquired by Lorenzo Onofrio Colonna (1637–89), Duke of Paliano and Grand Constable of the Kingdom of Naples, and at the Palazzo Colonna, Rome, between 1664 and 1679;[1] possibly identified in the Colonna collection, Rome, in 1783;[2] in the collection of William Young Ottley (1771–1836) certainly by 24 January 1801 when offered for sale by him by private contract, but probably by March 1799 when Ottley returned to London from Rome;[3] offered by Ottley at auction, Christie's, 16 May 1801 (lot 32, bought in(?) at 700 guineas);[4] William Young Ottley sale, Christie's, 25 May 1811 (lot 89, 650 guineas to Sir Charles Long);[5] lent by Long to the British Institution in 1816 and 1832 (see Exhibitions);[6] bequeathed by Long (then Lord Farnborough) in 1838.

Exhibitions

London 1816, BI (68);[7] London 1832, BI (19) (?);[8] London 1953–7, Victoria and Albert Museum, long-term loan; Bologna 1962, Palazzo dell'Archiginnasio, *L'Ideale Classico del Seicento in Italia e la Pittura di Paesaggio* (119); London 1980, Kenwood House, *Gaspard Dughet called Gaspar Poussin 1615–75* (22); Coventry, Derby, Doncaster, Bath 1982, p. 34; Kendal 1991, Abbot Hall Art Gallery, *Classical and Picturesque Landscapes*.

Related Works

PAINTINGS[9]

(1) A copy. Whereabouts unknown, of *c.*1800, sold Dorotheum, Vienna, 30 November 1965, lot 36. 52 × 82 cm;[10]

(2) A copy(?) said to be seventeenth century. Paris, Mme Jean Bonnardel in 1958;[11]

(3) A copy with variants of *c.*1700(?), sold Paris, Delavenne & Lafarge, 22 November 1996, lot 80. 82 × 168 cm.

DRAWINGS

(1) Paul J. Weis, New York (formerly, Raleigh, North Carolina Museum of Art, inv. no. G.63.19.1., by whom sold, Sotheby's, New York, 27 January 1999, lot 80). Fig. 2;[12]

(2) London, private collection. An early nineteenth-century watercolour copy attributed to Copley Fielding;[13]

(3) Wembley, Middlesex, private collection. Bolognese(?), copy of the left-hand side of NG 161.[14]

PRINT

By John, James or William Linnell in *Engravings of Fifty of the most Celebrated Pictures in the National Gallery*, London n.d. [after 1841]. The Linnell engraving appears also in *Felix Summerly's Hand Book for the National Gallery*, London 1843, p. 43.

Technical Notes

In reasonable condition, having suffered some general wear, blanching in the foliage and some blooming in the varnish.

There are discoloured retouchings at the right particularly by the man at the extreme right and near the bottom edges, and a 3 cm-long crescent-shaped tear in the canvas in the area of the trees some 20 cm from the left-hand edge. NG 161 was last fully restored in 1953. The primary support is a medium to coarse twill canvas, relined possibly in 1878, or at any rate before 1853 when conservation records began, onto a stretcher marked *W Morrill Liner*. The X-radiograph (fig. 1) shows no cusping of the canvas along the top or bottom edges, suggesting that it may have been cut down. Tacking holes and a line of damage along the bottom edge of the canvas suggest that at some point after it was presumably cut down, it was fixed to a smaller stretcher than the present one. The ground appears to be red. The paint medium, according to analysis of samples taken from the top edge (blue sky) and left-hand edge (lime-green foliage), is linseed oil with a little pine resin.[15]

There are pentimenti to the left-hand dog, and to the buildings at the upper right. The buildings appear to have been reduced in size, while the town appears to have been extended at the right over what was once landscape. The X-radiograph indicates some reworking of the two reclining figures at left; it also shows that the two figures right of centre were painted over an existing landscape background, and that the figure at the extreme right was originally placed further away from the picture plane and a little to the left.

The landscape may be based on that at Tivoli, as proposed by Davies,[16] and at first sight this seems confirmed by the drawing now in the Paul J. Weis collection, New York (fig. 2). Goldfarb rightly raised the possibility that the drawing might be a ricordo rather than a preparatory drawing,[17] but minor changes of detail between drawing and painting suggest that it is the latter. For example, the campanile at the left of the town has been given an added storey in the painting, and the pedimented building a little behind it and to the right has been raised so that its columned porch emerges. However, the topography shown in the drawing does not seem entirely consistent with the actual topography of Tivoli. The most likely viewpoint for the drawing would seem to be the far bank of the river Aniene to the north of the town, but the celebrated Temple of Vesta does not appear in the left middle distance where one might expect it, and the identity of the site depicted must remain a matter of speculation, if indeed it is a real rather than an imagined site.[18]

As for the dating of NG 161, Sutton proposed the second part of the 1640s, grouping it (and other pictures) with the series of gouaches Dughet painted for the Palazzo Colonna, themselves dated by Sutton to this period.[19] Arcangeli, however, thought NG 161 too accomplished to be a youthful work and dated it *c.*1670, considering it to be characteristic of how Dughet's biographer Lione Pascoli (1674–1744) described the artist's third (in time) style, that is, 'vaga ed amena'.[20] In spite of the problems of ascribing particular works to indeterminate periods of Dughet's life based on Pascoli's brief description, published 55 years after Dughet's death,[21] Arcangeli's

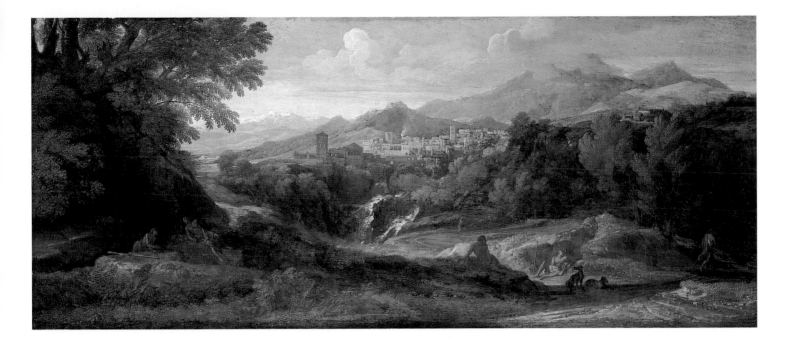

Fig. 1 X-radiograph.

dating of NG 161 has been generally, and is here, accepted.[22] The Colonna gouaches were probably painted in 1671–3, so justifying Sutton's comparison of NG 161 with them, if not his dating of the picture.[23]

The unusual dimensions of NG 161 – its length is more than double its height – suggest that it may once have been part of a decorative scheme. A painting by Dughet of virtually identical size exists at Chatsworth,[24] but there is no evidence to connect it to NG 161.

As Egerton has pointed out, the price paid by Long in 1811 for NG 161 – 650 guineas – testifies to the great esteem in which Dughet's landscapes were then held by British collectors, who at the same sale failed to buy Rembrandt's *Bathsheba* (Paris, Louvre), which was bought in at 180 guineas.[25] Ruskin never wrote specifically of NG 161, but was generally scathing of Dughet, whose popularity with collectors has never regained its early nineteenth-century heights.

General References
Davies 1957, p. 88; Wright 1985b, p. 106; Boisclair 1986, no. 342.

NOTES

1. No painting corresponding to NG 161 appears in the 1664 inventory of Lorenzo Onofrio's pictures. In the 1679 inventory item 150 is described as 'Un Quadro di p.mi 6½ e 3 con paese e figurine con cornice color di noce con foglie, e festone dorato opera di Gasparo Pusino', and item 322 as 'Due Quadri per sopraporti cioè uno di p:mi 5 e 3, e l'altro di 6 e 2½ con cornici dorate con paesi; opere di Gasparo Pusino' (see Safarik and Pujia 1996, pp. 127, 133).

Lorenzo Onofrio's 1689 inventory contains no paintings attributed to Dughet. The posthumous inventory of Filippo II Colonna (1663–1714) of 1714 includes as item 641 'Una sopraporta di palmj sette, e tre rapp.te un Paese originale di Gaspare Pusino con diverse figure con cornice [color dj noce etc]', and as item 646 'Un quadro dj misura dj palmi sette, e tre per traverso rapp.te un Paese, originale dj Gaspare Pusino con molte figurine cornice [con fondj color di noce etc.]'. Either could correspond to item 150 of the 1679 inventory, but possibly neither to item 322. Item 646 of the 1714 inventory, however, cannot be NG 161 because it is described as higher than it is broad. NG 161 may therefore be item 641 of the 1714 inventory, which seems more likely, on the basis of its size, to correspond to item 150 of the 1679 inventory than to item 322.

None of the other Colonna inventories published by Safarik (op. cit.) refers to a picture with sufficient detail to identify it with NG 161 other than perhaps the 1783 inventory (see note 2 below).

Identifying a picture described only as '*paese*' in Roman inventories is not necessarily made easier when measurements are given, because, as Jo Kirby has advised me, three different versions of the *palma* were in use in Rome: that used for cloth (21.2 cm); that known as the Palma Romana, used in architecture (22.3 cm) from 1525; and the mercantile palma (24.9 cm). Depending on which type was employed, item 150 of the 1679 inventory was measured as 63.6 × 137.8 cm, 66.9 × 145 cm or 74.7 × 161.9 cm, and item 641 of the 1714 inventory as 63.6 × 148.4 cm, 66.9 × 156.1 cm or 74.7 × 174.3 cm. But it is also clear that all the inventoried measurements were approximations.

2. Perhaps no. 159 of the 1783 inventory: '159 Un Quadro nell'altro Angolo verso il Vicolo di 2½, e 6. per traverso = Paese con figure = detto Pussino', *Catalogo dei quadrj, e pitture esistenti nel palazzo dell'eccellentissima Casa Colonna in Roma*, Rome 1783, p. 26. The painting is here described as being on the 'Quarta facciata in due parti Laterali verso il Corpo della Galleria'. The inventoried measurements,

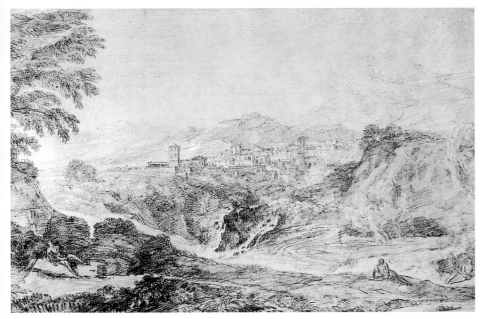

Fig. 2 *Classical Landscape, thought to be a View of Tivoli*, c.1670. Red chalk, 34.3 × 51.4 cm. New York, Paul J. Weis.

the equivalent of 53 × 127.2 cm, 55.8 × 133.8 cm or 62.3 × 149.4 cm (see note 1), are smaller than those of NG 161. The picture may have been noted by Ramdohr 1787, vol. 2, p. 77, but his description is vague.

3. 'FROM THE PALACE COLONNA / ... 11. Gaspar Poussin. Landscape with Figures; supposed a View of Nemi, near Rome. Breadth, 5f 6½ in. Height, 2f. 6in', *A Catalogue of Pictures from the Colonna, Borghese, and Corsini Palaces, & c. & c. purchased in Rome in the years 1799 and 1800. Now on exhibition and sale by private contract, at no. 118, Pall-Mall, late the Milton Gallery* [London 1801]. According to a letter of 9 December 1987 from B.B. Fredericksen, the date of this sale was 24 January 1801.

For the date of Ottley's return to London, see Ingamells 1997, p. 728; and see also on the date of Ottley's importation of pictures into England the discussion in *Index of Paintings Sold*, vol. 1, p. 3 and following note.

4. 'Gaspar Poussin. 32 LANDSCAPE and FIGURES – A View of *Nemi*, near Rome, capital, from the *Colonna Palace*, (Cat. no. 159) – *size 5 feet 6½, by 2 feet 6*.' The amount of the bid is given in an annotation to the catalogue and in Buchanan, *Memoirs*, vol. 2, p. 26, where the vertical dimension is wrongly given as 3½ feet. According to Buchanan, Ottley bought the pictures in Rome 'about the end of 1798 or beginning of 1799' (*Memoirs*, p. 20), but the 1801 private sale catalogue (see note 3 above) says 1799 or 1800. Since Ottley returned from Italy in M7arch 1799, 1798–9 seems a more likely acquisition date. But none of the six Dughets from the Colonna Palace offered for sale by Ottley in 1799 at 31 Margaret Street, London, corresponds to NG 161 (*Private View of Twenty-Six Capital Pictures, Purchased at Rome, in Dec.1798, from the Colonna, Borghese, and Aldobrandini Palaces*), and this seems confirmed by Farington's diary entry for

4 June 1799, so he may have imported the picture following his return to England. Ottley was known for his collection of Italian old master drawings.

An annotation to the copy of the Christie's catalogue in the Metropolitan Museum of Art, New York, reads: 'The City too crowded with houses: high up & c. Whence this Apathy?': *Index of Paintings Sold*, vol. 1, p. 252.

5. According to a pencilled annotation in a copy of the catalogue in the NG Library, the bid was £681 10s., but £682 10s., or 650 guineas, seems more likely and is confirmed in Christie's copy of the catalogue (letter of 2 July 1970 from Lady Dorothy Lygon). Lady Lygon also writes that 'it is recorded as being unsold to a bid of 650 guineas by Sir George Beaumont', but an annotation to a copy of the catalogue in the National Gallery of Ireland reads 'Mr Christie on knocking down this picture, exclaim'd I give it as Alexander did his Kingdom, to the Worthies bowing to the Hon. C. Long who was the purchaser': see *Index of Paintings Sold*, vol. 3, p. 354, where it is also stated to have been bought by Long on behalf of Beaumont. That Long was the purchaser is shown by a letter he wrote on 1 June 1811 to Cumberland, to which Judy Egerton has kindly drawn my attention: 'I have bought a picture which I have been long looking after – it is Ottley's Gaspar... one of the finest things I know of that Masters it is a long picture & was formerly in the Colonna Palace at Rome' (Add. MSS. 36, 516 f.160 v.). Cumberland noted what may well have been NG 161 hanging at Bromley-Hill in 1811: George Cumberland, *Bromley-Hill*, London 1811, p. 17 ('a Poussin').

Charles Long (1760–1838), politician, was created Baron Farnborough in 1826. In 1823–4 as Paymaster General he had been involved in negotiating the purchase of the Angerstein collection of paintings for the nation, see Egerton 1998, pp. 376–87.

6. NG 161 is described by Waagen in his Letter XI dated 21 June [1835]: 'I there saw a large landscape of an oblong shape by Gaspar Poussin, which is one of the capital pictures of the master. It represents an extensive view of a richly-wooded range of bold mountains, in which the high poetic feeling of Poussin is combined with an uncommon clearness and brilliancy of colouring, and very careful execution': Waagen 1838, vol. 2, p. 40. For Waagen's subsequent misdescription of the measurements of the picture, see *Treasures of Art*, I, 1854, pp. 343–4.

7. 'Landscape, from the Colonna Palace. G. Poussin. Right Hon. Charles Long.'

8. 'Landscape. Gaspar Poussin. Lord Farnborough.'

9. There is no copy of NG 161 at Sandon Hall, Stafford, as stated in Boisclair 1986: letter of 3 February 1998 from the Earl of Harrowby, T.D.

10. According to Boisclair 1986, p. 274.

11. Letter in NG dossier of 17 February 1958 from Mme Jean Bonnardel.

12. Boisclair 1986, p. 377 and Fig. 376. For a recent discussion of this drawing, see H.T. Goldfarb, *From Fontainebleau to the Louvre: French Drawing from the Seventeenth Century*, Cleveland 1989, no. 41.

13. Letter of 16 February 1981 from Anne French. (Probably the painting sold Christie, Manson & Woods Ltd, 3 December 1948, lot 87.)

14. Ibid.

15. White and Pilc 1996, pp. 94, 99.

16. Davies 1957, p. 88.

17. Goldfarb, cited in note 12.

18. A point raised by the author of the catalogue of Ottley's 1811 sale, who wrote (p. 16): 'Whether this rich and luxuriant scene is in every respect a real view, or whether it is a combination of the scattered beauties of nature, is difficult to determine.'

19. Sutton 1962, pp. 294–5.

20. Translated as 'fair, and lovely' by M. Roethlisberger in Roethlisberger 1975, p. 12, and as 'charmante et agréable' by Boisclair in Boisclair 1986, p. 115.

21. Lione Pascoli, *Vite de' Pittori, Scultori ed Architetti Moderni*, 2 vols, Rome 1730–6. The life of Dughet is in vol. 1 (1730), pp. 57–63.

22. See Waddingham 1963, pp. 37–54 at p. 47; J. Thuillier and A. Chatelet, *French Painting From Le Nain to Fragonard*, Geneva 1964, p. 55; A. French in London, Kenwood 1980, p. 45; Kitson 1980, p. 651; Boisclair 1986, and Goldfarb, cited in note 12. But L. Salerno appears to suggest a dating to the 1650s: Salerno 1977–8, vol. 2, pp. 524–6.

23. Boisclair 1986, pp. 63–4 and 278–82.

24. Boisclair 1986, no. 198. This painting was already in the Devonshire collection by 1725.

25. Egerton 1998, p. 384.

NG 1159
Landscape with Elijah and the Angel

c.1663
Oil on canvas, 201.8 × 154.0 cm

Provenance
'Recorded' at the Palazzo Colonna in an inventory said to be of 1654;[1] recorded in the collection of Lorenzo Onofrio Colonna (1637–89) in 1664;[2] possibly item 236 of a posthumous inventory of Filippo II Colonna (1663–1714) of 1714,[3] but probably referred to in another inventory of his dated 1714–16;[4] presumably one of the several landscapes by Dughet recorded in the Stanza de' Paesi[5] of the Palazzo Colonna *c*.1740;[6] recorded at the Palazzo Colonna by Ramdohr;[7] sold to Giovanni Gherardo de Rossi (1754–*c*.1830), poet and writer,[8] perhaps *c*.1797/8;[9] apparently bought by William Beckford (1760–1844), the writer and collector, of Fonthill Abbey, Wiltshire (until 1822), and then of 20 Lansdown Terrace, Bath,[10] perhaps from William Buchanan in or after 1803;[11] apparently acquired from Beckford by Richard Hart Davies (1766–1842), MP for Bristol;[12] certainly in the collection of Philip John Miles (d.1845), in the dining room at Leigh Court, near Bristol, by 1 February 1822,[13] and most likely by 1816;[14] by descent to his grandson, Sir Philip Miles MP (1825–88), of 75 Cornwall Gardens, London,[15] by whom sold, Christie, Manson & Woods, 28 June 1884 (lot 49, £1995, as 'The Calling of Abraham'), to Agnew's on behalf of the National Gallery.

Exhibitions
London 1816, BI (39?);[16] London 1870, RA, *Exhibition of the works of the old masters, associated with A Collection from the works of Charles Robert Leslie, R.A., and Clarkson Stanfield, R.A.* (22);[17] London 1948, Whitechapel Art Gallery, *Five Centuries of European Painting* (37);[18] London 1980, Kenwood House, *Gaspard Dughet called Gaspar Poussin 1615–75. A French landscape painter in seventeenth century Rome and his influence on British art* (15);[19] Copenhagen 1992 (2).

Related Works
PAINTINGS
(1) Schleissheim, Staatsgalerie Schloss, inv. 2231. Oil on canvas, 184 × 138 cm. A copy, in the collection of the Elector of Düsseldorf by 1788;[20]
(2) Sold by Richard L. Feigen & Co., New York, at Christie's, 19 April 2000 (lot 48, where wrongly stated to be a pair to NG 31). Oil on canvas, 193.5 × 143.5 cm. A copy. According to Boisclair, probably by the same hand as the Schleissheim painting;[21]
(3) Whereabouts unknown. Oil on canvas, 29 × 25 in., sold by B.C. Smith Esq. of Glasgow at Christie, Manson & Woods, 8 October 1948 (lot 131, £6 6s. to Cohen, as 'Jacob and the Angel') and sold at the same location, 7 December 1951 (lot 163, £9 9s. to Bagnell, with the same title). A copy;
(4) Whereabouts unknown. Oil on canvas, 90 × 132.5 cm. Sold Parke Bernet, Florence, 14 November 1978. According

to Boisclair, an autograph reprise of NG 1159 in horizontal format and with a different (unidentified) subject;[22]
(5) Palazzo Camuccini, Cantalupo. A copy by Vincenzo Camuccini (1771–1844), perhaps made when NG 1159 was removed from the Palazzo Colonna;[23]
(6) A version of (4) above, also presumably autograph, is recorded in an engraving by G.F. Gmelin as in the Colonna collection before 1813 and measuring 'palmi 9 e p.7 e once 2';[24]
(7) Reims, Musée des Beaux-Arts. Oil on canvas, 72 × 110 cm. A copy of (4) above, perhaps made in 1814.[25]
DRAWING
Düsseldorf, Kunstmuseum, inv. FP 4740 (fig. 2).[26]
PRINTS
(1) By Pietro Parboni, fl. Rome, *c*.1800;[27]
(2) by G.F. Gmelin in Rome, 1813. An engraving of a version of NG 1159 (see Paintings (6) above);
(3) by John Young, published London 1822 in the Leigh Court catalogue.[28]

Technical Notes
There is some wear in the foreground, and blanching throughout the greens. An old damage has left a raised horizontal crack some 8 cm long, about 76 cm from the top and starting about 30 cm from the left. The primary support is a medium-weight plain-weave canvas, relined prior to the painting's purchase by the Gallery and probably in the nineteenth century. The double cross-braced wooden stretcher is also probably nineteenth century. The right-hand stretcher bar bears the mark *8641*. Last fully restored in 1955.

The ground is a pale red-brown. Technical analysis has shown that the brightest blue parts of the sky contain finely ground ultramarine, and that the grey-blue areas contain smalt in addition to ultramarine and charcoal.

The precise subject of NG 1159 was unrecognised even in Dughet's lifetime, the author of the inventory said to be of 1654 calling it a landscape 'with an angel showing the Eternal Father to an old man'.[29] The picture's titles have also included 'Saint Anthony with an Angel',[30] 'The Calling of Abraham',[31] 'Moses and the Angel (?)',[32] 'Jacob and the Angel'[33] and 'The Storm',[34] and, in relation to the Düsseldorf drawing, 'The Calling of Matthew'.[35] Waagen seems to have been the first to propose that the subject of NG 1159 was, in his words, 'Elijah, to whom an angel is pointing out Jehovah passing over in the clouds'.[36] Although this identification was rejected by Davies,[37] it has since been accepted by Graf, French and Boisclair.[38]

The reasons why the other suggested titles can be rejected may be briefly summarised. 'The Storm' is clearly inadequate. As for the title 'Saint Anthony with an Angel', the figure at the left of NG 1159 has none of the usual attributes of this hermit saint of Egypt, and no incident in his story is depicted. According to all four Gospels the calling of Saint Matthew takes place in an urban setting. Although there are several episodes in Genesis in which Abraham could reasonably be

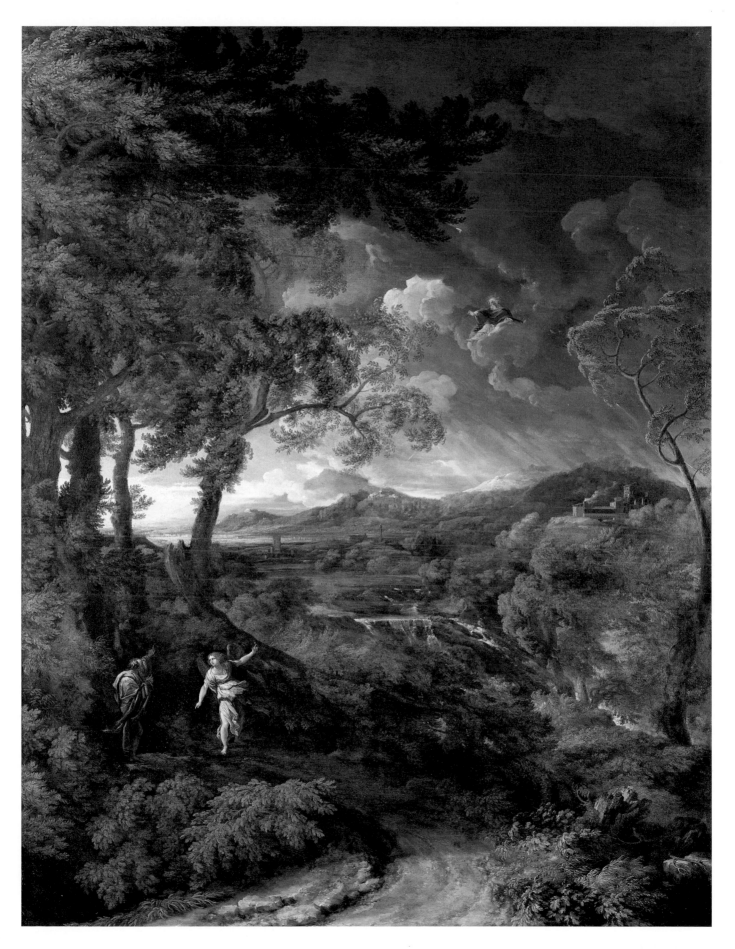

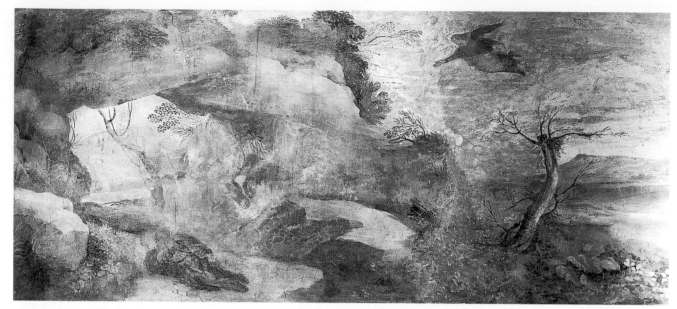

Fig. 1 *Dream of Elijah and the Angel on Mount Horeb*, before 1647. Fresco, 124 × 242 cm. Rome, San Martino ai Monti.

shown communicating with God in an extensive landscape (Genesis 12: 1; 13: 14–17; 15: 18–21), in none of these is there an intervening angel. Such intervention occurs only in the binding of Isaac, clearly not the subject of NG 1159. Nor is there any episode in the story of Jacob with which the figures in NG 1159 can satisfactorily fit. Davies's suggestion that the episode shown was that of Moses and the angel in Exodus 23: 20ff.[39] is scarcely more satisfactory, because the gesture of the figure at the left seems inappropriate.

More convincing is Waagen's identification of the subject with 1 Kings 19: 11, where an angel speaks to Elijah on Mount Horeb: 'Go forth, and stand upon the mount before the Lord. And, behold, the Lord passed by, and a great and strong wind rent the mountains, and brake in pieces the rocks before the Lord...' The bending of the trees in the wind and the shaft of light(ning?) leading from the Lord to the mountain top at the centre of NG 1159 support Waagen's suggestion. In addition, Dughet's treatment of this subject in NG 1159 is similar to his treatment of the previous episode in 1 Kings in a fresco (fig. 1) in the Carmelite church of S. Martino ai Monti, Rome,[40] where the subject is not in doubt.[41]

Boisclair suggested that NG 1159 could be one of two pictures for which Dughet was paid in 1660, the other being NG 31. This has been disputed,[42] and on stylistic grounds alone a date of *c.*1662–4 seems likely.[43] The fact that Dughet used a similar technique in the preparatory drawing for NG 1159, now in Düsseldorf (fig. 2), as he did in preparatory drawings for a series of gouaches dated to the early 1670s supports dating NG 1159 to the 1660s rather than the previous decade.[44] However, it has been argued that NG 1159 is among a number of paintings which, by virtue of their appearance in an inventory dated on its cover 1654, and in a section preceded by the headings on different pages '...robbe diversi compre nove nell'anno 1654' and 'quadri diversi novam.te fatti' ('various possessions newly bought in 1654', 'various pictures newly made'), must have all been bought or executed in that year.[45] Over 120 paintings are recorded under those headings, which seems an improbably large number of purchases and commissions for a single year. Although the relevant section of the inventory seems not to be a running inventory,[46] and some of the pictures in it were indeed bought in 1654,[47] it cannot have been completed in that year since it includes references to portraits of Pope Alexander VII (f.239),[48] who did not become pope until April 1655, of Queen Christina of Sweden (f.231), whose public reception into the Catholic faith did not occur until November 1655 and who did not reach Rome until the following month,[49] and of the Emperor Leopold (f.239), who was not elected Emperor until July 1658.[50] Hence there is no reason to doubt that the painting by Claude, *Landscape with the Flight into Egypt* (Madrid, Thyssen-Bornemisza Collection; fig. 3), which appears in the inventory and is signed and dated 1663, was not completed that year, rather than in 1654 as Safarik has proposed.[51] The dimensions of the Claude, 193 × 147 cm,[52] are close to those of NG 1159, which immediately follows the Claude in the '1654' inventory, where the two pictures are described as similarly framed. It seems reasonable to conclude that they were commissioned more or less simultaneously and hung as a pair. A date of *c.*1663 is therefore here proposed for NG 1159.

The picture was praised by Ramdohr,[53] by Waagen, who called it 'a chef-d'oeuvre of landscape-painting',[54] and, assuming that it was indeed the painting exhibited at the British Institution in 1816, by an anonymous critic who wrote, 'This if it were low enough to be seen might be praised according to its deserts. It is a fine picture and appears to be in excellent order.'[55] Waagen also stated that the figures were by Poussin,[56] an idea not entirely rejected by Davies.[57] However, the figures are quite unlike those of Poussin's later years. In any event Dughet was capable of painting the human figure, as is

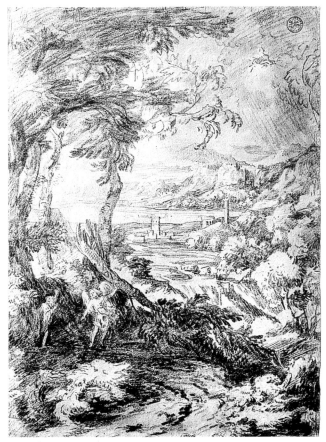

Fig. 2 *Elijah at the Cave of Mount Horeb*, c.1662–3. Black chalk, heightened with white on paper originally green, but now grey-yellow, 60 × 42 cm. Düsseldorf, Kunstmuseum. Sammlung der Kunstakademie.

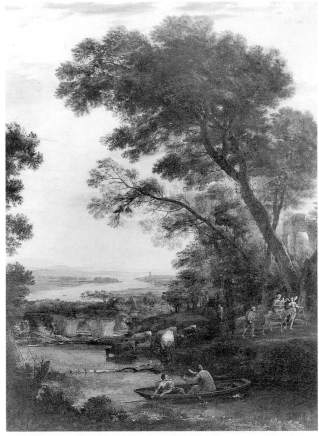

Fig. 3 Claude Lorrain, *Landscape with the Flight into Egypt*, signed and dated 1663. Oil on canvas, 193 × 147 cm. Madrid, Thyssen-Bornemisza Collection.

evident from his *Landscape with the Disobedient Prophet* (Le Havre, Musée des Beaux-Arts, inv. A318), and the Düsseldorf drawing is further evidence that he himself painted the figures in NG 1159 (fig. 4).

General References
Davies 1957, pp. 88–9; Wright 1985b, p. 106; Boisclair 1986, no. 201.

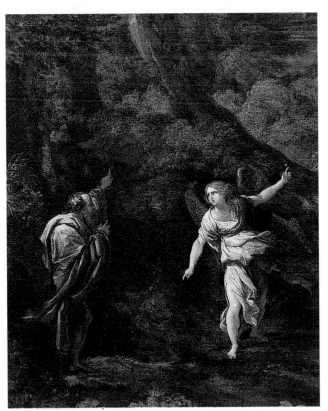

Fig. 4 Detail of NG 1159.

NOTES

1. *Inven.rio del s.r. Conte.le in Roma*, f.237: 'Quadro di grandezza simile [alto p.mi nove largo p.mi sette] di paesi con alberi con un Angelo che mostra il Padre Eterno ad un vecchio opera di Gasparo Pusino con Cornice [alla fiorentina tutta dorata con un Cordone grosso granito]': Safarik and Pujia 1996, p. 82. The painting may have been bought or commissioned by Marcantonio V Colonna in 1654 (ibid., p.76), but this seems unlikely (see Text).

2. *Inventario delle robbe dell'Ecc:mo Sig:re Gran Contestabile Don Lorenzo Onofrio Colonna... 16 Marzo 1664*, f.43: 'Quadro in tela di grandezza simile al sud:o [alta p:mi nove, larg:a p.mi 7 in circa] con paese, et alberi, con l'Occidente, con un'Angelo che mostra il Pre Eterno ad un'Vecchio, opera di Gaspare Pusino, con sua Cornice [alla fiorentina con un' cordone grosso granito, dorata tutta]': Safarik and Pujia 1996, p. 95. NG 1159 can probably also be identified with 'Un Quadro di p.mi 8 e 6 con paese con cornicie [sic] dorata con cordone dorato opera di Gasparo Pusino' in an inventory of 1679 of Lorenzo Onofrio Colonna (Safarik and Pujia 1996, p.127), assuming that the writer of the inventory used the merantile *palmo* (24.9 cm), which appears to be the case by comparison with the description of Domenichino's *Tobias and the Angel* (NG 48) in the same inventory. NG 1159 may also be identified with 'Un paese in tela di palmi sei e otto con cornice indorata vi sono da una parte alcuni alberi grandi e sotto vi un angelo con una altra figura in mezo vi scorre un fiume con il Cielo nuvolato' in Lorenzo's posthumous inventory of 1689 (Safarik and Pujia 1996, p.167).

3. 'Un quadro di misura p. mi 8.5 per alto rapp. te un Paese orig. e di GASPARE PUSINO'. For the reference see note 2 to the entry of NG 31.

4. 'Un quadro dj misura dj palmi otto, e cinque per alto, rapp.te un Paese originale dj Gaspare Pusino con due figure che rappresentano un Angelo e S. Ant.o con sua cornice dorata con riporto rustico usata spett.e come sopra', *Inventario... Don Filippo II Colonna*, 15 December 1714 to 6 March 1716 (Rome, Archivio di Stato, Not. Giuseppe Perugini, no. 5782, vol. I, Thursday 10 January 1715). (Safarik and Pujia 1996, p. 288, and cited by Davies 1957, p. 89, n.4 and Boisclair 1986, pp. 234–5.)

5. Besides Dughet, this room contained landscapes by, among others, Albani, Claude, Domenichino and Salvator Rosa: Safarik and Pujia 1996, p. 600.

6. Safarik and Pujia 1996, p. 600.

7. 'Eine andere Landschaft eben dieses Meisters [i.e. Dughet], gleichfalls in Fehl, wird von Kennern der vorigen beinahe gleich geschätzt. Das historische Süjet ist die Verheizung Abrahams. Gott erscheint in den Lüften, und vor dem Schauer, der seine Gegenwart begleitet, beugen sich die Gipfel der Bäume wie im Sturme. Der Gedanke ist erhaben, und die Ausführung glücklich,' Ramdohr 1787, vol. 2, p. 77.

8. De Rossi's writings included appreciations of Canova and a biography of Angelica Kauffmann: *Biographie Universelle (Michaud) Ancienne et Moderne, (nouvelle édition)*, Paris and Leipzig, n.d., vol. 36, pp. 523–4. The picture's acquisition by de Rossi is related by John Young, *A Catalogue of the pictures at Leigh Court, near Bristol, the seat of Philip John Miles, Esq., M.P.*, London 1822, p. 10.

9. John Young, op. cit., says that the picture was sold to de Rossi 'during the confiscations of the French Revolution'. The Colonna family sold a number of works of art following the Treaty of Tolentino of 19 February 1797 made between the French Republic and the Papacy: F. Zeri in E.A. Safarik and G. Milantoni, *Catalogo sommario della Galleria Colonna in Roma, Dipinti*, Rome 1981, p. 9.

10. According to John Young, cited in note 8. The brief biographical details on Beckford are derived from Richard Garnett's account of his life in *DNB*. NG 1159 has not been identified in the Beckford 1789 or 1802 sales as Davies pointed out (Davies 1957, p. 88). Nor is it mentioned in James Storer, *A Description of Fonthill Abbey, Wiltshire*, London 1812.

11. In his *Memoirs of Painting* (vol. 2, pp. 121–2), William Buchanan quotes a letter dated 8 March 1803 from his friend James Irvine in Rome in which Irvine writes, 'I have purchased the upright Gaspar Poussin, a grand storm, and I hope it will turn out well.' Boisclair points out that NG 1159 is Dughet's only vertical-format storm picture so far known: Boisclair 1986, p. 235. For the (unlikely) suggestion that NG 1159 was the painting bought by Beckford in Paris in 1814, see *Life at Fonthill 1807–1822 With Interludes in Paris and London from the correspondence of William Beckford*, translated and edited by Boyd Alexander, London 1957, pp. 165–6.

12. John Young, cited in note 8. It was in 1810, and so when NG 1159 was probably in the Hart Davies collection, that Augustus Wall Callcott completed, with his friend William Owen who provided the figures, a *Diana and Actaeon* (National Trust, Stourhead), the composition of which appears to be based on the Dughet: see D.B. Brown, *Augustus Wall Callcott*, exh. cat., London, The Tate Gallery 1981, p. 34, figs 4 and 5, and p. 35.

13. The date of John Young's preface to his catalogue of Miles's collection, cited in note 8.

14. See under Exhibitions. Miles built Leigh Court about 1816, and acquired pictures initially from his friend Hart Davies, and then from others, with which to furnish it: George Redford, *Art Sales*, London 1888, vol. 1, p. 361, reproducing the *Times* article of 16 June 1884, 'The Leigh Court Collection'.

15. F. Boase, *Modern English Biography*, London 1897 (1965 reprint), vol. 2, p. 872.

16. Described in the exhibition handlist as 'Landscape, from the Colonna Palace – G. Poussin – Ph. J. Miles, Esq.'

17. Described in the handlist as 'THE STORM... Gaspar Poussin. /Canvas – 79 in. by 60 in. Lent by SIR WILLIAM MILES, Bart.'

18. The exhibition catalogue (by Hugh Scrutton?) calls the painting 'Storm, with Biblical Figures'.

19. Where called in the exhibition catalogue (by Anne French) 'Storm: Elijah and the Angel'.

20. See Boisclair 1986, no. R12.

21. Boisclair 1986, pp. 235 and 303.

22. Boisclair 1986, no. 202, and fig. 244.

23. According to a MS note by Martin Davies in the NG dossier.

24. Boisclair 1986, no. G.166 and fig. 637, and see p. 310.

25. Boisclair 1986, no. R.129 and fig. 488.

26. Boisclair 1986, p. 376 and fig. 243; and see Dieter Graf, *Master Drawings of the Roman Baroque from the Kunstmuseum, Düsseldorf: A Selection from the Lambert Krahe Collection*, London and Edinburgh 1973, no. 43. A letter in the NG dossier dated 14 January 1949 from Mary Woodall to Martin Davies suggests that there may exist a British School drawn copy after NG 1159 of *c.*1800.

27. See note 15 to the entry for NG 31.

28. See note 8.

29. See note 1.

30. See note 4.

31. See note 7.

32. Davies 1957, p. 88.

33. A. Busiri Vici, *Jan Frans van Bloemen. Orizzonte e l'origine del paesaggio romano settecentensco*, Rome 1974, p.80.

34. See notes 17 and 18.

35. Illa Budde, *Beschreibender Katalog der Handzeichnungen in der Staatlichen Kunstakademie Düsseldorf*, Düsseldorf 1930, no. 712.

36. Waagen 1854, III, p. 179.

37. Davies 1957, p. 88.

38. Graf, cited in note 26; French in the Kenwood 1980 exhibition; and Boisclair in Boisclair 1986, no. 201.

39. 'Behold, I send an angel before thee, to keep thee in the way, and to bring thee into the place which I have prepared': Exodus 23:20.

40. For the Elijah frescoes in S. Martino ai Monti, see Boisclair 1986, pp. 193 ff. For the particular episode, see Boisclair nos 87 and G.101.

41. S.J. Bandes, 'Gaspard Dughet and San Martino ai Monti', *Storia dell'Arte*, 26, 1976, pp. 45–60. An exegesis of the biblical passage published by a Carmelite theologian in 1653 in connection with the fresco cycle interpreted it as intended to demonstrate that God would defend his worshippers: Bandes, pp. 46, 54. Whether the subject had particular significance for Lorenzo Onofrio Colonna is unknown. Possibly he simply wanted a picture of a storm in a landscape based on an Old Testament subject. Colonna seems to have been uninterested in the association which the Carmelites made between their order and Elijah, since in NG 1159 Elijah is shown wearing a blue

mantle, and not the white of the Carmelite Order.

42. See note 1 to the entry for NG 31.

43. For the suggestion, based on reading too much into Baldinucci, that NG 1159 predates Poussin's *Pyramus and Thisbe* of 1651, see D. Sutton, 'Gaspard Dughet: some aspects of his art', *GBA*, 60, 1962, pp. 269–312 at p. 293. Michael Kitson seemed to date NG 1159 to the 1650s in 'Gaspard Dughet at Kenwood', *BM*, 122, 1980, pp. 644–51 at p. 650.

44. See M. Chiarini, 'Gaspard Dughet : Some Drawings connected with Paintings', *BM*, 111, 1969, pp. 750–4 at p. 753 for the comparison in question, and see Boisclair 1986, pp. 280–2 for the gouaches made, as it happens, for the Palazzo Colonna.

45. Safarik and Pujia 1996, pp. 76, 79.

46. Because it appears to have been written at one time, and not continually added to: letter of 10 September 1999 from Burton Fredericksen, basing his opinion on photocopies of the relevant folios at the Getty Research Institute for the History of Art and the Humanities.

47. For example two pictures by Mattia Preti: see John T. Spike, *Mattia Preti. I documenti*, Florence 1998, p. 81. These paintings appear at the very end of the '1654' inventory.

48. The portrait reappears in a 1664 Colonna inventory, fo.44 as 'Papa Alessandro 7o.'

49. Von Pastor, vol. 31 (1940, ed. E. Graf), pp. 54–8. The '1654' inventory also includes (f.239) two paintings by Andrea Sacchi that were probably among those inventoried in Sacchi's posthumous inventory of June 1661 (no. 117(?) and no. 222: see A.S. Harris, *Andrea Sacchi*, Oxford 1977, pp. 120–1), and hence sold to Colonna at some subsequent date.

50. R.R. Betts, 'The Habsburg Lands', *The New Cambridge Modern History*. Volume V. *The Ascendancy of France 1648–88*, ed. F.L. Carsten, Cambridge 1961 (1990 reprint), pp. 474–99 at p. 487.

51. Safarik and Pujia 1996.

52. J.M. Pita Andrade and M. del Mar Borobia Guerrero, *Old Masters, Thyssen-Bornemisza Museum*, Madrid 1992, p. 611.

53. See note 7.

54. Waagen 1854, III, p. 179.

55. *A Catalogue Raisonné of the Pictures now Exhibiting in Pall Mall*, [London] 1816, p. 32. The author may have been Robert Smirke (1752–1845).

56. Waagen 1854, III, p. 179.

57. Davies 1957, p. 88.

NG 2619
Landscape with a Cowherd

*c.*1637
Oil on canvas, 54.2 × 43.5 cm

Provenance

In the collection of Lucien Bonaparte (1775–1840), younger brother of Napoleon, at the Palazzo Lancellotti, Via dei Coronari, Rome, by 13 June 1804, as 'Mercurio, e la Vacca Io, Paesaggio, di Gasparo Pussino';[1] according to Buchanan, bought (by private contract, London, 6ff. February 1815)[2] from Lucien Bonaparte's collection by Alexander Baring, but presumably this was a mistake on Buchanan's part because subsequently sold as the property of Lucien Bonaparte, London, Stanley, 16 May 1816 (lot 150, £81 18s. to an unknown purchaser);[3] according to John Smith, the dealer, sold by John Webb, London, Phillips, 30–31 May 1821 (lot 181, £105 as by N. Poussin);[4] there bought by Noseda;[5] in the collection of Alexander Baring (1774–1848, 1st Baron Ashburton) by 1837;[6] by descent to Francis Denzil Edward Baring, 5th Baron Ashburton (1866–1938), of Bath House, Piccadilly, in whose collection recorded in 1890 (see under Exhibitions) and in 1903;[7] presumably purchased from him with the rest of the collection *c.*1907 by Agnew's; bought from Agnew's by George Salting of 86 St James's Street, London;[8] George Salting Bequest, 1910.[9]

Exhibitions

London 1815, The New Gallery, 60 Pall Mall, *Catalogue of the splendid collection of pictures belonging to Prince Lucien Bonaparte* (42); London 1871, RA, *Exhibition of the Works of the Old Masters* (195) (as by Nicholas (sic) Poussin);[10] London 1890, RA, *Exhibition of Works by the Old Masters* (62) (as by Nicholas (sic) Poussin);[11] London 1910, Thos Agnew & Sons, *Catalogue of the collection of Pictures and Drawings of the late Mr George Salting* (9) (as by Nicholas (sic) Poussin); London 1938–41, 10 Downing Street, long-term loan; Manchester 1951–69, Manchester City Art Gallery, long-term loan; Gloucester 1979–85, City Museum and Art Gallery, long-term loan; Kendal 1991, Abbot Hall Art Gallery, *Classical and Picturesque Landscape* (no catalogue).

Related Works[12]
PRINTS
(1) By Pietro Parboni in *Choix de Gravures à l'eau forte d'après les peintures originales et les marbres de la galerie de Lucien Bonaparte*, London 1812, no. 68 (plate 39), as 'Mercurio ed Io', and as painted by Gaspar Poussin;
(2) another (anon.) engraving is no. 124 of *La galerie de tableaux du prince Lucien Bonaparte*, no date but printed Paris 1819.[13]

Technical Notes
The picture is quite abraded along the right-hand edge and in the trees, and there is a horizontal tear left of centre. There has been retouching along the edges, to part of the left-hand cow, and near to the right-hand cow and the herdsman, all prior to the picture's acquisition by the Gallery in 1910. Some of the greens may have become darker. The primary support is a fine plain-weave canvas, lined, probably in the nineteenth century, but at any rate prior to 1910. The stretcher, which appears to be nineteenth century, has the following labels affixed: (i) a round label with blue margins marked *4526*; (ii) a label marked in pencil *27_/...2* [?]; (iii) a typed label: *Poussin. Landscape with herdsmen and cattle/near a river, buildings seen in distance. 1ft. 9in. _ 1ft. 4¾ in.* The ground is brown. There is a possible pentimento to the right-hand cow, and the area of the trees was left mainly in reserve when Dughet painted the background.

For most of the nineteenth century NG 2619 was called 'Mercury and Io' or 'Jupiter and Io', but neither title is convincing: the male figure at the right has none of the attributes of Hermes (Mercury), and, although Zeus (Jupiter) changed himself into a bull to visit Io, herself already metamorphosed into a white heifer (Ovid, *Metamorphoses*, I: 611), no cowherd appears in the story and the white cow in the picture is clearly fully grown. The more prosaic title used on the picture's exhibition in 1890, namely 'Landscape', was retained by the Gallery when it acquired the picture.[14]

NG 2619 was acquired as by Nicolas Poussin.[15] It was relegated to 'School of' soon afterwards but with a tentative attribution to Pietro Testa,[16] to whose paintings, however, it bears no resemblance. Davies doubted that the picture was by Poussin and attributed it to a follower. He found the attribution to Dughet in the Bonaparte collection to be defensible, and would perhaps have opted for Dughet 'except that hardly anything is known of the variations of Dughet's style', and, as Davies noted, W. Friedländer had proposed that NG 2619 might be by a Fleming influenced by Poussin.[17] In 1950 Anthony Blunt ascribed the painting to the so-called Silver Birch Master.[18] Blunt nevertheless acknowledged the picture's 'close resemblance to the work of Gaspar Poussin',[19] and himself later attributed it to the young Dughet.[20] Recently Whitfield proposed an attribution to Nicolas Poussin on the basis of comparisons in particular with the trees in Poussin's *Pan and Syrinx* of 1637 at Dresden and his *Nurture of Jupiter* of *c.*1635–7 at Dulwich.[21] However, the attribution to Dughet is now accepted by most authorities,[22] and it is difficult to imagine Poussin being responsible for the somewhat weightless herdsman in NG 2619, or for the awkward anatomy of the goatherd in a painting of similar size and composition and by the same hand – here considered to be that of Dughet – in a private collection (fig. 1).[23] In addition, as Susan Wise has pointed out, NG 2619 shares with Dughet's *Landscape with a Herdsman and Goats* (Chicago, The Art Institute) a common manner of execution, particularly in the rendering of the figures and animals.[24] Nevertheless, the composition may well have been influenced by Poussin's *Pan and Syrinx*, and, given that the construction of the recession in NG 2619 is more secure than that in a series of gouaches painted by Dughet in

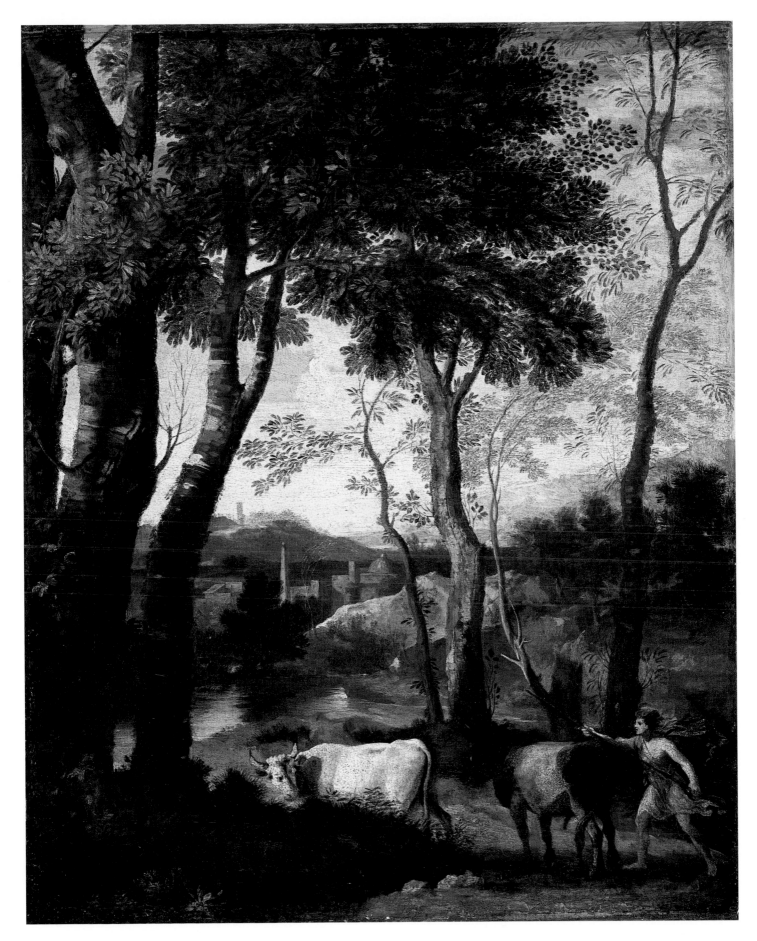

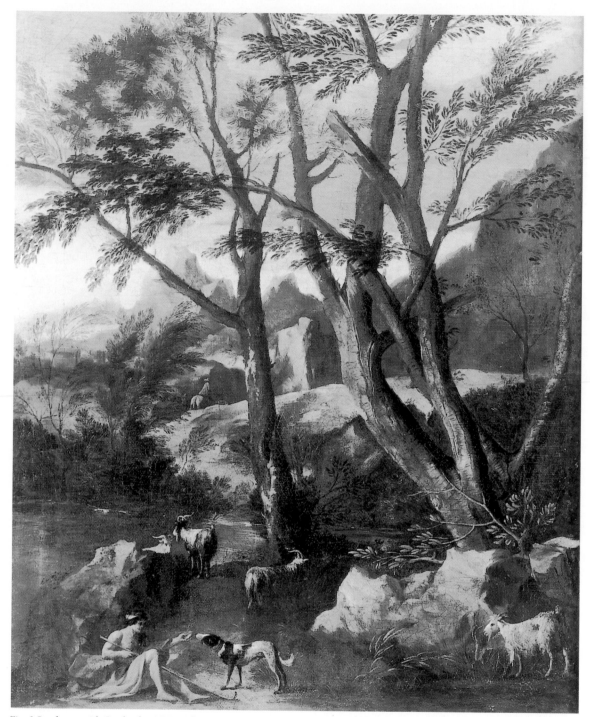

Fig. 1 *Landscape with Goatherd*, *c.*1637. Oil on canvas, 57 × 45 cm. Private collection.

the Casa Costaguti possibly before 1635,[25] a date for NG 2619 of *c.*1637 seems preferable to that of 1633–5, assigned to it by Boisclair.[26]

General References
Grautoff 1914, vol. II, p. 265 (as Dughet); Magne 1914, no. 65 and no. 320 (as Poussin); Davies 1957, p. 192 (as follower of Nicolas Poussin(?)); Blunt 1966, no. R139 (as attributed to Dughet); Thuillier 1974, no. R.137 (as not by Poussin); Roethlisberger 1975, p. 30 (as Dughet); Salerno 1977–8, vol. 3, p. 1017, no. 4 (as by the young Dughet, or by some other, unknown artist); Wild 1980, no. R8a (as Dughet); Wright 1985b, pp. 137–8 (as attributed to Poussin); Boisclair 1986, no. 6 (as Dughet); B. Edelein-Badie, *La collection de tableaux de Lucien Bonaparte, prince de Canino*, Paris 1997, no. 75 (as Dughet); Thuillier 1994, no. R131 (as not by Poussin); R.B. Contini, 'La Galleria Bonaparte. Catalogo' in *Luciano Bonaparte*, Rome 1995, p. 343 (no. 135, as Dughet).

NOTES

1. Archivio di Stato di Roma 1804, Camerale II, Antichità e Belle Arti, busta 7, fasc. 204. (I elenco). 'Galleria Bonaparte 1804', an inventory published by Rosella Carloni in 'Per una ricostruzione della collezione dei dipinti di Luciano: acquisti, vendite e qualque nota sul mercato antiquario romano del primo Ottocento', *Luciano Bonaparte le sue collezioni d'arte le sue residenze a Roma, nel Lazio, in Italia (1804–1840)*, ed. Marina Natoli, Rome 1995, pp. 5–47 at pp. 40–2. According to the inventory, NG 2619 was hung in the second salon with the other French School paintings in the collection and was among those (the great majority) brought by Lucien Bonaparte from Paris to Rome. Lucien arrived in Rome by 23 or 29 April 1804: Mina Gregori, 'La collezione dei dipinti antichi', *Luciano Bonaparte*, Rome 1995, pp. 263–313 at p. 278. This article also contains an account of the collection of paintings. The identification of NG 2619 with the picture in Lucien Bonaparte's collection is confirmed by Parboni's engraving published in 1812 (see under Prints). NG 2619 was also recorded in the Bonaparte collection in Rome in 1808 by Abate Guattani as 'Mercurio ed Jo, paese di Gaspare Pussino': B. Edelein-Badie, *La collection de tableaux de Lucien Bonaparte, prince de Canino*, Paris 1997, p. 182, and M. Natoli, 'Luciano Bonaparte, le sue collezioni e le sue dimore a Roma e nel Lazio (1804–40)', *Paragone*, 489, 1990, pp. 83–110 at pp. 105 and 109, no. 26.

2. See *Catalogue of the splendid collection of pictures belonging to Prince Lucien Buonaparte... at The New Gallery (Mr. Buchanan's) no. 60, Pall-Mall*, London 1815, no. 42 (as by Gaspar Poussin), and Buchanan, *Memoirs*, 1824, vol. 2, pp. 285–6 ('A few pictures of a fine class were sold out of this collection immediately on its being notified to be for sale, among which were a Landscape, by Gaspar Poussin, ... purchased by Mr. Baring'). No other painting attributed to Dughet was in the Bonaparte collection, as offered by Buchanan in 1815. For an account of the 1815 sale, see *Index of Paintings Sold*, vol. 3, p. 79.

3. 'Lot 150/GASPAR POUSSIN./Landscape, with the Story of Io, treated in a grand, yet simple, manner, with a firm, decided Pencil, in a rich tone of Colour, and a beautiful diffusion of light, tempered with the most delicate shadows: on Canvass, 21 inches by 17.' For the sale price, see *Index of Paintings Sold*, vol. 4, part 1, p. 315, and Smith 1837, no. 329.

Possibly Baring paid Buchanan a deposit in 1815 with a view to buying NG 2619 but failed to complete the purchase, leaving the picture free to be included in the 1816 sale.

4. See Smith 1837, no. 329. The painting was described in John Webb's sale as 'Jupiter and Io, in a classical Italian Landscape, from the collection of Lucien Buonaparte'.

5. Redford, *Art Sales*, 1888, vol. 2, p. 281. Anthony and Giovanni Noseda were both dealers in pictures and curiosities: *Index of Paintings Sold*, vol. 4, part 2, p. 1186. They seem to have been active purchasers in London from 1813.

6. Smith 1837, no. 329. Alexander Baring was created 1st Lord Ashburton on 10 April 1835, so Smith's note of this painting must have been written between then and 1837 when this part of his work was published. Baring was a trustee of the National Gallery from 1835 until his death.

7. As by Dughet ('Landscape') in M. Bryan, *Dictionary of Painters and Engravers*, 5 vols, London 1903–5, vol. II (1903), p. 97.

8. Gabriel Naughton has kindly told me that she has been unable to find any records at Agnew's which might confirm these presumptions.

9. A MS valuation, undated but of 27 January 1911, by Hawes Turner, values NG 2619 at £200: NG Archive, Salting Collection Papers; NG Letter Book 1909–12, fo. 529.

10. 'A Landscape: Jupiter and Io... Nicholas Poussin./Canvas –22 in. by 17½ in. Lent by Lord Ashburton.'

11. Wrongly described in the catalogue as on panel. Called 'A Landscape' and said to be by Nicolas Poussin.

12. Blunt (Blunt 1980, no. R139) noted a compositional similarity between a drawing in Besançon by a follower of Poussin and NG 2619 (and another painting by Dughet, Boisclair no. 3). The drawing has been attributed to an unknown imitator of Poussin by Rosenberg and Prat (Rosenberg and Prat 1994, no. R. 82) – the rendering of light and shade is too even for it to be by Dughet.

13. B. Edelein-Badie, cited in note 1, pp. 182, 409.

14. *An abridged catalogue of the pictures in the National Gallery*, London 1911, p. 257.

15. Ibid.

16. *National Gallery: Abridged Descriptive and Historical Catalogue of the British and Foreign Pictures*, London 1915, p. 248.

17. Davies 1946, p. 81, and Davies 1957, p. 192.

18. Davies 1957, p. 192, and Anthony Blunt, 'Poussin Studies V: The Silver Birch Master', *BM*, 92, 1950, pp. 69–73 at pp. 69–70, who there called NG 2619 'Landscape with Shepherd.'

19. Anthony Blunt, op. cit., p. 69.

20. Blunt 1966, no. R139, and see Anthony Blunt, 'The Silver Birch Master, Nicolas Poussin, Gaspard Dughet and others,' *BM*, 122, 1980, pp. 577–82 at p. 578.

21. Clovis Whitfield, 'Poussin's Early Landscapes', *BM*, 121, 1979, pp. 10–19, at pp. 16–19, and *idem*, 'À propos des paysages de Poussin,' *Poussin Colloque 1994*, vol. 1, pp. 243–67 at pp. 250–1. For further discussion of the question of the 'Silver Birch Master', see Sivigliano Alloisi, 'Note sul "Maestro della Betulla"', *Intorno a Poussin. Dipinti romano a confronto*, Galleria Nazionale d'Arte Antica e Palazzo Barberini, Rome 1994–5, pp. 114–25.

22. See under General References, and Sir Denis Mahon also considers NG 2619 to be by Dughet: in conversation, 29 March 1995.

23. The painting's measurements are 57 × 45 cm. It was in the James Morrison collection, Basildon Park, by 1857 and in the 1980 Kenwood exhibition, no. 1 (as attributed to Nicolas Poussin). Another painting close in size (51 × 40 cm) and in composition to NG 2619 is Dughet's *Landscape with Fisherman* in the Uffizi: *Gli Uffizi. Catalogo Generale*, Florence 1979, p. 254. This has been assigned to the period 1664–8 by Boisclair (Boisclair no. 252), but a landscape of this size and format would be exceptional at this stage in Dughet's career.

24. Susan Wise and Malcolm Warner, *French and British Paintings from 1600 to 1800 in The Art Institute of Chicago*, Chicago 1996, p. 53.

25. See Alloisi, cited in note 21, and Alloisi, *Quadri senza casa dai depositi della Galleria Colonna*, exh. cat., Palazzo Corsini, Rome 1993–4, p. 38.

26. Boisclair 1986, pp. 170–1.

Gaspard DUGHET and Carlo MARATTA

Carlo Maratta
1625–1713

Maratta ran one of the largest and most successful workshops in Rome during the second half of the seventeenth century, achieving international renown. He was born in Camerano, near Ancona, but spent most of his working life in Rome, collaborating there with Poussin and other distinguished artists. He painted frescoes and altarpieces for the city's pre-eminent patrons, including members of the Colonna, Barberini, Chigi and Rospigliosi families. He was a celebrated portraitist, and also carried out designs for sculpture and architecture. He died in Rome in 1713, aged 88, and was buried with great ceremony in S. Maria degli Angeli.

NG 95
Landscape with the Union of Dido and Aeneas

c.1664–8
Oil on canvas, 152.9 × 223.7 cm

Provenance
In the Palazzo Falconieri, Via Giulia, Rome, by 1717;[1] and seen there by 1773/4(?) by Weston;[2] in the collection in Rome of Alexander Sloane by 1802 and then by inheritance to his widow and/or son;[3] bought by Buchanan through Irvine between August and December 1803 for £500;[4] bought from Buchanan by William Holwell Carr for £1100 by July 1805;[5] bequeathed to the National Gallery in 1831 by William Holwell Carr of 29 Devonshire Place, London, by his will dated 28 August 1828 in memory of his wife Charlotte and his son William.[6]

Exhibitions
Rome 1717, S. Salvatore in Lauro;[7] London 1805, 18 Oxenden Street (no catalogue);[8] London 1806, BI (lent by Carr for study);[9] London 1807, BI (lent by Carr for study);[10] London 1816, BI (35).[11]

Related Works
PAINTINGS
(1) In Robert Harpur's collection in Rome in 1677, a 'cop[y]: A faire Landskippe representing a tempest, Dido & Aeneas retiered [sic] to their amours under a Rock frome Gasparo Possino';[12]
(2) Whereabouts unknown, a copy attributed to 'V. Dyck', Admiral Lord Radstock deceased sale, Christie's, 12 May 1826 (lot 28, £63 to Emmerson), 24 × 39 in.;[13]
(3) Whereabouts unknown. A painting of the same subject as NG 95 was sold at Edinburgh, Dowell's, 16 April 1921, lot 59, 59 × 43 in., as after (Gaspar) Poussin. It was bought from the Falconieri in Rome by Hamilton Nisbet via Robert Fagan on 27 September 1801, and was recorded in the family inventory of 1838 at Biel;[14]
(4) Kingston, Ontario, Agnes Etherington Art Center, inv. 9–12, 73.9 × 91.4 cm. An eighteenth(?)-century work of a different subject in which the landscape composition is broadly that of NG 95.[15]

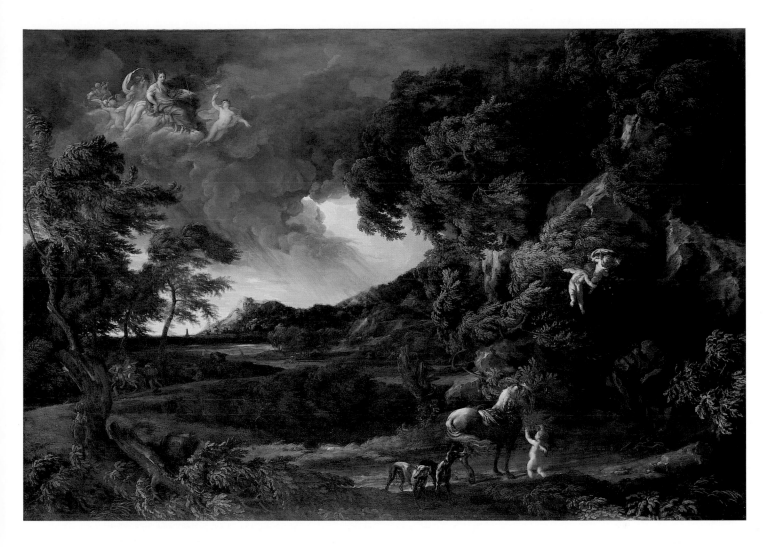

DRAWINGS
(1) The drawing in Düsseldorf for NG 1159 (see that entry) may have been reused by Dughet for the tree and foliage at the left of NG 95;[16]
(2) Madrid, Academia de San Fernando, Maratti collection, inv. no. 1455b (fig. 3). Studies for the dogs in the foreground.
PRINTS
(1) By Giovanni Volpato (1733–1803) after a drawing by Hendrik Voogt (1766–1839),[17] datable between 1788, when Voogt went to Italy, and 1803, when Volpato died;
(2) by Thomas Starling, c.1828–31;[18]
(3) by J.C. Varrall, 1838(?).[19]

Technical Notes

Overall in reasonably good condition, but there is a loss some 3 cm across and 2 cm high to the left of the right hip of the torchbearer in the sky, and other scattered small losses. There is some wear in the flesh of the putti, and the paint has become more transparent with age, especially in the area of the figures of Dido and Aeneas. There is some wrinkling of the surface, particularly in the sky, caused by a relining, possibly that undertaken in 1870 (the most recent) or one undertaken at some time before 1853.[20] There is also some blanching in the foliage. At least some of these problems are old ones, because soon after NG 95 was acquired by the Gallery in 1831 the author of *Valpy's National Gallery* wrote: 'The present picture has been injured by the hand of time or perhaps the indiscreet use of some preparation of lead in the colours. It has assumed a dark hue absorbing entirely the original colouring, and blending all in one mass of deep black shade, so that the details are with difficulty made out.'[21] Ottley considered the darkness of the picture to have been possibly caused by 'the destructive nature of the earth used in priming the canvass (sic), and the small body of colour employed in painting it'.[22]

The primary support is two pieces of coarse twill canvas joined horizontally some 27 cm from the bottom. The ground is a red-brown colour. NG 95 was last restored in 1969. The stretcher is nineteenth century.

Visual examination shows the figures to have been painted over the landscape. An infra-red photograph suggests a pentimento to the line of Aeneas' neck and shoulder, and that there was originally a flying putto to the right, facing the torchbearer (Hymen) (fig. 1), and another figure above him, both on a larger scale than the putti in this group in the finished painting.

The X-radiograph (fig. 2) confirms the existence of these two additional figures (although the first is obscured by the image of a stretcher bar), and shows the one above the torchbearer to be female and to have been holding billowing drapery. This figure can therefore be identified as Venus, whose position was changed in the painting. Aeneas' left hand seems originally to have been held flatter as if about to caress Dido, rather than gesture towards her.

Fig. 1
Infra-red detail.

Fig. 2 X-ray detail.

The subject is from Virgil's *Aeneid* (IV: 117ff). When Aeneas went hunting with Dido, Queen of Carthage, Juno created a storm. With the connivance of Venus, Juno then arranged for Dido and Aeneas to seek shelter in a cave and there become illicit lovers. In NG 95 Dido and Aeneas are shown at right, and his horse and hunting dogs at bottom centre. Other members of the party are shown at left fleeing the storm. In the sky at top left is Juno, crowned. To the left of Juno is Venus and to the right, holding a torch, is Hymen, god of marriage, who does not, however, feature in Virgil's account. As Virgil relates, after the lovers had consummated their passion, Dido 'calls it marriage and with that name veils her sin!'[23] Although the picture has darkened with age (see under Technical Notes), it was probably, as an early writer on the National Gallery argued, 'always... murkily and gloomily dark, and ought to be so, or it would not else accord with the poetry whence it is avowedly derived',[24] for Juno promised to 'pour down from above a black rain mingled with hail' and to veil the company 'in gloom of night'.

It has long been noted that the figures in NG 95 are not in Dughet's style. Buchanan believed them to be by Francesco Albani (1578–1660).[25] Ottley thought that only the group in the sky was the work of Albani, the other figures having 'more of the manner of Mola'.[26] Smith listed the painting as a whole as a work of Nicolas Poussin,[27] but this is plainly wrong on stylistic grounds where the landscape and the figures are concerned.[28] The figures were first attributed to a painter other than Dughet, namely Carlo Maratta, by the painter and sculptor Giuseppe Ghezzi (1634–1721), when NG 95 was exhibited in 1717 (four years after Maratta's death) in the courtyard of S. Salvatore in Lauro, Rome. The manuscript in which Ghezzi's attribution was made, entitled 'Quadri delle Case dei Principi in Roma', was published in 1956,[29] and the attribution of the figures to Maratta has since been accepted

by Salerno[30] and Boisclair,[31] and can be confirmed by the existence of a drawing (fig. 3) by Maratta which is a study for the dogs in the foreground.[32] This drawing has been assigned to a group of drawings made by Maratta *c*.1650,[33] thus considerably advancing the date of NG 95, which on stylistic grounds Boisclair assigned to the period 1664–8,[34] and which Salerno saw as not earlier than 1659.[35] One may suppose, in support of an earlier dating for NG 95, that once he had become an established artist, in the 1650s, Maratta would have had no need to collaborate with other painters on pictures in which his contribution – the figures – would play a minor role. However, he seems to have so collaborated with the flower painter Mario dei Fiori (1603–73) in 1660,[36] and with Dughet, whose company he enjoyed[37] and three of whose paintings he owned,[38] on several other paintings, including probably the

Fig. 3 Maratta, *Study of dogs*, *c*.1650? Black and red chalk with white highlights on green-grey paper, 27 × 41.8 cm. Madrid, Academia de Bellas Artes de San Fernando.

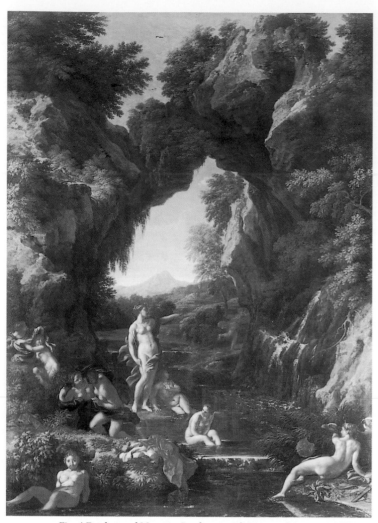

Fig. 4 Dughet and Maratta, *Landscape with Diana and Acteon, c.*1657.
Oil on canvas, 195.5 × 144.8 cm. Chatsworth, Devonshire Collection.

Landscape with Diana and Acteon (fig. 4) at Chatsworth, which has been dated to *c.*1657[39] but may be later.[40] The narrative structure of NG 95 seems more considered than that of the Chatsworth painting and its figures are better integrated into the landscape. Hence Boisclair's dating of NG 95 to the period 1664–8 seems reasonable. This would not necessarily be inconsistent with Maratta having used a drawing for the dogs which he had made much earlier in his career.

Buchanan referred to NG 95 as 'the Grand Gaspar' in 1805, and in 1837 Smith called it 'a Landscape of singular grandeur and sublime effect'.[41] That the painting was not universally popular is evidenced by an anonymous critic of the British Institution exhibition in 1816, who wrote that 'no one will be able to discover anything to the advantage of G. Poussin, but the most egregious connoisseur, or think this specimen of "Gross Darkness" a bit better than a black board'.[42] Nevertheless, NG 95 was sufficiently celebrated in Holwell Carr's collection to be given a prominent position in Pieter Christoffel Wonder's large painting *Patrons and Lovers of Art, or the Imaginary Picture Gallery*, which was perhaps completed in 1826 and certainly exhibited in 1831.[43] There it is shown (in a French rococo-style frame, not its present one) hung over the door of the imaginary gallery, which leads to a terrace and landscape view beyond.

General References

Smith 1837, no. 330 (as by Poussin); Davies 1957, p. 87 (as by Dughet with figures by (?) Albano and Mola); Blunt 1966, no. R76 (as by Dughet); Thuillier 1974, no. R115 (as by Dughet, with figures added by another hand); Wright 1985b, p. 106 (as by Dughet with figures attributed to Maratta); Boisclair 1986, no. 245 (as Dughet and Maratta); Thuillier 1994, no. R123 (as by Dughet and Maratta).

NOTES

1. Exhibited in December 1717 at S. Salvatore in Lauro, Rome, and described as 'Un paese rappresentante temporale, misura di nove e sei, di Gaspare Pusino, con le figure del Cavaliver Maratti': Giulia De Marchi, *Mostre di quadri a S. Salvatore in Lauro (1682–1725). Stime di collezioni Romane*, Rome 1987, p. 342. Orazio Falconieri purchased the palazzo from Pietro Farnese in 1638 and had it enlarged by Borromini in 1646–9: C. Pietrangeli, *Guide Rionali di Roma. Rione VII–Regola. Parte III*, 2nd edn, Rome 1979, pp. 44–8.

2. [S. Weston], *Viaggiana: or, detached remarks on the Buildings, Pictures, Statues, Inscriptions, &c, of Ancient and Modern Rome*, London n.d. (1776?), p. 90: 'FALCONIERI PALACE./... Fine Poussin. (Nicolas.) Subject, Dido and Aeneas.' The reference to Nicolas Poussin is wrong, because no other reference to a picture by Nicolas of this or any remotely similar subject in the Falconieri Palace is known (see Blunt 1966, nos L22, L48, L81 and R113). Of the two paintings of the subject attributed to Poussin, one could not

have been in the Falconieri Palace in the 1770s, namely that at Toledo, Ohio (inv. no. 54.87), which was in the Scarsdale collection by 1758 (*The Toledo Museum of Art. European Paintings*, Toledo, Ohio, 1976, p. 130). The only other candidate, the picture at Besançon (Blunt 1966, no. R75), was once in the collection of Jean Gigoux (1806–94) and so was presumably acquired on the French art market well into the nineteenth century.

The S. Weston who was the author of *Viaggiana* was probably the antiquary Stephen Weston (1747–1830), who travelled to Italy in 1773–4: Ingamells 1997, p. 994.

3. Buchanan 1824, vol. 2, pp. 112, 120–1. According to the *Index of Paintings Sold*, vol. 1, p. 1030, Sloane's correct name was Alexander Sloane, not T. Sloane. According to Buchanan's *Memoirs* (Buchanan 1824, p. 120), his agent in Rome, James Irvine, wrote to Buchanan on 23 February 1803 that the dealer 'Sir Simon Clarke told me that Mrs. S[loane] had consulted him on the subject of my offer [for Sloane's pictures], and

that he had advised her to accept it, as he thought it a very fair one, and added, that the great collectors in England will not go to so great a sum for a landscape as for an historical picture.' On 23 July of that year Buchanan wrote to Irvine on the subject of the Sloane pictures: 'The only picture in all his collection after the Salvator Rosa worth acquiring is his large Gaspar Poussin landscape, and if you could get that from him on a credit of 9 months for £600 or £700 I think you should on no account lose it. The taste as I have said is *grand landscapes*. The Historical does not really appear to be so well understood or at least so much relished in this Country...' (Brigstocke 1982, p. 91). There are numerous references to NG 95 in the correspondence published by Brigstocke: see letters nos 14, 15, 18, 21, 26, 27, 28, 29, 32, 33, 35, 39, 44, 50, 54, 55, 58, 61, 65, 68, 77, 78, 79, 80, 81, 83, 85, 86, 87, 88, 89 and 97.

4. See Brigstocke 1982a, letters 15 and 18, dated respectively 6 August and 23 December 1803. In the latter Buchanan writes to

Stewart: 'By a letter I have just received from Mr. Irvine I find that he has secured for me Sloane's fine Gaspar Poussin which is esteemed the Chef d'oeuvre of that Master for £500 payable in six months.'

NG 95 also figures in an undated list among the papers of William Hamilton Nisbet (1747–1822) in the Scottish Record Office, Edinburgh. This list, discovered and kindly sent in photocopy form to the National Gallery by Sergio Benedetti, is headed 'Catalogue of Ancient Pictures painted by the best masters existing in the hands of Mr. Alexr. Slone (sic) Banker in Rome & to be sold of the Dimensions & at the following prices to wit–' and includes as item 7 'A Beautiful Landscape by Poussin representing Enias in the Grotto with Dido & Juno descending in a Storm painted for Falconieri the figures by Albani – – feet by – – [£]1000.' This item is the only one of twenty-seven in the list where an 'X' has been marked by the price, and Hugh Brigstocke has suggested that Nisbet may have marked this item because of the comparison with his own recently acquired picture: letter of 19 January 1998, and see under Related Works (3). NG 95 was despatched from Rome by ship at about the end of February 1804 (Brigstocke 1982, letter 50) and seems to have arrived in London in June (letter 68). In December it was shipped to Leith to show to Lord Wemyss in Edinburgh (letter 78, which also contains Buchanan's description of how the painting was packed for transport and instructions how Stewart should 'take off the damp'), and returned to London by February 1805 (letter 85), where it was made available for viewing at 18 Oxendon Street, Haymarket, London (letter 87), before being exhibited there with other old masters belonging to Buchanan (letter 88).

5. A minute of a meeting of the Select Committee of the British Institution held on 15 July 1805 records that 'Mr. [William] Smith reported that the Reverend Mr. Carr had instructed him to acquaint the Committee that having purchased a very fine Landscape by Poussin (the Story of Dido & Aeneas) he was willing to lend it to the Gallery for the use of such artists as might be disposed to copy from it.' Victoria and Albert Museum, English MSS. CR.V.11, p. 35 (*Minutes of the British Institution*, hereafter cited as *Minutes*).

Buchanan wrote to Irvine on 20 August 1805: 'I believe I formerly mentioned that Carr took the Grand Gaspar of the Falconieri at £1100. I very foolishly took a person's advice in the beginning of the Season and refused 1200 Guineas offered by Earl Wemyss, but indeed Wemyss behaved ill in regard to it by holding out for £1500 if I would send it down for his refusal to Scotland, and afterwards only offered twelve, though he admitted that he admired it much. It was however a little too dark.' (Brigstocke 1982a, letter 97).

There was in the Raikes(?) sale, Christie's, 19 May 1827, a painting (lot 24) which could correspond to NG 95, but, unless it was bought by Carr at that sale after he had some time previously sold it, it is more likely to refer to another painting altogether. It was sold for 270 guineas, and described in the catalogue as 'Gaspar Poussin... 24 A grand heroic landscape, lately in the possession of the Rev. H. Carr, and brought from the Falconieri Palace at Rome'. A copy of the catalogue at Christie's (photograph in NG Library, Box AXI.6.9) is annotated with the sale price and the words 'Cost Mr Carr L700'.

6. NG 95 is described in a list placed with a contemporary extract of Holwell Carr's will under item 15: 'Dido and Aneas Falconieri Palace /Gaspar Poussin' (NG Archive NG5/15/1831). Carr's wife, Lady Charlotte Hay, had died in 1801 after giving birth to William who died aged five: Egerton 1998, p. 399.

7. See note 1 above.

8. These were Buchanan's premises. See note 4 above.

9. *Minutes*, pp. 145–6, 157. Carr was one of the founding subscribers of the British Institution and lent generously to its exhibitions. For an account of Carr, especially as a collector, see Egerton 1998, pp. 399–405.

10. Thomas Smith, *Recollections of the British Institution*, London 1860, p. 40, and *Minutes*, pp. 215–16.

11. Described as 'Landscape, Storm, with Dido and Aeneas, from the Falconieri Palace –/ G. Poussin/Rev. W. H. Carr.'

12. Burdon 1960, p. 23.

13. Following a description of the picture's subject, the catalogue continues: 'A Study from the Grand Landscape by G. Poussin and Albano, formerly in the Falconieri Palace, but now in the collection of Mr. Holwell Carr, – executed at Rome; and as a Landscape by V. Dyck, probably unique...', and, it may be added, certainly impossible if the reference is to Anthony van Dyck, who was in Rome in 1623 when Dughet was eight and Maratta not yet born.

14. Letter from Hugh Brigstocke, 19 January 1998.

15. Boisclair 1986, no. R.66.

16. As suggested in Bologna 1962, p. 446.

17. Boisclair 1986, no. G.222.

18. In V*alpy's National Gallery*, opposite p. 9, and called 'Dido and Aeneas in the Storm'.

19. In [J. Landseer?], *The National Gallery of Pictures* (1838?), pl. 97, called 'Dido and Aeneas in the Storm' and including the legend: 'The queen and prince, as love or fortune guides,/ One common cavern in its bosom hides.'

20. The date conservation records commenced.

21. *Valpy's National Gallery*, p. 9.

22. Ottley 1832, p. 65. Passavant 1836 considered NG 95 to be 'much darkened with age': vol. 1, p. 47.

23. *Aeneid*, IV: 172, trans. H. Rushton Fairclough, Loeb edn, Cambridge, Mass., and London 1974, p. 407.

24. [J. Landseer?], cited in note 19.

25. He wrote to Irvine on 6 August 1803, 'I should wish you if possible upon similar terms to procure Sloane's large Poussin with figures by Albano...' (Brigstocke 1982a, letter 15).

26. Ottley 1832, p. 65; Mola's dates were 1612–66.

27. Smith 1837, p. 167.

28. Both Blunt and Thuillier have rejected Nicolas Poussin's authorship of NG 95 (see under General References).

29. This manuscript was first published by N. di Carpegna in *Paesisti e Vedutisti a Roma nel '600 e nel '700*, Rome, Palazzo Barberini, March–April 1956, pp. 40–4. A list of the Falconieri pictures exhibited in 1717, annotated by Giuseppe Ghezzi, has also been published by De Marchi, cited in note 1.

30. Salerno 1977–8, vol. 2, p. 528.

31. Boisclair 1986, p. 248.

32. Academia de San Fernando, Madrid, Maratti collection (inv. no. 1455b). The recto of this sheet (inv. no. 1455a) contains what may be a study for one of the putti at top left of the painting. I am grateful to Manuela B. Mena Marqués, who noted the connection between this sheet and NG 95, and to Mercedes Amezúa for her help in identifying it in the Academia's Maratti collection.

33. M.B. Mena Marqués, 'Maratti [Maratta]. Carlo', *The Dictionary of Art*, 1996, vol. 20, pp. 373–9, at p. 374.

34. Boisclair 1986, pp. 247–8, although at p. 60 she seems to suggest a date of 1668–9.

35. Salerno 1975, pp. 227–36, at p. 233 and Salerno 1977–8, vol. 2, p. 528.

36. Safarik and Milantoni 1981, nos 109, 110. This collaboration was evidently well known since it is referred to by Pascolini in his *Vite de' Pittori, Scultori ed Architetti Moderni*, 2 vols, Rome 1730–6, vol. 1 (1730), p. 139.

37. Boisclair 1986, p. 15.

38. Boisclair 1986, p. 217.

39. The date c.1657 has been proposed for the Chatsworth painting by Boisclair: Boisclair 1986, p. 223. It may have been one of the five paintings by Dughet and Maratta, including NG 95, recorded in the Falconieri collection in 1717: see G. De Marchi, cited in note 1, pp. 344, 345.

40. As Boisclair (Boisclair 1986) has noted, presumably by reference to Arcangeli in Bologna 1962, p. 271, and Salerno 1977–8, vol. 2, p. 528.

41. Smith 1837, p. 167.

42. *A Catalogue Raisonné of the Pictures now Exhibiting in Pall Mall*, London 1816, p. 31. This pamphlet may have been written by Robert Smirke: see G.C. Tyack, 'Robert Smirke', in *The Dictionary of Art*, 1996, vol. 28, p. 872.

43. Egerton 1998, p. 402 and p. 403, fig. 2.

French or Flemish

Perseus turning the Followers of Phineus into Stone

1650s
Oil on canvas, 165 × 243.4 cm

Provenance

Possibly in the sale of James Brydges, 1st Duke of Chandos (1674–1744), or of his heir, Henry (1708–71), 1747 (2nd day, lot 96, unsold?);[1] possibly Lord Orford's sale, 1748 (1st day, lot 67, £28 17s. 6d. to Raymond);[2] in the collection of Sir Peter Burrell MP (1754–1820), Deputy Lord Chamberlain, of Langley Park, Beckenham, Kent, probably by 1792;[3] his posthumous sale, Christie's, 8 May 1829 (lot 75, £105 to John Smith);[4] anon. [the Hon. George Vernon] sale, Christie & Manson, 16 April 1831 (lot 31, bought in at £73 10s.);[5] anon. [the Hon. George Vernon?] sale, Christie & Manson, 26 May 1832 (lot 123, £37 16s.);[6] with George Stanley by 1837;[7] presented to the Gallery in 1837 by Lieutenant General William Thornton of 3 Grosvenor Gate, Park Lane.[8]

Exhibitions

London 1859–62, The South Kensington Museum (long-term loan);[9] Dublin 1862–1926, National Gallery of Ireland (long-term loan);[10] Sheffield 1936–8, Graves Art Gallery (long-term loan); London 1995, NG, *Poussin Problems* (no catalogue).

Technical Notes

The picture suffers from wear overall, particularly in the darks. As the paint has become more transparent with age, many mid-tones have been lost as a result of the dark red ground colour showing through, a condition already notice-able by 1855.[11] The painting was last restored in 1964. It was painted on a coarse plain-weave canvas, which may have been cut down at right and along the bottom since there is no cusping along these edges. It has been relined (before 1853 when Gallery conservation records began) with a medium-fine twill canvas. The stretcher is a nineteenth-century type labelled *James Bourlet & Sons. Ltd., Fine Art Packers, Frame makers. B14957.*

The X-radiograph reveals no changes in the composition, but a few minor pentimenti are visible to the naked eye – namely, a change in the outline of Athene's right hand, alter-ations to the shoulder of the warrior second from left, and a change to the drapery of the figure lying in the centre-right foreground. This figure may have had a dagger or sword lying across its thigh, held by the dead man (wearing red and blue-black) who lies behind.

The subject is (in its best-known version) related in Ovid's *Metamorphoses*:[12] Andromeda, a daughter of Cepheus, king of Ethiopia, was tied naked to a rock as a sacrifice to a sea-monster. Perseus, son of Zeus and Danae, flying overhead on his winged horse Pegasus, promised to rescue her if she were given to him in marriage. However, the marriage was opposed by Andromeda's uncle, Phineus, to whom she had been betrothed, and at the wedding feast Phineus tried to murder Perseus and the wedding guests (*Metamorphoses*, V: 157). After a bloody battle, Perseus used the Medusa's head to turn Phineus and his thousand followers to stone.

The setting of NG 83 is 'the great golden palace-hall with a rich banquet spread, where Cepheus' princely courtiers grace the feast' (*Metamorphoses*, IV: 763–4).[13] Perseus stands left of centre brandishing the Medusa's head. Above Perseus is Pallas (Minerva), his half-sister. In his long and gory account Ovid describes a number of the individuals caught up in the carnage, some of whom are identifiable in NG 83. The dead youth in the bottom left corner may be Athis, a follower of Phineus, described by Ovid as 'of surpassing beauty... a sturdy boy of sixteen years, clad in a purple mantle fringed with gold; a golden chain adorned his neck, and a golden circlet held his locks in place' (V: 50–3). Lying dead on Athis (if it is Athis, since his cloak here is red, not purple) is his comrade and lover Lycakas, who fell at his side (V: 59–73). The bearded corpse in the centre holding a javelin may be Idas, who was 'just about to hurl back [at Phineus] the javelin which he had drawn out of his own body, when he fell fainting, his limbs all drained of blood' (V: 95–6). The figure in the centre foreground clad in white is probably Ampycus, a priest of Ceres and follower of Phineus, 'his temples wreathed with white fillets' (V: 110). The figure behind and to the left of Perseus may be Thescelus, metamorphosed into stone in the very act of raising his javelin against Perseus (V: 182–3). Facing Perseus is Nileus, 'who had on his shield engraved the image of the [Nile's] seven mouths, part silver and part gold' (fig. 1) and whose last words were cut off in mid-speech as he too turned to stone (V: 188–93). The deity at the extreme left on a dais is presumably Zeus, to whom Perseus had erected an altar before the wedding feast (IV: 753–5), albeit on an earthen mound. Phineus is not identifiable in NG 83, but since, according to Ovid, he took refuge behind an altar during part of the fighting (V: 36–7), this need not be surprising. The small figures at top right in the background presumably include Andromeda and her father.

No entirely convincing attribution of NG 83 has been given. It entered the National Gallery as by Poussin,[14] but by 1855 some considered it to be a copy by Stella.[15] It was called 'School of N. Poussin... possibly an early work by Poussin' in the 1929 catalogue[16] following a suggestion by Walter Friedländer,[17] but it did not appear at all in Martin Davies's French School

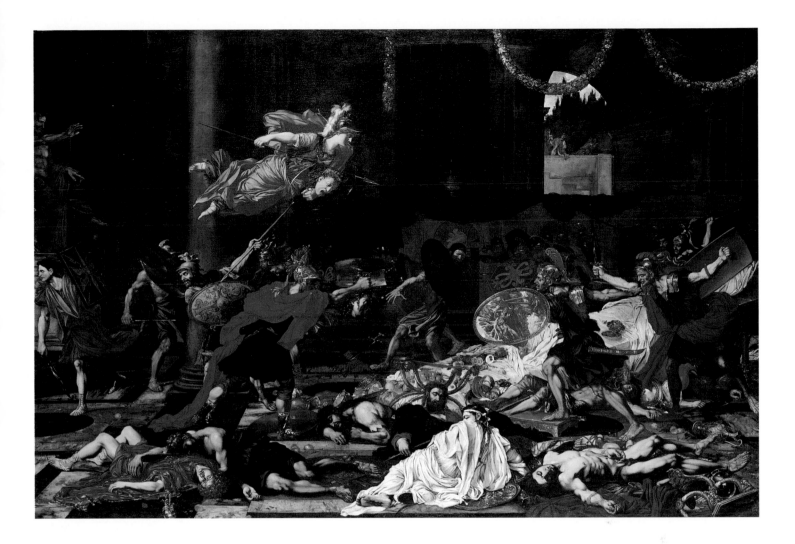

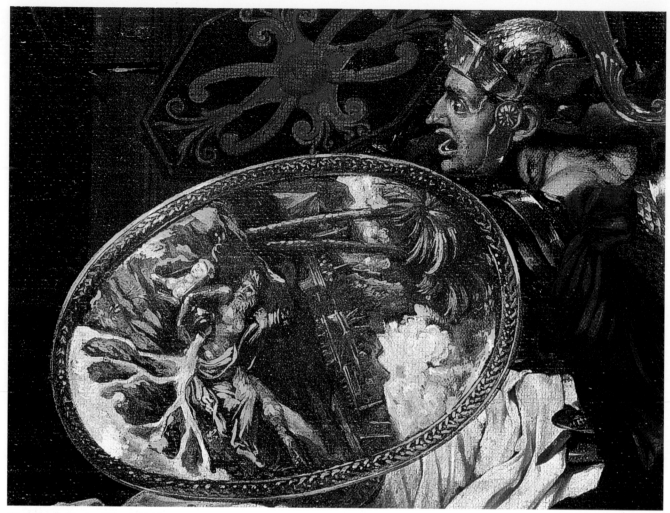

Fig. 1 Detail showing Nileus' shield.

catalogues of 1946 and 1957.[18] Nor, in spite of its being attributed by some to the Flemish painter Bertholet Flémal (1614–75), did it appear in Gregory Martin's 1970 catalogue of the Flemish School.[19] Cleaning in 1932 resulted in a flurry of attributions – for example, to Dufresnoy by Friedländer[20] and to either a pupil of Poussin or a Dutch or German seventeenth-century painter living in Italy by Otto Grautoff.[21] Paul Jamot proposed Flémal,[22] stating that if NG 83 were compared to Flémal's *Punishment of Heliodorus* in Brussels (fig. 2) and the then recently sold *Conversion of Saint Paul*, 'it may be considered that my hypothesis has become a certainty',[23] while a correspondent to the *Burlington Magazine* fiercely defended the picture's attribution to Poussin.[24] Martin Davies rejected the attribution to Flémal, as did Jacques Hendrick, who wrote that neither the composition of the figures nor their sharply delineated musculature were characteristic of the artist and tentatively proposed Gérard de Lairesse (1640–1711) as the picture's author.[25] Jan Timmers, however, rejected Lairesse, preferring an attribution to Flémal and, like Jamot, comparing NG 83 to the Brussels *Heliodorus*.[26] More recently Claude Bosson has rejected the attribution to Flémal,[27] and Jan de Maere has proposed the Flemish painter Lambert Blendeff (1650–1721), a pupil of Flémal, likening the treatment of

the heads in NG 83 to that in Blendeff's *Saint Francis Xavier exorcising a Possessed Man*, dated 1696 (Mechelen, Church of Sts Peter and Paul; fig. 3).[28]

NG 83 is now generally accepted as not by Poussin, nor has there been support for the proposal that it is French.[29] Given that there is an approximate compositional similarity between NG 83 and Annibale Carracci's fresco of the same subject in the Farnese Gallery, and that the corpse lying on its back in the bottom left corner of NG 83 appears to be derived from that in the bottom right corner of the Annibale, a Roman origin for NG 83 is possible. However, even this is far from certain since an engraving after Annibale's fresco was available by 1657.[30] If NG 83 was painted in Rome, it is interesting to note that Flémal was there in 1638 when Poussin was painting *The Destruction of the Temple in Jerusalem* (Vienna, Kunsthistorisches Museum), the picture by Poussin closest to NG 83 in terms of its crowded composition and the arrested movement of the figures. No great confidence, however, can be given to an attribution to Flémal, and NG 83 seems not to be by the same hand as, for example, *The Flight of Cloelia* (Liverpool, Walker Art Gallery), recently attributed by Thuillier to Flémal as an early work.[31] Furthermore, NG 83 has a notably complex composition but only minor pentimenti (see

Technical Notes), so it is unlikely to be early. On the other hand, Flémal's later paintings of violent scenes, such as the *Heliodorus* and *The Death of Pyrrhus*[32] (both Brussels, Musées Royaux des Beaux-Arts, and datable *c.*1650), are more concentrated in composition than NG 83.

Although Flémal himself seems an unlikely candidate as author of NG 83, the picture may well have been executed in the 1650s by an artist in his circle working in Liège after Flémal's return there by 1646.[33] NG 83 seems too competent to be by Blendeff, as has recently been suggested (see above), but until more detailed work on this artist and others in Flémal's circle has been undertaken, this cannot be determined.

Although sometimes admired, NG 83 has never been much liked, Reynolds 'turning from it in disgust', before finding on closer inspection 'what we may expect always to find in the works of Poussin, correct drawing, forcible expression,

and just character; in short all the excellencies which so much distinguish the works of this learned painter'.[34] Mrs Jameson found the painting discordant, but deliberately so, Poussin in her view contriving that 'the tumultuous and startling effect of his picture should be an "echo" to the subject, which is all confusion, discord, hurry, horror and perplexity.'[35] Foggo called the painting 'a graceless jumble… as confused as a number of rude boys letting off crackers at each other on Guy Fawkes' night',[36] and Waagen, although accepting NG 83 as by Poussin, described it as 'unworthy'.[37]

General References

Graham 1820, 'Profane History and Poetry' no. 16; Smith 1837, pp. 143–5, and John Smith, *Supplement to the Catalogue Raisonné*, London 1852 (as by Poussin); *National Gallery, Trafalgar Square: catalogue*, 86th edn, London 1929, p. 289.

Fig. 2 Bertholet Flémal, *The Punishment of Heliodorus*, *c.*1650. Oil on canvas, 146 × 174 cm. Brussels, Musées Royaux des Beaux-Arts.

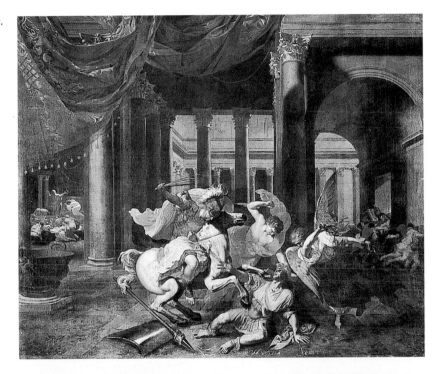

Fig. 3 Lambert Blendeff, *Saint Francis Xavier exorcising a Possessed Man*, 1696. Oil on canvas, 350 × 475 cm. Mechelen, Church of Sts Peter and Paul.

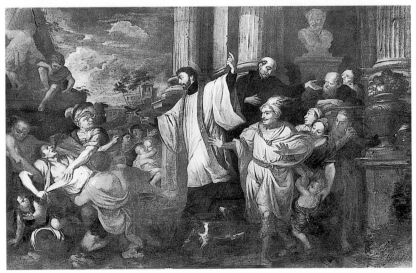

NOTES

1. *Victoria and Albert Museum, MS. sales, 1711–1759*, vol. I(c), p. 405. Described as 'Perseus with Medusa's Head. N. Poussin'. Although the attribution of NG 83 to Gérard de Lairesse is here rejected (see Text), it is possible that it may be 'Le Repas de Perseus', attributed to Lairesse as his last work, measuring 5 pieds by 7 pieds (162.4 × 227.3 cm), and sold in Amsterdam, 29 April 1732: see Alain Roy, *Gérard de Lairesse (1640–1711)*, Paris 1992, p. 490 (no. M.85).

2. *Victoria and Albert Museum, MS. sales, 1711–1759*, vol. I(c), p. 389. Described as 'Perseus turning Atlas K of Mauritania into stone. N. Poussin'. In 1748 a reference to Lord Orford would have been to Robert Walpole, 3rd Earl of Orford (c.1701–51): *The Complete Peerage*, vol. 10, p. 85. He visited Padua, Rome and Naples in 1722–3: Ingamells 1997, pp. 976–7. Raymond may have been Jones Raymond of Leadenhall Street, a director of the East Indies Company and an amateur engraver, who spent £676 on fifty European paintings at 27 auctions, and who had a house at Langley: L. Lippincott, *Selling Art in Georgian London. The Rise of Arthur Pond*, New Haven and London 1983, pp. 63, 94, 122.

3. Sir Joshua Reynolds, *Discourses on Art*, ed. R.R. Wark, San Marino, California, 1959, p. 125. Reynolds made no reference to NG 83 in his Seventh Discourse delivered at the Royal Academy, as published in 1777, nor in his *Seven Discourses delivered in the Royal Academy by the President*, London 1778. The first reference to NG 83 and to its being in 'the Cabinet of Sir Peter Burrel [sic]' appeared in Malone's edition of the *Discourses* published in 1797.

Burrell was knighted on 6 July 1781 and created Baron Gwydyr on 16 June 1796 (*The Complete Peerage*, vol. 6, pp. 220–2). If the reference to Burrell was made by Malone, it must have been written before that last date, but it was probably made by Reynolds, who had died in 1792. Burrell became extremely wealthy on his marriage to Priscilla, Lady Willoughby, in 1779. Given this and the subject matter of NG 83, he may have bought the painting on or soon after his marriage.

4. Described as 'N. Poussin…75 Perseus exhibiting the head of Medusa and Phineas and his armed attendants turned into stone, which is expressed by the colouring of the figures; of the very finest time of the master, and a magnificent specimen of the skill of the painter in composition and design'. According to the catalogue, pictures in the sale were bought from the family seat, Grimsthorpe Castle, Lincs, and the London mansion at Whitehall. The date of the sale is presumably connected with the death of Gwydyr's widow, Priscilla, Baroness Willoughby, in December 1828. According to John Britton, *The Beauties of England and Wales*, vol. 9 (1807), p. 790, the principal dining room on the first floor of Grimsthorpe Castle was 'ornamented with a collection of pictures and fine portraits' (John Britton and Edward Wedlake Brayley, *The Beauties of England and Wales*, 18 vols, London 1801–15). For the identification of the purchaser as John Smith, see Smith 1837, p. 145.

5. Sold for 70 guineas according to Smith 1837, and to Jameson 1842, part 1, p. 104, but no buyer's name appears in the annotated copy of the sale catalogue in the NG Library, and the picture reappears at the sale the following year of another anonymous gentleman. The catalogue describes NG 83 as formerly in the collections of the Earl of Pembroke and Lord Gwydir (sic), but there is no reference to a painting corresponding to NG 83 in R. Cowdry, *A Description of the… Curiosities at the Earl of Pembroke's House at Wilton*, London 1751, or J. Kennedy, *A New Description of the…Curiosities at the Earl of Pembroke's House at Wilton*, Salisbury 1784, *Aedes Pembrochianae*, Salisbury 1784, or *A Description of the Antiquities and Curiosities in Wilton House*, Salisbury 1786. (On this point, see also C. Norris in a letter in *BM*, 60, 1932, pp. 315–16.) George Vernon may have been George John Venables-Vernon (1803–66), who became the 5th Lord Vernon, Baron of Kinderton, on the death of his father in 1835: see *The Complete Peerage*, vol. 12, pp. 262–3. The Vernon family had a town house in Park Place, London, and a country seat at Sudbury House, near Uttoxeter: *A Biographical Index to the Present House of Lords*, London 1808, pp. 595–7.

6. The Pembroke and Gwydyr provenance is repeated in the 1832 catalogue.

7. Smith 1837, p. 145, and Jameson 1842, p. 104. George Stanley may have been the auctioneer of that name with rooms at 21 Old Bond Street, referred to (*passim*) in Whitley 1930.

8. In the year he gave NG 83 to the National Gallery, Thornton also became an annual subscriber to the British Institution, and so continued until 1841.

9. The Keeper reported to the NG Board of Trustees on 30 November 1859 that NG 83 (and two other paintings) 'already hung in a bad position in the hall, have been removed to the new gallery at South Kensington'.

10. *National Gallery. Catalogue of the Pictures at Trafalgar Square*, London 1920, p. 232.

11. *National Gallery MS Catalogue* (NG 10), vol. 1 (n.p.).

12. The story is told also by Apollodorus of Athens (2, ch. 1 and 4) and in the *Fabulae* (ch. 64), a work attributed to Ovid's friend, Hyginus.

13. This and the following quotations are taken from the translation by F.J. Miller in the Loeb edn, London and Cambridge, Mass., 1966.

14. *A Catalogue of the Pictures in the National Gallery*, London 1838, p. 28.

15. *National Gallery MS Catalogue* (NG 10), vol. 1 (n.p.).

16. *National Gallery Trafalgar Square Catalogue*, London 1929, p. 289.

17. Note in the NG dossier of Friedländer's opinion given in October 1928.

18. It was described as by a 'Follower of Nicolas Poussin' in the *National Gallery Catalogues. Summary Catalogue*, London 1958, p. 192.

19. Gregory Martin, *National Gallery Catalogues. The Flemish School circa. 1600– circa 1900*, London 1970.

20. Note in NG dossier. The attribution to Dufresnoy has been rejected by Sylvain Laveissière, who considers NG 83 to be probably by an artist from Liège: letter of 26 November 1996.

21. Letter of 4 March 1932.

22. Paul Jamot, 'Poussin and Berthollet Flemalle II', *BM*, 60, 1932, pp. 192–7.

23. Ibid., p. 197. A pencilled note in Martin Davies's hand by this comment in the NG copy of this volume of the *Burlington Magazine* reads 'Rubbish'.

24. K. Romney-Towndrow, *BM*, 60, 1932, pp. 314–15.

25. See note 23, and letters of 11 October and 2 November 1934 from Jacques Hendrick in the NG dossier.

26. Letter of 10 May 1955.

27. Note of 18 April 1980.

28. Letter of 13 February 1995.

29. In 1995 I proposed it as French of the 1690s, but now think this is wrong. H. Wine, 'Poussin Problems at the National Gallery', *Apollo*, 141, 1995, pp. 25–8.

30. For the engraving by Carlo Cesio (1626–86), see Paolo Bellini, *The Illustrated Bartsch*, 47, (Commentary, Part 1), *Italian Masters of the seventeenth century*, New York 1987, pp. 78–97, and *The Illustrated Bartsch*, 47, p. 64.

31. J. Thuillier, 'Bertholet Flémal: problèmes de catalogue et chronologie', *Colloque: La peinture Liégeoise des XVIIᵉ et XVIIIᵉ siècles*, Université de Liège, 20–22 January 1986, pp. 16–20.

32. For the attribution of *The Death of Pyrrhus* to Flémal, see A. Roy, cited in note 1, p. 495.

33. As suggested by Jan de Maere and Sylvain Laveissière, see notes 20 and 28.

34. Sir Joshua Reynolds, *Discourses*, 1959 edn, cited in note 3, p. 126.

35. Jameson 1842, pp. 102–4.

36. Foggo 1845, p. 29.

37. Pencilled note by Waagen in a copy in the NG Library of *A Catalogue of the Pictures in The National Gallery*, London 1854, p. 20.

French or North Italian

NG 5448
The Visitation

*c.*1630
Oil on canvas, 113.6 × 218 cm, including additions at top and left

Provenance
In the collection of George Florence Irby, 6th Baron Boston (1860–1941), of Hedsor, Cookham, Bucks, then Monkshatch, Compton, Guildford, then Lligwy, Moelfre, Anglesey;[1] his posthumous sale, Christie, Manson & Woods Ltd, 6 March 1942 (lot 64, £21 to Leger, as 'Murillo'); bought, using the Martin Colnaghi Fund, from P. & D. Colnaghi & Co. Ltd, for £350 in 1944.

Exhibition
London 1983, NG, *The Neglected National Gallery* (24).

Technical Notes
Extensively worn especially in the dark areas, and overcleaned around Joseph's staff sometime before its acquisition by the Gallery. The red lake pigments in the drapery of the Virgin and Joseph have faded. There is a horizontal stretcher-bar mark some two-thirds of the way up the painting. The painting was surface cleaned and revarnished in 1982.

The stretcher, which is not the original, may be nineteenth century. The primary support is a plain-weave medium to fine canvas, relined possibly shortly before the painting's acquisition. There are added strips of 5.5 cm at top and 6.3 cm at left. There are tacking holes down the right edge some 3.5 cm in from the edge. The ground is a mid-grey/brown. Its constitution (calcium carbonate, silica, some lead white with ochre or umber) is common in earlier seventeenth-century paintings on canvas. There are numerous pentimenti to the figure at the right (Saint Zacharias), particularly in the area of his right arm. The X-ray photograph shows that the far end of the arched passage at left originally sprang from the tip of Joseph's nose rather than his forehead and so was lower in the picture.

Ultramarine has been detected as one of the constituent pigments in the Virgin's drapery, the sky and (mixed with red lake) the sleeve of Joseph's cloak. Natural malachite has been identified in Saint Elizabeth's drapery. Also detected (in the impasto highlight on the back of Joseph's cloak) was the use of pure lead antimony yellow (genuine Naples yellow), the geographical distribution of which during the seventeenth century is uncertain. It is thought to have been available in Italy in the sixteenth century and possibly in the seventeenth (although to date only lead-tin yellow or lead-tin-antimony yellow have been found in other seventeenth-century pictures in the Gallery), but there are no reported examples of the use of pure lead antimony yellow in seventeenth-century Flemish or Spanish painting, nor in any picture painted in England in the mid-seventeenth century.

The subject is from Luke 1:36–55. After the Annunciation Mary visited her aged cousin Elizabeth, who was then six months pregnant (with Saint John the Baptist), in the house of Zacharias. The cousins mutually rejoiced at their pregnancies, and Elizabeth blessed that of Mary. Joseph does not figure in the biblical account of the Visitation but was often included in pictures of it. Here he is shown at the left, and there follow (from left to right) Mary, Elizabeth and Zacharias.

The composition is based on a painting of the same subject by Palma Vecchio (Vienna, Kunsthistorisches Museum, inv. no. 56; fig. 2), datable 1520–2. That painting was in Venice until about 1637; between 1642 and 1649 it was recorded in the collection of the 1st Duke of Hamilton in England, and subsequently it was with Archduke Leopold Wilhelm in Brussels, before being bequeathed to Emperor Leopold I of Austria in 1662.[2] NG 5448 may have been painted by an artist with knowledge of the Palma, or of one of two copies after it, both by David Teniers the Younger. One copy is shown in *The Picture Gallery of Archduke Leopold Wilhelm, Brussels* (Vienna, Kunsthistorisches Museum) of *c.*1651; the other, a small copy on panel, is in Glasgow (Art Gallery and Museum, inv. no. 27). The Glasgow panel is one of the copies of 244 Italian paintings that Teniers was asked to make for the use of engravers by Leopold Wilhelm when he arrived in Brussels with his collection in 1646. The engraving (by P. van Lisebetten) after the Glasgow picture was published in the *Theatrum pictorium*, 1660.[3]

NG 5448 was once incorrectly ascribed to Murillo (see Provenance), but in any case a Spanish origin for the painting is unlikely because of the use of ultramarine. It was bought by the Gallery as possibly by Philippe de Champaigne, which it is not. Given the history of the Palma Vecchio, a Flemish origin is possible, but this seems excluded by the use of Naples yellow (see Technical Notes). The Italianate elements of the architecture, the use of Naples yellow and the fact that the Palma was in Venice until about 1637 means that a North Italian origin for NG 5448 seems possible.[4] Nevertheless, stylistically NG 5448 is more French than North Italian;[5] it is perhaps by a French artist working in North Italy around 1630.

General References
Davies 1957, pp. 104–5 (as 'French School(?)').

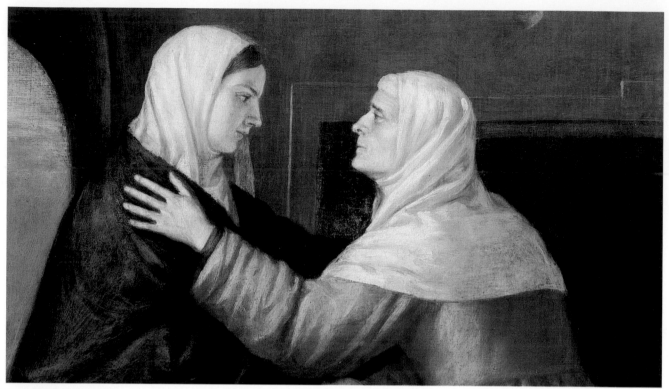

Fig. 1 Detail of NG 5448.

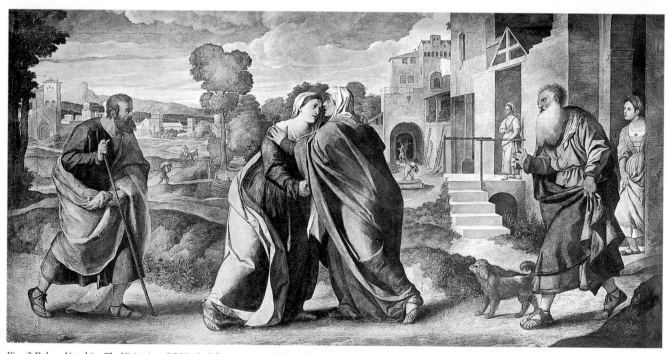

Fig. 2 Palma Vecchio, *The Visitation*, 1520–2. Oil on canvas, 168 × 354 cm. Vienna, Kunsthistorisches Museum.

NOTES

1. Letter of 22 March 1944 from the 7th Lord Boston. Davies 1957 (p. 105, n. 3) noted that an Annunciation by 'Morellio' was mentioned at Hedsor by Thomas Langley, *The History and Antiquities of the Hundred of Desborough*, London 1797, p. 278, but it seems scarcely likely that such well-known subjects as the Annunciation and the Visitation could have been confused.

2. P. Rylands, *Palma Vecchio*, Cambridge 1992, p. 191.

3. [Hamish Miles], *Dutch and Flemish Netherlandish and German Paintings*, 2 vols, Glasgow 1961, vol. 1, p. 134.

4. As suggested by Alastair Laing in conversation.

5. Opinions of Sir Denis Mahon and Arnauld Brejon de Lavergnée in conversation.

The Visitation

Laurent de La Hyre
1606–1656

A versatile Paris-born painter of large altarpieces, decorative ensembles and easel pictures, La Hyre became one of the twelve founder members of the Académie de Peinture et de Sculpture in 1648. He was first taught painting by his father, Etienne. Between 1622 and 1625 he studied at the Château of Fontainebleau and, influenced by the work of Primaticcio, painted erotic scenes in a Mannerist style, such as *Hercules and Omphale* (Heidelberg, Kurpfälzisches Museum). Around 1625 he spent some months in the studio of the Paris painter Georges Lallemant.

The commission that probably secured La Hyre's reputation in Paris was a series of paintings for the Capuchin church in the Marais, on which he worked from around 1627 to 1635. In 1627 or 1628 he also successfully exhibited a *Martyrdom of Saint Bartholomew* (Mâcon, Cathédrale St-Vincent) executed in a Caravaggist style quite distinct from his earlier Mannerism. By 1631 he was sufficiently established to hold a *brevet du roi*, which exempted him from paying dues to the painters' guild. In 1635 he painted *Saint Peter curing the Sick by his Shadow*, which was his first 'May', that is, the painting given each year to the cathedral of Notre-Dame by the confraternity of Saint Anne and Saint Marcel of the Paris Goldsmiths. Subsequently he executed a number of large altarpieces.

In the late 1630s La Hyre dispensed with the tenebrism of his *Saint Bartholomew* and adopted a lighter palette with a greater feeling for light and space, while still retaining his richness of colour and close observation of nature. From 1638, in accordance with the French trend towards classicism, the Baroque vigour of his earlier work gave way to a more serene style. The profiles of his figures also approximated more to the antique, or at least to his concept of it.

From around 1645, his work showed an increasing elegance of line and spareness of composition. In the last decade of his life he undertook both large altarpieces, such as the Rouen *Descent from the Cross*, and decorative schemes for aristocratic Paris town houses. Many of these have disappeared, but his suite of the Seven Liberal Arts, of which NG 6329 is one, for Gédéon Tallemant, serves as a reminder of their quality. In this period La Hyre also painted a number of landscapes as cabinet pictures, often with classical ruins in a serene countryside – for example, his *Landscape with Justice and Peace Embracing* (Cleveland, Museum of Art). La Hyre died in Paris in 1656.

Unlike Le Brun or Vouet, La Hyre never ran a large studio of painters. He took on several apprentices, however, including his youngest brother, Louis (1629–53), who painted in a similar style.

NG 6329
Allegory of Grammar

Oil on canvas, 101.9 × 112.2 cm

Signed and dated, bottom left: *l. de la hire in x.f 1650*
Inscribed: VOX LITTERATA ET ARTICVLATA DEBITO MODO PRONVNCIATA

Provenance
Painted (as one of a series of the Seven Liberal Arts) for the hôtel of Gédéon Tallemant (1613–68) in the rue d'Angoûmois in the Marais district of Paris;[1] offered for sale (with the rest of the series) on or soon after 23 February 1760 at premises in the rue du Temple 'via-à-vis la rue Chapon';[2] probably sale of Pierre de Grand-Pré, Paris, Paillet & Langlier, 16–24 February 1809 (part lot 28, with the *Allegory of Arithmetic*, bought 140 francs by Simon, probably for Cardinal Fesch);[3] Fesch Collection, no. 1677;[4] Fesch Sale, Rome, Palais Ricci, George, March–April 1845 (lot 366, sold together with lot 365, the *Allegory of Arithmetic*, 25 scudi to Marini);[5] in the collection of André J. Seligmann, Paris, by 1937,[6] and sold by him to Francis Falconer Madan (d.1961) in 1938 for 35,000 French francs;[7] bequeathed by Francis Falconer Madan of Queen's Gate Gardens, London SW7, via the NACF to the National Gallery (with other pictures) in 1961.

Exhibitions
Paris 1937, Palais National des Arts, *Chefs d'Oeuvre de l'Art Français* (80); Oxford 1939, Ashmolean Museum;[8] London 1947, Wildenstein & Co. Ltd, *A Loan Exhibition of French Painting of the XVIIth Century in aid of the Merchant Navy Comforts Service* (16); Oxford 1947–51, Ashmolean Museum;[9] London 1962, Colnaghi, *Memorial Exhibition of Paintings and Drawings from the Collection of Francis Falconer Madan* (9); London 1979, NG, *Howard Hodgkin: The Artist's Eye* (11); Grenoble, Rennes, Bordeaux 1989–90, *Laurent de La Hyre 1606–1656: l'homme et l'oeuvre* (261); Copenhagen 1992 (3); London 1994, NG, *Themes and Variations. Ideas Personified* (no catalogue).

Related Work
PAINTING
Baltimore, Walters Art Gallery. Oil on canvas, 103.2 × 112.4 cm. A good old copy, signed. Acquired by Henry Walters, 1902, from the Massarenti Collection, Rome, dated and inscribed as NG 6329. It has been tentatively attributed to Louis de La Hyre.[10]

Technical Notes

This painting, which was last cleaned and retouched in 1990, has suffered losses around the figure's head and left sleeve, and in the area of the columns. There has been some blanching in the leaves of the right-hand potted plant. The support is a plain-weave medium-weight canvas cusped at the tacking margins. It was relined in 1946/7 by Horace A. Buttery (who then also cleaned and restored the picture).[11] There is also evidence of another relining having been carried out in France, presumably before the picture's acquisition by F.F. Madan.[12]

The painting has a double ground, the lower layer being a bright brick red (ferric oxide) and the upper layer a cool grey. Pigments identified (mixed with others) in the upper paint layers include green verditer (in a green leaf in the right-hand potted plant), red lake (terracotta pots), yellow ochre and yellow lake (the headdress) and ultramarine (the dress).[13] There are labels on the back of the stretcher relating to the 1937 exhibition (see above) and to the painting's deposit at the National Gallery in August 1942 for safekeeping during the war.[14] There are also two circular labels both inscribed in ink, one *HAB/42/F.*, the other *22(?)04*.

The X-radiograph (fig. 2) shows there to have been a number of alterations: to the position of the inscribed scroll and to the shape of the figure's left sleeve, and at bottom centre there was once a box-shaped object. Visual inspection shows that the foliage of the trees and the urn at the right were painted over the sky (unlike in the Baltimore version, where these areas were left in reserve).[15]

The subject of NG 6329 is identifiable from the action of the figure and the inscription on the scroll, both of which La Hyre is likely to have derived from Jean Baudoin's French-language edition of Cesare Ripa's *Iconologia*. The first illustrated edition of Ripa was published in Rome in 1603. In Baudoin's edition, published in Paris in 1644, two versions of the allegorical figure of Grammar were described. One was a young woman holding a metal file in one hand and a whip or birch-rod in the other, while milk poured from her breasts. The other, more appealing, alternative was a woman described by Baudoin as holding in her left hand 'un Rouleau, où elle est definie un Art qui apprend à parler correctement, et à prononcer comme il faut. Et de la [main] droite un Vase plein d'eau, dont elle arrouse [sic] une plante: par où elle veut signifier, Qui'il en est de mesme des jeunes esprits, & qu'à force d'estre cultivez, comme des plantes encore tendres, ils portent des fruits d'exquise doctrine, pour la commune utilité du public' ('a scroll whereby she is defined as an Art which teaches correct speech and pronunciation. And in her right hand [she holds] a vase full of water with which she waters a plant: by which is meant that just as with young minds so with tender plants, it is through cultivation that they bear the fruits of refined learning for the general public good').[16] It was only this gentler approach to pedagogy that was illustrated (fig. 3) and La Hyre presumably used it as his starting point for NG 6329. It seems later to have become the established way of

representing Grammar.[17] La Hyre's principal departure from the *Iconologia*, and the one noted by both Guillet and Philippe de La Hyre, was that his allegorical figure was not full-length, an inevitable consequence of choosing to make it life-size, given the requirements of the decorative scheme of which it was a part: hence, for example, the more complex pattern of the inscribed scroll of La Hyre's figure of Grammar compared to that in the *Iconologia*, and the particularly fortunate idea of turning her away from strict profile and bending her right arm at the elbow towards the spectator.

The inscription VOX LITTERATA ET ARTICVLATA DEBITO MODO PRONVNCIATA, which may be translated as 'A meaningful utterance which can be written down, pronounced in the proper way', is based on Priscian, the sixth-century grammarian of the Imperial court at Constantinople.[18] Wittkower, noting that there were two flowerpots in NG 6329, rather than one, a detail that could not have been derived from Ripa, suggested that La Hyre's study of literary sources may well have gone beyond Ripa, and that the two pots were intended to illustrate the two positive parts of Priscian's definition of Grammar, 'articulata' (meaningful) and 'litterata' (capable of being written down).[19]

Ripa specified no particular plant. In NG 6329 La Hyre has chosen a red and white anemone for the larger pot and a pale pink primula for the other. The latter, the French name for which, '*primevère*', once also meant Spring,[20] may well have seemed an appropriate choice as a visual metaphor for young minds being cultivated. Whether the anemone was intended to have any symbolic significance is unclear, but conceivably it may have been seen as a reference to the need for spiritual cultivation of the mind.[21] The jug is probably an invention of the artist, combining a European shape with decoration inspired by late Ming Transitional-style porcelain, known in Europe by 1650.[22]

NG 6329 is one of a series of seven half-length figures by Laurent de La Hyre depicting the Seven Liberal Arts. According to the artist's son, Philippe de La Hyre (1640–1718), writing around 1690, there were in the Marais district of Paris, 'dans une maison qui appartenoit autrefois à M. Tallemant, maistre des requestes, sept tableaux représentant les sept arts libéraux qui font l'ornement d'une chambre; les figures ne sont pas entières; elles sont grandes comme nature et ces tableaux sont ornés d'architecture et accompagnés d'enfants' ('in a house which once belonged to Mr. Tallemant, master of requests, and forming the decoration of a room seven pictures showing the seven Liberal Arts; the figures are not full-length; they are life-size and the pictures are decorated with architecture and include children').[23] This account, broadly speaking, corresponds with that of about the same time by Guillet de Saint-Georges, the historiographer of the Académie Royale de Peinture et de Sculpture, who also mentions that it was La Hyre's work for the Capuchin church in the Marais that led to the commission for the *Seven Liberal Arts* in a house close by.[24] It was presumably these seven pictures which were, together with their accompanying paintings of putti, the 'Tableaux, entre autres les Arts libéraux', offered for sale in February 1760 at premises in the same area of the Marais as Tallemant's

Fig. 1 *Allegory of Arithmetic*, 1650. Oil on canvas, 103 × 109 cm. Heino, Fondation Hannema-de Stuers.

Fig. 2 RIGHT X-radiograph.

Fig. 3 BOTTOM RIGHT *Grammar*, from Cesare Ripa, *Iconologie*, translated by J. Baudouin, Paris 1644. London, British Library.

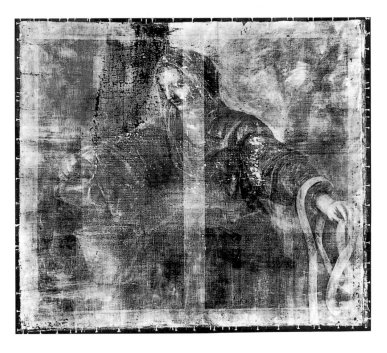

house had been situated.[25] It is likely, therefore, that the *Seven Liberal Arts* were still in their original location in 1760. If they were, in fact, sold in 1760, it is not known whether they were sold in one or several lots. There is no known further trace of any of the paintings until 1809, when NG 6329 and the *Allegory of Arithmetic* (Heino, Fondation Hannema-de Stuers; fig. 1) were sold in Paris. By 1809, therefore, if not before, La Hyre's series was split up.[26]

La Hyre's patron, Gédéon Tallemant (1613–68), held the court office of Maître des Requêtes, to which he had been appointed in 1640.[27] According to the memoirs of his cousin Tallemant des Réaux, Gédéon's expenditure was outrageously lavish. Among other things, he bought pictures, jewels, prints and books, as well as a house for 100,000 livres described as needing substantial building work, in a district that was 'effroyable tout au fond du Marais'.[28] This was presumably the house for which La Hyre painted the series of the *Liberal Arts*.

Of the seven principal paintings in the series, three (*Geometry*, *Music* and *Astronomy*) are dated 1649 and the rest 1650, which may indicate only that the paintings were executed over the winter of 1649–50. As the description by Philippe de La Hyre makes clear (see above), all of the paintings hung in a single room, as might be expected, but their precise arrangement is not known. The Liberal Arts were traditionally divided into the Trivium (Grammar, Rhetoric and Dialectic) and the Quadrivium (Arithmetic, Music, Geometry and Astronomy). This division is not, however, reflected in the respective sizes of the paintings: *Astronomy*, *Music* and *Geometry* are of elongated form, while the format of the remaining four, *Grammar*, *Arithmetic*, *Rhetoric* and *Dialectic*, is nearly square. It has been suggested that *Grammar* may have been a

pendant to *Arithmetic* (fig. 1), with *Rhetoric* and *Dialectic* forming another pair.[29] One possible arrangement is that *Music*, with its two accompanying paintings of putti, was on the long wall opposite the window wall. Each of the end walls would then have accommodated either *Astronomy* or *Geometry*, with the nearly square-format *Grammar*, *Arithmetic*, *Rhetoric* and *Dialectic* along the other long wall punctuated by three windows.[30] The internal composition of each painting along the window wall would suggest a possible order (from left to right), namely *Arithmetic*, *Rhetoric*, *Dialectic* and finally *Grammar*. This does not, however, accord with the fall of light within each painting, and it may be that the room which housed the *Seven Liberal Arts* was of irregular shape, or had doors and windows at irregular intervals.[31]

Whatever the disposition of La Hyre's *Liberal Arts* around the room in Gédéon Tallemant's house, they were probably inserted into panelling and hung above head height rather like the large history paintings executed by Eustache Le Sueur in 1645–7 for the Cabinet de l'Amour of the Hôtel Lambert.[32]

Of the seven paintings in La Hyre's series, three are known to have been copied. These are *Grammar* (copy in the Walters Art Gallery, Baltimore), *Arithmetic* (copy also at Baltimore), and *Geometry* (the original in a private American collection, the copy in the Toledo Art Museum, Ohio). Given the likely position of the original series high on the walls in Gédéon Tallemant's house, it seems reasonable to assume that the copies were made while the originals were in the studio. The fact that the Baltimore copy is roughly contemporary with NG 6329[33] is consistent with a second series having been painted at that time. The possibility of a second series has often been postulated on the basis of Dezallier d'Argenville's account of the life of La Hyre in his *Abrégé de la vie des plus fameux peintres* (Paris 1745).[34] There Dezallier referred to 'sept grands tableaux représentant les sept arts libéraux avec des fonds enrichis d'architecture pour la même ville [de Rouen]'.[35] No mention was made by Dezallier of a series in Paris. Although it has been argued that Dezallier's reference to Rouen was a slip, and that there never was a complete second series,[36] it is worth noting that Gédéon Tallemant's mother, Anne de Rambouillet, was from a wealthy Rouen family.[37] Possibly a second series of the Liberal Arts was made in the studio, perhaps by Laurent's brother, Louis (1629–53),[38] for one of the Rambouillet family living in Rouen.[39]

General References
National Gallery Catalogues. Acquisitions 1953–62, London [1963], p. 47, Wright 1985b, p.112.

NOTES

1. See Guillet de Saint-George's biography of the artist printed in L. Dussieux et al., *Mémoires inédits sur la vie et les ouvrages des membres de l'Académie Royale de Peinture et de Sculpture*, 2 vols, Paris 1854, vol. I, pp. 104–14 at p. 107, and Philippe de La Hyre's biography of his father printed in Ph. de Chennevières and A. de Montaiglon, eds, *Abécédario de P.J. Mariette et autres notes inédites de cet amateur sur les arts et les artistes*, 6 vols, Paris 1851–60, vol. III, pp. 42–51 at pp. 48–9. For the location of Tallemant's hôtel in the rue d'Angoûmois (now 58 rue Charlot) in the Marais district, see Tallemant des Réaux, *Historiettes*, ed. A. Adam, 2 vols, Paris 1960, vol. II, p. 547, Alfred Franklin, *Les rues de Paris sous Louis XIII*, Paris 1968, p. 82, and Grenoble, Rennes, Bordeaux 1989–90, p. 292, and I. Dérens and M. Weil-Curiel, 'Répertoire des plafonds peints du XVIIe siècle disparus ou subsistants', *Revue de l'Art*, no. 122, 1998, 4, p. 108.

2. Grenoble, Rennes, Bordeaux 1989–90, p. 292, citing *Annonces, affiches et avis divers*, 21 February 1760.

3. Letter of 5 February 1996 to the author from Burton B. Fredericksen, who points out that many of Simon's purchases were destined for Cardinal Fesch. Lot 28 is described in the Grand-Pré sale catalogue as 'Deux Sujets allégoriques aux mathématiques et à l'agriculture personnifiées par deux belles Femmes drapées de bon style et vues à mi-corps, qui se détachent sur des fonds de riche architecture melée de paysage. Ces tableaux et le suivant attendent et méritent une restauration. Sur Toile, larg. 41, haut. 37p.' Fredericksen has also kindly pointed out that the copy of the sale catalogue in the library of the Brussels Musées Royaux des Beaux-Arts is annotated 'très commun [?] et d'un ton gris et noir'. For further information on this posthumous sale of the picture dealer Pierre de Grand-Pré and on some of the higher priced lots, see Jo Lynn Edwards, *Alexandre Joseph Paillet*, Paris 1996, pp. 323–4, and *Répertoire 1800–1810*, vol. 1, pp. 54–5.

4. *Catalogue des tableaux composant la galerie de feu Son Eminence le Cardinal Fesch*, Rome 1841, p. 72.

5. George, *Galerie de feu S.E. Le Cardinal Fesch, Deuxième et Troisième Parties*, Rome 1844, Troisième Partie, pp. 32–3 (annotated copy in NG Library), where described as '366. 1677. La Rhétorique. / Figure à mi-jambes./ La tête couverte d'un voile dont la couleur grise s'harmonise avec le ton verdâtre de sa tunique et la nuance indécise de son manteau, une jeune femme arrose des fleurs qui croissent dans des pots placés sur un fragment d'architecture, au pied de deux colonnes cannelées. Autour de son bras gauche se roule une banderobe sur laquelle on lit ces mots: vox litterata et articulata debito modo pronunciata. / T.H. 3p. 2p. 6 l. – L. 3p. 5p. 9 l.' This was one of many paintings in the sale which, according to George, were brought out of France by Fesch 'et qui sont affranchis de tous droits de sortie': George, *Galerie*, op. cit., Conditions de la Vente, n.p.

6. As 'Allégorie de la Littérature', in Paris 1937, Palais National des Arts, no. 80. André Seligmann's archives were entirely lost, stolen or destroyed during World War II (letter of 26 September 1997 from his brother F.G. Seligmann). Hence it has not yet been possible to establish the immediately preceding provenance.

7. Receipted invoice in NG dossier. The painting was sold as 'La Littérature', but the figure had been recognised as Grammar before the 1947 exhibition at Wildenstein's (letter of 15 April 1947 from F.C. Van Duzer to F.F. Madan in NG dossier). Madan was in the Indian Civil Service, from which he had retired by 1937 (letter of 8 February 1999 from Venetia Phair).

8. *Report of the Visitors of the Ashmolean Museum*, Oxford 1939, p. 36, and ibid., 1947, p. 31. I am grateful to Jon Whiteley for these references. According to the 1939 *Report* the painting was evacuated at the outbreak of war.

9. Letter of 29 September 1997 from Jon Whiteley.

10. Eric M. Zafran, *Fifty Old Master Paintings from the Walters Art Gallery*, Baltimore 1988, no. 46 (where illustrated).

11. Receipted invoice in the NG dossier.

12. Wine, Ackroyd and Burnstock 1993, pp. 22–33 at p. 26 and n. 25.

13. Wine, Ackroyd and Burstock 1993, p. 30, and see that article generally for a full discussion of the materials and technique of NG 6329, and J. Kirby and D. Saunders, 'Sixteenth- to Eighteenth-Century Green Colours in Landscape and Flower Paintings: Composition and Deterioration', *Contributions to the Dublin Congress 7–11 September 1998. Painting Techniques. History, Materials and Studio Practice*, ed. A. Roy and P. Smith, London 1999, pp. 155–9 at p. 156.

14. Correspondence in NG dossier and in NG Archive, S953-Bequests, from which it may be inferred that NG 6329 was kept at Manod in Wales from 1942 until shortly after 22 April 1945 when Madan wrote agreeing to its return to Trafalgar Square. It remained at Trafalgar Square until 4 November 1946, when collected by Horace Buttery for cleaning and restoration.

15. See further in Wine, Ackroyd and Burnstock 1993.

16. C. Ripa, *Iconologie, ou, Explication nouvelle de plusieurs images…tirée des recherches et des figures de César Ripa, moralisées par I. Baudouin*, Paris 1644, p. 84.

17. For example by Bourdon at the Hôtel de Bretonvilliers. In his description of Bourdon's paintings Guillet de Saint-Georges referred to 'les sept arts libéraux avec leurs symboles ordinaires': L. Dussieux et.al., *Mémoires inédits*, cited in note 1, vol. 1, p. 98.

18. I am grateful to Elizabeth McGrath for providing this translation.

19. R. Wittkower, 'Grammatica : From Martianus Capella to Hogarth', *JWI*, vol. 2, 1938–9, pp. 82–4, who notes that Ripa's depiction of Grammar was derived ultimately from an engraving by Marcantonio Raimondi. Questions of French grammar were much debated at the time that NG 6329 was painted – Claude Faure de Vaugelas's *Remarques sur la langue françoise utiles à ceux qui veulent bien parler et bien escrire* (Paris 1647) proved controversial. For a proposal that La Hyre's *Allegory of Music* (New York, Metropolitan Museum) was based on contemporary music

theory and practice, see Gabriele Frings, 'Ut Musica Pictura. Laurent de La Hyre's Allegory of Music (1649) as a mirror of Baroque art and music theory', *GBA*, vol.123, 1994, pp.14–28.

20. E. Littré, *Dictionnaire de la Langue Française*, Paris 1869.

21. See Alain Tapié, 'La Nature, l'Allégorie,' *Symbolique & botanique. Le sens caché des fleurs dans la peinture au XVIIe siècle*, exh. cat., Caen, Musée des Beaux-Arts, 9 July–26 October 1987, who quotes from the Jesuit Le Roy Alard's *La Saincteté de vie tirée de la considération des plantes*, Liège 1641, pp. a4–a5, 'l'Anémone ouvre le coeur pour recevoir les inspirations du Saint Esprit.' For the possibility of a flower painting carrying both secular and religious connotations, see Alain Tapié, op. cit., no. 29 and no. 5 of the exhibition.

22. I am grateful to J.V.G. Mallet and J. Ayers for this information.

23. Philippe de La Hyre, cited in note 1, pp. 48–9. In the context, 'ornés d'architecture' probably means that the paintings included architectural elements, rather than that they were framed as part of a decorative architectural scheme, although they probably were that as well.

24. Guillet de Saint-Georges, cited in note 1, p. 107. The Capuchins were originally installed in the rue d'Angoûmois. In 1624 they acquired neighbouring properties where they built the church now called St-Jean-St-François: J-P. Babelon, 'Essor et décadence du Marais. De la Renaissance à la Révolution', in *Le Marais – mythe et réalité*, exh. cat., Paris, Hôtel de Sully, 1987, p. 96.

25. See Provenance and Grenoble, Rennes, Bordeaux 1989–90, cited in note 2.

26. See Provenance and note 3 above. The allegories of *Dialectic* and *Rhetoric* were in the Simon deceased sale, Paris, Regnault, 20–24 December 1814. As Fredericksen has noted (letter of 5 February 1996), an *Allegory of Music* by La Hyre, presumably the picture now in the Metropolitan Museum of Art, New York, was also in the Grand-Pré sale of 1809 (lot 29) and was also bought by Simon. The allegories of *Astronomy* (Orléans, Musée des Beaux-Arts) and *Geometry* (USA, private collection) were probably the paintings in the Brunet deceased sale, Paris, Henry, 8 March 1830, lot 6. Given that none of the seven paintings is known to have been on the market between 1760 and 1809, it is possible that they were bought as a single lot in 1760 and remained together through the French Revolution. However, the two paintings of putti (Dijon, Musée Magnin) once on either side of the *Allegory of Music* in Gédéon Tallemant's hotel were in the collection of the duc de Brissac in 1793 and sold that year by Le Noir (Paris, New York, Chicago 1982, p. 251). The conclusion must therefore be that the series was then, if not before, broken up.

27. H.Greenwald, 'Laurent de La Hire's *Allegory of Music*. Antiquity Updated', *RidIM/RCMI Newsletter*, vol. 12, no. 1, 1987, pp. 2–11 at p. 8.

28. Tallemant des Réaux, *Historiettes*, cited in note 1.

29. Grenoble, Rennes, Bordeaux 1989–90, p. 294.

30. Such a rhythm of painting and window was behind the organisation of Sébastien Bourdon's paintings of the Liberal Arts in the gallery of the hôtel de Bretonvilliers: see J. Wilhelm, 'La galerie de l'hôtel de Bretonvilliers', *BSHAF*, Année1956 (1957), pp. 137–50; and see B. Montgolfier, *Ile Saint-Louis*, exh. cat., Paris, Musée Carnavelet, 1980, pp. 45–51.

31. The plans of rooms in seventeenth-century Paris were not always rectilinear, especially in the old quarters of Paris: see J-P. Babelon, *Demeures parisiennes sous Henri IV et Louis XIII*, Paris 1965, p. 131.

32. General accounts of interiors in seventeenth-century Paris may be found in Babelon, cited in note 31, and in Alain Mérot, *Retraites mondaines*, Paris 1990. For the hôtel Lambert, see J.-P. Babelon, G. de Lastic, P. Rosenberg, A. Schnapper, *Le Cabinet de l'Amour de l'hôtel Lambert*, exh. cat., Paris, Louvre, 1972; Natalie Rosenberg Henderson, 'Le Sueur's Decorations for the Cabinet des Muses in the Hôtel Lambert', *AB*, 56, 1974, pp. 555–70; and Alain Mérot, 'Eustache Le Sueur: l'Histoire de l'Amour, cinq modelli pour un plafond', *La Revue du Louvre et des Musées de France*, 1989, pp. 164–71.

33. In Wine, Ackroyd and Burnstock 1993, at p. 29.

34. See C. Sterling, *The Metropolitan Museum of Art. A Catalogue of French Paintings XV–XVIII Centuries*, Cambridge, Mass., 1955, p. 87; P.-M. Auzas, 'A propos de Laurent de la Hire', *La Revue du Louvre et des Musées de France*, 18e année, 1968, no.1, pp. 3–12 at p. 12; M. O'Neill, *Musée des Beaux-Arts d'Orléans. Catalogue critique. Les Peintures de l'École Française des XVIIe et XVIIIe siècles*, Nantes 1981, p. 86; P. Rosenberg in 1982, Paris, New York, Chicago, exh. cat., p.251.

35. Dezallier d'Argenville 1762, vol. 4, p. 66.

36. Grenoble, Rennes, Bordeaux 1989–90, p. 292. The reasoning in that catalogue that no second series ever existed has been accepted by Hilliard T. Goldfarb, *From Fontainebleau to the Louvre: French Drawing from the Seventeenth Century*, exh. cat., Cleveland 1989, p. 174.

37. Tallemant des Réaux, *Historiettes*, cited in note 1, vol. 2, p. 1354, n. 4.

38. Pierre Rosenberg attributed the Baltimore paintings to Louis de La Hyre in *Nouvelles acquisitions du musée d'Orléans*, exh. cat., Louvre, Pavillon de Flore, Paris 1976–7, p. 49. For Louis de La Hyre's place in Laurent's studio, see in Grenoble, Rennes, Bordeaux 1989–90, pp. 64–6.

39. The Capuchins of Rouen, as well as of Paris, commissioned work from La Hyre. If the drawing of *Rhetoric* in the Fogg Art Museum, Harvard University, is a ricordo made for the studio, as suggested by Goldfarb, cited in note 36, pp. 174–5, this would reinforce the possibility of a complete second series having been made.

The Le Nain Brothers

Antoine *c*.1600(?)–1648, Louis *c*.1603(?)–1648, Mathieu 1607–1677

Little is known of the early lives of the three Le Nain brothers. They were all born in or near Laon around the first decade of the seventeenth century. All died in Paris, Antoine and Louis suddenly in 1648, and Mathieu in 1677.

Antoine had evidently left Laon by 1629, that being the year he was admitted to the guild of painters of St-Germain-des-Prés just outside Paris. This allowed him to set up a studio in which Louis and Mathieu could work without having to pay guild fees. The brothers' reputation, initially as portraitists, must have been established in Paris by 1632 when Antoine obtained the important commission to paint a group portrait of the aldermen of Paris. In the following year Mathieu was commissioned to decorate the Chapel of the Virgin at the church of St-Germain-des-Prés, and was appointed Peintre Ordinaire de la ville de Paris, probably with responsibility for conserving the city's paintings. Mathieu is said to have painted the portrait of the queen, Anne of Austria, before 1643, and in 1646 or earlier that of Cardinal Mazarin. In 1648 all three brothers were among the founder members of the Académie Royale de Peinture et de Sculpture. After the deaths of Antoine and Louis that same year, Mathieu continued to paint, at least until the mid-1650s. In 1662 he was received into the Order of St Michael, an unusual honour for a painter, but he was expelled from it a year later. In 1666 he was imprisoned for wrongly wearing the collar of the Order.

Throughout their working lives in Paris the three brothers shared a studio. Although from 1641 they began to sign and date their works, it was always only as 'Lenain' without identifying initials. No single work can confidently be dated to the years when Mathieu alone was alive. Hence, although it is possible to ascribe particular groups of works to different hands, it is not possible to identify the hands in question.

The Le Nain brothers are most readily associated with peasant scenes in which their subjects are shown with great sensitivity and sympathy. The early provenance of these works is unknown, so it is not possible to say who bought such paintings, or where they were hung, or how they were enjoyed.

NG 1425

A Woman and Five Children

Oil on copper, 21.8 × 29.2 cm, subsequently enlarged all round
Signed and dated lower right: *Lenain f[e]cit.1642.*

Provenance

Remoissenet sale, Paris, Regnault, 6 June 1803 (lot 35, 95 francs to Lafontaine);[1] Pierre Joseph Lafontaine sale, Christie's, 13 June 1807 (lot 11, £52 10s. bought in);[2] anonymous sale, probably Bryant, London, Phillips, 13 May 1862 (lot 39, £13 13s. bought Busso, presumably on behalf of Bohn);[3] in the collection of Henry George Bohn (1796–1884), bookseller and publisher of North End House, Twickenham;[4] Bohn's executors' sale, Christie, Manson & Woods, 19 March 1885 (lot 34, £52 10s. to Lesser as L. and A. Le Nain); [D.P.] Sellar of London sale, Paris, Petit et Lasquin, 6 June 1889 (lot 44, as Antoine Le Nain, unsold);[5] D.P. Sellar of 68 Prince's Gate [London] sale, Christie, Manson & Woods, 17 March 1894 (lot 88 as Le Nain, £110 5s. to Lesser); presented by Lesser Lesser of 123 New Bond Street, London, in 1894.[6]

Exhibition

Paris 1978–9 (18).

Related Work

PRINT
By Claude Faivre for the catalogue of D.P. Sellar's Paris sale of 1889 (see above and note 5).

Technical Notes

Painted on copper. This was fixed by 1885 to a wooden cradle measuring 26.7 × 32.8 cm.[7] There is some wear in the background and heavy restoration at the upper left margin and just above the seated boy's head. There is also some wear in the third head from left, and there are minor losses throughout. The painting was last restored in 1985. There is a possible pentimento around the contour of the woman's head. The back of the panel has been twice stencilled *3038* and the number *5199* has been written in black ink(?).[8]

Before its acquisition by the Gallery, NG 1425 was variously called 'A Family Party', 'Le Goûter' and 'The Tasting', but on entry into the collection it was called 'Portrait Group'.[9] Although the possibility of a family portrait cannot be wholly excluded,[10] this last of these titles was rightly regarded as too presumptuous by Martin Davies, who called the painting 'A Woman and Five Children'.[11] Nor can it be more than a

speculative possibility that NG 1425 and other similar Le Nain paintings represent the theme of charitable assistance to the poor,[12] or more specifically, portraits of abandoned children being cared for in bourgeois homes.[13] Most recently it has been tentatively proposed that NG 1425 was painted as a pair, or as part of an unfinished series, with *The Village Piper* (The Detroit Institute of Arts; fig. 1), which is also on copper, of a similar size, and signed and dated 1642, the latter representing the sense of hearing, and NG 1425 by implication the sense of taste.[14] This attractive theory – attractive because it would bring the subject matter of both paintings back within the seventeenth-century mainstream – is not, however, helped by the fact that both the bowl and the glass in NG 1425 are empty, nor by the apparent disparity in the economic circumstances of the respective protagonists of the two paintings. It has frequently been commented upon in relation to NG 1425 (as well as to other Le Nain pictures) that the figures are shown with both individuality and dignity, but this does not necessarily mean that the painting is invested with particular meaning. These qualities may signify no more than that the Le Nain brothers (in the words of P.J. Mariette) 'painted

Bamboccianti in the French style'.[15] At all events, given the precision with which NG 1425 is painted, its intense colour and its copper support, it was evidently made as a luxury object.

The size of NG 1425, as well as its uniform style, precludes more than one hand. Although the particular Le Nain brother responsible for it cannot be identified, all commentators agree that it is by the same hand as other small Le Nain paintings on copper, such as *Le Bénédicité* (Pittsburgh, The Frick Art Museum), whom some identify as Antoine Le Nain.[16]

NG 1425 is signed and dated 1642, the same date as *The Village Piper* and a year prior to *The Little Card Players* (Williamstown, Sterling and Francine Clark Art Institute), attesting to a certain vogue for such scenes with children in these years. As has been noted,[17] a stoneware jug like that in NG 1425 appears in *Portraits in an Interior* (Paris, Louvre; fig. 2) which is signed and dated 1647. The jug is of lead-glazed earthenware, probably made locally in imitation of German stoneware made in this shape since the 1580s.[18] The glass held by the boy is Venetian style, possibly as early as the last quarter of the sixteenth century, but it could be contemporary

Fig. 1 *The Village Piper*, 1642. Oil on copper, 21.3 × 29.2 cm. The Detroit Institute of Arts. City of Detroit purchase.

with the painting and French 'à la façon de Venise' or a Venetian import.[19] A chair like that in NG 1425 appears frequently in Le Nain paintings. Although it has been supposed that the woman in NG 1425 is seated on a very low stool,[20] this would make the perspective and/or the disappearance of her legs more difficult to explain. She could be kneeling, but her attitude is not prayerful; she could have suffered restricted growth, but shows no other characteristics of dwarfism. Probably the perspective is wrong and the artist painted the tablecloth to mask the error.

General References

Witt 1910, p. 29; Fierens 1933, Antoine Le Nain, no. 4; Isarlo 1938, no. 217; Davies 1957, pp. 134–5; Wright 1985b, p. 118; Rosenberg 1993, no. 13.

Fig. 2 Detail from *Portraits in an Interior*, 1647. Oil on canvas, 27 × 37.5 cm. Paris, Musée du Louvre.

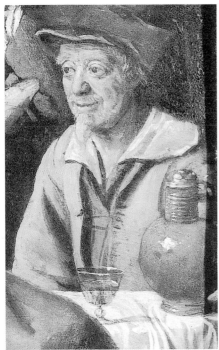

NOTES

1. '5 [Lenain (Louis)]. Une Femme accompagnée de quatre enfans, un jeune garçon assis devant elle tient une cruche de la main droite & de l'autre un verre de vin. Cette Composition du Nain est touchée avec esprit. Hauteur 8 pouces, largeur 10 pouces, 6 lignes. C.' See Rosenberg 1993, p. 23, and Lugt 6651. Remoissenet was a print dealer with premises on the quai Voltaire between 1801 and 1812: *Répertoire 1801–1810*, vol. 1, p. 21.

2. 'Le Nain, A Peasant's Family at their Repast, a Mother and Five Children: painted with Naïevete,and firmness of Pencil': letter of 26 February 1991 in the NG dossier from Burton B. Fredericksen. Pierre-Joseph Lafontaine (1758–1835) was a French dealer and painter: *The Index of Paintings Sold*, vol. 2, 1806–1810, part 2, *O–Z and Anonymous*, ed. B.B. Fredericksen, p. 1342, but his identification has also been proposed as probably Pierre-Maximilien Delafontaine (1774–1860) by Rosenberg (1993, p. 74).

3. 'Le Nain. A Family Party'. The copy of the catalogue in the Courtauld Institute of Art Library is annotated with the price and the name of the purchaser Seramo(?) Busso. Bryant was a vendor at the sale (see Lugt 26794) and NG 1425 was recorded in Bohn's catalogue as having belonged to Bryant (see note 4).

4. [Henry G. Bohn and Mrs F.K. Munton, his daughter]. *Catalogue of the Pictures, Miniatures and Art Books collected during the last fifty years by Henry George Bohn*, London, privately printed, 1884, p. 139, as Louis and Antoine Le Nain, 'A FAMILY PARTY, CONSISTING OF FOUR FEMALE CHILDREN ASSEMBLED ROUND AN OLD WOMAN, who is seated with a basin in her lap, and a jug and glass before her held by a youth, who is also seated. Carefully finished. / Panel – 11 in. by 13 in. Phillip's, May 13th, 1862, 131.13s./ This picture had belonged to Bryant, the picture dealer of St. James's Street, who valued it at 50 guineas.'

Incorporated into this book is a note on the Bohn sale of 19 March 1885 in which it is stated that 'it was thought desirable to analyse and compare a few of the Lots… with the original invoices or other memoranda in the family possession, showing not only the prices given by the deceased, but in most instances the source through which the pictures were obtained, and the artist's names as bought and as recently sold'. The Le Nain is stated to have been bought at Phillips in 1862 for £13 13s. and to have realised £52 10s. in 1885. For Henry George Bohn see *DNB*, vol. II, pp. 766–8.

5. Entitled 'Le Goûter' in the sale catalogue. The engraving shows the additions all round.

6. According to a letter from G.E. Ambrose to L. Lesser of 29 August 1894, the following numbers were stamped on the back of NG 1425: 674[D], 3638 and 5119.

7. As noted by Davies (1957, p. 135), the catalogue of the Bohn sale gives the dimensions as 11 × 13 ins.

8. See also note 6 above.

9. *Descriptive and Historical Catalogue of the Pictures in the National Gallery with Biographical Notices of the Painters. Foreign Schools*, London 1894, p. 257.

10. As J. Thuillier pointed out in Paris 1978–9, p. 149.

11. Davies 1946, p. 63, and Davies 1957, p. 134.

12. See on this Adhémar 1979, pp. 69–74.

13. Cuzin 1994, at pp. 486–7. Other interpretations of the Le Nain brothers' peasant scenes as a class are noted in the entry for NG 3879.

14. Letter of 30 August 1995 from Iva Lisikewycz to Jacques Thuillier (copy in NG dossier).

15. 'Ils peignaient des Bamboches dans le style français…', P-J. Mariette, *Abécédario*, ed. Ph. de Chennevières and A. de Montaiglon, 6 vols, Paris 1851–60, vol. 3, p. 136.

16. NG 1425 has been attributed to Antoine by, among others, P. Jamot, *Les le Nain*, Paris 1929, p. 31; W. Weisbach, *Französische Malerei des XVII. Jahrhunderts in Rahmen von Kultur und Gesellschaft*, Berlin 1932, pp. 98–9; P. Fierens, *Les Le Nain*, Paris 1933, pp. 20 and 59; V. Bloch, 'Louis Le Nain and his Brothers', *BM*, 75, 1939, pp. 50–9 at p. 53; A. Blunt, *Art and Architecture in France 1500–1700*, London 1953, p. 155; and Rosenberg 1993, p. 13. Others have attributed NG 1425 to the same hand as a group of pictures by one of the Le Nain whom some find convenient to call 'Antoine': see Witt 1910, p. 12; Davies 1946, p. 63, and Davies 1957, p. 134; J. Thuillier in Paris 1978–9; Cuzin 1994; and Mérot 1994, p. 174.

17. J. Thuillier in Paris 1978–9, p. 234, and Rosenberg 1993, p. 76.

18. I am grateful to Robin Hildyard and Reino Liefkes for this information.

19. I am grateful to Reino Liefkes for this information.

20. J. Thuillier in Paris 1978–9, p. 149.

NG 3879

Four Figures at a Table

*c.*1643
Oil on canvas, 44.8 × 55 cm

Provenance

Possibly Général du Taillis sale, Paris, Pérignon, 27 November 1815, lot 48;[1] in the possession of Percy Moore Turner (1877–1950) by 1922; bought from him (possibly some years previously) by Frank Hindley-Smith of Southport, Lancashire;[2] presented by Hindley-Smith in 1924, a commission to Turner being paid by the National Gallery out of the Lewis Fund.[3]

Exhibitions

Paris 1923, Galerie Louis Sambon, *Exposition Le Nain... au profit de l'Oeuvre de la Préservation contre la Tuberculose à Reims* (2); Paris 1978–9 (23); Copenhagen 1992 (5).

Related Works

PAINTINGS
(1) Nancy, Musée des Beaux-Arts (inv. no. 517), 51 × 63.5 cm. From the La Caze collection. A copy 'signed' at the left: *a Le nain.fecit.*[4] Signature now invisible.[5] Photograph in NG dossier;
(2) Whereabouts unknown. 17½ × 21½ in. Sold Sotheby's, 25 June 1958, lot 60 (£100 to Lacey). Formerly in the Cook Collection, Richmond.[6] A copy;
(3) Whereabouts unknown, 45.5 × 58.5 cm. Sold New York, Sotheby's, 3 June 1988, lot 16, as Circle of Louis Le Nain ($34,100). Formerly in the Bondy collection, Vienna, then with Leger, London, and then the Linsky collection. A copy. Photographs in NG dossier. Possibly the same painting as lot 224 of the Charles Sedelmeyer sale (Paris, 16–18 May 1907), although there measured as 49 × 58 cm;
(4) Helsinki, Finland, private collection, 57 × 68.5 cm. A poor copy of part of the composition excluding the figure, etc. to the left of the boy. Photograph in NG dossier;
(5) Whereabouts unknown. 50 × 61 cm. Sold Lyon, Chenu et Scrive, 29 April 1997 (lot 5, 291,000 francs). A good old variant copy attributed to Louis Le Nain, with a lidded saucepan and spoon at bottom right;
(6) A figure like that of the old woman is in *Peasants in a Landscape* (inv. no. 1931.210) in the Wadsworth Atheneum, Hartford, Connecticut (fig. 3).

Technical Notes

There are losses along the edges and along the bottom and in the area of the girl at the left, and some wear in the background. Otherwise the condition is good. The support is a medium to fine plain-weave canvas relined in 1978 when the painting was last cleaned. The upper layer of the ground is a warmish grey colour above a lower layer of orange-red.[7] There is a possible pentimento to the right contour of the girl at the left. The dossier contains a customs label removed from the back of the previous lining canvas, the stamp of which reads DOUANE D[illegible]...BATIGNO[LLES?], perhaps dating from the time of the painting's exhibition in Paris in 1923.

This work was described as a copy by Davies in 1957,[8] but following its restoration in 1978–9 it was universally acknowledged as autograph. An X-radiograph (fig. 1) made during that restoration revealed the more or less finished half-length portrait of a man underneath the picture surface.[9] This portrait was covered by a further ground layer closely resembling the upper grey ground layer beneath the portrait, which strongly suggests that the final composition was executed in the same studio as the portrait, a hypothesis reinforced by the similarity of results in the pigment analyses of paint used for the hair of the man in the portrait and that used in the black-brown passages of the final composition.

Since the craquelure patterns of the final composition and the underlying portrait are similar, the two compositions may well be close in date.[10] The costume worn by the unknown sitter in the portrait can be dated around 1625–30,[11] a period mainly before the Le Nain brothers are known to have worked in Paris – or within the jurisdiction of the corporation of St-Germain des Prés. This in turn suggests an earlier date for NG 3879 than that of the 1630s or later, as previously assumed. However, the underlying portrait may have been a repetition of an earlier portrait; it may even have been done as a speculative exercise, based on an earlier image, whether print or painting (and, if the latter, not necessarily one by the Le Nain), or it may have been a study for an image within an image as in the supposed *Portrait of the Le Nain Brothers* (private collection), which shows one of the sitters seated before a portrait on an easel.[12]

The assured handling of NG 3879 certainly suggests a mature work. Furthermore, the boy's costume with its large collar lying flat along his shoulder is of the 1640s.[13] The painting was dated *c.*1643 by Jamot,[14] which seems reasonable.

The question of which of the three Le Nain brothers executed NG 3879 is problematic. (The question is addressed in more general terms in their biography on p. 194.) Although they undoubtedly co-operated in the same studio, it is difficult to believe that a relatively small painting like NG 3879 would have been executed by more than one hand. It has generally been assigned to Louis,[15] both for reasons of style and because of its atmosphere of melancholy.[16] However, there is no single work that can be securely identified with Louis alone, and, although the attribution to him seems reinforced by the X-radiograph revealing a half-length portrait, a genre in which Louis is said to have excelled early in his career, the portrait, insofar as it can be judged, is of no special merit. The technical evidence (see Technical Notes) suggests that the now hidden portrait and the final composition were executed in the same studio, but it does not follow that they were by the same hand. The hand that executed NG 3879 is surely the same as that which executed, for example, *The Little Card Players* (Royal Collection; fig. 2), and although the latter has also been given most recently to Louis,[17] most prior attributions have been to Mathieu,[18] which underlines the difficulty of assigning Le Nain paintings to any single personality.[19]

The painting was formerly called *Saying Grace* or *Le Bénédicité*,[20] but the title was rejected by Davies, who rightly pointed out that it was unclear whether the little girl was indeed

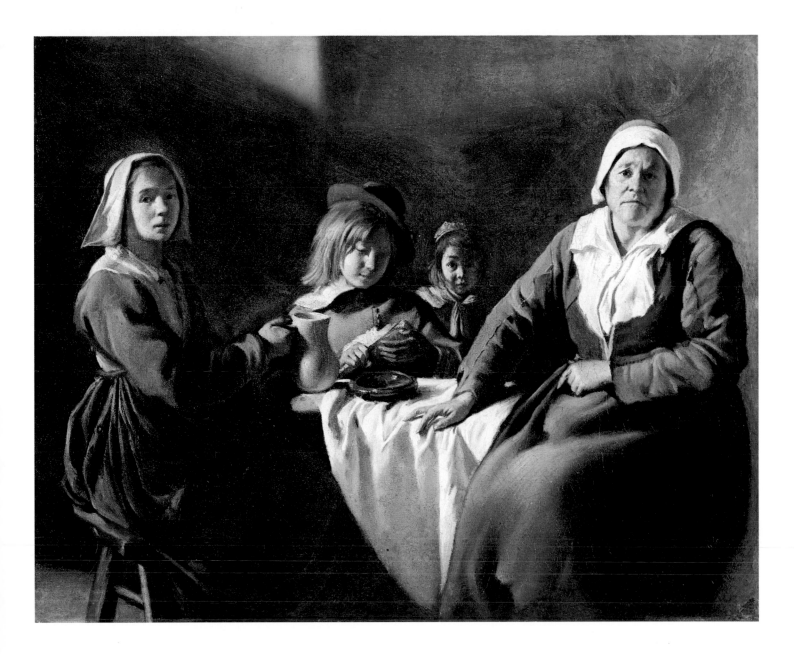

Fig. 1 X-radiograph of NG 3879 turned through 90 degrees.

praying.[21] More recently it has been suggested that the subject is The Three Ages, that is to say a comparison between the old woman, the young woman and the children with its implicit suggestion to the viewer to reflect on human destiny.[22] This would certainly accord with a typical theme of seventeenth-century painting, but it is doubtful whether the painting has the Three Ages as its specific subject. For one thing, only two generations may be represented: a mother with three children shown (from the left) in a diagonally receding order of seniority. Secondly, the look of the young woman is scarcely less apprehensive than that of her 'mother' so that there is insufficient differentiation between them to suggest changing attitudes to life. Thirdly, at least as telling a contrast as that between the ages is that between the sexes: male activity, albeit self-centred, as against female passivity.[23] The old woman in NG 3879, the grey colour of whose costume may have been intended to demonstrate her poverty,[24] appears also in the *Peasants in a Landscape* (Hartford, Wadsworth Atheneum; fig. 3), as does the young girl.[25]

The purpose of what may loosely be called the Le Nain 'peasant pictures' is unknown. Recent suggestions have been that they record the association of the possibly Protestant-influenced urban owners of the paintings with their tenant farmers;[26] that they are sympathetic studies of the stoic victims of Richelieu's tax demands;[27] that they functioned both as an upper-class denial of a riotous, turbulent peasantry and as images of the virtues of patience, endurance and humility attributed to the idealised poor;[28] and that they are, at least in some cases, portraits recording the charity of the painting's owner towards the figures portrayed in them.[29] Pending further research, these suggestions remain speculative.

General References

Fierens 1933, no. 17 (as Louis Le Nain); Isarlo 1938, no. 218; Davies 1957, p. 135; Paris 1978–9, no. 23; Wright 1985b, p. 118; Rosenberg 1993, no. 29.

Fig. 2 *The Little Card Players*, c.1635. Oil on canvas, 55 × 64 cm. Windsor, The Royal Collection.

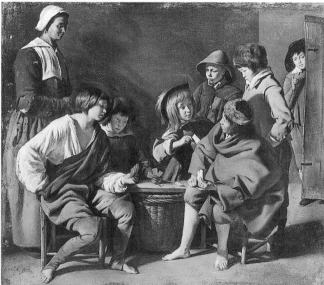

Fig. 3 *Peasants in a Landscape*, c.1640? Oil on canvas, 41.5 × 55 cm. Hartford, Conn., Wadsworth Atheneum, The Ella Gallup Sumner and Mary Catlin Sumner Collection Fund.

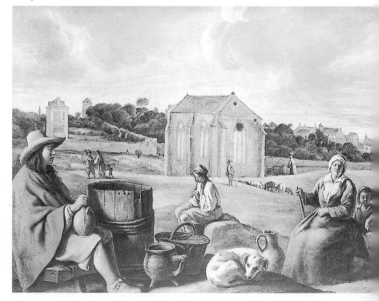

NOTES

1. There inscribed as 'Une femme de la campagne et ses trois enfants auprès d'une table où ils s'apprêtent à prendre leur repas; la plus jeune, les mains jointes semble dire son Bénédicité. Morceau frappant de vérité et d'un effet très piquant. L.20 po.; H.16 po. T.' The measurements are extremely close to those of NG 3879, but they may be those of one of the versions (see Related Works).

Also to be noted is lot 499 of the Abbé de Gevigney Sale, Paris, 1–29 December 1779, described as '[Louis Le Nain]. Une Vieille Femme assise sur un banc, et près d'elle deux Enfants occupés l'un à couper du pain, l'autre à dire son Bénédicité. Ce Tableau, dont les figures sont vues à mi-corps, est peint sur toile. H.20 po. et demi, l.24.' The metric equivalent is 55 × 64.8 cm. The discrepancy in measurements of the painting seems too great for NG 3879 to be certainly identified with it – quite apart from the description not entirely corresponding. A painting called 'Le Bénédicité, tableau du Nain' was in an anonymous sale [Poismenu and others], Nagus, Paris, 2 June 1779, lot 89.

2. Hindley-Smith was a benefactor of the Ashmolean Museum, Oxford. He mostly collected French nineteenth- and early twentieth-century pictures. I am grateful to Nicholas Penny for this information.

3. Smith wrote to the Gallery on 17 March 1924: 'I bought it [i.e. NG 3879] some ten years ago for £600 and believe it worth now £1000.' (Letter in NG dossier.)

4. *Musée de Nancy. Tableaux, dessins, statues & objets d'art. Catalogue descriptif et annoté*, Nancy 1909, no. 476.

5. Rosenberg 1993, p. 78.

6. See *Doughty House Catalogue*, vol. III, London 1915, p. 54, no. 435 and pl. 435, where attributed to Mathieu Le Nain, and Burlington Fine Arts Club, *Pictures by the Brothers Le Nain*, 1910 (illustrated catalogue, p. 31 and pl. II).

7. See Plesters 1978–9, pp. 314–17.

8. Davies 1957, p. 135.

9. Wilson 1978, p. 530–3; and Plesters 1978–9, pp. 314–17. As Wilson (op. cit., p. 530, n. 7) noted, all parts of the portrait save the hair seem to have been painted thickly in pale colours containing a high proportion of lead white, whereas the final composition is, except for the few white garments and the tablecloth, fairly thinly painted in colours containing little or no lead white – hence the portrait is clearly seen in the X-radiograph and the final composition hardly at all.

10. Plesters 1978–9, pp. 314–17.

11. Cuzin 1994, at p. 481.

12. The suggestion was made in Paris 1978–9, p. 162, that the portrait was a study that was kept in the studio as a model for repetition or adaptation.

13. Dated works by the Le Nain brothers are not a great help in this respect. The collars worn by the men in *La réunion musicale* (Rosenberg 1993, no. 11), which is dated 1642, have points falling onto the chest, whereas that worn by the man at the left of *Portraits d'un intérieur* (Rosenberg 1993, no. 20), dated 1647, although flatter and lying along the shoulder as in NG 3879, is cut square at the neck. The boy's collar in NG 3879 is like that of the boy with long hair at the centre of *The Little Card Players*, but neither version of this composition is dated (Rosenberg 1993, nos 21 and 22). Some of the figures in *The Academy* (Rosenberg 1993, no. 44) wear collars quite close in cut to the boy's in NG 3879. Although *The Academy* is not dated, the abundant use of lace in some of the sitters' costumes suggests that it was painted before Mazarin's edict of 1644 prohibiting the use of that material. (On Mazarin's edict, see J.R. Planché, *A Cyclopaedia of Costume or Dictionary of Dress*, 2 vols, London 1876–9, vol. 2 (1879), p. 254.)

14. P. Jamot, *Les Le Nain*, Paris 1929, p. 63, and 'Essai de Chronologie des Oeuvres des Frères Le Nain', *GBA*, 7, 1923, pp. 157–66 at p. 161.

15. See the bibliography to Paris 1978–9, no. 23, and also Anthony Blunt, 'The Le Nain Exhibition at the Grand Palais, Paris: Le Nain Problems', *BM*, 120, 1978, p. 873.

16. Rosenberg 1993, no. 29.

17. Rosenberg 1993, no. 22.

18. See the bibliography to Paris 1978–9, no. 17.

19. Similar caution has recently been expressed by Jean-Pierre Cuzin (Cuzin 1994, at pp. 488, 490). Cuzin earlier stated the difficulties of distinguishing between the hands of Antoine and Louis, at the same time giving to the same hand as NG 3879 a group of paintings including *The Little Card Players* in the Royal Collection: see 'Les frerès Le Nain: la part de Mathieu', *Paragone*, nos 349–51, 1979, pp. 58–70 at p. 70, n. 14.

20. *National Gallery Catalogue 1929*, p. 189. The copy in the Cook Collection was there called *Grace before Meat*. And see Paul Jamot, 'Sur quelques oeuvres de Louis et de Mathieu Le Nain. A propos d'une exposition', *GBA*, 7, 1923 (I), pp. 31–40 at p. 32, and (*idem*), *Les Le Nain*, Paris 1929, pp. 37–8, 47–9 and 62–3 where NG 3879 was proposed as an autograph work of Louis Le Nain.

21. Davies 1946, p. 63, and Davies 1957, p. 135.

22. J. Thuillier in Paris 1978–9, p. 162. Rosenberg has described the title *The Three Ages* as partially justified: Rosenberg 1993, p. 79.

23. These arguments against calling NG 3879 *The Three Ages* were advanced by me in Copenhagen 1992, p. 100.

24. Judith Akenhurst, cited in note 27, p. 95, notes the association between grey clothing and the perception of poverty in seventeenth-century France.

25. For the Hartford painting, see Paris 1978–9, no. 32; Paris, New York, Chicago 1982, no. 48, and Rosenberg 1993, no. 33.

26. Neil MacGregor, 'The Le Nain Brothers and changes in French Rural Life', *Art History*, 2, 1979, pp. 401–12.

27. Judith Akenhurst, *The Haven of Innocence and the Deserving Poor: Social Attitudes and Literary Convention in Paintings by the Le Nain brothers*, PhD thesis, University of Minnesota, 1987.

28. Martha Kellogg Smith, *Les nus-pieds et la pauvreté d'esprit: French Counter Reformation Thought and the Peasant Paintings of the Le Nain Brothers*, PhD thesis, University of Washington, 1989.

29. Cuzin 1994, broadly following Adhémar 1979, pp. 69–74.

NG 4857
Three Men and a Boy

*c.*1647–8
Oil on canvas, 54.1 × 64.5 cm

Provenance
In the collection of John Walter (1776–1847) of Bearwood, Wokingham, Berkshire, by 1846, where noted in the drawing room;[1] A.F. Walter, deceased of Bearwood, his sale, London, Christie, Manson & Woods, 20 June 1913 (lot 126 as by A.L. and M. Le Nain, £525 to Agnew's);[2] sold by Agnew's to Norman Clark Neill, 5 February 1918 (£750);[3] presented by Mrs Norman Clark Neill of the Isle of Wight(?)[4] in memory of her husband, 1936.

Exhibition
Paris 1978–9 (46).

Technical Notes
Evidently unfinished. The figure at the extreme right is badly worn. It is part of an earlier composition, since the outline of the third man from the left is painted over it. The canvas is a moderately coarse plain weave that was last relined in 1968 when the picture was last cleaned and restored. The lower ground is orange-red and contains ochre, calcium carbonate and red lead. The mid-grey upper ground, consisting of a mix of charcoal black and white, is left uncovered in the unfinished parts of the three central figures.

Analysis of the pigments in the costume of the boy at the right shows no materials inconsistent with a seventeenth-century date for this part of the composition, the yellow being a lead-tin yellow then widely used. Comparison of the red parts of the drapery near the boy's chest with an area of similar colour lower down and slightly to the left suggested that these fragments were once part of the same drapery. For the results of the X-radiograph, see below.

When first acquired, NG 4857 was attributed to a 'Lenain pasticheur (Flemish School? ca. 1700 or later)',[5] and a similar attribution, to 'Follower of The Brothers Lenain(?)', was retained when Martin Davies published his 1957 catalogue.[6] Indeed, when the gift was accepted by the Gallery trustees, the minutes record that one of them thought the picture 'would be admirable as a furniture piece for lending to Government Offices...[and] it was agreed that the picture be accepted, provided the Donatrix understood that it could not be put on regular exhibition.'[7] However, when the painting was cleaned in 1968, large areas of later, poor quality over-painting were removed (as can be seen from the state of the painting prior to its restoration (fig. 1)). The picture was shortly thereafter published as autograph by Thuillier,[8] and exhibited as such in the 1978–9 Le Nain exhibition in Paris.[9] Although, in a review of that exhibition, Blunt rejected the attribution to the brothers Le Nain,[10] NG 4857 was accepted as autograph by Cuzin[11] and this is now universally agreed. As Wilson pointed out, referring to the boy at the right of the painting and the drapery underneath, both of which were revealed by cleaning, 'the informal juxtaposition of the studies – which do not appear to be related – and their unfinished state hardly favour the view that this is the work of a pasticheur'.[12] The attribution is reinforced by the results of the X-ray photograph (fig. 2) showing that NG 4857 was painted over what appears to be part of a bust-length portrait of a woman.[13] NG 3879 is another example of the Le Nain brothers painting a composition over a portrait turned through 90 degrees.

Both Wilson and Thuillier have hypothesised that the principal figures in NG 4857 may represent a portrait of Antoine, Louis and Mathieu Le Nain.[14] Thuillier noted the similar shapes of the three figures' noses and chins, and Wilson proposed that 'the picture represents the three artists and was painted in two stages, the two outer figures at one sitting and the central figure, a self-portrait, later.'[15] More recently, Rosenberg has repeated the hypothesis with approval, calling NG 4857 'Portrait présumé de Mathieu, Louis et Antoine Le Nain',[16] although he was more cautious than Wilson and Thuillier in drawing comparisons between the sitters here and some of the figures (who are assumed to be the Le Nain brothers) in *The Painter's Studio* (private collection), datable to *c.*1645 (fig. 3).[17] From the costume, NG 4857 is of the late 1640s or early 1650s, when broad collars of the kind worn by the sitters were fashionable.[18] If the picture is a portrait from the life of the Le Nain brothers it cannot be later than 1648, when Louis and Antoine died. Indeed, their deaths might well explain the picture's unfinished state. Assuming the painting to have been started in, say, 1647, the youngest of the three brothers, Mathieu, was then aged 40 (if his age of 70 at his death in 1677 was given correctly).[19] However, two of the three men in NG 4857 look distinctly younger than that, and younger than the figures usually identified as the three artists in *The Painter's Studio*. These factors weaken the theory that NG 4857 shows the Le Nain brothers, and the admitted family resemblance between the figures may be as much to do with the portraitist's own habits of depiction as with any actual resemblance.

Although the authorship of NG 4857 has been given to Louis Le Nain by Rosenberg,[20] it seems more prudent, following Cuzin, to assign it to a group of paintings (which includes NG 3879 and NG 6331) all apparently by the same brother, who, for convenience, can be called 'Louis'.[21] Rosenberg has proposed, as had Thuillier,[22] a resemblance between the figure at the right of NG 4857 and that at the right of *The Musicians* (Dulwich College Picture Gallery), a picture which Rosenberg has attributed to Mathieu.[23] However, given the unfinished state of NG 4857, it is unsafe to conclude that the two figures represent the same individual.

General References
Isarlo 1938, fig.152 (as rejected); Davies 1957, pp.135–6; Rosenberg 1993, no. 25.

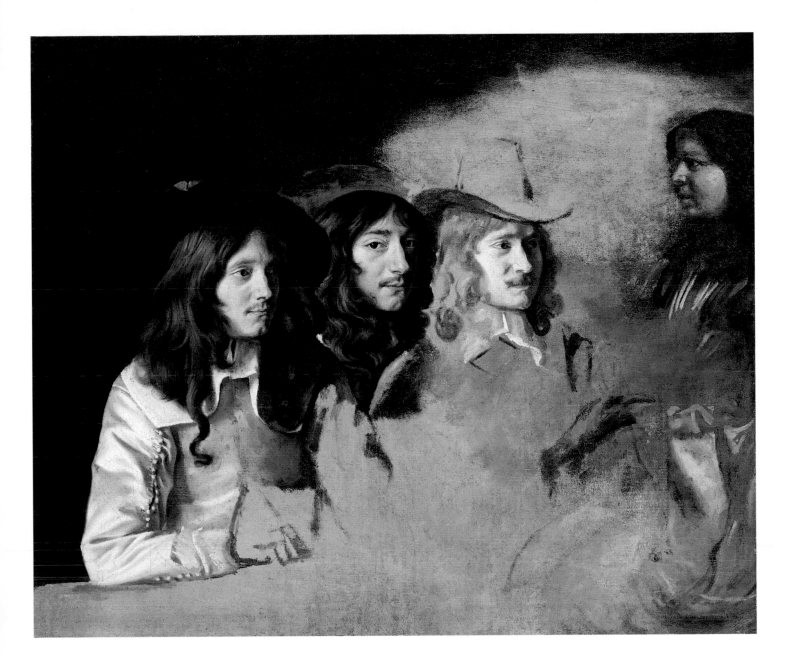

Fig. 1 NG 4857 before restoration.

Fig. 2 X-radiograph of NG 4857 turned through 90 degrees anticlockwise.

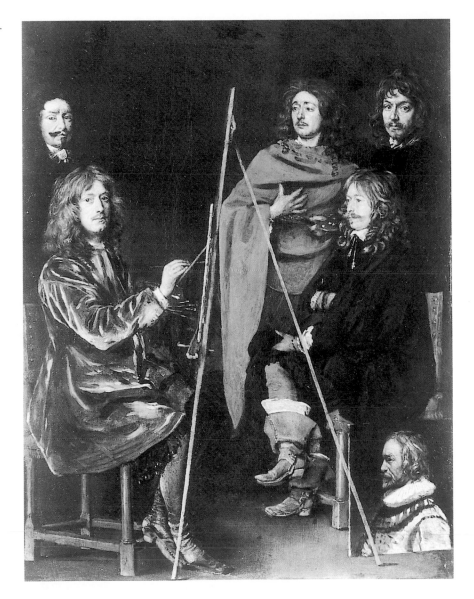

Fig. 3 *The Painter's Studio*, *c*.1645. Oil on panel. 42 × 31 cm. Great Britain, private collection.

NOTES

1. 'Visits to Private Galleries no. XII. The Collection of John Walter, Esq. of Bearwood, Berks', *The Art Union*, London, 1 June 1846, pp. 165–6, where described as 'LE NAIN. "Three half-length Figures looking at a Globe"'. John Walter was proprietor of *The Times* and second son of the newspaper's founder, John Walter (1739–1812). NG 4857 was not recorded by Waagen (1857, pp. 293–8) but it is clear that there had been some rearrangement of the Bearwood pictures since 1846. Bearwood was rebuilt in 1865–70 (Pevsner, *Berkshire*, 1966, pp. 79–84). NG 4857 was not among the presumably further rearranged paintings noted in *A Handbook for Travellers in Berkshire, Buckinghamshire, and Oxfordshire* (2nd edn, revised), London 1872, pp. 33–4.

2. Arthur Fraser Walter (1846–1910) was a grandson of the John Walter in whose collection NG 4857 was noted in 1846.

3. Letter of 3 December 1991 from Gabriel Naughton.

4. The Isle of Wight location is suggested by a shipper's label dated 29 September 1936

removed from the old lining canvas and now in the Conservation Dossier.

5. *National Gallery and Tate Gallery Directors' Reports 1936*, London 1937, p. 4.

6. Davies 1957, pp. 135-6.

7. NG Board Minutes, 6 October 1936.

8. Jacques Thuillier, 'Trois tableaux des frerès Le Nain acquis par les musées de France', *La Revue du Louvre et des Musées de France*, 24e année, 1974, no. 3, pp. 157–74 at pp. 170–1.

9. Paris 1978–9, no. 46.

10. A. Blunt, 'The Le Nain Exhibition at the Grand Palais, Paris: Le Nain Problems', *BM*, 120, 1978, pp. 870–5 at p. 873, ('[it] seems to me Flemish rather than French and certainly not at all close to the style of the Le Nains').

11. J.-P. Cuzin, 'Les frerès Le Nain: la part de Mathieu', *Paragone*, anno XXX, nos 349–351, May 1979, at p. 70, n. 14.

12. Michael Wilson, 'Two Le Nain Paintings in the National Gallery Re-appraised', *BM*, 120, 1978, pp. 530–3 at p. 533.

13. The X-radiograph was first published by Michael Wilson, op. cit., p. 533 and p. 532, fig. 44.

14. Wilson, op. cit. p. 533, and Thuillier in Paris 1978–9, p. 248.

15. Wilson, op. cit.

16. P. Rosenberg, *Tout l'oeuvre peint des Le Nain*, Paris 1993, p. 77.

17. For this dating, see Paris 1978–9, p. 232.

18. Conversation on 24 March 1997 with Aileen Ribeiro.

19. P. Rosenberg, cited in note 16, pp. 70, 72.

20. P. Rosenberg, cited in note 16, p. 77.

21. J.-P. Cuzin, cited in note 11, at n. 10.

22. Paris 1978–9, p. 248, where Thuillier also proposed a resemblance between the figure at the right of NG 4857 and that at the right of *Les Tricheurs* (Reims, Musée Saint Denis), which is probably not by any of the Le Nain.

23. P. Rosenberg, cited in note 16, p. 91.

NG 6331
Adoration of the Shepherds

*c.*1640
Oil on canvas, 109.2 × 138.7 cm

Provenance
Possibly Robert Strange sale, Christie's, 7 February 1771, as Le Nain (lot 21, £42 to Walters);[1] possibly sale of George Robert Fitzgerald and others, Christie's, 20 March 1773, as Le Naine (sic), (lot 85, £15 4s. 6d. to C Bruy(?));[2] in the collection of George Spencer (1739–1817), 4th Duke of Marlborough, at Blenheim Palace, near Woodstock, by 1777, as by Luca Giordano;[3] George Charles Spencer-Churchill (1844–92), 8th Duke of Marlborough, sale, Christie, Manson & Woods, 7 August 1886 (lot 652, £52 10s. to Davis as by Luca Giordano);[4] acquired by Henry Fitzalan-Howard (1847–1917), 15th Duke of Norfolk; recorded (as by Giordano) as hanging in 'the Prince's Bedroom' at Arundel Castle, East Sussex, in 1902;[5] bought from Bernard Marmaduke Fitzalan-Howard (1908–75), 16th Duke of Norfolk, through Oscar Johnson, then of Leggatt Bros, in 1962 as by Le Nain.

Exhibitions
Paris 1978–9 (9); Copenhagen 1992 (6).

Related Work
See p. 210, fig. 5, for a painting of the same subject with some compositional similarities in the National Gallery of Ireland, Dublin.

Technical Notes
In good condition apart from some minor losses. There is some wear in the area of Saint Joseph's hair and patches of grey ground can be seen near to the ox and to the Christ Child. There is an upper ground of grey over a lower red ground. The ground contains some unidentified gritty material. The support is a moderately fine plain-weave canvas, last relined soon after the picture's acquisition in 1962, when it was also cleaned and restored. The painting had previously been lined, cleaned and repaired by W. Dyer & Sons of 7 Mount Street, London W1, in 1904 (or possibly 1907).[6] Clearly visible is a major pentimento above the wings of the angel in green (fig. 1). From this it would seem that in an earlier composition the Virgin (?) was kneeling with her head inclined towards the lower right of the composition. The donkey may also once have been lower in the composition, as evidenced by the visible trace of a rein some 7 cm below its position in the finished painting. There is a pentimento at the tip of the right-hand wing of the angel in green, and others to the outline of the kneeling shepherd, for example at his left heel.

Fig. 1 Detail of angel showing pentimento.

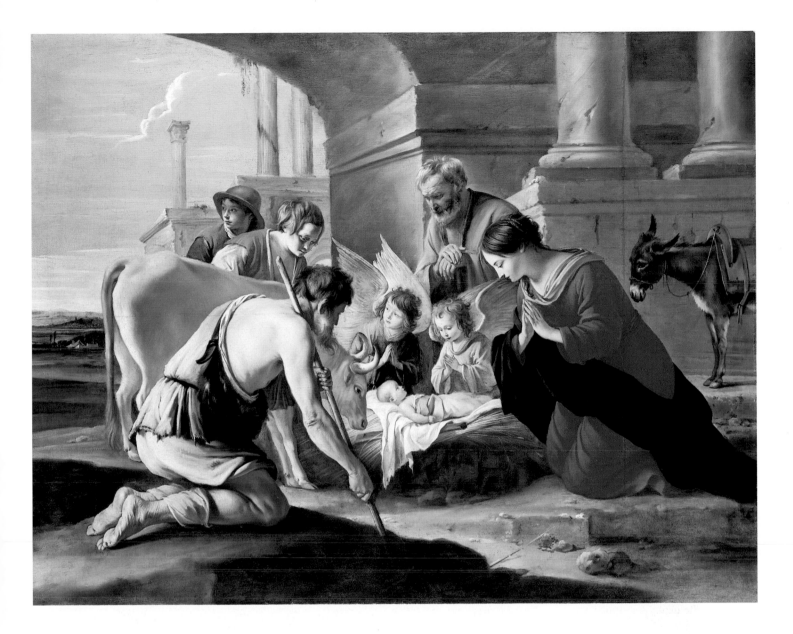

The subject of NG 6331 is taken from Luke 2: 8–20. The inclusion of the ox and the ass derives from the Gospel of Pseudo-Matthew (ch. XIV) which was purportedly based on the vision of Isaiah and Habakkuk, and had a longer tradition in the visual arts than that of the adoration of the shepherds.[7] Unusually, one of the angels and one of the shepherds are shown looking away from the Christ Child as if at some occurrence outside our field of view. It has been suggested that this may be the arrival of the Magi,[8] although that story is related in the Gospel of Saint Matthew, not that of Saint Luke; the apprehensive expressions of the shepherd and angel also belie this. Another possibility is that NG 6331 once had a pendant towards which these two figures were 'looking'.[9]

NG 6331 was once attributed to Luca Giordano (see Provenance),[10] but it is certainly by one of the Le Nain brothers. It may be by the same Le Nain who painted, for example, *The Pilgrims of Emmaus* (Paris, Louvre) and *Bacchus and Ariadne* (Orléans, Musée des Beaux-Arts), as has been suggested by both Cuzin and Rosenberg, who identify the hand as that of Mathieu[11] on the assumption that those two paintings are by the same hand as *The Painter's Studio* (Poughkeepsie, NY, Vassar College; fig. 2). On the basis of costume this last painting has been dated to after 1648 and so after the deaths of both Louis and Antoine.[12] The precise authorship of NG 6331 cannot, however, be confirmed without additional evidence.[13]

NG 6331 has been dated 1635–40 by Thuillier[14] and to the 1630s by Rosenberg, who also pointed out certain stylistic affinities between it and the paintings of La Hyre.[15] Indeed, the architectural elements and *mise-en-scène* of the National Gallery's painting recall in reverse La Hyre's *Mercury confiding the Infant Bacchus to the Nymphs* (St Petersburg, Hermitage Museum; fig. 3), signed and dated 1638.[16] This seems to be the likely earliest date for NG 6331, which, however, with its strong geometrical emphasis, has compositional affinities to the *Peasant Family* (Petworth House, National Trust) which is probably by the same hand and apparently dated 1642.[17]

Fig. 2 *The Painter's Studio*, after 1648. Oil on canvas, 73 × 89.8 cm. Poughkeepsie, New York, Vassar College. Purchase, Matthew Vassar Fund.

Fig. 3 Laurent de La Hyre, *Mercury confiding Bacchus to the Nymphs*, 1638. Oil on canvas, 125 × 153 cm. St Petersburg, Hermitage Museum.

Fig. 4 *The Milkmaid's Family*, 1641? Oil on canvas, 51 × 59 cm. St Petersburg, Hermitage Museum.

Fig. 5 Attributed to Le Nain, *Adoration of the Shepherds*, 1644? Oil on canvas, 59 × 67 cm. Dublin, National Gallery of Ireland.

A date for NG 6331 of *c*.1640 is therefore proposed. Such a date would also fit well with the date of 1641 suggested[18] for *The Milkmaid's Family* (St Petersburg, Hermitage Museum; fig. 4), in which the ass is very close to that in NG 6331,[19] albeit on a smaller scale. A painting in Dublin (fig. 5) inscribed and dated 'Lenain. F 1644' also has evident similarities to NG 6331. However, its attribution to the Le Nain has been rightly doubted on the grounds of its quality.[20]

General References
Wright 1985b, p. 119; Rosenberg 1993, no. 50.

1. '21. The Adoration of the Shepherds. It is but seldom we meet with historical compositions of this master [Le Nain]. The general appearance, however, of this picture is striking and abundantly demonstrates that knowledge of the union of colours and careful imitation of nature, which are peculiar to the Dutch School. The two figures towards the extremities of the picture are painted with great freedom. 41 × 53 in. [111 × 143.4 cm].' This sale and the next have been noted by P. Rosenberg in Rosenberg 1993, p. 110. The prices and purchasers in both cases are those annotated in copies of the catalogue in Christie's archive.

The title page to the 1771 Strange sale refers to all the paintings in it as 'collected during a Journey of several Years in ITALY and FRANCE'. It is, therefore, perhaps worth noting lot 92 of an anonymous sale at the hôtel des Americains, Paris, on 21 March 1763, sold for 72 livres: 'Un tableau représentant l'Adoration des bergers, peint par Le Nain, très beau tableau de ce maître, tant pour la composition que pour l'accord qui y règne, sur toile, moyen tableau dans sa bordure dorée': see Marie-Thérèse de Roodenbeke, 'Précisions nouvelles sur les oeuvres des Le Nain', *BSHAF*, Année 1979 (1981), pp. 101–10, at p. 103.

2. '85. The Adoration of the Shepherds'. The annotation of the buyer's name in Christie's copy of the catalogue is faint.

3. *The New Oxford Guide: or, Companion through the University... by a Gentleman of Oxford*, 6th edn corrected and enlarged, Oxford n.d. (1777?), p. 104: 'Drawing Room to the Right of the Salon... On the pannel near the window, next the/Salon, is,/The Adoration of the Shepherds, by Luca Giordano.' There is no reference to the painting in previous editions, nor in, for example, *The Beauties of England Displayed*, London 1762 (1770 reprint), pp. 212ff. The painting was recorded in the Green Drawing Room at Blenheim in [William Mavor], *New Description of Blenheim*, 6th edn, Oxford 1803, p. 41, where the room is described as 'hung with tapestry, representing, in vivid colours, some of the military exploits of John Duke of Marlborough'. Most of the paintings in Mavor's description hung in the same room as that in which the Giordano hung, according to *The New Oxford Guide*, so the rooms were presumably one and the same. The Giordano was also recorded in the Green Drawing Room by J.N. Brewer, *The Beauties of England and Wales*, vol. XII, part II, London 1813, p. 406; *The Oxford University and City Guide... to which is added, A Guide to Blenheim and Nuneham*, Oxford 1831, p. 200; and W. Hazlitt, *Criticisms on Art*, London 1843, p. lxxxi. It was recorded in the Bow-Window Room, over the door leading into the State Bedroom by George Scharf in his *Catalogue Raisonné; or a List of the Pictures in Blenheim Palace; with Occasional Remarks and Illustrative Notes*, London 1862, p. 134, where described as: 'LUCA GIORDANO. – The Nativity and Adoration of the Shepherds. The Virgin and two angels kneel in adoration before the Infant Saviour. The ox looks reverently towards the new-born child (in early paintings it is always represented kneeling). The ass also is introduced in the right hand corner. /The style of the composition shows that Luca Giordano had been much influenced by earlier representations of the subject.' If NG 6331 was the painting attributed to Giordano at Blenheim, my suggestion in Copenhagen 1992, p. 102, that it may have been lot 54 of the duc de Chartres sale of 28/29 November 1834 is wrong.

4. The catalogue description follows that of Scharf (see note 3 above) save with additions of the measurements, 43 × 56 in (109.2 × 142.2 cm). Davis was presumably the dealer Charles Davis, of 147 New Bond Street, London, who acted for the 15th Duke of Norfolk on picture purchases: letter of 7 January 1992 from John Martin Robinson. As John Martin Robinson has kindly informed me (letter of 30 April 1997), Charles Davis's accounts for 1886 do not survive. It is not therefore possible to determine whether he was bidding on his own behalf or on behalf of the Duke of Norfolk at the Marlborough sale. The date of the Marlborough sale is wrongly given as 1866 in O. Ferrari and G. Scavizzi, *Luca Giordano. L'opera completa*, 2 vols, Naples 1992, vol. 1, p. 389.

5. Arundel Castle Archive, IN 28. *Copy list of pictures at Arundel Castle; made by Chas. Davis 1902*: '335, Adoration of Infant Jesus Divine Infant laid in cradle Blessed Virgin at foot to right Shepherd cow & two figures to left two angels kneeling beside Cradle St. Joseph with hands on Staff behind them Ass standing to right / 432 × 562 / on frame L Giordano.' The painting also appears in an undated inventory of c.1900: Arundel Castle Archive, IN 36, *Inventory of Pictures at Arundel Castle*, p. 7, and in a further undated inventory of c.1900: Arundel Castle Archive IN 38, *Inventory and Valuation for Fire Insurance Purposes of the Pictures, Furniture, Silver, etc. at Arundel Castle* [made by W.E. Hurcomb, Auctioneer and Valuer, 170/3 Piccadilly, W.1]. I am grateful to John Martin Robinson and Anne Thackray for these further references.

6. According to a printed label and an inscription on the back of the stretcher, and to a bill from W. Dyer in the Arundel Castle Archive, MD 1679, dated 'Xmas 1904' but which also has the date 1907 on it.

7. See Gertrud Schiller, *Iconography of Christian Art* (trans. J. Seligman), 2 vols, London 1971, vol. 1, pp. 59ff.

8. *NGCIC*, p. 372. The suggestion made by me that this shepherd may represent a non-believer (Copenhagen 1992, p. 105) no longer seems tenable. Although there is no biblical justification for the adoration of the shepherds and Magi to be shown contemporaneously, they sometimes were (Louis Réau, *Iconographie de l'art chrétien*, 3 vols, Paris 1955–9, vol. 2, part 2, p. 234).

9. It is perhaps worth noting that the Le Nains' *The Carrying of the Cross* (whereabouts unknown; Rosenberg 1993, no. 83) has approximately similar dimensions to NG 6331. It could fit quite well as a pendant iconographically, but less easily compositionally.

10. The misattribution may have been made in an attempt to inflate the picture's value. *The Little Card Players* (London, Buckingham Palace), which was sold in London in the Walsh Porter sale of 1803 as by Caravaggio for £388 10s. (while a picture attributed to Le Nain in the same sale fetched £15 15s.), could be a parallel case – perhaps with more justification since Christie's, who conducted the sale, at least believed Le Nain to be 'a pupil of Mic. Angelo Caravagio, whose manner he imbibed' (Earl of Bessborough deceased sale, Christie's, 7 February 1801, lot 59). A more appropriate misattribution would have been to Orazio Gentileschi. For the latter's influence on the Le Nain, see R. Ward Bissell, *Orazio Gentileschi and the Poetic Tradition in Caravaggesque Painting*, Philadelphia and London 1981, pp. 76–7.

11. J-P. Cuzin, 'Les freres Le Nain: la part de Mathieu', *Paragone*, XXX, nos 349–51, May 1979, pp. 58–70; idem, 'Meaux. French painting', *BM*, 131, 1989, pp. 587–8 at p. 588; Pierre Rosenberg, 'L'exposition Le Nain: une proposition', *Revue de l'Art*, no. 43, 1979, pp. 91–100, and Rosenberg 1993, pp. 85ff.

12. J-P. Cuzin, 'A Hypothesis concerning the Le Nain Brothers', *BM*, 120, 1978, pp. 875–6.

13. The picture frame shown in the Vassar College painting is of a bolection type and may well be of the seventeenth century, as Michael Gregory has kindly confirmed in conversation. The bust at lower left looks curiously early nineteenth century, but, as Nicholas Penny has pointed out, such quasi-antique heads may have existed in the seventeenth century. It is unusual to see paintings of the seventeenth century showing painters working on a picture in its frame.

14. Paris 1978–9, p. 118.

15. Rosenberg 1993, p. 86, where the author refers to 'La troisième décennie', but presumably means the fourth decade, i.e. the 1630s.

16. Pierre Rosenberg and Jacques Thuillier, *Laurent de La Hyre 1606–1656*, exh. cat., Grenoble, Rennes, Bordeaux 1989–90, no. 151.

17. For the attribution and dating of the Petworth picture, see Rosenberg 1993, no. 64.

18. Paris 1978–9, p. 200; Rosenberg 1993, no. 63.

19. As was pointed out by Jacques Thuillier in Paris 1978–9, p. 200.

20. As acknowledged by Pierre Rosenberg (Rosenberg 1993, no. 68), who, however, proposes it as an autograph work by Mathieu.

Eustache Le Sueur
1616–1655

Brought up in an artisanal environment in the parish of St Eustache, Paris, Le Sueur entered the busy and prestigious studio of Simon Vouet probably around 1631. There he became one of Vouet's principal assistants in the execution of numerous decorative schemes in religious and secular buildings. He so thoroughly absorbed Vouet's style that some of his earlier works are sometimes confused with the later works of his master. Le Sueur never went to Rome, but studied prints after Raphael, whose influence on his compositions would become increasingly clear.

Le Sueur painted a few portraits, including the *Réunion d'Amis* (Paris, Louvre), around 1640–1 shortly before his independent career was fully established. His reputation was made – both in his lifetime and thereafter – by the series of paintings on the life of Saint Bruno, executed in the years 1645–8 for the Paris Carthusians. Le Sueur's style here is quite distinct from that of Vouet, and eighteenth-century writers often cited the Saint Bruno series when likening Le Sueur to Raphael. At this period Le Sueur was also undertaking decorations at various private houses in Paris. The best known are those executed at the hôtel Lambert around 1644–7 and 1652–5, which combine a harmonious composition with graceful elegance.

In 1648 he became one of the founder members of the Académie Royale de Peinture et de Sculpture, and the following year he completed the prestigious commission of the 'May' for the cathedral of Notre-Dame, for which NG 6299 is a sketch. Whereas the hôtel Lambert decorations combine charm with sensuous colour, some of Le Sueur's later works, such as *Solomon and the Queen of Sheba* (Birmingham, The Barber Institute of Fine Arts), are severe in composition, colour and in the style of the figures. During his final years he painted political allegories for the French crown at the Louvre, but few of them survive.

Le Sueur's posthumous reputation was at its height in the late eighteenth century, when he was often referred to with the same awe as Raphael and Poussin.

NG 6299
Saint Paul preaching at Ephesus

1649
Oil on canvas, 100.8 × 84.8 cm

Provenance
Acquired by Le Normand, chief clerk to the Great Council, at some date prior to October 1684 and in his collection until 1699 or later;[1] possibly sold by the dealer Lebrun at Christie's, 19 March 1774 (lot 17, £8 8s. to Lord Townshend);[2] possibly in Lebrun's sale at Christie's, 18 March 1785 (lot 48, bought in(?) at £12 12s.);[3] possibly the picture bought by Edward Knight (1734–1812) for £9 9s. on 12 March 1790 as 'Magicians burning their books at Athens – after Le Sueur';[4] possibly sale of Edward Hussey-Montague, Earl Beaulieu (d.1802), of Dover Street, London, and Beaulieu, near Southampton, at London, James Denew, 29 April 1808 (lot 28, £16 5s. 6d.);[5] possibly in the sale of John Willett Willett (1744/5–1815?), London, Peter Coxe & Co., 31 May–2 June 1813 (lot 19, £28 7s. to Carpenter, Bond Street);[6] possibly the sale of John Bartie deceased of Newman Street, London, Foster & Sons, 20–21 June 1838 (lot 99, £20);[7] in the collection of Hender Delves Molesworth (1907–78) in 1957;[8] bought from P. & D. Colnaghi for £2000 in 1959.

Exhibitions
Manchester 1957, City Art Gallery, *Art Treasures Centenary. European Old Masters* (184); Copenhagen 1992 (7); Grenoble 2000 (26).

Related Works
PAINTINGS
(1) Algiers, Musée National des Beaux-Arts, inv. 2370 (fig. 2), oil on canvas, 102 × 81 cm (Mérot 2000, no. 84). This painting was in the posthumous sale of Louis Girou de Buzareingues (Paris, Chevallier, 26 February 1892, lot 44, 20,000 francs). A good old copy (with minor variations in the paving stones in the foreground) of NG 6299;[9]
(2) Paris, Louvre (inv. 8020), oil on canvas, 394 × 328 cm (Mérot 2000, no. 85; fig. 1);
(3) and (4) There existed two autograph reductions of (2) made for Philippe Regnaut (or Renaut) and Gilles Crevon, the masters of the Paris confraternity, who commissioned the work now in the Louvre.[10] One of these may be the picture once in the gallery of the castle at Schwerin in Prussia and destroyed during the Second World War.[11]

For other works related to (2) above, including a painting claimed to be a *première pensée* sold at the Martin sale, Paris, Paillet, 5 April 1802 (lot 114, 180 francs to St Romains) with given dimensions equivalent to 78.5 × 65 cm, see Mérot 2000, pp. 239–240.

DRAWINGS

Numerous drawings are catalogued by Mérot as connected with the Louvre painting.[12] The following seem to be preparatory to NG 6299 rather than to the Louvre painting:

(1) Madrid, Biblioteca Nacional (inv. 8927; fig. 4);[13]

(2) Frankfurt, Städelsches Kunstinstitut (inv. 1003; fig. 5).[14]

PRINTS

(1) By Benoît I Audran (1661–1721) in reverse, 52.6 × 36.9 cm.[15] The print was published by Etienne Picart (1632–1721), probably before c.1710 when he emigrated to Amsterdam, since it is inscribed *C.P.R*;[16]

(2) Audran's engraving was reproduced as a line engraving by C. Normand for C.P. Landon, *Vies et Oeuvres des Peintres les plus célèbres de toutes les écoles*, 25 vols, Paris 1813, vol. 21, p. 67. Landon comments in relation to the painting: 'On ignore où ce tableau a passé' (ibid., 'Table des Planches de l'Oeuvre d'Eustache Le Sueur', p. 6).

Technical Notes

NG 6299 is in reasonably good condition, although there are losses around the edges and across a horizontal strip about 7 cm wide through and to the left of the kneeling foreground figure's left ankle. It was last retouched in 1992. The primary support is a plain-weave canvas, double lined (on different occasions). The stretcher is not original, but is probably nineteenth century and bears the following marks: scratched at top left *Dining Room*; nearby in white chalk *393Y*(?) and the traces of an old label which reads *...frames made to the pattern ...lined...*; further along the top of the stretcher, *...Ob* (?) and at the top right a small, round label *2097*. On the central vertical bar appears *3...* in white chalk, the letters *Ce* have been scratched in, and *8387* is on a round label. *19* has been scratched onto the central horizontal stretcher, perhaps referring to the 1813 Willett sale (see Provenance).

There is a double ground layer of grey over red. Most of the blue draperies are rather blanched, possibly because of the use of poor-quality ultramarine. Unusually, the underlayers for some of the draperies are of brownish-yellow colour, containing ultramarine mixed with yellow lake and ochre.[17]

There are visible pentimenti at the bottom right.

The subject is from Acts 19: during Paul's mission to the city of Ephesus, the capital of the Roman province of Asia, many Jews and Greeks were converted to the teachings of Christ. 'And many that believed came, and confessed, and shewed their deeds. Many of them also which used curious arts brought their books together, and burned them before all men: and they counted the price of them, and found it fifty thousand pieces of silver' (Acts 19: 18–19). In NG 6299 books are being burnt in the foreground under the direction of Paul, who stands in a red cloak at the top of a short flight of steps. To the right people are confessing. To the left behind a balustrade a clerk is keeping an account. The temple at the right is presumably intended to represent Ephesus' great temple of Diana (now entirely destroyed), the magnificence of which

was celebrated throughout the ancient world, and which was also referred to in Acts 19:27. The building's connection with Diana is made explicit in the Louvre painting (fig. 1) in which a statue of the goddess appears in a niche in the temple façade. This has been turned almost parallel to the picture plane, perhaps better to contrast the Doric order, which stood for orthodoxy, with the more elegant Ionic order, associable with luxury and paganism.[18]

This change in the architectural background is among a number of significant differences between NG 6299 and the very much larger Louvre painting, but before discussing these it is necessary to consider the respective functions of the two works. The painting in the Louvre, nearly four metres high, was given to the cathedral of Notre-Dame, Paris, by Philippe Renault and Gilles Crevon on behalf of the confraternity of Sainte-Anne and Saint-Marcel of the Paris goldsmiths' guild as the 'May' of 1649.[19] At this period the 'May' was an annual offering to the cathedral by the confraternity of a large painting depicting an episode from the Acts of the Apostles. It was exhibited outside the cathedral entrance on the first day of May, and then before the altar of the Virgin Mary for the rest of the month before being hung in the cathedral. The practice of offering such paintings to Notre-Dame lasted from 1630 to 1707, but smaller paintings had been given since 1533.[20]

It was also customary for the artist to provide each of the two masters of the confraternity with a smaller version of the original. One of these could be NG 6299, but according to the *Cabinet des singularitez* of Florent Le Comte, published in Paris in 1699–1700, the two paintings for the confraternity masters were different from the small version of the original.[21] Félibien also makes it clear that there is a difference between what he called Le Sueur's *'première pensée, ou plutôt l'original'* and the 'May'.[22] Consequently, whether called a *première pensée* or a small-scale original, only one treatment existed, almost certainly NG 6299.[23] The painting now in Algiers (fig. 2) is a copy of the London picture (with slight variations); and the two ricordi made for the confraternity masters, which would have replicated the 'May' now in the Louvre, must have been either lost or destroyed.[24]

Besides the change to the architectural background, there are a number of other significant differences between NG 6299 and the 'May' in the Louvre. The figure in the right foreground has been altered. The three figures in the left foreground have been entirely modified. The man nearest the picture plane has been changed from one weighed down by four heavy volumes in the London picture to an upright figure ripping apart a single volume. The man doing the reckoning has been made older and more severe in the Paris picture. At the right the figure dispensing charity has become one pointing to the burning books, and the figure immediately behind Paul giving a blessing has disappeared, as have the figures at the right making confessions. Instead, a figure bent over by the weight of the books he carries has been introduced.

The changes between the small-scale original and the 'May' mentioned by Félibien and Le Comte were considered at greater length by the author of the catalogue of the 1892 Girou de Buzareingues sale, at which the copy of NG 6299

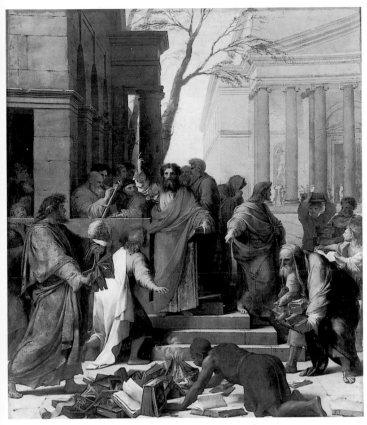

Fig. 1 *Saint Paul preaching at Ephesus*, 1649. Oil on canvas, 394 × 328 cm. Paris, Musée du Louvre.

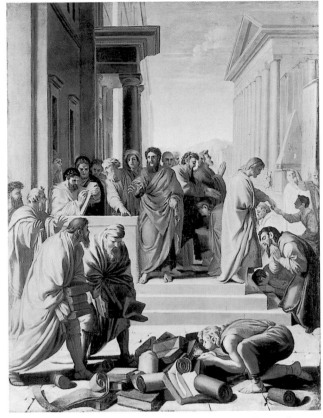

Fig. 2 After Eustache Le Sueur, *Saint Paul preaching at Ephesus*, after 1648–9. Oil on canvas, 102 × 81 cm. Algiers, Musée des Beaux-Arts.

now in Algiers was sold.[25] The two versions of Paul, he proposed, were based respectively on the figures of Plato, for the 'May', and Aristotle, for the Algiers picture, in Raphael's *School of Athens* (fig. 3) – representing in the case of Plato the inspiring and passionate word of the apostle and in the case of Aristotle the reasoned conviction of the goodness and utility of Christianity.[26] These quotations from *The School of Athens*, which were surely intended to be recognised, were not, however, straightforward: although Paul's gesture in NG 6299 is like that of Aristotle, his left hand grasps his cloak like that of Plato. Conversely, in the 'May' Paul indeed gestures with his right hand like Plato, but he holds a book in his left like Aristotle, so that it would be difficult to sustain an argument that Le Sueur was switching from an Aristotelian view of Christianity in NG 6299 to a Platonic view in the 'May'. Rather, the various changes were probably required by the authorities at Notre-Dame,[27] in order to change the image from one of repentance and forgiveness to one of authority and submission, perhaps to indicate a more robust antagonism towards heresy. The choice by the church authorities of this particular episode from the Acts of the Apostles may have been connected to what seems to have been a controversy concerning the boundary between prayer on the one hand and magic on the other.[28]

NG 6299 contains other borrowings from Raphael. Broadly speaking, the composition is similar to that of *The*

Fig. 3 Raphael, *The School of Athens* (detail), 1510. Fresco. Rome, Vatican, Stanza della Segnatura.

School of Athens. The figure of the 'accountant' is derived from that of Pythagoras, and the white bearded man to the accountant's right is like the standing figure with a book (who has been variously identified)[29] to the right of Pythagoras (fig. 3). The figure in the left foreground is derived from the figure in that position in the tapestry after Raphael's cartoon of *The Sacrifice at Lystra*.[30] Assuming that the preparatory drawing in Madrid (fig. 4) is earlier than that in Frankfurt (fig. 5) – the two central figures and architectural background of which are clearly inspired by *The School of Athens* – it would seem that Le Sueur formed a basic idea of how he proposed to depict the episode from Acts 19 and then consciously subjected that idea to a process of 'Raphaelisation'. Having more or less repeated from the Madrid drawing the figure at the left carrying books, he then seems to have defaced it in the Frankfurt drawing and drawn a head a little to the right and above. It is also clear from the Frankfurt drawing that neither the number nor the position of the foreground figures was finally resolved.

NG 6299 was the subject of a long discourse in Félibien's ninth *Entretien*, first published in 1688. Besides praising it, Félibien compared NG 6299 favourably to the 'May', and, implicitly criticising the cathedral chapter of Notre-Dame, suggested that the 'May' was not as good because the artist had deferred to the judgement of others rather than following his own.[31]

General References

National Gallery Catalogues. Acquisitions 1953–62, London [1963], pp. 58–9; Wright 1985b, p. 121; Mérot 2000, no. 83.

Fig. 4 Study for NG 6299, *c*.1648–9. Black chalk, 28.1 × 21.7 cm. Madrid, Biblioteca Nacional.

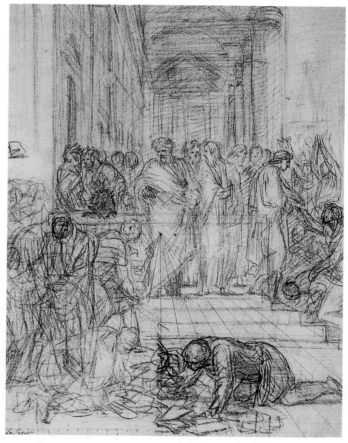

Fig. 5 Study for NG 6299, *c*.1648–9. Black chalk, pen and brown ink, 33.6 × 27.2 cm. Frankfurt, Städelsches Kunstinstitut.

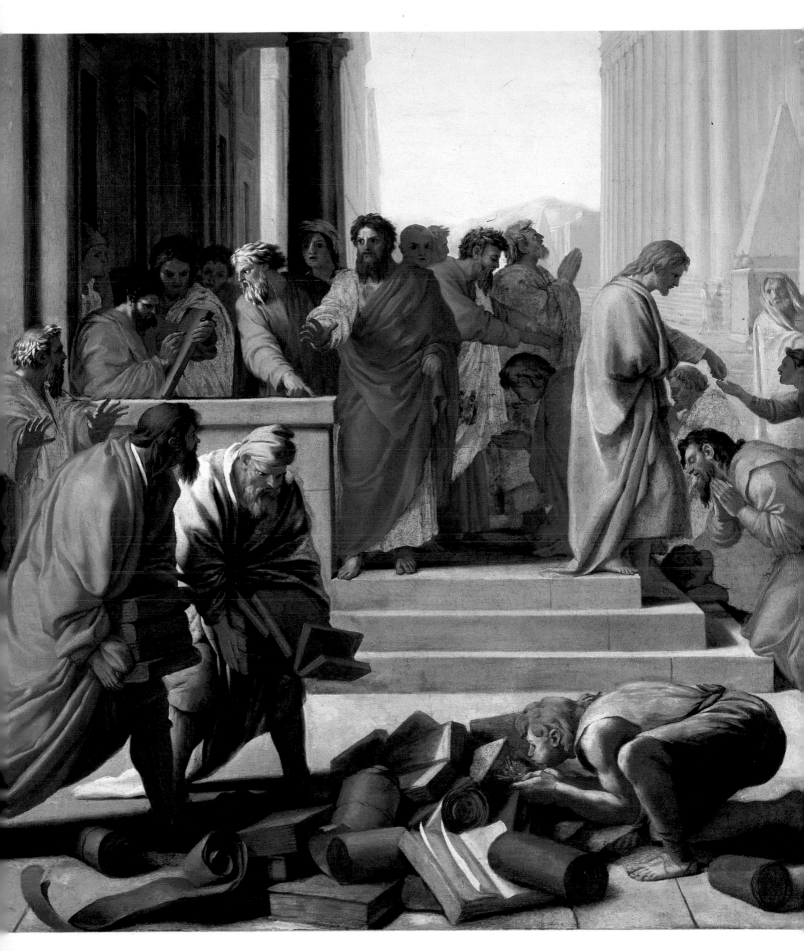

Saint Paul preaching at Ephesus (NG 6299), detail.

NOTES

1. 'En 1650 il (i.e. Le Sueur) fit le Tableau qu'on a coutume de présenter tous les ans à Notre-Dame de Paris... la première pensée, ou plutôt l'original de ce tableau est, comme vous le sçavez, dans le cabinet de M. Le Normand, Greffier en chef du Grand Conseil et Secrétaire du Roy. J'ai vu cet original, interrompit aussitôt Pymandre: notre ami qui le possède, prétend qu'il y a des choses plus belles que dans celui qui est à Notre-Dame. Les premières pensées des Grands hommes, lui dis-je, sont souvent les meilleures': A. Félibien, *Entretiens 1685–88*, vol. 2, 1688, pp. 471–2. There is a similar passage in *Entretiens 1685*, p. 37, and it is clear from pp. 39–40 that Le Normand was not the first owner of the picture. *Entretiens 1685*, although bearing the publication date 1685, was printed in October 1684.

'Le May qui represente la maniere avec laquelle sont brûlez les livres condamnez par saint Paul, est un des Tableaux de sa main (i.e. Le Sueur) qui fait le plus d'honneur à son Nom; on en voit l'original en petit chez Monsieur le Normand Greffier en chef du grand Conseil, mais il est differemment traité, des deux petites representations qu'il fit pour Messieurs Regnaut & Crevon Orphévres & Administrateurs en charge alors': Florent Le Comte, *Cabinet des singularitez d'architecture, peinture, sculpture, et gravure*, 3 vols, Paris 1699–1700, vol. 3 (1700), p. 91. Le Normand apparently lived in the rue des Vieux-Augustins, Paris: see Bonnaffé 1884, p. 178.

2. The catalogue description is: 'LE SUEUR – 17 St. Paul at Athens [sic], the sketch after the large picture of, at Notre Dame at Paris – [Ft. In. High] 3 6 [Ft. In. Wide] 2 6.' (The actual measurements in inches of NG 6299 are 40 × 34.) The sale details are taken from a copy of the catalogue in the NG Library. See also Marguerite Sapin, 'Précisions sur l'histoire de quelques tableaux d'Eustache Le Sueur', *BSHAF*, 1984, pp. 53–68 at p.62.

George Townshend (1723/4–1807), 4th Viscount Townshend of Raynham, followed a military career, seeing action at, among other places, Culloden and Quebec, the surrender of which he took in 1759 following the death of General Wolfe. Townshend was certainly in London in 1773, when he married his second wife, Anne Montgomery, who appears at the right of Reynolds's painting, *The Montgomery Sisters: 'Three Ladies adorning a Term of Hymen'* (London, Tate Gallery), commissioned that year. *The Complete Peerage*, vol. XII (1953), pp. 808–10, contains a number of assessments of Townshend by contemporaries, none of which suggests that NG 6299 would have appealed to him, and see *Reynolds*, exh. cat., Royal Academy (ed. N. Penny), London 1986, pp. 262–3. Townshend's country seat was at Raynham Hall, Norfolk. If NG 6299 was ever at Raynham Hall, it was not there by 1810: see J. Durham, *The Collection of Pictures at Raynham Hall*, Raynham 1926 (copy in NG Library).

3. Described in the catalogue as 'Le Sueur – 48 St. Paul at Athens'. However, NG 6299 could not have been in the 1785 Lebrun sale if it was the picture in the posthumous sale of

Thomas Newton, Bishop of Bristol (1704–82), which did not take place until 30 April 1790. Lot 96 (£30 19s. 6d. to Vandergucht) of the 1790 sale was described in the catalogue as 'Le Seuer [sic] – 96 The burning the magical books at Ephesus'. The painting was not among those included in the sale (by private contract) of Dr Newton and others on 8ff. April 1788 at 125 Pall Mall, London. Newton's autobiography was published soon after his death in *The Works of the Right Reverend Thomas Newton, D.D. Late Lord Bishop of Bristol and Dean of St. Paul's with some Account of his Life, and Anecdotes of several of his Friends, Written by Himself*, 3 vols, London 1782. He was known as a lover of pictures by 1750 (see vol. 1, p. 51) and wrote that '...he possessed a never-failing fund of employment and entertainment too in his books and pictures. These were the only expensive articles of his life, and especially the latter... His design was to form not so much a great as a good collection, and to have something of the principal masters, and only of the principal masters of the different schools' (p. 105). If NG 6299 was in Newton's sale in April 1790, it would exclude it not only from having been in the 1785 Lebrun sale, but also from being the picture bought by Edward Knight in March 1790 (see Provenance and note 4).

4. But see the previous note. Knight's purchase is recorded in *Pocket Book of Edward Knight, March 1786–March 1791* (Kidderminster Public Library, MS no. 000290). For Edward Knight of 52 Portland Place, London, and Wolverley House, Worcs., see E. Hendriks, 'The First Patron of John Flaxman', *BM*, 126, 1984, pp. 618–25, and Joan Lane,'"The Dark Knight", Edward Knight of Wolverley and his Collections', *Apollo*, 149, 1999, pp. 25–30. His nephew John (d. 1850) owned a copy of the Audran engraving of NG 6299 (see Prints) which was lot 342 of his sale of 19–24 July 1841, London, Phillips, but the only painting of his which could correspond to NG 6299 was 'Le Sueur Historical', sold at London, Phillips, 24 March 1819 (lot 166, sold £5 15s.). This seems unlikely to have been NG 6299.

5. Described in the catalogue as 'Le Sueur – 28 Paul at Athens'.

6. Described in the catalogue as 'Le Seur (sic)/ Burning the Books at Ephesus... From the Collection of Newton, Bishop of Bristol'. John Willett Willett, MP for Romney, 1796–1806, was born John Willett Adye, but changed his name on inheriting the estate of his cousin, Ralph Willett (1719–95), who collected mainly books but pictures as well. Carpenter was presumably the bookseller James Carpenter, of 12 Old Bond Street, London, who also dealt in, and possibly collected, pictures: see Whitley 1930, pp. 161–2; *DNB*, vol. III, p. 1077. In 1837 he sat on the committee which helped acquire Constable's *The Cornfield* (NG 130) for the National Gallery: Whitley 1930, p. 338.

7. Described in the sale catalogue as 'La Seur (sic)... Paul preaching at Athens, with many figures'.

8. H.D. Molesworth was appointed Keeper of

Sculpture at the Victoria and Albert Museum in 1946, and Keeper of Woodwork in 1954: *Who Was Who 1971–1980*, London 1989, p. 550. For other paintings in his collection, see Sotheby's, 4 April 1962, lots 15–22.

9. Marguerite Sapin considered the Algiers painting to be a copy (extract from thesis presented to the Ecole du Louvre in 1977, copy in the Louvre dossier). A. Mérot considered the London version to be the better, but accepted the autograph status of the Algiers picture: Mérot 1987, p. 237, albeit subsequently with reservations: see Grenoble 2000, no. 27. However, when the London and Algiers pictures were exhibited side by side in Grenoble in 2000, it was clear that the Algiers picture was a copy (as I had thought on the basis of a photograph in the Louvre dossier), a view with which Mérot now agrees (in conversation, 12 May 2000).

The copy of the 1892 sale catalogue in the library of the Frick Collection is inscribed '10,000' in the left-hand margin, presumably the reserve, and '20,000' in the right-hand margin, presumably the sale price.

10. See Florent Le Comte quoted in note 1 above.

11. Mérot 2000, pp. 237, 239.

12. Mérot 2000, pp. 237–9.

13. Mérot 2000, p. 237, and A.M. de Barcia, *Catálogo de la colleción de dibujos originales de la Biblioteca Nacional*, Madrid 1906, p. 759.

14. Mérot 2000, pp. 238, 480, and Frankfurt 1986–7, Stadtische Galerie in Städelschen Kunstinstitut, *Französische Zeichnungen im Städelschen Kunstinstitut 1550 bis 1800*, no. 19.

15. Weigert 1939, vol. 1, p. 111.

16. That is, *cum privilegio regis*.

17. A. Roy and M. Spring, 'National Gallery Report on Inorganic Analysis', 1992–3 (unpublished).

18. As T.P. Olson has suggested: *Nicolas Poussin, His French Clientele and the Social Construction of Style* (PhD thesis, University of Michigan, 1994), pp. 415–16. For a discussion of a drawing of the goddess Diana by Le Sueur in the Art Museum, Princeton University, and the extent of its connection with the Louvre painting, see Goldfarb 1989, pp. 186–8.

19. The Louvre painting has been extensively catalogued by Alain Mérot in his monograph on Le Sueur (Mérot 2000, no. 85 and p. 480).

20. J.J. Guiffrey, 'Les Mays de Notre-Dame de Paris', *Mémoires de la Société de l'Histoire de Paris et de l'Ile-de-France*, v, XIII (1886), Paris 1887, pp. 289–316; P.M. Auzas, 'Les Grands "Mays" de Notre-Dame de Paris', *GBA*, 36, 1949, pp. 177–200, and other articles cited at n. 3 thereof. For a recent account of the 'Mays', see *Les Mays de Notre-Dame de Paris*, ed. Annick Notter, Arras 1999.

21. See Florent Le Comte quoted in note 1 and Dezallier d'Argenville 1745, vol. 2, p. 293, n.(c): 'Le Sueur a fait deux différens tableaux du même sujet, ils sont gravés.' Le Comte's testimony that three small

pictures of Saint Paul preaching at Ephesus, all by the hand of Le Sueur, were known in 1700 necessarily devalues references to such works in catalogues and inventories when it comes to proposing a provenance for NG 6299. Indeed, it seems that there were two versions of the picture on the market at almost the same time in 1790 (see Provenance). It should, however, be noted that there are references in 1701, 1712 and 1729 to paintings, one or more of which could have been NG 6299 (see Mérot 2000, p. 239), and one, identified in Sapin 1977, cited in note 9, in an anonymous sale (Sotheby's, 21 July 1831), which also could have been the National Gallery picture – but with less probability, given that it was called 'Paul preaching at Athens' and Ephesus had been identified as the true location in the Newton and Willett sales.

22. See Félibien, quoted in note 1.

23. Conceivably the picture in the 1802 Martin sale (see Related Works) was preliminary to the 'May' now in the Louvre, in which case Le Sueur would have made two small-scale pictures before the 'May', only one of which was known to Félibien and Le Comte. Mérot (in conversation 12 May 2000) wondered whether NG 6299 was not too finished to be a *première pensée*, as Félibien describes it. However, Félibien in fact calls it 'la première pensée, ou plutôt l'original'.

24. See Related Works (3) and (4). If the picture once at Schwerin was one of the ricordi, then these were somewhat larger than NG 6299, namely 133 × 109 cm. A painting or paintings of this size, said to be the same as the 'May', appeared in the Lenglier sale, Paris, Lebrun, 10 March 1788 (lot 235), and in the Constantin sale, Paris, Pérignon, 18 November 1816 (lot 418): Sapin 1977, cited in note 9, and Mérot 2000, pp. 239–40.

25. Lot 44. Chevallier, Paris, 26 February 1892.

26. Ibid., pp. 29–30. '...dans son tableau du Louvre, est rendu l'idéalisme avec le geste de Platon, c'est la parole entraînante et passionée de l'apôtre faisant planer sur ses auditeurs les menaces de la toute-puissante céleste. / Dans la composition appartenant à M. Girou de Buzareingues, c'est le disciple convaincu démontrant dans la pose d'Aristote la bonté du christianisme et l'utilité de son application ici-bas. Dans le premier tableau, l'entraînement de la passion domine... Dans le second, c'est la conviction raisonnée qui se traduit d'une façon plus mesurée.'

27. On the need for the cathedral chapter to approve the 'Mays', see Patrick Laharie, 'La Confrérie Saint-Anne des orfèvres parisiens 1449–1712', in ed. Notter 1999, cited in note 20, pp. 3–21 at pp. 14–15, and Denis Lavalle, 'Les Grands Mays de Notre-Dame de Paris 1630–1707', in *idem*, pp. 43–58 at p. 45. Olson, cited in note 18, has argued that the austere style of the Louvre painting 'makes a claim to represent the interests of the Parlement and its constitutive rhetorical culture...The goldsmiths, who were allied with the Parlement of Paris, sought in pictorial representation an expression of their authority'. This seems unlikely.

28. This controversy centred around the figure of Thomas Campanella (1568–1639), who had found refuge in Paris after being forced to flee Rome in 1634. He had been released from prison in 1626 by Urban VIII, who, it seems, for a period practised magic with him. His release was much later celebrated in *Panegyricus Urbano VIII dictus ob beneficia ab ipso in Campanellam collata*, Paris 1644, written by Gabriel Naudé, Mazarin's librarian: see D.P. Walker, *Spiritual and Demonic Magic from Ficino to Campanella*, Notre Dame and London 1975, pp. 208ff., and *Dizionario Biografico degli Italiani*, vol. 11, p. 372.

29. As Terpander or Nicodemus by Bellori: G.P. Bellori, 'The Image of the ancient Gymnasium of Athens or Philosophy', trans. by A.S. Wohl, *Raphael's 'School of Athens'*, ed. Marcia Hall, Cambridge 1997, p. 52; and as Anagoras by Passavant: J.D. Passavant, *Raphael d'Urbin et son père Giovanni Santi*, 2 vols, Paris 1860, vol. 1, p. 123.

30. Francis I of France had ordered a set of the tapesteries of the Acts of the Apostles after Raphael's design around 1532. The set remained the property of the French crown and then of the government until its destruction in 1797: *Raphael et l'art Français*, exh. cat., Grand Palais, Paris 1983–4, p. 243, and *Raphael dans les collections françaises*, exh. cat., Grand Palais, Paris 1983–4, p. 402. For other examples of Le Sueur borrowing from the Acts of the Apostles, see nos 157 and 158 of the former catalogue.

No print after *The Sacrifice at Lystra* is known to have existed prior to Le Sueur's death, but there existed prints of *The Death of Ananias* by both Ugo Da Carpi and Agostino Veneziano (see S. Massari in *Raphael Invenit. Stampe da Raffaello nelle Collezioni dell'Istituto Nazionale per la Grafica*, Rome 1985, pp. 131–2 and 567–8). As regards *The School of Athens*, there existed prints of the whole composition by Giorgio Ghisi and Nicolò Nelli, and a print of the Pythagoras group by Agostino Veneziano (see Massari, op. cit., pp. 38–9, 286 and 289).

31. 'Les premières pensées des grands hommes... sont souvent les meilleures, non seulement parce que la force de ce premier feu qui échaufe leur imagination s'y trouve toute entiere, mais aussi à cause qu'ayant beaucoup d'esprit & de lumiéres, ils sont capables de juger par eux-mêmes de la bonté de ce qu'ils produisent, & discerner le bien d'avec le mal. Cependant comme ils n'ont pas moins de sagesse & de prudence que de capacité, ils écoutent tous les avis qu'on leur donne, & il arrive quelquefois qu'aimant mieux déferer au jugement des autres qu'à leur propre sens, ils quittent leur opinion particuliére, & prennent le plus mauvais parti.': *Entretiens 1685–88*, vol. 2, pp. 471–3.

NG 6548
Christ on the Cross with the Magdalen, the Virgin and Saint John the Evangelist

*c.*1643
Oil on canvas, 109 × 73.1 cm

Provenance
In the chapel of the Bar Convent, Micklegate, York, probably by 1836;[1] the property of the IBVM Charitable Trust, the Bar Convent; bought Christie's, 10 June 1994, by Agnew's on behalf of the National Gallery with support from the Corporate Benefactors (lot 7, £397,500 including buyer's premium).

Exhibition
Leeds 1979, City Art Gallery, *Church Art From Catholic Yorkshire* (11).

Related Works
PAINTINGS
(1) Paris, Louvre (inv. no. 8494), oil on canvas, 195 × 122 cm with arched top (fig. 3), as by Simon Vouet;[2]
(2) Church of Croissy (Yvelines). An old copy of (1) above by François Lemaire, given to the church in 1645 and stolen in 1990;[3]
(3) Meunier (?) sale, Paris, Ch. Elie, 4 April 1808 (lot 114, sold for 50 francs).[4] A copy of NG 6548?;
(4) Robert de Saint-Victor deceased sale, Paris, Pierre Roux, 26 November 1822 and 7 January 1823, lot 501 (341 livres, 11 sols to Henry(?)).[5] A copy of NG 6548?
DRAWINGS
A drawing by Simon Vouet in Besançon, Musée des Beaux-Arts (inv. no. D.1349), has some similarity to the figure of the Magdalen in NG 6548, and a drawing in the Louvre Cabinet des Dessins (inv. no. RF 28204), also by Vouet, could be a study on which the head of Saint John was based.[6] In addition, a drawing by Le Sueur at Alençon, Musée des Beaux-Arts et de la Dentelle (inv. no. 869.119), also bears some resemblance to the Magdalen in NG 6548, but insufficient to say with certainty that it is a preparatory drawing specific to this figure. The drawing has also been connected with two paintings of different subjects in the Musée Magnin, Dijon.[7]

Technical Notes
In good condition overall, although showing some wear, with losses along the bottom edge and isolated small losses elsewhere; some blanching (?) in the green of Saint John's tunic, and some fading of the red lake pigment in those of the Virgin and Mary Magdalene. There has also been some deterioration in the blue of the Virgin's cloak. The stretcher is recent, and the plain-weave canvas support was relined probably shortly before the Gallery's acquisition of the painting. The ground is a bright red colour.

There are pentimenti to the right of the Virgin's cloak, the right arm of the cross and the left contour of Christ. As the X-radiograph (fig. 1) confirms, the Virgin's head was originally angled lower.

The presence of the Virgin Mary and Saint John the Evangelist in paintings of the Crucifixion was sanctioned by John 19:26–7, where Christ entrusted the care of his mother to John. Mary Magdalene was frequently included in the scene, although the biblical justification for this is unclear. Christ is shown dying rather than dead and nailed to the cross with four nails rather than three, as, for example, in Guido Reni's *Crucifixion* of 1619 (Bologna, Pinacoteca Nazionale), which, as Crelly noted, may be the ultimate source for the graceful, contrapposto figure of Christ in the Louvre version of NG 6548.[8] NG 6548 shares these characteristics, as well as an imagined view of Jerusalem, with a composition by Simon Vouet's studio in the Hermitage, engraved in 1638 by Pierre Daret (fig. 2). This composition was possibly a starting point for Le Sueur, who worked in Vouet's studio for over ten years from around 1631.[9] There are, however, significant differences: in the placement and gestures of Saint John and the Magdalen; in the face of the Virgin, which has lost all vestiges of the sweetness of Vouet's Hermitage Virgin and in the cross, which in NG 6548 is parallel to the picture plane.[10]

These and other differences noted below are significant because the attribution of the Louvre version (fig. 3), and, by extension, of NG 6548, to Le Sueur has been questioned. Although attributed to Le Sueur by Mérot,[11] the Louvre picture has been exhibited as 'Atelier de Simon Vouet' and NG 6548 declared on the basis of a photograph as even further removed from Le Sueur.[12] Yet more recently the Louvre painting has been reattributed to Simon Vouet by Arnauld Brejon de Lavergnée,[13] an attribution with which Sylvain Laveissière disagrees, considering the Louvre version to be by Le Sueur.[14] It is therefore necessary to review the arguments on attribution in some detail. These have mainly concerned the Louvre picture, because until its recent acquisition by the National Gallery NG 6548 was little known.

The Louvre picture has been catalogued by the Louvre as an autograph work by Simon Vouet since 1909.[15] It was given to Vouet by Crelly in his catalogue raisonné of the artist's work published in 1962.[16] Crelly regarded it as a work of the very late 1630s, and he noted the 'strong contrast' between it and Vouet's representations of the subject in Genoa and Lyon, commenting that it is 'very much simplified and, in a sense, purified in comparison'.[17] Correctly referring to the dignity and restraint with which the figures express their grief, he wrote that the Louvre picture 'has a sense of contained emotional drama that may also be called classical'.[18]

The attribution to Vouet of the Louvre picture was first questioned by Mérot in his catalogue raisonné of Le Sueur's paintings and drawings. He established that it must have been painted by 1645, and that it was apparently commissioned by Louis XIV's mother, Anne of Austria, not necessarily, however, for her own use. Mérot noted 'the drawn out forms' of the Louvre picture, 'less heavy than with Vouet, the type of faces, the delicacy of the colouring (such as the pink shaded with yellow of the Magdalen's cloak)' and concluded that the Louvre and London versions were made in Vouet's studio after a Vouet prototype – not by Vouet, but by the hand of 'a very gifted and more sensitive pupil who has a strong possibility of

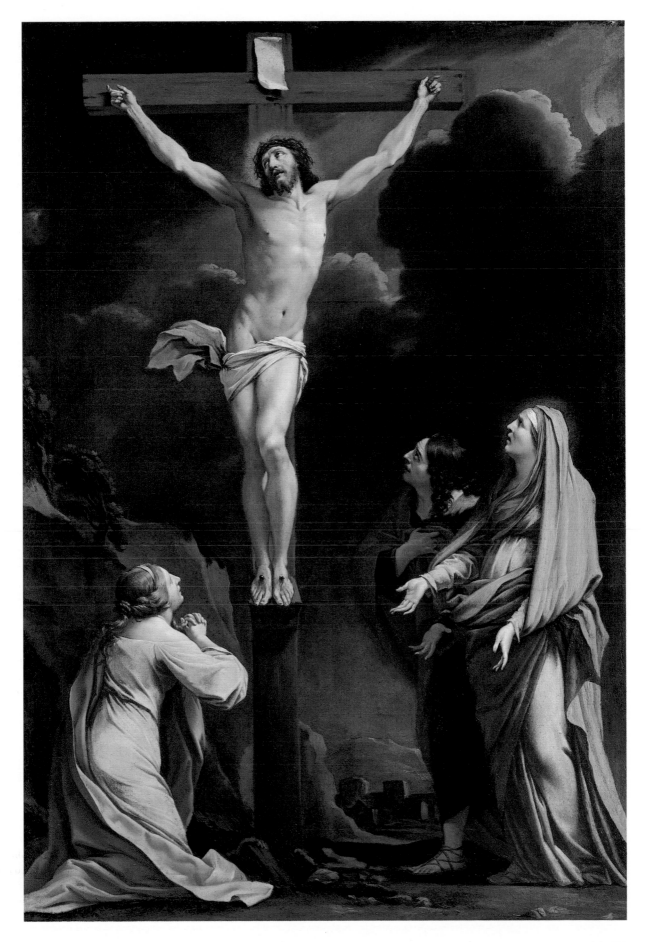

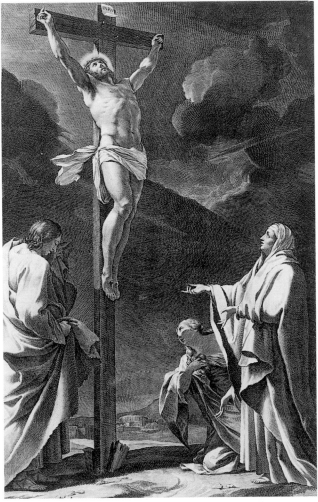

Fig. 2 Pierre Daret after Simon Vouet, *Christ on the Cross*, 1638. Engraving. 48.2 × 29.8 cm. Paris, Bibliothèque Nationale.

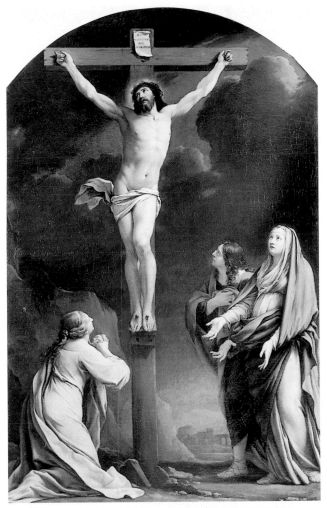

Fig. 3 *Christ on the Cross*, c.1641–2 (?). Oil on canvas, 195 × 122 cm. Paris, Musée du Louvre.

LEFT
Fig. 1 X-radiograph.

being Le Sueur'. Mérot considered the picture an early work and placed it in his catalogue immediately after another work of Le Sueur engraved as a frontispiece in 1643.[19]

For Barbara Brejon de Lavergnée the Louvre painting is neither by Vouet nor by Le Sueur, although she thinks it is a product of the Vouet studio. She proposed that, albeit under Vouet's direct influence, Le Sueur was already developing his own style: 'gentleness of the figures, a taste for the refined profile, characteristic faces with the eyes always emphasised, a play of light colours' ('douceur des figures, goût du profil soigné, visages si particuliers aux yeux toujours soulignés, jeu des coloris clairs'). She considered that in the Louvre picture

the treatment of the figures was too powerful, the faces too realistic and the overall sentiment too dramatic to belong to Le Sueur.[20] But dramatic treatment is what one might expect, given the powerful and tragic nature of the subject, and this would also account for colours which, for Le Sueur, are indeed relatively dark and saturated.[21] The figure of the Magdalen in both the Louvre and London paintings seems consistent with the foreground figure in Le Sueur's *Presentation of the Virgin* (St Petersburg, Hermitage Museum), datable c.1638;[22] the Virgin in the Louvre painting is close in facial type and expression to a seated figure clothed in white towards the right of that artist's *Polyphilus kneeling before Eleutherilda* (Rouen,

Fig. 4 Detail from *Polyphilus kneeling before Eleutherilda, c.*1640–3. Oil on canvas, 97 × 139 cm. Rouen, Musée des Beaux-Arts.

Fig. 6 Jean Couvay after Eustache Le Sueur, detail of crucifix from *Saint Charles Borromeo, c.*1640. Engraving, 36 × 27.3 cm. Paris, Bibliothèque Nationale.

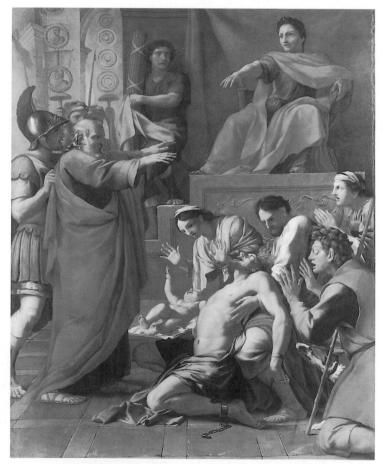

Fig. 5 *Saint Paul exorcising a Possessed Man, c.*1645–6. Oil on canvas, 175.1 × 137.7 cm. Cambridge, Mass., Harvard University Art Museums, Fogg Art Museum (on loan from an anonymous private collection).

Musée de Beaux-Arts; fig. 4), possibly of the early 1640s;[23] and the somewhat attenuated figure of Christ seems close in type to that in an engraving after Le Sueur's *Saint Charles Borromeo*, datable *c.*1640 (fig. 6).[24] This last work suggests that when dealing with a serious subject, Le Sueur would give the protagonists features that were both serious and realistic. In the context of the argument that the faces in the Louvre painting are too realistic to have been painted by Le Sueur, it is worth noting that it was just in the years around 1640 that he was painting a number of male portraits.[25]

Besides the difference in size, NG 6548 differs from the Louvre picture in that there is no inscription on the cartellino fixed to the cross. It is not clear why this should be so. The other main difference is in the change in position and features of the Virgin's head. The somewhat vacuous features of the Virgin in the Louvre picture, which among other things rightly put Crelly in mind of Guido Reni, have become in NG 6548 far more severe and distraught, and even masculine. Some of these qualities also appear in the features of Camma in *Camma and Synorix in the Temple of Diana* (Boston, Museum of Fine Arts), dated by Mérot to a little before 1645[26] (and showing how Le Sueur modified his protagonists' features to suit the subject). The particular type of the Virgin's features in NG 6548 can be seen in a figure at the right of *Saint Paul exorcising a Possessed Man* (private collection; on loan to the Fogg Art Museum; fig. 5) datable to about 1645–6. However, given the evidently strong influence of Vouet, NG 6548 must be earlier than this. Around 1641–2 seems an appropriate dating for the Louvre picture, which, on the evidence of the drawings in Besançon and the Louvre (see Drawings above), must have been executed while Le Sueur had ready access to them in Vouet's studio. NG 6548 may be later;[27] it is too polished to

have been a modello for the Louvre picture and was perhaps executed at the moment when Le Sueur was emerging from Vouet's studio and developing a style more distinctly his own. A date around 1643 is therefore suggested.

General References

The National Gallery Report April 1994–March 1995, pp. 8–9; Mérot 2000, pp. 178, 479.

NOTES

1. NG 6548, hanging framed in a shallow alcove, is shown on the left-hand side of the chapel, looking towards the altar, in a crude and not wholly accurate engraving by Henry Brown (1816–70). The date of publication of the print is uncertain because, although listed on the contents page of a set of 83 wood-engraved views of York by Henry Brown and his brother William published in 1836, it was not in fact included in the volume. The print of the interior of the chapel is, however, larger than the others in the series and was available separately for three pence, unlike the others, which were available for one penny. Possibly, therefore, this print was only available separately. I am indebted to Richard Green for this information (letter of 29 July 1994), derived in part from a 1992 catalogue of the York bookseller Ken Spelman. Sister Gregory of the Institute of the Blessed Virgin Mary kindly supplied a photocopy of the print.

It has been stated that NG 6548 was presented to the Bar Convent in 1769 on completion of the chapel (letter of 27 February 1979 from James Lomax to Pierre Rosenberg), but an extensive search of the convent archives by Anne Thackray failed to verify this. Alastair Laing (in conversation) considers the frame on the painting to be early nineteenth-century French, making it likely that NG 6548 left France then rather than earlier. There were two paintings on the London art market in 1818 which could be NG 6548, but in neither case is the description adequate to merit more than a footnote. They are (i) 12 March 1818, London, Phillips, lot 461 ('S. Vouet / Crucifixion'), sold by Angelo Bonnelli and bought by Bartie for 12 guineas, and (ii) 21 November 1818, London, Edward Foster, lot 72 ('Le Suer/The Crucifixion, very fine'), sold by Hawkins and bought by Johnson for three guineas: *The Index of Paintings Sold*, vol. 4, part 2, p. 874, and part 1, p. 494. A picture that was auctioned in Paris in 1822–3 and is evidently too small to be NG 6548 is noted under Related Works.

For works mentioned during the *ancien régime* which are also possible candidates to be NG 6548, see Mérot 2000, nos M.29, M.31, M.34, M.35, M.127 and M.130.

2. I. Compin and A. Roquebert, *Catalogue sommaire illustré des peintures du musée du Louvre et du musée d'Orsay, Ecole française L–Z*, Paris 1986, p. 277, and Crelly 1962, no. 106. Sylvain Laveissière, however, considers that

the Louvre painting is by Le Sueur, and sees no reason to doubt that NG 6548 is by the same hand (conversation, 13 May 2000).

3. Mérot 2000, p. 178, and J.C. Bonnet, *Le Village de Croissy-sur-Seine*, Angers 1894, p. 101, n. 2. The dimensions of the Croissy painting were 220 × 140 cm, and so somewhat greater than those of the picture in the Louvre, according to Y. Picart, *La Vie et l'oeuvre de Simon Vouet*, Paris 1958, p. 49, but the painting's dimensions were stated as 185 × 127 cm when it was reported stolen in the *Gazette de Drouot*, 12 October 1990.

4. 'E. Le Sueur/ le Christ à la Croix; on voit à ses pieds Saint Jean et les deux saintes Femmes, dont l'attitude et l'expression peignent la forte douleur de l'âme. Les belles formes, le grandiose des plis, des nuages bien groupés, forment un ensemble heureux et très-harmonieux./: sur toile Haut. 3 pi. Larg. 29 po.' (i.e. 97.4 × 78.5 cm): see *Répertoire* 1998, p.630.

5. '501 LE SUEUR (Eustache)/ Jésus Christ cloué sur la croix; les yeux élévés vers le ciel, il attend avec une noble résignation la consommation de son sacrifice; au bas on voit la Vierge, saint Jean et la Madeleine, qui expriment leur douleur à l'approche de ce moment fatal. De belles expressions, de beaux mouvemens caractérisent cette production, digne de la jeunesse de l'auteur. T. l. 13p. h. 17p.'

6. See Brejon de Lavergnée 1987a, nos VIII and 60.

7. See Coutances and Le Mans 1996–7, *Autour de Simon Vouet*, exh. cat., no. 25 (catalogue entry by Françoise Chaserant).

8. Crelly 1962, p. 65.

9. Mérot 2000, p. 19.

10. Unlike Vouet's painting in Genoa, Chiesa di Gesù, and in Lyon, Musée des Beaux-Arts, where the cross is strongly angled away from the picture plane, and the church of Neuilly-Saint-Front where it is slightly angled, albeit in the opposite direction to that in the preliminary drawing: see Paris 1990–1, Grand Palais, *Vouet*, no. 112.

11. Mérot 2000, no. 29.

12. Barbara Brejon de Lavergnée in Coutances and Le Mans 1996–7, p. 84.

13. Letter of 5 March 1997 to Neil MacGregor and Humphrey Wine; A. Brejon de Lavergnée,

'Notes parisiennes: Philippe de Champaigne et non Le Sueur , Le Sueur et non Vouet', *Curiosité. Études d'histoire de l'art en l'honneur d'Antoine Schnapper*, ed. O. Bonfait et al., Paris 1998, pp. 47–51 at pp. 47–8; and *idem*, *BM*, 142, 2000, p. 521 (in a review of Grenoble 2000).

14. See note 2.

15. *Musée National du Louvre. Catalogue Sommaire des Peintures. Ecole Française*, Paris 1909, no. 974. The painting then disappeared from Louvre catalogues until after publication of William Crelly's catalogue raisonné on Vouet. See also I. Compin and A. Roquebert, cited in note 2.

16. Crelly 1962, no. 106 (possibly the work mentioned as lost under no. 171).

17. Crelly 1962, pp. 65–6.

18. Ibid.

19. Mérot 1987, p.178. ('Les formes étirées, moins pesantes que chez Vouet, le type des visages, la délicatesse des coloris (ainsi le rose nuancé de jaune du manteau de la Madeleine)un élève très doué et plus sensible, qui a de fortes chances d'être Le Sueur'). This is repeated in Mérot 2000 at p. 178, and Mérot adds (p. 479): 'La version de la [National Gallery], d'excellente qualité, est une réduction... avec variants par rapport au tableau du Louvre.'

20. Coutances and Le Mans 1996–7, p. 82.

21. There is probably more ultramarine pigment in the Virgin's cloak in the Louvre painting than in NG 6548. Many other features of the Louvre picture – the shot pink and orange of the Magdalen's drapery, the deep red and green of Saint John's, the use of pale ochre highlights in the Magdalen's hair and red in the shadows of her fingers – are similar, as are the pinky grey hues at the edges of the clouds.

22. Mérot 2000, no. 16.

23. Mérot 2000, no. 7.

24. Mérot 2000, no. 20.

25. Mérot 2000, nos 21, 22, 23, 24.

26. Mérot 2000, no. 32.

27. In the *National Gallery Report April 1994– March 1995* (pp. 8–9) I suggested *c.*1641–2 as the date for NG 6548.

NG 6576
Alexander and his Doctor

c.1648–9
Oil on canvas, 96.0 cm diameter

Provenance

Painted for Jérôme de Nouveau, seigneur de Fromont (1613–64), Surintendant des Postes, for his hôtel in the place Royale, Paris;[1] bought, certainly by 1711,[2] by Philippe, duc d'Orléans (1674–1723), apparently through Pierre Crozat[3] and, according to Sir James Thornhill who noted it at the Palais-Royal in 1717, for 2000 livres;[4] inventoried at the Palais-Royal in 1724 (when valued at 3200 livres), in 1752, in 1785 (when valued at 10,000 livres) and in March 1788;[5] sold in 1791, together with the other Italian and French school paintings in the Orléans collection, for 750,000 livres to the Brussels banker Edouard de Walkiers, who sold them on to his cousin François-Louis-Joseph de Laborde-Méréville (1761–1802), a banker of Paris; brought to Belgium, then England with the other Italian and French paintings from the Orléans collection in 1793, the lot mortgaged in 1793 for £40,000, subject to a five-year option to redeem, to the banker Jeremiah Harman; sold in 1798 by Harman, together with the other Italian and French paintings in the Orléans collection, for £43,000 to a consortium comprising the Duke of Bridgewater, Earl Gower and the Earl of Carlisle;[6] offered for sale by private contract by the consortium at Bryan's Gallery, 88 Pall Mall, London, from 26 December 1798 (no. 133); first seen there by Lady Amabel Lucas (1751–1833) on 29 December 1798 and agreed to be bought by her on 1 January 1799 for 300 guineas;[7] delivery of the pictures made to Lady Lucas's London home in St James's Square on 2 August 1799;[8] recorded as hanging on the north wall of the principal drawing room on the first floor in an undated inventory apparently made soon after Lady Lucas's death;[9] fitted as an overdoor at the north-east corner of the principal drawing room on the first floor, probably soon after Lady Lucas's death;[10] by descent (as one of the fixtures in the house) in the De Grey family until 1908 when the house passed from that family to Charles Henry Alexander Paget, 6th Marquess of Anglesey;[11] bought (as one of the fixtures on sale of the house) by Waldorf Astor in 1912, and then by HM Ministry of Works in 1948; sold by the Secretary of State for the Environment (as one of the fixtures) to Tabwell Holdings Limited on 17 May 1993, and so transferred by that company to the State of Qatar on 19 February 1996; sold (as one of the fixtures) by the State of Qatar to In and Out Limited on 18 December 1996;[12] removed in October 1997 under a temporary planning consent from 4 St James's Square to the National Gallery, which bought the painting from In and Out Limited (the Naval and Military Club) in September 1999 following the grant of Listed Building Consent.

Exhibitions

London 1798–9, Bryan's Gallery, 88 Pall Mall, *A catalogue of the Orleans Italian Pictures which will be exhibited for sale by private contract on Wednesday the 26th of December 1798 and following days* (133); London 1818, BI (126); Grenoble 2000 (30).

Related Works
PAINTINGS
(1) France, private collection. An apparently good-quality copy in rectangular format. Oil on canvas, 128 × 96 cm;[13]
(2) Formerly collection of Eustache II Le Sueur (1645–95) of place Maubert, Paris, 'un grand tableau ovalle peint sur toile représentant Alexandre Malade garni de sa bordure de bois doré prisé cenquarante livres'[14] (by Le Sueur?);
(3) In 1784 in the collection of Louis-Robert de Saint-Victor (1738–1822), Président de la Chambre des Comptes à Rouen, 'une esquisse terminée, ou plutôt le tableau en petit du grand du Palais-Royal';[15]
(4) Formerly in the collection of the comte d'Houdetot, a picture said by Victor Cousin to be an autograph replica;[16]
(5) Anon. sale, Paris, Drouot, 11 December 1919, no. 41, possibly a copy of (1) above;[17]
(6) Lord Wm Fhowler sale, Milan, 12–15 December 1955, lot 121, a copy by Ercole Graziani[18] in reverse after the engraving by Audran (see Prints (1));
(7) Anon. sale, Sotheby's, 26 June 1974, lot 84, as 'E. Lesuer The Death of Socrates 19½ in. by 25½ in. : 50 cm by 64 cm'. Possibly a copy based on NG 6576;
(8) Paris, Louvre (inv. no. 8699). A poor, eighteenth-century copy of NG 6576, gouache on paper laid down on canvas, 65 cm diameter;[19]
(9) Anon. sale, Paris, Paillet, 16 February 1778, lot 29, as 'La *Maladie d'Alexandre*, copie d'après le tableau original de Le Sueur, qui est au Palais Royal; hauteur 4 pieds 2 pouces, largeur 2 pieds' (135 × 65 cm);[20]
(10) Exhibited in 1779, Montpellier, Société des Beaux-Arts, no. 113, as 'D'après Eustache Le Sueur: l'héroïque assurance d'Alexandre prenant le breuvage préparé par Philippe son médecin';[21]
(11) A copy by Alexandre Lenoir was noted in 1819.[22]
DRAWINGS[23]
(1) Besançon, Musée des Beaux-Arts (inv. D.850; fig. 5). Annotated on the verso: *Le Sueur no. 222*. A composition study;
(2) Paris, Louvre, Cabinet des Dessins (inv. RF 34 517; fig. 4). Annotated, presumably by the artist, at top left: *Le point distance a six pieds neuf pouces du poinct de vüe*, and at top right: [deleted: *le point de distance est a*] *six pieds du poinct de vue*. Further annotated at bottom left: *E. Le Sueur*;
(3) Montpellier, Musée Fabre (inv. D. 2209/837.1.26; fig. 8). A study for the figure of Alexander;
(4) Rotterdam, Museum Boijmans Van Beuningen (inv. DN 180/77) (fig. 13). A study for the figure standing with his back to the viewer at the right.
PRINTS
(1) By Benoît I Audran, 1711. In reverse. Dedicated to the duc d'Orléans and with the following legend: *Alexandre étant tombé malade et ayant / receu avis de Parmenion, que Philippe son / medecin devoit l'empoisonner ne laisse pas de / prendre avec confiance la coupe qu'il lui présente / et dans le temps qu'il la porte a sa*

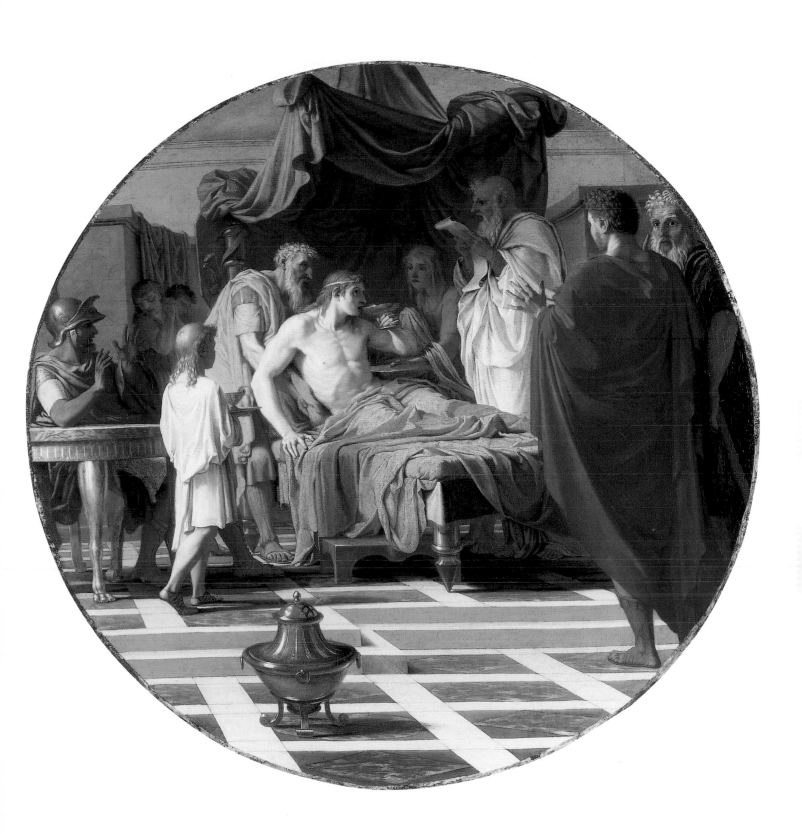

bouche il luy / remet entre les mains la lettre de Parmenion / Une promte guerison justifia le medecin / et ce Prince fit voir par sa fermeté que les / grandes ames sont si éloignées de certains / crimes quelles ne sauroient même en concevoir / la soupçon dans les autres. / Q. Curce L. 3.;

(2) by Le Rouge and Robert Delaunay in reverse in L.-A. de Bonafons, abbé de Fontenay, *La Galerie du Palais-Royal gravée d'après les tableaux des différentes écoles qui la composent, sous la direction de J. Couché. Description historique de chaque tableau par l'Abbé de Fontenay*, 3 vols, Paris 1786–1808, vol. 3, folio 76;[24]

(3) by Le Bas in reverse: *Confiance d'Alexandre dans son médecin* in C.-P. Landon, *Vies et Oeuvres des Peintres les plus célèbres de toutes les écoles*, Paris 1811, pl. 108; and C.-P. Landon, *Galerie des peintres les plus célèbres*, 12 vols, Paris 1844–6, vol. 12, *Oeuvres complètes d'Eustache Le Sueur et choix de Jouvenet*, pl. 108;

(4) by Gsell in 1843 in reverse in *Confiance d'Alexandre dans son médecin* in L. Vitet, *Eustache Le Sueur. Sa vie et ses oeuvres*, Paris 1849, pl. 65.

Technical Notes

The condition is good, with only minor losses, mainly around the edges. The painting had an old lining on it when acquired by the Gallery, and this was strengthened by the addition of a second lining when the Gallery cleaned and restored NG 6576 in 1999–2000. The stretcher is of an unusual construction, with the pieces of wood forming the circle buttressed by one piece of wood placed vertically across the diameter, into which six other pieces of wood have been slotted rather like the spokes of a wheel (fig. 1). NG 6576 once had a circular stretcher with a cruciform brace, the ghost of which is visible on the X-radiograph (fig. 2), and the present stretcher must be late eighteenth century or later since it is keyed. In fact it most likely dates to 1813, when the restorer William (?) Comyns charged Lady Amabel Lucas, the picture's then owner, eight guineas for 'Cleaning Ironing down stoping [sic] and mending Alixander [sic] and his Physician by Le Sueur'.[25] The former stretcher, which may have been the original, was probably slightly smaller, since the diameter of the painted surface (96 cm) is less than that of the present stretcher (99 cm). The present stretcher, which is pine, is marked 25 in ink. This number corresponds to that of NG 6576 as (re)numbered in an inventory of Lady Lucas's collection made soon after her death.[26] During the course of the picture's restoration by the Gallery the following labels, all written in ink on paper, were removed from the back of the stretcher: (1) in an eighteenth(?)-century hand, *Nᵒ 228*; (2) in a different eighteenth(?)-century hand, *Alexandre et son / medecin par le / Sueur – 10...*; (3) *Le Seur [sic] / Alexander the Great & his Physician / Originally in the Orleans Collection / B'ot by Amabel Countess de Grey / about 1799.*[27]

The primary support consists of three pieces of fine, plain-weave canvas sewn together, an unusual construction for a picture less than a metre wide in any direction. It has been established that the central and right-hand strips, and so probably the left-hand strip, have triple grounds, consisting of a lower orange-red layer, largely earth pigment, with a second,

much yellower, layer of earth pigment on top. This second layer varies considerably in thickness, and may have been applied to provide a more uniform surface to the assemblage of canvas strips. The third, uppermost, ground layer is a mid-brown-grey made up of lead white, charcoal black and some red lead pigment.

Le Sueur first worked his composition over the uppermost ground layer in a series of semi-monochrome passages of mid- and greyish brown paints, which play an important role in the painting's overall tonality, before applying brighter coloured pigments in the final layers. These pigments include red lake glazes over underpaints containing vermilion mixed with red lake for the pinkish mauve drapery of the seated figure at the left; greater or lesser amounts of finely ground natural ultramarine in the greyish blue drapery (blanched) between the legs of that figure and in the grey-green and yellow (blanched and faded) drapery of the attendant supporting Alexander; combinations of yellow earth, yellow lake and lead-tin yellow, with the more orange highlights incorporating realgar, in the yellow-orange colours of the bedclothes; red lake with a little white over a mid-brown underlayer in the purple bedhangings above Alexander; vermilion in combination with red lake glazes for the drapery of the figure with his back to the viewer at the right of the painting; and an ultramarine glaze (now a little blanched) for the drapery of the figure at the extreme right.

The story of Alexander and his doctor Philip is told by a number of ancient authors. These include the first-century BC Sicilian historian Diodorus Siculus in *Bibliotheke historike*; the first-century AD Greek historian Plutarch in his *Parallel Lives*; the first-century AD Roman historian Quintus Curtius Rufus in *Historia Alexandri Magni*; his contemporary Valerius Maximus in *De Factis Dictisque Memorabilibus Libri IX*, a collection of the acts and sayings of worthy men; the second-century AD Greek writer Arrian in his *Anabasis of Alexander*; and, in *Historiae Philippicae*, Marcus Junianus Justinus, a Roman historian who lived possibly in the second or third century AD.[28] All these accounts were available in print in Latin and/or Greek by around the middle of the sixteenth century. Those of Plutarch and Valerius Maximus were among the most familiar, and, although they differ in certain details, both relate how Alexander (BC 356–23), who was King of Macedonia and called the Great, fell ill after bathing in the cold waters of the River Cydnus, and how one of his generals, Parmenion, warned him in a letter to beware Philip, Alexander's doctor and old friend. Parmenion claimed that Philip was in the pay of the Persian enemy. Notwithstanding the warning,[29] Alexander fearlessly drank the medicinal potion prepared for him by Philip, to whom he handed Parmenion's letter to read, and after some days recovered.

NG 6576 most likely derived from Plutarch's account, the French translation of which by Jacques Amyot had first appeared in 1559 and was often reprinted. Guillet de Saint-Georges cited Plutarch in his account of NG 6576 in his

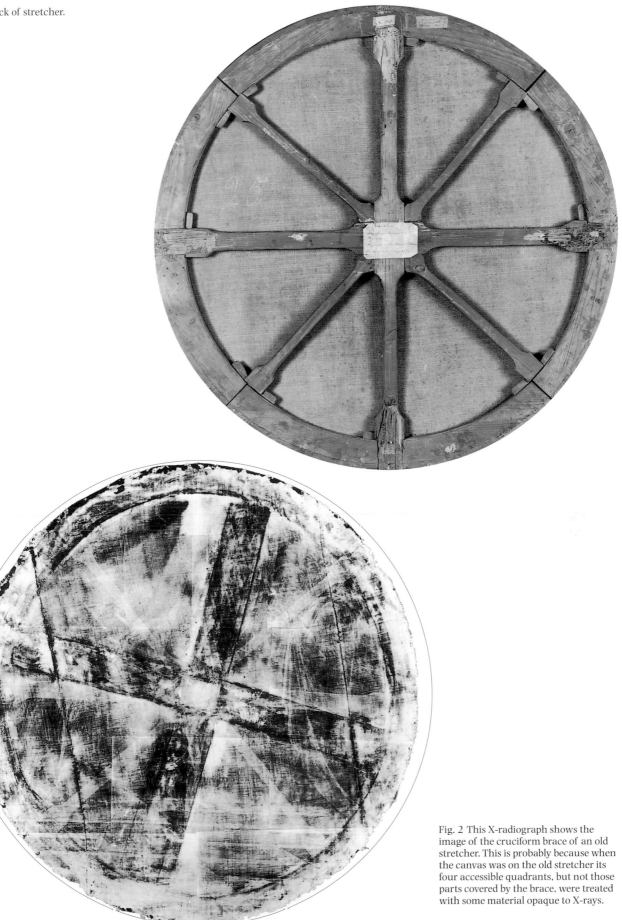

Fig. 1 Back of stretcher.

Fig. 2 This X-radiograph shows the image of the cruciform brace of an old stretcher. This is probably because when the canvas was on the old stretcher its four accessible quadrants, but not those parts covered by the brace, were treated with some material opaque to X-rays.

lecture on Le Sueur's life and work given to the Académie in 1690.[30] The 1645 Paris edition of Amyot's translation relates: '…when the time arrived for taking the medicine, Philip entered the bedchamber with the King's other close friends carrying the cup with the medicine in it. Alexander then gave him the letter, and at the same moment unhesitatingly took the cup without showing any doubt or suspicion. A wondrous thing it was, and splendid to see, how one on one side was reading the letter and the other at the same time drinking the potion, and to reflect on their simultaneously scrutinising each other, albeit not with the same countenance: for Alexander looked frank and cheerful, showing his confidence in his doctor Philip, and his friendship for him; the other with the face of a man deeply upset and tormented by the false accusation laid against him.'[31]

If this account corresponds most closely to NG 6576, it is nevertheless worth noting just how available French translations of other accounts of the episode were from the later 1640s. In 1646 Perrot d'Ablancourt published his translation (reprinted in 1654) of Arrian, *Les Guerres d'Alexandre*, which relates (Book II, ch. III) that 'by chance Alexander received this news [ie. Parmenion's letter accusing Philip of treachery] as the medicine was brought to him; but without showing any mistrust of someone [Philip] whom he loved, he gave him the letter with one hand, and drank the potion with the other; such that the one was drinking at the same time as the other was reading, the latter showing sufficiently by his face and his expression that he was innocent.'[32] In 1647 there was published *Valerie Maxime traduit en françois Par Le Sʳ De Claveret*, which relates that 'Alexander having seen these letters, gave them to Philip to read, nevertheless taking from his hand the medicine which he swallowed.'[33] In 1650 there appeared a translation into French of Quintus Curtius, published in Rouen containing (Book III) a slightly different account of the incident in which Alexander first swallowed the medicine and then gave Philip the letter scrutinising his face for signs of conscience: 'He [Philip] entered, carrying the potion in his hands in a goblet. When Alexander saw him, he raised himself resting on his elbow, and holding Parmenion's letter in one hand, he took with the other the medicine which he swallowed without hesitation, and then presented the letter to Philip ordering him to read it, and while he read it he (i.e. Alexander) fixed his eyes on him, being sure in his mind that he would spot any signs of conscience on his face. Philip, having read the entire letter, showed more anger than fear', and swore eternal loyalty to Alexander.[34] Three years later another translation of Quintus Curtius, by Claude Favre de Vaugelas (d.1650), was published in Paris.[35] This too recounts how Alexander held Parmenion's letter in one hand and simultaneously swallowed the medicine from a goblet held in the other, and only then gave Philip the letter: '…fixing his eyes on him while he [Philip] read, he sought on his countenance some sign which would show him the interior feeling of his soul.'[36] Besides these accounts in French, Johann Freinshem published his compilation in Latin of the two lost books of Quintus Curtius's *Historia* in Strasbourg in 1648, further evidencing the interest in Alexander at this time.[37]

It is clear that most accounts of the episode of Alexander and his doctor contain two interrelated themes. The first is stoicism – the school of philosophic thought which argued that human emotions were rational responses to external circumstances, but that they should be controlled by reason – which appealed to many in the professional classes of seventeenth-century France and, as has often been noted,[38] to Poussin. Alexander was described by Guillet de Saint-Georges in his account of NG 6576 as fearless (*intrépide*) and resolute (*inébranlable*),[39] and was seen as the model stoic hero who, through control of his emotions (and his courage), reached a correct decision. The second is the interaction between the emotions of the soul, 'the passions', and their expression on the human face, a question most famously addressed in Descartes's *Les Passions de l'âme* (Amsterdam and Paris 1649).[40] Guillet's account shows clearly the importance he assumed his listeners would attach to the way in which Le Sueur expressed the protagonists' emotions. It may therefore be true to say that for contemporaries, and for many in the following century,[41] NG 6576 was exemplary in two ways: it showed a virtuous action, and it showed how such an action might be depicted.

Visual sources

The subject of Alexander and his doctor was not a common one for French painters in the first half of the seventeenth century.[42] It was treated by François Perrier for a Paris patron *c.*1632–5,[43] and it has been suggested that it was treated in a different composition by Le Sueur (but if so at an earlier moment in his career).[44] Lanfranco's oval picture – one of a series on Alexander's life by various artists, painted by 1616 for Cardinal Alessandro Peretti-Montalto for his villa on the Esquiline hill, Rome – may have been known to Le Sueur (who never went to Rome) through a copy.[45] It resembles NG 6576, however, only in the angle of the bed to the picture plane and in the bed having a canopy, but its emotional tenor, with a sickly rather than resolute Alexander, is quite different. Closer in composition is a drawing by Giovanni Baglione (fig. 3) which, it has been suggested, was connected with the Peretti-Montalto commission.[46] The angle of the bed to the picture plane, the spatial relationship between Alexander and Philip, the two standing figures at the right and a soldier seated at a table at the left are compositional elements shared by both the drawing and Le Sueur's painting. The drawing, however, is not known ever to have been in Paris,[47] so, unless it is evidence of a lost painting by Baglione of which some other graphic record was available to Le Sueur, it must be presumed that the two artists independently reached similar compositional conclusions.

Conceivably, Le Sueur knew Poussin's *Death of Germanicus* through a drawn or painted copy,[48] since in two preparatory drawings by Le Sueur (figs 4 and 5) the disconsolate woman seated to the left of Alexander recalls Agrippina in Poussin's painting.[49] In addition, the pose of the attendant supporting Alexander in NG 6576 is close (in reverse) to that of the woman standing at the extreme right of *The Death of Germanicus*. However, in NG 6576 the disconsolate woman was replaced

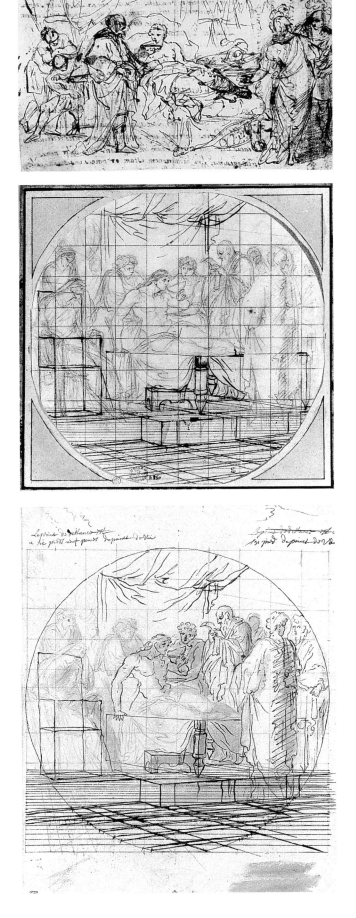

with the soldier seated by a round table with feet shaped like griffon claws (fig. 6), and this detail suggests the most likely visual sources for the composition of NG 6576, namely the two compositions by Raphael for the Vatican Loggie of *Isaac blessing Jacob* and *Isaac and Esau*.[50] A number of engravings of these would have been available to Le Sueur, including those of *Isaac blessing Jacob* by Lanfranco (fig. 7) and of *Isaac and Esau* by Badalocchio (1585–*c*.1619), part of the complete series of fifty-two Old Testament scenes in the Loggie engraved by these two artists. This series enjoyed widespread success and was published in several states – the first dated one in 1607.[51] As well as the round table, the pose of Alexander in the Montpellier drawing (fig. 8), in which he leans his elbow on a baluster, seems to be derived from that of Isaac in the Lanfranco and

Fig. 3 Giovanni Baglione, *Alexander and his Doctor, c.*1615–16? Pen and brown ink over black chalk, 15.5 × 27.2 cm. Düsseldorf, Kunstmuseum. Sammlung der Kunstakademie.

Fig. 4 *Alexander and his Doctor, c.*1648–9. Black chalk, partially strengthened in pen and brown ink, squared up in red chalk, 28.4 × 20.8 cm. Paris, Musée du Louvre, Cabinet des Dessins.

Fig. 5 *Alexander and his Doctor, c.*1648–9. Black chalk, squared up in red chalk, strengthened in pen and brown ink, 19.2 cm diameter. Besançon, Musée des Beaux-Arts et d'Archéologie.

Fig. 6 Detail of griffon claw table leg.

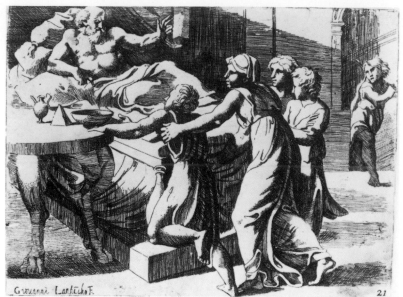

Badalocchio engravings.[52] So, too, does the angle of the bed to the picture plane and its placement on a platform in two of the preliminary drawings – as in *Isaac blessing Jacob*. Another series after the Vatican Loggie was engraved by Nicolas Chaperon (fig. 9) and published in 1649.[53] While this shows the interest in Raphael's compositions around the time NG 6576 was painted, the prior existence of the Lanfranco/Badalocchio engravings means that 1649 cannot be taken as the earliest possible date of execution for NG 6576.

Although the much-copied *Dying Alexander* (Florence, Uffizi) was generally believed in the seventeenth century to be a portrait of the Macedonian king,[54] the features of Le Sueur's Alexander are not evidently based on it, nor does he share the dying Alexander's leonine hair. Conceivably, Le Sueur's Alexander, with his long, lank hair, was derived from the portrait in Andrea Fulvio's *Illustrium Imagines* (Rome, 1517),[55] but more probably the source was Marcantonio Raimondi's print of a composition by Raphael, *Alexander preserving the Works of Homer* (fig. 10).[56] In any event, Le Sueur's conception of Alexander may have also been based on, or reinforced by,

direct or indirect knowledge of literary sources. Plutarch describes the hero as having a neck bent slightly to the left (which may explain Alexander's oddly prominent neck muscle in NG 6576), a melting glance and being fair of colour save for a ruddiness of the face and chest.[57] This last quality, however, may have been felt inappropriate for a man who was ill. Except for his pallor, and for the fact that his left eye is not visible, Le Sueur's portrayal of Alexander is consistent with that contained in Freinshem's creative compilation of Book I of Quintus Curtius's *Historia Alexandri Magni* published in 1648: 'His skin was white and fair, except for a handsome flush on his cheeks and also on his breast; his hair was golden and slightly curling; his nose was aquiline; his eyes did not match, for his left eye is said to have been grey and the other very black...'[58]

Le Sueur may have derived the motif of the hero's sword and shield hanging above him from Poussin. The motif did not appear in Poussin's *Germanicus*, but he did use it in two paintings which were in Paris by 1645 – namely, the version of *Extreme Unction* painted for Chantelou and the *Testament of*

Eudamidas painted for Michel Passart.[59] In Poussin's compositions sword and shield are shown hanging from a horizontal bar fixed to the wall behind, which Le Sueur may have felt would be ill adapted to a tondo composition – hence the solution of hanging these items from the bedpost. Some of the other details seem to have been derived from Pietro Testa's print, *The Symposium*, dated 1648 (fig. 11).[60] This includes a table with a fluted surround similar to that of the table in NG 6576. In addition, the feet of the triclinium in Testa's print is like the visible part of the foot of Alexander's bed, and the scale pattern of the bowl of the perfume-burner in the print may have been the immediate source for the pattern on the lid of the burner in NG 6576.[61] Finally, the young servant at the right of the print is close in type and (in reverse) in pose to that at the left of NG 6576, and in both print and painting there are two figures behind the servant merging into the shadows against an architectural background.

Development of the composition

The Montpellier drawing suggests that Le Sueur may originally have planned a frieze-like arrangement, as Poussin had used in *The Testament of Eudamidas* and as Le Sueur had himself adopted in *Christ healing the Blind Man* (Potsdam, Sanssouci), dated *c.*1646 by Mérot.[62] If so, such an arrangement was discarded in favour of angling the corner of the bed towards the viewer, a solution adopted by Le Sueur in two works probably quite close in date to NG 6576: *Saint Peter reviving Tabitha* (Toronto, Art Gallery of Ontario)[63] and *Saint Bruno revealing a Conspiracy to Count Roger in a Dream* (Paris, Louvre).[64] Both of these paintings show a bed raised on a platform, so positioning the heads of the principal protagonists somewhat above the centre of the picture. It is evident from two preparatory drawings in Besançon and the Louvre (figs 4 and 5), where the bed is placed on a raised level (rather than a raised platform), that Le Sueur planned something similar for *Alexander and his Doctor*. In fact, this is precisely what he seems to have first painted before altering the single step between the two levels to a double step. The alteration is most evident just to the right of the lower lip of the perfume-burner (fig. 12). Inspection shows that this accessory was added after the tiled floor and steps had been painted, perhaps to mask the not wholly successful alteration to the steps.

The other main difference between the two compositional drawings and the painting is at the left, where in both drawings there appear in faint black chalk the figures of a seated woman weeping and her companion standing behind her, and drawn over them in brown ink a schematic rendering of the woman's high-backed chair. In the painting the woman, her chair and her companion were replaced by the soldier seated at a marble-topped table, a young attendant in front of the table, and behind it two disconsolate-looking figures. Other changes from the Louvre and Besançon drawings are the incorporation of a bedpost behind Alexander supporting his sword and shield, the addition of the semicircular wall in the background, and slighter changes to the two figures at the extreme right which resulted in their hiding one of the legs of the bed.

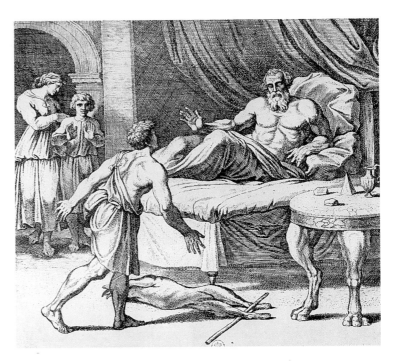

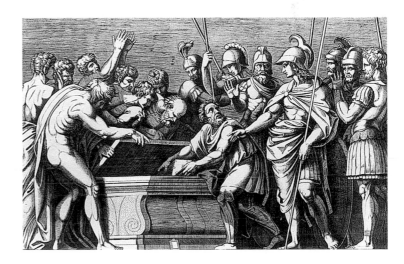

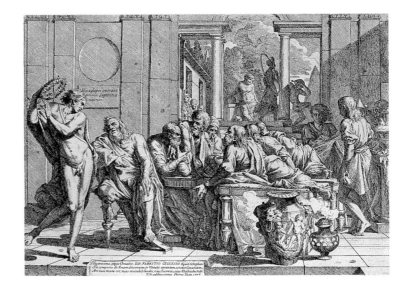

Fig. 12 Detail of burner.

It is also clear from the Besançon and Louvre drawings that Le Sueur was concerned with the geometry of the composition as a whole, and in particular the tiled floor and its relationship to the raised level. Between these drawings and the painting, the plan of the raised level was altered to recess it at the right instead of the left. On the Louvre drawing Le Sueur annotated the distance (*'six pieds neuf pouces'*) 'between' the picture plane and the point in the picture space of the vanishing point, demonstrating his interest in the precise construction of perspective.[65] The Rotterdam drawing (fig. 13), a study for the figure in the right foreground with his back to the spectator, was probably the last of the known drawings to be made.

The date of the painting
The patron of NG 6576, Jérôme de Nouveau (1613–64), inherited the position of Surintendant des Postes from his father in 1639, when he was living in Paris in the rue de Berry. He was described by his contemporary Tallemant des Réaux as rich and ostentatious, and prepared to borrow heavily – when he died, his estate was crippled by debt.[66] A moral exemplar such as NG 6576, painted in its sober style, may seem unlikely to have appealed to such a man. However, De Nouveau had already shown some taste for the severe in specifying pilasters in a rustic Doric order for his home in the rue de Berry,[67] and he and his wife were evidently particular about the nuances of interior decoration.[68] Consequently, De Nouveau was likely to be conscious of the fashionably

austere style of Paris painting around 1650, of which NG 6576 is a prime example. Aside from questions of style, the episode shown in NG 6576, revolving as it does around the delivery and reading of a letter, may perhaps have appealed to a man responsible for the country's postal system.[69]

The date of NG 6576 cannot be determined with certainty. Immediately after the passage describing the painting in his life of Le Sueur, Guillet de Saint-Georges wrote that it was at that time that Le Sueur undertook the *Saint Bruno* series for the Paris Carthusians. This was most probably painted during the years 1645–8. However, De Nouveau bought his hôtel in the place Royale – in which, according to Florent Le Comte, NG 6576 was installed as a chimney-piece[70] – in various stages between 1645 and 1646, making 1645 an improbable date for NG 6576, quite apart from stylistic considerations. Certainly during the period 1648–51 De Nouveau was improving his new home.[71] (According to Guillet de Saint-Georges, besides NG 6576 Le Sueur painted for De Nouveau an *Exposition of Moses* and a *Finding of Moses*,[72] as well as two ceiling paintings, *Diana in a Chariot with Sleep and Death* and an *Aurora*.[73]) This suggests 1648 as the earliest possible date for NG 6576. That date is supported by the evidence of Le Sueur's interest in the construction of perspective (a subject on which Abraham Bosse was publishing in 1648 and 1649), the depiction of Alexander by Le Sueur in a way consistent with Quintus Curtius's description of him as published by Frensheim in 1648, the date of Pietro Testa's print, and finally Guillet de Saint-Georges's testimony. However, in view of

Nicolas Chaperon's publication the following year of a new series of engravings after the Vatican Loggie, and Félibien's placing of Le Sueur's works for De Nouveau, albeit not specifically NG 6576, after, rather than during, the painting of the *Saint Bruno* series,[74] 1649 seems at least as likely.[75] In either 1648 or 1649 both the subject and its stylistic treatment would have been fashionable, something which might have appealed to the ostentatious side of De Nouveau (as well as permitting him to live up to his name). Such a dating is supported by the stylistic evidence. The austere composition, strong modelling and emphatic expressions are in accord with Le Sueur's other paintings of these years, when he affirms his indebtedness to Raphael as much as to Poussin – in, for example, *Caligula depositing the Ashes of his Mother and Brother in the Sepulchre of his Ancestors* (Hampton Court, Royal Collection) of 1647, *Saint Peter reviving Tabitha* (Toronto, Art Gallery of Ontario) of the same year, and the 1649 May for Notre-Dame, *Saint Paul preaching at Ephesus* (Paris, Louvre).

NG 6576 remained at De Nouveau's hôtel during his lifetime, but was removed from there, or at least from its position on the chimney-piece of the so-called Italian Room, immediately after his death.[76] Following De Nouveau's death, the hôtel was bought by Geoffroy de Laigue, captain of the Guard of Monsieur and a long-time friend of De Nouveau,[77] although he never lived there; it was then inherited by De Laigue's niece, Marguerite, who sold it in 1678 to Philippe de Courcillon, Marquis de Dangeau, who made some repairs and improvements to the property. It would be reasonable to infer from Guillet's account of Le Sueur's life and work[78] that NG 6576 was then still in the place Royale and nothing to the contrary need be inferred from Florent Le Comte's reference to the painting published ten years later, but De Nouveau's recently discovered inventory strongly suggests otherwise, and knowledge of the painting's subsequent whereabouts, before it was acquired by Philippe d'Orléans, may depend on a yet to be discovered inventory of his widow.[79] On the other hand, if NG 6576 was reinstalled at the hôtel de Nouveau, it was surely removed when Louis-Nicolas Le Tonnelier de Breteuil, Introducteur des Ambassadeurs et des Princes Etrangers auprès du Roi, bought the property in or soon after 1706. The hôtel was by then in a dilapidated state, and Le Tonnelier made urgent improvements to it.[80] It would have been around this time, when Philippe d'Orléans's picture collecting was in full spate, that NG 6576 left the place Royale for the Palais-Royal.[81] At all events it was in the Orléans collection by 1711, the date on the engraving after it by Benoît Audran which he dedicated to Philippe d'Orléans.

The painting's subsequent critical reception and history
NG 6576 was one of the most celebrated paintings in the Orléans collection, as numerous references to it testify.[82] In 1717 Hogarth's future father-in-law, Sir James Thornhill, described the location of the painting: 'over ye Chimney in ye same little Antiroom [sic] is a round Picture of le Sueur ye finest I ever saw.'[83] The painter Joseph Highmore echoed Thornhill's sentiment when he visited Paris in 1734, calling NG 6576 'perhaps the best in ye whole [Orléans] collection...

This picture is one of the most perfect I ever saw in all respects in the Drawing Expression disposition and the Co[rng] beyond any of the french ma[rs]'.[84] The 'little Antiroom' was in fact a temple to French seventeenth-century painting, housing, among other pictures, Le Brun's *Massacre of the Innocents* (London, Dulwich Picture Gallery) and Poussin's *Esther before Ahasuerus* (St Petersburg, Hermitage), *Moses striking the Rock* (Dunrobin Castle, Duke of Sutherland's collection), *The Exposition of Moses* (Oxford, Ashmolean Museum) and the second set of *The Seven Sacraments* (Edinburgh, National Gallery of Scotland, on loan from the Duke of Sutherland). It was called the 'Cabinet des Poussin' then and long after Poussin's paintings had been hung elsewhere in the Palais-Royal, and during Orléans's lifetime was at a pivotal point in the private

Fig. 13 *Study for a Standing Figure*, c.1648–9. Black chalk and white highlights on grey-brown paper, 38.6 × 20 cm. Rotterdam, Boijmans Van Beuningen Museum.

Fig. 14 Hypothetical plan of the hang of the paintings in the Cabinet des Poussin of the Palais-Royal, Paris, in 1717 as proposed by Françoise Mardrus (drawing by R. Baroin, G. Pimienta). All paintings by Nicolas Poussin except where otherwise stated.

1. *Baptism*
2. *Confirmation*
3. *Penitence*
4. *Eucharist*
5. *Extreme Unction*
6. *Ordination*
7. *Marriage*
8. *Massacre of the Innocents* by Charles Le Brun
9. *Esther and Ahasuerus*
10. *Alexander and his Doctor* by Eustache Le Sueur
11. *Moses striking the Rock*
12. *The Exposition of Moses*

apartments.[85] Within this room NG 6576 must have been a focus for attention since it probably hung alone on the chimney-piece. *The Seven Sacraments* and *The Exposition of Moses* were on the opposite wall (fig. 14).[86]

Although the hang in the Cabinet des Poussin had changed by the time of publication of the 1719 edition of Le Rouge's *Les Curiositez de Paris*, NG 6576 remained in that room together with *The Seven Sacraments* and other paintings by Poussin, Raphael and (as then attributed) Carracci.[87] How long this arrangement lasted is unknown. Certainly by 1749 NG 6576 had been removed to one of the 'grands appartemens',[88] but it remained readily available to view, which helps to explain the number of copies (see Related Works) and derivations. The renderings of the subject of Alexander and his Doctor which appear to have been influenced by the composition of NG 6576 are (in order of date): Jean Restout, 1747 (Amiens, Musée de Picardie; fig. 15), based on the text of Quintus Curtius rather than Plutarch;[89] Charles Eisen for an edition of Quintus Curtius's *De rebus Alexandri*, Paris 1757;[90] Jean-Simon Berthélemy, 1773 (Besançon, Musée des Beaux-Arts);[91] Jean

Bardin, 1774 (Montbard, Musée des Beaux-Arts),[92] and Louis-Jean-François Lagrenée, *c.*1795–6.[93] A representation of NG 6576 itself also figures in reverse in a drawing signed and dated 1746 by Charles Natoire, *An Academy of Painting* (London, Courtauld Institute; fig. 17), showing an idealised academy with antique statues and works by French masters,[94] and the soldier seated at the left of NG 6576 quite possibly inspired J.-L. David's soldier at the left of his *Belisarius* (Lille, Musée des Beaux-Arts) completed in Paris in 1781.[95] Even after NG 6576 left France, its composition continued to be influential through engravings, and the engraving in reverse published in 1808 (see Prints (2)) evidently provided an additional visual source for students who painted sketches of the subject for the preliminary round of the Prix de Rome of the following year[96] – as it did for a later generation who competed for the 1846 Prix de Rome, whose definitive subject for the history painting prize was Alexander and his Doctor.[97]

Le Sueur's composition also had admirers outside the artistic community. Although the reputation of Alexander as a historical personality had become a matter of some controversy during the eighteenth century, Rousseau wrote of the episode of the Macedonian leader and his doctor, and by inference probably of Le Sueur's painting, in the second volume of *Emile* (1762).[98] Finally, the nineteenth-century philosopher Victor Cousin expressed particular regret about not seeing the painting during his visit to England.[99]

NG 6576 was among the Italian and French School pictures in the Orléans collection which, following their sale in 1791 by the then duc d'Orléans, Philippe-Egalité, were exported first to Brussels and then to London, where they were exhibited from the end of 1798 at Bryan's Gallery in Pall Mall.[100] There NG 6576 was bought early the following year by Lady Amabel Lucas (1751–1833), an enthusiastic collector of old master paintings. She had first seen NG 6576 in 1778 when at the age of 27, as Lady Yorke, she visited the Orléans collection on her way back from Nice, where her husband, Lord Polwarth, had gone to convalesce. Her diary entry for 11 July 1778 records NG 6576 hanging in what she called the third room of the Palais-Royal with, among other pictures, one of its companions from the time of Thornhill's visit in 1717, Le Brun's *Massacre of the Innocents* (London, Dulwich Picture Gallery), and one of its present companions in the National Gallery's collection, Sebastiano del Piombo's *Raising of Lazarus* (NG 1). At the time Lady Lucas noted of NG 6576: 'I think the colours rather too bright, the piercing Eye of Alexander better hit off than the Physician's Countenance.'[101] Lady Lucas renewed her acquaintance with NG 6576 twenty years later when, on 29 December 1798, she went to see the Italian and French paintings from the Orléans collection, noting that 'the smaller ones [are shown] at Bryan's Rooms in Pallmall, the larger at the Lyceum, Strand, which being a colder place I have not yet ventur'd to'. Then on the first day of the New Year she wrote: 'However the New Year may begin with others, some people being alarm'd for the public. And more I believe alarm'd for their money, on account of the Income Bill, I have begun the year whether foolishly I know not by purchasing two of the Orleans Collection, the Woman

holding up a Casket, call'd Titian's Daughter by Titian, and the Alexander and his Physician by Le Soeur [sic] and am still in doubt whether I shall purchase a Guido.' In fact, as is evident from subsequent diary entries and from letters written to Lady Lucas by her agent, Charles Ware, she bought four pictures in all from this part of the Orléans collection at a total cost of 1000 guineas. A note by Ware confirms the price for the Le Sueur as 300 guineas and that it was in a 4 foot 3 inch-square frame which, in a letter of 3 August 1799, he calls 'the original'. All four paintings had been sent to St James's Square the previous day (after Ware had arranged payment of the outstanding balance), when Ware wrote to Lady Lucas: 'I have placed them in the Room in which the Harpsichord stands, and out of the reach of the Sun and I think in no danger of any other Injury.' Lady Lucas was evidently out of London at the time, returning to town in the early autumn. Her diary entry for 11 October 1799 records: 'I was employ'd most part of the Morning in hanging up the Pictures bought from the Orleans Collection, & giving Directions about papering the first Book-Room below.'[102]

Lady Lucas's close personal involvement in the hang of her paintings makes especially valuable an inventory of her collection, undated but probably made soon after her death in 1833, incorporating wall elevation drawings showing precisely how the pictures were arranged. One of these drawings (fig. 16) shows the Le Sueur, numbered 24 in ink, apparently still in the square frame in which it had been delivered to St James's Square in 1799, in the centre of the lower tier of paintings hung on the north wall of the principal drawing room on the first floor, called 'The Great Room' in the inventory.

Fig. 16 Anonymous, elevation drawing of the north wall of The Great Room of 4 St James's Square, London, ?1833. Pen and black ink and pencil, drawing of north wall measuring 8 × 12.4 cm, reproduced by kind permission of Lord Lucas of Crudwell.

Its immediate neighbours as described in the inventory were: Van Dyck's *Portrait of Anne Kirk* above;[103] to the left, numbered 25 in ink on the elevation, a Guido *Head of Christ*, and to the right, numbered 22 in ink, 'a Parmiggiano [sic] *Madonna del Collo lungo*'.[104] From this it is clear that Lady Lucas's arrangement of the pictures was neither by genre nor by school. She nevertheless cared greatly for her pictures, whether bought or inherited, organising a campaign of cleaning and restoration, and carefully retaining receipts for the costs she so incurred. Among the several accounts from her picture cleaner William(?) Comyns is one dated 29 September 1813 relating to NG 6576.[105]

Fig. 15 Jean Restout, *Alexander and his Doctor*, 1747. Oil on canvas, 148 × 188 cm. Amiens, Musée de Picardie.

Fig. 17 Charles Natoire, *An Academy of Painting*, 1746. Black chalk, black ink and watercolour, 45.4 × 32.3 cm. London, Courtauld Institute of Art.

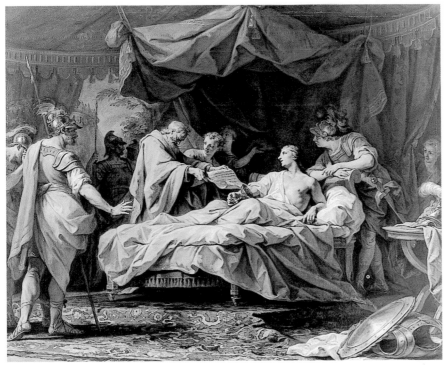

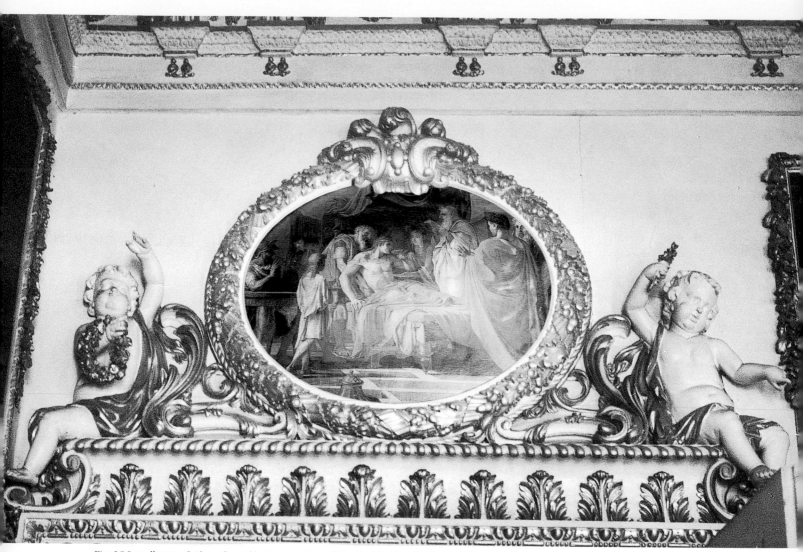

Fig. 18 Installation of *Alexander and his Doctor* when still in the Naval and Military Club in London.

Unfortunately, at the time that she bought the painting Lady Lucas did not record what it was she appreciated in NG 6576. It is reasonable to assume, however, that she shared the view of other admirers of the painting in the seventeenth and eighteenth centuries that it exemplified the representation of expression, as Guillet de Saint-Georges made explicit in his lecture to the Académie in which he spoke (inaccurately) of Phillip, who, 'cruelly agitated by what he had just read, raises his hands towards the heavens as witness to his innocence, and greatly annoyed to learn that there were those who wished to make him appear disloyal to his king, simultaneously finds in the latter an untroubled countenance and even an amused look. These various gestures are expressed with all the charm and vigour that one could wish.' It was Le Sueur's rendering of expression which appealed in particular also to l'abbé Leblanc in the mid-eighteenth century. Nevertheless, Leblanc acknowledged that some connoisseurs found Alexander's action and expression equivocal.[106] Perhaps it was awareness of such reported remarks that encouraged Henry Fuseli

(1742–1825) to express disdain for NG 6576 in his lecture V, *Composition, Expression*, written in 1802:

Perhaps no picture is, in spite of common sense, oftener quoted for its expression than Alexander sick on his bed with the cup at his lips, observing the culumniated [sic] physician. The manner in which he is represented is as inconsistent with the story as injurious to the character of the Macedonian hero. The Alexander of Le Sueur has the prying look of a spy. He who was capable of that look would no more have ventured on quaffing a single drop of the suspected medicine, than on the conquest of the Persian empire. If Alexander, when he drank the cup, had not the most positive faith in the incorruptibility of Philippus, he was more than an ideot [sic], he was a felon against himself and a traitour [sic] to his enemy, whose safety depended on the success of the experiment. His expression

ought to be open and unconcerned confidence – as that of his physician, a contemptuous smile, or curiosity suspended by indignation, or the indifference of a mind conscious of innocence, and fully relying on its being known to his friend. Le Sueur, instead of these, has given him little more than a stupid stare and vulgar form.[107]

During Lady Lucas's lifetime NG 6576 enjoyed a prominent position on the north wall of the principal room of her house at 4 St James's Square (fig. 16). It seems to have been shortly after her death in 1833, however, that her successor and nephew Lord de Grey (1781–1859) rendered the painting effectively invisible by incorporating it into an oval frame fitted over one of this room's doors some 12 feet above floor level (fig. 18).[108] The other overdoor was the stylistically unrelated *Continence of Scipio* by Jacopo Amigoni (fig. 19). It may not be entirely coincidental that in the decade or so preceding the relegation of NG 6576 to a minor decorative function Fuseli's

comments on it had been published several times.[109] At all events Le Sueur's picture, considered a copy by Blunt,[110] and unrecognised throughout the occupation of 4 St James's Square from 1947 until 1967 by the Arts Council of Great Britain, fell into obscurity until brought to the National Gallery's attention by Alastair Laing in 1991. Although French art critics were more familiar with Le Sueur's work than their English counterparts, and some may also have been familiar with 4 St James's Square during the Second World War when the Free French Forces had a canteen there, the circumstances were no doubt not conducive to art-historical investigation.[111]

General References

Louis Vitet, *Eustache Le Sueur. Sa vie et ses oeuvres*, Paris 1849, plate 65; L. Dussieux, 'Nouvelles recherches sur la vie at les ouvrages de Le Sueur', *AAF*, 2, 1852–3, pp. 1–124 at pp. 64, 97–8, 109 and 112; Gabriel Rouchès, *Eustache Le Sueur*, Paris 1923, p. 48; Mérot 2000, no. 79 and p. 480.

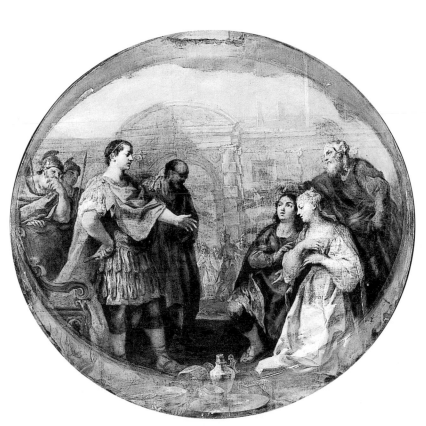

Fig. 19 Jacopo Amigoni (1685–1752), *The Continence of Scipio*. Oil on canvas, *c*.100 cm diameter. London, The Naval and Military Club. This photograph of the picture before its most recent cleaning shows the areas masked from earlier cleanings by the oval frame.

NOTES

1. Moana Weil-Curiel has kindly advised me (letters of 12 and 20 February 2001) that Jerôme de Nouveau's posthumous inventory of 10 September–23 October 1664 contains the following: 'dans la cheminée de la chambre qui est entre celle de Mme et la salle du balcon, appelée la chambre italienne... un tableau en rond peint sur toile représentant un malade dans un lit et autres personnages, lequel n'estoit en ladite cheminée lors de l'inventoire des meubles de ladite chambre, et depuis n'estoit prisés, estimé la somme de —— ' (A.N., M.C., CVIII, 147 10 IX 1665, fos 17V°–18r°). And see Guillet de Saint-Georges, 'Mémoire historique des ouvrages de M. Eustache Le Sueur, Peintre et l'un des douzes anciens de l'Académie – Lu à l'Académie le 5 août 1690', in *Mémoires inédits sur la vie at les ouvrages des membres de l'Académie Royale de Peinture et de Sculpture*, ed. L Dussieux et al., 2 vols, Paris 1854, vol. 1, pp. 147– 73, at pp. 158–9 quoted in note 39.

De Nouveau's hôtel was at what is now 12 place des Vosges, Paris: Isabelle Dérens and Moana Weil-Curiel, 'Répertoire des plafonds peints du XVIIᵉ siècle disparus ou subsistants', *Revue de l'Art*, 122, 1998, pp. 74–112 at p. 108, and Isabelle Dérens, 'No. 12 Hôtel de Castille, puis de Nouveau, de Dangeau et Le Tonnelier', *De la place Royale à la place des Vosges*, Paris 1996, pp. 331–9 at pp. 332–4.

2. The date of Audran's engraving – see Prints (1).

3. V. Champier and R.-G. Sandoz, *Le Palais-Royal d'après des documents inédits (1629–1900)*, 2 vols, Paris 1900, vol. 1, p. 297.

4. Sir James Thornhill, *A Notebook of a visit to France February–April 1717*, MS, National Art Library, Victoria and Albert Museum (Pressmark 86.EE.87/MSL 146[5]). For a discussion of this manuscript, see Françoise Mardrus, 'À propos du voyage de Sir James Thornhill en France. Remarques sur les tableaux de Poussin acquis par le Régent', *Poussin Colloque 1994*, vol. 2, pp. 809–33, and the publications cited by her at p. 825, n.1.

5. V. Champier and R.-G. Sandoz, cited in note 3, vol. 1, p. 521; and Mérot 2000, p. 231, who cites the call numbers in the Archives Nationales, Paris, of the first three inventories. The 1788 inventory accompanies a copy of a contract dated 21 October 1790 (Paris, Bibliothèque Nationale, Mss. Fr. 14845) between Nathaniel Parker Forth (1) on behalf of the duc d'Orléans, and James Christie (2) for the sale of the Orléans collection to Christie for 100,000 guineas. The contract was never completed: V. Champier and R.-G. Sandoz, pp. 445–7 and 506.

NG 6576 was also recorded at the Palais-Royal by Dubois de Saint-Gelais, *Description des Tableaux du Palais Royal*, Paris 1727, pp. 127–9 (2nd edn, Paris 1737, pp. 127–9); and it was noted by numerous writers of guidebooks and other compilations including [Le Rouge], *Les Curiositez de Paris*, 2 vols, Paris 1733, vol. 1, p. 166 (recorded in the Premier Cabinet, which housed also Poussin's second *Set of Sacraments*); [l'abbé Antonini], *Mémorial de Paris et de ses environs*, 2 parts, Paris 1749, part 1, p. 310 (recorded in the third room of the 'grands appartemens' on the chimney and

next to the door); Antoine-Nicolas Dezallier d'Argenville], *Voyage Pittoresque de Paris ou Indication de tout ce qu'il y a de plus beau dans cette grande Ville en Peinture, Sculpture, & Architecture*, Paris 1749, p. 72 (recorded in the third room 'd'enfilade au grand salon'); Dezallier d'Argenville 1762, vol. 4, pp. 116–17; 4th edn, Paris 1765, pp. 95–6 (recorded as in the 1749 edn); M. Hébert, *Dictionnaire pittoresque et historique*, 2 vols, Paris 1766, vol. 1 p. 351; [Papillon de la Ferté], *Extraits de différens ouvrages publiés sur la vie des peintres*, 2 vols, Paris 1776, vol. 2, p. 485; Hurtaut et Magny, *Dictionnaire historique de la Ville de Paris et de ses environs*, 4 vols, Paris 1779, vol. 3, p. 739; Thiéry, *Guide des amateurs et des étrangers voyagers à Paris*, 2 vols, Paris 1787, vol. 1, p. 256 (recorded in the 'troisième grande pièce'); J.J. Volkman, *Neueste Reisen durch Frankreich*, 3 vols, Leipzig 1787–8, vol. 1, p. 286 (recorded in 'Das dritte Zimmer [der Reihe]').

6. V. Champier and R.-G. Sandoz, cited in note 3, p. 447, and F. Boyer, 'Les collections de François de Laborde-Méréville (1761–1802)', *BSHAF*, année 1967 (1968), pp. 141–52.

7. *Diaries of Lady Amabel Yorke 1769–1827*, vol. 17, pp. 276–8. This confirms the price recorded in the National Gallery's copy of the sale catalogue. I am grateful to Frank Felsenstein for drawing my attention to these diaries, and to Brett Harrison for facilitating access to them.

8. Letter of 2 August 1799 and note of the following day, both to Lady Lucas from her agent Charles Ware of Gray's Inn: Wrest Documents, Bedfordshire Record Office, inv. nos L30/11/301/19 and L30/11/301/20. I am grateful to James Collett-White for supplying copies of these documents and for his advice.

9. I am grateful to Lord Lucas of Crudwell for lending this inventory and related papers to the National Gallery. The inventory is discussed further in the text.

10. The plasterwork in this room, of which the oval cartouche into which NG 6576 was fitted was a part, is evidently nineteenth-century Rococo revival. It was probably installed soon after the death of Lady Lucas by her heir, the architect Thomas Philip, 2nd Earl de Grey of Wrest, in view of Waagen's comment that 'the appartements in which [Lord de Grey's] collection is distributed are very magnificently decorated in the absurd style of Louis XV, which has lately come of age in England. This taste proves that the English often aim more at the rich and splendid, than a noble and beautiful effect': Waagen 1838, vol. 2, p. 393. Waagen writes of the collection in letter XXII dated 'London, August 18 [1835]'. See also S. Colvin, *A Biographical Dictionary of British Architects 1600–1840*, 3rd edn, New Haven and London 1995, p. 432, and my introductory essay.

11. M.J. McRobert, *Some Notes on the History of No. 4 St James's Square*, London 1951 (1964 reprint), pp. 18–19.

12. I am grateful to Claire McCarthy of Berwin Leighton and Hugh Woodeson of Hunters for advising me of these dates.

13. Mérot 2000, no. 80.

14. The citation is from the posthumous inventory of Eustache Le Sueur's eldest son, drawn up on 22 February 1695: see Mérot 2000, pp. 122, 232.

15. Mérot 2000, p. 232.

16. Victor Cousin, *Du Vrai, du Beau, du Bien*, 7th edn, Paris 1868, p. 468, and, for other references to this picture, see the works cited in Mérot 2000, p. 232.

17. Mérot 2000, p. 232.

18. Whether the elder Ercole Graziani (d.1726) or the younger (d.1765) is unclear.

19. For an illustration, see *Catalogue sommaire illustré des peintures du musée du Louvre et du musée d'Orsay. III, IV, V: Ecole française*, Paris 1986, vol. IV, p. 61.

20. M. Sapin, 'Précisions sur l'histoire de quelques tableaux d'Eustache Le Sueur', *BSHAF*, année 1984 (1986), pp. 53–88 at pp. 80–1. Sapin has proposed that this work be identified with a quite different composition attributed by Mérot to Charles Poerson (Mérot 2000, p. 232 and R.87), but to Le Sueur by B. Brejon de Lavergnée, N. De Reyniès and N. Sainte Fare Garnot, *Charles Poerson 1609–1667*, Paris 1997, pp. 211–12.

21. Henri Stein, 'La Société des Beaux-Arts de Montpellier (1779–1787)', *Mélanges offerts à M. Henri Lemonnier, AAF, (NP)*, vol. 7, 1913, pp. 365–403 at p. 397.

22. See Mérot 2000, p. 233.

23. For the provenance of these drawings, all noted by Mérot, see Mérot 2000, pp. 231–2, where they are catalogued respectively as nos D.207, D.208, D.209 and D.210. For the mention of another drawing in an 1859 sale, and of a sketch of NG 6576 by Gabriel de Saint-Aubin, see Mérot 2000, p. 232. For a drawing in the Louvre, Cabinet des Dessins, related to the painted rectangular treatment (see Related Works, Paintings (1)), see also Mérot 2000, p. 233.

24. The three volumes of *La Galerie du Palais-Royal* were published together in 1808, but the prints were made after drawings which Couché had made in 1786–91: F. Mardrus, 'La Galerie du Palais-Royal: mémoire de l'Art', *Destins d'objets*, ed. J. Cuisenier, Paris 1988, pp. 79–97 at p. 82.

25. Comyns's account is among the papers belonging to Lord Lucas of Crudwell presently on loan to the National Gallery.

26. NG 6576 was originally numbered '24' in this inventory.

27. Lady Lucas was created Countess de Grey of Wrest in 1816.

28. In compiling this paragraph I have used the *Dictionary of Greek and Roman Biography and Mythology*, ed. William Smith, 3 vols, London 1849–50, and *The Oxford Companion to Classical Literature*, 2nd edn, ed. M.C. Howatson, Oxford 1989, 5th impression (with corrections) 1993.

29. Diodorus Siculus, however, does not mention Parmenion's warning letter.

30. See note 1 above.

31. '...Quand l'heure de prendre la medicine fut venuë, Philippus entra dedans la chambre avec les autres privez amis du Roy portant en sa main le gobelet où estoit la medicine. Alexandre adonc luy donna la lettre, & prit l'au mesme instant le gobelet de la medicine franchement, sans monstrer qu'il eust doute ny soupçon de rien. Si fut chose esmerveillable, & qu'il faisoit fort bon voir, que l'un d'un costé lisant la lettre, & l'autre beuvant le breuvage en mesme temps, & de considerer comme ils jetterent tous deux ensemble les yeux l'un sur l'autre, mais non pas avec une mesme chere: mais Alexandre avec un visage riant & ouvert, tesmoignant la confiance qu'il avoit en son medecin Philippus, & l'amitié qu'il luy portoit: l'autre avec contenance d'un homme qui se passionnoit & se tourmentoit pour ceste fausse calomnie qu'on luy avoit mise sus...': *Les vies des hommes illustres grecs et romains... Traduites de grec en françois par Iacques Amyot*, 2 vols, Paris 1645, pp. 130–1. A copy is in the British Library (136.f.2, 3).

32. 'Par hazard Alexandre receut cette nouvelle comme on luy apporta la medicine; mais sans témoigner aucune défiance d'une personne qu'il aimoit, il luy donna la lettre d'une main, & prit le breuvage de l'autre; de sorte qu'en mesme temps l'un beuvoit & l'autre lisoit, celuy-ci témoignant assez à son visage et à sa contenance, qu'il étoit innocent.': *Les Guerres d'Alexandre par Arrian de la Traduction de Nicolas Perrot, Sieur d'Ablancourt*, Paris 1654, pp. 50–1. The first edition of this book was published in 1646: see *Dictionnaire de Biographie Française*. It was dedicated to Louis de Bourbon (1621–86), duc d'Enghien (and later prince de Condé), as was the 1645 edition of Amyot's translation of Plutarch. Enghien won a celebrated victory over the Spanish at Rocroi in 1643, a fact which may help to explain the vogue for translations of the story of Alexander at this time. Significantly Jean Puget de La Serre's *Les Parallèles d'Alexandre le Grand et de Monseigneur le duc d'Anguien*, which made the parallels between the two generals explicit, was published in 1645: J.C. Boyer, *Le peintre, le roi, le héros. L'Andromède de Pierre Mignard*, Paris 1990, p. 103.

33. 'Alexandre ayant veu ces letres, les donna à lire à Philippe, & prit cependant de sa main la medicine qu'il avala.': *Valerie Maxime*, 2 vols, Paris 1647, pp. 282–4.

34. 'Luy entra, portant le breuvage entre ses mains dedans un gobelet. Quand Alexandre l'apperceut, il leva le corps tout entier & se mit sur son coude, & tenant d'une main la lettre de Parmenion, il prit de l'autre la medicine qu'il avala sans marchander, & puis presenta la lettre à Philippe, & luy commanda de la lire, & pendant qu'il la leut il n'osta point les yeux de dessus luy, s'asseurant bien de recognoistre sur son visage des temoignages de sa conscience. Philippe l'ayant leuë toute entiere monstra plus de colere que de peur.': *Histoire d'Alexandre le Grand. Escrite par Q. Curse, chevalier romain. Traduction nouvelle*, Rouen 1650.

35. V. Fournel, 'Vaugelas', *Nouvelle Biographie Générale*, ed. Hoefer, vol. 45, 1866, pp. 1026–8.

36. '... fixant les yeux sur lui pendant qu'il lisait, il cherchait sur son visage quelque indice qui lui découvrit le sentiment intérieur de son âme.'

Another ancient account of the incident of Alexander and his doctor is contained in Justinus' *Epitome of the Philippic History of Pompeius Trogus*, numerous editions of which were published in Latin from 1470. I have traced only one translation into French made before Le Sueur's death, that by Claude de Seyssel, Bishop of Marseille (Paris 1559). Justinus recounts that Alexander 'took the cup, handed the letter to the doctor and, as he drank, gazed intently at the man's face while he read. When he saw Philip unperturbed, his spirits rose and he recovered three days later.' (Book II: 8, 5–9, trans. from the Latin by J.C. Yardley, *Epitome of the Philippic history of Pompeius Trogus*, Oxford 1997, p. 49).

37. See Quintus Curtius, *History of Alexander*, with English translation by J.C. Rolfe, 2 vols, London and Cambridge, Mass, 1952; for Freinsham, see vol. 1, p. ix.

38. See, for example, Blunt 1958, pp. 160ff. For the appeal of stoicism in mid-seventeenth-century Paris, see Le Roy Ladurie 1996.

39. 'Il fit aussi pour M. de Nouveau un tableau particulier qui eut beaucoup d'estime; il y a traité une circonstance de l'histoire d'Alexandre rapportée par Plutarque, et qui prouve que ce conquérant intrépide bravoit la mort sous quelque apparence qu'elle se présentât à lui. Ce prince, gardant le lit pour une dangereuse maladie et se disposant à prendre médecine, reçoit une letter que Parménion lui a écrite pour l'avertir que son médecin Philippe Acarnanien, corrompu par les riches presents de Darius et par l'espérance d'épouser sa fille, a résolu de l'empoisonner avec un breuvage.

'Alexandre, toujours inébranlable, voit en même temps venir le médecin Philippe qui, étant accompagné des principaux de la cour, lui présente la coupe où est la médecine. Ce prince, sans se rebuter, reçoit la coupe, donne la letter de Parménion à Philippe, et prend la médecine en jetant ses regards sur le médecin qui, cruellement agité de ce qu'il vient de lire, lève les mains au ciel, comme le prenant à témoin de son innocence, et très irrité de voir qu'on le veut render suspect à son roi, lui trouve en même temps le visage tranquille et même un air souriant. Ces divers mouvements sont exprimés dans le tableau avec toute la grace et la force qu'on y peut souhaiter.': Guillet de Saint-Georges, cited in note 1, vol. 1, pp. 158–9.

40. On other works in French concerned, at least in part, with this question, see Jennifer Montagu, *The Expression of the Passions. The Origin and Influence of Charles Le Brun's Conférence sur l'expression générale et particulière*, New Haven and London 1994, pp. 17 and 156.

41. Evidently, NG 6576 was criticised by some during the eighteenth century. See [L'abbé Leblanc], *Lettre sur l'exposition des ouvrages de peinture, sculpture, &ca de l'Année 1747*, Paris 1747, pp. 36–7.

42. A. Pigler, *Barockthemen*, 2 vols, Budapest 1974, p. 360, includes among paintings of

the subject a lost picture said to be by Poussin, once in the Palazzo Falconieri and catalogued as no. L48 in Blunt 1967. However, there is no reason to connect this picture with Poussin.

43. *Mémoires inédits*, ed. L. Dussieux, cited in note 1, vol. 1, p. 130.

44. B. Brejon de Lavergnée et al., cited in note 20.

45. See Erich Schleier, 'Un nuovo dipinto del Lanfranco e la sua attività giovanile', *Paragone*, 177, 1964, p. 14, n. 28; idem, 'Domenichino, Lanfranco, Albani and Cardinal Montalto's Alexander Cycle', *AB*, 50, 1968, pp. 188–93; idem, 'Le "storie di Alessandro Magno" del Cardinale Montalto', *Arte Illustrata*, V, no. 50, 1972, pp. 310–20, and Catherine R. Puglisi, *Francesco Albani*, New Haven and London 1999, no. 45. One of the three known copies after Lanfranco's picture, that at Lamport Hall, near Northampton, was not made until 1677–8 (Schleier 1964, op. cit.) and so could not have been known to Le Sueur.

46. N. Turner, 'Lanfranco at the Farnesina', *BM*, 126, 1984, pp. 177–81 at p. 178.

47. As Sonja Brink has kindly advised me (letter of 18 January 2000), it was bought in Rome by Lambert Krahe, who returned with it and several thousand other drawings to Düsseldorf in 1756. Another drawing, this by Polidoro da Caravaggio, which also has some compositional similarities to NG 6576 and which was sold in 1963 as representing Alexander and his Physician (Sotheby's, 12 March 1963, lot 21; now in Washington, National Gallery of Art, David E. Rust collection) is not recorded as ever having been in France. It is connected to a fresco in the Palazzo Melchiorre Baldassini, Rome, of an unidentified death-bed scene, itself by Polidoro or by Perino del Vaga (see L. Ravelli, *Polidoro Caldera da Caravaggio*, Bergamo 1978, no. 52, and E. Parma Armani, *Perin del Vaga. L'anello mancante*, Genoa 1980, p. 34 ff. and figs 35, 36). I am grateful to Jennifer Montagu for bringing Polidoro's drawing to my attention. I am not aware of any engraving after it or after the fresco.

48. For the numerous painted copies after Poussin's work, see Paris 1994, p. 156.

49. As suggested in A. Mérot and H. Wine, ' "Alexander and his Doctor": a rediscovered masterpiece by Eustache Le Sueur', *BM*, 152, 2000, pp. 292–6.

50. The influence of Raphael's composition of *Isaac and Esau* was suggested by Gabriel Rouchès, *Eustache Le Sueur*, Paris 1923, p. 49.

51. See G. Bernini Pezzini, S. Massari and S. Prosperi Valenti Rodinò, *Raphael Invenit. Stampe da Raffaello nelle collezioni dell'Istituto Nazionale per la Grafica*, Rome 1985, pp. 77–80 and 386–95. A similar table is also in Lanfranco's engraving of the episode of *David and Samuel*: ibid., p. 393, no. 40. The source of the Raphael composition was possibly the antique relief of *Bacchus visiting the Poet Icarius* (London, British Museum), on which see Bober and Rubinstein 1986, pp. 122–4. The composition of *Isaac blessing Jacob* was also engraved (with some variations) by

Agostino Veneziano in 1524 (G. Bernini Pezzini et al., op. cit., p. 73). Both the *Isaac blessing Jacob* and the *Isaac and Esau* were engraved by Baldassare Aloisi Galanini in 1613 (ibid., pp. 80–1) and by Orazio Borgianni in 1615 (ibid., pp. 82–4).

52. The pose of Alexander in the Montpellier drawing is also quite close to that of the River Tigris, a statue installed by Michelangelo on the Campidoglio, Rome, of which an engraving (in reverse) was included in François Perrier's *Segmenta nobilium signorum et statuarum quae Romae adhuc exstant*, Rome 1638, but this is probably just coincidental. On this statue, see Bober and Rubinstein 1986, pp. 101–2 and pl. 65A.

53. Bernini Pezzini et al., cited in note 51, pp. 86–9 and 416–25.

54. E. Schwarzenberg, 'From the *Alessandro Morente* to the Alexandre Richelieu. The Portraiture of Alexander the Great in Seventeenth-Century Italy and France', *JWCI*, 32, 1969, pp. 398–405. According to Schwarzenberg, the seventeenth century recognised two other 'portraits' of Alexander, a cameo from the Gonzaga collection and a head of Helios (Rome, Capitoline Museum). The former shows Alexander lightly bearded, and the latter with a leonine head of hair. The identity of the male figures in the *Dioscuri* as Alexander was a matter of published dispute in the 1630s (see Haskell and Penny 1981, p. 136), and so would have represented an inappropriate model.

55. On Fulvio's book and the portrait of Alexander, see N. Hadjinicolaou in *Alexander the Great in European Art*, Institute for Mediterranean Studies, 22 September 1997– 11 January 1998 (and the illustration on p. 163 of the Greek language edition).

56. See *The Illustrated Bartsch*, vol. 26, no. 207.

57. See Plutarch, *Lives. Demosthenes and Cicero, Alexander and Caesar*, with English translation and an introduction by B. Perrin, London and Cambridge, Mass., 1919, *Alexander*, book IV, 1–2.

58. See Quintus Curtius, cited in note 37, p. 6.

59. For this treatment of *Extreme Unction* and for *The Testament of Eudamidas*, see the catalogue entries by P. Rosenberg in Paris 1994–5, nos 107 and 139.

60. I am grateful to Elizabeth Miller and Michael Snodin for drawing my attention to Testa's print and to the similarities of detail between it and NG 6576. For an account of the print, see E. Cropper, *Pietro Testa 1612–1650. Prints and Drawings*, exh. cat., Philadelphia and Cambridge, Mass. 1988–9, pp. 245–9. Cropper incorrectly describes the table as goat-footed (p. 246).

61. Michael Snodin has advised that the burner in the painting 'is a recreation of an Antique object as no such objects survive, the form is adapted from stone vases of the cinerary urn type, but that it is very generalised and much more likely to be derived from print sources' such as the Testa, and one reproduced in W. Oeschslin and O. Bätschmann, *Die Vase*, exh. cat.,

Kunstgewerbe Museum der Stadt Zuerich, Museum fur Gestaltung, 9 September– 14 November 1982, p. 8, showing comparable curly legs (letter of 10 May 2000).

62. Mérot 2000, no. 71.

63. Ibid., no. 75.

64. Ibid., no. 54.

65. Le Sueur's precise application of the concept of perspective to a flat surface was probably due to the influence of Abraham Bosse, who started teaching perspective at the Académie de Peinture et de Sculpture soon after it opened in 1648, and who that year published *Maniere universelle de M. Desargues pour pratiquer la perspective par petit pied comme le geometral*, which included a plan of perspective construction not unlike the perspective lines on the drawing of *Saint Bruno revealing a Conspiracy to Count Roger* (see Mérot 2000, no. D 143). In his *Sentimens sur la distinction des diverses manieres de peinture, dessein & gravure* published the following year, Bosse insisted on the fundamental importance of geometry in the construction of picture space.

66. Dérens 1996, cited in note 1, pp. 332–4.

67. M.A. Fleury, *Documents du Minutier Central concernant les peintres, les sculpteurs et les graveurs au XVII*ᵉ *siècle (1600–1650)*, vol. 1, Paris 1969, p. 192.

68. Ibid., p. 676, and Dérens 1996, cited in note 1, pp. 333–4.

69. During the Fronde there was a move to have De Nouveau replace Michel Le Tellier as Secrétaire de la Guerre, but it came to nothing. J.F.P. de Gondi, *Mémoires*, ed. G. Mongrédian, Paris 1935, vol. 4, pp. 17–18.

70. See note 1.

71. Dérens 1996, cited in note 1, pp. 334–5.

72. On these, see Mérot 2000, nos 108, 109.

73. On these, see Mérot 2000, no. 18, although as Dérens (Dérens 1996, cited in note 1, pp. 333–4) has pointed out, these ceiling paintings could not have been installed in De Nouveau's hôtel as early as 1639 since he only bought it in 1645–6. Prior to that he lived in the rue de Berry: M.A. Fleury, cited in note 67, pp. 192, 676.
For De Nouveau's commission for a ceiling painting from Charles Le Brun in 1650, see Jennifer Montagu, 'Oeuvres de Charles Le Brun', *Etudes de la revue du Louvre. I. La donation Suzanne et Henri Baderou au musée de Rouen. Peintures et dessins de l'Ecole Française*, Paris 1980, pp. 41–4, and P. Rosenberg and F. Bergot, *French Master Drawings from the Rouen Museum. From Caron to Delacroix*, exh. cat., Washington DC 1981–2, no. 65.

74. Félibien, *Entretiens 1688*, p.37. Not too much reliance, however, should be put on Félibien's chronological accuracy at this point, firstly because he was in Rome from May 1647 until August 1649, and secondly because, immediately after the passage referring to De Nouveau, he states wrongly that Le Sueur's *Saint Paul preaching at Ephesus* was painted for Notre-Dame in 1650, whereas it is signed and dated 1649.

75. Alain Mérot has recently dated NG 6576 'vers 1648–50': Grenoble 2000, no. 30 bis.

76. See note 1. Charles Le Brun was evidently familiar with NG 6576 when planning his own (never executed) rendering of the subject of Alexander and his Doctor as part of the series of pictures on the history of Alexander which he painted in the 1660s, suggesting that NG 6576 was then still in Paris. I am grateful to Jennifer Montagu for drawing my attention to this element of Le Brun's project. For drawings connected with it, see L. Beauvais, *Musée du Louvre, Département des arts graphiques. Inventaire générale des dessins. École française, Charles Le Brun 1619–1690*, 2 vols, Paris 2000, vol. 1, nos 1898–1900.

77. J.F.P. de Gondi, cited in note 69.

78. Guillet de Saint-Georges, cited in note 1.

79. F. Le Comte, 1699–1700. For De Nouveau's inventory see note 1.

80. On this, see Dérens 1996, cited in note 1, pp. 334–6.

81. On the formation of Philippe d'Orléans's picture collection, see Françoise Mardrus, 'Le Régent, mécène et collectionneur', *Le Palais Royal*, exh. cat., Musée Carnavalet, Paris 1988, pp. 78–143 at pp. 95–8. The date *c*.1706 for Orléans's purchase of NG 6576 would be consistent with its having been acquired through Pierre Crozat, who took up permanent residence in Paris shortly after 1700: M. Stuffman, 'Les tableaux de la collection de Pierre Crozat. Historique et destinée d'un ensemble célèbre, établis en partant d'un inventaire après décès inédit (1740)', *GBA*, 72, 1968, pp. 11–144 at p. 14.

82. See note 5.

83. See note 4.

84. Elizabeth Johnston, 'Joseph Highmore's Paris Journal, 1734', *Walpole Society*, vol. 42, 1968–70, pp. 61–104 at pp. 78–9. In 1760 Highmore commented that the subject of NG 6576 was an episode 'where the principal incidents are crowded into a moment, and are, as it were, instantaneous, there is room for the display of the painter's skill': *The Gentleman's Magazine*, vol. 36, 1766, pp. 354, 356.

85. See F. Mardrus, cited in note 4, pp. 813–16. The hang in the Cabinet des Poussin effectively rebuts Mathieu Marais's scathing comment about Philippe d'Orléans: 'Les connoisseurs sont étonnés de ce qu'avec ce goût pour la peinture, il n'en a aucun pour l'arrangement, mettant un tableau de dévotion auprès d'une nudité, un tableau de grande architecture auprès d'un paysage, et ainsi du reste. Il ne se plaît qu'à en amasser beaucoup.': *Journal et mémoires de Mathieu Marais avocat au parlement de Paris sur la régence et le règne de Louis XV (1715–1737)*, ed. M. de Lescure, 2 vols, Paris 1864, vol. 2, p. 465 (entry for 11 June 1723).

86. F. Mardrus, cited in note 4, pp. 813–16.

87. Ibid., pp. 816–17 and p. 827, n. 30.

88. See [L'abbé Antonini], *Mémorial*, cited in note 5.

89. Nathalie Volle in *De Watteau à David. Peintures et Dessins des musées de provinces français*, exh. cat., Palais des Beaux-Arts, Brussels 1975, no. 63, p. 100. On Restout's painting and comparison between it and NG 6576 on its exhibition in 1747, see Christine Gouzi, *Jean Restout 1692–1768 peintre d'histoire à Paris*, Paris 2000, pp. 283–4.

90. C. Grell and C. Michel, *L'Ecole des Princes ou Alexandre disgrâcié. Essai sur la mythologie monarchique de la France absolutiste*, Paris 1988, p. 127.

91. Nathalie Volle, *Jean-Simon Berthélemy (1743–1811) Peintre d'histoire*, Paris 1979, no. 123, pp. 108–9; Marc Sandoz, *Jean-Simon Berthélemy 1743–1811*, Paris 1979, no. 16, p. 80.

92. See *La Gazette de l'Hôtel Drouot*, 17 December 1999, p. 90.

93. Marc Sandoz, *Les Lagrenée I.- Louis, Jean, François Lagrenée 1725–1805*, Paris 1983, no. 408, p. 296. It is perhaps also worth noting that Du Vivier made a medal of the subject of Alexander and his Doctor for the Faculté de Médecine in 1781: C. Grell and C. Michel, cited in note 90, p.127.

94. See G. Kennedy and A. Thackray, *French Drawings XVI–XIX Centuries*, exh. cat., Courtauld Institute Galleries, 4 July–6 October 1991, no. 35. For the autograph replica of the Courtauld drawing in Montpellier which bears the date '1745', see *Petits et Grands Maîtres de Musée Atger. Cent dessins français des 17ème et 18ème siècles*, exh. cat., Bibliothèque Interuniversitaire de Montpellier 1996, no. 35. Natoire was in Paris during 1745/6. Perhaps his use of Le Sueur's composition in reverse is indicative of Audran's print after it

being one of the standard works copied by students at the Académie.

95. I am grateful to Christian Michel for this suggestion, made when we looked at NG 6576 together in Grenoble.

96. See P. Grunchec, *Les concours des Prix de Rome 1797–1863*, 2 vols, Paris 1989, vol. 2, pp. 40–1.

97. See ibid., pp. 168–70. The Académie's instructions to its students were clearly based on Plutarch's account: ibid., p. 294, n. 23.

98. On this, see C. Grell and C. Michel, cited in note 90, p. 126, and J.J. Rousseau, *Émile*, trans. B. Foxley, intro. by P.D. Jimack, London 1993, pp. 88–9.

99. 'De tous les tableaux de Lesueur qui sont en Angleterre, celui que nous regrettons le plus de n'avoir pu voir est *Alexandre et son médecin* peint pour M de Nouveau, directeur général des postes...': Victor Cousin, *Cours de philosophie professé à la Faculté des lettres pendant l'année 1818... sur le fondement des idées absolues du vrai, du beau et du bien; publié... d'après les meilleures rédactions de ce cours par M Adolphe Garnier*, 7th edn, Paris 1858, p. 468. Cousin visited England in 1853, and, in spite of the title of his book, it is likely that this was the visit to which he was referring: see his 'De divers tableaux du Poussin qui sont en Angleterre et particulièrement de l'Inspiration du Poète', *AAF*, vol. 3, 1853–5, pp. 3–18.

100. See Provenance for further details.

101. *Diaries of Lady Amabel Yorke 1769–1827*, cited in note 7, vol. 5, fo. 231.

102. See notes 7 and 8.

103. This was one of a dozen pictures in the Great Room which had been bought in the late seventeenth century by Anthony Grey, 10th Earl of Kent.

104. For some additional information on the Van Dyck and the paintings attributed to Guido Reni and Parmigianino, see A. Mérot and H. Wine, cited in note 49, at p. 294 and p. 294, nn. 20–2.

105. Quoted above in Technical Notes.

106. L'abbé Leblanc, cited in note 41.

107. *Fuseli's lectures*, London 1830, pp. 63–4. NG 6576 nevertheless had defenders: see William Hayley, *The Life of Sir George Romney, Esq.*, London 1809, pp. 34–5.

108. See note 10.

109. Fuseli's lecture V was first published in 1820: *Henry Fuseli 1741–1825*, exh. cat., Tate Gallery, London 1975, p. 48. The lectures were republished in 1830, and again in 1831 as part of John Knowles's *The Life and Writings of Henry Fuseli*, 3 vols, London 1831.

110. Anthony Blunt, 'Poussin and his Roman Patrons', *Walter Friedländer zum 90. Geburtstag*, Berlin 1965, pp. 58–75, p. 70.

111. M.J. McRobert, *Some Notes on the History of No. 4 St James's Square*, London 1951 (1964 reprint), pp. 18–20, states that the Free French HQ was there, but it was in fact at 4 Carlton House Gardens (see John Reed, 'London's Wartime Headquarters', *After the Battle*, 37, August 1982, pp. 37–51 at p. 40) and only a Free French canteen was at 4 St James's Square (Philip Ziegler, *London at War 1939–1945*, London 1995, p. 93). I am grateful to Sally Korman for clarifying this point.

Pierre Mignard
1612–1695

Mignard was born in Troyes and studied initially in Bourges under Jean Boucher. He entered Simon Vouet's studio in 1633, leaving it in 1635 to go to Italy, where he remained for twenty-two years. In Italy he forged a lasting friendship with Charles-Alphonse Dufresnoy, a painter and later a writer on art. Among the portraits Mignard painted in Rome are *The Children of the duc de Bouillon* (Honolulu, Academy of Arts, 1647) (the duc de Bouillon commissioned Claude NG 12 and Claude NG 14) and *Pope Alexander VII* (whereabouts unknown). Besides portraits, Mignard produced a number of pictures of the Virgin and Child, punningly known as 'Mignardes' because of their delicate style and sentiment, and, particularly later in his career, multi-figured history paintings, such as *The Carrying of the Cross* (Paris, Louvre) of 1684. He also created decorative schemes. Most of these are now destroyed, but his decoration of the cupola of the church of the Val-de-Grâce (1663–6), incorporating some two hundred figures, survives. Although in his *Self Portrait* of 1690 (Paris, Louvre) Mignard shows himself as a history painter, with Michel Corneille's grisaille copy of his Val-de-Grâce decoration in the background, he was most in demand as a painter of portraits, NG 2967 being among his finest.

Mignard was the great rival of Charles Le Brun, chancellor then rector of the Académie Royale de Peinture et de Sculpture, and never joined the Académie during Le Brun's lifetime. On the latter's death in 1690, Mignard was appointed the Académie's rector as well as Premier Peintre du Roi. The year after Mignard died, his daughter Catherine married the Count of Feuquières. It was her papers that provided the basis for de Monville's *La Vie de Pierre Mignard Premier Peintre du Roi* (Paris 1730), the first book devoted to the life of a French artist to be published.

NG 2967
The Marquise de Seignelay and Two of her Sons

Oil on canvas, 194.5 × 154.4 cm
Signed and dated bottom right: P.MIGNard/PINXIT. 1691

Provenance
Collection of Quintin Craufurd (1743–1819), his posthumous sale, Paris, 20–21 November 1820, Delaroche & Paillet (lot 162, 299.95 francs(?) to Dalbatre);[1] collection of Sir Richard Wallace (1818–90) of Paris and London by 1874, probably after 1870;[2] by inheritance to Lady Amélie Julie Charlotte Wallace (née Castelnau) (1819–97) in 1890 when recorded at no. 2 rue Laffitte, Paris;[3] inherited from her by Sir John Edward Arthur Murray Scott (1843–1912), who bequeathed NG 2967 (among other paintings all then in Paris) to the National Gallery,[4] which was advised of the bequest in 1914 and accepted it that year, agreeing to pay French Mutation Duty of 7780 francs.[5]

Exhibitions
Paris 1874, Palais de la Présidence du Corps Législatif, *Exposition au profit de la colonisation de l'Algérie par les Alsaciens-Lorrains* (931) (as 'Portrait en pied d'une princesse et de ses enfants'); Paris 1888, *Exposition de l'Art Français sous Louis XIV et sous Louis XV au profit de l'Oeuvre de l'Hospitalité de nuit* (27); London 1956–76, Lancaster House on long-term loan to the Government Art Collection; Montreal 1981, *Largillierre and the French 17th Century Portrait* (7).

Technical Notes
The condition is generally good apart from some minor wear, particularly in the older child's hair. What appear as vertical staining or wear, mostly in the sea and the sky, are traces of an earlier composition (see below). There has been some fading in the red lake of the older child's cloak.

The primary support consists of two pieces of plain-weave canvas joined vertically some 41 cm from the right-hand edge. This support was relined sometime before the Gallery's acquisition of the painting, probably during the nineteenth century. The stretcher, which bears a circular stamp MOMPER/PARIS is also probably nineteenth century.[6] NG 2967 was last restored in 1956.

Cross-sections have shown that the painting has a double ground consisting of a rich mid-brown lower layer and a mid-pink upper layer. Double grounds are usual in French seventeenth-century paintings, but typically consist of orange, red or brown ochreous first layers with a second priming of grey, grey-brown or light brown over them. The particular composition of lead white mixed with crystalline mineral red

iron oxide for the lower layer, and fine red earth mixed with a large proportion of lead white for the upper layer, as found in NG 2967, may, however, be typical of paintings by Mignard.[7] It may be the way in which the ground was applied, probably with a spatula, that has caused the vertical streaks visible on the surface of the painting, but from the infra-red photograph (fig. 1) it seems more likely that there were once three columns in the background and a small ketch to the left of them.

The intense blue of the marquise's cloak is painted in ultramarine of the highest quality, while smalt has been used in the sea and azurite in the boy's breeches – in both cases mixed with other pigments. The glaze on the younger child's red drapery contains a cochineal-based red lake pigment. The paint medium has been identified as walnut oil.[8]

Pentimenti are visible to the position of the younger child's right foot, at the top of his quiver and to the outline of the marquise's right shoulder. It seems from the X-radiograph that the marquise's hand holding the locket was originally painted slightly higher and 2–3 cm to the left, and that it was not holding any pearls. The X-radiograph also shows that the lace of the marquise's dress was originally lower and revealed her right breast.

Fig. 1 Infra-red photograph.

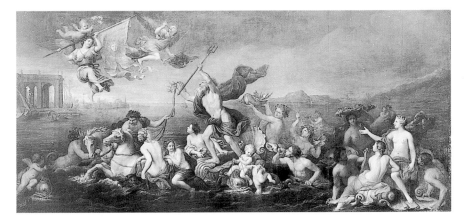

It is rare for the Gallery's Trustees to overrule the Director over the acquisition of a painting. This, however, is what occurred in the case of NG 2967. Following his visit to Paris with J.P.H. Heseltine in 1914 to see the painting (and the others in Murray Scott's bequest), the then Director of the National Gallery, Charles Holroyd, noted it as 'a large cold picture dull in composition & colour but well painted; a fair example of this dull painter. *I recommend that it be declined.* If accepted, it could only be hung downstairs.'[9] Holroyd's attitude may have been influenced by the fact that, as far as he was aware, the portrait's subjects were unknown. The description of the picture in the letter from Murray Scott's executors' solicitors to the Gallery, itself quoting from Murray Scott's will, dated 26 October 1900, called it 'Portrait of a Queen with sin (sic!) and Cupid by Mignard'.[10]

Murray Scott's description is surprising, given that the sitters had been identified by Mantz in 1874 (by reference to the abbé de Monville's biography of Mignard, first published in Paris in 1730) as Madame de Seignelay and her two sons.[11] The painting had also been so published by M.J.J. Guiffrey in 1875, as well as being exhibited as such in Paris in 1888 (see Exhibitions).[12] However, the question of the mythological guises in which Madame de Seignelay and her companions appeared seemed not then to have been settled. De Monville, on whom Mantz had relied, had been quite clear: '[Mignard] painted among others Madame de Seignelay and her two sons full length in the same picture; Madame de Seignelay, who has the younger of them by her as Cupid, is shown as Thetis with all the attributes of the sovereign queen of the seas; and her elder son is painted as Achilles: the sea forms the picture's background.'[13] However, on the occasion of the picture's exhibition in Paris in 1888, the marquise and her elder son were said to be in the roles of Amphitrite and Mars. When NG 2967 first appeared in a National Gallery catalogue, its compiler – presumably Holroyd – identified the marquise as Amphitrite and the younger child as Cupid, but called the elder child 'a boy who stands as a Roman Warrior'.[14]

The current mythological identification of the figures, in accordance with de Monville's description, was first adopted by the Gallery in 1929[15] and has not been questioned since, but only in 1946 were the two children in the portrait acknowledged by the Gallery as sons of the marquise.[16] Since de Monville claimed that his biography of Mignard was based on the recollections of the painter's cherished daughter, Catherine, who was then still alive, it seems reasonable to rely on it, at least so far as the identification of the principal sitter as Madame de Seignelay is concerned.[17] However, in one respect de Monville's biography is inaccurate, because the marquise had five sons, not two, and it is unclear which two are represented.[18] This also raises the question of whether de Monville correctly identified the sitter's mythological guises, but before considering this, some account of the marquise herself seems appropriate.

Catherine-Thérèse de Matignon-Thorigny, marquise de Lonrai (1662–99), was the younger daughter of Henri de Goyon-Matignon, comte de Thorigny, and Marie-Françoise Le Tellier. Henri de Goyon-Matignon (1633–82) became governor of Cherbourg and, like other members of his family, followed a military career. In 1679 Catherine-Thérèse married, as his second wife, Jean-Baptiste-Antoine Colbert (1651–90), marquis de Seignelay and eldest son of the great Colbert (1619–85).[19] After learning the principles of sailing in 1670, Seignelay toured Europe the following year, visiting Provence to learn about the Levant trade, Italy to study the fine arts, and Holland and England to look at shipyards. In 1676 he was appointed Minister of the Marine, and in 1683, on the death of his father, he became Secretary of State at the Marine. As such he developed the French fleet to the height of its power under Louis XIV. He also, however, saw active service, directing operations in naval battles with the English as well as the naval bombardments of Genoa and Algiers.[20] As Secretary of State at the Marine, Seignelay was in constant rivalry with the marquis de Louvois (1641–91), Secretary of State for War and the most powerful of Louis XIV's ministers after the death of Colbert. This rivalry, known as the 'debate between the Earth (i.e. Louvois) and Seas (i.e. Seignelay)' also found expression in Seignelay and Louvois competing to patronise Mignard, and it was presumably with Seignelay's encouragement that in 1684 the artist painted for Louis XIV at Versailles *Neptune offers the Empire of the Sea to the King* (Compiègne, Musée National du Château; fig. 2), as an allegorical homage from Seignelay to his monarch.[21]

As well as being an admirer of Mignard,[22] Seignelay was a collector of old masters on a lavish scale.[23] Indeed, his whole style of living was distinguished by its magnificence,[24] which seems to have suited Catherine-Thérèse well. According to

Saint-Simon she was a tall, good-looking woman whose excessive pride was sustained by that of her husband and by 'his opulence, his magnificence, his authority in the [King's] council and his position'.[25] When Seignelay died in 1690, she was, according to Madame de Sévigné, inconsolable,[26] but, and this also according to Saint-Simon, 'she was consumed with desire for a rank and another name although she had several children'.[27] Jilted by the duc de Luxembourg after all the arrangements for her wedding to him had been made, Catherine-Thérèse found another man to give her the rank she felt her due and, it seems, a better home than Luxembourg could have done.[28] This was Charles de Lorraine-Armagnac, comte de Marsan and Grand Ecuyer de France, whom she married quietly in Paris in 1696.[29] She died three years later.

Catherine-Thérèse had had five sons by her marriage to Seignelay: Marie-Jean Baptiste (1683–1712), Paul-Edouard (1686–1756), Louis-Henri-Charles (1687?–1705?), Charles-Eléonore (d.1740) and Théodore-Alexandre (1690?–95?).[30] The three sons who survived into adulthood all followed military careers rather than, as might have been expected, careers in the navy.[31]

Portraits in allegorical, mythological or historical guise were common in both the seventeenth and the eighteenth centuries. Mignard, for example, painted various ladies of the court as goddesses for the decoration of the Petits Appartements du Roi at Versailles.[32] This fashion in portraiture presumably required a degree of learning on the part of painters, who were no doubt happy enough to display it. However, neither the choice of Amphitrite nor that of Thetis seems entirely appropriate to the marquise de Seignelay – although portraitists did not always make appropriate choices in this regard.[33] Certainly, Amphitrite, as the wife of Poseidon, was goddess of the sea and as such would clearly have alluded to the position of the marquis as Minister of the Marine. It is also true that, given the frequent identification of the Greek god Poseidon with the Roman god Neptune, Catherine-Thérèse's portrayal as Amphitrite would have fitted neatly with the message of Mignard's earlier *Neptune offers the Empire of the Sea to the King* at Versailles. However, if Catherine-Thérèse was Amphitrite, her son by Seignelay/Poseidon would have been Triton, who, besides living at the bottom of the sea, was always shown with the lower body of a fish.

On the other hand, if some ancient authors were followed, Thetis would have been a distinctly unhappy choice. Thetis was a granddaughter of Poseidon and so a marine divinity. She married the mortal Peleus and bore him Achilles, who would become the Greek hero of the Trojan war. However, this marriage was against her wishes (*Iliad*, XVIII: 432–3), and Peleus, unlike the marquis de Seignelay, survived the death of his son Achilles. More disturbing, a number of ancient writers state that Thetis destroyed by fire six children she had by Peleus, and it was only his intervention that prevented her from doing the same with the seventh, Achilles. On the other hand, in support of de Monville's identification of the figure, according to Homer, Thetis showed Achilles great tenderness and it was she who procured for him from Hephaestus, god of fire, 'shield and helmet, and goodly greaves fitted with

ankle-pieces, and corselet' (which, save for the greaves, appear in NG 2967).[34] However, more relevant perhaps than Homer was *Thetis et Pelée*, a play by Bernard Le Bovier de Fontenelle with music by Colasse,[35] published by the Académie Royale de Musique in 1689 and so presumably well known in court circles. In this there is no suggestion of Thetis' infanticide, and, far from being the unwilling partner of the mortal Peleus, she loves him with a constancy (which he reciprocates) that persuades Jupiter to restore him to her.[36] It seems perfectly possible that it was this very recent characterisation of Thetis which the marquise and/or Mignard had in mind when NG 2967 was being painted. Moreover, it is to Hephaestus, whose forge was Mount Etna, that the smoking volcano in the background probably alludes. Jean-Claude Boyer has pointed out that the volcano may also allude to a particular naval battle: either that of 10 February 1675 by the volcanic island of Stromboli, in which a French fleet of nine ships under Duquesne vanquished a Spanish fleet nearly five times its size, or the celebrated battle of 22 April 1676 at Agosta opposite Mount Etna, which saw the death of the Dutch admiral Ruyter.[37] It was during these years that Seignelay was signing naval dispatches under the supervision of his father, Colbert, so NG 2967 may well have been intended to recall the politics of Colbert and Seignelay as well as memories of the men themselves. The volcano with its double cone as depicted by Mignard seems not accurately to represent Stromboli, Etna or, for that matter, Vesuvius, although it is likely that eruptions have changed their shapes. However, the depiction of the volcano may have been based on a misunderstanding of Seignelay's own fascinated account of Vesuvius written during his trip to Italy in 1671, in which he wrote of the volcano's inner crater being pierced at its summit by two large holes vomiting thick and sulphurous smoke.[38] Mignard has painted the volcano with two summits belching smoke.

Another mythological identification of the figures which would be consistent with the volcano being identified as the forge of Hephaestus, and more consistent with the younger child being identified as Cupid, would be to see the marquise and the elder child as Venus and Aeneas. In legend, Venus was the mother of both Cupid and Aeneas and her standard attributes included the scallop shell, on which the marquise's right foot is resting here, and strings of pearls, which in NG 2967 are prominently displayed by, and offered to, the marquise. The oval locket (?) held by the marquise is faced with a giant pearl (of anthropomorphic shape?), reinforcing this connection.[39] Furthermore, according to Virgil's *Aeneid* (VIII: 370–85) Venus went to the forge of Vulcan (Hephaestus) to procure arms for Aeneas. Paintings of Venus presenting arms to Aeneas usually portrayed Aeneas as a mature warrior,[40] but this can be ignored given the ages of the marquise's children. However, had the pearls and scallop shell, not to mention Cupid, led the marquise's contemporaries to identify her with Venus, this would also have led to some awkward, and presumably unintended, conclusions, because anyone following this line of mythologically based interpretation to its conclusion would have deduced that the marquise (Venus) while married to Seignelay (Vulcan) had had an adulterous

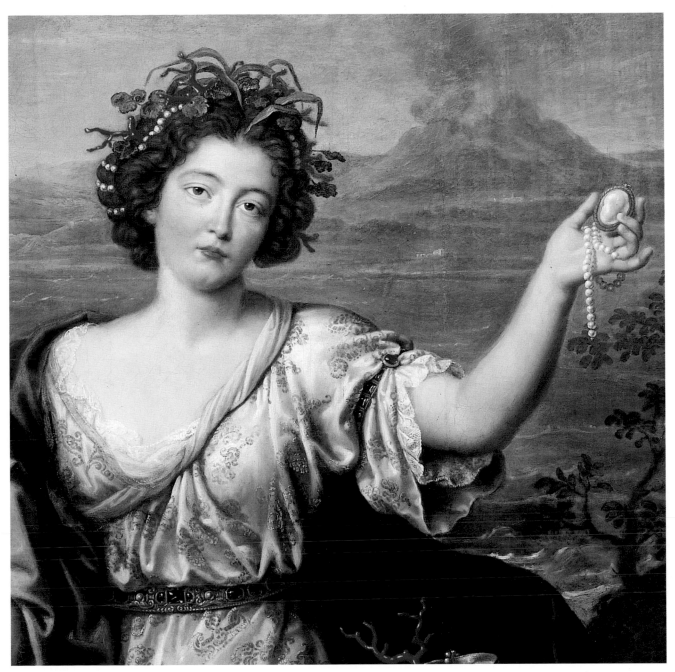

Fig. 3 Detail of NG 2967.

relationship with his great rival, Louvois (Mars).[41] One must conclude, therefore, that de Monville's reading of the picture is correct, but that Mignard either imperfectly realised the project, or more probably that he deliberately, and flatteringly, gave the marquise certain of Venus' attributes while, as the X-radiograph shows, covering the naked breast which might have suggested her identification with that goddess. The fact that she is represented with reeds and coral in her hair – neither usual attributes of Venus – as well as pearls, and that she uses Venus' attribute of the scallop shell as a foot-rest, may be meant to show the marquise de Seignelay's superiority to the goddess of beauty (fig. 3).

By the time de Monville came to write his biography of Mignard,[42] there had arisen another circumstance which, with hindsight, must have made the identification of the sitters as Thetis and Achilles seem additionally appropriate, namely the early death of the marquise's eldest son, Marie-Jean Baptiste. Thetis told Achilles that he would either have a long but inglorious life or one that was short but of imperishable renown (*Iliad*, 410–16).[43] Marie-Jean Baptiste saw significant active service in the years 1702–11, rising to the rank of brigadier by the age of 25, only to die four years later. Present at the battles of Friedlingen (1702) and Malplaquet (1709) among others, wounded at the second battle of Hochstaedt,

Fig. 4 South German, *Drinking Vessel in the form of a Sea Shell*, early 1600s. Shell in silver-gilt mount, 22 cm high. Florence, Palazzo Pitti.

Figs 5 and 5A Detail of seashells, with drawing identifying them.

1 *Voluta musica*, Caribbean
2 *Turbo marmoratus Linnaeus*, Indo-Pacific
3 *Phalium glaucum*, Indo-Pacific
4 *Turbo imperialis Gmelin*, Indo-west Pacific
5 Unidentified
6 Possibly meant to represent a species of *Epitonium*, worldwide
7 *Cookia sulcata*, New Zeland
8 See 4
9 Unidentified
10 A scallop, possibly *Pecten maximus*
11 See 6
12, 13 Possibly oysters (*Ostraea* sp.)
14 A greatly enlarged scallop, possibly *Pecten maximus*

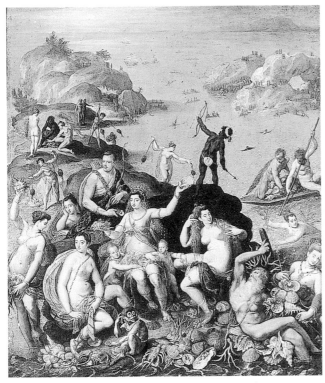

Fig. 6 Jacopo Zucchi, *The Reign of Amphitrite*, c.1585. Oil on copper, 53 × 43 cm. Lviv, Picture Gallery.

Fig. 7 *An Altar Relief*. Engraving from Jean-Jacques Boissard, *Romanae urbis topographiae et antiquitatum*, Part IV, Frankfurt 1597–1602. London, British Library.

his life was indeed short. It must be admitted, however, that his death from apoplexy lacked glory, and his renown was not elevated by Saint-Simon's comment shortly afterwards that 'although extremely fat, he excelled in dancing'.[44]

If the identification of the marquise as Thetis and the child at the left as Achilles is not entirely satisfactory, it is nevertheless surely correct. And given the ages of her children, 'Achilles' must be her eldest son Marie-Jean Baptiste, nine years old in 1691 when the picture was painted. There can be no doubt also that the winged child with his quiver is correctly identified as Cupid, and if he was intended to represent any of Catherine-Thérèse's children, then the youngest, Théodore-Alexandre, seems the most likely. This would provide a certain symmetry between oldest and youngest, and whereas the eldest looks towards the locket(?) held by the marquise, which presumably contains a portrait of Seignelay,[45] the youngest, who may have been born after his father's death and in any event could not have known him in any meaningful sense, looks towards his mother. It is not, however, clear why the marquise had herself portrayed with only two of her children.

The cup that Cupid offers to Thetis is similar to a shell cup with a gilded silver base in the Palazzo Pitti (fig. 4).[46] Itself an object of rarity, and possibly one of the 'thousand other things which marked the fine powers of discernment' of Seignelay,[47] it holds pearls symbolising the wealth of the sea, and coral, which according to Ripa had properties protective against evil.[48] At the bottom of the picture (fig. 5) are various seashells, some of them imaginary, but those which can be identified

include examples from New Zealand, the Caribbean and the Pacific Ocean.[49] The shells may therefore have a threefold symbolic function: they refer to the marine nature of Thetis; like the shell cup they point to the wealth and rarity of Seignelay's collections; and they reinforce the global nature of Colbert's and Seignelay's marine ambitions.

One other point integral to NG 2967 is the extensive use of ultramarine of the highest quality (see Technical Notes). This may be seen as a reference to the wealth, power and progeny of the marquise herself.

The pose of the marquise may have been derived from that of the central figure in Jacopo Zucchi's *Reign of Amphitrite*, one of the four known versions of which – that now in Lviv (fig. 6) – was probably at the Villa Medici during Mignard's sojourn in Rome in the years 1635–57.[50] The cross-legged stance of the marquise's elder son may have been derived from an altar relief now in the Museo Chiaramonti in the Vatican, but which Mignard may have seen in the Giustiniani collection in Rome, and which had also been engraved in 1602 (fig. 7).[51] As has been pointed out, in his choice of intense colours, his facial types and his placing of large figures close to the picture plane, Mignard was possibly influenced by Guido Reni, whose works he would have known both in Rome and from the series of *The Labours of Hercules* then in the Grands Appartements of Louis XIV at Versailles.[52]

NG 2967 is clearly dated 1691. It is possible that it was started before Seignelay's death on 5 November 1690, since the marquise is not shown in mourning dress, and that a

Fig. 8 Attributed to François de Troy, *La duchesse de La Ferté with the Children of the duc de Bourgogne, c.1712*. Oil on canvas, 167.6 × 153 cm. Leeds, Temple Newsam House.

paired painting showing Seignelay with the other children was projected. But Seignelay would almost certainly have had himself portrayed with his heir, Marie-Jean Baptiste, who, however, is shown in NG 2967 with his mother. It is therefore safer to assume that the marquise herself commissioned the portrait soon after her first husband's death, and that once it had been decided to portray her as Thetis, mourning dress was deemed inappropriate. Regrettably, no record of the commission and of the picture's early history is known,[53] though a painting attributed to François de Troy and datable *c.*1712 (fig. 8) seems to be derived from NG 2967,[54] suggesting that the latter remained in the area of Paris or Versailles at least until then. If NG 2967 was once at the hôtel Colbert, rue Neuve des Petits-Champs, it was presumably removed by 1720 when the duc d'Orléans established his stables there.[55]

General References

L'abbé de Monville 1730, p. 148. (1731 edn, 123); Guiffrey 1874–5, p. 143; Le Brun-Dalbanne, 'Pierre Mignard sa famille et quelques-uns de ses tableaux', *Mémoires de la Société Académique d'Agriculture des Sciences, Arts et Belles-Lettres du Département de l'Aube*, vol. 14, 3rd series, 1877, pp. 215–368, no. 290; Davies 1946, p. 69; Davies 1957, p. 157; Nikolenko 1983, pp. 94–5; Wright 1985b, p. 122; Nantes and Toulouse 1997–8, p. 226.

NOTES

1. Quintin Craufurd was born in Kilwinning, Ayrshire. He settled in Paris in the 1780s. Before the Revolution Craufurd had been a friend of Calonne (one-time owner of NG 62), who arranged to have made at Craufurd's expense the carriage in which the French royal family left the Palais des Tuileries in 1791 in an attempt to escape: see R. Lacour-Gayet, *Calonne, Financier Réformateur Contre-Révolutionnaire 1734–1802*, Paris 1963, p. 333, n. 1. Craufurd sold a collection of pictures, marbles and bronzes from his house in Berkley Street, Portman Square, at Christie's, 27–28 January 1786. His hôtel in Paris was at 21 rue d'Anjou, St-Honoré, where he had a collection of mainly seventeenth-century French historical portraits: *Catalogue de tableaux… composant le Cabinet de feu M. Quintin Craufurd*, Paris 1820. Craufurd published a number of works in London and Paris, including *Sur Périclès et sur l'influence des beaux-arts* (London 1815). He

was described as 'peut-être le seul homme de son pays qui ait dévoué, aux moeurs et aux écrivains de la France, toutes ses études et tout son temps' (A.V. Arnault et al., *Biographie Nouvelle des Contemporains ou Dictionnaire historique et raisonné*, 20 vols, Paris 1820–5, vol. 5 (1822), p. 114).

Lot 162 of the 1820 sale was identified by Nikolenko (Nikolenko 1983, pp. 94–5) as a reduced-size copy of NG 2967, measuring 71 × 57 cm. However, since the measurements of a full-length portrait by Van Dyck of the Count of Nassau, described in the catalogue as 'de grandeur naturelle', are 78 × 45, it is clear that they are in pouces, not centimetres. The metric equivalent of the measurements for lot 162 are 192.1 × 154.2 cm. It is described as follows:

Madame de Thianges, soeur de madame de Montespan, représentée en Vénus amphitrite, assise au bord de la mer et ayant près d'elle un jeune garçon, le Duc du Maine en Achille, la tête inclinée sur l'epaule gauche; elle a le regard fixé sur le spectateur, et tient de la main gauche un bracelet à plusieurs rangs de perles; l'Amour à genoux devant elle lui présente une coupe en burgau, surmontée d'une branche de corail semblable à celui qui orne ses cheveux; à ses pieds on distingue divers coquillages. Ce tableau, d'une couleur séduisante, du plus beau faire de ce peintre habile, doit avoir aux yeux des connaisseurs un double mérite, celui d'une belle exécution jointe à l'intérêt des personnages qu'il représente.

A copy of the catalogue in the Bibliothèque Doucet gives the price as 301 francs: letter of 4 January 1998 from J.-C. Boyer.

For a general description of Craufurd's collection see T.F. Dibdin, *A Bibliographical Antiquarian and Picturesque Tour in France and Germany*, 2nd edn, 3 vols, London 1829, vol. 2, pp. 295–308, in which the only picture

which could correspond to NG 2967 is briefly described at p. 299: 'Madame Scarron, with the Duc du Maine; apparently by Mignard: in a very fresh and perfect state.' The child at the left of NG 2967 cannot be the duc de Maine, the son of Louis XIV and Madame de Montespan, who was born in 1670. His youngest male sibling was the comte de Toulouse born in 1678, but the child at the left looks younger than 13. Possibly the identification of the principal sitter as Madame de Thianges, who was indeed the sister of one of Louis XIV's mistresses, the marquise de Montespan, was wishful thinking on the part of Craufurd, who seemed to have a great interest in the king's mistresses: see *Notices sur mesdames de La Vallière, de Montespan, de Fontange et de Maintenon; extraites du catalogue raisonné de la collection de portraits de M. Craufurd*, Paris 1818. The catalogue raisonné itself appears not to have been published.

It is not known when or where Craufurd acquired NG 2967. If the painting remained with the Colbert family, then it may have come onto the market on 13 December 1795 when the goods, including pictures from the hôtel de Seignelay, of the émigré Jean-Baptiste Antonin Colbert (1731–1813) were sold, or following the emigration of the baron de Montmorency, a descendant by marriage of Marie-Jean-Baptiste Colbert, the Achilles in NG 2967: W.-B. Henry, *Histoire de Seignelay*, vol. 1, Paris 1833, pp. 360–1. However, Craufurd was by then himself an émigré. NG 2967 seems more likely initially at least to have followed the marquise to the home of her second husband, Charles de Lorraine-Armagnac, at the hôtel de Marsan, rue de l'Université (which Charles bought in 1698: see Sylvie Allermoz-Wallez and J. de La Gorce, 'Hôtel Tambonneau puis De Marsan puis De Pons puis De Villeroy', *Le Faubourg Saint-Germain. Rue de l'Université*, ed. F. Magny, Paris 1987, pp. 23–31 at p. 24), where Catherine-Thérèse died on 7 December 1696 (Chantilly, Musée Condé, ms. no. 1307, p. 5). Similarly, the series of tapestries of *Attributs de la Marine*, which Seignelay had commissioned but which were not finished until after his death, also found their way to the hôtel de Marsan: Allermoz-Wallace and de La Gorce, op. cit., pp. 26–7; and J. de La Gorce, *Berain Dessinateur de Roi Soleil*, Paris 1986, p. 44, who notes that Seignelay's coat of arms on the tapestries were replaced with those of Charles de Lorrain-Armagnac and Catherine-Thérèse.

2. Exhibited in 1874 as from his collection (see Exhibitions), but not mentioned in W. Bürger's description of Wallace's collection in Paris, 'Les Collections Particulières', *Paris Guide*, 2 parts, Paris 1867, part 1, pp. 536–51 at pp. 537–9, nor in the inventories dated 16–21 August 1871 of items at 2 rue Laffitte or those removed from the château de Bagatelle to nos 3 and 5 rue Taitbout after the death of the 4th Marquess of Hertford on 25 August 1870. A typed copy of those inventories is in the Wallace Collection Library (File no. 24M).

Sir Richard Wallace had started to buy paintings in the 1840s, but he also inherited the art collection in London and Paris of Richard Seymour-Conway, 4th Marquess of Hertford (1800–70). The 4th Marquess had

in turn been the residuary legatee of Francis Charles Seymour-Conway, the 3rd Marquess (1777–1842), who had owned a substantial art collection, as well as himself accumulating a quantity of paintings and other artworks. In 1874 and 1888 NG 2967 was certainly in Paris (see Exhibitions), where Sir Richard had homes inherited from the 4th Marquess at no. 2 rue Laffitte and at the Bagatelle, his Louis XVI château in the Bois de Boulogne. See Donald Mallet, *The Greatest Collector. Lord Hertford and the Founding of the Wallace Collection*, London 1979; Peter Hughes, *The Founders of the Wallace Collection*, London 1981, and ed. John Ingamells, *The Hertford Mawson Letters. The 4th Marquess of Hertford to his agent Samuel Mawson*, London 1981.

3. The inventory after the death of Sir Richard Wallace, dated 13–14 August 1890, records: '230 Grand tableau par Mignard; groupe de trois figures, prisé six mille francs, 6000.' The picture was in a room described as a salon lit by two windows looking onto the rue Laffitte between a small dining room and the (main?) dining room (where hung Horace Vernet's four *Battle Scenes*, now in the National Gallery). The inventory is in the Archives de Paris (D48 E376), but a photocopy of the manuscript and a typed copy are in the Wallace Collection Library. In the inventory Sir Richard Wallace is recorded as living at no. 3 rue Laffitte, and Lady Wallace at no. 2.

4. Murray Scott, who was Lady Wallace's residuary legatee, inherited all of her art collection save what was then on the ground and first floors of Hertford House, which she bequeathed to the nation; it is now called the Wallace Collection. It is therefore possible that NG 2967 was in London when Lady Wallace died. However, this seems unlikely, since the painting was certainly at no. 2 rue Laffitte in 1890 (see note 2) and in 1900 (see below). It was also there in 1912, following Murray Scott's death, and not recorded at his London home at 5 Connaught Place in 1903 (Scott had sold the Bagatelle to the City of Paris in 1904). For the location of the pictures in 1900, see Murray Scott's will of 26 October 1900 (copy in Wallace Collection Library). The inventory of contents of Murray Scott's London house at 5 Connaught Place of May 1903 (Wallace Collection Library) mentions at pp. 117 and 142 three portraits by Mignard, none of which seems to be NG 2967. In their letter of 26 February 1914 to the National Gallery, the solicitors of Murray Scott's estate refer to the 'pictures... now in the picture gallery at no. 4 (sic) rue Laffitte Paris', but I have found no other reference to Murray Scott or his predecessors in title having acquired no. 4 as well as no. 2 rue Laffitte. In any event, NG 2967 was recorded at no. 2 rue Laffitte in Murray Scott's posthumous inventory of 16 February 1912 (and days following) on p. 48: 'Portrait d'une reine avec son fils et Cupidon par Mignard prisé huit mille francs...8.000.–'. In the inventory, a copy of which is in the Wallace Collection Library, NG 2967 and the other pictures bequeathed by Murray Scott to the National Gallery were recorded separately from all other paintings and there is no identification of the rooms in which they were hung.

5. The amount payable by the Gallery in sterling was £308 2s. 3d.

6. A 'Momper ainé' is listed at 12 Marais-Saint-Germain, under the heading 'Restaurateurs de Tableaux' in the 1858 edition of the *Annuaire et Almanach de Commerce*. I am grateful to Jo Kirby-Atkinson for this reference.

7. See T. Bajou, 'À propos de quelques tableaux de Mignard conservés au château de Versailles', *Pierre Mignard 'le Romain'. Actes du Colloque organisé au musée du Louvre par le Service culturel le 29 septembre 1995*, Paris 1997, pp. 195–223 at p. 202.

8. J. Kirby and R. White, 'The Identification of Red Lake Pigment Dyestuffs and a Discussion of their Use', *NGTB*, 17, 1996, pp. 56–80 at pp. 68, 73.

9. NG Archive NG1/15, p. 184 and NG7/446/1914.

10. See NG Archive, NG7/446/1914.

11. Paul Mantz, 'Exposition en faveur de l'oeuvre des Alsaciens et Lorrains', *GBA*, 10, 1874, pp. 97–114, 193–215, 289–309 at p. 110.

12. M.J.J. Guiffrey, 'Documents sur Pierre Mignard et sur sa famille (1660–1696)', *NAAF*, series I, vol. 3, 1874–5, pp. 1–144 at pp. 137, 143.

13. Simon-Philippe Mazière, l'abbé de Monville, *La Vie de Pierre Mignard, Peintre du Roy*, Amsterdam 1731, p. 123: 'il peignit entr'autres Madame de Seignelay & ses deux fils, en figure entiere dans le même tableau; Madame de Seignelay qui a le plus jeune auprès d'elle en Amour, est representée en Thetis, avec tous les attributs de la souveraine des mers; & son fils aîné est peint en Achille: la mer fait le fond du tableau.' The first edition of de Monville's work was published in Paris in 1730 but, according to the approbation, completed in 1729.

14. *National Gallery: Abridged descriptive and historical catalogue of the British and Foreign Pictures*, London 1915, p. 206.

15. *National Gallery Trafalgar Square Catalogue*, 86th edn, London 1929, p. 238.

16. Davies 1946, p. 69.

17. Catherine-Marguerite Mignard (1652–1742). She married the Comte de Feuquières c.1696.

18. As Davies pointed out: Davies 1946, p. 69.

19. According to Primi Visconti, *Mémoires sur la cour de Louis XIV*, ed. J. Lemoine, Paris 1908, p. 228: 'on conclut pour [Seignelay] un second mariage avec une héritière de la maison de Matignon [i.e. Catherine-Thérèse] car en France les ministres n'ont qu'à vouloir...'.

20. *DBF*, fascicule XLIX, Paris 1960, pp. 190ff.; and E. Taillemite, *Dictionnaire des Marins François*, [n.l.] 1982.

21. Jean-Claude Boyer7, *Le peintre, le roi, le héros. L'Andromède de Pierre Mignard*, Paris 1989, pp. 63–5.

22. Seignelay always had 'les yeux ouverts pour le merite de Monsieur Mignard'

according to Le Maire, *Paris ancien et noveau*, 3 vols, Paris 1685, vol. 3, p. 268. According to de Monville (cited in note 13; p. 80) the two men became friends. Possibly Catherine-Thérèse had met Mignard before Seignelay had, since the artist seems to have painted two pictures of religious subjects for her father: see de Monville, p. 128.

23. His posthumous inventory dated 7 November 1690 and following days has been lost (see Boyer 1988, pp. 11–15 at p. 12 and n. 4), but an idea of the extent and and importance of Seignelay's collection can be gained from Monique de Savignac's article 'Les trente-neuf tableaux de Thomas de Dreux achetés par le marquis de Seignelay en 1681', *BSHAF*, 1991, pp. 93–103, as well as from Le Maire, cited in note 22. See also Schnapper 1994, pp. 367–75 and *passim*.

24. For this reputation, see, for example, Brice 1698, vol. 1, p. 203. The hôtel in the rue Neuve des Petits-Champs was added to by the great Colbert and afterwards by Seignelay, whom Brice described as 'un des plus magnifiques hommes de son siècle'.

25. Saint-Simon 1856–8, vol. 1 (1856), p. 302. ('C'était une grande femme, trés-beau faite, avec une grande mine et de grands restes de beauté. Sa hauteur excessive avait été soutenue par celle de son mari, par son opulence, sa magnificence, son autorité dans le conseil et dans sa place...')

26. Madame de Sévigné, *Lettres*, ed. Gérard-Gailly, 3 vols, Paris 1953–7, vol. 3 (1957), p. 782 (letter of 1 December 1690).

27. Saint-Simon 1856–8, vol 1, p. 302 ('...devenue veuve elle brûloit d'un rang et d'un autre nom quoiqu'elle eût plusieurs enfants').

28. The hôtel de Marsan was described by the *Mercure galant* on the occasion of Monsieur's visit to it during Charles de Lorraine-Armagnac's brief marriage to Catherine-Thérèse: 'Il y a peu de maisons à Paris aussi belles que celle que le comte de Marsan a achetée il y a quelque temps de monsieur le président Tambonneau. Les appartements hauts et bas sont doubles, et sont de cinq pièces chacun. Ils ont vue sur le jardin qui est trés beau et dont le parterre est du dessin de monsieur Lenôtre.' The description, quoted in Allermoz-Wallez and de La Gorce, cited in note 1, at p. 26, continues with praise for the staircase, the magnificent furnishings, tapestries after Giulio Romano and Berain, and mirrors.

29. Saint-Simon 1856–8, vol. 1, p. 303, and Visconti, cited in note 19, p. 255.

30. The dates which are queried have been taken from De La Chenaye and Badier 1866, vol. 6, pp. 25ff. Other dates are from *DBF*, cited in note 20.

31. *DBF*, cited in note 20. The last of the line was a son of Charles-Eléonore, Louis-Jean-Baptiste-Antonin, Marquis de Seignelay (1731–1813), who also followed a military career: see J.B.P.J. de Courcelles, *Dictionnaire*

universel de la noblesse, 5 vols, Paris 1820–2, vol. 1.

32. L'abbé de Monville, cited in note 13, p. 113.

33. For an example of an inappropriate choice, see Dominique Brême, *François de Troy 1645–1730*, Paris and Toulouse 1997, p. 160.

34. Homer, *Iliad*: 457–60.

35. I am grateful to J.-C. Boyer for pointing out to me that Colasse was the composer.

36. *Thetis et Pelée, tragédie en musique, representée par l'Académie Royalle de Musique*, Paris 1689. Thetis also willingly married Peleus in Giacomo Torelli's ballet, *Le Nozze de Teti*: see G.B. Amalteo, *Scene e machine preparate alle Nozze de Teti, balletto reale representato nella sala del piccolo Borbone, et da Giacomo Torelli inuentore dedicate all'Eminentissimo Prencipe Cardinal Mazzarino*, Paris 1654.

37. As J.-C. Boyer kindly wrote to me on 25 September 1995.

38. 'Relation du voyage du Marquis de Seignelay en Italie', *GBA*, 18, 1865 (1), pp. 176–85, 357–71 and 445–64 at p. 454. Vesuvius had erupted spectacularly forty years before Seignelay's visit; several thousand people were killed.

39. The suggestion was made in a letter of 23 March 1989 to Neil MacGregor from W.D.I. Rolfe, Keeper of Geology, Royal Museum of Scotland.

40. For example, by Poussin (Rouen, Musée des Beaux-Arts).

41. Cupid was Venus' son by Mercury according to some ancient authors, or by Jupiter according to others. Aeneas, however, was her son by the mortal Anchises. So the marquise as Venus would have been shown with two children differently fathered, neither by her mythological husband, Vulcan (Hephaestus), whom she had cuckolded (with Mars) and who is shown smouldering (as well he might!) in the background. Hence neither artist nor patron could have intended to show the marquise as Venus.

42. By 1729: see note 13.

43. The references to the stories of Achilles, Peleus and Thetis are, unless otherwise indicated, derived from the entries under those names in the *Dictionary of Greek and Roman Biography and Mythology*, ed. William Smith, 3 vols, London 1849–50.

44. Saint-Simon 1856–8, vol. 10, p. 163. Marie-Jean Baptiste left two daughters, of whom one, Marie-Sophie, survived to be his universal legatee. She married Charles-François de Montmorency-Luxembourg in 1724. The baron de Montmorency was a great-grandson of Marie-Sophie: see W.-B. Henry, cited in note 1.

45. Conceivably, the pearl, if that is what it is, alludes to the marquise's own origins, since

the hôtel de Thorigny was on the rue de la Perle: Charles Sellier, 'L' Hôtel de Thorigny', *Bulletin de la Société de l'Histoire de Paris et de l'Ile-de-France*, 22e année, 1895, pp. 67–73.

46. Thanks are due to W.D.I. Rolfe for pointing this out, and for forwarding a photocopy of the relevant page of the exhibition catalogue, *Salzburgs Alte Schatzkammer*, Salzburg, Oratorien des Salzberger Domes, 1967, where it was exhibited as no. 31.

47. Brice 1698, vol. 1, p. 203. ('...mille autres choses qui marquoient le discernement délicat du maître.')

48. Cesare Ripa, *Iconologia*, Venice 1645, p. 148.

49. Kathie Way of the Natural History Museum kindly identified the shells (letter of 20 November 1989, and communication of 9 October 2000).

50. I am grateful to Carol Plazzotta for drawing my attention to Zucchi's composition and to Kristina Herrman Fiore for information about it. The other version of Zucchi's compositions are in the R. Bordetti collection, Milan, and in the Galleria Borghese, Rome. The first record of the latter is in the 1693 Borghese inventory. As Ms Fiore points out (letter of 24 July 1998), the inclusion of a portrait of Ferdinando de Medici in the Lvov variant version makes it much more likely to have been that noted at the Villa Medici by Baglione in his life of Jacopo Zucchi. For the date and subject of the Lvov picture, see *Villa Medici. Il sogno di un cardinale*, Rome 1999, nos 85–6 (entry by Philippe Morel).

51. In J.J. Boissard's *Romanae urbis topographiae et antiquitatum*, part IV, Frankfurt 1602, pl. 58. I am grateful to Ruth Rubenstein for drawing my attention to this.

52. A. Schnapper in Montreal 1981, p. 78.

53. Given that NG 2967 is dated 1691, one would not expect to find it in the inventory of the marquis de Seignelay of 7ff. November 1690 – which is in any event lost: see Boyer 1988, pp. 11–15 at p. 12 and n. 4. It cannot be identified in the inventory of 2 January–3 February 1700 of Catherine-Thérèse de Matignon (Chantilly, Musée Condé, ms. no. 1307), nor in those of the duchesse d'Estouteville of 15ff. September 1744 (A.N., M.C., I, 417) or Paul-Edouard Colbert (who became duc d'Estouteville by 1736) of 10ff. March 1756 (A.N., M.C., I, 477), both prepared at their hôtel in the rue St Dominique. I am grateful to Michel Borjon for the A.N. references.

54. See William Wells, 'Pictures in the Collection. A royal portrait from the Hôtel de La Ferté', *Leeds Art Calendar*, vol. 5, no. 18 (1952), pp. 23–9. James Lomax of Temple Newsam House kindly advised me of the current attribution (letter of 3 April 1997).

55. Brice 1698, vol. 1, p. 444.

Francisque Millet
1642–1679

Millet was born in Antwerp, the son of an ivory carver. He worked in the studio of Laureys Franck, with whom he went to Paris in 1659 and whose daughter he married in 1662. He is said to have journeyed to Flanders, Holland and England, but he worked mainly in Paris, where he executed four paintings for the Cabinet de la Reine at the Tuileries Palace in 1666–8. He gained provisional admission to the Académie Royale de Peinture et de Sculpture in 1673. Twenty-eight engravings assigned to Théodore of landscapes by Millet, including one after NG 5593, give an idea of his work in the genre for which he is best known. Some paintings, such as his *Landscape with Mercury and Battus* (New York, Metropolitan Museum of Art), recall the late landscapes of Poussin. Others, including NG 5593, with their sweeping views from an elevated position, ultimately derive from Flemish landscape painting of the sixteenth century. Both his son Jean (*c.*1666–1723) and his grandson Joseph (*c.*1688–1777) painted landscapes in the style of Francisque, whose name they adopted.

NG 5593
Mountain Landscape with Lightning

*c.*1675
Oil on canvas, 97.3 × 127.1 cm

Provenance
Possibly owned by Paul Vérani (d.1713), sieur de Varenne;[1] possibly in M. Martin's sale, London, Christie & Ansell, 18 April 1777 (lot 3, bought Pigan);[2] anon. (J.C. Wombwell) sale, London, Phillips, 4 June 1850 (lot 29, 19 guineas to Fuller);[3] possibly in the collection of John, 2nd Baron Northwick (1770–1859), in the Cabinet Room at Thirlestane House, Cheltenham, in 1858[4] and in his posthumous sale there, Phillips, 26ff. July 1859 (lot 248, £6 16s 6d. to Willein);[5] by 1868 in the collection of J.C. Robinson,[6] by whom presumably sold to Francis Cook, Viscount Monserrate (1817–1901), in whose collection it was in the same year;[7] recorded at Doughty House, Richmond Hill (First Gallery, no. 19), in the collection of his heir, Sir Frederick Lucas Cook (1844–1920),[8] and then in the collection of Sir Herbert Frederick Cook (1868–1939);[9] purchased from the trustees of the Cook Collection for £750 with the aid of the Clarke fund, 1945.[10]

Exhibitions
Leeds 1868, Leeds Infirmary, *National Exhibition of Works of Art* (56), as 'Landscape, with Flight of Ahab'; London 1915/16, Burlington Fine Arts Club, *Winter Exhibition* (14), as 'Heroic Landscape'; Paris 1925, Petit Palais, *Le Paysage Français de Poussin à Corot* (P.213), as 'Le feu du ciel frappe les cités de Sodome et de Gomorrhe'; London 1930, Magnasco Society (at Messrs Spink & Son), *Landscape Pictures of Different Periods* (13), as 'The Destruction of the Cities of the Plain';[11] London 1938, RA, *Exhibition of 17th Century Art in Europe* (334), as 'Landscape: the Destruction of the Cities of the Plain'.[12]

Related Works
PAINTING
A work attributed to Millet and described as 'Landscape; tempest' was offered for sale by the Truchsessian Gallery in 1804 (no. 887). Its dimensions (1 ft 11 in. × 2 ft 3 in.) were too small for it to have been NG 5593.[13] It, rather than NG 5593, may be the painting that was in the Northwick sale, Phillips, 26ff. July 1859 (see above).[14]
PRINT
[In reverse], assigned to Théodore,[15] inscribed in the plate: *Francisque Pin[xit] Simon ex.[cudit] C.[um] p.[rivilegio] R.[egis]*. 202 × 297 cm (fig. 1). The foreground is deeper in the engraving than in the painting, suggesting that the latter may have been cut down along the bottom, but since there is cusping

on all four sides of the painting (see Technical Notes), and another significant variation between painting and print, namely replacement of the lake in the background of the painting with a river, this cannot be the case.[16]

Technical Notes

The support is a fairly fine plain-weave canvas, relined in 1977. The ground is a terracotta colour. Besides some wear in the sky and the lake, there are numerous small retouched flake losses and two horizontal tears, respectively some 5 cm and 7 cm long, just above the lake, as well as a loss below and to the right of the thunderbolt, and other damages, mainly in the area of the triumphal arch, along the river shore to the left of the town, in the lower left corner and along the edges; there has been slight blanching in the greens. However, the condition as a whole is quite good. Two labels removed from the former lining canvas in 1977 and now in the dossier relate to the 1868 and 1938 exhibitions (see above), and another possibly to the 1930 exhibition. The X-radiograph is difficult to read, but shows cusping of the canvas along all edges, albeit less marked along the top.

The subject – if indeed there is one – has not been satisfactorily identified. If it was the picture in the Martin sale of 1777, NG 5593 was there called 'Lot and his daughters leaving Sodom', and its subject was similarly identified in the 1920s and 1930s (see under Exhibitions).[17] However, this would be a very loose rendering of the biblical narrative of Genesis 19:17–26, which seems improbable for an artist well able to paint other easily identifiable scenes from the Bible and from mythology.[18] The painting was also once called 'The Flight of Ahab', but no such biblical subject exists. If NG 5593 has no identifiable subject, it is possible to propose a theme: the helpless figures, the puny town which appears so vulnerable in spite of its fortifications, the majestic mountains, and above all the dramatic shaft of lightning, all suggest man's feebleness in the face of nature, or perhaps, given the numerous associations in the Bible between storms and the divine, in the face of the divine as manifested in nature.[19]

A desire on Millet's part to emulate Poussin may have been the spur for NG 5593. The latter's *Storm* (Rouen, Musée des Beaux-Arts) had been in the Pointel collection until 1660, was engraved sometime before 1680,[20] and was the inspiration for a challenging passage in Félibien's *Cinquième Entretien* (1679): 'Toutes les actions promptes & passageres ne sont pas favorables aux Peintres: et lors que quelqu'un y reussit, les choses qu'il fait sont autant de miracles dans son art.'[21] ('All rapid and fleeting actions are difficult for painters: and when [a painter] succeeds in this respect, the things he does are like so many miracles of his art.') Félibien also referred to Apelles, who had, according to Pliny, 'even painted things that cannot be represented in pictures – thunder, lightning and thunderbolts…'[22] Although Félibien's *Cinquième Entretien* was not published

until the very end of Millet's life, it seems reasonable to assume that Pliny's comment on Apelles was already well known.[23]

If one source of inspiration for NG 5593 may have been Poussin, the loose brushwork of the landscape in the lowest third of the painting, and the description of the path, the figure on horseback and his companion at the lower right recall Gaspard Dughet.[24] However, the composition as a whole, lacking any framing trees or others breaking the skyline, is uncharacteristic of Dughet (or, indeed, Poussin or Claude), and the high viewpoint and extensive view are more reminiscent of Flemish sixteenth-century landscape painting. Furthermore, it is not certain that Millet, who worked mainly in Paris and is not known to have travelled to Rome, ever saw any of Dughet's paintings, of which there were relatively few in Paris.[25]

In our present state of knowledge no chronology for Millet's oeuvre can be established,[26] although it has been supposed, presumably in view of Millet's birth in Antwerp and his apprenticeship (albeit in Paris) to a Flemish painter, Laureys Franck, that Flemish influence on his art was stronger earlier

in his career, and that his more classical landscapes belong to his maturity.[27] It may be, however, that Millet's more classical landscapes belong to the 1660s when a number of Poussin's most classical landscapes in the Pointel collection came on to the market,[28] and his more naturalistic ones to the 1670s. The naturalism of the low-lying land by the lake in NG 5593 is remarkable, and even more so that of the mountain at the left (suggesting Millet's familiarity with mountainous landscape in spite of his not being recorded working outside Paris other than in the Low Countries and England).[29] The composition of the landscape and the position of the figures in the foreground are like those of Millet's *Italian Landscape* (Alte Pinakothek, Munich, inv. no. 400; fig. 2) for which a date around 1670 has been reasonably proposed.[30] The ambitious nature of NG 5593 suggests that it is of Francisque's maturity and datable to the early 1670s.

General References

Davies 1948, p. 24; Davies 1957, p. 159, Wright 1985b, p. 123.

Fig. 2 *Italian Landscape*, c.1670. Oil on canvas, 107 × 119 cm. Munich, Alte Pinakothek, Bayerische Staatsgemäldesammlungen.

NOTES

1. 'Un grand Francisque: Tonnere 500 l.' was included in Vérani's posthumous inventory dated 31 October 1713, made at his home in the place Dauphine, Paris, at the request of his widow, Marie-Louise de la Rivière: M. Rambaud, *Documents du Minutier Central concernant l'Histoire de l'Art (1700–1750)*, 2 vols, Paris 1964 and 1971, vol. 1, p. 539. In the inventory Vérani was described as 'conseiller secrétaire du roi, maison, couronne de France et de ses finances et joaillier ordinaire du roi'. He was a dealer rather than a collector: Schnapper 1994, p. 102.

2. There described as 'F. Mille [sic] – 3 Lot and his daughters leaving Sodom'. The identity of the buyer and seller were given in a letter of 2 June 1987 from M. Hepworth of the Getty Art History Information Program.

3. There described as: 'F. MILLÉ./A View over a very extensive tract of Hilly Country, and a river. In the foreground, figures, under the effect of a storm with lightning./Equal to G. Poussin./3ft. by 3ft. 11in.'. The painting was seen in Wombwell's collection in 1850 by Waagen: *Treasures of Art in Great Britain*, 1854, vol. 1, p. iii, and vol. 2, p. 310. ('alps and glaciers, river and lake, seen under the aspect of a thunder-storm'). John Webb's posthumous sale of 8–10 February 1849, London, Christie & Manson, included as lot 264 'F. Millé A landscape near a bay, with a tempest'; it was sold with the following lot, a portrait by Rigaud, to Deare for 2 guineas, a price which seems too low for lot 264 to be identified as NG 5593.

4. *Hours in Lord Northwick's Picture Galleries*, Cheltenham 1858, p. 66, where no. 564 is described as 'The Land-Storm. F. Mille.' The painting is not mentioned by Waagen 1854, vol. 3, pp. 195–212.

5. Described as 'F. Millet /A Classical Landscape with Figures – effect of storm'. But see under Related Works, Painting.

6. J.C. Robinson, *Memoranda on Fifty Pictures*, London 1868, no. 48, where described as 'Historical Landscape, with the Flight of Ahab'. Herbert Cook described Robinson as Sir Francis Cook's 'chief friend and adviser' (ed. Herbert Cook, *A Catalogue of the Paintings at Doughty House, Richmond & elsewhere in the Collection of Sir Frederick Cook Bt Visconte de Monserrate*, 3 vols, London 1913–15, vol. 3 (by Maurice W. Brockwell), p. vi).

7. Loaned by Francis Cook to the 1868 Leeds exhibition (see under Exhibitions). Cook was created a baronet in 1886.

8. Ed. Herbert Cook, cited in note 6, no. 436, as 'Landscape with the Flight of Ahab'.

9. [Maurice W. Brockwell], *Abridged Catalogue of the Pictures at Doughty House, Richmond, Surrey, in the Collection of Sir Herbert Cook, Bart*, London 1932, p. 8, as 'The Cities of the Plain'. Sir Herbert Frederick Cook was a trustee of the National Gallery 1923–30, and one of the founders of the National Art Collections Fund.

10. NG Board Minutes, vol. 12, pp. 101, 105; and NG Correspondence, Cook Collection, 1939–40 and 1942–9.

11. O. Sitwell, 'The Magnasco Society', *Apollo*, 79, 1964, pp. 378–390 at p. 390.

12. According to the exhibition catalogue by, or under the direction of, E.K. Waterhouse, 'Lot and his family struggle upwards towards the spectator'.

13. *Summary Catalogue of the Pictures now exhibiting and on sale at the Truchsessian Gallery, New Road, opposite Portland Place, London, May the 1st, 1804*; and see *Index of Paintings Sold*, vol. 1, p. 471.

14. It may have been the landscape by Millet seen in the Northwick collection in 1846: 'Visits to Private Galleries. No. XV. The Collection of the Right Hon. Lord Northwick, Thirlestane House, Cheltenham', *The Art Union*, VIII (1846), pp. 251–6 at p. 255.

15. For the identification of the engraver as the otherwise unknown Théodore see Florent le Comte, *Cabinet des Singularitez*, 3 vols, Paris, 1699–1700, vol. 2 (1699), p. 332, and Martin Davies, 'A Note on Francisque Millet', *Société Poussin*, Second Cahier, Dec. 1948, pp. 13–26 at pp. 22–4. Thierry Bajou has pointed out that Théodore was a painter as well as an engraver, so he may well have been Millet's pupil (letter of 23 August 1999). For a possible alternative identification of the engraver as Gerard Hoet (1648–1733), see Davies, op. cit., p. 24, n. 25.

16. Ed. O. Naumann, *The Illustrated Bartsch, 7, Netherlandish Artists*, New York 1978, p. 151 (and see Adam Bartsch, *Le Peintre Graveur*, 21 vols, Vienna 1803–21, vol. 5 (1805), pp. 336–7, and A.-P.-F. Robert-Dumesnil, *Le Peintre-Graveur Français*, 9 vols, Paris, 1835–65, vol. I (1835), p. 258).

17. Thierry Bajou has kindly advised that a painting by Millet described as 'Lot et ses filles quittant Sodome' was sold by Morelli, Paris, Clisorius, 23 January 1809, lot 47 (bought by Clisorius, 4(?) francs), and sold by Clisorius, Paris, Clisorius, 10 July 1809 (lot 55, 9 francs to an unknown buyer). The catalogue of the latter sale says of the picture that Sodom can be seen in flames, a fact which, together with the low price achieved, suggests that it is unlikely to be NG 5593.

18. For example, *The Saving of Moses* (*The Illustrated Bartsch*, cited in note 16, p. 158) and *Landscape with Hermes and Herse* (Brussels, Musées Royaux des Beaux-Arts, inv. no. 6267), although, as Mary O'Neill pointed out, the figure of Mercury in the landscape, the subject of which she identified as Mercury and Battus, has none of the god's usual attributes: M. O'Neill, *Musée des Beaux-Arts d'Orléans. Catalogue critique. Les Peintures de l'École Française des XVIIe et XVIIIe siècles*, 2 vols, Nantes 1981, vol. 1, p. 99.

19. Lightning was also one of the principal attributes of Jupiter: see, for example, G. de Tervarent, *Attributs et Symboles dans l'Art Profane 1450–1600*, Geneva 1959, p. 194. For a proposal linking landscape with religious sentiment, mainly in connection with Dutch art, see Josua Bruyn, 'Le paysage hollandais du XVIIe siècle comme métaphore religieuse', *Le paysage en Europe du XVIe au XVIIIe siècle: Actes du colloque organisé au musée du Louvre par le Service culturel du 25 au 27 janvier 1990*, Paris 1994, pp. 67–88. See also Wine 1994, pp. 34–7, for a brief discussion of aspects of nature as manifestation of the divine among French and Italian seventeenth-century authors.

20. See Paris 1994, no. 200.

21. André Félibien, *Entretiens sur les vies et sur les ouvrages des plus excellens peintres anciens et modernes*, 3 vols, Paris 1666–79, vol. 3 (1679), p. 60; and see Whitfield 1977, pp. 4–12.

22. Pliny, *Natural History* (Book XXXV, ch. XXXVI, para. 96), trans. H. Rackham (Loeb edition, 1968, vol. IX, p. 333).

23. The first complete translation of Pliny's *Historia Naturalis* into French was that of Antoine Du Pinet, published in Lyon in 1562: T. Redier, 'Une illustration lyonnaise de Pline l'Ancien au XVIe siècle', *A Travers L'Image. Lecture iconographique et sens de l'oeuvre. Actes du Séminaire CNRS (G.D.R.712) (Paris, 1991)*, Langres 1994, pp. 137–50.

24. C.L. von Hagedorn, *Lettre à un Amateur de la Peinture*, Dresden 1755, p. 120, and most recently, Bernard Biard, 'Les paysages de Francisque Millet (1642–1679) dans les collections publiques françaises,' *Revue du Louvre*, 2, 1997, pp. 58–66.

25. Boisclair 1986, pp. 105, 148–9.

26. See Pierre Rosenberg in Paris, New York, Chicago, 1982, p. 291.

27. M. Roethlisberger, 'Quelques nouveaux indices sur Francisque.' *GBA*, 76, 1970, pp. 319–24 at p. 322.

28. J. Thuillier and C. Mignot, 'Collectionneur et Peintre au XVIIe ; Pointel et Poussin,' *Revue de l'Art*, 39, 1978, pp. 39–58.

29. Thierry Bajou has tentatively suggested (letter of 23 August 1999) that NG 5593 may show an actual view in the Rhône valley, or even one in southern Germany, and points out that a painting attributed to Millet, sold Christie's, 11 May 1824 (lot 35), was described as 'A Landscape, and the fall[s] of Schaffhausen'.

30. As Davies pointed out (1957, p. 159), the landscape by Francisque Millet once at Munich is of rather similar character. That painting has been dated c.1670 by J.G. Prinz von Hohenzollern: *Alte Pinakothek München. Erläuterungen zu den ausgestellten Gemälden*, Munich 1983, p. 352.

François de Nomé
*c.*1593–after 1630

Born in Metz in the duchy of Lorraine, de Nomé went to Rome as a child and stayed there some eight years. He was taught painting by a Maestro Baldassare, possibly the Flemish landscape painter Balthazar Lauwers, whose son-in-law was the painter Angelo Caroselli (see p. 16). In 1610 de Nomé went to Naples, where three years later he married Isabella Croys, whose family was Flemish, and he seems to have remained in that city for the rest of his life. He was known as 'Monsù Desiderio' (as was Didier Barra, another painter of landscapes and architecture from Metz – with resulting confusion). Over one hundred paintings are assigned to de Nomé, mainly of fantastic architecture, often ruined or in the course of collapse, peopled with awkward, elongated figures. His architecture is usually encrusted with curious decorative reliefs and his lighting has a flickering, ghostly quality, giving his pictures an other-worldly look. A number of his paintings are inscribed with dates in the early 1620s, but sometimes they are difficult to read: the date on *The Martyrdom of Saint Catherine* (Southampton, City Art Gallery), for instance, has been variously interpreted as 1607, 1617 and 1647. It is not known when de Nomé died.

NG 3811
Fantastic Ruins with Saint Augustine and the Child

Oil on canvas, 45.7 × 65.7cm
Dated lower right on the balcony of a window: 1623

Provenance
In Sicily, or more probably Naples, at some time between 1816 and 1861;[1] probably in the collection of Ernest Govett of Soffiano, near Florence, and then from *c.*1906 of London, and given by him to E. Hamilton Moore of Sutherland Square, London, in 1914/15;[2] bought from E. Hamilton Moore for £25 by Sir Philip Sassoon (1888–1939) in 1923, by whom immediately presented to the Gallery through the NACF.[3]

Exhibitions
London 1968–9, British Museum, *Giovanni Battista Piranesi, his predecessors and his heritage* (7); Coventry, Derby, Doncaster and Bath 1982, p. 39; Canterbury, Wolverhampton, Lincoln and Exeter 1984, *The Capricious View: an Exhibition of Townscapes* (4); Oxford and London 1990–1, *Italy by Moonlight, the Night in Italian Painting 1550–1850* (p. 100).

Related Works
PAINTING
According to a note on the NG dossier, 'Picture similar to NG 3811 offered Feb. 1936 c.12'2 H 21'4 – dated 162... seal of Neapolitan customs'.

Technical Notes
In generally good condition albeit suffering from minor damage around the edges, and some wear in the centre and bottom right. The primary support is a moderately fine plain-weave canvas on which a warm brown ground has been applied. NG 3811 was relined in 1981, and a new stretcher was then fitted. At the same time the picture was retouched and revarnished. An infra-red photograph reveals a pentimento on the right-hand side of the tallest building, as if the artist had originally intended to show that side of the structure collapsing. The X-radiograph shows the raggedness of the edges, from which Davies (1946, p. 34) supposed that the picture may once have been slightly larger.

Fig. 1 Detail of Saint Augustine and the Child.

Acquired in 1923 as a Dutch school picture of the circle of Hercules Seghers, NG 3811 was in the same year published first as by Jacques Callot[4] and then, on the suggestion of Louis Demonts of the Louvre, as by Monsù Desiderio.[5] Subsequent research revealed that the name 'Monsù Desiderio' had been applied to three different artists: the engraver Francesco Desideri, the Lorrainese landscape painter Didier Barra, and the latter's contemporary, also Lorrainese, François de Nomé.[6] It is to the last named that NG 3811 is now given.[7]

If attribution of the painting proved problematic, the minuscule figures of Saint Augustine and the Child in the foreground (fig. 1) were early recognised.[8] Saint Augustine (354–430) was Bishop of Hippo Regius (in what is now Algeria) from 395 until his death. His best-known works are the *Confessions*, *De Civitate Dei* and *De Trinitate*. This last work was written between 400 and 416, but meditating on the Trinity was, it seems, Augustine's constant preoccupation.[9] A legend arose according to which Augustine had a vision of a child, variously Christ or an angel, trying to empty the sea into a hole in the sand; when challenged by Augustine with the impossibility of this task, the child replied that it was no more impossible than Augustine trying to understand the mystery of the Trinity.[10] In the seventeenth century the subject was often painted for Augustinian convents,[11] but, given the insignificance of the figures here, it seems doubtful that NG 3811 could have had a contemplative function, at least in a religious sense. The suggestion that de Nomé may have intended to contrast, through architecture, a quotidian present with a monumental past seems unlikely, given that buildings of both ancient and modern style are depicted in the course of collapse.[12] It has also been tentatively suggested[13] that the crumbling buildings and wrecked boat are metaphors for the futility of trying to imagine the perfection of God's city (in contrast to earthly cities). This, however, seems unlikely given the prevalence of crumbling buildings in de Nomé's paintings. In any event, the boat in the foreground is not wrecked, but moored at low tide. Its crew appear to be seated unconcerned around a table, while, perhaps to introduce a humorous element, a monkey (?) has climbed onto one of the spars.[14]

As is typical in de Nomé's oeuvre, however, the dominant elements in NG 3811 are architectural, not figural. Nappi has recently drawn attention to the prints of Hans Vredeman de Vries, Jacques Androuet du Cerceau and Wendel Dietterlin as possible sources of inspiration for de Nomé's architecture, although no particular elements of NG 3811 seem to have been so directly derived.[15] The collapsing circular building towards the right recalls the Temple of Vesta at Tivoli. More freely painted versions of this building and of the curious column encrusted with figures left of centre appear in another picture by de Nomé dated by Nappi to 1614–16.[16] As in other paintings by de Nomé, NG 3811 contains a mixture of architectural styles, in this case classical and, in respect of some of the buildings in the left background, Gothic.[17] The perspectival construction of the landscape by way of a diagonal in depth perhaps derives ultimately from the work of Adam Elsheimer, who also painted moonlit scenes, and is found in other works by de Nomé.[18] The limited palette of NG 3811 is typical of the artist.

General References
Davies 1946, pp. 34–5 (as Monsù Desiderio);[19] 1950 Rome, Galleria dell'Obelisco, *Monsù Desiderio*, no. 12 (as Monsù Desiderio); A. Scharf in Sarasota 1950, John and Mable Ringling Museum of Art, *The Fantastic Visions of Monsù Desiderio*, no. 23 (as Monsù Desiderio); J. Thuillier in 1982 Rome, Accademia di Francia a Roma, *Claude Lorrain e i pittori lorenesi in Italia nel XVII secolo*, pp. 191, 194; Wright 1985b, p. 102 (as by Didier Barra or François de Nomé); Nappi 1991, no. A100.

NOTES

1. There is a customs seal of the Kingdom of the Two Sicilies on the back of the original canvas. The seal was identified by Davies (Davies 1946, p. 35). NG 3811 has since been relined, but a photograph of the seal is on p. 10 of the Conservation Dossier.

2. Letter of 12 May 1923 from E. Hamilton Moore to Sir Charles Holmes in the NG dossier.

3. Correspondence of May 1923 between E. Hamilton Moore and Sir Charles Holmes in the NG dossier, according to which the Trustees of the Gallery 'were unanimous in thinking that it was not good enough for them to buy, even at the price of £25—'.This episode was confirmed by Sir Charles Holmes in 'An oil painting attributed to Jacques Callot', BM, 43, 1923, pp. 4–9. According to the correspondence, Moore called the picture 'The Parable of St Anthony' and attributed it to El Greco. According to the minutes of a meeting of the Trustees (8 May 1923), it was identified as 'St. Augustine amid Ruins' and attributed to the Dutch School.

4. Sir Charles Holmes, cited in note 3.

5. Sir Charles Holmes, cited in note 3; and see National Gallery Trafalgar Square Catalogue, London 1925, pp. 88–9. The attribution to Desiderio was agreed by L. Réau, 'L'enigme de Monsù Desiderio"', GBA, 13, 1935, pp. 2422–51.

6. For an account of this research, see J. Patrice Marandel in Houston 1991–2, The Menil Collection, François de Nomé. Mysteries of a Seventeenth-Century Neapolitan Painter, pp. 13–19. As there pointed out, the fundamental article on the identity of de Nomé is Raffaello Causa's 'Francesco Nomé detto Monsù Desiderio', Paragone, 75, 1956, pp. 30–46. The splitting of 'Monsù Desiderio'

into three distinct personalities unintentionally echoes the schizophrenia from which he has been said to have suffered by A.L. Romdahl, 'Notes on Monsù Desiderio', Göteborgs Högskolas Årsskrift L, 1944–5, pp. 3–15, and by F. Sluys, 'Monsù Desiderio peintre de l'irréel', La Vie Médicale. Art et Psychopathologie, Christmas 1956, pp. 53–63.

7. Since 1956 (by implication) by Causa, cited in note 6, p. 44, n. 1, and in the same year by Sluys, cited in note 6. For an earlier article identifying Monsù Desiderio with the engraver Francesco Desideri, and attributing NG 3811 (among other paintings) to him, see A. Scharf, 'Francesco Desiderio', BM, 92, 1950, pp. 18–22, and the same author in Sarasota 1950 (see General References).

8. Sir Charles Holmes, cited in note 3. For other representations of the subject, see Pigler 1974, vol. 1, pp. 425–7.

9. Bibliotheca Sanctorum, Rome 1961, vol. 1, p. 513.

10. Ibid., p. 599, and P. Guérin, Les Petits Bollandistes, 7th edn, 17 vols, Paris, Bar-le-Duc [printed] 1882, vol. 10, p. 296. The legend seems first to have been recorded at the beginning of the thirteenth century, but not to have become popular until the fifteenth: see L. Réau, Iconographie de l'Art Chrétien, vol. III(I), Paris, 1958, p. 150.

11. E. Mâle, L'arte religiosa nell' 1600, Milan 1984, pp. 381–2. Another, earlier, example of the subject in the Gallery is the painting of c.1520 by Garofalo (NG 81).

12. M.R. Nappi, François de Nomé e Didier Barra, l'enigma Monsù Desiderio, Milan 1991, p. 180.

13. By Tom Henry in London and Oxford 1990 1, 2nd edn, p. 100.

14. That there may have been a comic dimension to de Nomé's apparently apocalyptic vision is suggested by the inclusion in another rendering of the subject of Saint Augustine and the Child (Nappi, cited in note 12, no. A103) of the statue called Pasquino, which had a well-known satirical function in Rome by the seventeenth century. For the statue and its decoration with satirical verses, see F. Haskell and N. Penny, Taste and the Antique, New Haven and London 1981, pp. 291–2. Two other treatments of the subject by de Nomé are catalogued by Nappi, nos A104 and A105.

15. M.R. Nappi, 'François de Nomé: un problema di fortuna critica', Scritti di storia dell'arte in onore di Raffaello Causa, Naples 1988, pp. 166–74.

16. Nappi 1991, no. A20. A circular temple-like structure with a broken dome also appears in nos A41, A44, A59, A83, A102 and A125. The encrusted column also makes numerous appearances in de Nomé's paintings.

17. A fascination with architecture and a tendency to mix architectural styles were characteristics that de Nomé shared with his slightly younger compatriot, Claude Lorrain. On this aspect of Claude's art see M. Kitson in London 1969, p. 28, and Kennedy 1972, pp. 265–6.

18. For example, Nappi 1991, nos A64, A127, A129, A132 and A134.

19. Davies omitted NG 3811 from his 1957 catalogue, reserving it for that of the Seventeenth Century Italian School: Davies 1957, p. 5. In the event, however, it was not included in Michael Levey's National Gallery Catalogues. The Seventeenth and Eighteenth Century Italian Schools, London 1971.

Joseph Parrocel

1646–1704

Born in Brignoles in Provence, Parrocel was trained by his father, Barthélemy, and then by his older brother Louis before going to Paris and Rome. In Rome, where he went in about 1667, he became the pupil of Jacques Courtois, a painter of battle scenes. Parrocel returned to Paris in 1675 and was admitted to the Académie Royale de Peinture et de Sculpture the following year. His reception piece for the Académie was the *Siege of Maastricht* (Draguinan, Musée Municipal). The bulk of his production consisted of equestrian battle scenes. He painted a series of eleven canvases for the king's first antechamber at Versailles, all of equestrian combats or manoeuvres, and another battle scene for the Salle des Gardes du Roi there; for the château of Marly he painted the *Crossing of the Rhine* (Paris, Louvre) in 1699. However, Parrocel also painted equestrian 'gallant' pictures, such as *La Foire à Bezons* (Tours, Musée des Beaux-Arts) in 1700, and hunting scenes. Less characteristically he made religious paintings, one of which, *Saint John the Baptist Preaching* (Arras, Musée des Beaux-Arts), was the 'May' of Notre-Dame de Paris of 1694. It is executed with the same kind of lively brushwork and range of colour as are evident in NG 6473 and 6474. Parrocel also engraved a series of *Mysteries from the Life of Jesus Christ* and of *Miracles from the Life of Our Lord Jesus Christ*. He exhibited sixteen pictures at the 1699 Salon, including military scenes, religious pictures and landscapes. His pupils included his son Charles and his nephews Pierre and Ignace-Jacques; the latter's son, Etienne, also became a painter.

NG 6473
The Boar Hunt

c.1700
Oil on canvas, 109 × 104.1 cm

Provenance
In the collection of Pierre Joseph Titon de Cogny (d.1758), rue de Montreuil, faubourg St Antoine,[1] and then in the collection of his uncle, Evrard Titon du Tillet (1677–1762), also rue de Montreuil;[2] bequeathed by Evrard Titon to his great-niece, Mme Rouillé Ducoudray, wife of M. Maréchal, Garde des Sceaux;[3] in the collection of Alphonse-Louis, comte de Sinety de Puylon, of Aix-en-Provence, by 1861;[4] bought by Georges Wildenstein, Paris, from the then comte de Sinety, château de Chazeron, in 1925 and sold by him in 1927 to E. de Villiers du Terrage;[5] by descent to his daughter, Jeanne-Marie, duchesse de Rochefoucault (née Villiers du Terrage), of avenue Montaigne, Paris, from whom bought by Maurice Segoura, Paris, in 1978;[6] bought by the National Gallery from Maurice Segoura, New York, in 1982.

Exhibitions
Marseille 1861 (723); New York 1979 (1); Amiens and Versailles 1995–6 (57).

Related Work[7]
PAINTING
Anon. [Delaroche, Mailard et al.], Paris, Dufossé and Martin, 7/8 January 1819 (lot 71 with its pendant, 48 livres(?) to Durand): possibly a smaller, autograph(?), version in horizontal format.[8]

Technical Notes
There has been some retouching around the edges, where there are a few losses, but otherwise the painting is in good condition. The primary support is a plain-weave moderately fine canvas, which has been lined. The ground is a palish pink colour. The stretcher is probably nineteenth century. On it are part of a French colourman's label of *c*.1900(?); another label marked *4118* and a red, round stamp, *Douane/Paris/Exposition*. A similar stamp appears on the back of the lining canvas. It is not known when the painting was last cleaned, but it may have been shortly before the Gallery acquired it.

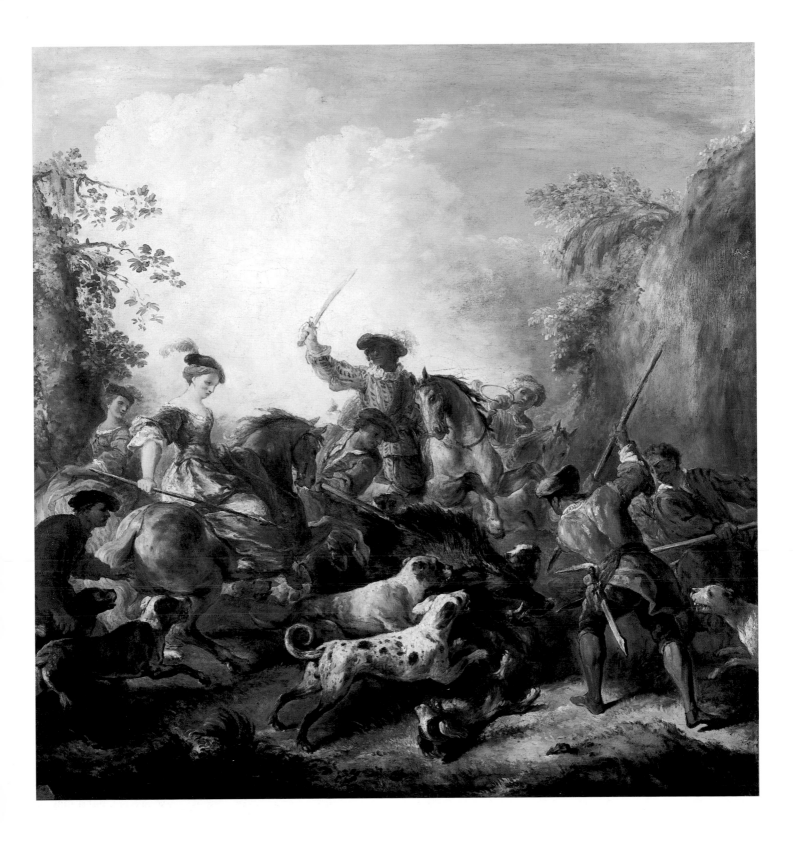

Boar hunting was an aristocratic pursuit throughout Europe, conducted on foot and on horseback with dogs. The traditional weapon was the spear, although guns were used also.[9] Prints of hunting scenes after Jan van de Straet (1523–1605) and Rubens, and by Antonio Tempesta (1555–1630) were widely available in France.[10] The male figure with the dog at the extreme left of NG 6473 may derive from a similar motif in one of Tempesta's prints of a *Boar Hunt* (fig. 1).[11] The two figures with spears at the right of NG 6473 may be based on a reversal of the two spear-carriers in the same Tempesta print. A print in reverse by Pieter Soutman (d.1657) (fig. 2) after Rubens's *Wolf and Fox Hunt* (New York, Metropolitan Museum of Art) seems to have provided Parrocel with the figure of the female rider on the rearing horse, Parrocel replacing Rubens's male rider with an adaptation of his female companion.[12] The grey horse to the right of centre of NG 6473 appears to be derived from the horse in a similar position in Soutman's print. While the inclusion of women in hunting scenes was quite common, to show one participating in the kill, as in NG 6473, was relatively unusual.[13]

The costume of the rider with a sabre recalls those of the bravos painted by Manfredi (1582–1622) and Valentin (1591–1632), but (save for the hat) may have been inspired by the theatrical costume of the *commedia dell'arte* character Mezzetin.[14] The outfits worn by the rider's companions evoke the early seventeenth century. In terms of costume, chromatic scale and the lush, impasto technique, NG 6473 has much in common with *The Fair at Bezons* (Tours, Musée des Beaux-Arts), datable to 1700–4.[15]

It was once thought[16] that NG 6473 and its companion NG 6474 represented allegories of Europe and Asia respectively and were part of the series of four paintings comprising the *Four Parts of the World*, commissioned by Louis XIV together with the Tours picture.[17] But, as has been argued in connection with NG 6474, the 'Chinese' umbrella is thin evidence for investing the picture with such allegorical significance.[18] Nevertheless, a date of *c*.1700 for NG 6473 and NG 6474 seems reasonable, and so the pictures are perhaps a little earlier than their highly elaborate frames (fig. 3).[19]

Fig. 1 Antonio Tempesta, *A Boar Hunt*, *c*.1608–21. Engraving, 18.9 × 28 cm (including lower margin). Paris, Bibliothèque Nationale.

Fig. 2 Pieter Soutman after Rubens, *A Wolf and Fox Hunt*, *c*.1642. Etching, 45.9 × 62.8 cm. London, British Museum, Department of Prints and Drawings.

Fig. 3 Detail of NG 6473 showing part of the frame.

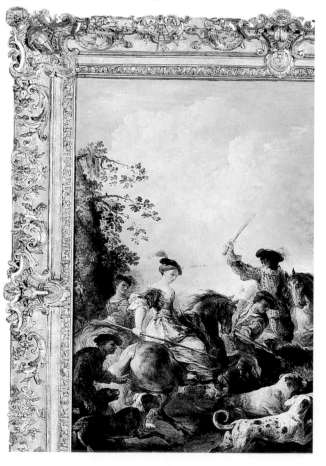

General References

E. Parrocel, *Monographie des Parrocel*, Marseille 1861, pp. 37–8; Pierre Parrocel, 'Les Parrocel. Notes Rectificatives ou Complémentaires', *Réunion des Sociétés des Beaux-Arts des Départements*, Paris 1894, pp. 203–22 at p. 219 (as by Charles Parrocel); A. Schnapper, 'Deux Tableaux de Joseph Parrocel au musée de Rouen', *La Revue du Louvre et des musées de France*, 1970, no. 1, pp. 78–82 at p. 82 (as of the last years of Joseph Parrocel); Wilson 1985, p. 76; *The National Gallery Report January 1982–December 1984*, London 1985, pp. 14–15.

NOTES

1. For a description of the house in the rue de Montreuil, see G. Brice (1752 edn), vol. 2, pp. 256–61. NG 6473 and its companion NG 6474 were hung in a room overlooking the street and next to the dining room; they were described as 'deux tableaux pendans peints sur toile originaux de ~~Parrocel~~ [deleted] Parossel pere representans des batailles, ~~deux autres tableaux aussi peins sur toile representant une dame~~ [illegible] [deleted] deux autres tableaux aussi peins sur toile representans l'un une chasse au sanglier et l'autre un retour de chasse dans leurs bordures de bois sculpté doré prisés quatre cen livres': posthumous inventory of Pierre Joseph Titon de Cogny dated 2 May 1758 (A.N., M.C., LXXXVIII, 647). The inventory was cited by V. Lavergne-Durey in 'Les Titon, mécènes et collectionneurs à Paris à la fin du XVIIᵉ et au XVIIIᵉ siècles', *BSHAF*, Année 1989 (1990), pp. 77–103, at p. 91, n. 41. The inventory does not say explicitly that the 'deux autres tableaux' were painted by 'Parossel pere' (that is, Joseph Parrocel), so they may be those attributed to Charles Parrocel in Pierre Joseph Titon de Cogny's will: 'Je nomme et choisit pour exécuteur testamentaire M. Poshouin Dhuillet avocat au parlement que je prie d'en prendre la peine et d'agréer le don et legs que je lui fais en cette considération de quatre tableaux dont deux de M. Parocel le père représentant des batailles et deux de M. Parrocel le fils représentant des chasses lesquels tableaux sont dans la chambre à coucher de ma femme donnant sur la rue de Montreuil': cited by Lavergne-Durey, p. 92, n. 86. However, this seems unlikely since NG 6473 and NG 6474 were later recorded in the collection of Evrard Titon du Tillet (see Provenance and note 2 below).

2. The posthumous inventory of 8 January 1763 of Evrard Titon du Tillet includes: 'Item deux tableaux peints par Parosel dont un représente une chasse de sanglier où l'on voit une Dame à cheval et l'autre un retour de chasse près d'une fontaine avec chevaux chiens et gibier dans leurs bordures de bois sculpté doré prisés ensemble douze cents livres' (A.N., M.C., XII, 582), see V. Lavergne-Durey, cited in note 1, p. 93, and see also p. 80. Evrard Titon du Tillet is best known for publication of the work *Description du Parnasse François*, Paris 1726, an account of French poets and musicians: see Judith Colton, *The 'Parnasse François'. Titon du Tillet and the origins of the monument to genius*, New Haven and London 1979; for information on his life and art collection, see Lavergne-Durey, pp. 78, 83–6, 93–8 and *passim*.

3. V. Lavergne-Durey, cited in note 1, p. 96, n. [6].

4. Marseille 1861, no. 723 (see Exhibitions) and Etienne Parrocel, *Monographie des Parrocel*, Marseille 1861, pp. 37–8. Alphonse-Louis was the great-grandson of Jean-Baptiste-Ignace-Elzéar Sinety de Puylon (1703–79), who became Commissaire Général de la Marine at Marseille but was also a man of letters; the grandson of André-Louis-Esprit (d.1811), who after retiring from a military career was elected as deputy for the nobility of Marseille at the States-General of 1789 and later wrote a treatise on agriculture; and the son of Antoine, who wrote works on the rural economy: see L.G. Michaud, *Biographie Universelle Ancienne et Moderne*, 45 vols, Paris 1843–65, vol. 39, pp. 405–6.

5. According to a photograph in the Witt Collection and to a fax dated 21 November 1997 from Joseph Baillio.

6. Letter from Maurice Segoura dated 17 November 1997.

7. A signed painting by Antoine-Charles-Horace (Carle) Vernet, of a *Boar Hunt in Poland*, dated 'Rome 1831' (Paris, Ader Picard Tajan, 12 December 1988, lot 77) may be derived from NG 6473, but it is just as possible that both pictures derive independently from compositions by Rubens.

8. Lot 71 of the 1819 Delaroche etc. sale was described as 'une chasse au sanglier au moment où les chiens l'assaillent de tous côtés, et où l'animal va recevoir le coup de lance de la main des chasseurs', and as the pendant to the previous lot, itself described as 'Une halte de chasse. Plusieurs dames et chevaliers se reposent à l'ombre de quelques arbres, des fatigues qu'ils viennent d'éprouver. Le résultat de leur chasse fait l'ornement du premier plan. Ce tableau, dans la manière de Vatteau, est d'une couleur vigoureux, et d'une exécution savante. Sur toile, hauteur 2 p. 3 p., largeur 2 p. 10 p.' (i.e. 73.1 × 92 cm).

9. See Antonio Tempesta's print in *The Illustrated Bartsch*, vol. 36, p. 325.

10. X. Salmon in Amiens and Versailles 1995–6, pp. 100–1.

11. Illustrated in F. Hamilton Hazlehurst, 'The Wild Beasts Pursued: The Petite Galerie of Louis XV at Versailles', *AB*, 66, 1984, pp. 224–36, at p. 228, fig. 7.

12. The posture of the horse at the left of NG 6473 is like that of curvetting: D. Rosand, 'Rubens's Munich *Lion Hunt*: its sources and significance', *AB*, 51, 1969, pp. 29–40 at pp. 36–7, n. 56, but in the context of a hunt its posture, like that of the horse at the left of Soutman's print, is better described as rearing: see W.A. Liedtke, *Flemish Paintings in the Metropolitan Museum of Art*, 2 vols, New York 1984, vol. 1, p. 200, for this point in connection with Rubens's painting.

13. Unless the woman was the goddess Diana or one of her nymphs, or Atalanta in depictions of *The Calydonian Boar Hunt* (as related by Ovid, *Metamorphoses*, VIII: 271 ff.). On the occasions that women appear in Tempesta's numerous hunting scenes it is nearly always as observers rather than participators. A female rider accompanying a male companion does appear in a print by Daniel Rebel of *c*.1628, *La Chasse au faucon*: see Véronique Meyer, 'L'oeuvre gravé de Daniel Rebel', *Nouvelles de l'Estampes*, no. 67, January–February 1983, pp. 6–15, at p. 9, fig. 5. Her position is (in reverse) not unlike that of the female rider in NG 6473. There are no female participants in Joseph Parrocel's *Boar Hunt* (Aix-en-Provence, Musée Granet, inv. no. 860-1-24); however, another painting by him of that subject shows a huntress with spear in hand, as Xavier Salmon kindly pointed out; and see *A Stag in the Forest* (NG 829) by Hackaert and Nicholas Berchem in the National Gallery.

14. As X. Salmon, cited in note 10, p. 142, pointed out. For Mezzetin's costume, see François Moureau, 'Theatre Costumes in the Work of Watteau', *Watteau 1684–1721*, National Gallery of Art, Washington 1984, pp. 507–26 at pp. 508–10.

15. R. Fohr, *Tours, musée des Beaux-Arts… Tableaux français et italiens du XVIIᵉ siècle*, Paris 1982, no. 53.

16. Wilson 1985, pp. 76–7.

17. See R. Fohr, cited in note 15, for a summary history of Louis XIV's commission, and for the proposal that NG 6473 and 6474 were part of the commission, see New York 1979, p. 11.

18. V. Lavergne-Durey, cited in note 1, p. 80, and X. Salmon, cited in note 10, p. 142. Alastair Laing independently pointed out that NG 6473 and 6474 were not among the pictures commissioned by Louis XIV: conversation of 15 February 1991.

19. The frames resemble those made for the Bâtiments du Roi in the years 1710–30. See Bruno Pons, 'Les cadres français du XVIIIᵉ siècle et leurs ornements', *Revue de l'Art*, 76, 1987, pp. 41–50 at p. 46.

NG 6474
The Return from the Hunt

*c.*1700
Oil on canvas, 109 × 104 cm

Provenance
As for NG 6473.

Exhibitions
Marseilles 1861(724); New York 1979(2); Amiens and Versailles 1995–6(58).

Related Works
PAINTINGS
(1) Anon. [Delaroche, Maillard et al.] sale, Paris, Dufossé & Martin, 7/8 January 1819, lot 70 (with its pendant 48 livres(?) to Durand): possibly a smaller, autograph(?) version in horizontal format;[1]
(2) Whereabouts unknown. A copy (107 × 142.5 cm) attributed to Jérome-François Chantereau (*c.*1710–57) was offered for sale 9 March 1972 (Paris, Palais Galliera, lot 5), and 29 November 1972 (Paris, Hôtel Drouot, Room 10, lot 107), and 23 May 1978 (Versailles, lot 64).[2]
DRAWINGS
(1) Paris, Louvre, Cabinet des Dessins, inv. 32213 (fig. 1). Possibly a preliminary compositional drawing by Joseph Parrocel either for NG 6474 or for a variant work, but the Louvre's current attribution of the drawing is to his son, Charles Parrocel;[3]
(2) Paris, Louvre, Cabinet des Dessins, inv. 25191. Attributed to Jérome Chantereau. The composition of the drawing is close to that of the painting attributed to Chantereau (noted above) save for some simplification of the landscape background.[4]

Technical Notes
In good condition except for a horizontal tear some 5 cm long along the left edge. The primary support, its relining, the stretcher and the ground are as for NG 6473, as is the likely restoration history. The following are on the back of the stretcher: (i) a label marked *4119*, (ii) a custom stamp, *Paris*, which is also on the lining canvas, and (iii) a label marked *S58/1.739*.

The subject of an elegantly dressed group with one or more amorous couples resting after the hunt was popular in Dutch seventeenth-century art, reflecting a long tradition of associating hunting with courtship,[5] and NG 6474 may be seen as one of the many examples of French paintings from *c.*1700 influenced by Dutch genre subjects. In this case the exotic costumes, the gushing fountains and the coy-looking woman holding flowers at the centre of the composition add to the air of romance. The presence of hunting dogs accounts for the dead deer and boar in the bottom left foreground, but the hare and duck were presumably victims of the falcon[6] held by the man seated on the edge of the fountain. Falconry was an especially popular aristocratic pursuit in the sixteenth and early seventeenth centuries, but its practice declined during Louis XIV's reign.[7] The costumes of the two main actors in Parrocel's rural romance seem to belong to the early seventeenth century, possibly reflecting historicising on the artist's part and the influence of engravings by or after earlier artists such as Tempesta and Rubens. The figure in the background holding a parasol appears to be derived from a similar figure in Tempesta's *Lady observing a Stag Hunt* (fig. 2).[8] The principal female figure might have emerged, as it were, from Marie de' Medici's entourage in Rubens's celebrated series then in the Palais du Luxembourg. The bright and attractive colouring of the picture and the freedom with which the paint has been applied also testify to the influence of Rubens's art in France around 1700, although the young woman seated immediately to the left of the amorous couple looks like a Raphael Madonna in disguise.

NG 6473 and NG 6474 have generally been identified as two of the pictures in Titon de Cogny's posthumous inventory of 1758 (see Provenance to NG 6473), and were there treated as a pair.

General References
As for NG 6473.

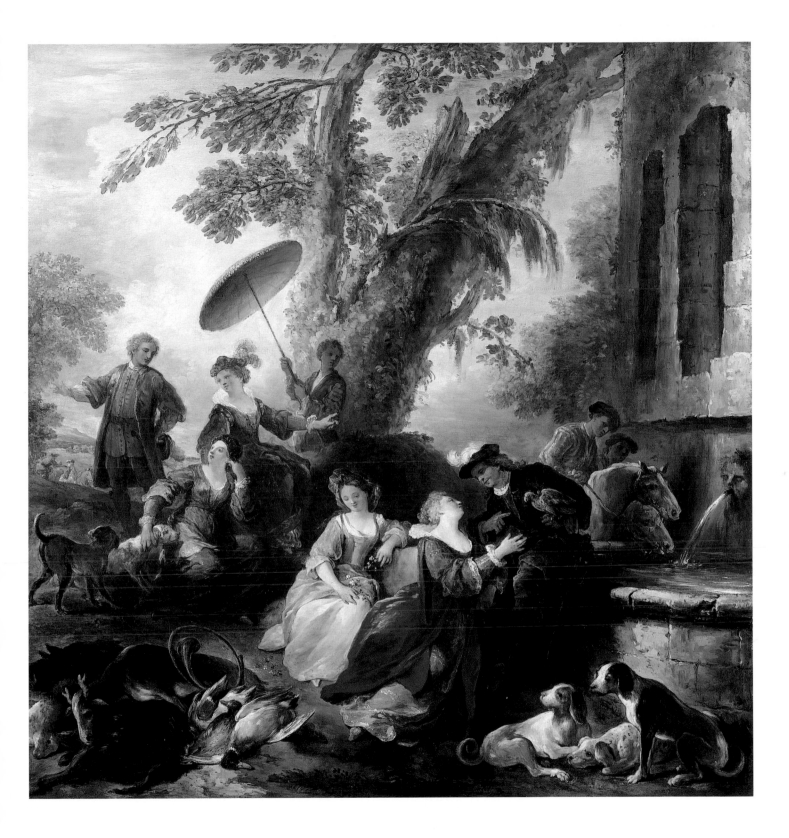

Fig. 1 Joseph Parrocel(?), *Halte de Chasse*, c.1699–1700? Pen and brown ink, grey and brown wash, and red chalk. 21.1 cm × 29 cm. Paris, Musée du Louvre, Cabinet des Dessins.

Fig. 2 Antonio Tempesta (1555–1630), *Lady observing a Stag Hunt*. Engraving, 26.3 × 39.6 cm. London, British Museum, Department of Prints and Drawings.

NOTES

1. See note 8 to the entry for NG 6473.

2. As noted by Xavier Salmon in Amiens and Versailles 1995–6, p. 142.

3. J.F. Méjanès attributes the drawing to Charles Parrocel in *Inventaire général des dessins du musée du Louvre et du musée d'Orsay, Ecole française, Volume XIII, De Pagnest à Puvis de Chavannes*, Paris 1997, p. 116.

4. The drawing is reproduced in New York 1979, Maurice Segoura, p. 13, fig. 1. It is also catalogued and reproduced in *Inventaire général des dessins du Musée du Louvre et de Versailles. Ecole Française*, by J. Guiffrey and E. Marcel, vol. 3, Paris 1909, p. 56, no. 2200, repr. p. 57, fig. 2200.

5. Wayne Franits, 'The Pursuit of Love. The Theme of the Hunting Party at Rest in Seventeenth Century Dutch Art', *Konsthistorisk tidskrift*, vol. 61, 1992, pt. 3, pp. 106–15.

6. Recognisable more from its keeper's glove than from its parrot-like head.

7. Pierre Jacky, *Alexandre-François Desportes. Tableaux de chasse*, exh. cat., Paris, Mona Bismarck Foundation, and Gien, Musée International de la Chasse, Paris 1998, p. 75.

8. *The Illustrated Bartsch*, vol. 37, p. 60.

The Return from the Hunt (NG 6474), detail.

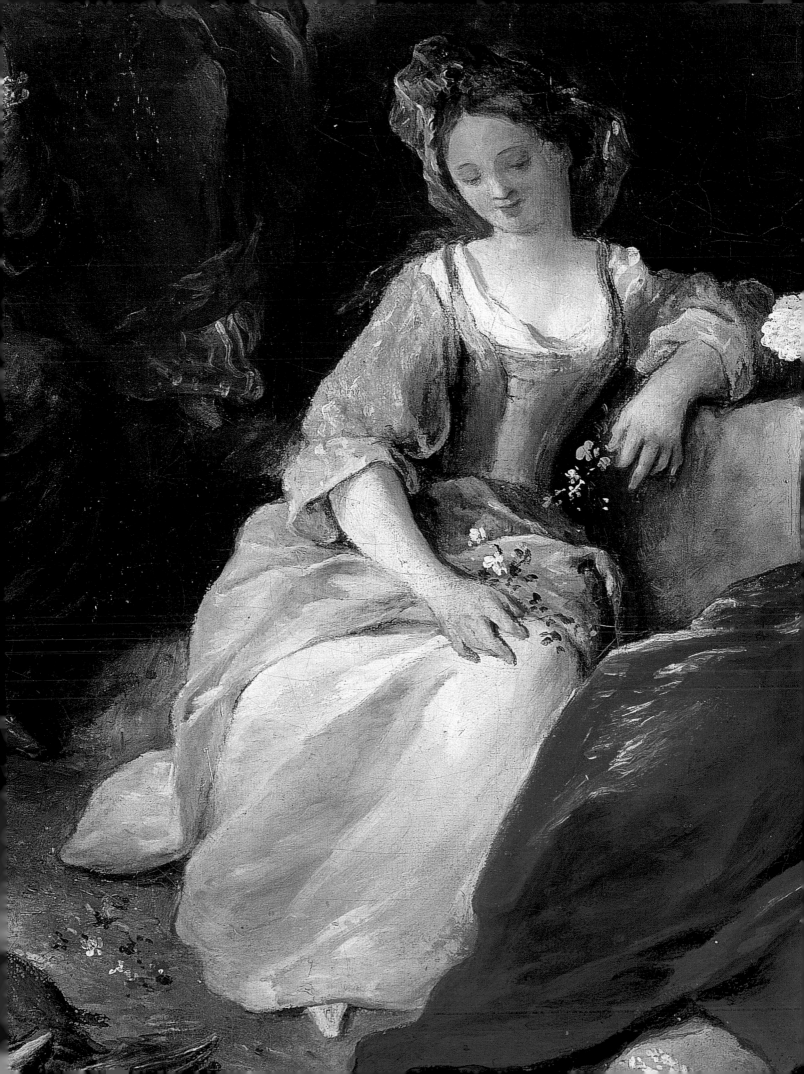

Pierre Patel

*c.*1605–1676

Patel was born around 1605 at Chauny in Picardy. It is not known where he first learned to paint. He was in Paris by 1633 and was admitted to the Académie de St-Luc (the Paris painters' guild) in 1635. Later he worked for Simon Vouet, assisting with cartoons for tapestries. In 1646–7 and 1651–5 he took part in the decoration of the hôtel Lambert with Eustache Le Sueur. In 1660 he executed two landscapes for Anne of Austria showing episodes from the life of Moses (Paris, Louvre), and between 1668 and 1676 he painted a series of views of royal residences – the one that survives, *View of the Château of Versailles in 1668*, is still at Versailles. He never became a member of the Académie Royale de Peinture et de Sculpture. Patel's landscapes are similar in composition to those of Claude – in the eighteenth century he was called 'the Claude Lorrain of France' – a substantial part of the picture space being taken up by precisely rendered, elaborate ruins of fictive classical buildings, typically having fluted columns and pilasters and decorated with relief sculpture. This is often balanced on the other side by framing trees with an extensive view into the distance from a slightly elevated viewpoint. Patel's son, Pierre-Antoine, painted in a similar style.

NG 6513
Landscape with the Rest on the Flight into Egypt

Oil on canvas, 97.7 × 138.0 cm
Signed and dated at bottom: .P.PATEL.INVE.PIN/.1652.

Provenance
Possibly in the sale of James, 2nd Earl Waldegrave (1715–63), friend and adviser to George II and relation by marriage to Horace Walpole,[1] London, Prestage, 16 November 1763 (lot 34, £52 10s. to 'Mr Brown (he was mad, put up again)') where described as 'Virgin and Child and St Joseph... 55 × 38';[2] possibly in the sale of Richard, 1st Earl Grosvenor (1731–1802), Grosvenor Square, London, Christie's, 13 October 1802 (lot 56, £21 10s. 6d., purchaser unknown), where described as 'A beautiful Landscape and Ruins, with a Reposo, capital';[3] possibly in the sale of William Court of Bristol, Christie's, 22 February 1812 (lot 93, £60 18s. to Morland), where described as 'An elegant Italian Landscape with the Reposo – a truly elegant and richly coloured chef d'oeuvre'; anon. sale, Bologna, Christie's, 27/28 September 1986 (lot 333, 35 million lire plus premium to Didier Aaron Inc.); bought, 1988.

Exhibition
New York 1987, Didier Aaron Inc., *A Timeless Heritage. Masterworks of Painting for Today's Collector* (6).

Related Works
DRAWING
A black chalk and watercolour drawing of a landscape without figures in the collection of the Ecole Nationale Supérieure des Beaux-Arts, Paris (inv. no. 1396) (fig. 1), is closely related compositionally to NG 6513 but may be by Patel's son Pierre-Antoine Patel.[4] In any event, given the frequency with which Patel used compositions of this type, the drawing cannot be said unequivocally to be preparatory to NG 6513.[5]

Technical Notes
The painting is in generally good condition with no significant loss or damage. There are, however, paint losses in the foliage and trunk of the tree at the left, and some wear in the sky. NG 6513 was painted on a quite fine plain-weave canvas, which had been relined and loose lined shortly before its acquisition by the Gallery. The ground is a warm red colour. The figures and the donkey have been painted on top of the background. However, there are no textural or other differences in the paint between figures, buildings and landscape to suggest the work of more than one hand. This conclusion is supported by EDX analysis of a sample of orange-brown paint from Joseph's cloak at the shoulder which was compared to a

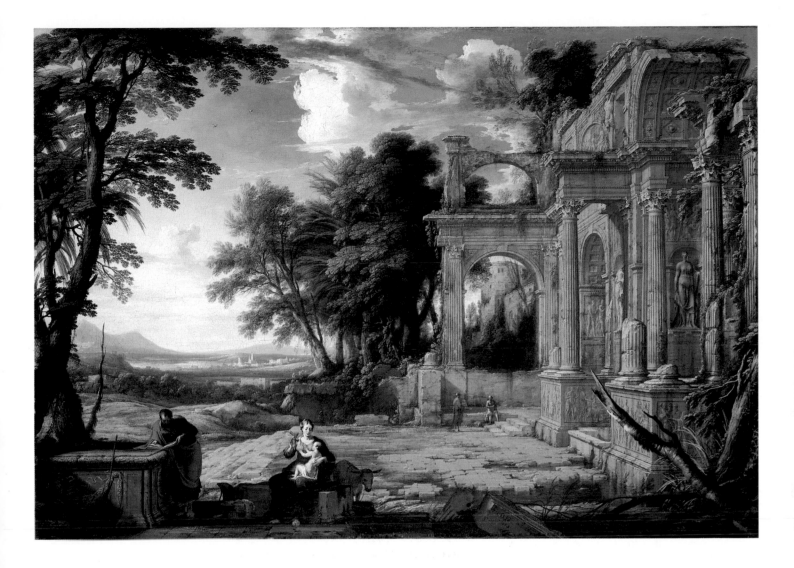

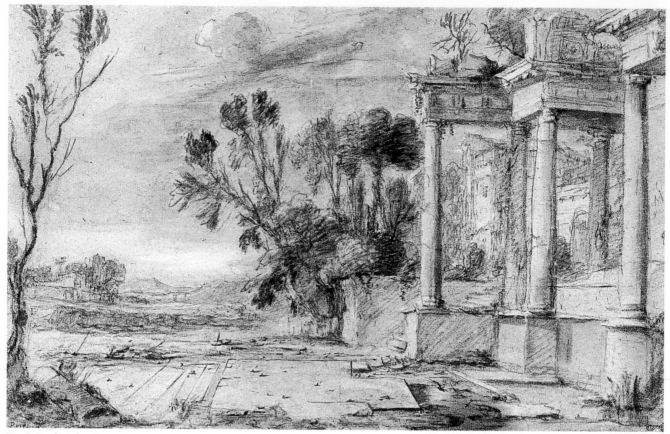

Fig. 1 Attributed to Pierre-Antoine Patel (1648–1707), *Landscape*. Black chalk, watercolour and white heightening, 25.6 × 40.9 cm. Paris, Ecole Nationale Supérieure des Beaux-Arts.

similar colour taken from foliage on the low branch of the large tree at left – the constitution of the paint in the two areas appears identical. The outline of the Virgin's left shoulder shows a pentimento, and the oval shape between the white cloud and the tree at the left may be a painted-out cloud. There are later retouchings in the outline of the Virgin to the left of the Child's knee and in the lower right outline of Joseph's robe. The brightest blue colour of the sky consists of finely ground, high-quality lapis lazuli ultramarine painted over an under-layer consisting of smalt and white. The most intense greens in the foliage owe their colour to a high proportion of mineral azurite in the paint, while the duller greens also contain yellow lake, white and iron oxide colours.

The story of the Flight of the Holy Family into Egypt is related in the Gospel of Saint Matthew (2:13–15), but the subject of the Rest is taken from apocryphal gospel of the Pseudo Matthew (*Evangelium 21–2*), the Latin version of which dates back to the eighth or ninth century.[6] Patel's depiction, like that of many other painters, ignores much of the detail of the Pseudo Matthew legend in favour of pictorial effect. For example, whereas the Pseudo Matthew recounts that the Holy Family found shelter from the sun in the shade of a palm tree, the Virgin and Child are only in partial shade, and that from an oak. It is also curious that a niche in the architecture contains a complete marble figure of a goddess; this is inconsistent with the spirit of the Pseudo Matthew, which describes the Holy Family entering a temple at Sotina and all the idols falling from the altar. The fact that the heathen temple in NG 6513 is in ruins is, however, appropriate, although without source in the Pseudo Matthew. The bas-reliefs on the ruins are probably imagined,[7] as are the ruins themselves. If the ruins have a source, or rather an inspiration, it is in such paintings by Claude as *Seaport with Ulysses restituting Chryseis to Chryses* (Paris, Louvre) and *Seaport with the Embarkation of the Queen of Sheba* (NG 14), both of which had probably arrived in Paris in the years preceding execution of NG 6513. NG 14, for example, gives prominence to fluted columns and pilasters in a way adopted in NG 6513 and in others paintings by Patel.[8]

The basic composition of classically inspired ruins on one side and a framing tree on the other before an extensive landscape may be seen in other works by Patel, notably *Landscape with the Journey to Emmaus*, also signed and dated 1652 (Norfolk, Virginia, The Chrysler Museum),[9] and *Landscape with Ruins and Shepherds* (Paris, Louvre).[10] Paintings by Patel of the same subject as NG 6513 but smaller are at Tours, Ottawa and the Louvre.[11] The first is dated 1658, the second, on copper, 1662, and the third, also on copper, 1673.

General Reference
The National Gallery Report, 1985–7, London 1988, pp. 35–6.

NOTES

1. See *DNB*, vol. 20, pp. 475–7.

2. See the copy of this catalogue in the British Library. The measurements suggest an upright format, but there is nothing in the description of the painting in the Phillips MS 10254 to support this ('Patel. Our Saviour, &c in a Landscape, with Buildings – Buildings fine, otherwise a dark gloomy Picture'). Even if the measurements corresponded better, the subject is too common to propose this provenance with great confidence, and similar caution is appropriate in respect of the subsequent provenance of NG 6513 until 1986.

3. A 'Landscape with a Reposo. A pleasing and genuine Specimen of the French Claude' was also offered at Liverpool, Winstanley, 13 April 1810, lot 107: *The Index of Paintings Sold*, vol. 2, part 2, p. 722.

4. Letter of 20 February 1987 from Natalie Coural.

5. See *De Michel-Ange à Géricault. Dessins de la Donation Armand-Valton*, Paris 1981–2, ENSB-A, Paris, Malibu, Ca., The J. Paul Getty Museum, and Hamburg, Kunsthalle, no. 148 (where illustrated in colour).

6. For this and the following comments in the Text on the *Evangelium*, see Gertrud Schiller, *Iconography of Christian Art*, 2 vols (1st English edition trans. J. Seligman), London 1971, vol. 1, pp. 117ff.

7. As advised by Jennifer Montagu: see *The National Gallery Report 1985–7*, London 1988, p. 36, n. 1.

8. For an appreciation of Patel as a painter of architecture, see J.B. Deperthes, *Histoire de l'Art du Paysage depuis la Renaissance des Beaux Arts jusqu'au dix-huitième siècle*, Paris 1822, pp. 293–4.

9. See Jefferson C. Harrison, *French Paintings from the Chrysler Museum, 1986–7*, North Carolina Museum of Art and Birmingham [Alabama] Museum of Art, no. 3.

10. See Natalie Coural, 'Le Paysage avec ruines et pasteurs de Pierre Patel (1605–1676)', *Revue du Louvre*, (4) 1990, pp. 307–9, who rightly notes (p. 308) the affinity between NG 6513 and the Louvre painting in respect of the composition, direction of light, and grouping of the figures in the foreground shade.

11. Tours, Musée des Beaux-Arts (R.F. 1985-70), 40 × 57 cm; Ottawa, National Gallery of Canada (no. 17608), 26 × 35.2 cm; Louvre (R.F. 3981), 41 × 50 cm. Another version of the subject by Patel painted in 1657 on canvas was last recorded in the Lepke sale, Berlin, 12–18 October 1908, lot 81: ed. M. Laskin and M. Pantazzi, *Catalogue of the National Gallery of Canada Ottawa. European and American Painting, Sculpture, and Decorative Arts*, vol. 1/1300–1800/Text, Ottawa 1987, p. 217. Laskin and Pantazzi (ibid.) also note a black-chalk drawing by Patel of the subject, in the form of a tondo, in the museum at Besançon (exh. Paris 1958, Petit Palais, *Le XVIIe Siècle Français*, no. 225, and London 1958, RA, *The Age of Louis XIV*, no. 260). Finally, an undated painting on canvas of the same subject was sold at Sotheby's, Monaco, 19 June 1994, lot 459 (there described as by Pierre Patel).

Nicolas Poussin
1594–1665

Poussin was probably educated at the Jesuit college in Rouen near his birthplace at Les Andelys in Normandy. He may have first been taught to paint by Noël Jouvenet and Quentin Varin in Rouen before going to Paris in 1612. There he worked in the studios of Georges Lallemant and Ferdinand Elle. As a young man he made two unsuccessful attempts to reach Rome, on one occasion getting as far as Florence. Then in 1622 he was commissioned to paint six large pictures for the Jesuit college in Paris. Their success brought Poussin to the attention of the poet Giovanni Battista Marino, who was himself in Paris at that time.

Poussin finally reached Rome in 1624, encouraged by Marino, who introduced him to the wealthy Marcello Sacchetti through whom he met Cardinal Francesco Barberini, nephew of the Pope. Marino, however, soon left Rome, as did Barberini, who went on an embassy to France with Cassiano dal Pozzo. The financial difficulties in which Poussin then found himself were alleviated when, on Barberini's and Dal Pozzo's return to Rome at the end of 1625, Barberini commissioned *The Destruction of the Temple in Jerusalem* (Jerusalem, The Israel Museum). In 1626, following another embassy, this time to Spain, Barberini commissioned *The Death of Germanicus* (Minneapolis). Among numerous commissions from Dal Pozzo or members of his family which Poussin received from the later 1620s were the *Adoration of the Golden Calf* (NG 5597) and the first series of *The Sacraments* (1636–42).

Poussin's paintings for Cardinal Richelieu, including the *Triumph of Pan* (NG 6477), strengthened the artist's reputation in France, to which country he was eventually persuaded to return in 1640 by royal command. Following an unhappy two years in Paris, he returned to Rome. Thereafter his work was produced for mainly French patrons. Its tone became more erudite, as with the second series of *The Sacraments* (1644–8), the *Phocion* landscapes in Liverpool and Cardiff of 1648 and the *Judgement of Solomon* of 1649 (Paris, Louvre). According to his biographer, Bellori, Poussin considered this last painting to be his greatest achievement.

In 1657 Poussin rejected the offer to become principal of the Accademia di San Luca in Rome. His health began to fail in 1660, but it was during his final years that he painted for the duc de Richelieu the suite of *The Four Seasons* (Paris, Louvre), one of his most personal and poetic works. Poussin's wife, Anne-Marie Dughet, sister of the painter Gaspard Dughet (see p. 143), died childless in 1664. Poussin himself died the following year.

NG 39
The Nurture of Bacchus

*c.*1628
Oil on canvas, 80.9 × 97.7 cm (including an addition along the top of the canvas of 5.9 cm)[1]

Provenance
Possibly in the collection of Jean-Baptiste de Bretagne (d.1650) as inventoried on 25 October 1650;[2] probably in the duc de Tallard's sale, Paris, Rémy & Glomy, 22 March–13 May 1756, lot 161 (1200 livres to Mariette),[3] in which case in the Tallard collection by 1752,[4] and in the Mariette sale, Paris, Basan, 15 November 1775–30 January 1776, lot 18 (2310 livres to Neuilly for de la Valade);[5] noted on 8 March 1788 by Edward Knight (1734–1812) (of Wolverley House near Kidderminster, Worcestershire, and 52 Portland Place, London) as bought by him for £400, probably in the previous month;[6] John Knight (1765–1850) presumably by inheritance;[7] his sale of paintings 'removed from his residence in Portland Place', London, Phillips, 23/24 March 1819 (lot 110, bought in or passed at 550 guineas);[8] his sale, London, Phillips, 17 March 1821 (lot 42, £619 10s. to Cholmondeley);[9] George James Cholmondeley bequest to the National Gallery in 1831, subject to a life interest for the Hon. Mrs Phipps, who died in 1836, when the painting entered the collection.

Exhibitions
London 1816, BI (49) as 'Bacchanalians in a Landscape – N. Poussin John Knight, Esq.';[10] London 1947, NG, *An Exhibition of Cleaned Pictures (1936–1947)* (59); Rome 1977–8, Villa Medici, and Düsseldorf 1978, Städtische Kunsthalle, *Nicolas Poussin 1594–1665* (10) (exhibited only in Düsseldorf); London 1986–7, Dulwich Picture Gallery, *Nicolas Poussin. Venus and Mercury* (8); Fort Worth 1988, Kimbell Art Museum, *Poussin. The Early Years in Rome* (27); Copenhagen 1992 (16); London 1995, NG, *Poussin Problems* (no catalogue); Rome 1998–9, *Nicolas Poussin. I primi anni romani* (33).

Related Works
PAINTINGS
(1) Autograph variant in the Louvre (inv. no. 7295), 97 × 136 cm (fig. 2);[11]
(2) Dulwich Picture Gallery (no. 477). 73.6 × 99.4 cm. A copy, perhaps eighteenth century.[12] Photograph in NG dossier;
(3) Private collection, Brussels. A copy, perhaps by a French hand, *c.*1720, 55 × 70 cm, with slight variations in the figures and a reduced margin of landscape around them. Previously with G. Flamant, Brussels, in 1970. Photograph in NG dossier;

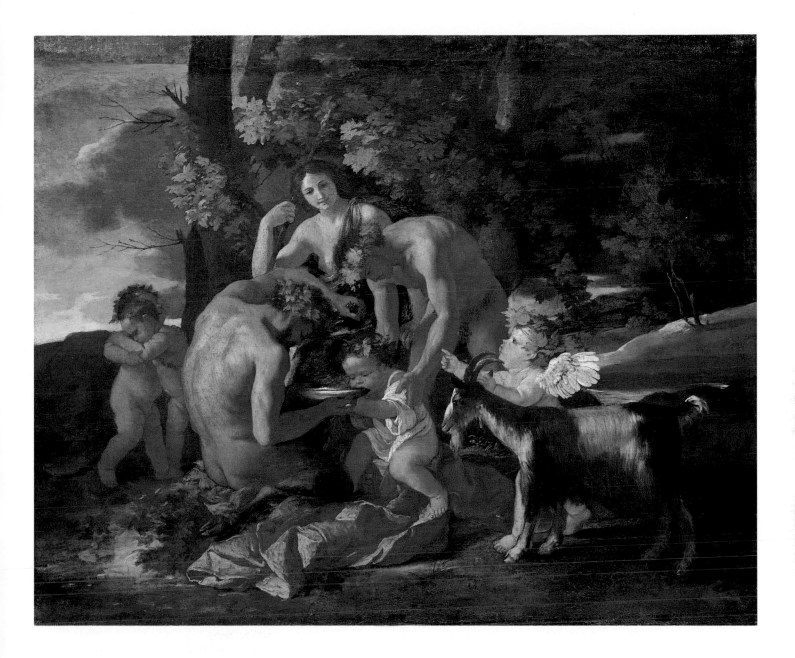

(4) A copy recorded in 1989 in London, private collection, 55 × 76 cm. Photograph in NG dossier;

(5) In the sale of the executors of the late Major Eric A. Knight, Wolverley House, Wolverley, 24–28 April 1945, lot 348 was described as 'Large oil painting in gilt frame "Childhood of Bacchus"' and may have been a copy of NG 39, given the provenance of the latter;

(6) The Montpellier painter Samuel Boissière (1620–1703) owned a *Nurture of Bacchus* by Poussin, modestly valued at 60 livres;[13]

(7) A painting of a similar subject, but too large to be NG 39, was recorded in the collection of Pierre Gruyn (d.1722), from whose estate it was bought by Charles-Henry, comte de Hoym;[14]

(8) The satyr and the male figure holding Bacchus recur in a painting in the Hermitage attributed by Blunt to the 'Master of the Clumsy Children' (Blunt 1966, R67), and by Thuillier to 'un habile pasticheur' (Thuillier 1994, R59).

DRAWINGS

None known by Poussin. A drawing of the same subject in the Louvre attributed to the milieu of Nicolas Chaperon (1612–56) may be derived from NG 39.[15]

PRINTS

The Louvre variant was first engraved in reverse by Matthys Pool, Amsterdam, in 1699[16] (Andresen 364). It may have been this engraving that was referred to in the Tallard sale catalogue (see Provenance). Other engravings of the Louvre painting were made between 1805 and 1832,[17] and an etching in the same sense as the picture was made by Alphonse Masson in 1869.[18]

Technical Notes

There is a later addition of some 5.9 cm along the top, and the bottom edge is irregular.[19] The original canvas is generally quite worn, and rubbed in the drapery, the leaves bottom left and the branches top left. There is an L-shaped tear about 3 cm long each way in the left flank of the standing man and the tree behind him, and a loss over the heads of the putti at the left. The blue of the drapery has deteriorated. The support is a plain-weave canvas that was lined before 1853, perhaps *c*.1800 and strip-lined in 1943. The ground is a warm buff colour, but the strip at the top has a white ground and may be of the same material as the relining.

The painting was last retouched in 1976. Prior to that the picture had been cleaned in 1942, when most of the standing man's girdle of vine leaves, a modern addition, was removed. Although said by Davies (1957, p. 170) to be unfinished in the landscape at left and right, this is questionable. There is a pentimento to the goat's left forefoot. The X-radiograph shows that the area of the nymph's drapery was left in reserve, and that her right elbow was drawn over the ground in outline. The infra-red photograph (fig. 1) suggests that some of the outlines, mainly of the kneeling satyr, were drawn or painted on the priming layer.

Samples taken from the original paint and that on the added strip indicate the media as linseed oil with a little pine resin and walnut oil respectively.[20]

The subject of NG 39, although apparently connected with the story of the infancy of Bacchus as related in Ovid's *Metamorphoses*, is problematic. The painting entered the collection as 'The Nursing of Bacchus' and retained this title in all catalogues up to and including that of 1946.[21] Davies there briefly expressed doubts about the title, however, and in his 1957 edition called the painting 'Bacchanal', arguing that even if the child drinking was Bacchus, 'the scene appears not to correspond with any known story of the infancy of Bacchus'.[22] In a sense Davies was right, because the subject of NG 39 is not that commonly assumed (as much in respect of the variant in the Louvre as NG 39), namely the nursing of the infant Bacchus by the nymphs of Nysa.[23] This well-known episode was briefly related by Ovid (*Metamorphoses*, III: 314–15): '[Bacchus] was confided to the nymphs of Nysa, who hid him in their cave and nurtured him with milk').[24] In NG 39, however, there is only one nymph, whereas there were six Nysiades (in the related Louvre picture, also autograph, there is a second nymph, but her state of abandon has rendered her – temporarily at least – incapable of nurturing or anything else), there is no cave, and although the goat, if female,[25] might allude to milk, it is clear that the infant is drinking wine.

The solution to the apparent problem may lie in the immediately preceding episode in the life of the infant Bacchus, as related by Ovid (*Metamorphoses*, III: 313–14): 'In secret [Bacchus'] mother's sister, Ino, watched over his infancy'. If the female in NG 39 is identified as the mortal Ino, the standing male may be Athamas, her husband and son of Aeolus, god of the winds, and the two putti as their sons, namely Learchus and Melicertes.[26] As related later in the *Metamorphoses* (IV: 420–1), Ino, who 'knew naught of grief', was 'proud of her children, of her husband, Athamas, and proud above all of her divine foster-son [Bacchus]'.[27] It may be the happy and proud Ino who is shown in NG 39 looking on as Athamas holds the infant Bacchus and a seated satyr presses the grapes. It was, however, precisely Ino's pride and happiness in Bacchus, who was the product of the unlawful union of Jupiter and Semele, which aroused Juno's envious anger and hence the story's tragic outcome: Ino and Athamas went insane, causing Athamas to kill Learchus and Ino to jump into the sea with Melicertes.[28] Although Blunt considered NG 39 to be a painting without hidden meanings and a straightforward rendering of a traditional classical story,[29] it is possibly this tragedy to which Poussin alludes both in the dark cloud at the left and in the goat being held by a winged cupid. The goat was an animal sacrificed to Bacchus as punishment for the harm it did to vines.[30] The grapes being squeezed by the satyr, to which the winged cupid points, may be a reference to this, since Ovid relates in the *Fasti* that the bacchic sacrifice of the goat involved wine being sprinkled on its horns.[31] The goat in NG 39 would then be not a nurturing animal but a sacrificial one, and the winged cupid's gesture may allude to another sacrifice to an angry divinity, namely that of Ino and Athamas to Juno. In each case the victim's 'crime' was heedless disregard of divine sensitivities.

In its intimation of death within an idyllic scene NG 39 can be linked thematically to a number of other pictures by

Poussin, and in its use of myth to point out a moral (that disregard of divine sensibilities will not go unpunished) it can be linked with the Dulwich *Venus and Mercury*, which must have been painted a little earlier in the artist's career.[32] It has been suggested that the triangular composition of NG 39 – also seen in the Louvre painting and *The Childhood of Bacchus* at Chantilly (Musée Condé, inv. no. 298) – reflects the view expressed in Blaise de Vigenère's *Images ou tableaux de platte Peinture de Philostrate* (1578), a book known to Poussin possibly in the 1614 edition,[33] that '[Bacchus] is represented by a triangle: the highest and most excellent mark or symbol of all those attributable to divinity'.[34] However, the triangular composition of these paintings more likely reflects the strong influence of sixteenth-century Venetian painting on Poussin at this stage of his career.

If NG 39 indeed shows the nurture of Bacchus by Ino and Athamas, it seems unlikely that Poussin would have modified this by adding a sleeping bacchante, as in the Louvre variant (fig. 2), whose presence would be at best irrelevant and at worst prejudicial to the dramatic impact of the image. Moreover, the use of the figure of the bacchante so obviously borrowed from Titian[35] seems more appropriate to an artist still lacking in confidence. Its removal from NG 39 creates a more refined subject and a composition of balanced triangularity. All this is relevant to the dating of NG 39 relative to the Louvre picture, now universally accepted as autograph[36] and generally dated to 1626–7,[37] but which has usually been wrongly seen as a later modification of NG 39.[38] NG 39 should be regarded as the later of the two paintings, as is increasingly accepted,[39] and it was clear also from the confrontation between the pictures in London in 1995 that the modelling of the figures in the Louvre painting, admittedly in less good condition than NG 39, is relatively crude. Mahon's recently proposed dating of NG 39 to 1628 seems right and for the reasons most recently given by him[40] (making the picture later than the Dulwich *Venus and Mercury* to which it has been said to be closely contemporary).[41]

General References

Smith 1837, 209; Magne 1914, 16; Bertin-Mourot 1948, XIX; Davies 1946, pp. 74–5; Davies 1957, pp. 170–2; Blunt 1966, 133; Badt 1969, 101; Thuillier 1974, 31; Wild 1980, R26 as by 'the Master of the Bacchanals'; Wright 1985a, 16; Wright 1985b, p. 134; Oberhuber 1988, 27; Mérot 1990a, 123; Thuillier 1994, 52.

Fig. 1 Infra-red photograph, showing detail of satyrs.

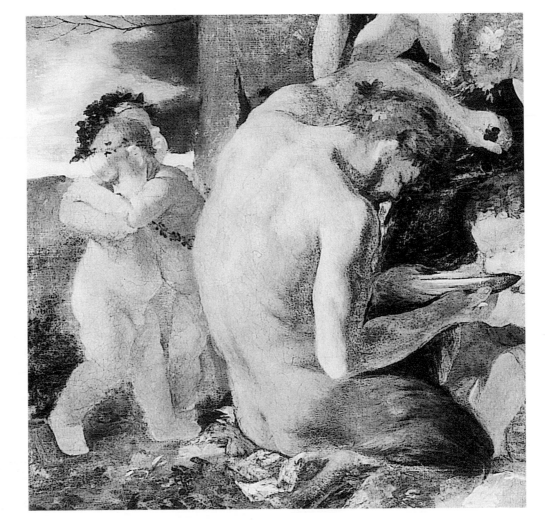

1. The addition comprises a canvas strip of 3.9 cm and additional filler of 2 cm.

2. 'Item un tableau peint sur thoille du Poussin avecq sa bordure d'or bruny représentant L'éducation de Bachus, prisé six vingtz livres', Claude Mignot, 'Le cabinet de Jean-Baptiste de Bretagne, un "curieux" parisien oublié (1650)', *AAF*, vol. 26, 1984, pp. 71–87 at p. 76 and p. 86, n. 97. This painting may, however, have been Poussin's much larger picture, *The Infancy of Bacchus* in the Musée Condé, Chantilly; or *The Nurture of Bacchus* bought by Louis XIV from M. de La Feuille in 1671 and now in the Louvre (Chomer and Laveissière 1994, no. 5). For the Chantilly picture, see *Nicolas Poussin. La collection du musée Condé à Chantilly*, Musée Condé, Château de Chantilly, 1994–5, no. 2.

3. Mariette commented on making this acquisition: 'Je suis très content de l'acquisition. Tout le monde m'en fait compliment et me l'a envié' (Mariette, *Abecedario*, vol. 4, p. 205). I am grateful to Colin B. Bailey for drawing my attention to Mariette's comment.

4. 'NICOLAS POUSSIN./161. Bacchus accompagné de plusieurs Satyres & Enfans: très beau Tableau d'une composition savante & gracieuse, & d'un coloris plus vigoureux que n'ont coutume de l'être ordinairement les Tableaux de ce grand Peintre. Il est peint sur toile, de 26 pouces de haut, sur 35 de large, & il a été gravé à l'eau forte.' A copy of the sale catalogue in the NG Library is annotated '1200 Mariette'. In his *Voyage Pittoresque de Paris*, 2nd edn, 1752, p. 211, Dezallier d'Argenville noted an *Education of Bacchus* by Poussin in the duc de Tallard's collection. The hôtel of the duc de Tallard was at the corner of the rue des Enfans Rouges and the rue d'Anjou in the Marais: Piganiol de la Force, *Description Historique de la ville de Paris*, 10 vols, Paris 1765, vol. 4, p. 365.

5. 'Nicolas Poussin./18. Jupiter enfant, à qui un Satyre présente à boire: un beau Groupe de quatre figures & de plusieurs enfants sur un fond de paysage, fait la composition de ce savant Tableau, peint en Italie, & où l'on trouve la correction de dessin & la beauté des contours qui font avec justice admirer ce grand homme, qui illustrera à jamais notre Ecole; il porte 3 pieds sur 27 pouces de haut.' In Mariette's *Abecedario*, vol. 4, p. 205, Chennevières and Montaiglon note that two different buyers' names are recorded, Neuilly and De la Valade, and conclude that the first can only be that of the agent. It is possible that the painting in the Tallard and Mariette sales is that now in Dulwich (no. 477).

6. *Edward Knight: Pocket Book, March 1786 to March 1791*, Kidderminster Public Library, ms. 000290: 'Mar.8 [1788] Education of Bac. Poussin – 400/Whereof paid Feb 1/2 100. 300.–.–.' Edward Knight was a cousin of Richard Payne Knight and a patron of Flaxman. His nephew and heir was John Knight (1765–1850): see Ella Hendricks, 'The first patron of John Flaxman', *BM*, 126, 1984, pp. 618–25. See also *The Index of Paintings Sold*, vol. 4, part 1, p. 67 for Edward and John Knight, and Joan Lane, '"The Dark Knight" Edward Knight of Wolverley and his Collections', *Apollo*, 149, 1999, pp. 25–30, for an account of Edward Knight's collecting activities and for his address in Portland Place.

7. Davies (1957, p. 171) noted a painting called *The Nursing of Bacchus* in the Hon. Thomas Bowes's sale, London, Coxe, 27 June 1812 (lot 88, withdrawn), and Blunt thought that this might possibly be NG 39. This would only be possible had Edward Knight sold NG 39 during his lifetime. NG 39 was noted in John Knight's collection in John Feltham's *The Picture of London for 1813* [London 1813], p. 324.

8. According to Smith 1837, 209.

9. Redford, *Art Sales*, vol. 2, p. 281. Cholmondeley (1752–1830) was receiver-

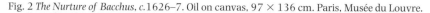

Fig. 2 *The Nurture of Bacchus*, c.1626–7. Oil on canvas, 97 × 136 cm. Paris, Musée du Louvre.

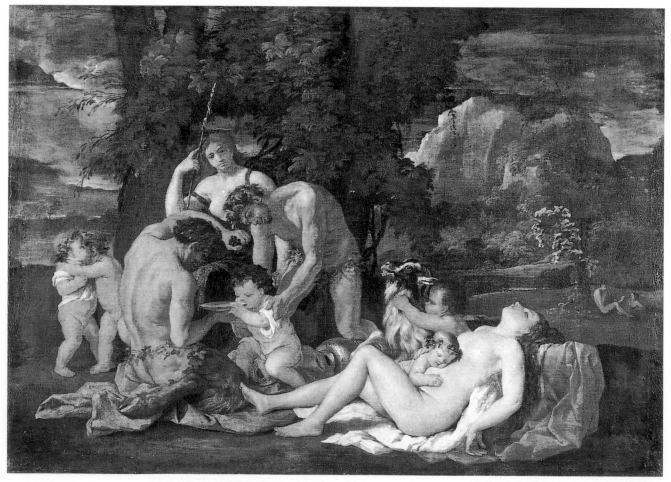

general of excise: *Index of Paintings Sold*, vol. 3, p. 1354.

10. For criticism of where this picture was hung in the exhibition, see Smirke [?] 1816, p. 42.

11. Most recently catalogued in Paris 1994–5, no. 5, and in Rome 1998–9, no. 14. The copy of NG 39 recorded in Blunt 1966, no. 133, as in the R. Hoe sale, New York in 1911, is a copy after the Louvre variant.

12. For Hazlitt's comment on the Dulwich picture, see *A Descriptive and Historical Catalogue of the Pictures in the Gallery of Alleyn's College of God's Gift at Dulwich*, Dulwich 1826, p. 245.

13. Boissière made an undated list of 'mes tableaux que j'ay en mon pouvoir, leur nombre et leur prix'. These included 'un autre tableau de Mr. Poussin representant La Nourriture de Bachus, valant Soixante pistoles', which was presumably no. 39 of his posthumous inventory of 5 July 1703, 'Un Tableau represesans la nourriture de bachus... 60 livres'. The lack of a reference to Poussin in the inventory and the low valuation suggest that the painting may have been regarded as a copy. For Samuel Boissière, see Schnapper 1994, pp. 421–3. The list and inventory are in the *Archives de l'Hérault, Archives hospitalières, hôpital général de Montpellier avant 1790*, B49. I am grateful to Jean Le Pottier and Monique Théron-Navatel for locating and photocopying these documents for me.

14. Schapper 1994, p. 415. The metric equivalent of the Gruyn/Hoym painting was 96.1 × 113.7 cm. For more information on the comte de Hoym, see the entry to NG 55, note 1.

15. Rosenberg and Prat 1994, vol. 2, p. 980 (no. R.781).

16. G. Wildenstein, 'Les graveurs de Poussin au XVIIᵉ siècle', *GBA*, 46, 1955 (publ. 1957), pp. 81–371 (with introd. by J. Cain at pp. 77–80), no. 129.

17. *Le Classicisme Français. Masterpieces of Seventeenth Century Painting*, exh. cat., National Gallery of Ireland, Dublin 1985, p. 58.

18. Courtauld Institute Galleries, Coutil Collection.

19. See note 1.

20. White and Pilc 1996, at pp. 98–9 and p. 102, n. 44.

21. Davies 1946, pp. 74–5.

22. Davies 1957, p. 171. For the history of the division of opinion over the title of the Louvre variant, see *Le Classicisme Français*, cited in note 17, pp. 58–9.

23. For such an identification of the subject, see for example, Thuillier 1974, 31 and 37; Rome 1977–8, no. 10; Wright 16 and 23; *Le Classicisme Français*, cited in note 17; and Thuillier 1994, 50 and 52.

24. Trans. F.J. Miller in the Loeb edn, 1966.

25. There is no consensus on the goat's sex: see correspondence in NG dossier.

26. I proposed such identifications in Copenhagen 1992. Blunt made a similar identification based on Apollodorus' *Bibliotheca*, III, 4, 3 (Blunt 1967, p. 123), but in this account Ino and Athamas were driven mad because they raised Bacchus as a girl, of which there is no hint in NG 39. Elizabeth McGrath has pointed out in conversation (24 October 1997) that, according to Ovid, Ino and Athamas lived in a palace and that no building appears in NG 39. However, Poussin did not always conform strictly to his text.

27. Trans. F.J. Miller in the Loeb edn, 1966.

28. Ovid, *Metamorphoses*, IV: 416–542. Finally, Venus transformed Ino and Melicertes into deities. For another version of the story, see Ovid, *Fasti*, VI: 485–550.

29. A. Blunt, 'The Heroic and the Ideal Landscape in the work of Nicolas Poussin', *JWCI*, 7, 1944, at p. 167. Blunt's view of NG 39 was disputed by Dora Panofsky, who read the picture as Bacchus 'blissfully ignoring the well-meant warnings of the winged(!) putto... who urges upon him milk of a reproachful goat... and hence as a "Choice of Hercules" in reverse': 'Narcissus and Echo: Notes on Poussin's *Birth of Bacchus* in the Fogg Museum of Art', *AB*, 31, no. 2, 1949, at p. 117, n. 18. Wild adopted Panofsky's interpretation and used it to reject the attribution of NG 39 to Poussin ('la trouvaille pédante d'un cerveau dépourvu de génie'): D. Wild, 'Charles Mellin ou Nicolas Poussin', *GBA*, 69, 1967, pp. 3–42 at p. 4.

30. Vicenzo Cartari, *Imagini de gli dei delli antichi*, ed. L. Pignoria, Padua 1626, p. 364.

31. Ovid, *Fasti*, I: 353–60; and see Virgil, *Georgics*, II: 376–96.

32. See London 1986–7, *passim*.

33. Blunt 1967, pp. 106, 350 and fig. 103, and *Poussin Colloque 1994*, p. 528.

34. 'on le [Bacchus] représente par un triangle; la plus haute et excellente marque ou symbole de toutes celles qu'on attribuë à la Divinité': quoted by Oskar Bätschmann, *Nicolas Poussin. Dialectics of Painting*, London 1990 (first published in German in 1982), pp. 62–3. De Vigenère's book was republished in Paris in 1629. For the Chantilly painting, see *Nicolas Poussin. La collection du musée Condé à Chantilly*, no. 2, cited in note 2.

35. Titian's *Bacchanal* (Madrid, Prado) was in the Aldobrandini-Ludovisi Collection in Rome during Poussin's early years there.

36. For the attribution of the Louvre painting, see *Le Classicisme Français*, cited in note 17, and Paris 1994, no. 5.

37. For example by Oberhuber in Fort Worth 1988; and by Mahon 1995a. Most recently Mahon has proposed 1626 for the Louvre picture (Mahon 1999, p. 94).

38. Paris 1960, no. 29; Rome 1977–8, nos 10 and 11; Thuillier 1974, 31 and 37; Wright 1985a, 16 and 23; *Le Classicisme Français*, cited in note 17, p. 59; Mérot 2000, 123 and 124, and p. 38.

39. Oberhuber 1988, 23 and 27; Erich Schleier, *Pier Francesco Mola, 1612–1666*, Lugano and Rome 1989–90, p. 307; Thuillier II, 50 and 52, where the London picture is placed later although both in the bracket 1626–7; Mahon 1995a. I expressed similar views in Copenhagen 1992, p. 165, and in '"Poussin Problems" at the National Gallery', *Apollo*, 141, 1995, pp. 25–8 at pp. 27–8.

40. I had suggested 1627 as the date for NG 39 in Copenhagen 1992, p. 165. Mahon 1995a, dated NG 39 to 1628–9 but had dated it *c.*1630 in *Poussiniana. Afterthoughts arising from the exhibition*, Paris 1962, p. 29. Most recently he has suggested a date of 1628: Mahon 1999, p. 140.

Standring has noted that NG 39 shares a similar palette and technique of rendering pleats and foliage with the Walker Art Gallery *Landscape with Nymphs and Satyrs* (inv. 1313) and an *Infancy of Bacchus* in the collection of the Philip Conway Thomas Trustees, London: see T.J. Standring, 'Poussin's *Infancy of Bacchus* Once Owned by Sir Joshua Reynolds: A New Addition to the Corpus of His Early Roman Pictures', *Artibus et Historiae*, no. 34 (XVII), 1996, pp. 53–68 at p. 59. The compositions and figure drawing in these paintings are awkward, and NG 39 must be later than both. The date of the *Infancy of Bacchus* most recently proposed by Mahon is 1627: Rome 1998–9, p. 86.

41. Richard Verdi, 'Poussin's *Venus and Mercury* in the Dulwich Picture Gallery', *Nicolas Poussin. Venus and Mercury*, Dulwich Picture Gallery 1986–7, p. 11; and Oberhuber nos 27 and 28a.

Landscape with a Man washing his Feet at a Fountain

*c.*1648
Oil on canvas, 74.0 × 100.3 cm

Provenance

Possibly one of the paintings recorded in the posthumous inventory dated 20–22 December 1660 of Jean Pointel (d.1660);[1] bought by Sir George Beaumont, probably in January 1785 for £40 from Weston (but possibly in January 1787 for £200 from the dealer Vandergucht);[2] moved from Beaumont's London home to Coleorton Hall after 17 June 1808[3] and noted by Neale as hanging in the breakfast room there;[4] given by Beaumont to the National Gallery in 1826.

Exhibitions

London 1816, BI (88), where called 'Landscape with Figures'; London 1821, RA, on loan;[5] Coventry, Derby, Doncaster and Bath 1982, pp. 32–3; London 1988, NG (8); Edinburgh 1990, National Gallery of Scotland (20); London 1994–5, Courtauld Institute Galleries, and Manchester, Whitworth Art Gallery (1); London 1995, NG, *Poussin Problems* (no catalogue).

Related Works

PAINTINGS[6]

(1) Dublin, National Gallery of Ireland, inv. no. 1924. A copy on panel (16.5 × 21 cm) by James Barry (1741–1806) initialled *JB* at bottom left and scratched on the back *J Barry/ Roma 1767*, with, deleted, the words 'Phocion after Poussin'. Photograph in NG dossier;[7]

(2) Nîmes, Musée des Beaux-Arts, inv. no. I.P.1572. 80.5 × 101.5 cm. A seventeenth- or eighteenth-century copy after the Baudet engraving, probably once in the Robert Gower collection bequeathed to the museum in 1867.[8] Photograph in NG dossier;

(3) Whereabouts unknown, a copy, 29½ × 35½ in. Anon. sale, Sotheby's, 8 March 1950, lot 65 (as 'Orizonti'), £8 to W.R. Jeudwine. Photograph in NG dossier;

(4) Whereabouts unknown, a copy, 30 × 39 in. (sold as S. Bourdon, Christie, Manson & Woods, 21 December 1951, lot 108).[9] Photograph in NG dossier;

(5) Private collection, Scotland. A copy by James Norie (1684–1757), 35 × 38 in. Photograph in NG dossier;

(6) There is a reference in the NG dossier to a letter of 1 March 1962 from F.H. Lem of Paris, claiming to have in his possession(?) a better version of NG 40;

(7) Whereabouts unknown, a copy, 22.9 × 30.5 cm. The late Dr J.H. Smidt van Gelder sale, Christie's, 10 April 1970, lot 74, from the collection of H.E. Ten Cate (£199 10s. to Zanolin). Photograph in NG dossier;

(8) Whereabouts unknown, a copy, 74 × 101 cm. Anon. sale, Sotheby's, New York, 3 November 1983, lot 140 ($10,450). Photograph in NG dossier;

(9) Whereabouts unknown, a copy, 81 × 101 cm. Anon. sale, Chambelland, Giafferi, Veyrac, Doutrebente, Paris, 14 October 1992, lot 10 (as 'attribué à Francisque Millet'). Photograph in NG dossier;

(10) Whereabouts unknown, a copy, 88.8 × 111.8 cm. Anon. sale, Christie's, South Kensington, 22 October 1992, lot 144. Photograph in NG dossier;

(11) The partial copy, listed by Blunt as no. 8 in his list of copies, is of the lower right-hand side of the composition and not, as stated by Blunt, of the lower left-hand side. As Blunt stated, it was sold anonymously as by Sébastien Bourdon (Christie's, 16 July 1954, lot 270, £22 to Claas).[10] It re-appeared in another anonymous sale as Bourdon (Sotheby's, 27 January 1965, lot 61, £100 to Rosa). Present whereabouts unknown. Photographs in NG dossier;

(12) Anon. sale, Sotheby's, New York, 21 May 1998 (lot 242, $19,550 inc. premium), as 'attributed to Sébastien Bourdon' and formerly in the collections of H.G. Sperling and Joseph Epstein. A copy, 75.6 × 99.7 cm;

(13) Three other copies were listed by Blunt as respectively in a Texan private collection; with Böhler, Munich before 1934 (as Millet); and with de Beer, London, 1946;

(14) A copy after Poussin, described in an inventory of 1693 of the possessions of Claudine Bouzonnet Stella as 'Un tableau de 2 pied sur 3: un Paysage, sur le devant est un Tombeau, coppié après *le Poussin*', may have been a version of NG 40.[11]

DRAWINGS

(1) Düsseldorf, Kunstmuseum (FP 2502) (R.-P. R352). Acquired with the collection of W.L. Krahe (1712–90) and attributed by Rosenberg and Prat to Passeri;

(2) Besançon, Musée des Beaux-Arts et d'Archéologie, inv. no. D.2678 (R.-P. R172). Blunt tentatively suggested this to be connected with NG 40, noting that it had in common with the painting the seated traveller, the woman carrying a bundle on her head and the trophies on the tree.[12] Rightly rejected as being by Poussin by Rosenberg and Prat, who propose as its author Etienne Allegrain (1644–1736);

(3) Birmingham, City Art Gallery, inv. no. 26'22, by Edward Dayes (1763–1804). Signed and dated *E.Dayes, 1783*. Photograph in NG dossier. Dayes was a pupil of William Pether (see under Prints below).

PRINTS

(1) By Etienne Baudet (1636–1711) (Andresen 445; Wildenstein 182). Dated 1684 and engraved after a drawing by Pierre Mosnier (1641–1703), and dedicated with three others in a series to the prince de Condé, of which this is probably the last (Davies and Blunt 1962, p. 215);

(2) by Simon de la Vallée (1680–*c.*1730) (Andresen 445a; Wildenstein 182), engraved in reverse;

(3) William Pether (1738–1821) (Andresen 445b). Mezzotint. Published 18 January 1787 and inscribed *A Grecian Votary…from a Picture in the Collection of Sr. G. Beaumont Bt...*;

(4) by Achille Réveil (1800–51). Etching in Duchesne Aîné, Paris and London 1828–33, vol. 3 (1828), no. 214;

(5) by J. Dickson, active mid-nineteenth century. Lithograph. Inscribed title: LANDSCAPE./TRAVELLERS REPOSING;

(6) by W. Radclyffe (1780–1855). Engraving. Inscribed title: *Landscape and Figures*. Plate 15 of *The National Gallery of Pictures by the Great Masters*, London [1838?].

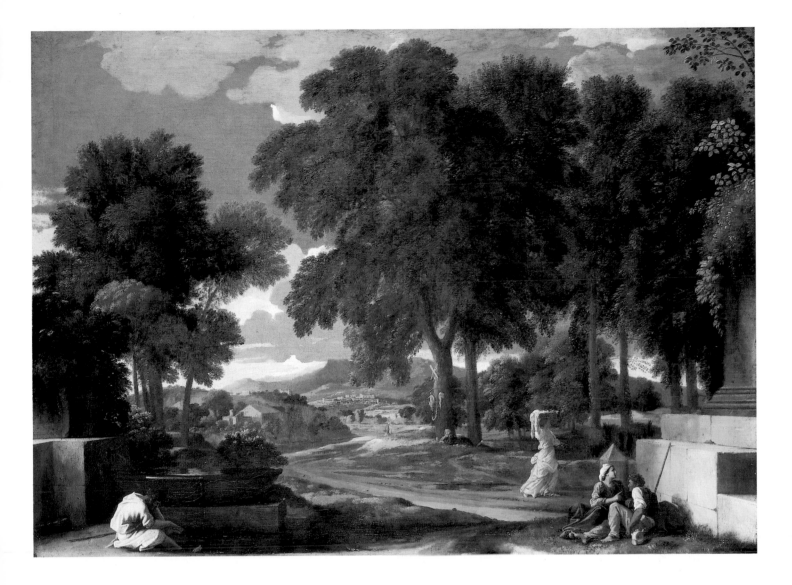

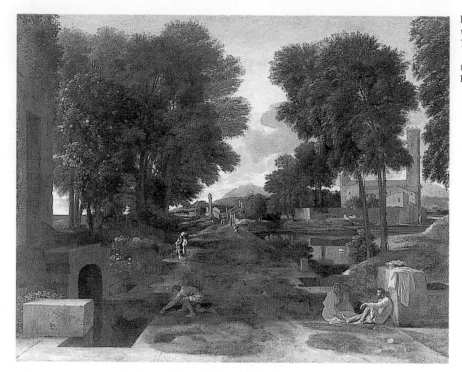

Fig. 1 Attributed to Nicolas Poussin, *Landscape with a Roman Road*, c.1648. Oil on canvas, 79.3 × 100 cm. Dulwich Picture Gallery.

RIGHT
Fig. 2 Detail of shrine fixed to tree.

Technical Notes

Mainly in good condition, although there is a small retouched loss some 15 cm above the head of the standing woman, small losses in the left-hand group of trees, and some blanching in both groups of trees. There is also some wear, notably on the edges of the trees and in the sky, lower centre. There are stretcher-bar marks some 4 cm in from all four edges.

The support is a plain-weave canvas. The painting has a double ground with a dark red-brown lower layer and a warm brownish-grey upper layer. The sky is natural ultramarine. The paint media are linseed oil in the sky and walnut oil in the green foliage at the right.[13] The painting was last relined in 1945. It had previously been relined at some time before 1853 when the Gallery's Conservation Records began. A photograph of the now removed previous lining, possibly of the eighteenth century, is in the Conservation Dossier.

The seated figure at the left was once identified as the Athenian general Phocion, and 'Phocion' was for a period around 1900 adopted by the Gallery as an alternative title for NG 40. However, such an identification was long doubted before being discarded in the Gallery's 1929 catalogue.[14] NG 40 does not show any identifiable episode from ancient literature. John Constable saw it as a landscape 'full of religious & moral feeling [showing] how much of his own nature God has implanted in the mind of man'.[15] It has also often been invested with meaning by way of contrast with a painting in Dulwich Picture Gallery called *Landscape with a Roman Road* (DPG 203) (fig. 1) by, or more likely after, Poussin, of which it is often considered to be the pair.[16] The two paintings have been variously seen as contrasting rural and uncultivated landscape with the civilising hand of man,[17] as contrasting nature with culture,[18] and as contrasting Greek with Roman civilisation. This last suggestion has been based on the supposition that NG 40 shows the Vale of Tempe in Thessaly as described by Aelian in the *Varia historia*, translated into French in Blaise de Vigenère's edition of Philostratus, which Poussin is known to have consulted.[19] Aelian writes that 'In the valley [of Tempe] there are infinite glades, shaded completely by the leaves of the trees, which in the summer offer pleasant refuges for travellers, where they can take recreation and refreshment with great pleasure and comfort. There are numerous springs and fountains running with cool water, delicious, and very agreeable to drink'.[20] Although this part of Aelian's description fits well with NG 40 and may in part have inspired it, there are too many differences from the description as a whole to accept that the landscape in NG 40 was intended to represent the Vale of Tempe. For example, the valley as described by Aelian is steep, whereas it scarcely exists in the painting, and there are no ivies in abundance as described by both Aelian and Pliny.[21]

The various interpretations of NG 40 depend, or depend in part, on whether it was conceived as a pair with (the original of) the *Roman Road*. Both paintings are close, although not identical, in size and both paintings were engraved by Etienne Baudet in 1684 as part of a set of four; the other two, *Landscape with the Body of Phocion carried out of Athens* and *The Ashes of Phocion collected by his Widow*, were painted as a pair in 1648.[22] It may therefore seem reasonable to infer that NG 40 and the *Landscape with a Roman Road* were regarded as a pair, at least by Baudet.[23] However, Félibien, who published his life of Poussin in 1685, refers only to a landscape 'où est un grand chemin' being in the collection of the chevalier de Lorraine. Hence it may equally reasonably be inferred that in 1685 at the latest the two paintings were not together.[24] Furthermore, NG 40 and the *Roman Road* have no obvious left or right bias to complement each other, nor do they share the same horizon line, so it seems that they were conceived independently as variations on a theme. Finally, although NG 40 has been identified as having belonged to Poussin's friend and patron Pointel, the *Landscape with a Roman Road* has not. It has therefore been argued that the two paintings were variants on a theme painted for two different collectors.[25]

It is important to state that NG 40 and the *Roman Road* would have been an improbable pair even had they both originally been in Pointel's collection (and it is arguable that both were). One of the paintings in that collection was described as on canvas and as three feet wide by two and a half feet high 'representing a flat landscape with pools and figures'.[26] This has been supposed to refer to NG 40, but may well refer to the original of the Dulwich composition. Not only is the landscape in the Dulwich composition flatter than that in NG 40, but there is more than one pool, which is not the case in NG 40. (Assuming the Dulwich painting to be a copy, it is not safe to rely on its size as evidence one way or the other.)

However, even if there is some doubt as to whether NG 40 can be identified with the 'flat landscape with pools and figures', it may nevertheless correspond to another painting by Poussin also inventoried in Pointel's collection in 1660 and hitherto not identified with any existing picture. This is the painting on canvas recorded as three *pieds* wide by two *pieds* high 'on which is painted a landscape with a form of altar'.[27] The compiler of the Pointel inventory (Philippe de Champaigne) may have been thinking of the structure at the extreme right of the National Gallery painting (which, however, is more like a tomb than an altar), or may have had in mind the roadside shrine fixed to the tree in the middle ground (fig. 2). Champaigne makes no mention of the figures or of the pool in NG 40, and this is certainly a weakness in identifying the picture with that in the Pointel inventory, but it is not necessarily a fatal one, because, for example, he makes no mention of the figures in his description of the *Landscape with a Storm* now at Rouen, which certainly belonged to Pointel. It is true that the metric equivalents of the measurements of the picture which Champaigne describes as a landscape with an altar, namely 65 × 97 cm, are less than those of NG 40, which are 74 × 100.3 cm. However, when Pointel's pictures were inventoried, it seems that they were stacked in piles by

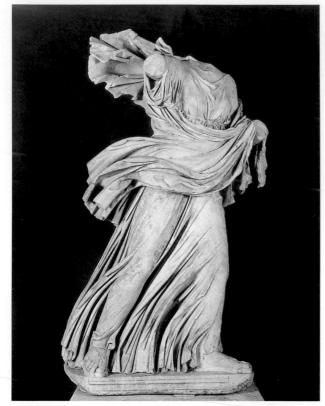

Fig. 3 *Niobid Chiaramonti*, third or fourth century BC. Marble, height 176 cm. Rome, Museo Gregoriano Profano.

Roman Road was in Pointel's collection, in which case they could not have been a pair, or they were both inventoried in that collection but with different sizes, so making their conceptual pairing highly unlikely – aside from the other reasons given.

Regarding individual motifs in NG 40, Poussin may have been aware that large basins of the type shown at the left were installed near temples so that worshippers could wash their feet as an act of ritual purification before entering. This in turn may explain the nature of the ruined structure at the right of the painting.[29] The figure in the tree shrine in NG 40 has not been identified. The objects above this figure appear to be a sword and a scabbard, and below them a garland and hair (?), perhaps votive dedications.[30] The sword and scabbard may be those of the man in the blue cloak lying below the tree, who, Blunt supposed, may have dedicated them to the deity after retiring from a military life.[31] The pose (but not the drapery) of the woman walking towards the right has been identified as possibly derived from the Chiaramonti Niobid (fig. 3).[32]

Although rejected by Davies, NG 40 is now accepted as an autograph work of Poussin by most authorities.[33] It is generally dated c.1648 by comparison with the *Roman Road*, itself assigned to the year 1648 by Félibien.[34] Although comparison with the Dulwich picture cannot be the sole criterion for dating the picture, the engravings after both paintings suggest a similarity of style, and there seems no reason to depart from the date c.1648 generally accepted for NG 40.

General References

Graham 1820, 'Profane History and Poetry', no. 19?; Smith 1837, 309; Grautoff 1914, 127; Magne 1914, 317; Davies 1957, p. 182 (as after Nicolas Poussin); Blunt 1966, 211; Thuillier 1974 (as a copy); Wild 1980, 144 (as c.1644); Wright 1985a, 158; Wright 1985b, p. 135; Mérot 1990, 230; Thuillier 1994, 175 (as a copy).

approximate size only, since, with the exception of two small panels by Poussin, Champaigne nowhere in the inventory refines his measurements beyond half a *pied* (that is, six *pouces*).[28] Since the height of NG 40 is only fractionally above what would have been calculated as two *pieds*, three *pouces*, he may in this instance have rounded down to two *pieds*. To summarise, either only NG 40 or only the original of the

NOTES

1. 'Item un autre tableau pareillement peinct sur thoille de trois pieds de long sur deux pieds et demy de hault sans bordure, représentant un paysage d'un pays plat où il y a des fontaines et des figures aussy dudit Poussin prisé la somme de deux cent livres cy.' Pointel's inventory has been published in Jacques Thuillier and Claude Mignot, 'Collectionneur et Peintre au XVIIe: Pointel et Poussin', *Revue de l'Art*, 39, 1978, pp. 39–58 at p. 49, where the authors propose an identification of NG 40 with the picture described above.

2. It has been assumed that NG 40 was bought in 1787 from Vandergucht: London 1988, pp. 23 and 47. However, Felicity Owen has written (letter of 8 February 2000): 'Looking at Beaumont's bank account again and Farington's later estimate of costs [see note 3], ...the £200 paid to Vandergucht could have been for [NG 58] rather than [NG 40]. The date [of the payment] was January 1787 whereas in January 1785 Weston was paid £40...I believe he was a dealer.' Benjamin Vandergucht, an artist-dealer was sued (successfully) in 1787 by the

dealer Desenfans, regarding the authenticity of another picture by Poussin that Vandergucht had sold him. One of the witnesses for Vandergucht was the French dealer Lebrun, which suggests a close business relationship between the two men and a possible source for French pictures, including NG 40, passing through Vandergucht's hands. (For an account of Desenfans v. Vandergucht, see W.T. Whitley, *Thomas Gainsborough*, London 1915, pp. 276–81, and *Artists and their Friends in England 1700–1799*, 2 vols, London and Boston 1928, vol. 2, pp. 87–8.) NG 40 may have been the painting referred to in a passage on Poussin's landscapes in Nicolas Guillain's *Essai sur la vie et sur les tableaux du Poussin*, Paris 1783, p. 36: 'C'est un Vieillard sous un arbre touffu, se livrant à des réflexions philosophiques, après avoir suspendu les armes & la lyre de sa jeunesse, à l'arbre qui lui prête son ombre.' This may be evidence for the painting's presence in Paris, but Guillain (also known as Cambray) may have known it only through a print.

3. *The Diary of Joseph Farington*, vol. IX, p. 3297, according to which NG 40 was one of thirteen paintings listed as having been arranged by Seguier to be sent to Coleorton, 'the frames new gilt'. Farington estimated the cost of NG 40 to Beaumont at £44 2s.

4. J.P. Neale, *Views of the Seats of Noblemen and Gentlemen in England, Wales, Scotland and Ireland*, 6 vols, London 1812–23, vol. 1 (1818), p. 71.

5. John Constable wrote to Fisher on 20 September 1821: '...there is a noble N. Poussin at the Academy – a solemn, deep, still, summer's noon – with large umbrageous trees, and a man washing his feet at a fountain near them – through the breaks of the trees is mountain scenery & clouds collecting about them with the most enchanting effects possible – indeed it is the most affecting picture I almost ever stood before. It cannot surely be saying too much when I assert that his landscape is full of religious & moral feeling, & shows how much of his own nature God has implanted in the mind of man. It is not large – about 3½ feet –

and I should like, & will if possible possess a fac simile of it. I must make time – the opportunity will not happen again. If I cannot come to you I will send you the *results of this summers study*.' *John Constable's Correspondence*, 6 vols, Ipswich 1964–70, vol. VI (1968), pp. 74–5. (For David Lucas's annotation to this letter as published in C.R. Leslie's *Memoirs of the Life of John Constable, Esq., R.A.*, see *John Constable: Further Documents and Correspondence*, London and Ipswich, 1975, p. 57.) For a brief account of loans of pictures to the Royal Academy School, see Whitley 1928, pp. 253–4. NG 40 must have been the Poussin which the Royal Academy Schools asked to borrow for the season on 20 July 1821. On 25 July 1821 Beaumont replied saying that he would be pleased to lend the painting and was anxious to promote a wider appreciation of such landscape. I am grateful to A.W. Potter of the Royal Academy of Arts for this additional information.

6. If John Constable ever made a copy of NG 40 (see previous note), it has not been identified.

7. Given the number of known copies of NG 40 and the existence of the Baudet engraving, the fact that Barry's was painted in Rome cannot be treated as evidence that NG 40 itself was in Rome at the time.

8. Information kindly supplied by Alain Chevalier.

9. Possibly the same painting as that exhibited in 1801 at 118 Pall Mall ('56. Nicolo Poussin. Landscape, with Figures. Breadth 3f. 3in Height 2f. 5in) – see *A Catalogue of Pictures from the Colonna, Borghese, and Corsini Palaces, &c. &c. purchased in Rome in the years 1799 and 1800*. Blunt (Blunt 1966, p. 145) states that this copy is in Auckland City Art Gallery, New Zealand, but Mary Kisler of that institution has kindly advised me that there is no record of any such work there.

10. Blunt 1966, p. 145.

11. M.J.J. Guiffrey, 'Testament et Inventaire des Biens...de Claudine Bouzonnet Stella...', *NAAF*, 1877, pp. 1–113 at p. 40. Also included in the inventory was a painting of the same size, but double the value, described as 'un Paysage, au milieu un grand chemin, coppié du *Poussin*', which, as Blunt noted (Blunt 1966, p. 144) might be the same composition as the Dulwich *Landscape with a Roman Road*.

12. Blunt 1944, p. 156, n. 6.

13. White and Pilc 1996, pp. 91–103.

14. See, for example, *A Catalogue of the Pictures in the National Gallery*, London 1843, p. 14, and Jameson 1842, p. 70. She wrote that the figure was 'supposed to represent Phocion in an undyed robe – the emblem of the purity and simplicity of his life'. NG 40 was engraved in 1684 by Baudet (see under Prints) as part of a set of four which included the two *Phocion* landscapes, but the text to the engraving, unlike the texts to the engravings of the *Phocion* landscapes, makes no mention of the Athenian general. That, and the fact that NG 40 shows no part of the Phocion

story, clearly confirms that the former identification of the seated figure was incorrect (as pointed out by Blunt 1944, p. 156).

15. See note 5.

16. For the Dulwich picture, see Blunt 1966, pp. 144–5; Peter Murray, *Dulwich Picture Gallery. A Catalogue*, London 1980, pp. 92–3; Edinburgh 1990, no. 21; and R. Beresford, *Dulwich Picture Gallery. Complete Illustrated Catalogue*, London 1998, p. 186. NG 40 was proposed as an almost certain pair to the Dulwich picture by Blunt in Blunt 1966, nos 210 and 211, and Blunt's suggestion accepted as very probable by Murray (op. cit.) and by Verdi in Edinburgh 1990, no. 20 ('there is good reason to believe'). Rosenberg has asked whether the Dulwich painting is an original or a good copy: Paris 1994, pp. 363–4. Beresford catalogues the Dulwich picture as after Poussin, and Ian Dejardin has kindly pointed out to me, citing Helen Glanville's conservation report, that the original dimensions have been retained, so that Baudet's engraving does not quite correspond to it, making the Dulwich composition more likely to be a copy. The X-radiograph of the Dulwich picture, reproduced in Blunt 1966 facing p. 181, shows figures identical to the three left-hand figures in *Moses trampling on Pharaoh's Crown* in the Louvre (for the dating of which see Mahon in Bologna 1962, p. 194, and Rosenberg in Paris 1994–5, p. 363). The conclusion that the composition revealed by the X-radiograph, and hence the *Landscape with a Roman Road*, are the works of a copyist seems evident. Verdi has pointed out (ms note) that when NG 40 and the Dulwich picture were brought together at the Edinburgh exhibition, it became clear that they had been painted on different types of canvas. It is difficult, however, to conclude much from this one way or the other, since the types of canvas used for example in Poussin's second set of the *Sacraments* are not uniform.

17. R. Verdi in Edinburgh 1990, p. 103.

18. Mérot 1990, p. 150.

19. E. Cropper and C. Dempsey, *Nicolas Poussin. Friendship and the Love of Painting*, Princeton 1996, pp. 284–9.

20. Translation by E. Cropper and C. Dempsey, op. cit., p. 289.

21. Pliny mentions three varieties of climbing ivy specific to Tempe and parasitic on trees: *Natural History*, Book 16, 92.

22. Félibien, *Entretiens 1685*, vol. 4, p. 299, and *Entretiens 1685–88*, vol. 2, p. 356.

23. Copies of both compositions were also in the collection of Claudine Bouzonnet Stella (see note 11 above), numbered 135 and 137 in her inventory. This suggests that she treated the copies as a pair, but this evidence should be viewed with caution since Claudine owned over forty other pictures there attributed to or after Poussin, this in turn suggesting more of an accumulation than a collection. The pictures attributed to or after Poussin in that inventory are conveniently listed in E. Coquery, 'Les oeuvres de Poussin

dans les collections des peintres français sous Louis XIV', *Poussin Colloque 1994*, pp. 837–64 at pp. 852–6.

24. Félibien, *Entretiens*, cited in note 22.

25. Thuillier and Mignot, cited in note 1, at p. 49. The Dulwich painting is no. 55 of Desenfans' 1801 catalogue. Its earlier provenance is uncertain.

26. '...représentant un paysage d'un pays plat où il y a des fontaines et des figures...': Thuillier and Mignot, cited in note 1.

27. The full entry in the inventory is: 'Item un autre tableau aussy peint sur toile sans bordure de trois pieds de long sur deux pieds de hault sur lequel est dépeint un paysage ou y a une forme d'autel, prisé et estimé la somme de deux cent livres cy ouvrage dudit Poussin'. See Thuillier and Mignot, cited in note 1, at p. 48, who regard no known painting as corresponding. The metric equivalent of a *pouce* (of which there were twelve to a *pied*) is 2.706 cm.

28. Thuillier and Mignot, cited in note 1, p. 40 and p. 44, n. 14. For example, the picture immediately preceding the 'Landscape with an Altar' in the Pointel inventory was Poussin's *Self Portrait* now in Berlin (Thuillier and Mignot, p. 48). The dimensions of that painting as inventoried were identical to those of the 'Landscape with an Altar' as inventoried. The present size of the Pointel *Self Portrait* is 78.3 × 64.5 cm, but it has evidently been trimmed slightly down the sides (as well as along the top), so its original width would have been closer to 70 cm – that is, 5 cm more than the corresponding dimensions of the 'Landscape with an Altar'. (See Poussin 1994–5, no. 189, and in particular the reproduction of the engraving by Jean Pesne there reproduced as fig. 189d.)

29. I am grateful to Ruth Rubenstein for this suggestion.

30. As suggested by Antonio Corso to Ruth Rubenstein.

31. Blunt 1967, p. 292. Blunt suggested (ibid., p. 242, n. 29) that Poussin may have had in mind Horace's *Epistle* (I: 1, 4–5): 'Veinanus hangs up his arms at Hercules' door, then lies hidden in the country...' (Horace, *Satires, Epistles and Ars Poetica*, trans. H. Rushton Fairclough, London and Cambridge, Mass., 1926, 1970 reprint, p. 251).

32. This identification was made by Antonio Corso and kindly notified to me by Ruth Rubenstein. See W. Amelung, *Die Sculpturen des Vaticanischen Museums*, Berlin 1903, vol. 1, text, pp. 422–6, and plates, pl. 44.

33. Although not by Thuillier: see under General References. Pierre Rosenberg has confirmed that in his opinion NG 40 is fully autograph (in conversation 29 March 1994). Mahon did not initially question Davies's rejection of NG 40 (see his 'Réflexions sur les paysages de Poussin', *Art de France*, 1, 1961, pp. 119–32 at p. 125, n. 14), but soon afterwards examined the picture with Charles Sterling and agreed with his conclusion that it must be autograph.

34. Félibien, *Entretiens*, cited in note 22.

NG 62
A Bacchanalian Revel before a Term [1]

1632–3
Oil on canvas, 98.0 × 142.8 cm

Provenance
Possibly in the collection of (Pierre-François?) Basan;[2] Pierre-Louis-Paul Randon de Boisset (1708–1776), Receveur-Général des Finances de Lyon, resident in Paris,[3] his posthumous sale, Paris, Rémy & Juliot, 27ff. February 1777 (lot 165, 14,999 livres 19 sols to Le Brun);[4] in the collection of Joseph-Hyacinthe-François de Paule de Rigaud, comte de Vaudreuil (1740–1817), by 1786;[5] his sale, Paris, Lebrun, 27 November 1787 (lot 28, 15,100 livres to Lebrun);[6] Charles-Alexandre de Calonne (1734–1802), French minister of Finance, 1783–7, his mortgagees' sale, London, Skinner & Dyke, 28 March 1795 (lot 96, 870 guineas, bought in);[7] exhibited at Bryan's Gallery, Savile Row, London, 27ff. April 1795, no. 134,[8] where bought for 'about £1200' by 'Mr Hamilton',[9] elsewhere identified as 'the Rev. Mr. [Frederick] Hamilton, (brother of Sir William Hamilton...)' by whom apparently sold to Troward;[10] Troward sale, London, Phillips, 18 April 1807 (lot 10, 1500 guineas to Lord Kinnaird);[11] Lord Kinnaird sale of pictures removed from his house at 53 Lower Grosvenor Street, London, Phillips, 21 May 1811 (lot 14, 1400 guineas),[12] presumably bought in, because in Lord Kinnaird's sale, London, Phillips, 5 March 1813 (lot 86, withdrawn); bought privately (with NG 35 and 194) by the dealer Alexis Delahante;[13] sold by Delahante to the Revd Thomas Baseley before 19 June 1813 conditional on payment;[14] by 22 May 1816 owned by Thomas Hamlet, goldsmith and jeweller, of Cavendish Square, London;[15] sold by him with NG 9 and NG 35 to the National Gallery for £9000[16] in March 1826.

Exhibitions
London 1795, Bryan's Gallery (134); London 1801, European Museum (possibly 577); London 1816, BI (122); London 1945, NG, *Fifty-four pictures on exhibition at the reopening of the Gallery 17th May 1945* (no catalogue); London 1947, NG (60); Paris 1960, Louvre (50) (where dated *c.*1637); Edinburgh 1981 (15); Paris 1994–5, Grand Palais (47) (where dated 1631–3); London 1995, RA (28) (where dated *c.*1634).

Related Works
PAINTINGS
(1) A copy on a coarse canvas was recorded by Duchesne Aîné as belonging to a Venetian, Sivri, in 1827 who had taken it to Vienna to sell for 6000 francs;[17]
(2) Lyon, Musée des Beaux-Arts (no. 361), 63 × 127 cm, acquired in 1860. A mediocre copy;[18]
(3) Vire, Musée Municipal, 80 × 136 cm, destroyed during hostilities in 1944.[19] Described as exactly like NG 62 apart from the dimensions, and as having been one of three Bacchanals painted for the duc de Montmorency;[20]
(4) Paris, private collection in 1973. A copy;[21]

(5) Wilton House, Wiltshire. A copy of the two children on the left, published by Grautoff as autograph,[22] was said by Blunt to have been painted under Poussin's direct supervision,[23] 14 × 11¾ in.; at Wilton House since before 1730,[24] but not by Poussin;
(6) John Vaughan Dutton deceased sale, Christie & Manson, 28 April 1838 (lot 252, £32 11s. to Baedel), where described as 'a replica of the beautiful picture in the National Gallery'.
(7) Sydney, National Gallery of New South Wales, no. 166. 1979. Oil on canvas, 94.5 × 124.5 cm. A copy, bequeathed by Miss C.V.F.F. Anderson, 1979.
DRAWINGS (by, or attributed to, Poussin)[25]
(1) Stockholm, National Museum (inv. no. NM THC 5404a) (R.-P. 44) (fig. 4). A sketch for the two children at the left;
(2) Windsor Castle, Royal Library (inv. no. 11979) (R.-P. 57) (fig. 2). Not strictly speaking preparatory for NG 62, from which it shows considerable differences, but more likely an early idea for the subject. Dated by Mahon 1632–3, by Rosenberg and Prat 1628–30, by Clayton *c.*1631–2,[26] and by Brigstocke 1632.[27] An engraving by F.C. Lewis of this drawing was published in *Original Designs of the most celebrated masters in His Majesty's Collection*, London 1812;
(3) London, British Museum (Sloane 5237-147) (R.-P. R517) (fig. 8). Controversially rejected as an autograph work by Rosenberg and Prat and previously by Rosenberg,[28] defended as autograph by Brigstocke,[29] Clayton[30] and Verdi, but rejected by A.S. Harris;[31]
(4) Florence, Gabinetto Disegni e Stampe degli Uffizi (inv. 905 E) (R.-P. 86). The drawing (see p. 355, fig. 9) is preparatory for Poussin's *Triumph of Pan* (NG 6477) but, as Brigstocke pointed out,[32] it includes at the left the motif of a putto drinking from a fountain found at the right of NG 62;
(5) Paris, Louvre, Département des Arts Graphiques (inv. no. 32459) (R.-P. R741). The theme is similar to that of NG 62. The child in the left foreground of the drawing is closely related to the reclining child at the left of NG 62, and whoever was the author of this drawing (Poussin according to Oberhuber, 1988, D. 135, but rejected by Rosenberg and Prat and by Clayton) seems likely to have had knowledge of NG 62;
(6) Edinburgh, National Gallery of Scotland (D3229) (R.-P. R378r). This drawing, attributed by Rosenberg to Chaperon and connected by him to NG 62, is surely inspired by *The Triumph of Pan* (NG 6477).[33]
OTHER DRAWING
London, National Portrait Gallery. A squared-up pencil copy of NG 62 by Henry Bone (1755–1834), inscribed at the bottom: *after Poussin, original in the possession of T. Hamlet Esqre. Aug.11 1819*, and at the top in a different hand: *now in the National Gallery*. The drawing was made for an enamel.[34]
PRINTS
(1) In reverse, an etching in the style of François Perrier (1590–1650) according to Andresen (Andresen 369), but by Michel Dorigny (*c.*1617–65) according to Wildenstein (Wildenstein 132) following Robert-Dumesnil (vol. IV, pp. 264–5, no. 44). According to Davies and Blunt 1962, p. 214, an impression seems to have belonged to Michel de Marolles by 1666 or soon after. Wildenstein records the print in three

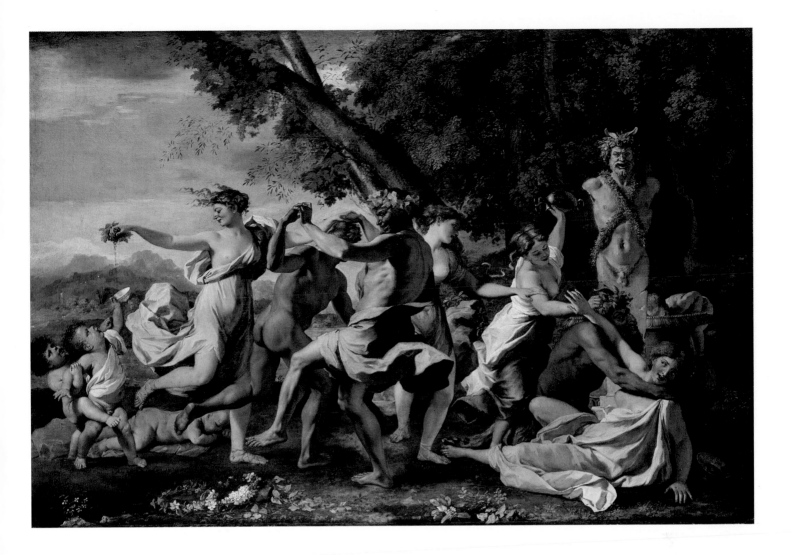

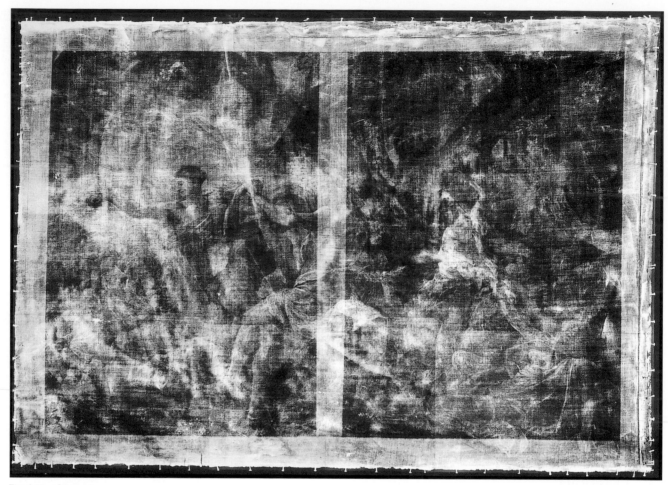

Fig. 1 X-radiograph.

states, with the *excudit* of Van Merle (1616–82),[35] with that of Philippe Huart (d.1670),[36] and without *excudit*;

(2) According to Blunt (Blunt 1966, p. 101) there exists an engraving inscribed on the plate: *Le poussin inv.*, and in the margin: *Nic. Poussin del.* and *Ex Collect.ᵉ Basan*;

(3) Engraved by R. Cooper, bound as a proof with *Kinnaird Collection; or Cabinet Picture Gallery*, London 1809, but inscribed as published in 1811;

(4) Line engraved in reverse by E. Lingée, plate CLXXIII of C.P. Landon, *Vie et Oeuvre Complète de Nicolas Poussin*, Paris 1813;

(5) Line engraved by [E.A.] Réveil in *Musée de Peinture et de Sculpture ou Recueil des Principaux Tableaux Statues et Bas-Reliefs des Collections Publiques et Particulières de l'Europe; avec des notices descriptives, critiques et historiques*, par Duchesne Aîné, 14 vols, Paris 1828–33, vol. 10, 1831, no. 671;

(6) Engraved by George T. Doo, 1834 (Andresen 370), and included as a plate in *Engravings from the Pictures of the National Gallery*, 1840, and (differently inscribed) in *The National Gallery. A Selection from its Pictures. Engraved by George Doo... and others*, London 1875;

(7) Engraved by S.S. Smith, no. 60 of *The National Gallery of Pictures by the Great Masters* [1838?];

(8) According to John Smith by de Paray (see Smith no. 221).

Technical Notes

In good condition, but with some wear in the sky at the left. The ridges apparent at the top may be caused by the way the ground was applied. There is some dirt stuck in the hollows of the canvas. There has been some degradation of the ultramarine pigment in the drapery of the left-hand figure. The yellow draperies are composed of lead-tin yellow, which occurs also in the impasto lights of the foliage greens, combined with green earth (*terre verte*) and other earth pigments.

The primary support is a medium/heavy plain-weave canvas, relined possibly early in the nineteenth century, but certainly before 1853 when the Gallery's conservation records began, and probably before Sir Charles Eastlake's appointment as Keeper in November 1843.[37] The top centre of the stretcher (not original) is inscribed *17* in black paint or wax crayon. The double ground is unusual in constitution, with a pink lower layer comprising largely calcium carbonate and red lead (lead textroxide minium), and a grey ground over it. The paint medium used in the green foliage was a heat-bodied linseed oil giving the paint extra body as well as improving drying.[38] NG 62 was last cleaned in 1940.[39]

The X-radiograph (fig. 1), which is difficult to read because of the double ground, shows that NG 62 was painted over another composition, the details of which are unclear. The

X-radiograph also indicates some changes in the composition of NG 62 itself: there may have been another figure to the right of the term, possibly garlanding it; the arm of the central dancing figure was lower, so exposing the face of the dancing male figure behind him; the direction of the tree trunks has been changed; and there are other illegible alterations at bottom left.

The subject has no specific literary source, but can be broadly associated with bacchic festivities. The painting seems to have been first called 'Bacchanalian Revel before a Term of Pan' in 1946 by Davies, who retained the title in the 1957 edition of his catalogue, without, however, explaining it.[40] Blunt questioned Davies's identification of the term as one of Pan, arguing that 'the fact it is hung with garlands of flowers and that there are floral wreaths in the foreground suggests that it is really the image of Priapus, the god of gardens'.[41] Although the term lacks the exaggerated genitalia associated with Priapus, who was principally a fertility god, this would have been unnecessary to indicate his secondary role as god of gardens, and in any event would presumably have been regarded as unacceptable in a painting. The identification of the term as one of Priapus receives further support from the fact that the pipes and crook which identify the term in the Windsor drawing (fig. 2) as one of Pan have been abandoned in NG 62. In addition, the amorous male figure at the right has the usual attributes of Pan (goat's legs and ears and horns, as well as a partiality to nymphs). If that figure was intended as Pan, rather than simply a satyr, he would be unlikely to feature again in the same painting.

The theme of figures dancing before a term is one which Poussin may have previously explored in a now lost picture once in a Piedmontese collection,[42] and one which he used in another lost painting, probably later in date than NG 62, now known through an engraving and several copies.[43] The theme is also broadly like that of NG 6477. In NG 62, however, drunkenness seems confined to the putto asleep at the left, while the jar held aloft by the maenad standing at the right and the single dish discarded in the bottom right corner suggest only a moderate consumption of alcohol by Poussin's other figures, who seem to have heeded Ovid's counsel: 'Wine prepares the heart for love, unless you take o'ermuch and your spirits are dulled and drowned by too much liquor.'[44] In the Windsor drawing (fig. 2), which has a thematic but not necessarily compositional connection to NG 62 (see below), discarded wine jars are more evident, the dancing is less measured, and the branches snaking around the tree trunks suggest rampant excess. The painting shares the bacchic theme of the drawing, but the former's frieze-like composition suggests a less abandoned, more controlled frenzy.

It is now generally agreed that NG 62 was executed before *The Adoration of the Golden Calf* (NG 5597), with which it shares the central group of dancers in reverse. As Mahon noted, there are obvious differences between the two paintings, not merely in tonality but also in handling and texture, rendering questionable the idea that the two paintings could have been contemporary.[45] Elsewhere he also noted an evident link between NG 62 and the pictures associable with the Dresden *Adoration of the Magi* of 1633 (which include the Dulwich *Triumph of David*),[46] and in 1962 he argued for a dating of 1633–4 for NG 62.[47] But since then it has been discovered that Poussin's *Saving of the Infant Pyrrhus* (Paris, Louvre) was completed by September 1634,[48] and that *The Adoration of the Golden Calf* (NG 5597) was commissioned in 1632 and consequently was most probably completed before the *Pyrrhus*. Although the coppery tonality of the *Pyrrhus* would in any event be justified by the time of day (evening) at which Plutarch relates the action as having occurred,[49] that is not necessarily the case for, say, *The Adoration of the Shepherds* (NG 6277) or *The Adoration of the Golden Calf* (NG 5597), which share the same tonality, and it is reasonable to assume that Poussin adopted it generally at some time in 1633 and throughout 1634. NG 62 does not have this coppery tonality, suggesting early 1633 as the latest conceivable date for it. The figures in NG 62 are more robust than those in, say, the Madrid *Apollo and the Muses*, which is generally dated 1631–2, making late 1632 or early 1633 the most likely date for the National Gallery picture.[50]

The motif of the sleeping putto lying face down was used by Poussin two or three years earlier, namely in *Midas before Bacchus* (Munich, Alte Pinakothek), itself probably painted shortly before 1631.[51] The motif of a putto climbing onto a large urn to drink from it, as at the right of NG 62, is also found at the left of Poussin's *Bacchanal of Putti* (Rome, Palazzo Barberini, inv. 2592; fig. 3) probably of 1626.[52] Davies also noted[53] the partial resemblance of the pose of the fallen nymph at the right of NG 62 with that of a figure in a drawing at Windsor (inv. 11889) which can be dated *c*.1637;[54] both are ultimately derived from the figure at the bottom right of Raphael's *Expulsion of Heliodorus from the Temple*.[55]

The drawing at Windsor Castle (RL 11979) (fig. 2) is related thematically to NG 62, with which it also shares some compositional elements. Poussin may have turned to it as he

Fig. 2 *Bacchanal before a Term*, *c*.1632. Pen, brown ink and brown wash and some graphite underdrawing, 20.6 × 32.7 cm. Windsor, Royal Library, The Royal Collection.

worked on NG 62, as he seems also to have done later when starting work on NG 6477 (see pp. 350–65). The Stockholm drawing (fig. 4), however, is clearly preparatory and shows both children at the left holding up bowls. Assuming the now disputed London drawing (fig. 8) to be autograph, there are a number of differences between it and NG 62 (the nymph holding a vase rather than grapes, her coiffure, the position of the bowl held up by the child, the background, etc.). It is not possible to see from the X-radiograph whether these differences ever formed part of NG 62. The London drawing may be an autograph compositional study made late in the planning stage, or, as Clayton has suggested, a modello-type cartoon.[56]

Brigstocke has suggested that the dancers may have been inspired by an engraving after Mantegna (fig. 5),[57] although the spirit of the dance in NG 62 is much more robust than it is in that engraving, and numerous other engraved dance images would have been available to Poussin. More closely related is an engraving of the *Dance of the Seasons and the Hours* (fig. 7) in Blaise de Vigenère's translation of 1614 of Philostratus' *Imagines*, a book which Poussin probably knew.[58] The figure at the left is close to the figure at the left of the dancing group in the Windsor drawing (RL 1.1979); the figure at the back is close to the dancing satyr in that drawing; and the figure with her back turned to the viewer resembles the figure at the right of the drawing. Poussin's particular invention in both the drawing and NG 62 is that of the figure going under the arms of the other dancers, which explains his abandonment in the Windsor drawing of the figure at the right of the engraving in the *Imagines*. It appears, however, slightly modified, as the dancing satyr in the centre of NG 62. Poussin's use of this

engraving lends support to a tentative suggestion made by Rosenberg (who seemed unaware of the engraving, at least in this context) that the dancing group represents the Seasons.[59] On that basis the nymph at the left would have to represent Autumn because of the grapes she is pressing, but it is difficult to identify any of the other figures, and furthermore the dance is not circular and so does not reflect the seasons' continuity.[60]

The early history of NG 62 is unknown. There is no evidence that it was one of the bacchanalian subjects painted for Cardinal Richelieu and at the Palais-Cardinal,[61] and it was certainly not one of those painted for the Cabinet du Roi at the Château de Richelieu (see entries for NG 42 and NG 6477).[62] A group of dancing figures at the right of Sébastien Bourdon's *Classical Landscape* (New York, Metropolitan Museum of Art; fig. 6), which may be dated *c.*1660, could be derived from the dancing figures in NG 62 or a print after it. If so, this would suggest that NG 62 was in a Paris collection by then, since Bourdon never went to Rome, but it must in any event have been in Paris by 1665, the latest date that Michel Dorigny could have made a print after it.[63] The painting was widely admired after it entered the National Gallery, Waagen, for example, clearly preferring it to all other works there which were then attributed to Poussin.[64]

General References

Graham 1820, *Profane History and Poetry*, no. 48; Smith 1837, 221; Grautoff 1914, 83; Magne 1914, 27; Davies 1946, pp. 75–7; Davies 1957, pp. 172–4; Blunt 1966, 141; Badt 1969, 94; Thuillier 1974, 71; Wild 1980, 49; Wright 1985a, 79; Wright 1985b, p. 134; Mérot 1990, 133; Thuillier 1994, 87.

Fig. 3 *Bacchanal of Putti*, 1626(?). Gouache, tempera and oil on canvas, 74 × 84 cm. Rome, Galleria Nazionale d'Arte Antica (Palazzo Barberini).

Fig. 4 *Playing Putti*, *c.*1628–30. Black chalk, 11 × 7.9 cm. Stockholm, Nationalmuseum.

Fig. 5 Giovanni Antonio da Brescia(?) (*c*.1460–*c*.1520), after Mantegna, *Four Women dancing*. Engraving, 24.8 × 32 cm. London, British Museum, Department of Prints and Drawings.

Fig. 7 *Dance of the Seasons and the Hours*. Engraving in Philostratus the Elder, *Les Images ou Tableaux de platte peinture...*, Paris 1615. London, British Library.

Fig. 6 Sébastien Bourdon, *Classical Landscape, c*.1660? Oil on canvas, 69.9 × 92.1 cm. New York, Metropolitan Museum of Art. Gift of Atwood A. Allaire, Pamela Askew and Phoebe A. DesMarais in memory of their mother, Constance Askew, 1985.

Fig. 8 *Bacchanalian Revel before a Term, c*.1632. Black chalk, brown and pink wash, squared in pink chalk, 20.6 × 32.7 cm. London, British Museum, Department of Prints and Drawings.

1. Not a herm, which is 'a statue, consisting of a four-cornered pillar surmounted by a head or bust, usually that of Hermes...', but a term, which is 'a statue or bust like those of the god TERMINUS, representing the upper part of the body, sometimes without the arms, and terminating below in a pillar or pedestal out of which it appears to spring...' *The Shorter Oxford English Dictionary*, 3rd edn with corrections, Oxford 1975.

2. Blunt 1966, p. 101. Blunt cites an anonymous engraving based on NG 62, the location of which he does not specify, and which is inscribed in the margin 'Ex Collect.ᶜ Basan'. The well-known engraver and print-seller Pierre-François Basan (1723–97) seems the most likely candidate. It has been suggested that NG 62 influenced James Barry's *A Grecian Harvest-Home* (Royal Society of Arts). Barry's painting was completed by 1783 when NG 62 was still in Paris. Barry was in Paris in 1765–6 and in 1771: William L. Pressly, *The Life and Art of James Barry*, New Haven and London 1981, pp. 7–8, 16, 95–6.

3. Clément de Ris 1877, pp. 358–81. The earliest possible date for Randon de Boisset's purchase of NG 62 seems to be 1752 (Bailey in Paris, Philadelphia and Fort Worth 1991–2, pp. 375–6), but see note 2 above.

4. According to an inscription in a copy of the catalogue in the National Gallery Library. The painting is described in the catalogue as: 'Nicolas Poussin/165 UNE Fête en l'honneur du Dieu Pan: on voit au bas de cette statue une femme assise qui se défend d'un satyre qui veut l'embrasser, une autre femme le tient par les cheveux, & veut le frapper avec un vase qu'elle tient de la main gauche, plus loin deux hommes & deux femmes dansent, une d'elles presse dans une de ses mains une grappe de raisins dont un enfant reçoit le jus qu'un autre enfant veut lui disputer, un troisième est endormi couché par terre. Les sept figures qui composent ce sujet ont chacune 18 pouces de proportion./Ce tableau, qui tient un rang dans le nombre des plus beaux de ce célèbre Artiste, est peint sur une toile de 3 pieds 6 lignes de haut, sur 4 pieds 3 pouces 6 lignes de large.'
NG 62 was item 167 in Randon de Boisset's inventory of 18 October 1776 (A.N., M.C., LXXXIV, 546), where described as in the 'Sallon' and as 'un Tableau dont le sujet est des Bacchanales dans un paysage peint sur toille par Nicolas Poussin dans sa bordure de bois sculpté et doré prisé la so[mme] de trois mille six cent livres cy 3600–ˈ–".'

5. Thiéry's *Guide des amateurs*, Paris 1787, contains a long description of the hôtel de Vaudreuil, rue de la Chaise, in the Salon of which to the right of the entrance door was 'le beau Bacchanale du Poussin, venant de chez M. Randon de Boisset' (vol. 2, p. 547). The manuscript of Thiéry's book was approved by the government censor on 6 January 1787, and so must have been submitted the previous year, although, to judge from the date of the consent to publish, the book was in preparation from 1784. What was probably NG 62 was also noted by the American painter John Trumbull in Vaudreuil's collection ('Bacchanals, by Poussin, very good') in the summer of 1786: ed. T. Sizer, *The Autobiography of Colonel John Trumbull Patriot-Artist, 1756–1843*, New Haven 1953, p. 98, and p. 98 n. 48. (That NG 62 may have been in Vaudreuil's collection by 1784 may also be inferred from J.B.P. Le Brun's statement in the preface to the catalogue of Vaudreuil's 1784 sale that he intended to keep his French pictures.)

6. According to inscriptions in the copy of the catalogue in the British Library. The description of NG 62 in the catalogue of the Vaudreuil sale was the same as that in Randon de Boisset's sale (see note 4), but added the information that it had been no. 165 of de Boisset's sale and there sold for 14,999 livres, 19 sols.

7. According to an inscription in the copy of the catalogue in the National Gallery Library the purchaser was Bryan. In his *Memoirs of Painting* (1824) Buchanan says (p. 218) that most of the pictures of consequence were bought in by the mortgagees and then exhibited by Bryan in his Savile Row premises. Since NG 62 was so exhibited, it must be assumed that Bryan's purchase was on the mortgagees' behalf. Another marginal inscription reads: 'twas knd. down first at 900 gs. but being a dispute put up agn.' The catalogue description includes the following: 'Out of the collection of Mons. Le Compte Vaudruil and was publicly sold in Paris for 900 Louis d'ors.'

8. A typed copy of this catalogue, copied from a catalogue recorded as belonging to E.K. Waterhouse in 1947, is in the NG Library.

9. *The Diary of Joseph Farington*, vol. 2, p. 350 (7 June 1795).

10. John Young, *A Catalogue of the Pictures at Leigh Court, near Bristol; the seat of Philip John Miles, Esq., M.P.*, London 1822, p. 19, where said to have come from the Palazzo Colonna. Troward was presumably the lawyer Richard Troward in whose sale of 6–7 March 1803 were three paintings attributed to Poussin: *Index of Paintings Sold*, vol. 1, pp. 567, 1036.

11. According to a photographed copy of the catalogue with manuscript additions, which also identify the vendor as 'Mr Troward of Pall Mall'. Another inscription, immediately following the catalogue entry (which identifies the painting as 'N. Poussin... A bachanalian...from collection of the Count du Veudreul') reads '5. & 51/2 4. in grn. light yellow'. Smith 1837 confuses NG 42 and NG 62. The painting in Richard Walker's sale of 1803 was NG 42, and that in the Troward sale of 1807 was NG 62: see Smith, nos 221 and 222.

12. Manuscript additions to the catalogue (photograph copy in the NG Library) identify the vendor and the price, and a further manuscript addition in the right margin reads: '53½p. 10 figs. Blue yelw [illegible]', that is, $5 \times 3\frac{1}{2}$ panel, 10 figures. Described in *Kinnaird Collection; or Cabinet Picture Gallery*, London 1809, as from the collection of 'the Compte de Vergennes'. See also George Redford, *Art Sales: a history of sales of pictures and other works of art*, 2 vols, London 1888, vol. 1, p. 109.

13. The information that NG 62 was withdrawn from the sale and sold privately to Delahante derives from a manuscript note in the copy of the catalogue in the NG Library. Although the note states the buyer to be Delahante or another French dealer, Pierre Joseph Lafontaine, it was apparently the former: Whitley 1928, pp. 213–14.

14. Whitley 1928, Farington relates: '[Ward] told me that Lord Kinnaird sold his 3 pictures viz: Bacchus & Ariadne by Titian, The Judgement of Paris by Rubens; & [blank] for 6500 guineas to [blank] the picture [dealer] & that these pictures are now in the possession of Baseley.' (Entry for 19 June 1813: *The Diary of Joseph Farington*, vol. 12, p. 4375.)

15. Catalogue of the British Institution exhibition of 1816, and see [Rev. James Dallaway], *An Account of all the Pictures as exhibited in the rooms of the British Institution from 1813 to 1823*, London 1824, pp. 116–17. NG 62 was seen in Hamlet's house in Cavendish Square by John Smith in 1823: *Index of Paintings Sold*, vol. 3, p. 771.

16. *Return (Pursuant to an Order of the House of Lords, dated 13th July 1869) of All Pictures purchased for the National Gallery*, London 1869, p. 1.

17. Réveil and Duchesne aîné, *Musée de Peinture et de Sculpture*, 14 vols, Paris and London 1828–33, vol. 10 (1831), no. 671.

18. According to Thuillier in *Poussin Colloque 1958*, vol. 2, p. 292, and it so appears from the small photograph in the NG dossier.

19. Note from the Curator of the Musée Municipal, Vire, dated 7 November 1996.

20. P. Butet-Hamel, *Catalogue Sommaire des Peintures...exposés au Musée de Vire*, Vire 1909, no. 43.

21. Noted by Pierre Rosenberg in Paris 1994–5, p. 210, and seen by him in 1973 in the Paris home of a now deceased collector (letter of 24 November 1997).

22. Grautoff 1914, no. 31.

23. Blunt 1966, p. 102.

24. Sidney, 16th Earl of Pembroke, *A Catalogue of the Paintings & Drawings of the Collection at Wilton House Salisbury, Wiltshire*, London and New York 1968, no. 187, where published as an autograph sketch for NG 62.

25. For three drawings of bacchanals before a term which have in the past been attributed to Poussin but are rejected by Rosenberg and Prat: see R-P.R 368, R741 and R1202. In R741, considered by Oberhuber to be by Poussin (Fort Worth 1988, pp. 177–9), there is a sleeping putto in the left foreground like that at the left of NG 62; otherwise none of the drawings, even if by Poussin, can be related to NG 62.

26. Clayton 1995, pp. 75–7.

27. Brigstocke 1995, pp. 60–3, at p. 63.

28. P. Rosenberg, 'Poussin drawings from British collections', *BM*, 133, 1991, pp. 210–13 at p. 211.

29. Brigstocke 1995, pp. 61–2.

30. *BM*, 138, 1996, pp. 467–8.

31. *Master Drawings*, vol. 34, no. 4, 1996, p. 426.

32. Edinburgh 1981, p. 41.

33. Rosenberg 1982, pp. 376–80, at p. 379, n. 1.

34. Richard Walker, 'Henry Bone's Pencil Drawings in the National Portrait Gallery', *The Walpole Society*, 61, 1999, pp. 305–67 at p. 356.

35. M. Préaud, 'Jacques van Merle. A Flemish Dealer in Paris', *Print Quarterly*, vol. 1, 1984, pp. 81–95, according to whom Van Merle was in Paris by 1646 (p. 82), and the etching was by Dorigny and first published by Huart and then by Van Merle (p. 90 and n. 72).

36. M. Grivel, *Le Commerce de l'Estampe à Paris au XVII^e siècle*, Geneva 1986, p. 165.

37. *Report of the Select Committee on the National Gallery*, London 1853, paras 4771–2.

38. White and Pilc 1996, pp. 91–103, at pp. 93, 98–9 and 102, n. 45.

39. For a summary of its earlier conservation history, see London 1947, no. 60.

40. Davies 1946, p. 75, and Davies 1957, p. 172.

41. Blunt 1967, p. 144.

42. See Cifani and Monetti 1994, pp. 749–807 at p. 765 and p. 800, n. 71.

43. Blunt 1967, no. 140.

44. Ovid, *Remedia Amoris*, trans. by J.H. Mozley, Loeb edn, 1929, p. 233.

45. Mahon 1965, pp. 113–42, at p. 135.

46. Mahon, 1962b, p. 94.

47. NG 62 was dated 1633–4 by Denis Mahon in Mahon 1962a, pp. 175–6, and in Mahon, *Poussiniana*, 1962b, p. 83; it was dated 1633 by H. Brigstocke in Brigstocke 1982a, p. 240, but 1634–5 by him in Oxford 1990–1, no. 28; dated 1631–3 by J. Thuillier in Thuillier 1974, p. 94, and in Thuillier 1994, p. 252; and 1632–3 by P. Rosenberg in Paris 1994–5, p. 210.

48. L. Barroero, 'Nuove acquisizioni per la cronologia di Poussin', *Bollettino d'Arte*, LXIV, 4, October–December 1979, pp. 69–74.

49. Plutarch's *Life of Pyrrhus*, II, 3.

50. For dating of NG 62 by others, see under Exhibitions and note 47 above. NG 62 was dated to 1633 by me in Wine 1995 at p. 52.

51. Costello 1950, p. 278.

52. See Mahon 1999, no. 10.

53. Davies 1957, p. 173.

54. Clayton 1995, cited in note 26, no. 47.

55. As Martin Clayton has pointed out in a manuscript note.

56. MS note.

57. Edinburgh 1981, pp. 41–2 and fig. 7.

58. On Poussin and Philostratus, see, for example, Thuillier 1994, pp. 37–8, and Rosenberg in Paris 1994–5, p. 153. The engraving appears on p. 552 of the 1615 edition of Blaise de Vigenère's translation of Philostratus' *Imagines*. It has also been suggested that the group of figures in NG 62 derives from Peruzzi's *Apollo and the Muses* (Florence, Pitti Palace), of which a print was made by Thomassin in 1615: G. Kauffmann, 'Peruzzis Musenreigen', *Mitteilungen des Kunsthistorischen Instituts in Florenz*, XI, December 1963–September 1965, pp. 55–62.

59. Paris 1994–5, p. 210. John Smith also identified the four dancing figures with the Seasons: Smith 1837, no. 221.

60. For Poussin's use of a circular dance as a visual metaphor for continuity, see his *Dance to the Music of Time* (London, Wallace Collection), in which each of the dancing figures is also distinctly identifiable as Poverty, Labour, Wealth and Pleasure: R. Beresford, *A Dance to the Music of Time by Nicolas Poussin*, London 1995. The Wallace Collection picture is now generally agreed to date from 1634–5.

61. Levi 1985.

62. A painting like NG 62, once at Vire but now destroyed, was formerly at the Château de Montmorency until the time of the French Revolution, when it was bought by Robert Mérimée (see under Related Works: Paintings (3)). Both when bought by Mérimée and when at Vire, the painting was regarded as autograph, but by analogy with the copy of Poussin's *Triumph of Pan* (NG 6477) now at Tours but once at the Château de Richelieu, it may have been a copy, rather than an autograph replica, of NG 62, and NG 62 may have been replaced with a copy at Montmorency.

Another possibility is that Henry Hurault, comte de Cheverny, reconstructed the Château de Cheverny near Blois in 1634 and decorated the (now destroyed) loggia with Bacchanals by Poussin (see Bonnaffé 1884, p. 62). This date would fit with the likely date of NG 62. Félibien in his life of Poussin in effect states that Poussin executed the Cheverny Bacchanals before, and possibly some years before, he went to Rome (*Entretiens 1685*, p. 244, and *Entretiens 1685–88*, vol. 2, pp. 312–13), and in his *Mémoires pour servir à l'histoire des maisons royales*, written in 1681 (ed. A. de Montaiglon, Paris 1874, p. 65) he asserts that Poussin was extremely young when he painted these pictures, which were by then 'assez gastées'. However, the local historian Jean Bernier in his *Histoire de Blois*, Paris 1682, gives a different account, referring to there being at the château 'une Bacchanelle de la bonne manière de Poussin, qu'on ne conserve pas assez' (p. 89), so suggesting a work of Poussin's Roman period. But even if Bernier's evidence were to be preferred, the generally good condition of NG 62 would seem to exclude it from being the picture described by him. Thuillier has recently proposed *c.*1617 as a date for the Cheverny Bacchanals: Thuillier 1995, p. 47. See Blunt 1966, p. 162, for a note of other now lost Bacchanals recorded as by Poussin.

63. See note 35.

64. Waagen 1854, vol. 1, pp. 344–5. For some other expressions of admiration for the picture, see Landseer 1834, pp. 312 ff., and A. Lavice, *Revue des Musées d'Angleterre*, Paris 1867, p. 56. For William Hazlitt's comment on NG 62, see Verdi 1981, pp. 1–18 at p. 12. For a less enthusiastic response, see Foggo 1845, p. 24.

NG 65
Cephalus and Aurora

*c.*1630
Oil on canvas, 96.9 × 131.3 cm

Provenance[1]
Possibly in the collection of Antoinette Oudaille (d.1712), wife of the painter Antoine Benoist;[2] included in the posthumous inventory of 26 August 1735 of Pierre d'Hariague, rue de Richelieu, Paris, chief adviser to the duc d'Orleans;[3] sale of Madame d'Hariague deceased, Paris, 14 April 1750 (lot 19);[4] probably posthumous sale of Peilhon, rue Neuve-des-Petits-Champs, Paris, Sécretaire du Roi, Rémy, Paris, 16 May 1763 (lot 57);[5] bought by Edward Knight (1734–1812) of Wolverley House, Worcestershire, and 52 Portland Place, London, on 10 January 1789 for £315;[6] by descent to his nephew, John Knight (1765–1850), in whose collection it was recorded in 1816 when exhibited at the British Institution (no. 67); in John Knight's sale, Phillips, London, 24 March 1819 (lot 139, 720 guineas, bought in);[7] his sale, Phillips, London, 17 March 1821 (lot 45, 690 guineas) where bought by G.H. [sic] Cholmondely;[8] bequeathed by G.J. Cholmondely to the Gallery, 1831.

Exhibitions
London 1816, BI (67); London 1975, NG, *The Rival of Nature. Renaissance Painting in its Context* (176); Edinburgh 1981, National Gallery of Scotland, *Poussin Sacraments and Bacchanals* (12); London 1993, NG, *Pictures in Pictures* (no catalogue); London 1995, RA, *Nicolas Poussin, 1594–1665* (16).

Related Works
PAINTINGS
No copies of NG 65 are recorded. There is an autograph treatment of the subject with a different composition and of earlier date at Hovingham Hall, Yorkshire (Blunt 1966, no. 145, Thuillier 1994, no. 25). A drawing in the Hermitage (R.-P. R1115), not by Poussin, may be a record of a third treatment of the subject (not necessarily painted). A figure in George Richmond's *Comus* (Liverpool, Walker Art Gallery), painted by 1864 (fig. 1), combines elements of Cephalus in NG 65 and of Bacchus in Titian's *Bacchus and Ariadne* (NG 35). There exists a derivation of the composition of NG 65 by Leon Kossoff (b.1926) painted in oil on board (colour transparency in NG dossier).
PRINTS
(1) By Charles Marr, 1833, in Cunningham 1833;
(2) by W[illiam] Holl (the Younger?), no. 70 of *The National Gallery Pictures by Great Masters*, London n.d. (1838?).

Technical Notes
The condition is poor, with extensive wear. There are tears or losses through the left shoulder, chest and drapery of Cephalus, by the head of the putto at the right, but the largest tear is through the body of the reclining river god, caused by a fall of slate at Manod Quarry where the painting was stored during World War II. There is also some blanching in the foliage and some filling down the left-hand edge. In common with many paintings by Poussin, for example NG 5763, the visual appeal has suffered mainly because the increased transparency of the paint with age reveals more of the ground colour beneath. However, NG 65 has suffered from past restoration treatments. It is known to have been restored at least once before 1853,[9] and was most recently cleaned in 1949/50, when a variety of solvents were used, including, in the sky at upper left, morphaline, which is not normally used as a cleaning agent because of its potential danger to paint layers. It was during this last cleaning that the overpainted drapery covering the genitals of the reclining river god was removed.

The canvas was last relined and restored in 1949–50, when Davies noted 'something like WBO in chalk on the side of stretcher'. According to Gallery conservation records, it had been lined at some date before 1853. The ground is a warm buff colour. A paint sample taken from the sky indicates linseed as the paint medium, and this is probably the medium used in a sample taken from the brownish-red sheet at the right.[10]

Pentimenti are visible to the outlines of some of the figures and Aurora's cloak originally covered her hip.

The X-radiograph (fig. 2) reveals substantial changes to the composition: there were two additional trees at the left; also at the left was a two-wheeled chariot where the reclining goddess now is; a little to the right was another tree trunk from which hung an extensive swathe of drapery; the head of the putto holding the portrait of Procris seems to have been altered; to the putto's right is a large shield(?); and to the right of where Procris is sitting was a candlestick(?), possibly painted by a later restorer.

The subject is derived from the tale of Cephalus and Procris, the most familiar version of which is in Ovid's *Metamorphoses* (VII: 690–862), but which is also related in the *Fabulae* of Hyginus (nos 125, 189) and by the ancient Athenian writer Apollodorus (I: 9, paragraph 4, and III: 15, paragraph 1). As related by Ovid, Cephalus, prince of Phocis, was married to Procris, whom he loved; he was, however, also loved by the goddess of the dawn, Aurora, who carried him away against his will. Cephalus yearned for Procris and, in anger at her rejection, Aurora sent him back to her with a warning that he would wish he had never had her. Cephalus and Procris then in turn wrongly doubted the fidelity of the other, and tragically Cephalus accidentally killed Procris with the magic spear she (Procris) had given him in the course of an earlier reconciliation. In NG 65 Cephalus turns away from the embrace of Aurora to look lovingly at the portrait of his wife held up by a putto. To the left of the putto, resting on an urn, is a reclining river god, probably Oceanus, the father of all river gods and the site of the rising and the setting of the sun, and hence the place from which Aurora emerges.[11]

Behind these principal figures is the winged horse Pegasus, described by some ancient and later writers as the horse of Aurora[12] but rarely shown in art as motionless as in NG 65.[13]

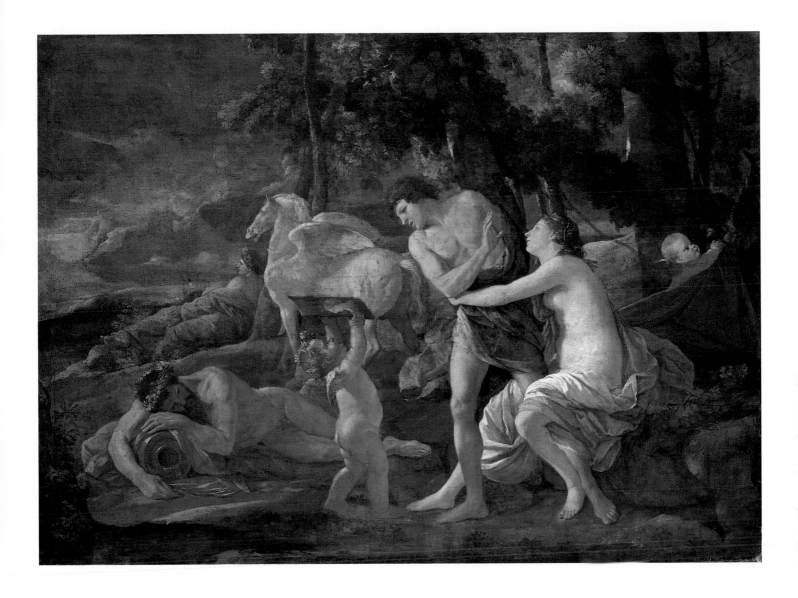

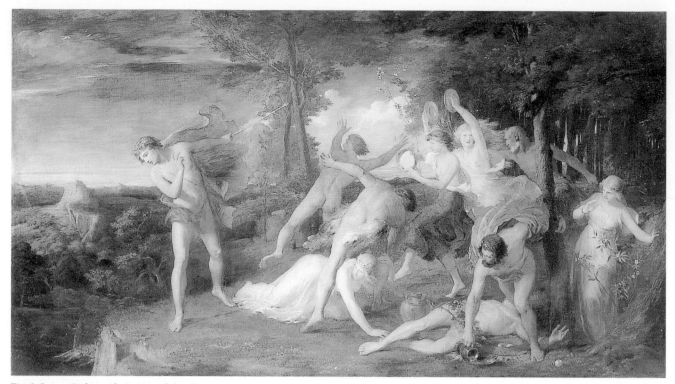

Fig. 1 George Richmond, *Comus*, exhibited 1864. Oil on canvas, 115 × 209 cm. Liverpool, Walker Art Gallery.

The identity of the reclining figure to the left of Pegasus is uncertain. The figure has been assumed to be female and identified,[14] surely wrongly, as Procris, whose presence would make no sense here because the inclusion of her portrait makes it clear that she is absent. The figure has also been described – more reasonably, given that she wears a wreath of corn and holds some flowers – as an earth goddess,[15] and more specifically as Terra, the goddess associated with the day begin-ning and the awakening earth.[16] Terra might have been seen as connected to Oceanus, the source of the fertility that comes from water,[17] and as indicating the cosmic resonance of the myth that the sun shines on the earth after rising out of the ocean.[18] Poussin may also have been aware of the use of Terra and Oceanus as framing figures on ancient sarcophagi.[19] Nevertheless, there is no psychological nor obvious com-positional connection between these two figures in NG 65 such as might reinforce the figure's identity as Terra.

In the background to the left the sun god Apollo drives his chariot across the sky. If Apollo in his role as sun god is taken to allude to the element of Fire, then the reclining goddess may allude to Earth, Pegasus to Air, and Oceanus to Water.[20] Given that the reclining goddess was a late addition (see Technical Notes above), her inclusion may indeed be intended as no more than an allusion to the element of Earth. However, what, if anything, Poussin intended by alluding to the Four Elements in NG 65 is, unclear.[21] An imaginative interpretation of the figures of Oceanus and of the uniden-tified goddess was made by John Landseer in *A Descriptive, Explanatory, and Critical, Catalogue of Fifty of the Earliest Pictures Contained in the National Gallery of Great Britain* (London 1834, p. 296):

in order to indicate the early hour – or to accord with it rather – Poussin has introduced, just beyond his principal group, a river-god as not conscious of day-light – as literally "sleeping o'er his urn"; and a little farther on in the picture, upon higher ground, appears a Naiad, with her smaller vase beside her, who is just awakening: the allegoric meaning – delicately, but efficiently expressed – is that mountain streamlets glitter in the early morning light, while the deeper river-beds are yet in the dark.

A more recent suggestion is that NG 65 combines both the Four Elements and an allegory of time, with Aurora playing a dual role by representing both fire and the dawn, and Apollo representing the day, and the awaiting darkness the night.[22] This, however, seems improbable because to give Aurora, and her alone, a dual role is inelegant as well as unnecessarily mystifying, and also denies what is, after all, her primary role, namely as player in a tragic drama.[23] Indeed, the inclusion of Oceanus – if it is he – may have been intended to underline the tragedy: to atone for having killed Procris, Cephalus leapt into the sea (that is, Oceanus), an action which in Poussin's picture seems entirely possible, but for Aurora's restraining hand. Cephalus' present yearning for the absent Procris is thereby linked to his future yearning for the dead Procris, whose portrait can be seen as both a living likeness and a commemoration.[24]

The centrality of the portrait of Procris in NG 65 and the possible temporal ambiguity of Cephalus' evident emotion of yearning give some support for Sohm's suggestion that Poussin's source for the painting was Ronsard's *Le ravissement*

de Cephale, first published in Paris in 1550.[25] As Sohm points out, Ronsard unusually places the first meeting of Cephalus and Aurora after Procris's death. Aurora finds Cephalus grieving over an 'image' of Procris and, stricken with desire, asks him 'Pourquoi pers tu de ton age/ Le printens à lamenter/ Une froide & morte image/ Qui ne peut te contenter?' ('Why do you lose the springtime of your age in grieving over a cold, dead image which cannot make you happy?') As Sohm recognises, however, Ronsard's popularity was on the wane in Poussin's time,[26] and it is not clear that he ever was popular among the literate public of Rome – one of whom, rather than a French owner, was likely to have been the original purchaser of NG 65 at this stage of Poussin's career (for the dating of NG 65, see below). The painting should not, therefore, be seen as illustrating Ronsard's account of the myth, although the idea of Procris being represented by her portrait may be derived from it. Besides, Poussin's inclusion in NG 65 of subsidiary figures who have no role in Ronsard's ode cautions against drawing too direct a parallel between Poussin's painting and this source.

The triangularity of the composition of the main figures and the treatment of the landscape background recall Venetian sixteenth-century painting. More specifically, the pose of Cephalus recalls that of Bacchus in Titian's *Bacchus and Ariadne* (NG 35), then in the Aldobrandini Collection, Rome.[27] The figure of Oceanus may be derived from that of Tithonus in Agostino Carracci's fresco of *Cephalus and Aurora* in the Palazzo Farnese, Rome,[28] but such similarities as exist are more likely to be coincidental. Davies noted the parallel between the motif of the portrait in NG 65 and that of Marie de' Medici in Rubens's *Henri IV contemplating the Portrait of Marie de' Medici* (Paris, Louvre), installed in the Luxembourg Palace, Paris in 1623,[29] but this, too, may be coincidental. Probably no less so is the resemblance noted between Poussin's central group and a composition by G.B. Trotti (1555–1619), who worked in Parma.[30]

Of all the possible visual sources, the one most likely to have been consulted by Poussin is the Palazzo Farnese, but whereas the Carracci fresco of Cephalus and Aurora is in spirit the Ovidian equivalent of the biblical story of Joseph and

Fig. 2 X-radiograph.

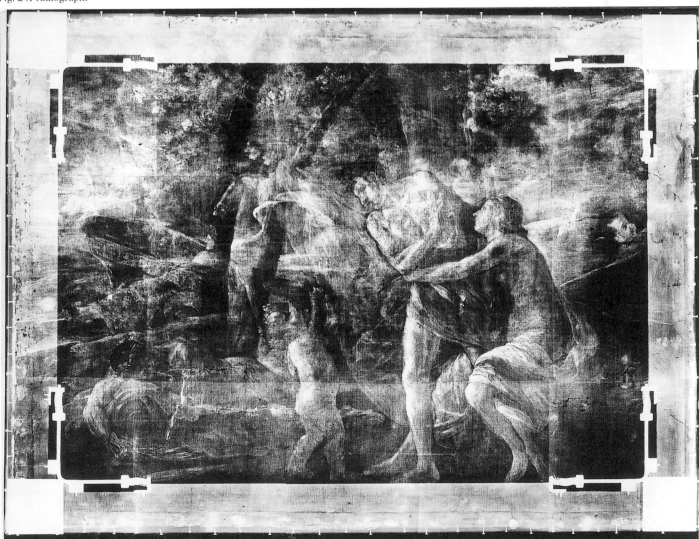

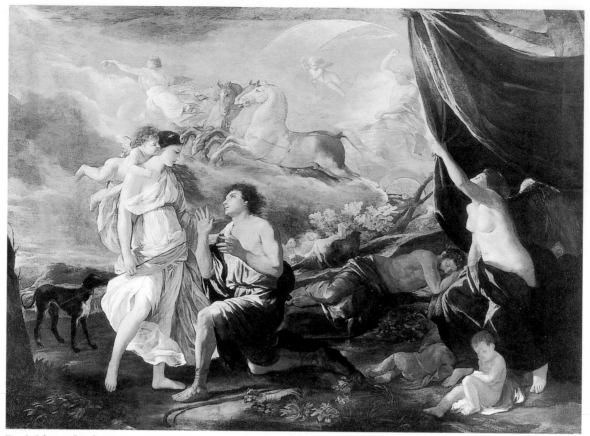

Fig. 3 *Selene and Endymion*, c.1629–30. Oil on canvas, 121.9 × 168.9 cm. Detroit Institute of Arts. Founders Society Purchase, General Membership Fund.

Potiphar's wife, NG 65 is imbued with a poetic melancholy common to a number of Poussin's paintings from his first decade in Rome. Among these are the Madrid *Triumph of David* and the Detroit *Selene and Endymion* (fig. 3). NG 65 shares with the latter an almost identical reclining male figure, albeit in reverse.[31] Resemblances between NG 65 and the Detroit painting have often been noted, for example in the drapery of Aurora and that of Diana[32] and in the physiognomies of the figures,[33] leading most authorities to date NG 65 to the period 1628–30.[34] NG 65 certainly precedes the Dresden *Kingdom of Flora*, securely dated to 1631, but the significantly earlier dating advanced by some[35] for NG 65 – a painting which is mature both in composition and in representation of the human form, as well as so poetically sensitive – seems improbable. As Mahon has pointed out,[36] Poussin was likely to have been painting in a Berninesque manner when he was working on the *Martyrdom of Saint Erasmus* (Rome, Vatican Museums, Pinacoteca) and on *The Virgin appearing to Saint James* (Paris,

Louvre) in 1628–9, so that his suggested date of c.1630 for the stylistically different NG 65 is likely.

As Verdi has pointed out, NG 65 was widely admired by nineteenth-century British critics after it entered the Gallery's collection.[37] William Hazlitt called it 'a suffusion of golden light' and John Landseer described it as 'dreamy, and poetical, and beautiful'.[38] A less generous response was that of George Foggo, who considered it 'flat and outliny... Among the works of great masters this may be called flimsy'.[39] It has been suggested that Turner's rendering of the horses of the sun in *Ulysses deriding Polyphemus* (NG 508) was influenced by Poussin's in NG 65.[40]

General References

Smith 1842, 251; Grautoff 1914, 47; Magne 1914, 39; Davies 1957, p. 174; Blunt 1966, 144; Badt 1969, 106; Thuillier 1974, 30; Wild 1980, 8; Wright 1985a, 24; Wright 1985b, p. 134 Oberhuber 1988, 61; Mérot 1990, 136; Thuillier 1994, 43.

NOTES

1. It has recently been hypothesised that NG 65 may be one of the 53 paintings without attribution sold in 1633 by the Genoese dealer, Giovanni Stefano Roccatagliata (d.1652) to Francesco Scarlati in Florence: Elena Fumagalli, 'Poussin et les collectionneurs romains au XVIIᵉ siècle', in Paris 1994, pp. 48–57 at pp. 52–3 and nn. 62 and 64. These paintings included seven original works by Poussin and five copies. The

notarial document, in which no attribution is made, refers to 'Un quadro di Cefalo, Aurora e primavera di palmi sei e tre' and another of the same subject of 9 palmi by 7. Neither of the measurements corresponds to those of NG 65, as Fumagalli recognises. If, as Fumagalli suggests, two of the paintings sold at the same time by Roccatagliata indeed included the Munich *Midas and Bacchus* (98 × 130 cm) and the Fort Worth *Venus and*

Adonis (98.5 × 134.6 cm), the sizes of which are described as 'in tela d'Imperatore', then it would be odd for NG 65 (96.9 × 131.3 cm) not to be similarly described. For NG 65 to correspond to either of the two paintings of the subject of Cephalus and Aurora sold to Scarlati, it would need either to have had its height increased by a 30 cm strip of canvas after the sale (clearly not the case) or to have been cut down substantially on all sides (for

which there is no evidence). The larger of the two paintings of Cephalus and Aurora sold to Scarlati had dimensions similar to a painting of the same subject recorded in the Dal Pozzo collection in 1695 ('114. Altro di 7, e 9 rappresentante gl'amori di Cefano (sic), et Aurora del detto [i.e. Poussin]', Sparti 1992, p. 210), but this cannot be the picture now in Hovingham Hall, Yorkshire (Standring 1988, pp. 608–26 at p. 619) since, as a Dal Pozzo picture, it would not have been sent to Florence. It would seem, therefore, that Poussin painted the subject of Cephalus and Aurora at least four times, that is, the two treatments sent to Florence, the Dal Pozzo picture and NG 65.

2. See E. Coquery, 'Les oeuvres de Poussin dans les collections des peintres français sous Louis XIV', *Poussin Colloque 1994*, pp. 837–64 at p. 860. The painting is described in Oudaille's posthumous inventory of 29ff April 1712 as 'un autre grand tableau du Poussin representant Cephale et Laurore dans sa bordure dorée de trois pieds huit pouces sur cinq pieds deux pouces de Large [119.06 × 167.77 cm] numeroté Sept. prisé Mil Livres' (A.N., M.C., XXVII, 71). If the measurements referred to the frame rather than the painting (which could explain the discrepancy between them and those of NG 65), one would expect the discrepancies in height and width to be the same, but in fact there is a difference of some 14 cm between them.

3. Rambaud 1964–71, vol. 1, p. 579. The valuation of NG 65 in the inventory was 1000 livres.

4. The sale catalogue (photocopy in NG Library – Box A.IX.3.6) is inscribed 'Dressé par Mariette', and in the margin by lot 19 are inscribed the figures '1122', presumably the price in livres. The painting in the d'Hariague collection was possibly that noted in Dezallier d'Argenville 1745 as being in France (vol. 2, p. 254). See also G. Duplessis, *Les Ventes de Tableaux, Dessins, Estampes et Objets d'Art aux XVIIᵉ et XVIIIᵉ Siècles*, Paris 1874, p. 12.

5. '57 Un autre beau Tableau du Poussin, peint sur toile, de trois pieds de haut sur quatre de large: il représente Cephale & l'Aurore, un Amour qui tient un miroir, & un Fleuve couché sur son urne.'

6. *Edward Knight's Pocket Book, March 1786 to March 1791*. Kidderminster Public Library, ms. 000290. ('Jan.10 [1789] Cephalus & Aurora Nic.Poussin 315.–.–') For further references, see note 7 to NG 39.

7. Smith 1837, vol. 8, p. 130. The painting is described in the sale catalogue only as 'Cephalus & Aurora'. The catalogue's title page states that Knight's paintings had been 'removed from his residence at Portland Place'.

8. Smith, cited in note 7, and see Redford 1888, vol. 2, p. 281.

9. *Report of the Select Committee on the National Gallery*, London 1853, para. 2181.

10. R. White and J. Pilc, 'Analyses of Paint Media', *NGTB*, 16, 1995, pp. 85–95 at pp. 90–1 and 94, n. 20.

11. See I. Lavin, 'Cephalus and Procris. Transformations of an Ovidian Myth', *JWCI*, 17, 1954, pp. 260–87 at pp. 284–5. Lavin claims, probably wrongly, that the sleeping figure in NG 65 is Aurora's husband Tithonus resting his head upon the traditional water symbol, probably indicating Ocean, the site of his original love with Aurora. Would he, after all, be shown lying nearby? He is anyway usually shown as old and grizzled.

12. Davies 1957, pp. 175–6, n. 3. As Elizabeth McGrath has pointed out in a letter of 22 March 1996, the 1615 edition of Cartari published in Padua shows Aurora in a chariot drawn by Pegasus (p. 89).

13. See ed. C. Brink and W. Hornbostel, *Pegasus and the Arts*, Hamburg 1993 (trans. E. Clegg, E. Martin et al.).

14. Lavin, cited in note 11, p. 285.

15. By Verdi in London 1995, p. 174.

16. Davies 1957, p. 175.

17. Blunt 1966, p. 105.

18. As suggested in correspondence by Elizabeth McGrath.

19. Ibid.

20. See Blunt 1966, p. 105, for this suggestion, although Blunt here associated Aurora with fire, rather than Apollo.

21. Lavin, cited in note 11, suggested that NG 65 reflected a pictorial tradition inspired by the play *Il Rapimento di Cefalo*, performed in Florence in 1600 and written by Gabriello Chiabrera (1552–1637). But as Davies 1957 noted (pp. 175 and 176, n. 5), nothing connects NG 65 to the specifics of that play.

22. Ursula Mildner-Flesch, *Das Decorum, Herkunft, Wesen und Wirkung des Sujetstils am Beispiel Nicolas Poussin*, Sankt Augustin 1983, pp. 159–65. Cited by Philip L. Sohm, 'Ronsard's Odes as a Source for Poussin's Aurora and Cephalus', *JWCI*, 1986, 49, pp. 259–61 at p. 260.

23. The centrality of the narrative is not, however, denied by Badt, who sees in NG 65 certain themes which recur in Poussin's paintings, including those of the opposition of celestial and earthly love, and of love as seducer and love as protector: Kurt Badt, *Die Kunst des Nicolas Poussin*, Cologne 1969, pp. 516–17.

24. On the functions of portraits as commemorations and keepsakes in the sixteenth century, see Lorne Campbell, *Renaissance Portraits. European Portrait-Painting in the 14th, 15th and 16th Centuries*, New Haven and London 1990, p. 193.

25. Philip L. Sohm, cited in note 22. For *Le Ravissement de Cephale* in a modern edition, see Pierre de Ronsard, *Oeuvres Complètes*, 20 vols, Paris 1914–75, vol. 2, p. 133.

26. Philip L. Sohm, cited in note 22.

27. Denis Mahon, 'Nicolas Poussin and Venetian Painting: A New Connexion', *BM*, 88, 1946, pp. 15–20 and 37–42, at p. 38, and Mahon 1962a, p. 47, n. 139. Davies adopted Panofsky's suggestion that the pose of Cephalus recalled that of Adam in Michelangelo's *Expulsion* in the Sistine Chapel: Davies 1957, p. 175.

28. First suggested by Lavin, cited in note 11, p. 284.

29. Davies 1957, p. 175, n. 1, followed in this by Blunt 1966, p. 105.

30. Lavin, cited in note 11, p. 284, n. 3.

31. As noted by Rosenberg in Paris 1994, p. 192.

32. Mahon 1962a, pp. 57–8, where both paintings were dated to 1631–2. Mahon later revised his dating of the Detroit painting to the end of 1630: Paris 1994, p. 192.

33. R. Verdi in London 1995, p. 179.

34. Verdi dates NG 65 to 1629–30; Rosenberg in Paris 1994, p. 192 at n. 21, by implication to 1628–29. Oberhuber places both paintings in 1628: K. Oberhuber, *Poussin. The Early Years in Rome*, Oxford 1988, pp. 191–2 and 278. Blunt 1966 (before 1630); Brigstocke 1981 (around 1630).

35. NG 65 is dated to 1625–6 (with reworkings in 1626–7) in Thuillier 1994 and to 1625–6 with reworkings c.1627–8 in J. Thuillier, 'Poussin et le laboratoire', *Techne*, no.1, 1994, pp.13–20 at p.16; c.1626 by Mérot in Mérot 1990, p. 109, by comparison with the Louvre *Bacchanal with a Guitar Player*, the tonalities of which are, however, quite different; and 1624/6 by Wild in Wild 1980.

36. Mahon 1999, p. 30, n. 54 and p. 37.

37. Verdi 1976, pp. 298–9 and p. 316, and in London 1995, pp. 174–5.

38. W. Hazlitt, *Criticism on art with catalogues of the principal picture galleries of England*, Second Series, London 1844, p. 197; Landseer 1834, p. 283.

39. Foggo 1845, p. 25.

40. William Chubb, 'Minerva Medica and the Tall Trees', *Turner Studies*, I, no. 2, 1981, p. 31, cited by Egerton 1998, p. 286.

Nymph with Satyrs

*c.*1627
Oil on canvas, 66.4 × 50.3 cm

Provenance

Possibly Calonne Sale, Skinner and Dyke, London, 28 March 1795 (lot 39, sold 46 guineas);[1] in the collection of Henry(?) Hope (1736–1811) by 1796;[2] sale of John William Hope, Christie's, 29 June 1816 (lot 55, £152 5s. to the dealer Delahante); bequeathed by the Revd William Holwell Carr by his will dated 28 August 1828, proved on 9 March 1831, where described as 'Jupiter and Antiope. N. Poussin. From Paris'.[3]

Exhibitions

London 1995, NG, *Poussin Problems* (no catalogue); London 1997, NG, *Themes and Variations: Sleep* (no catalogue); Rome 1998–9, Palazzo delle Esposizioni, *Nicolas Poussin. I primi anni romani* (19).

Related Works

PAINTINGS[4]

(1) There is an autograph, and probably earlier, treatment in horizontal format in the Kunsthaus, Zurich[5] (fig. 5, and see below), and a copy of the Zurich painting (perhaps by a Neapolitan painter around 1700) in a Swiss private collection;[6] the Zurich painting was engraved by Jean Daullé, 1760,[7] by Matthys Pool and by Mme Soyer (C.P. Landon, *Vies et Oeuvres des Peintres les plus célèbres... Ecole Française. Vie et Oeuvre complète de Nicolas Poussin*, Paris 1813, plate CLXXII);

(2) A version has been said to be in a New York private collection;[8]

(3) A copy of NG 91 by William Hilton RA (1786–1839) was sold at Sotheby's, 7 April 1965 (lot 225) (photographs in NG dossier);

(4) William Etty's reception piece *Sleeping Nymph and Satyr* (London, Royal Academy; presented 1828) may have been derived from NG 91 or from an engraving.[9]

DRAWING

A thematically related drawing is at Windsor, Royal Collection (RL 11987, R.-P. 50).[10] For other related drawings offered in eighteenth-century sales, see Rosenberg and Prat, vol. 2, pp. 1155, 1160.

PRINT

By W.T. Fry in *The National Gallery of Pictures by the Great Masters presented by Individuals or purchased by grant of Parliament*, 2 vols, London [1838?], vol. 2, no. 111.

Technical Notes

Some wear throughout. There is a horizontal tear across most of the canvas, about 15 cm from the top, and an irregular damage above the kneeling satyr's shoulder. There is some damage in the bottom left and top right corners, and some transparency in the paint, which was in any event always thin.

The support is a plain-weave medium canvas lined sometime before 1853 when Gallery conservation records began, relined in 1955 and again in 1994, when the painting was also retouched and revarnished.

The ground is a red-pink colour, probably composed of calcium carbonate mixed with some orange and brown earth pigment. There is also silica in the ground. On the back of the original canvas a hand has been sketchily painted (fig. 1). The X-radiograph (fig. 4) shows parts of several different compositions below the paint surface. The infra-red photograph shows the nymph's right arm to have been painted over drapery.

A pentimento to the foremost satyr's left elbow is visible, and some contours, drawn probably in paint, outline parts of his right forearm and left shoulder. The drapery being removed from the nymph was painted over her legs. This is clearest where it covers her right leg.

The subject of NG 91 has proved problematic. When the painting was in the collection of the Revd Holwell Carr, by whom it was bequeathed in 1831, it was known as 'Jupiter and Antiope'. In Greek mythology Antiope, the daughter of the river god Asopus, was loved by Zeus in the guise of a satyr, but in Ovid's brief reference to the myth (*Metamorphoses*, VI: 110–11) Antiope was not asleep, as the nymph may be in NG 91.[11] Nor was she asleep in the fables of Hyginus (*Fabulae*, VII, VIII). Homer's account of the story (*The Odyssey*, XI: 260–1) contains no suggestion of Zeus appearing in the guise of a satyr.[12] The nymph was also once identified as Venus, but, unlike the Zurich painting (fig. 5) in which there are doves, NG 91 contains none of Venus's attributes (other than the putto, not firmly identifiable as Cupid) as included, for example, in Correggio's *Venus, Cupid and Satyr* (Paris, Louvre).[13] Hence the figures in NG 91 cannot be designated as more than a nymph and satyrs.

The immediate visual source of NG 91 may have been the print by Agostino Carracci of a *Satyr and Nymph* (Bohlin 185; fig. 2), which strengthens the suspicion that the satyr behind the tree in Poussin's painting is to be understood as masturbating.[14] The theme of a satyr disrobing a sleeping nymph would, however, have been well enough known through, for example, the print of the subject by(?) Marcantonio Raimondi (fig. 3).[15] The more recent title, 'Sleeping Nymph surprised by Satyrs', was therefore an improvement over the title given by Holwell Carr. Were the nymph sleeping, however, she could not be surprised – although she might well be, should she wake up. As likely a possibility is that she has, as Rosenberg has suggested, 'swooned in ecstasy at the delights of her solitary (sic) pleasures'.[16]

The painting's erotic character has coloured scholars' attitudes to it. In a lengthy discussion of the subject matter, Davies stated that: 'Cupid appears, not to be trying to stop what is going on... but rather to be designating the most forward satyr; this, if Venus is concerned, seems repulsive, and the compiler would be glad not to see Venus in that composition.'[17]

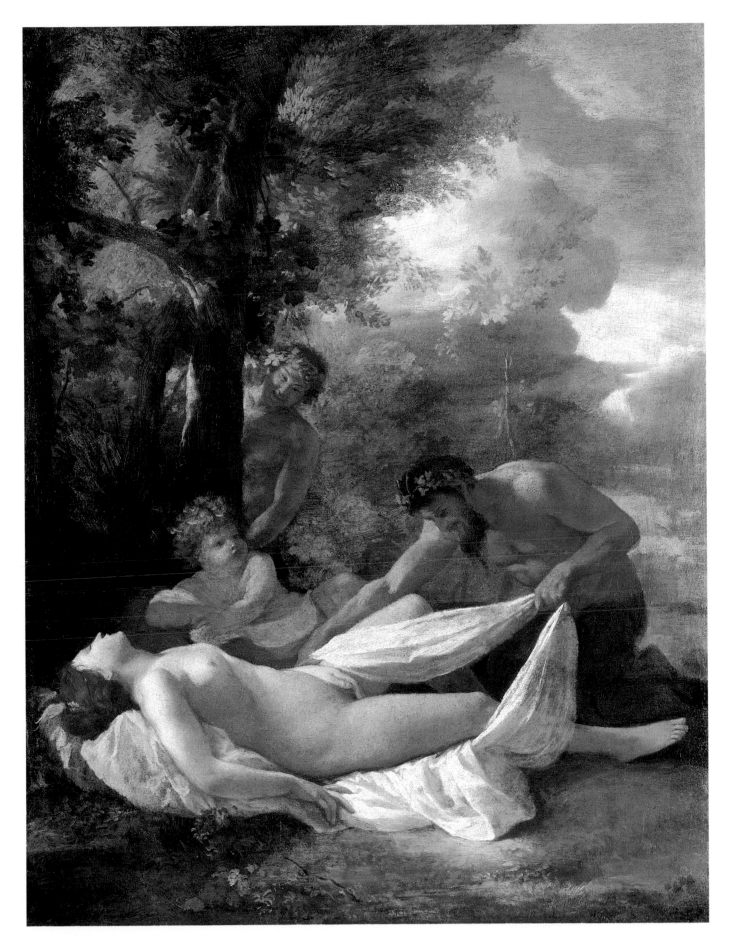

Fig. 1 NG 91, reverse of canvas.

More judgementally, in discussing an erotic painting by an unknown artist in the Zorn Museum, Mora, Sweden, Blunt stated: 'It is also rare to find this particular kind of salaciousness in genuine works by Poussin. Of the various *Nymphs surprised by Satyrs* ascribed to him, one, of which the best version is in the Kunsthaus, Zurich... is certainly not by him... the painting in Dresden [Blunt no. 189] is probably genuine, but is much more decent than the other compositions in question.'[18] The late Georgians, by contrast, did not allow the eroticism of NG 91 to interfere with its attribution to Poussin. This was unquestioned, even if the painting's exhibition to the public was delayed, probably on grounds of public decency (see further below).[19]

Paradoxically, the current attribution of NG 91 to Poussin himself rests (albeit secondarily) on its erotic nature. If, as is here claimed, NG 91 is autograph, it certainly belongs to Poussin's early years in Rome – that is, *c.*1627[20] – and so around the time when, without the security of regular patronage, the artist would have been likely to defer grander ideas to immediate needs by dashing off some easily saleable

erotica. The freedom of technique which for Davies was a reason for rejecting this painting, the summary drawing of the nymph's hands, and indeed the subject, all suggest a rapidly made picture by a young artist working for the market.[21]

Although accepted by Smith and Grautoff, NG 91 was rejected as an autograph work by Thuillier and Wild, as well as by Davies and Blunt. Recently, however, it has been published as autograph by Rosenberg, Mahon and Wine.[22] The attribution to Poussin is based firstly on a comparison of style and handling between NG 91 and other now generally accepted works, such as the fragment of the Dulwich *Venus and Mercury* in the Louvre[23] and the Cleveland *Amor Vincit Omnia*,[24] and secondly on the evidence of the X-radiograph (fig. 4). This shows a number of unrelated, partial compositions, but most clearly visible is the head and torso of a man looking up with right arm raised, whose features are close in type to those of figures in Poussin's *Victory of Joshua over the Amalekites* (St Petersburg, Hermitage Museum).[25]

As Davies noted, the pose of the man looking up in the X-radiograph resembles that of Midas in *Midas giving Thanks to Bacchus* (Munich, Alte Pinakothek), and the head is similar to that of Endymion in *Selene and Endymion* (Detroit Institute of Arts).[26] Both these paintings have been dated to *c.*1629–30. On this basis it has been proposed that the X-radiograph is evidence of NG 91 being the work of a copyist.[27] Although the resemblances noted by Davies are correct, there are also significant differences which one would not expect from a copyist: the figure in the X-radiograph is looking up with his head at a different angle from the figure of Midas, and the highlight on Midas' crown, which one would expect to show on the X-radiograph of a copy of that figure, does not. Comparing the figure in the X-radiograph with that of Endymion, the neck of the former figure is stretched further back, the

Fig. 2 Agostino Carracci (1557–1602), *Satyr and Nymph*. Engraving, 15.6 × 11.7 cm. London, British Museum, Department of Prints and Drawings.

Fig. 3 Marcantonio Raimondi (*c.*1470/82–1527/34), *A Satyr disrobing a Sleeping Nymph*. Engraving, 11.2 × 17.8 cm. London, British Museum, Department of Prints and Drawings.

Fig. 4 X-radiograph of NG 91 turned 90 degrees anticlockwise.

head is turned slightly more towards the viewer and, most obviously, the position of the right arm is quite different. The pose of the sleeping nymph in NG 91 is also distinct from that of the nymph in the Munich painting. Moreover, that Poussin sometimes used a canvas for sketching parts of compositions which were unrelated to each other or to the painting itself is clear from the X-radiograph of a work undoubtedly by him, namely the Louvre's *Echo and Narcissus*.

If it is accepted that neither the painting nor the figures revealed by the X-radiograph are mere copies (and it is of note that the sizes of the figures in the London and Zurich paintings are not the same), then they are at the very least the work of someone who was not only familiar with Poussin's work, but capable of improving on it, because NG 91 is far from being a laboured or timid version of the Zurich painting (fig. 5). On the contrary, and this is the third argument to sustain the attribution of NG 91 to Poussin, it is rather better. Some who have accepted the authenticity of NG 91 have proposed that it was a sketch for the Zurich painting.[28] However, although NG 91 is smaller, has fewer figures and is

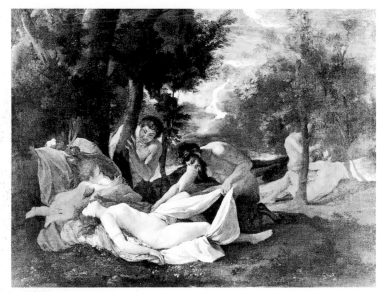

Fig. 5 *Sleeping Nymphs and Satyrs*, c.1626. Oil on canvas, 77 × 100 cm. Zurich, Kunsthaus.

in some respects more summarily treated, its composition is more resolved. This is particularly apparent when comparing the awkwardness of the placing of the Cupid in the Zurich picture with that in NG 91. In addition, as was apparent when the paintings were hung side by side at the National Gallery in 1995, the modelling of anatomy, particularly that of the foremost satyr, is more convincing and the colours more harmonious. If the Zurich painting is by Poussin, as many now claim, it is difficult to believe that NG 91 is not also by Poussin and postdates the Zurich painting by about a year.[29]

Alone among the paintings in the Holwell Carr bequest, NG 91's exhibition to the public was delayed, and it appears not to have been until 1835, four years after the painting entered the Gallery's collection, that the picture went on display. Presumably this was because of concern that the subject matter might offend public sensibilities.[30] When a painting with a similar subject, Franchoys Wouter's *Nymphs surprised by Satyrs* (NG 1871), was given to the Gallery in 1845, it seems to have stayed hidden from view until 1847 at least.[31] The Gallery may well have been particularly sensitive to these questions at this period, because it was in 1845 that George Foggo published criticism of its policy of displaying works without regard to their potential effect on morals. Foggo was particularly hard on Poussin, writing that

the obscenity and coarseness in some of [his] bacchanaliae, do not impress the English working classes with a favorable opinion of the '*philosopher painter*', or of the prelates or nobles who directed his talent to vulgar purposes; they do not inspire

them with respect for the pretended taste of their superiors. A few other pictures may be censured for their folly or vicious tendency, and we unhesitatingly avow that we should prefer, particularly for a National Gallery, inferior skill employed on worthier subjects.[32]

Foggo's comment on NG 91 itself was succinct: 'A bad subject not nicely treated; the colouring is however rich, soft and true.'[33] Nevertheless, if he hoped for the picture's removal from public gaze, he must have known that the battle had already been lost. Etty's painting of *A Sleeping Nymph and Satyr*, based on NG 91 (or on an engraving after the Zurich picture, see Related Works: Paintings), had been accepted by the Royal Academy as his reception piece nearly twenty years previously,[34] and an engraving of NG 91 itself had been issued in 1838(?) as part of a compilation in book form of engravings after National Gallery pictures,[35] so entrenching this work by Poussin in the public domain.

General References
Smith 1837, 230; Grautoff 1914, 24; Magne 1914, 111; Davies 1946, p. 79; Davies 1957, pp. 183–5; Blunt 1966, R 113; Thuillier 1974, B15; Wild 1980, R 31; Wright 1985a, A 34; Wright 1985b, p. 1139 (as a copy); Thuillier 1994, B8; Mahon 1999, no. 19. (See Erich Schleier in *Pier Francesco Mola, 1612–1666*, exh. cat., Lugano and Rome 1989–90, no. IV. 5 for the Kunsthaus, Zurich, version, and Pierre Rosenberg in Paris 1994, p. 22.)

NOTES

1. Where described as '[Lot] 39. Poussin. Jupiter and Antiope. Capital – much in stile of the antique'. NG 91 is said to have come from the Calonne collection in Mrs Jameson's *A Handbook to the Public Galleries of Art in and near London*, London 1842, p.108, and in R.N. Wornum's *Catalogue of the Pictures in the National Gallery*, London 1856, p. 135. There are numerous references in eighteenth- and nineteenth-century catalogues to paintings by Poussin which may be NG 91, including, for example 'A bacchanti [sic] Venus sleeping' which was lot 42 of Fulke Greville's sale, Christie's, 18 November 1794 (£8 18s. 6d. to C.G.) (I am grateful to Judy Egerton for this reference); 'Antiope asleep in a forest, discovered by Jupiter, a most spirited performance', London, European Museum, 16 November 1801 and 13 June 1803 (lot 516). The *Venus surprised by Satyrs* in the Bryan sale, 14 March 1809, is probably the painting now in the Kunsthaus, Zurich, no. 2480, see E. Schleier, *Pier Francesco Mola, 1612–1666*, exh. cat., Lugano and Rome 1989–90, pp. 306–7. The Zurich picture, the dimensions of which are 77 × 100 cm, may

be that in Dr Bragge's sale, London, Prestage, 25 January 1754 (lot 57, £13 2s. 6d.), where described as 'Venus asleep, two satyrs looking at her, with Cupid, from Lord Orford's collection – [width] 3 [feet] [height] 2 [feet].' The picture in the Bragge sale was lot 41 of Lord Orford's 1748 sale (£6 to Bragge) and may correspond with that from the Palazzo Falconieri, exhibited in Rome in 1717 (G. De Marchi, *Mostre di quadri a S. Salvatore in Lauro (1682–1725). Stime di collezioni romane. Note e appunti di Giuseppe Ghezzi*, Rome 1987, pp. 346 ('una Venere dormiente rimarata da un satiro, di misura palmi 4, di Nicolò Pussino, esposta nel arsenale'). It may have been bought at the Bragge sale by William Hamilton, in whose sale, London, Prestage & Hobbs, on 20 February 1761 it was (lot 74, £30 9s.). I am grateful to Kim Sloan for drawing my attention to the Bragge sale, but, in view of the dimensions of the picture as described in that sale's catalogue, think it more likely to be the Zurich picture than NG 91, *pace* Sloan, 'Sir William Hamilton's "Insuperable Taste for Painting"', *Journal of the History of Collections*, vol. 9, no. 2 (1997),

pp. 205–27 at p. 211). The picture in Bryan's 1809 sale was then in John Parke's sales, London, Coxe, 9 May 1812 (lot 38, £115 10s., bought in), and Christie's, 25 April 1818 (lot 102, £86 2s. to White): *Index of Paintings Sold*, vol. 3, part 2, p. 768, and vol. 4 part 2, p. 640.

If NG 91 was once in the Calonne collection, it may also have been lot 48 in an anonymous sale in Paris, Copreau, 25ff. June 1779: 'Une femme nue, & deux Satyres, par le Poussin.'

2. In a diary entry for Friday, 29 January 1796, Lady Amabel Lucas records: 'I went with Mr. Carew to see Mr. Hope's pictures which he has brought safe from Holland (as well as those of a cousin) & placed them in Lord Hopton's house in Cavendish Square which he has taken & in part of which he has a counting house & carries on some mercantile business.–Two landscapes of N. Poussin known by the prints called *The Burial of Phocion*: the One with the shade of high trees is very good. *A Holy Family*, Ditto, *A Sleeping Venus & Cupid* better colored than

usual for N.P....' *Diaries of Lady Amabel Yorke 1769–1827.* Lady Lucas's reference to 'a cousin' is presumably John William Hope, to whom, therefore, NG 91 may have belonged in 1796 even though it was in the posthumous sale of his uncle, Henry, in 1816. In fact, after Henry's death in 1811, and until it was sold in 1816, NG 91 indeed belonged to John William, who was the legatee of Henry's collection: see *Index of Paintings Sold,* vol. 3, p. 10 and vol. 4, p. 14.

3. Copy of will in NG Archive.

4. For some paintings by French eighteenth-century painters which are thematically and compositionally related to NG 91, see M.M. Grasselli and P. Rosenberg, *Watteau 1684–1721,* Washington, Paris, Berlin 1984–5, p. 330, figs 4 and 5, and P. Rosenberg, *Dessins français de la collection Prat XVIIe–XVIIIe–XIXe siècles,* Paris, Edinburgh, Oxford 1995, p. 94, fig.1.

5. For the Kunsthaus painting, see E. Schleier, cited in note 1, and for the suggested relationship between the painting in the National Gallery and that in the Kunsthaus, see also Wine 1996, p. 234, Wine 1995, pp. 25–8 at pp. 27–8, Mahon in Rome 1998–9, p.71, and Mahon 1999, pp. 28–9, 102. The Kunsthaus painting has been increasingly accepted as autograph: see R.-P., p. 94, but for a contrary view, see C. Dempsey, 'Poussin Problems', *Art in America,* October 1991, p. 43.

6. Letter of 16 August 1989 from Christian Klemm in NG dossier.

7. Andresen 1962, no. 357.

8. Friedländer and Blunt, vol. III, p. 32.

9. Richard Verdi, 'La Situation de Poussin dans la France et l'Angleterre des XVIIIe et XIXe siècles', in Paris 1994, pp. 98–104 at p. 102.

10. See Martin Clayton, *Poussin. Works on Paper,* Dulwich, Houston, Cleveland and New York 1995–6, no. 27.

11. The nude in Correggio's painting in the Louvre, *Venus, a Satyr and Cupid,* seems not to have been identified with Antiope before 1709–10. She was correctly called Venus in various inventories of other collections made during Poussin's lifetime: see A. Luzio, *La Galleria dei Gonzaga venduta all'Inghilterra nel 1627–28,* Milan 1913, p. 90; O. Millar, 'Abraham van der Doort's Catalogue of the Collection of Charles I', *The Walpole Society,* 1958–60, vol. 37, p. 22; G.-J. De Cosnac, *Les Richesses du Palais Mazarin,* Paris 1885, p. 299; F. Engerand, *Inventaire des Tableaux du Roy rédigé en 1709 et 1710 Par Nicolas Bailly,* Paris 1899, p. 129.

12. Homer, *The Odyssey,* trans. A.T. Murray, 1966, vol. 1, p. 405. I am grateful to Elizabeth McGrath for her comments on this passage in Homer.

13. For the identification of the subject of the Louvre's Correggio during Poussin's lifetime, see note 11.

14. This print and others from Agostino Carracci's so-called series of *Lascivie* seem to have been widely circulated: see D. DeGrazia Bohlin, *Prints and Related Drawings by the Carracci family: a catalogue raisonné,* Washington 1979, p. 289. The series has been dated *c.*1594–7 by B. Bohn, *The Illustrated Bartsch,* 1995, p. 310.

15. *The Illustrated Bartsch,* vol. 26, p. 221. Davies 1957, p. 184, noted a reference by Lomazzo in *Idea del Tempio della Pittura,* Milan 1590, p. 133, to a painting by Titian of 'una Venere che dorme con Sattiri che gli scoprono le parti più occulte...'

16. P. Rosenberg in a review of Rome 1998–9, *BM,* 141, 1999, p. 192.

17. Davies 1957, p. 183.

18. Blunt 1961, p. 458, n. 15. Blunt was, however, aware that Poussin painted subjects of this type, himself referring to Loménie de Brienne mutilating a picture which he found 'trop nue et trop immodeste' (Blunt 1966, p. 133). For the Dresden picture, which is probably autograph of *c.*1627, although its authenticity is not universally accepted, see *Gemäldegalerie Dresden Alte Meister. Katalog des Ausgestellten Werke,* Dresden and Leipzig 1992, p. 306.

19. On 20 June 1831, William Seguier, then Keeper of the National Gallery, wrote to Revd J. Forshall, the Secretary to the British Museum, that 'The Executor [of Holwell-Carr], the Revd Mr [Edward] Holwell, has detained one Picture on the ground of it being a delicate subject, although the Picture was for many years in a conspicuous situation in the late Revd Mr Carr's Drawing room and remained there till the time of his decease'. That Seguier was referring to NG 91 is clear from Edward Holwell's letter of 27 June 1831 to the Trustees' solicitors explaining why three of the deceased's paintings had been retained: 'The third, representing a Nymph and Satyr, is so very indecent in its character, that I did not conceive that it could with any propriety be exhibited with the others according to the directions of the Testator.' Although the other paintings in the Holwell-Carr bequest appeared in the National Gallery handlists or catalogues from 1831, NG 91's first appearance was only four years later (Ottley 1835, p. 27). NG 91 together with the other paintings retained by Edward Holwell appears to have been in the possession of the British Museum Trustees by 9 July 1831 according to a Minute of a meeting of Trustees on that date. This Minute and the letters cited are in the archive of the British Museum's Secretariat. I am grateful to Christopher Date of the Secretariat for his help.

20. That is, a year later than I suggested in Wine 1996, p. 234. For Mahon's slightly earlier dating to 1626–7, see Mahon 1999, p. 102.

21. Wine 1996, p. 234.

22. For Rosenberg's view, see Paris 1994, p. 22, *BM,* 137, 1995, p. 690 (with L.-A. Prat) and *BM,* 141, 1999, p. 192; for Mahon's view, see Mahon 1999, pp. 28–9, 102; for mine, see Wine 1996.

23. The Louvre fragment inv. no. 7299 is *c.*1627.

24. For the Cleveland painting, see Mahon 1999, no. 20, where dated 1626–7.

25. Wine 1996. Olivier Bonfait has noted this point with approval, 'Poussin aujourd'hui', *Revue de l'Art,* no.119, 1998–1, pp. 62–76 at p. 73, n. 39.

26. Davies 1957, p. 184, n. 1.

27. Keazor 1995, pp. 349–50.

28. Paul Jamot, *Connaissance de Poussin,* Paris 1948, p. 17. Thérèse Bertin-Mourot, 'Addenda au Catalogue de Grautoff, depuis 1914', *Bulletin de la Société Poussin,* Second Cahier, December 1948, p. 49, regarded it also as a sketch, albeit for the painting in a Swiss private collection, now regarded as a copy (see Related Works)

29. Sir Denis Mahon in conversation originally suggested that NG 91 was two years later than the Zurich painting, that is, of 1627–8, but now considers that the interval between them is likely to have been less than a year: Mahon 1999, p. 102.

30. See note 19.

31. *The Art Union,* May 1847, p. 181.

32. Foggo 1845, p. iii.

33. Ibid., p.31.

34. See note 9.

35. See Related Works (Prints).

NG 5472
The Annunciation

Oil on canvas 104.3 × 103.1 cm (excluding a later extension of up to 2 cm on all four sides)

Signed, dated and inscribed: POVSSIN. FACIEBAT./ ANNO. SALVTIS. MDCLVII./ALEX. SEPT. PONT. MAX REGNANTE./.ROMA. (Poussin made [this]/ [in] the year of Salvation 1657/ Alexander VII reigning as Supreme Pontiff/ Rome)

Provenance

In the collection of Robert Udny (1722–1802), West India merchant, of Teddington, Middlesex;[1] in his sale, London, Philipe Scott, 26 May–10 June 1802 (lot 63, bought in), and Christie's, 19 May 1804 (lot 96, £157 10s. to H. Phillips);[2] in the sale of Robert Heathcote (active 1800–14), or others, Phillips, London, 5 April 1805 (lot 45, £102 18s. to (?) De Blyny);[3] probably the J.M. Raikes sale, London, Squibb & Son, 22 June 1821 (lot 70), where described as 'from the Orleans Collection. Engraved', and again Christie's, 6 June 1829 (lot 37, £97 13s. to Peacock) where described as 'from the Orleans Gallery';[4] possibly sale of Thomas Emmerson of Stratford Place, London, Phillips, 16 June 1832 (lot 119);[5] according to Smith sold anonymously in 1836 for 135 guineas;[6] sale of Thomas Wright of Upton Hall, Newark, Christie & Manson, 7 June 1845 (lot 41, £91 7s. to Buchanan); sale of William Buchanan of Pall Mall, London, Christie & Manson, 4 July 1846 (lot 30, £80 to Evans for Scarisbrick); sale of Charles Scarisbrick deceased of pictures removed from Scarisbrick Hall and Wrightington Hall, Lancashire, Christie, Manson & Woods, 18 May 1861 (lot 476, £45 3s. to Part); c.1877 in Thomas Part's collection at Astley Hall, Chorley, near Wigan;[7] by descent to his grandson Alexander F. Part of London SW7, by whom sold to Christopher Norris c.1936;[8] presented by Christopher Norris in 1944.

Exhibitions

Copenhagen 1992 (22); Paris 1994–5 (227); London 1995 (81); Rome 2000–1 (6); Paris 2001 (14).

Related Works
PAINTINGS[9]
(1) Lyon, private collection, 105 × 103 cm. A good copy, probably eighteenth century[10] (photograph in NG dossier);
(2) Munich, Bayerische Staatsgemäldesammlungen (fig. 1). Oil on wood, 45 × 38 cm. The attribution to Poussin is doubtful;[11]
(3) Lebrun, Rémy, Paris, 22 September 1774, lot 90.[12] Presumably a copy of NG 5472;
(4) The painting in the Louis Bauyn de Cormery (d.1701)[13] and Paul Poisson de Bourvallais (d.1718)[14] collections was probably a copy of NG 5472, given its relatively low estimated value,[15] although 500 livres is not that low.[16]

There are other possible copies.[17] The 'tableau en longueur peint sur toile... representant une "annonciation"...d'après le Poussin' recorded in the posthumous inventory of 13 June 1681 of Louis Phélypeaux de la Vrillière is more likely to have been a copy of the painting in the Musée Condé, Chantilly (inv. 303), for which the possible authorship of Charles Mellin has been recently suggested, but which was engraved in reverse by 1665 by Gérard Edelinck (and others in the seventeenth century) as after Poussin.[18] If by Poussin, which remains likely, the Chantilly painting would be c.1626–7.

The Musée des Beaux-Arts, Tours, possesses a painting on paper laid down on canvas (48 × 38 cm) by an unidentified French hand c.1800 of a head said to be analogous to that of the Virgin in NG 5472: see R. Fohr, *Tours, musée des Beaux-Arts... – Tableaux français et italiens du XVIIᵉ siècle*, Paris 1982, p. 176 (no. R6, illustrated). However, such resemblance as there is may be coincidental (photograph in NG dossier).
DRAWINGS
None of the drawings of an Annunciation recorded by Friedländer[19] has any connection with NG 5472, nor has any of them been accepted by Rosenberg and Prat as by Poussin.
PRINTS
The engravings by Pietro del Po (Andresen 95) and Paul van Somer (Andresen 96) correspond to the composition of the painting in Munich (see under Related Works).

Technical Notes
In reasonably good condition, although there is a tear some 15 cm long top right, a retouched damage top left of centre; a piece of canvas some 3 cm square has been sewn into the top left corner and there are small losses to the right of the dove's right wing and just above the angel's left hand. There is some wear in the tablet at the bottom, in the green curtain and in the background. There has been some fading in the red glazes of the Virgin's drapery. NG 5472 was last cleaned and restored in 1977. The support is a medium-fine plain-weave canvas, relined at some time before the painting was acquired by the Gallery in 1944. The ground consists of a dark brown upper layer containing charcoal as well as earth pigments, over a mid-brown layer. The stretcher appears older than the lining and is stamped twice *MADE IN FRANCE*, and a twentieth-century label on the stretcher reads *A. & G.[...]/13 Rue [...] Paris*, so NG 5472 seems at some time to have been restored in Paris. A round label on the stretcher's centre bar is inscribed *J.475*.

The X-radiograph shows that the left half of the book was painted on top of the Virgin's drapery, and that where the pages are lifting slightly the book may have had some kind of marker in it. The infra-red photograph shows that the angel's head was painted smaller than the area apparently left in reserve for it.

The bright yellow pigment of the Virgin's robe is of a type that appears to be specific to seventeenth-century Rome and consists of a compound of lead, antimony and tin.

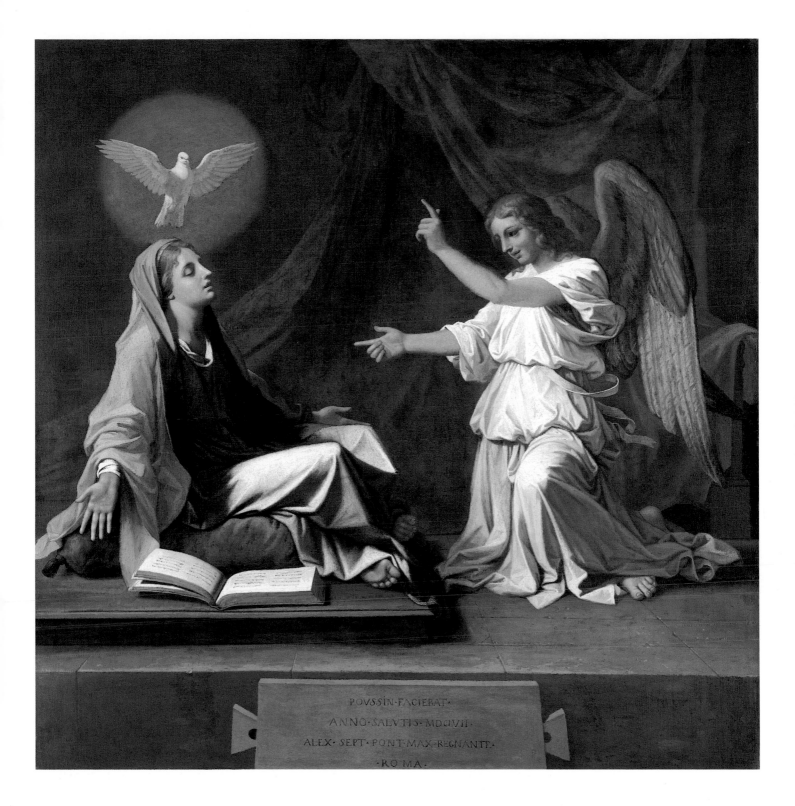

The inscription on the tablet reads:

POVSSIN·FACIEBAT·
ANNO·SALVTIS·MDCLVII·
ALEX·SEPT·PONT·MAX·REGNANTE·
·ROMA·

Fig. 1 Follower of Poussin, *The Annunciation*, after 1657. Oil on panel, 45 × 38 cm. Munich, Alte Pinakothek, Bayerische Staatsgemälde-sammlungen.

Fig. 2 Gian Lorenzo Bernini, *The Ecstasy of Saint Teresa*, 1645–52. Figures in marble, life-size. Rome, Santa Maria della Vittoria.

The episode of the Annunciation is related in Luke 1:26–38. Poussin's austere treatment – the Annunciation is shown as taking place within a sparsely furnished room – differs from traditional depictions of the subject. The conventional seventeenth-century rendering included numerous putti, celestial clouds, and the Archangel Gabriel bearing lilies, as in, for example, a painting in the Musée Condé with an old attribution to Poussin, but which has recently been tentatively attributed to Charles Mellin (d.1649).[20] Further, as Blunt pointed out, traditionally the Annunciate Virgin was shown standing, kneeling or seated in a chair or a throne. Her position in NG 5472, where she is seated cross-legged on a cushion, may represent Poussin's orientalising of the subject,[21] perhaps based, as Wilberding has suggested, on an iconographic type found in Middle Eastern manuscripts (see BN, ms. arabe 1495),[22] or Poussin may have intended a reference to the Madonna of Humility.[23] The only elements of traditional iconography, besides the simple furniture, are the book and the dove of the Holy Spirit. Gabriel's words that 'the Holy Ghost shall come upon thee and the power of the Highest shall overshadow thee' have been interpreted literally by Poussin, who shows the dove in a shadowy circle directly above Mary's head. The book as an iconographic feature dates back to Carolingian times when Mary was described as reading the Psalter when

the Angel Gabriel arrived, but Poussin's treatment of the subject as a whole shows him thinking afresh on one of the most commonly depicted episodes in Western art.

The Virgin's utterly receptive pose with hands outstretched was possibly intended to express her words when told by the Archangel Gabriel that she would give birth to Jesus: 'Behold the handmaid of the Lord: be it done to me according to thy word.'[24] Poussin has used vertical downlighting like that in Bernini's *Ecstasy of Saint Teresa* (fig. 2) in Santa Maria della Vittoria, Rome, which had been completed only a few years previously, but if Poussin was influenced at all by Bernini's work, even in reaction to it as Davies suggested,[25] he vastly simplified the draperies and the setting.

In the Annunciation, Mary's words indicate positive acceptance of God's will, not passive reception. Her words 'be it done to me' show her active participation in Christ's conception. Mary's acceptance of her destiny is therefore conscious and her closed eyes may be interpreted as a sign of total faith. By contrast, as Wittkower has pointed out, Bernini represented the supreme moment of Teresa's vision, when she was in a state of ecstasy.[26] Quite aside from the different stylistic predilections of the two artists, therefore, Teresa's rapture required a different treatment from Mary's conscious involvement.[27]

One other iconographic matter is also of interest. The Virgin was traditionally shown wearing a blue cloak and veil, the colour being symbolic of heaven, and a red dress or habit, red being symbolic of the martyrdom of Christ. Poussin has, however, painted the Virgin's cloak blue on the inside, and yellow on the outside. Such a departure from the norm was almost certainly intended to have symbolic significance. In his *Trattato dell'arte de la Pittura* (Milan 1584) Lomazzo associated the colour yellow with hope,[28] which might have been understood as appropriate to a subject associated with the birth of Christ and ultimately with the Redemption. Lomazzo further associated blue in the Virgin's costume with elevation of mind,[29] and red with sacrifice and martyrdom.[30] A different explanation for Poussin's choice of colours was provided indirectly and posthumously by Charles Le Brun in his talk to the Académie in 1671. Referring to Poussin's *Ecstasy of Saint Paul* (1650, Paris, Louvre), Le Brun associated yellow with 'purity', blue with 'committed grace' and red with 'ardent charity'.[31] Poussin may also have been aware of Marin Cureau de la Chambre's three-colour theory propounded in 1650, which proposed yellow, red and blue as the basis of all other colours,[32] in which case he might have deemed them appropriate for the Annunciate Virgin in her role as the source of Christianity. The evidence for such thinking on Poussin's part is, however, both limited and indirect.[33]

Early Provenance

For reasons explained by Mahon[34] it is unsurprising that Félibien makes no mention of NG 5472, and Bellori's omission of any reference to it may be due to the fact that he appears not to have visited Poussin's studio that year. However, it is certainly odd that the provenance for a painting of such high quality as NG 5472, and one that is so prominently signed and dated, cannot be traced back beyond 1802, when in the collection of Robert Udny's executors and said to have been 'constantly in the Pope's chapel till very lately, when it was brought to England'.[35] Udny's collection had been largely acquired through the agency of his brother John, who dealt in pictures while British Consul in Venice (1761–76) and then Livorno (1776–96), briefly visiting Florence and Rome in 1774 and in 1796–7. John Udny was sending his brother Robert pictures for the latter's collection while Consul at Livorno, but Robert himself was in both Turin and Rome in 1769–70, and again in Rome in 1775.[36] At all events, whether Robert bought NG 5472 direct or through his brother's agency, the fact that it was in his collection makes it likely that it came from Italy, and correspondingly less likely that it was the picture in the collections of Bauyn de Cormery and Poisson de Bourvallais in Paris in the early eighteenth century (see Related Works (4) and notes 13 to 16). This is also consistent with an eighteenth-century copy of the painting having been acquired in Rome in 1760 (see Related Works (1)). The small *Annunciation* in Munich (fig. 1), the quality of which does not seem worthy of Poussin, and which was probably in the collection of the Paris art dealer Antoine Benoist (1632–1717), may be evidence that the Bauyn de Cormery picture was a now lost variant of NG 5472.

The hypothesis that NG 5472 came from a papal chapel rests primarily on the statement in the 1802 catalogue of Robert Udny's collection (see above). That the pope referred to was Alexander VII Chigi is evident both from the inscription on the painting and from the use of the word 'constantly'. There is nothing to suggest that the compiler of the 1802 catalogue intended to refer to Pius VI, pope until 1799, or to his successor, Pius VII.[37] Nevertheless, none of the numerous guidebooks to Rome mentions NG 5472 in any chapel in the Papal Palace or the Quirinal Palace, or in the Palazzo Chigi or Villa Chigi. François Deseine, in the 1690 edition of his *Description de la ville de Rome*, refers to a painting or paintings by Poussin in the *salone* of the Palazzo Chigi, without, however, identifying it or them, and there is a similar reference in the 1707 edition of Posterla's guide.[38] Probably these paintings were the 'deux esquisses de Bacchanales du Poussin' which Lalande noted in the Palazzo Chigi later in the eighteenth century.[39] Nor can NG 5472 be identified from the inventories of paintings at the papal residence at Castel Gandolfo.[40] Finally, no mention of the painting has been found in eighteenth-century guidebooks to Siena, Siena being the native town of the Chigi, who continued to have a palazzo there.[41] In short the statement that NG 5472 has been 'till very lately' in the Pope's chapel cannot be verified, and that statement itself may have been, at least in part, prompted by the inscription on the painting. In addition, although Pope Alexander VII probably had an interest in Egyptology, as Wilberding has rightly noted,[42] the Middle Eastern pose of the Virgin in NG 5472 is itself a matter of speculation and so insufficient to connect the painting with him. It is, therefore, difficult to conclude that NG 5472 was painted for Alexander VII, who, indeed, never mentioned Poussin's name in his diary.[43]

An alternative hypothesis, advanced by Costello, is that NG 5472 was painted for Cassiano Dal Pozzo's tomb, because it bears the date of Cassiano's death, its composition appears suited to the painting's incorporation within an architectural setting, and its character seems appropriate for a memorial.[44] Costello supports this attractive theory with two items of external evidence. Firstly, Poussin himself wrote to his friend and patron Chantelou on 24 December 1657: 'Nostre bon ami Mr. le Chevallier du Puis est décédé et nous trauaillons à sa sépulture' ('Our good friend, Cavaliere Dal Pozzo has died and we are working on his sepulchre').[45] Secondly, Dal Pozzo was buried in the Roman church of Santa Maria sopra Minerva. This was the principal church of the Dominican Order and the representation of the Virgin as the Madonna of Humility (see above) was associated with the Dominicans.[46] Indeed, Santa Maria sopra Minerva was dedicated to the mystery of the Annunciation and one of its chapels belonged to the Confraternity of the Annunciation.[47] Nevertheless, no trace of a tomb for Cassiano has been found, although there seems to have been a Dal Pozzo family sepulchre in the church,[48] in which it seems likely that Cassiano was buried, after being provisionally interred in the tomb of the Confraternity of the Most Holy Rosary in the same church.[49] The Dal Pozzo family tomb was located in front of the high altar, and was marked, in the case of members of the family later

buried there, by inscribed stones. As Wilberding has pointed out, a painting could not have been part of it, and Poussin's reference to his working on Cassiano's tomb may have meant that he was working in tandem with a sculptor on an inscribed stone to be set before the high altar.[50] In short, neither a Chigi nor a Dal Pozzo provenance is convincing, and for the time being the matter cannot be resolved.[51]

General References

Graham 1820, New Testament no. 2; Smith 1837, no. 45; Magne 1914, 181; Bertin-Mourot 1948, 7; Davies 1946, p. 77; Davies 1957, pp. 176–7; Blunt 1966, 39; Badt 1969, 228; Thuillier 1974, 203; Wild 1980, 1962, 192; Wright 1985a, 188; Wright 1985b, pp. 134–5; Mérot 1990, 52; Thuillier 1994, 228.

NOTES

1. *Catalogue of the Entire Collection of Pictures belonging to Robert Udny, Esq. deceased*, London 1802, no. 63: 'The Annunciation of the Virgin; two whole figures, small life; by Nicolo Poussin. This is a truly sublime and capital work of this great master, and upon which he has bestowed the greatest attention. It had been constantly in the Pope's chapel till very lately, when it was brought to England. 3ft.6in. by 3ft.5in.' The painting was said to hang at the side of the gallery opposite the chimney in Udny's Teddington house.

2. See *Index of Paintings Sold*, vol. I, p. 575. Described in the 1804 catalogue as: 'The Annunciation of the Virgin, a truly capital work of this great master, it had been constantly in the Pope's chapel till very lately, when it was brought to England.' Annotated 33 – that is, 3ft by 3ft – in the copy in the Metropolitan Museum, New York. As Davies pointed out (1957, p. 176), if NG 5472 had indeed only recently been brought to England, it cannot have been the picture in the Thomas Bladen sale, London, 10 March 1775 (lot 84).

3. Described in the catalogue as formerly in the Pope's Chapel and as later in the Udney (sic) collection. Redford (*Art Sales*, 2 vols, London 1888, vol. 2, p. 280) recorded the purchaser's name as De Blyny. This may be correct: see *Index of Paintings Sold*, vol. 1, p. 50, where it is also noted that other identified vendors at this sale were Woodburn and John Parke.

4. Further described in the 1829 catalogue as 'an elegant Composition of two Figures. Beneath, on a tablet, is inscribed, "Poussin faciebat, Anno Salutis MDCLVII. Alex. Sept. Pont. Max. Romae".' In spite of the discrepancy between the inscription here recorded and that on the painting, the description seems conclusive proof that the painting owned by Raikes in 1821 and sold by him in 1829 was NG 5472 – unless it was a now lost copy. The manuscript annotation '120 15 –' in the 1821 catalogue was presumably a reserve price, which was reduced to 60 guineas for the 1829 sale.

NG 5472 corresponds to no painting recorded in the 1727, 1737 or 1786 descriptions of the pictures in the Orléans Gallery, nor to any shown in the exhibition of the Orléans collection in London in the 1790s. The only painting described as being an *Annunciation* in the Orléans collection was a Lanfranco (item 247 of the 1798 catalogue).

5. Where described as 'The ANNUNCIATION; grandly composed and finely executed'.

6. Smith 1837, no. 45.

7. Letter of 22 February 1946 from A.F. Part in the NG dossier.

8. Copy letter of 20 February 1946 from Martin Davies in the NG dossier.

9. The painting in the Hunterian Museum and Art Gallery, Glasgow, of an *Annunciation* attributed to Poussin in Sir Robert Strange's sale (Christie's, 8 February 1771, lot 88) has too little in common with NG 5472 to be regarded as a related work, *pace* P. Rosenberg in Paris 1994–5, p. 496. It is eighteenth century in date and has been recognised as not by Poussin since 1813: letter of 6 December 1996 from Martin Hopkinson.

10. Bought in Rome in 1760 by Commandant Bourin, according to Gilles Chomer, who has seen it and who kindly wrote to me concerning the painting's history (letter of 30 January 1997).

11. See Paris 1994–5, no. 216, where exhibited as by Poussin, but I share Sir Denis Mahon's doubts (expressed in conversation), and those of Hugh Brigstocke, 'Variantes, copies et imitations', *Poussin Colloque 1994*, vol. 1, pp. 201–28 at p. 214. Mahon has suggested that the Munich painting is a pastiche (probably by Pietro del Po, who was a painter as well as an engraver) based on a preliminary drawing by Poussin: letter of 25 July 1999 to Marc Fumaroli (photocopy in NG dossier).

12. Noted in Wildenstein 1955 at p. 141. Described in the sale catalogue as: 'NICOLAS POUSSIN / 90 L'Annonciation de la Vierge, tableau d'un dessein correct & d'un bon ton de couleur, sur toile de deux pieds 9 pouces de haut, sur 3 pieds 2 pieds de large. On y lit: Nicolas Poussin, anno salutis M. DC. LVII.'

13. Daniel Wildenstein, *Inventaires après décès d'artistes et de collectionneurs français du XVIIIᵉ siècle*, Paris 1967, pp. 7–8: 'No. 431 – Item un autre tableau sur toile avec sa bordure dorée de deux pieds et demy de hault et trois pieds et demy de large ou environ, figure carrée représentant une Annonciation de la Vierge, composé de deux figures, le Saint Esprit sur la teste de la Vierge, l'ange à jenoux devant la Vierge habillé de blanc, peint par POUSSIN, prisé...500 1.' Louis Bauyn de Cormery was Trésorier de France at Montauban and later a Fermier Général: A. Schnapper, *Curieux du Grand Siècle*, Paris 1994, p. 410. His inventory was taken at his house in the Place des Victoires, Paris, and his sale took place over the period 5 April–9 September 1701: Rambaud 1964–71, vol. 1, pp. 519–20.

14. Brice, describing Poisson's former house, wrote: 'On y a vu pendant quelque temps des tableaux de conséquence, achetez à inventaire de Cormery, Fermier général; entre autres un grand tableau sur bois de *Paul Rubens* qui représente la Madeleine aux pies de Notre Seigneur, de la première beauté de ce grand Maître; un autre de *Paul Veronese*, & une Annonciation de Nicolas Poussin qui ont coûté au moins la somme de dix huit mille livres.' *Description de la ville de Paris et de tout qu'elle contient de plus remarquable*, 5th edn, 2 vols, Paris 1701, vol. 1, p. 226, quoted in Thuillier 1994, p. 214. As Schnapper 1994 (p. 413) points out the painting does not appear in Poisson's posthumous inventory.

15. As Rosenberg suggested: Paris 1994–5, p. 496.

16. As Emmanuel Coquery has pointed out, the fact that a painting was given a low valuation should not automatically exclude it from being considered as an original as opposed to a copy: 'Les Oeuvres de Poussin dans les collections des peintres français sous Louis XIV', *Poussin Colloque 1994*, pp. 837–64 at p. 839. From this point of view it

is interesting to compare some valuations in the Bauyn de Cormery inventory made in 1701 and published by Wildenstein 1967, cited in note 13, and prices achieved on sale the same year as published by Rambaud (also cited in note 13). In each case the sale price is in square brackets:

Nativity by Romanelli – 100 l. [431 l.]

Annunciation by the same – 100 l. [330 l.]

Diana with one of her Nymphs by Rubens – 150 l. [272 l.]

This suggests a market value for the Poussin *Annunciation* in the Bauyn de Cormery collection in excess of 1000 *livres*.

17. Jacob Spon recorded a painting of an Annunciation by Poussin in the collection of Jean de la Fourcade of Lyon (d.1693) in 1673: Bonnaffé 1884, p. 151; and Schnapper 1994, p. 233. It is insufficiently described to include as being a copy of NG 5472, although Thuillier seems to suggest that it later entered the Bourvallais collection (on which see Related Works and note 14): Thuillier 1994, p. 214, n. 95. This objection applies also to the painting in the Thomas Bladen sale, 10 March 1775 (lot 84), on which see also note 2, to that recorded in the posthumous inventory of 7 May 1709 of Henri-Jules de Bourbon, prince de Condé (Rambaud 1965, I, pp. 527, 595, 676), and to that in the anonymous sale in Paris of 25 June 1779, lot 89, noted in Chantilly 1994–5, p. 71. The picture of an Annunciation, said to be by Poussin and the principal altarpiece of the convent of the Annonciades Célestes, rue de la clôture-Sainte Catherine, Paris (J.A. Dulaure, *Nouvelle description des curiosités de Paris*, Paris 1785, p. 38, and 1791, part 1, p. 54), seems to have been by Etienne de Lavallé-Poussin (1735–1802): P. and M-L. Biver, *Abbayes, monastères, couvents de femmes à Paris des origines à la fin du XVIIIᵉ siècle*, Paris 1975, p. 134.

18. For the painting in the La Vrillière collection, see Sabine Cotté, 'Inventaire après décès de Louis Phélypeaux de La Vrillière', *AAF*, 27, 1985, pp. 89–100 at p. 95. For the *Annunciation* at Chantilly and Edelink's engraving, see Chantilly 1994–5, no. 7. The attribution to Mellin is open to doubt.

19. W. Friedländer, *The Drawings of Nicolas Poussin*, London 1939, p. 18.

20. Inv. no.303. See note 18.

21. A. Blunt, 'The Annunciation by Nicolas Poussin', *Bulletin de la Société Poussin*, premier cahier, June 1947, pp. 18–25 at pp. 20–1, pp. 20–2, and see J. Costello in 'Poussin's Annunciation in London', *Essays in honour of Walter Friedländer*, New York 1965, pp. 16–22, who has proposed that Poussin's representation of the Virgin was intended 'to partake of the identities of Minerva and Isis, who with her share in the manifestation of Divine Wisdom' (p. 21). On the iconography of the book and the dove in scenes of the Annunciation, see Schiller 1971–2, vol. I, pp. 42ff.

22. E. Wilberding, *History and Prophecy: Selected Problems in the Religious Paintings of Nicolas Poussin*' PhD dissertation, New York

University 1997, pp. 378ff., and *idem*, 'L'Annonciation de 1657,' *Poussin Colloque 1994*, vol. I, pp. 179–200, at pp. 188–9. Wilberding points out that there was a vogue for collecting Middle Eastern manuscripts at the time. Subsequent references in these notes to Wilberding are to his 1997 thesis, the relevant chapter of which is a slightly modified version of his article in *Poussin Colloque 1994*.

23. Schiller 1971–2, pp. 47–8. The suggestion that this was Poussin's purpose was made by J. Costello, cited in note 21, pp. 16–22, in support of her proposal that NG 5472 was intended for the Dominican church of Santa Maria sopra Minerva. The cult of the Madonna of Humility was fostered mainly, but not exclusively, by the Dominican order: Millard Meiss, 'The Madonna of Humility', *AB*, 18, 1936, pp. 435–64 at pp. 451–2.

24. Luke 1: 26–38.

25. Davies 1957, p. 176

26. Rudolf Wittkower, *Bernini*, Oxford 1981, p. 216.

27. Blunt 1947, cited in note 21, pp. 18–24 at p. 22, noted both the apparent simplicity of Poussin's treatment of the subject, and the distinction between Saint Teresa's swoon in Bernini's sculpture and the Virgin's 'intense expression of a conscious state of mind'.

28. Lomazzo 1584, p. 207. Wilberding (cited in note 22, p. 385) has noted that a papal decree of 1629 required Roman Jews (men and women) to wear a yellow headdress, and has suggested that Poussin's use of yellow in NG 5472 was meant to signify a Middle Eastern Annunciation.

29. Lomazzo 1584, p. 208.

30. Ibid., pp. 205–6.

31. See *Les Conférences de l'Académie royale de peinture et de sculpture au XVIIe siècle*, ed. A. Mérot, Paris 1996, pp. 196–8.

32. Martin Kemp, *The Science of Art*, New Haven and London 1990, p. 281. Marin Cureau de la Chambre (1594–1669), médecin ordinaire du roi, was chosen by Richelieu in 1635 as a member of the Académie Française, and one of the first members of the Académie des Sciences on its foundation in 1666.

33. In his lecture of 3 December 1667 to the Académie about Poussin's *Christ healing the Blind* (Paris, Louvre) Sébastien Bourdon noted the pigments used by Poussin for Christ's robe and cloak (respectively yellow and white, and red and blue), concluding: 'Ainsi ces habits étant de couleurs très lumineuses et toutes célestes, ils conviennent parfaitement à celui qui les porte, comme le plus digne et le principal objet de tout le tableau': see H. Jouin, *Conférences de l'Académie Royale de peinture et de sculpture*, Paris 1883, pp. 73–4.

34. Namely that a hiatus occurred in Félibien's sources of information from early 1657, see Mahon 1995, pp. 176–82 at p. 177.

35. See note 1.

36. Brigstocke 1982a, p. 476. Patrizio Turi, 'Un disegno settecentesco del "Ratto di Dina" di Fra Bartolomeo', *Memorie Domenicane*, NS 25, 1994, at pp. 271–5, mentions (p. 274, n. 68) that in 1787 Robert Udny was an expert witness in a dispute regarding the authenticity of a Poussin *Vierge aux Enfants*. And see Ingamells 1997, pp. 961–4.

37. Although Pius VI was a supporter of the arts: Jules Gendry, *Pie VI. Sa Vie–Son Pontificat (1717–1799)*, 2 vols, Paris n.d., pp. 136–8. For Pius VII, see *New Catholic Encyclopaedia*, vol. XI, Washington 1969, pp. 400ff.

38. François Deseine, *Description de la ville de Rome en faveur des étrangers*, 4 vols, Lyon 1690, vol. 2, pp. 151–2; Francesco Posterla, *Roma sacra e moderna*, Rome 1707, p. 386.

39. Joseph Jerôme Le Français de Lalande, *Voyage d'un François en Italie fait dans les années 1765 & 1766*, 8 vols, Yverdon 1769–70, vol. 3, p. 496.

40. Letter of 27 November 1993 from Erich Wilberding to Pierre Rosenberg (copy in NG dossier). Blunt had supposed that NG 5472 had been destined for Castel Gandolfo, Alexander VII's favourite residence (Blunt 1947, cited in note 21, at p. 18).

41. The Chigi family owned property elsewhere in Italy, for example in Ariccia and Viterbo, which I have not researched for evidence of the provenance of NG 5472. However, Francesco Petrucci, Conservatore of the Palazzo Chigi, Ariccia, has kindly advised me that he is not aware of any reference to NG 5472 ever having been in Ariccia (letter of 1 March 2000).

42. Wilberding 1997, cited in note 22, pp. 382–4.

43. R. Krautheimer and R.B.S. Jones, 'The Diary of Alexander VII: Notes on Art, Artists and Buildings', *Römisches Jahrbuch für Kunstgeschichte*, vol. 15, 1975, pp. 199–233.

44. Costello, cited in note 21.

45. Ch. Jouanny, 'Correspondence de Nicolas Poussin', *AAF*, 1911, pp. 444–6.

46. Costello (cited in note 21, p.18) points out that the association continued into the seventeenth century, since a Dominican church in Rome called Santa Maria dell' Humilità was completed in 1603. Cassiano's funeral took place on 22 October 1657: see Sparti 1992, p. 35.

47. Le P. Nicolas de Braliou, *Les Curiositez de l'une et de l'autre Rome*, 2 vols, Paris 1655, vol. 1, part 2, pp. 113–16.

48. Sparti 1992, p. 35, n. 2, citing the request of Cosimo Antonio dal Pozzo in his will of 1728 to be buried 'nella Chiesa di Santa Maria sopra Minerva nella Sepoltura della famiglia dal Pozzo fatto da i miei antenati...'

49. Wilberding 1997, p. 370.

50. Wilberding 1997, pp. 371–2.

51. Marc Fumaroli has suggested that NG 5472 was painted as a memorial to Cassiano dal Pozzo for a private chapel of Pope Alexander VII: Paris 2001, pp. 104–5.

NG 5597
The Adoration of the Golden Calf

1633–4
Oil on canvas, 153.4 × 211.8 cm

Provenance

Painted, together with its pendant *The Crossing of the Red Sea* (Melbourne, National Gallery of New South Wales), with which it remained until 1945, for Amedeo dal Pozzo (1579–1644);[1] recorded in his running inventory of possessions at the Palazzo Dal Pozzo della Cisterna, Turin, of 1634–44[2] and in his posthumous inventory of 1644;[3] recorded at the same location in inventories of 1668 and 1676;[4] apparently sold for 3000 ducats by Giacomo Maurizio dal Pozzo to an un-named painter acting on behalf of Louis XIV, presumably around 1680 since by October 1684 it was in the collection of Philippe, the Chevalier de Lorraine (1644–1702), in Paris;[5] bought *c.*1686–8 by the jeweller Pierre Le Tessier de Montarsy (1647–1710) and sold by him at this time with its pendant for 14,000 livres to the marquis de Seignelay (1651–90);[6] acquired before 1698[7] by Jean Neyret de la Ravoye, Trésorier Général de la Marine (d.1701), in whose posthumous inventory of August 1701 it is recorded on the ground floor of his Paris hôtel in the rue de La Perle and valued at 3000 livres;[8] recorded in 1712 in the posthumous inventory of Jean-Baptiste Le Ragois de Bretonvilliers, Seigneur de Saint Dié, Conseiller du Roi and Lieutenant Général du Gouvernement de Paris (d.1712), at the hôtel de Bretonvilliers, Ile St-Louis, where NG 5597 and its pendant were valued at 3500 livres each;[9] possibly inherited and sold by Benigne Le Ragois, marquis de Bretonvilliers (1690–1760), the nephew of Jean-Baptiste, and Lieutenant Général du Gouvernement de Paris;[10] bought in Paris in 1741 with its pendant by the dealer Samuel Paris for Sir Jacob de Bouverie (1694?–1761) of Longford Castle, near Salisbury (later the 1st Viscount Folkestone, whose son became the Earl of Radnor in 1765), for £481 5s. plus commission;[11] possibly temporarily removed to London for restoration(?) *c.*1744,[12] but seen in the gallery at Longford Castle in 1776;[13] by descent to the 7th Earl of Radnor (1895–1968);[14] bought from him by the National Gallery in 1945 out of the Florence Fund with a contribution from the NACF.

Exhibitions

London 1873, RA, *Exhibition of the Works of the Old Masters* (155); London 1903, RA, *Exhibition of the Works of the Old Masters* (63); London 1932, RA, *Exhibition of French Art 1200–1900* (143) (no. 123 of the *Commemorative Catalogue* of the same exhibition); London 1945–6, NG, *Exhibition in Honour of Sir Robert Witt, C.B.E., D.LITT, E.S.A. of the principal acquisitions made for the Nation through the National Art Collections Fund* (18); Paris 1960, Louvre, *Nicolas Poussin* (38).

Related Works

PAINTINGS

The question of copies of NG 5597 is complicated by the fact that at least two other treatments of this subject by, or once

attributed to, Poussin are known. One is the treatment known both through the engraving of J.B. de Poilly and through the painting in the M.H. De Young Memorial Museum, San Francisco, the authenticity of which is questionable and which is regarded by some as a pastiche;[15] another is the painting recorded by Félibien as having been painted for a Neapolitan patron, damaged in 1647, a fragment of which was recorded by Blunt in an English private collection.[16] The posthumous inventory of Etienne Gantrel (d.1706) recorded 'une autre copie du *Veau d'or*, moyenne' valued at 60 livres, which may have been a copy after Poussin.[17] A lost painting recorded in the van Biesum sale, Rotterdam, 1719, may, according to Rosenberg, have been the treatment of the theme providing the basis for the San Francisco work.[18]

The following are copies of NG 5597:
(1) Karlsruhe, Staatliche Kunsthalle, no. 1931, 99 × 133 cm;[19]
(2) Private collection, England, recorded in 1948. Probably a nineteenth-century copy, to judge from the photograph in the NG dossier;
(3) In reverse, a small oil sketch (11½ × 15½ in.) sold Christie's, 14 January 1972 (lot 101, 80 guineas). Photograph in NG dossier;
(4) Ader Picard Tajan, Paris, 30 June 1989 (lot 196), 56.5 × 71 cm (illustrated);
(5) Moscow, Pushkin Museum, 114 × 167 cm; according to Réau, a copy dating to the beginning of the eighteenth century;[20]
(6) A copy said to be by Charles Lebrun was in the Robert Strange sale, Christie's, 5 March 1773, lot 109;[21]
(7) A variant treatment in a private collection, London, recorded in 1970;[22]
(8) A painting of NG 5597 by Pierre de Sève (1623–95) for the Gobelins tapestry works was made sometime between 1684 and 1691,[23] probably towards the beginning of this period when NG 5597 was owned by Philippe de Lorraine (see Provenance and note 5).

The following may be copies of NG 5597:
(1) Lot 101 of the Dufresne sale, Amsterdam, 1770, the recorded size of which was 41 × 68 pouces (i.e. 111 × 184 cm);
(2) Item 64 recorded in the posthumous inventory of J.-B. Maximilien Titon on 12 August 1768;[24]
(3) The painting of the *Adoration of the Golden Calf* offered for sale by Aureliano Albano, chief secretary of Prince Carlo Emanuele of Savoy, to another of the prince's secretaries in a letter of 17 December 1862 in which Aureliano claimed his painting to be by Poussin and to have been made for 'il cardinale Del (sic) Pozzo';[25]
(4) Lancret sale, Paris, Rémy, 5 April 1782, lot 332 included an 'Adoration du Veau d'or... genre de Poussin', 154 × 122 cm ('4 pieds 9 pouces de haut, sur 3 pieds 9 pouces de large'). Since this lot included a pendant of similar size of 'Les Israëlites après le passage de la mer rouge', it seems reasonable to suppose that the version of the first painting broadly corresponded, albeit in vertical format, to NG 5597. The sale comprised pictures belonging to Madame Lancret and others belonging to 'M**'. It is unclear to whom lot 332 belonged;

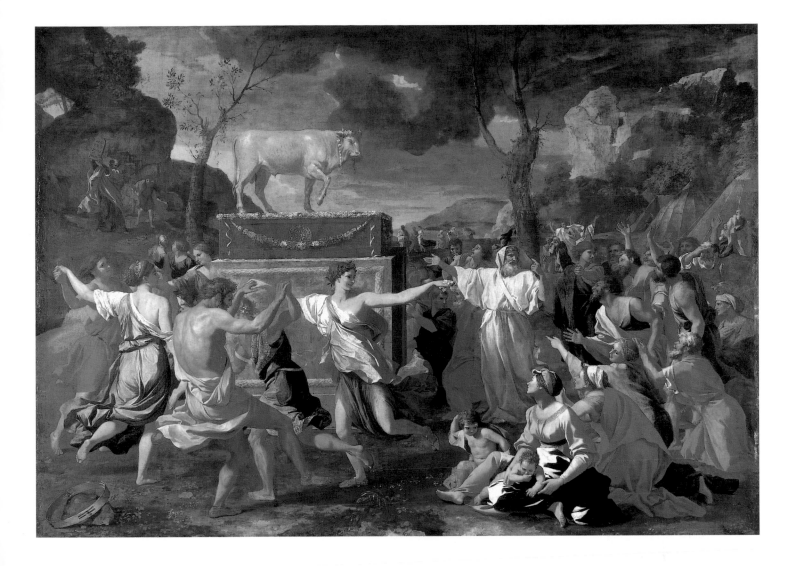

Fig. 1 X-ray detail.

Fig. 2 Detail of frame.

(5) Dezallier d'Argenville included among works by Poussin then in Rome 'le passage de la mer rouge, l'adoration du veau d'or' and among those by him in France in one of various unnamed collections 'le veau d'or';[26]

(6) A painting of the *Golden Calf* purporting to be by Poussin was exhibited at the Académie Royale de Toulouse in 1783.[27]

A painting of Moses and Aaron holding the Tablets of the Law in which the figure of Aaron is based on that in NG 5597 is in the parish church of Harwich, Essex. It was acquired from William Paris in 1700.[28]

DRAWINGS

There is a study for a figure like the dancer at the centre of NG 5597 in a Brussels private collection (R.-P. 312v). It is on the verso of a sheet which includes a study for a *Crossing of the Red Sea*, not the picture in Melbourne but one projected in 1647 and not completed.[29] No original drawings preparatory for NG 5597 are known, but presumed copies of preparatory drawings for it exist: R.-P. R672, R906 and R1088; R.-P. R1105 is a copy of R.-P. R906; R.-P. R81 is a drawing of the whole composition with variants and is also possibly a copy of a compositional drawing by Poussin. All of these drawings include a dancing figure facing three-quarters towards the viewer ducking under the upraised arms of two other dancers, a motif not used by Poussin in the final composition. There is nothing in any of these drawings to link them either to the painting in San Francisco or to the fragment once in an English private collection, and the motif of the dance, so central to NG 5597, appears in them all. Nevertheless, their status is too uncertain to suggest more than that a straightforward reversal of the dancing figure in *A Bacchanalian Revel* (NG 62; see pp. 288–95) was not Poussin's initial choice. A highly finished drawing (48.5 × 64.5 cm, medium unknown) recorded in a Bolognese private collection in 1978 is after the painting and is not by Poussin.[30]

For other drawings in eighteenth-century sales which may be connected with NG 5597, see R.-P,. vol. 2, pp. 1154, 1161 and 1163.

PRINTS

(1) By Etienne Baudet (1638–1711) (Andresen 68; Wildenstein 22) drawn by P. Monier. This print records the Chevalier de Lorraine's ownership of NG 5597 in Paris, but states its size as 4ft 10in. × 5ft 8in. As Davies and Blunt pointed out, this last measurement is certainly a slip for 6ft 8in. With the measurement so revised it would correspond both with the proportions of Baudet's print and with the size of NG 5597.[31] Baudet presented an impression of his print to the Académie on 27 May 1684;[32]

(2) anon., published by J.F. Cars (d.1771) (Andresen 69);

(3) anon., published by J. Audran (1667–1756) (Andresen 70);

(4) anon., published by E. Gantrel (1646–1706) (Andresen 71), possibly an earlier state of Andresen 69;[33]

(5) by E. Gantrel and finished by L. de Surugue (1686–1762) (Andresen 72);

(6) in reverse, anonymous in a Dutch Bible (Andresen 73);

(7) in reverse, C.P.J. Normand (1765–1840) or possibly by his son, L.J. Normand. Plate XXIV of C.P. Landon's *Vie et Oeuvre Complète de Nicolas Poussin*, Paris 1813.

TAPESTRY

(i) Gobelins *c.*1700,[34] and (ii) Aubusson (?), eighteenth century, in reverse.[35]

Technical Notes

NG 5597, which shows some wear throughout – but little in the important parts of the picture – and a small amount of blanching, was repaired and retouched in 1978 following serious malicious damage.[36] The most serious areas of paint loss were near the top of the bull's head, the upper part of the face of the man in a tunic to the right of Aaron, and above and to the left of the woman at the extreme right. During the 1978 restoration the relining canvas, which had been applied at some date before the painting's acquisition by the Gallery, was removed. There are also small losses at the extreme top right, along the right edge, other small scattered losses, and some diagonal losses just above and to the left of the head of the woman kneeling at the extreme centre right.

The canvas is a medium plain-weave. The ground is a single layer of a grey-ochre colour. Its composition – calcium carbonate, silica, a little iron oxide pigment, but virtually no lead white – is identical to that of the Gallery's *Finding of Moses* (NG 6519) painted more than fifteen years later. The greyer parts of the sky consist of smalt mixed with white over a greyish-brown underlayer; the bluer parts contain ultramarine. The foliage greens are based on lead-tin yellow combined with green earth and yellow-brown ochre. In the draperies the blue is ultramarine and white for the lights, with ultramarine glaze over a black underlayer for the darks; the bright yellow is lead-tin yellow, and the more orange tones contain lead-tin yellow with vermilion and fine red earth (Venetian red); the orange-brown is Venetian red with lead white; the bright reds are vermilion with Venetian red; and the green is green earth with lead-tin yellow, other earth pigments and white. The pigments in the flesh are vermilion with white, a copper green, yellow earth and black, and, in the browner flesh areas, Venetian red with white over a brown underlayer. Generally the flesh paints are multi-layered. Media analysis by gas chromatography has shown the use of linseed oil.[37]

There are pentimenti visible to the naked eye to the left of Aaron's drapery and to the outline of the jowl of the golden 'calf'. The X-radiograph shows that the position of the thumb of the woman pointing at the right was adjusted downwards, and that the infant lying across its mother's knees in the foreground may have been holding an object of some kind (fig. 1).

The magnificent frame (fig. 2), probably the finest in the Gallery's collection, is early eighteenth-century French and is the same pattern as that on the painting's pendant now in Melbourne.[38] Possibly both frames were commissioned by Jean-Baptiste Le Ragois de Bretonvilliers, who once owned the London and Melbourne paintings (see under Provenance), soon after his older brother's death in 1709. It was at this time that he undertook a major redecoration of his Paris hôtel.[39]

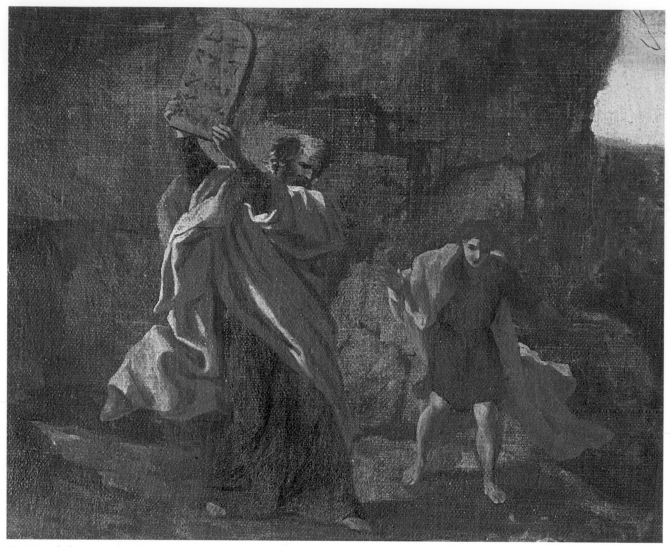

Fig. 3 Detail of Moses and Joshua.

The subject is from Exodus. Chapter 24 tells that Moses ascended Mount Sinai to receive the Law from the Lord, leaving the children of Israel in the charge of Aaron and Hur. Chapter 32 relates that when the people thought that Moses would not return they asked Aaron to make them other gods. Aaron made a golden calf from the people's earrings and set it upon an altar before which the Israelites made offerings. When Moses returned and saw the calf, and the people dancing, in his anger he broke the stone tablets on which the Lord had written his Commandments.

Moses is shown in the left background about to break one of the tablets (fig. 3). He is accompanied by Joshua. Aaron is shown centre right in white gesturing towards the golden 'calf', which in NG 5597 is evidently a bull. It seems likely, as Dempsey has suggested, that Poussin intended the bull to represent Apis, the bull-god of Memphis, so showing the Israelites returning to Egyptian ritual, and that NG 5597 may be seen as an example of Poussin's syncretising approach to pagan and Christian (sic) myth.[40] Philo of Alexandria, a French translation of whose works by Pierre Bellier was published in

Paris in 1612, relates both that the Israelites returned to the practices of the Egyptians and that they forged a god in the shape of a bull.[41]

The position of Moses and Joshua in relation to the picture as a whole, and the figures in the foreground and middle ground to the right of Aaron, appear to derive from the depiction of the same episode by Raphael and his studio in the Vatican Loggie (fig. 4),[42] and, as in the Vatican fresco, Poussin's Moses looks towards Joshua, his successor. However, as Bätschmann has pointed out, the idea for the overall composition was taken by Poussin from one of the illustrations in Gabriele Simeoni's *Figure de la Biblia illustrate de stanze Tuscane* published in Lyon in 1564 (fig. 5),[43] a source which he seems to have used only rarely.[44] In both this and NG 5597 there is a group of clothed dancers at the left, a group of kneeling figures at the right and tents in the right background. There are differences, however: Poussin has his figures dance around the Golden Calf rather than to one side, and has replaced the column supporting the idol in Simeoni's illustration with a plinth; and unlike Simeoni, who shows Aaron as a passive

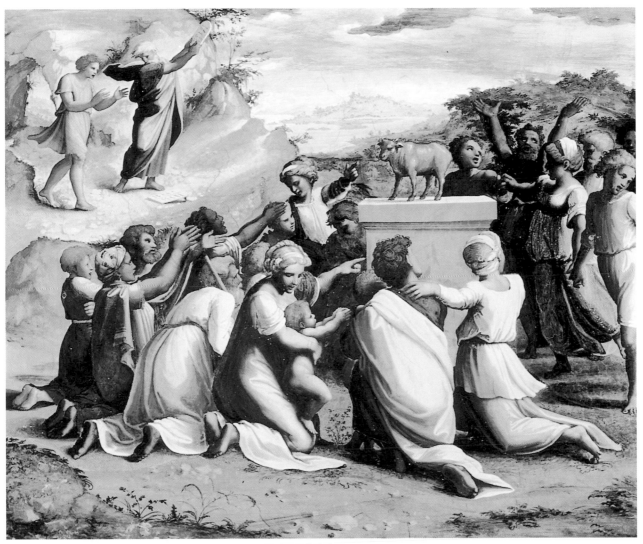

Fig. 4 Studio of Raphael, *Adoration of the Golden Calf*, 1518–19. Fresco. Rome, Vatican Loggie.

spectator in the background, Poussin has made Aaron more prominent and, with the altar, the pivot around which the dancers rotate and the Israelites worship, so underlining the High Priest's responsibility in the affair.[45] The inclusion of dancing figures as a motif, besides following the Simeoni engraving, is consistent with the Bible, since it was when Moses saw both the calf and the dancing that he broke the tablets of stone (Exodus 32:19). Poussin does not, however, show the Israelites naked as is related in Exodus 32:25. Poussin's group of dancing figures, as has often been noted,[46] is a reversal of that in NG 62.[47]

It has been assumed – on the basis of common provenance, size, chromatic values and related subject matter – that NG 5597 is a pair with the Melbourne *Crossing of the Red Sea* (fig. 6), although their compositions are not such as to class them as left/right pendants. As has recently become evident, however, Pietro da Cortona's *Gathering of the Manna* (fig. 7) and Giovanni Francesco Romanelli's *Construction of the Tabernacle* (fig. 8) were both recorded in Amedeo dal Pozzo's running inventory of 1634–44 as being of the same size as the

Fig. 5 *Adoration of the Golden Calf*, engraving from Gabriele Simeoni, *Figure de la Biblia illustrate de stanze Tuscane*, Lyon 1564. London, British Library.

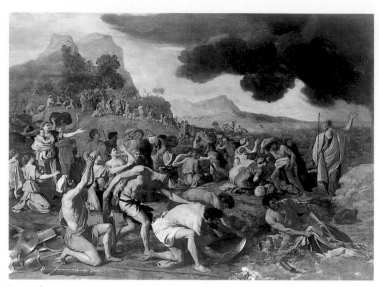

Fig. 6 *The Crossing of the Red Sea*, *c*.1633–4. Oil on canvas, 155.6 × 215.3 cm. Melbourne, National Gallery of Victoria. Felton Bequest, 1948.

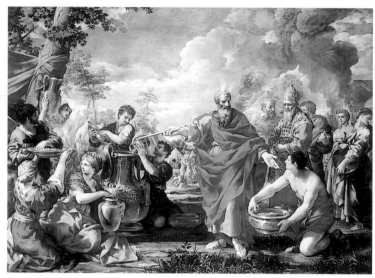

Fig. 7 Pietro da Cortona, *The Gathering of the Manna*, *c*.1635. Oil on canvas, 148 × 205 cm. Turin, Palazzo della Provincia.

Fig. 8 Giovanni Francesco Romanelli, *The Construction of the Tabernacle*, *c*.1635. Oil on canvas, 148 × 205 cm. Turin, Palazzo della Provincia.

two paintings by Poussin, and both have likely dates of 1635, suggesting that the four pictures were acquired by Amedeo for the Palazzo Dal Pozzo della Cisterna as a cycle of Mosaic subjects.[48] Although this may be the case, the figures in the Cortona and the Romanelli paintings are, broadly speaking, closer to the picture plane and hence larger than those in the two Poussins. Furthermore, whereas both the Cortona and Romanelli share a common theme – the making of offerings to the Lord – the Poussin paintings, the themes of which are respectively salvation and idolatry, do not. This suggests that Poussin was not particularly constrained in his choice of subjects, or in his manner of treating them.

Conceptually, NG 5597 and the Melbourne picture belong to a group of paintings of Old Testament subjects datable to between 1631 and 1638, such as *The Plague at Ashdod* (Paris, Louvre), *The Triumph of David* (London, Dulwich Picture Gallery) and the *Destruction of the Temple at Jerusalem* (Vienna, Kunsthistoriches Museum), in which Poussin showed a dramatic scene rather than a single dramatic moment. Both NG 5597 and its pair were generally regarded as dating to *c*.1635–7.[49] Then, in 1985, an article publishing an Amedeo dal Pozzo inventory supposedly of 1634, which included NG 5597, apparently provided a final date for the work.[50] However, it was subsequently established that the inventory in question was a running inventory which started in 1634 and continued for a decade,[51] so that the dating of NG 5597 had to derive from comparison with other datable works, in particular a group of coppery-toned works of which one, *The Saving of the Infant Pyrrhus* (Paris, Louvre), is now known to have entered the collection of Gian Maria Roscioli (1604–44) by September 1634.[52] Consequently, a date of *c*.1634 seemed reasonable for both the London and the Melbourne paintings, which were referred to consecutively in Amedeo dal Pozzo's running inventory, and so presumably were completed within months of each other.[53] Recently, however, new documents have emerged which suggest that this date should be advanced. Firstly, it is now clear that by August 1631 Amedeo was writing to his cousin – Poussin's patron Cassiano – with a view to acquiring major paintings for his palazzo, albeit not necessarily the Mosaic cycle of which NG 5597 was part.[54] Secondly, it now seems very likely that in July 1632 Poussin received via Cassiano dal Pozzo a relatively modest payment of 50 *ducatone* on account of his two paintings for Amedeo.[55] This payment was most likely made when the London and Melbourne paintings were commissioned. Bearing in mind their size and complexity, they were probably not finished until well into 1633 at the earliest, and work on them may have continued into 1634. In any case they seem likely to have been completed before *The Saving of the Infant Pyrrhus*, which was delivered in the autumn of 1634, but after the Dresden *Adoration of the Magi*, which bears the date 1633 but does not have the same intense coppery colouring as NG 5597.[56] The date of 1633–4 for NG 5597 would be consistent with a drawing at Windsor by G.B. Castiglione (RL 4054; fig. 9) which has long been recognised as in part derived from it.[57] Castiglione is not recorded as having visited Turin so he must have seen NG 5597 in Rome. Castiglione

was in Rome by 1632 but had left for Naples by the end of March 1635, probably not returning before 1636.[58] A date between 1633 and 1634[59] for NG 5597 would also be consistent with the date of *c*.1634 suggested for preliminary drawings in the Louvre related to *The Crossing of the Red Sea*,[60] albeit that the proposed dating of the Louvre drawing was itself in part influenced by the mistaken belief that the Dal Pozzo inventory referred to above was dated 1634, rather than a running inventory of 1634–44.

General References

Graham 1820, Old Testament no. 22; Smith 1837, 33; Grautoff 1914, 88; Magne 1914, 124, 125;[61] Davies 1956, pp. 177–9; Blunt 1966, 26; Thuillier 1974, 83; Wild 1980, 64; Wright 1985a, 86; Wright 1985b, p. 135; Mérot 1990, 21; Thuillier 1994, 100 (where wrongly stated to be the pendant to *The Saving of the Infant Pyrrhus* in the Louvre).

Fig. 9 Giovanni Benedetto Castiglione, *Worship of the Golden Calf*, *c*.1634–5. Red-brown oil paint on paper, 39.4 × 55.3 cm. Windsor, Royal Library, The Royal Collection.

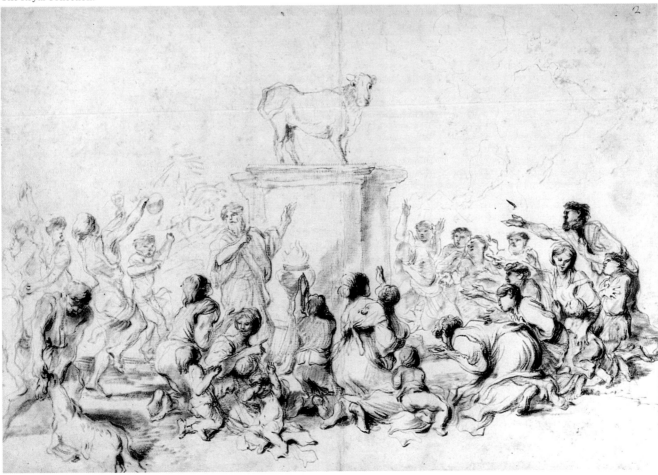

NG 5763
Landscape with a Man killed by a Snake

1648?
Oil on canvas, 118.2 × 197.8 cm

Provenance
Painted for the Parisian merchant Jean Pointel[1] (d.1660), perhaps by 31 August 1648;[2] recorded in his posthumous inventory of 20–22 December 1660 with an estimated value of 1000 livres;[3] sold by his executors[4] and bought by [Nicolas?] du Plessis-Rambouillet (c.1576–1664) for 1800 livres;[5] by October 1684 in the collection of Denis Moreau (c.1630–1707),[6] who in 1689 became premier valet de chambre to the duke of Burgundy; thence, presumably by descent, to Moreau's nephew, François-Louis de Nyert, marquis de Gambais, seigneur de Neuville (d.1719);[7] then to his son Louis de Nyert (d.1736), among whose posts was governorship of the Louvre and whose posthumous inventory of 2 May 1736 records NG 5763 in his apartment there;[8] then presumably to Louis's son, Alexandre-Denis Nyert (d.1744), and by descent in the family;[9] bought from the family (but not at the de Nyert sale, Paris, 30 March 1772) by the engraver and dealer Robert Strange;[10] Robert Strange sale, Christie's, 5–6 March 1773 (lot 113, £650 to Sir Watkin Williams-Wynn, 4th baronet of Wynnstay, near Wrexham, and 20 St James's Square, London);[11] presumably the painting recorded in 1885 in the Green Drawing Room, Wynnstay, as 'Large Oil Painting in Gilt Frame Landscape with figures by Poussin';[12] by descent to Sir H.L. Watkin Williams-Wynn, 8th baronet at Wynnstay (where seen by E.K. Waterhouse in 1939),[13] from whom purchased (through Horace Buttery) in 1947 for £6500.

Exhibitions
London(?)1816, BI (60) ('Landscape with Figures. N. Poussin. Sir W.W. Wynn, Bart.');[14] London(?)1847 (2) ('*The Story of Phocion* Sir W.W. Wynn, Bt., M.P.');[15] London(?)1867, BI (18) (described as in the 1847 catalogue); Cardiff 1960, National Museum of Wales (54); Paris 1960, Louvre (83); Bologna 1962, Palazzo dell'Archiginnasio (74); London 1978, NG, *The Artist's Eye: Richard Hamilton* (8); Paris 1994–5, Grand Palais (179); London 1995, RA (69); Los Angeles 2000, J. Paul Getty Museum (pl. 65).

Related Works
PAINTINGS[16]
(1) Dijon, Musée Magnin (no. 806),[17] 100 × 173 cm, in which the drapery of the dead man is red and the seated woman wears a pale red dress under her blue tunic. A good quality copy, probably late seventeenth century. Photograph in NG dossier;[18]
(2) Recorded in 1949 with John Hutton, Glasgow, 48 × 76 in., and said by E.K. Waterhouse to be a contemporary copy;[19]
(3) According to Blunt,[20] a small copy, possibly after the engraving by Baudet (see below) and attributed to Richard Wilson, with Mrs Pascal, London;
(4) Dufourny sale, Delaroche, Paris, 22 November 1819 and

days following, lot 88 (22 × 30 in.), where claimed as that painted for Pointel;
(5) A copy recorded in Lord Northwick's collection in 1846[21] in the drawing room at Thirlestane House, Cheltenham, but not in his posthumous sale of 1859, nor in *A Catalogue of the Pictures, Works of Art, &c. At Northwick Park*, 1864;
(6) Sotheby's, 2 March 1977 (lot 105) as 'N. Poussin', 122 × 193 cm. A copy;
(7) Christie's, 5 December 1989 (lot 76, sold for £3300 including premium) as 'Circle of Joseph Goupy' and described as bodycolour with touches of gum arabic on vellum, 46 × 60.3 cm;
(8) New York, Sotheby's (Arcade), 17 January 1990 (lot 122), as after Nicolas Poussin, 17½ × 21¼ in.

A painting in the Dal Pozzo collection, once thought to be a copy of NG 5763, is now identified with Poussin's *Man pursued by a Snake* (Montreal, Museum of Fine Arts).[22] A painting, *Homme au serpent*, was proposed as a purchase to the Louvre by Ozou in 1850, and another, *L'effet de la terreur*, by Hunes in 1865.[23]

DRAWINGS (by Poussin)
(1) R.-P. 335 (Dijon, Musée des Beaux-Arts; inv. no. CA.872; fig. 5) is related to NG 5763, although considered by Rosenberg and Prat to be more probably connected with Poussin's *Landscape: a Calm* (Malibu, Getty Museum of Art);[24]
(2) R.-P. 334 (Paris, Louvre, Département des Arts Graphiques, inv. no. 32481). More probably connected with the Getty Museum painting than with NG 5763;
(3) R.-P. 351 (stolen in 1971–2, but formerly in the University Library, Uppsala). This drawing of a group of five trees may be connected with NG 5763 and/or *Landscape with the Ashes of Phocion* (Liverpool);
(4) R.-P. 348 (Düsseldorf, Kunstmuseum, Kupferstichkabinett; inv. no. FP 4699). Shearman noted that the whole of the composition on the Düsseldorf recto, with the exception of the blazing castle and motifs to the left of it, is 'closely related in reverse to the Dijon drawing…for the Snake landscape…and appears to precede it…';[25]
(5) A drawing of a landscape in the Musée Bonnat, Bayonne (inv. no. A1 1673; NI 48. R.-P. 213 verso) has, as Rosenberg and Prat say, no connection with NG 5763. It has been suggested that it is connected with NG 6390, which it cannot be since the recto is several years later than that painting.
OTHER DRAWINGS
(1) Some studies, not by Poussin, in the Louvre, Département des Arts Graphiques (R.-P. R856), have been connected with NG 5763;
(2) A sketchy copy in watercolour and pen by J.M.W. Turner, c.1798–9, London, British Museum, Dolbadern sketchbook, XLVI, p. 114a;[26]
(3) An anonymous variant drawn copy, Paris, Louvre, Département des Arts Graphiques.
PRINTS
(1) By Etienne Baudet (1638–1711), one of four landscapes by Poussin engraved by Baudet, dedicated to Louis XIV and dated 1701 (Wildenstein 180). The engraving (fig. 1) bears an explanatory text: 'Divers effets d'Horreur et de craintes sont

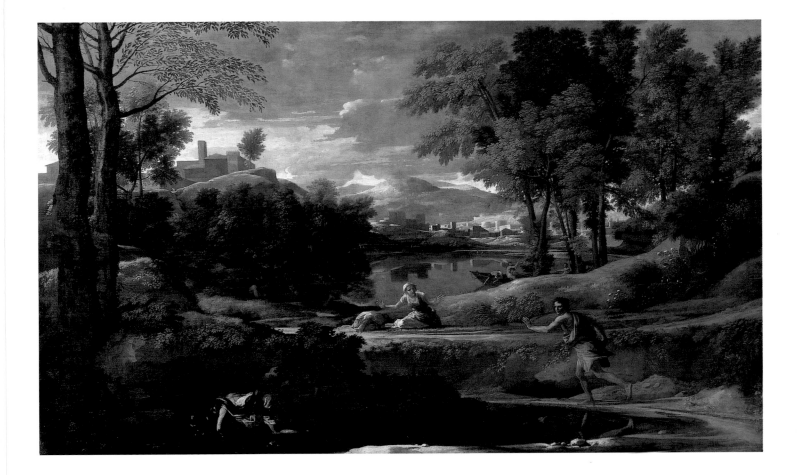

DIIS MANIBVS
SACRVM
HERBASIAE
CLYMENES
SEX HERBASIVS
NAVTILVS SIBI ET
CONIVGI SVAE
SANCTISSIMAE FECIT

IN.FR.P.XVIII. IN AGR: P. XVII.

Fig. 2 Jean-Jacques Boissard, detail of *Funerary Urn of Herbasia Clymenes*, engraving from *Romanae urbis topographiae et antiquitatum*, Frankfurt 1597–1602. London, British Library.

into those in which there is placed some subject from history or myth, and others showing 'some extraordinary actions which satisfy one's intelligence and entertain one's eye'.[45] It is clear from the context that for Félibien NG 5763 fell into the latter category and that it was about the depiction, facial and bodily, of horror and fear,[46] for which a snake had provided Poussin's figures a similar agent for the expression of emotions some years earlier in the *Man pursued by a Snake* (Montreal, Museum of Fine Arts; see p. 345, fig. 3). At the time Félibien was writing, the expression of the passions was a key concern within the Académie de Peinture, whose doctrinal position he shared.[47] Given Félibien's overarching project, to present Poussin as an exemplar in this respect, a reference to the Terracina incident would have been irrelevant, if not undermining.

It is in a similar context that the fictional dialogue between Leonardo da Vinci and Poussin written by Fénelon may be understood.[48] 'Is it a story?' Leonardo asks about NG 5763. 'I don't know it. Rather it's a caprice.' 'It is a caprice,' Poussin confirms, in the course of an explanation of the painting as a depiction of the different degrees of fear and surprise, and as being about figures in the background who go about their business in a peaceful landscape oblivious of, and in contrast to, the horror in the foreground.[49] There is nothing inherently inconsistent between the functions of the painting as perceived by Félibien and Fénelon (and by implication Poussin

and Pointel) and knowledge of the Terracina incident, if it occurred, providing Poussin with a starting point for it.[50] On the contrary, such a tragedy would have served to increase the relevance of Poussin's choice of incident. It is possible, as has been suggested, that Poussin may also, or alternatively, have had in mind a passage from Homer's *Iliad* (III: 33ff.): 'As a man who has come upon a snake in the mountain valley steps back, and the shivers come over his body, and he draws back and away, cheeks filled with a green pallor...'[51] A visual source for the artist may have been relief sculptures on two antique funerary urns in the Barberini collection, which were the subject of engravings by, among others, Boissard in *Romanae urbis topographiae* (fig. 2).[52]

NG 5763 was probably also intended to remind the viewer of the whims of fortune, a theme in which Poussin expressed an interest in a letter written to Chantelou in June 1648.[53] The theme of the snake in the grass as representative of the omnipresence of death in the midst of peaceable nature was a common one in antique texts likely to have been familiar to Poussin, and one which he had explored in other works,[54] and it would have been an especially appropriate manifestation of a trick of fortune in a landscape setting. Indeed, there is a passage in Apuleius' *Metamorphoses*, which appears shortly after that cited by Gault de Saint-Germain (see above), that seems peculiarly appropriate to NG 5763: '"Aristomenes" [Socrates] answered, "you just do not know the slippery windings and shifting attacks and alternating reversals of Fortune".'[55] If Poussin had the passage in mind, then the snake alludes to 'slippery windings'; the 'shifting attacks' and 'alternating reversals' are perhaps expressed by the respective attitudes of the figures, and their zig-zag placement within the landscape, as well as by the alternating areas of light and dark.[56] The possibility that Poussin intended to show a trick of fortune is suggested both by the figures faintly visible to the left of the woman (fig. 3) who are playing the guessing game *morra*, then popular in Italy,[57] and by the association frequently made between the word 'caprice' (in Poussin's 'comment' to Leonardo in Fénelon's *Dialogues*: 'It's a caprice') and the word 'hasard'.[58]

Thus, although NG 5763 shows no specific incident from mythology, the subject may have been inspired by an account of a contemporary tragedy and/or by the literary topos of the snake in the grass. Further, the painting may well have been intended to show a trick of fortune in a particular guise. Assuming this to be so, one may ask to what extent such a reading would be affected by the pendant to NG 5763, if indeed it had one? According to Félibien '[Poussin] executed two large landscapes for the same Pointel: in one of them there is a dead man encircled by a snake, and another frightened man fleeing'.[59] Félibien does not say that the two landscapes were intended to be a pair, but it would not be unreasonable to assume that that is what he meant.[60] Nor does he describe the second landscape, although at another point in the *Entretiens* he contrasts NG 5763 with the *Landscape with Three Monks* now in Belgrade, which for that reason has been proposed as having been NG 5763's pendant.[61] However, the discovery that the Louvre's *Landscape with Orpheus and Eurydice* (fig. 4), which is close in size to NG 5763,[62] was in Pointel's collection[63]

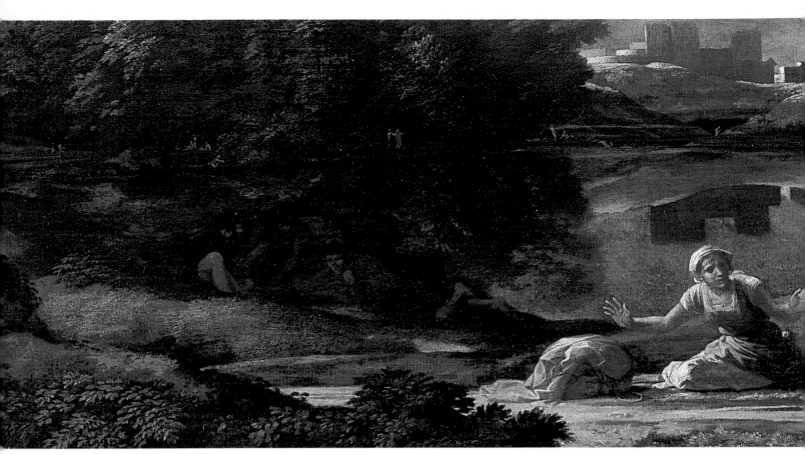

Fig. 3 Detail of NG 5763.

appears to support the suggestion, first made by Wild, that this was the pendant to the London picture.[64] As Rosenberg has pointed out, the likely dates of NG 5763 and the *Orpheus* are close; the one follows the other in the Pointel inventory; they share a number of motifs (the attitudes of the fleeing man and of Eurydice, the still waters of the lakes with their reflections, the incidental figures in or around the water, not to mention the snake); and they share a common theme, namely sudden death in an idyllic landscape.[65] Rosenberg concluded, however, that they were variations on a theme rather than pendants strictly speaking,[66] and that caution seems justified by a difference in the heights of the two paintings as recorded in the Pointel inventory, that of the *Orpheus* being some 16 cm greater than that of NG 5763.[67] The sizes of the two paintings as shown in Baudet's engravings of 1701 appear extremely close, but this evidence cannot be trusted because the *Orpheus* had been reduced to its present height by 1685,[68] suggesting that Baudet had manipulated their format so that the suite of four engraved landscapes of which they were a part accorded in size. Furthermore, in none of Poussin's other known pairings of landscapes did the artist mix a subject based on an identifiable literary source (the *Orpheus*) with one that was not (NG 5763). It nevertheless remains a possibility that, even if Poussin did not conceive the two paintings as a pair, Pointel decided to pair them by reason of the motifs and theme that they shared.[69]

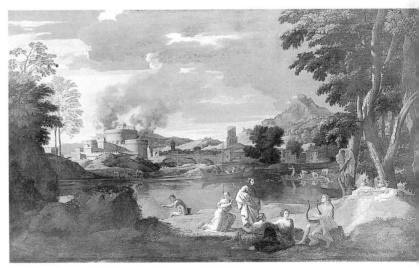

Fig. 4 *Landscape with Orpheus and Eurydice*, 1648? Oil on canvas, 124 × 200 cm. Paris, Musée du Louvre.

As Deperthes noted, both paintings heighten the viewer's interest by locating violence in a tranquil setting.[70] However, whereas in the *Orpheus* there is a contrast between Eurydice's horror and Orpheus' blissful lack of awareness, both of which occur in the foreground, in NG 5763, as has often been stated, there is a gradation in the responses of the figures – from horror (the fleeing man) to fear (the woman) to mild curiosity

Fig. 5 *Landscape with a Man carrying a Net and a Staff, c.*1648. Pen and brown ink, grey and brown wash and black chalk, 26.3 × 39 cm. Dijon, Musée des Beaux-Arts.

(the man in the boat), as they recede in zig-zag fashion away from the source of concern into the landscape.[71] These gradations of response are functions not just of distance but of what is revealed and hidden by the landscape, so that if the *Orpheus* is about nature *in* landscape, NG 5763 is also about the nature *of* landscape.[72]

On the assumption that the drawings in Dijon (fig. 5), Paris and Bayonne (see Drawings above) were preparatory to NG 5763, Shearman proposed that the subject of the picture was of minor importance and no more than accessory to an already determined landscape.[73] Although the Bayonne and Paris drawings may not have had any connections with NG 5763, it is true that the fleeing man and the woman were painted over a pre-existing landscape (see Technical Notes). This is not, however, true of the man killed by the snake. Consequently, it seems more likely that Poussin left the other figures to the end, not because the subject was undecided, but because their precise location or attitude had yet to be determined.[74] Were it the case, however, that Poussin decided on the subject at the last minute, it would support the view that there was no predetermined programme to pair NG 5763 and the *Orpheus*. As one would expect from Poussin, the positions and attitudes of the fleeing man and the kneeling woman have been carefully considered: a line drawn from the fleeing man's left hand to the morra-players through the woman's right hand intersects, at the centre of her body, with a line drawn from the dead man's head to the boatmen through the woman's left hand. The kneeling woman therefore serves both a compositional purpose (uniting left and right, foreground and background) and a narrative purpose (indicating oppositions between work and play, the active and the passive, life and death).[75]

It has generally been assumed that NG 5763 was painted in 1648 on the basis of the statement in the catalogue of the 1773 Strange sale that 'Mr. Demaso has in his custody a series of letters wrote by the hand of Poussin to several of his friends, and amongst others is one to the above Pointel, dated from Rome the last of August 1648, and wherein he gives him advice of his having finished the above picture...' The letter is lost. Since it is not known exactly what it said, or even that it mentioned a snake, it may have been referring to some other landscape painted for Pointel, of which there were several. Félibien was in Rome in the years 1647–9, and might have been expected to have been aware of this large and unusual painting. However, after a passage about a painting executed in 1651, he says that NG 5763 was painted 'dans le même temps'. As Blunt pointed out, Félibien's formulation is not as precise as 'in the same year', but in the continued absence of the Demaso letter, the possibility that NG 5763 was painted shortly after Félibien left Rome cannot be excluded.[76]

The composition of NG 5763 was well known in France through copies and engravings and figured in early nineteenth-century writings on landscape painting by J.B. Deperthes and Pierre Henri de Valenciennes.[77] Turner seems to have made a copy of the painting around 1798–9 when he was in Wales.[78] The subject of NG 5763, if not the composition, found an echo in paintings of the same period by Valenciennes, Girodet-Trianon and Michallon.[79]

General References
Gault de Saint-Germain 1806, 21; Smith 1837, 308; Grautoff 1914, vol. II, p. 259; Friedländer 1914, p. 122; Bertin-Mourot 1948, XXXVI; Davies 1957, pp. 179–82; Blunt 1966, 209; Thuillier 1974, 159; Wild 1980, 140; Wright 1985a, 155; Wright 1985b, p. 135; Mérot 1990, 236; Thuillier 1994, 178.

NOTES

1. Félibien, *Entretiens 1685*, part 4, p. 303, and *Entretiens 1685–88*, vol. 2, pp. 358–9.

2. According to a letter (whereabouts unknown) from Poussin to Pointel dated 31 August 1648 and cited in the catalogue of Robert Strange's sale of 1773 (lot 113), but Félibien, *op. cit.*, places NG 5763 in 1651. See discussion on p. 328.

3. Thuillier and Mignot 1978, pp. 39–58. The paintings in the Pointel collection, which at the time of his death seem to have been piled up in a small room in Pointel's lodgings in the place du Chevalier-du-Guet, were valued by Philippe de Champaigne.

4. Thuillier and Mignot 1978, p. 44, n. 8.

5. Loménie de Brienne, *Discours sur les ouvrages des plus excellens peintres anciens et nouveaux avec un traité de la peinture composé et imaginé par M^{re} L. H. de L. C. de B. Reclus, c.*1695 (MS, Paris, Bibliothèque Nationale, anc. Saint-Germain 16986), reproduced in Thuillier 1994, pp. 201–5. The identity of the purchaser as du Plessis-Rambouillet is given by Félibien, cited in note 1. In neither case is his Christian name given, but E. Bonnaffé (Bonnaffé 1884, p. 95) says it was Nicolas, father-in-law of Gédéon Tallemant, for whom La Hyre painted the *Seven Liberal Arts* (see NG 6329). Nicolas du Plessis Rambouillet was part of a powerful family of Protestant bankers: Schnapper 1994, p. 237.

6. According to Félibien, cited in note 1, p. 303, whose life of Poussin was contained in the *Huitième Entretien*. For Denis Moreau, see Davies 1957, p. 181, n. 22, and Schnapper 1994, pp. 393–4. NG 5763 may have been seen in Moreau's apartments at Versailles on 22 March, 1702 by Elizabeth Charlotte, Duchess of Orléans: her letter of 23 March 1702, quoted by Thomas Bodkin, *BM*, 46, 1925, p. 322.

7. Davies 1957, pp. 180–2.

8. 'Paysage, avec des figures dont une entourée par un serpent, original de Poussin, b.b.d. 6 pieds et demi de large sur 4 pieds et demi de haut. 800 l.[ivres]'. Rambaud 1964–71, vol. I, pp. 583–6 and 707–8.

9. See note 11 to entry NG 6519.

10. The catalogue of Robert Strange's sale of 5–6 March 1773 states that 'Since the death of Moreau this picture has been in the collection of Monsieur des Niert first valet de chambre to the king, from whose family it was lately purchased.'

11. For Sir Watkin Williams-Wynn, 4th baronet (1749–89), see E.K. Waterhouse, 'Nicolas Poussin's *Landscape with the Snake*', *BM*, 74, 1939, p. 103; F.J.B. Watson, 'A New Poussin for the National Gallery', *BM*, 91, 1949, pp. 14–18; Brinsley Ford, 'Sir Watkin Williams-Wynn. A Welsh Maecenas', *Apollo*, 99, 1974, pp. 435–9, who mentions (p. 439) how the price Williams-Wynn paid for NG 5763 astonished Horace Walpole and Fanny Burney; and Oliver Fairclough, 'Sir Watkin Williams-Wynn and Robert Adam: commissions for silver 1768–80', *BM*, 137, 1995, pp. 376–86.
The price of £650 is confirmed in the Account Book of 1773 and Box 115/24/5 of the Wynnstay Manuscripts at the National Museum of Wales. Poussin is not mentioned in an inventory of Wynnstay taken in February 1790 (Wynnstay Misc.16 – 1952 Deposit), so NG 5763 was probably then at 20 St James's Square. I am grateful to Paul Joyner for this information. Nor is the painting mentioned in J.P. Neale's description of Wynnstay in Neale 1824–9, vol. 5 (1829). The 5th baronet (1772–1840) was a subscriber to the British Institution and 'appears to be also an amateur of an institution of a very different kind, his b.c. [bay colt?] by Meteor, having lately run at the Staffordshire races': Joshua Wilson, *A Biographical Index to the present House of Commons, ... corrected to February, 1808*, London [1808], p. 176.

12. Schedules of heirlooms at Wynnstay, Llangedwin Hall and 20 St. James's Square, London, pursuant to the will of Sir W W Wynn, Bart, deceased, 1885, (3 vols) Denbighshire Records Office, no. DD/WY/7950.

13. E.K. Waterhouse, cited in note 11. For a description of Wynnstay, see The Rev. J. Evans [Britton's], *The Beauties of England and Wales*, vol. XVII, London 1812, pp. 578ff. Evans's account makes no mention of NG 5763.
The painting was included in a list of pictures at Wynnstay dated 18 October 1946, where valued at £2500, and in another list of '1947–8' as in 'J' bedroom, first floor,

Wynnstay: Denbighshire Record Office, DD/WY/7964 and 7972. I am grateful to S.E. Owens for this information and for that in the preceding note.

14. The anonymous author, possibly Robert Smirke, of a *Catalogue Raisonné of the Pictures now exhibiting in Pall Mall, Part Second*, London 1816, wrote of the Poussin landscape exhibited by Sir W.W. Wynn: 'AND this you call a Poussin, Sir Watkin? Believe us (Sir Watkin) from our own direct knowledge, and without any malice, but merely to speak of this thing as of our own making, it is a most notable liar – "the owner of no one good quality worthy of your Worship's entertainment"' (p. 14). This would have been a curious comment to have made about a painting as well known (through engravings) as NG 5763, but as Paul Joyner has pointed out, Sir Watkin owned several Poussins including, besides NG 5763, a 'Large historical landscape' and a companion: Paul Joyner, *A Place for Poussin*, PhD thesis, Cambridge University 1989, p. 153, and letter of 21 July 1998. Consequently, it cannot be assumed that the picture exhibited at the British Institution in 1816 or subsequently was NG 5763.

15. Called a 'very ugly picture' in a ms. note by Harriet Gunn, daughter of Dawson Turner, in the British Library copy of the catalogue (7856.e.24). The mark '2' on the back of the stretcher (see Technical Notes) makes it likely that NG 5763 was the picture exhibited in 1847 in spite of its curious description in the catalogue, and hence in 1867 also.

16. The version of NG 5763 noted by Davies (1957, p. 180) as recorded in the Dal Pozzo collection in Rome in the early eighteenth century is probably the compositionally unrelated picture now in the Museum of Fine Arts, Montreal, called *Man pursued by a Snake*.

17. [Jeanne Magnin], *Musée Magnin, Peintures et dessins de l'École française*, Dijon 1938, no. 806, where published as by Nicolas Poussin.

18. In his article, cited in note 11, Waterhouse wrote of the Dijon picture: 'Its condition still makes it inscrutable, but it is undoubtedly of very good quality, and I confess that, when I have seen it, I have always held it to be au fond an original.' Although the Dijon picture was regarded as the original by Jamot (*Connaissance de Poussin*, Paris 1948, p. 68) and has been said by Wright to be only 'slightly inferior' to NG 5763 (Wright 1985a, 155), it is the London picture which is now universally accepted as that painted for Pointel. Wright also admired the Dijon picture in 'L'Opera Completa di Poussin di J.Thuillier', *Antologia di Belle Arti*, 1, 1977, p. 117.

19. Letter of 3 May 1949.

20. Blunt 1966, p. 143.

21. 'Visits to private galleries, no. XV. The collection of the Rt. Hon. Lord Northwick, Thirlestane House, Cheltenham', *The Art Union*, 8, 1846, pp. 251–6, at p. 253, where described as 'N. Poussin. Large landscape, called the "Echo". This picture is well known by the figure of a dead man entwined by a

serpent lying near a pond in the front, and various figures in the middle distance expressing alarm. It is a capital work, and has been frequently engraved. It was painted in 1650, for M. Pointel, and has been subsequently in the collections of Duplessis, Rambouillet, and others.'

22. Brejon de Lavergnée 1973, pp. 79–96 at p. 88; and Standring 1988, pp. 608–26, at pp. 621–2. And see note 16.

23. Wildenstein 1955, no. 180.

24. The compositional correspondences are much closer between this drawing and NG 5763 than between it and the Getty Museum painting. The argument that the drawing better evokes the latter because 'la scène est toute paisible' misses part of the point of NG 5763. The connection between this drawing and NG 5763 was not questioned by J.F. Méjanès in *Dessins français du XVIe siècle dans les collections publiques françaises*, exh. cat., Louvre, Paris 1993, no. 43.

25. In Friedländer and Blunt 1963, vol. IV, p. 50. Dated by Rosenberg and Prat to 1649–50 and connected by them to *Landscape with Orpheus and Eurydice* (Paris, Louvre) and *Landscape with Pyramus and Thisbe* (Frankfurt, Städelsches Kunstinstitut).

26. See Ziff 1963, pp. 315–21, where illustrated (fig. 43). Ziff notes that in 1798 and 1799 Turner was in the vicinity of Wynnstay, the family seat of the owner of NG 5763. For Constable's admiration of the painting, see Leslie 1937, p. 382.

27. Wildenstein 1955, no. 180 (and Andresen, no. 442). The text may be translated as: 'Various effects of Horror and Fear are here expressed. A dead youth lies close to a spring, his whole body surrounded by a snake of enormous size. This frightening sight causes to flee another man whose perturbed look and hair standing on end on his brow scare a woman further away seated at the side of the path. And her cries cause some fishermen yet further away to look round... It is said that Poussin painted this picture on the occurrence of a similar incident which happened during his day in the area of Rome.'

28. P.M. Gault de Saint-Germain, *Vie de Nicolas Poussin, considéré comme chef de l'école françoise*, Paris 1806, p. 34. The anonymous author writing in 1846 in *Magasin pittoresque*, and cited by Rosenberg 1995 (p. 406) as the originator of the suggestion, was clearly repeating that of Gault de Saint-Germain.
The passage cited by Gault de Saint-Germain was: 'Diceres dei medici baculo, quod ramulis semiam putatis nodosum gerit, serpentem generosum lubricis amplexibus inhaerere.' The translation of part of that passage in the text is that of J. Arthur Hanson in the Loeb edition of Apuleius, *Metamorphoses*, 1989.

29. Trans. by J. Arthur Hanson, cited in note 28.

30. For this interpretation of NG 5763 made by A.S.F. Gow, see F.J.B. Watson, cited in note 11, p. 17, n. 17, and Davies 1957, p. 180,

n. 8. Blunt also rejected this and other mythological interpretations: Blunt 1967, p. 286.

31. 'Le Véritable Sujet du Paysage au Serpent de Poussin à la National Gallery de Londres', *GBA*, 40, 1952, pp. 343–50.

32. See translation by F.J. Miller in the Loeb edition.

33. L. Glózer, 'Archemoros oder der Tod des Opheltes. Zu Poussins *Landschaft mit der Schlange*', *Kunstgeschichtliche Studien für Kurt Bauch*, Munich and Berlin 1967, pp. 211–22.

34. Apollodorus, *Bibliotheca*, I, 9, 14 and III, 6, 4.

35. Pausanius, *Description of Greece*, Book II, XV, 3.

36. Bull 1993, pp. 48–9.

37. Bull 1998, pp. 724–38 at p. 729, here substituting his earlier suggestion that the figure in NG 5763 (and the Montreal *Landscape*) was directly inspired by Aepytus (p. 729, n. 40). The translation cited by Bull is that by Claude Boitet de Frauville, *Les Dionysiaques; ou Les metamorphoses, les voyages, les amours, et, les advantures et les conquestes de Bacchus aux Indes*, Paris 1625. The relevant passage in *Les Dionysiaques* at p. 410 reads: 'Tyle Citoyen de Moerne passoit par le fleuve de Migdo, aux montagnes voisines d'Herme. Il voulut attaquer un dragon, dont la rencontre luy fut fatale, car il se jetta dessus luy, et l'estouffa de son venim, luy entourant le col de sa queuë en couronne, Tyle tomba mort, semblable à un arbre insensible. Une Naiade qui se rencontra à ce malheur poursuivit cet animal pour le recognoistre, deplorant son destin. Ce serpent estoit accoustumé à tuer les passans et les bergers, et Tyle n'estoit pas le premier.' However, the woman in NG 5763 is not a naiad and, more significantly, what she witnesses is not the attack by the snake, which a rise in the ground prevents her from seeing, but the fleeing man.

38. See Prints (1) for the French text of the inscription, and note 27 for a translation of it.

39. Blunt 1967, p. 287. According to Blunt 1966, p. 144, following Davies 1957, p. 180, n. 5, 'The Demaso in question is almost certainly a member of the Lyons Family of Demaso or Demasso, one of whom was the mother of Jacques Stella.' See also Blunt 1974, pp. 745–51.

40. Blunt 1967, pp. 287–90. Blunt again proposed a possible journey by Poussin and Pointel south of Rome in 'A newly discovered Will of Nicolas Poussin', *BM*, 124, 1982, pp. 703–4.

41. See Blunt 1967, pp. 287–8, and Cropper and Dempsey 1996, p. 343, n. 15.

42. For a brief account of the ancient city, see E.T. Salmon, 'Tarracina' (sic), *The Oxford Classical Dictionary*, ed. N.G.L. Hammond and H.H. Scullard, Oxford 1970, p. 1039. The English traveller John Raymond, who visited Fondi, makes no mention of snakes, instead remarking that 'the territoire about is very fruitfull of Orange trees, so much that wee went into an orchard, and for twenty Citrons

& about thirty oranges, we gave the Owner a Julio, (that comes to an English sixpence) which very well contented him...' (*An Itinerary Contayning a Voyage Made through Italy In the yeare 1646, and 1647*, London 1648, pp. 127–8).

43. Félibien was in Rome from 1647 to 1649 and claimed to have struck up a close friendship there with Poussin: Félibien, *Entretiens 1685–88*, vol. 1, preface (n.p.).

44. 'On y voit un homme, qui voulant s'approcher d'une fontaine, demeure tout effrayé en appercevant un corps mort environné d'un serpent: Et plus loin une femme assise & toute épouventée, voyant avec quelle frayeur cet homme s'enfuit. On découvre dans le contenance de l'homme, & sur les traits de son visage non seulement l'horreur qu'il a de voir ce corps mort estendu sur le bord de la fontaine, mais aussi la crainte qui l'a saisi à la rencontre de cét affreux serpent dont il appréhende un traitement semblable.' Félibien, *Entretiens 1666–79*, vol. III (1679), p. 215. The same passage with minor alterations may be found in Félibien, *Entretiens 1685*, part 4, p. 398, and *Entretiens 1685–88*, vol. 2, p. 21.

45. Félibien, *Entretiens 1685*, part 4, p. 397, and *Entretiens 1685–88*, vol. 2, p. 432 ('...quelques actions extraordinaires qui satisfont l'esprit, & divertissent les yeux').

46. He describes NG 5763 as follows: 'La situation du lieu en est merveilleuse, mais il y a sur le devant des figures qui expriment l'horreur et la crainte. Ce corps mort, & étendu au bord d'une fontaine , & entouré d'un serpent; cét homme qui fuit avec la frayeur sur le visage; cette femme assise, & étonnée de le voir courir & si épouvanté, sont des passions que peu d'autres Peintres ont sceû figurer aussi dignement que luy. On voit cét homme court veritablement, tant l'équilibre de son corps est bien disposé pour representer une personne qui fuit de toute sa force; & cependant il semble qu'il ne court pas aussi viste qu'il voudroit. Ce n'est point, comme disoit il y a quelque temps un de nos amis, de la seule grimace qu'il s'enfuit; ses jambes & tout son corps marquent du mouvement.' (Félibien, *Entretiens 1685*, part 4, p. 398, and *Entretiens 1685–88*, vol. 2, pp. 432–3.)

47. Félibien's role is best approached through Claire Pace's *Félibien's Life of Poussin*, London 1981. On the expression of the passions, see Jennifer Montagu, *The Expression of the Passions: The Origins and Influence of Charles Le Brun's Conférence sur l'expression générale et particulière*, New Haven and London 1994.

48. Fénelon probably wrote the dialogue in the 1690s when NG 5763 was owned by Moreau, see Davies 1957, p. 181, n. 22.

49. The *Dialogues sur la peinture* by François de Salignac de La Mothe-Fénelon (1651–1715), Archbishop of Cambrai, were published posthumously, bound with de Monville's *La Vie de Pierre Mignard*, Amsterdam 1731. The translated passage appears at p. 190: ([Leonardo] 'Est-ce une histoire? Je ne la connois pas. C'est plûtot un caprice'./ [Poussin] 'C'est un caprice'. Diderot also noted with admiration how Poussin had

thrust horror and fear into the surrounds of a pleasing landscape. Diderot, *Salons*, ed. J. Seznec and J. Adhémar, vol. III (1767), Oxford 1963, pp. 267–8.

50. Martin Davies reached a similar conclusion. See Davies 1957, p. 179.

51. Cropper and Dempsey 1996, p. 293. The passage is quoted as there translated.

52. Cropper and Dempsey 1996, p. 291, who point out that the subject of the reliefs, the story of Archemorus, was not recognised as a possible subject until 1726, because the figure crushed by a snake appears of adult size.

53. Verdi 1982, pp. 681–5, and in London 1995, p. 280. McTighe's suggestion that Poussin's letter should be taken to refer only to Poussin's storm paintings seems too narrow: McTighe 1989, pp. 333–61, at p. 343.

54. See R.Verdi in London 1995, p. 280, who quotes Virgil's *Eclogues* (III: 92–3) by way of example: 'You lads there gathering flowers and strawberries from their earthly beds, take to your heels! There's a clammy snake lurking in the grass.' The theme of death in peaceable nature is central to Poussin's two versions of *Et in Arcadia Ego* at Chatsworth and Paris. For further discussion of this theme in relation to NG 5763, see, for example, Cropper and Dempsey 1996, p. 294; and McTighe 1990, p. 55. McTighe's suggestion that NG 5763 was 'an allegory of nature's processes... expressed in "hieroglyphic" form' has not been generally accepted. As Rosenberg has said (Paris 1994–5, p. 407), the complex argument on which the suggestion is based assumes a level of learning which Poussin was far from possessing. That said, it is perfectly possible that erudite viewers of the painting in seventeenth-century Paris may have reflected on it long enough to extract such an allegorical meaning. For the suggestion that NG 5763 is an allegory of corruption and renewal derived from hieroglyphics see S. McTighe, *Nicholas Poussin's Landscape Allegories*, Cambridge 1996, pp. 80–5, 126–35.

55. Trans. by J. Arthur Hanson, cited in note 28, p. 15.

56. The zig-zag nature of the composition has been noted by Mérot (p. 153), albeit not in relation to the passage in Apuleius' *Metamorphoses*.

57. The game consists of one player guessing the number of fingers held up simultaneously by another player. It was ruefully described by John Raymond , cited in note 42, p. xxix, as appearing ' at the first... but childishly ridiculous; after better acquaintance, a kinde of Conjuration; Tis of force to binde the Fancy; yet the most illiterate are best at the Game'.

The men's activity was identified by Fénelon in *Dialogues sur la peinture*, cited in note 49, p. 191. Based partly on this and on Ripa's description and illustration of 'peccato', a male nude being devoured by a serpent, NG 5763 has been seen as a warning against sin: M. Stanic, *Poussin. Beauté de l'Enigme*, Paris 1994, pp. 52–3. For a

psychosexual interpretation of NG 5763, see R. Démoris, 'L'étrange affaire de l'Homme au serpent :Poussin et le paysage de 1648 à 1651', *Cahiers de Littérature du XVII^e siècle*, 1986, no. 8, pp.197–218.

58. Jean de La Bruyère (1645–96) wrote of 'les caprices du hasard ou les jeux de la fortune' (*Les Caractères de Theophraste*, VI: 80, publ. 1688), and Montesquieu (1689–1755) of 'les caprices du hasard et de la fortune' (*Lettres Persanes*, 1721, no. 104).

59. 'Ce fut encore dans le mesme temps qu'il fit pour le mesme Pointel deux grands païsages: dans l'un il y a un homme mort & entouré d'un serpent, & un autre homme effrayé qui s'enfuit'. Félibien, *Entretiens 1685*, part 4, p. 303, and *Entretiens 1685–88*, vol. 2, pp. 358–9.

60. Of the two landscapes now respectively at the Getty Museum, Malibu, and the Musée des Beaux-Arts, Rouen, which certainly are pendants, Félibien wrote: 'Pour le sieur Pointel deux païsages, l'un representant un orage, & l'autre un temps calme & serain: ils sont à Lyon chez le sieur Bay Marchand': Félibien, *Entretiens 1685*, part 4, p. 303, and *Entretiens 1685–88*, vol. 2, p. 358.

61. Whitfield 1977, pp. 4–12, endorsing a tentative suggestion (since abandoned) originally made in 1961 by Mahon in 'Réflexions sur les paysages de Poussin', *Art de France*, 1961, pp. 119–32, at p. 125, n. 21. Another candidate once proposed as a pendant for NG 5763 was the Prado, *Landscape with Three Men* (also sometimes known as *Landscape with Diogenes*). As Mahon pointed out, once the *Orpheus and Euridyce* was known to have belonged to Pointel, its candidature as a pendant to NG 5763 became evident, particularly since the Prado landscape seemed likely to have been painted for a different patron, namely Lumague: Mahon 1995b, pp. 176–82.

62. 124 × 200 cm.

63. Thuillier and Mignot 1978, pp. 39–58.

64. D. Wild, '*L'Adoration des Bergers* de Poussin à Munich et ses tableaux religieux des années cinquante', *GBA*, 60, 1962, pp. 223–48, at p. 244.

65. Paris 1994–5, p. 410. Both paintings have been seen as images of 'total irremediable loss' by L.D. Steefel, 'Rereading Poussin's Orpheus and Eurydice', *Konsthistorisk tidskrift*, vol. LXI, 1991, 1–2, p. 61, n. 5.
One may also add that both paintings are on a twill canvas, but their thread counts are not the same. That of the *Orpheus and Eurydice* is 12 × 20 per cm (E. Ravaud and B. Chantelard, 'Les supports utilisés par Poussin à travers l'étude des radiographies du laboratoire de recherche des musées de France. Analyse et étude comparative',

Techne, no. 1, 1994, pp. 23–34 at p. 34), whereas that of NG 5763 is about 14 × 26.

66. Paris 1994–5, p. 410. As Mahon has told me, he found Rosenberg's arguments concerning the close connection between the two pictures so convincing that he incautiously but inaccurately used the shorthand of 'a pair' when referring to the conclusion of Rosenberg, who had discussed them as 'deux compositions complémentaires': see Mahon 1995b, pp. 176–82, at p. 177.

67. Thuillier and Mignot 1978, at pp. 51–2, where not regarded as pendants. Possibly the measurements are misrecorded in the inventory, because those of the *Orpheus* are given as 'six pieds de long sur quatre et demy de hault', and those of NG 5763, the next painting in the list, as '*aussy* de six pieds de long sur quatre de hault' (my emphasis). The metric eqivalents of these measurements (height before width) are 146.1 × 194.8 cm for the *Orpheus* and 130 × 194.8 cm for NG 5763.

68. Brejon de Lavergnée 1987, pp. 37, 74.

69. Keazor has independently reached a similar conclusion. See Keazor 1998, pp. 159–61.

70. J.B. Deperthes, *Histoire de l'art du paysage depuis la renaissance des beaux-arts jusqu'au dix-huitieme siècle*, Paris 1822, pp. 110–12. 'Une autre fois, [Poussin] imagine de placer ses personnages dans des situations tout opposées; et, à l'aide de cet artifice, il réussit à donner à l'action du sujet un plus haut degré d'intérêt: en effet, de même qu'au milieu d'une mélodie expressive un changement de modulation ne frappe subitement l'oreille que pour produire une impression d'autant plus sensible qu'elle est moins attendue; ainsi, dans la peinture, un contraste bien prononcé, agissant à l'improviste sur le sens de la vue, doit nécessairement faire prendre un nouvel essor à l'imagination, et lui imprimer un mouvement plus rapide et plus énergique' (p. 110). Deperthes then discusses the *Orpheus* and the composition of NG 5763 in this context. Besides being remarkable for being the first to link the two landscapes thematically, Deperthes's observation invites the speculation that in both paintings Poussin was deliberately subverting the theory of the modes. For a reading of the picture which saw the landscape as horrific as the event, however, see [Nicolas Guillain], *Essai sur la vie et sur les tableaux du Poussin*, Paris 1783, p. 36.

71. The first explicit published interpretation of the painting on these lines seems to be in the text of Baudet's engraving. Fénelon's similar interpretation was not published until 1735, although probably written in the 1690s.

72. It is worth noting that Gault de Saint-Germain (cited in note 28, pp. 34–5) interpreted NG 5763, which he called 'L'Echo', not as reflecting what its participants could see, but what they could hear, the cry of the frightened traveller diminishing in effect as it diminished in volume. In his 1767 Salon (ed. 1963, pp. 267–8) Diderot described the painting as showing the effects of both sight and sound. It is not clear, however, that any sound is uttered by the participants – on the contrary, the traveller appears dumbstruck. Diderot's account of NG 5763 is unique in reading the picture from background to foreground: Diderot, *Salons*, cited in note 49, pp. 267–8.

73. John Shearman, 'Les dessins de paysages de Poussin', *Poussin Colloque 1958*, I, pp. 179–88 at p. 186.

74. It certainly seems out of character for Poussin not to have considered his subject before starting work, as Ann Sutherland Harris suggested in relation to NG 5763 in a letter in *BM*, 109, 1967, p. 308. Avigdor Arikha has proposed that NG 5763 is among the paintings for which Poussin did not use a draped mannequin for the figures: 'De la bôite, des figurines et du mannequin', *Poussin Colloque 1994*, pp. 44–7, at p. 46.

75. For an interpretation of NG 5763 as containing a series of binary opposites, see Louis Marin, 'La description de l'image: à propos d'un paysage de Poussin', *Communications*, 15, 1970, pp. 186–209. Marin also suggests that the kneeling woman serves as a link between decor (background) and narrative (foreground), but this underestimates the significance of the landscape.

76. See Blunt 1966, p. 144. Mahon has pointed out (Mahon 1995 at p. 177, n. 5) that Félibien may not have frequented Poussin's studio so assiduously as to be aware of everything painted in this period. Because of its size, however, NG 5763 was likely to have been in the studio for some time. See also note 2.

77. See J.B. Deperthes, *Théorie du Paysage*, Paris 1818, pp. 225–7, and *Histoire de l'art du paysage*, cited in note 70, p. 112; and P.H. de Valenciennes, *Elémens de la Perspective Practique*, Paris 1820, p. 151.

78. See under Related Works, Drawings and note 26 above.

79. See P.H. de Valenciennes' *Mountain Landscape with a Man frightened by a Snake*, s. and d. 1817, and A.E. Michallon's *Landscape with Ruins and a Man frightened by a Snake*, s. and d.1817 (both Barnard Castle, Bowes Museum). The painting by Girodet-Trianon is in the Musée Magnin, Dijon: see Verdi 1993, pp.13–29, at p. 20 and pl. 1.

NG 6277
The Adoration of the Shepherds

c.1633–4
Oil on canvas, 97.2 × 74.0 cm (edges irregular)
Signed on the stone at lower right: *N. Pusin.fe* (fig. 1)

Provenance
By 1637 in the collection of Cardinal Giovan Carlo de' Medici (1611–63) at the Villa Mezzomonte near Florence,[1] and from 1644 at the Casino di Via della Scala, Florence;[2] where recorded in 1647 and again in 1663 in a posthumous inventory of the cardinal's possessions;[3] possibly the *Nativity* by Poussin seen by Bernini in 1665 in the hôtel of Louis II Phélypeaux de La Vrillière (1599–1681), secretary of state to Louis XIV, and recorded in 1672 in the collection of La Vrillière's wife, Marie Particelli;[4] possibly in the collection of André Le Nôtre (1613–1700);[5] possibly in the collection of Pierre Gruyn, Conseiller du Roi (d.1722);[6] posthumous sale of De Selle, Trésorier Générale de la Marine, at his house, rue Ste Anne, Butte St Roch, Paris, Rémy, 19–28 February 1761 (lot 35, 2400 livres to Thibauls);[7] sale of Sir Joshua Reynolds, deceased, Christie's, 17 March 1795 (lot 97, 205 guineas to Henry Walton);[8] sold by Walton by 12 March 1796 for 300 guineas to Sir Thomas Beauchamp-Proctor (1756–1827) of Langley Park, Norfolk,[9] and noted there by Neale hanging in the Cabinet Room;[10] recorded in the collection of Sir William Beauchamp Proctor in 1829[11] and thence by descent to Jocelyn Beauchamp of Langley Park, Norfolk, in whose sale, Sotheby's, 11 July 1956 (lot 119, £29,000 to D. Koetser as agent for a collector overseas);[12] purchased in 1957 for £33,100, following deferral of an export licence, with money from the Temple-West Fund, a special Treasury grant and assistance from the NACF.

Exhibitions
London 1880, RA, *Exhibition of Works by Old Masters* (125); London 1963, NG, *Exhibition of Acquisitions 1953–1962* (p. 70); London 1975, NG, *The Rival of Nature – Renaissance*

Fig. 1 Detail of signature.

Painting in its Context (191); London 1989, NG, *The Artist's Eye: Bridget Riley*, pl. 6, p. 34; Birmingham 1992–3, Birmingham Museum and Art Gallery, *Nicolas Poussin – 'Tancred & Erminia'* (8); Paris 1994–5, Grand Palais, *Nicolas Poussin, 1594–1665* (46); London 1995, RA, *Nicolas Poussin. 1594–1665* (25).

Related Works[13]
PAINTINGS
(1) Formerly in the chapel of the château de Torigny-sur-Vire, Normandy, in the collection of the comte de Torigny, but destroyed by fire.[14] A copy of NG 6277, but larger and with an arched top;
(2) Eglise Saint-Pierre, rue de Taulignan, Avignon. A copy, approx. 250 × 150 cm;[15]
(3) A seventeenth-century copy of the lower part of the composition with variations in Rome, Cassa Depositi e Prestiti, inv. no. 50, 58 × 72 cm;[16]
(4) Sale of Sir Thomas Seabright and Thomas Bacon, both deceased, London, Cock, 19 May 1737 (lot 86). A copy of NG 6277?;
(5) Sir William Hillary sale, London, Squibb, 25 June 1808 (lot 53, £178 10s.), 2 ft × 2 ft 3 in. on panel.[17] A copy of NG 6277?;
(6) Stokes sales, Christie's, 4 March 1809 (lot 49, bought in), 17 November 1809 (lot 47, bought in), 1 December 1810 (lot 35, bought in), 2 February 1811 (lot 44, £2 2s. to Woodin). A copy of NG 6277?;
(7) London, Victoria and Albert Museum, no. 343–1878, 54.5 × 71 cm, a copy of the lower half only. Formerly in the Radstock collection;[18]
(8) Detroit, Institute of Arts, no. F71.2, 99.1 × 75.6 cm, gift of William Suhr. A copy, probably of the seventeenth century.[19] Photograph in NG dossier;
(9) Grosskopf sale, Frankfurt, 5 May 1925, lot 53, according to Blunt;[20]
(10) Cologne, Lempertz, 23 March 1927, lot 6 (as Bassano), according to Blunt;[21]
(11) A copy was formerly with Wildenstein, London, 1936, 39 × 29⅞ in.;[22]
(12) Duke of Northumberland sale, Sotheby's, 14 February 1968 (lot 13, £480 to Poggi), 22 × 28½ in.;[23] A copy of only the lower half of NG 6277. Photograph in NG dossier;
(13) Christie's, 13 December 1968 (lot 15, 260 guineas to Carnes), 21 × 27½ in., described as from the collection of Sir Richard Sutton, Bt. A copy of only the lower half of NG 6277. Photograph in NG dossier;
(14) At Locko Park, Derbyshire, a copy, 36 × 27 in., early eighteenth century;[24]
(15 and 16) According to Wild, besides the copies listed by Blunt 'zwei weitere unwichtige, in Privatsammlungen von Rom und Florenz';[25]
(17) According to Blunt, Robert Draper collection, Miami, Florida, 39 × 30 in., inscribed: *Nicolo Pousin*.[26] Formerly on the art market, Florence;
(18) New York, Sotheby's Arcade, 20 January 1993, lot 175, 99.7 × 74.3 cm, a copy in reverse with variations. Photograph in NG dossier;

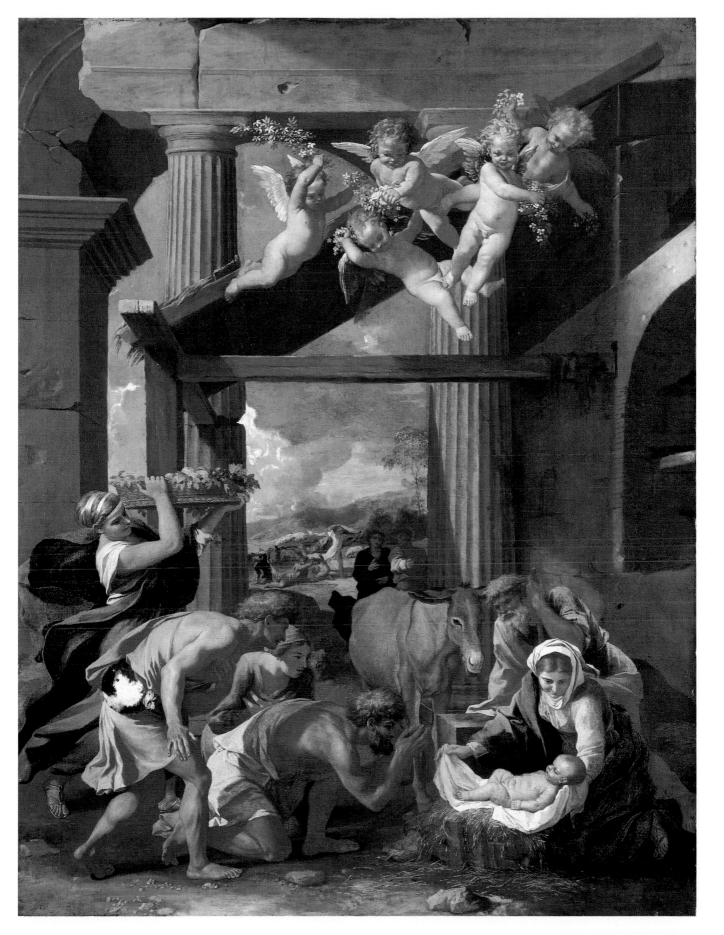

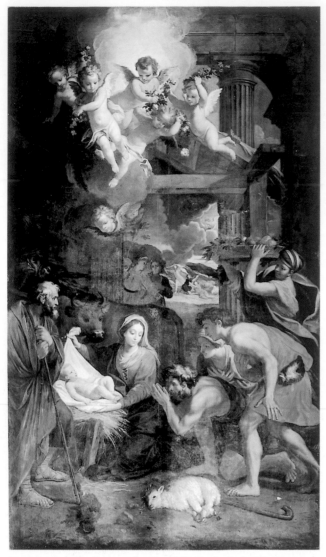

Fig. 2 Louis de Boullogne, *Adoration of the Shepherds*, 1693. Oil on canvas, 369 × 213 cm. Chantilly, Eglise de Chantilly.

(19) Private collection, Barcelona, 97 × 74 cm, with variations and attributed to Pedro de Orrente;[27]

(20) Eglise de Chantilly (fig. 2), a variant composition in reverse, and so probably derived from the Picart engraving, by Louis de Boullogne.[28]

DRAWINGS

(1) London, British Museum (inv. ff. 2–163, R.-P. 75) (fig. 7). The attribution of this drawing has also been doubted – see the discussion under R.-P. 75 – but it was engraved in Poussin's lifetime as after a drawing by him in the Jabach collection (see Print (3) below);

(2) Windsor, Royal Collection (inv. RL 11903 verso, and verso of R.-P. 80) (fig. 8);[29]

(3) Oxford, Christ Church (inv. 1047; R.-P. 74) (fig. 9). For a discussion of the doubts expressed about the attribution of this drawing, and for a copy of the drawing by Michel II Corneille, see R.-P. 74;

(4) Chantilly, Musée Condé (inv. A1 191 b; N1 232. R.-P. 360). Considerably later than NG 6277, but thematically and compositionally related to the painting;

(5) Paris, Louvre, Département des Arts Graphiques (inv. no. 32456. R.-P. R738). By Poussin? A drawing in reverse of the lower part of the composition and so perhaps after print (3) below.

PRINTS[30]

(1) By Etienne Picart (1632–1721) (Andresen 104; Wildenstein 37) in reverse and dedicated to 'Illustrissimo viro Domino D. Joanni Baptistae Colbert Regi ab initimis Consilijs et Secretis, Generalis Aerarij Moderatori, summo Regiorum Aedificorum praefecto, Regiorum ordinu quaestori, Marchioni de Segnelay Baroni de Seaux'. The dedication is to the elder Colbert (d.1683),[31] and not, as Wildenstein suggested, to his son, who shared with his father the given names Jean-Baptiste, and who succeeded to the marquisate of Seignelay but was never 'summo Regiorum Aedificorum praefecto';

(2) a smaller version of (1) published by Pierre Drevet (1644–1739) (Andresen 105; Wildenstein 37);

(3) by Charles Massé (b.1631) (Andresen 107; Wildenstein 38) in reverse of lower part of the composition, and so connected to drawing (1) above. Engraved as after a drawing by Poussin in the Jabach collection and so before 1665;[32]

(4) by Pieter Schenk (1660–1713);[33]

(5) by Arthur Pond (1705–58) (Andresen 106), in reverse of the lower part of the composition like the Massé engraving, but an etching and woodcut printed in colours from three blocks. Dated 1735, one of the series *Prints in Imitation of Drawings*;[34]

(6) by L. Schmidt in mezzotint;[35]

(7) by Thérèse-Eléonore Lingée (b.1753), Plate XXXVIII of C.P. Landon's *Vie et Oeuvre Complète de Nicolas Poussin*, Paris 1813.

Technical Notes

The painting, which was last cleaned and restored in 1958 and surface cleaned and revarnished in 1975, is in generally good condition, but with some wear, especially between the legs of the kneeling shepherd. There are also some discoloured retouchings, for example in the Virgin's tunic and in the background. There has been some deterioration of the ultramarine pigment, which has become greyer in appearance.

The support is a fine plain-weave canvas, with a twentieth-century, but pre-1958, lining. The ground is a single layer of a hot red-brown colour. The paint medium is linseed oil.[36] The stretcher is probably nineteenth century, and there are a number of marks on it.[37] There are some minor pentimenti in the outlines of the cherubs, and the fluting of the right-hand column is visible under its base, which must therefore have been painted subsequently. The X-radiograph suggests that the area where the cherubs were painted was left in reserve and that some of their outlines were first sketched in with darker pigment, presumably containing a considerable amount of lead white, since the outlines do not appear in the infra-red photograph.

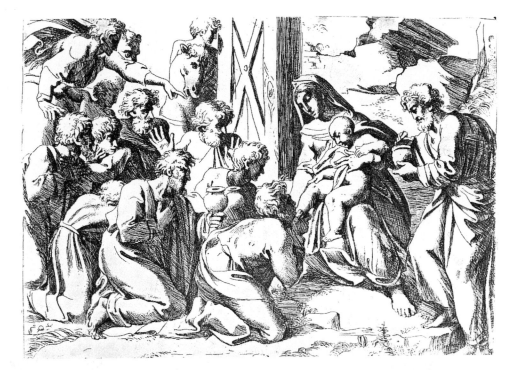

Even allowing for possible duplication among them, the number of known copies of NG 6277[38] testifies to the popularity of Poussin's treatment of this subject, based on Luke 2:15–16.[39] To the traditional iconography of the Holy Family with shepherds, an ox and ass, Poussin has added the woman at the left bearing a basket of fruit, while in the background, 'framed' by the architecture, appears the earlier episode of the Annunciation to the Shepherds (Luke 2: 8–14). This concept, unusual in early Italian seventeenth-century painting, of showing the two episodes – one as the main subject and the other as a picture within a picture, so to speak – influenced the composition of Pietro Testa's *Adoration of the Shepherds* (Edinburgh, National Gallery of Scotland).[40]

While dividing foreground from background, the architecture unifies the upper and lower parts of the picture. A diagonal drawn from the head of the infant Christ through that of the woman at the left to the edge of the picture would meet a projection of the diagonal of the stable roof at the midway point of the picture's left edge. Just as careful as the structuring of the architecture is Poussin's study of expression and gesture in the lower figures, while in the upper part of the painting the emphatic architectural lines are softened by the group of five cherubs about to release a shower of flowers.

As Levey pointed out,[41] the motif of the kneeling shepherd derives from one of the magi in *The Adoration of the Magi* (see engraving, fig. 3) in the Vatican Loggie and was also used by Poussin in his *Adoration* now in Dresden. The figure of the woman at the left carrying a basket of fruit (fig. 4) may have been inspired by the female figure at the extreme right of the tapestry of *The Healing of the Lame Man* after Raphael (fig. 5) in the Vatican. There was a Florentine custom of bringing food and fruit to women after childbirth, a custom mentioned by

Fig. 6 Detail of putti with flowers.

Vasari in his life of Domenichino Ghirlandaio.[42] In addition, Donatello's now lost, but then prominent, statue of *Dovizia* (Plenty), who also carried a basket of fruit on her head (and a cornucopia in her right arm),[43] in the Mercato Vecchio, Florence, would have carried associations with the city. Inclusion of the basket-carrying woman – a far from rare motif – may have added to the painting's appeal to Cardinal Giovan Carlo de' Medici, in whose collection near Florence it was by 1637 (see Provenance).[44] That is not to say, however, that Poussin had such matters in mind when painting NG 6277.

The fruit in the basket appear to be apples and grapes. The apples may be a reference to the infant Christ as the new Adam or to the Virgin as the new Eve, and the grapes may also allude to Christ, or to his redemptive blood.[45] The spray held by the putto at top left is jasmine, a symbol of the Virgin (fig. 6).[46] The other white flowers may be stocks, sweet-smelling members of the *Cruciferae* family, which, being cruciform, were often associated with the childhood of Christ and his subsequent crucifixion.[47] The blue flowers about to be thrown by the bottommost putto may be forget-me-nots, long symbolic of remembrance, but without a specific religious significance. The red flower may be a rose, which was associated with the Virgin and her sorrow at Christ's Passion, and with the Passion itself,[48] or a poppy, which was also associated with the Passion.[49] The scattering of various flowers, a frequent motif in Poussin's paintings, both secular and religious, may here be symbolic primarily of homage rather than martyrdom, although some of the flowers being scattered are sometimes associated with martyrdom.[50]

As has been noted,[51] the coppery colours of NG 6277 are close to those of *The Saving of the Infant Pyrrhus* in the Louvre, and on that basis NG 6277 was dated 1637 by Blunt.[52] However, the *Pyrrhus* is now known to have been finished by September 1634.[53] Although a date of 1631–3 has been proposed for NG 6277,[54] Verdi suggested 1634–5 because it shared with the *Pyrrhus* 'its coppery colouration, emphatically posed figures, and slightly acid blues and pinks'.[55] More recently he has proposed 1633–4,[56] which is surely correct. The coppery colouring of NG 6277 is not so apparent in the Dresden *Adoration of the Magi*, which is signed and dated 1633 and is closer in its chromatic range to, say, the Dulwich *Triumph of David*, generally dated *c*.1632/3 (a painting whose attribution to Poussin is still unjustifiably doubted by a few), than to NG 6277, which would therefore appear to be later than both the Dulwich and Dresden paintings. The fact that there is an architectural detail (fig. 7) at the bottom left of the preparatory drawing in the British Museum like that in Dulwich's *Triumph of David* is not inconsistent with this view. It merely suggests that between the planning and the execution of NG 6277 Poussin decided to discard this kind of architectural detail, which had previously interested him when painting the Dulwich and Dresden pictures.[57]

A dating of 1633–4 seems confirmed by the discovery of a faint preparatory drawing for NG 6277 on the verso of a drawing for the New York *Rape of the Sabine Women*[58] (fig. 8), commissioned by the maréchal de Créquy during his ambassadorship in Rome between June 1633 and July 1634.[59] Clayton has proposed that this may be an abandoned underdrawing for a finished, modello-like sheet and that it must have been executed before the drawing for the New York picture.[60] It is, however, not axiomatic that NG 6277 was executed by 1633 at the latest. Planning in 1633 and painting the following year seems more likely.

The existence of the British Museum drawing (fig. 7) suggests that Poussin may originally have conceived of painting the subject in the horizontal format in which it would eventually be engraved by Massé. However, this is far from certain, since the drawing has been cut along the top.[61] At all events, between drawing and painting Poussin eliminated the lamb below the infant Christ as well as the upturned pediment in the left foreground. Neither the architectural background of the Christ Church drawing (fig. 9) nor that of the British Museum drawing was wholly incorporated into NG 6277 by Poussin. The careful structuring of the architecture in the painting suggests, as might be expected, that Poussin worked out the figures first and subordinated the architecture to them.

Signed works by Poussin are rare. It is not known why Poussin should have made an exception both for the Dresden painting (which he also dated) and for NG 6277. But certainly both showed popular subjects and were, as the number of copies or derivations show, among the most likely paintings of these years to be plagiarised.[62]

General References

Gault de Saint Germain 1806, 25; Smith 1837, 53; Grautoff 1914, 103 (copy no. 5 above); Magne 1914, 17; *National Gallery Acquisitions 1963*, pp. 70–1; Blunt 1966, 40; Thuillier 1974, 72; Wild 1980, 50; Wright 1985a, 74; Wright 1985b, p. 135; Mérot 1990, 56; Thuillier 1994, 92.

Fig. 7 *Adoration of the Shepherds*, c.1633. Pen and brown ink and brown wash, 19 × 25.8 cm. London, British Museum, Department of Prints and Drawings.

Fig. 8 *Adoration of the Shepherds*, c.1633. Faint black chalk lines reinforced schematically on the photograph (with ink staining through from the recto), 11.3 × 19.4 cm. Windsor, Royal Library, The Royal Collection.

Fig. 9 *Putti scattering Flowers*, c.1633. Pen and brown ink, brown wash and red chalk, 12.1 × 17.4 cm. Oxford, Christ Church.

1. S. Mascalchi, *Le collezioni di Giovan Carlo de' Medici. Una vicenda del Seicento Fiorentino riconsiderata alla luce dei documenti*, PhD thesis, Università degli Studi di Firenze, 2 vols, 1984 (Mascalchi 1984a), vol. 2, p. 619, citing *Inventario delle Masserizie di Mezzomonte fatto questo dì 2 agosto 1637 dal G. Gen. Ubaldini presente N.s. Francesco Conti Guardaroba scritto da me Lodovico Barabelli e per. ma.*, Archivio di Stato di Firenze (ASF), Poss., f.4279, c.41 v. Idem, 'Giovan Carlo de' Medici: An Outstanding but Neglected Collector in Seventeenth-Century Florence', *Apollo*, 120, 1984, pp. 268–72 (Mascalchi 1984b).

2. Mascalchi 1984b p. 271.

3. Mascalchi 1984a, vol. 1, p. 288, and vol. 2, p. 619 (citing but not publishing the 1647 inventory); and ibid., vol. 2, pp. 411, 413, publishing the *Inventario o Recognizione dele Masserizie che si trovano nel Casino di Via della Scala* (the 1663 inventory in ASF, Misc. Medicea, f.31, ins.10):

> Nella Camera, a Canto alla Porta di via, che riesce con le finestre in Via della Scala, e con l'uscio su la Loggia...
>
> ...Un quadro in tela, entrovi un Presepio, con più figure, e sua Capanna, con un gruppo di cinque Angioli per Aria, che seminano fiori, con l'Adorazione de Pastori, di mano di monsù Pozzino, con adornamento intagliato e dorato, con sue Cordone.

Another inventory, *Inventario de' Quadri che si ritrovano in Via della Scala nel casino di Sua Altezza R.ma di gl.me. Card. le Gio : Carlo de' Medici da vendersi all'incanto; l'anno 1662*, (ASF, Strozziane, Ia serie, f.25/39), evidently prepared for the ensuing auction sale, contains the dimensions and valuation, '(48) Un quadro entrovi un Presepio di mano del Pozzino adornamento dorato di braccia 2½ altezza e braccia 2 larghezza. doble 122½': Mascalchi 1984a, vol. 2, pp. 489, 497.

On 15 January 1664 the marchese Filippo Niccolini wrote to Rinuccini: 'Già che sento la M.tà della Regina di Svezia, possa aver fatto provvisione di Quadri, svanirà l'assegniamento di poterne dalla Maestà sua farne partito con noi, perciò fo[sic] tirare avanti le stime per cominciare la vendita fra pochi giorni, dicendo a V.S. Ill.ma che farò riconoscere la stima del quadro del Presepio dove sono più figure di mano del Pozzino credendo assolutamente sia stato preso equivoco nel prezzo da scudi 60 in 600': Mascalchi 1984a, vol. 1, pp. 343–4.

4. '[Bernini] a estimé...une Nativité du Poussin...Revoyant [the Louvre version of *Camillus and the Schoolmaster of the Falerii*], il a dit qu'il était un grand homme de se pouvoir ainsi transformer, qu'il était d'une manière tout à fait différente de cette *Nativité*, qui est d'un coloris lombard et l'autre à l'imitation de Raphaël': Paul Fréart de Chantelou, 'Journal du Voyage du Cavalier Bernin en France', ed. L. Lalanne, *GBA*, 1877–85, vol. 29 (May 1884), pp. 453–4. The *Camillus* was painted in 1637, and it seems that Bernini saw the *Nativity* as earlier. See also Schnapper 1994, p. 169. The painting does not appear in La Vrillière's posthumous inventory of 13 June

1681 (see Sabine Cotté, 'Inventaire après décès de Louis Phélypeaux de La Vrillière', *AAF*, 27, 1985, pp. 89–100), but is presumably the same as that recorded in the post-mortem inventory of his wife, Marie Particelli, of 29 August 1672: see Christel Haffner, 'La Vrillière, collectionneur et mécène', *Seicento. Le siècle de Caravage dans les collections françaises*, exh. cat., Grand Palais, Paris, and Palazzo Reale, Milan, 1988–9, pp. 29–38 at p. 35.

5. Inventory of 24 September 1700 and following days: '...un grand tableau du Poussin, peint sur toille, à bordure de bois doré, représentant une Nativité, ayant 3 pieds et demy de haut sur 2 pieds de largeur, prisé 800 livres': J. Guiffrey, 'Testament et Inventaire après décès de André Le Nostre et autres documents le concernant', *BSHAF*, 1911, pp. 217–82 at p. 248.

6. His posthumous inventory of 16 March 1722 included a Poussin *Nativity* valued at 800 livres: Schnapper 1994, pp. 414–15. ('Item un autre Tableau de Poussin representan une nativite peins sur toile dans sa bordure de bois sculpté dore no. 27 prise huis cen livres': A.N., M.C., XIV, 255). Gruyn is recorded in Paris in 1705 (as a witness to the marriage of the daughter of the composer and bass viol player, Marin Marais): see S. Milliot and J. de La Gorce, *Marin Marais*, Paris 1992, p. 47.

7. 'Nicolas Poussin./ 35 La Vierge à genoux, tenant de la main droite un linge sur lequel est l'Enfant Jesus, couché nu, S. Joseph qu'on ne voit qu'à mi-corps, est derriere la Vierge, il a la main gauche posée sur la base d'une colonne, & la droite appuyée sur son bâton: le boeuf & l'âne sont à ses côtés; un Pasteur prosterné, un autre à genoux, & une femme qui a les mains jointes, adorent l'Enfant Jesus; une femme de bout derriere ces Pasteurs, tient une corbeille de fleurs. Le fond représente de l'architecture, qui étant percée, laisse voir dans l'éloignement, une campagne où l'Ange annonce la venue du Messie.

Ce Tableau est d'une composition heureuse, agréable & savante: il est chaud de couleur: les figures sveltes & d'une grande correction, ont un pied de proportion. Il est peint sur toile de trois pieds un pouce de haut, sur 2 pieds 3 pouces & demi de large: ou en trouve l'Estampe gravée par Stephanus Picart, & dédiée à M. Colbert.'

8. A. Graves and W.V. Cronin, *A History of the Works of Sir Joshua Reynolds, P.R.A.*, London 1901, vol. IV, pp. 1627, 1632. A copy of the catalogue in the NG Library has MS notes by Martin Davies copying MS notes in a copy of the catalogue ex Lord Ridley. That for lot 97 reads: 'For this picture Sir Joshua asked 400, and had...refused 350.' It is not known when Reynolds bought his painting. A Poussin *Adoration of the Shepherds* was sold at the posthumous sale of the Revd Dr Bearcroft, Master of Charterhouse, London, Longford, 11 February 1762 (lot 68, £2 17s.), but the price suggests a copy.

9. *The Diary of Joseph Farington*, vol. 2, p. 507 (entry for 12 March 1796), contradicting Blunt's inference from Dawson Turner, *Outlines in Lithography from a small collection of*

pictures, Yarmouth 1840, p. 21, that Walton bought the picture on Beauchamp Proctor's behalf rather than his own. See also Francis Brown, *Sir Joshua Reynolds' Collection of Paintings*, PhD dissertation, Princeton University 1987, pp. 208–9.

10. Neale 1818–23, vol. 6, n.p.

11. John Stacy, *History of Norfolk*, 1829, vol. 2, p. 845.

12. For an account of the sale of NG 6277 at this auction, see Robert Lacey, *Sotheby's: Bidding for Class*, Boston 1998, pp. 109–12.

13. Hippolyte Mireur (*Dictionnaire des ventes d'art faites en France et à l'Etranger pendant les XVIII^me & XIX^me siècles*, 7 vols, Paris 1911–12, vol. 6 (1912), pp. 59, 61) notes paintings of the *Adoration of the Shepherds* attributed to Poussin in the following sales: W. Hilloy, 1800; Weyer, Cologne, 1802; General G., 22 May 1900, but none is necessarily of the same composition as NG 6277.

14. H. Soulange-Boudin, *Les Châteaux de Normandie*, Paris 1949, plate 42, and pp. 70, 152. The château was owned by the Matignon family from 1450 until the Revolution. The Torigny version of NG 6277 may have been bought by Honoré III de Grimaldi-Matignon (1720–95), who lived at the château and had a collection of art at the hôtel Matignon, Paris: see Soulange-Bodin, pp. 68–70.

15. Letter of 8 October 1996 from R.P. Yves Lacrambe.

16. Italo Faldi, *La Quadreria della Cassa Depositi e Prestiti*, Rome 1956, pp. 39–40; *Intorno a Poussin. Dipinti romani a confronto*, exh. cat., Galleria Nazionale d'Arte Antica, Rome 1994–5, no. 12.

17. *Index of Paintings Sold*, vol. 2, part 2, p. 757.

18. See Davies 1957 under no. 1862, and C.M. Kauffman, *Victoria and Albert Museum. Catalogue of Foreign Paintings – I. Before 1800*, London 1973, no. 285. The painting was on loan to the National Gallery from 1895 until 1960.

19. Letter of 26 September 1996 from George Keyser.

20. Blunt 1966, p. 32.

21. Ibid.

22. Grautoff 1914, no. 103. From the Dollfus and Eugenie Favier collections and, according to Blunt (Blunt 1966, p. 32), 'probably the painting which appeared in the Aignot sale, Pillet, Paris, 1f.iii. 1875, lot 55'. Probably the painting with Segredakis, 191 rue Saint-Honoré, Paris, in 1935 (of which there is a photograph in the NG dossier); the painting was recorded with Wildenstein in 1936.

23. Not part of the Camuccini collection bought by the 4th Duke of Northumberland in 1854: see Clare Baxter, *The Camuccini Collection*, compiled 1992, revised 1995 (typescript in NG Library).

24. Courtauld Institute photograph B73/1161.

25. Wild 1980, vol. 2, p. 50.

26. Blunt 1966, p. 32.

27. Charles Sterling, 'Quelques imitateurs et copistes de Poussin', *Poussin Colloque 1958*, 2 vols, Paris 1960, vol.1, pp. 265–76 at p. 276, n. 8.

28. A. Schnapper, 'Louis de Boullogne à l'église de Chantilly', *Revue de l'Art*, no. 34, 1976, pp. 57–60, illustrated p. 60, fig. 8.

29. See Clayton 1995, p. 86.

30. For two engravings not after Poussin but using elements from NG 6277, see A. Blunt, 'Poussin Studies XIII; Early Falsifications of Poussin', *BM*, 104, 1962, pp. 486–98 at pp. 488–9.

31. M. Davies and A. Blunt, 'Some Corrections and Additions to M. Wildenstein's "Graveurs de Poussin au XVIIe Siècle"', *GBA*, 60, 1962, p. 210.

32. R.-P., p. 134.

33. *Pieter Schenk Hollstein's Dutch and Flemish Etchings, Engravings and Woodcuts ca.1450–1750*, vol. 25, compiled by G.S. Keyes, Amsterdam 1981, p. 41. I am grateful to Richard Verdi for this reference.

34. Ed. Sarah Hyde and Katie Scott, *Prints (Re)presenting Poussin*, Courtauld Institute of Art, London 1995, no. 15.

35. According to Smith 1837, 53.

36. R. White and J. Pilc, 'Analyses of Paint Media', *NGTB*, 16, 1995, pp. 85–95 at pp. 90–1.

37. Namely: *SF* in yellow chalk; *X1112* on a round label; *30* once in blue crayon and once in pencil; and *27* in white chalk.

38. See Related Works, Paintings. In addition, as has recently been pointed out, the ass in a painting of *The Entry of Christ into Jerusalem* (Nancy, Musée des Beaux-Arts, no. 368) tentatively attributed to Sébastien Bourdon is a direct borrowing from NG 6277: see G. Chomer and S. Laveissière, *Autour de Poussin*, Louvre, Paris 1994–5, p. 34.

39. According to Félibien, Poussin also painted an *Adoration of the Shepherds* for Séraphin de Mauroy in 1653: *Entretiens 1685*, vol. 4, p. 303, and *Entretiens 1685–88*, vol. 2, p. 359. On this work being possibly later than 1653, see R. Beresford, 'Séraphin de Mauroy. Un commanditaire dévot', *Poussin Colloque 1994*, pp. 721–45.

40. Hugh Brigstocke, 'Testa's Adoration of the Shepherds in Edinburgh and some new thoughts on his stylistic development', *Paragone*, 321, 1976, pp. 15–28; ibid., 'Poussin et ses amis en Italie', *Rencontres de l'Ecole du Louvre. Seicento. La Peinture italienne du XVIIᵉ siècle et la France*, Paris 1990, pp.

215–29; ibid., *Italian and Spanish Paintings in the National Gallery of Scotland*, 2nd edn, Edinburgh 1993, p. 153.

41. *National Gallery Acquisitions 1953–62*, London [1963], p. 70. Levey also pointed out an affinity between the lower part of NG 6277 and a woodcut of the same subject attributed to Titian in F. Mauroner, *Le Incisioni di Tiziano*, Le Tre Venezie [Padua] 1943, plate 28.

42. Vasari, *Vite*, 1568, vol. 1, p. 461, in reference to Ghirlandaio's fresco of *The Birth of Saint John the Baptist* in the Tornabuoni Chapel, Santa Maria Novella, Florence. I am grateful to Lorne Campbell for drawing my attention to this.

43. J. Pope-Hennessy, *Donatello Sculptor*, New York, London, Paris 1993, pp. 143–4. I am grateful to Catherine Reynolds for this reference.

44. It is perhaps worth noting that in March 1633 the dealer Roccatagliata sent seven paintings by Poussin to a certain Francesco Scarlati in Florence. None can be identified from the document cited by Timothy J. Standring, 'Some pictures by Poussin in the Dal Pozzo collection: three new inventories', *BM*, 130, 1988, pp. 608–26 at p. 617, n. 51, but on stylistic grounds it is unlikely that NG 6277 could have been painted before 1633 and so included in Roccatagliata's consignment. Arrival of the consignment in Florence may, however, have prompted Giovan Carlo de' Medici's commission of NG 6277, if indeed he did commission it.

45. See Mirella Levi d'Ancona, *The Garden of the Renaissance. Botanical Symbolism in Italian Painting*, Florence 1977, pp. 48, 159–61, and Celia Fisher, *Flowers and Fruit*, London 1998, pp. 25–7. I am grateful to Celia Fisher for her identification of the flowers and fruit in NG 6277 and for her suggestions regarding their possible symbolism.

46. M. Levi d'Ancona, cited in note 45, p. 193.

47. Letter of 27 February 2000 from Celia Fisher in the NG dossier.

48. M. Levi d'Ancona, cited in note 45, pp. 332ff.

49. Ibid.

50. For the scattering of flowers as symbolic of martyrdom, see Diane de Grazia, 'Poussin's Holy Family on the Steps in context', *Cleveland Studies in the History of Art*, 4, 1999, pp. 26–63 at pp. 32–3. For the suggestion that the motif may be primarily symbolic of homage, see the letter of 27 February 2000 from Celia Fisher cited in note 47.

51. For example by Mahon 1962, p. 103.

52. Blunt 1966, no. 40.

53. L. Barroero, 'Nuove acquisizioni per la cronologia di Poussin', *Bollettino d'Arte*, LXIV, 4, October–December 1979, pp. 69–74, and see Paris 1994, no. 51.

54. See Thuillier 1974, 72; Wild 1980, 50; Mérot 1990, 56; Thuillier 1994, 92; Rosenberg in *Paris 1994–5*, pp. 208–9, and Brigstocke 1990, cited in note 40, p. 222 ('sans doute du début des années 1630'). Brigstocke dated NG 6277 c.1633 in *A Loan Exhibition of Drawings by Nicolas Poussin from British Collections*, Ashmolean Museum, Oxford, 1990–1, no. 25, but would now say 1632–3, believing it to be earlier than the Dresden *Adoration of the Kings* on the basis of what he regards as the later drawings for the latter painting, now at Chantilly (letter of 21 July 1998).

55. Birmingham 1992–3, p. 52.

56. London 1995, p. 196.

57. Keazor has proposed, wrongly in my view, that the detail in the British Museum drawing strongly suggests that NG 6277 was painted in the years 1631/3; he finds support for his view in that the Chantilly preparatory drawing for the *David*, as well as the painting itself, shows similar fragments of a column lying on the ground to those in the Dresden *Adoration* and its preparatory drawing in Chantilly, and that both the Dresden and London *Adorations* are signed: Keazor 1998, pp. 21–2, n. 41. None of this, however, is inconsistent with NG 6277 having been planned in 1633 and executed the following year.

58. Clayton 1995, no. 29.

59. J-C. Boyer and I. Volf, 'Rome à Paris: les tableaux du maréchal de Créquy (1638)', *Revue de l'Art*, 79, 1988, pp. 22–41 at p. 32.

60. Clayton 1995, pp. 86–7.

61. See Rosenberg and Prat's entry for R.-P. **75**.

62. Plagiarism became a concern of Claude in the mid-1630s. In conversation Mahon has suggested that if in fact NG 6277 was commissioned by such a distinguished collector as the Cardinal de' Medici, Poussin may have thought it opportune to sign it, since his name was not yet very widely known in 1634. (On this point see also Mahon 1999, pp. 37–8, n. 85: in his *Memoria* (Rome 1638, pp. 74–5) Gaspare Celio simply described Poussin's *Martyrdom of Saint Erasmus* in St Peter's as by 'M. Francese', adding that on the altarpiece 'vi è il nome', which he evidently did not recall at the time of writing. Valentin's adjoining altarpiece was similarly treated by Celio.) However, if NG 6277 were so commissioned, it would be equally arguable that Poussin's name was indeed well known.

NG 6390

Landscape with a Man scooping Water from a Stream

*c.*1637
Oil on canvas, 63 × 77.7 cm

Provenance

Painted for Cassiano dal Pozzo and/or his younger brother, Carlo Antonio dal Pozzo; thence by descent to Giuseppppe Boccapaduli (1729–1809); probably sold by him to the painter and dealer Gavin Hamilton (1723–98) in 1779;[1] probably in the collection of William Wyndham, 1st Lord Grenville (1759–1834), Prime Minister 1806–7, at Dropmore House, Bucks;[2] by descent to his widow, Anne Pitt (1773– 1864), and then to the Hon. George Matthew Fortescue; in the sale of the Fortescue collection in 1939 as by Poussin (Dropmore House, Burnham, 27 February 1939, Farebrother, Ellis & Co., part lot 217);[3] there bought by Tomas Harris, from whom bought by 1945 by Sir George Leon (1875–1947) of Warfield House, Bracknell; inherited by his widow, Dorothy, and sold(?) by her to R.F. Heathcoat-Amory; sold by his executors, Sotheby's, 27 June 1962 (lot 88, £14,000 to Leggatt); bought by Mrs D.M. Allnatt of Doughty House, Richmond Hill; on loan to the National Gallery from 1962; bought from Mrs Allnatt's executors in 1970 under an option contained in the loan agreement.

Exhibitions

London 1949–50, RA, *Landscape in French Art* (30 or 32); Bologna 1962, Palazzo dell'Archiginnasio, *L'Ideale Classico del Seicento in Italia e la Pittura di Paesaggio* (64); London 1975, NG, *The Rival of Nature – Renaissance Painting in its Context* (208); Edinburgh 1990, National Gallery of Scotland, *Cézanne and Poussin: The Classical Vision of Landscape* (1); Copenhagen 1992 (18).

Related Works

NG 6391 was treated as a companion to NG 6390 after both left the Dal Pozzo/Boccapaduli collection. See discussion below.
DRAWINGS
The verso of a drawing in Bayonne (R.-P. 213v) has been connected with NG 6390.[4] This connection is apparently endorsed by Rosenberg and Prat[5] even though it would assign to the painting a date of 1643–4, which is now widely regarded as improbable. If the landscape drawing in the Ashmolean Museum (R.-P. 289) is by Poussin, its date, *c.*1645 according to Rosenberg and Prat,[6] makes a connection between it and NG 6390, as suggested by Blunt,[7] impossible.

Technical Notes

The condition of NG 6390 is good, with only minor wear and blanching. Like NG 6391, it is painted on a plain medium-weight canvas, which has been lined – possibly in the eighteenth century. Its stretcher, possibly of poplar, is fixed and may be the original; its ground, probably a single ground, to judge from the X-radiograph, is red in colour. The X-radiograph

shows that the trees were painted over areas left in reserve and that cusping is present along the four edges of the canvas. The defects apparent in the weave of the canvas in NG 6391 do not appear in NG 6390.

The subject of the painting has no known literary source, although it echoes the story of the Cynic philosopher Diogenes of Sinope (*c.*400–325 BC) throwing away his cup on seeing a boy drink from his hand – a subject which Poussin was to treat later in his career. Here the older man, who is not Diogenes,[8] has a water bottle and watches the younger man scooping water with a pottery shard. He may have conveyed some association with the philosophy of the Stoics, which was attributed to Diogenes[9] and in which Poussin himself took an interest.[10]

In 1945 Blunt drew attention to the fact that on the back of the stretchers of both NG 6390 and 6391 were labels indicating that on 8 August 1739 Cosimo Antonio dal Pozzo gave the pictures to his daughter Maria Laura (see figs 1 and 2).[11] She had married Pietro Paolo Boccapaduli twelve years earlier. Cosimo Antonio was the grandson of Carlo Antonio dal Pozzo and hence the great-nephew of Cassiano dal Pozzo, Poussin's friend and patron in Rome. Blunt surmised that it 'is therefore practically certain that the paintings belonged to Cassiano himself'.[12] Brejon de Lavergnée subsequently proposed that NG 6390 and 6391 were among 'Cinque quadri in tela poco più grandi di testa con paesi e fi/gurine cornici dorate si credono del Posino' listed in the posthumous 1689 inventory of Carlo Antonio dal Pozzo,[13] and that they were among five landscapes listed in the 1695 posthumous inventory of Gabriele dal Pozzo.[14] These landscapes were nos 92, 94, 96, 106 and 108 of the 1695 inventory (as numbered in Brejon's article). No. 106, described as having three figures, a possible description for NG 6390, is not stated to be by Poussin, while no. 108 is described as 'di tre palmi scarsi con più figure' ('of scarcely three *palmi* [66.9 cm][15] with many [not 'more' in this context] figures'), which seems to exclude it from being identified with either NG 6390 or NG 6391. No. 94 can reasonably be identified as the *Man pursued by a Snake* (Montreal, Museum of Fine Arts; fig. 3).[16] This leaves no. 92, 'Altro di tela di tre palmi Paese con tre, o 4 figure di Monsù/ Pusino', and no. 96, 'Altro di tre palmi con paese con due figure del Pusino' as the probable candidates for the National Gallery paintings, as Standring proposed.[17] Although three *palmi* may somewhat understate the size of NG 6390 and 6391,[18] no. 96 (a landscape with two figures) would seem to fit NG 6390, leaving no. 92 (a landscape with three or four figures) to be identified with NG 6391. The fact that no. 92 was not found by the compiler of Cosimo Antonio's inventory when he died in 1740 would fit in with it being identical to NG 6391, which had been given to Maria Laura Boccapaduli the previous year;[19] and indeed neither no. 92 nor no. 96 can be found in the 1740 inventory.

Assuming that NG 6390 and 6391 can be identified in the 1689 inventory among the five undifferentiated 'paesi

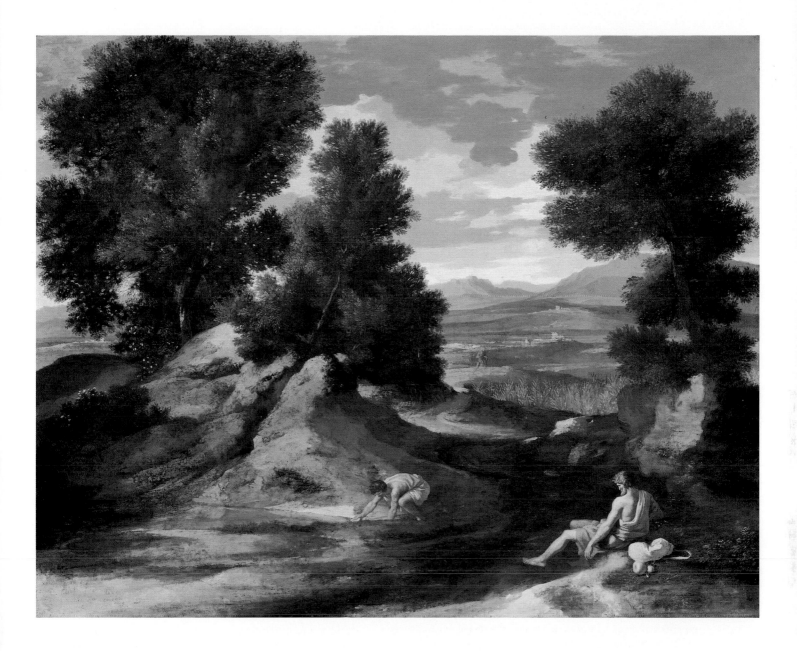

Fig. 1 Detail of label on the back of NG 6390.

Fig. 2 Detail of label on the back of NG 6391.

e figurine', nothing in that inventory describes them as pendants, although they presumably hung close together. Certainly, Palumbus Perellus, the notary who prepared the 1689 inventory,[20] did not recognise them as such, although he described another pair of paintings in the Dal Pozzo palazzo as pendants, or as otherwise grouped.[21] From the point of view of describing the hang, the 1695 inventory, prepared by the notary Marius Clarici,[22] is more helpful. It is clear that nos 92 and 96 – the landscapes by Poussin with which NG 6391 and 6390 have been identified – hung on the same wall. But it is equally clear that they did not hang next to each other. Nor were they hung in any aesthetic relationship to each other, because the paintings in the inventory numbered 93, 94 and 95 were of very different sizes.[23] So although the landscape now in Montreal (no. 94 of the 1695 inventory) is close in size to the London landscapes, of the other intervening pictures no. 93 was nearly twice as large as no. 95. Indeed, far from no. 96 being paired with no. 92, Clarici seems to have paired it with no. 97, as he described the latter as 'Altro Compagno con Paese con un' S. Girolamo del Pusino'.[24] The 1689 and 1695 inventories do not, therefore, support the assertion that NG 6390 and 6391 were either painted or hung as pendants, nor the recently made suggestion that they hung in the Dal Pozzo collection on either side of a painting by Jean Lemaire, although other landscapes by Poussin may well have done so.[25]

Both the 1689 and the 1695 inventories listed the contents of the Dal Pozzo palazzo on the via dei Chiavari, Rome. Tessin's account of the collection there, written in 1687–8, refers to no painting which can be identified as NG 6390 or NG 6391.[26] De Cotte's account, written before 1690, besides the large *Landscape with Pyramus and Thisbe*, now in Frankfurt, merely mentions 'neuf autres petits païsages'.[27] The next known list of paintings in the Dal Pozzo collection is that prepared in 1715 by Giuseppe Ghezzi, but by that time the pictures were no longer in the palazzo on the via dei Chiavari,[28] and that they had undergone a radical rearrangement is clear from the fact that the *Seven Sacraments* no longer hung together in the same room.[29] Hence, although Ghezzi does list pairs of paintings which could be NG 6390 and 6391, this need not be evidence that they were then hung, let alone originally conceived, as pendants.[30] A similar difficulty applies to an inventory taken in 1729 of the paintings in the house of the marchesa Anna Theresa Ginnetti Lancellotti on behalf of her son, Cosimo Antonio dal Pozzo.[31] The result is that NG 6390 and 6391 cannot with any certainty be regarded as having been treated as a pair before 1739, when they were given to Maria Laura Boccapaduli by her father, Cosimo Antonio dal Pozzo. Even then it is not clear that they continued to be so treated after Maria Laura acquired the rest of the collection (presumably including the Montreal landscape) in 1743.[32]

The best case that could be made for NG 6390 and 6391 being a pair would be to put *Landscape with Travellers Resting* (NG 6391) to the left of *Landscape with a Man scooping Water from a Stream* (NG 6390), then the foreground figures in each picture would seem to relate to each other by pose, some of the lights and darks of the adjacent edges towards the bottom of both paintings would seem to match, and the views into the distance would be towards the left and right respectively, so providing some balance between the pictures. But it is also apparent from such a juxtaposition that the emphatic closing off of the composition at the left of the *Travellers Resting* is not matched at the right of the *Man scooping Water* and that, as has been pointed out, the pictures do not share a common horizon line as would be usual with pendants.[33] Nor can any particularly convincing case be made for treating either landscape as a pendant to the Montreal picture. Rather, the National Gallery pictures would seem to be independent compositions.

If NG 6390 and 6391 are not conceptual pendants,[34] then they are less likely to have been painted at the same date.[35] The former division of opinion as to whether the National Gallery pictures were painted before or after Poussin's trip to Paris of 1640–2 has been effectively resolved by the discovery that his *Landscape with Saint Matthew* (Staatliche Museen zu Berlin, Gemäldegalerie) and *Landscape with Saint John on Patmos* (The Art Institute of Chicago) were both finished by October 1640. Consequently, both NG 6390 and NG 6391 must on stylistic grounds have been painted before the Paris trip.[36] The Berlin and Chicago landscapes are undoubtedly more accomplished than the two London pictures, which must therefore have preceded them. Although Poussin seems to have been painting landscapes as early as 1629,[37] NG 6390 and 6391 contain none of the obviously Venetian influences apparent in some of his work up to about 1635, nor the coppery tonalities prevalent around 1633–4. NG 6390 shares some of the same awkwardness of landscape construction and lack of integration of figures and landscape as the *Ordination* (Grantham, Belvoir Castle, The Trustees of the Rutland Trust) from the first series of *Sacraments*. The treatment of the foliage and the foreground in NG 6390 bears some resemblance to that of the *Ordination*. However, the *Ordination* cannot be dated more securely than 1636–40. Some of these shared characteristics are also apparent in the admittedly more ambitious Louvre *Manna*, certainly finished by March 1639, and presumably started in 1638 or even 1637.[38] In addition, the figures in NG 6390 seem to come from the same stable, as it were, as those in the *Manna*, whereas the tonality of the sky is close to that of *The Triumph of Pan*[39] painted by 1636. A date of *c*.1637 is therefore proposed for NG 6390.[40]

The more spatially convincing landscape of NG 6391, as well as the more successful integration of the figures within it, suggests a slightly later date for this painting than for NG 6390. The same rationality seems to be at work here as is apparent in a picture of a quite different type, the Louvre *Shepherds of Arcadia*, generally dated to 1638–9,[41] and it is this date bracket which is here assigned to NG 6391.[42]

General References
Blunt 1966, 213; Thuillier 1974, 133; Wild 1980, 113; Wright 1985a, 148; Wright 1985b, pp. 135–6; Mérot 1990, 233; Thuillier 1994, 133.

Fig. 3 *Man pursued by a Snake*, *c*.1638–9? Oil on canvas, 65 × 76 cm. Montreal, Museum of Fine Arts. Purchase, special replacement fund.

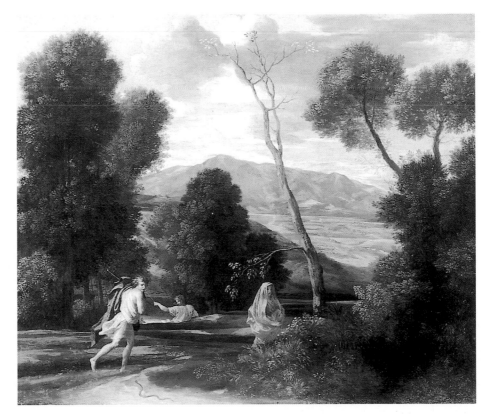

1. Standring 1988, pp. 608–26, at pp. 620–1 and p. 624, n. 84.

2. Blunt 1945, pp. 186–8. Dropmore House was built shortly after 1792 with additions *c.*1810: see N. Pevsner, *The Buildings of England. Buckinghamshire*, Harmondsworth 1960, p. 112.

3. Blunt 1945, pp. 186–8. NG 6390 and 6391 were sold together as 'N. Poussin. "A landscape with two classical figures at a stream" and the companion picture, "A landscape with figures at a stream". Canvases 24″ × 30″'.

4. Thuillier 1974, no. 133.

5. See R.-P. 213.

6. See R.-P. 289. It was Blunt who first proposed a connection between NG 6390 and the drawing now in the Ashmolean: Friedländer and Blunt, V, p. 125.

7. Blunt 1967, p. 283. Blunt did, of course, then believe the painting to have been executed *c.*1643–4.

8. Although the older man wears the *duplex pannum* (single cloak folded double) associated with Diogenes, he has it draped over his right shoulder rather than the left. See C. Dempsey, 'The Greek Style and the Prehistory of Neoclassicism', *Pietro Testa 1612–1650. Prints and Drawings*, Philadelphia 1988, pp. xxxvii–lxv.

9. Kurt von Fritz, 'Diogenes (2)', *The Oxford Classical Dictionary*, ed. N.G.L. Hammond and H.H. Scullard, 2nd edn, Oxford 1970, p. 348.

10. On this, see Blunt 1967, pp. 160ff. and *passim*.

11. Blunt 1945, pp. 186–8. The label on the back of NG 6390 reads: '.na Veduta ò Sia Bosc.../ del Pusino regalata d./ Sigor. Commre. del../..alla sig.ra Lau... Pozzo Bocca... dì 8 Agos...'. The label is sealed with three circular seals with a crown on top and a crab and eagle underneath. At the bottom left of the stretcher is another seal of a winged female figure, and in black paint (?) on the bottom stretcher are inscribed the words 'Nicolo Pusino' in an old hand.

Similar seals and a similar inscription are on the back of the stretcher of NG 6391, which also has a more complete version of the other's label, namely: 'Una Veduta o Sia Boscare/. cia del Pusino regalata/... Sig... Comere. del Pozzo/alla Sigra. Laura del Pozzo Boccapaduli sotto/ il dì 8 Agosto 1739.' My reading of these labels differs slightly from that published by Blunt.

12. See Blunt 1945, p. 186. For the line of succession from Cassiano and Carlo Antonio dal Pozzo to Maria Laura Boccapaduli and thence to her son Giuseppe, see Sparti 1992, pp. 28ff. and pp. 166–7.

13. Brejon de Lavergnée 1973, pp. 79–96 at pp. 82, 87–8. The relevant part of the inventory is dated 11 October 1689 and the paintings in question were in the 'Stanza appresso [Appartam.to di mezzo/stanza intitolata de Sagramenti]'. A fuller version of the inventory was published by Donatella L. Sparti in 'The dal Pozzo collection again: the inventories of 1689 and 1695 and the family Archive', *BM*, 132, 1990, pp. 551–70, and again by her in Sparti 1992.

14. Brejon de Lavergnée 1973, at pp. 83 and 87–8. The inventory is dated 5–7 March 1695 and the paintings in question were in a large room which contained numerous pictures by Poussin. A fuller version of the inventory was published in Sparti 1990, cited in note 13, and Sparti 1992.

15. Jo Kirby has kindly advised me that the metric equivalent of the *palmo Romano* from 1525 was 22.3 cm, but that in the cloth trade the *palmo* was 21.2 cm, whereas it was 24.9 cm for other merchants. Were the last unit of measure that adopted for the 1695 inventory, three *palmi* would be equivalent to 74.7 cm, but it seems more likely that the *palmo Romano* was adopted in the measurement of paintings, since Félibien states in a marginal note in his life of Poussin that 'La Palme de Rome dont on se sert à present est de 8. Pouces 3. lig.' (see Félibien, *Entretiens 1685*, p. 258). The metric equivalent of three *palmi* would then be marginally less than 67 cm.

16. Standring 1988, at pp. 621–2.

17. Standring 1988.

18. If referring to width and depending on which type of *palmo* was adopted as the unit of measurement – see note 15 above.

19. Standring 1988, pp. 620–1, and see note 13 above.

20. Sparti 1990, cited in note 13, p. 556.

21. For example, in the same room were noted 'Due quadri compagni, uno rappresentante la Samaritana e l'altro Rachele tele d'Imperatore per traverso cornici dorate si credono di Posino'.

22. Sparti 1990, cited in note 13, p. 561.

23. '93. Altro di 7, e 9 rappresentante una tempesta./94. Altro di tre palmi.../95. Altro di tela di 4 palmi...'

24. The painting has not been identified.

25. The suggestion was made by D.L. Sparti in 'Criteri museografici nella collezione dal Pozzo alla luce di documentazione inedita', *Cassiano dal Pozzo. Atti del Seminario Internazionale di Studi*, ed. F. Solinas, Rome 1989, pp. 221–40, at p. 232 and fig. 8. Crucial for her assertion is a letter written by Cassiano dal Pozzo to Agnolo Galli describing his proposed picture hang. The letter was, however, written in 1629, six years before the earliest likely date for NG 6390 and 6391. See also Sparti 1992, pp. 106–7 and figs 58–61 (where figs 59 and 60 have been transposed). Cassiano's letter of 17 November 1629 to Galli was first published by Sheila Rinehart in 'Cassiano dal Pozzo (1588–1657). Some Unknown Letters', *Italian Studies*, vol. XVI, 1961, pp. 35–59, and can also be found in Cristina de Benedictis, *Per la Storia del Collezionismo Italiano*, Florence 1995, p. 266 (although there said to have been written on 1 September 1629). It has recently been suggested that NG 6390 and 6391 represent a dawn and a sunset: M. Fagiolo dell'Arco,

Jean Lemaire pittore antiquario, Rome 1996, pp. 126, 129. The look of the pictures does not, however, support this.

26. Sheila Somers Rinehart, 'Poussin et la famille Dal Pozzo', *Poussin Colloque 1958*, vol. I, pp. 21–4; and Brejon de Lavergnée 1973, at p. 92. Tessin's account confirms that the Dal Pozzo Poussins were in two adjacent rooms, as shown by the 1689 inventory, although he exaggerates the number of pictures by Poussin in each: see Osvald Siren, *Nicodemus Tessin D.Y: S. Studieresor*, Stockholm 1914, p. 187.

27. For de Cotte's account, see Ph. de Chennevières-Pointel, *Recherches sur la vie et les ouvrages de quelques peintres provinciaux de l'ancienne France*, 4 vols, Paris 1847–62, vol. 3 (1854), pp. 152ff, and Appendix 2 to the article by F. Haskell and S. Rinehart, 'The Dal Pozzo Collection, Some New Evidence', *BM*, 102, 1960, pp. 318–26. For the date of de Cotte's account, see T. Bertin-Mourot, 'Notes et documents', *Société Poussin. Premier Cahier*, June 1947, p. 73, n. 4.

28. Haskell and Rinehart, cited in note 27.

29. Haskell and Rinehart, cited in note 27, pp. 320, 324.

30. Brejon de Lavergnée 1973, at p. 92, identified from Ghezzi's list the following as possibly among the paintings described in Carlo Antonio's inventory of 1689 as 'Cinque quadri in tela poco più grandi di testa con paesi e fi/gurine cornice dorate si credono del Posino': '33–34 Due Paesi con figure da 4 pal. di Pusino', '48 Altro Paese in tela da testa sotto al sud.o del med. o'; '139 Paese da testa piccola di Pussino'. Other possibilities are: '7–8 Li due Paese laterali à d.o quadro da 4 pal. di Posino'; '80–81 Due laterali di sopra del med.o di Pusino'; '85–86 Li due laterali alla sud. a di Pusino'; and '139 Paese da testa piccola di Pussino'.

31. Extracts from the 1729 inventory were first published by Standring 1988. It has been transcribed in Sparti 1992, pp. 234ff. The Marchesa was then living in a palazzo near S. Andrea della Valle, whereas the Ghezzi inventory of 1715 (see note 30) lists paintings in a palazzo on the Strada Paolina. The Via de' Chiavari, where Cassiano and Carlo Antonio dal Pozzo lived, leads directly to S. Andrea della Valle, so the Marchesa may have been living in the old Palazzo Dal Pozzo. The Strada Paolina, however, now the Via del Babuino (see Stefano Borsi, *Roma di Urbano VIII. La pianta di Giovanni Maggi, 1625*, Rome 1990, pp. 45, 89), is some two kilometres away, so the paintings appear to have moved at least twice between 1695 and 1727.

The candidates for NG 6390 and/or 6391 in the 1727 inventory (unnumbered) are: '[c.6r.] Un altra [quadro in tela di palmi trè per traverso fuori di misura] con Paese, e due figure di Nicolò Pusino con cornice dorata... [c.6v.] Due Quadri compagni in tela di palmi quattro per traverso rappresentanti due Paesi, e figure di Nicolò Pusino con cornici dorate...[c. 10 v] Un Quadro da testa per traverso rappresentante un Paese con alcune figure del Pusini cornice dorata...[c.11 r.] Un altro da testa grande per traverso con Paese,

e figure del Pusini, cornice dorata...[c. 12 r.] Un Quadro da testa per traverso con Paese, e figure di Nicolò Pusino cornice dorata. Un Quadro da testa per traverso, che rappresenta un Paese con figure di Nicolò Pusino cornice dorata.' The last two paintings were apparently separated by only one other, an octagonal picture of a Magdalen three *palmi* high, and so may have been hung as pendants.

32. Among the paintings bought in 1779 by Gavin Hamilton from Giuseppe Boccapaduli, Maria Laura's son, was 'un paese...con figurine, restaurato dal Michelini' and 'altri due paesi piccoli...parim.e con figurine'. Even if the painting restored by Michelini (d.1756) is the Montreal picture rather than one of the London ones, it does not follow that the London pictures were treated as a pair in the period 1743–79.

33. R. Verdi in Edinburgh 1990, p. 66, who also suggests as a reason for the differences between the two pictures 'the artist's determination to create two contrasting and independent compositions, together with the willingness to improve upon one landscape when devising the other' (p. 67).

34. The assumption is made, for example, in Blunt 1966 (nos 213, 214) and in Thuillier 1974 (nos 132, 133).

35. They could have been painted a year or two apart even if they were pendants.

36. L. Barroero, 'Nuove acquisizioni per la cronologia di Poussin', *Bollettino d'Arte*, LXIV, 4, 1979, pp. 69–74. For a summary of the dates proposed by various authors for NG 6390 and 6391, see H. Wine and O. Koester, *Fransk Guldalder. Poussin og Claude og maleriet i det 17 århundredes Frankrig*, Copenhagen 1992, p. 179. Thuillier has revised his dating of the two paintings to *c.*1637–8? on the basis of Barroero's article: Thuillier 1994, no. 133. Mahon had proposed the dates of 1638–9 for both landscapes in 'Réflexions sur les paysages de Poussin', *Art de France*, 1961, pp. 120. For the Chicago painting, see S. Wise and M. Warner, *French and British Paintings from 1600 to 1800 in The Art Institute of Chicago*, Chicago 1996, pp. 117–24.

37. See note 25 above.

38. For the dating of the Louvre *Manna*, see Paris 1994–5, no. 78.

39. As kindly pointed out to me by Richard Verdi in a note proposing 1635–6 as the date of NG 6390. Hugh Brigstocke has suggested 1635–6 for NG 6390 by comparison with the *Triumph of Bacchus* in Kansas City.

40. The difference in quality between NG 6390 and NG 6391 caused Denys Sutton tentatively to attribute the former to Dughet: 'The Classical Ideal – An Exhibition at Bologna', *Apollo*, 104, 1962, p. 618, n. 2.

41. See P. Rosenberg in Paris 1994, no. 93 (where dated 1638), and Thuillier 1994, no. 137 (where dated 1638–9), for the Louvre's *Shepherds in Arcadia*.

42. I had proposed slightly later dates for both National Gallery pictures in Wine and Koester, cited in note 36, p. 179, namely 1638 for NG 6390 and 1639–40 for NG 6391.

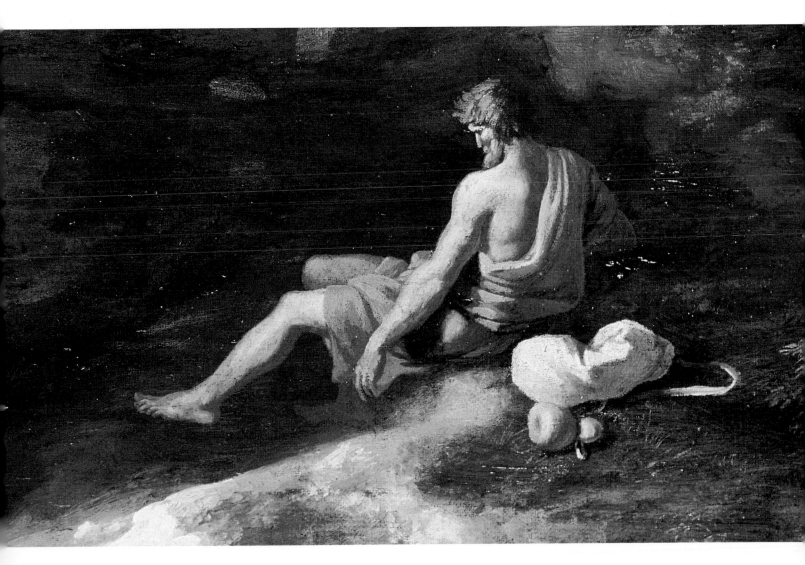

Landscape with a Man scooping Water from a Stream (NG 6390), detail.

NG 6391
Landscape with Travellers Resting

*c.*1638–9
Oil on canvas, 63.0 × 77.8 cm

Provenance
The provenance is the same as that of NG 6390; that painting and NG 6391 were treated as a pair after they left the Boccapaduli collection.

Exhibitions
London 1949–50, Royal Academy, *Landscape into French Art* (30 or 32); Bologna 1962, Palazzo dell'Archiginnasio, *L'Ideale Classico del Seicento in Italia e la Pittura di Paesaggio* (65); Edinburgh 1990, National Gallery of Scotland, *Cézanne and Poussin: The Classical Vision of Landscape* (2); Copenhagen 1992 (19).

Related Works
NG 6390 has been treated as a pendant. See discussion under that entry.
DRAWING
A drawing in the Ashmolean Museum, Oxford (R.-P. 289), was connected by Blunt with both NG 6390 and NG 6391,[1] but for the reasons given under Related Works: Drawings in the entry for NG 6390, it seems unlikely that they are related.

Technical Notes
The condition is good, although there is a little wear and there are some small holes at top right and in the centre of the landscape. The support is a plain medium-weight canvas, which has been lined, possibly during the eighteenth century. The stretcher, possibly of poplar, is fixed and may be the original.

 The ground is red in colour and, to judge from the X-radiograph, may be a single ground, rather than the double ground (lower ground reddish, upper greyish) often found in paintings by Poussin. The paint has become slightly more transparent with age. The tree at the left was painted over an area left in reserve. There are defects in the weave of the canvas not apparent in NG 6390. For an illustration and the text of the label on the back, see p. 344, fig. 2, and p. 346, note 11.

This painting has no known literary source. See the entry for NG 6390 for the relationship between the two paintings.

General References
Blunt 1966, 214; Thuillier 1974, 132; Wild 1980, 112; Wright 1985a, 147; Wright 1985b, p. 136; Mérot 1990, 234; Thuillier 1994, 134.

NOTE
1. Blunt 1964, pp. 58–75 at p. 64, where more particularly connected with NG 6390.

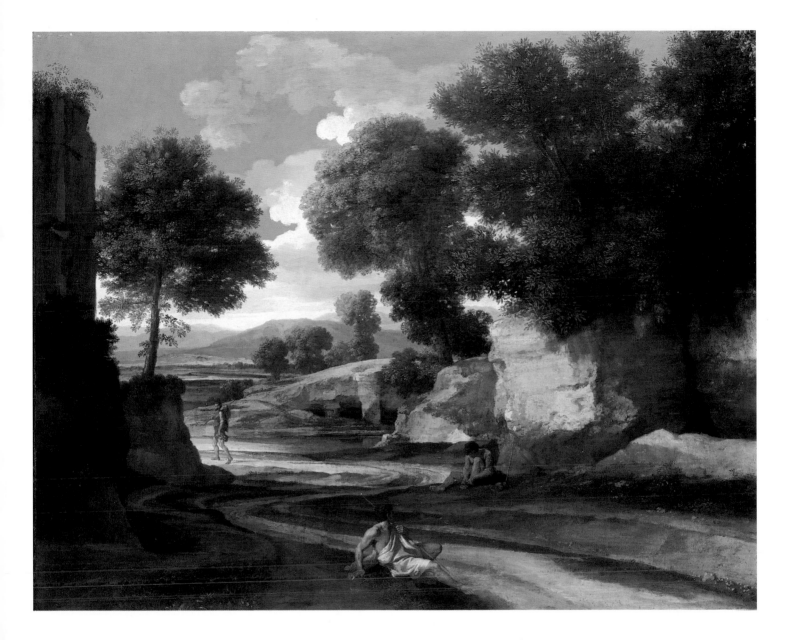

NG 6477

The Triumph of Pan

1636
Oil on canvas, 135.9 × 146 cm

Provenance

Painted for Armand-Jean du Plessis, cardinal de Richelieu (1585–1642), probably by May 1636 and delivered to his château at Richelieu for installation in the Cabinet du Roi;[1] replaced by a copy (now in the Musée des Beaux-Arts, Tours, see below) possibly after the death of Armand-Jean de Wignerod du Plessis, duc de Richelieu (1629–1715), but evidently by 1741, when NG 6477 itself was seen in London by Vertue with its companion, *The Triumph of Bacchus* (Kansas City, Nelson-Atkins Museum);[2] sold at Samuel Paris's sale, 1741/2 (lot 49, £252 to Peter Delmé);[3] seen at Peter Delmé's house in Grosvenor Square, London, in 1743 by Vertue;[4] Delmé sale, Christie's, 13 February 1790 (lot 62, £950 5s. to Rupile(?) for John, 2nd Earl of Ashburnham (1724–1812) of Ashburnham Place, near Battle, Sussex, and Dover Street, London);[5] noted by Neale in the drawing room at Ashburnham Place;[6] Bertram, 4th Earl of Ashburnham (1797–1878) sale, Christie & Manson, 20 July 1850 (lot 64, £1239 to Hume for James Morrison); seen in the Morrison collection at Basildon Park, Berkshire, in 1856–7;[7] by descent to the Trustees of the Walter Morrison Pictures Settlement at Sudeley Castle, Gloucestershire, from whom purchased in 1982 with help from the NHMF and the NACF.[8]

Exhibitions

London 1882, RA, *Exhibition of Works by the Old Masters and by Deceased Masters of the British School* (141) (where wrongly said to have been painted for the duc de Montmorenci); London 1914–15, Grosvenor Gallery, *III National Loan Exhibition. Pictures from the Basildon Park and Fonthill Collections* (3); London 1938, RA, *Exhibition of 17th Century Art in Europe* (331); Paris 1960, Louvre, *Nicolas Poussin* (45); Edinburgh 1981, *Nicolas Poussin. Sacraments and Bacchanals* (18); London 1989, NG, *The Artist's Eye: Bridget Riley* (5); Copenhagen 1992 (17); London 1995, RA, *Nicolas Poussin, 1594–1665* (29); London 1997, Christie's, *Treasures for Everyone: Saved by the National Art Collections Fund* (no catalogue).

Related Works

PAINTINGS
(1) Paul Fréart de Chantelou showed his copy to Bernini in 1665.[9] It was in his family until at least 1694;[10]
(2) The copy in the Musée des Beaux-Arts, Tours (inv. no. 795.1.3; 162 × 142 cm), was confiscated in the years 1790–4 from the château de Richelieu, where it had replaced the original, presumably by 1741 (see Provenance);[11]
(3) A copy in the Ashburnham collection was possibly the painting which Reynolds called *The Sacrifice to Silenus* in his Discourse of 10 December 1776[12] and was in that collection until 1850, when sold at the same sale as NG 6477 (lot 11, 19 guineas to Waters). It may be (7) below;

(4) A copy once in the Musée des Beaux-Arts, Béziers (139 × 145 cm), and traditionally attributed to Jacques Stella (1596–1657);[13]
(5) A copy has been in the Musée des Beaux-Arts, Rouen (inv. no. 811-9; 145 × 147 cm), since 1809;[14]
(6) A copy is in the Victoria and Albert Museum, London, presented in 1867 by Captain Hans Busk (inv. no. 55–1867; 143 × 145 cm);[15]
(7) A good old copy, until recently considered autograph, is in the Louvre (inv. no. R.F. 1941.21; 138 × 157 cm). It was bequeathed by Paul Jamot. The provenance can be traced back only to 1910 and it may be the same as (3) above. This version was copied by Picasso in his studio in 1944,[16] presumably from a photographic reproduction;[17]
(8) A copy (142 × 147 cm) in the Ecole Nationale Supérieure des Beaux-Arts, Paris, apparently given to the institution c.1850 by the French Government;
(9) A copy (74 × 61 cm) described as eighteenth century was offered at auction (Millon & Robert, Paris, 27 November 1995, lot 4);
(10) A seventeenth(?)-century copy with variants in the left third (oil on canvas, 75 × 64 cm), once in the collection of Doctor Lerat, is in a Paris private collection. Photograph in NG dossier. An X-radiograph of this work reveals a portrait head of a man underneath.

In *La Peinture Parlante* (Toulouse 1653) Hilaire Pader describes in verse what seems to be a composite version of the Richelieu Bacchanals, but whether from personal knowledge or not is unclear, or he may be describing another painting by Poussin, now lost.[18]

DRAWINGS[19]
The drawings listed below are those accepted as autograph in Rosenberg and Prat (R.-P.). They are in a possible chronological order of execution, for the discussion of which see pp. 355–8.[20]
(1) Bayonne, Musée Bonnat, inv. no. A1 1671 (R.-P. 85) (fig. 7);
(2) Windsor, Royal Library, inv. no. RL 11902 recto (R.-P. 87) (fig. 8);
(3) Florence, Uffizi, Gabinetto dei Disegni, inv. no. 905e, recto (R.-P. 86) (fig. 9);
(4) Florence, Uffizi, Gabinetto dei Disegni, inv. no. 905e, verso (R.-P. 86 v) (fig. 10);
(5) New York, Metropolitan Museum of Art, inv. no. 1998.225 (R.-P. 93) (fig. 11);
(6) Bayonne, Musée Bonnat, inv. no. A1 1672 (R.-P. 84) (fig. 12);
(7) Bayonne, Musée Bonnat, inv. no. A1 1672 verso (R.-P. 84 verso) (fig. 13);
(8) and (10) Windsor, Royal Library, inv. no. RL 11905 verso (R.-P. 83 verso), a sheet on which Poussin made two drawings, here numbered separately (figs 14 and 15);
(9) Bayonne, Musée Bonnat, inv. no. A1 1669 (R.-P. 90) (fig. 16);
(11) Windsor, Royal Library, inv. no. RL 11995 (R.-P. 94) (fig. 17).

Rosenberg and Prat 1994 attribute to Nicolas Chaperon (1612–56) a drawing in Edinburgh which has compositional

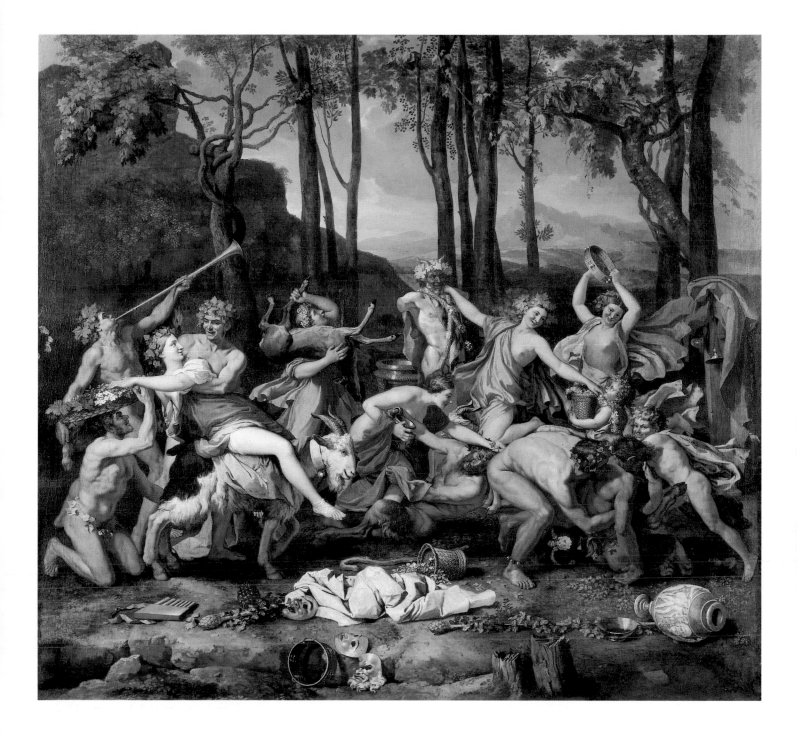

similarities to *The Triumph of Pan* (R.-P. R378r), and they record the following drawings of the subject of NG 6477 in eighteenth-century sales, none of which they relate to any of those above: anon. sale, Paris, 21 November 1763, lot 192; Cayeux sale, Paris, 11 December 1769, lot 142; [Lempereur] sale, Paris, 24 May 1773 and days following, lot 450.[21]

A drawn copy of NG 6477 by 'Mr. Edwards' was no. 11 in *Mr. Boydell's Exhibition of Drawings from many of the Most Capital Pictures in England* at Mr Ford's Great Room, Haymarket, London [1770], where described as 'A Sacrifice to Pan, In the Collection of Peter Delmé, Esq.'.

Technical Notes

The painting, which was last cleaned and restored for the 1981 Edinburgh exhibition – shortly before its acquisition by the National Gallery – is in good condition, although there is some wear on the top of the plain-weave canvas threads, a small repaired tear in the bottom centre, retouchings down both edges, and some blanching of the greens to the right of Pan. The painting is on two pieces of canvas joined horizontally across the centre. The canvas was lined, probably early in the nineteenth century. The number 53 written on the back of the lining cannot be connected with any known inventory or auction sale. There is a double ground typical of Poussin, in this case a lower reddish-brown ground and an upper buff-coloured one. A pentimento is visible in the line of the left leg of the faun at the extreme right. The trees have been painted over areas left in reserve. To the left of the head of Pan there is an unexplained horizontal line of paint which then goes down at an angle. The X-radiograph (fig. 1) shows a shape at top centre which could be a bull (evidence perhaps of another treatment of *The Adoration of the Golden Calf*), but it is difficult to read. Pigment analysis shows a similar composition to that of the *The Triumph of Silenus* (NG 42), for which see the Technical Notes of that entry. The paint medium is linseed oil.[22]

Fig. 1 X-radiograph.

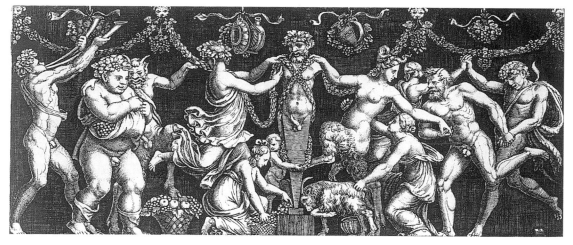

Fig. 2 Master of
the Die after Giulio
Romano, *A Sacrifice
to Priapus, c.*1532.
Engraving,
15.7 × 28.4 cm.
London,
British Museum,
Department of Prints
and Drawings.

lthough the picture is called *The Triumph of Pan*, the term
at the centre of the composition may equally be Priapus,
since both were described by ancient authors as red or (in the
case of Priapus) red-faced,[23] and their mythological functions
overlapped, both being associated with fertility and pastoral
life. The bent stick and the pipes refer to Pan, but the garlands
of flowers around the term suggest Priapus, as does the
placing of drapery over what would be his most clearly identify-
ing feature, a phallus, significantly shown clearly in one of the
preparatory drawings at Bayonne (fig. 12). But for the lack of
horns, it might be possible to identify the seated satyr at the
right as Pan by virtue of his wreath of pine leaves[24] – over-
come by his love of riotous assembly, he has discarded his
stick and pipes.[25] Whether Pan or Priapus, the term's triumph
has no known literary source, although there are numerous
references by ancient authors to the worship of both deities,
and to their involvement in frolicsome bacchic rites. Philo-
stratus describes a painting of Bacchus, god of wine, mentor
of Pan and father of Priapus, as untypical because flowered
garments, thyrsi and fawn skins were not included, nor were
bacchantes clashing cymbals or satyrs playing the flute.[26]
Other objects discarded in the foreground are associated with
Pan or Bacchus: from left to right the pipes (syrinx) which Pan
is said to have invented and played; the staff tipped by a pine
cone and wrapped with ivy leaves (thyrsus), of which there is
another right of centre, which was carried in bacchic rights;
the three masks, tragic, comic and satiric, referring to the role
of Bacchus as protector of theatres;[27] cymbals, tambourines
and a trumpet, all symbolic of Pan's love of riotous noise but
also associated with bacchic revelries;[28] the bent shepherd's
crook (lagobolon) referring to Pan as god of shepherds and
flocks (which Priapus protected also) and as god of the hunt;
and a wine jar and saucer of wine. The goat may refer to the
sacrificial role of that animal in bacchic rites (see NG 39,
p. 278) and to its association with lust; the fawn being carried
upside down is presumably being readied for sacrifice, but
may also be intended to recall the wearing of fawn skins by
the maenads during their ecstasies inspired by Bacchus. The
mountainous background is perhaps intended to represent
Arcadia, of which Pan was a native god.[29]

Visual Sources

As Blunt pointed out,[30] the composition is based on an en-
graving of *A Sacrifice to Priapus* of *c.*1532 by the Master of the
Die after Giulio Romano (fig. 2), which is in turn a reprise of
an ancient sarcophagus then in the Villa Doria-Pamphilj and
drawn for the Museo Cartaceo (Paper Museum) of Poussin's
patron, Cassiano dal Pozzo.[31] Although it seems unlikely that
Poussin had direct knowledge of the five pictures bought
by Richelieu from the Duke of Mantua for the château de
Richelieu, and installed in the Cabinet du Roi there with
NG 6477 (and other paintings by Poussin), there is sufficient
correspondence between their dimensions and the scale of
their figures and those of Poussin's paintings to suggest that
he was aware of their overall appearance; one possibility,
among others, is that he may have looked at another series
of Renaissance studiolo paintings then in Rome which had
been executed by Titian and Bellini for Alfonso d'Este,
Isabella's brother.[32] There are numerous references in the
Poussin Bacchanals to motifs in Bellini's *Feast of the Gods* and
Titian's *The Andrians*. Some are referred to in the entry to
NG 42 (see pp. 376–83). That specific to the present painting
is the screen of trees derived from Bellini's picture. The final
composition, as has been frequently noted, is highly formal,
its insistent planarity perhaps reflecting Poussin's perception
of Mantegna, and the complex surface pattern possibly indi-
cating a continuing influence on Poussin of Mannerism.[33]
Although the screen of trees is evidently inspired by *The Feast
of the Gods*, the arrangement of trees in three groups and
largely in the same plane recalls the columns in Poussin's
earlier *Triumph of David* (Dulwich Picture Gallery) and the
groups of trees in his Raphaelesque *Apollo and the Muses*
(Madrid, Prado). The painting's theme would have recalled
Titian, while the modelling of the figures seems inspired by
Annibale Carracci.

A number of motifs in NG 6477 are derived from ancient
reliefs of bacchic ceremonies and the ritual objects associated
with them, which the artist studied both directly and from en-
gravings by Renaissance artists.[34] Blunt proposed that Poussin
probably knew an engraved illustration of *The Worship of
Priapus* (fig. 3), in which a woman at the right carries on her

Dansans au son des voix dans un val de
 Parnasse.
Apollon est assis, qui d'un juste compas
Marque avec son archet la cadence à leurs
 pas.
Là le cirque Romain ses colonnes estale,
Où Tite respand l'or de sa main libérale.
Voyez le peuple actif, les femmes, les
 enfans,
Pour le désir de l'or esmeus et s'estouffans.
Mais Tite, nul icy n'admire tes largesses,
Où l'Art bien plus que toy nous respand de
 richesses.

58. H.M. Van den Berg, 'Willem Schellinks en Lambert Doomer in Frankrijk', *Oudheidkundig Jaarboek*, XI, 1942, pp. 1–31 at p. 17 ('Het apartement des koninks...van Poessyn, 3 heelyke en vercierlyke thriumfe...').

59. See note 1. Daillon left Rome on 5 June 1636: J.-C. Boyer, 'Un amateur méconnu de Poussin: Gaspard de Daillon', *Poussin Colloque 1996*, pp. 697–717 at p. 708, n. 11.

60. Thuillier 1994, p. 155.

61. See note 1.

62. Blunt 1966, p. 95; Verdi 1995, p. 202. It was only after the 1981 Edinburgh exhibition (see Exhibitions above) that NG 6477 was universally accepted as autograph.

63. M. Laurain-Portemer, 'Mazarin militant de l'art baroque au temps de Richelieu (1634–1642)', *BSHAF*, 1976, pp. 65–100 at p. 81 and on p. 157. Regarding whether the third Bacchanal was delivered before or after the other two, Schnapper has suggested that Frangipani's phrase 'due quadri de' Baccanali, che il Poesino hà già forniti' shows that the two pictures were the start of the commission, and that the third and last picture must have followed the year after: Schnapper 1994, p. 231.

64. For the identification of Vignier, see Schloder 1985, pp. 115–27, p. 117, n. 10.

65. Benjamin Vignier, *Le Chasteau de Richelieu ou l'Histoire des dieux et des héros de l'antiquité*, Saumur 1676. The privilege for this book was granted in 1665, suggesting that it was written by then, since a book's manuscript had to be submitted and approved before a privilege was granted: H.J. Martin, *Livre, pouvoirs et société à Paris au XVIIᵉ siècle 1598–1701*, 2 vols, Geneva 1969, vol. 2, p. 691; B. Barbiche, 'Le régime de l'édition', *Histoire de l'édition française*, 4 vols, Paris 1982, vol. 1, *Le livre conquérant. Du Moyen Âge au milieu du XVIIe siècle*, pp. 367–77 at pp. 369, 372.

66. R. Lightbown, *Mantegna*, Oxford 1986, p. 442.

67. Schloder 1988, fig. 9. I am grateful to Professor Schloder for sending me a copy of his thesis.

68. Keazor 1998, has proposed (pp. 85–6) that the *Silenus* was hung above the chimney-piece on the south wall, at least before Stella's painting was placed there. Although it would thus have announced the room's theme, it would have been a very poor painting in terms of quality to take such a prominent position. Keazor argues that until Stella's painting arrived the chimney-piece would have been incomplete, unless the *Silenus* were

in place there. But, firstly, the latter may well in any event have arrived at the château after the *Pan* and the *Bacchus* (see NG 42), and, secondly, even in 1641 it was still expected that more pictures would be commissioned.

69. 'Dans l'autre face vis à vis de ce tableau [Costa's *Allegory*] il y en a un de Monsieur Poussin qui représente un Triomphe de Bacchus ...'

70. 'Description du Château de Richelieu par un anonyme du milieu du XVIIIe siècle', ed. Ch. de Grandmaison, *NAAF*, III, 1882, pp. 211–37 at pp. 222–4.

71. L-A. Bosseboeuf, *Histoire de Richelieu et des environs*, Tours 1890, pp. 341ff.

72. However, M. Montembault and J. Schloder have written: 'La plupart des historiens considèrent que la dispersion de la collection a commencé en 1727, mais les grands travaux faits au XVIIᵉ siècle par les héritiers du Cardinal dans les divers appartements ont dû modifier sensiblement l'arrangement de la collection. Souvent, d'ailleurs, les descriptions du château datant des années 1650–1670 citent de nouveaux tableaux à la place des anciens mentionnés dans des descriptions antérieures': *L'album Canini du Louvre et la collection d'antiques de Richelieu*, Paris 1988, p. 57, n. 183.

73. Ibid., p. 88, according to which the duc de Richelieu made the Appartement du Roi his own, installing a bathroom there and modifying the decor. His second wife, Elizabeth Sophie de Lorraine, Mlle de Guise, died in 1740 and he then returned to Paris to live in his hôtel in the rue Neuve Saint-Augustin: ibid., p. 89. This may have provided another occasion to sell paintings from the château de Richelieu.

74. P. Santucci, *Poussin, Tradizione Ermetica e Classicismo Gesuita*, Salerno 1985, pp. 27–8, according to whom the parallel with Christianity was based on the bacchic legend that 'il membro del dio ucciso, portato via in un cesto, divenne fonte di nuova vita'. The numerous baskets of flowers in NG 6477 may refer obliquely to this legend without Poussin having intended, or viewers of the picture having perceived, any parallel between it and Christian doctrine.

75. Dempsey 1965, pp. 338–43 at p. 341.

76. See Paris 1994, pp. 224–6, and Richard Verdi, *Nicolas Poussin 1594–1665*, London 1995, p. 205. That the Philadelphia picture was probably not one of the Richelieu Bacchanals was acknowledged by Dempsey soon after his 1965 article (Dempsey 1965, pp. 338–43). See his 'The textual sources of Poussin's Marine Venus in Philadelphia', *JWCI*, 29, 1966, pp. 438–42, at p. 442.

77. Dempsey 1960, pp. 219–49 at pp. 243–5. Dempsey's interpretation has been endorsed by Elizabeth Cropper – see, for example, her 'Virtue's Wintry Reward: Pietro Testa's Etchings of the Seasons', *JWCI*, 37, 1974, pp. 249–79, at p. 250.

78. For a discussion of the composition of Poussin's paintings as a signifier of meaning in relation to NG 6477, see Oskar Bätschmann, *Dialektik der Malerei von Nicolas Poussin*, Munich 1982, pp. 73–6, and *Nicolas*

Poussin. Dialectics of Painting, London 1990, pp. 64–6.

79. Bull 1995, pp. 5–11.

80. On the town of Richelieu and the cardinal's ambitions for it, see, for example, Louis Batiffol, *Autour de Richelieu*, Paris 1937, and Claude Mignot, 'Le Château et la ville de Richelieu en Poitou', *Richelieu et Le Monde de l'Esprit*, Paris 1985, pp. 67–74.

81. Keazor 1998, pp. 87–8.

82. Robin 1998, pp. 47, 66, 90 and *passim*. For an earlier interpretation of the *Triumph of Bacchus* as a political allegory – the triumphant resurrection of civilising imperial wisdom – see R.D. Meadows-Rogers, 'Procession and Return. Bacchus, Poussin, and the Conquest of Ancient Territory', *Athanor*, 9, 1990, pp. 25–35.

83. Vignier 1676, cited in note 65, p. 9.

84. Vignier 1676, cited in note 65, p. 21. For references to other busts and statues of Bacchus, see pp. 29, 32, 42–3 and 46.

85. Vignier 1676, cited in note 65, p. 9.

Savez-vous bien pourquoy ce Dieu/ Qui chasse la mélancolie,/ Estime si fort Richelieu?/ C'est qu'il s'y trouve une Folie./ Qui fut par la Sagesse introduite en ce lieu.

Les Habitans de Richelieu n'ont jamais temoigné plus de Sagesse qu'en plantant quantité de Vignes dans un lieu proche de la Ville qui étoit inculte, & qui s'appelle la Folie – le vin en est tres-bon & peut disputer l'avantage avec le plus excellent Bourguignon.

86. Vignier 1676, cited in note 65, p. 63: 'Que les vapeurs du vin causent d'étranges maux!/ Un homme en étant pris fait voir tous ses défauts, Il ne peut rien cacher de ce qu'il a dans l'ame;/ Et fait plus de bruit qu'un Lutin:/ Mais c'est bien pis quand une femme,/ Se laisse échauffer par le vin/ Puis qu'elle devient une infame,/ Et sans un grand hazard, une grande Putain.'

87. Waagen 1857, vol. 4, p. 304.

88. Letter of 27 February 1804 from William Buchanan in Edinburgh to his London agent, David Stewart: Brigstocke 1982a, pp. 153–4.

89. For example, Rosenberg (1982, pp. 376–80 at p. 379) wrote of NG 6477 and the Kansas City picture: 'Admittedly, both pictures are ungrateful in execution and composition. Admittedly, they strike us as less than seductive and seem to have been created as *tours de force* to impress Richelieu.' It was possibly with such words in mind that Brigstocke perceptively commented: 'The aesthetic and emotional self-sufficiency of the Richelieu *Bacchanals*, which deny the spectator any reassuring sense of human empathy, probably accounts for the persistent manner in which art historians have denied their artistic quality.' (*Art International*, vol. 26, September/October 1983, pp. 12–15 at p. 13.)

90. Although Blunt suggested studio participation in respect of NG 6477 in his review of the 1981 Edinburgh exhibition in *French Studies*, 36, 1982, pp. 327–9, and in 'French Seventeenth Century Painting: the

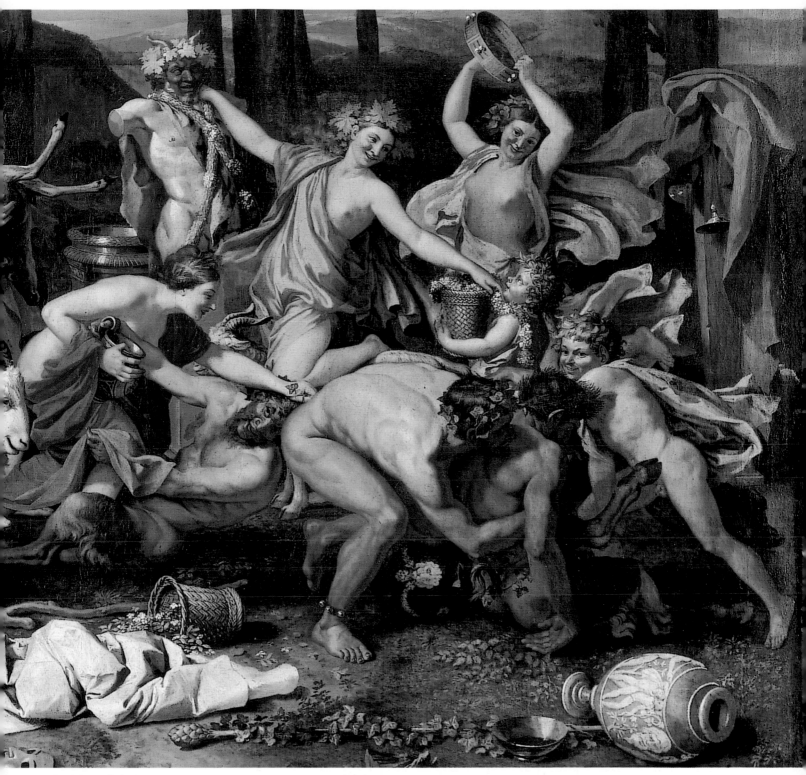

Fig. 20 Detail of NG 6477.

Literature of the Last Ten Years', *BM*, 124, 1982, pp. 705–11, at p. 707, Rosenberg (Rosenberg 1982, pp. 376–80 at p. 379) stated: 'Now that it is restored, the Morrison picture is demonstrably superior to the copy in the Louvre and reveals a quality as high as – although no higher than – the [Kansas City]

picture, which I have always believed authentic.' But even before the Edinburgh exhibition, NG 6477 had been exhibited as the autograph version in Paris in 1960, accepted by Mahon in 1962 (Mahon 1962a, p. 100, n. 290), and accepted by Wild in her catalogue raisonné published in 1980.

Thuillier was non-committal over the respective merits of NG 6477 and the Louvre copy in his 1974 catalogue raisonné, but has acknowledged NG 6477 as the only autograph version in his revised catalogue of 1994.

NG 6519
The Finding of Moses

1651
Oil on canvas, 115.7 × 175.3 cm.

Provenance

According to Félibien, painted in 1651 for Raynon (sic),[1] who has been identified as Bernardin Reynon (1613–86), a Lyon silk merchant;[2] acquired by the duc de Richelieu (1629–1715), great-nephew of cardinal de Richelieu, who exchanged it by 1662 for a landscape then attributed to Annibale Carracci in the collection of Louis-Henri Loménie de Brienne (1635–98);[3] sold by Loménie de Brienne to du Housset, chancellor to Monsieur (Philippe, duc d'Orléans and Louis XIV's only brother), for 3000 livres;[4] according to Loménie de Brienne sold at an inflated price by du Housset to Jean-Baptiste Colbert (1651–90), marquis de Seignelay[5] and son of the great Colbert, this by 1685[6] and possibly in 1683;[7] with a 'Mr Païot' from whom acquired by 1702 by Denis Moreau (c.1630–1707), premier valet de chambre of the Duke of Burgundy,[8] then presumably by descent to Moreau's nephew, François-Louis de Nyert, marquis de Gambais, Seigneur de Neuville (d.1719);[9] by descent to Louis de Nyert (d.1736), among whose offices was the governorship of the Louvre, and whose posthumous inventory of 2 May 1736 records NG 6519 in his apartment there;[10] then to his son, Alexandre-Denis Nyert (d.1744);[11] posthumous sale of de Nyert, premier valet de chambre of Louis XV and governor of the Louvre, Musier, Paris, 30ff. March 1772 (lot 1, 4580 livres to Rémy);[12] Greenwood sale, Christie's, 21 April 1773, lot 25 (unsold at 420 guineas), and subsequently bought that year by Robert Clive, Lord Clive of Plassey (1725–74) for £327 12s. on the advice of Benjamin West;[13] collection of Robert Clive in the 'Great drawing Room' of 45 Berkeley Square, London, in 1774/5;[14] then by descent in the collections of the Earls of Powis and so to the Styche Trust in favour of Mrs Derek Schreiber (Vida, Lady Clive) of Bellasis House, Dorking, Surrey; from whom purchased jointly by the National Gallery and the National Museum of Wales in 1988 with assistance from Mr J. Paul Getty Jnr (through the American Friends of the National Gallery), the NHMF, the NACF (allocated from the Eugene Cremetti Bequest), Mrs Derek Schreiber (formerly Vida, Lady Clive), the Esmée Fairbairn Trust, the Moorgate Trusts, Sir Denis Mahon and anonymous donors.

Exhibitions

London 1949–50 (73); Paris 1960 (102); Cardiff 1960 (56); Paris 1994–5 (211); London 1995 (66).

Related Works

Two other treatments of the subject by Poussin exist in the Louvre, one (inv. no. 7271) painted in 1638 and the other (inv. no. 7272) painted before the end of 1647 for Pointel. A further treatment of the subject was recorded in 1643 as item 1044 in the posthumous inventory of Cardinal Richelieu measuring six 'pieds' by five 'pieds' and valued at 1200 livres,[15]

and an oval was recorded as being in the Dal Pozzo collection by 1644 and last noted in 1877 in the collection of Maria Vittoria of Saxony, née Princess Dal Pozzo Della Cisterna.[16]

PAINTINGS

(1) Musée de Lisieux, version in reverse with only five figures (150 × 213 cm);

(2) A good old copy in the Musée des Beaux-Arts, Rouen (inv. no. 811-29), in that collection by 1809, once attributed to Sébastien Bourdon (98 × 143 cm).[17] Photograph in NG dossier;

(3) An old, damaged copy (117 × 174 cm) formerly attributed to De Troy, Musée de Tessé, Le Mans (inv. no. 10.511), confiscated in 1794 from Bocquet de Grandval of Le Mans.[18] Photograph in NG dossier;

(4) The posthumous inventory dated 6 December 1715 of Anne de Souvré, marquise de Louvois et de Courtanvaux and widow of François-Michel Letellier, marquis de Louvois, records a 'Moïse sorti des eaux, copie d'après Poussin, 30 [livres]'.[19] The title suggests that the painting may have been after the 1638 version;

(5) The posthumous inventory of 22 March 1724 of Claude Houarnet, widow of Jean Guitton, included two copies after Poussin, one described as 'Moïse sauvé des eaux, tableau d'environ 3 pieds de haut' and the other as 'Moïse trouvé sur les eaux... tableau de 4 pieds quelques pouces de long';[20]

(6) Vente Bertrand, Roux, Paris, 2 June 1824, lot 87 (119 × 222 cm);

(7) Anon. sale, Honfleur, 21 January 1990, lot 12. A copy;

(8) Anon. sale, Dax, M.-C. Donzeau, 24 November 1996 (as 'Ecole Française XVIIe – Présentation à Sainte Anne'). A copy.

For what may be copies after NG 6519 or after another treatment of the subject by Poussin, see Deruet sale, London, Prestage, 21 January 1764, lot 70; anon. sale, London, Prestage, 27 February 1766, lot 63 (by Bon Boulogne after Poussin); Richard sale, Paris, Paillet, 27 January 1786, lot 11.

DRAWINGS

(1) A drawing first recorded in the collection of Jonathan Richardson, Sr (1665–1745) now in the Louvre (R.F. 749) was considered by Blunt to be a study for NG 6519 (see F.-B. no. 6). Its attribution by J. Thuillier to C.-A. Dufresnoy (1611–68) is considered possible by Rosenberg and Prat, who in any event exclude the drawing from Poussin's oeuvre (see R.-P. R848). There are numerous differences between the drawing and NG 6519, especially in the landscape and on the right-hand side, where, as in the Rouen copy of the painting, the river god does not appear, but the drawing must have been made, if not by Poussin, then by someone with knowledge of Poussin's composition in some form;[21]

(2) A drawing recorded by Gabriel de Saint-Aubin (lot 1323, Mariette sale, Paris, 15 November 1775–30 January 1776) is clearly not the same drawing as that now in Budapest, Szépmüvészeti Múzeum (inv. no. 2881), as proposed by Rosenberg and Prat (see R.-P. 307), if Saint-Aubin's sketch is to be believed. If by Poussin, it may have been connected with the version of the subject painted in 1647 for Pointel, or with NG 6519;

Fig. 1 X-radiograph.

(3) A drawing recently offered for sale at Sotheby's, New York (20 July 1995, lot 4 (ii)), and there described as after NG 6519 is an independent composition, although loosely based on it.

For other drawings of the subject of NG 6519 attributed to Poussin which were offered at auction, see R.-P., vol. 2, p. 1162.

PRINTS

(1) Engraved in reverse in 1676[22] by Alexis Loir and presumably the print presented by him to the Académie on 5 March 1678 and accepted as his reception piece three weeks later;[23]
(2) by Etienne Gantrel (1646?–1706) in reverse, by 1692;[24]
(3) by Gérard Audran (1640–1703);[25]
(4) by Jeaurat;[26]
(5) line engraved in reverse by G.F. Ferrero (fl. 1830–62).[27]

Other Related Work

An ivory relief (12 × 18.5 cm) of NG 6519 in reverse attributed to Ignaz Elhafen (1658–1715) working in Rome (Poulain, Le Fur, Paris, 21 June 1995, lot 224) includes two bathers (?) in the background, who do not appear in Loir's print (nor in NG 6519) and must be Elhafen's invention (photograph in NG dossier).

Technical Notes

Generally in reasonably good condition, but there are some small flake losses, some wear throughout and some blanching in the greens. In common with many pictures by Poussin, the ground of NG 6519 – the composition of which is identical to that of NG 5597, *The Adoration of the Golden Calf* (see Technical Notes for that entry) – shows through the top layers of paint, as they have become increasingly transparent with age, particularly at lower right. This necessitated some retouching in the flesh and drapery to re-establish form when the painting was last restored and relined in 1989.

The old stretcher (possibly the original) has a label marked *B893* and is also marked *WO 1705/4* in white chalk. The twill canvas had previously been lined at an unknown date and again in about 1950, when a new stretcher was made. The medium is mainly linseed oil, but a sample of the sky at the left-hand edge suggests the possible use of walnut oil as well.[28] Pigment analysis has shown the use of ultramarine with white over smalt mixed with white, with black in the lower layer of the greyer parts; smalt, black and white in the grey architecture; mixtures of green earth, copper green pigments, a variety of earths, yellow lake and lead white in the foliage and landscape greens; and in the draperies, green earth with ultramarine and some white in the strong cold greens, ultramarine over charcoal black and ultramarine and white for the blue darks and lights respectively, lead-tin yellow (with white in the paler areas), vermilion and vermilion with white in the strongest reds, but with Venetian red in the browner areas (the only part of the picture where this pigment has been detected), and red lakes with white for the pinks. The pigments in the flesh are white and vermilion for the pink tones, ultramarine for the coolest shadows, and green earth with vermilion for the greenish tones.

The X-radiograph (fig. 1) revealed a number of pentimenti, of which the more significant are: (1) the obelisk, centre left,

was originally some 7 cm higher; (2) the trunk of the large tree at the left continued below the grey wall; (3) the line of the jaw of the young girl in white was lower.

The subject is taken from Exodus 2:1–10. Pharaoh had ordered all boys born to the Hebrews to be cast into the river. Moses' mother, however, hid him in an ark of bulrushes in the shallows. As Moses' sister Miriam watched, Pharaoh's daughter came to the river to wash, saw the ark, bade her maid fetch it, and discovered the child inside. She recognised Moses as a Hebrew child, but decided to spare him and sent Miriam to find a Hebrew wet-nurse. Miriam returned with Moses' mother. Moses was then adopted by Pharaoh's daughter, who called him Moses 'because I drew him out of the water'.

The subject was popular with painters throughout the Renaissance and Baroque periods, when it was seen as prefiguring the incident of the infant Jesus escaping the Massacre of the Innocents. The subject offered painters the opportunity to show a variety of reactions from the onlookers according to their status, in this case a dignified response from Pharaoh's daughter and a more animated one from her handmaidens. Poussin painted three, or possibly four, versions of the subject (see under Related Works).[29]

In NG 6519 the perceived link between Moses and Christ is apparent from the attitudes of the four maids at the left, which recall those of figures in scenes of the Adoration (for example, NG 6277). In addition, Pharaoh's daughter, derived ultimately, as Blunt pointed out, from the Marcantonio engraving after a *Pietà* by Raphael,[30] recalls images of the Virgin – a connection made by Loménie de Brienne, who, when he owned NG 6519, referred to her as 'the Regal Virgin'.[31] That Poussin's paintings could be seen by his contemporaries as sources for multi-layered meanings is evidenced by (once

again) Loménie de Brienne, who referred to Moses in connection with the 1647 version and NG 6519 as 'the Mosche of the Hebrews, the Pan of Arcadia, the Priapus of the Hellespont, the Anubis of the Egyptians',[32] apparently adopting such comparisons as had been made by Pierre Daniel Huet, Bishop of Avranches, in *Demonstratio Evangelica* (Paris 1679). The infant Priapus, Huet noted, had also been exposed by his mother,[33] and, according to Plutarch's *Isis et Osiris*, Anubis, the Egyptian deity who took the form of a jackal, was brought up by Isis, who was not his real mother. Pan also had a role as shepherd and as such had been identified with Christ the Good Shepherd.[34] Likewise, Anubis had a role as guardian and protector[35] and Priapus as a protector of flocks, so reinforcing the links between the births of Moses and Christ and their respective roles as leaders.[36] Seventeenth-century commentators also linked Moses with Bacchus and with the Egyptian god Osiris,[37] although no such link appears to have been made in relation to NG 6519.

Whether or not Loménie de Brienne's perception of the nature of Moses was shared by Poussin, there can be little doubt of the artist's concern to include historically convincing detail. Although it has been suggested that the two palm trees on the right of the painting may have been intended to refer to the Virgin Mary and Joseph,[38] more obviously they provide local colour for the depiction of an event that occurred in Egypt by the banks of the Nile (here represented by a river god holding a cornucopia and accompanied by a sphinx, based on one of the antique statues of the River Nile then in Rome).[39] The attendant in the left foreground holding the infant Moses resembles the nymph in the left foreground of a print in G.B. Ferrari's *Hesperides, sive De malorum aureorum cultura* (Rome 1646) by Cornelis Bloemaert, after a drawing of 1642 by Poussin (fig. 2).[40] As Charles Dempsey has proposed, a number of elements in the painting seem likely to be derived from details of paintings in a grave chamber discovered in 1644–5

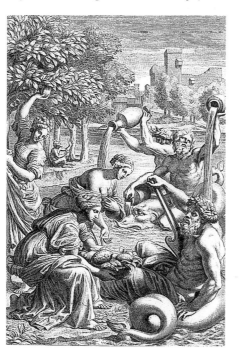

Fig. 2 Cornelis Bloemaert after Nicolas Poussin, *The Nymphs of Lake Garda offering Lemons to the River-god Benalus*, in G.B. Ferrari, *Hesperides, sive De malorum aureorum cultura*, Rome 1646. Paris, Bibliothèque Nationale.

Fig. 3 Detail of NG 6519.

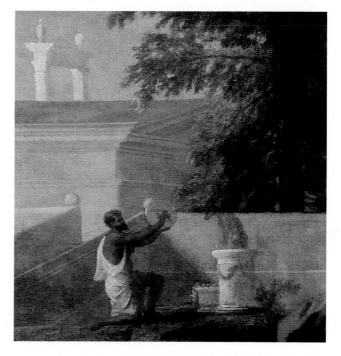

during construction of the Villa Doria-Pamphilj in Rome, or possibly from mosaic fragments then in Santa Maria in Trastevere. These elements are the Porta Sacra at the extreme left of NG 6519 (fig. 3), the tree growing within the confines of a temple, and the depiction of Pharaoh's daughter, Thermutis, as a priestess rather than a princess.[41] The curious building in the background left of centre, with a concave roof and a large vase to catch the dew, is taken from a mosaic discovered around 1600 in the Temple of Fortuna at Praeneste, of which Poussin's Roman patron, Cassiano dal Pozzo, had watercolour copies made in the years 1614–30.[42] There is a similar building at the extreme right in Poussin's *Holy Family in Egypt* (St Petersburg, Hermitage Museum). Poussin's reasons for including in NG 6519 a number of details then believed to be archaeologically correct were presumably similar to the reasons he gave Chantelou in connection with the *Holy Family in Egypt*: 'I have put all these things in this painting to delight by their novelty and variety and to show that the Virgin… is in Egypt.'[43]

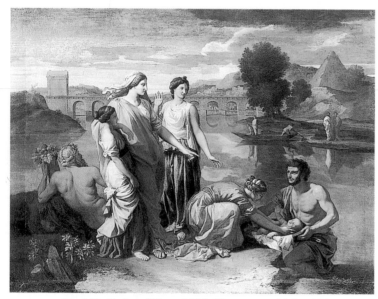

Fig. 4 *The Finding of Moses*, 1638. Oil on canvas, 93.5 × 121 cm. Paris, Musée du Louvre.

Fig. 5 *The Finding of Moses*, by 1647. Oil on canvas, 121 × 195 cm. Paris, Musée du Louvre.

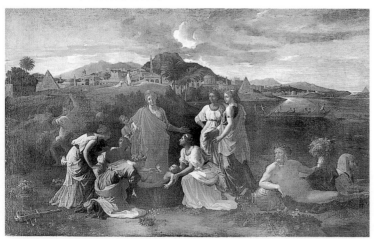

The 1638 version of the *Finding of Moses* (fig. 4) shows the moment of the infant's discovery. In the 1647 version painted for Pointel (fig. 5) the infant has already been discovered and the moment shown is that of his recognition by Pharaoh's daughter, Thermutis,[44] as one of the Hebrews' children, and by extension her recognition of Moses' divine function. The young girl peeping out from behind the princess is probably Moses' sister, Miriam, alluding to her future role in the story. The group of maidens around the infant has a clear compositional similarity to that in NG 6519, painted four years later. Blunt considered that the agitated drapery of the maidens at the left of NG 6519 was intended by Poussin to convey the excitement of the unexpected discovery of Moses.[45] While this may be true of the maidens, the gesture of Thermutis is altered from one of surprise in the Pointel picture to something more decisive. Arguably, the woman in white is Moses' mother, Jochabed, her state of partial undress signalling her readiness to breastfeed, in which case the moment shown in NG 6519 would be when Thermutis instructed her to 'take this child away, and nurse it for me, and I will give thee thy wages' (Exodus 2:9).[46] However, the woman appears to be too young to be Jochabed (on the basis of what can be deduced from the Bible to have been her age),[47] and she is not the only woman in NG 6519 in a state of semi-undress. Furthermore, it would have been odd for Poussin to have included the figure at the right climbing out of the water had he planned Jochabed's appearance in the picture, because in Exodus it is clear that a period of time elapsed between Moses being saved and his being handed to his mother. Indeed, according to Josephus' *Antiquities of the Jews* (II, IX: 5), with which Poussin was evidently familiar,[48] Jochabed only arrived on the scene after several attempts to nurse Moses with a non-Hebrew woman had failed, and when Jochabed did arrive she was accompanied by Miriam – which is not the case in NG 6519. Finally, it is not clear whether Moses is being handed to, or held by, the woman in white. Although it remains possible that this figure was intended by Poussin to be no more than another of Thermutis' handmaidens, it seems more likely that she is Moses' sister, Miriam. In that case, what Poussin shows in NG 6519 is the moment when Thermutis orders Miriam to fetch a wet-nurse from among the Hebrews, hence the crucial moment of choice – after Moses has been found and after he has been recognised as a Hebrew child – when Thermutis decides to spare him. Consequently, it would not be unreasonable to differentiate between Poussin's three extant versions of the theme, not just by their compositions, but by calling them respectively the Finding, the Recognition, and the Sparing of Moses.

Such distinctions were not, however, made by Félibien in his account of Poussin's life and work, first published in 1685. He referred to the 1638 version of the painting as 'un petit Moïse trouvé sur les eaux',[49] and to the 1647 version painted for Pointel as 'Moïse sauvé des eaux',[50] but later in the same account as 'le petit Moïse trouvé sur les eaux',[51] having in 1677 in a different work called it 'Moïse sauvé des eaux par la fille de Pharaon'.[52] Félibien called NG 6519 'un Moïse trouvé sur les eaux',[53] but it is clear that for him the terms 'trouvé'

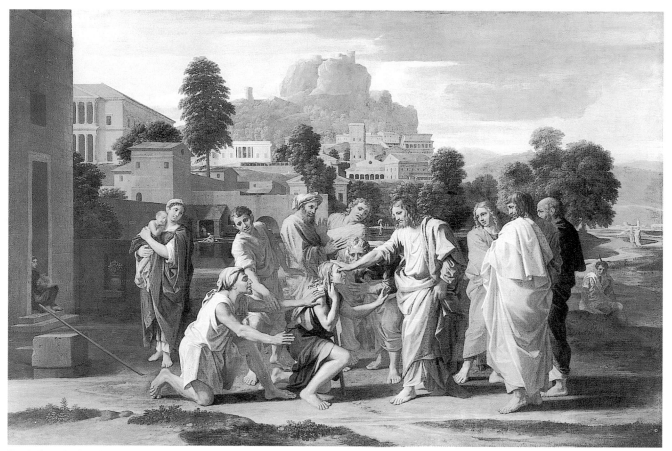

Fig. 6 *Christ healing the Blind*, 1650. Oil on canvas, 119 × 176 cm. Paris, Musée du Louvre.

and 'sauvé' were interchangeable, and from his description of the Pointel version it is also clear that what interested Félibien most was the local detail which Poussin included in the painting.[54] Consequently the traditional title for NG 6519 has been retained. How Poussin depicted human emotions and which emotions he chose to depict, and how he interpreted this biblical story, were not discussed by Félibien any more than they seem to have been by Philippe de Champaigne in his 1668 lecture to the Académie on the 1647 version.[55]

As Félibien relates, in 1650 – one year before painting NG 6519 for Reynon – Poussin painted for the same patron *Christ healing the Blind* (Paris, Louvre; fig. 6).[56] The two paintings are virtually the same size, and allowing for the difference in states of conservation, their tonalities, unusually bright for Poussin, are similar.[57] As MacGregor has suggested, the Louvre painting 'is, as it were, an all-male pendant to our female picture'.[58]

If indeed the paintings were conceptual pendants, can they be linked iconographically? The episode of Christ healing the blind was understood as leading from darkness into light, and hence metaphorically from unbelief to belief.[59] That of the saving of Moses was generally seen as a prefiguration of the escape of the infant Jesus from the Massacre of the Innocents. However, without excluding such a meaning, NG 6519, alone among the extant versions of the subject by Poussin, includes among the localising details the scene of a figure kneeling before the statue of the Egyptian god Seth (fig. 3).[60] In

gesturing towards Moses, Thermutis turns her back on such idolatry. Indeed, apart from the small figure·in the left background, none of the figures in the painting looks towards, or can see, the idol. Thus it is possible to discern some iconographic link between Reynon's two paintings in the theme of new-found faith, a faith found moreover through the resource of sight – obviously in the case of *Christ healing the Blind*, and more subtly in the case of NG 6519, where the sparing of Moses was preceded by his discovery and recognition (both acts of seeing) by Pharaoh's daughter.

Such an interpretation seems supported by the high colours of both paintings, which express the idea of light, both actual and spiritual, and of joy. The link between light and joy was made explicitly by a member of the Académie, probably Charles Le Brun, in a response to Sébastien Bourdon's lecture of December 1677 to the Académie on *Christ healing the Blind*:

> But what is most unusual and marvellous in this work is Jesus Christ going to give light to these two blind men and to spread joy in their souls; one sees that the painter has also spread a certain character of levity in his painting, and a beauty of daylight which expresses in a general way what he wishes to represent by its particular subject matter; and this joy which he communicates so well to all his figures is the cause of that which one feels on seeing them.[61]

It is clear from the remarks which follow this passage that the speaker had in mind the so-called 'theory of the modes' as it might be applied to painting, about which Poussin, basing himself on Gioseffo Zarlino's *Istitutione harmoniche* (Venice 1558), had written in 1647 to his good friend and patron Chantelou.[62] That NG 6519 was also seen as a joyful painting is evident from Le Maire's description of it when it was in the Seignelay collection: 'il règne un enjouëment dans ce Tableau, qui est si singulier, qu'il est impossible de voir sans prendre part à la joye qui est excitée dans toutes les figures de cet ouvrage par la beauté du petit Moyse.'[63] At all events, it is more probable that the high colours of NG 6519 refer to its joyful subject matter than to the fact that the patron, Reynon, was a

silk merchant.[64] It seems unlikely that so independent-minded an artist as Poussin would have allowed the nature of his patron's trade to dictate the manner of his painting, particularly at such an advanced stage in his own career.

General References

Graham 1820, Old Testament no. 7; Smith 1837, 13 (where wrongly said to be in the Louvre); Grautoff 1914, vol. 2, p. 254; Magne 1914, 157 (where confused with his no. 155, which is not the Reynon version as there stated, but the Pointel version); Blunt 1966, 14; Badt 1969, 176; Thuillier 1974, 178; Wild 1980, 166; Wright 1985a, 176; *National Gallery Report 1988–9*, pp. 12–14; Mérot 1990, 11; Thuillier 1994, 197.

NOTES

1. Félibien, *Entretiens 1685*, vol. 4, p. 303, and *Entretiens 1685–88*, vol. 2, p. 358.

2. See Chomer and Laveissière 1994, pp. 76–7, for further information on Reynon. He was one of the Lyon collectors noted by Jacob Spon as owning paintings by Poussin: *Recherche des antiquités et curiosités de la ville de Lyon*, Lyon 1676, p. 204.

3. See Thuillier 1994, pp. 173, 194 and 204, and *Le Catalogue de Brienne (1662)*, ann. E. Bonnaffé, Paris 1873, pp. 20, 34. The painting then attributed to Annibale Carracci is now considered to be by G.B. Viola (Paris, Louvre, inv. no. 208). Loménie de Brienne says that at the time of the exchange the duc de Richelieu valued the painting at 3000 livres. Loménie de Brienne was a secretary of state who had inherited his office from his father in 1658: Schnapper 1994, p. 243. For the painting by Viola, see Stéphane Loire, *Musée du Louvre Département des Peintures Ecole Italienne, XVII^e Siècle I. Bologne*, Paris 1996, pp. 361–4.

4. See Thuillier 1994, pp. 202, 204, and Schnapper 1994, vol. 2, p. 237.

5. See Thuillier 1994, pp. 202, 204.

6. Loménie de Brienne's *Discours sur les ouvrages des plus excellens peintres anciens et nouveaux avec un traité de la peinture composé et imaginé par M^re L.H. de L.C. de B. Reclus* (MS BN anc. Saint Germain 16986) was written in about 1695, when de Brienne was in prison, but NG 6519 is recorded in the Seignelay collection at the hôtel Colbert in the rue des Petits-Champs in Le Maire's *Paris ancien et nouveau*, 3 vols, Paris 1685, vol. 3, p. 265; and in Félibien, *Entretiens 1685*, vol. 4, p. 303, and *Entretiens 1685–88*, vol. 2, p. 358.

7. In 1683 du Housset had to pay a fine of 680,000 livres imposed by the Chambre des Comptes: Schnapper 1994. This may have prompted him to sell NG 6519.

8. Davies 1957, p. 181, n. 26. Moreau was premier valet de garde-robe of Louis XIV before becoming in 1689 premier valet de chambre of the young duke of Burgundy, the son of the Grand Dauphin: Schnapper 1994, vol. 2, p. 393, where Schnapper raises a doubt as to whether NG 6519 was in Moreau's collection, since its dimensions as

given in the 1736 inventory (see note 10), namely 'cinq pieds sur sept' (approximately 162 × 227 cm), are too large to be identified with NG 6519 – unless the measurements were referring to the frame. This must be assumed to be the case. The duchesse d'Orléans noted NG 6519 in Moreau's collection in a letter to the duchess of Hanover written in Versailles, 23 March 1702: ed. E. Jaeglé, *Correspondance de Mme, duchesse d'Orléans*, 3 vols, Paris 1890, vol. 1, p. 261.

9. See Schnapper 1994, vol. 2, p. 393, and Davies 1957, pp. 180.

10. Rambaud 1964–71, vol. 1 (1964), pp. 583–6 and 707–8. The inventory of paintings was prepared by Claude Lallemant, master painter, who recorded among the deceased's pictures: 'Moïse sauvé des eaux, avec plusieurs figures et un fond de paysage, original de Poussin, b.b.d. 7 pieds le long sur 5 de large. 5,000 l.' On these measurements, see note 8 above.

11. Mariette, *Abécédario*, vol. IV, Paris (1857–8), pp. 56–7. According to Mariette, de Nyert ' voyoit avec peine le gout moderne...L'antique, Raphaël, Polidore étoient ses héros...' Conceivably NG 6519 was first inherited by Marie-Anne Marsollier, widow of Louis de Nyert: Rambaud 1964–71, vol. 1 (1964), pp. 583–6. Alexandre-Denis dying without issue, the marquisate fell to his sisters, Jeanne and Marie-Agnès. In 1748 or 1749 the former ceded the same to Marie-Agnès, who on 4 September 1748 married Charles François-Henri de Revol, Conseiller au Parlement de Paris: De la Chenaye-Desbois et Badier, *Dictionnaire de la Noblesse*, 3rd edn, 19 vols, Paris 1863–76, vol. 14 (1869), pp. 959–60, and vol. 17 (1872), pp. 3–4.

12. Information annotated in the copy of the catalogue in the Bibliothèque Nationale, Département des Estampes. The painting is described as 'Moyse retiré des eaux, & présenté à la fille de Pharaon. Ce tableau, composé de dix figures principales d'environ 18 à 20 pouces de proportion, est peint par Nicolas Poussin, sur toile de 3 pieds 7 pouces de haut, sur 5 pieds 6 pouces de large: on en trouve l'estampe gravée par [].' See also Ch. Blanc, *Le Trésor de la Curiosité*, 2 vols, Paris 1857–8, vol. 1, p. 188.

13. M. Bence-Jones, 'Clive of India as Builder and Collector, II', *Country Life*, 25 November 1971, pp. 1446–8, and by the same author, *Clive of India*, London 1974, p. 266, according to which the picture was hung at Clive's house in Berkeley Square, London. West was certainly advising Clive on which pictures to acquire by 1771, as can be inferred from a letter written by the latter to his private secretary, Sir Henry Strachey, on 15 May of that year: Oriental and India Office, Clive Papers, Mss.Eur.F.128/93. For further information on Clive as a collector, see Laing 1995, pp. 235–6.

14. *Inventory of Pictures, Prints and Drawings* and *List of Lord Clive's Pictures* (respectively 552/7/130/5, 552/7/130/6, Shropshire Records Office, Shrewsbury). I am grateful to Juliet Carey for sending me photocopies of these (undated) documents.

15. H. Levi, 'L'inventaire après décès du Cardinal de Richelieu', *AAF*, 27, 1985, at p. 64; possibly the picture of which James Thornhill wrote: 'Monsr Poussiniere demands for a large poussin of the finding of Moses 4000 livres', *A Notebook of a visit to France February–April 1717*, fo. 87, Victoria and Albert Museum, 86.EE.87.

16. Cifani and Monetti, *Poussin Colloque 1994*, pp. 749–807 at pp. 767, 782.

17. Rosenberg 1966, p. 109; and see *Nicolas Poussin et son temps*, Rouen 1961, no. 114; G.E. Fowle (PhD thesis, University of Michigan, 1970), n. X-12 (as not by Bourdon).

18. E. Foucart-Walter, *Le Mans, musée de Tessé. Peintures françaises du XVIIème*, Paris 1982, pp. 105–6. The right half of the Le Mans picture appears to have been cleaned. The canvas is unlined and on a stretcher with corner braces typical of seventeenth-century construction, suggesting that it is a seventeenth-century copy. It may be the painting in the Lebrun sale, Paris, Pierre Rémy, 22 September 1774, lot 91: 'Moyse sauvé des eaux parla [sic] fille de Pharaon, composition de douze figures d'après le Poussin, sur toile de 3 pieds 6 pouces de haut, sur 5 pieds 4 pouces de large.'

19. Rambaud 1964–71, vol. 1 (1964), p. 545.

The Finding of Moses (NG 6519), detail.

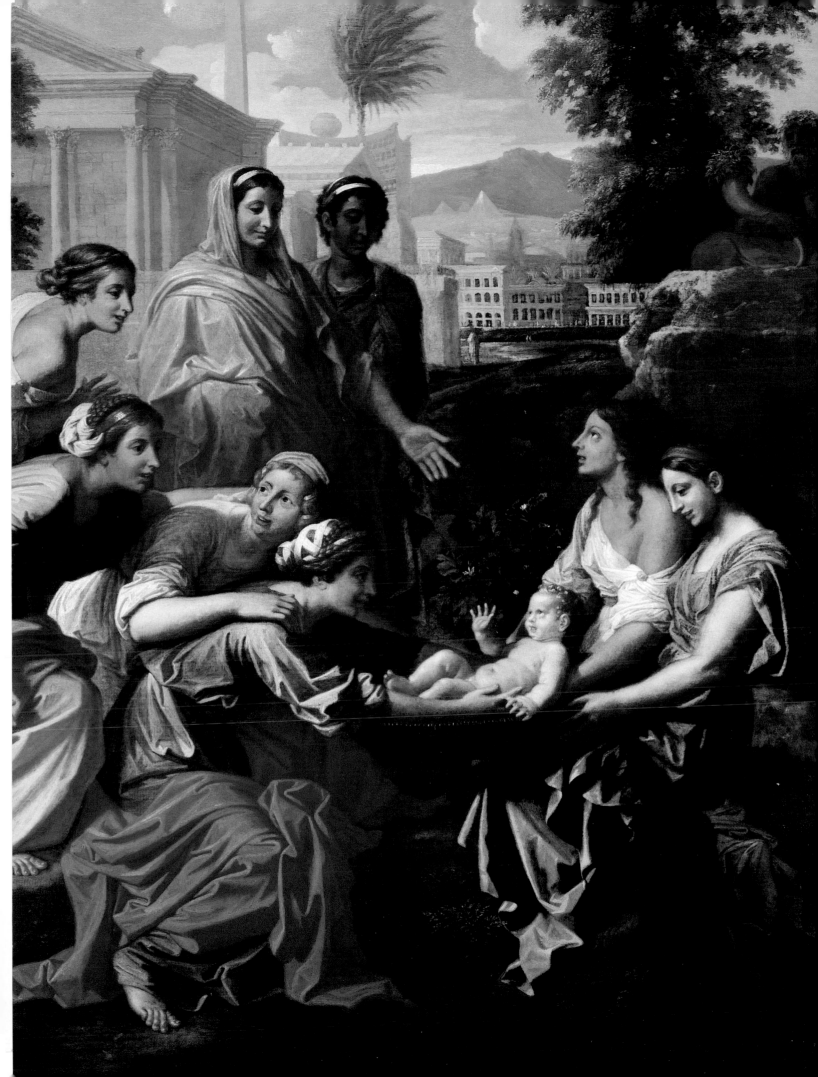

After Poussin

NG 42
The Triumph of Silenus

c.1637?
Oil on canvas, 142.9 × 120.5 cm

Provenance
Stated by W.Y. Ottley to have come from the Barberini Collection, but not recorded in the published inventories of the seventeenth century;[1] said in the 1838 and later editions of the National Gallery catalogue to have been 'one of a series of three painted by Poussin for the Duke of Montmorenci';[2] according to John Smith, in the collection of John Lock (perhaps meaning William Lock of Norbury Park) and then in that of John Purling (of 68 Portland Place, London); his sale (London, 17 February 1801, lot 100, 670 guineas);[3] sale of Richard Walker of Liverpool, Christie's, London, 5 March 1803 (lot 8, 800 guineas to Angerstein);[4] presumably the painting noted in the Angerstein collection in 1809;[5] purchased as part of the Angerstein collection, 1824.

Exhibitions
London 1948, Whitechapel Art Gallery, *Five Centuries of European Painting: Pictures lent from the National Gallery, the Cook Collection and the Collection of Viscount Bearsted* (11) (as 'ascribed to Pierre Dulin, 1669–1748'); Edinburgh 1981, National Gallery of Scotland, *Poussin, Sacraments and Bacchanals: Paintings and Drawings on sacred and profane themes by Nicolas Poussin 1594–1665* (26) (as 'after Nicolas Poussin'); London 1995, NG, *Poussin Problems* (no catalogue).

Related Works
PAINTINGS
(1) In 1665 Chantelou showed Bernini 'quelques copies dont les originaux [par Poussin] étaient à Richelieu' (see p. 379);[6]
(2) There is a copy corresponding to NG 42 (as well as of the National Gallery's *Triumph of Pan* and the Kansas City *Triumph of Bacchus*) in the Musée des Beaux-Arts, Tours. All three copies were confiscated in the years 1790–4 from the château de Richelieu, where they had replaced at least two of the originals by 1741.[7] The Tours version (photograph in NG dossier) of NG 42 has been enlarged at the top and its overall dimensions are 162 × 118 cm.[8] Another painting at Tours of a *Triumph of Silenus* long attributed to Poussin is by Mattia Preti;[9]
(3) A copy in the Musée des Beaux-Arts, Béziers, of 145 × 120 cm, has traditionally been attributed to Jacques Stella and was in the collection of Mgr de Saint-Simon, last Bishop of Agde, before 1789 and then with the Coste family, from whom it was acquired by the museum in 1862; this provenance and attribution were shared by Bézier's copy of Poussin's *Triumph of Bacchus* (Kansas City, Nelson-Atkins Museum) and another

picture, lost around 1870, which was probably a copy after Poussin's *Triumph of Pan* (NG 6477);
(4) A reduced-size (30 × 25 in) copy of NG 42 was notified to the Gallery by its owner, James Criswick, in 1877. Photograph in NG dossier;
(5) A reduced-size copy with slight differences (75 × 63 cm) was offered at Lucerne (Galerie Fischer, 5/6 November 1992, lot 2327, catalogued as nineteenth-century German).
DRAWINGS
(1) A figure faintly drawn on the verso of a drawing in the Royal Collection, Windsor Castle (RL 11919; R.-P. 139) (fig. 1), appears to be a study for the figure of Silenus in NG 42 (or the original version of it). The recto of this drawing, showing the *Death of Cato*, has been dated to the later 1630s.[10]
(2) There is a loose connection between the group of Silenus and the two youths supporting him in NG 42 and a similar group at the left of a drawing at Windsor Castle for *The Triumph of Bacchus* (RL 11905, recto; R.-P. 83r).
(3) The verso of a preparatory drawing for *The Triumph of Pan* (Bayonne, Musée Bonnat, inv. no. A1 1672; N147; R.-P. 84v) has two studies for a sprawling Silenus, but these have been identified as connected with another subject, that of Silenus and the nymph Aegle.[11]
(4) There exists in the Hermitage a drawing (R.-P. R1102; fig. 2) of similar style and media to a drawing at Windsor connected with *The Triumph of Pan* (RL 11995; R.-P. 94) and which, although in horizontal format, is clearly related to NG 42. It has been suggested that it is a good copy (perhaps by Michel II Corneille) of a lost original drawing.[12]
PRINTS
(1) By John Young in Young 1823 and also published separately in smaller format by John Young and John Murray in March 1823;
(2) By E.A. Réveil in Duchesne 1828–33, vol. 6, opposite p. 387;
(3) Anon. publication by Allan Bell & Co., Warwick Square, London 1834, pl.VI;[13]
(4) By T. Phillibrown by 1837 (see Smith 1837, no. 213);
(5) By John Charles(?) Bromley in 1836,[14] probably the engraving published in *The National Gallery of Pictures by the Great Masters*, [1838?], vol. 1, p. 49.

Technical Notes
The condition is fair. There are no significant paint losses, but there is considerable wear throughout, and the red lake pigments have faded. The ultramarine in the hanging drapery at the left is badly worn with possible degradation of the pigment in the areas of pale blue. The painting was last cleaned and restored in 1949. The date of its relining is unknown, but was certainly before 1853 when conservation records of National Gallery paintings first began to be kept.

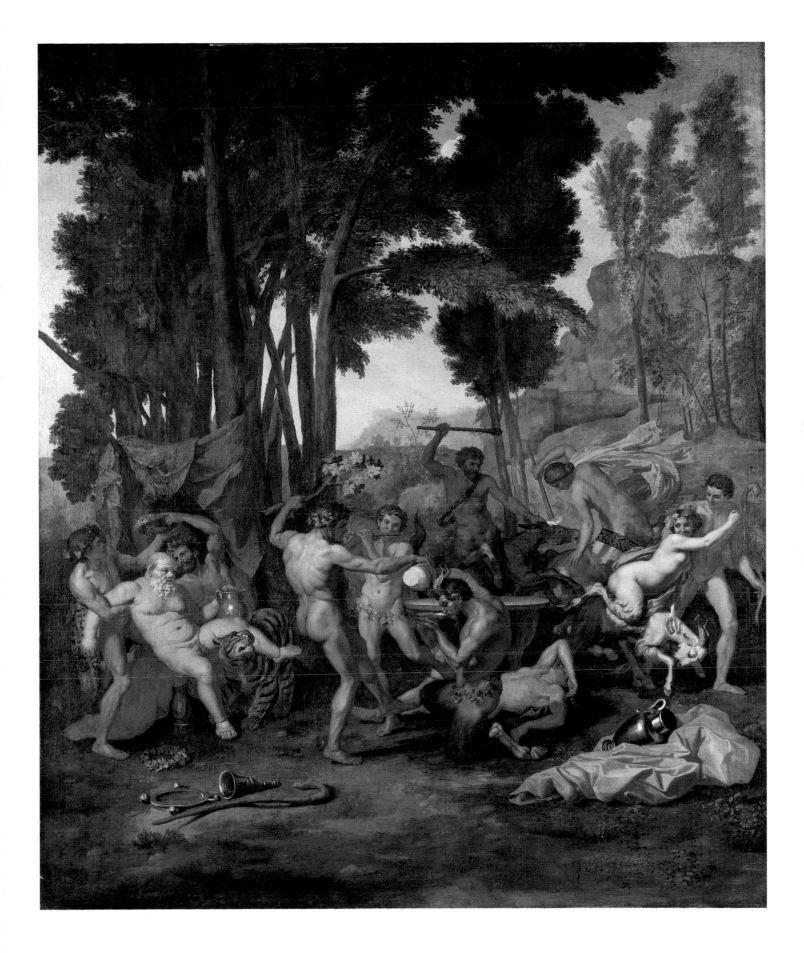

After Poussin(?)

The Holy Family with Saints Elizabeth and John

18th century
Oil on canvas, 68.6 × 50.8 cm

Provenance
Possibly the sale of Charles-Alexandre de Calonne (1734–1802), London, Skinner & Dyke, 28 March 1795 (lot 14, as Le Sueur, 34 guineas bought in),[1] and exhibited at Bryan's Gallery, Savile Row, 27ff. April 1795 (no. 108 as Le Sueur), or possibly imported from Italy into England in the eighteenth century;[2] certainly in the sale of W.B. Tiffin deceased, formerly of The Strand and then of Canonbury, Christie's, 28 May 1877 (lot 32, as by Le Sueur, £8 18s. 6d. to Bacon on behalf of Frances Turner Palgrave);[3] presented by Francis Turner Palgrave in 1894 and accepted as by Le Sueur.

Exhibitions
Liverpool 1953–9, Walker Art Gallery under the Arts Council Provincial Galleries Loan Scheme; Coventry, Derby, Doncaster, Bath 1982, pp. 36–7; London 1995, NG, *Poussin Problems* (no catalogue).

Related Work
NG 1422 is a virtual copy of a painting in the Musée Condé, Chantilly (inv. no. 304) (fig. 1), which was originally in the Rospigliosi collection. It has usually been attributed to Poussin, but has recently been proposed as a pastiche by an unidentified, possibly French, seventeenth-century artist, imitating Poussin.[4] For paintings, drawings and engravings related to the Chantilly picture, see Chantilly 1994–5, no. 8, Rosenberg and Prat 1994, nos R560 and R1321, and Martin Clayton's review in *BM*, 138, 1996, pp. 167–9. For discussion of the relationship between NG 1422 and the Chantilly picture, see below.

Technical Notes
In good condition save for a small horizontal tear through Saint John's thigh and a few small old losses. The blues in the drapery may have faded slightly. The painting was last restored in 1994. There is a pentimento at the bottom right of the Virgin's cloak.

The support is a medium to heavy plain-weave canvas which is lined. The top bar of the stretcher is embossed *Brown 163 High Holborn*, dating it to between 1839 and 1856, respectively the earliest date when Brown started using this stamp and the date when his firm discontinued business.[5] The stretcher is also marked at the top left in stencil *O54* and on the left-hand side in white crayon(?) *May../77*.

Microscopical examination and a microchemical test have confirmed that the principal blue pigment in Mary's drapery is Prussian blue (its greyish tone arising in part from the admixture of black pigment in addition to white in the paint layer), so placing the picture after 1710 at the earliest. The microscopical character of the Prussian blue pigment – very deep blue, flattish, translucent flakes – is closer to eighteenth- than nineteenth-century specimens.[6]

This painting is a virtual copy, made after 1710 (see Technical Notes), of a seventeenth-century painting in the Musée Condé, Chantilly. Usually considered to be by Poussin (see fig. 1), and so recorded in the inventory of Giovanni Battista Rospigliosi of 26 June 1713, it was recently proposed as an able pastiche by an unknown hand, possibly French.[7] There are, however, several small differences between the Chantilly painting and NG 1422, although their sizes are virtually identical. In NG 1422: (1) the course of masonry to the left of the Virgin's head and the column immediately to the right of Joseph's head are shown as damaged; (2) to the right of the central column there is a cornice separating the arch from the masonry, which becomes a shallow groove to the left of the column; (3) a pebble(?) on the ground just above and to the left of the pedestal on which the Virgin rests her foot is missing; (4) a red robe appears under the Virgin's veil at her neck; (5) Saint Anne is shown without sandals; (6) the column to the right of Saint Anne is shown without its base; (7) the head of the infant Christ is slightly more inclined to the viewer; (8) the Virgin looks more abstracted and Joseph more sentimental.

These differences (save for no. 2) indicate that the engravings Andresen 133 and 134 – made in the seventeenth and eighteenth centuries respectively, both in the reverse sense – were after the Chantilly picture and not after NG 1422, and that although NG 1422 clearly depends on the Chantilly picture, its maker possibly intended it not to be taken as the original. Since the Chantilly picture was apparently in the Rospigliosi collection in 1713 at the latest and was recorded in the Palazzo Rospigliosi in guides at least as late as 1791,[8] it seems likely that NG 1422 was painted in Rome in the eighteenth century, possibly by a French hand.[9] The widespread use of Prussian blue in NG 1422 certainly excludes it from the oeuvre of either Poussin or Le Sueur, to whom it was also once attributed (see Provenance).

It has been suggested that the depiction of Joseph leaning on a rule and with a T-square by his side may have been an allusion to him as a master of mathematics or architecture and so of higher status than a carpenter.[10]

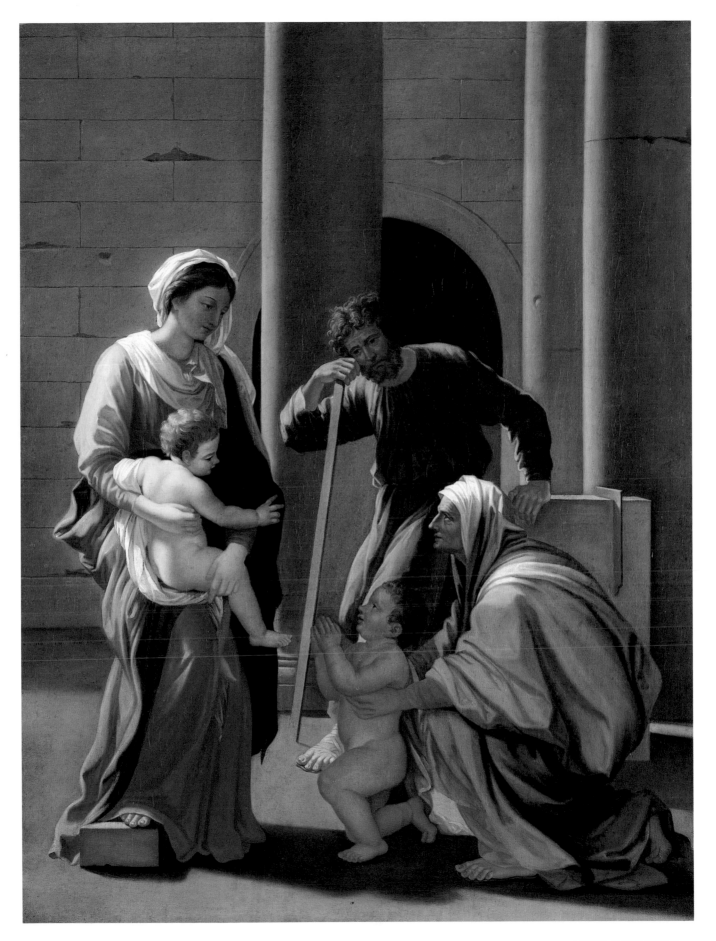

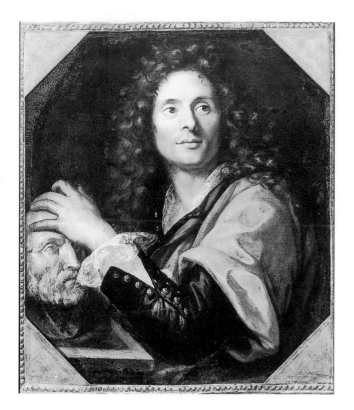

This was done to the plans of Claude Perrault (1613–88), but at the suggestion of the astronomer and mathematician Adrien Auzout (d.1691). (The Observatoire Royal as an institution was founded in 1671.) The sitter in NG 2929 is too young to be Perrault. Auzout's date of birth is unknown, but a portrait of him would be likely to show him with his principal invention, a micrometer. Among others associated with the Observatoire in its early days were Gian Domenico Cassini (1625–1712) and Philippe de La Hyre (1640–?1718),[14] the son of the painter Laurent de La Hyre, both of whom had lodgings there.[15] However, to judge from engraved portraits, neither resembles the sitter in this painting.[16]

General References

Davies 1957, p. 158 (as ascribed to Pierre Mignard); Nikolenko 1983, p. 107, no. 25 (as falsely attributed to Mignard); Wright 1985b, p. 123 (as 'Studio and followers of Pierre Mignard').

Fig. 1 *Portrait of an Unknown Sculptor, c.*1680. Oil on canvas, 66 × 55 cm. Portland, Oregon, Portland Art Museum. Gift of Dr and Mrs Edwin Binney 3rd.

NOTES

1. Described in the catalogue as 'Migniard – 33 A capital portrait of Des Cartes'. The sale information is derived from a photograph of the catalogue sheets in the NG Library. It is possible that the reference to 'Briand' was to the well-known dealer Michael Bryan, in which case NG 2929 could be the painting sold by Bryan (London, 6 November 1801, no. 108, £73 10s. to an unknown buyer) and described as 'P. De Champagne/Portrait of Descartes': *Index of Paintings Sold*, vol. 1, 1801–5, p. 185, but not that offered for sale by the Earl of Bessborough some months earlier (Christie's, 5 February 1801, lot 35, bought in) and described as 'Phil. de Champagne/A Portrait of Descartes', because the size of this last painting was, according to annotations to a copy of the catalogue, 3ft × 2½ft and so too small to be NG 2929; and because it reappeared in another Bessborough sale in 1850 (Dorival 1976, vol. 2, p. 166).

The title to the earldom of Bessborough was held in 1796 by Frederick Ponsonby, the 3rd earl (1758–1844): *Complete Peerage*, vol. II, p. 171.

2. Castle Howard Catalogue, 1805, no. LXV.

3. John Bigland, *The Beauties of England and Wales*, vol. 16, London 1812, p. 257 ('No. 65. Portrait of Descartes... Rigaud./The figure is extremely graceful, and full of dignity').

4. A descriptive catalogue of the pictures at Castle Howard, Malton 1814 ('No. 65. Mignard. Portrait of Des Cartes. Extremely graceful, and full of dignity').

5. Waagen 1854, vol. 3, pp. 323–4 ('PIERRE MIGNARD. – The portrait of Descartes; half-length; a circular picture. A very sensible, reflecting countenance, with a trace of melancholy. More individual in conception, and more true in colouring, than is usual with Mignard, and, at the same time, very carefully painted').

6. Rosalind, Countess of Carlisle was widowed on the death of George Howard, 9th Earl of Carlisle. He was a trustee of the National Gallery from 1881 until his death, and an amateur landscape painter. She campaigned for women's suffrage (among other things): *DNB*, 1912–21, pp. 274–5.

7. National Gallery Minutes of Board Meeting, 11 June 1912.

8. Scientific Department Report to the Trustees, 1995–6, p. 23 (unpublished).

9. As, in the case of Pierre Mignard, Waagen unwittingly acknowledged: see note 5 above.

10. Note by Stella Pearce in the NG dossier.

11. NG 2929 is not, however, included in the catalogue raisonné of Revel's work in Brême's *Mémoire de maîtrise, Gabriel Revel 1643–1712*, Institut d'Histoire de l'Art et d'Archéologie de l'Université de Paris IV Sorbonne, 1980.

12. Paris, New York and Chicago 1982, p. 372, and *Visages du Grand Siècle. Le portrait français sous le règne de Louis XIV, 1660–1715*, exh. cat. Nantes and Toulouse 1997–8, p. 235.

13. Letter of 21 November 1997 from Jane Wess, Curator of Astronomy, The Science Museum.

14. For these dates, see P. Rosenberg and J. Thuillier, in Grenoble, Rennes and Bordeaux 1989–90, *Laurent de La Hyre 1606–1656. L'homme et l'oeuvre*, p. 93.

15. Germain Brice, *Description Nouvelle de la Ville de Paris*, Paris 1706, p. 182.

16. Engraved likenesses of Cassini and P. de La Hyre are in the Département des Estampes, Bibliothèque Nationale, Paris.

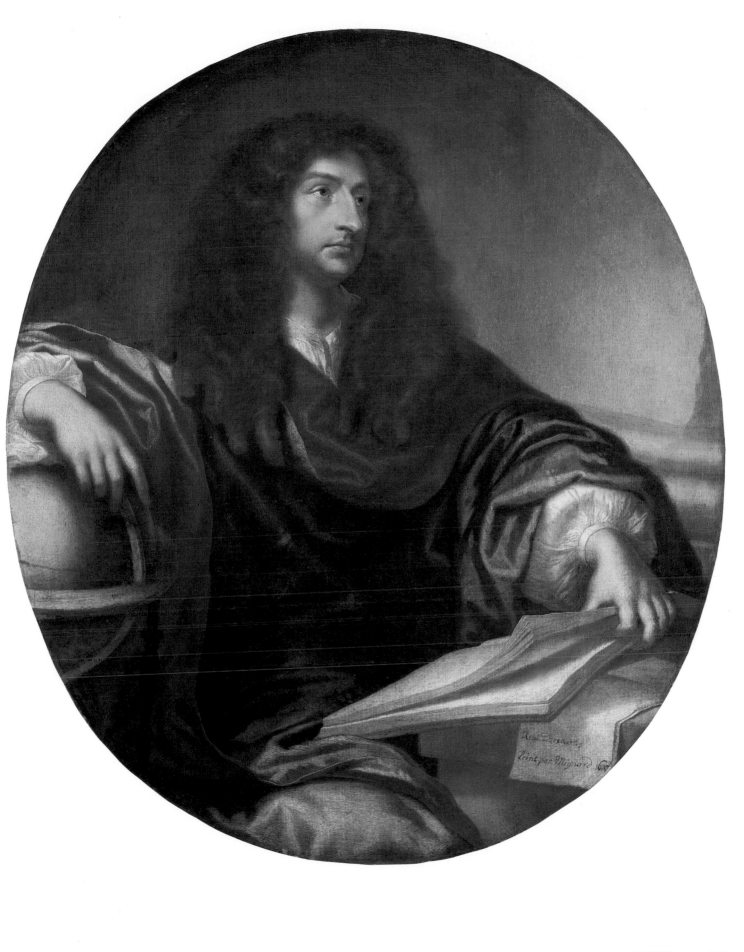

Valentin de Boulogne
1591–1632

Valentin's father was a painter and glass worker, and it was presumably he who gave Valentin his first instruction in painting. Valentin may have reached Rome by 1611, but there is no definite record of him there before 1620. From 1624 he associated with the roisterous group of Northern artists in Rome called the Bentvueghels. His first documented work dates from 1627, a *David with the Head of Goliath* bought for 15 scudi by Cardinal Francesco Barberini, nephew of Pope Urban VIII. Other commissions from Barberini followed and it was doubtless through him that Valentin was commissioned in 1629 to paint a major altarpiece for St Peter's, Rome, *The Martyrdom of Saints Processus and Martinian*. This painting, now in the Pinacoteca Vaticana, Rome, clearly shows the Caravaggism that was the basis of Valentin's style throughout his life. However, he was also open to other influences, including that of Vouet, as some of his later works show. Among Valentin's patrons were Angelo Giori, also a patron of Claude's, and Valguarnera, who in 1631 commissioned Caroselli's copy after Poussin's *Plague at Ashdod* (NG 165). According to the painter Baglione (1571–1644), Valentin died after a night's drinking when, plunging into cold water to clear his head, he contracted a mortal fever.

NG 4919
The Four Ages of Man

*c.*1629
Oil on canvas, 96.5 × 134.0 cm

Provenance
Probably in the collection of Michel Particelli, seigneur d'Emery (1596–1650), rue Neuve-des-Petits-Champs, Paris;[1] probably in the collection of Catherine Lybault (d.1652) and her husband, Jacques Bordier (d.1658), rue du Parc-Royal, Paris;[2] Dussé;[3] in the collection of Philippe, duc d'Orléans and Regent of France (1672–1723), at the Palais Royal, Paris;[4] sold in 1791 by his descendant Philippe-Egalité, with the other French and Italian pictures in the Orléans Collection, to the Brussels banker Edouard de Walkiers and sold by him (with other pictures) to his cousin François de Laborde-Méréville (1761–1802), who, following his emigration to England in 1793, charged them to the banker Jeremiah Harman, by whom all the paintings were sold in 1798 to a syndicate consisting of Francis Egerton, 3rd Duke of Bridgewater, Frederick Howard, 5th Earl of Carlisle, and Granville Leveson-Gower, 1st Marquess of Stafford;[5] sold by the syndicate at Bryan's Gallery, 88 Pall Mall, London, 26 December 1798 (lot 72, £84 to John Julius Angerstein),[6] but not among the pictures noted at Angerstein's London house by William Buchanan in 1802,[7] nor part of the Angerstein collection (comprising only pictures at the London house) purchased for the National Gallery in 1824; sale of the Trustees of William Angerstein (1812–97)[8] of pictures removed from Weeting Hall,[9] Norfolk, Christie, Manson & Woods, 4 December 1897 (lot 36 as Titian, £35 14s. to Beadel); in the collection of Marcus Samuel, 1st Viscount Bearsted (1853–1927), at The Mote, Maidstone, Kent, apparently as by Caravaggio;[10] probably at 1 Carlton Gardens, London SW1,[11] in the collection of Walter Horace Samuel, 2nd Viscount Bearsted (1882–1948), by whom presented to the National Gallery as by Valentin through the NACF, 1938.

Exhibitions
London 1938, Royal Academy of Arts, *Exhibition of 17th Century Art in Europe* (290) (as by Valentin); Paris 1974, Grand Palais, *Valentin et les Caravagesques Français* (49); Copenhagen 1992 (23); Rome 1994–5, Villa Medici, *Roma 1630. Il trionfo del pennello*, pp. 196–203; San Francisco 1997, Fine Arts Musuem of San Francisco, *Masters of Light: Dutch Painting in Utrecht during the Golden Age* (ex-catalogue).

Related Works
PAINTINGS
(1) Poughkeepsie, New York, Vassar College Art Gallery. Oil

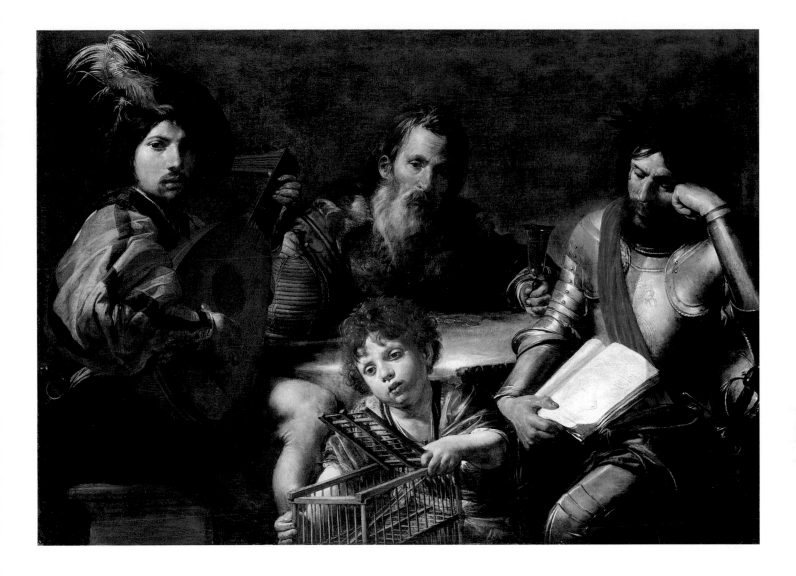

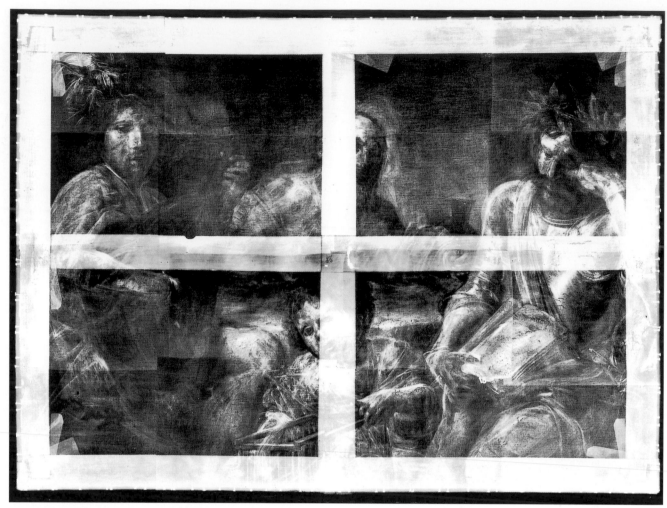

Fig. 1 X-radiograph.

on canvas, 38½ × 51¼ in., acquired in 1939 from the Engel collection, Vienna.[12] A copy[13] (Mojana 112);

(2) Wawra sale, Vienna, 17 December 1920, lot 18, 106 × 134 cm (41 × 52 in.), where attributed to Theodor Rombouts. A copy;

(3) Anon. sale, Christie's, 29 June 1962 (lot 163 as after Valentin, 280 guineas) 40½ × 51½ in. Photograph in NG dossier (Mojana 109).[14] A copy;

(4) Anon. sale, Lucerne, Fischer, 29 June 1973 (lot 541 as by Honthorst). 110 × 138 cm (Mojana 111). A copy;

(5) Anon. sale, Sotheby's, 28 July 1976 (lot 187 as after Valentin, £420). 93.5 × 127 cm. A copy. Photograph in NG dossier;

(6) Anon sale, Milan, Finarte, 4 February 1986 (lot 118 as by Nicolas Régnier). Oil on canvas, 94 × 130 cm (Mojana 110). A copy;

(7) Lombardy, private collection. Oil on canvas, 97 × 133 cm (Mojana 113). Possibly the same copy as (5) after restoration;

(8) Bordeaux, Musée et Galerie des Beaux-Arts. Oil on canvas, 114 × 150 cm. An adaptation attributed to Alexis Grimou (1678–1733).[15] Photograph in NG dossier (Mojana 116);

(9) Private collection. Anon. sale, Sotheby's 13 July 1977 (lot 87, unsold as by Gysbert van der Kuil).[16] An adaptation, illustrated in Rome 1994–5, p. 202;

(10) [Henry] Parr sale, Christie's, 11 March 1815 (lot 81, £10 10s. to Dillon). Described as 'Valentini. The Four Stages of Human Life';[17]

(11) A copy of the luteplayer was in an unknown private collection in 1954 as of the school of Manfredi;[18]

(12) A copy of the head and upper torso of the soldier. Anon. sale, Geneva, 26 May 1978 (lot 117). Oil on canvas, 49 × 42 cm (Mojana 115);

(13) St Louis, Missouri, St Louis Art Museum. As has been noted, the pose of the figure at the left of Nicolas Tournier's *Musical Party* (inv. 90: 1942) resembles that of the figure at the left of NG 4919.[19]

PRINTS

(1) By Antoine Louis Romanet (1742/3–1810) after a drawing of the painting by Antoine Borel (b.1743) in *Galerie du Palais-Royal*, 3 vols, Paris, 1786–1808, vol. 3 (1808) (Mojana 114) (fig. 3);

(2) According to the catalogue of the 1897 Angerstein sale (see Provenance), the painting was 'engraved in the Angerstein Gallery'. This certainly does not refer to John Young's illustrated catalogue of J.J. Angerstein's paintings published in 1823, but (possibly) to an as yet untraced illustrated catalogue of William Angerstein's collection.

Technical Notes

In reasonable condition, but, to judge from engraving (1) – that is, both the engraved image itself and the measurements of the painting stated on it[20] – cut down on all sides, especially along the bottom and the right-hand sides. There are some losses around the edges and a few small losses to the left of the lutenist, a tear in the soldier's cuirass some 10 cm long and other damages in this area and to the right of it by the sword handle, and there has been some fading in the reds and discolouring in the greens of the lutenist's costume.

The ground is a warm buff colour laid onto a medium-weight plain-weave canvas. The painting was relined at some time before its acquisition by the Gallery in 1938 onto a (presumably) nineteenth-century stretcher, since a handwritten label in ink on the back states: 'I have examined this picture in January 1898 – It has at some time been either oiled over the varnish, or oil-varnished, therefore the old varnish can only be removed, if at all, by a very skilled expert. J.D. Crace.' In addition there are the following marks on the back of the stretcher: (i) in black stencil, upper left, *606*; (ii) gouged into the wood, *40*; (iii) in ink on an old paper label, *No. 290*, presumably applied for the 1938 exhibition (see above), and on the central upright cross-member a Royal Academy label, 'Exhibition of 17th-century European Art, 1938. Owner Viscount Bearsted, 1, Carlton Gardens, SW1.'; (iv) in black stencil, *210*(?), but possibly *290*, and (v) in white chalk *GX*, presumably a reference to Gallery X of the Royal Academy, in which the painting hung for the 1938 exhibition.

The X-ray photograph (fig. 1) indicates some alterations around the figure of the child, in the position of the lutenist's knee and, perhaps, to the position of the old man which may once have been a few centimetres further right, and to the outline of the soldier's right shoulder. A change in the position of the latter's left thigh is visible to the naked eye, as is a change to the outline of the left-hand (as seen by the viewer) page of the book. A photograph taken after cleaning and before restoration in 1967, when NG 4919 was last restored, shows that the original position of the lutenist's left calf was further to the left.

There is no reason to doubt the long-standing title of NG 4919 nor its attribution, both of which date back to when the picture was in the Orléans collection. The subject of the Ages of Man was not uncommon in the sixteenth and seventeenth centuries, although the number of ages depicted varied from three to nine.[21] Ripa noted that the ancient philosophers considered that man had three ages (beginning, middle and end), whereas the medical profession distinguished four ages, 'adolescentia, gioventù, virilità, & vecchiaia', corresponding, to paraphrase Ripa, to the periods of physical growth, youth, maturity, and physical decline.[22] This fourfold division of human life was the more commonly held view, and was also favoured by several poets, including Ovid in the *Metamorphoses* (XV: 199–213) and Dante, as well as Valentin's near contemporary Gian Battista Marino (1569–1625); the latter's poem on the *Instabilità e la varietà del tempo* was published in *La lira*, Rome.[23]

However, Valentin's picture in its details owes little to these poets or to Ripa. Its figures are closer to the genre of indoor concerts and drinking parties, a type of painting in which Valentin (among numerous painters during the early seventeenth century) specialised. Thus, a figure in similar costume to that of the lutenist (here representing Youth) appears at the left of Valentin's *Gathering in a Tavern* (Paris, Louvre, inv. 8255; fig. 2) and in his *The Denial of Peter* (Moscow, Pushkin Museum), while the old man is close in type to the figure in the centre in *The Concert with Four Musicians and a Drinker* (New York, private collection) and to the old viol da gamba(?) player in the *Assembly with a Fortune-Teller* (private collection, on loan to the Art Gallery of Ontario).

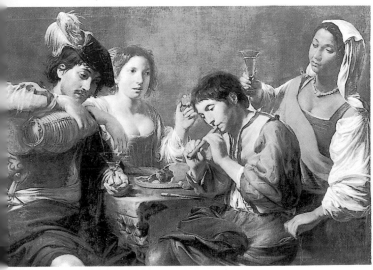

Fig. 2 *Gathering in a Tavern*, c.1625. Oil on canvas, 96 × 133 cm. Paris, Musée du Louvre.

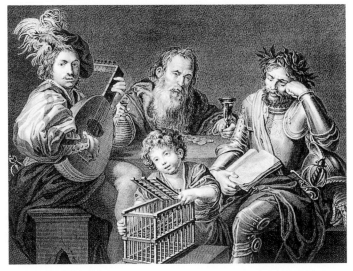

Fig. 3 A.L. Romanet after a drawing by Antoine Borel of NG 4919. Engraving in *Galerie du Palais-Royal gravée d'après les tableaux des différentes écoles qui la composent*, 3 vols, Paris 1786–1808.

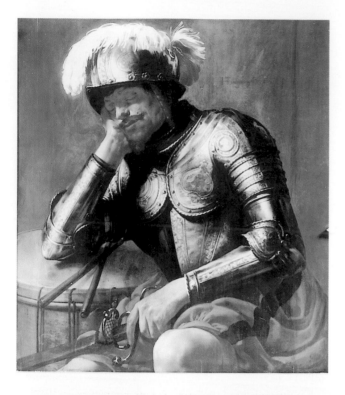

Valentin has given each figure attributes appropriate to his age. The empty object held by the child may be a birdcage symbolising hope (the captive bird hoping for its freedom)[24] or it may be a trap, as Bonfait has suggested.[25] But since, as is more clearly apparent from Romanet's print (fig. 3), the bird (if indeed the cage or trap is for birds) has flown, it may represent childish naivety or, less cynically, innocence – a state of mind in keeping with the child's expression. The youth at the left plays a large tenor or bass lute, whose striped back indicates that it would have been made from yew and whose number of string courses (9 or 10)[26] and body shape suggest an instrument of the type made in Venice or Padua between 1610 and 1650.[27] The lute may have been intended to symbolise pleasure or amorous longings.[28] The youth's striped sleeve, found in other paintings by Valentin as well as by Caravaggio and other Caravaggisti, may allude to Ripa's statement that changing colour represents the state of youth, which easily changes its mind.[29] More probably his costume was meant to recall that of the early sixteenth century, as would the fur-lined gown of the old man have recalled the costume of the mid-sixteenth century,[30] so distancing an evidently allegorical painting from the viewer's immediate experience. The warrior at the right represents *virilità*. He is crowned with the victor's laurel and

Fig. 4 Hendrick ter Brugghen, *Sleeping Mars*, 1620s. Oil on panel, 106 × 93 cm. Utrecht, Centraal Museum.

Fig. 5 *Samson*, 1630–1. Oil on canvas, 135.6 × 102.8 cm. Cleveland Museum of Art.

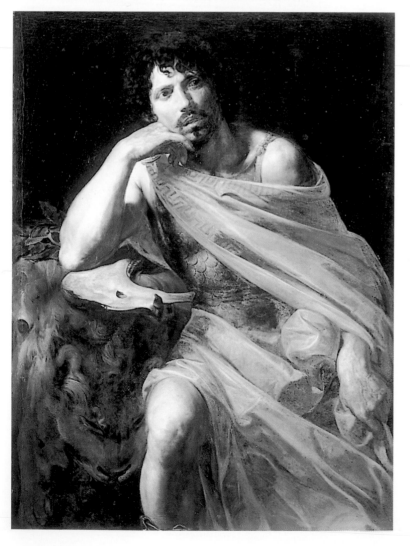

holds a book on which can faintly be seen the plan of fortifications. His left elbow rests on his helmet, which (as shown in the print) once covered his gauntlets. His pose is close to that of Ter Brugghen's *Sleeping Mars* (Utrecht, Centraal Museum; fig. 4).[31] His sleeping state suggests negligence:[32] in spite of his armour and laurels he is not only himself vulnerable but displays the plans of the fort for all to see, although in what may be another reference to the passage of time, these plans appear to have been painted as having faded,[33] like the writing on the page, which in turn appears to be manuscript rather than print, suggesting that the dog-eared book as a whole is old. The old man is shown with a pile of coins – a symbol of avarice, itself sometimes associated with old age.[34] He holds a wine-flask protected by matting, and a glass (the glass has a hollow baluster stem typical of seventeenth-century Venetian style)[35] which may be intended to be symbolic of the fragility of life. All in all, Valentin's painting may be seen as a depiction of the four stages of human folly.

NG 4919 cannot be dated with certainty. Mojana has proposed 1624/5,[36] Bonfait 1626–8[37] and Cuzin 1627–32,[38] the last of these periods being the only one to which other works by Valentin are certainly datable. As Cuzin has pointed out,[39] Valentin's style has little distinctive chronological develop-ment, but he is surely right to have placed NG 4919 in the same chronological bracket as the Munich *Erminia among the Shepherds* and the Louvre *Fortune-Teller*,[40] dated by Mojana to 1629–30 and c.1628 respectively. Contrary to Mojana, there seems to be no reason to separate NG 4919 chronologically from these two works.[41] The rather weak-chinned model for the lutenist in NG 4919 may be the one Valentin used for his *Samson* (Cleveland Museum of Art, inv. no. 72.50; fig. 5), a picture for which Valentin received payments between December 1630 and July 1631.[42] The tonality of NG 4919 is, however, darker than that of the Cleveland painting and so may be a little earlier, say c.1629 – that is, close in date to the *Allegory of Rome* (Rome, Villa Lante).[43]

General References

G.K. Nagler, *Neues allgemeines Kunstler-Lexicon*, vol. 19, Munich 1849, p. 325; Waagen 1854, vol. II, p. 498; Casimir Stryienski, *La Galerie du Régent Philippe, Duc d'Orléans*, Paris 1913, p. 178; Davies 1957, pp. 214–15; Roberto Longhi, 'A propos de Valentin', *La Revue des Arts*, 1958, II, p. 61; Wright 1985b, p. 143; B. Nicholson, *Caravaggism in Europe*, 2nd edn, 3 vols, Milan 1989, vol. 1, p. 200 and pl. 682; Mojana 1989, no. 35.

NOTES

1. E. Coyecque, 'La documentation de l'histoire de l'art français. A propos de la loi du 14 mars 1928 sur les archives notariales', *BSHAF*, 1930, pp. 92–9, at p. 97. According to his posthumous inventory of 1 August 1650, Particelli, who died on 23 May 1650, owned several paintings, including 'les Quatre ages de l'homme, de Valentin', valued at 200 livres. Particelli was a Lyonnais with interests in banking and silk manufacturing. He became Secrétaire du Roi in 1627 and Intendant des Finances in 1629. He was later appointed French ambassador at Turin (1635–9). On returning to Paris he lived in his new hôtel (demolished in 1685) in rue Nueve-des-Petits-Champs, opposite that of his son-in-law Louis II Phélypeaux, marquis de la Vrillière. He bought the office of Contrôleur Général des Finances, and in 1647 became Surintendant des Finances and minister of state: see Schnapper 1994, vol. II, p. 172; T. Claeys and A. Gady, 'No. 28 Hôtel d'Epinoy', *De la place Royal à la place des Vosges*, Paris 1996, pp. 392–8 at p. 393.

2. See Robert Le Blant, 'Les inventaires après décès des époux Jacques Bordier (1652–1660)', *Actes du 101e Congrès national des Sociétés, Lille, 1976, Section d'archéologie et d'histoire de l'art – Archéologie militaire – les pays du nord*, pp. 395ff. And Claude Mignot, 'Les tableaux de Jacques Bordier', *Cahiers de l'Inventaire, 5, l'hôtel de Vigny*, Paris 1985, pp. 39–40 and pp. 49–50. An inventory taken on 30 December 1652 of the jointly owned property of Jacques Bordier and his wife Catherine Lybault, after her death, included: 'Au cabinet dudit sieur Bordier... 5. Un tableau de Valentin des Quatre âges de l'homme, prisé 400Lt.' The inventory taken on 2 October 1660 after Bordier's own death included: '1. Un tableau des Quatre âges de l'homme de Valentin, prisé la somme de mille livres. 1000 Lt.' The valuation for the 1660 inventory was supplied by Mignard.

Jacques Bordier, a lawyer who became Intendant Général de la Maison du Roi et de ses Finances by 1638, bought the hôtel in rue du Parc-Royal (now no. 12 of that street) in 1628 and substantially improved it c.1642–5. It was sold in 1661 to Anne de Villiers together with the 'peintures et tableaux sur aucunes des cheminées et portes de ladite grande maison', but these items probably did not include the Valentin, which was one of several paintings inventoried in 1652 in Bordier's study on the ground floor of the hôtel: see Robert Le Blant, op. cit., pp. 361–2, and Claude Mignot, op. cit., pp. 14–32 and p. 57.

3. Dubois de Saint Gelais 1727, pp. xx and 482. No other painting is mentioned by Dubois de Saint Gelais as having come from Dussé, presumably a reference to either (i) Louis Bernin, marquis d'Ussé, seigneur de Valentiné (d.1709), Contrôleur Général de la Maison du Roy, Receveur Général des Finances à Tours, or (ii) his son, Louis Bernin-de-Valentiné, marquis d'Ussé (1663–1740?), Receveur-Général des Finances à Tours and Contrôleur Général de la Maison du Roy in succession to his father: De La Chenaye-Desbois et Badier, *Dictionnaire de la Noblesse*, 3rd edn, 5 vols, Paris 1863–76, vol. 3, p. 18 (Kraus reprint, 1969); A. Jal, *Dictionnaire critique de biographie et d'histoire*, 2nd edn, Paris 1872, pp. 1216–17 and 1227; D. Wildenstein, *Inventaires après décès d'artistes et de collectionneurs français du XVIIIe siècle*, Paris 1967, p. 131.

The coincidence of family names between the artist and the seigneur de Valentiné would scarcely be sufficient reason for the latter to have acquired NG 4919. One of its additional attractions may have been the plan of fortifications shown in the book held by the figure at the right of the painting. In 1691 Louis Bernin-de-Valentiné married the twelve-year-old Jeanne-Françoise Le Prêtre, the second daughter of Sébastien Le Prêtre de Vauban (1633–1707), more usually known as le Maréchal de Vauban, Louis XIV's celebrated fortifications engineer.

4. Possibly no. 142 or 144 in the 1724 posthumous inventory of Philippe d'Orléans, both pictures described as in 'la chambre des Poussins' and as 'Concert' by Valentin: see Françoise Madrus, 'Les collections du Régent au Palais-Royal', *Le Palais Royal*, Musée Carnavalet, Paris 1988, pp. 95–111 at pp. 102, 103, n. 40. Clearly described by Dubois de Saint Gelais 1727 as 'LES QUATRE AGES./ Peint sur toile, haut de trois pieds cinq pouces & demi, large de quatre pieds six pouces. Fig. de grandeur naturelle./ M. Dussé./ Trois hommes sont rangés au tour d'une table. Celui de la droite est un Guerrier qui a une écharpe par dessus son armure, il y a devant lui un livre de Cartes géographiques. Celui qui lui est opposé est un jeune garçon habillé en Hongrois aiant une aigrete sur son bonnet, qui joue du luth, & celui du milieu est un vieillard qui boit. Sur le devant est un enfant qui tient une cage où il y a un oiseau.' The painting is similarly described in the second edition (1737) of this work (p. 480).

Both editions describe two other works by Valentin, one, 'La Musique', with precisely the same dimensions as those of NG 4919 as there described. 'La Musique', which can be identified as the *Musical Party* (Los Angeles, County Museum of Art, inv. no. AC 1998.58.1), was acquired by Philippe d'Orléans from the Nancré collection and was painted *c*.1620, but seems to have been hung as a pair with NG 4919 at the Palais Royal.

For some other references to NG 4919 while in the Orléans collection, see [G.L.] Le Rouge, *Les Curiositiez de Paris*, 2 vols, Paris 1733, vol. 1, p. 168; Dezallier d'Argenville 1749, p. 60, where described as being in a room called 'La Chambre des Poussins' containing twenty pictures (of which only one was then by Poussin), and Dezallier d'Argenville 1745, vol. 2, p. 262; [L'abbé Antonini], *Memorial de Paris et de ses environs*, 2 vols, Paris 1749, vol. 1, p. 300, where described as hanging to the right of the door on entering the 'Grand Cabinet de Monsigneur, appelé ci-devant la Chambre des Poussins' together with (among other pictures) the paintings by Valentin called respectively 'Une Femme qui joue de la Guitare' and 'La Musique' by Dubois de Saint Gelais 1727, pp. 480–1 (I am grateful to Nicholas Penny for referring me to this source); Thiéry, *Guide des Amateurs et des Etrangers Voyageurs à Paris*, 2 vols, Paris 1787, vol. 1, p. 241, where described as in the 'Chambre appellée du Poussin', by now apparently devoid of pictures by that artist; and J.J. Volkmann, *Neueste Reisen durch Frankreich*, 3 vols, Leipzig 1787–8, vol. 1, p. 286, where included among twelve paintings hanging in the so-called Poussin Room. See also Engravings, and V. Champier and G.-R. Sandoz, *Le Palais Royal d'après des documents inédits (1629–1900)*, 2 vols, Paris 1900, vol. 1, p. 515.

5. Buchanan 1824, vol. 1, pp. 17–18; Casmir Stryienski, *La Galerie du Régent Philippe, Duc d'Orléans*, Paris 1913, pp. 138–40; and Ferdinand Boyer, 'Les collections de François de Laborde-Méréville', *BSHAF*, 1967, 1968, pp. 141–52 at pp. 144–5.

6. On John Julius Angerstein (1735–1823), see especially *John Julius Angerstein and Woodlands 1774–1974*, exh. cat., London, Woodlands Art Gallery, 13 September to 5 November 1974; and Egerton 1998, pp. 358–69. The price is given as in the annotated copy of the sale catalogue in the NG Library.

7. See Brigstocke 1982a, pp. 51–2. J.J. Angerstein did not buy Weeting Hall, whence the picture was eventually sold by his grandson's trustees, until 1808, so perhaps NG 4919 was at Woodlands, Blackheath, until 1870, when William Angerstein ceased to live there: see *John Julius Angerstein*, 1974, cited in note 6, p. 66.

8. William was John Julius's youngest grandson.

9. Now demolished: see Pevsner 1962, p. 369.

10. Davies 1957, p. 214 (under Provenance). For Marcus Samuel, the joint founder of Shell Transport and Trading Co. Ltd, who bought The Mote in 1895, see *DNB 1922–1930*,

London 1937 (1953 reprint), pp. 737–8, and Robert Henriques, *Marcus Samuel, First Viscount Bearsted and founder of the 'Shell' Transport and Trading Company 1853–1927*, London 1960. According to a letter in the NG dossier written on 3 June 1937 by Viscount Bearsted's secretary to Kenneth Clark, the painting was attributed to Valentin by Alfred Scharf.

11. According to a label on the back of the stretcher applied when the painting was loaned to the Royal Academy in 1938. For Walter Samuel, see Laing 1995, pp. 239–40.

12. *Vassar College Art Gallery Catalogue*, Poughkeepsie 1939, p. 33; and *Vassar College Art Gallery. Selections from the Permanent Collection*, Poughkeepsie 1967, p. 18.

13. Classed as an original in the publications cited in note 12, but as a copy in *La peinture française du XVIIᵉ siècle dans les collections américaines*, exh. cat., Paris, New York, Chicago 1982, p. 373. I have not seen the painting.

14. From this photograph it appears that Mojana no. 109 is this painting, and not the one auctioned by Sotheby's on 28 July 1976.

15. See Paris 1954, no. 49, under Exhibitions, and Bordeaux, *Musée des Beaux-Arts. Peinture italienne XVᵉ–XIXᵉ Siècles*, Paris 1987, p. 230.

16. Now attributed to Gerard van Kuijl (or Kuyl) (1604–73): see B. Nicholson, *Caravaggism in Europe*, 2nd edn revised by L. Vertova, 3 vols, Oxford 1979, vol. I, p. 131, illus. vol. III, fig. 1368. And see Rome 1994–5, p. 202.

17. *The Index of Paintings Sold*, pp. 1051, 1365 and 1408.

18. Paris 1954, p. 162.

19. Paris, New York, Chicago 1982, no. 105.

20. 'Peint sur Toile, ayant de hauteur 3 Pieds 6 Pouces, sur 4 Pieds 6 Pouces de large.' The metric equivalent of these measurements is 113.7 × 146.1 cm.

21. A. Pigler, *Barockthemen*, 3 vols, Budapest 1974, vol. 2, pp. 494–5.

22. Cesare Ripa, *Iconologia*, Venice 1645, p. 184. The first edition of Ripa's *Iconologia* was published in 1593, and the first illustrated edition ten years later. Ripa also noted the opinion of others who considered there were respectively five, six or seven ages: ibid., p. 185.

23. See Rome 1994–5, p. 201, where Olivier Bonfait suggests that Valentin's conception of the Four Ages may have originated within the Barberini circle. NG 4919 has been connected – improbably – to the theme of a poem dedicated to Simon Vouet by Marino's contemporary and adversary Tommaso Stigliani (1573–1651), praising a picture by Vouet of three allegorical figures representing the ages of man as 'Infanzia, giovinezza, età canuta': see B. Brejon de Lavergné, 'Portraits de poètes italiens par Simon Vouet et Claude Mellan à Rome', *Revue de l'Art*, 50, 1980, pp. 51–7.

24. A.P. de Mirimonde, *L'Iconographie Musicale sous les Rois Bourbons*, Paris 1975,

pp. 43–4; and G. de Tervarent, *Attributs et Symboles dans l'Art Profane 1450–1600*, Geneva 1959, pp. 58–9. Mirimonde cites I. Bergström, 'The Iconological Origins of Spes by Pieter Brughel the Elder', *Nederlands Kunsthistorisch Jaarboek*, vol. 7, 1956, pp. 53–63, which illustrates a woodcut by Heinrich Vogtherr the Elder (1490–1556) of the figure of Spes standing on a cage of birds. The cage in Vogtherr's woodcut is, however, firmly closed.

25. In Rome 1994–5, p. 201.

26. Probably 10, but it is not absolutely clear from looking at the painting.

27. Information kindly supplied by Lance Whitehead, Royal College of Music.

28. G. de Tervarent, cited in note 24, p. 225.

29. Ripa, cited in note 22, p. 186.

30. I am grateful to Aileen Ribeiro for this suggestion and for drawing my attention to Stella Mary Pearce's article, 'Costume in Caravaggio's Painting', *Magazine of Art*, April 1953, pp. 147–54. Ribeiro doubts Pearce's conclusion that costumes such as that of the youth in NG 4919 were meant to indicate that their wearers were liveried pages.

31. As noted in B. Nicolson, *Hendrick Terbrugghen*, The Hague 1958, p. 103, and by L.J. Slatkes, *Dirck van Baburen (c.1595–1624). A Dutch Painter in Utrecht and Rome*, Utrecht 1965, p. 72, n. 59. The similarity is probably no more than a coincidence, as Brejon de Lavergnée and Cuzin suggested in Paris 1974, p. 160.

32. For a contrary reading, see Paris 1974, p. 160 ('l'homme d'étude et d'action').

33. Rome 1994–5, p. 202.

34. Ripa, cited in note 22, p. 51.

35. This information has been kindly provided by Reino Liefkes, who has also informed me that the bottle, which is a serving bottle, is of a type evidently used in Italy from the fifteenth century onwards, but possibly much earlier. (Letters of 27 April and 29 June 1999.)

36. Mojana 1989, pp. 28 and 122.

37. Olivier Bonfait in Rome 1994–5, p. 203.

38. J-P. Cuzin, 'Problèmes de caravagisme. Pour Valentin', *Revue de l'Art*, 28, 1975, pp. 53–61 at p. 60.

39. Ibid., p. 57.

40. Ibid., p. 60.

41. In Paris 1974 it was suggested that Tournier, who left Rome in 1626, may have used Valentin's lutenist as the figure at the left of his *Musical Party* (St Louis Art Museum), so giving a *terminus ante quem* for NG 4919, but figures of this kind were too common in paintings of this period for any such conclusion to be drawn.

42. *European Paintings of the 16th, 17th and 18th Centuries. The Cleveland Museum of Art Catalogue of Paintings. Part Three*, Cleveland 1982, p. 149.

43. For the dating of Valentin's *Allegory of Rome*, see Mojana 1989, p. 150.

Jakob Ferdinand Voet

1639–1689

Born in Antwerp, where he was probably apprenticed, Voet was in Rome by 1663. In 1678 he was briefly expelled for allegedly libertine conduct, but in fact his expulsion was probably a reaction to the success of his celebrated series of portraits of women from Rome's high society, not all of whom were examples of virtue. He returned to Rome in 1679, was briefly in Florence in 1682 and was then in Turin, where he remained until 1684, when he went to Antwerp via Lyon and Paris. He must have returned to Paris quite soon afterwards since his portrait of the French minister François Le Tellier was engraved in 1686. Voet died there three years later.

Although Houbraken, in a brief biography published in 1721, wrote that Voet painted landscapes and history pictures, his fame rested on his portraits. Soon after his arrival in Rome he painted Maria Virginia Borghese, wife of Prince Agostino Chigi (for whom Claude had painted NG 6). Some years later he portrayed Agostino himself, as well as other members of the Chigi family. Voet enjoyed his greatest success during and soon after the papacies of Clement IX (1667–9) and Clement X (1670–6), portraying numerous important sitters, including *Queen Christina of Sweden* (Florence, Uffizi), *Sir Thomas Burnet* (London, National Portrait Gallery), *Cardinal Carlo Cerri* (NG 174) and *Livio Odescalchi*, the nephew of Pope Innocent XI (Baltimore, Walters Art Gallery). In 1672 Cardinal Flavio Chigi commissioned the series of portraits of Roman women (see above); there followed commissions for replicas from other aristocratic families, such as the Colonna, the Savoia and the Altieri. Paintings from this series have been much copied.

References

F. Petrucci, 'Monsù Ferdinando ritrattista. Note su Jacob Ferdinand Voet (1639–1700?)', *Storia dell'arte*, 84, 1995, pp. 283–306. T. Montanari, 'Jacob Ferdinand Voet e Livio Odescalchi', *Prospettiva*, 81, June 1996, pp. 52–5.

NG 2291
Cardinal de Retz

1676
Oil on canvas, 72.5 × 58.2 cm
Inscribed at a later date top left: *Le cardinal de Retz*

Provenance

In the collection of George Fielder (1811–86) of West Horsley Place, Leatherhead, Surrey, by 1878 as by Philippe de Champaigne; bequeathed to the National Gallery by Fielder in 1908.[1]

Exhibitions

Guildford 1884, *Surrey Art Loan Exhibition* (29) (as by P. de Champaigne); Barnsley 1958–63, Cannon Hall, long-term loan through the Arts Council of Great Britain; Barnard Castle 1970–5, Bowes Museum, long-term loan through the Arts Council of Great Britain.

Technical Notes

In generally good condition. There are some minor losses at the bottom in the drapery and where the two sides of the collar overlap, some wear in the hair, some discoloured retouchings, and the varnish is very yellow. Minor treatment was undertaken for flaking paint in 1938, and for blisters in 1970. Otherwise not restored since prior to acquisition.

The stretcher is not the original; marks of a previous stretcher with cruciform supports can be seen on the surface of the painting. The primary support is a fine plain-weave canvas relined at some date before acquisition. A lack of cusping along the bottom of the canvas suggests that the painting may have been cut down. The lining canvas is marked *30* in grey paint, and, also in grey paint but in what appears to be an older hand, *n:79*. NG 2291 is faintly inscribed at the upper left *Le cardinal de Retz*. Technical analysis has revealed the use of no materials exclusive to painting practice in either France or any part of Italy.[2]

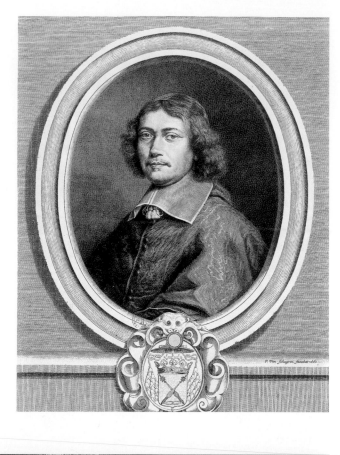

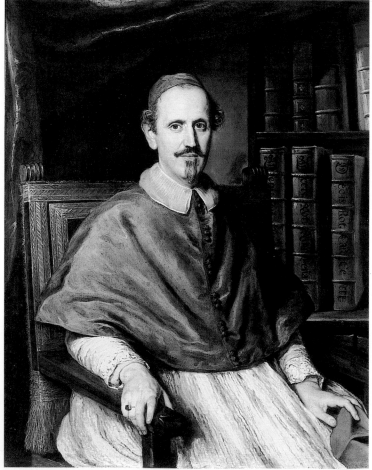

Jean François-Paul de Gondi (1614–79), Cardinal de Retz, was the second son of Philippe-Emmanuel de Gondi, a general of the galleys of France, and the nephew of Henri de Gondi, archbishop of Paris, who was created a cardinal in 1618. His identification as the sitter here is confirmed by comparison with engraved portraits by Etienne Picart of 1652[3] and by P. van Schuppen of 1662 (fig. 1).[4] Jean François-Paul was appointed co-adjutor to the archbishop of Paris in 1643. He was a leader of the Fronde and an enemy of Cardinal Mazarin. He was himself made a cardinal in February 1652 but was imprisoned by Mazarin in December that year. He escaped from prison in 1654 and then had to flee Rome in 1656. He spent some six years on the run from Mazarin's agents in the Franche-Comté, Switzerland, Germany, Holland and England, before returning to France after Mazarin's death at the end of 1661 and retiring to his château at Commercy early the following year. He had in 1655 attended the conclave that elected the Chigi pope, Alexander VII. Subsequently, on the instructions of Louis XIV – who, however, never fully forgave him for his part in the Fronde – he attended the conclaves in Rome that elected Clement IX in 1667, Clement X in 1670 and Innocent XI in 1676.[5] He died in Paris at the hôtel de Lesdiguières. His memoirs, addressed to an anonymous lady who was probably Madame de Sévigné, with whom he corresponded, were first published in 1717.

The traditional attribution of NG 2291 to Philippe de Champaigne was rightly rejected by Martin Davies,[6] and by Dorival.[7] Brière proposed Pierre Mignard,[8] an attribution which seems equally improbable. Recently Xavier Salmon has suggested Voet as the author, an attribution accepted, on the basis of a photograph, by Francesco Petrucci, who dates the painting to 1676 on stylistic grounds.[9] Although there is no clear stylistic similarity between this painting and the Gallery's *Cardinal Carlo Cerri* (NG 174; fig. 2), which is firmly attributed to Voet,[10] the rapidity of the brushwork of the

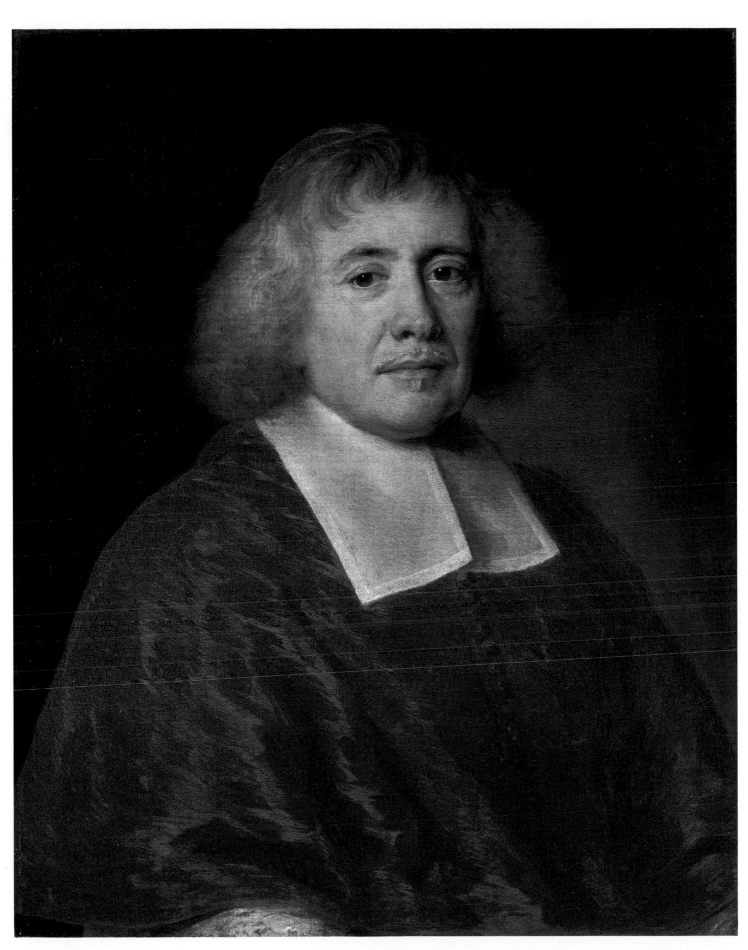

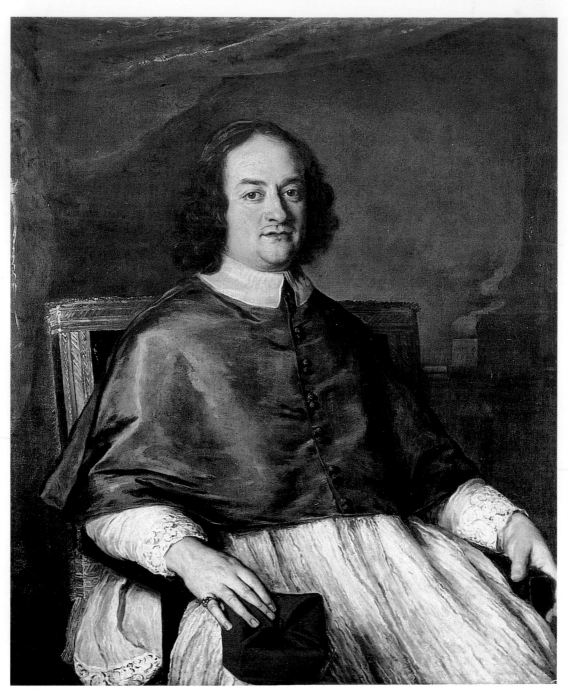

drapery, the manner of delineating the sitter's left shoulder and the thoughtful, introspective look of de Retz recall similar qualities in Voet's *Cardinal Alessandro Crescenzi* (formerly London, Heim Gallery) and *Cardinal Decio Azzolini* (Berlin, Staatliche Museen; fig. 3).

Given the age of de Retz in NG 2291, Voet may have portrayed him during one of the conclaves he attended in 1667, 1670 or 1676. None of these visits to Rome is mentioned in de Retz's *Mémoires*, which do not deal with his last years or with any portrait he might have commissioned during that time.[11] The first conclave lasted three weeks and that of 1676 two months, August and September. The 1670 conclave continued over some four months, so providing the most likely opportunity for de Retz to have commissioned a portrait[12] – and, furthermore, Voet was at this time painting portraits of a number of other cardinals in Rome[13] – but the stylistic similarities between NG 2291 and a portrait of a member of the Rangoni family inscribed with the date 1676 are so striking that NG 2291 must date from that year, when de Retz was nearly 62, as Petrucci has suggested.[14]

General References

Davies 1957, p. 27 (as 'ascribed to Philippe de Champaigne'); Dorival 1976, no. 1779 (as not by Philippe de Champaigne).

NOTES

1. By a codicil dated 22 October 1878 to his will dated 9 October 1878, George Fielder bequeathed to the trustees of the British Museum for the National Gallery of Pictures at Trafalgar Square thirteen paintings including 'Portrait of Cardinal de Retz, by Philip de Champagne [sic]...', that is, NG 2291. The bequest was subject to a life interest for Fielder's wife, Laura Mary, née Sanders, who died on 31 March 1908. Of the thirteen paintings comprising the bequest, five, including NG 2291, were accepted: NG Archives, NG7/341/1908. See also the minutes of the meeting of the National Gallery Trustees of 12 May 1908 recording acceptance of the bequest.

2. Marika Spring writes: 'The initial preparatory layer is brown in colour, containing a red earth pigment consisting of red iron oxide and miscellaneous silicaceous materials, as well as some calcium carbonate and a small amount of lead white. There is a second, thicker, preparatory layer containing lead white and translucent colourless particles which presumably serve as an extender. On EDX analysis these proved to consist of calcium carbonate, silica (quartz?), and other colourless silicates. The brown background behind the figure is painted with a mixture of yellow earth and bone black (confirmed by EDX analysis). The red paint of a shadow on his sleeve contains vermilion and red lake.' (Note dated November 1998.)

3. B.N., Estampes, no. N2-D247087; and see N2-D247090 for an anonymous engraved portrait of Cardinal de Retz.

4. B.N., Estampes, no. N2-D247070.

5. L. von Pastor, The History of the Popes (trans. E. Graf), vol. 31 (1940), p. 437, and vol. 32 (1940), pp. 2–7; Cardinal de Retz, Mémoires, preface and notes by G. Mongrédien, 4 vols, Paris 1935, pp. ix–x.

6. Davies 1957, p. 27. Davies had earlier rejected the attribution in Davies 1946, pp. 14–15.

7. Dorival 1976, vol. 2, p. 329.

8. Letter of 31 October 1929 from Robert Witt reporting on a letter he had received from Brière.

9. In conversation with Xavier Salmon, and letter of 18 September 1998 from F. Petrucci. Petrucci accepts NG 2291 as an autograph work of Voet on the basis of a photograph, and suggests that on stylistic grounds it may have been made during the 1676 conclave (letter of 18 September 1998).

10. Levey 1971, pp. 243–4; F. Petrucci, 'Monsù Ferdinando ritrattista. Note su Jacob Ferdinand Voet (1639–1700?)', Storia dell'arte, no. 84, 1995, pp. 283–306 at pp. 284, 302.

11. Augustin Gazier, Les dernières années du Cardinal de Retz, 1655–1679. Etude historique et littéraire, Paris 1875.

12. L. von Pastor, cited in note 5, vol. 31, gives the dates of the 1667 conclave as 2–20 June (p. 318) and those to elect Clement X as 20 December 1669–29 April 1670 (pp. 432, 437), although Cardinal de Retz arrived in Rome only on 16 January 1670 (p. 434).

13. F. Petrucci, cited in note 10, p. 287; A. Brejon de Lavergnée, 'Deux portraits de Jacob-Ferdinand Voet', Revue du Louvre, 1983, pp. 372–4 at p. 372.

14. For the Rangoni portrait, see F. Petrucci in Arte Lombarda, 129, 2000/2, pp. 29–38 at pp. 31, 34 and 38, n. 4. For Petrucci's dating of NG 2291, see his article cited in note 10.

Simon Vouet

1590–1649

Vouet's first teacher was his father, the Paris painter Laurent Vouet. At the age of 14 he was invited to London to paint the portrait of a noblewoman. In 1611–12 he accompanied the French ambassador to Constantinople, where he is said to have executed a portrait of 'le Grand Seigneur'. Then, after a year in Venice, he reached Rome, probably in 1614. He was granted a pension by the Regent of France, Marie de Médicis. He spent several months in Genoa and en route back to Rome in 1621 visited a number of art collections, armed with letters of recommendation from Cassiano dal Pozzo, who would later become Poussin's principal Roman patron.

The period Vouet spent in Rome between 1622 and 1627 was outstandingly successful: commissions for churches, including in 1624 an altarpiece for St Peter's, work for Cardinal Filomarino and Marcello Sacchetti, and election as the principal of the Accademia di San Luca. At the end of 1626 Louis XIII recalled Vouet to Paris, where he arrived in late 1627. He was made Premier Peintre du Roi, given lodgings in the Louvre and awarded an annual pension of 1000 livres. He was soon commissioned by the French Crown to make a series of cartoons for tapestries based on Old Testament episodes; other royal commissions followed, as well as commissions to decorate aristocratic hôtels and châteaux and to work for religious institutions.

In Paris the influences which had predominated in Vouet's Italian period, namely those of Caravaggio, Manfredi and Lanfranco, gave way to a lighter, more elegant manner, and he developed a fine sense of colour. He continued to draw after the model, and in his studio pupils and assistants could do the same. His Italian-born wife, Virginia de Vezzi, taught drawing to women. Vouet's dominance of painting in Paris was temporarily threatened when Poussin returned there in 1640–2, and again in the last year of his life when the founding of the Académie Royale de Peinture et de Sculpture offered students an alternative studio for instruction. Nevertheless, many of the most important of the next generation of painters, including Le Sueur, Pierre Mignard and Charles Le Brun, who would later establish his own major studio, were formed in the studio of Vouet.

Simon Vouet and Studio

NG 6292
Ceres and Harvesting Cupids

1634–5?
Oil on canvas, 145.5 × 188 cm

Provenance
Possibly painted for Claude de Bullion (1570–1640), sieur de Bonnelles and Surintendant des Finances, for his hôtel, rue Plâtrière (now rue Jean-Jacques Rousseau), Paris,[1] and if so, probably removed from there by 1785;[2] bought by François Heim at an anonymous sale, Paris, R. Boisgirard, spring 1957 (as Flemish School, seventeenth century);[3] bought for £4000 from the Galerie Heim, Paris, in 1958 out of the Henry Oppenheimer Fund, with a contribution from Mr Edgar Ivens.

Exhibitions
Paris 1958, Galerie Heim, *Tableaux de Maîtres Anciens* (4); London 1963, NG, *The Exhibition of Acquisitions, 1953–62*, pp. 86–7; Copenhagen 1992 (25).

Technical Notes
There is some wear, especially in the sky and in the area of the corn, and some repaired losses around the edges.

The primary support consists of two pieces of a medium-weight plain-weave canvas joined horizontally about 42 cm from the top. Relining was probably undertaken shortly before the picture's acquisition by the National Gallery. The relining bears a French Customs stamp. No cusping of the canvas is visible, so the picture has possibly been cut down on all sides by a few centimetres. The ground layer is a pinky red. The stretcher may date from when the painting was last relined.

There are minor pentimenti visible to the outlines of Ceres (her heel, for example) and the clouds. The figure of Ceres has been painted in an area left in reserve.

Ceres, the name by which the Romans called the Greek goddess Demeter, was a sister to Jupiter and Neptune and goddess of the earth and of its fertility. As such, she was frequently represented crowned with a garland of ears of corn,[4] a characteristic which she retained in seventeenth- and eighteenth-century representations.[5] Ceres made frequent appearances in Baroque art, including works by Vouet and his studio in which she might variously personify one of the four elements (Earth)[6] or one of the four seasons (Summer).[7] If, however, NG 6292 is the same painting as that identified at the hôtel de Bullion by Dezallier d'Argenville, then it is more specifically an allegory of the harvest.

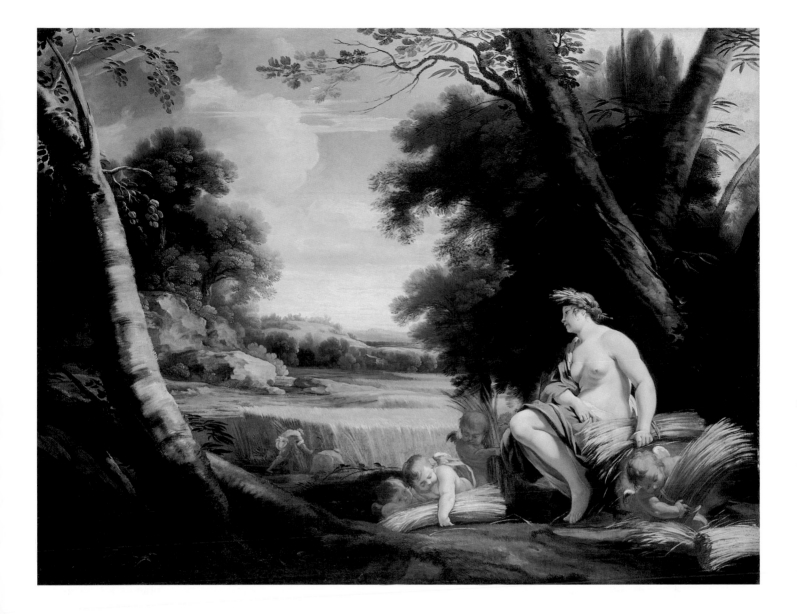

In the fourth edition of his *Voyage Pittoresque de Paris*, published in 1765 (but possibly written by 1761), Dezallier describes three paintings by Vouet in a small study on the first floor of the hôtel de Bullion: the Hunt symbolised by Diana and Actaeon, the Wine Harvest by Silenus and satyrs, and the Harvest by Ceres and harvesting Cupids.[8] Dezallier also refers to other rooms at the hôtel de Bullion decorated by Vouet, namely 'Le grand Cabinet qui précède la galerie' with nine pictures of the story of Diana on the walls and an octagonal ceiling painting of Venus and Diana, and the gallery itself 'toute de la main de Vouet' containing thirty-four wall and ceiling paintings on the story of Ulysses.[9] The 'small study' can possibly be identified as that mentioned by Brice as at the far end of the gallery on the first floor of the hôtel and simply described by him as being 'also his work' – 'aussi de lui' (i.e. Vouet).[10] Unfortunately, no other more detailed description of this room is known, nor is there any trace of the compositions said by Dezallier to symbolise the Hunt and the Wine Harvest. Furthermore, although the contract entered into on 1 March 1634 by Claude de Bullion, Simon Vouet and the sculptor Jacques Sarrazin contained detailed terms for the decoration of the gallery on the first floor, it was vague with regard to the decoration of the rooms at each end of the gallery.[11] One of these rooms is presumably the small study described by Dezallier. The contract specified only that 'sera peinct plancher, frises et cheminée du cabinet des coulleurs qui plairont le plus avecq les tableaux pour les dictes cheminées des deux cabinetz'[12] ('There will be painted the ceiling, friezes and chimney of the room with the most pleasing colours for the pictures for the said chimneys of the two rooms'). It therefore only provided for the decoration of the rooms in harmony with their respective chimney paintings, which may have already existed but were not necessarily then installed. When that part of the hôtel de Bullion which housed the gallery was bought in 1778 by the dealer and auctioneer Alexandre-Joseph Paillet, he substantially renovated the interior. If the *Ceres and Harvesting Cupids* and its two companions were not then removed, it seems likely that they were by 1785, or at least removed from their original location within the hôtel de Bullion.[13] In short, although NG 6292 is indeed a picture of Ceres with harvesting cupids and is certainly within the ambit of Vouet, one cannot be certain that it was the painting once at the hôtel de Bullion.[14] The discussion will, however, proceed on the basis that it was.

The contract of 1 March 1634 had required Vouet to provide thirty-four paintings relating to the story of Ulysses for the gallery, as well as at least one more of an unspecified subject for each of the end rooms. Sarrazin and Vouet were obliged to complete the painted and sculpted decoration of the gallery, including gilding, carving and so on, within ten months. The fact that these decorations were to be executed in accordance with a previously agreed design and that Sarrazin and Vouet were described as 'les entrepreneurs' (the contractors) suggests that their role was anticipated as supervisory and not, or not only, executory.[15] Indeed, it would be difficult to believe in any other possibility were the works to be carried out in time, although apparently the project was not completed until 1635.[16] Possibly any one of the three paintings – NG 6292, the Wine Harvest or the Hunt – formed the chimney-piece of one of the end rooms and at some point during or soon after the contract period it was decided to add the other two paintings, or possibly none was the chimney-piece and all three were overdoors. If the former, the order in which Dezallier describes the three paintings and the composition of NG 6292 suggest that it would have been placed to the right of the fireplace.

Arguably, paintings which may have afforded the opportunity for close study would have been executed by Vouet himself. On the other hand, given his concern for his reputation,[17] it is equally arguable that Vouet would not have chosen to paint a picture that was destined for a room at the far end of the gallery and, possibly, for a subsidiary position within it. This would reinforce doubts elsewhere expressed on stylistic grounds as to whether NG 6292 might not be at least partly by an assistant rather than by Vouet himself. Rosenberg has suggested Jean Mosnier (1600–56) as the sole author of NG 6292 on the basis of perceived similarities between it and the paintings once installed at the Château de Chenailles (now at Toledo, Ohio), themselves attributed by Rosenberg to Mosnier.[18] However, the figures in the Chenailles pictures seem less competent than those in NG 6292, which cannot be by the same hand. Laveissière has attributed NG 6292 (or at least the figures in it) to Nicolas Chaperon, who may have entered Vouet's studio around 1632, noting the similar rich modelling of Ceres in NG 6292 and of Venus in Chaperon's *Alliance of Bacchus and Venus* (Paris, private collection); the similarity of Ceres' profile with that of the bacchante at the right of Chaperon's *Drunken Silenus* (Florence, Uffizi Gallery; fig. 2); the resemblance of the putti in NG 6292 to those in a drawing attributed to Chaperon (Paris, Louvre, Département des Arts Graphiques, inv. 34 142; fig. 1); the similarity of the modelling of the two peasants in the background of NG 6292 to that of the shepherd in the background of Chaperon's *Nurture of Jupiter* (Chapel Hill, NC, The Ackland Art Museum, University of North Carolina); and the touches of pink, russet and brown in Ceres' hair and the blue of her drapery in NG 6292, which are consistent with Chaperon.[19] However, the similarities between NG 6292 and works by Chaperon that were recently exhibited in Nîmes were insufficiently strong to attribute the Ceres to him with any confidence. In particular, NG 6292 does not share with *The Alliance of Bacchus and Venus* the latter's much redder colour, a feature of most of Chaperon's paintings, nor have the features of Ceres that much in common with those of Venus after allowing for the fact that Vouet and those working for him shared a 'house style'. As for Chaperon's painting in the Uffizi, it is less accomplished than NG 6292, the profile of the bacchante, for example, being much cruder. In addition, NG 6292 is clearly by a different hand from that which painted *The Rest on the Flight into Egypt* (private collection; fig. 3). Since this last picture can be securely attributed to Chaperon,[20] NG 6292 cannot be by him. Finally, if NG 6292 was painted in 1634–5, its figures, whatever their defects, seem too accomplished by comparison with those in Chaperon's engravings of that period.[21]

Fig. 1 Attributed to
Nicolas Chaperon,
Three Putti, c.1635.
Black chalk with
heightening in white
chalk on blue-green
paper, 17 × 25 cm. Paris,
Musée du Louvre,
Département des Arts
Graphiques.

Fig. 2 Nicolas Chaperon,
Drunken Silenus,
c.1637. Oil on canvas,
115 × 84 cm. Florence,
Uffizi.

Fig. 3 Nicolas Chaperon,
*Rest on the Flight into
Egypt*, c.1641. Oil on
panel, 63.5 × 49.5 cm.
Private collection.

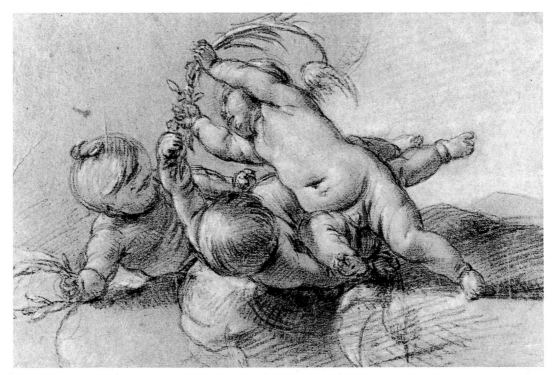

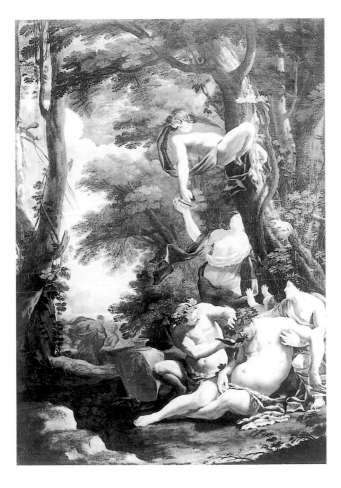

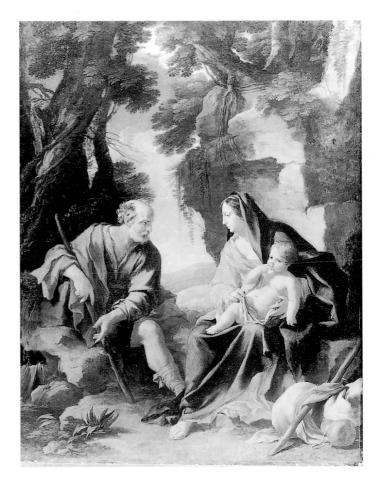

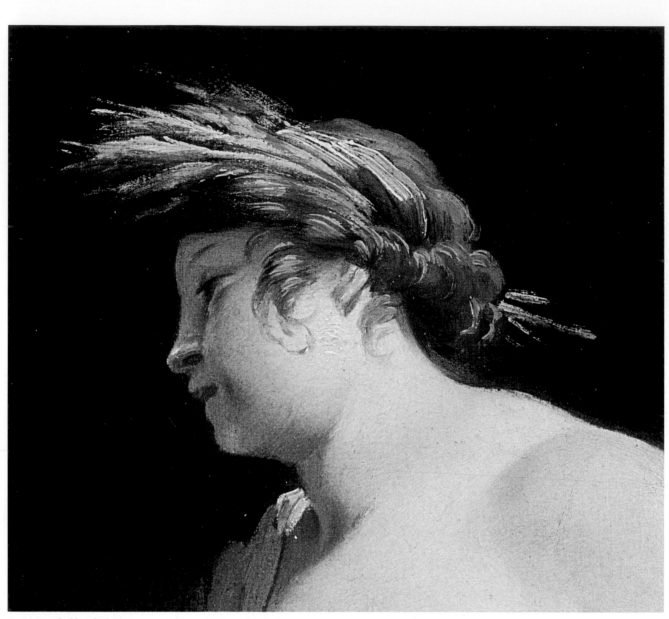

Fig. 4 Detail of head of Ceres.

Crelly, although ultimately not rejecting the picture from Vouet's autograph oeuvre, expressed the view that it had been executed in a 'rather summary, even careless manner, as is especially discernible in the hands, feet and draperies of the figures, and the Ceres is far below the standard set by the best of [Vouet's] decorative works'.[22] As Crelly noted, some of the landscape elements in *Muses in a Landscape* (whereabouts unknown), which he attributed to Vouet's studio, resemble those of NG 6292.[23] He suggested that NG 6292 might be a tapestry cartoon based on the painting in the small cabinet, proposing this as an explanation for a lack of finish in the details.[24] Rapidity of execution, however, is just what one might expect given the short time available for the contract as a whole. Indeed, if NG 6292 was one of some forty paintings executed in less than a year, then what is remarkable is the competence of the work, not the reverse. The head of Ceres (fig. 4), whose figure was painted in an area left in reserve, and the sheafs of

corn are painted with considerable freedom and confidence, and if the painting of the putti is more casual, it is no more so than that of, say, the putto in Vouet's (admittedly worn) *Allegory of Charity* (Paris, Louvre) of *c.*1634. It is reasonable to assume at the very least the intervention of Vouet's hand in the painting of the foreground figures and some of the landscape elements, even if responsibility for them was shared with the studio.[25]

A recent tentative attribution of the landscape in NG 6292 to François Belin, one of the landscapists who worked for Vouet, seems unlikely to be correct.[26] Allowing for the differences in media, there appears to be a closer comparison between the landscape in NG 6292 and that of a tapestry of *The Finding of Moses* (fig. 5) designed by Vouet probably during the first half of the 1630s.[27] In particular, the shape of both the nearer and more distant trees is comparable, as is the way the bark is designed, and the individual branches and leaves.

The near horizontal tree trunk at the bottom left of NG 6292 is like the (broken) trunk at the bottom right of the tapestry; both tree trunks are entwined with ivy and a small but telling detail suggesting that the same hand was at work is the way in which tall trees are used to block out an area of sky between nearer trees at the top right of both compositions. It seems reasonable to conclude that the landscapes in both NG 6292 and (the now lost or destroyed cartoon of) *The Finding of Moses* were at least designed by the same artist – surely Vouet himself. If Belin is excluded as the executant, two other landscapists whom Vouet is known to have employed emerge as possible candidates: Frédéric Scalberge, who was in Paris by 1636 but of whom little is known, and Pierre Patel, who, however, is not documented as working for Vouet before 1640 and whose candidature would present stylistic difficulties.[28] At present, therefore, it is not possible to say with certainty which member, or members, of Vouet's studio helped him with the execution of NG 6292.

General References
National Gallery Catalogues. Acquisitions 1953–62, pp. 86–7; Crelly 1962, no. 52; Wright 1985b, p. 145.

Fig. 5 After Simon Vouet, *The Finding of Moses*, c.1640. Wool and silk tapestry, 495 × 588 cm. Paris, Musée du Louvre.

NOTES

1. Rue Plâtrière was renamed rue Jean-Jacques Rousseau at the time of the French Revolution. The possible early history of NG 6292 is discussed in the text. Bullion was appointed Surintendant des Finances in 1632 and Garde des Sceaux des Ordres du Roi in the following year: see Marguerite Charageat, 'Notes sur cinq marchés passés par M. de Bullion, Surintendant des Finances du Roi Louis XIII, avec Jacques Sarrazin, Simon Vouët, Pierre Collot, Charles Grouard, Charles David, Pierre Denis et Jehan Le Boyteaux, et du rôle qu'y joue Le Mercier', *BSHAF*, 1927, pp. 179–207 at p. 180.

2. In October 1778 Alexandre-Joseph Paillet acquired that part of the hôtel which contained the upper gallery that had been decorated by Simon Vouet. At the end of this gallery was the small room described by Dezallier as having been decorated by Vouet with three paintings, including (possibly) NG 6292. That the decorative scheme of the upper gallery and the two end rooms was in place until 1776 at least is evident from a record of the sale of the property on 30 December of that year by Jacqueline Hortense de Bullion, duchesse de Laval, and Anne Julie Françoise de Cruzsol et Uzel, duchesse de la Vallière, to Marie Louise César Roulleau, Conseiller du Roi, and his wife Louise Julie Ansermond for 440,000 livres, including 70,000 livres for certain 'effets mobiliers'. These included 'plusieurs Tableaux dessus de portes faites par les plus grands maitres, cy ...3,500 [livres] / Les Tableaux en Ornemens Etant dans les appartemens et dans une galerie de 140 pieds de Longueur...24(?) de Largeur et dans les deux Cabinets qui son aux deux Bouts de cette galerie estimés comme étans de la plus grande Beauté et des plus grands maitres. La somme _____ 20,000 [livres].' (A.N., M.C., CXVI 502. I am grateful to JoLynn Edwards for drawing my attention to this document.) The decorative scheme was probably still in place when Paillet bought the premises, since another document, dated 5 October 1778 and kindly quoted in part by Edwards in a letter to me of 30 October 1997, records that Paillet paid 35,000 livres for '...Tous les effets mobiliers généralement quelconques, tels que boiseries, tableaux, ferrures et autres ornements étant dans les batiments... pour par les Sieur et Dame Paillet jouir et disposer desd. objets comme les choses leur apartenans au moyen des présents...' (A.N., M.C., XXXV 839).

Paillet undertook extensive internal remodelling to the property, turning it into public auction rooms and, upstairs, living quarters for his family. It is clear from J.A. Dulaure's *Nouvelle description des Curiosités de Paris* (p. 315), published in Paris in 1785, that by then Vouet's decorations in the hôtel were no longer in place. It seems reasonable to assume that the paintings had been removed by Paillet when he undertook the building works. These works may well have been completed by the end of November 1779 when the first auction sale at the hôtel de Bullion was announced, although Dulaure states that they were undertaken in 1780. Some of the paintings in the upper gallery were sold by 1788 (see note 13), but it is possible that others may just have been removed to another part of the hôtel for storage, because a *Procès verbal de publication et adjudication de l'hôtel de Bullion* dated 17 June 1793 (A.N., M.C., XXXV 964), when Paillet was forced to sell the hôtel, states, 'Dans cette [illegible] sont comprises les boiseries et tous les ornements a demeure. a l'égard des glaces elles sont toutes indépendants de l'immeuble...' (letter of 30 October 1997 from JoLynn Edwards).

For Paillet's purchase, remodelling and eventual sale of the hôtel de Bullion, see JoLynn Edwards, *Expert et marchand de tableaux à la fin du XVIIIᵉ siècle. Alexandre-Joseph Paillet*, Paris 1996, pp. 22–4. The hôtel de Bullion was demolished in the nineteenth century: see E-J. Ciprut, 'Salomon de Brosse et l'ancien hôtel de Bullion', *BSHAF*, 1955, pp. 121–4.

3. I am grateful to François Heim for this information.

4. Ed. W. Smith, *Dictionary of Greek and Roman Biography and Mythology*, 3 vols, London 1849–50, vol. 1 (1850), p. 961.

5. Cesare Ripa, *Iconologia*, Venice 1645, pp. 599–600; [Lacombe de Prezel], *Dictionnaire Iconologique*, Paris 1766, p. 52.

6. As in a painting for the vestibule of the queen's quarters at Fontainebleau, now lost but known through a drawing by Vouet and an engraving by Michel Dorigny dated 1644: see Brejon de Lavergnée 1987b, no. CVII.

7. As in a painting by Michel Dorigny of *The Four Seasons*, Glasgow Art Gallery (inv. no. 218): see A. Brejon de Lavergnée, 'Nouveaux tableaux de chevalet de Michel Dorigny', *Simon Vouet. Actes du colloque international Galeries nationales du Grand Palais 5–6–7 Février 1991*, ed. S. Loire, Paris 1992, pp. 422–4, or in a painting of the same subject by Vouet in Dublin, National Gallery of Ireland (inv. no. 1.982).

8. 'On voit au premier étage dans un petit cabinet peint par Vouet la Chasse sous l'emblème de Diane & Actéon; la Vendange désignée par Silene avec des Satyres; la Moisson par Cérès & des Amours qui moissonnent.' Dezallier d'Argenville 1765, p. 174. As Mahon has pointed out, this is the first known published description of this room in the hôtel de Bullion in which the paintings themselves are described: see Editorial Note to Yves Picart, 'A Vouet for the National Gallery', *BM*, 101, 1959, pp. 27–8. It may be the only such published description.

9. Dezallier d'Argenville 1765, pp. 174–5.

10. Brice 1698, vol. 1, p. 214.

11. Félibien says no more than that in 1634 and 1635 Vouet painted for Bullion a 'grande galerie haute...& un cabinet qui la separe d'avec la chambre': *Entretiens 1685*, p. 84.

12. Marguerite Charageat, cited in note 1.

13. See note 2. Paillet was obliged to sell the premises in 1793. Fifteen paintings by Vouet on the story of Ulysses which formed part of the decoration of the first-floor gallery at the hôtel de Bullion had certainly been removed from there by 24 November 1788, when they were included in the De Wailly sale: Brejon de Lavergnée 1987b, pp. 85–6.

14. For a painting by Louis de Boullogne le Jeune, once attributed to Jacques Blanchard and thought to be the *Ceres* from the hôtel de Bullion, see Rosenberg 1966, no. 7.

15. See Marguerite Charageat, cited in note 1, pp. 194–6; and J. Thuillier et al., *Vouet*, Grand Palais, Paris 1990–1, p. 120. The tight schedule for executing the works at the hôtel de Bullion was not matched by its proprietor's promptness in paying for them, since they had not been fully paid for by 3 April 1640: see G. Brière, 'Inventaire du Logis de Simon Vouet dans la Grande Galerie du Louvre (1639 et 1640)', *Fédération des Sociétés Historiques et Archéologiques de Paris et de l'Ile-de-France. Mémoires*, vol. 3, Paris 1951, pp. 117–72 at p. 168.

16. Brice (1698) writes that Vouet was working on the project in 1635, and Félibien, cited in note 11, that he was doing so in 1634–5.

17. See, for example, J. Thuillier in *Vouet*, cited in note 15, p. 61, and R.-A. Weigert, 'Une tenture tissé par l'atelier du Louvre pour Simon Vouet (1637)', *GBA*, 35 (1949), pp. 11–20 at pp. 16–17.

18. Letters of 30 March and 20 April 1998. See also *La peinture française du XVIIᵉ siècle dans les collections américaines*, exh. cat., Paris, New York, Chicago 1982, p. 367.

19. S. Laveissière, *Nicolas Chaperon 1612–1654/1655*, exh. cat., Nîmes 1999, p. 23.

20. Ibid., p. 75.

21. Ibid., nos 1A, 1B, 1C and 1D.

22. Crelly 1962, p. 171.

23. Crelly 1962, p. 172, no. 121 and fig. 124. The painting is of a similar size to that of NG 6292, but this is probably coincidental.

24. Crelly 1962.

25. For Vouet's studio, see, for example, J. Thuillier, *Vouet*, cited in note 15, p. 45–53; and, in *Vouet – Actes* (cited in note 7), see S. Loire, 'François Tortebat', pp. 435–54; Y. Picart, 'Michel Corneille, un des premiers collaborateurs de Simon Vouet. Aperçus sur sa vie et sa carrière', pp. 455–71; N. Sainte-Fare Garnot, 'Noël Quillerier, peintre...', pp. 473–97. Y. Picart, 'A Vouet for the National Gallery', *BM*, 101, 1959, pp. 27–8, pointed out that the figure of Ceres in *Love dispelling Chaos* painted for the lower gallery of the hôtel Seguier in the 1640s, now known only through an engraving, bears some resemblance to the Ceres in NG 6292. However, this can be of little help in determining whether that figure in NG 6292 is by Vouet or by a member of his studio.

26. The attribution of NG 6292 to François Belin has been made by J-C. Boyer, 'Fas et néfas: Simon Vouet, sa gloire et les voies de celles-ci', *Vouet – Actes*, cited in note 7, pp. 583–93 at p. 587. See also J. Thuillier et al., *Vouet*, cited in note 15, pp. 42–3. Félibien says that Belin worked in the manner of his master Jacques Foucquier (*Entretiens 1685–88*, vol. 2, p. 660), but the straight,

sturdy tree trunks in NG 6292 are not characteristic of Foucquier: see W. Stechow, 'Drawings and Etchings by Jacques Foucquier', *GBA*, 34, 1948, pp. 419–34, nor are they apparent in two engravings tentatively attributed to Belin by J. Thuillier, op. cit., p. 43, and there illustrated.

27. See R.-A. Weigert, cited in note 17; D. Lavalle, 'Simon Vouet et la tapisserie', *Vouet*, cited in note 15, pp. 504–7, and Lavalle, 'Tenture de l'Ancien Testament (Château d'Oiron)', *Lisses et délices. Chefs d'oeuvre de la tapisserie de Henri IV à Louis XIV*, Paris 1996, pp. 143–53. A preparatory drawing in the Louvre for one of the figures in the composition has been dated to the early 1630s: see Brejon de Lavergnée 1987b, no. 37.

28. J. Thuillier in *Vouet*, cited in note 15, p. 42, says that Patel was working for Vouet in 1638, but in a letter to me of 25 October 1999 Natalie Coural writes: 'On ne sait pas exactement quand Patel entre chez Vouet mais il y est documenté en 1640 (Vouet lui doit 1000 l.) et en 1641 (Patel est le parrain d'un enfant de Vouet).' Coural also writes that NG 6292 'est tout à fait différent des premiers tableaux connus de Patel (ceux-ci sont très marqués par l'influence nordique, en particulier celle de Jacques Fouquières)'.

Photographic credits

All photographs are © National Gallery, London unless otherwise stated.

ALGIERS © Musée National des Beaux-Arts, Algiers. *Photo:* Giraudon: p. 215, fig. 2. AMIENS © Musée de Picardie, Amiens: p. 237, fig. 15. BAYONNE © Musée Bonnat, Bayonne. *Photos:* V. Minard: p. 69, fig. 5; p. 355, fig. 7; p. 356, figs 12–13; p. 359, fig. 16. BERLIN © Kupferstichkabinett – Staatliche Museen zu Berlin. *Photo:* Jörg P. Anders: p. 233, fig. 11. © Staatliche Museen zu Berlin. *Photo:* Jörg P. Anders: p. 400, fig. 3. BESANÇON © Musée des Beaux-Arts et d'Archéologie, Besançon. *Photo:* Charles Choffet: p. 231, fig. 5. BIRMINGHAM © The Barber Institute of Fine Arts, Birmingham: p. xiii. fig. 2. BOSTON Courtesy, Museum of Fine Arts, Boston. Reproduced with permission. © 2001 Museum of Fine Arts, Boston (all rights reserved): p. 96. fig. 1. BRISTOL © By permission of Bristol Museums and Art Gallery, Bristol: p. xvii. fig. 7. BRUSSELS © KIK-IRPA: p. 183, figs 2–3. CAEN © Musée des Beaux-Arts, Caen. *Photo:* M. Seyve: p. 35, fig. 3. CAMBRIDGE © Fitzwilliam Museum, University of Cambridge. *Photos:* p. 73, fig. 9; p. 125, fig. 3 CAMBRIDGE, Mass. © President and Fellows of Harvard College, Harvard University. Courtesy, Colnaghi, London. *Photo:* Prudence Cumming Associates Ltd: p. 224, fig. 5. CHANTILLY Eglise de Chantilly, Chantilly. © Photo RMN, Paris: p. 336, fig. 2. Musée Condé, Chantilly. © RMN, Paris. *Photos:* R.G. Ojeda: p. 132, fig. 3; p. 386, fig. 1. CHATSWORTH © Devonshire Collection, Chatsworth (reproduced by permission of the Duke of Devonshire and the Chatsworth Settlement Trustees): p. 18, figs 1–2. *Photo:* Photographic Survey, Courtauld Institute of Art: p. 178, fig. 4. CLEVELAND, Ohio. © The Cleveland Museum of Art, Cleveland: p. 394, fig. 5. COLOGNE © Wallraf-Richartz-Museum, Cologne. *Photo:* Rheinisches Bildarchiv: p. 132, fig. 4. COMPIEGNE © Musée National du Château de Compiègne: p. 247, fig. 2. COPENHAGEN © Museum of Fine Arts, Copenhagen: p. 91, fig. 4. DETROIT © 1993 The Detroit Institute of Arts, Detroit: p. 196, fig. 1. © 2000 The Detroit Institute of Arts, Detroit: p. 300, fig. 3. DIJON © Musée des Beaux-Arts de Dijon: p. 330, fig. 5. DUBLIN © Reproduction courtesy of The National Gallery of Ireland, Dublin: p. 210, fig. 5. DÜSSELDORF © Kunstmuseum Düsseldorf: p. 167, fig. 2; p. 231, fig. 3. FLORENCE © Soprintendenza per i Beni Artistici e Storici per le province di Firenze, Prato e Pistoia. *Photo:* Bridgeman Art Library, London: p. 405, fig. 2. © Soprintendenza per i Beni Artistici e Storici di Roma Gabinetto Fotografico: p. 250, fig. 4. © Soprintendenza per i Beni Artistici e Storici di Roma: p. 355, fig. 9; p. 356, fig. 10. FRANKFURT AM MAIN *Photo:* © Ursula Edelmann: p. 216, fig. 5. FREDERICTON © *Photo:* The Beaverbrook Art Gallery, Fredericton, New Brunswick, Canada: p. xiii, fig. 3. HARTFORD, Conn. © Wadsworth Atheneum, Hartford: p. 99, fig. 4; p. 200, fig. 3. HEINO *Photo:* © Hans Westerink, Zwolle: p. 91, fig. 1. HOLKHAM © By kind permission of the Earl of Leicester and the Trustees of the Holkham Estate: p. 150, fig. 3. *Photo:* Photographic Survey, Courtauld Institute of Art: p. 119, fig. 5. KANSAS CITY © The Nelson-Atkins Museum of Art, Kansas City: p. 60, fig. 5. *Photo:* Mel McLean: p. 359, fig. 18. KARLSRUHE *Photo:* © Hazlitt Gooden and Fox: p. 158, fig. 1. © Staatliche Kunsthalle, Karlsruhe: p. 134, fig. 9. LEEDS © Leeds Museums and Galleries (Temple Newsam House). *Photo:* Courtauld Gallery, London: p. 252, fig. 8. LIVERPOOL © Walker Art Gallery, Liverpool. Board of Trustees of the National Museums and Galleries on Merseyside. *Photo:* John Mills (Photography) Ltd: p. 298, fig. 1. LONDON © Courtauld Gallery, London: p. 237, fig. 17. © By Permission of the Trustees of the Dulwich Picture Gallery: p. 284, fig. 1. © The British Library, London: p. xx, fig. 11; p. 133, figs 7–8; p. 191, fig. 3; p. 251. fig. 7; p. 293, fig. 7; p. 319, fig. 5; p. 328, fig. 2; p. 354, figs 3, 6; p. 374, fig. 7. © The British Museum, London: p. xvi, fig. 5; p. xviii, fig. 10; p. 47, fig. 1; p. 52, fig. 1; p. 68, fig. 4; p. 74, figs 10–11; p. 75, fig. 12; p. 91, fig. 3; p. 92, fig. 5; p. 100, figs 5–6; p. 102, fig. 7; p. 106, fig. 1; p. 108, fig. 4; p. 113, figs 2, 4; p. 130, fig. 1; p. 133, fig. 5; p. 140, fig. 1; p. 256, fig. 1; p. 266, fig. 2; p. 270, fig. 2; p. 293, figs 5, 8; p. 304, figs 2–3; p. 327, fig. 1; p. 353, fig. 2; p. 381, fig. 5; © The Board of Trustees of the Victoria and Albert Museum, London: p. 114, fig. 5; p. 134, fig. 10. LOS ANGELES © The J. Paul Getty Museum, Los Angeles: p. xxii, fig. 12. LVIV © Lviv Picture Gallery: p. 251, fig. 6. MADRID © Biblioteca Nacional, Madrid: p. 216, fig. 4. © Museo de la Real Academia de Bellas Artes de San Fernando, Madrid: p. 177, fig. 3. © Museo Thyssen-Bornemisza, Madrid: p. 167, fig. 3. MELBOURNE © National Gallery of Victoria, Melbourne, Australia: p. 322, fig. 6. MONTPELLIER © Musée Fabre, Montpellier. *Photo:* Frédéric Jaulmes: p. 232, fig. 8. MONTREAL © The Montreal Museum of Fine Arts. *Photo:* Brian Merrett, MBAM/MMFA:

p. 345, fig. 3. MUNICH © private collection, on loan to Bayerische Staatsgemäldesammlungen, Alte Pinakothek (reproduced by kind permission of the owner): p. 258, fig. 2. © Bayerische Staatsgemäldesammlungen, Alte Pinakothek: p. 310, fig. 1. © Staatliche Antikensammlungen und Glyptothek, Munich: p. 381, fig. 4. NEW YORK Lunde Collection, private © (reproduced by kind permission of the owner): p. 13, fig. 2. Paul J. Weis, New York. © Reproduced by kind permission of the owner. *Photo:* National Gallery, London: p. 163, fig. 2. © The Metropolitan Museum of Art, New York: p. 293, fig. 6; p. 356, fig. 11. © The Morgan Library, New York: p. 58, fig. 4. NOTRE DAME, Indiana © The Snite Museum of Art, University of Notre Dame: p. 5, fig. 2. OTTAWA © National Gallery of Canada, Ottawa: p. 90, fig. 1. OXFORD © By permission of the governing body, Christ Church, Oxford: p. 341, fig. 9. PARIS © Bibliothèque Nationale de France, Paris: p. 27, fig. 2; p. 28, fig. 3; p. 35, fig. 2; p. 61, fig. 6; p. 71, fig. 7; p. 223, fig. 2; p. 224, fig. 6; p. 233, fig. 9. *Photo:* R. Baroin, G. Pimienta: p. 236, fig. 14; p. 266, fig. 1; p. 360, fig. 19; p. 369, fig. 2; p. 380, fig. 3; p. 398, fig. 1. © Centre historique des Archives nationales à Paris: p. 70, fig. 6. © Chancellerie de l'Université de la Sorbonne: p. 27, fig. 1. © Ecole Nationale Supérieure des Beaux-Arts, Paris: p. 274, fig. 1. © Photos RMN, Paris: p. xvii, fig. 9; p. 19, fig. 3; p. 86, fig. 5; p. 223, fig. 3; p. 270, fig. 1; p. 370, figs 4–5. © RMN, Paris. *Photos:* Arnaudet: p. 329, fig. 4; p. 407, fig. 5. *Photo:* M. Beck-Coppola: p. 41, fig. 2. *Photo:* J.G. Berizzi: p. 231, fig. 4. *Photo:* Gérard Blot: p. 215, fig. 1. *Photos:* R.G. Ojeda: p. 197, fig. 2; p. 280, fig. 2; p. 371, fig. 6. *Photo:* Thierry Ollivier: p. 405, fig. 1. *Photo:* F. Raux: p. 393, fig. 2. PORTLAND, Oregon © Portland Art Museum, Portland: p. 388, fig. 1. POUGHKEEPSIE, NY © The Francis Lehman Loeb Art Center, Vassar College: p. 208, fig. 2. PRIVATE COLLECTION *Photo:* Matthew Hollow: p. xvi, fig. 6. © reproduced by kind permission of the owner: p. 58, fig. 2. Rome, private collection: p. 85, fig. 4. *Photo:* © Dorothy Zeidman: p. 119, fig. 3. © Courtesy Richard L. Feigen & Co. *Photo:* Prudence Cumming Associates Ltd: p. 172, fig. 1. Great Britain, private collection. *Photo:* National Gallery, London: p. 205, fig. 3. © Reproduced by kind permission of Lord Lucas of Crudwell. *Photos:* National Gallery, London: p. 237, fig. 16; p. 407, fig. 3. PROVIDENCE, Rhode Island © Museum of Art, Rhode Island School of Design, Providence. *Photo:* Erik Gould: p. xxiii, fig. 13. ROME *Photo:* Bridgeman Art Library, London. © Vatican Museums, Archivio Fotografico Musei Vaticani: p. 215, fig. 3. © Istituto Centrale per il Restauro, Rome: p. 141, fig. 3. © Istituto Nazionale per la Grafica. *Photo:* National Gallery, London: p. 232, fig. 7. © By kind permission of Il Ministero per i Beni e le Attività Culturali, Rome: p. 119, fig. 2. © Palazzo Lancellotti, Rome: p. 103, fig. 8. Rospigliosi-Pallavicini Collection, Rome. © *Photo:* Immobiliare Toscana Agricola S.A.I.T.A, Rome: p. 106, fig. 2. © Rospigliosi-Pallavicini Collection, Rome. *Photo:* S. Fabi / M. Mancini: p. 119, fig. 4. © *Photos:* SCALA, Florence: p. 52, figs 2–3; p. 67, fig. 1; p. 68, fig. 3; p. 321, fig. 4. © Soprintendenza per i Beni Artistici e Storici di Roma: p. 166, fig. 1; p. 292, fig. 3; p. 312, fig. 2. © Vatican Museums, Archivio Fotografico Musei Vaticani: p. 286, fig. 3; p. 337, fig. 5. ROTTERDAM © Museum Boijmans Van Beuningen, Rotterdam: p. 58, figs 1, 3; p. 235, fig. 13. ROUEN © Musée des Beaux-Arts de Rouen. *Photos:* Didier Tragin / Catherine Lancien: p. 148, fig. 2; p. 224, fig. 4. ST PETERSBURG © With permission from The State Hermitage Museum, St Petersburg: p. 124, fig. 1; p. 209, figs 3–4; p. 379, fig. 2. SARASOTA, Florida © Collection of The John and Mable Ringling Museum of Art, the State Art Museum of Florida: p. xv, fig. 4. STOCKHOLM © The National Art Museums of Sweden, Stockholm. *Photo:* Nationalmuseum: p. 292, fig. 4. STRASBOURG © Musées de Strasbourg: p. 42, figs 3–4. SYDNEY © Art Gallery of New South Wales, Sydney. *Photo:* Jenni Carter for AGNSW: p. 108, fig. 5. TURIN © Palazzo della Provincia, Turin: p. 322, figs 7–8. UTRECHT © Centraal Museum, Utrecht: p. 396, fig. 4. VIENNA © Albertina, Vienna: p. 354, fig. 5. © Graphische Sammlung Albertina, Vienna: p. 75, fig. 13; p. 233, fig. 10. © KHM, Vienna: p. x, fig. 1; p. 186, fig. 2. WASHINGTON, DC © The Library of Congress, Washington, DC: p. 133, fig. 6. WINDSOR The Royal Collection. © 2001, Her Majesty Queen Elizabeth II: p. 200, fig. 2; p. 291, fig. 2; p. 321, fig. 9; p. 339, fig. 8; p. 355, fig. 8; p. 357, figs 14–15; p. 359, fig. 17; p. 378, fig. 1. © Reproduced by permission of the Royal Palaces under licence from the Controller of Her Majesty's Stationery Office: p. xvii, fig. 8. ZURICH © 2001 Kunsthaus Zürich (all rights reserved): p. 305, fig. 5.

List of publications cited

ADELSON 1975
Adelson, C., 'Nicolas Poussin et les tableaux du Studiolo d'Isabelle d'Este', *La Revue du Louvre et des Musées de France*, 4, 1975, pp. 237–41

ADHÉMAR 1979
Adhémar, H., 'Les Frères Le Nain et les personnes charitables à Paris sous Louis XIII', *GBA*, 93, 1979, pp. 69–74

AIGUEPERSE 1836
Aigueperse, P.G., *Biographie ou Dictionnaire Historique des Personnages d'Auvergne*, 2 vols, Clermont-Ferrand 1836

ANDRESEN 1962
Andresen, A., *Catalogue des Graveurs de Poussin par Andresen*, abbreviated and translated by Georges Wildenstein, *GBA*, 60, 1962, pp. 139–202

ANTONINI 1749
Antonini, l'Abbé, *Memorial de Paris et de ses environs*, 2 vols, Paris 1749

APOLLODORUS
Apollodorus, *Bibliotheca*, I, 9, 14, and III, 6, 4

APULEIUS
Apuleius, *Metamorphoses*, trans. J. Arthur Hudson, Loeb edn, 2 vols, London and Cambridge, Mass., 1989

BADT 1969
Badt, K., *Die Kunst des Nicolas Poussin*, 2 vols, Cologne etc. 1969

BAILEY 1991–2
Bailey, C.B., *The Loves of the Gods. Mythological Painting from Watteau to David*, exh. cat., Paris, Philadelphia and Fort Worth 1991–2

BALDINUCCI 1812
Baldinucci, F., *Notizie de' professori del disegno*, 13 vols, Milan 1812 (first published Florence 1681–1728)

BANDES 1976
Bandes, S.J., 'Gaspard Dughet and San Martino ai Monti', *Storia dell'Arte*, 26, 1976, pp. 45–60

BARROERO 1979
Barroero, L., 'Nuove acquisizioni per la cronologia di Poussin', *Bollettino d'Arte*, 64, 1979, pp. 69–74

BÄTSCHMANN 1982
Bätschmann, O., *Dialektik der Malerei von Nicolas Poussin*, Munich 1982; English trans. by M. Daniel, *Nicolas Poussin: Dialectics of Painting*, London 1990

BAUDOUIN 1644
SEE UNDER *Iconologie*

BELLORI 1672
Bellori, G.B., *Le Vite de' Pittori, Scultori et Architetti Moderni*, Rome 1672

BERESFORD 1998
Beresford, R., *Dulwich Picture Gallery. Complete Illustrated Catalogue*, London 1998

BERNINI PEZZINI 1985
Bernini Pezzini, G., Massari, S., and Prosperi Valenti Rodino, S., *Raphael Invenit. Stampe da Raffaello nelle collezioni dell'Istituto Nazionale per la Grafica*, Rome 1985

BERNSTOCK 2000
Bernstock, J., *Poussin and French Dynastic Ideology*, Bern etc. 2000

BERTIN-MOUROT 1948
Bertin-Mourot, T., 'Addenda au catalogue de Grautoff depuis 1914', *Bulletin de la Société Poussin*, Second Cahier, December 1948, pp. 43–87

Bibliotheca Sanctorum, 12 vols and index, Rome 1961–70

BLAISE DE VIGENERE 1615
Blaise de Vigenère, *Les Images ou Tableaux de platte peinture Philostrates Sophistes Grecs mis en François par Blaise de Vigenère*, Paris 1615

BLANC 1857
Blanc, Ch., *Le Trésor de la Curiosité*, 2 vols, Paris 1857–8

BLUNT 1944
Blunt, A., 'The Heroic and the Ideal Landscape in the work of Nicolas Poussin', *JWCI*, 7, 1944, pp. 154–68

BLUNT 1945
Blunt, A., 'Two Newly Discovered Landscapes by Nicolas Poussin', *BM*, 87, 1945, pp. 186–9

BLUNT 1953
Blunt, A., *Art and Architecture in France 1500–1700*, Harmondsworth 1953

BLUNT 1954
Blunt, A., *The Drawings of G.B. Castiglione and Stefano della Bella in the collection of Her Majesty the Queen at Windsor Castle*, London 1954

BLUNT 1961
Blunt, A., 'Poussin Studies XII: The Hovingham Master', *BM*, 103, 1961, pp. 454–61

BLUNT 1962
Blunt, A., 'Poussin Studies XIII; Early Falsifications of Poussin', *BM*, 104, 1962, pp. 486–98

BLUNT 1965
Blunt, A., 'Poussin and his Roman Patrons', *Walter Friedländer zum 90. Geburtstag*, Berlin 1965, pp. 58–75

BLUNT 1966
Blunt, A., *The Paintings of Nicolas Poussin. A Critical Catalogue*, London 1966

BLUNT 1967
Blunt, A., *Nicolas Poussin. The A.W. Mellon Lectures in the Fine Arts 1958, National Gallery of Art, Washington, DC*, New York and London 1967

BLUNT 1969
Blunt, A., 'A lost portrait of Richelieu by Philippe de Champaigne', *Bulletin du Musée National de Varsovie*, 10, 1969, p. 3

BLUNT 1974
Blunt, A., 'Jacques Stella, the de Masso Family, and falsifications of Poussin', *BM*, 116, 1974, pp. 745–51

BLUNT 1977
Blunt, A., 'A new book on Philippe de Champaigne', *BM*, 119, 1977, pp. 574–9

BLUNT 1978
Blunt, A., 'The Le Nain Exhibition at the Grand Palais, Paris: "Le Nain Problems"', *BM*, 120, 1978, pp. 870–5

BLUNT 1982a
Blunt, A., *Guide to Baroque Rome*, London etc. 1982

BLUNT 1982b
Blunt, A., 'A newly discovered Will of Nicolas Poussin', *BM*, 124, 1982, pp. 703–4

BOBER AND RUBINSTEIN 1986
Bober, P.P., and Rubinstein, R., *Renaissance Artists & Antique Sculpture. A Handbook of Sources*, Oxford and New York 1986

BOISCLAIR 1986
Boisclair, M.-N., *Gaspard Dughet: Sa vie et son oeuvre (1615–1675)*, Paris 1986

BOISSARD 1597–1602
Boissard, J.J., *Romanae urbis topographiae et antiquitatum*, 4 parts, Frankfurt 1597–1602

BONFAIT 1988
Bonfait, O., 'The second generation of collectors of Poussin: Jean Neyret de la Ravoye', *BM*, 130, 1988, pp. 459–64

BONFAIT 1998
Bonfait, O., 'Poussin aujourd'hui', *Revue de l'Art*, 119, 1998–1, pp. 62–76

BONNAFFE 1873
Bonnaffé, E., *Les Collectionneurs de l'Ancienne France. Notes d'un Amateur*, Paris 1873

BONNAFFE 1884
Bonnaffé, E., *Dictionnaire des amateurs français au XVIIᵉ siècle*, Paris 1884

BOYER 1968
Boyer, F., 'Les collections de François de Laborde-Méréville (1761–1802)', *BSHAF*, année 1967 [1968], pp. 141–52

BOYER 1988
Boyer, J.-C., 'Quatre lettres de Pierre Mignard', *AAF*, 29, 1988, pp. 11–15

BOYER 1996
Boyer, J.-C., 'Un amateur méconnu de Poussin: Gaspard de Daillon', *Poussin Colloque 1994* [1996], pp. 697–717

BREJON DE LAVERGNEE 1973
Brejon de Lavergnée, A., 'Tableaux de Poussin et d'autres artistes français dans la collection Dal Pozzo: deux inventaires inédits', *Revue de l'Art*, 19, 1973, pp. 79–96

BREJON DE LAVERGNEE 1987a
Brejon de Lavergnée, A., *L'inventaire Le Brun de 1683, La collection de tableaux de Louis XIV*, Paris 1987

BREJON DE LAVERGNEE 1987b
Brejon de Lavergnée, A., *Musée du Louvre. Cabinet des dessins. Inventaire général des dessins. Ecole Française. Dessins de Simon Vouet 1590–1649*, Paris 1987

BREJON DE LAVERGNEE 1992
Brejon de Lavergnée, A., 'Nouveaux tableaux de chevalet de Michel Dorigny', *Simon Vouet. Actes du colloque international. Galeries nationales du Grand Palais 5–6–7 février 1991*, ed. S. Loire, Paris 1992, pp. 417–33

BRICE 1684
Brice, G., *Description nouvelle de ce qu'il y a de plus remarquable dans la ville de Paris*, 2 vols, Paris 1684

BRICE 1698/1706
Brice, G., *Description nouvelle de la ville de Paris*, 2 vols, 3rd edn, Paris 1698; 5th edn, Paris 1706

BRIGSTOCKE 1982a
Brigstocke, H., *William Buchanan and the 19th Century Art Trade: 100 letters to his agents in London and Italy*, London 1982

BRIGSTOCKE 1982b
Brigstocke H., 'Poussin in Edinburgh', *BM*, 124, 1982, pp. 239–40

BRIGSTOCKE 1983
Brigstocke, H., 'Poussin's "Triumph of Pan" and "The Rape of the Sabines"', *Art International*, 26, September–October 1983, pp. 12–15

BRIGSTOCKE 1990
Brigstocke, H., 'Poussin et ses amis en Italie', *Rencontres de l'Ecole du Louvre. Seicento. La peinture italienne du XVIIe siècle et la France*, (Colloque, Paris 1988) Paris 1990, pp. 215–29

BRIGSTOCKE 1995
Brigstocke, H., 'The Mystery of Poussin's drawings. New clues, new solutions, and the inevitable red herring', *Apollo*, 142, November 1995, pp. 60–3

BRIGSTOCKE 1996
Brigstocke, H., 'Variantes, copies et imitations. Quelques réflexions sur les méthodes de travail de Poussin', *Poussin Colloque 1994* [1996], pp. 201–28

BRITTON 1801–15
Britton, J., and Wedlake Brayley, E., *The Beauties of England and Wales*, 18 vols, London 1801–15

BUCHANAN 1824
Buchanan, W., *Memoirs of Painting with a Chronological History of the Importation of Pictures by the Great Masters into England since the French Revolution*, 2 vols, London 1824

BULL 1993
Bull, M., 'Poussin's Snakes', *Cézanne and Poussin. A Symposium* (Edinburgh 1990), Sheffield 1993, pp. 48–9

BULL 1995
Bull, M., 'Poussin's bacchanals for Cardinal Richelieu', *BM*, 137, 1995, pp. 5–11

BULL 1998
Bull, M., 'Poussin and Nonnos', *BM*, 140, 1998, pp. 724–38

BURDON 1960
Burdon, G., 'Sir Thomas Isham. An English Collector in Rome 1677–8', *Italian Studies*, vol. 15, 1960, pp. 1–25

Catalogue of the Celebrated Collection of Pictures of the late John Julius Angerstein Esq., London 1823

Catalogue of the Pictures in the National Gallery, London 1838

Catalogue of the Pictures in the National Gallery, London 1840

Catalogue Raisonné of the Pictures now Exhibiting in Pall Mall, London(?) 1816 – see SMIRKE 1816

CHALON 1860
Chalon, R., *Le Dernier Duc de Bouillon (1815)*, Paris 1860

CHAMPIER AND SANDOZ 1900
Champier, V., and Sandoz, R.-G., *Le Palais-Royal d'après des documents inédits, (1629–1900)*, 2 vols, Paris 1900

CHANTELOU 1877–85
Chantelou, P.F. de, 'Journal du Voyage du Cavalier Bernin en France par M. De Chantelou', ed. Lalanne, L., various related articles published in and from *GBA*, 15, February 1877, to and including *GBA*, 32, August 1885

CHASTEL 1958
Chastel, A., 'Poussin et la postérité', *Poussin Colloque 1958* [1990], I, pp. 297–310

CHIARINI 1969
Chiarini, M., 'Gaspard Dughet: Some Drawings connected with Paintings', *BM*, 111, 1969, pp. 750–4

CHOMER AND LAVEISSIERE 1994
Chomer, G., and Laveissière, S., *Autour de Poussin*, exh. cat., Musée du Louvre, Paris 1994

CIFANI AND MONETTI 1994
Cifani, A., and Monetti, F., 'Poussin dans les collections piémontaises aux XVIIe, XVIIIe et XIXe siècles', *Poussin Colloque 1994* [1996], pp. 747–807

CIFANI AND MONETTI 1995
Cifani, A., and Monetti, F., 'Two unpublished paintings by Pietro da Cortona and Giovanni Francesco Romanelli from the collection of Amedeo Dal Pozzo', *BM*, 137, 1995, pp. 612–16

CLAYTON 1995
Clayton, M., *Poussin. Works on Paper, Drawings from the Collection of Her Majesty Queen Elizabeth II*, London 1995

CLEMENT DE RIS 1877
Clément de Ris, L., *Les Amateurs d'autrefois*, Paris 1877

COMPLETE PEERAGE
The Complete Peerage, ed. H.A. Doubleday, Lord Howard de Walden, G.H. White and R.S. Lea, 13 vols, London 1910–59

CONISBEE 1979
Conisbee, P., 'Pre-Romantic *Plein-Air* Painting', *AH*, 2, 1979, pp. 413–28

CONSTABLE 1962–8
John Constable's Correspondence, ed. R.B. Beckett, 6 vols, Ipswich 1962–8

CONSTABLE 1970
John Constable's Discourses, compiled and annotated by R.B. Beckett, Ipswich 1970

CONSTABLE 1953
Constable, W.G., *Richard Wilson*, London 1953

COQUERY 1994
Coquery, E., 'Les oeuvres de Poussin dans les collections des peintres français sous Louis XIV', *Poussin Colloque 1994* [1996], pp. 835–64

CORDINGLY 1976
Cordingly, D., 'Claude Lorrain and the Southern Seaport Tradition', *Apollo*, 103, 1976, pp. 208–13

COSTELLO 1950
Costello, J., 'The Twelve Pictures "Ordered by Velasquez" and the Trial of Valguarnera', *JWCI*, 13, 1950, pp. 237–84

COTTE 1985
Cotté, S., 'Inventaire après décès de Louis Phélypeaux de La Vrillière', *AAF*, 27, 1985, pp. 89–100

CRELLY 1962
Crelly, W.R., *The Painting of Simon Vouet*, New Haven and London 1962

CROPPER AND DEMPSEY 1996
Cropper, E., and Dempsey, C., *Nicolas Poussin, Friendship and the Love of Painting*, Princeton 1996

CUNNINGHAM 1833
Cunningham, A., *The Cabinet Gallery of Pictures, selected from the splendid collections of art, public and private, which adorn Great Britain; with biographical and critical descriptions*, 2 vols, London 1833

CUZIN 1978
Cuzin, J.-P., 'A Hypothesis concerning the Le Nain Brothers', *BM*, 120, 1978, pp. 875–6

CUZIN 1979
Cuzin, J.-P., 'Les frères Le Nain: la part de Mathieu', *Paragone*, 349–51, 1979, pp. 58–70

CUZIN 1994
Cuzin, J.-P., 'Les frères Le Nain: le mystère des portraits', *Hommage à Michel Laclotte. Etudes sur la peinture du Moyen Age et de la Renaissance*, Paris 1994, pp. 480–93

DALLAWAY 1824
Dallaway, J., *An account of all the pictures as exhibited in the rooms of the British Institution from 1813 to 1823...*, London 1824

DAMISCH 1984
Damisch, H., 'Claude: A Problem in Perspective', *Claude Lorrain 1600–1682: A Symposium*, ed. P. Askew, *Studies in the History of Art*, 14, 1984, pp. 29–44

DAVIES 1946
Davies, M., *National Gallery Catalogues, French School*, London 1946

DAVIES 1957
Davies, M., *National Gallery Catalogues, French School*, 2nd edn revised, London 1957

DAVIES AND BLUNT 1962
Davies, M., and Blunt, A., 'Some Corrections and Additions to M. Wildenstein's "Graveurs de Poussin au XVIIᵉ Siècle"', *GBA*, 60, 1962, pp. 205–22

DE LA CHENAYE AND BADIER 1863–76
De La Chenaye-Desbois, A., and Badier, *Dictionnaire de la noblesse*, 3rd edn, 19 vols, Paris 1863–76 (reprinted, Neudeln 1969)

DE MARCHI 1987
De Marchi, G., *Mostre di quadri a S. Salvatore in Lauro (1682–1725). Stime di collezioni romane. Note e appunti di Giuseppe Ghezzi*, Rome 1987

DEMPSEY 1963
Dempsey, C., 'Poussin and Egypt', *AB*, 45, 1963, pp. 109–19

DEMPSEY 1965
Dempsey, C., 'Poussin's Marine Venus at Philadelphia: A Re-Identification Accepted', *JWCI*, 28, 1965, pp. 338–43

DEMPSEY 1966
Dempsey, C., 'The Classical Perception of Nature in Poussin's Earlier Works', *JWCI*, 29, 1966, pp. 219–49

DEMPSEY 1991
Dempsey, C., 'Poussin Problems', *Art in America*, 79, October 1991, pp. 41–3

DEPERTHES 1822
Deperthes, J.B., *Histoire de l'Art du Paysage depuis la Renaissance des Beaux-Arts jusqu'au dix-huitième siècle*, Paris 1822

DERENS 1996
Dérens, I., 'No. 12 Hôtel de Castille, puis de Nouveau, de Dangeau et le Tonnelier', *De la place Royale à la place des Vosges*, Paris 1996, pp. 331–9

DERENS AND WEIL-CURIEL 1998
Dérens, I., and Weil-Curiel, M., 'Répertoire des plafonds peints du XVIIe siècle disparus ou subsistants', *Revue de l'Art*, 122, 1998, pp. 74–112

Descriptive and Historical Catalogue of the Pictures in the National Gallery with Biographical Notices of the Painters. Foreign Schools, London 1894

DESENFANS 1801
Desenfans, N., *A Descriptive Catalogue... of some Pictures... purchased for His Majesty the Late King of Poland*, London 1801

DESMARETS 1653
Desmarets de Saint-Sorlin, *Les Promenades de Richelieu*, Paris 1653

DEZALLIER D'ARGENVILLE 1745/1762
Dezallier d'Argenville, A.J., *Abrégé de la vie des plus fameux peintres*, 2 vols, Paris 1745; 4 vols, 1762 edn

DEZALLIER D'ARGENVILLE 1749/1757/1765
Dezallier d'Argenville, A.N., *Voyage pittoresque de Paris ou Indication de tout ce qu'il y a de plus beau dans cette grande Ville en Peinture, Sculpture, & Architecture*, Paris 1749 (3rd edn, Paris 1757; 4th edn, Paris 1765)

Diaries of Lady Amabel Yorke 1769–1827, 37 MS vols, Leeds District Archives, West Yorkshire Archive Service

Diary of Joseph Farington – see under FARINGTON DIARY

DIMIER 1924–6
Dimier, L., *Histoire de la Peinture de Portrait en France au XVIᵉ*, 3 vols, Paris and Brussels 1924–6

DORIVAL 1970a
Dorival, B., 'Recherches sur les portraits gravés aux XVIIe et XVIIIe siècles d'après Philippe de Champaigne', *GBA*, 75, 1970, pp. 257–330

DORIVAL 1970b
Dorival, B., 'Un portrait inconnu de Richelieu par Philippe de Champaigne', *La Revue du Louvre et des Musées de France*, 1, 1970, pp. 15–28

DORIVAL 1971
Dorival, B., 'Philippe de Champaigne et les *Hiéroglyphiques* de Pierius', *Revue de l'Art*, 11, 1971, pp. 31–41

DORIVAL 1974
Dorival, B., 'Art et Politique en France au XVIIe siècle: la Galerie des Hommes Illustres du Palais Cardinal', *BSHAF*, année 1973 [1974], pp. 43–60

DORIVAL 1976
Dorival, B., *Philippe de Champaigne 1602–1674*, 2 vols, Paris 1976

DORIVAL 1992
Dorival, B., *Supplément au Catalogue raisonné de l'oeuvre de Philippe de Champaigne*, Paris 1992

DUBOIS DE SAINT-GELAIS 1727
Dubois de Saint-Gelais, L.F., *Description des tableaux du Palais Royal*, Paris 1727

DUCHESNE 1828–33
Duchesne aîné, *Musée de peinture et de sculpture ou recueil des principaux tableaux statues et bas-reliefs des collections publiques et particulières de l'Europe*, 14 vols, Paris 1828–33

DULAURE 1785
Dulaure, J.A., *Nouvelle description des Curiosités de Paris*, Paris 1785

DUSSIEUX 1854
Mémoires inédits sur la vie et les ouvrages des membres de l'Académie Royale de Peinture et de Sculpture, ed. L. Dussieux et al., 2 vols, Paris 1854

DU VAL 1656
Du Val, P., *La Relation du voyage fait à Rome par Monsieur le duc de Bouillon en l'année 1644*, Paris 1656

EASTLAKE 1847
Eastlake, C.L., *Descriptive and Historical Catalogue of the Pictures in the National Gallery*, London 1847

EDWARDS 1996
Edwards, J.L., *Alexandre-Joseph Paillet: expert et marchand de tableaux à la fin du XVIIIe siècle*, Paris 1996

EGERTON 1998
Egerton, J., *National Gallery Catalogues. The British School*, London 1998

Engravings from the Pictures of the National Gallery, London 1840

Engravings of the Fifty Most Celebrated Pictures in the National Gallery, by John, James, & William Linnell, London [after 1841]

EUDEL 1882
Eudel, P., *L'Hôtel Drouot en 1881*, Paris 1882

EUDEL 1886
Eudel, P., *L'Hôtel Drouot et la curiosité en 1884–1885*, Paris 1886

EUDEL 1887
Eudel, P., *L'Hôtel Drouot et la curiosité en 1885–1886*, Paris 1887

Les Expositions de l'Académie Royale de Toulouse de 1751 à 1791, ed. R. Mesuret, Toulouse 1972

FARINGTON DIARY
The Diary of Joseph Farington, ed. K. Garlick, Y. Macintyre and K. Cave, with Index (1998) by E. Newby, 16 vols, New Haven and London 1978–84

FÉLIBIEN, ENTRETIENS 1685
and ENTRETIENS 1685–88
Félibien, A., *Entretiens sur les vies et sur les ouvrages des plus excellens peintres anciens et modernes*, 3 vols, Paris 1666–79. The *Entretiens* was a multi-part work, the first part of which was published in 1666 and the last in 1679. It was then republished in two volumes. The first volume, containing the first five *Entretiens*, bears a publication date of 1685 but was first printed in this edition in 1686, according to an extract on the *privilège du roy* bound into the British Library copy (Shelfmark: 134.a.6–7). The second volume, containing the life of Poussin, was published under the same *privilège* in 1688.

FELIX SUMMERLY'S HAND BOOK
[Henry Cole] *Felix Summerly's Hand Book for the National Gallery*, London 1843

FELTHAM 1807
Feltham, J.F., *The Picture of London, for 1807*, London n.d. [1807]

FIERENS 1933
Fierens, P., *Les Le Nain*, Paris 1933

FOGGO 1845
Foggo, G., *A Catalogue of the Pictures in the National Gallery with critical notes*, London 1845

FOHR 1982
Fohr, R., *Tours, musée des Beaux-Arts... Tableaux français et italiens du XVIIᵉ siècle*, Paris 1982

FOWLE 1970
Fowle, G.E., *The Biblical Paintings of Sébastien Bourdon*, PhD thesis, University of Michigan 1970

FREDERICKSEN, *INDEX*
Fredericksen, B., ed., *The Index of Paintings Sold in the British Isles during the Nineteenth Century*, 4 vols, Santa Barbara and Oxford 1988–90; Munich, London, New York, Paris 1993; and Santa Monica 1996

FREEDBERG 1989
Freedberg, D., *The Power of Images: Studies in the History and Theory of Response*, Chicago and London 1989

FRIEDLÄNDER AND BLUNT
Friedländer, W., and Blunt, A., *The Drawings of Nicolas Poussin. A catalogue raisonné*, 5 vols, London 1939–74

FUMAGALLI 1994
Fumagalli, E., 'Poussin et les collectionneurs romains au XVIIᵉ siècle', in exh. cat., Paris 1994–5, pp. 48–57

FUMAROLI 1984
Fumaroli, M., 'Muta Eloquentia: la représentation de l'éloquence dans l'oeuvre de Nicolas Poussin', *BSHAF*, année 1982 [1984], pp. 29–48

GAULT DE SAINT-GERMAIN 1806
Gault de Saint-Germain, P.M., *Vie de Nicolas Poussin, considéré comme chef de l'école française*, Paris 1806

GEORGE 1844
George, *Galerie de feu S.E. le Cardinal Fesch, deuxième et troisième parties*, Rome 1844

GERSAINT 1747
Gersaint, E.F., *Catalogue raisonné des bijoux, porcelaines... provenans de la Succession de M. Angran, Vicomte de Fonspertuis*, Paris 1747

GOLDFARB 1989
Goldfarb, H.T., *From Fontainebleau to the Louvre: French Drawing from the Seventeenth Century*, exh. cat., Cleveland 1989

GOULD 1975
Gould, C., *National Gallery Catalogues. The Sixteenth Century Italian Schools*, London 1975

GRAHAM 1820
Graham, M., *Memoirs of the Life of Nicholas Poussin*, London 1820

GRAUTOFF 1914
Grautoff, O., *Nicolas Poussin: sein Werk und sein Leben*, Munich 1914

GUERIN 1882
Guérin, P., *Les Petits Bollandistes: vie des saints de l'Ancien et du Nouveau Testament*, 7th edn, 17 vols, Paris 1882

GUILLET DE SAINT-GEORGES
Guillet de Saint-Georges, 'Mémoire historique des ouvrages de M. Eustache Le Sueur, Peintre et l'un des douze anciens de l'Académie – Lu à l'Académie le 5 août 1690', and 'Mémoire historique des principaux ouvrages de Philippe Champagne, nommé ordinairement Champagne l'oncle' in DUSSIEUX 1854, vol. 1, pp. 147–73 and pp. 239–58

HAGEDORN 1775
Hagedorn, C.L. de, *Réflexions sur la peinture*, Leipzig 1775

HARVEY 1992
Harvey, M.J., 'Death and Dynasty in the Bouillon Tomb Commissions', *AB*, 74, 1992, pp. 271–96

HASKELL AND PENNY 1981
Haskell, F., and Penny, N., *Taste and the Antique. The Lure of Classical Sculpture 1500–1900*, New Haven and London 1981

HAZLITT 1823
Hazlitt, W., 'The Dulwich Gallery', *London Magazine*, January 1823 (reprinted in *Selected Essays of William Hazlitt 1778–1830*, ed. G. Keynes, London 1942, pp. 666–79)

HAZLITT 1843
Hazlitt, W., *Criticisms on Art and Sketches of the Picture Galleries of England*, London 1843

HOMER, *ILIAD*
Homer, *The Iliad*, trans. A.T. Murray, Loeb edn, 2 vols, London and Cambridge, Mass., 1971 reprint

HOMER, *ODYSSEY*
Homer, *The Odyssey*, trans. A.T. Murray, Loeb edn, 2 vols, London and Cambridge, Mass., 1966

HORACE, *SATIRES*
Horace, *Satires, Epistles and Ars Poetica*, trans. H. Rushton Fairclough, Loeb edn, London and Cambridge, Mass., 1926 (1970 reprint)

Iconologie, ou, Explication nouvelle de plusieurs images... tirée des recherches & des figures de César Ripa, moralisées par I. Baudoin, Paris 1644

ILLUSTRATED BARTSCH
Bartsch, A. von, *The Illustrated Bartsch*, ed. W.I. Strauss, New York 1978–

INDEX OF PAINTINGS
See under Fredericksen

INGAMELLS 1997
Ingamells, J., *A Dictionary of British and Irish Travellers in Italy 1701–1800 compiled from the Brinsley Ford Archive*, New Haven and London 1997

ISARLO 1938
Isarlo, G., 'Les trois Le Nain et leur suite', *La Renaissance*, March 1938, pp. 1–58

JAMESON 1842
Jameson, Mrs, *A Handbook to the Public Galleries of Art in and near London*, 2 parts, London 1842

JAMOT 1923a
Jamot, P., 'Sur quelques oeuvres de Louis et de Mathieu Le Nain. A propos d'une exposition', *GBA*, 7, 1923 (I), pp. 31–40

JAMOT 1923b
Jamot, P., 'Essai de chronologie des oeuvres des frères Le Nain', *GBA*, 7, 1923, pp. 157–66

JAMOT 1929
Jamot, P., *Les Le Nain*, Paris 1929

JAMOT 1948
Jamot, P., *Connaissance de Poussin*, Paris 1948

KEAZOR 1995
Keazor, H., 'Nicolas Poussin', *Kunstchronik*, August 1995, pp. 337–59

KEAZOR 1998
Keazor, H., *Poussins Parerga: Quellen, Entwicklung und Bedeutung der Kleinkompositionen in den Gemälden Nicolas Poussins*, Regensburg 1998

KENNEDY 1969
Kennedy, I.G., 'Claude Lorrain and Topography', *Apollo*, 90, 1969, pp. 304–9

KENNEDY 1972
Kennedy, I.G., 'Claude and Architecture', *JWCI*, 35, 1972, pp. 260–83

Kinnaird collection; or cabinet picture gallery, London 1809

KIRBY AND WHITE 1996
Kirby, J., and White, R., 'The Identification of Red Lake Pigment Dyestuffs and a Discussion of their Use', *NGTB*, 17, 1996, pp. 56–80

KITSON 1961
Kitson, M., 'The Relationship between Claude and Poussin in Landscape', *Zeitschrift für Kunstgeschichte*, 24, 1961, pp. 142–62

KITSON 1969
Kitson, M., *The Art of Claude Lorrain*, exh. cat., Hayward Gallery, London 1969

KITSON 1978
Kitson, M., *Claude Lorrain: Liber Veritatis*, London 1978

KITSON 1980
Kitson, M., 'Gaspard Dughet at Kenwood', *BM*, 122, 1980, pp. 644–51

KITSON 1982
Kitson, M., 'A small sketchbook by Claude', *BM*, 124, 1982, pp. 698–703

KITSON 1983
Kitson, M., 'Turner and Claude', *Turner Studies*, vol. 2, no. 2, 1983, pp. 2–15

KITSON 1999
Kitson, M., 'Anthony Blunt's *Nicolas Poussin* in context', *Commemorating Poussin. Reception and Interpretation of the Artist*, ed. K. Scott and G. Warwick, Cambridge 1999, pp. 211–30

KITSON AND ROETHLISBERGER 1959
Kitson, M., and Roethlisberger, M., 'Claude Lorrain and the *Liber Veritatis* – I', *BM*, 101, 1959, pp. 14–25

KNAB 1960
Knab, E., 'Die Anfänge des Claude Lorrain', *Jahrbuch der Kunsthistorischen Sammlungen in Wien*, 56, 1960, pp. 63–164

KNIGHT 1791
Knight, E., *Pocket Book of Edward Knight, March 1786–March 1791*, MS, Kidderminster Public Library

LAING 1995
Laing, A., *In Trust for the Nation. Paintings from National Trust Houses*, exh. cat., National Gallery, London 1995

LANDON 1813
Landon, C.P., *Vie et oeuvre complète de Nicolas Poussin*, Paris 1813

LANDSEER 1834
Landseer, J., *A Descriptive, Explanatory, and Critical Catalogue of Fifty of the Earliest Pictures contained in the National Gallery of Great Britain*, London 1834

LANE 1999
Lane, J., 'The Dark Knight', Edward Knight of Wolverley and his Collections', *Apollo*, 149, June 1999, pp. 25–30

LANGDON 1996
Langdon, H., 'The Imaginative Geographies of Claude Lorrain', *Transports, Travel, Pleasure, and Imaginative Geography, 1660–1850, Studies in British Art 3*, ed. C. Chard and H. Langdon, New Haven and London 1996, pp. 151–78

LASKIN AND PANTAZZI 1987
Laskin, M., and Pantazzi, M., eds, *Catalogue of the National Gallery of Canada Ottawa, European and American Painting, Sculpture and Decorative Arts, vol. 1, 1300–1800*, Ottawa 1987

LAURAIN-PORTEMER 1976
Laurain-Portemer, M., 'Mazarin militant de l'art baroque au temps de Richelieu (1634–1642)', *BSHAF*, année 1975 [1976], pp. 65–100

LAVERGNE-DUREY 1989
Lavergne-Durey, V., 'Les Titon, mécènes et collectionneurs à Paris à la fin du XVIIe et au XVIIIe siècles', *BSHAF*, 1989 [1990], pp. 77–103

LAVIN 1954
Lavin, I., 'Cephalus and Procris. Transformations of an Ovidian Myth', *JWCI*, 17, 1954, pp. 260–87

LAVIN 1975
Lavin, M.A., *Seventeenth-Century Barberini Documents and Inventories of Art*, New York 1975

LE COMTE 1699–1700
Le Comte, F., *Cabinet des singularitez d'architecture, peinture, sculpture, et gravure*, 3 vols, Paris 1699–1700

LEFRANÇOIS DE LALANDE 1769–70
Lefrançois de Lalande, J.-J., *Voyage d'un français en Italie: fait dans les années 1765 & 1766. Nouvelle édition corrigée*, 8 vols, Yverdon 1769–70

LE MAIRE 1685
Le Maire, C., *Paris ancien et nouveau*, 3 vols, Paris 1685

LE ROUGE 1733
Le Rouge, G.L., *Les Curiositez de Paris...*, 2 vols, Paris 1733

LE ROY LADURIE 1996
Le Roy Ladurie, E., *The Ancien Regime: a history of France 1610–1774*, trans. M. Greengrass, Oxford and Cambridge, Mass., 1996

LESLIE 1845/1937
Leslie, C.R., *Memoirs of the Life of John Constable, Esq., R.A.*, London 1845 (ed. A. Shirley, London 1937)

LEVEY 1962
Levey, M., 'A Claude Signature and Date revealed after cleaning', *BM*, 104, 1962, pp. 390–1

LEVEY 1971
Levey, M., *National Gallery Catalogues. The Seventeenth and Eighteenth Century Italian Schools*, London 1971 (1986 reprint)

LEVEY 1988
Levey, M., '"The Enchanted Castle" by Claude: subject, significance and interpretation', *BM*, 130, 1988, pp. 812–20

LEVI 1978
Levi, H., *Richelieu and the Arts: His Homes and Gardens: His Iconography*, PhD thesis, University of Edinburgh 1978

LEVI 1985
Levi, H., 'L'inventaire après décès du cardinal de Richelieu', *AAF (N.P.)*, 27, 1985, pp. 9–83

LIPPINCOTT 1983
Lippincott, L., *Selling Art in Georgian London. The Rise of Arthur Pond*, New Haven and London 1983

LITTRE 1873
Littré, E., *Dictionnaire de la langue française*, 4 vols, Paris 1873, and *Supplément*, Paris 1874

LOMAZZO 1590
Lomazzo, *Idea del Tempio della Pittura*, Milan 1590

London and its Environs Described: Containing an account of whatever is most remarkable for grandeur, elegance, curiosity or use, in the city and in the country twenty miles around it, 6 vols, London 1761

MABILLE DE PONCHEVILLE 1938
Mabille de Ponchevillle, A., *Philippe de Champaigne*, Paris 1938

MACGREGOR 1988
MacGregor, N., 'Recent acquisitions at the National Gallery, London', *BM*, 130, 1988, pp. 569–76

MAGNE 1914
Magne, E., *Nicolas Poussin premier peintre du Roi 1594–1665*, Brussels and Paris 1914

MAHON 1946
Mahon, D., 'Nicolas Poussin and Venetian Painting: A New Connexion', *BM*, 88, 1946, pp. 15–20 and 37–42

MAHON 1961
Mahon, D., 'Réflexions sur les paysages de Poussin', *Art de France*, 1961, pp. 119–32

MAHON 1962a
Mahon, D., Entries in *L'Ideale Classico del Seicento in Italia e la Pittura di Paesaggio*, exh. cat., Bologna 1962

MAHON 1962b
Mahon, D., *Poussiniana. Afterthoughts arising from the exhibition*, Paris 1962

MAHON 1965
Mahon, D., 'A Plea for Poussin as a Painter', *Walter Friedländer zum 90. Geburtstag*, Berlin 1965, pp. 113–42

MAHON 1995a
Mahon, D., *Early Poussin Reconsidered*, Dulwich Picture Gallery, London 1995

MAHON 1995b
Mahon, D., 'The written sources for Poussin's landscapes, with special reference to his two landscapes with Diogenes', *BM*, 137, 1995, pp. 176–82

MAHON 1999
Mahon, D., *Nicolas Poussin. Works from his First Years in Rome*, Jerusalem 1999

MALONE 1797
Malone, E., *The Works of Sir Joshua Reynolds, Knt.*, 2 vols, London 1797

MARDRUS 1996
Mardrus, F., 'A propos du voyage de Sir James Thornhill en France. Remarques sur les tableaux de Poussin acquis par le Régent', *Poussin Colloque 1994* [1996], pp. 809–33

MARIETTE, *ABECEDARIO*
Abecedario de P.J. Mariette: et autres notes inédites de cet amateur sur les arts et les artistes, ed. Ph. de Chennevières and A. de Montaiglon, 6 vols, Paris 1851–60

MARTIN 1970
Martin, G., *National Gallery Catalogues. The Flemish School circa 1600–circa 1900*, London 1970

MASCALCHI 1984a
Mascalchi, S., *Le collezioni di Giovan Carlo de' Medici. Una vicenda del Seicento Fiorentino riconsiderata alla luce dei documenti*, PhD thesis, University of Florence 1984

MASCALCHI 1984b
Mascalchi, S., 'Giovan Carlo de' Medici: An Outstanding but Neglected Collector in Seventeenth Century Florence', *Apollo*, 120, 1984, pp. 268–72

MCTIGHE 1989
McTighe, S., 'Nicolas Poussin's representations of storms and *libertinage* in the mid-seventeenth century', *Word and Image*, 5, 1989, pp. 333–61

MCTIGHE 1990
McTighe, S., entry in *Claude to Corot. The Development of Landscape Painting in France*, exh. cat., ed. A. Wintermute, Colnaghi, New York 1990, pp. 50–6

MCTIGHE 1996
McTighe, S., *Nicolas Poussin's Landscape Allegories*, Cambridge 1996

MEROT 1989
Mérot, A., 'Eustache le Sueur: L'Histoire de l'Amour, cinq *modelli* pour un plafond',

La Revue du Louvre et des Musées de France, 3, 1989, pp. 164–71

MEROT 1990a
Mérot, A., *Nicolas Poussin*, London 1990

MEROT 1990b
Mérot, A., *Retraites mondaines: aspects de la décoration intérieure à Paris au XVIIe siècle*, Paris 1990

MEROT 1994
Mérot, A., *La peinture française au XVIIe siècle*, Paris 1994

MEROT 2000
Mérot, A., *Eustache Le Sueur (1616–1655)*, Paris 2000

MEROT AND WINE 2000
Mérot, A., and Wine, H., '"Alexander and his Doctor": a rediscovered masterpiece by Eustache Le Sueur', *BM*, 142, 2000, pp. 292–6

MIGNOT 1984
Mignot, C., 'Le cabinet de Jean-Baptiste de Bretagne, un "curieux" parisien oublié (1650)', *AAF*, 26, 1984, pp. 71–87

MILLS AND WHITE 1980
Mills, J., and White, R., 'Analyses of Paint Media', *NGTB*, 4, 1980, pp. 65–7

MOJANA 1989
Mojana, M., *Valentin de Boulogne*, Milan 1989

MONVILLE 1731
Monville, Abbé de, *La vie de Pierre Mignard, premier peintre du Roy*, 2nd edn, Amsterdam 1731

MURRAY 1980
Murray, P., *Dulwich Picture Gallery. A Catalogue*, London 1980

Murray's Handbook for Travellers in Surrey, Hampshire and The Isle of Wight, London 1858

Murray's Handbook for Travellers in Worcestershire and Herefordshire, 4th edn, London 1894

National Gallery of Pictures by the Great Masters presented by Individuals or purchased by grant of Parliament, 2 vols, London n.d. [1838?]

National Gallery. A Selection of its Pictures. Engraved by George Doo... and others, London 1875

National Gallery: Abridged descriptive and historical catalogue of the British and Foreign Pictures, London 1915

National Gallery Trafalgar Square: Catalogue, 86th edn, London 1929

National Gallery Catalogue. Acquisitions 1953–62, London 1963

National Gallery Report January 1980–December 1981, London 1982

National Gallery Master Paintings from the collection of Wynn Ellis of Whitstable, London 1990

NEALE 1818–23
Neale, J.P., *Views of the Seats of Noblemen and Gentlemen in England, Wales, Scotland and Ireland*, 1st series, 6 vols, London 1818–23

NIEMEIJER 1965
Niemeijer, J.W., 'Aeneas op Delos', *Bulletin van het Rijksmuseum*, 13, 2, 1965, pp. 41–4

NIEUWENHUYS 1843
Nieuwenhuys, C.J., *Description de la Galerie des tableaux de S.M. le Roi des Pays-Bas*, Brussels 1843

NIKOLENKO 1983
Nikolenko, L., *Pierre Mignard, the portrait painter of the Grand Siècle*, Munich 1983

OBERHUBER 1988
Oberhuber, K., *Poussin: the early years in Rome: the origins of French classicism*, Oxford 1988

OLSON 1994
Olson, T.P., *Nicolas Poussin, his French clientele and the social construction of style*, PhD thesis, University of Michigan 1994

O'NEILL 1981
O'Neill, M., *Musée des Beaux-Arts d'Orléans. Les Peintures de L'Ecole Française des XVIIᵉ et XVIIIᵉ siècles*, Nantes 1981

OTTLEY 1832
Ottley, W.Y., *A Descritive [sic] Catalogue of the Pictures in the National Gallery...*, London 1832

OTTLEY 1835
Ottley, W.Y., *A Descriptive Catalogue of the Pictures in the National Gallery with Critical Remarks on their Merits*, London 1835

OVID, *FASTI*
Ovid, *Fasti*, trans. Sir J. G. Frazer, Cambridge, Mass., and London 1931 (1967 reprint)

OVID, *METAMORPHOSES*
Ovid, *Metamorphoses*, trans. F. J. Miller, 2 vols, Loeb edn, London 1916 (1966 reprint)

OVID, *REMEDIA AMORIS*
Ovid, *Remedia Amoris*, trans. J.H. Mozley, Loeb edn, London 1929

OWEN AND BROWN 1988
Owen, F., and Blayney Brown, D., *Collector of Genius: A Life of Sir George Beaumont*, New Haven and London 1988

PACE 1969
Pace, C., 'Claude the Enchanted: Interpretations of Claude in England in the earlier Nineteenth Century', *BM*, 111, 1969, pp. 733–40

PACE 1981
Pace, C., *Félibien's Life of Poussin*, London 1981

PASCOLI 1730–6
Pascoli, L., *Vite de' Pittori, Scultori ed Architetti moderni*, 2 vols, Rome 1730–6

PASSAVANT 1836
Passavant, J.D., *Tour of a German Artist in England, with notices of private galleries, and remarks on the state of art*, 2 vols, London 1836

VON PASTOR
von Pastor, L., *The History of the Popes*, ed. R.F. Kerr, D.E. Graf and E.F. Peeler, 40 vols, London 1912–53

PATMORE 1824
Patmore, P.G., *British Galleries of Art*, London 1824

PATTISON 1884
Pattison, M., *Claude Lorrain. Sa vie et ses oeuvres d'après des documents inédits*, Paris 1884

PAUSANIUS
Pausanius, *Description of Greece*, trans. W.H.S. Jones et al., 5 vols, Loeb edn, London 1918–35 (1965–9 reprints)

PERONNET AND FREDERICKSEN 1998
Peronnet, B., and Fredericksen, B.B., eds, *Répertoire des tableaux vendus en France au XIXe siècle, Volume I, 1801–1810*, 2 vols, Los Angeles 1998

PEVSNER 1952
Pevsner, N., *The Buildings of England. London except the Cities of London and Westminster*, Harmondsworth 1952

PEVSNER 1960
Pevsner, N., *The Buildings of England. Buckinghamshire*, Harmondsworth 1960

PEVSNER 1962
Pevsner, N., *The Buildings of England. North-West and South Norfolk*, Harmondsworth 1962

PEVSNER 1973
Pevsner, N. (revised by B. Cherry), *The Buildings of England, London I. The Cities of London and Westminister*, 3rd edn, Harmondsworth 1973

PHILO OF ALEXANDRIA 1612
Les Oeuvres de Philon, Mises de Grec en François, par P. Bellier, Paris 1612

PHILOSTRATUS, *IMAGINES*
Philostratus, *Imagines*, trans. A. Fairbanks, Loeb edn, London and Cambridge, Mass., 1931 (1969 reprint)

PIGANIOL 1765
Piganiol de la Force, J.A., *Description historique de la ville de Paris et de ses environs*, 10 vols, Paris 1765

PIGLER 1974
Pigler, A., *Barockthemen: eine Auswahl von Verzeichnissen zur Ikonographie des 17. und 18. Jarhunderts*, 3 vols, Budapest 1974

PLESTERS 1978–9
Plesters, J., '"Les trois âges" à la National Gallery de Londres', in exh. cat., Paris 1978–9, pp. 314–17

PLESTERS 1980
Plesters, J., 'Possible causes of blanching involving changes in pigment or interaction of pigment and medium', *NGTB*, 4, 1980, pp. 61–3

PLINY, *NATURAL HISTORY*
Pliny, *Natural History*, trans. H. Rackham et al., 10 vols, Loeb edn, London and Cambridge, Mass., 1938–62

PLUTARCH, *LIFE OF ALEXANDER*
Plutarch, *Life of Alexander*, trans. Bernadotte Perrin, vol. 7 of Plutarch's *Lives*, Loeb edn, London 1919 (reprint 1994)

The Portfolio comprising the original engravings from those... pictures forming the... Stafford and Angerstein Collections, the latter of which is now known as the National Gallery, London 1834

POUSSIN COLLOQUE 1958
Nicolas Poussin [Actes du Colloque] Paris 19–21 Septembre 1958, 2 vols, Paris 1960

POUSSIN COLLOQUE 1994
Nicolas Poussin (1594–1665). Actes du colloque organisé au musée du Louvre par le Service culturel du 19 au 21 octobre 1994, 2 vols, Paris 1996

POUSSIN CORRESPONDANCE 1911
Correspondance de Nicolas Poussin, ed. Ch. Jouanny, Paris 1911 (AAF, n.p., 5, 1911)

POUSSIN AND ROME 1994
Poussin et Rome. Actes du colloque à l'Académie de France à Rome et à la Bibliotheca Herziana, 16–18 November 1994, ed. O. Bonfait et al., Paris 1996

PREAUD 1996
Préaud, M., 'Nicolas Poussin dans les éditions d'Etienne Gantrel', Poussin Colloque 1994 [1996], pp. 669–93

PRESSLY 1981
Pressly, W.L., The Life and Art of James Barry, New Haven and London 1981

PROCES-VERBAUX
Procès-Verbaux de l'Académie Royale de Peinture et de Sculpture 1648–1793, ed. A. de Montaiglon, 10 vols, Paris 1875–92, and Index by P. Cornu, Paris 1909

PROUST-PERRAULT 1996
Proust-Perrault, J., 'No. 10 Hôtel Chastillon', De la place Royale à la place des Vosges, Paris 1996, pp. 324–30

RAMBAUD 1964–71
Rambaud, M., Documents du Minutier Central concernant l'Histoire de l'Art (1700–1750), 2 vols, Paris 1964–71

RAMDOHR 1787
Ramdohr, F.W.B. von, Ueber Mahlerei und Bildhauerarbeit in Rom, 3 vols, Leipzig 1787

REAU 1955–9
Réau, L., Iconographie de l'art chrétien, 3 vols, Paris 1955–9

REDFORD 1888
Redford, G., Art Sales. A History of Sales of Pictures and other Works of Art, 2 vols, London 1888

REINACH 1909–12
Reinach, S., Répertoire des reliefs Grecs et Romains, 3 vols, Paris 1909–12

REISET 1887
Reiset, F., Une Visite à la Galerie Nationale de Londres, Paris 1887

REPERTOIRE 1801–10
See PERONNET AND FREDERICKSEN 1998

REPORT 1853
Report from the Select Committee on the National Gallery, London 1853

REYNOLDS 1959
Reynolds, Sir J., Discourses on Art, ed. R.R. Wark, San Marino, CA, 1959

RIPA 1645
Ripa, C., Iconologia, Venice 1645 (for the version in French published the previous year, see under Iconologie)

ROBIN 1998
Robin, D., Etude iconographique des Bacchanales Richelieu de Nicolas Poussin, PhD thesis, Université de Paris IV, 1998

ROETHLISBERGER 1958
Roethlisberger, M., 'Les pendants dans l'oeuvre de Claude Lorrain', GBA, 5, 1958, pp. 215–18

ROETHLISBERGER 1960
Roethlisberger, M., 'The Subjects of Claude Lorrain's Paintings', GBA, 55, 1960, pp. 209–24

ROETHLISBERGER 1961
Roethlisberger, M., Claude Lorrain: The Paintings, 2 vols, London 1961

ROETHLISBERGER 1968a
Roethlisberger, M., 'Additions to Claude', BM, 110, 1968, pp. 115–19, 122–3

ROETHLISBERGER 1968b
Roethlisberger, M., Claude Lorrain. The Drawings, 2 vols, Berkeley and Los Angeles 1968

ROETHLISBERGER 1969
Roethlisberger, M., 'De Bril à Claude: tableaux inédits', Revue de l'Art, 5, 1969, pp. 54–60

ROETHLISBERGER 1970
Roethlisberger, M., 'Quelques nouveaux indices sur Francisque', GBA, 76, 1970, pp. 319–24

ROETHLISBERGER 1971
Roethlisberger, M., The Claude Lorrain Album in the Norton Simon, Inc. Museum of Art, Los Angeles 1971

ROETHLISBERGER 1975
Roethlisberger, M., Gaspard Dughet, Rome 1615–1675, Richard Feigen & Co., New York, and Herner Wengraf Ltd, London, 1975

ROETHLISBERGER 1979
Roethlisberger, M., 'Additional Works by Goffredo Wals and Claude Lorrain', BM, 121, 1979, pp. 20–8

ROETHLISBERGER 1983
Roethlisberger, M., et al., Im Licht von Claude Lorrain. Landschaftsmalerei aus drei Jahrhunderten, exh. cat., Haus der Kunst, Munich 1983

ROETHLISBERGER 1984a
Roethlisberger, M., 'New Works by Tassi, Claude and Desiderii', Apollo, 120, 1984, pp. 93–7

ROETHLISBERGER 1984b
Roethlisberger, M., 'Claude Lorrain: Some New Perspectives', Studies in the History of Art, 14, Claude Lorrain 1600–1682: A Symposium, Washington DC 1984, pp. 47–65

ROETHLISBERGER 1986
Roethlisberger, M., 'Claude Lorrain, Nouveaux dessins, tableaux et lettres', BSHAF, année 1986 [1988], pp. 33–55

ROETHLISBERGER 1993
Roethlisberger, M., 'Newly Discovered Drawings by Claude Lorrain', Drawing, 15, no. 1, May–June 1993, pp. 7–10

ROETHLISBERGER AND CECCHI 1975
Roethlisberger, M., and Cecchi, D., L'opera completa di Claude Lorrain, Milan 1975

ROSENBERG 1966
Rosenberg, P., Inventaire des collections publiques françaises. Rouen – Musée des Beaux-Arts. Tableaux français du XVIIème siècle et italiens des XVIIème et XVIIIème siècles, Paris 1966

ROSENBERG 1979
Rosenberg, P., 'L'exposition Le Nain: une proposition', Revue de l'Art, 43, 1979, pp. 91–100

ROSENBERG 1982
Rosenberg, P., 'Edinburgh – Poussin considered', BM, 124, 1982, pp. 376–80

ROSENBERG 1993
Rosenberg, P., Tout l'oeuvre peint des Le Nain, Paris 1993

ROSENBERG 1995
Rosenberg, P., Dessins français de la collection Prat XVIIe–XVIIIe–XIXe siècles, exh. cat., Paris, Edinburgh, Oxford 1995

ROSENBERG 1999
Rosenberg, P., review of Rome 1998–9, BM, 141, 1999, pp. 191–3

ROSENBERG AND PRAT 1994
Rosenberg, P., and Prat, L.-A., Nicolas Poussin 1594–1665 Catalogue raisonné des dessins, 2 vols, Milan 1994

ROSENBERG AND STEWART 1987
Rosenberg, P., and Stewart, M.C., French Paintings 1500–1825. The Fine Arts Museum of San Francisco, San Francisco 1987

ROSENBERG AND THUILLIER 1989–90
Rosenberg, P., and Thuillier, J., Laurent de La Hyre 1606–1656: l'homme et l'oeuvre, exh. cat., Grenoble, Rennes, Bordeaux 1989–90

ROY AND SMITH 1998
Roy, A., and Smith, P., eds, Painting Techniques. History, Materials and Studio Practice, Contributions to the Dublin Congress 7–11 September 1998, London 1998

RUSKIN, MODERN PAINTERS
[Ruskin, J.], Modern Painters, 5 vols, London 1846–60

RUSKIN, WORKS
The Works of John Ruskin, ed. E.T. Cook and A. Wedderburn, 39 vols, London 1903–12

RUSSELL 1982
Russell, H.D., Claude Lorrain 1600–1682, exh. cat., National Gallery of Art, Washington DC 1982

RUSSELL 1984
Russell, H.D., 'Claude's Psyche Pendants: London and Cologne', Studies in the

History of Art, 14, *Claude Lorrain 1600–1682: A Symposium*, ed. P. Askew, National Gallery of Art, Washington DC 1984, pp. 67–81

SAFARIK AND MILANTONI 1981
Safarik, E.A., and Milantoni, G., *Catalogo sommario della Galleria Colonna in Roma, Dipinti*, Rome 1981

SAFARIK AND PUJIA 1996
Safarik, E.A., assisted by Pujia, C., *Italian Inventories 2. The Colonna Collection of Paintings. Inventories 1611–1795*, Munich, New Providence, London, Paris 1996

SAINT-SIMON 1856–8
Louis de Rouvroy, duc de Saint-Simon, *Mémoires complets et authentiques du duc de Saint-Simon sur le siècle de Louis XIV et la Régénce*, 20 vols, Paris 1856–8

SALERNO 1975
Salerno, L., 'La cronologia di Gaspard Dughet', *Etudes d'art français offertes à Charles Sterling*, Paris 1975, pp. 227–36

SALERNO 1977–80
Salerno, L., *Pittori di paesaggio del seicento a Roma*, trans. C. Whitfield, 3 vols, Rome 1977–80

SANDRART 1675–9
Sandrart, J. von, *Teutsche Academie der edlen Bau-, Bild-, und Mahlerey-Künste*, 2 vols, Nuremberg 1675–9

SCHILLER 1971–2
Schiller, G., *Iconography of Christian Art*, 2 vols, London 1971–2

SCHLEIER 1989
Schleier, E., *Pier Franceso Mola, 1612–1666*, exh. cat, Lugano, Rome, Milan 1989

SCHLODER 1985
Schloder, J., 'Richelieu, mécène au château de Richelieu', *Richelieu et le Monde de l'Esprit*, Paris 1985, pp. 115–27

SCHLODER 1988
Schloder, J.E., *La Peinture au Château de Richelieu*, PhD thesis, Université de Paris, 1988

SCHNAPPER 1976
Schnapper, A., 'Louis de Boullogne à l'église de Chantilly', *Revue de l'Art*, 34, 1976, pp. 57–60

SCHNAPPER 1994
Schnapper, A., *Curieux du Grand Siècle. Collections et collectionneurs dans la France du XVIIe siècle, II – Oeuvres d'art*, Paris 1994

SCOTT 1973
Scott, B., 'The Comtesse de Verrue. A Lover of Dutch and Flemish art', *Apollo*, 97, 1973, pp. 20–4

SENECHAL 1994
Sénéchal, P., 'Fortunes de quelques antiques Farnèse auprès des peintures à Rome au début du XVIIe siècle', *Poussin and Rome*, 1994, pp. 31–45

SITWELL 1964
Sitwell, O., 'The Magnasco Society', *Apollo*, 79, 1964, pp. 378–90

SMIRKE 1816
[?Smirke, R.], *A Catalogue Raisonné of the Pictures now Exhibiting in Pall Mall*, [London?] 1816

SMITH 1837
Smith, J., *A Catalogue Raisonné of the Most Eminent Dutch, Flemish and French Painters*, London 1829–42, 9 vols; vol. 8, *French Painters*, London 1837

SMITH, *DICTIONARY*
Ed. W. Smith, *Dictionary of Greek and Roman Biography and Mythology*, 3 vols, London 1849–50

SOHM 1986
Sohm, P.L., 'Ronsard's *Odes* as a source for Poussin's *Aurora and Cephalus*', *JWCI*, 49, 1986, pp. 259–61

SPARTI 1990
Sparti, D.L., 'The dal Pozzo collection again: the inventories of 1689 and 1695 and the family archive', *BM*, 132, 1990, pp. 551–70

SPARTI 1992
Sparti, D.L., *Le collezioni dal Pozzo. Storia di una famiglia e del suo museo nella Roma seicentesca*, Modena 1992

SPIKE 1998
Spike, J.T., *Mattia Preti. I documenti*, Florence 1998

SPON 1676
Spon, J., *Recherche des antiquités et curiosités de la ville de Lyon...*, Lyon 1676

STANDRING 1988
Standring, T.J., 'Some Pictures by Poussin in the Dal Pozzo Collection: three new inventories', *BM*, 130, 1988, pp. 608–26

SUTTON 1962
Sutton, D., 'Gaspard Dughet: some aspects of his art', *GBA*, 60, 1962, pp. 269–312

TALLEMENT DES REAUX 1960
Tallement des Réaux, *Historiettes*, ed. A. Adam, 2 vols, Paris 1960

TERVARENT 1959
Tervarent, G. de, *Attributs et Symboles dans l'Art Profane 1450–1600*, Geneva 1959

THIERY 1787
Thiéry, M., *Guide des Amateurs et des Etrangers Voyageurs à Paris*, 2 vols, Paris 1787

THORNHILL 1717
Thornhill, Sir J., *A Notebook of a visit to France February–April 1717*, MS, National Art Library, Victoria & Albert Museum, London

THUILLIER 1958
Thuillier, J., 'Tableaux attribués à Poussin dans les galeries italiennes', *Poussin Colloque 1958* [1960], II, pp. 263–326

THUILLIER 1960
Thuillier, J., 'Pour un "Corpus Pussinianum"', *Poussin Colloque 1958* [1960], II, pp. 49–238

THUILLER 1974
Thuillier, J., *L'opera completa di Poussin*, Milan 1974

THUILLER 1982
Thuillier, J., *Claude Lorrain e i pittori loronesi in Italia nel XVII secolo*, exh. cat., Accademia di Francia a Roma, Rome 1982

THUILLIER 1994a
Thuillier, J., *Nicolas Poussin*, Paris 1994

THUILLIER 1994b
Thuillier, J., 'Poussin et le laboratoire', *Techne*, 1, 1994, pp. 13–20

THUILLIER 1995
Thuillier, J., *Poussin before Rome 1594–1624*, London 1995

THUILLIER 2000
Thuillier, J., *Sébastien Bourdon 1616–1671*, exh. cat., Montpellier and Strasbourg 2000–1

THUILLER ET AL. 1990
Thuillier, J., Brejon de Lavergnée, B., and Lavalle, D., *Vouet*, exh. cat., Grand Palais, Paris 1990

THUILLER AND MIGNOT 1978
Thuillier, J., and Mignot, C., 'Collectionneur et Peintre au XVIIe; Pointel et Poussin', *Revue de l'Art*, 39, 1978, pp. 39–58

TYACK 1996
Tyack, G.C., 'Robert Smirke', *The Dictionary of Art*, London 1996

VALPY'S NATIONAL GALLERY
Valpy's National Gallery of Painting and Sculpture..., London, n.d. [1831?]

VAN DEN BERG 1942
Van den Berg, H.M., 'Willem Schellinks en Lambert Doomer in Frankrijk', *Oudheidkundig Jaarboek*, II, 1942, pp. 1–31

VASI 1797
Vasi, M., *Itinéraire instructif de Rome*, Rome 1797

VERDI 1976
Verdi, R., *Poussin's Critical Fortunes. The study of the artist and the criticism of his works from c.1690 to c.1830 with particular reference to France and England*, PhD thesis, Courtauld Institute of Art 1976

VERDI 1981
Verdi, R., 'Hazlitt and Poussin', *Keats-Shelley Memorial Association Bulletin*, 32, 1981, pp. 1–18

VERDI 1982
Verdi, R., 'Poussin and the "Tricks of Fortune"', *BM*, 124, 1982, pp. 681–5

VERDI 1986–7
Verdi, R., 'Poussin's *Venus and Mercury* in the Dulwich Picture Gallery', *Nicolas Poussin – Venus and Mercury*, exh. cat., Dulwich Picture Gallery, London 1986–7, pp. 5–18

VERDI 1993
Verdi, R., 'The Reputation of Poussin's Landscape Paintings in France from Félibien to Cézanne', *Cézanne and Poussin. A Symposium* [Edinburgh 1990], ed. R. Kendall, Sheffield 1993, pp. 13–29

VERDI 1994
Verdi, R., 'Situation de Poussin dans la France et l'Angleterre des XVIIIe et XIXe

siècles' in exh. cat., Paris 1994–5, pp. 98–104

VERTUE NOTE BOOKS
Vertue Note Books, III, The Walpole Society, 22, 1933–4

VIGNIER 1676
Vignier, B., *Le Chasteau de Richelieu ou l'Histoire des dieux et des héros de l'antiquité*, Saumur 1676

VIRGIL, *ECLOGUES, GEORGICS, AENEID*
Virgil, *Eclogues, Georgics, Aeneid, The Minor Poems*, trans. H. Rushton Fairclough, revised Loeb edn, 2 vols, 1969–74

VOLKMANN 1787–8
Volkmann, J.J., *Neueste Reisen durch Frankreich*, 3 vols, Leipzig 1787–8

WAAGEN 1838
Waagen, G.F., *Works of Art and Artists in England*, 3 vols, London 1838

WAAGEN 1854
Waagen, G.F., *Treasures of Art in Great Britain: being an account of the chief collections of paintings...*, 3 vols, London 1854

WAAGEN 1857
Waagen, G.F., *Galleries and Cabinets of Art in Great Britain... visited in 1854 and 1856...*, London 1857

WADDINGHAM 1961
Waddingham, M.R., 'Alla ricerca di Agostino Tassi', *Paragone*, 139, 1961, pp. 9–23

WADDINGHAM 1963
Waddingham, M.R., 'The Dughet Problem', *Paragone*, 161, 1963, pp. 37–54

WARD 1885
Ward, T.H., *Men of the Reign...*, London 1885

WATERHOUSE 1960
Waterhouse, E.K., 'Poussin et l'Angleterre jusqu'en 1744', *Poussin Colloque 1958* [1960], I, pp. 283–96

WEIGERT 1939
Weigert, R.A., *Bibliothèque Nationale. Département des Estampes. Inventaire du fonds français. Graveurs du XVIIe siècle*, vol. 1, Paris 1939

WESTMACOTT 1824
Westmacott, C.M., *British Galleries of Painting and Sculpture...*, London 1824

WHITE AND PILC 1995
White, R., and Pilc, J., 'Analyses of Paint Media', *NGTB*, 16, 1995, pp. 85–95

WHITE AND PILC 1996
White, R., and Pilc, J., 'Analyses of Paint Media', *NGTB*, 17, 1996, pp. 91–103

WHITELEY 1998
Whiteley, J.J.L., *Claude Lorrain. Drawings from the Collections of the British Museum and the Ashmolean Museum*, exh. cat., London 1998

WHITFIELD 1977
Whitfield, C., 'Nicolas Poussin's "Orage" and "Temps Calme"', *BM*, 119, 1977, pp. 4–12

WHITLEY 1928a
Whitley, W.T., *Artist and their friends in England 1700–1799*, 2 vols, London and Boston 1928

WHITLEY 1928b
Whitley, W.T., *Art in England 1800–1820*, Cambridge 1928

WHITLEY 1930
Whitley, W.T., *Art in England 1821–1837*, Cambridge 1930

WILD 1962
Wild, D., '*L'Adoration des Bergers* de Poussin à Munich et ses tableaux religieux des années cinquante', *GBA*, 60, 1962, pp. 223–48

WILD 1980
Wild, D., *Nicolas Poussin*, 2 vols, Zurich 1980

WILDENSTEIN 1955
Wildenstein, G., 'Les Graveurs de Poussin au XVIIe Siècle', *GBA*, 46, 1955, pp. 81–371

WILDENSTEIN 1967
Wildenstein, D., *Inventaires après décès d'artistes et de collectionneurs français du XVIIIe siècle*, Paris 1967

WILSON 1808
Wilson, J., *A Biographical Index to the present House of Commons, ... corrected to February, 1808*, London 1808

WILSON 1978
Wilson, M., 'Two Le Nain Paintings in the National Gallery Re-appraised', *BM*, 120, 1978, pp. 530–3

WILSON 1985
Wilson, M., *French Paintings before 1800*, London 1985

WINE 1994
Wine, H., *Claude. The Poetic Landscape*, exh. cat. National Gallery, London 1994

WINE 1995
Wine, H., '"Poussin Problems" at the National Gallery', *Apollo*, 141, March 1995, pp. 25–8

WINE 1996
Wine, H., '*La Nymphe endormie* de Londres. L'apport des radiographies', *Poussin Colloque 1994* [1996], pp. 229–42

WINE, ACKROYD AND BURNSTOCK 1993
Wine, H., Ackroyd, P., and Burnstock, A., 'Laurent de La Hyre's Allegorical Figure of Grammar', *NGTB*, 14, 1993, pp. 22–33

WITT 1910
Witt, R., *Illustrated Catalogue of Pictures by the Brothers Le Nain*, Burlington Fine Arts Club, London 1910

WORNUM 1847
Wornum, R.N., revised by C.L. Eastlake, *Descriptive and Historical Catalogue of the Pictures in the National Gallery*, London 1847

WORNUM 1854
Wornum, R.N., *Descriptive and Historical Catalogue of the Pictures in the National Gallery*, London 1854

WORNUM 1877
Wornum, R.N., *Descriptive and Historical Catalogue of the Pictures in the National Gallery... Foreign Schools*, London 1877

WRIGHT 1985a
Wright, C., *Poussin paintings: a catalogue raisonné*, London 1985

WRIGHT 1985b
Wright, C., *Masterpieces of reality: French 17th century painting*, exh. cat., Leicester 1985–6

WYLD, MILLS AND PLESTERS 1980
Wyld, M., Mills, J., and Plesters, J., 'Some Observations on Blanching (with Special Reference to the Paintings of Claude)', *NGTB*, 4, 1980, pp. 48–63

YOUNG 1822
Young, J., *A Catalogue of the Pictures at Leigh Court, near Bristol; the seat of Philip John Miles, Esq., M.P.*, London 1822

YOUNG 1823
Young, J., *A Catalogue of the Celebrated Collection of Pictures of the late John Julius Angerstein, Esq.*, London 1823

ZIFF 1963
Ziff, J., 'Turner and Poussin', *BM*, 105, 1963, pp. 315–21

ZIFF 1965
Ziff, J., 'Copies of Claude's Paintings in the Sketch Books of J.M.W. Turner', *GBA*, 65, 1965, pp. 51–64

List of exhibitions (compiled by Sally Korman)

Unless otherwise indicated, name(s) in brackets are those of the principal author(s), or the author(s) of the relevant entries, where known.

1717 Rome, S. Salvatore in Lauro, *Quadri dell' Ill.ma Casa Falconieri... l'anno 1717*

1773 London, Robert Strange Collection

1786 London, 125 Pall Mall (April), Desenfans's exhibition

1786 London, 125 Pall Mall (June), Desenfans's exhibition

1795 London, Bryan's Gallery, Savile Row

1798–9 London, Bryan's Gallery, 88 Pall Mall, *A catalogue of the Orleans Italian Pictures which will be exhibited for sale by private contract on Wednesday the 26th of December 1798 and following days*

1801 London, European Museum, *The plan and new descriptive catalogue of the European Museum, King Street, St James's Square*

1801 London, 118 Pall Mall, *A Catalogue of Pictures from the Colonna, Borghese and Corsini Palaces...purchased in Rome in the years 1799 and 1800*

1815 London, The New Gallery, 60 Pall Mall, *Catalogue of the splendid collection of pictures belonging to Prince Lucien Bonaparte*

1816 London, British Institution, *Catalogue of pictures of the Italian and Spanish Schools*

1818 London, British Institution, *Catalogue of pictures of the Italian, Spanish, Flemish, Dutch and French Schools*

1819 London, British Institution, *Catalogue of pictures of the Italian, Spanish, Flemish and Dutch Schools*

1821 London, British Institution, *Catalogue of pictures of the Italian, Spanish, Flemish and Dutch Schools*

1822 London, British Institution, *Catalogue of pictures of the Italian, Spanish, Flemish and Dutch Schools*

1828 London, British Institution, *Catalogue of pictures by Italian, Spanish, Flemish and Dutch masters*

1832 London, British Institution, *Catalogue of pictures by Italian, Spanish, Flemish, Dutch and English masters*

1836 London, British Institution, *Catalogue of pictures by Italian, Spanish, Flemish, Dutch and English masters*

1838 London, British Institution, *Catalogue of pictures by Italian, Spanish, Flemish, Dutch and French masters*

1847 London, British Institution, *Catalogue of pictures by Italian, Spanish, Flemish, Dutch, French and English masters*

1851 London, British Institution, *Catalogue of pictures by Italian, Spanish, Flemish, Dutch, French and English masters*

1861 Marseille, Galeries de l'Exposition, 126 Boulevard de la Magdaleine, *Exposition des Beaux-Arts, Marseille*

1866 London, South Kensington Museum, *The First Special Exhibition of National Portraits*

1867 London, British Institution, *Catalogue of pictures by Italian, Spanish, Flemish, Dutch, French and English masters*

1868 Leeds, Leeds Infirmary, *National Exhibition of Works of Art*

1870 London, Royal Academy, *Exhibition of the works of the old masters, associated with A Collection from the works of Charles Robert Leslie, R.A., and Clarkson Stanfield, R.A.*

1871 London, Royal Academy, *Exhibition of the Works of the Old Masters*

1873 London, Royal Academy, *Exhibition of the Works of the Old Masters*

1874 Paris, Palais de la Présidence du Corps législatif, *Exposition au profit de la colonisation de l'Algérie par les Alsaciens-Lorrains*

1880 London, Royal Academy, *Exhibition of Works by Old Masters*

1882 London, Royal Academy, *Exhibition of Works by the Old Masters and by Deceased Masters of the British School*

1884 Guildford, *Surrey Art Loan Exhibition*

1888 London, Royal Academy, *Exhibition of Works by the Old Masters*

1888 Paris, *Exposition de l'Art Français sous Louis XIV et sous Louis XV au profit de l'Oeuvre de l'Hospitalité de nuit*

1890 London, Royal Academy, *Exhibition of Works by the Old Masters*

1892 London, Guildhall, *Descriptive Catalogue of the Loan Collection of Pictures*

1899–1900 London, The New Gallery, Regent Street, *Exhibition of Pictures by Masters of the Flemish and British Schools*

1902 London, Royal Academy, *Exhibition of Works by the Old Masters*

1903 London, Royal Academy, *Exhibition of the Works of the Old Masters*

1907 Paris, Bibliothèque Nationale, *Portraits peints et dessinés du XIIIe au XVIIe siècle*

1910 London, Agnews, *Catalogue of the collection of pictures and drawings of the late Mr. George Salting*

1914–15 London, Grosvenor Gallery, *III National Loan Exhibition. Pictures from the Basildon Park and Fonthill Collections*

1915–16 London, Burlington Fine Arts Club, *Winter Exhibition*

1923 Paris, Galerie Louis Sambon, *Exposition Le Nain... au profit de l'Oeuvre de la Présérvation contre le Tuberculose à Reims* (L. Sambon)

1925 Paris, Petit Palais, *Le Paysage Français de Poussin à Corot* (H. Lapauze, C. Gronkowski, A. Fauchier-Magnau)

1930 London, The Magnasco Society at Messrs Spink & Son, *Landscape Pictures of Different Periods*

1932 London, Royal Academy, *Exhibition of French Art 1200–1900* (T. Cox)

1934 Oxford, Ashmolean Museum, *Pictures from Lockinge House, Wantage*

1937 Paris, Palais National des Arts, *Chefs d'Oeuvre de l'Art Français* (C. Sterling et al.)

1938 London, Royal Academy, *Exhibition of 17th Century Art in Europe* (E.K. Waterhouse, F. Dodd, H. Isherwood Kay)

1939 London, National Gallery, *Exhibition of Portraits* (no catalogue)

1945 Birmingham, City of Birmingham Museum and Art Gallery, *Catalogue of Paintings and Tapestries from Lockinge House Wantage lent by Captain C.L. Loyd, M.C.*

1945 London, National Gallery, *Fifty-four pictures on exhibition at the reopening of the Gallery 17th May 1945* (no catalogue)

1945–6 London, National Gallery, *Exhibition in Honour of Sir Robert Witt, C.B.E., D.LITT, F.S.A. of the principal acquisitions made for the Nation through the National Art-Collections Fund*

1947 London, Wildenstein & Co. Ltd, *A Loan Exhibition of French Painting of the XVIIth Century in aid of The Merchant Navy Comforts Service* (D. Sutton)

1947 London, National Gallery, *An Exhibition of Cleaned Pictures (1936–47)*

1948 London, Whitechapel Art Gallery, *Five Centuries of European Painting: Pictures lent from the National Gallery, the Cook Collection and the Collection of Viscount Bearsted* (H. Scoutton)

1948–9 Birmingham, City Museum and Art Gallery, and London, The Tate

Gallery, *Richard Wilson and his Circle* (M. Woodall)

1949–50 London, Royal Academy, *An Exhibition of Landscape in French Art 1550–1900*

1951 Pittsburgh, Carnegie Institute, *French Painting 1100–1900* (C. Sterling)

1952 Paris, Orangerie des Tuilleries, *Philippe de Champaigne* (B. Dorival)

1953 New York, Jacques Seligmann and Company, *Seventeenth Century French Paintings*

1956 London, Thos Agnew & Sons Ltd, *Summer Exhibition of Pictures by Old Masters Including a Group on Loan from the Lockinge Collection*

1956 Manchester, City of Manchester Art Gallery, *John Constable 1776–1837*

1957 Manchester, City Art Gallery, *Art Treasures Centenary. European Old Masters* (S.D. Cleveland and D. Hall)

1958 Orléans, Musée des Beaux-Arts, *Artistes Orléanais du XVIIe siècle*

1958 Paris, Galerie Heim, *Tableaux de Maîtres Anciens*

1958 Stockholm, Nationalmuseum, *Fem Sekler Fransk Konst* (P. Grate and P. Bjuström)

1960 Cardiff, National Museum of Wales, *Ideal & classical landscape* (P. Barlow)

1960 Paris, Musée du Louvre, *Exposition Nicolas Poussin* (A. Blunt)

1961–2 Montreal Museum of Fine Arts; Le Musée de la Province de Québec; Ottawa, The National Gallery of Canada; The Art Gallery of Toronto, *Héritage de France. French Painting 1610–1760*

1962 Bologna, Palazzo dell'Archiginnasio, *L'Ideale Classico del Seicento in Italia e la Pittura di Paesaggio* (D. Mahon, M. Kitson, F. Arcangeli)

1962 London, Colnaghi, *Memorial Exhibition of Paintings and Drawings from the Collection of Francis Falconer Madan*

1963 London, National Gallery, *Exhibition of Acquisitions, 1953–62* (M. Levey)

1967 London, Christie's, *Christie's Bi-Centenary Exhibition* (no catalogue)

1968–9 London, British Museum, *Giovanni Battista Piranesi, his predecessors and his heritage*

1969 London, Hayward Gallery, *The Art of Claude Lorrain* (M. Kitson)

1973–4 London, Tate Gallery, *Landscape in Britain circa 1750–1850* (L. Parris)

1974 London, Woodlands Art Gallery, *John Julius Angerstein and Woodlands 1774–1974*

1974 Paris, Grand Palais, *Valentin et les Caravagesques Français* (A. Brejon de Lavergnée and J.-P. Cuzin)

1975 London, National Gallery, *The Rival of Nature. Renaissance Painting in its context*

1976–7 Paris, Musée du Louvre, Pavillon de Flore, *Nouvelles acquisitions du musée d'Orléans* (P. Rosenberg)

1977–8 Rome, Villa Medici, and Düsseldorf, Städtische Kunsthalle, *Nicolas Poussin 1594–1665* (P. Rosenberg)

1978 London, National Gallery, *The Artist's Eye: Richard Hamilton*

1978–9 Paris, Grand Palais, *Les frères Le Nain* (J. Thuillier)

1979 Leeds, City Art Gallery, *Church Art From Catholic Yorkshire*

1979 London, National Gallery, *Howard Hodgkin: The Artist's Eye*

1979 New York, Maurice Segoura, *Eighteenth Century French Academic Art. Selected Works* (C.P. Janet and P.L. Affif)

1980 London, Kenwood House, *Gaspard Dughet called Gaspar Poussin 1615–75. A French landscape painter in seventeenth century Rome and his influence on British art* (A. French)

1980 London, National Gallery, *Second Sight. Claude–Turner* (M. Wilson)

1980–1 Cambridge, Fitzwilliam Museum, *Painting from Nature. The tradition of open-air oil sketching from the 17th to 19th centuries*

1981 Edinburgh, National Gallery of Scotland, *Poussin, Sacraments and Bacchanals: Paintings and Drawings on sacred and profane themes by Nicolas Poussin 1594–1665* (H. Brigstoke)

1981 Montreal, Montreal Museum of Fine Arts, *Largillierre and the Eighteenth Century Portrait* (A. Schnapper)

1982 Coventry, Herbert Art Gallery; Derby, Museum and Art Gallery; Doncaster, Museum and Art Gallery; Bath, Victoria Art Gallery, *The National Gallery lends Paintings of the Warm South by Foreign Painters in Italy in the Seventeenth Century* (D. Gordon)

1982 London, National Gallery, *Acquisition in Focus. Claude. The Enchanted Castle* (M. Wilson)

1982 London, National Gallery, *Watch this Space* (no catalogue)

1982 Paris, Grand Palais; New York, Metropolitan Museum of Art; Chicago, Art Institute, *La peinture française du XVIIe siècle dans les collections américaines* (P. Rosenberg)

1982–3 Washington DC, National Gallery of Art, and Paris, Grand Palais, *Claude Lorrain 1600–1682* (H.D. Russell)

1983 London, National Gallery, *The Neglected National Gallery*

1984 Canterbury, Royal Museum; Wolverhampton Art Gallery; Lincoln, Usher Art Gallery; Exeter, Royal Albert Memorial Museum, *The capricious view: an exhibition of townscapes* (M. Helston)

1984 Madrid, Museo del Prado, *Claudio de Lorena el ideal clásico de paisaje en el siglo XVII* (J.J. Luna)

1985 Dublin, National Gallery of Ireland, *Le Classicisme Français. Masterpieces of Seventeenth Century Painting* (S. Laveissière)

1985 New York, Richard L. Feigen & Co., *Landscape Painting in Rome 1595–1675* (A.S. Harris)

1985 Paris, Sorbonne, *Richelieu et le Monde de l'Esprit* (A. Tuilier et al.)

1985–6 Leicester, Leicestershire Museum and Art Gallery, *Masterpieces of Reality. French 17th Century Painting* (C. Wright)

1986–7 London, Dulwich Picture Gallery, *Nicolas Poussin. Venus and Mercury* (G. Waterfield)

1987 Caen, Musée des Beaux-Arts, *Symbolique & botanique. Le sens caché des fleurs dans la peinture au XVIIe siècle* (A. Tapié)

1987 London, National Gallery, *Director's Choice. Selected Acquisitions 1973–1986. An exhibition to mark the retirement of Sir Michael Levey as Director of the National Gallery* (A. Braham et al.)

1987 New York, Didier Aaron, Inc., *A Timeless Heritage. Masterworks of Painting for Today's Collector*

1988 Fort Worth, Kimbell Art Museum, *Poussin. The Early Years in Rome* (K. Oberhuber)

1988 Leningrad, Hermitage Museum, and Moscow, Pushkin Museum, *Masterpieces from the National Gallery, London* (no catalogue)

1988 London, National Gallery, *'Noble and Patriotic.' The Beaumont Gift 1828* (J. Leighton)

1988–9 London, British Museum, *Treasures for the Nation: conserving our heritage*

1989 London, National Gallery, *The Artist's Eye: Bridget Riley – An Exhibition of National Gallery Paintings selected by the artist*

1989–90 Grenoble, Musée; Rennes, Musée des Beaux-Arts et d'Archéologie; Bordeaux, Musée des Beaux-Arts, *Laurent de La Hyre 1606–1656: l'homme et l'oeuvre* (P. Rosenberg and J. Thuillier)

1990 Edinburgh, National Gallery of Scotland, *Cézanne and Poussin: The Classical Vision of Landscape* (R. Verdi)

1990 London, National Gallery, *The Artist's Eye: Victor Pasmore*

1990–1 Oxford, Ashmolean Museum, *A Loan Exhibition of Drawings by Nicolas Poussin from British Collections* (H. Brigstocke)

1990–1 Oxford, Ashmolean Museum, and London, Accademia Italiana; *Italy by Moonlight, the Night in Italian Painting 1550–1850* (T. Henry)

1990–1 Paris, Grand Palais, *Vouet* (J. Thuillier)

1991 Amsterdam, Rijksmuseum, *Meeting of Masterpieces: Jan Both – Claude Lorrain* (P.J.J. van Thiel and H. Wine)

1991 Kendal, Abbot Hall Art Gallery, *Classical and Picturesque Landscapes*

1991–2 Paris, Grand Palais; Philadelphia, Museum of Art; Fort Worth, Kimbell Art Museum, *Les Amours des Dieux. La peinture mythologique de Watteau à David* (C.B. Bailey)

1992 Copenhagen, Statens Museum for Kunst, *Fransk Guldalder. Poussin og Claude og maleriet i det 17. århundredes Frankrig* (H. Wine and O. Koester)

1992–3 Birmingham, Birmingham Museum and Art Gallery, *Nicolas Poussin – 'Tancred & Erminia'* (R. Verdi)

1993 London, National Gallery. *Pictures in Pictures* (leaflet)

1994 London, National Gallery, *Themes and Variations. Ideas Personified* (leaflet)

1994 London, National Gallery, *Claude. The Poetic Landscape* (H. Wine)

1994–5 Chantilly, Institut de France, Musée Condé, Château de Chantilly, *Nicolas Poussin. La collection du musée Condé à Chantilly* (P. Rosenberg and L.-A. Prat)

1994–5 London, Courtauld Institute Galleries, and Manchester, Whitworth Art Gallery, *Prints (re)presenting Poussin* (S. Hyde and K. Scott)

1994–5 Paris, Grand Palais, *Nicolas Poussin, 1594–1665* (P. Rosenberg)

1994–5 Rome, Académie de France à Rome, Villa Medici, *Roma 1630: Il trionfo del pennello* (O. Bonfait)

1995 London, National Gallery, *Gombrich on Shadows* (E.H. Gombrich)

1995 London, National Gallery, *Poussin Problems* (no catalogue)

1995 London, Royal Academy, *Nicolas Poussin. 1594–1665* (R. Verdi)

1995–6 Amiens, Musée de Picardie, and Versailles, Musée National des Châteaux de Versailles et de Trianon, *Versailles: les chasses exotiques de Louis XV* (X. Salmon)

1995–6 London, British Library, *John Keats* (no catalogue)

1996–7 London, National Gallery, *John Julius Angerstein* (no catalogue)

1996–7 Washington, Brooklyn, St Louis, *In the Light of Italy. Corot and Early Open-Air Painting* (P. Galassi)

1997 London, Christie's, *Treasures for Everyone: Saved by the National Art Collections Fund* (no catalogue)

1997 London, National Gallery, *Themes and Variations: Sleep* (leaflet)

1997 San Francisco, Fine Arts Musuem of San Francisco, and London, National Gallery, *Masters of Light: Dutch Painting in Utrecht during the Golden Age* (C. Brown)

1998–9 Rome, Palazzo delle Esposizioni, *Nicolas Poussin. I primi anni romani* (D. Mahon)

1998 Tokyo, National Musuem of Western Art, *Claude Lorrain and the Ideal Landscape* (M. Roethlisberger and A. Kofuku)

2000 Los Angeles, J. Paul Getty Museum, *Drawn to painting: Leon Kossoff* (R. Kendall)

2000 Grenoble, Musée des Beaux-Arts, *Eustache Le Sueur* (A. Mérot)

2000–1 Jerusalem, Israel Museum of Art, *Landscapes of the Bible* (H. Wine)

2000–1 London, National Gallery, *Telling Time* (A. Sturgis)

2000–1 Montpellier, Musée Fabre, and Strasbourg, Musée des Beaux-Arts, *Sébastien Bourdon 1616–1671* (J. Thuillier)

2000–1 Rome, Villa Medici, *The Hidden God: Painting and Spirituality in France of Port-Royal and St Vincent de Paul* (N. MacGregor and A. le Pas de Sécheval)

2001 Paris, Musée du Louvre, *Un tableau de Poussin redécouvert: Sainte Françoise Romaine* (M. Fumaroli)

Index by inventory number

List of attributions changed from the 1957 French School catalogue

OLD ATTRIBUTION	INVENTORY NUMBER	NEW ATTRIBUTION
Philippe de Champaigne	798	Philippe de Champaigne and Studio
Ascribed to Philippe de Champaigne	2291	Jakob Ferdinand Voet
After Claude	55	Studio of Claude
Ascribed to Claude	1319	Claude
Seventeenth Century French School (?)	5448	French or North Italian
'Antoine' Lenain	1425	The Le Nain Brothers
After 'Louis' Lenain	3879	The Le Nain Brothers
Follower of the Brothers Lenain	4857	The Le Nain Brothers
Ascribed to Pierre Mignard	2929	Gabriel Revel
After Nicolas Poussin	40	Nicolas Poussin
After Nicolas Poussin	91	Nicolas Poussin
After Nicolas Poussin	165	Angelo Caroselli
After Nicolas Poussin	1422	After Poussin (?)
After Nicolas Poussin (?)	42	After Poussin
Follower of Nicolas Poussin	2619	Gaspard Dughet

Index of previous owners

Aglié, Cesare Ambrogio San Martino, Count d': Claude NG 1319

Aglié, Count St Martin d': Claude NG 1319

Allnatt, Mrs D.M.: Poussin NG 6390, NG 6391

Angerstein, John Julius: Claude NG 2, NG 12, NG 14, NG 30; Dughet NG 31, NG 36; after Poussin NG 42; Valentin NG 4919

Anglesey, Charles Henry Alexander Paget, 6th Marquess of: Le Sueur NG 6576

Ansell, Robert: Claude NG 58

Ashburnham, Bertram, 4th Earl of: Poussin NG 6477

Ashburnham, John, 2nd Earl of: Poussin NG 6477

Ashburton, Alexander Baring, 1st Baron: Dughet NG 2619

Ashburton, Francis Denzil Edward Baring, 5th Baron: Dughet NG 2619

Astor, Waldorf: Le Sueur NG 6576

Barberini, Cardinal Carlo: Claude NG 30

Barberini, Cardinal Francesco: Claude NG 30

Barberini family: after Poussin NG 42

Bartie, John: Le Sueur NG 6299

Basan, Pierre-François(?): Poussin NG 62

Baseley, Revd Thomas: Poussin NG 62

Bearsted, Marcus Samuel, 1st Viscount: Valentin NG 4919

Bearsted, Walter Horace, 2nd Viscount: Valentin NG 4919

Beauchamp, Jocelyn: Poussin NG 6277

Beauchamp-Proctor, Sir Thomas: Poussin NG 6277

Beauchamp-Proctor, Sir William: Poussin NG 6277

Beaulieu, Edward Hussey-Montague, Earl: Le Sueur NG 6299

Beaumont, Sir George: Bourdon NG 64; Claude NG 19, NG 58, NG 61; Studio of Claude NG 55; Poussin NG 40

Beckford, William: Dughet NG 1159

Blencowe, Misses M.E. and C.M.: Blancour NG 6358

Blondel de Gagny, Augustin de: Claude NG 61, NG 1018

Boccapaduli, Giuseppe: Poussin NG 6390, NG 6391

Bohn, Henry George: Le Nain NG 1425

Bonaparte, Lucien: Dughet NG 2619

Bordier, Jacques: Valentin NG 4919

Boston, George Florence Irby, 6th Baron: French/Italian NG 5448

Bouillon, Frédéric-Maurice de la Tour d'Auvergne, duc de: Claude NG 12, NG 14

Bouverie, Sir Jacob de: Poussin NG 5597

Bretagne, Jean-Baptiste de: Poussin NG 39

Bretonvilliers, Benigne Le Ragois, marquis de: Poussin NG 5597

Bretonvilliers, Jean-Baptiste Le Ragois de: Poussin NG 5597

Bridgewater, Francis Egerton, 3rd Duke of: Le Sueur NG 6576; Valentin NG 4919

Brienne, Louis-Henri Loménie de: Poussin NG 6519

Buchanan, William: Poussin NG 5472

Bullion, Claude de: Vouet and Studio NG 6292

Burrell, Sir Peter: French/Flemish NG 83

Butler, Charles: Champaigne NG 1449

Calonne, Charles-Alexandre de: Claude NG 6471; Poussin NG 62; after Poussin NG 1422

Carlisle, Frederick Howard, 5th Earl of: Le Sueur NG 6576; Valentin NG 4919

Carr, Revd W. Holwell: Claude NG 6; Dughet NG 68, NG 98; Dughet and Maratta NG 95; Poussin NG 91

Champernowne: Caroselli NG 165

Chandos, Henry Brydges, 2nd Duke of: French/Flemish NG 83

Chandos, James Brydges, 1st Duke of: French/Flemish NG 83

Châteauneuf, Jacques-Louis de Beringhen, marquis de: Studio of Claude NG 55

Chauncey, Nathaniel: Claude NG 6471

Chigi, Prince Agostino: Claude NG 6

Choiseul-Praslin, Louis-César-Renaud, duc de: Claude NG 2, NG 5

Cholmondeley, George James: Poussin NG 39, NG 65

Clarke, Sir Simon: Caroselli NG 165

Clive of Plassey, Robert Clive, Lord: Poussin NG 6519

Colonna, Filippo II: Caroselli NG 165; Dughet NG 31, NG 1159

Colonna, Filippo III: Caroselli NG 165

Colonna, Lorenzo Onofrio: Claude NG 6471; Dughet NG 31, NG 161, NG 1159

Cook, Sir Frederick Lucas: Millet NG 5593

Cook, Sir Herbert Frederick: Millet NG 5593

Court, William: Patel NG 6513

Craufurd, Quintin: Mignard NG 2967

dal Pozzo, Amedeo: Poussin NG 5597

dal Pozzo, Cassiano: Poussin NG 6390, NG 6391

dal Pozzo, Giacomo Maurizio: Poussin NG 5597

Davenant, Henry: Claude NG 6471

Davies, Richard Hart: Dughet NG 1159

Day, Alexander: Caroselli NG 165

De Grey family: Le Sueur NG 6576

Delmé, Peter: Claude NG 19; Dughet NG 36; Poussin NG 6477

Desenfans, Noel Joseph: Claude NG 30, NG 1319

Didier Aaron, Inc: Patel NG 6513

du Housset: Poussin NG 6519

du Plessis-Rambouillet, Nicolas(?): Poussin NG 5763

du Taillis, Général: Le Nain NG 3879

du Vivier: Claude NG 1018

Duane, Matthew: Claude NG 61

Ducoudray, Mme Rouillé: Parrocel NG 6473, NG 6474

Ellis, Wynn: Claude NG 1018

Emmerson, Thomas: Poussin NG 5472

Espagnac, comte d': Champaigne NG 1449

Farnborough, Charles Long, Lord: Dughet NG 161

Fesch, Cardinal Joseph: Champaigne NG 6276; La Hyre NG 6329

Fielder, George: Baugin NG 2293; Voet NG 2291

Fitzgerald, George Robert: Le Nain NG 6331

Fonspertuis, Louis-Auguste Angran, vicomte de: Claude NG 1018

Fortescue, Hon. George Matthew: Poussin NG 6390, NG 6391

Franks, Sir Augustus Wollaston: Champaigne and Studio NG 798

Franks, Frederick: Champaigne and Studio NG 798

Furtado-Heine, Cécile-Charlotte: Champaigne NG 6276

Gaignat, Louis-Jean: Claude NG 5

Gambais, François-Louis de Nyert, marquis de: Poussin NG 5763, NG 6519

Giori, Angelo: Claude NG 5

Government (HM): Dughet NG 36

Govett, Ernest: Nomé NG 260

Gower, Earl see Stafford

Grenville, William Wyndham, 1st Lord: Poussin NG 6390, NG 6391

Grosvenor, Richard, 1st Earl: Patel NG 6513

Gruyn, Pierre: Poussin NG 6277

Hamilton, Revd Mr Frederick: Poussin NG 62

Hamilton, Gavin: Poussin NG 6390, NG 6391

Hamlet, Thomas: Poussin NG 62

Hampden, Thomas, 2nd Viscount: Claude NG 1319

Hariague, Madame: Poussin NG 65

Hariague, Pierre: Poussin NG 65

Harman, Jeremiah: Claude NG 1018; Le Sueur NG 6576; Valentin NG 4919

Harris, Tomas: Poussin NG 6390, NG 6391

Hartley, Mrs: Caroselli NG 165

Heathcoat-Amory, R.F.: Poussin NG 6390, NG 6391

Heathcote, Robert: Poussin NG 5472

Heim, François: Vouet and Studio NG 6292

Henry, Thomas: Champaigne NG 1449

Herries, Sir Robert: Claude NG 2, NG 5

Heythusen, Gerard Levinge van: Claude NG 30, NG 1319

Higginson, Edmund: Claude NG 1018

Hindley-Smith, Frank: Le Nain NG 3879

Hope, Henry(?): Poussin NG 91

Hope, John William: Poussin NG 91

Hoym, comte de: Studio of Claude NG 55

In and Out Ltd (Naval and Military Club): Le Sueur NG 6576

Jones, Thomas: Caroselli NG 165

Kinnaird, Lord: Poussin NG 62

Knight, Edward: Le Sueur NG 6299; Poussin NG 39, NG 65

Knight, John: Poussin NG 39, NG 65

General index

Bold type has been used for references to the main catalogue entries; page numbers in italics refer to illustrations.